150 Years of Photo Journalism

**Jahre Photojournalismus
ans de photos de presse**

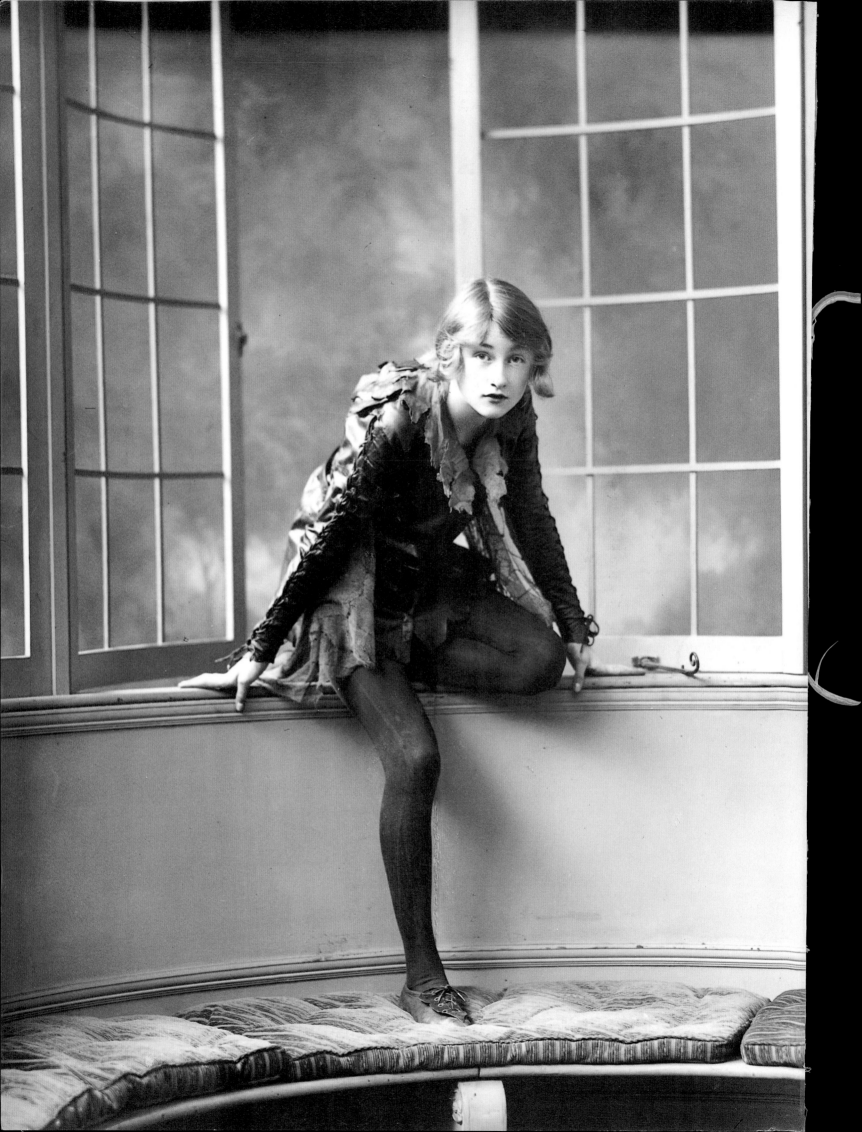

The Hulton Getty Picture Collection

150 Years of Photo Journalism

Jahre Photojournalismus
ans de photos de presse

Nick Yapp (Part I)

Amanda Hopkinson (Part II)

KÖNEMANN

(FRONTISPIECE) STEPHANIE STEPHENS AS PETER PAN IN 1915.
(FRONTISPIZ) STEPHANIE STEPHENS ALS PETER PAN, 1915.
(FRONTISPICE) STEPHANIE STEPHENS DANS LE RÔLE DE PETER PAN, 1915.

© 1995 Könemann Verlagsgesellschaft mbH
Bonner Straße 126, D-50968 Köln
© 1995 Hulton Getty Picture Collection Ltd
This book is a single-volume version of the 1995 two-volume publication of the same name.

All photographs: drawn from the Hulton Getty Picture Collection, London

This book was produced by The Hulton Getty Picture Collection Ltd
Unique House, 21-31 Woodfield Road, London W9 2BA

Publishing concept: Charles Merullo
Art director: Peter Feierabend
Production manager: Detlev Schaper
Design: Paul Welti
Cover design: Peter Feierabend, Claudio Martinez
Picture research: Sue Percival, Leon Meyer
Project editor: Elisabeth Ingles
German translation: Birgit Herbst (part I), Manfred Allié (part II)
French translation: Sylvie Adam-Kuenen, Michèle Schreyer
Typesetting: Peter Howard
Colour separation: Imago
Printed and bound by Mateu Cromo Artes, Madrid
Printed in Spain

ISBN 3-89508-099-3

10 9 8 7 6 5 4

Contents

Inhalt

Sommaire

Part I
1850–1918

HIGH BRIDGE, GENESEE RIVER, NEAR ROCHESTER,
NEW YORK.

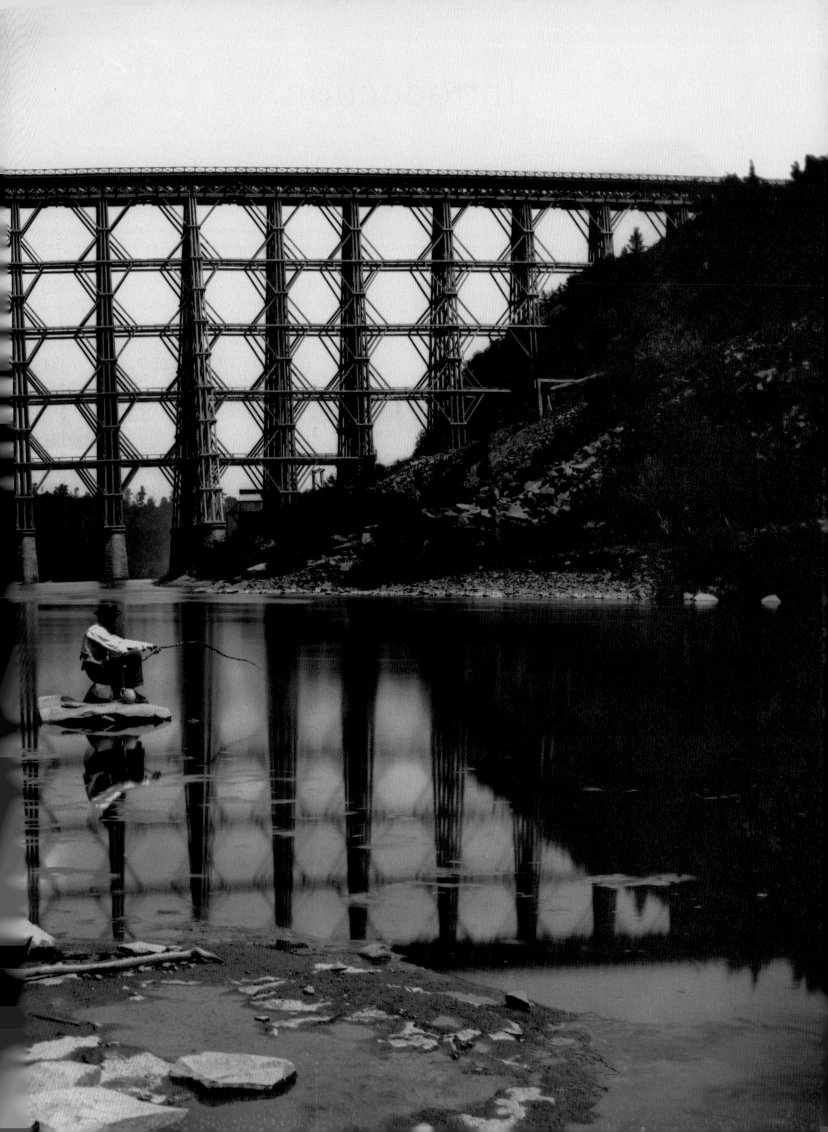

Introduction

LIFE was a lottery in the mid-19th century. Whether rich or poor, mother and baby both needed luck to survive the perils of childbirth. Infant mortality rates were terrifyingly high, and cholera, typhus, diphtheria and a dozen other diseases were in constant brooding attendance. Of those who did survive into infancy, childhood and adulthood, the rich lived longer, ate better, had more to enjoy. The poor struggled to exist in bad housing, worked exhausting hours, ailed and died, often in their thirties and forties. The average expectation of life in the industrial world varied from country to country as well as from class to class. In the slums and sweatshops it could be as low as thirty-five; in villas and offices it could be as high as sixty. For white men and women in the ever-extending colonies it could be little more than forty. Death seemed always near at hand and people fervently prayed for a longer, as well as a better, life hereafter.

But if you won the lottery, what a time it was to be alive! Those born in 1850 who were granted their threescore years and ten witnessed a transformation of life on earth hitherto unknown. They entered a world where most people travelled only as fast as a horse could carry them – though steam locomotives were already rattling along at 45 miles an hour (72kph), shocking Queen Victoria, but delighting many. To sail to another land meant a voyage of considerable discomfort, often prolonged by the vagaries of the wind. Most people still lived, worked and died on the land. Anaesthetics were unknown. Family planning was unheard of. Open sewers ran along the centres of even the most fashionable streets in the smartest cities. There was no electricity, and gas, as a fuel for light or heat, was still something of a novelty.

In Europe there was a sprinkling of insecure republics, but in most countries, king or emperor sat firmly on his throne and all was, on the face of it, right with the world. The indigenous North Americans hunted buffalo on the central plains; the interiors of Africa, Australia and South America were unknown to white people; Japan and China were closed communities. The old order prevailed. Dukes and princes, bishops and cardinals hunted for sport and oppressed for a living. To the vast majority, the deliberations of central government were of far less concern than the whims of the local lord. If you were a poor male and wanted to travel, you joined the army. If you were a poor female and wanted to travel, you couldn't.

A lifetime later, so much had changed. A succession of wars had redrawn the frontiers of Europe. Italy and Germany had both forged painful unification. Russia had given birth to a revolution that was to bring hope and terror to millions in almost equal shares. The great empires of Austro-Hungary and Turkey had collapsed. The bitter fight to win the endless arms race had led to breathtaking developments of plane, submarine, machine gun, tank and a multitude of other toys of war. Colonial greed had hacked and dug its way through most of Africa, India and America, and invaded the far-flung islands of the Pacific Ocean. Custer's Last Stand had proved to be the native Americans' last victory, and train excursions of sharpshooters from the Eastern States had all but removed the buffalo from the plains. Scott and Amundsen had raced to the South Pole. To the Norwegian victor had been immediate glory: to the English loser, fame as lasting as his own body in the frozen wastes of that terrible land.

There was electricity, the gramophone, the cinema. Thomas Crapper had invented the flush lavatory, bringing at first disease and dread to those who used it, but, later, hope and health. The internal combustion engine was shunting the horse off the road: the steam traction engine was driving horses from the land. There was town planning. There were underground sewers and underground railways. There were suburbs, skyscrapers, department stores, millionaires, strikes and cheap newspapers. There was mass production and mass consumption. Women had the vote. Men were conscripted into monster armies. Children received education, whether they liked it or not. International sport had been revived – the first time tribes had met in playful rivalry since the ancient Olympic Games. There was the telephone and the telegraph. In 1919, when those born in 1850 would have been venerable, and quite possibly exhausted, Alcock and Brown flew a Vickers Vimy bi-plane across the Atlantic at 100 miles an hour (160kph), just beating the arrival of the Original Dixieland Jazz Band in Europe. The world had shrunk. The 20th century had arrived.

It was the high-water mark of European domination. The United States was rapidly becoming the richest country in the world, but was still looking inwards on itself, pursuing a policy of isolation and loath to become involved in foreign affairs. Europeans constructed the railways that crossed South America and Africa; engineered the canals that joined oceans; and even built an opera house 3,000 miles up the Amazon River.

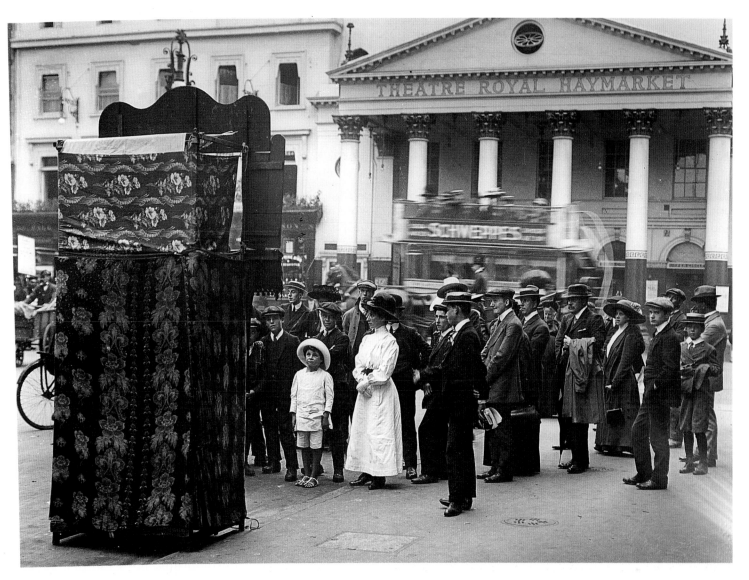

A PUNCH AND JUDY SHOW IN THE HAYMARKET, LONDON, AROUND 1900.

PUPPENTHEATER AUF DEM HAYMARKET, LONDON, UM 1900.

THÉÂTRE DE MARIONNETTES SUR LE HAYMARKET, LONDRES, VERS 1900.

Wherever they went, the French took with them the Code Napoléon: the British took a few foxes and packs of hounds. The ports of Europe filled with the riches of the present: cotton, wool, manganese, copper, rubber, tea and coffee, meat and grain. The museums of Europe filled with the riches of the past: gongs, temple bells, statues, jewellery, fossils, amulets, skeletons, whole tombs. In exchange, entire continents received beads, guns and Bibles – and a second-hand language and culture.

But millions benefited from the advance of science and learning, from better housing, from education. Life was still harsh and brutish for many, but at least fewer people risked losing everything in the lottery. More babies survived. Children were healthier. The poor were a little less poor; the rich, for the most part, a little less rich. Some women had professional and social freedom. People ate better food, but probably breathed worse air. The future seemed to hold much.

On pages 16 and 17 is a gallery of some of the most famous – or notorious – figures of the seventy-year period.

Towards the end of this lifetime of achievement, Europe tore itself apart in the worst war in history, a war that nobody wanted. When the guns finally stopped, an exhausted continent had lost its grip on the world. Germany was crippled, defeated, bankrupt. France and Britain had lost a generation of hope and promise. Russia was emerging from the pangs of revolution into the searing pain of civil war. Serbia, Macedonia and Bosnia had disappeared from the map.

President Woodrow Wilson of the United States laid the ground rules for the Treaty of Versailles and then withdrew his troops and his involvement. But the United States had accumulated a massive self-confidence during the war, and was poised for its turn to plunder the rest of the world – including Europe.

Einleitung

IN der Mitte des 19. Jahrhunderts war das Leben ein Glücksspiel. Ob reich oder arm, Mutter und Kind brauchten Glück, um die Gefahren der Geburt zu überleben. Die Kindersterblichkeitsrate war erschreckend hoch, und Cholera, Typhus, Diphtherie und ein Dutzend anderer Krankheiten grassierten. Von denen, die bis zum Erwachsenenalter durchhielten, konnten sich die Reichen, nicht zuletzt aufgrund einer besseren Ernährung, eines längeren und angenehmeren Lebens erfreuen. Die Armen kämpften in schlechten Unterkünften um ihre Existenz, arbeiteten bis zur Erschöp-fung, wurden krank und starben häufig schon zwischen dem dreißigsten und vierzigsten Lebensjahr. Die durchschnittliche Lebenserwartung in der industrialisierten Welt war sowohl von Land zu Land als auch von Klasse zu Klasse verschieden. In den Slums und den Ausbeuterbetrieben wurden die Menschen oft nur 35, in den Villen und Büros jedoch bis zu 60 Jahre alt. Weiße Männer und Frauen, die in den ständig wachsenden Kolonien lebten, hatten eine Lebenserwartung von knapp über 40 Jahren. Der Tod schien überall zu lauern, und die Menschen beteten für ein längeres und besseres Leben im Jenseits.

Wenn man jedoch das große Los gezogen hatte, konnte das Leben herrlich sein. Jene, die 1850 geboren wurden und das siebzigste Lebensjahr erreichten, erlebten bis dahin ungekannte Veränderungen. Sie traten ein in eine Welt, in der die meisten Menschen nur so schnell reisten, wie ein Pferd sie tragen konnte, obwohl die Dampflokomotiven – zum Schrecken von Königin Victoria, aber zur Freude vieler – bereits mit 70 Stundenkilometern dahinratterten. In ein anderes Land zu segeln bedeutete, eine mit beträchtlichen Unannehmlichkeiten verbundene Reise anzutreten, die häufig durch die Unberechenbarkeit des Windes noch verlängert wurde. Die meisten Menschen lebten, arbeiteten und starben noch immer auf dem Land. Betäubungsmittel kannte man nicht, und von Familienplanung hatte man ebenfalls noch nichts gehört. Die Abwässer flossen offen durch die Straßen in den Zentren selbst der elegantesten Städte. Es gab keine Elektrizität, und Gas für Lampen oder Heizungen war noch immer etwas Neues.

In Europa gab es ein paar vereinzelte ungefestigte Republiken, aber in den meisten Ländern saßen Könige oder Kaiser fest auf ihrem Thron, und nach außen hin hatte alles seine Ordnung. In den Ebenen Nordamerikas jagten die Eingeborenen Büffel; das Innere von Afrika, Australien und Südamerika hatte noch kein Weißer gesehen; Japan und China waren geschlossene Gemeinschaften. Die alte Ordnung blieb vorherrschend. Herzöge und Prinzen, Bischöfe und Kardinäle jagten zum Vergnügen und unterdrückten zur Bereicherung. Für die große Mehrheit der Bevölkerung waren die Entscheidungen der zentralen Landesregierung von weitaus geringerer Bedeutung als die Launen ihres Gutsherrn. Mittellose Männer, die reisen wollten, gingen in die Armee, für mittellose Frauen gab es keine solche Möglichkeit.

Eine Generation später hatte sich sehr viel verändert. Eine Reihe von Kriegen hatte die Grenzen Europas verschoben. Sowohl Italien als auch Deutschland hatten einen schmerzhaften Vereinigungsprozeß erlebt. In Rußland hatte sich eine Revolution vollzogen, die für Millionen von Menschen fast ebensoviel Hoffnung wie Schrecken bedeuten sollte. Die großen Reiche Österreich-Ungarn und Türkei waren zusammengebrochen. Der bittere Kampf um den Sieg im Rüstungswettlauf hatte zur atemberaubend schnellen Entwicklung von Flugzeugen, Unterseebooten, Maschinengewehren, Panzern und einer Vielzahl anderer »Kriegsspielzeuge« geführt. Die Gier der Kolonialmächte hatte sich einen Weg durch den größten Teil von Afrika, Indien und Amerika geschlagen und war über die entlegenen Inseln des Pazifischen Ozeans hergefallen. General Custers letztes Gefecht hatte sich als letzter Sieg der amerikanischen Ureinwohner erwiesen, und Trupps von Scharfschützen aus den Oststaaten hatten die Büffel fast vollständig von den Ebenen verschwinden lassen. Scott und Amundsen hatten sich ein Wettrennen zum Südpol geliefert. Dem norwegischen Sieger wurde unmittelbarer Ruhm zuteil, während der britische Verlierer im ewigen Eis dieses grausamen Landes zurückblieb.

Es gab nun Elektrizität, das Grammophon, das Kino. Thomas Crapper hatte das Wasserklosett erfunden und seinen ersten Benutzern Krankheit und Schrecken gebracht, später jedoch Hoffnung und Gesundheit. Der Verbrennungsmotor verdrängte das Pferd von den Straßen, der dampfbetriebene Traktor vertrieb es vom Land. Man betrieb Stadtplanung. Es gab unterirdische Abwasserkanäle und unterirdische Züge. Es gab Vororte, Hochhäuser, Kaufhäuser, Millionäre, Streiks und billige Zeitungen, Massenproduktion und Massenkonsum. Frauen erhielten das Wahlrecht. Männer wurden in Schreckensarmeen eingezogen. Kinder erhielten Er-

ziehung und Ausbildung, ob sie wollten oder nicht. Der internationale Sport war wiederbelebt worden; zum ersten Mal seit den Olympischen Spielen der Antike hatten sich wieder Völker zum spielerischen Wettkampf zusammen-gefunden. Es gab das Telephon und den Fernschreiber. Im Jahre 1919, in dem die 1850 Geborenen mit großer Wahrscheinlichkeit alt und verbraucht gewesen wären, flogen Alcock und Brown in einem Vickers-Vimy-Doppeldecker mit einer Geschwindigkeit von 160 Stundenkilometern über den Atlantik und erreichten Europa kurz vor der Ankunft der Original Dixieland Jazz Band. Die Welt war kleiner geworden. Das zwanzigste Jahrhundert hatte begonnen.

Die europäische Vorherrschaft hatte mittlerweile ihren Höhepunkt erreicht. Die Vereinigten Staaten von Amerika wurden schnell zur reichsten Nation der Welt, waren jedoch noch immer äußerst selbstbezogen und verfolgten eine Politik der Isolation, mit dem erklärten Ziel der Nichteinmischung in fremde Angelegenheiten. Die Europäer bauten Eisenbahnen in Südamerika und in Afrika, sie konstruierten Kanäle, die Ozeane miteinander verbanden, und mitten im Urwald, am Oberlauf des Amazonas, errichteten sie sogar ein Opernhaus. Wo immer sie auch hinkamen, brachten die Franzosen den Code Napoléon und die Briten ein paar Füchse und Jagdhunde mit. Die Häfen Europas füllten sich mit den Reichtümern der Gegenwart: mit Baumwolle, Wolle, Mangan, Kupfer, Kautschuk, Tee und Kaffee, mit Fleisch und Getreide. Die Museen Europas hingegen füllten sich mit den Reichtümern der Vergangenheit: riesige Gongs, Tempelglocken, Statuen, Juwelen, Fossilien, Amulette, Skelette, sogar vollständige Grabanlagen. Im Gegenzug erhielten ganze Kontinente Perlenketten, Gewehre und Bibeln sowie eine Sprache und eine Kultur sozusagen aus zweiter Hand.

Millionen Menschen jedoch profitierten vom Fortschritt der Wissenschaft und den neuen Erkenntnissen, von besserer Unterkunft, Erziehung und Ausbildung. Für viele war das Leben noch immer schwer, aber zumindest liefen weniger Menschen Gefahr, alles in der Lebenslotterie zu verlieren. Mehr Babies überlebten, und die Kinder waren gesünder. Die Armen waren ein bißchen weniger arm und die meisten Reichen ein bißchen weniger reich. Einige Frauen genossen berufliche und soziale Freiheit. Die Menschen ernährten sich besser, atmeten aber schlechtere Luft. Die Zukunft schien vieles bereit-zuhalten.

Auf den Seiten 16 und 17 finden Sie eine Porträtgalerie einiger der berühmtesten – berüchtigtsten – Persönlichkeiten jener fast 70 Jahre zwischen 1850 und 1918.

Gegen Ende dieser Zeit der bahnbrechenden Errungenschaften zerriß sich Europa im verheerendsten Krieg der Geschichte, einem Krieg, den niemand gewollt hatte. Als die Gewehre endlich schwiegen, hatte ein erschöpfter Kontinent seine Macht über die Welt verloren. Deutschland war geschunden, geschlagen und bankrott. Frankreich und Großbritannien hatten eine hoffnungsvolle und vielversprechende Generation verloren. Rußland war dabei, die Schrecken der Revolution gegen die des Bürgerkrieges einzutauschen. Serbien, Mazedonien und Bosnien waren von der Landkarte verschwunden.

Nachdem der Präsident der Vereinigten Staaten, Woodrow Wilson, die Statuten des Versailler Vertrages festgelegt hatte, zog er seine Truppen zurück und überließ Europa seinem Schicksal. Aber die Vereinigten Staaten hatten während des Krieges großes Selbstvertrauen gewonnen und waren bereit, den Rest der Welt – einschließlich Europa – zu plündern.

Introduction

LA vie, au milieu du XIX^e siècle, était un événement aléatoire. Riches ou pauvres, mères et enfants devaient avoir de la chance pour survivre à l'épreuve de l'accouchement. La mortalité infantile était terriblement élevée à une époque où le choléra, le typhus, la diphtérie et une dizaine d'autres maladies sévissaient. Parmi ceux qui survivaient à la petite enfance et à l'enfance pour atteindre l'âge adulte, c'était les riches qui vivaient le plus longtemps, grâce à une meilleure alimentation et à des avantages plus nombreux. Les pauvres luttaient pour survivre dans de méchants logements, s'échinaient au travail, étaient en mauvaise santé et mourraient souvent avant d'atteindre 50 ans, voire la quarantaine. L'espérance de vie moyenne dans le monde industriel variait aussi bien d'un pays à l'autre que d'une classe à l'autre. Dans les bidonvilles et les ateliers où la main-d'œuvre se faisait exploiter, elle pouvait être de 35 ans seulement. Dans les villas et dans les bureaux, elle pouvait monter jusqu'à 60 ans. Pour les hommes et les femmes de race blanche, dans les colonies en expansion, elle pouvait légèrement dépasser 40 ans. On priait avec ferveur pour une vie plus longue et meilleure après la mort qui semblait toujours rôder.

Mais si vous étiez chanceux, quelle époque bénie ! Ceux qui naquirent en 1850 et eurent la bonne fortune de vivre jusqu'à 70 ans furent témoins d'une transformation sans précédent de leur existence ici-bas. Ils pénétraient dans un monde où la plupart des gens ne voyageaient pas plus loin qu'un cheval pouvait les porter, même si les locomotives à vapeur roulaient déjà, dans un vacarme strident, à 70 km/h, choquant la reine Victoria mais ravissant le plus grand nombre. Les voyages à l'étranger en bateau étaient synonymes de bien des désagréments qu'aggravaient souvent les vents capricieux. La plupart des gens continuaient à vivre, travailler et mourir à la campagne. Les anesthésiques étaient inconnus, tout comme le planning familial. Les collecteurs d'eaux usées étaient disposés à ciel ouvert au beau milieu des rues, même dans les plus élégantes des villes les plus pimpantes. Il n'y avait pas d'électricité ; quant au gaz, pour s'éclairer ou se chauffer, il faisait encore figure de nouveauté.

En Europe, il y avait bien ici et là quelques républiques peu stables, mais dans la majorité des pays régnait un roi ou un empereur fermement assis sur son trône. Tout était pour le mieux dans le meilleur des mondes ; l'ordre établi prévalait. Les ducs et les princes, les évêques et les cardinaux avaient fait de la chasse un sport, et de l'oppression un moyen d'existence. Pour l'immense majorité des gens, les délibérations du gouvernement central étaient bien moins préoccupantes que les caprices du seigneur local. L'homme pauvre qui voulait voyager entrait dans l'armée. Pour la femme pauvre, c'était impossible.

Que de changements en l'espace d'une vie. Une cascade de guerres avait redessiné les frontières en Europe. L'Italie et l'Allemagne avaient toutes deux forgé une unification douloureuse. La Russie avait enfanté une révolution qui allait être synonyme d'espoir et de terreur pour des millions de personnes. Les grands empires d'Autriche-Hongrie et de Turquie s'étaient effondrés. La bataille acharnée en vue de remporter l'interminable course aux armements avait abouti à des progrès stupéfiants : l'avion, le sous-marin, la mitrailleuse, le char d'assaut et tant d'autres engins de guerre étaient apparus. La cupidité coloniale s'était frayée un chemin par la violence à travers la plus grande partie de l'Afrique, de l'Inde et de l'Amérique, jusqu'aux îles qui fourmillaient dans l'océan Pacifique. Le massacre des hommes de Custer fut la dernière victoire des Amérindiens. Les chasseurs des états de l'Est, venus par trains, firent peu à peu disparaître les bisons de la prairie. Scott et Amundsen s'étaient lancés dans une course au pôle Sud. Le vainqueur norvégien en avait tiré une gloire immédiate; son malheureux concurrent anglais une popularité qui devait durer aussi longtemps que son propre corps pris dans la glace.

Il y avait l'électricité, le gramophone et le cinéma. Thomas Crapper avait inventé la chasse d'eau qui commença par répandre la maladie parmi ses utilisateurs avant d'apporter l'hygiène. Le moteur à combustion interne était en passe de supplanter le cheval ; la traction à vapeur sur le point d'éliminer les chevaux des campagnes. On urbanisait. Il y avait les collecteurs de déchets et les chemins de fer souterrains. Il y avait les banlieues, les gratte-ciel, les grandes surfaces, les millionnaires, les grèves et les journaux bon marché. Il y avait la production en série et la consommation de

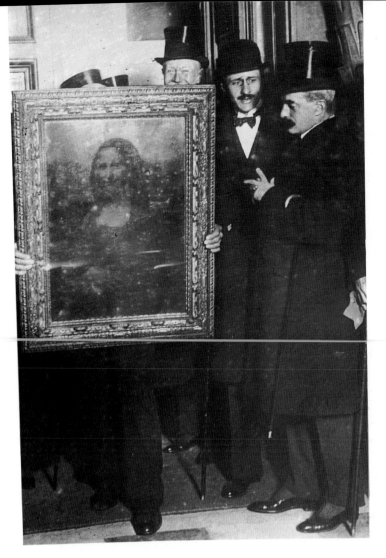

THE MONA LISA ARRIVING AT THE
ÉCOLE DES BEAUX ARTS, PARIS.

DIE ANKUNFT DER MONA LISA IN DER
ÉCOLE DES BEAUX ARTS, PARIS.

LA JOCONDE ARRIVE À
L'ÉCOLE DES BEAUX-ARTS, PARIS.

masse. Les femmes votaient. Les hommes devaient s'enrôler dans des armées gigantesques. Les enfants étaient instruits, quel qu'en fût leur désir. Le sport international avait été remis à l'honneur : c'était la première fois que des tribus rivalisaient dans des joutes amicales depuis les Jeux olympiques de l'Antiquité. Il y avait le téléphone et le télégraphe. En 1919, alors que ceux qui avaient vu le jour en 1850 étaient normalement devenus de vénérables vieillards vraisemblablement fatigués, Alcock et Brown traversaient l'Atlantique à 160 km/h dans un biplan, le Vickers Vimy, précédant de peu l'arrivée en Europe de l'Original Dixieland Jazz Band. Le monde avait rapetissé. Le XXᵉ siècle était là.

La domination de l'Europe était à son apogée. Les États-Unis, en passe de devenir le pays le plus riche du monde, continuaient à faire de l'introspection et à poursuivre leur politique d'isolement, répugnant à s'engager dans les affaires des autres nations. Les Européens avaient construit des chemins de fer pour traverser l'Amérique du Sud et l'Afrique, des canaux pour relier les océans et même un opéra à quelque 48 000 kilomètres en amont de l'Amazone. Partout où ils allaient, les Français emportaient avec eux le code Napoléon, les Britanniques quelques renards et des meutes de chiens de chasse. Les ports d'Europe s'emplissaient de coton, de laine, de manganèse, de cuivre, de caoutchouc, de thé, de café, de viande et de céréales. Les musées d'Europe accumulaient les richesses du passé : gongs, cloches de temples, statues, joyaux, fossiles, amulettes, squelettes et tombes intactes. En échange, des continents entiers recevaient des colliers de perles, des armes à feu, des canons, des bibles, ainsi qu'une langue et une culture importées.

Mais ils furent des millions à profiter des progrès de la science et des nouvelles connaissances, à bénéficier de meilleures conditions de logement et de l'instruction. Si la vie restait dans l'ensemble âpre et brutale, moins nombreux étaient les perdants. Davantage de bébés survivaient. Les enfants étaient en meilleure santé. Les pauvres étaient un peu moins pauvres et les riches, en majorité, un peu moins riches. Certaines femmes jouissaient d'une liberté dans le domaine social et professionnel. La qualité des aliments s'était améliorée, et bien que celle de l'air eût certainement empiré, l'avenir semblait riche de promesses.

Vous trouverez aux pages 16 et 17 une galerie de portraits de quelques – unes des personnalités les plus célèbres et les plus considérées durant ces presque 70 années de 1850 à 1918.

Après cette période faste, l'Europe connut la pire guerre de son histoire. Lorsque les armes se turent enfin, un continent exsangue avait perdu son emprise sur le monde. L'Allemagne était vaincue et ruinée. La France et la Grande-Bretagne avaient perdu une génération pleine d'espoir et de promesses. La Russie émergeait des convulsions de la révolution pour plonger dans une guerre civile douloureuse. La Serbie, la Macédoine et la Bosnie avaient été rayées de la carte.

Le président américain Woodrow Wilson jeta les bases du traité de Versailles, puis retira ses troupes et se désengagea. Toutefois, les États-Unis avaient fait preuve d'une immense assurance au cours de la guerre, et ils étaient bien décidés à accroître leur hégémonie économique.

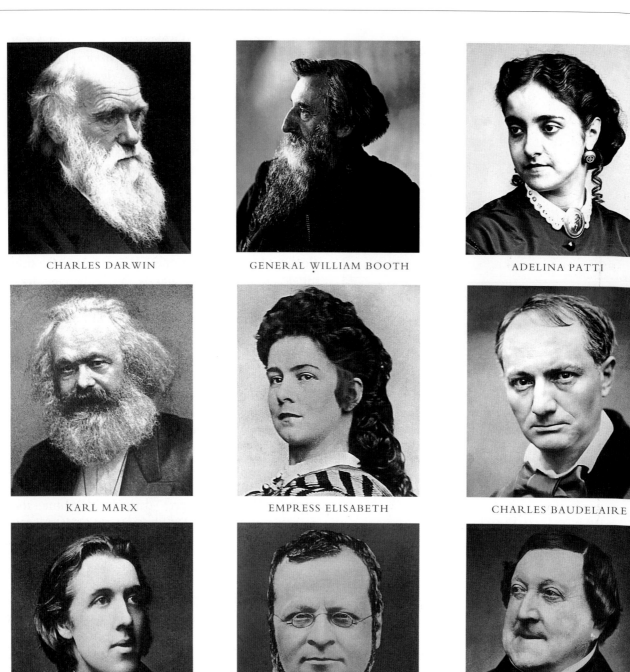

CHARLES DARWIN GENERAL WILLIAM BOOTH ADELINA PATTI

KARL MARX EMPRESS ELISABETH CHARLES BAUDELAIRE

OSCAR WILDE CAMILLO CAVOUR GIOACCHINO ROSSINI

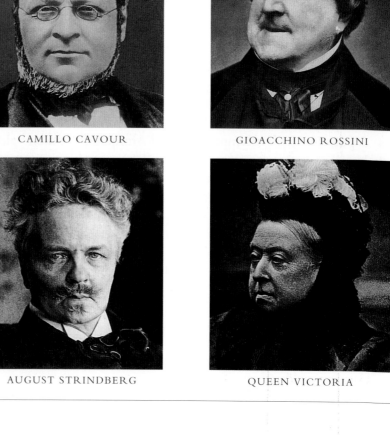

OTTO VON BISMARCK AUGUST STRINDBERG QUEEN VICTORIA

GIUSEPPE MAZZINI

FLORENCE NIGHTINGALE

ENRICO CARUSO

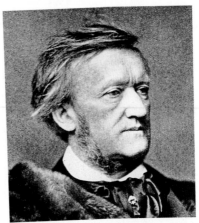

RICHARD WAGNER

GEORGE BERNARD SHAW

NAPOLÉON III

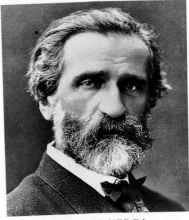

GIUSEPPE VERDI

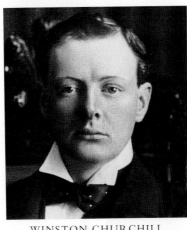

WINSTON CHURCHILL

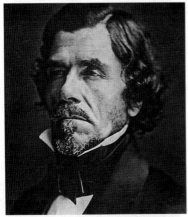

EUGÈNE DELACROIX

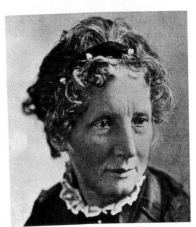

HARRIET BEECHER STOWE

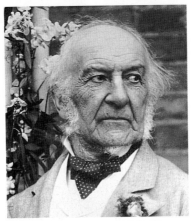

WILLIAM GLADSTONE

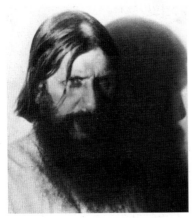

GRIGORI RASPUTIN

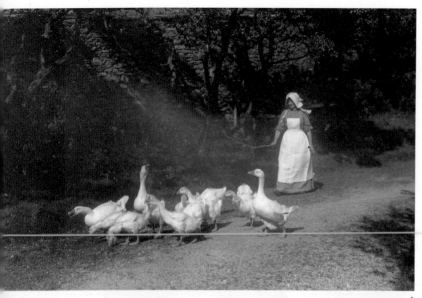

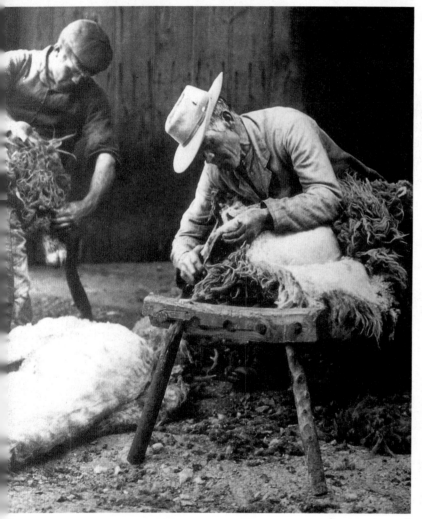

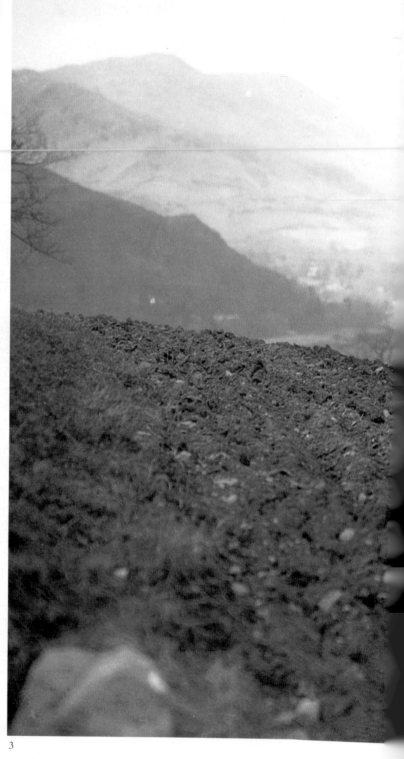

It was a time of rapid change in country life. Farmworkers and their families left the fields to trudge to the city and seek work in the factories. Steam-driven new machines replaced men and beasts on the land, and the old rhythms of rural life died away or were pushed aside. But itinerant sheep-shearers still found plenty of work in the summer (2); the farmer's wife tended the geese that pecked in the yard (1); and teams of horses or oxen ploughed furrows as straight as the eye of man could dictate (3).

Die Menschen auf dem Land erlebten eine Zeit der schnellen Veränderungen. Landarbeiter und ihre Familien verließen die Felder und zogen in die Städte, um Arbeit in den Fabriken zu suchen. Dampfbetriebene neue Maschinen ersetzten Menschen und Tiere, und der alte Rhythmus des

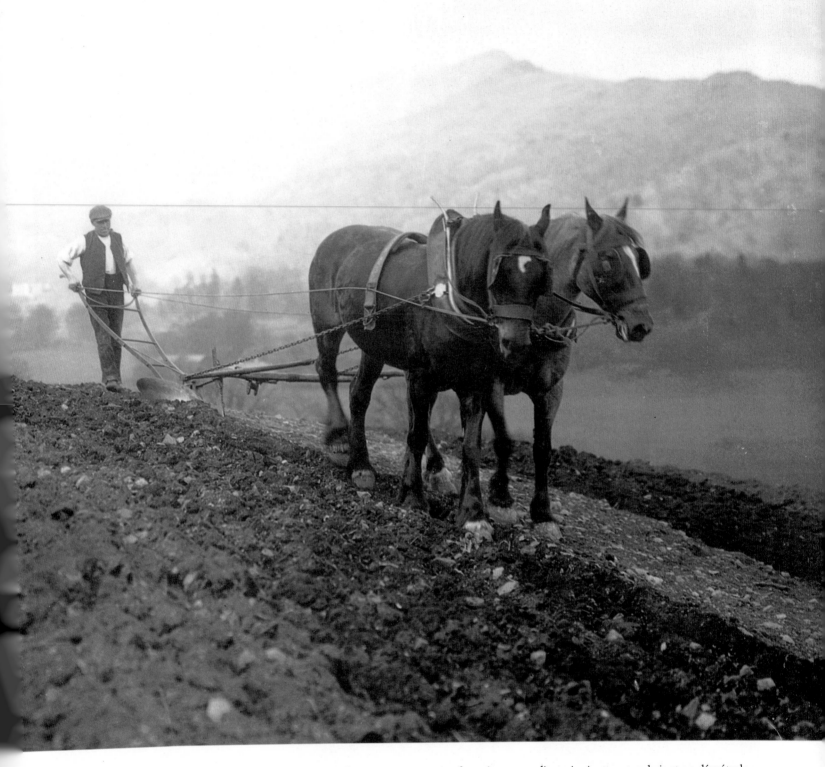

Landlebens kam zum Stillstand oder wurde verdrängt. Umherreisende Schafscherer jedoch fanden im Sommer noch immer genügend Arbeit (2); die Frau des Bauern hütete die Gänse, die auf dem Hof pickten (1), und Pferde- und Ochsengespanne pflügten schnurgerade Furchen (3).

L A vie des campagnes se transformait rapidement. Les ouvriers agricoles quittaient les champs avec leurs familles pour gagner la ville à la recherche d'un emploi en usine. Les nouvelles machines à vapeur remplaçaient les hommes et les bêtes, tandis que les rythmes, qui avaient autrefois ponctué la vie rurale,

disparaissaient ou tombaient en désuétude. Toutefois, pendant l'été, le travail ne manquait pas pour les tondeurs de moutons itinérants (2). Quant à la femme du fermier, elle s'occupait des oies qui picoraient dans la cour (1), tandis que les attelages de chevaux ou de bœufs labouraient des sillons aussi droits que le permettait l'œil humain (3).

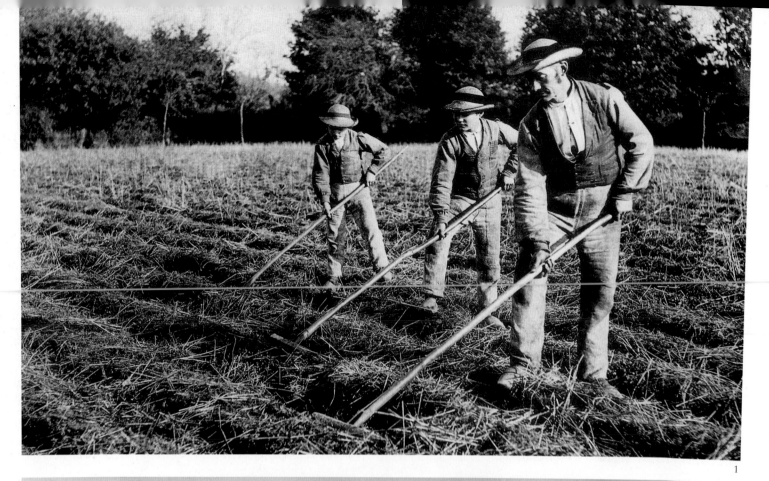

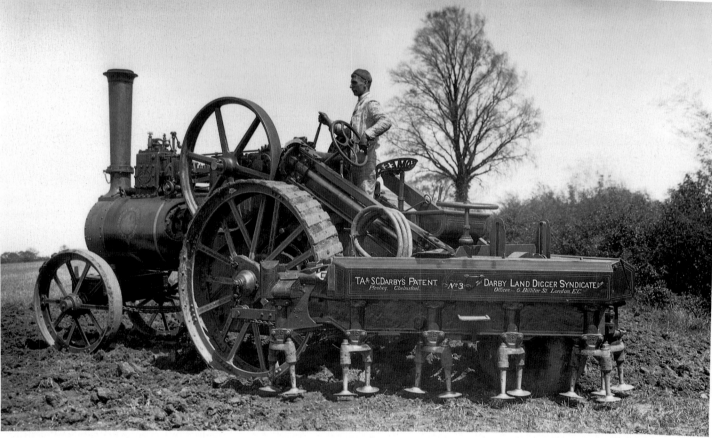

STEAM traction engines first appeared in the 1860s (2). They were cumbersome, but powerful and reliable for ploughing, harrowing, reaping, threshing. On smaller farms, man still provided much of the power – father and son moved in line to rake the hay (1). Much of the work on this English turkey farm would have been seasonal (5), and plucking poultry was traditionally a woman's job (3). There was still plenty of wildlife to be stalked and shot (4), and conservation never entered anyone's head.

DAMPFBETRIEBENE Traktoren tauchten zum ersten Mal in den 1860er Jahren auf (2). Sie waren schwer zu manövrieren, aber leistungsstark und verläßlich und konnten für viele Aufgaben eingesetzt werden – zum Pflügen, Eggen, Mähen und Dreschen. Auf kleineren Farmen bewältigte noch immer der Mensch den größten Teil der Arbeit; Vater und

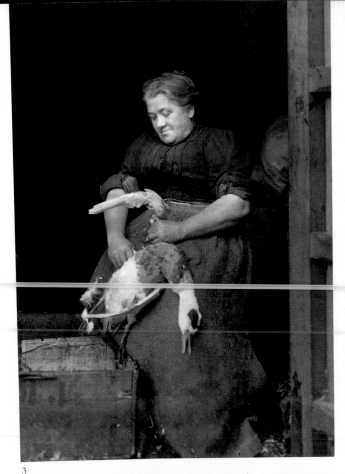

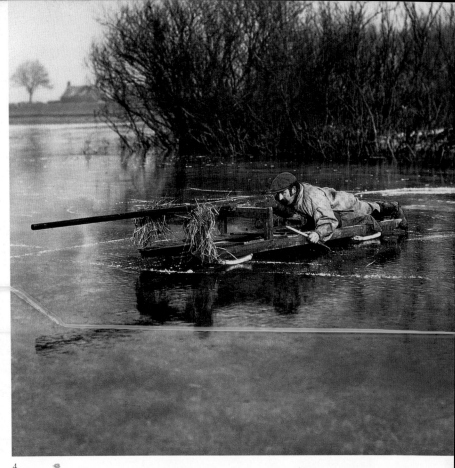

3

4

5

Sohn bewegten sich in einer Reihe und harkten das Heu (1). Ein Großteil der Arbeit auf dieser englischen Truthahnfarm war saisonbedingt (5), und das Rupfen des Geflügels war traditionsgemäß Aufgabe der Frauen (3). Es gab noch immer viele wilde Tiere, auf die man Jagd machen konnte (4), und niemand dachte an Naturschutz.

Les premières machines à traction à vapeur firent leur apparition dans les années 1860 (2). Quoique encombrantes, elles étaient puissantes et fiables, et pouvaient remplir de multiples tâches : le labourage, l'hersage, le moissonnage et le battage. Sur les petites exploitations, l'homme fournissait encore une grosse partie de l'énergie : père et fils râtelant le foin en ligne (1). Lorsque

c'était possible, les exploitants se spécialisaient. Une grosse partie du travail dans cet élevage de dindes en Angleterre avait très certainement un caractère saisonnier (5). Plumer la volaille était traditionnellement un travail de femme (3). Le gibier restait abondant pour la chasse à l'approche (4), et défendre l'environnement ne venait à l'idée de personne.

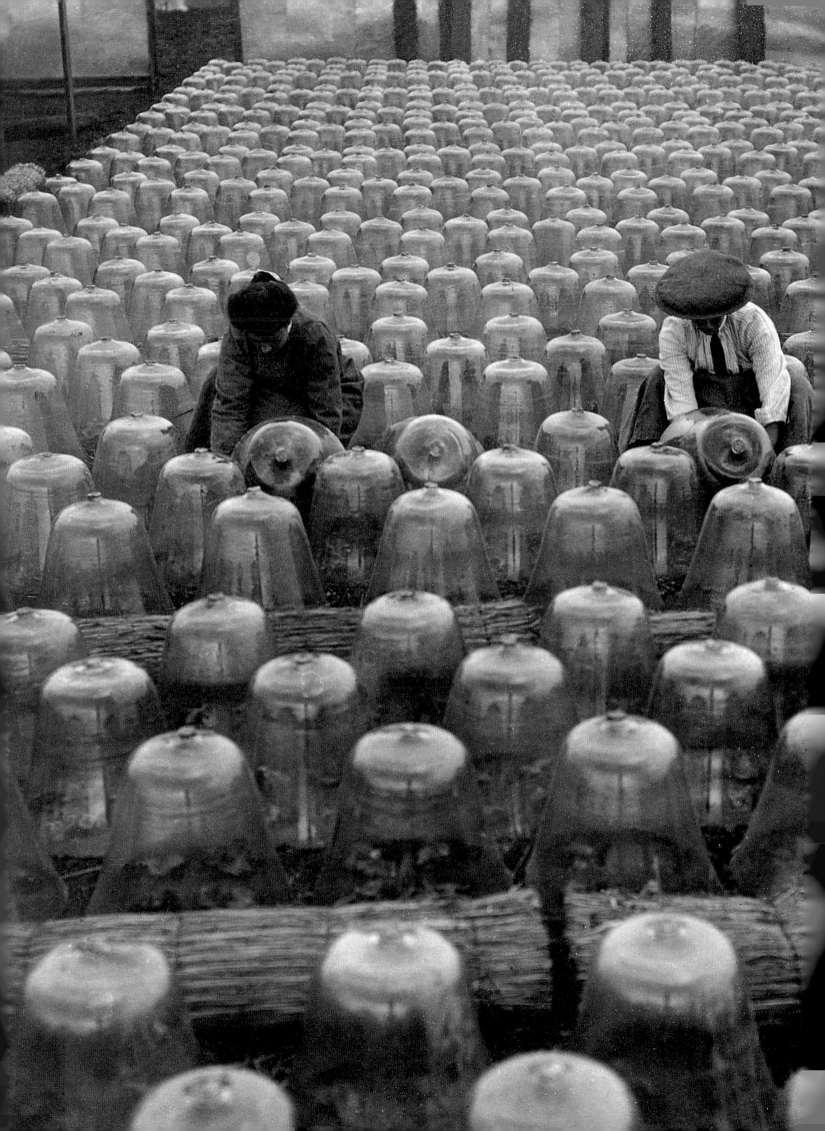

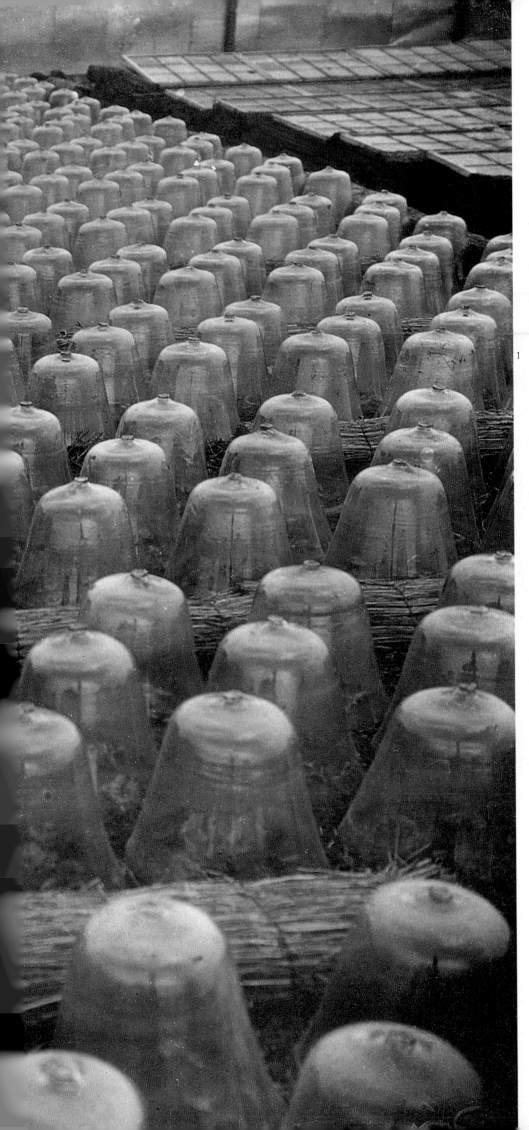

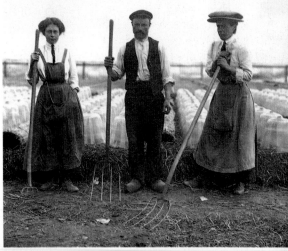

B Y the second half of the 19th century
fruit and vegetable growers used
cloches (1) to lengthen the growing season.
Regular train services ensured that the
crops reached market while still fresh. This
changed people's tastes – and in the boom
years of the 1860s, 1870s, and 1890s there
was more money to spend on food.
Scratching a living from the land had
become a little less back-breaking (2).

I N der zweiten Hälfte des 19. Jahr-
hunderts verwendeten Obst- und
Gemüsezüchter Glasglocken (1), um die
Reifezeit zu verlängern. Regelmäßige
Bahntransporte sorgten dafür, daß die Ernte
den Markt erreichte, solange sie frisch
war. Dieser Umstand hatte Einfluß auf den
Geschmack der Menschen, und in der
Blütezeit der 60er, 70er und 90er Jahre des
19. Jahrhunderts gab man mehr Geld für
Essen aus. Sich seinen Lebensunterhalt auf
dem Land zu verdienen war etwas weniger
anstrengend geworden (2).

D ÈS la seconde moitié du XIX^e siècle,
les maraîchers utilisèrent des cloches
(1) pour allonger la période de maturation.
Grâce aux liaisons ferroviaires régulières,
les produits arrivaient frais sur le marché.
Les goûts s'en trouvèrent modifiés. Pendant
les années de prospérité que furent les
années 1860, 1870 et 1890, on consacra
davantage d'argent à l'alimentation. Tirer
sa subsistance de la terre n'avait jamais
été facile ; c'était tout de même devenu
un peu moins éreintant (2).

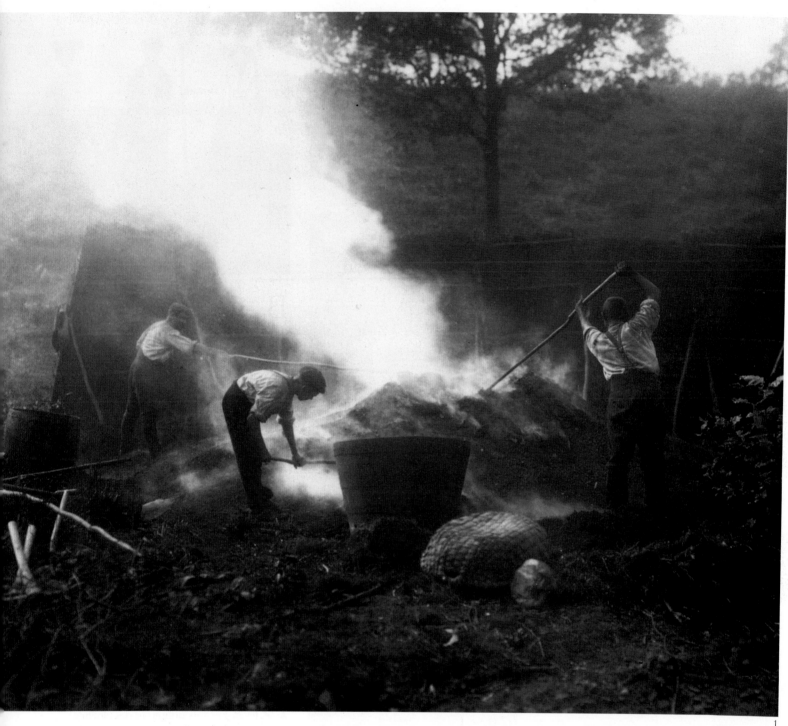

1

THERE were still many parts of Europe where charcoal was used to smelt iron, and in woods and coppices the charcoal burners made their smoking puddings (1), damping down the wet turf that covered the fires and ensured the wood smouldered steadily within, never bursting into flame. But it took nearly 7400 acres (3,000 hectares) of woodland to supply an average-sized furnace with enough charcoal. In flat waterlands, reeds were cut and bundled (2), and stored in reed-ricks to dry and await the coming of thatchers, for thatch was still a cheap and popular roofing material.

IN vielen Teilen Europas wurde noch immer Holzkohle zum Schmelzen von Eisen verwendet, und in den Wäldern bereiteten die Köhler ihren rauchenden Brei (1), indem sie den feuchten Torf, der die Feuer bedeckte, abdämpften und darauf achteten, daß das Holz darunter gleichmäßig verglühte und keine Flammen schlug. Es waren jedoch fast 3 000 Hektar Wald erforderlich, um einen Ofen von durchschnittlicher Größe mit genügend Holzkohle zu speisen. In flachen, wasserreichen Gegenden wurde Schilf geschnitten, gebündelt (2) und in Reetschobern zum Trocknen gelagert, bis die Dachdecker kamen, denn Reet war noch immer ein billiges und beliebtes Material zum Decken von Dächern.

DANS bien des régions d'Europe, le charbon était encore utilisé pour la fonte du fer, et les charbonniers fabriquaient dans les bois et les taillis leurs gâteaux fumants (1) recouverts d'une tourbe humide sous laquelle couvait un feu, veillant à ce que le bois brûlât lentement en dessous sans jamais s'enflammer. Cependant, il fallait près de 3 000 ha de forêts pour fournir suffisamment de charbon de bois à un fourneau de taille moyenne. Dans les marécages, les roseaux étaient coupés, liés (2) et mis en meules pour sécher en attendant l'arrivée des chaumiers. En effet, le chaume restait un matériau de toiture bon marché et fort prisé.

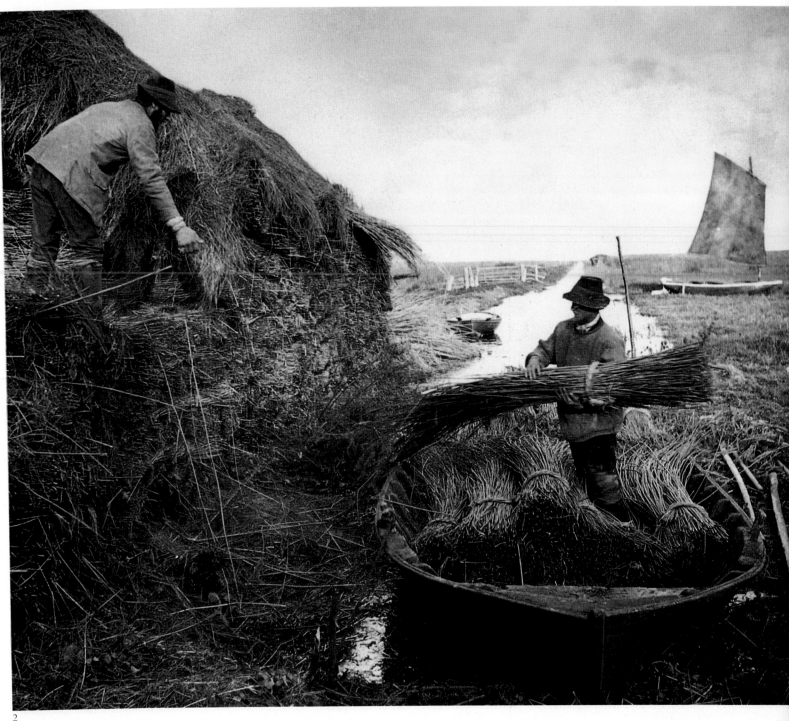

2

(*Overleaf*)

THE scene is peaceful enough: a crofter's house on the Shetland Isles. This was the romantic view of rural life in the late 19th century. The reality was less idyllic. Many farmworkers faced redundancy and eviction from their tied cottages. This photograph was probably taken within a few years of the Crofters' War, when police and soldiers fought men and women on these remote Scottish islands.

(*Folgende Seiten*)

DIESE idyllische Szene zeigt das Haus eines Kleinpächters auf den Shetlandinseln. Dies war die romantische Sicht des Landlebens im späten 19. Jahrhundert. Aber die Realität war weniger idyllisch. Viele Bauern sahen sich mit Arbeitslosigkeit und der anschließenden Vertreibung aus ihren gepachteten Hütten konfrontiert. Diese Photographie wurde vermutlich wenige Jahre vor dem »Crofters' War«, dem Krieg der Kleinpächter, aufgenommen, als Polizei und Soldaten gegen die Männer und Frauen auf diesen fernen schottischen Inseln kämpften.

(*Pages suivantes*)

CE tableau de la maison en pierre d'un petit fermier des îles Shetland ne manque pas de sérénité. Telle était la vision romantique qu'on se faisait de la vie rurale à la fin du XIXᵉ siècle. La réalité était moins rose. Le travail se faisait rare dans la plupart des campagnes européennes. Nombreux étaient les ouvriers agricoles que menaçait le licenciement, inévitablement suivi par l'expulsion de leur logement de fonction. Cette photographie a vraisemblablement été prise durant les quelques années de résistance menée par ces petits fermiers contre les forces de police et les soldats qui combattaient les hommes et les femmes de ces îles situées au fin fond de l'Écosse.

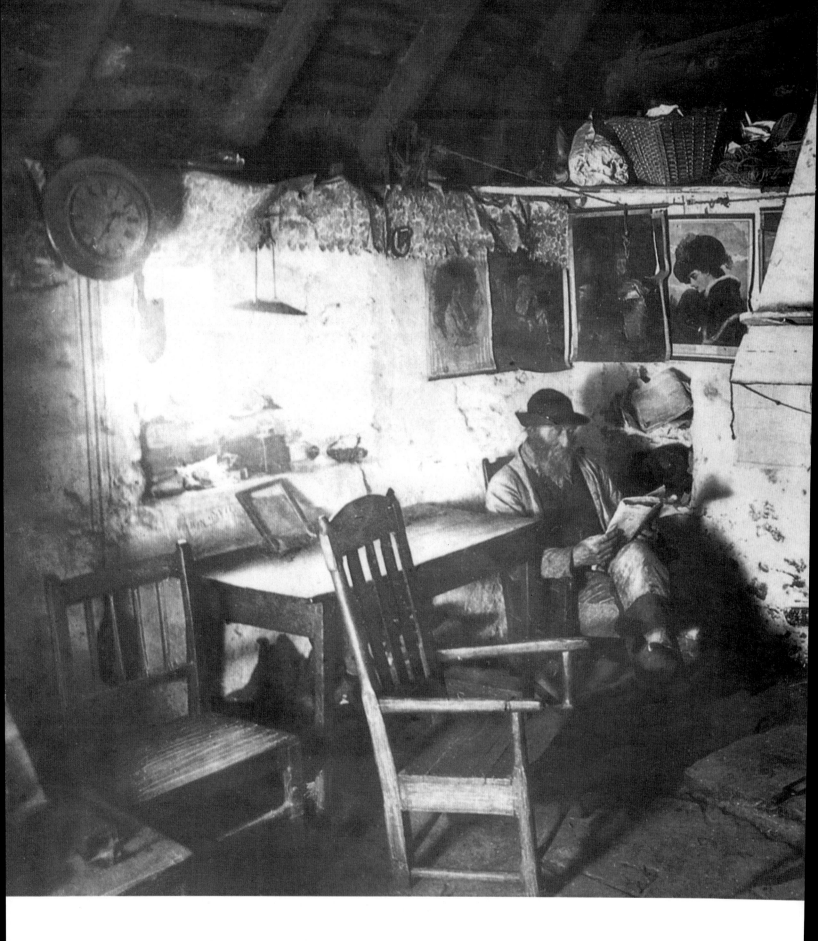

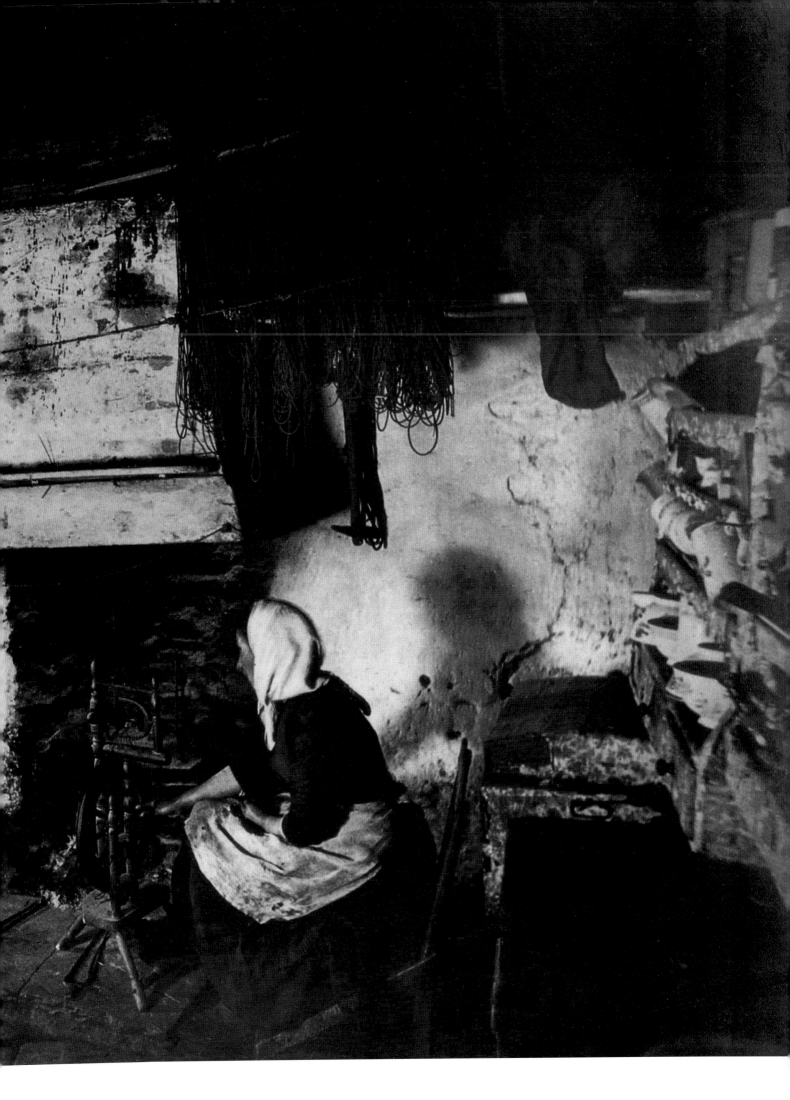

1

OCCASIONALLY there were moments of rest for those who worked the land – time to lean on the gate and indulge in a little courting, or at least fancying (1). Gleaners (2), however, had to work quickly. Any grain they saved was collected by the local miller, who ground it into flour. But, for all the back-breaking work, long hours and total submission to the landlord's authority, the countryside was still a good place to bring up children (3).

FÜR die Landarbeiter gab es manchmal Momente der Ruhe – Zeit, sich an das Tor zu lehnen und ein wenig zu freien oder zumindest zu flirten (1). Ähren-leserinnen (2) jedoch hatten wenig Zeit zum Verschnaufen. Jedes Korn, das sie retteten, wurde vom Müller gesammelt, der es zu Mehl vermahlte. Aber trotz der vielen Stunden ermüdender Arbeit und der totalen Unterwerfung unter die Autorität des Gutsbesitzers war das Land ein guter Platz, um Kinder großzuziehen (3).

IL y avait de temps à autre des moments de repos pour ceux qui travaillaient la terre : le temps de s'accouder à la barrière pour faire un brin de cour, ou tout au moins pour rêvasser (1). Les glaneuses (2), elles, n'avaient guère le temps de poser. Chaque grain récolté était entreposé chez le meunier qui le transformait en farine. Mais malgré le travail exténuant, les longues heures et la soumission totale à l'autorité du seigneur terrien, la campagne restait l'endroit idéal pour élever les enfants (3).

2

3

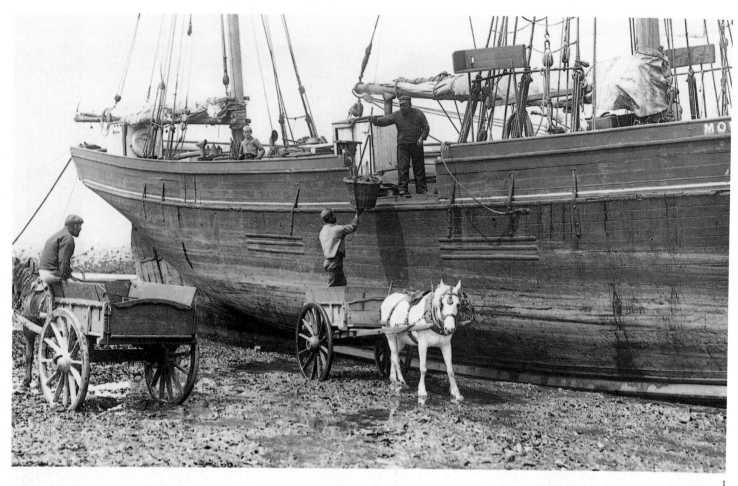

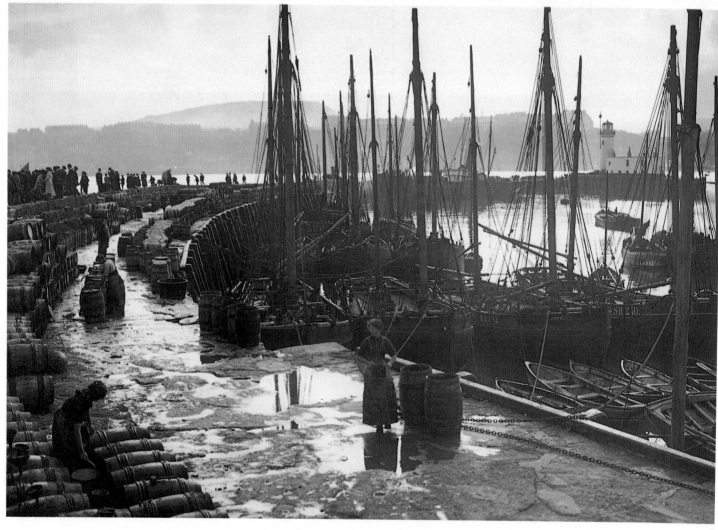

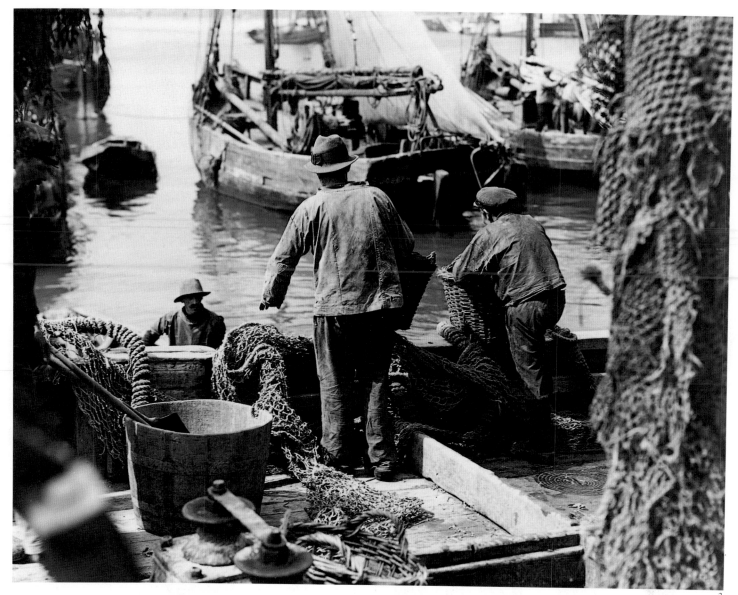

IMPROVED road and rail transport also led to an increased demand for fresh fish. Ports throughout the world were busy, bustling places, with fleets of boats discharging their catches of herring, sardine, cod, tuna, mackerel, flatfish and all the riches of the sea (1). Fishing was a labour-intensive industry. The old harbour at Scarborough, England (2), employed as many ashore as it did afloat – gutting, cleaning and packing the daily catch. In ports like Blankenberge, Belgium (3), fishermen followed the old routines of repairing the nets and baskets in which they made their catch.

DER verbesserte Straßen- und Schienentransport führte auch zu einer erhöhten Nachfrage nach frischem Fisch. Die Häfen in der ganzen Welt waren geschäftige Orte, wo unzählige Boote ihre Fänge abluden: Heringe, Sardinen, Kabeljau, Thunfisch, Makrelen, Schollen und alle Reichtümer des Meeres (1). Die Fischerei war eine bedeutender Industriezweig. Der alte Hafen von Scarborough in England (2) beschäftigte ebenso viele Menschen auf See wie an Land, um die täglichen Fänge auszunehmen, zu säubern und zu verpacken. In Häfen wie Blankenberge in Belgien (3) folgten die Fischer ihrer alten Gewohnheit und flickten die Netze und Reusen, mit denen sie ihre Fänge machten.

L'AMÉLIORATION des routes et du transport ferroviaire augmenta aussi la demande en poisson frais. Partout dans le monde, les ports bouillonnaient d'activité grâce aux flottes de bateaux qui y déchargeaient leurs prises de harengs, de sardines, de morues, de thons, de maquereaux, de poissons plats et toutes les richesses de la mer (1). La pêche employait énormément de bras. Le vieux port de Scarborough en Angleterre (2) occupait autant de personnes à terre qu'au large. Elles vidaient, nettoyaient et emballaient la pêche du jour. Dans les ports, comme celui de Blankenberge en Belgique (3), les pêcheurs continuaient comme par le passé à réparer les filets et les paniers dont ils se servaient.

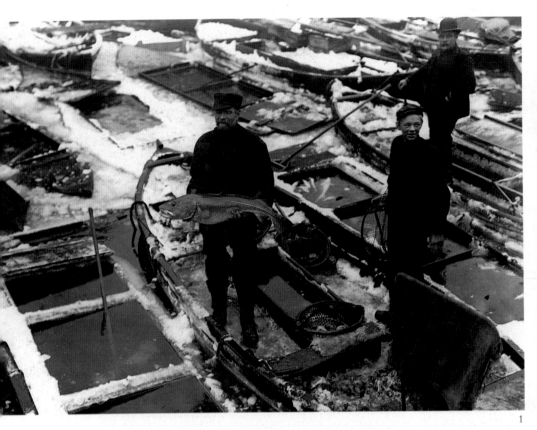

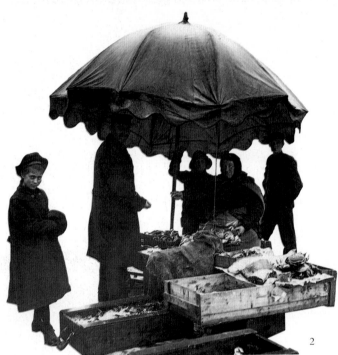

For centuries before these photographs were taken, the people of Copenhagen had hauled a living from the North Sea. Catches were loaded into tanks (1), to keep them fresh until they reached the old port. The fish were then gutted on the quayside, and loaded into boxes or baskets for sale (2, 3). It was good food, but prices were as low as the market could force them, and the men who went to sea and the women who sold what they caught earned barely enough to survive.

Bereits Jahrhunderte bevor diese Aufnahmen gemacht wurden, hatten die Einwohner von Kopenhagen von der Nordsee gelebt. Die Fänge wurden in Wasserbecken (1) verladen, um sie so bis zur Ankunft im alten Hafen frisch zu halten. Der Fisch wurde dann am Kai aus-

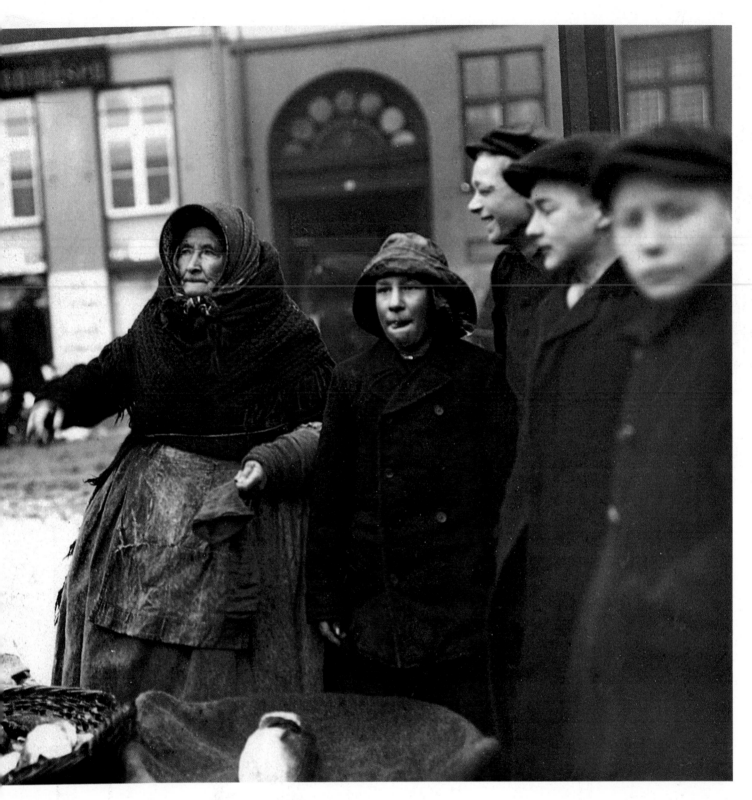

genommen und zum Verkauf in Kisten oder Körbe gefüllt (2, 3). Fisch war ein gutes Nahrungsmittel, aber die Preise waren so niedrig, wie der Markt sie drücken konnte, und die Männer, die zur See fuhren, und die Fischverkäuferinnen verdienten kaum genug, um zu überleben.

Depuis des siècles, bien avant que ces photographies n'aient été prises, les habitants de Copenhague tiraient leur subsistance de la mer du Nord. Ils hissaient à bord leur pêche qu'ils entreposaient à l'intérieur de réservoirs (1), de manière à la conserver fraîche jusqu'à l'arrivée dans le vieux port. Le poisson était ensuite vidé à

quai avant d'être chargé dans des caisses ou dans des paniers pour être vendu (2 et 3). Le produit était de bonne qualité, mais les prix étaient maintenus aussi bas que possible par le marché. De telle sorte que les marins-pêcheurs et les femmes qui vendaient leurs prises gagnaient tout juste de quoi vivre.

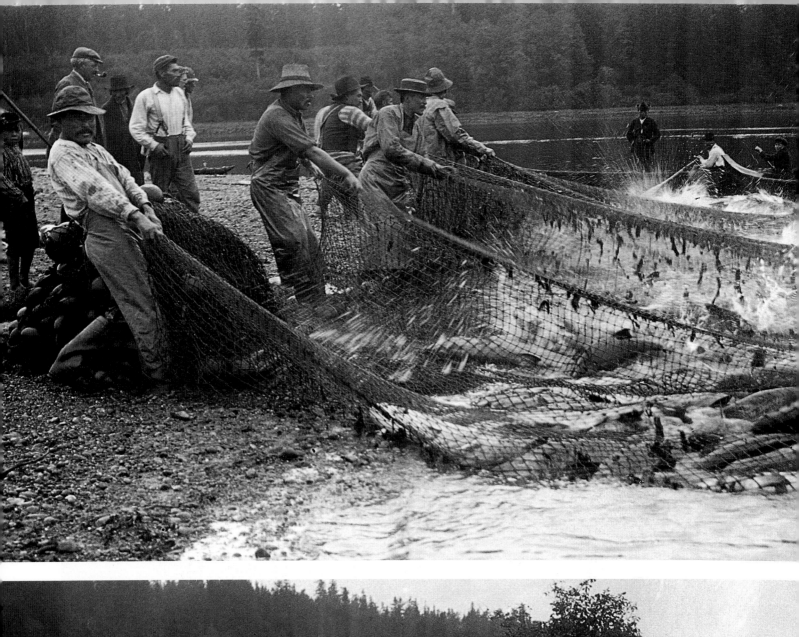
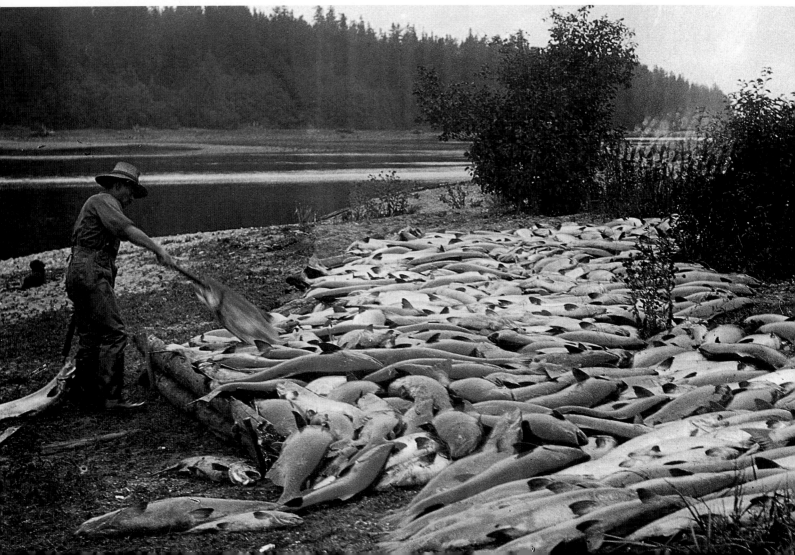

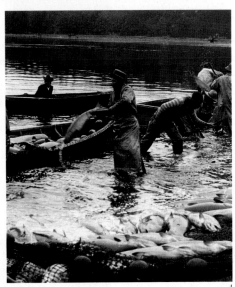

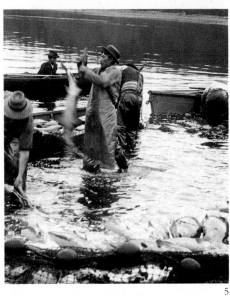

B Y the 1870s the process of preserving food by canning was well established, and the entire economic system of food production and trade was never the same again. The salmon rivers of British Columbia, Canada (photographed by Todd in the 1890s) were abundant larders. Hauling 30 lb (15 kg) salmon from the cold, clear, clean water was as easy as shelling peas. Salmon was the staple food of the Indian tribes indigenous to the region.

I N den 1870er Jahren hatte sich die Haltbarmachung von Lebensmitteln in Konserven durchgesetzt und das gesamte System von Nahrungsmittelherstellung und -handel revolutioniert. Die Lachsflüsse von British Columbia in Kanada (in den 1890er Jahren von Todd photographiert) waren übervolle Speisekammern. Fünfzehn Kilogramm Lachs aus dem kalten, klaren und sauberen Wasser zu fangen war so einfach wie Erbsenschälen. Lachs war das Grundnahrungsmittel der in dieser Region lebenden Indianerstämme.

D ÈS les années 1870, le procédé de mise en conserve des aliments était bien établi. Le système économique qui réglait la production et le commerce des denrées alimentaires allait changer du tout au tout. Les rivières à saumon de la Colombie-Britannique, au Canada (photo-graphiées par Todd dans les années 1890), se transformèrent en un garde-manger qui approvisionnait abondamment une grande partie du monde. Remonter 15 kg de saumon des eaux froides et cristallines était aussi aisé qu'écosser des petits pois. Le saumon constituait la nourriture de base des tribus indigènes de la région.

Street Life

IT was always cheaper to sell on the street than to rent a shop. Cities were crowded with all kinds of tinkers, pedlars and wandering traders who had lost their country customers as people moved from the land. Hours were long. 'Why, I can assure you,' said one London street trader, 'there's my missus – she sits at the corner of the street with fruit... she's out from ten in the morning till ten at night.' Earnings were poor for the army of knife-grinders, shrimp-sellers, old-clothes dealers, window-menders, boot-blacks and flower-sellers.

For the old blind beggar, with his tray of almanacs, bootlaces, brushes and pencils (1), life was a desperate struggle, with only his dog for support. 'We must either go to the workhouse or starve. If we go to the workhouse, they'll give us a piece of dry bread and abuse us worse than dogs.'

At the top end of the scale was Cast-Iron Billy (3, overleaf), one of the most famous omnibus drivers in London in the 1870s, portrayed in neat billycock hat and shining shoes in John Thomson's photograph. Near the bottom of the scale was the match-seller (4, overleaf), who relied as much on charity as on custom. The flower-sellers (2) probably had their pitch in the middle of the road to avoid being charged by the police with obstructing the pavement.

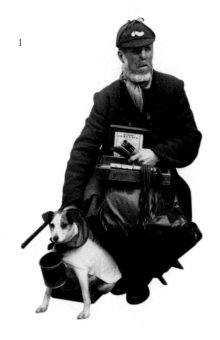

1

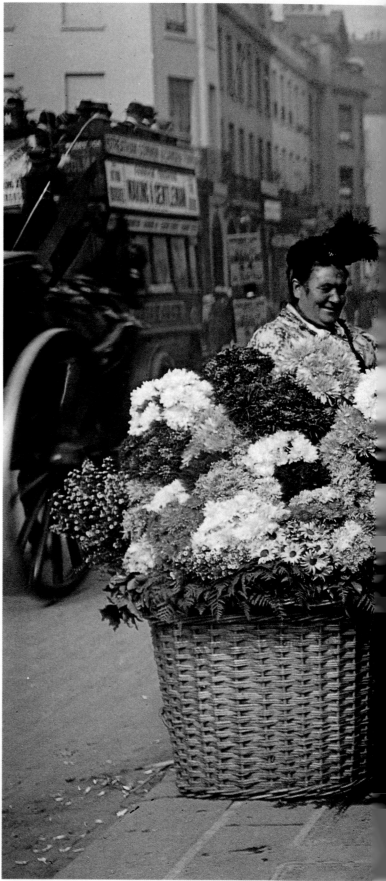

2

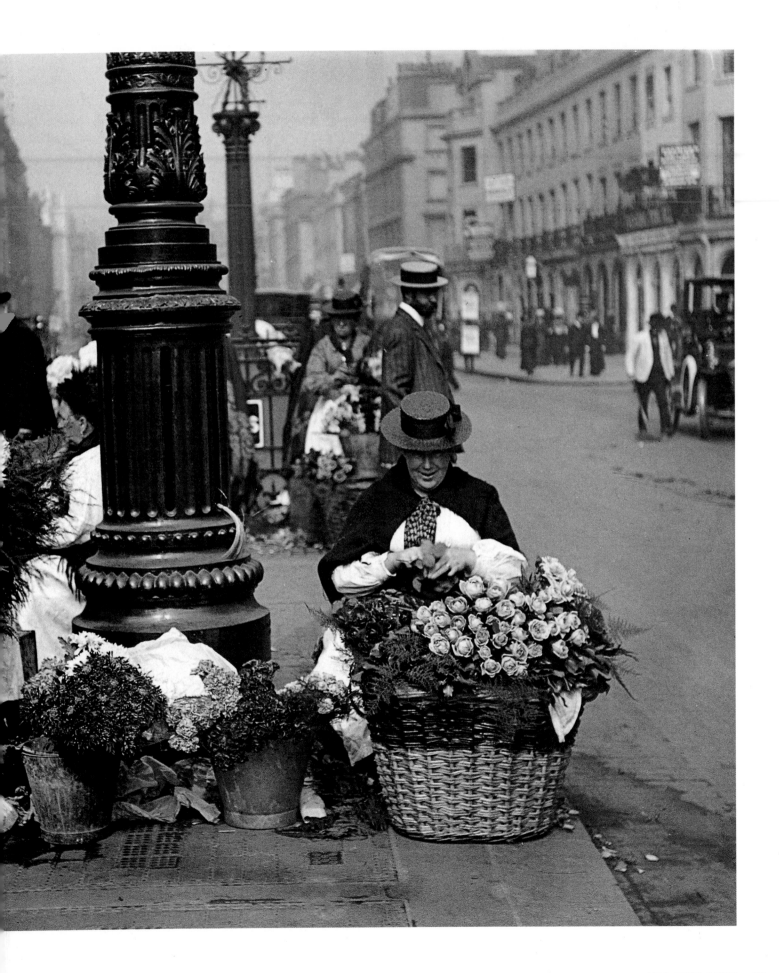

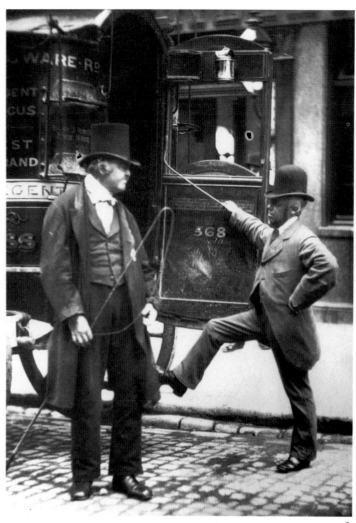

3

4

Es war stets billiger, seine Waren auf der Straße zu verkaufen, als einen Laden zu mieten. Die Städte waren überfüllt mit Kesselflickern, Hausierern und fahrenden Händlern, die ihre Kundschaft auf dem Land verloren hatten, als die Menschen in die Städte zogen. Die Tage waren lang. »Sie können mir glauben«, sagte ein Londoner Straßenhändler, »meine Frau dort drüben sitzt an der Straßenecke und verkauft Obst ... sie ist von morgens um zehn bis abends um zehn draußen.« Die unzähligen Scherenschleifer, Krabbenverkäufer, Altkleiderhändler, Schuhputzer und Blumenverkäufer verdienten wenig.

Für den blinden alten Bettler mit seinem Bauchladen voller Kalender, Schnürsenkel, Bürsten und Bleistifte (1) war das Leben ein bitterer Kampf, in dem ihm nur sein Hund zur Seite stand. »Wir müssen entweder ins Armenhaus oder verhungern. Wenn wir ins Armenhaus gehen, geben sie uns ein Stück trockenes Brot und behandeln uns schlimmer als Hunde.«

Am obersten Ende der sozialen Leiter stand Cast-Iron Billy (3), einer der berühmtesten Omnibusfahrer im London der 1870er Jahre, der in dieser Photographie von John Thomson mit feiner Melone und blankpolierten Schuhen zu sehen ist. Am unteren Ende der Leiter stand die Zündholzverkäuferin (4), die ebensosehr auf Almosen wie auf zahlende Kunden angewiesen war. Die Blumenverkäuferinnen (2) hatten ihren Stand vermutlich auf dem Mittelstreifen der Straße, um eine Geldstrafe wegen Blockierung des Gehsteigs zu vermeiden.

Il était toujours plus avantageux de vendre dans la rue que de payer un bail. Les villes étaient pleines de rétameurs, camelots et marchands ambulants de toutes sortes ayant perdu leur clientèle campagnarde à la suite de l'exode rural. Les heures étaient longues. « En tous les cas, je peux vous assurer, déclarait un marchand de rue à Londres, que ma bourgeoise qui est assise au coin de la rue avec ses fruits ... est dehors de dix heures du matin à dix heures du soir. » Les revenus étaient maigres pour cette armée de rémouleurs, vendeurs de crevettes, fripiers, réparateurs de fenêtres, cireurs de chaussures et vendeurs de fleurs. Quant au vieux mendiant aveugle qui offrait sur son plateau des almanachs, des lacets, des brosses et des crayons (1), sa vie était un combat désespéré avec son chien pour seul soutien. « Nous avons le choix entre la maison des pauvres ou mourir de faim. Si nous allons dans la maison des pauvres, nous recevrons un morceau de pain sec et serons traités pire que des chiens. »

Tout en haut de l'échelle se trouvait « l'inflexible » Billy (3), l'un des conducteurs d'omnibus les plus célèbres de Londres dans les années 1870 et que le photographe John Thomson a pris en chapeau melon et chaussures étincelantes. La vendeuse d'allumettes (4), au bas de l'échelle, comptait autant sur la charité que sur la fidélité de sa clientèle. Les vendeuses de fleurs (2) avaient placé leur éventaire au beau milieu de la chaussée, vraisemblablement pour éviter d'être accusées par les forces de l'ordre d'obstruer le trottoir.

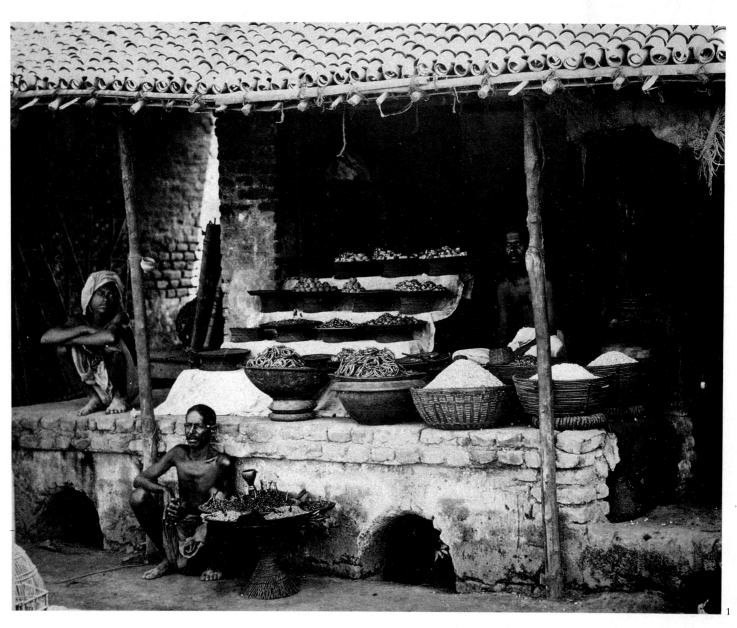

1

INDIA was repeatedly plagued by famine. British officials there took it as a fact of life. But there was always food to be found in luckier parts of the sub-continent. An Indian sweet-seller's shop (1), open to the street, might be plagued with flies, but there were plenty of tempting sweetmeats, biscuits and nuts. In Egypt, shoe-pedlars (2) trudged the dusty streets, their wares slung round their necks.

INDIEN wurde wiederholt von Hungersnöten heimgesucht. Für die britischen Beamten dort gehörte das zum Leben. In den gesegneteren Teilen des Subkontinents jedoch gab es immer etwas zu essen. Der zur Straße hin offene Laden eines indischen Süßwarenverkäufers (1) mochte zwar voller Fliegen sein, aber es gab viele verlockende Leckereien, Kekse und Nüsse. In Ägypten durchstreiften Schuhverkäufer (2) mit ihren um den Hals gehängten Waren die staubigen Straßen.

L'INDE était régulièrement frappée par la famine. Les Britanniques qui s'y trouvaient en poste officiel jugeaient la chose normale. Pourtant les régions plus chanceuses du sous-continent avaient souvent de quoi manger. Le magasin du confiseur indien (1), ouvert sur la rue, était infesté de mouches mais regorgeait de sucreries, de biscuits, d'arachides, toutes choses bien tentantes. En Égypte, les marchands de chaussures ambulants (2) allaient pesamment le long des routes poussiéreuses, portant leurs marchandises autour du cou.

2

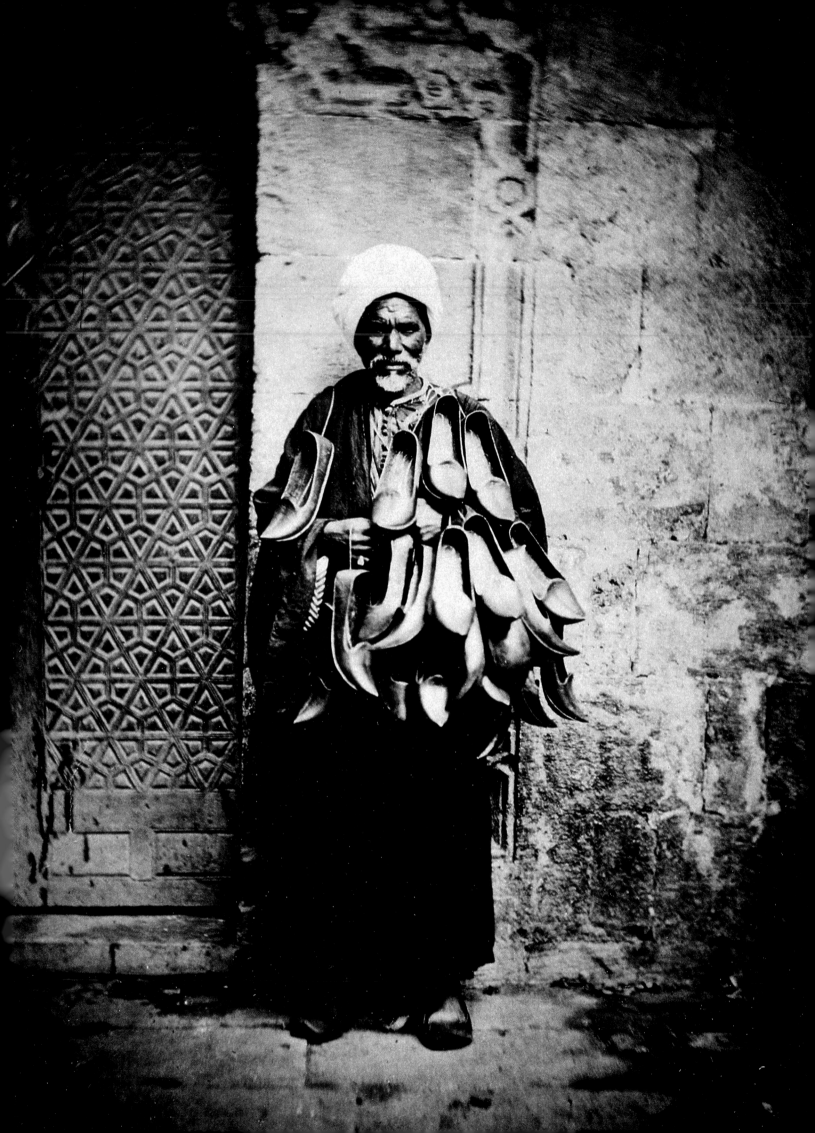

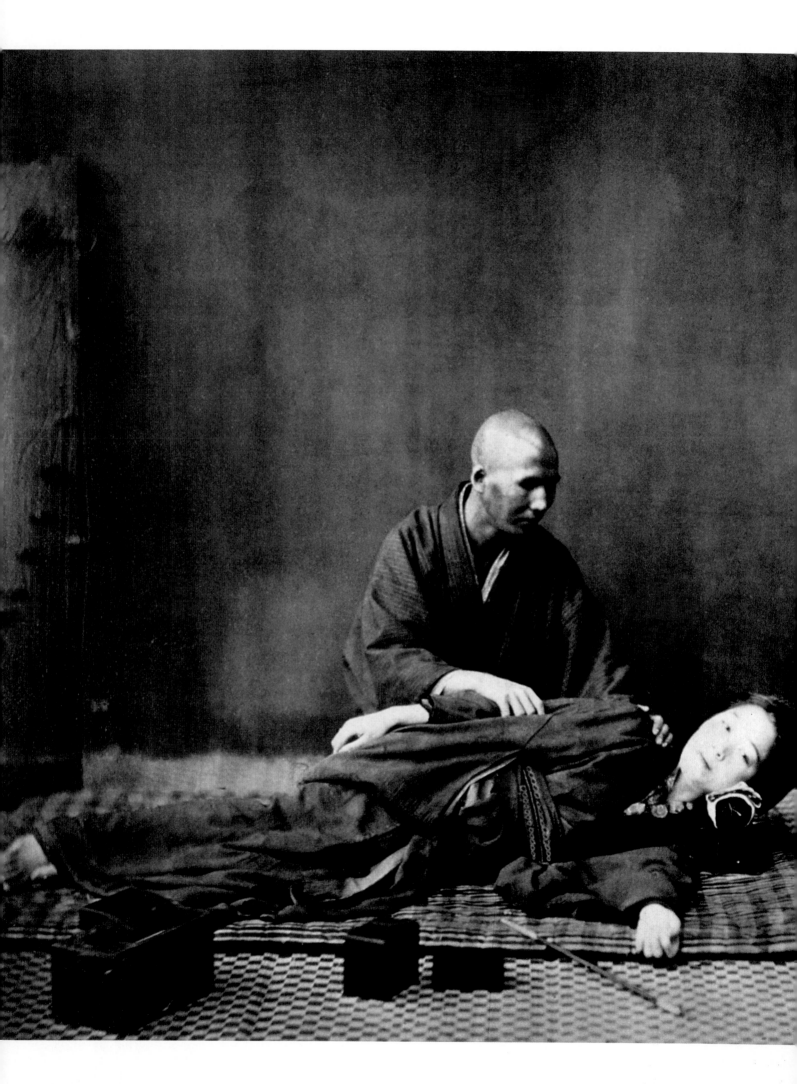

I N 1853 Commander Perry of the US Navy sailed into Edo (now Tokyo) harbour, and Japan's determined isolation from the rest of the world was rudely interrupted. A dozen years later, the Italian-born photographer Felice Beato recorded scenes of everyday life in a society that was about to change dramatically. Japanese shampooers were wealthy, privileged, and usually blind. They were wandering workers, advertising their approach by blowing on bamboo whistles. They were much in demand to massage away the pains of rheumatism, headaches, and the stresses and strains of the body.

I M Jahre 1853 lief Commander Perry von der US Navy in den Hafen von Edo (dem heutigen Tokio) ein, und Japans Isolation vom Rest der Welt wurde jäh durchbrochen. Zwölf Jahre später hielt der in Italien geborene Photograph Felice Beato Szenen aus dem Alltag einer Gesellschaft fest, die im Begriff war, sich radikal zu verändern. Japanische Haarwäscher waren reich, privilegiert und meistens blind. Sie waren Wanderarbeiter und kündigten ihre Ankunft in einer Stadt mit Bambuspfeifen an. Ihre Dienste waren sehr gefragt, denn sie konnten rheumatische Schmerzen, Kopfschmerzen und die Verspannungen des Körpers durch Massagen lindern.

E N 1853, le commandant américain Perry pénétra dans le port d'Edo (aujourd'hui Tokyo), mettant brutalement fin à l'isolement dans lequel le Japon s'était résolument enfermé. Une dizaine d'années plus tard, le photographe d'origine italienne Felice Beato fixait les scènes de la vie quotidienne d'une société en passe de connaître d'immenses bouleversements. Les shampouineurs japonais étaient aisés, privilégiés et habituellement aveugles. Ils exerçaient de manière itinérante en soufflant dans des sifflets en bambou pour signaler leur approche. Ils étaient très prisés car leurs massages faisaient disparaître les douleurs rhumatismales, les maux de tête ainsi que les tensions et les fatigues du corps.

1

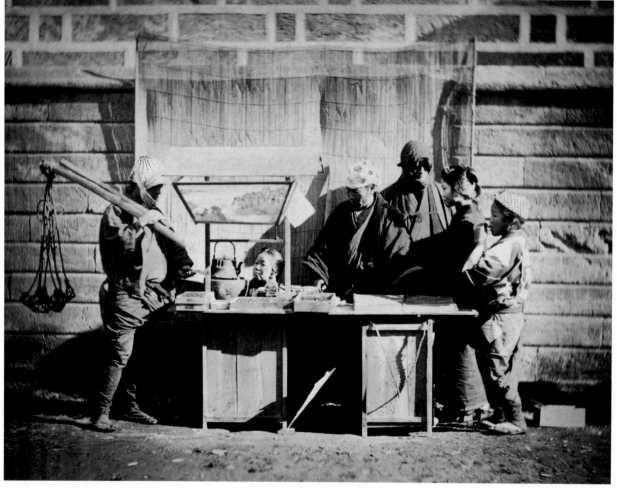

2

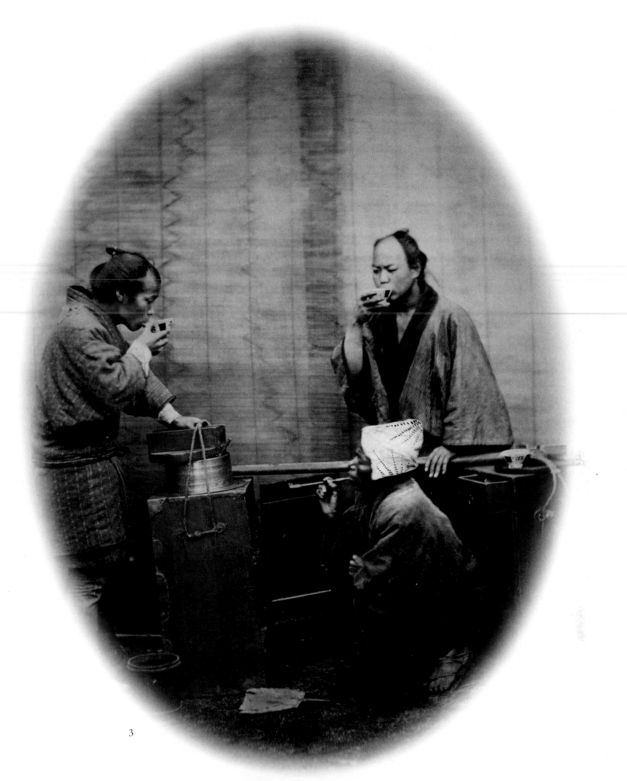

3

WHILE some moved from house to house, other traders had permanent shops, open to the street. Lanterns were made of split bamboo cane and thin paper, painted by hand (1). Ya-tai-mise (2) were refreshment stalls, set up at busy street corners, with small charcoal fires over which tea was prepared and a little cooking done. No respectable Japanese patronized these street-traders, who supplied the working coolies. The saki-seller (3) was an itinerant trader providing weak, sweet rice beer, flavoured with mint or salt.

WÄHREND einige japanische Händler von Haus zu Haus zogen, besaßen andere feste, zur Straße hin offene Läden. Laternen wurden aus gespaltenen Bambusrohren und dünnem Papier gefertigt und von Hand bemalt (1). An geschäftigen Straßenecken wurden die Ya-tai-mise (2) aufgestellt, Erfrischungsstände, in denen kleine Holzkohlefeuer brannten, auf denen man Tee und kleine Mahlzeiten zubereitete. Kein angesehener Japaner behandelte diese Straßenhändler, die die Tagelöhner versorgten, mit Herablassung. Der Sakeverkäufer (3) war ebenfalls ein umherziehender Händler, der dünnen, süßen, mit Minze oder Salz aromatisierten Reiswein feilbot.

ALORS que certains Japonais faisaient du porte à porte, d'autres avaient un fonds de commerce ouvert sur la rue. Les lanternes, fabriquées avec des cannes de bambou fendues et du papier fin, étaient peintes à la main (1). Le «Ya-tai-mise » (2) était un étal placé au coin des rues très passantes où l'on pouvait se restaurer en prenant du thé ou des plats légers préparés sur des braises. Aucun Japonais respectable ne patronnait ces marchands de rue, dont les coolies étaient les clients. Le vendeur de saké (3) était un autre de ces marchands ambulants ; sa bière légère et douce, parfumée à la menthe ou salée, était très appréciée.

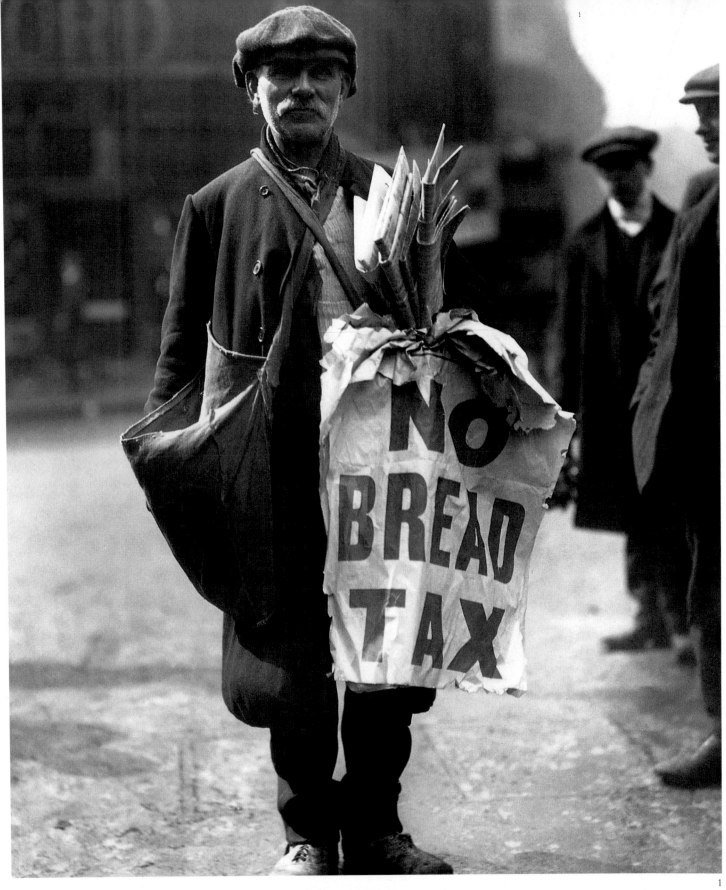

1

SELLING papers (1) provided a regular, if scant, living. The first cheap mass-circulation newspapers were founded in the 1890s. Toys (2) were a more seasonal trade, and the streets at Christmas were thronged with toy-sellers. In the 1860s eggs used to be suspended in these wire baskets in huge jars of preservative (3).

DER Verkauf von Zeitungen (1) sicherte ein zwar mageres, aber regelmäßiges Einkommen. Die ersten billigen Massen-zeitungen wurden in den 1890er Jahren gegründet. Der Handel mit Spielzeug (2) war dagegen eher ein saisonbedingtes Geschäft, und in der Weihnachtszeit waren die Straßen überfüllt von Spielzeugver-käufern. In den 1860er Jahren war es üblich, Eier in solchen Drahtkörben in große Frischhaltegläser zu hängen (3).

LA vente des journaux (1) fournissait régulièrement, quoique chichement, de quoi vivre. Les premiers journaux bon marché à grande circulation furent fondés dans les années 1890. Les jouets (2) avaient un caractère plus saisonnier, de sorte qu'à Noël les rues étaient encombrées de ven-deurs de jouets. La vendeuse de paniers à œufs (3) existait dans les années 1860, à l'époque où les œufs se conservaient dans ces immenses casiers en fer suspendus.

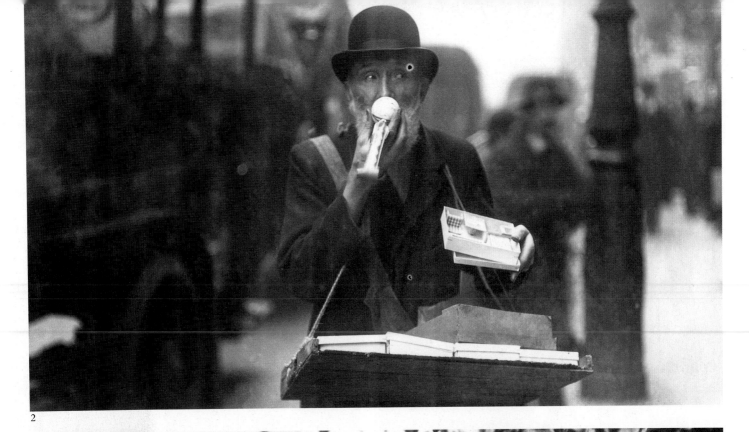

2

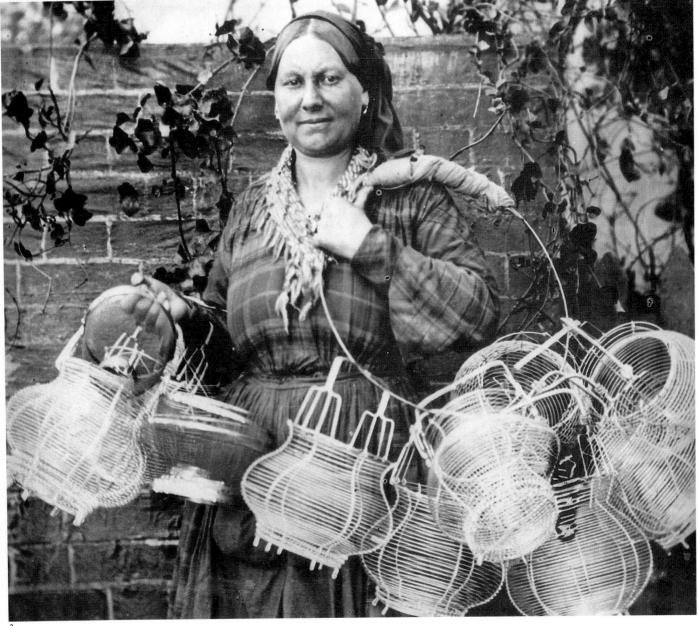

3

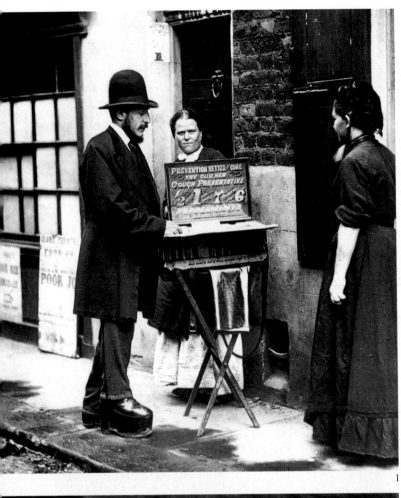

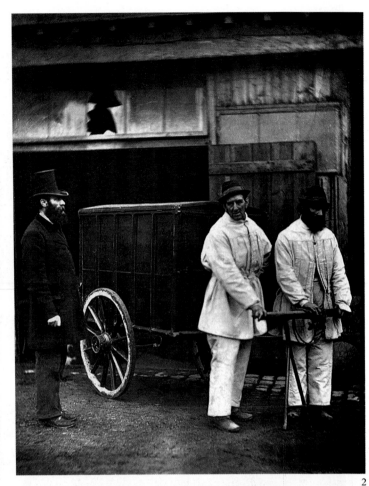

1

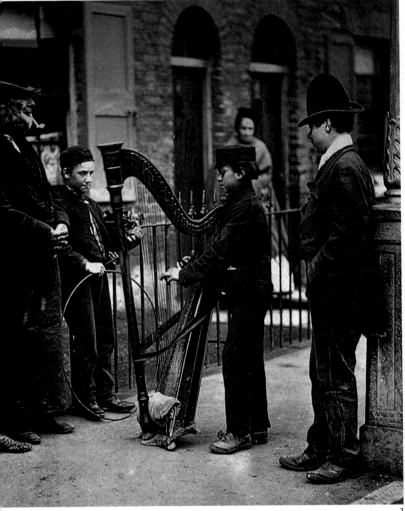

3

2

4

THE crippled seller of medicines (1) peddled cough preventions, peppermints, Herbal Pills and lozenges. In the 1890s it was the public disinfectors' job to sanitize the streets after an outbreak of smallpox (2). Street musicians (3) relied largely on children for an audience. The signwriter (4) was a Parisian who was befriended by the novelist George Moore. The street chemist (5) did a surprisingly good trade, but there was too much competition for the toy-sellers (6). The dealer in fancy ware (7) claimed: 'Saturday and Monday nights are our best times; when the people are looking through a glass of gin our things seem wonderfully tempting.'

DER verwachsene Arzneiverkäufer (1) hausierte mit Hustenmitteln, Pfefferminze, Kräuterpillen und Pastillen. In den 1890er Jahren bestand die Aufgabe der städtischen Desinfektoren (2) unter anderem darin, die Straßen nach einer Pockenepidemie zu desinfizieren. Das Publikum der Straßenmusiker (3) waren meist Kinder. Der Schildermaler (4) war ein Pariser, befreundet mit dem Romancier George Moore. Der Straßenapotheker (5) machte mit Stärkungsmitteln und Elixieren erstaunlich gute Geschäfte, aber unter den Spielzeugverkäufern war die Konkurrenz einfach zu groß (6). Der Verkäufer von Geschenkartikeln (7) behauptete: »Samstags und montags abends machen wir unsere besten Geschäfte; wenn die Leute durch ein Glas Gin schauen, erscheinen unsere Sachen unheimlich verlockend.«

LE vendeur handicapé de potions (1) s'habillait de manière élégante pour vendre aux clients ses préparations contre la toux, sa menthe poivrée, ses comprimés et ses pastilles. Dans les années 1890, les agents chargés de la désinfection (2) assainissaient les rues lorsqu'une épidémie de petite vérole s'était déclarée. Les musiciens (3) de rue avaient surtout un auditoire d'enfants. Le calligraphe (4) était un Parisien ayant vécu à New York et à Londres, où le romancier George Moore en avait fait son ami. L'apothicaire ambulant (5) proposait tout un assortiment de toniques et d'élixirs, et ses affaires marchaient étonnamment bien. En revanche, la concurrence entre les vendeurs de jouets était trop grande (6). Le marchand de bibelots (7) affirmait : « Les nuits du samedi et du lundi sont nos meilleures périodes. Vus au travers d'un verre de gin, nos articles apparaissent merveilleusement tentants. »

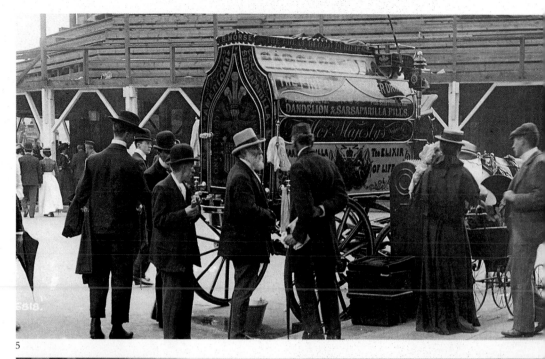

5

6

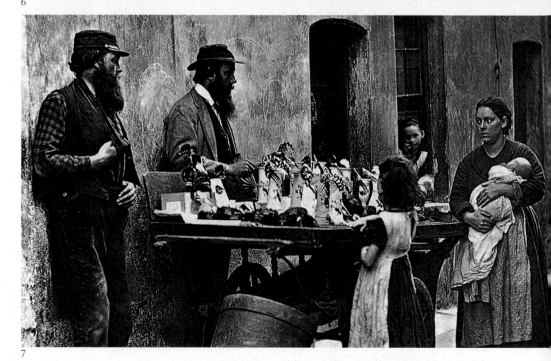

7

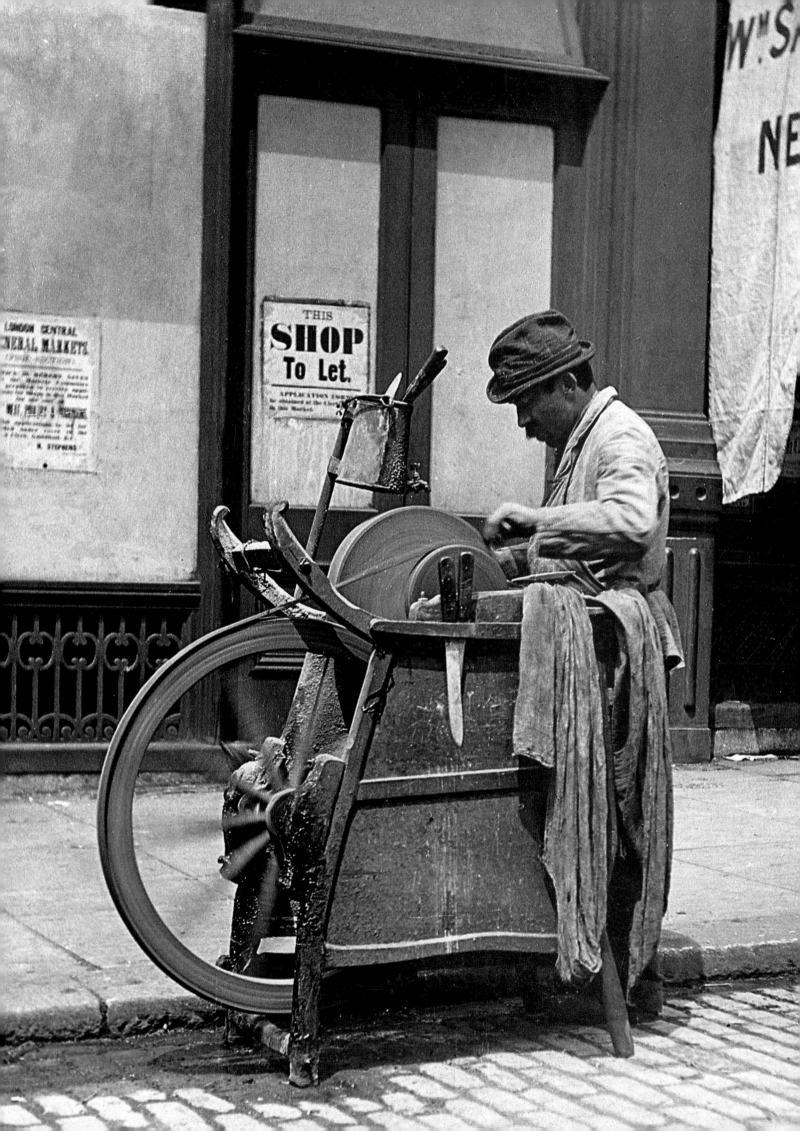

For the knife-grinder (1) trade was regular – meat was tough. By 1912, the motor car would have destroyed much of the whip-minder's trade (2). The cat-and-dog meat man (3) could always attract customers.

Für den Scherenschleifer (1) lief das Geschäft recht gut, denn das Fleisch war meist zäh. Die Existenz der Peitschen-hüterin (2) war um 1912 durch die zunehmende Motorisierung bedroht. Der Fleischer für Hunde und Katzen (3) zog dagegen immer Kunden an.

Le rémouleur (1) avait un travail régulier – la viande était dure. L'automobile avait en 1912 enlevé une grande partie de la clientèle aux cochers. Le boucher pour chats et chiens (3) était toujours sûr d'attirer les clients.

3

2

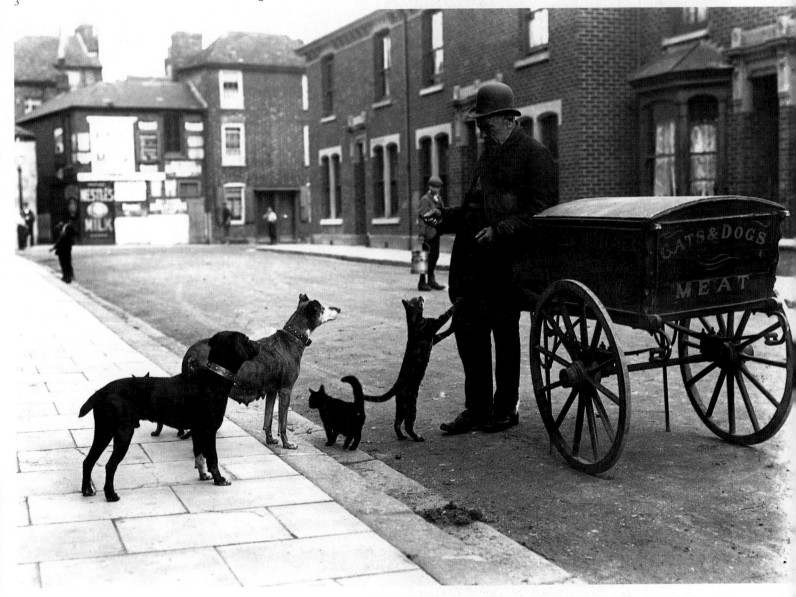

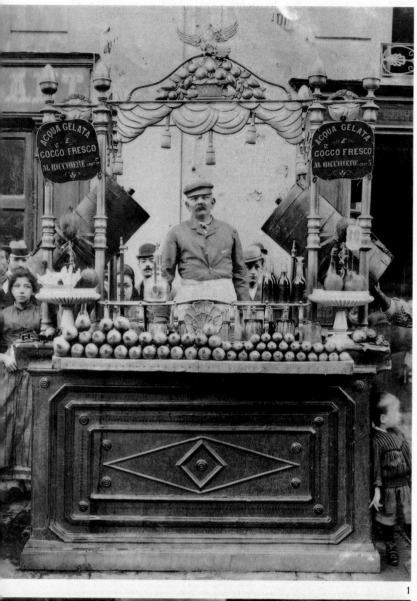

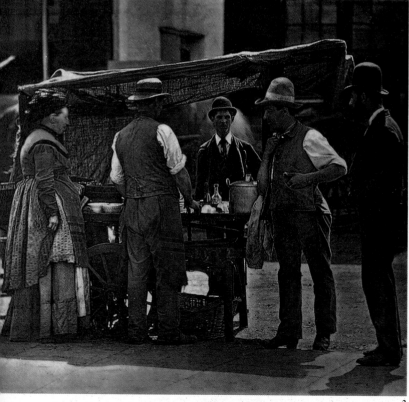

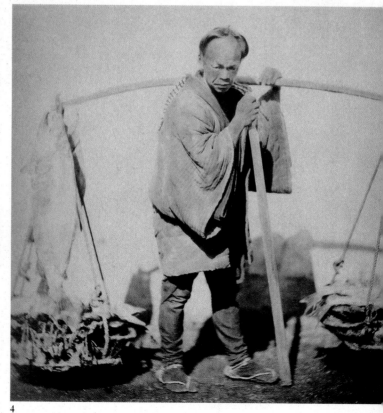

1 2
3 4

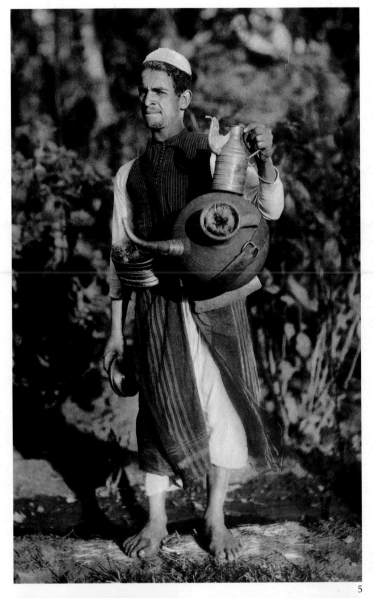

THE Neapolitan lemonade and ice-cream seller (1) had a stall that was both sturdy and ornate – the pride and joy and the living of the entire family, and an impressive contrast to the humble barrow of his London counterpart (2). The shellfish stall holder (3) told the photographer (Thomson): 'Find out a prime thirsty spot, which you know by the number of public houses it supports. Oysters, whelks and liquor go together invariable.' The Japanese fishmonger (4) carried dried or salted salmon and tuna fish tied to his long bamboo pole. In Cairo, the lemonade seller (5) offered refreshing glasses on small brass trays, while his London counterpart (6) sold a mixture of sherbet and water.

DER neapolitanische Limonaden- und Eiscremeverkäufer (1) besaß einen Stand, der nicht nur stabil, sondern auch reich verziert war. Er war der Stolz, die Freude und der Lebensunterhalt der ganzen Familie und stand in beeindruckendem Kontrast zu seinem bescheidenen Londoner Pendant (2). Der Inhaber des Schalentierstandes (3) empfahl dem Photographen (Thomson): »Suchen Sie sich einen Platz, wo die Leute ihren Durst löschen, dort, wo es viele Pubs gibt. Austern, Wellhornschnecken und Alkohol gehören einfach zusammen.« Der japanische Fischhändler (4) trug getrockneten oder gesalzenen Lachs und Thunfisch in Schalen, die an einem langen Bambusstab hingen. In Kairo bot der Limonadenverkäufer (5) erfrischende Getränke auf kleinen Messingtabletts an, während sein Londoner Kollege (6) eine Mischung aus Brause und Wasser verkaufte.

LE vendeur napolitain de limonade et de glaces (1) avait une échoppe à la fois solide et bien décorée : elle était l'orgueil, la joie et la source de revenus de toute la famille, et contrastait de manière impressionnante avec l'humble voiture de quatre saisons de son homologue londonien (2). Le propriétaire de l'étal de coquillages et de fruits de mer (3) expliqua au photographe (Thomson) : « Repérez un endroit où l'on boit bien au nombre de bars qu'il accueille. Les huîtres, les buccins et la liqueur vont toujours de compagnie. » Le poissonnier japonais (4) portait ses saumons et ses thons, séchés ou salés, attachés à une longue tige de bambou. Au Caire, le vendeur de limonade (5) offrait ses boissons rafraîchissantes dans des verres présentés sur des petits plateaux en laiton, tandis que son homologue londonien (6) proposait un mélange de jus de fruits glacés et d'eau.

5

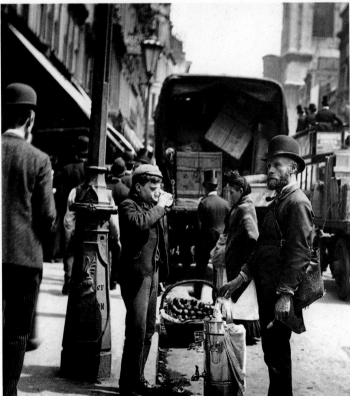

6

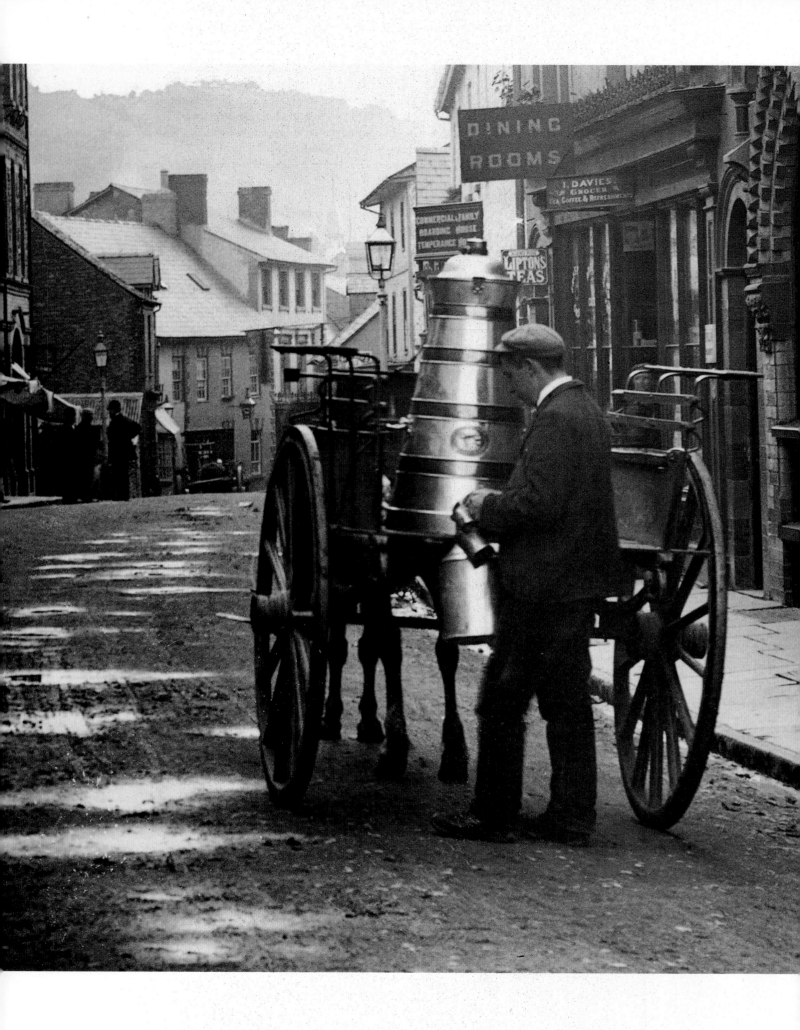

2

W̲ater from the well, milk from the cart. All over the world
milk was brought to the customer. Fresh, it was claimed,
and unadulterated and undiluted. There were always rumours of
what could be done with chalk and water, but the real danger
came more from the unhygienic circumstances in which cows
were milked than from fraudulent practices. Regular customers
had their own jugs and measures, filled straight from the churn – in
the case of this Welsh supplier (1) – or from jars – in the case of
the Argentinian milkman (2).

W̲asser aus der Quelle, Milch vom Karren. In der ganzen
Welt wurde die Milch zum Kunden gebracht. Frisch mußte
sie sein, nicht gepanscht und nicht verdünnt. Es kursierten immer
Gerüchte, was man mit Kalk und Wasser alles machen könne, aber
die wirkliche Gefahr waren eher die unhygienischen Bedingungen,
unter denen die Kühe gemolken wurden, als betrügerische
Machenschaften. Stammkunden hatten ihre eigenen Kannen und
Meßbecher und füllten diese, wie bei dem walisischen Lieferanten
(1), direkt aus der Milchkanne oder, wie bei diesem argentinischen
Milchmann, vom Faß (2).

L̲'eau venait du puits, le lait de la carriole. Dans le monde entier
on livrait le lait au client. On le prétendait frais, pur et non
dilué. Des bruits couraient sans cesse sur ce qu'on pouvait faire avec
de la craie et de l'eau ; mais le véritable danger venait davantage
des conditions peu hygiéniques dans lesquelles on trayait les vaches
que des pratiques frauduleuses. Les chalands se servaient de leurs
propres récipients et mesures, remplis directement au bidon de ce
fournisseur gallois (1) ou à la jarre de ce laitier argentin (2).

1

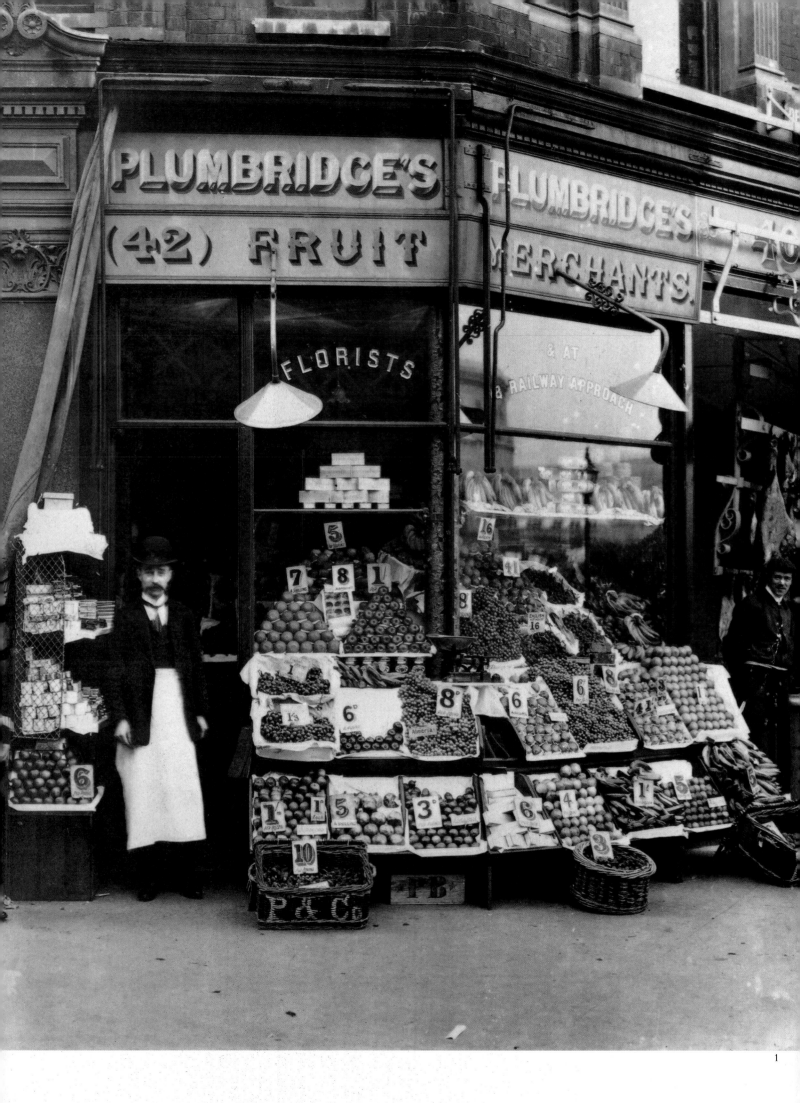

At the beginning of the 20th century, food shops were better stocked than ever before. The grocer's window (2), the greengrocer's display (1) and the Italian delicatessen (4) all provide evidence of thriving world trade. The cobbler's shop (3) is an oddity. It was the smallest shop in London – 6 ft 6 in (2 m) wide, 5 ft (1.60 m) high, 2 ft (0.6 m) deep. The broad-shouldered cobbler could barely stand in it, but the rent was cheap and it gave him a living.

Zu Beginn des 20. Jahrhunderts war das Angebot in den Lebensmittelgeschäften größer als je zuvor. Das Schaufenster des Kaufmanns (2), die Auslage des Obst- und Gemüsehändlers (1) und des italienischen Delikatessengeschäfts (4) liefern den Beweis für einen blühenden Welthandel. Der Laden des Schusters (3) ist eine Besonderheit, denn er war das kleinste Geschäft in ganz London (2 Meter breit, 1,60 Meter hoch und 0,60 Meter tief). Der breitschultrige Schuster konnte kaum darin stehen, aber die Miete war niedrig, und er hatte sein Auskommen.

Au début du XXᵉ siècle, les magasins d'alimentation étaient mieux approvisionnés que par le passé. La devanture de l'épicier (2), l'étalage du marchand de légumes et de fruits (1), tout comme les plats cuisinés de l'Italien (4) étaient autant de preuves d'un commerce mondial florissant. La boutique du savetier (3) était une curiosité. C'était la plus petite boutique de Londres (2 m de large, 1,60 m de haut, 60 cm de profondeur). Le savetier pouvait tout juste y tenir debout avec ses larges épaules; mais le loyer était bon marché et son travail lui permettait de vivre.

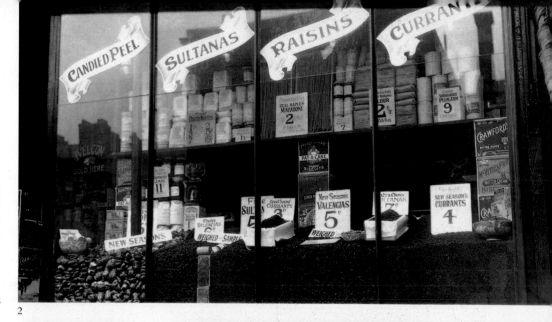

2

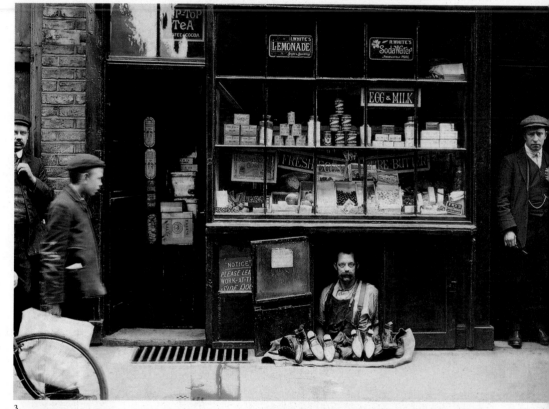

3

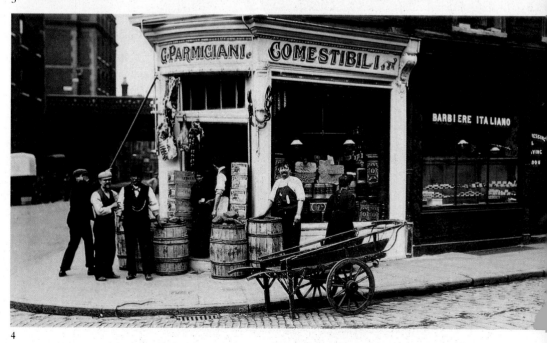

4

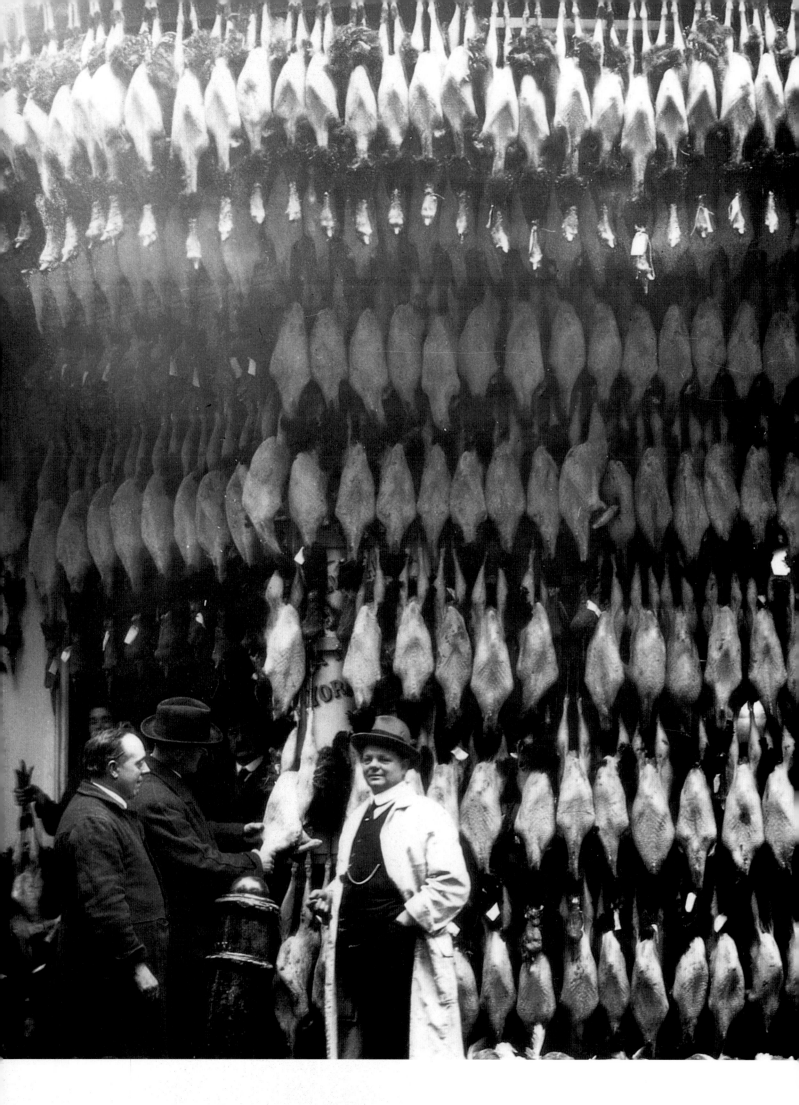

After the pre-war years of plenty, most Europeans had to tighten their belts during the First World War. The governments of the major powers all imposed restrictions and controls. In 1916 the first supplies of meat under municipal control went on sale in Paris (2). Unlike the austere aftermath of the Second World War, once hostilities came to an end, however, supplies returned in plenty to much of Europe – as this poulterer's display of 1919 shows (1).

Nach den goldenen Vorkriegsjahren mußten viele Europäer im Ersten Weltkrieg ihren Gürtel enger schnallen. Die Regierungen der Großmächte verordneten Restriktionen und Kontrollen. Im Jahre 1916 wurden in Paris die ersten Fleisch-lieferungen unter städtischer Kontrolle verkauft (2). Anders als in den mageren Jahren nach dem Zweiten Weltkrieg, füllten sich nach dem Ende des Ersten Weltkriegs die Läden rasch wieder, wie diese Auslage eines Geflügelhändlers aus dem Jahre 1919 zeigt (1).

Après les années d'abondance, la plupart des Européens durent se serrer la ceinture pendant la Première Guerre mondiale. Les gouvernements des grandes puissances imposèrent des restrictions et des contrôles. En 1916 eut lieu à Paris la première vente de viande sous la surveillance des autorités de la ville (2). Contrairement à l'époque d'austérité qui succéda à la Deuxième Guerre mondiale, en 1919, une fois les hostilités terminées, presque toute l'Europe se retrouva abondamment réapprovisionnée comme le montre l'étal de ce marchand de volailles et de gibier (1).

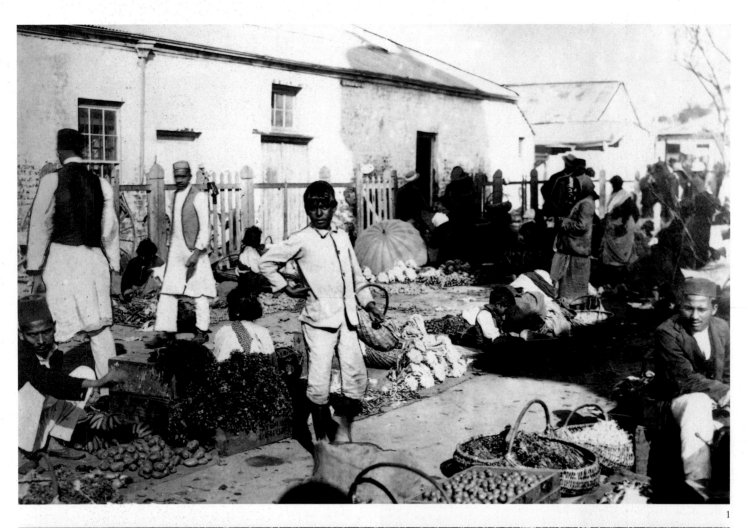

1

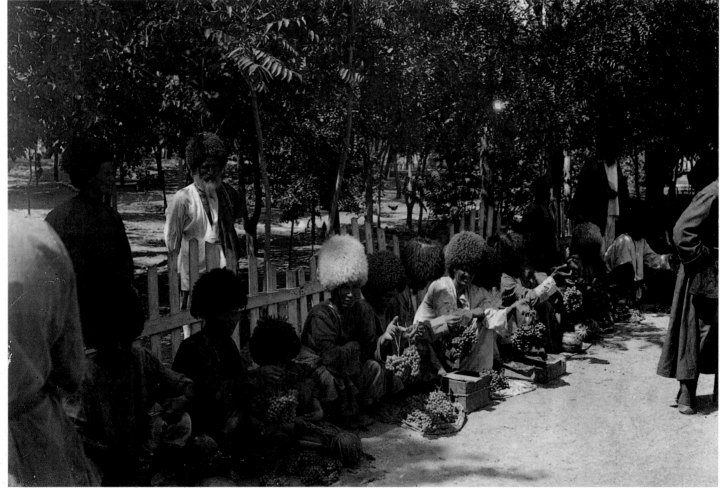

2

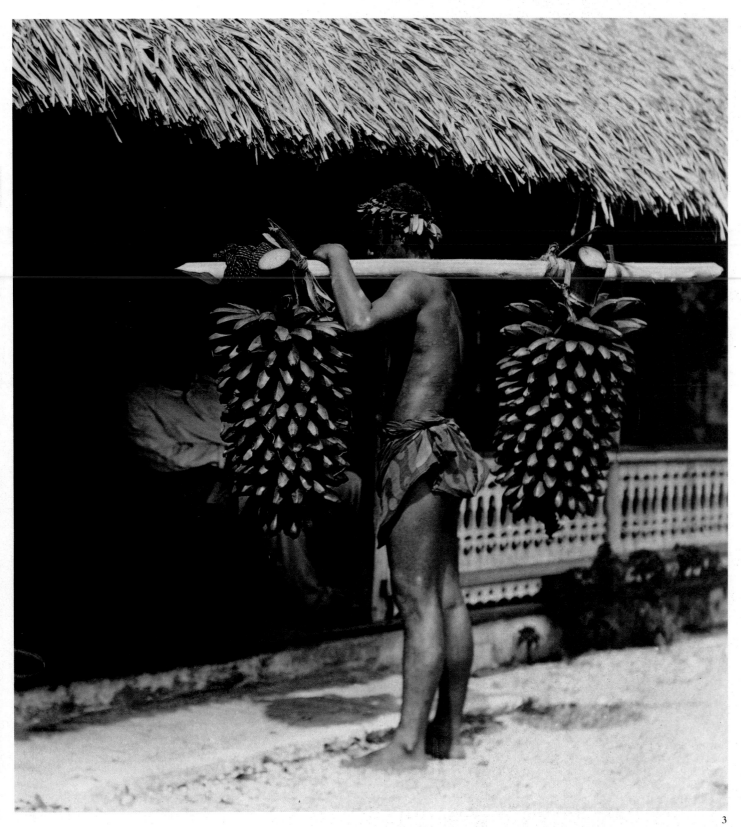

3

IN little-known regions, adventurers, explorers and fortune hunters stopped to photograph local markets and buy supplies. In South Africa, many market traders were Indian immigrants (1). In Russian Kirghizia, peasants offered grapes to members of the Tien-Shan Expedition of the 1890s (2). In Tahiti, 50 kg of plantain were painfully hauled to the white man's veranda (3).

IN den weniger bekannten Regionen der Welt machten Abenteurer, Entdecker und Globetrotter halt, um einheimische Märkte zu photographieren und einheimische Waren zu kaufen. Viele der Markthändler in Südafrika waren indische Einwanderer (1). Im russischen Kirgisien boten Bauern den Mitgliedern der Tien-Shan-Expedition in den 1890er Jahren Weintrauben an (2). In Tahiti wurden 50 Kilogramm Bananen mühsam zur Veranda des weißen Mannes geschleppt (3).

LES aventuriers, les explorateurs et les coureurs de dots s'arrêtaient dans des régions peu connues, le temps de photographier les marchés locaux et d'y acheter des produits. En Afrique du Sud, les commerçants du marché étaient souvent d'origine indienne (1). En Géorgie, les paysans offrirent des raisins aux membres de l'expédition de Tien-Shan dans les années 1890 (2). À Tahiti, 50 kg de bananes sont péniblement hissées jusqu'à la véranda de l'homme blanc (3).

1

2

TRADITIONAL markets still flourished in Europe. The cheese-market in Alkmaar, Noord Holland (1), had been set up every Friday from May to October for hundreds of years when this photograph was taken in 1910. Dried fish, as on this stall in a Belgian market (2), had been part of the staple diet of North Europeans for a long time. Catholic restrictions on the eating of meat had made fish a popular substitute on fast days, and had brought prosperity to many great fish merchants over the centuries.

IN Europa florierten noch immer die traditionellen Märkte. Als diese Photographie 1910 aufgenommen wurde, fand der Käsemarkt in Alkmaar, Nordholland (1), bereits seit Hunderten von Jahren von Mai bis Oktober jeden Freitag statt. Getrockneter Fisch, wie er an diesem Stand auf einem belgischen Markt verkauft

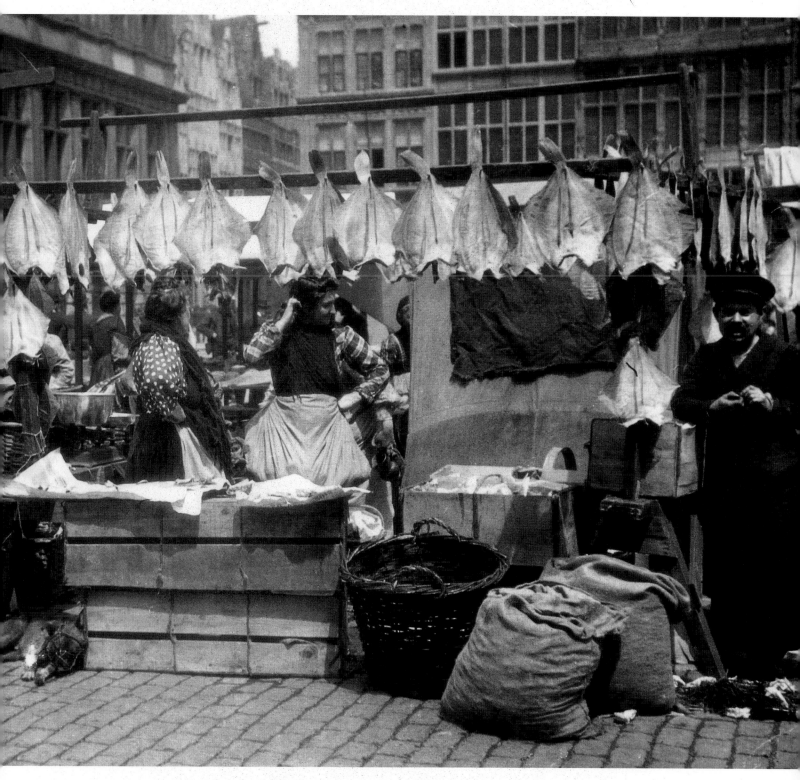

wurde (2), hatte lange Zeit zu den Grundnahrungsmitteln der Nordeuropäer gehört. Restriktionen der katholischen Kirche bezüglich des Verzehrs von Fleisch hatten Fisch zu einem beliebten Ersatz an Fastentagen gemacht und im Laufe der Jahrhunderte vielen Fischhändlern zu großem Reichtum verholfen.

EN Europe, les marchés traditionnels étaient toujours aussi florissants. Le marché aux fromages d'Alkmaar, en Hollande septentrionale (1), se tenait chaque vendredi de mai à octobre depuis déjà des siècles lorsque, en 1910, cette photographie a été prise. Le poisson séché, comme sur cet étal d'un marché belge (2), constituait depuis

longtemps l'aliment de base des Européens du Nord. La consommation de viande étant limitée par les catholiques, le poisson était devenu un aliment populaire de remplacement les jours de jeûne et faisait depuis des siècles la fortune de bien des grands marchands de poissons.

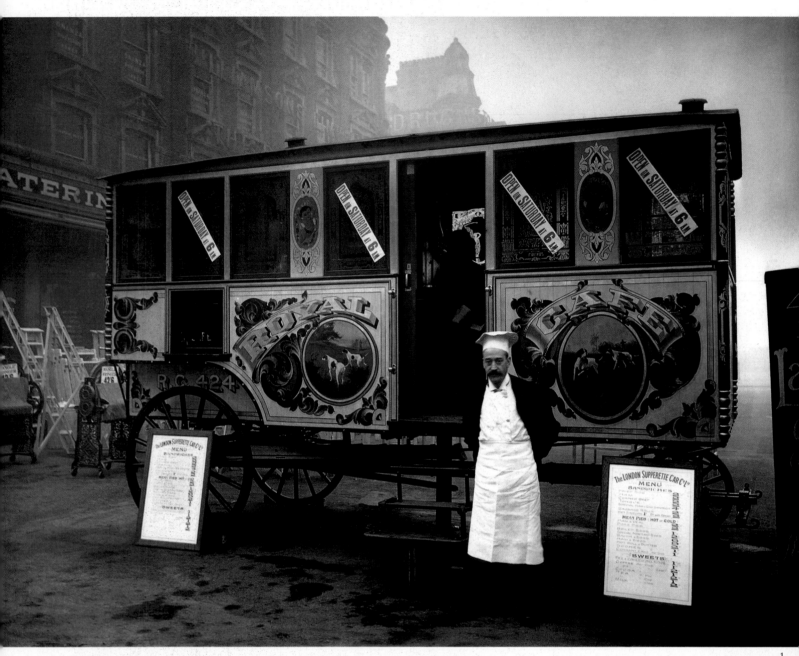

THE Royal Cafe and Night Lunch (1) was the first open-air car-restaurant in Britain. 'The car-restaurant,' boasted its manager, 'is a place into which a man may safely bring his wife or his sweetheart.' The hotel kitchen (2) was a place of toil and trouble, and sweated labour: 'a stifling, low-ceilinged inferno of a cellar… deafening with oaths and the clanging of pots and pans… In the middle were furnaces, where twelve cooks skipped to and fro, their faces dripping with sweat in spite of their white caps.' But the customer, quietly dining in Baker's Chop House, London (3), would have seen and heard none of this.

DAS Royal Café and Night Lunch (1) war das erste mobile Freiluft-Restaurant in Großbritannien. Das »Wagen-Restaurant«, prahlte sein Manager, »ist ein Ort, an den ein Mann sicher seine Frau oder seine Geliebte führen kann.« Die Hotelküche (2) war ein Ort des Chaos, der Hektik und der schweißtreibenden Arbeit: »Eine stickige, niedrige Kellerhölle mit ohrenbetäubendem Lärm aus Flüchen und dem Scheppern von Töpfen und Pfannen … In der Mitte Öfen, an denen zwölf Köche hantierten, die Gesichter schweiß-überströmt, trotz ihrer weißen Mützen.« Aber der Gast, der in aller Ruhe in Baker's Chop House in London (3) dinierte, sah und hörte von all dem nichts.

LE Royal Café and Night Lunch (1) fut la première voiture-restaurant en plein air en Grande-Bretagne. « La voiture-restaurant », proclamait le gérant, « est un endroit dans lequel un homme peut en toute sécurité amener son épouse ou sa petite amie ». La cuisine de l'hôtel (2) n'était pas de tout repos, c'était plutôt un lieu de labeur : « Un enfer étouffant au plafond bas dans une cave … où retentissaient les ju-rons, les bruits des marmites et des casseroles s'entrechoquant … Au milieu se trouvaient les fourneaux autour desquels s'affairaient douze cuisiniers, aux visages dégoulinant de sueur malgré leurs toques blanches.» Toutefois le client qui dînait tranquillement au Baker's Chop House à Londres (3) n'en avait certainement jamais entendu parler.

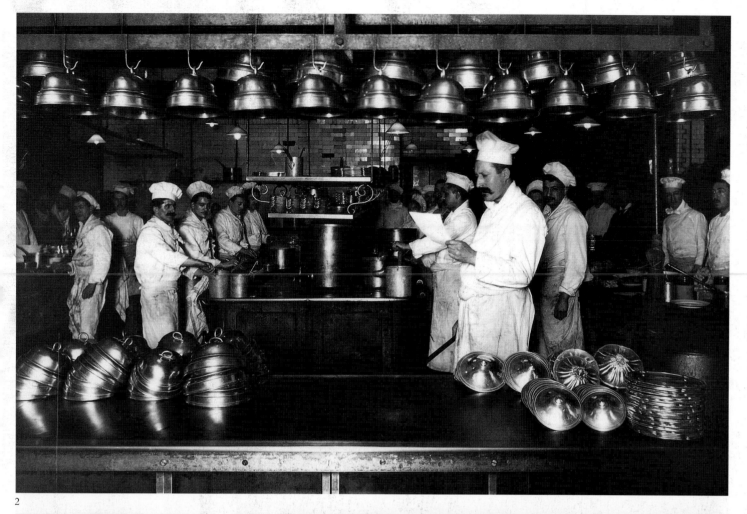

2

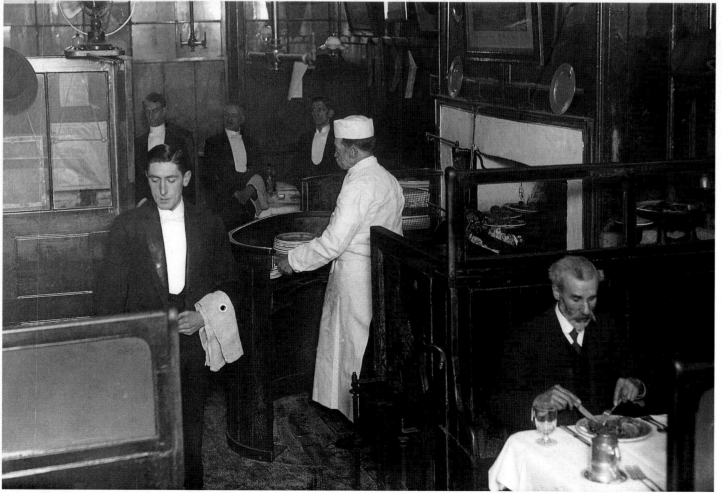

3

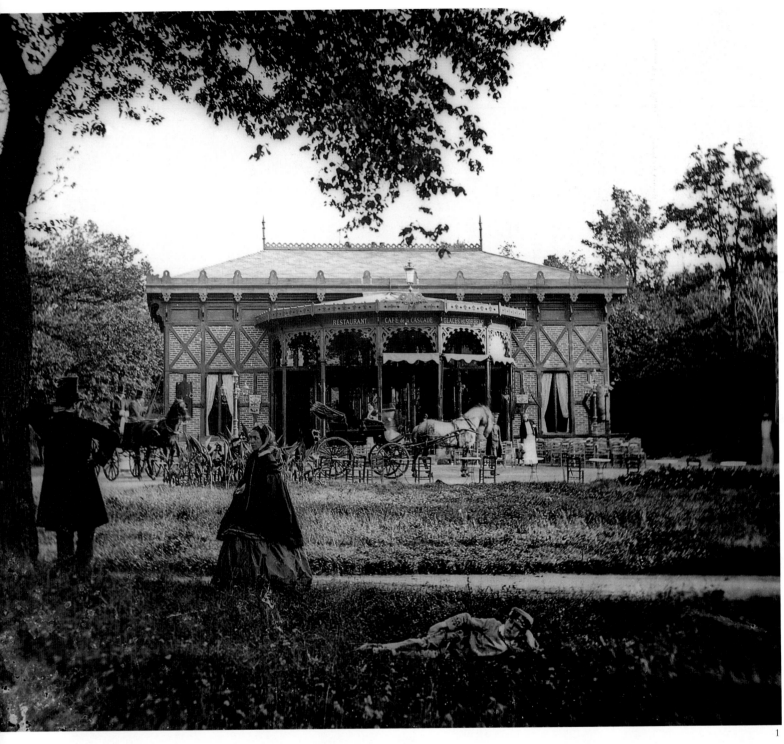

'IT was a pleasure to eat where everything was so tidy, the food so well cooked, the waiters so polite, and the coming and departing company so moustached, so frisky, so affable, so fearfully and wonderfully Frenchie!' wrote Mark Twain of his visit to a Paris restaurant in 1866. The Café de la Cascade, in the Bois de Boulogne (1), certainly had an air of calm and order as it awaited custom on a summer day in 1859. Eating out was a feature of 19th-century life, and every hotel, every railway terminus and exhibition hall had its own fully equipped dining room – like this at the London International Exhibition in 1862 (2).

Es war ein Vergnügen, dort zu speisen, wo alles so sauber, das Essen so gut zubereitet, die Kellner so höflich, die kommende und gehende Gesellschaft so schnurrbärtig, so verspielt, so freundlich, so schrecklich und wunderbar französisch war!« schrieb Mark Twain 1866 nach seinem Besuch in einem französischen Restaurant. Im Café de la Cascade im Bois de Boulogne (1) herrschte gewiß eine

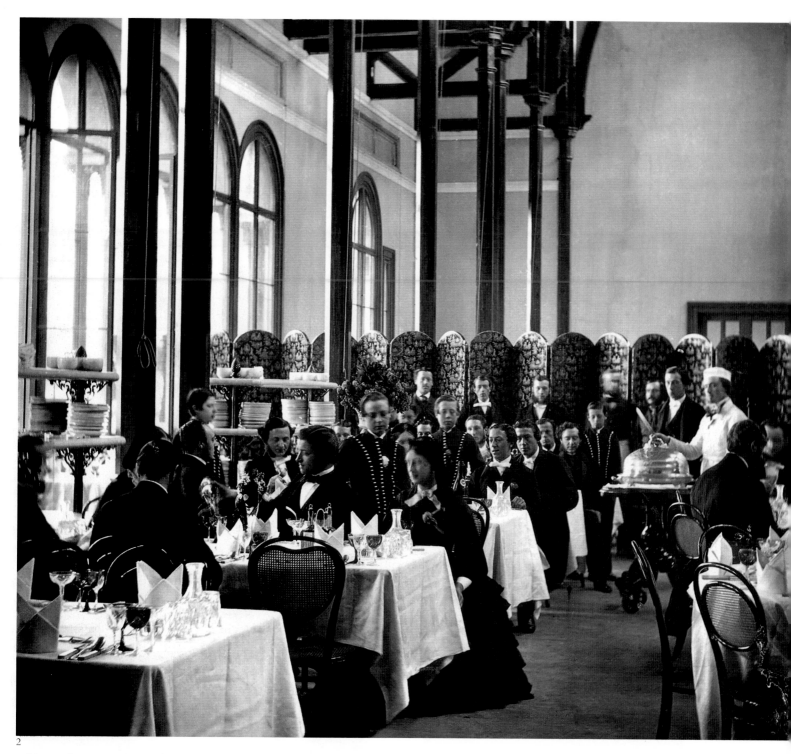

2

ruhige und gesittete Atmosphäre, wenn an einem Sommertag des Jahres 1859 die Gäste erwartet wurden. Auswärts zu essen war typisch für das Leben im 19. Jahrhundert, und jedes Hotel, jeder Bahnhof und jedes Museum besaßen einen eigenen, komplett ausgestatteten Speisesaal wie z. B. diesen, den man 1862 auf der Londoner internationalen Ausstellung besuchen konnte (2).

C'ÉTAIT un plaisir de manger dans un endroit où tout était si propre, où la nourriture était si bien cuisinée, où les garçons étaient si polis et où entraient et sortaient des clients si moustachus, si enjoués, si affables, si épouvantablement et merveilleusement typiquement français ! » écrivait Marc Twain relatant ses souvenirs d'un restaurant parisien en 1866. Le Café de la

Cascade au Bois de Boulogne (1) dégageait certainement cette impression de calme et d'ordre avant l'arrivée des clients en ce jour d'été 1859. Manger à l'extérieur était très prisé au XIXe siècle. De plus, chaque hôtel, chaque terminus de train et chaque salon d'exposition disposaient d'une salle à manger aménagée, semblable à celle de l'Exposition internationale à Londres en 1862 (2).

Industry

IN 1852, a factory inspector reported to the British government: 'I believe the work people never were so well off as they are at present; constant employment, good wages, cheap food, and cheap clothing; many cheap, innocent and elevating amusements brought within their reach… the greater proportion of all the operatives in mills have at length time for some mental improvement, healthful reaction, and enjoyment of their families and friends.'

It was an assertion reiterated often in the next 60 years. The workers had never had it so good, were they black cotton pickers in the American south (1), or mill workers in cotton factories in Europe (2, 3). Shorter hours, improved conditions, better pay – all fought for by the newly legitimized unions – freed most factory hands from the conditions of near-slavery in which their grandparents had toiled.

But life in the average industrial town was still ugly and foul: '… a town of machinery and tall chimneys, out of which interminable serpents of smoke trailed themselves for ever and ever, and never got uncoiled. It had a black canal in it, and a river than ran purple with ill-smelling dye, and vast piles of building… where the piston of a steam engine ran monotonously up and down, like an elephant in a state of melancholy madness' (Charles Dickens).

The workers may never have had it so good – before the end of the century they showed they wanted it a good deal better.

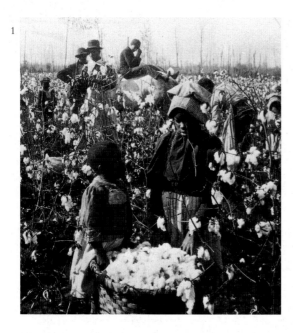

1

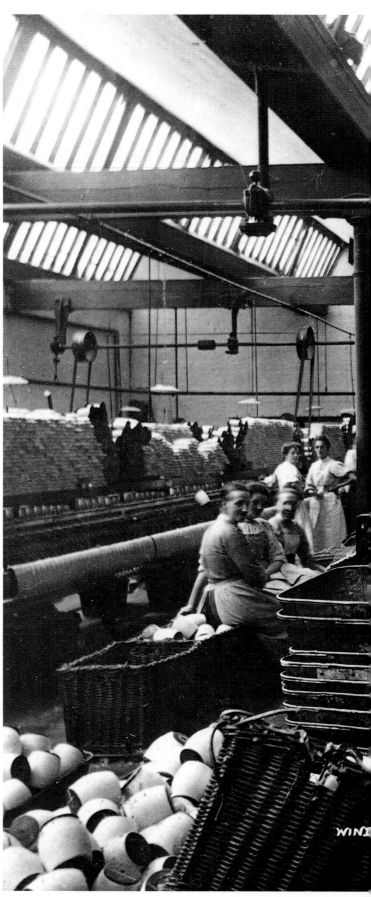

2

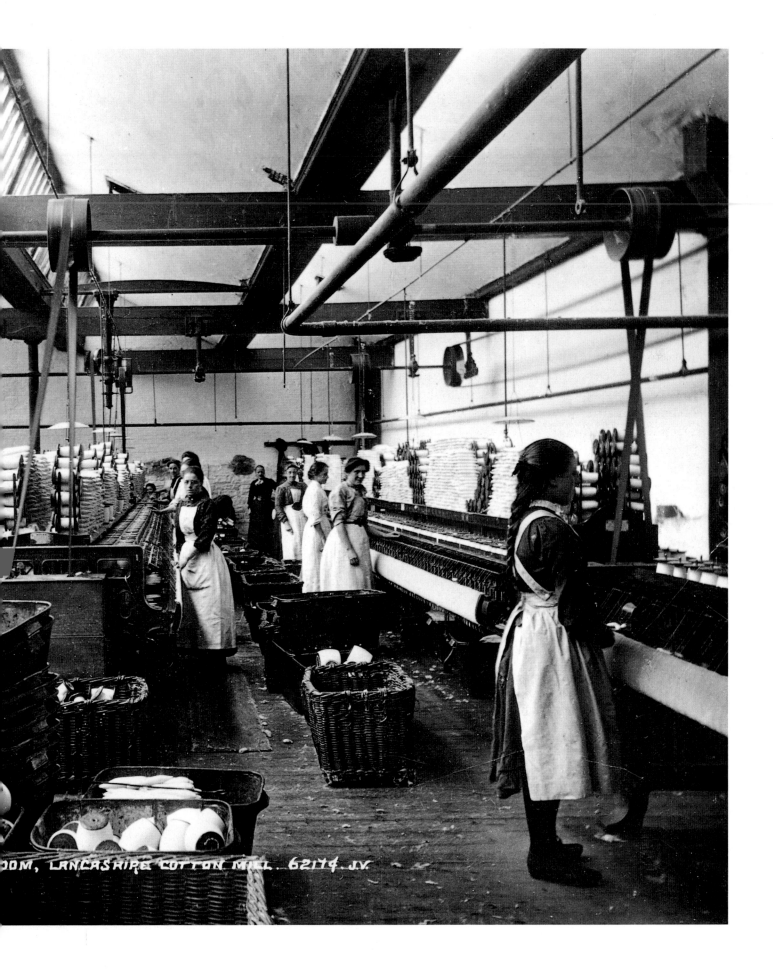

0OM, LANCASHIRE COTTON MILL. 62174. J.V.

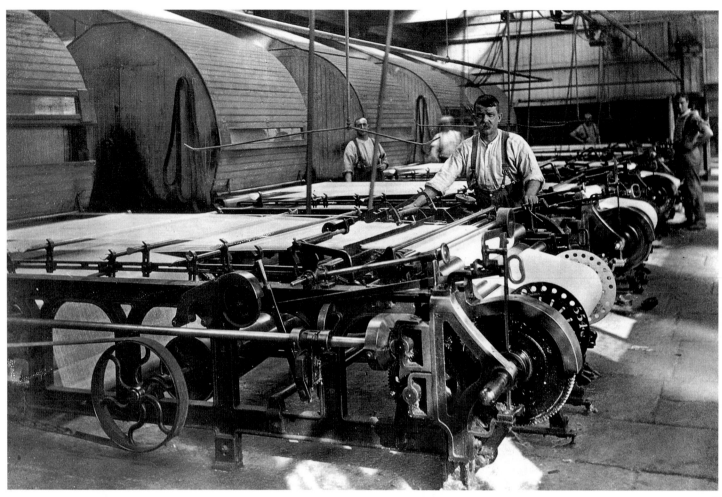

3

Im Jahre 1852 berichtete ein Fabrikinspektor der britischen Regierung: »Ich bin der Ansicht, daß es den Arbeitern noch nie so gut ging wie heute; dauerhafte Beschäftigung, gute Löhne, billiges Essen und billige Kleidung, harmlose und erheiternde Unterhaltung stehen ihnen zur Verfügung …, die meisten der Fabrikarbeiter haben genügend Zeit für geistige Fortbildung, gesunde Körperertüchtigung und vergnügliches Zusammensein mit Freunden und Familie.«

Diese Behauptung wurde in den folgenden sechzig Jahren ständig wiederholt. Die Arbeiter hatten es niemals so gut gehabt, ob es sich nun um schwarze Baumwollpflücker im Süden der Vereinigten Staaten (1) oder um Arbeiter in europäischen Baumwollfabriken (2, 3) handelte. Die von den wieder legitimierten Gewerkschaften erkämpften kürzeren Arbeitszeiten, verbesserten Arbeitsbedingungen und besseren Löhne befreiten die meisten Fabrikarbeiter von Zuständen, die fast an Sklaverei gegrenzt und unter denen ihre Großväter noch gelitten hatten.

Aber das Leben in einer durchschnittlichen Industriestadt war noch immer öde und grau: »… eine Stadt von Maschinen und hohen Schornsteinen, aus denen ohne Unterlaß endlos lange Rauchschlangen stiegen. In ihr wanden sich ein schwarzer Kanal und ein Fluß, in dem rote, stinkende Farbe floß, und es gab große Gebäudeberge …, in denen der Kolben einer Dampfmaschine monoton auf und ab stampfte, wie ein Elefant im Zustand melancholischen Wahnsinns.« (Charles Dickens)

Den Arbeitern mochte es niemals so gut gegangen sein, aber vor dem Ende des Jahrhunderts machten sie deutlich, daß sie es in der Zukunft noch viel besser haben wollten.

En 1852, un inspecteur d'usine signalait au gouvernement britannique : « Je suis convaincu que les travailleurs n'ont jamais été aussi bien qu'aujourd'hui ; l'emploi ne manque pas et il est bien payé, la nourriture est bon marché et les vêtements de prix modiques ; de nombreux amusements innocents qui élèvent l'esprit sont mis à leur portée... la très grande majorité des ouvriers dans les fabriques ont tout le temps de perfectionner leur entendement, de prendre soin de leur santé et d'apprécier la compagnie de leurs familles et de leurs amis. »

On répéta cette affirmation tout au long des soixante années qui suivirent. La condition des travailleurs n'avait jamais été aussi bonne, qu'il s'agît des cueilleurs de coton noirs du sud des États-Unis (1) ou des ouvriers dans les filatures de coton européennes (2 et 3). La diminution des horaires, l'amélioration des conditions de travail et la revalorisation des salaires arrachés par les syndicats fraîchement légitimés libérèrent la plupart des ouvriers travaillant en usine du quasi-esclavage qui avait été le lot de leurs grands-parents.

La vie dans la ville industrielle moyenne n'en restait pas moins laide et insalubre : « ... une ville de machines et de hautes cheminées desquelles s'échappaient continuellement d'interminables serpents de fumées qui ne déroulaient jamais leurs anneaux. Elle possédait un canal noir et une rivière aux eaux violettes qui empestaient la teinture, ainsi que de vastes empilements de constructions ... où le piston d'un moteur à vapeur montait et descendait à la façon monotone d'un éléphant pris de folie mélancolique. » (Charles Dickens)

Même si la condition des travailleurs n'avait jamais été aussi bonne, ceux-ci montrèrent avant la fin du siècle qu'ils la voulaient meilleure encore.

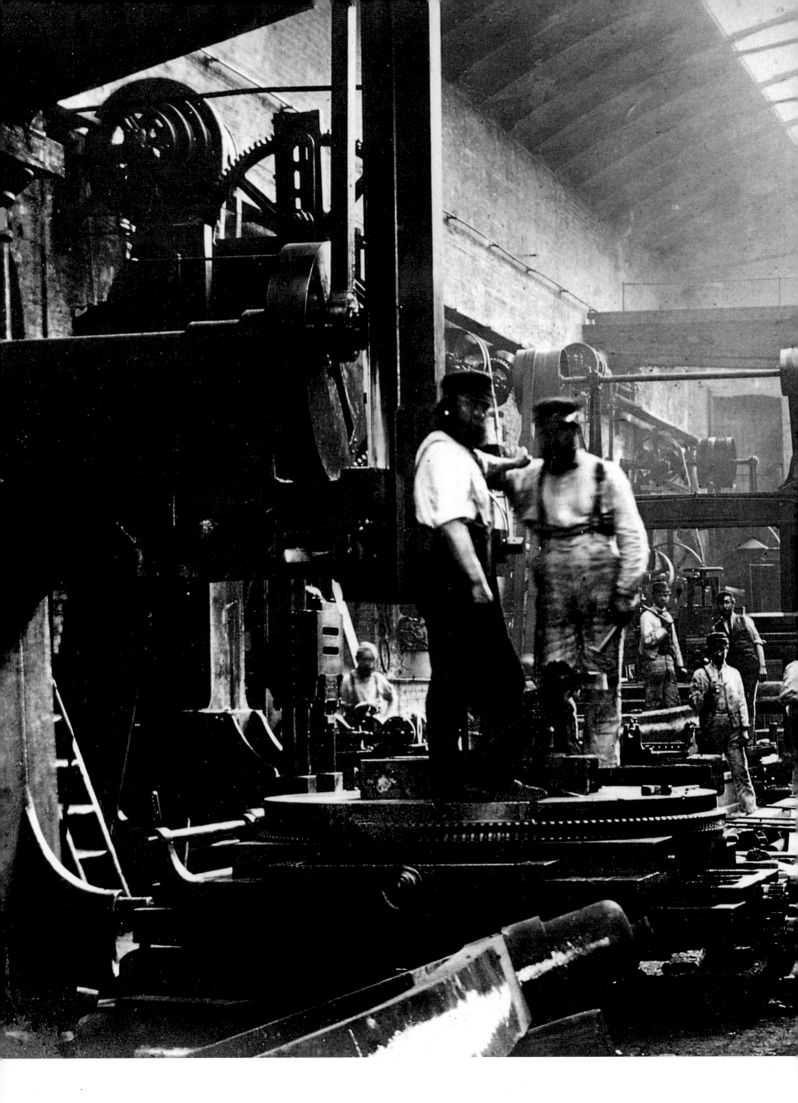

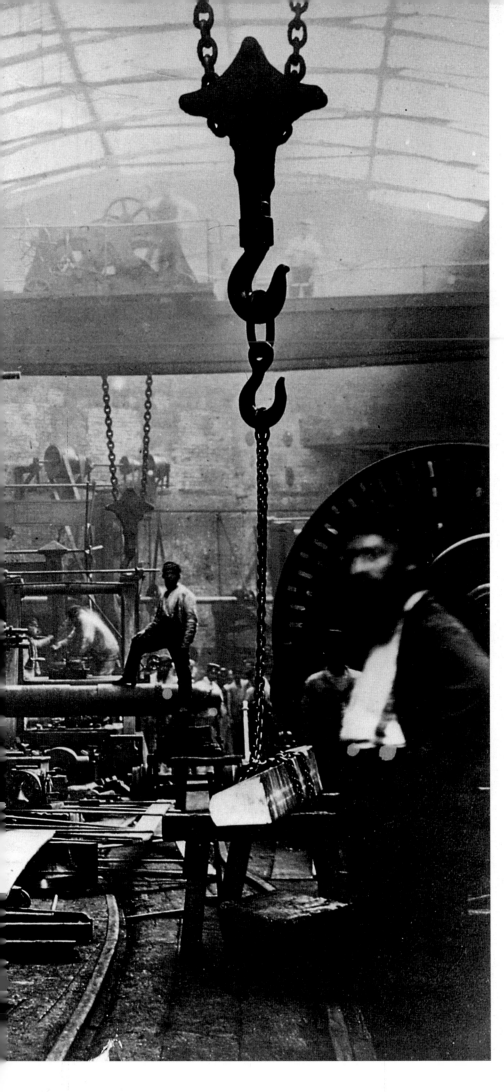

FOR all the faults and horrors of industrialization, the 19th century was in love with machines and the vast edifices that housed them. A visit to a factory or workshop was as exciting as a trip to a leisure park may be to us today. An engineering shed, such as this at the Thomas Ironworks, London, in 1867, echoed to the ringing blows of the workmen's hammers, and throbbed with the mighty machinery that had harnessed the power of steam.

Any major construction site – bridge, tunnel, railway, dock or building – could expect a visit from a photographer, and the men and women would pause from their labour and pose for a moment of eternity.

TROTZ aller Mißstände und Schrecken der Industrialisierung war man im 19. Jahrhundert vernarrt in Maschinen und in die riesigen Gebäude, in denen sie untergebracht waren. Der Besuch in einer Fabrik oder Werkstatt war ebenso aufregend wie heutzutage ein Ausflug in einen Vergnügungspark. In einer Maschinenhalle wie dieser der Thomas Eisenwerke in London ertönte 1867 das Echo der Hammerschläge der Arbeiter und die Vibration der Maschinen, die die Kraft des Dampfes zügelten.

Jede Großbaustelle, ob Brücke, Tunnel, Eisenbahn, Dock oder Gebäude, war bei Photographen beliebt, und Männer und Frauen unterbrachen ihre Arbeit, um für einen Moment der Ewigkeit zu posieren.

MALGRÉ toutes les fautes et les horreurs de l'industrialisation, le XIXᵉ siècle était amoureux des machines et des vastes édifices qui les abritaient. Pour les nantis, la visite d'une usine ou d'un atelier était tout aussi excitante que le serait peut-être pour nous aujourd'hui le parc de loisirs. Un hangar de construction tel que celui de Thomas Ironworks à Londres en 1867 résonnait des coups assenés par les marteaux des ouvriers et des puissantes machines qui exploitaient à l'unisson le pouvoir de la vapeur.

N'importe quel site de construction, pont, tunnel, chemin de fer, chantier – naval ou non – pouvait compter sur la visite du photographe, ce qui permettait à ces hommes et à ces femmes d'interrompre leur travail, le temps de poser pour un moment d'éternité.

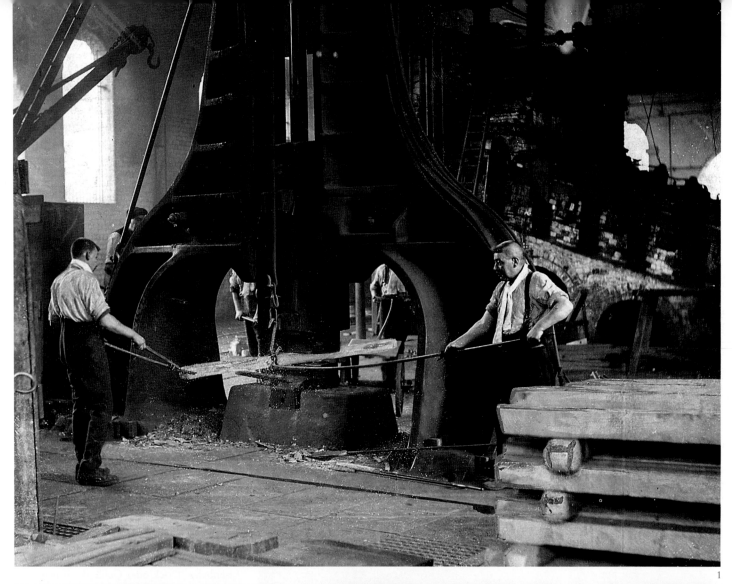

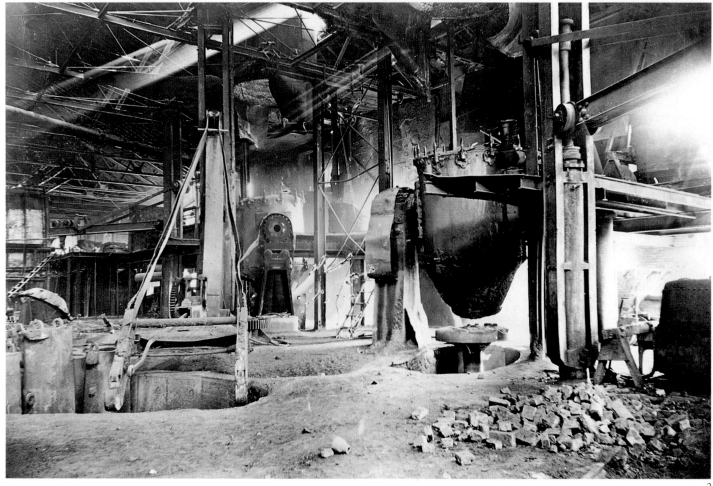

IN the great industrial race it was the United States that eventually emerged the winner. The Bessemer Converter, introduced in 1856, revolutionized steel production, as in the Otis Steel Works in Pittsburgh, USA (1, 2). Krupps of Essen (4) was the biggest works in Europe, and employed over 16,000 people when this photograph was taken in 1870. Harland and Wolff's shipyard in Belfast was hard at work in 1910 on perhaps the most famous liner of all – the *Titanic* (3).

IM großen Wettlauf der Industrialisierung machten schließlich die Vereinigten Staaten das Rennen. Der Bessemer Konverter, 1856 erfunden, revolutionierte die Stahlproduktion, beispielsweise in den Otis Stahlwerken in Pittsburgh, USA (1, 2). Krupp in Essen (4) war die größte Stahlfabrik Europas und beschäftigte über 16 000 Menschen, als diese Photographie im Jahre 1870 aufgenommen wurde. In der Werft von Harland und Wolff in Belfast wurde im Jahre 1910 hart gearbeitet, und zwar am vielleicht berühmtesten Ozeanriesen aller Zeiten, der *Titanic* (3).

LES États-Unis sortirent vainqueurs de la formidable course industrielle. Le procédé de Bessemer, introduit en 1856, révolutionna la sidérurgie, comme ici dans les usines Otis Steel Works de Pittsburg (1 et 2). Les usines Krupp, à Essen, (4) étaient les plus importantes d'Europe et elles employaient plus de 16 000 personnes, en 1870, à l'époque où cette photographie fut prise. Les chantiers navals d'Harland and Wolff à Belfast travaillaient d'arrache-pied en 1910 à la construction de ce qui restera peut-être le paquebot le plus fameux de tous les temps, le *Titanic* (3).

3

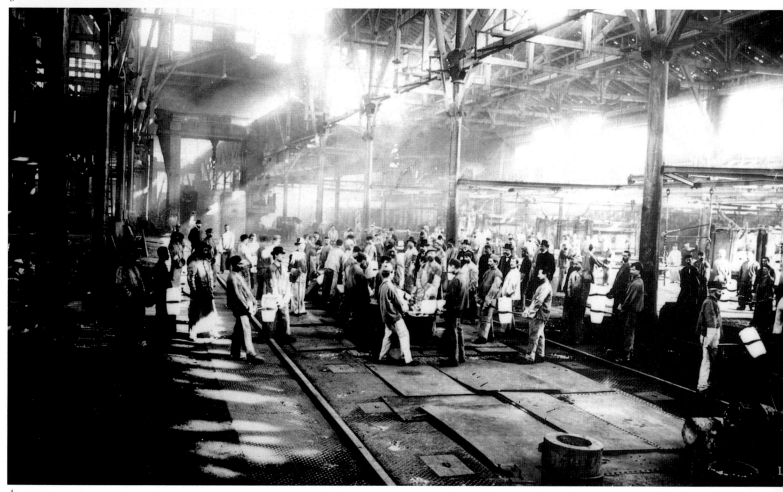

4

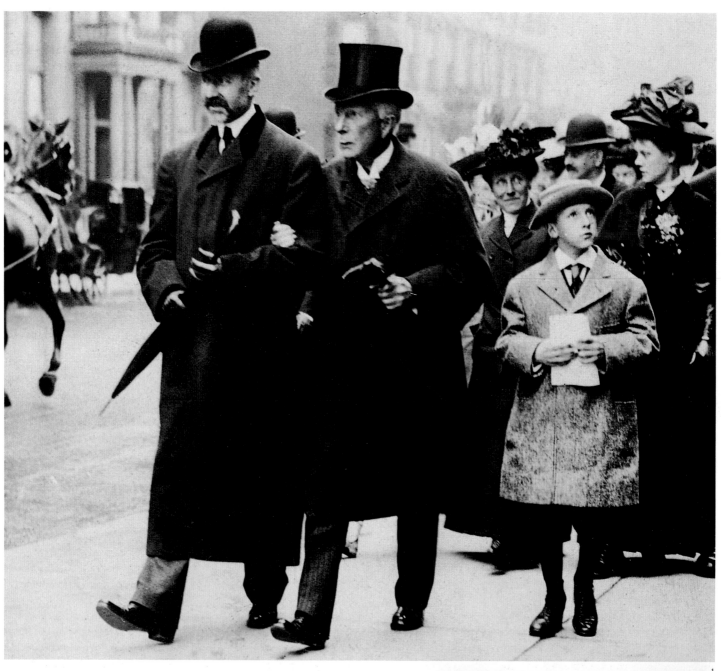

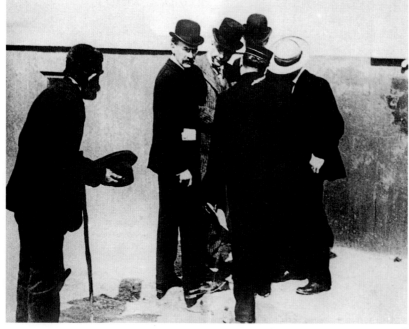

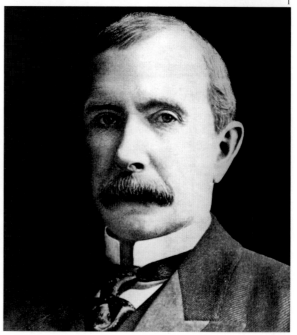

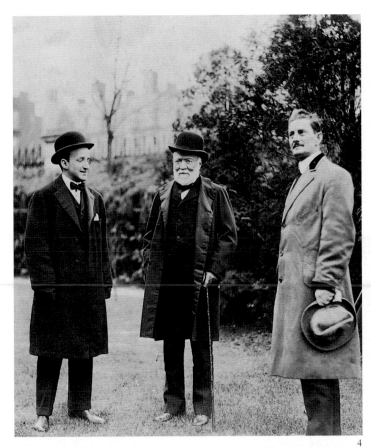

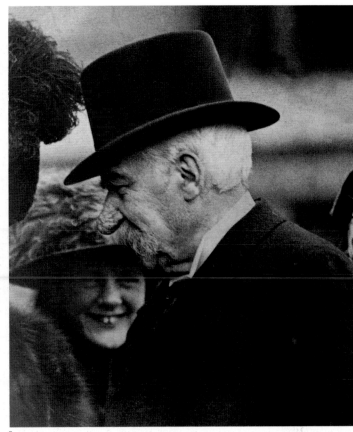

4 5

IT was the first (but not the last) heyday of the multi-millionaire – of Rothschild and Vanderbilt, the great banking houses and the industrial tycoons. John D. Rockefeller (1, in bowler hat; 3), walked the streets of New York, but refused to give to a beggar (2). The Rockefeller family paid to have publication of this picture suppressed. Andrew Carnegie (4 – with white beard) was more generous: he donated $350 million to various good causes. John Pierpont Morgan Snr (5) was once asked how much it cost to run a luxury yacht. 'If you have to ask,' he said, 'you can't afford it.'

ES war die erste (aber nicht letzte) Blütezeit der Multimillionäre, von Rothschild und Vanderbilt, der großen Bankiers und Industriemagnaten. John D. Rockefeller (1, mit Melone; 3) spazierte durch die Straßen New Yorks, verweigerte aber einem Bettler ein Almosen (2). Die Familie Rockefeller zahlte viel Geld, um die Veröffentlichung dieses Photos zu verhindern. Andrew Carnegie (4, mit weißem Bart) war großzügiger: er spendete 350 Millionen Dollar für verschiedene wohltätige Zwecke. John Pierpont Morgan senior (5) wurde einmal gefragt, wieviel es koste, eine Luxusjacht zu unterhalten. »Wenn Sie schon fragen müssen«, antwortete er, »werden Sie es sich wohl nicht leisten können.«

C'ÉTAIT la première (mais non la dernière) grande époque des multimillionnaires, des Rothschild et des Vanderbilt, des grands établissements banquiers et des magnats de l'industrie. John D. Rockefeller (1, en chapeau melon et 3) marchant dans les rues de New York et refusant l'aumône à un mendiant (2). La famille Rockefeller paya pour empêcher la publication de cette photographie. Andrew Carnegie (4, en barbe blanche) était plus généreux : il distribua l'équivalent de 350 millions de dollars à diverses bonnes causes. Un jour qu'on demandait à John Pierpont Morgan père (5) ce que coûtait la possession d'un yacht de luxe, il répondit : « Si vous le demandez ce n'est donc pas à votre portée. »

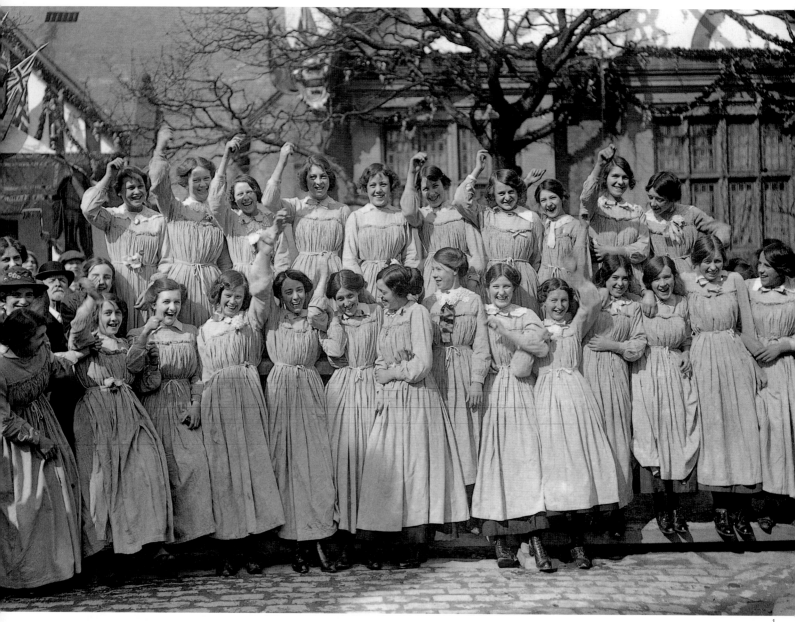

1

NEW machines demanded new skills. The typewriter, patented by C. L. Sholes in 1868, became the means by which women entered the office world, as evidenced by the British House of Commons type-writing staff in 1919 (3). But more traditional industries, like hatting in this Manchester factory (2), also required nimble fingers. It was hard work, poorly paid, and there were many who were forced into prostitution for better pickings. Occasionally, however, young women took to the streets for happier reasons. These English workers from Port Sunlight were setting out to welcome the King and Queen on an official visit in 1914 (1).

NEUE Maschinen erforderten neue Fertigkeiten. Die Schreibmaschine, 1868 von C. L. Sholes patentiert, wurde für Frauen zum Schlüssel zur Bürowelt, wie es die 1919 photographierten Schreibkräfte des britischen Unterhauses zeigen (3). Aber auch traditionellere Industriezweige, wie diese Hutfabrik in Manchester (2), verlangten geschickte Finger. Es war harte, schlecht bezahlte Arbeit, und es gab viele Frauen, die zur Prostitution gezwungen waren, um ihren Lebensunterhalt zu verdienen. Zuweilen gingen die Frauen jedoch auch aus erfreulicheren Gründen auf die Straße. Diese englischen Arbeiterinnen aus Port Sunlight machten sich 1914 auf, um den König und die Königin bei ihrem offiziellen Besuch zu begrüßen (1).

À nouvelles machines nouvelles qualifications. La machine à écrire, brevetée par C. L. Sholes en 1868, ouvrit aux femmes le monde des bureaux, comme en témoignent les dactylographes de la Chambre des Communes britannique en 1919 (3). Cependant des industries plus traditionnelles comme la confection de chapeaux dans cette chapellerie de Manchester (2) avaient besoin, elles aussi, de doigts agiles. Le travail était dur et mal payé. Beaucoup de femmes devaient se prostituer pour arrondir leurs fins de mois. De temps à autre, cependant, des raisons plus gaies amenaient les jeunes femmes dans les rues. Ces ouvrières anglaises à Port Sunlight s'apprêtent à accueillir le roi et la reine en visite officielle en 1914 (1).

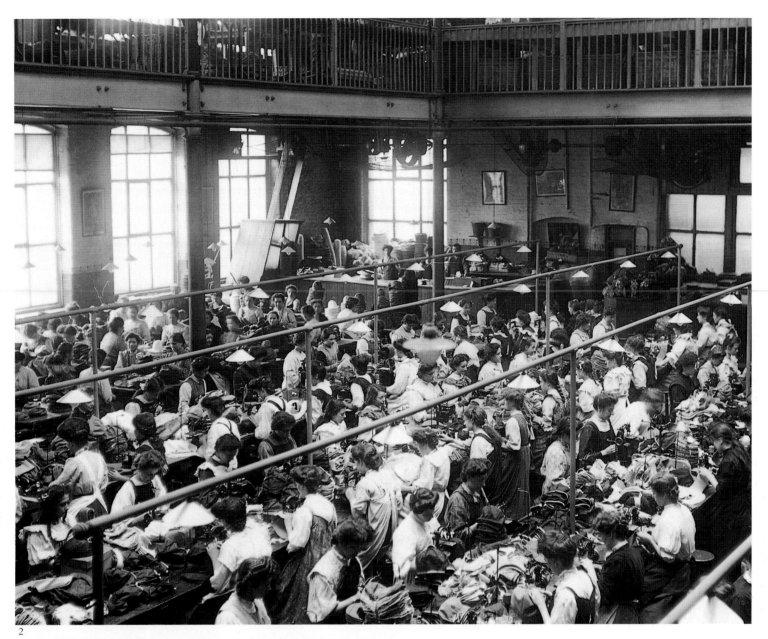

2

3

Home and Transport

IN 1865 John Ruskin, the artist and critic, described what he believed was the true nature of the 19th-century home: 'It is a place of Peace; the shelter, not only from all injury, but from all terror, doubt and division...' Many would have agreed – home was a refuge from the turmoil and frenzy of work and the wider world. But home was also a prison – for many women, for the poor, and for anyone unhappy with the stifling conventions of family life.

Home could be anything from a hollow in a mud bank for an evicted Irish family, to the palatial mansion staffed by a hundred servants and stuffed with the plunder of centuries. It could be epitomized by the splendid mantelpiece of a suburban villa (1), or by the opulence of the second-floor salon in Castle Konopischt, now in the Czech Republic, one of the retreats of the Archduke Franz Ferdinand (2, see following pages).

Whatever the splendour or the squalor, in most homes more attention was paid to public display than to private comfort. Bedrooms were unheated, plainly furnished, often poorly decorated. The front room or the parlour was the showpiece – crammed with knick-knacks and crowded with furniture, a haven for dust, a nightmare to clean. But then, in a well regulated home, cleaning was someone else's problem. After all, what were servants for?

'Prompt notice,' wrote Mrs Beeton, 'should be taken of the first appearance of slackness, neglect, or any faults in domestic work, so that the servant may know that the mistress is quick to detect the least disorder, and will not pass unsatisfactory work.'

1

DER Künstler und Kritiker John Ruskin beschrieb 1865, was er für das wahre Wesen des Heims des 19. Jahrhunderts hielt: »Es ist ein Ort des Friedens, des Schutzes nicht nur vor Verletzungen, sondern vor allen Schrecken, Zweifeln und Konflikten ...« Dem hätten viele zugestimmt – das Heim bot eine Zuflucht vor dem Chaos und der Hektik der Arbeit und des Lebens. Aber für viele Frauen, für die Armen und für jeden, der sich in den Konventionen der Familie unwohl fühlte, war das Heim auch ein Gefängnis.

Zuhause konnte alles sein, von der Mulde im Moor für eine vertriebene irische Familie bis zum palastartigen Herrenhaus mit hundert Bediensteten, vollgestopft mit Requisiten der Jahrhunderte. Das Heim konnte durch den herrlichen Kaminsims einer Vorortvilla (1) verkörpert werden oder durch einen Salon im zweiten Stock der Burg Konopischt in der heutigen tschechischen Republik, eines der Refugien der Erzherzogs Franz Ferdinand (2, siehe folgende Seiten).

Egal wie prächtig oder wie elend, in den meisten Heimen legte man mehr Wert auf Zurschaustellung als auf privaten Komfort. Die Schlafzimmer waren nicht beheizt, einfach und sparsam eingerichtet. Das Schaustück war das Wohnzimmer oder der Salon. Überladen mit Nippes und Möbeln, glich er einem riesigen Staubfänger, in dem Putzen zum Alptraum wurde. Aber in den besseren Häusern war Putzen das Problem anderer; wozu gab es schließlich Bedienstete?

»Bei den ersten Anzeichen von Nachlässigkeit und jeder Art von Fehlern bei der Hausarbeit ist sofort Meldung zu machen, damit der Bedienstete weiß, daß die Hausherrin die geringste Unordnung schnell entdecken und schlampige Arbeit nicht dulden wird«, schrieb Mrs. Beeton.

EN 1865, le critique d'art John Ruskin décrivait ce qu'il estimait être la nature véritable du foyer au XIXe siècle : « C'est un endroit de paix, l'abri non seulement contre toutes les blessures mais aussi contre toute terreur, doute et division ... » Ils étaient certainement nombreux à convenir que le foyer était un refuge contre la tourmente et la folie du travail et du monde extérieur. Mais le foyer était aussi une prison pour bien des femmes, pour les pauvres et pour quiconque souffrait des conventions de la vie familiale.

Le foyer pouvait être un trou creusé dans la boue pour une famille irlandaise expulsée de son domicile ou une demeure somptueuse peuplée d'une centaine de serviteurs et regorgeant des pillages accumulés pendant des siècles. Il pouvait être symbolisé par le splendide manteau de cheminée d'une villa de banlieue (1), ou par l'opulence d'un salon au deuxième étage du château de Konopischt (République tchèque), une des retraites de l'archiduc François-Ferdinand (2, pages suivantes).

Quelle qu'en fût la splendeur ou la laideur, la plupart des foyers témoignaient davantage du souci de paraître que de celui du confort privé. Les chambres à coucher n'étaient pas chauffées, elles étaient sobrement meublées et médiocrement décorées. L'antichambre ou le parloir étaient par excellence les pièces que l'on montrait, et dans lesquelles s'entassaient les bibelots et les meubles : une aubaine pour la poussière et un cauchemar à nettoyer. De toute façon, dans une maison digne de ce nom, le nettoyage était le souci de quelqu'un d'autre.

Madame Beeton écrivait : « Il convient de relever immédiatement le plus petit signe de relâchement, négligence ou toute autre faute dans le service des domestiques de manière à faire connaître aux serviteurs que la maîtresse est prompte à détecter le moindre désordre et qu'elle ne tolèrera pas le travail mal fait. »

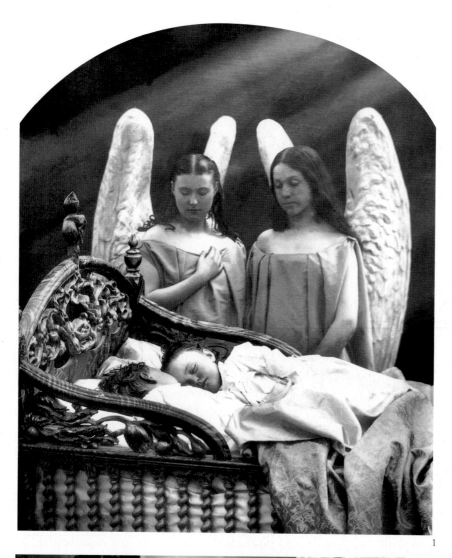

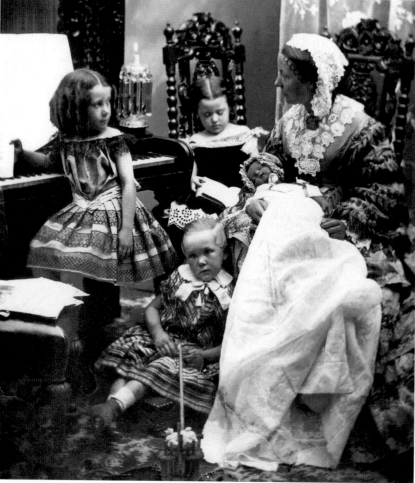

For rich and poor alike, the family was the centre of life, and babies and young children were as much worshipped in theory as they were abused in practice. In the photographer's studio, unrealistic 'angels' posed beside sleeping cherubs (1). In the front parlour, the fecundity of the family was paraded with pride (2), in an age which could do little more than condemn family planning. In parks and gardens, babies and their new-fangled folding carriages were put on public display (3).

Für die Reichen wie für die Armen war die Familie der Mittelpunkt des Lebens, und Säuglinge und kleine Kinder wurden theoretisch ebenso verehrt wie sie praktisch mißhandelt wurden. Im Atelier des Photographen posierten unrealistische »Engel« neben schlafenden Cherubinen (1). In einer Zeit, als man kaum etwas anderes tun konnte, als die Familienplanung zu verurteilen, wurde die Fruchtbarkeit der Familie stolz zur Schau gestellt (2). In Parks und Gärten präsentierte man die Kleinen und ihre neumodischen, zusammenklappbaren Kinderwagen der Öffentlichkeit (3).

Les riches comme les pauvres considéraient que la famille était le centre de leur vie ; quant aux bébés et aux jeunes enfants, ils étaient aussi adorés en théorie qu'ils étaient maltraités dans la pratique. Dans le studio du photographe, des « anges » peu réalistes posent à côté de chérubins endormis (1). Dans les antichambres, on exhibait fièrement la fécondité de la famille (2), à une époque où le planning familial était condamné. Dans les parcs et les jardins on montrait bébé et sa poussette pliante, un peu trop dernier cri au goût de certains (3).

1

2

3

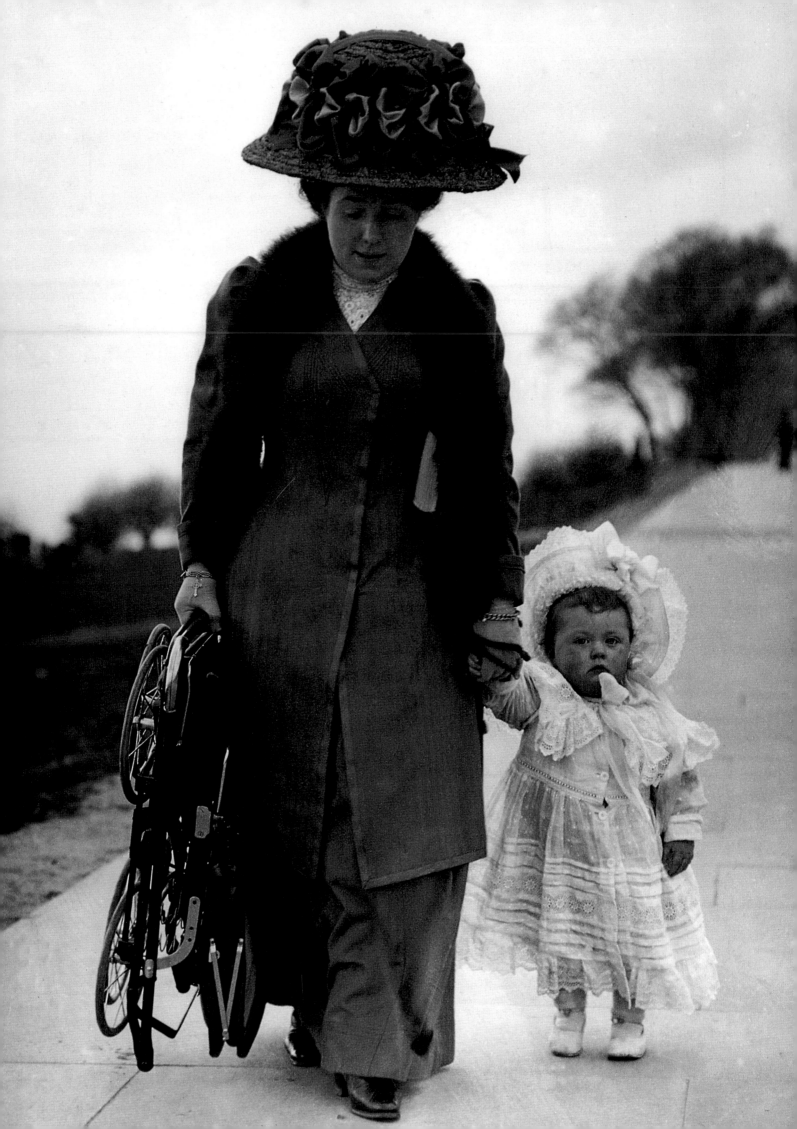

D AVID, the great-grandson of Queen Victoria, later Edward VIII and eventually Duke of Windsor, was just one year old in 1895 (2). Two of his less fortunate contemporaries, eating ice creams in a London park (3), would have been lucky if they survived the First World War to become his subjects. And for the very poor, crippled with rickets in the gloomy malnutrition of tenement life (1), the outlook was grotesquely bleak.

D AVID, der Urenkel von Königin Victoria, später Edward VIII. und schließlich Duke of Windsor, war im Jahre 1895 erst ein Jahr alt (2). Zwei seiner weniger glücklichen Zeitgenossen, die in einem Londoner Park Eiscreme essen (3), konnten von Glück reden, wenn sie den Ersten Weltkrieg überlebten, um seine Untertanen zu werden. Und für die Ärmsten der Armen, die wegen Unterernährung verwachsen waren und in freudlosen Mietskasernen lebten (1), gab es kaum noch Hoffnung.

D AVID, arrière-petit-fils de la reine Victoria, devenu plus tard Édouard VIII et ensuite duc de Windsor, avait tout juste un an en 1895 (2). Deux de ses contemporains moins fortunés, en train de manger des glaces dans un parc à Londres (3), auront de la chance s'ils survivent à la Première Guerre mondiale pour devenir ses sujets. Quant aux plus pauvres, que la malnutrition au foyer avait rendus rachitiques (1), leur avenir était affligeant.

2

3

WHERE they could, children like these 'mudlarks' on the Yorkshire sands in 1880 (2) snatched moments of play and rest from their day's work. The lad working in a factory in 1908 (1) may have been as young as 12. Further up the social scale, there were many hours to spend on a home-made seesaw (4). And, at the Richmond Regatta of 1917 (3), privileged children twirled their parasols in a life of ease.

JEDE freie Minute nutzten arbeitende Kinder, wie diese »Schmutzfinken« am Strand der Grafschaft Yorkshire im Jahre 1880 (2), um zu spielen oder sich auszuruhen. Der Junge, der 1908 in einer Fabrik arbeitete (1), war wohl kaum älter als zwölf Jahre. Diejenigen, die höher auf der sozialen Leiter standen, verbrachten viele Stunden, auf selbstgezimmerten

1

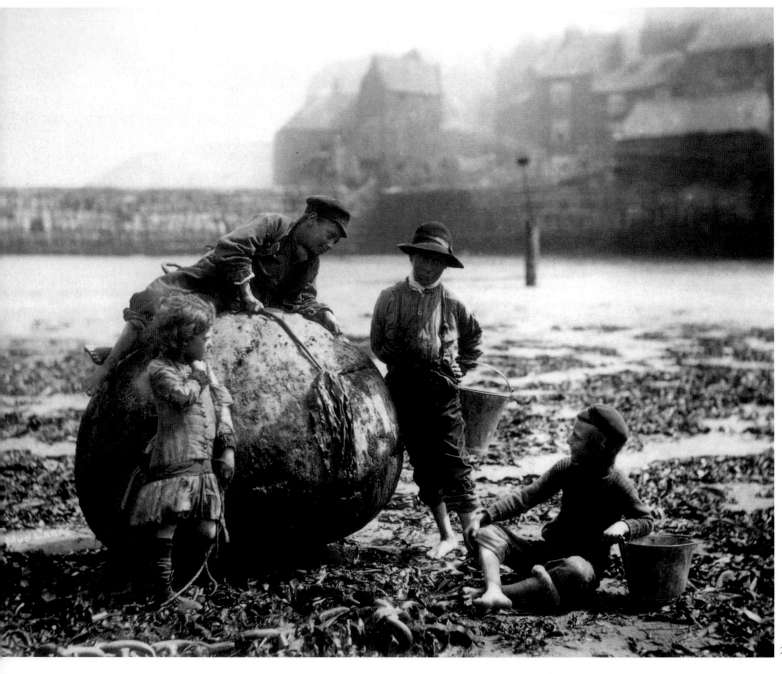

2

Wippen (4). Und bei der Richmond Regatta im Jahre 1917 (3) ließen privilegierte Kinder ihre Sonnenschirme kreisen und genossen ein unbeschwertes Leben.

CHAQUE fois qu'ils le pouvaient, les enfants, comme ces « fouilleurs de boue » sur les plages du Yorkshire en 1880 (2), dérobaient à leur travail quotidien des moments de jeu et de repos. Ce jeune garçon en 1908 (1) pouvait, bien qu'il n'eût que douze ans, travailler à l'usine en toute légitimité. Plus haut, dans l'échelle sociale, on jouait à loisir de nombreux après-midi durant sur une balançoire faite à la maison (4). À la régate de Richmond en 1917 (3), les enfants privilégiés faisaient tourner leurs parasols et s'exerçaient à une vie aisée.

3

4

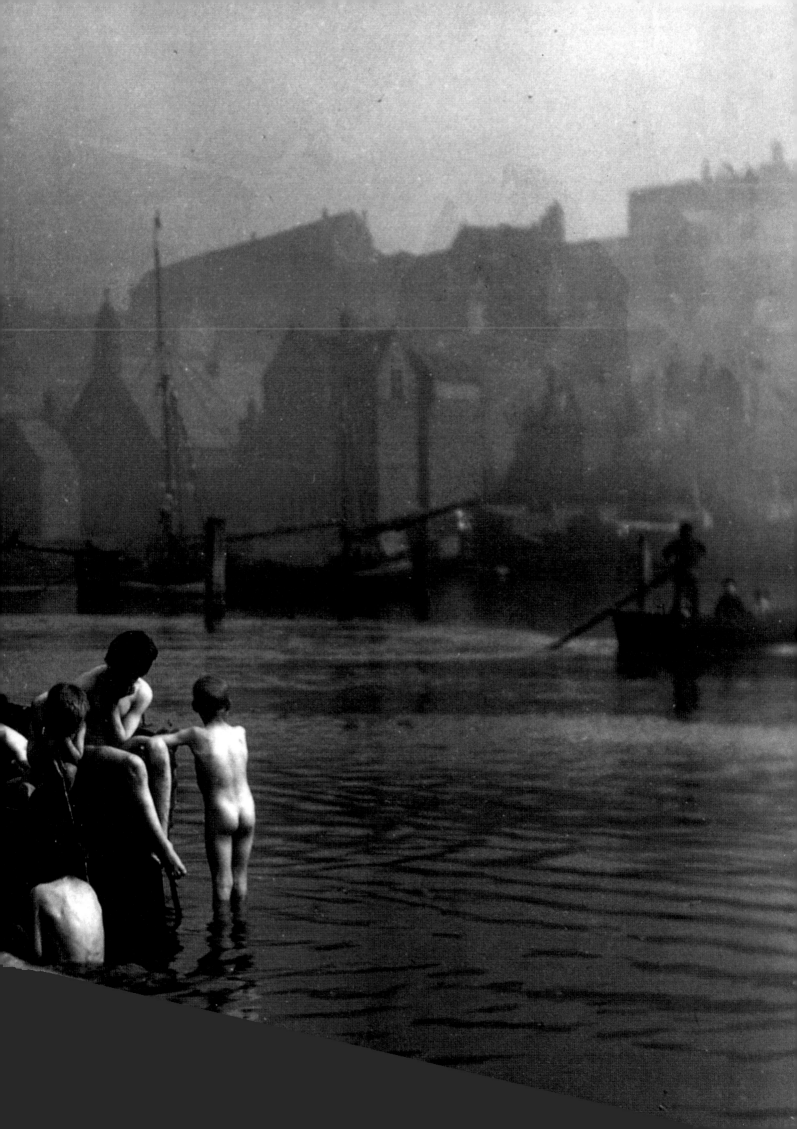

IT was a great age for messing about in boats, and, consequently, for drowning. Some parents went to ingenious lengths to teach their children how to swim (1). Others preferred to stay at home and have their portrait taken for the family album (2). Cameras became more and more portable, and studies more informal (3). And, early in the 20th century, another wonderful gadget was at hand to amuse and entertain – Thomas Edison's Phonograph, the hi-fi of 1908 (4).

(*Previous pages*)
A study of childhood innocence – Frank Meadow Sutcliffe's beautiful 'Water Rats', taken at Whitby in Yorkshire, England, some time in the late 1870s.

Es war eine Zeit, in der man herrlich in Booten herumgondeln und folglich auch ertrinken konnte. Einige Eltern scheuten keine Mühen, um ihren Kindern das Schwimmen beizubringen (1). Andere zogen es vor, zu Hause zu bleiben und sich für das Familienalbum porträtieren zu lassen (2). Die Photoapparate wurden immer handlicher und die Aufnahmen immer ungezwungener (3). Und zu Beginn des 20. Jahrhunderts gab es einen weiteren wunderbaren Apparat zur Belustigung und Unterhaltung, Thomas Edisons Phonograph, die Hifi-Anlage des Jahres 1908 (4).

(*Vorherige Seiten*)
EINE Studie der unschuldigen Kindheit; Frank Meadow Sutcliffes herrliche »Wasserratten«, gegen Ende der 1870er Jahre bei Whitby in Yorkshire, England, aufgenommen.

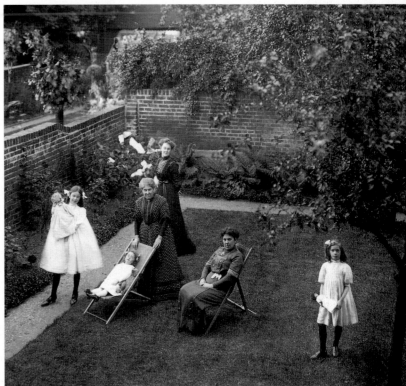

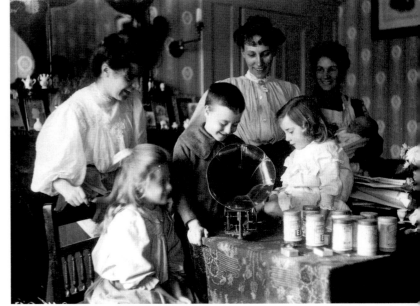

L'ÉPOQUE se prêtait tout à fait aux folles excursions en bateau, donc aux noyades. Certains parents déployaient des merveilles d'ingéniosité pour apprendre à nager à leurs enfants (1). D'autres préféraient rester poser chez eux pour l'album familial (2). Les appareils photographiques se firent de plus en plus maniables et les études de moins en moins formelles (3). Par ailleurs, on disposait au début du XXᵉ siècle d'un autre merveilleux objet d'amusement et de divertissement : le phonographe de Thomas Edison – la hi-fi de 1908 (4).

(Pages précédentes)
UNE étude de l'innocence enfantine – « les rats d'eau » de Frank Meadow Sutcliffe – réalisée à Whitby dans le Yorkshire anglais à une date indéterminée de la fin des années 1870.

IT was the heyday of the Punch and Judy Show, of the marionette theatre, of puppets and puppetry. Crowds gathered in parks and piazzas to see the traditional children's shows that had delighted their parents and grandparents (1). And, if you had enough pfennigs in your pocket, maybe you could buy a doll from this Berlin stall (2), and produce your own puppet play at home.

ES war die Blütezeit des Kasperletheaters, des Marionetten-theaters, der Puppen und Puppenspiele. In Parks und auf Plätzen versammelten sich die Kinder, um die traditionellen Vorführungen zu sehen, an denen sich bereits ihre Eltern und Großeltern erfreut hatten (1). Und wenn man genügend Pfennige in der Tasche hatte, konnte man an diesem Berliner Stand eine Puppe kaufen (2) und zu Hause sein eigenes Puppenspiel aufführen.

LE spectacle de Punch et de Judy, le théâtre de marionnettes, la production et la création de celles-ci, étaient en plein triomphe. On se pressait dans les parcs et sur les places publiques pour assister aux traditionnels spectacles pour enfants qui avaient fait le ravissement des parents et des grands-parents (1). Et si vous aviez suffisamment de pfennigs en poche, vous pouviez acheter une poupée dans cette boutique à Berlin (2) afin de monter votre propre spectacle de marionnettes à domicile.

1

2

4

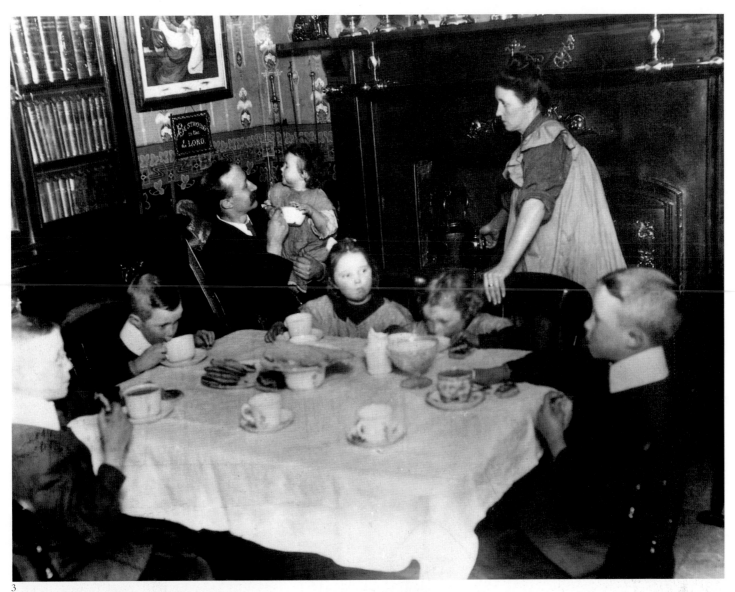

3

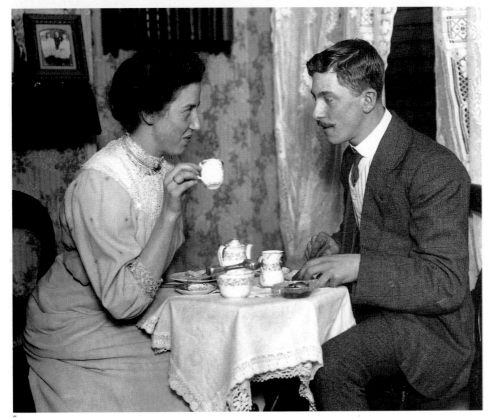

5

Tᴇᴀᴛɪᴍᴇ was part of the domestic ideal (3 and overleaf), when the husband returned from the office to hear the daily report on the family (1, 2). For the working class, it was the one chance to entertain guests (4). And it was a chance for a romantic *tête à tête* (5).

Dɪᴇ Teestunde war Teil des häuslichen Ideals (3 und folgende Seiten), wenn der Herr des Hauses aus dem Büro nach Hause kam und sich von seiner Frau berichten ließ, was die Familie den Tag über getan hatte (1, 2). Für die Arbeiterklasse war es die einzige Möglichkeit, gelegentlich Gäste einzuladen (4). Und sie bot Gelegenheit zu einem romantischen Tête-à-tête (5).

Lᴇ thé faisait partie du rite domestique (3 et pages suivantes), tandis que l'époux, rentrant du bureau, écoutait le rapport quotidien de sa femme (1 et 2). Dans les couches populaires il s'agissait du seul repas au cours duquel on était susceptible d'avoir des invités (4). Et c'était l'occasion d'un tête-à-tête romantique (5).

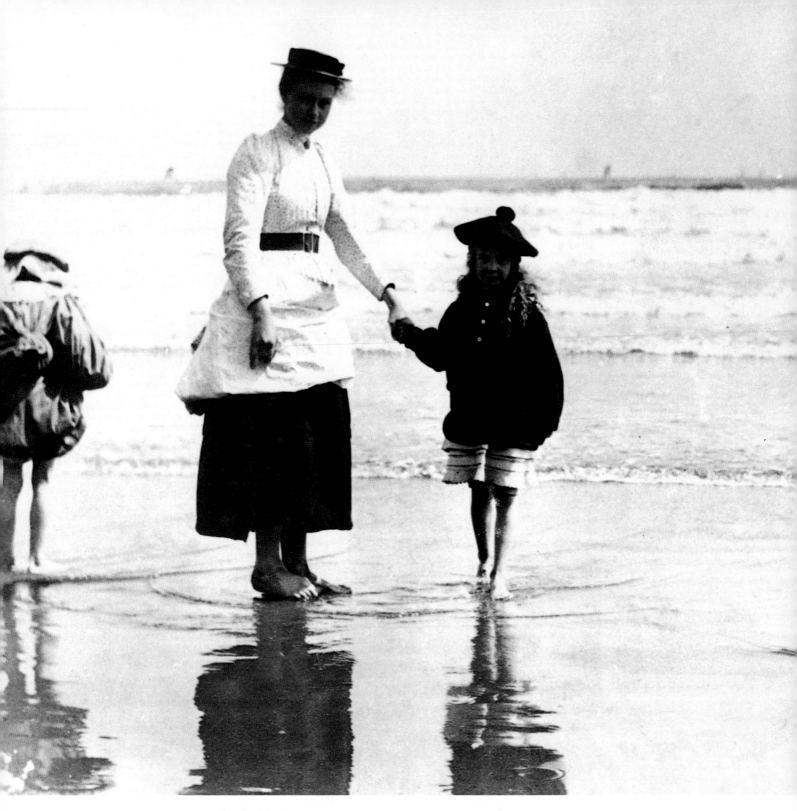

ACROSS Northern Europe and the eastern seaboard of the United States, resorts for the masses were crowded in the summer months. For the price of a cheap rail or charabanc ticket, families could enjoy a day by the sea (1) – an escape from the grim grind of the workplace and the foul smoke of the city. A week in a modest boarding house allowed leisurely enjoyment of the delights of bathing (3) and the promenade (5). Decorum fought decadence (2) under the watchful eye of the bathing machine attendant (4).

IN Nordeuropa und an der Ostküste der Vereinigten Staaten waren die Erholungsorte während der Sommermonate überfüllt. Zum Preis einer billigen Fahrkarte für den Zug oder den offenen Omnibus konnten Familien einen Tag am Meer verbringen (1) und sich vom monotonen Fabrikalltag und von der verpesteten Stadtluft erholen. Ein einwöchiger Aufenthalt in einer bescheidenen Pension bot die Möglichkeit, die Freuden des Badens (3) und Promenierens (5) zu genießen. Unter dem wachsamen Auge der Wärterin der transportablen Umkleidekabinen (4) lagen Anstand und Dekadenz dicht nebeneinander (2).

DANS toute l'Europe septentrionale et sur toute la côte est des États-Unis, on s'entassait pendant les mois d'été dans les stations ouvertes au public. Pour le prix d'un ticket de train ou d'autocar bon marché, on pouvait s'offrir une journée à la mer en famille (1), loin des corvées, de l'austérité du travail et des fumées pestilentielles de la ville. L'excursion d'un jour permettait une rapide partie de canotage, alors qu'une semaine entière dans une modeste pension donnait le temps de s'adonner aux plaisirs de la baignade (3) et de la promenade (5). Les convenances rivalisaient avec la décadence (2) sous l'œil vigilant de la surveillante des cabines de bains roulantes (4).

1

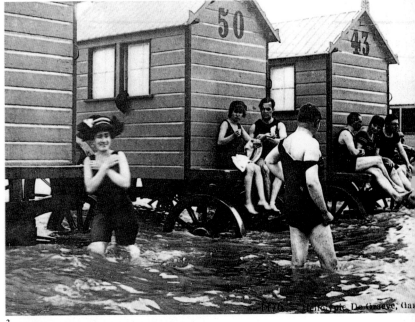

2

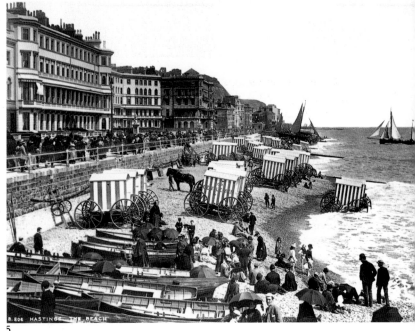

3

4

5

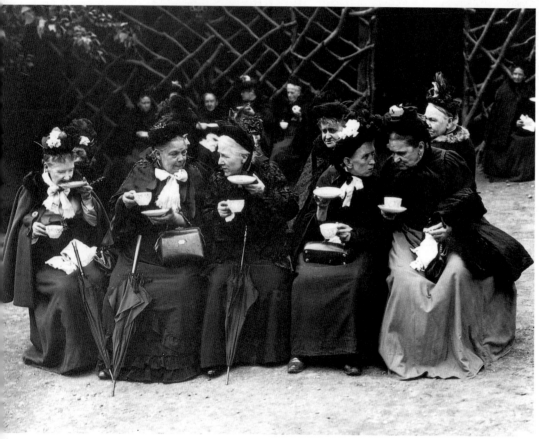

DESPITE the long hours demanded by the factory boss, the master or the mistress, there were Sundays and bank holidays when there was the chance of a day out – a visit to the park, the fair, the circus, the local menagerie, the country-side, friends and relations, the river or the races. Some put on their finest clothes (1). Others wore the uniform of their old age or institution, while they took a refreshing cup of tea (2). And those with a little spare cash to risk on a flutter set off to double it, treble it, or lose all at Goodwood Races (3).

AUCH wenn die Fabrikbesitzer wie der Herr und die Herrin viele Arbeits-stunden von ihren Beschäftigten verlangten, gab es Sonn- und Feiertage, die Gelegenheit zu Ausflügen boten – in den Park, zum Jahrmarkt, zum Zirkus, zum Tierpark, aufs Land, zu Freunden und Verwandten, zum Fluß oder zum Pferderennen. Einige zogen

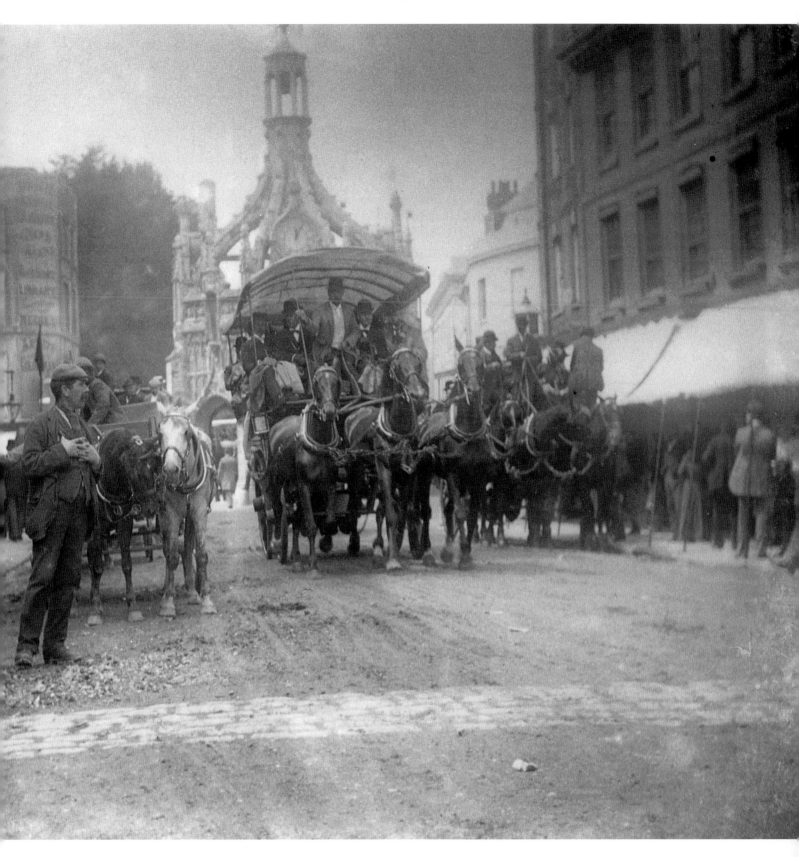

ihre besten Kleider an (1). Andere trugen ihrem Alter oder ihrer Stellung gemäße Kleidung, während sie sich bei einer Tasse Tee erfrischten (2). Und jene, die ein wenig Geld zum Wetten übrig hatten, machten sich zum Pferderennen nach Goodwood auf, um es zu verdoppeln, zu verdreifachen, oder aber alles zu verlieren (3).

EN dépit des longues heures exigées par le patron de l'usine, le maître ou la maîtresse, il y avait les dimanches et les jours fériés qui permettaient d'aller au parc, à la foire, au cirque, à la ménagerie du coin, à la campagne, chez les amis et les parents, à la rivière ou aux courses. Certains met-

taient leurs plus beaux habits (1). D'autres arboraient leur vieil uniforme ou celui de leur institution tout en prenant une tasse de thé (2). Et ceux qui avaient mis quelque argent de côté pour parier s'en allaient le doubler, le tripler ou tout perdre aux courses à Goodwood (3).

EVEN as early as the 1850s, a bucket and spade were the essential tools for a day at the seaside (1), although the fresh sea air could do nothing for the appalling state of most people's teeth (2). For some there was the occasional surprise of an exotic visitor – Winnipeg the Elephant returns to the circus ring after completing its toilet in January 1914 (3). But if the sun shone, there was no need to go further than the nearest heath or meadow (4), to dance and sing and forget tomorrow's early start back at work.

SCHON in den 1850er Jahren waren Eimer und Schaufel die wichtigsten Werkzeuge für einen Tag an der See (1). Die frische Meerluft konnte jedoch nichts am erschreckenden Zustand der Zähne der meisten Menschen ändern (2). Für manchen gab es gelegentlich Abwechslung durch einen exotischen Gast: Winnipeg, der Elefant, kehrt im Januar 1914 nach Beendigung der Toilette in die Manege zurück (3). Aber wenn die Sonne schien, brauchte man nicht weiter als zur nächsten Wiese zu gehen (4), um tanzen, singen und die Arbeit am nächsten Morgen vergessen zu können.

MÊME au début des années 1850, un seau et une pelle constituaient le bagage indispensable à une journée au bord de la mer (1). Si le bon air marin faisait des merveilles pour les poumons et le moral des plus vieux comme des plus jeunes, il ne pouvait rien faire contre l'état effroyable dans lequel se trouvaient les dents de la plupart des gens (2). Pour certains, il y avait de temps à autre la visite-surprise d'un visiteur exotique : en janvier 1914, Winnipeg l'éléphant regagnant la piste du cirque une fois sa toilette terminée (3). Mais lorsque le soleil brillait, il suffisait d'aller jusqu'à la première bruyère ou prairie (4) venue pour oublier que le travail reprendrait tôt le lendemain.

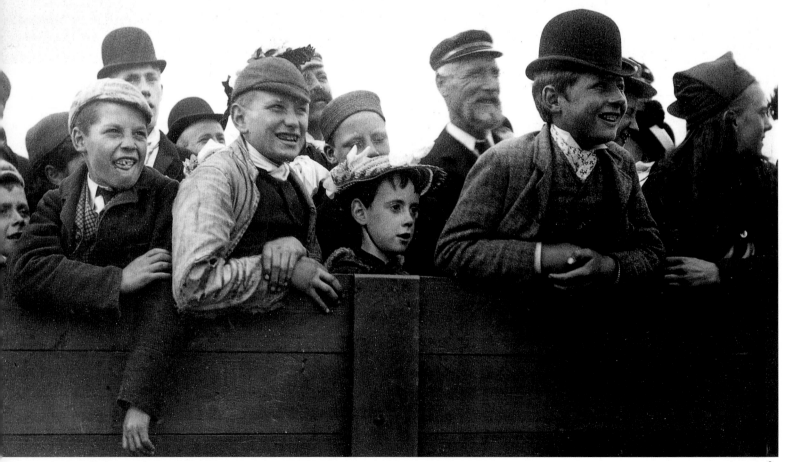

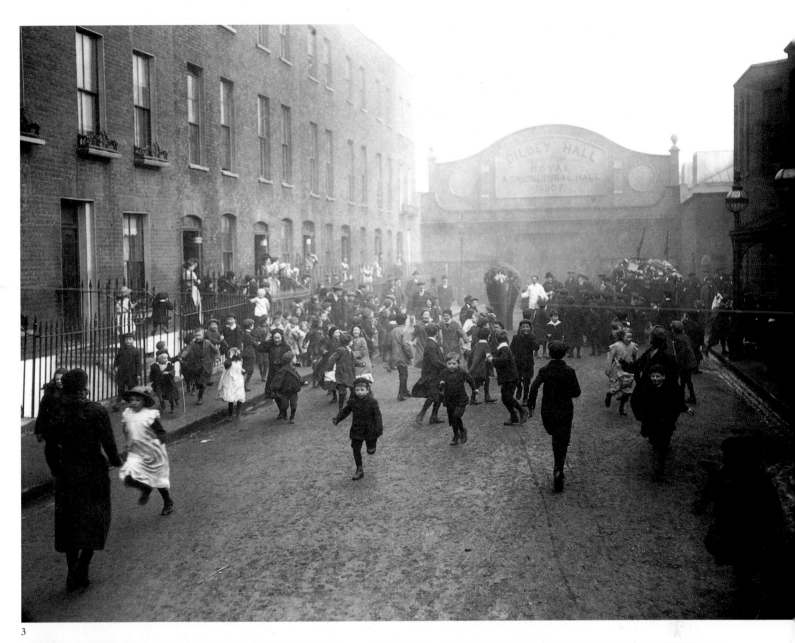

3

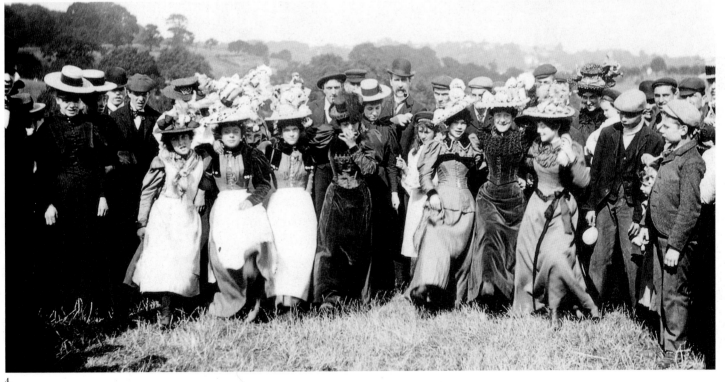

4

THE French invented the picnic in the mid-18th century. A hundred years later it had become a craze – a symbolic return to the simpler way of life that had existed before the industrial revolution. Some picnics were very private affairs (1), others hearty celebrations of friendship (2). Sometimes they were more formal luncheons – as in this outing to Netley Abbey, Hampshire, in 1900 (4). Best of all was a picnic on the river – the flat punt gently rocking under the willows (3) on the Sunday before Ascot Races, in 1912.

MITTE des 18. Jahrhunderts erfanden die Franzosen das Picknick. Hundert Jahre später kam es groß in Mode – eine symbolische Rückkehr zur einfacheren Lebensart der Zeit vor der industriellen Revolution. Einige Picknicks waren eine sehr private Angelegenheit (1), bei anderen wurde in geselliger Runde gefeiert (2). Manchmal war es ein eher formelles Mittagessen, wie dieser

1

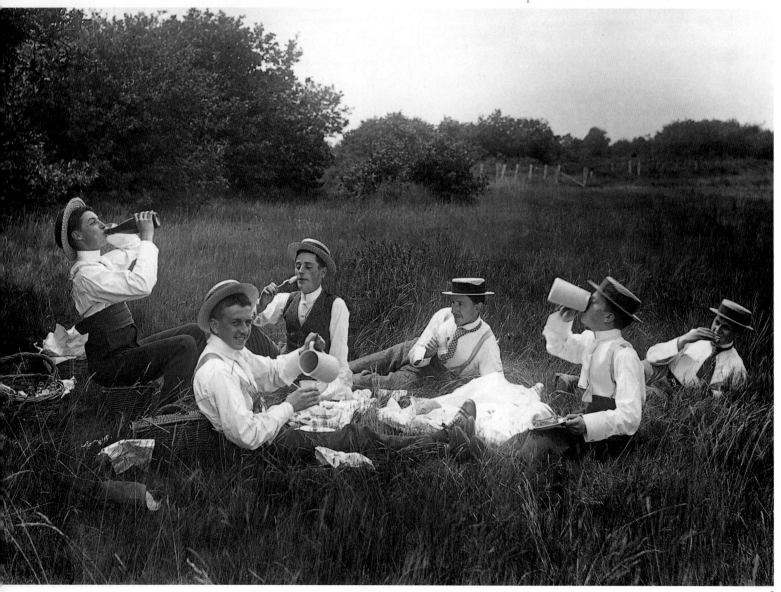

2

Ausflug zur Netley Abbey in Hampshire im Jahre 1900 (4). Am schönsten war wohl das Picknick auf dem Fluß, bei dem die flachen Kähne sanft unter den Weiden schaukelten (3), bevor es im Jahre 1912 zum Pferderennen von Ascot ging.

LES Français inventèrent le pique-nique au milieu du XVIIIe siècle. Une centaine d'années plus tard, c'était devenu une folie, un retour symbolique au mode de vie plus simple qui prévalait avant la révolution industrielle. Certains pique-niques étaient très intimes (1), d'autres l'occasion de bonnes et franches agapes (2). Il s'agissait parfois de déjeuners plus formels, tels que cette visite à l'abbaye de Netley dans le Hampshire en 1900 (4). Le summum était peut-être le pique-nique sur la rivière, tandis que le fond plat de la barque se balançait doucement sous les saules pleureurs (3), le dimanche qui précédait les courses à Ascot en 1912.

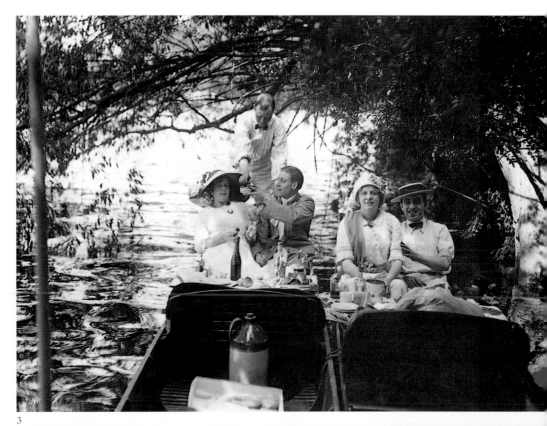

3

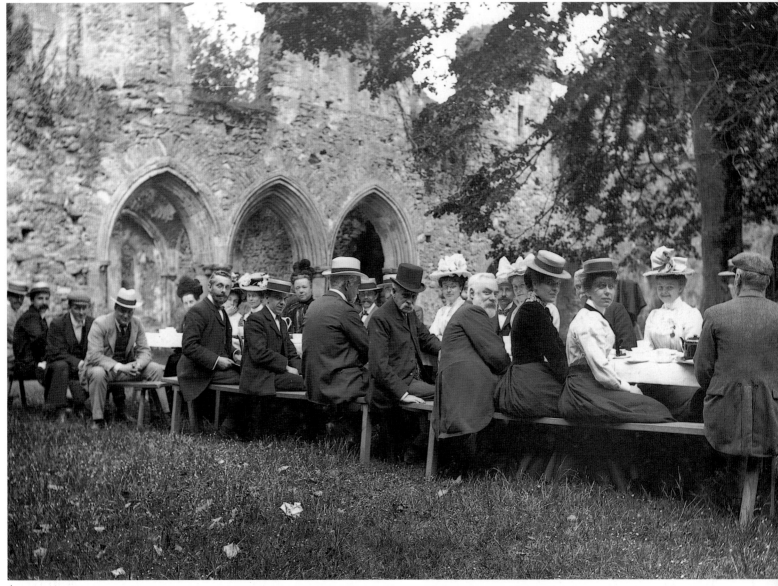

4

THE rich picnicked at the races (1), at the Bournemouth Aviation Show (2), at the Hurlingham Balloon Contest (3). At Stonehenge in 1877 the party included the Queen's son Prince Leopold (4).

DIE Reichen picknickten während der Pferderennen (1), der Flugschau in Bournemouth (2), beim Fesselballonwettbewerb von Hurlingham (3). In Stonehenge war 1877 auch der Sohn der Königin, Leopold, mit von der Partie (4).

LES riches pique-niquaient aux courses (1), au meeting aérien de Bournemouth (2), à la compétition de ballons à Hurlingham en 1909 (3). La partie de campagne à Stonehenge en 1877 incluait le prince Léopold, fils de la reine Victoria (4).

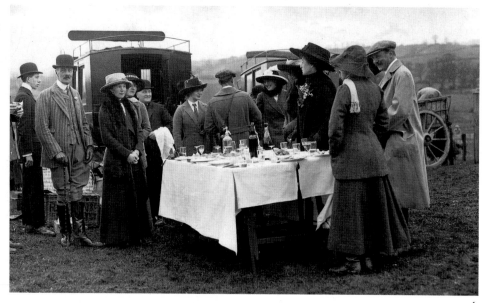

1

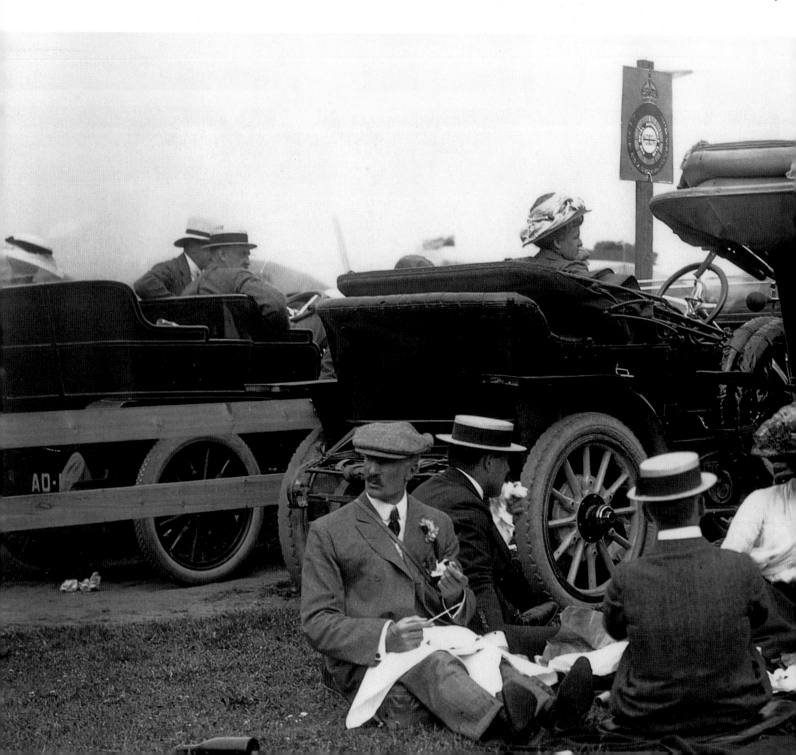

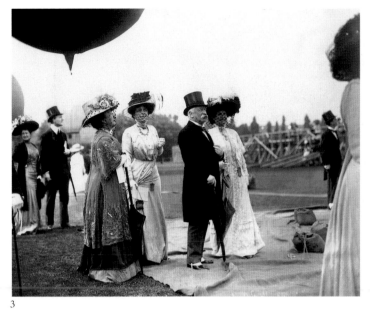

3

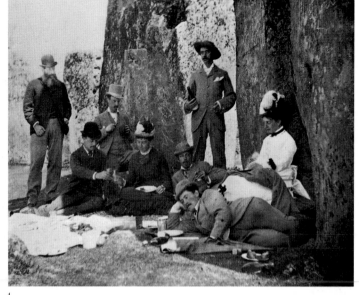

4

2

2

DUST was plentiful. Servants were cheap, which was just as well, for rooms had to be 'dressed', and it must have taken considerable time and effort to maintain the sparkling elegance of Lily Langtry's sitting-room in the 1890s (1). Less cluttered was Dame Nellie Melba's bedroom (2). By the end of the 19th century, tastes had changed, and the unfussy lines of Art Nouveau were in fashion – here typified by this drawing room of Wylie and Lockhead at the Glasgow Exhibition of 1901 (3), and a bedroom by Frank Brangwyn (4).

STAUB in Hülle und Fülle. Die Löhne des Hauspersonals waren zum Glück niedrig, denn die Zimmer mußten »hergerichtet« werden, und in den 1890er Jahren hat es wohl viel Zeit und Mühe gekostet, die funkelnde Eleganz von Lily Langtrys Wohnzimmer (1) zu erhalten. Dame Nellie Melbas Schlafzimmer war weniger vollgestopft (2). Gegen Ende des 19. Jahrhunderts hatte sich der Geschmack verändert, und der schlichte Jugendstil war in Mode, wie dieses Wohnzimmer von Wylie und Lockhead auf der Glasgower Ausstellung von 1901 (3) und ein Schlafzimmer von Frank Brangwyn (4) zeigen.

LA poussière s'entassait. Les serviteurs étaient peu rémunérés, et c'était tant mieux. En effet, étant donné que les pièces devaient être « habillées », l'élégance étincelante du salon d'une Lily Langtry dans les années 1890 (1) s'entretenait certainement au prix d'heures de travail considérables. La chambre à coucher de Dame Nellie Melba (2) faisait moins fouillis. Dès la fin du XIXᵉ siècle les goûts avaient changé et la mode épousait les lignes sans prétention de l'Art nouveau, représenté ici dans ce salon conçu par Wylie et Lockhead lors de l'exposition qui eut lieu à Glasgow en 1901 (3) et dans une chambre à coucher réalisée par Frank Brangwyn (4).

3

4

GOTTLIEB Daimler's invention spread rapidly. Like all English motorists, C. S. Rolls (1), driving his first car, an 1896 Peugeot, was preceded by a pedestrian carrying a red flag, for safety's sake. Henry Ford's first car (2) was steered by tiller. Thomas Edison patented an early electric car in the 1890s, the Baker (3). Daimler's son Paul drove one of the earliest four-wheeled cars (4). The designs may have appeared flimsy by modern standards, but at Achères, on l May 1899, Jenatzy drove his electric car, 'Jamais Contente', at a speed of over 100 kph (5).

GOTTLIEB Daimlers Erfindung verbreitete sich schnell. Wie vor allen englischen Autofahrern, lief auch vor C. S. Rolls (1), hier in seinem ersten Automobil, einem Peugeot aus dem Jahre 1896, aus Sicherheitsgründen ein Mann mit einer roten Fahne her. Henry Fords erster Wagen (2) wurde mit einer Ruderpinne gesteuert. Thomas Edison ließ in den 1890er Jahren eines der ersten Elektroautos, den Baker (3), patentieren. Daimlers Sohn Paul fuhr eines

der ersten Modelle mit Vierradantrieb (4). Gemessen an heutigen Standards mögen die Karosserien zerbrechlich wirken, aber am 1. Mai 1899 brachte Jenatzy sein Elektroauto »Jamais Contente« bei Achères auf eine Geschwindigkeit von über 100 Stundenkilometern (5).

L'INVENTION de Gottlieb Daimler se répandit rapidement. Comme tous les automobilistes anglais, C. S. Rolls (1), lorsqu'il était au volant de sa première voiture, la Peugeot de 1896, se faisait précéder d'un piéton portant un drapeau rouge par mesure de sécurité. La première voiture d'Henry Ford (2) était équipée d'un gouvernail. Thomas Edison breveta très tôt dans les années 1890 une voiture électrique, la Baker (3). Paul, le fils de G. Daimler, conduisit une des premières voitures à quatre roues (4). Même si, par rapport aux normes modernes, leurs lignes ne payent pas de mine, cela n'empêcha pas Jenatzy de rouler à plus de 100 km/h dans sa voiture électrique « Jamais Contente » à Achères, le 1er mai 1899 (5).

FIRST CAR

2

3

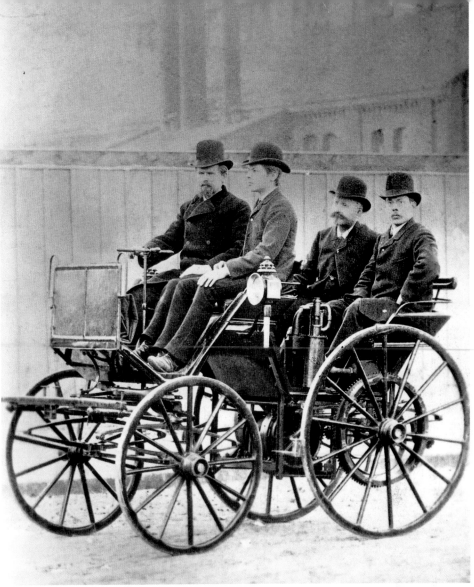

1 4

5

MOTORING became a craze. Races and rallies were organized across the world. M. Chauchard's car bustles through Flovenville on the Belgian border in the Paris–Berlin race of 1901 (1). Prince Borghese sits at the wheel of the Itala he drove from Peking to Paris in 1907 (2). Hemery passes the grandstand in the New York Automobile race of 1900 (3). Lorraine Barrow, in pensive mood in the De Dietrich he entered for the Paris–Madrid race of 1903 (4). A Panhard leads the field in the British 1,000 mile (1,600 km) trial in 1900 (5).

DAS Auto erfreute sich zunehmender Beliebtheit. Auf der ganzen Welt wurden Rennen und Rallyes veranstaltet. M. Chauchards Auto sauste 1901 bei der Rallye Paris–Berlin durch Flovenville in Belgien (1). Der Prinz Borghese sitzt am Steuer des Itala, in dem er 1907 von Peking nach Paris fuhr (2). Hemery fährt an den Tribünen des New Yorker Automobilrennens von 1900 vorbei (3). Ein nachdenklicher Lorraine Barrow in dem De Dietrich, mit dem er 1903 die Rallye Paris–Madrid bestritt (4). Ein Panhard liegt beim britischen 1 600-Kilometer-Rennen im Jahre 1900 an der Spitze des Feldes (5).

L'AUTOMOBILE faisait fureur. Des courses et des rallyes étaient organisés partout dans le monde. L'automobile de M. Chauchard fonce à travers Flovenville, à la frontière belge, dans la course du Paris–Berlin en 1901 (1). Le prince Borghese, au volant de l'Itala, fait le trajet Pékin–Paris en 1907 (2). Hemery passe devant les tribunes de la course automobile organisée à New York en 1900 (3). Lorraine Barrow est pensif dans la De Dietrich, au volant de laquelle il dispute la course du Paris–Madrid en 1903 (4). En 1900, c'est une Panhard qui domine les essais britanniques sur 1 600 km (5).

1 4

5

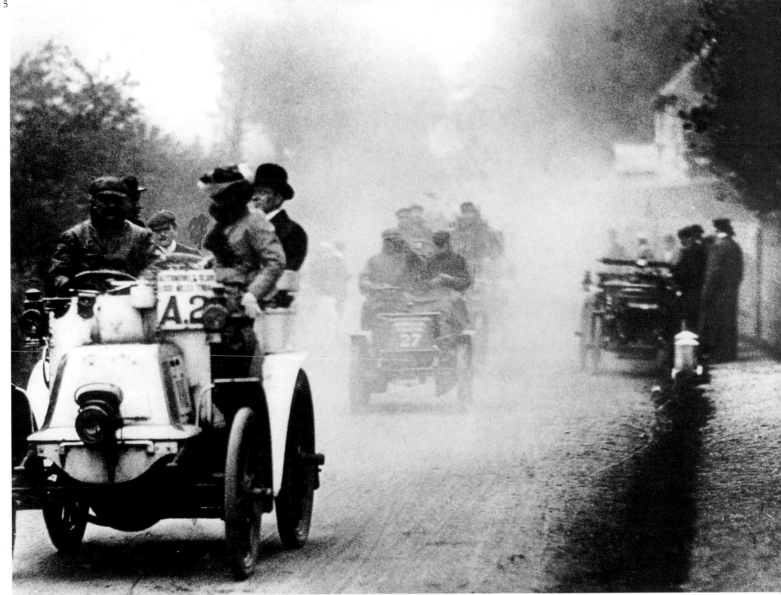

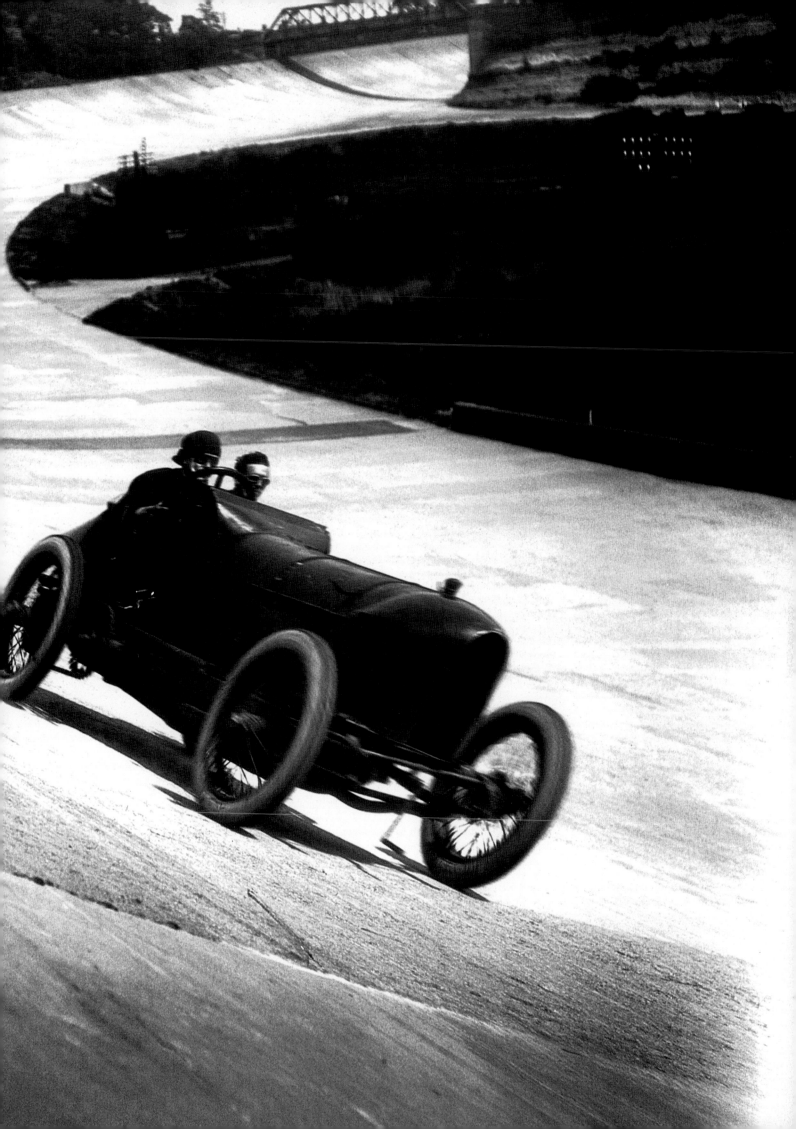

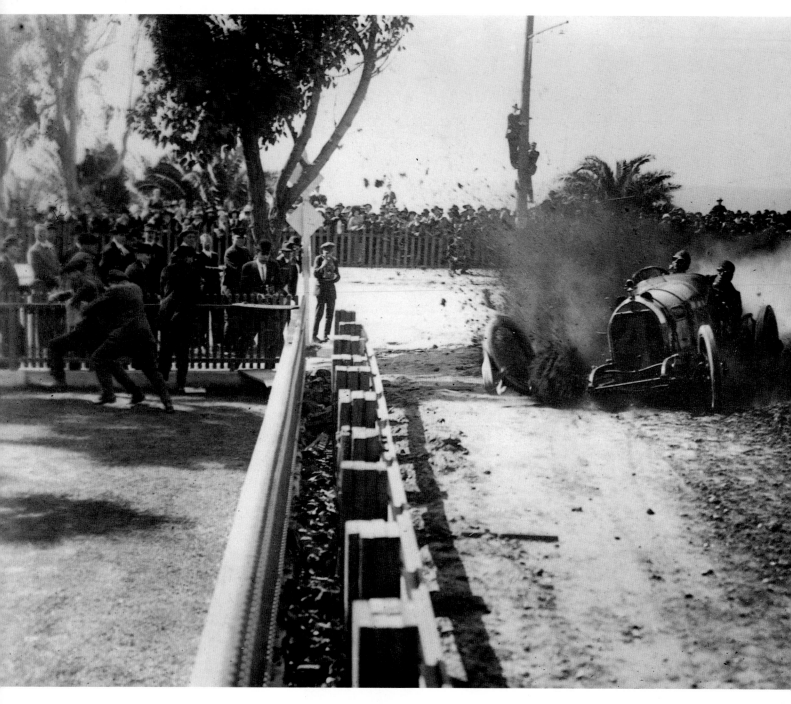

THE very first motor race was held in the United States – from Green Bay to Madison, Wisconsin – in 1878. By the early 20th century cars were streamlined and fast enough to be dangerous. In the Vanderbilt Cup race at Santa Monica, California, in 1914, a photographer caught the moment of drama when a wheel came off Pullen's Mercer as the car went into 'Death Curve' (1). Arthur Macdonald poses in his gleaming Napier (2); W. O. Bentley proudly shows off his record-breaking 12.1hp model in 1914 (3); and Sir Malcolm Campbell Snr puts early versions of the Bluebird through their paces at Brooklands (previous pages and 4) in 1912.

DAS erste Autorennen der Geschichte fand 1878 in den Vereinigten Staaten statt – von Green Bay nach Madison, Wisconsin. Zu Beginn des 20. Jahrhunderts waren die Autos stromlinienförmig und schnell genug, um gefährlich zu sein. Beim Rennen um den Vanderbilt Cup im kalifornischen Santa Monica im Jahre 1914 hielt ein Photograph den dramatischen Augenblick fest, in dem sich ein Rad von Pullens Mercer löste, als der Wagen in die »Todeskurve« einbog (1). Arthur Macdonald posiert in seinem glänzenden Napier (2); ein elegant gekleideter W. O. Bentley präsentiert 1914 stolz sein rekordbrechendes 12,1-PS-Modell (3); und 1912 prüft Sir Malcolm Campbell senior in Brooklands (vorherige Seiten und 4) frühe Modelle des Bluebird auf Herz und Nieren.

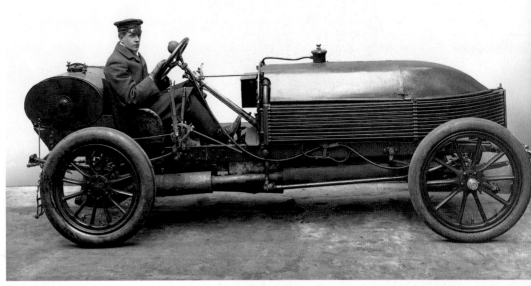

2

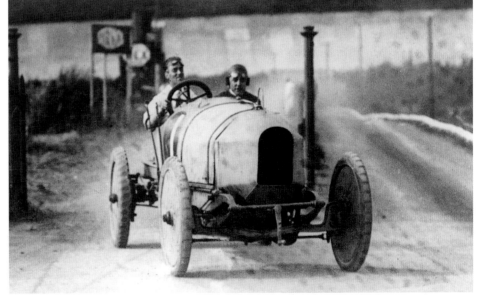

1 3

La toute première course automobile se déroula en 1878 de Green Bay à Madison, dans le Wisconsin, aux États-Unis. Dès le début du XXᵉ siècle, les voitures avaient adopté une forme aérodynamique qui les rendait assez rapides pour être dangereuses. Durant la course pour la coupe Vanderbilt, qui avait lieu en 1914 à Santa Monica en Californie, un photographe saisit le moment dramatique où la Mercer de Pullen perdit une roue en abordant le « virage de la mort » (1). Arthur Macdonald pose dans sa Napier flamboyante (2) ; un W. O. Bentley tiré à quatre épingles présente fièrement son modèle équipé de 12,1 chevaux qui améliora le record en 1914 (3) et Sir Malcolm Campbell père teste une des premières Bluebird à Brooklands (pages précédentes) en 1912 (4).

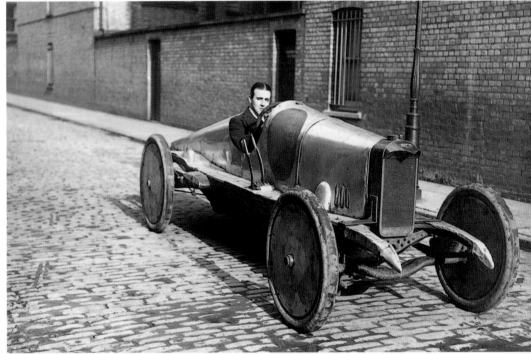

4

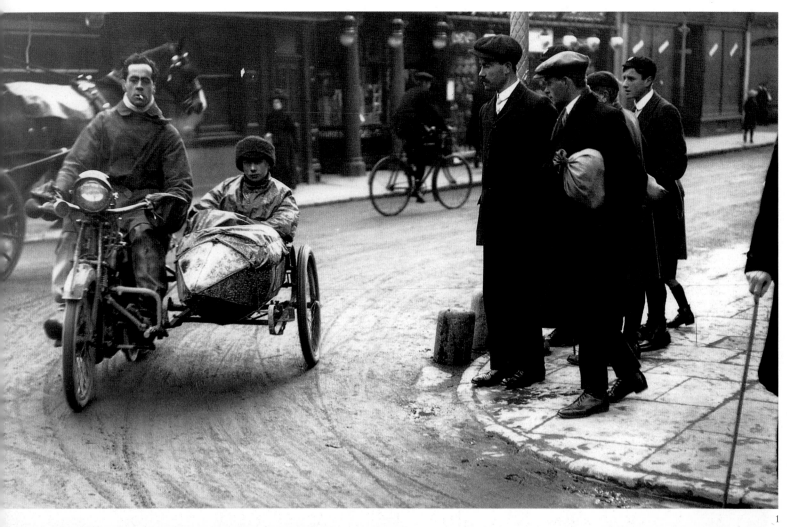

BY 1913 a Premier motor cycle (1) was powerful enough to carry six people up a steep gradient (2). A year later, A. J. Luce and H. Zenith won three races at Brooklands (3). Harley Davidsons were as powerful and as sought-after then as now – this one is rearing up a steep gradient on a cross-country run (4).

EIN Premier-Motorrad (1) war 1913 leistungsstark genug, um sechs Leute eine steile Steigung hinaufzubefördern (2). Ein Jahr später gewannen A. J. Luce und H. Zenith drei Rennen in Brooklands (3). Harley-Davidson-Motorräder waren ebenso schnell und begehrt wie heute; diese Harley kämpft sich in einem Geländerennen eine Steigung hinauf (4).

DÈS 1913, la motocyclette Premier (1) était suffisamment puissante pour monter avec six personnes une pente très inclinée (2). Un an plus tard, A. J. Luce et H. Zenith remportaient trois courses à Brooklands (3). Les Harley Davidson étaient alors aussi puissantes et recherchées qu'aujourd'hui : celle-ci attaque une pente raide dans une épreuve sur terrain accidenté (4).

Sport

THE 19th-century bicycle was a comparatively slow developer. It started life as the 'boneshaker', a wheeled hobby-horse with solid tyres, no pedals and no brakes. In the 1840s pedals and pneumatic tyres were added, giving much improved comfort and efficiency. The Penny Farthing (1), with its enormous front wheel, made getting on and off something of a circus trick, but gave a great return in ground covered for each revolution of the pedals fixed to it. With the invention of the safety cycle in the middle of the century, cycling became a craze, a mania. Cycling clubs were formed all over the world. The cycle was used for military purposes, for recreation, even for ceremony – Berlin cyclists take part in an historical pageant for the Gymnastics and Sports Week in the 1900s (2 overleaf).

Quiet rural areas were invaded by weekend tours and daily dashes. At first cycling was considered suitable for men only, but women rapidly caught up. 'Ten years ago,' wrote Jerome K. Jerome in 1900, 'no German woman caring for her reputation, hoping for a husband, would have dared to ride a bicycle; today they spin about the country in their thousands. The old folks shake their heads at them; but the young men, I notice, overtake them, and ride beside them' (*Three Men on a Bummel*).

They were pleasant days for cyclists. The motor car was still something of a noisy freak – rare and unreliable. Road surfaces were adequate, though thorns from hedgerows still produced many a puncture. Lanes smelt of honeysuckle or new-mown hay, there was the sound of birdsong, the skies above were blue and empty. 'One skimmed along,' wrote one early cyclist, 'almost without effort; one coasted downhill and even on the flat when speed had been attained, and later one free-wheeled. One was carefree, death did not lurk at every corner, at every crossing. There was space, there was room, there was freedom. You rang your bell, a musical enough little chime, when you went round a corner and only the very careless pedestrian who had not yet got bicycle-conscious or a yapping dog who had aversions for bicycles, or had been taught to attack them, could do you any damage' (W. MacQueen Pope).

Indeed, the only real danger came from other carefree road users, from other cyclists, or from the groups of children who had not yet learned that the road was not a playground. It was a good time, a gentle time – but Henry Ford and the conveyor belt and the mass-produced motor car were about to bring it all to a swift and noisy and smelly and dangerous end.

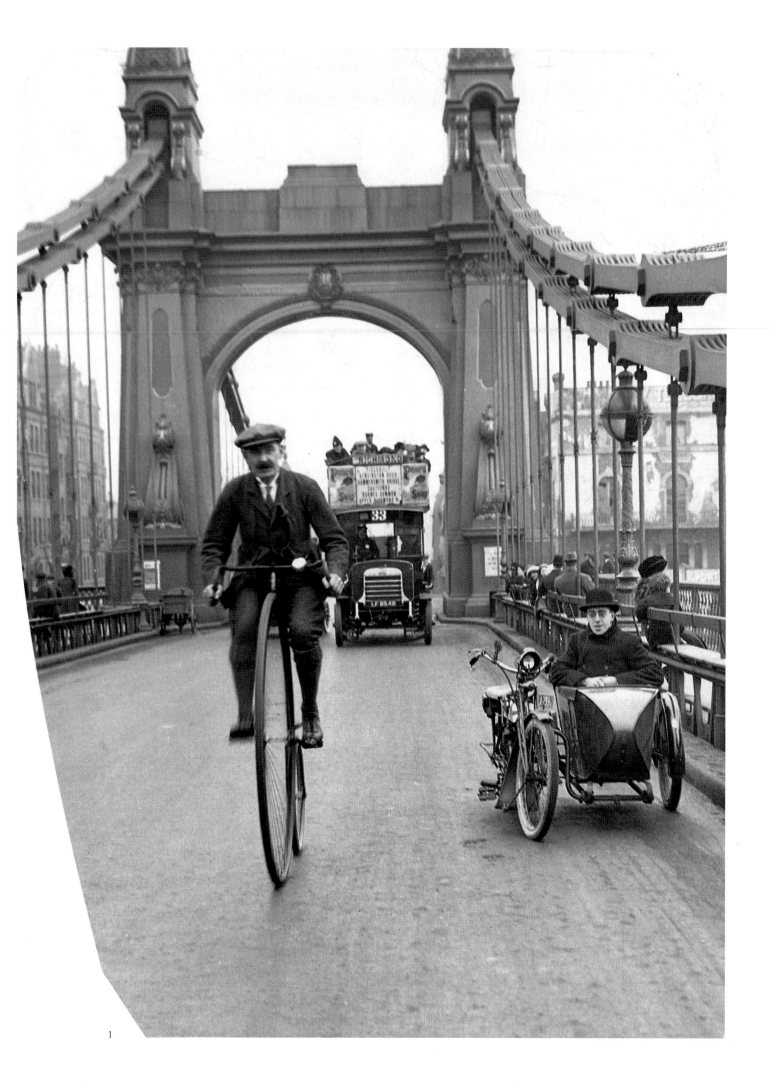

2

DAS Fahrrad des 19. Jahrhunderts war ein relativer Spätentwickler. Die ersten Modelle waren Klappergestelle, Drahtesel ohne Gummireifen, ohne Pedalen und ohne Bremsen. In den 1840er Jahren stattete man es mit Pedalen und Gummireifen aus und machte es so schneller und bequemer. Durch sein riesiges Vorderrad machte das Hochrad (1, vorherige Seite) das Auf- und Absteigen zu einer Art Zirkusnummer, aber mit jeder Umdrehung der daran befestigten Pedale konnte man sehr viel Boden gutmachen. Mit der Erfindung des Niederrades wurde Radfahren zur großen Mode, beinahe zur Manie. Überall auf der Welt wurden Fahrradclubs gegründet. Das Fahrrad wurde auch für militärische Zwecke genutzt, es diente der Freizeitgestaltung und wurde sogar bei Feierlichkeiten eingesetzt – Berliner Radfahrer nehmen im Jahre 1900 an einem historischen Umzug im Rahmen der Woche der Gymnastik und des Sports teil (2).

Fahrradfahrer störten die Ruhe ländlicher Gegenden nicht nur am Wochenende. Am Anfang war man der Ansicht, Radfahren sei nur für Männer geeignet, aber die Frauen holten schnell auf. »Vor zehn Jahren«, schrieb Jerome K. Jerome 1900, »hätte keine deutsche Frau, die um ihren Ruf besorgt war und auf einen Ehemann hoffte, gewagt, Fahrrad zu fahren; heute schwirren sie zu Tausenden durchs Land. Alte Leute schütteln bei ihrem Anblick den Kopf; aber junge Männer, so konnte ich beobachten, holen sie ein und fahren neben ihnen her.« (aus: *Three Men on a Bummel*)

Es war eine angenehme Zeit für Radfahrer. Das Auto war noch immer ein lärmendes Ungetüm, selten und unzuverlässig. Der Zustand der Straßen war gut, auch wenn die Dornen der Heckenreihen für so manchen platten Reifen sorgten. Auf den Wegen duftete es nach Geißblatt oder frisch gemähtem Gras, die Vögel zwitscherten, und der Himmel war blau und wolkenlos.

»Man glitt fast mühelos dahin«, schrieb einer der ersten Radfahrer, »man rollte spielend den Berg hinab und sogar über ebene Straßen, wenn man die richtige Geschwindigkeit erreicht hatte, und dann fuhr man im freien Lauf dahin. Man war sorglos, der Tod lauerte nicht an jeder Ecke, an jeder Kreuzung. Es gab Platz, es gab Raum, es gab Freiheit. Man klingelte, und es ertönte ein fast musikalisches Glockenspiel, wenn man um eine Ecke fuhr. Nur sehr unvorsichtige Fußgänger, die dem Fahrrad noch nicht genügend Respekt schenkten, oder ein kläffender Hund, der etwas gegen Fahrräder hatte oder dem man beigebracht hatte, sie anzugreifen, konnten einem gefährlich werden.« (W. MacQueen Pope)

Die einzige wirkliche Gefahr waren sorglose Fußgänger, andere Radfahrer oder Gruppen von Kindern, die noch nicht gelernt hatten, daß die Straße kein Spielplatz ist. Es war eine gute Zeit – aber Henry Ford, das Fließband und die Massenfertigung von Autos sollten sie zu einem schnellen, lauten, stickigen und gefährlichen Ende bringen.

LA bicyclette du XIXᵉ siècle mit, en comparaison, du temps à évoluer. Elle s'apparenta au début plutôt au « tapecul », sorte de cheval à roues doté de solides pneus, sans pédales ni freins. Dans les années 1840 vinrent s'y ajouter les pédales et les pneumatiques qui en améliorèrent nettement le confort et l'efficacité. Enfourcher le grand Bi (1) qui était monté sur une énorme roue frontale, ou en descendre, tenait plus ou moins de l'acrobatie, mais cela était compensé par l'énorme distance parcourue à chaque coup de pédale. Avec l'invention de la bicyclette, au milieu du siècle, le cyclisme devint à la mode et dégénéra en manie. Des clubs de cyclisme se constituèrent un peu partout dans le monde. La bicyclette servait à des fins militaires, récréatives et même cérémonielles : les cyclistes de Berlin participèrent à la reconstitution historique de la Semaine de la gymnastique et du sport dans les années 1900 (2).

Les paisibles zones rurales étaient envahies en fin de semaine par les cyclistes et secouées par les collisions quotidiennes. On considéra d'abord que le cyclisme ne convenait qu'aux hommes. Cependant les femmes s'y mirent rapidement. Jerome K. Jerome écrivait en 1900: « Il y a dix ans, aucune Allemande soucieuse de sa réputation ou de trouver un mari n'aurait osé monter sur une bicyclette. Aujourd'hui elles sont des milliers à pédaler dans tout le pays. Les vieilles personnes hochent la tête sur leur passage, tandis que les jeunes gens, je l'ai remarqué, les rattrapent pour pédaler à leurs côtés. » (*Three Men on a Bummel*)

C'était les beaux jours du cyclisme. L'automobile restait une sorte d'extravagance bruyante, rare et peu fiable. Les revêtements des routes lui convenaient même si, malgré tout, les épines des haies provoquaient bien des crevaisons. Les allées sentaient bon le chèvrefeuille ou le foin fraîchement coupé, on entendait les oiseaux chanter, les cieux étaient bleus et vides. Comme l'écrivait un de ces premiers cyclistes :

« On filait presque sans effort ; on descendait les pentes en roue libre en maintenant sur le plat la vitesse acquise, qui vous emportait sans que vous eussiez besoin de pédaler. On était insouciant. La mort ne guettait pas à chaque coin de rue ou à chaque carrefour. On avait de l'espace, on avait de la place, on avait la liberté. Vous actionniez votre timbre avertisseur, au doux carillon musical, en abordant un tournant, et seul le piéton le plus inattentif qui n'avait pas encore pris conscience de l'importance de la bicyclette, ou un chien glapissant qui exécrait les bicyclettes, ou dressé pour les attaquer, pouvaient vous faire courir un risque quelconque. » (W. MacQueen Pope)

En fait, le seul véritable danger provenait des usagers de la route, eux aussi insouciants, des autres cyclistes ou des groupes d'enfants qui n'avaient pas encore appris à la distinguer d'un terrain de jeux. C'était le bon temps – un temps bon enfant qui allait bien vite s'achever avec les inventions de Henry Ford : le tapis roulant et l'automobile fabriquée en série.

(*Overleaf*)
THE remarkable penny-farthing bicycle made its first appearance in the 1880s (2). Its enormous front wheel meant that a single turn of the pedals enabled the cyclist to advance a considerable distance. Cycling clubs were popular (1). Seaside towns were invaded by swarms of healthy young athletes demanding lemonade, tea, coffee, and refreshing sherbet.

(*Folgende Seiten*)
IN den 1880er Jahren tauchte das bemerkenswerte Hochrad auf (2). Durch sein riesiges Vorderrad konnte man durch eine einzige Umdrehung der Pedale eine beträchtliche Wegstrecke zurücklegen. Fahrradclubs waren sehr populär (1). In die Küstenorte fielen Schwärme kräftiger junger Athleten ein und verlangten Limonade, Tee, Kaffee und Brause zur Erfrischung.

(*Pages suivantes*)
L'extraordinaire grand Bi fit son apparition dans les années 1880 et remporta immédiatement un succès total (2). Son énorme roue frontale permettait au cycliste de couvrir en un seul coup de pédale une distance considérable. Les clubs de cyclisme étaient populaires (1). Les villes en bord de mer étaient envahies par des athlètes réclamant de la limonade, du thé, du café et des jus de fruits glacés.

2

Das Fahrrad, das 1884 auf den Markt kam, erlaubte auch Frauen die Freuden des Radfahrens zu genießen und sorgte für eine Revolution in der Damenmode. Die ersten Radfahrerinnen trugen Knickerbocker (1). Madame du Gast (2), eine berühmte französische Rad – und Autofahrerin, bevorzugte ihr *Costume de ballon*. Beide Kostüme waren zum Radfahren weitaus besser geeignet als der traditionelle lange Rock (3).

LA bicyclette qui arriva en 1884 permit aux femmes de goûter aux joies du cyclisme et fut à l'origine d'une révolution dans la mode féminine. Les premières cyclistes portaient des culottes de golf auxquelles étaient normalement assortis le chapeau et la jaquette (1). Madame du Gast (2), célèbre cycliste et automobiliste française, préférait porter son costume de ballon. Ces vêtements étaient bien plus pratiques en bicyclette que la longue jupe traditionnelle (3).

THE safety cycle arrived in 1884, making it possible for women to enjoy cycling, and leading to a revolution in women's fashion. The first female cyclists wore knickerbockers (1). Madame du Gast (2), a famous French cyclist and motorist, preferred her *costume de ballon*. Both costumes were considerably more practical for cycling than the traditional long skirt (3).

GREAT heavyweight boxers: Jim
Jeffries (right) and Tom Sharkey (3);
Jack Johnson (2), the first black World
Heavyweight Champion, here fighting Jess
Willard (1) in 1915.

GROSSE Schwergewichtsboxer: Jim
Jeffries (rechts) und Tom Sharkey (3).
Jack Johnson (2), der erste schwarze
Schwergewichtsweltmeister, hier 1915 in
einem Kampf gegen Jess Willard (1).

LES plus fameux poids lourds furent Jim
Jeffries (à droite) et Tom Sharkey (3).
Jack Johnson (2), le premier Noir à devenir
champion du monde dans la catégorie des
poids lourds, défend ici son titre contre Jess
Willard en 1915 à Cuba (1).

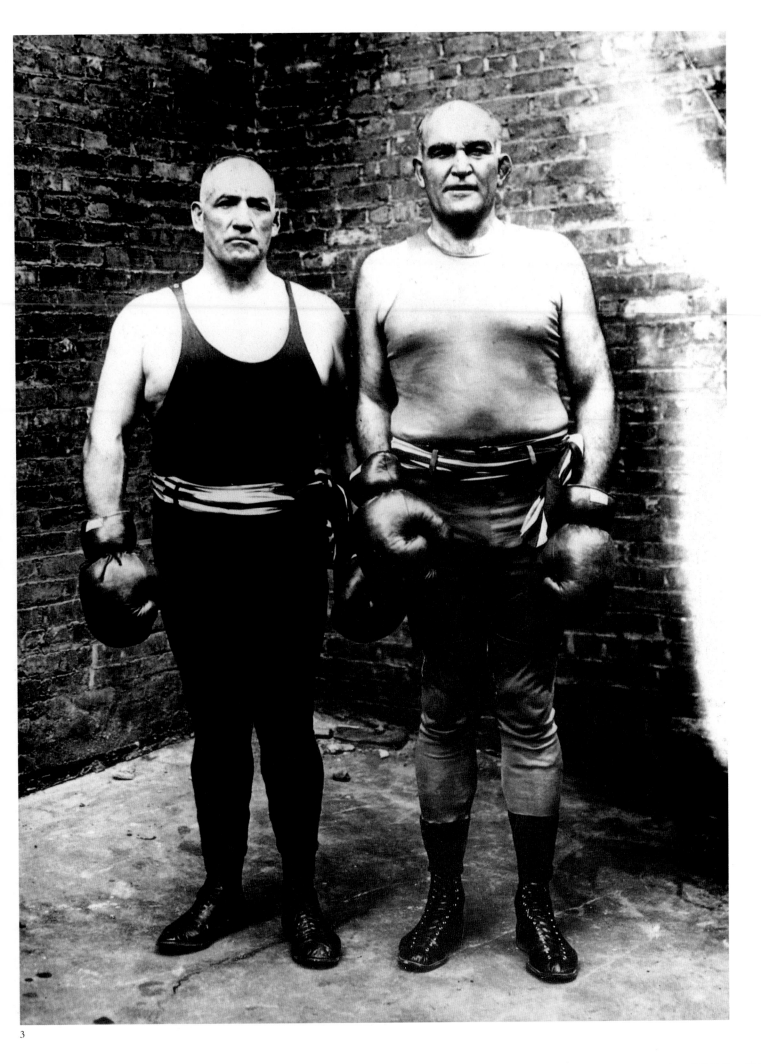

3

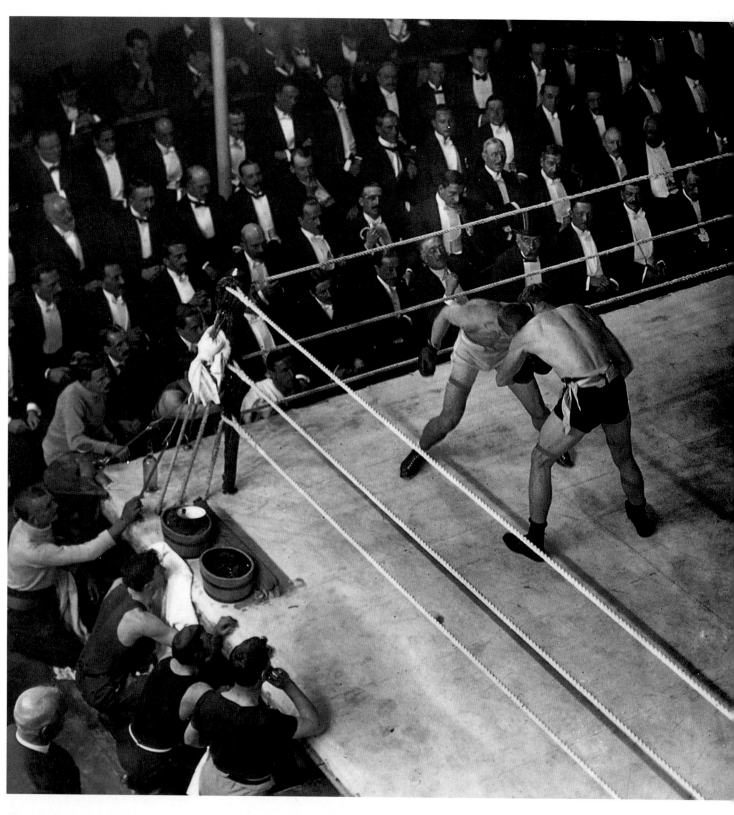

IF not the Sport of Kings, boxing was certainly the sport of gentlemen, given the sartorial elegance of the crowd watching the fight between Bombardier Billy Wells and Georges Carpentier (1) in December 1913. Matt Wells (2) held the World and Empire Welterweight titles 1914-1919. One of the greatest fighters of all was John L. Sullivan (3), the last bare-knuckle heavyweight champion. One of the most elegant was Gentleman Jim Corbett (4), who won the championship from Sullivan in 1892.

BOXEN war zwar nicht der Sport der Könige, aber wohl der der Gentlemen, wenn man nach dem eleganten Aussehen der Zuschauer urteilt, die im Dezember 1913 den Kampf zwischen »Bombardier« Billy Wells and Georges Carpentier (1) sahen. Matt Wells (2) war von 1914 bis 1919 Empire- und Weltmeister im Weltergewicht. Einer der größten Kämpfer von allen war John L. Sullivan (3), der letzte Schwergewichtschampion, der ohne Handschuhe boxte. Einer der elegantesten

war der Gentleman Jim Corbett (4), der Sullivan 1892 den Titel abnahm.

LA boxe était, sinon le sport des rois, en tout cas celui de la bonne société si on en juge par la tenue élégante du public qui suit le combat opposant Bombardier Billy Wells à Georges Carpentier (1) en décembre 1913. Matt Wells (2) conquit le monde et l'empire des titres mi-moyens de 1914 à 1919. John L. Sullivan (3), un des plus grands boxeurs, fut le dernier champion

à combattre à poings nus dans la catégorie des poids lourds. L'un des plus élégants était Gentleman Jim Corbett (4), qui conquit son titre de champion aux dépens de Sullivan en 1892.

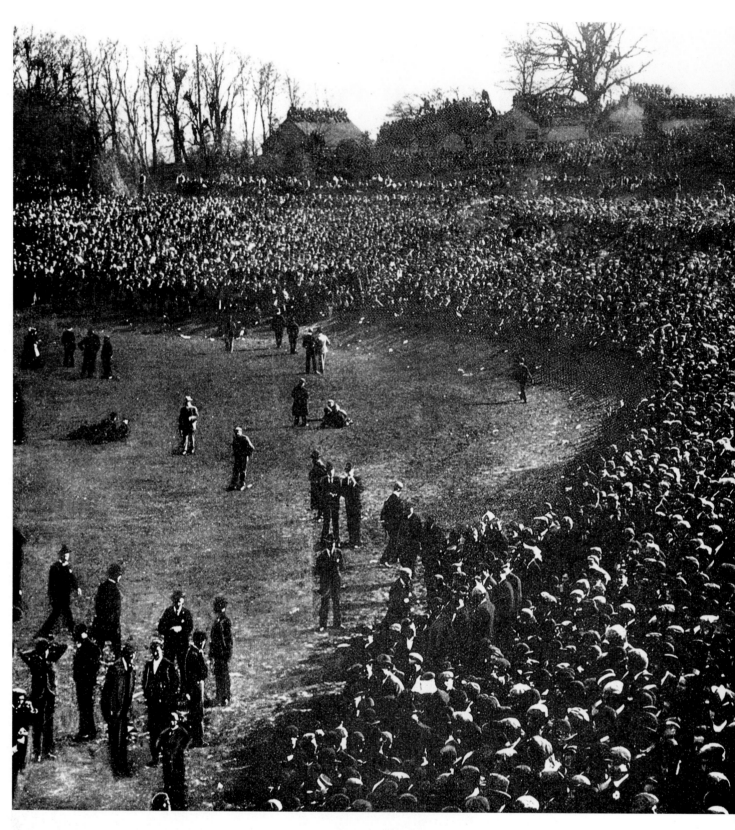

CUP FINALS and international
football matches were first played
in the 1870s. In 1906 vast crowds jolted
their way to Crystal Palace in South
London (2) to see Everton defeat
Newcastle by a goal to nil in the FA
Cup. Five years later Newcastle again
lost by the single goal in a Cup Final,
this time to Bradford City (3, 4).
Tottenham Hotspurs' triumph over
Sheffield United by three goals to

one was said to be one of the best
performances in a Cup Final (1).

POKALENDSPIELE und
internationale Fußballspiele wurden
zum ersten Mal in den 1870er Jahren
ausgetragen. Die Massen strömten 1906
zum Crystal Palace im Süden Londons (2),
um den 1:0-Sieg von Everton über
Newcastle im Spiel um den englischen
Meisterpokal zu sehen. Fünf Jahre später

verlor Newcastle erneut mit 1:0 in
einem Meisterschaftsspiel, diesmal gegen
Bradford City (3, 4). Der 3:0-Triumph
der Tottenham Hotspurs über Sheffield
United gilt als eines der besten Pokal-
Endspiele aller Zeiten (1).

LES matchs en coupe finale et les inter-
nationaux de football furent disputés
pour la première fois dans les années
1870. En 1906 des foules immenses se

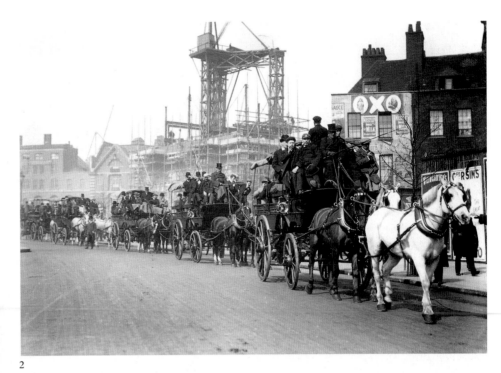

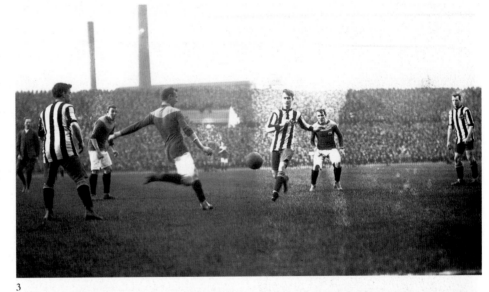

bousculaient pour aller assister à Crystal Palace, dans le sud de Londres (2), à la victoire par 1 but à 0 d'Everton sur Newcastle dans le match de la Coupe de la FA. Cinq années plus tard, Newcastle perdit de nouveau d'un but en finale, cette fois-ci contre Bradford City (3 et 4). La victoire éclatante de Tottenham Hotspur par 3 buts à 1 sur Sheffield United est considérée comme l'un des plus beaux matchs jamais disputés en coupe finale (1).

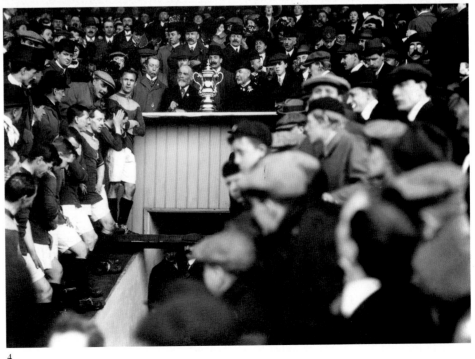

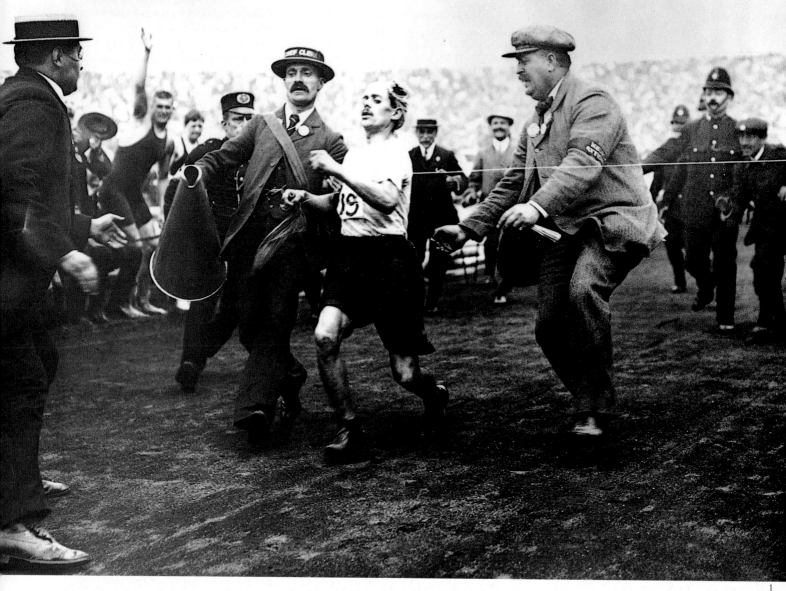

PIERRE de Fredi, Baron de Coubertin, inaugurated the modern Olympic Games in 1896. Early Olympic Games included some sports no longer covered (such as cricket) or no longer practised (like the Standing Long Jump, 3). Clothes were generally modest and cumbersome, though swimming trunks were brief, if not symmetrical (2).

The 1908 Marathon ended in high drama. The course had been lengthened by over a mile, at the request of the British Royal family, who wished it to start beneath Princess Mary's bedroom window at Windsor Castle. Towards the end of the race, Dorando Pietri of Italy was first into the stadium, leading by a considerable distance. He stumbled and fell, probably as a result of having to change direction – he had thought he should turn right on to the track, officials

pointed to the left. Pietri fell four more times in the next 250 metres, the last time opposite the Royal Box. He struggled to his feet but was helped across the finishing line (1) by, among others, Sir Arthur Conan Doyle (right, in cap). For this, poor Pietri was disqualified, and the gold medal went to an American, Johnny Hayes.

IM Jahre 1896 weihte Pierre de Fredi, Baron de Coubertin, die modernen Olympischen Spiele ein. Bei den frühen Olympischen Spielen gab es Disziplinen, die heute nicht mehr zugelassen (Kricket) oder ausgeübt werden (der Weitsprung aus dem Stand, 3). Die Sportkleidung war meist züchtig und deshalb hinderlich, abgesehen von den knappen, fast symmetrischen Badehosen (2).

Der Marathonlauf bei den Olympischen Spielen von 1908 endete äußerst

dramatisch. Die Strecke war auf Bitten des Königshauses um mehr als eine Meile verlängert worden, denn man wünschte, daß der Lauf unter dem Schlafzimmerfenster von Prinzessin Mary in Windsor Castle beginnen sollte. Der Italiener Dorando Pietri lief mit deutlichem Vorsprung als erster ins Stadion ein. Er stolperte und fiel, vermutlich weil er die Richtung wechseln mußte; er hatte geglaubt, er müsse nach rechts laufen, aber die Offiziellen zeigten nach links. Pietri fiel auf den nächsten 250 Metern noch viermal hin, das letzte Mal vor der königlichen Loge. Er rappelte sich wieder hoch, aber über die Ziellinie half ihm unter anderen Sir Arthur Conan Doyle (1, rechts, mit Kappe). Dafür wurde Pietri disqualifiziert, und die Goldmedaille ging an den Amerikaner Johnny Hayes.

2

PIERRE de Fredi, baron de Coubertin, inaugura en 1896 les Jeux olympiques modernes. Les premiers Jeux olympiques comprenaient des sports dont on ne parlait plus (tel le cricket) ou qui ne se pratiquaient plus, tel le saut en longueur à pieds joints (3). Les tenues étaient en général pudiques et encombrantes, même si les maillots de bain étaient courts, à défaut d'être symétriques (2).

En 1908, le marathon se termina sur un drame poignant. La course avait été rallongée de plus d'un kilomètre et demi sur les instances de la famille royale britannique qui souhaitait la faire débuter sous les fenêtres de la chambre à coucher de la princesse Mary, au château de Windsor. Vers la fin de la course, l'Italien Dorando Pietri fit le premier son entrée dans le stade en disposant d'une avance considérable. Il trébucha et tomba, probablement quand il lui fallut changer de direction : il croyait devoir tourner à droite sur la piste, mais les officiels lui indiquaient la gauche. Pietri tomba encore quatre fois au cours des 250 mètres suivants, la dernière chute eut lieu devant la loge royale. Il se releva péniblement et franchit la ligne d'arrivée (1), aidé notamment par Sir Arthur Conan Doyle (en casquette à droite). Cela valut au pauvre Pietri d'être disqualifié, tandis que la médaille d'or revenait à l'Américain Johnny Hayes.

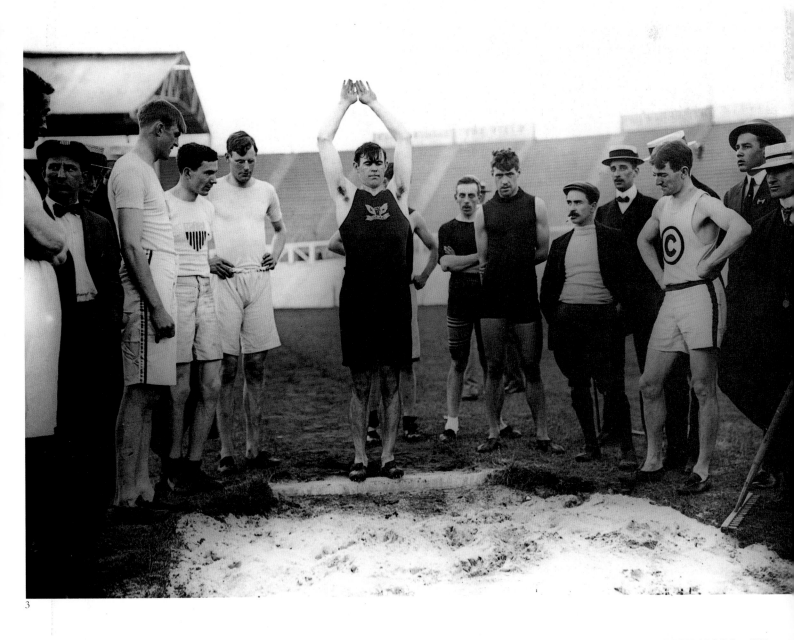

3

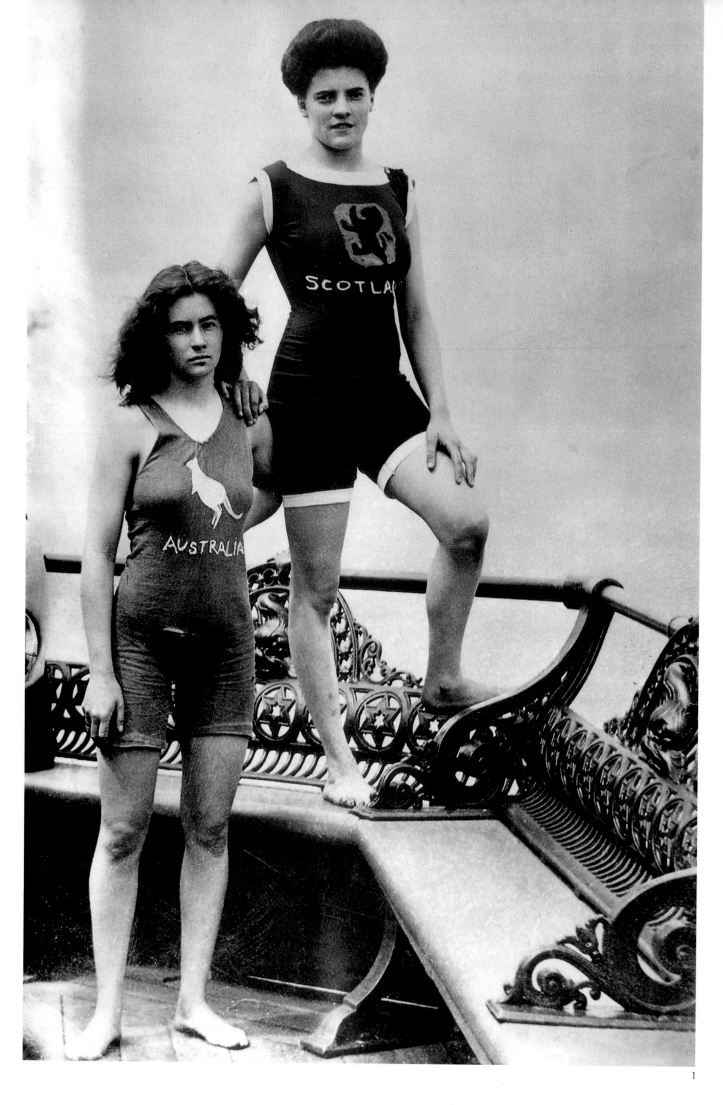

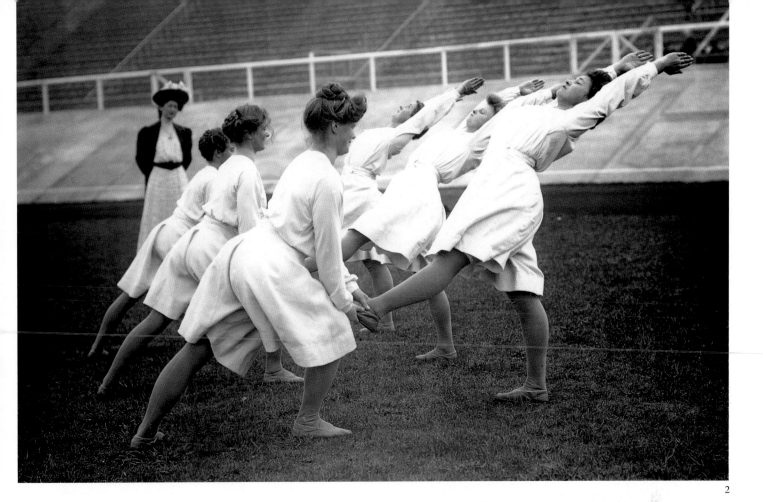

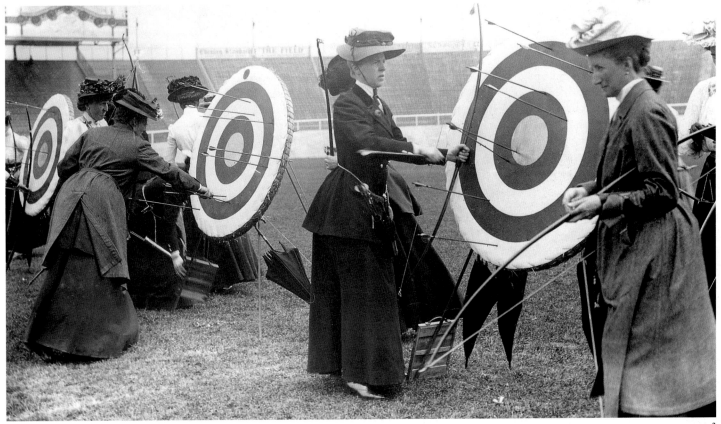

F OR women, sports costume appeared designed to maintain modesty and impede performance: one-piece bathing costumes in 1907 (1). Danish women gymnasts at the 1908 Olympics (2). Lady archers, sensibly wrapped against the cold of an English July (3).

S PORTKLEIDUNG für Frauen schien dafür gemacht, den Anstand zu wahren und die Bewegungsfreiheit einzuschränken: einteilige Badeanzüge aus dem Jahre 1907 (1). Die dänischen Gymnastinnen bei der Olympiade von 1908 (2). Weibliche Bogenschützen, gut gegen die Kälte des englischen Juli geschützt (3).

C HEZ les femmes, le vêtement de sport paraissait conçu pour protéger la pudeur et empêcher toute performance. Pour preuve ces maillots de bain une pièce en 1907 (1). Des gymnastes danoises aux Jeux olympiques de 1908 (2). Ces dames tirant à l'arc étaient judicieusement emmitouflées contre la froidure du mois de juillet en Angleterre (3).

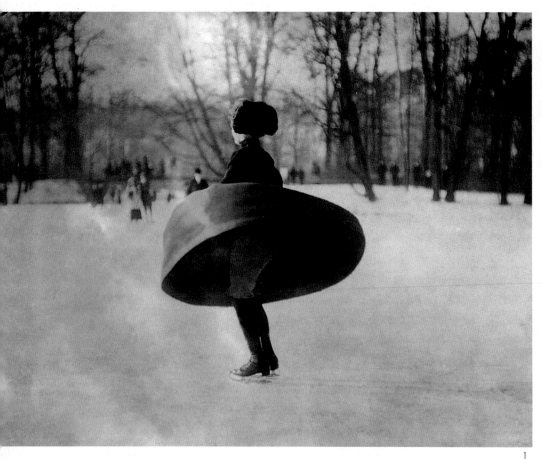

SPORT for women originated in the 'acceptable' sunny afternoon recreations of games such as archery and croquet. Archery was regarded as graceful, and to be able to play croquet was regarded as a social accomplishment. Women were gentle, delicate creatures, and it was wrong that they should do anything that caused them to appear flustered – at that time it was held that horses 'sweat', gentlemen 'perspire' and ladies 'glow'.

But women knew better. They swam, ran, rowed, roller-skated, climbed mountains, played tennis and cricket and golf, and, early in the 20th century, braved a bobsleigh run down the Dorf Dimson run at St Moritz (2). There was always the risk that in taking such exercise they would be branded 'shameless hussies'. Better, it was thought, that women should stick to gentle boating expeditions and picnics – organized by men, of course – and spend their winters sewing indoors, as God doubtless intended. If a woman insisted on winter exercise, then perhaps a little ice-skating was permissible, as in a Berlin park in January 1914 (1), where she could still look 'graceful'.

SPORT für Frauen hatte seinen Ursprung in »akzeptablen« nachmittäglichen Freizeitbeschäftigungen wie Bogenschießen und Krocket. Das Bogenschießen galt als anmutig, und wer Krocket spielen konnte, besaß angeblich gesellschaftliche Gewandtheit. Frauen waren sanfte, zerbrechliche Geschöpfe, denn zu dieser Zeit sagte man, daß Pferde »schwitzen«, Männer »transpirieren« und Frauen »glühen«.

Aber die Frauen waren anderer Ansicht. Sie schwammen, rannten, ruderten, fuhren Rollschuh, kletterten auf Berge, spielten Tennis, Kricket und Golf, und zu Beginn des 20. Jahrhunderts fuhren sie mutig die Rodelstrecke von Dorf Dimson in St. Moritz hinunter (2). Manchmal wurden die Frauen deshalb als »schamlose Gören« beschimpft. Man war der Ansicht, Frauen sollten sich besser auf harmlose, natürlich von Männern organisierte Bootsausflüge oder Picknicks beschränken, und den Winter in der warmen Stube mit Nähen verbringen, so, wie es Gott zweifellos für sie vorgesehen hatte. Wenn eine Frau unbedingt Wintersport treiben wollte, dann vielleicht ein wenig Schlittschuhlaufen, wie in einem Berliner Park im Januar 1914 (1), denn dabei konnte sie immer noch »anmutig« aussehen.

LE sport féminin trouvait son origine dans les jeux « acceptables » pratiqués pendant les après-midi ensoleillés, tels que le tir à l'arc et le croquet. Le tir à l'arc était jugé gracieux, et savoir jouer au croquet faisait partie des talents de société. Les femmes ne devaient pas faire quoi que ce soit qui les fît paraître agitées. À cette époque, on disait des

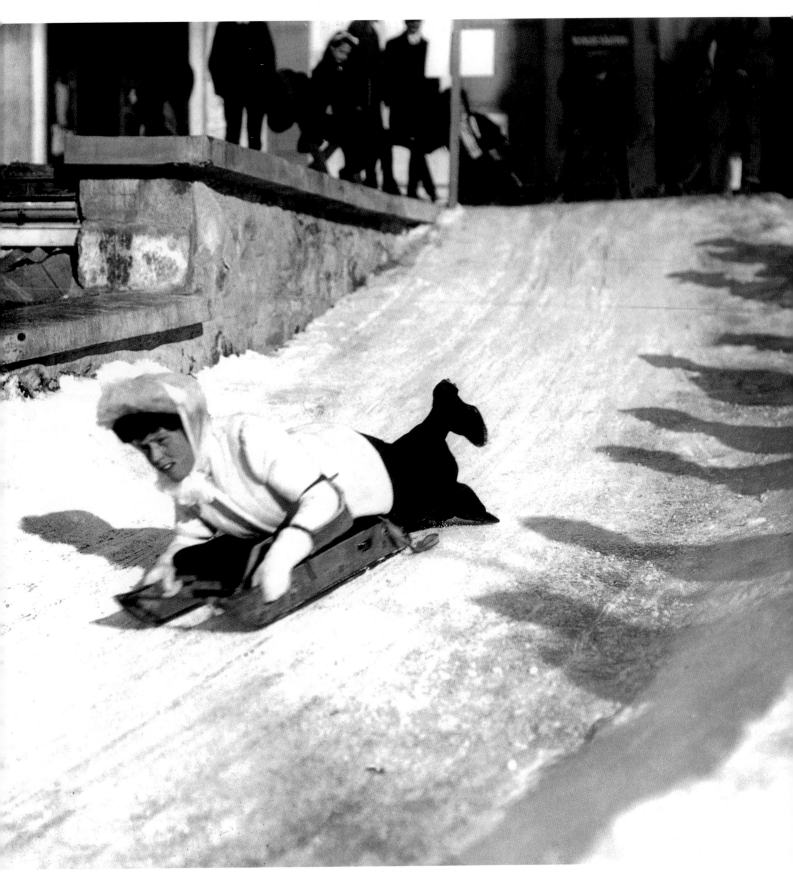

chevaux qu'ils « suaient », des messieurs qu'ils « transpiraient » et des dames qu'elles « étaient en feu ».

Mais les femmes ne s'en laissèrent pas compter. Elles nageaient, couraient, canotaient, faisaient du patin à roulettes, escaladaient les montagnes, jouaient au tennis, au cricket et au golf ; dès le début du XXe siècle, elles participèrent bravement à l'épreuve de descente en bobsleigh du Dorf Dimson à Saint-Moritz (2), au risque de se faire taxer de « dévergondées éhontées » . On considérait qu'il valait mieux que les femmes s'en tiennent aux aimables parties de canotage et aux pique-niques organisés, cela va de soi, par les hommes, et qu'elles passent leurs hivers à coudre enfermées, selon les vœux du Seigneur. Si une femme insistait pour faire de l'exercice l'hiver, on pouvait peut-être alors lui concéder un peu de patinage, comme dans le parc à Berlin en janvier 1914 (1), sport qui n'altèrerait en rien sa grâce.

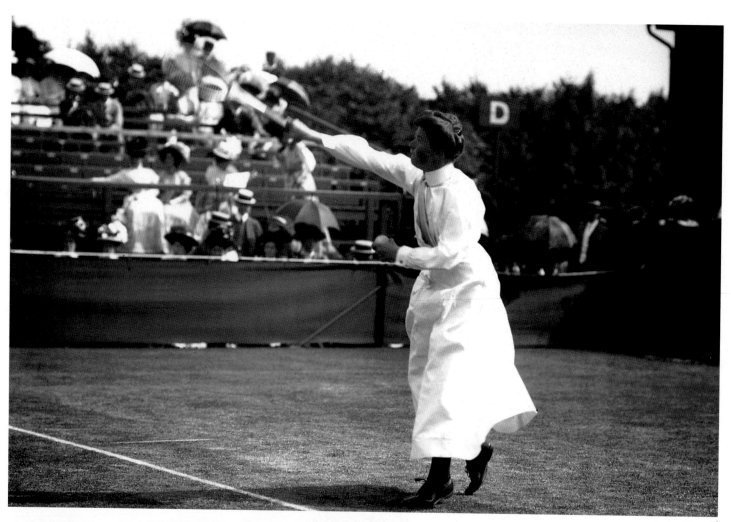

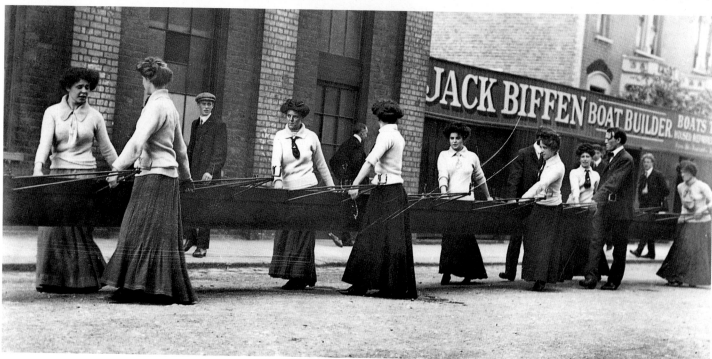

TENNIS for women began in the 1880s. An early champion was Mrs Stevry, here playing in 1908 (1). The Furnival Girls' Rowing Eight about to take to the water in 1907 (2). Shooting was a sport made respectable by royalty, and women were allowed their chance to slaughter wildlife (3). Women first strode the golf links in the 1890s, and were already accomplished players by the time this photograph was taken at Portrush, Ireland, in 1911 (4).

IN den 1880er Jahren begannen die Frauen, Tennis zu spielen. Eine der ersten Meisterinnen war Mrs. Stevry, hier bei einem Match im Jahre 1908 (1). Im Jahre 1907 wird der Achter der Furnival Girls ins Wasser getragen (2). Schießen war ein Sport, den die Mitglieder der königlichen Familie zu Ansehen gebracht hatten,

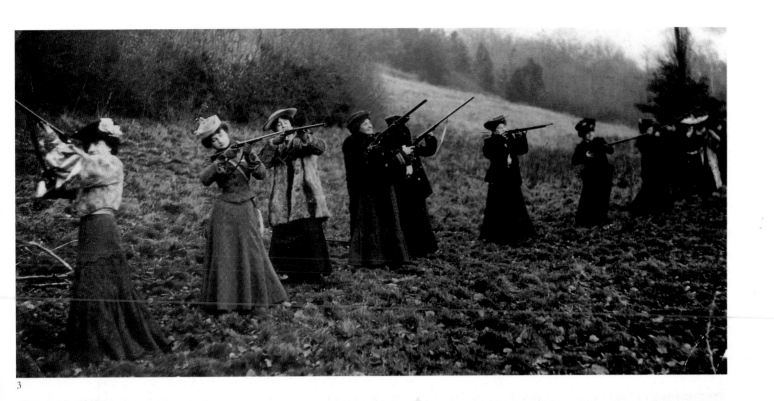

3

4

und Frauen war es immerhin gestattet, sich am Erlegen von Wild zu versuchen (3). In den 1890er Jahren begannen Frauen den Golfschläger zu schwingen und waren 1911 bereits anerkannte Spielerinnen, als diese Aufnahme im irischen Portrush gemacht wurde (4).

LE tennis commença à être pratiqué par les femmes dans les années 1880. L'une des premières championnes fut Madame Stevry, qui joue ici en 1908 (1). On voit ici l'équipe du Huit des Furnival Girls qui s'apprête à se mettre à l'eau en 1907 (2). Le tir était devenu un sport respectable grâce à la royauté qui avait autorisé les

femmes à tenter leur chance dans le massacre du gibier (3). Les femmes foulèrent les pelouses des terrains de golf pour la première fois dans les années 1890, et elles étaient déjà des joueuses accomplies au moment où cette photographie fut prise à Portrush en Irlande, en 1911 (4).

ONE of the highlights of the English 'season' was Cowes
Week, held every August on the Isle of Wight. It was –
and still is – part regatta, part ritual, part opportunity for the
rich and powerful to show off (2). Crowds gathered (3) to
watch the races between the graceful yachts, such as *Navahoe*
in the 1890s (1).

EINER der Höhepunkte der englischen »Saison« war die
Cowes Week, die jedes Jahr im August auf der Isle of
Wight stattfand. Sie war und ist noch immer zum Teil Regatta,
zum Teil Ritual und zum Teil eine Gelegenheit für die Reichen
und Mächtigen, ihren Wohlstand zu zeigen (2). Menschen-
trauben bildeten sich (3), um das Rennen der prächtigen
Jachten zu sehen, beispielsweise die *Navahoe* in den 1890er
Jahren (1).

L'UN des grands événements de la « saison » anglaise était
la Cowes Week qui se tenait chaque année au mois d'août
sur l'Île de Wight. Il s'agissait, et il s'agit toujours, à la fois
d'une régate, d'un rituel et d'une occasion de se montrer pour
les riches et les puissants (2). La foule s'entassait sur la plage (3)
pour suivre la course que se livraient les gracieux yachts, tel
le *Navahoe* ici au cours d'une régate dans les années 1890 (1).

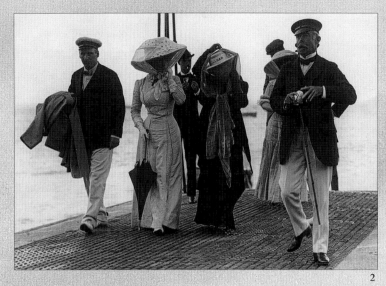

2

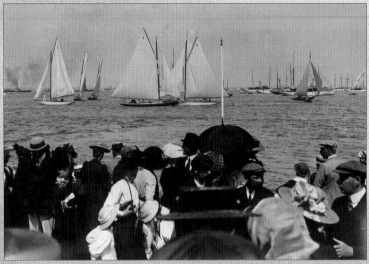

3

Entertainment

'THERE is a range of imagination in most of us,' wrote Charles Dickens, 'which no amount of steam engines will satisfy; and which The-great-exhibition-of-the-works-of-industry-of-all-nations will probably leave unappeased.'

High and low, rich and poor, at home and abroad – what people wanted was fun. And mass migration to towns and cities created lucrative markets for any showman, impresario or theatrical entrepreneur with a few fancy costumes, a portable stage and a voice loud enough to drum up an audience. Crowds flocked to theatres, music halls, cabarets, concerts in the park, and, later, the new bioscopes and cinemas. Top performers earned fortunes, were courted by kings and princes, commanded adoring devotion. Those at the foot of the bill raced from one venue to another, performing six, seven, eight shows a night, until their throats were hoarse and their feet bled. The show had to go on – somehow, somewhere – though audiences were too often crushed or choked or burnt to death in appalling blazes when gaslit theatres caught fire, or killjoy authorities fought bitter rearguard actions to outlaw the wild abandonment of the Can-Can or the shattering insights of an Ibsen play.

In major cities centres of pleasure evolved – Montmartre, Schwabing, Soho – bohemian quarters frequented by the artistic and the raffish, by socialites, intellectuals and tourists, rambling 'up and down the boulevards without encountering anything more exciting than the representatives of loitering and licensed vice' (Guy de Maupassant, *An Adventure in Paris*). Much popular entertainment sprang from poor country roots – the Neapolitan *canzone*, the Spanish *flamenco*, the Argentinian *tango*, the Wild West show. Some had a veneer of glib sophistication, of city slickness – the music hall, the burlesque theatre, the cabaret. All attracted audiences of all classes: from the nobs, swells and mashers who could afford to turn the pretty heads of chorus girls with champagne suppers, and of leading ladies with a good deal more, to the scruffy hecklers who could scarcely afford the cheapest seats in the house.

Ancient forms of entertainment received new leases of life. P. T. Barnum, the American showman, revived the circus with a mixture of magic and hokum, proving that you could fool most of the people most of the time. Zoos and menageries became more popular than ever before, their exotic exhibits augmented by the plunder of jungle and steppe, veldt and prairie. Travelling fairs brought a diet of sword-swallowing and fire-eating, and the wonders of the bearded lady, the mermaid and Siamese twins to the gullible of town and country alike. Jules Léotard extended the art of tightrope-walking, and gave his name to the figure-hugging garment, while Blondin walked further and higher, even crossing the mighty Niagara Falls.

The musical comedy was invented in the late 19th century, a popular if initially down-market development from the Savoy light operas of Gilbert and Sullivan. The musical revue was the lavish brainchild of Florence Ziegfeld, an American showman with more money than taste. For the discerning, the highbrow, or the plain snooty, there was a constant supply of new operas. Wagner, the boldest composer the world has known, wrote *The Flying Dutchman* in Paris, fled from Dresden, where he had flirted with revolution and had written *Tannhäuser* and *Lohengrin*, and began work on the *Ring* cycle in Switzerland. Famous and forgiven, he returned to Germany, settled in Ludwig II's Bavaria and staged the first full *Ring* at his new Festival Theatre in Bayreuth. In Italy, the no less revolutionary Verdi composed *Rigoletto*, *Il Trovatore*, *La Traviata*, *Otello* and his swansong comedy *Falstaff*. Less revolutionary, but as popular, were the offerings of Puccini: *Manon Lescaut*, *La Bohème*, *Tosca* and *Madame Butterfly*.

Theatres prospered as never before. It was the era of the great actor-managers – Belasco, Terry, Hicks, Beerbohm Tree, Kominarjevskaya – men and women with big dreams and large voices, who toured from town to town with their own companies of actors, scenery, props and costumes, doing flamboyant justice to anything from Shakespeare to Cinderella. It was the age of Ibsen, Strindberg, the young George Bernard Shaw, the precocious Oscar Wilde, Hauptmann and Hofmannsthal, Chekhov, Echegaray, Feydeau, Lopez de Ayala and Tamayo y Baus, Gorky, Hallstrom and dozens of other great playwrights.

Actors became stars, household names, gods and goddesses – the Divine Sarah, Adelaide Ristori, Mrs Patrick Campbell, Lily Langtry, Charles Fechter, Josef Kainz. And there was one actor who became the devil incarnate in his most famous role – John Wilkes Booth, who crashed into a box at the Ford Theatre in Washington DC, to interrupt a performance of Tim Taylor's *Our American Cousin* and assassinate the President of the United States.

Until 1850, the Romantic movement in art, literature and music had imposed restrictions on ballet.

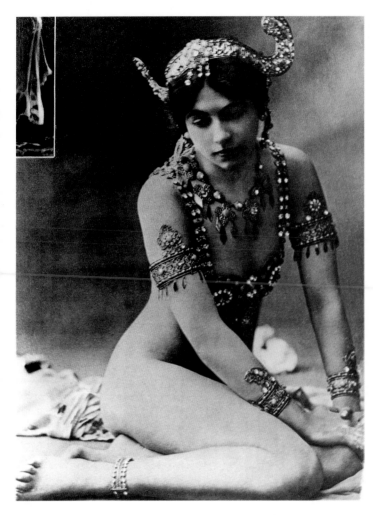

Dancers were expected to look and move like well-drilled sylphs or phantoms. After 1850, costumes became shorter, music more exciting, choreography bolder. Ballet became more athletic and dramatic, fuelled by the music of Delibes, Tchaikovsky and later Stravinsky. Dancers such as Pavlova, Karsavina, Nijinsky, Massine and Isadora Duncan leapt and pirouetted their way into international fame.

Mass education led to a rapidly growing appetite for literature. There was a huge market for the novels of Dickens and Thackeray, Freytag, Zola, the brothers Goncourt, Dumas *père et fils*, Hugo, Henry James and Thomas Hardy. Sir Arthur Conan Doyle created the greatest fictional detective of all time in 1887, when Sherlock Holmes first appeared in *A Study in Scarlet*. Robert Louis Stevenson unleashed *The Strange Case of Dr Jekyll and Mr Hyde* in 1886, and Alice disappeared down the rabbit hole into Wonderland for the first time in 1865.

Finally, it was also the age when the sensuality of Delacroix and the convention of massive historical paintings gave way to the bright purity of the Pre-Raphaelites and the shimmering beauty of the Impressionists. In 1894, Don Jose Ruiz handed his paints and brushes to his son Pablo Picasso, and the world was never quite the same again. And, all the while, the camera captured the world's beauties, its freaks and horrors, its bizarre and wonderful happenings.

E s gibt einen Bereich der Phantasie in den meisten von uns«, schrieb Charles Dickens, »den noch so viele Dampfmaschinen nicht zufriedenstellen können und den Die-große-Ausstellung-der-Industrieprodukte-aller-Nationen vermutlich kaltläßt.«

Von hoher oder niedriger Geburt, arm oder reich, zu Hause oder im Ausland – die Menschen wollten sich amüsieren. Und mit der Abwanderung der Massen in die Großstädte entstanden lukrative Märkte für Schausteller, Impresarios und Theaterbesitzer, die ein paar verrückte Kostüme, eine transportable Bühne und eine Stimme besaßen, die laut genug war, das Publikum neugierig zu machen. Die Menschen strömten in die Theater, Musikhallen, Kabaretts, Konzerte im Park und später in die neuen Bioskope und Lichtspieltheater. Die Stars dieser Veranstaltungen verdienten ein Vermögen, wurden von Königen und Prinzen verehrt und von den Massen bewundert. Die weniger Berühmten eilten von einer Veranstaltung zur nächsten und traten in sechs, sieben oder acht Vorführungen pro Abend auf, bis ihre Kehlen rauh waren und ihre Füße bluteten. Die Show mußte irgendwie und irgendwo weitergehen, obwohl das Publikum nur allzuoft zerquetscht wurde, erstickte oder verbrannte, wenn in mit Gas beleuchteten Theatern Feuer ausbrach. Gefahr ging auch von der Obrigkeit aus, die keinen Spaß verstand und sich in erbitterte Kämpfe stürzte, um den wilden, hemmungslosen Cancan oder die erschütternde Botschaft eines Ibsen-Stückes zu unterbinden.

In den großen Städten entstanden Vergnügungszentren – Montmartre, Schwabing, Soho – Künstlerviertel, die von den Schöngeistern, der Bohème, der feinen Gesellschaft, von Intellektuellen und Touristen aufgesucht wurden, die »die Boulevards entlangschlenderten, ohne auf etwas Aufregenderes zu stoßen als auf die herumstehenden Vertreter und Vertreterinnen des lizensierten Lasters« (Guy de Maupassant, *Une aventure parisienne*). Viele der populären Veranstaltungen hatten ihre Wurzeln in armen, ländlichen Regionen, z.B. die neapolitanische *Canzone*, der spanische *Flamenco*, der argentinische *Tango* oder die Wild-West-Show. Einige wiesen eine gewisse Eleganz und die Gewandtheit der Großstadt auf, wie beispielsweise das Varietétheater und das Kabarett. Sie alle zogen Zuschauer aller Klassen an: von »hohen Tieren« mit Rang und Namen, oder Frauenhelden, die es sich leisten konnten, den schönen Revuegirls den Kopf mit Champagner-Soupers und den der Damen der Gesellschaft mit weit Kostbarerem zu verdrehen, bis zu den verwegenen Schreihälsen, die kaum die billigsten Plätze des Hauses bezahlen konnten.

Frühe Formen des Entertainments erlebten einen neuen Aufschwung. P. T. Barnum, der amerikanische Schausteller, belebte den Zirkus mit einer Mischung aus Zauberei und Hokuspokus und zeigte, daß man die

MATA HARI WAS THE DAUGHTER OF A PROSPEROUS HATTER. HER REAL NAME WAS MARGARETHA GEERTRUIDA ZELLE. HER *DANCE OF THE SEVEN VEILS* WAS A SENSATIONAL SUCCESS, BUT HER CAREER IN ESPIONAGE WASN'T. SHE WAS SHOT AS A SPY IN OCTOBER 1917.

MATA HARI WAR DIE TOCHTER EINES WOHLHABENDEN HUTMACHERS. SIE HIESS EIGENTLICH MARGARETHA GEERTRUIDA ZELLE. IHR *TANZ DER SIEBEN SCHLEIER* WAR EIN SENSATIONELLER ERFOLG, GANZ IM GEGENSATZ ZU IHRER KARRIERE ALS SPIONIN. OB SIE DEN DEUTSCHEN VON NUTZEN GEWESEN IST, BLEIBT UNGEWISS. SIE WURDE IM OKTOBER 1917 ALS SPIONIN ERSCHOSSEN.

MATA HARI ÉTAIT LA FILLE D'UN CHAPELIER PROSPÈRE. ELLE SE NOMMAIT EN FAIT MARGARETHA GEERTRUIDA ZELLE. SI SA *DANSE DES SEPT VOILES* REMPORTA UN VIF SUCCÈS, CE NE FUT GUÈRE LE CAS DE SA CARRIÈRE D'ESPIONNE. ELLE FUT EN EFFET FUSILLÉE POUR ESPIONNAGE EN OCTOBRE 1917.

meisten Leute fast immer an der Nase herumführen kann. Zoos und Menagerien wurden beliebter als jemals zuvor, und ihre exotischen Ausstellungsstücke vermehrten sich durch die Plünderung der Urwälder, Steppen und Prärien. Fahrende Jahrmärkte zeigten den Leichtgläubigen von Stadt und Land Schwert- und Feuerschlucker, das Wunder der bärtigen Jungfrau, Nixen und siamesische Zwillinge. Jules Léotard perfektionierte die Kunst des Seiltanzes und gab dem figurbetonten Anzug seinen Namen, während sein Kollege Blondin immer weiter und immer höher kletterte und sogar die Niagarafälle überquerte.

Das Musical wurde gegen Ende des 19. Jahrhunderts erfunden, eine populäre, wenn auch anfänglich weniger anspruchsvolle Weiterentwicklung der leichten Opern von Gilbert und Sullivan aus dem Savoy. Die musikalische Revue war der lebhaften Phantasie von Florence Ziegfeld entsprungen, einem amerikanischen Showman mit mehr Geld als Geschmack. Für die Anspruchsvolleren, die Intellektuellen und die Hochnäsigen gab es ein reichhaltiges Angebot an Opern. Wagner, der kühne Komponist, schrieb den *Fliegenden Holländer* in Paris, floh aus Dresden, wo er mit der Revolution geliebäugelt, den *Tannhäuser* und den *Lohengrin* geschrieben hatte, und begann seine Arbeit am *Ring des Nibelungen* in der Schweiz. Dem berühmten Mann war vergeben worden, und er kehrte nach Deutschland zurück, ließ sich im Bayern Ludwigs II. nieder und führte erstmals den kompletten *Ring* in seinem neuen Bayreuther Festspieltheater auf. In Italien komponierte der nicht weniger revolutionäre Verdi *Rigoletto, Il Trovatore, La Traviata, Otello* und *Falstaff*. Nicht so revolutionär, aber ebenso populär waren die Werke von Puccini: *Manon Lescaut, La Bohème, Tosca* und *Madame Butterfly*.

Die Theater florierten wie niemals zuvor. Es war die Zeit der großen Schauspieler-Manager wie Belasco,

Terry, Hicks, Beerbohm Tree, Kominarjewskaja – Männer und Frauen mit großen Träumen und vollen Stimmen, die mit ihren eigenen Ensembles, Bühnendekorationen und Kostümen von Stadt zu Stadt zogen und alles von Shakespeare bis Cinderella aufführten. Es war die Zeit von Ibsen, Strindberg, dem jungen George Bernard Shaw, dem frühreifen Oscar Wilde, Hauptmann, Hofmannsthal, Tschechow, Echegaray, Feydeau, Lopez de Ayala und Tamayo y Baus, Gorki, Hallstrom und unzähliger anderer großer Dramatiker.

Schauspieler wurden zu Stars, zu Inbegriffen, zu Göttern und Göttinnen – die göttliche Sarah, Adelaide Ristori, Mrs. Patrick Campbell, Lily Langtry, Charles Fechter und Josef Kainz. Und es gab einen Schauspieler, der in seiner berühmtesten Rolle zum Teufel in Person wurde: John Wilkes Booth stürmte bei einer Aufführung von Tim Taylors *Our American Cousin* in eine Loge des Ford Theatres in Washington D. C. und tötete den Präsidenten der Vereinigten Staaten.

Bis 1850 hatte die romantische Bewegung in Kunst, Literatur und Musik dem Ballett Beschränkungen auferlegt. Die Tänzer sollten wie gedrillte Nymphen und Phantome aussehen und sich auch so bewegen. Nach 1850 wurden die Kostüme kürzer, die Musik aufregender und die Choreographie gewagter. Zu den Klängen der Musik von Delibes, Tschaikowsky und später Strawinsky wurde das Ballett athletischer und dramatischer. Tänzer wie Pawlowa, Karsawina, Nijin-sky, Massine und Isadora Duncan bahnten sich mit ihren Sprüngen und Pirouetten den Weg zu internationalem Ruhm.

Ein allen zugängliches Bildungs- und Erziehungswesen führte bald zu einem wachsenden Hunger nach Literatur. Es gab eine große Nachfrage nach den Romanen von Dickens und Thackeray, Freytag, Émile Zola, der Brüder Goncourt, von Vater und Sohn Dumas, Victor Hugo, Henry James und Thomas Hardy. Sir Arthur Conan Doyle schuf 1887 den größten Romandetektiv aller Zeiten: sein Sherlock Holmes trat erstmals in *A Study in Scarlet* auf. Robert Louis Stevenson gab 1886 *The Strange Case of Dr Jekyll and Mr Hyde* heraus, und Alice verschwand zum ersten Mal 1865 durch den Hasenbau ins Wunderland.

Es war auch die Zeit, da die Sinnlichkeit eines Delacroix und die Konventionen der gewaltigen Historiengemälde der strahlenden Reinheit der Präraffaeliten und der glänzenden Schönheit der Impressionisten wichen. Im Jahre 1894 übergab Don José Ruiz Farben und Pinsel seinem Sohn Pablo Picasso, und die Welt war seitdem nicht mehr dieselbe. In dieser Zeit fing der Photoapparat mehr und mehr die Schönheiten der Welt ein, ihre Absonderlichkeiten und Schrecken, ihre bizarren und wunderbaren Begebenheiten.

CHARLES Dickens écrivait : « La plupart d'entre nous ont une imagination effrénée que ne sauraient satisfaire les engins à vapeur, aussi nombreux soient-ils, et que la-fabuleuse-exposition-des-œuvres-de-l'industrie-de-toutes-les-nations laissera sans doute sur sa faim. »

Quelle que fût leur condition, qu'ils fussent riches ou pauvres, dans leur pays natal ou à l'étranger, les gens voulaient s'amuser. D'autre part, les grandes migrations vers les villes et les cités ouvraient des perspectives lucratives à n'importe quel forain, impresario ou entrepreneur de théâtre possédant quelques costumes, une scène portative et une voix suffisamment forte pour faire accourir les foules. On se précipitait au théâtre, aux variétés, au cabaret, aux concerts du parc, et plus tard dans les salles de projection assister aux balbutiements du cinéma. Les meilleurs artistes gagnaient des fortunes, étaient courtisés par les rois et les princes, objets d'adoration et de dévotion. Les gagne-petit couraient d'un spectacle à l'autre, exécutant six, sept, huit représentations dans la même nuit jusqu'à en avoir la voix enrouée et les pieds en sang. Le spectacle devait continuer quelque part, d'une manière ou d'une autre, même si pour cela le public devait trop souvent se retrouver entassé, voire écrasé ou encore risquer de périr brûlé dans les effroyables incendies qui éclataient dans les théâtres éclairés au gaz. Les pouvoirs publics livraient des batailles perdues d'avance pour interdire le cancan et ses débordements licencieux ou encore une pièce d'Ibsen bouleversante de lucidité.

Dans les grandes villes s'épanouissaient les centres de plaisirs – Montmartre, Schwabing, Soho – quartiers de bohème fréquentés par les artistes et les libertins, les gens de la haute, les intellectuels et les touristes parcourant « ...les boulevards sans rien voir, sinon le vice errant et numéroté ». (Guy de Maupassant, *Une aventure parisienne*). Bien des divertissements populaires étaient originaires des pays pauvres : le *canzone* napolitain, le *flamenco* espagnol, le *tango* argentin, le spectacle de l'Ouest sauvage. Certains avaient le vernis de l'improvisation nonchalante et de la superficialité citadine comme les variétés, le théâtre burlesque et le cabaret. Leur point commun était d'attirer les publics de toutes classes : des sommités, des élégants et des don juans – qui se proposaient de tourner les jolies têtes des filles de la troupe par des soupers au champagne, et celles des actrices principales en y mettant déjà de plus gros moyens – jusqu'aux gêneurs sans-le-sou qui pouvaient tout juste s'offrir une place bon marché.

D'anciennes formes de divertissement étaient remises à l'honneur. P. T. Barnum, un forain américain, ranima le cirque en lui conférant un mélange de magie et de niaiserie, prouvant ainsi que l'on peut presque toujours faire prendre aux gens des vessies pour des lanternes.

Les zoos et les ménageries connaissaient un succès sans précédent et présentaient de plus en plus d'attractions exotiques grâce au pillage de la jungle et de la steppe, du veldt et de la prairie. Les fêtes foraines servaient des avaleurs de sabres et des cracheurs de feu, d'« incroyables » femmes à barbe, sirènes et sœurs siamoises aux gogos des villes et des campagnes. Jules Léotard perfectionna l'art du funambule en donnant son nom au maillot moulant, pendant que Blondin allait plus loin, plus haut et traversait même les puissantes chutes du Niagara. Céline Celeste ouvrit la voie au mime moderne.

La comédie musicale fut inventée à la fin du XIXe siècle. C'était une variante très appréciée, bien qu'au départ d'origine populaire, des opéras légers de Gilbert et Sullivan au Savoy. La revue musicale était la somptueuse trouvaille de Florence Ziegfeld, forain américain qui possédait plus d'argent que de goût. Pour ceux qui faisaient des manières, pour les intellectuels ou les snobs, les nouveaux opéras ne manquaient pas. Wagner, le compositeur le plus hardi que le monde ait connu, écrivit *Le Vaisseau fantôme* à Paris, s'enfuit de Dresde où il avait flirté avec la révolution, écrivit *Tannhäuser* et *Lohengrin* et entama son cycle de *L'Anneau* en Suisse. Célèbre et pardonné, il retourna s'établir en Allemagne dans la Bavière de Louis II où il monta, dans le nouveau théâtre de Bayreuth consacré au festival de ses œuvres, la première représentation complète de *L'Anneau*. En Italie, le non moins révolutionnaire Verdi composait *Rigoletto*, *Il Trovatore*, *La Traviata*, *Othello* ainsi que la comédie qui fut son chant du cygne, *Falstaff*. Moins révolutionnaires mais tout aussi populaires étaient les offrandes de Puccini : *Manon Lescaut*, *La Bohème*, *Tosca* et *Madame Butterfly*.

Les théâtres prospéraient comme jamais auparavant. C'était l'époque des grands directeurs de compagnie – Belasco, Terry, Hicks, Beerbohm Tree, Kominarjevskaya – d'hommes et de femmes qui avaient de grands rêves et de puissantes voix, qui partaient faire la tournée des villes avec leurs propres troupes de comédiens, leurs décors, leurs accessoires et leurs costumes, et qui rendaient brillamment justice à tout, de Shakespeare à Cendrillon. C'était l'époque d'Ibsen, de Strindberg, du jeune George Bernard Shaw, du précoce Oscar Wilde, d'Hauptmann et d'Hofmannsthal, de Tchekhov, d'Echegaray, de Feydeau, de Lopez de Ayala et de Tamayo y Baus, de Gorki, de Hallstrom et de dizaines d'autres grands dramaturges.

Les comédiens devenaient des vedettes, des noms familiers, des dieux et des déesses, tels la divine Sarah, Adelaide Ristori, Madame Patrick Campbell, Lily Langtry, Charles Fechter et Josef Kainz. Un comédien s'incarna lui-même en démon dans son rôle le plus

fameux. Il s'agit de John Wilkes Booth qui se rua dans une loge au Ford Theatre de Washington DC en interrompant la représentation du *Our American Cousin* de Jim Taylor pour assassiner le président des États-Unis.

Jusqu'en 1850, le mouvement romantique illustré dans l'art, dans la littérature et dans la musique avait imposé des contraintes au ballet. On attendait des danseurs qu'ils ressemblent à des sylphes ou des fantômes exercés qui se déplacent à l'avenant. Après 1850, les costumes raccourcirent, la musique s'emporta et la chorégraphie s'enhardit. Le ballet devenait plus athlétique et plus dramatique sur des musiques de Delibes, Tchaïkovski et plus tard Stravinski. Les sauts et les pirouettes de Pavlova, Karsavina, Nijinski, Massine et Isadora Duncan valurent à ces danseurs une renommée internationale.

L'instruction populaire entraîna un appétit de littérature qui grandit rapidement. Il existait un énorme marché pour les romans de Dickens et de Thackeray, de Freytag, de Zola, des frères Goncourt, des Dumas père et fils, d'Hugo, d'Henry James et de Thomas Hardy. Sir Arthur Conan Doyle créa en 1887 la plus grande figure de détective de tous les temps lorsque Sherlock Holmes apparut pour la première fois dans *A Study in Scarlet*. Robert Louis Stevenson dévoila *The Strange case of Dr Jekyll and Mr Hyde* en 1886, tandis qu'Alice disparaissait pour la première fois en 1865 dans le trou de lapin qui allait la mener au Pays des merveilles.

Enfin, ce fut aussi à cette époque que la sensualité de Delacroix et les vastes fresques historiques conventionnelles cédèrent la place à la pureté brillante du mouvement des préraphaélites et à la beauté scintillante des impressionnistes. En 1894, don José Ruiz passait ses tubes de peinture et ses pinceaux à son fils, Pablo Picasso : après lui, le monde ne serait plus jamais le même. Pendant ce temps, l'appareil photographique ne cessait de capter les beautés du monde, ses extravagances et ses horreurs, ses bizarreries et ses merveilles.

1

By reputation the most shocking city in the world was Paris, and its decadent focus was Montmartre (1). The daring of *fin-de-siècle* Paris was typified by the Moulin Rouge, home of the infamous, noisy, brash Can-Can (2, 4). Dancers at the Moulin Rouge became celebrities in their own right, their fame spreading through the posters and paintings of Henri de Toulouse-Lautrec (3, with Tremolada, the Director of the Moulin Rouge). Some Can-Can dancers made wealthy marriages. One of the most famous, La Goulue (5), was reduced to opening her own fairground booth as her talents faded.

Paris stand in dem Ruf, die berüchtigste Stadt der Welt zu sein, und das Zentrum ihrer Dekadenz war Montmartre (1). Die Verkörperung des aufregenden Paris des *Fin de siècle* war das Moulin Rouge, die Heimat des berüchtigten, lauten Cancan (2, 4). Die Tänzerinnen des Moulin Rouge wurden zu Berühmtheiten, und ihr Ruhm vermehrte sich durch die Plakate und Gemälde von Henri de Toulouse-Lautrec (3, mit Tremolada, dem Direktor des Moulin Rouge). Einige Cancan-Tänzerinnen heirateten reiche Männer. Eine der berühmtesten, La Goulue (5), war gezwungen, eine Jahrmarktsbude zu eröffnen, als ihr Talent nachließ.

Paris avait la réputation d'être la cité la plus choquante du monde, et Montmartre son centre décadent (1). Les audaces de ce Paris-là se retrouvaient toutes entières au Moulin-Rouge qui popularisait l'infâme cancan, si bruyant et fripon (2 et 4). Les danseuses du Moulin-Rouge jouissaient d'une célébrité qu'elles ne devaient qu'à elles-mêmes, propagée par les affiches et les tableaux d'Henri de Toulouse-Lautrec (3, en compagnie de Tremolada, le directeur du Moulin-Rouge). Certaines danseuses de cancan épousèrent des hommes très riches. Une des plus célèbres, La Goulue (5) en fut pourtant réduite, après avoir brûlé les planches, à ouvrir son propre stand sur un champ de foire.

2

3

4

5

THE Wild West was sufficiently tamed to become a theatrical spectacle. Annie Oakley (2) was a sharpshooter who galloped and fusilladed her way to fame in circus and rodeo. Colonel William S. Cody, better known as Buffalo Bill (1), was an American Army scout, slaughterer of native Americans and buffalo, and the man who killed the Cheyenne leader, Yellow Hair, in single combat and took his scalp. Buck Taylor (3) was the self-styled King of the Cowboys.

DER Wilde Westen war inzwischen so zahm geworden, daß er zum Theaterspektakel ausgeartet war. Annie Oakley (2) war eine Scharfschützin, die durch die Vorführung ihrer Reit- und Schießkünste im Zirkus und im Rodeo zu Berühmtheit gelangte. Colonel William S. Cody, besser bekannt als Buffalo Bill (1), war Kundschafter der amerikanischen Army, Schlächter der amerikanischen Indianer und Büffel und der Mann, der den Häuptling der Cheyenne, Yellow Hair, im Kampf tötete und skalpierte. Buck Taylor (3) war der selbsternannte König der Cowboys.

L'OUEST sauvage avait été suffisamment apprivoisé pour se transformer en spectacle de théâtre. Annie Oakley (2) était une tireuse hors pair que ses fusillades en plein galop rendirent célèbre dans les cirques et les rodéos. Le colonel William S. Cody, plus connu sous le nom de Buffalo Bill (1), était un éclaireur de l'armée américaine, grand massacreur d'Amérindiens et de bisons ; il tua le chef cheyenne Yellow Hair en combat singulier et lui prit son scalp. Buck Taylor (3) s'était proclamé lui-même roi des cowboys.

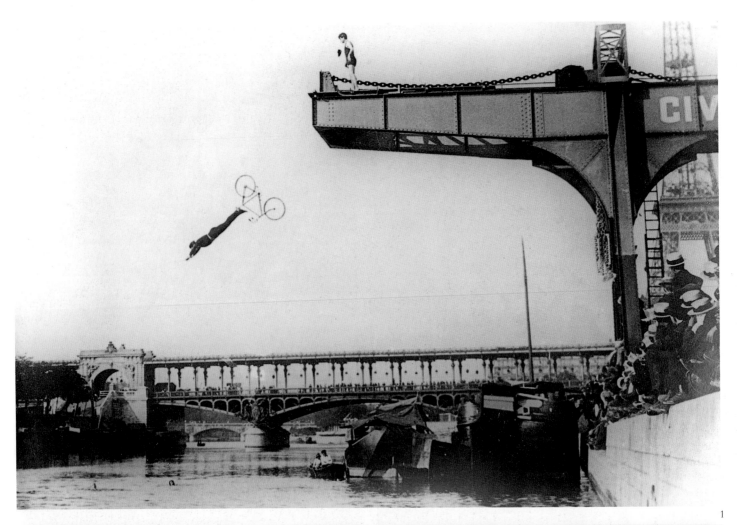

1

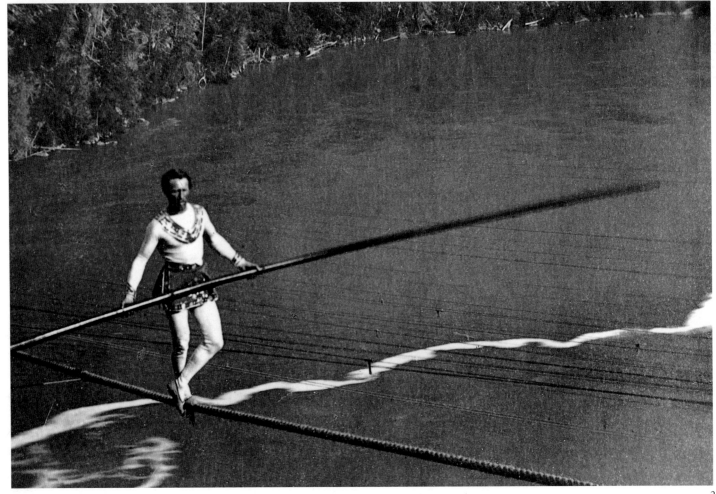

2

MANY acrobats – as these in London (3) – performed in the streets, a thin mat marking out their stage on the rough pavement. In Mexico (4) the Strong Señorita and the Clown's Baby Act would have had a softer landing in the sand. The greater the novelty, the bigger the crowd – hundreds of Parisians watched Gaston Mourand dive on his bicycle into the Seine at 'Swan's Island' (1). Perhaps the most famous circus performer of all time, Blondin was photographed by William England crossing Niagara Falls in 1859 (2).

WIE diese Londoner Akrobaten (3) führten viele ihre Kunststücke auf der Straße auf, wobei ihnen eine dünne Matte als Bühne auf dem harten Gehsteig diente. Die starken Señoritas und das kleine Mädchen in Mexiko (4) hatten vermutlich eine weichere Landung im Sand. Je größer die Sensation, desto größer die Zuschauermenge; Hunderte von Parisern sahen zu, wie Gaston Mourand mit seinem Fahrrad in der Nähe der »Schwaneninsel« in die Seine eintauchte (1). Der vielleicht berühmteste Zirkusartist aller Zeiten war Blondin, hier auf einer Photographie von William England beim Überqueren der Niagarafälle im Jahre 1859 (2).

DE nombreux acrobates, tels ceux-ci à Londres, (3) exécutaient leurs numéros dans les rues sur un mince paillasson qui délimitait la scène au milieu du trottoir. Au Mexique (4), Madame Muscle et Bébé clown faisaient un atterrissage plus moelleux dans le sable. Plus la nouveauté était grande et plus elle attirait de monde : des centaines de Parisiens regardent Gaston Mourand plonger dans la Seine sur sa bicyclette du haut de l'Île au Cygne (1). Le plus grand artiste de cirque de tous les temps fut peut-être Blondin, photographié ici en 1859 par William England en train de traverser les chutes du Niagara (2).

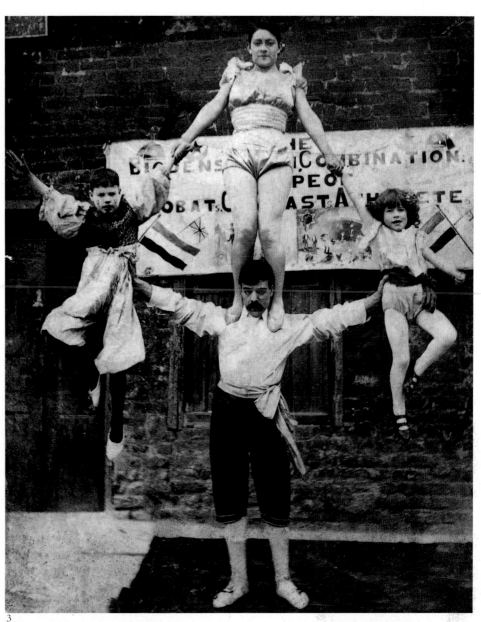

3

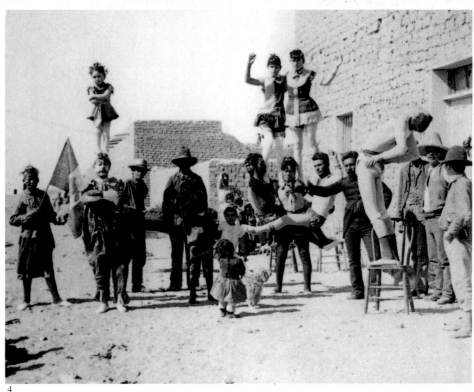

4

IT was an era of larger-than-life performances: Sir Henry Irving as Cardinal Wolsey in *Henry VIII* (1); Irene Vanburgh as Gwendolen Fairfax in *The Importance of Being Earnest* (3); Ellen Terry at sixteen in 1863 (2). Lily Langtry was adored by Edward VIII and

Oscar Wilde alike (4), but the darling of them all was the divine Sarah Bernhardt, whether on stage as Izeyl (5), or even Hamlet (6), or with her daughter (8). Her black page (7) had the job of guarding her rooms at the Savoy Hotel and of perfuming her carriage.

Es war eine Zeit faszinierender Aufführungen: Sir Henry Irving als Kardinal Wolsey in *Henry VIII* (1); Irene Vanburgh als Gwendolen Fairfax in *The Importance of Being Earnest* (3). Ellen Terry 1863 im Alter von sechzehn Jahren (2). Lily Langtry (4) erfreute sich der Bewunderung von Edward VIII. und Oscar

5

6

7

8

Wilde, aber aller Liebling war die göttliche Sarah Bernhardt, ob auf der Bühne als Izeyl (5) oder sogar als Hamlet (6) oder mit ihrer Tochter (8) im sogenannten wirklichen Leben. Ihr farbiger Diener (7) hatte die Aufgabe, ihre Räume im Savoy Hotel zu bewachen und ihren Wagen zu parfümieren.

L'ÉPOQUE était aux spectacles plus vrais que nature, ainsi que l'illustrent Sir Henry Irving en cardinal Wolsey dans *Henry VIII* (1) et Irene Vanburgh en Gwendolen Fairfax dans *The Importance of Being Earnest* (3). Ellen Terry en 1863 (2). Lily Langtry était aussi adorée d'Édouard VIII que d'Oscar Wilde (4) ; mais la petite chérie de tous était la divine Sarah Bernhardt, que ce soit sur scène jouant Izeyl (5) ou même Hamlet (6), ou avec sa fille (8). Son page noir (7) était chargé de monter la garde dans ses appartements au Savoy Hotel et de parfumer son attelage.

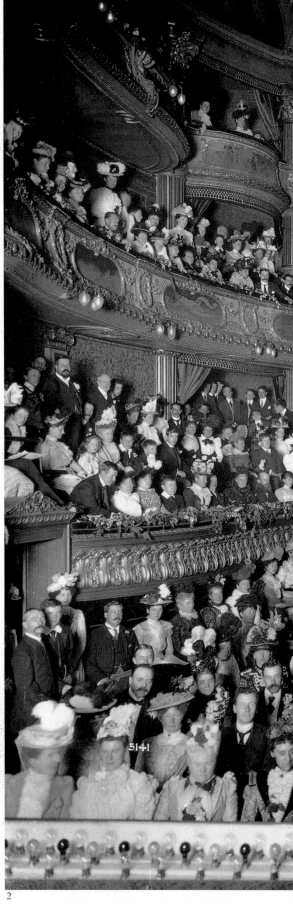

SIR Herbert Draper Beerbohm Tree was one of the greatest of all actor-managers. He staged lavish and spectacular productions of most of Shakespeare's plays, as well as the first performances of Wilde's *A Woman of No Importance* (1893) and Shaw's *Pygmalion* (1914), in which Tree created the part of Professor Higgins. His most fearsome role was that of Mephistopheles in Marlowe's *Doctor Faustus* (1). Many of his greatest successes were staged at the Haymarket Theatre (2), though by 1899, when this photograph was taken, Tree had moved to Her Majesty's.

SIR Herbert Draper Beerbohm Tree war einer der berühmtesten Schauspieler-Manager. Er inszenierte spektakuläre Aufführungen der meisten Shakespeare-Stücke sowie die erste Aufführung von Oscar Wildes *A Woman of No Importance* (1893) und Shaws *Pygmalion* (1914), in der Tree

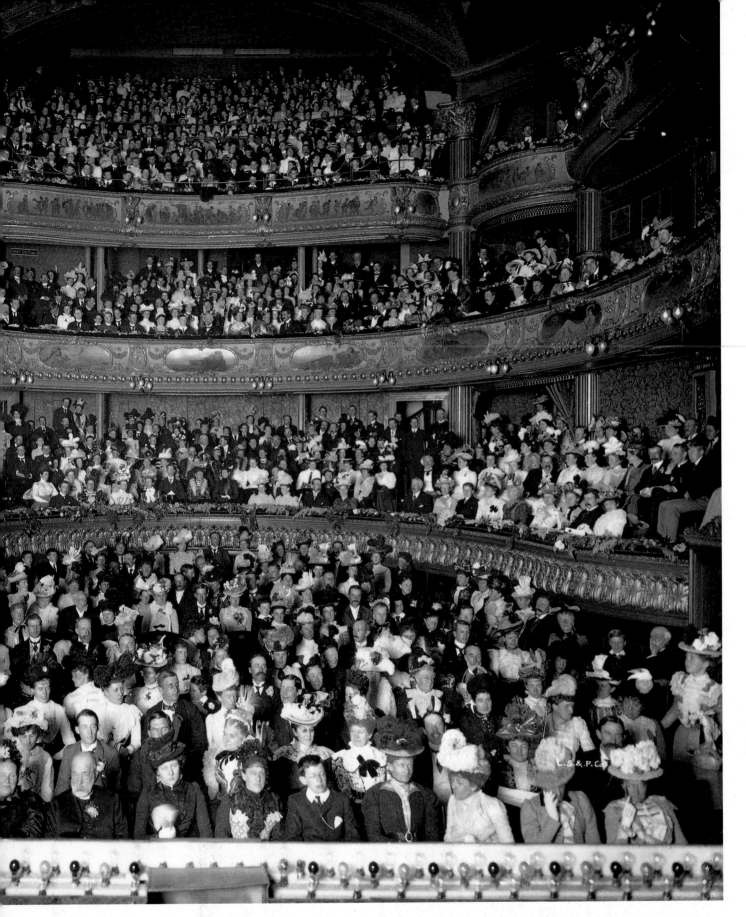

selbst die Rolle des Professor Higgins spielte. Seine furchterregendste Rolle war jedoch die des Mephistopheles in Marlowes *Doctor Faustus* (1). Viele seiner großen Erfolge feierte er im Haymarket Theatre (2). 1899, als diese Aufnahme gemacht wurde, hatte er bereits zum königlichen Theater gewechselt.

SIR Herbert Draper Beerbohm Tree était un des plus grands directeurs de compagnie. Il monta des productions somptueuses et spectaculaires de la plupart des pièces de Shakespeare, ainsi que les premières représentations de *A Woman of No Importance* (1893) d'Oscar Wilde et du *Pygmalion* de Shaw (1914), dans lequel il créa le personnage du professeur Higgins. Son rôle le plus effrayant fut celui de Méphistophélès dans le *Doctor Faustus* de Marlowe (1). Beaucoup de ses plus grands succès furent montés au théâtre de Haymarket (2), bien qu'en 1899, Tree eût déjà déménagé au Her Majesty's Theatre.

3

4

2

IN 1904 the 60-year-old Sarah Bernhardt went to London to play Pelléas opposite Mrs Patrick Campbell's Mélisande (1) – a romantic duo with the combined age of 99 years. Campbell (2) once described her then recent marriage as: 'the deep, deep peace of the double bed after the hurly-burly of the chaise-longue'. Martin Harvey (3), possibly a more likely Pelléas, was another famous actor-manager. William Gillette (4), an American, adapted and took the lead in the first stage production of *Sherlock Holmes*.

IM Jahre 1904 kam die sechzigjährige Sarah Bernhardt nach London, um an der Seite von Mrs. Patrick Campbell als Mélisande den Pelléas zu spielen (1) – ein romantisches Paar, das zusammen 99 Jahre zählte. Mrs. Campbell (2) beschrieb ihre damals noch junge Ehe als »den tiefen, tiefen Frieden des Ehebetts nach der Hektik der Chaiselongue«. Martin Harvey (3), vermutlich ein geeigneterer Pelléas, war ebenfalls ein bekannter Schauspieler-Manager. Der Amerikaner William Gillette (4) adaptierte den *Sherlock Holmes* erstmals für die Bühne und spielte selbst die Hauptrolle.

EN 1904, Sarah Bernhardt âgée de 60 ans se rendit à Londres pour jouer Pelléas, avec Madame Campbell dans le rôle de Mélisande (1) pour lui donner la réplique. Elles totalisaient 99 ans à elles deux. Campbell (2) avait un jour décrit son mariage alors récent comme « la profonde, profonde paix du grand lit après les tumultes de la chaise longue ». Martin Harvey (3), un Pelléas certainement plus vraisemblable, était lui aussi un directeur de compagnie célèbre. L'Américain William Gillette (4) adapta au théâtre les premiers *Sherlock Holmes*, dans lesquels il joua le rôle principal.

Arts

BALLET had shaken off the restraints and stiff formality of its courtly origins in the early 19th century. Dancing became more ethereal, and yet also more gymnastic, with the focus very much on the female dancer. Emma Pitteri (1) was the most fêted ballerina of the 1860s, though destined to die in squalid obscurity many years later while appearing in a dance hall on the Marseilles dockside.

From the middle of the century to the First World War, ballet employed huge forces. There were spectacular new works, new companies, new choreographers. Delibes, Tchaikovsky and Stravinsky wrote the most famous ballet scores of all time. Fokine, Bolm and Nijinsky brought new athleticism to ballet and restored the role of the male dancer; Duncan eschewed the style of dancing on points epitomized by the classical ballerina (2). It was a far cry from the quaint rigidity of the two dancers photographed by the London Stereoscopic Company in the 1860s (3) to Nijinsky's spectacular leap in *Spectre de la Rose*.

The finest dancing and the finest dancers came from the Russian Imperial School of Ballet in St Petersburg. Graduates toured Europe and the Americas, and found dancing standards considerably lower than those in Russia. Like missionaries of old, they brought their ideals (and, unlike missionaries, their genius) to companies all over the world.

1

ZU Beginn des 19. Jahrhunderts hatte das Ballett die Zurückhaltung und die steife Förmlichkeit seiner höfischen Ursprünge abgelegt. Die Tänze wurden ätherischer, aber gleichzeitig auch akrobatischer, und der männliche Tänzer stand deutlich im Mittelpunkt. Emma Pitteri (1) war die meistgefeierte Ballerina der 1860er Jahre; viele Jahre später sollte sie bei einem Auftritt in einem schäbigen Tanztheater im Hafen von Marseille sterben.

Von der Mitte des 19. Jahrhunderts bis zum Ersten Weltkrieg waren beim Ballett sehr viele Menschen beschäftigt. Es gab spektakuläre neue Werke, neue Truppen, neue Choreographen. Delibes, Tschaikowsky und Strawinsky schrieben die berühmteste Ballettmusik aller Zeiten. Fokine, Bolm und Nijinsky führten neue athletische Bewegungen ein und verliehen der Rolle des männlichen Tänzers ein neues Gesicht; Duncan verabscheute es, wie die klassische Ballerina (2) auf der Spitze zu tanzen. Die seltsame Steifheit der in den 60er Jahren von der London Stereoscopic Company photographierten Tänzer (3) war weit entfernt von Nijinskys spektakulären Sprüngen in *Spectre de la Rose*.

Die besten Tänze und Tänzer kamen aus der Kaiserlichen Russischen Ballettschule in St. Petersburg. Ihre Absolventen gastierten in Europa und Amerika, wo das Ballett ihrer Meinung nach ein weitaus niedrigeres Niveau als in Rußland hatte. Wie Missionare früherer Zeiten vermittelten sie ihre Ideale (und, anders als die Missionare, ihr Genie) den Tänzern in der ganzen Welt.

2

3

LE ballet s'était débarrassé des contraintes et de la formalité rigide qu'il devait à ses origines de cour du début du XIXᵉ siècle. La danse se fit plus éthérée tout en se rapprochant aussi davantage de la gymnastique, et mit en valeur la danseuse. Emma Pitteri (1), qui fut la plus fêtée des ballerines des années 1860, devait mourir dans un sordide anonymat quelques années plus tard, alors qu'elle dansait dans un cabaret du port de Marseille.

À partir du milieu du siècle et jusqu'à la Première Guerre mondiale, le ballet mit en branle des forces prodigieuses. Il y eut un nombre spectaculaire de nouvelles œuvres, de compagnies et de chorégraphes. Delibes, Tchaïkovski et Stravinski écrivirent les orchestrations pour ballet les plus célèbres de tous les temps.

Fokine, Bolm et Nijinski donnèrent au ballet un aspect plus physique et rétablirent le rôle du danseur. Duncan évita le style de la danse sur pointe que la ballerine classique incarnait (2). Il y a tout un monde entre la rigidité curieusement démodée des deux danseuses photographiées par la London Stereoscopic Company dans les années 1860 (3) et le spectaculaire bond de Nijinski dans le *Spectre de la rose*.

La plus belle danse et les plus beaux danseurs venaient de l'École du ballet impérial russe de Saint-Pétersbourg. Ses diplômés parcouraient l'Europe et les Amériques et constataient que les normes de danse y étaient bien inférieures à celles en vigueur en Russie. Tels des missionnaires du temps passé, ils apportaient leurs idéaux aux compagnies de danse du monde entier.

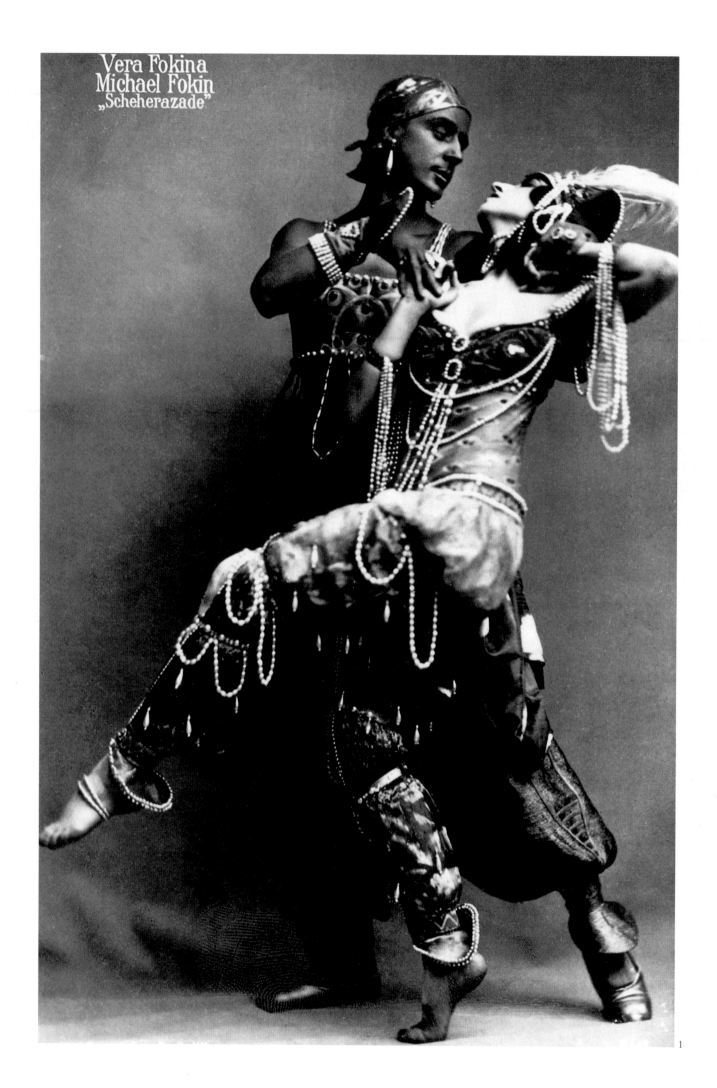

Vera Fokina
Michael Fokin
„Scheherazade"

2 3

THE most explosively exciting dance company was Diaghilev's Ballets Russes, formed in 1909 originally as a touring troupe of the Russian Imperial Ballet. It attracted the talents of the finest composers, painters and designers, as well as the leading choreographers and dancers. Those lucky enough to see them in Paris could thrill to Mikhail Fokine and Vera Fokina in Rimsky-Korsakov's *Scheherazade* (1), Adolphe Bolm in the Polovtsian Dances from Borodin's *Prince Igor* (2), and Tamara Karsavina (3), one of the first Russian dancers to be seen in the West.

DAS faszinierendste aller Tanzensembles waren Diaghilews Ballets Russes, die 1909 ursprünglich als Tourneetruppe des Kaiserlichen Russischen Balletts entstanden waren. Sie zogen die besten Komponisten, Maler und Designer sowie führende Choreographen und Tänzer an. Wer das Glück hatte, das Ensemble in Paris zu sehen, konnte sich von Michail Fokine und Vera Fokina in Rimski-Korsakows *Scheherazade* (1), Adolphe Bolm in Borodins *Prinz Igor* (2) und Tamara Karsawina (3), eine der ersten russischen Tänzerinnen, die im Westen auftrat, verzaubern lassen.

LA compagnie de danse la plus explosive et la plus excitante était celle des Ballets russes de Diaghilev. Initialement créée en 1909 pour servir de troupe itinérante au ballet impérial russe, elle attirait les talents des compositeurs, des peintres et des créateurs les plus brillants ainsi que les meilleurs chorégraphes et les meilleurs danseurs. Ceux qui avaient la chance de pouvoir assister à leurs spectacles à Paris pouvaient palpiter en regardant Michel Fokine et Vera Fokina danser dans *Schéhérazade* de Rimski-Korsakov (1), Adolphe Bolm dans les danses polovtsiennes du *Prince Igor* (2) de Borodine et Tamara Karsavina (3), qui fut l'une des premières danseuses russes à se produire en Occident.

4

EADWEARD Muybridge used his series of cameras to capture the flowing movements of the dancer Isadora Duncan (1, 2 and 3). Duncan (6, in later life) founded her own ballet company, inspired by the ancient Greek approach to art. 'I am inspired by the movement of the trees, the waves, the snows,' she wrote, 'by the connection between passion and the storm, between the breeze and gentleness…'. Among her pupils was her sister Erika (4). Duncan was 27 when her portrait was taken in 1905 (5). Her last words, before her long scarf caught in a car wheel in 1927 and broke her neck, were: 'Farewell, my friends. I am going to glory.'

EADWEARD Muybridge verwendete mehrere Kameras, um die fließenden Bewegungen der Tänzerin Isadora Duncan einzufangen (1, 2 und 3). Duncan (6, in reiferem Alter) gründete ihr eigenes Ballettensemble, inspiriert von der Kunstauffassung der alten Griechen. »Ich werde von der Bewegung der Bäume, der Wellen und der Schneeflocken inspiriert«, schrieb sie, »von der Verbindung zwischen der Leidenschaft und dem Sturm, zwischen der Brise und der Sanftheit …« Zu ihren Schülerinnen gehörte ihre Schwester Erika (4). Duncan war 27 Jahre alt, als dieses Portrait im Jahre 1905 aufgenommen wurde (5). Ihre letzten Worte, bevor sich der lange Schal, den sie trug, 1927 in einem Autoreifen verfing und ihr das Genick brach, waren: »Lebt wohl, meine Freunde, ich gehe in die Ewigkeit.«

EADWEARD Muybridge se servit d'une batterie d'appareils photographiques pour capter la fluidité des mouvements de la danseuse Isadora Duncan (1, 2 et 3). Duncan (6, plus âgée) fonda sa propre compagnie de ballets en s'inspirant de l'attitude de la Grèce antique vis-à-vis de l'art. Elle notait : « Je m'inspire du mouvement des arbres, des vagues et des neiges, du lien qui unit la passion et l'orage, la brise et la caresse… » Elle comptait au nombre de ses élèves sa propre sœur Erika (4). Duncan avait 27 ans en 1905 (5). Ses dernières paroles avant que sa longue écharpe ne lui rompît la nuque en se prenant dans la roue d'une voiture en 1927 ont été : « Adieu, mes amis. Je vais à la gloire. »

(*Previous pages*)

THE American Loie Fuller (1) was described by critics as 'less a dancer than a magician of light', an actress who turned to ballet and made astounding use of pieces of cheesecloth. She created a sensation on her début at the Folies Bergère. Adeline Genée (2) was Danish, enchantingly pretty and adored by audiences the world over. Maud Allen (3) was billed as a 'speciality dancer', and was famous for her reportedly scandalous *Vision of Salome*. There was a wealth of Russian talent (4) which failed to gain international fame but delighted Imperial audiences with technique and artistry of a high order.

(*Vorherige Seiten*)

IN der Amerikanerin Loie Fuller (1) sahen die Kritiker »weniger eine Tänzerin als eine Zauberin des Lichts«. Sie war ursprünglich Schauspielerin, bevor sie zum Ballett überwechselte und dort erstaunlichen Gebrauch von Baumwollstoff machte. Ihr Debut bei den Folies Bergère machte sie zur Sensation. Die hübsche Dänin Adeline Genée (2) wurde vom Publikum in der ganzen Welt bewundert. Maud Allen (3) wurde als »Spezialtänzerin« bezeichnet und war berühmt für ihre skandalösen Auftritte in *Vision of Salome*. Es gab viele russische Talente (4), die zwar keinen internationalen Ruhm erlangten, jedoch das Publikum der Kaiser- und Königshäuser mit ihrer Technik und ihrer hohen Kunst erfreuten.

(*Pages précédentes*)

L'AMÉRICAINE Loïe Fuller (1), selon les critiques « moins une danseuse qu'une magicienne de la lumière », était une comédienne venue au ballet ; elle faisait une utilisation étonnante des voiles de gaze. Elle fit sensation à ses débuts aux Folies Bergère. Adeline Genée (2) était danoise, jolie comme un cœur et adorée par les publics du monde entier. Maud Allen (3), qu'on présentait à l'affiche comme une « danseuse de fantaisie », avait été rendue célèbre par sa *Vision de Salomé* que l'on disait scandaleuse. Il existait une profusion de talents russes (4) que la renommée internationale boudait, mais qui ravissaient les cours impériales par leur virtuosité technique et artistique.

4

With best love Miss Duncan.

5

6

1

2

3

BIZET'S *Carmen* had its première in Paris in 1875. Emmy Soldene was an early Carmen – dead (5), and very much alive and smoking (6). From 1860 to 1905, the most celebrated soprano was Adelina Patti (1) – here as Marguerite in Gounod's *Faust*, with Mario. At the other end of several scales was the Russian baritone Feodor Chaliapin as Prince Igor (3). Enrico Caruso was perhaps the greatest tenor of all time, in his most famous role as Canio in *Pagliacci* (4). Another great soprano, and rival for the part of Marguerite, was Nellie Melba (2).

BIZETS *Carmen* hatte 1875 in Paris Premiere. Emmy Soldene spielte als eine der ersten die Carmen, tot (5) und sehr lebendig rauchend (6). Von 1860 bis 1905 war Adelina Patti (1), hier als Marguerite in Gounods *Faust* mit Mario, der meistgefeierte Sopran. Am anderen Ende der Tonleiter befand sich der russische Bariton Fjodor Schaljapin, hier als Prinz Igor (3). Enrico Caruso, der wohl größte Tenor aller Zeiten, hier in seiner bekanntesten Rolle als Canio in *Pagliacci* (4). Ein weiterer großer Sopran und Rivalin für die Rolle der Marguerite war Nellie Melba (2).

LA première du *Carmen* de Bizet eut lieu à Paris en 1875. Emmy Soldene incarna une des premières Carmen : morte (5) et bien vivante en train de fumer (6). Entre 1860 et 1905, Adelina Patti (1) était la soprano la plus célébrée : ici en Marguerite dans le *Faust* de Gounod où elle partageait la vedette avec Mario. À l'autre extrémité et plusieurs gammes au-dessous, le baryton russe Fedor Chaliapine dans le rôle du prince Igor (3). Enrico Caruso fut peut-être le plus grand ténor de tous les temps, et son rôle le plus célèbre celui de Canio dans le *Pagliacci* de Leoncavallo (4). L'autre grande soprano, une rivale dans le personnage de Marguerite, était Nellie Melba (2).

Wagner's *Lohengrin* was first produced at Weimar in 1850. A famous (later) tenor in the title role was Carl Langorlb (1). The four operas comprising the *Ring* made their first appearances between 1869 and 1876. Anton van Rooy (2), an 'heroic baritone', and Rudolf Berger (4), a great Siegmund though inclined to be 'dry and wooden', made some of the first ever recordings of Wagner's masterpiece. *Tristan and Isolde* was first produced in Munich in 1865 – Carl Burrian (3) was a strong, if wide-eyed, Tristan. Madame Grandjean (6) was a famous Brünnhilde, and Zdenka Fassbender (5) gave many outstanding Wagner performances. While she was in the middle of singing Isolde, at the Munich Festival in 1911, her husband, Felix Mottl, who was conducting, collapsed and died.

Wagners *Lohengrin* wurde 1850 in Weimar uraufgeführt. Ein berühmter (späterer) Tenor in der Titelrolle war Carl Langorlb (1). Die vier Opern, die zusammen den *Ring des Nibelungen* bilden, waren zwischen 1869 und 1876 zum ersten Mal zu sehen. Anton van Rooy (2), ein »heroischer Bariton«, und Rudolf Berger (4), ein großer Siegmund, jedoch mit einer Tendenz, »trocken und hölzern« zu wirken, bestritten einige der ersten Schallplattenaufnahmen von Wagners Meisterwerk. Die Uraufführung von *Tristan und Isolde* fand 1865 in München statt – mit Carl Burrian (3) als starkem, wenn auch erstaunt blickendem Tristan. Madame Grandjean (6) war die berühmte Brünnhilde, und auch Zdenka Fassbender (5) war in vielen herausragenden Wagneraufführungen zu sehen. Während sie bei den Münchner Festspielen im Jahre 1911 die Arie der Isolde sang, brach ihr Mann, Felix Mottl, der das Orchester dirigierte, zusammen und starb.

Lohengrin de Wagner fut présenté à Weimar pour la première fois en 1850. Le ténor célèbre (plus tard) dans le rôle du personnage qui donne son titre à la pièce était Carl Langorlb (1). Les quatre opéras qui composent *L'Anneau* furent joués pour la première fois entre 1869 et 1876. Anton van Rooy (2), un « baryton héroïque », et Rudolf Berger (4), magnifique Siegmund malgré une tendance à jouer « sec comme du bois », exécutèrent certains des tout premiers enregistrements du chef-d'œuvre de Wagner. *Tristan et Isolde* fut représenté pour la première fois à Munich en 1865. Carl Burrian (3) y jouait un Tristan robuste aux yeux quelque peu écarquillés. Madame Grandjean (6) fut une Brünnhilde célèbre, tandis que Zdenka Fassbender (5) donna plusieurs interprétations absolument remarquables de l'œuvre de Wagner. Alors qu'elle en était au beau milieu du chant d'Isolde, durant le festival de Munich en 1911, son mari Felix Mottl, qui dirigeait l'orchestre, s'effondra subitement pour ne plus se relever.

5

6

MORALISTS complained that they were fighting a battle against 'cheap' literature, and many were shocked by the work of Colette, and her friends Henri Gauthier-Villars and Polaire (1). Victor Hugo (2) shocked some by his politics, as did Leo Tolstoy, Charles Dickens and Émile Zola. Marcel Proust changed the shape of the modern novel. Gerhart Hauptmann wrote plays and novels and won the Nobel Prize for Literature in 1912. George Sand shocked people as much by her lifestyle as by her writing. Mark Twain delighted rather than shocked, but his compatriot, Walt Whitman, disturbed many with his poems that celebrated fertility and sensuality. Thomas Hardy's novels depressed and delighted almost everyone.

(Overleaf)

ART abounded and astounded. John Ruskin wrote, 'Remember that the most beautiful things in the world are the most useless.'

MORALISTEN klagten, sie müßten gegen »billige« Literatur ankämpfen, und viele waren schockiert über die Bücher von Colette und die ihrer Freunde Henri Gauthier-Villars und Polaire (1). Victor Hugo (2) schockierte so manchen durch seine politischen Ansichten, ebenso wie Leo Tolstoi, Charles Dickens und Émile Zola. Marcel Proust veränderte die Form des modernen Romans. Gerhart Hauptmann schrieb Theaterstücke und Romane und erhielt 1912 den Nobelpreis für Literatur. George Sand schockierte die Leute ebensosehr durch ihren Lebensstil wie durch ihre Bücher. Mark Twain erfreute eher, als zu schockieren, aber die Gedichte seines Landsmanns Walt Whitman, die Fruchtbarkeit und Sinnlichkeit priesen, fanden viele äußerst beunruhigend. Thomas Hardys Romane deprimierten und erfreuten fast jeden.

(Folgende Seiten)

DIE Kunst blühte und versetzte in Erstaunen. John Ruskin schrieb: »Denken Sie daran, die schönsten Dinge dieser Welt sind auch die nutzlosesten.«

LES moralistes se plaignaient de lutter contre une littérature « bon marché », et beaucoup étaient scandalisés par l'œuvre de Colette et par ses amis Henri Gauthier-Villars et Polaire (1). Victor Hugo (2) choquait par ses idées politiques et avec lui Léon Tolstoï, Charles Dickens et Émile Zola. Marcel Proust modifia la forme du roman moderne. Gerhart Hauptmann écrivait des pièces de théâtre et des romans ; il reçut le prix Nobel de littérature en 1912. George Sand offensait autant par son mode de vie que par ses écrits. Marc Twain ravissait plus qu'autre chose ; son compatriote, Walt Whitman, en revanche, en indisposait beaucoup par ses poèmes qui célébraient la fertilité et la sensualité. Les romans de Thomas Hardy déprimaient et enchantaient presque tout le monde.

(Pages suivantes)

L'ART abondait et étonnait. John Ruskin apporta une réponse originale et lourde de conséquences à l'éternelle question : « Qu'est ce que l'art ? » Il répondit : « Souvenez-vous que les choses les plus belles du monde sont les plus inutiles. »

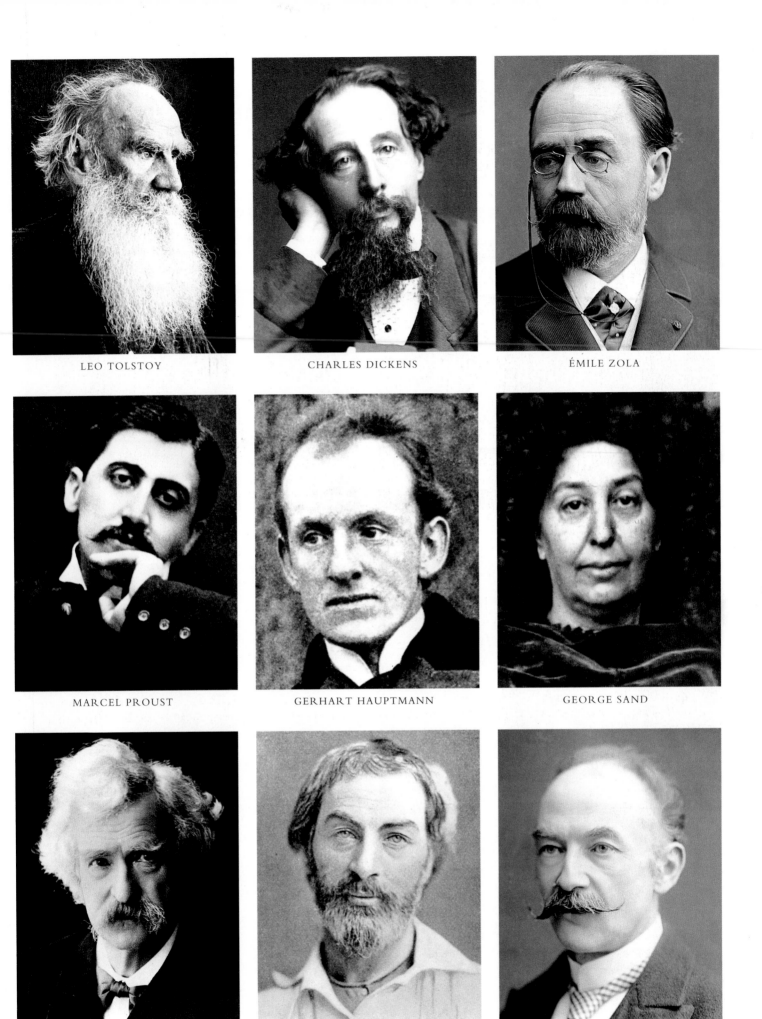

LEO TOLSTOY

CHARLES DICKENS

ÉMILE ZOLA

MARCEL PROUST

GERHART HAUPTMANN

GEORGE SAND

MARK TWAIN

WALT WHITMAN

THOMAS HARDY

JOHN RUSKIN (*centre*) WITH D. G. ROSSETTI (*right*)

WILLIAM HOLMAN HUNT

AUBREY BEARDSLEY

HENRI DE TOULOUSE-LAUTREC

AUGUSTE RENOIR

CLAUDE MONET

AUGUSTE RODIN

GUSTAVE DORÉ

Empire

By the end of the 19th century, the European powers directly ruled almost half the world's land-mass and half the world's population. From Germany, France, Spain, Britain, Portugal, Belgium and the Netherlands thousands of young men and women sailed by steamship to colonies that stretched from New Guinea in the South Pacific to Newfoundland and St Pierre et Miquelon in the North Atlantic. In the entire African continent, only Abyssinia and Liberia retained their independence. Most of the Indian sub-continent was under British rule. In the Far East, Laos, Cambodia and Indo-China belonged to France, and much of Japan and mainland China was under European influence, if not control, as a result of major financial investment. Between 1871 and 1914 the French Empire grew by nearly 4 million square miles and 47 million people, the German Empire by 1 million square miles and 14 million people.

But the greatest Imperial power of them all was Great Britain. In 1897, the year of Queen Victoria's Diamond Jubilee, Britain had the largest empire in the history of the world; vigorous, fertile, hard-working, ordered and exploited. To celebrate the Jubilee, every tenth convict was set free in Hyderabad, a week's free food was distributed to all the poor families in Jamaica. There was free travel on the state railways of Baroda for 24 hours, a Grand Ball in Rangoon, a dinner at the Sultan's Palace in Zanzibar, a performance of the Hallelujah Chorus in Hong Kong. Troops from Canada, South Africa, Australia, India, North Borneo, Cyprus and a dozen other subject states came to London to take part in the Jubilee procession. The *Kreuz Zeitung* in Berlin reported that the British Empire was 'practically unassailable'. The *New York Times* was a little more enthusiastic, declaring: 'We are a part, and a great part, of the Greater Britain which seems so plainly destined to dominate this planet.'

Europe brought the light of Christianity and civilization to heathen and savage swathes of darkness. Drew Gay of the *Daily Telegraph* described the Hindus as 'the worst washed men I ever saw'. 'The only people who have a right to India are the British,' wrote one outraged correspondent. 'The so-called Indians have no right whatsoever.' H. M. Stanley, the man who 'discovered' Dr Livingstone, wrote that the Congo was 'a murderous world, and we feel for the first time that we hate the filthy, vulturous ghouls who inhabit it'. The photographer John Thomson described the Chinese as 'revolting, diseased and filthy objects'. Less brutally, Mary Fitzgibbon, an engineer's wife, concluded that the native Icelanders were 'teachable servants, neat, clean and careful, but have not constitutional strength to endure hard work'.

No races, it seemed, matched the European, for ingenuity, hard work, honesty, invention and guts. When Imperial adventurers got themselves into diffi-culties and were surrounded by 'murdering native hordes', they shook hands with each other, sang their national anthem, and resolutely faced their own imminent massacre.

The young men and women who served as agents of the European powers in huts and cabins and bungalows and villas from Surinam to Singapore were undeniably brave. They risked their health and their sanity, clustered in expatriot ghettos where only bridge or the piano could relieve the monotony of life. They wrote long letters home, and sent them with their own children back to Europe, back to the 'old country', back to family, friends and the old familiarity. Left alone, they drank, tried to cultivate European-style gardens, and died before their time – to be buried in some parched cemetery or a rough clearing in the thick vegetation, or at sea when only a few weeks away from home.

For all the fine sentiments, the real aim of colonization was, of course, financial gain. The world was sacked by Europe for its metals, rubber, coffee, tea, oil, lumber, gold and diamonds, fruit and fish. White hunters trekked with gun and camera into the bush of East Africa, or the foothills of the Himalayas, or the Argentinian pampas, returning with bales of horn and skins and plenty of tales to tell. Colonies produced vast wealth of many sorts, little of which found its way back to its land of origin. Labour was cheap, and untouched by the impertinent arguments of trade unions back home. So African and Burmese, Cuban and Maori toiled for their white masters, accepting harsh discipline, long hours and the lowest of wages. If they were lucky, they were invited to join the lower ranks of white society – as soldiers, porters, servants, gardeners. If they were unlucky, they were cast aside, with their traditional way of life destroyed. Edmond La Meslée described what was left of aborigine society in Australia when the white man had finished with it: 'Men and

women, barely covered in veritable rags and tatters of decomposing woollen blankets, wandered about the camp. In the shelter of the huts, half enveloped in an ancient rag some old hag gnawed away at a kangaroo bone... never had I seen such a degrading spectacle, and I would never have believed that there were human beings capable of living in such a state of nastiness and misery.' Small wonder, perhaps, that a couple of decades later such people would be shot for sport by offspring of the original white settlers.

Chancellor Bismarck of Germany offered a novel solution to the problem of Ireland, Britain's nearest and most troublesome colony. He suggested that the Dutch and the Irish should change places. The industrious Dutch would soon turn Ireland into a thriving country, and the Irish would fail to maintain the dykes, and so be rapidly swept away. The lives of the indigenous populations of the colonies were always held very cheap.

But there was another side. There were those European settlers who fell in love with new worlds and new peoples; who devoted their lives to protecting and preserving traditional ways of life; who brought comfort and understanding, alternative medicine and alternative knowledge; who admired and did not ravage; who cried out, as Florence Nightingale did for the people of India: 'Have we no voice for these voiceless millions?'

GEGEN Ende des 19. Jahrhunderts beherrschten die europäischen Mächte fast die Hälfte der Landmasse und die Hälfte der Weltbevölkerung. Aus Deutschland, Frankreich, Spanien, Großbritannien, Portugal, Belgien und den Niederlanden brachen Männer und Frauen in Dampfschiffen in die Kolonien auf, die sich von Neuguinea im Südpazifik bis nach Neufundland und St. Pierre et Miquelon im Nordatlantik erstreckten. Von den Ländern des afrikanischen Kontinents behielten nur Abessinien und Liberia ihre Unabhängigkeit. Der größte Teil des indischen Subkontinents stand unter britischer Herrschaft. Im Fernen Osten gehörten Laos, Kambodscha und Indochina zu Frankreich, und weite Teile Japans sowie das Kernland Chinas standen als Folge umfangreicher finanzieller Investitionen unter dem Einfluß, wenn nicht der Kontrolle Europas. Zwischen 1871 und 1914 wuchs das französische Reich um fast vier Millionen Quadratmeilen und 47 Millionen Menschen an, das Deutsche Reich um eine Million Quadratmeilen und 14 Millionen Menschen.

Die größte Kolonialmacht jedoch war Großbritannien. Im Jahre 1897, dem Jahr, in dem Königin Victoria ihr 60. Amtsjubiläum feierte, besaß Großbritannien das größte Reich in der Geschichte der Welt; kraftvoll, fruchtbar, hart arbeitend, geordnet und aus-gebeutet. Zur Feier des Jubiläums wurde in Hyderabad jeder zehnte Häftling freigelassen; eine Woche lang wurde kostenloses Essen an arme Familien in Jamaika verteilt. Für die Dauer von 24 Stunden konnte man mit der staatlichen Eisenbahn von Baroda umsonst reisen, es gab einen großen Ball in Rangoon, ein Abendessen im Palast des Sultans von Sansibar und eine Aufführung des Halleluja-Chors in Hongkong. Truppen aus Kanada, Südafrika, Australien, Indien, Nord-Borneo, Zypern und einem Dutzend anderer Staaten des Empire kamen nach London, um an den Jubiläumsfeierlichkeiten teilzunehmen. Die Berliner *Kreuz Zeitung* berichtete, das britische Empire sei »praktisch unbezwingbar«. Die *New York Times* zeigte etwas mehr Begeisterung und erklärte: »Wir sind Teil, und zwar ein großer Teil des britischen Empire, dem es so deutlich bestimmt zu sein scheint, den gesamten Planeten zu beherrschen.«

Europa brachte den in Dunkelheit lebenden Heiden und Wilden das Licht des Christentums und der Zivilisation. Drew Gay vom *Daily Telegraph* beschrieb die Hindus als »die schmutzigsten Menschen, die ich je sah«. »Das einzige Volk, das ein Recht auf Indien besitzt, sind die Briten«, schrieb ein aufgebrachter Korrespondent. »Die sogenannten Inder haben nicht das geringste Recht.« H. M. Stanley, der Mann, der Dr. Livingstone »entdeckte«, schrieb, der Kongo sei »eine mörderische Welt, und wir spüren zum ersten Mal, daß wir die schmutzigen, vulgären Ghule hassen, die sie bewohnen«. Der Photograph John Thomson beschrieb die Chinesen als »aufsässige, verseuchte und dreckige Subjekte«. Weniger brutal war das Urteil von Mary Fitzgibbon, der Frau eines Ingenieurs, die zu dem Schluß kam, die Bewohner Islands seien »gelehrige Diener, sauber und umsichtig, aber ohne die nötige körperliche Konstitution für harte Arbeit«.

Keine Rasse, so schien es, konnte sich mit der europäischen messen, wenn es um Genialität, harte Arbeit, Ehrlichkeit, Erfindungsreichtum und Mut ging. Wenn Abenteurer des Empire in Schwierigkeiten gerieten und von »blutrünstigen Eingeborenenhorden« umzingelt waren, gaben sie einander die Hand, sangen ihre Nationalhymne und sahen entschlossen ihrem eigenen Tod ins Auge.

Die jungen Männer und Frauen, die als Vertreter der europäischen Mächte von Surinam bis Singapur in Hütten, Bungalows und Villen lebten, waren zweifelsohne tapfere Menschen. Sie setzten ihre körperliche und geistige Gesundheit aufs Spiel und lebten zusammengedrängt in Ghettos fernab der Heimat, wo nur Bridge und Klavierspiel eine Abwechslung zur Monotonie des Lebens boten. Sie schrieben lange Briefe nach Hause und schickten sie zusammen mit den eigenen Kindern nach Europa, zurück in das alte Land, zurück

zu Familie, Freunden und den alten, vertrauten Verhältnissen. Alleingelassen verfielen sie dem Alkohol, versuchten, europäische Gärten anzulegen und starben früh, um auf einem verdorrten Friedhof, einer Lichtung in der üppigen Vegetation oder nur wenige Wochen von der Heimat entfernt auf See beigesetzt zu werden.

Aber trotz all der beschönigenden Worte war das wirkliche Ziel der Kolonisation natürlich finanzielle Bereicherung. Die Welt wurde von den Europäern wegen ihrer Metalle, wegen Kautschuk, Kaffee, Tee, Öl, Holz, Gold und Diamanten, Früchten und Fisch regelrecht geplündert. Weiße Jäger zogen, mit Flinte und Kamera bewaffnet, in den ostafrikanischen Busch, in die Ausläufer des Himalaja oder in die argentinischen Pampas und kehrten mit Bündeln von Hörnern, Häuten und vielen abenteuerlichen Geschichten zurück. Die Kolonien produzierten große Reichtümer aller Art, von denen nur wenige den Weg zurück in ihr Ursprungsland fanden. Arbeitskräfte waren billig und unbeeinflußt von den »unverschämten« Forderungen der heimischen Gewerkschaften. So plagten sich Afrikaner und Burmesen, Kubaner und Maori für ihre weißen Herren, sie akzeptierten strenge Disziplin, lange Arbeitszeiten und niedrigste Löhne. Wenn sie Glück hatten, wurden sie als Soldaten, Pförtner, Diener oder Gärtner in die niedrigeren Ränge der weißen Gesellschaft aufgenommen. Wenn sie aber Pech hatten, wurden sie fallengelassen und fanden ihre traditionellen Lebensformen zerstört. Edmond La Meslée beschrieb, was von der Gesellschaft der australischen Ureinwohner übrigblieb, als der weiße Mann mit ihr fertig war: »Männer und Frauen, nur spärlich bekleidet mit regelrechten Lumpen und Fetzen aus zerfressenen Wolldecken, zogen durch das Lager. Im Schutz der Hütten nagte ein altes Weib, halb eingehüllt in einen alten Teppich, an einem Känguruhknochen … ich habe niemals ein solch erniedrigendes Schauspiel gesehen, und ich hätte niemals geglaubt, daß es Menschen gibt, die es ertragen, in solch abscheulichen und elenden Verhältnissen zu leben.« So verwundert es wohl kaum, daß sich ein paar Jahrzehnte später die Nachkommen der ersten weißen Siedler einen Sport daraus machten, diese Menschen abzuschießen.

Der deutsche Reichskanzler Bismarck schlug eine neuartige Lösung für das Problem Irland, Großbritanniens nächstgelegene und schwierigste Kolonie, vor. Er regte an, die Holländer und die Iren sollten ihre Plätze tauschen. Die fleißigen Holländer würden Irland schnell zu einem aufstrebenden Land machen, und weil die Iren es wohl kaum schaffen würden, die Deiche instandzuhalten, würden sie bald fortgespült werden. Das Leben der einheimischen Bevölkerung der Kolonien galt zu keiner Zeit viel.

Aber es gab auch eine andere Seite. Es gab jene Europäer, die sich in die neue Welt und ihre Menschen verliebten, die ihr Leben dem Schutz und der Bewahrung der traditionellen Lebensformen widmeten, die Trost und Verständnis aufbrachten, alternative Medizin und alternatives Wissen vermittelten, die bewunderten, statt zu plündern, und ihre Stimme erhoben, wie es Florence Nightingale für das indische Volk tat: »Haben wir keine Stimme für diese stummen Millionen?«

DÈS la fin du XIXᵉ siècle, les puissances européennes détenaient sous leur autorité directe près de la moitié de la masse terrestre du globe et la moitié de sa population. Partant d'Allemagne, de France, d'Espagne, de Grande-Bretagne, du Portugal, de Belgique et des Pays-Bas, des bateaux à vapeur emportaient à leur bord des milliers de jeunes gens et de jeunes femmes vers les colonies qui s'étendaient de la Nouvelle-Guinée dans le sud du Pacifique jusqu'à Terre-Neuve et Saint-Pierre-et-Miquelon dans le nord de l'Atlantique. Sur le continent africain, seuls l'Abyssinie et le Liberia conservèrent leur indépendance. La plus grande partie du sous-continent indien se trouvait sous la domination britannique. En Extrême-Orient, le Laos, le Cambodge et l'Indochine appartenaient à la France, tandis qu'une grande partie du Japon et de la Chine continentale se retrouvait sous l'influence européenne, pour ne pas parler de surveillance, à la suite de très gros investissements financiers. Entre 1871 et 1914, l'empire français avait gagné près de 4 millions de kilomètres carrés et 47 millions d'habitants, et l'empire allemand 1 million de kilomètres carrés et 14 millions d'habitants.

La Grande-Bretagne était cependant la plus grande puissance impériale. En 1897, l'année du soixantième anniversaire de la reine Victoria, elle possédait le plus vaste empire de l'Histoire : vigoureux, fertile, travaillant dur, dirigé et exploité. À l'occasion de cet anniversaire, on libéra un condamné sur dix à Hyderabad et on distribua l'équivalent d'une semaine de nourriture à toutes les familles pauvres de la Jamaïque. On put circuler gratuitement 24 heures durant dans les trains publics de la ville de Baroda ; on organisa un grand bal à Rangoon, un dîner dans le palais du sultan à Zanzibar et une représentation du Hallelujah Chorus à Hong Kong. Des troupes débarquèrent du Canada, d'Afrique du Sud, d'Australie, d'Inde, du Bornéo septentrional, de Chypre ainsi que d'une dizaine d'autres États sujets pour prendre part au défilé du cortège d'anniversaire à Londres. Le *Kreuz Zeitung* à Berlin écrivit que l'empire britannique était « pratiquement inattaquable ». Le *New York Times* se montra un peu plus enthousiaste : « Nous

sommes une partie, et une grande, de la plus grande Bretagne qui semble destinée si naturellement à dominer cette planète. »

L'Europe apportait la lumière de la chrétienté et de la civilisation au sein des forces obscures, païennes et sauvages. Drew Gay du *Daily Telegraph* disait des Hindous qu'ils étaient « les hommes les plus mal lavés qu'il m'ait été donné de voir ». « Les seuls à posséder un droit sur l'Inde sont les Britanniques », écrivait un correspondant maltraité, « les *prétendus* Indiens n'ont absolument aucun droit ». H. M. Stanley, l'homme qui « découvrit » le Dr Livingstone, consignait dans son journal que le Congo était « un monde de meurtriers, et pour la première fois nous ressentons de la haine envers les démons sales et les charognards qui le peuplent ». Le photographe John Thomson qualifiait les Chinois « d'objets révoltants, souffreteux et sales ». Mary Fitzgibbon, l'épouse d'un ingénieur, en concluait avec moins de brutalité que les natifs Islandais étaient des « serviteurs éducables, ordonnés, propres et soigneux mais que leur constitution physique rend inaptes aux durs travaux ».

Aucune race, semblait-il, n'égalait les Européens pour ce qui était de l'ingéniosité, du labeur, de l'honnêteté, de l'inventivité et du cran. Lorsque les aventuriers impériaux étaient encerclés par des « hordes indigènes sanguinaires », ils se serraient la main entre eux, entonnaient leur hymne national et affrontaient résolument leur propre massacre.

Les jeunes gens et jeunes femmes qui servaient les puissances européennes en vivant dans des cabanes, des bungalows ou des villas du Surinam à Singapour étaient sans conteste courageux. Regroupés avec leurs compatriotes dans des ghettos, avec le bridge et le piano pour toute distraction, ils risquaient leur santé physique et mentale. Ils écrivaient de longues lettres qu'ils expédiaient avec les enfants en Europe, « au pays », dans leur famille, chez les amis et vers tout ce qu'ils avaient laissé là-bas. Restés seuls, ils buvaient, essayaient de cultiver des jardins à l'européenne et mouraient prématurément ; on les inhumait dans quelque cimetière desséché ou vague clairière creusée dans l'épaisse végétation, ou bien en mer, parfois quelques semaines seulement avant qu'ils ne rentrent dans leurs foyers.

Quoi qu'en dît Ruskin en évoquant la « lumière » et la « paix », le véritable but de la colonisation était bien entendu le gain financier. Le monde était pillé par l'Europe pour ses métaux, son caoutchouc, son café, son thé, son huile, son bois d'œuvre, son or et ses diamants, ses fruits et ses poissons. Les chasseurs blancs armés de fusils et d'appareils photographiques progressaient péniblement dans la brousse de l'Afrique de l'Est, au pied de l'Himalaya ou dans la pampa argentine et en revenaient chargés de ballots de cornes, de peaux et pleins d'histoires. Les colonies produisaient toutes sortes de richesses, mais peu d'entre elles profitaient à leur pays d'origine. La main-d'œuvre bon marché n'avait pas été pervertie par les arguments oiseux des syndicats. Aussi les Africains et les Birmans, les Cubains et les Maoris s'échinaient-ils pour leurs maîtres blancs, acceptant la dure discipline, les longues heures de travail et les salaires de misère. S'ils avaient de la chance ils étaient invités à rejoindre les rangs inférieurs de la société blanche comme soldats, porteurs, serviteurs et jardiniers. Sinon on s'en défaisait après avoir détruit leur mode de vie traditionnel. Edmond La Meslée décrivit ce qui restait de la société des Aborigènes d'Australie une fois que le Blanc en eut fini avec elle : « Des hommes et des femmes que couvraient à peine de véritables lambeaux de couvertures en laine tombant en loques erraient à travers le camp. À l'abri des cabanes et à moitié enveloppée dans son antique guenille, une vieille sorcière mâchonnait obstinément un os de kangourou … Jamais je n'avais assisté à un spectacle aussi dégradant ni n'aurais cru possible que des êtres humains puissent vivre dans un tel état de saleté et de misère. » Il ne faut donc peut-être pas s'étonner si, une vingtaine d'années plus tard, la progéniture des premiers colons blancs leur tirait dessus pour la beauté du sport.

Le chancelier allemand Bismarck suggéra une nouvelle solution au problème de l'Irlande, la plus proche et la plus remuante des colonies de la Grande-Bretagne. Il proposa que les Néerlandais et les Irlandais permutassent. Les Néerlandais industrieux ne tarderaient pas à rendre l'Irlande prospère, et les Irlandais à se noyer faute d'entretenir les digues. Les vies des populations indigènes des colonies étaient toujours tenues pour négligeables.

Mais il y eut des colons européens qui tombèrent amoureux des nouveaux mondes et des nouveaux peuples, qui consacrèrent leurs vies à protéger et à préserver les modes de vie traditionnels, qui réconfortaient et comprenaient, qui délivraient une autre médecine et un autre enseignement, qui admiraient sans dévaster, qui, comme le fit Florence Nightingale en faveur du peuple indien, criaient : « N'aurons-nous pas de voix pour ces millions de sans-voix ? »

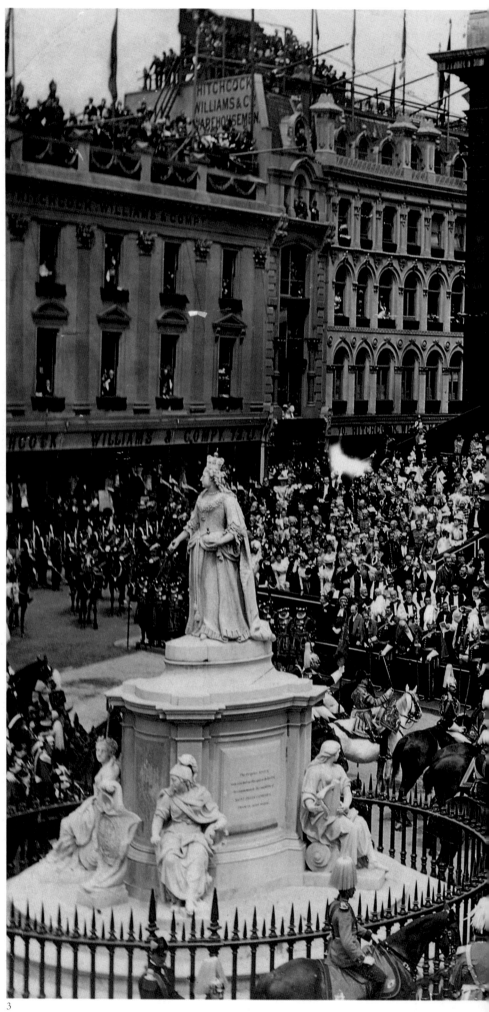

THE greatest moment in the history of the British Empire was the Diamond Jubilee of Queen Victoria on 22 June 1897. Her message to the world was:' Thank my beloved people. May God bless them.' Colonial troops, and admirers (1); members of the Australian contingent (2); the procession (3); crowds and soldiers (overleaf).

DER größte Augenblick in der Geschichte des britischen Empire war das 60jährige Amtsjubiläum von Königin Victoria am 22. Juni 1897. Ihre Botschaft an die ganze Welt lautete: »Danke, mein geliebtes Volk. Gott möge euch schützen.« Kolonialtruppen und Bewunderer (1), Angehörige der australischen Truppen (2), der Festzug (3), das Volk und Soldaten (folgende Seiten).

LE plus grand moment de l'histoire de l'empire britannique fut l'anniversaire des 60 ans de la reine Victoria, le 22 juin 1897. Son message au monde était simple : « Merci à mon peuple bien-aimé. Que Dieu le bénisse. » Les troupes coloniales et leurs admirateurs à Londres (1), les militaires du contingent australien (2), la foule et les soldats alignés sur le trajet du cortège (3, et pages suivantes).

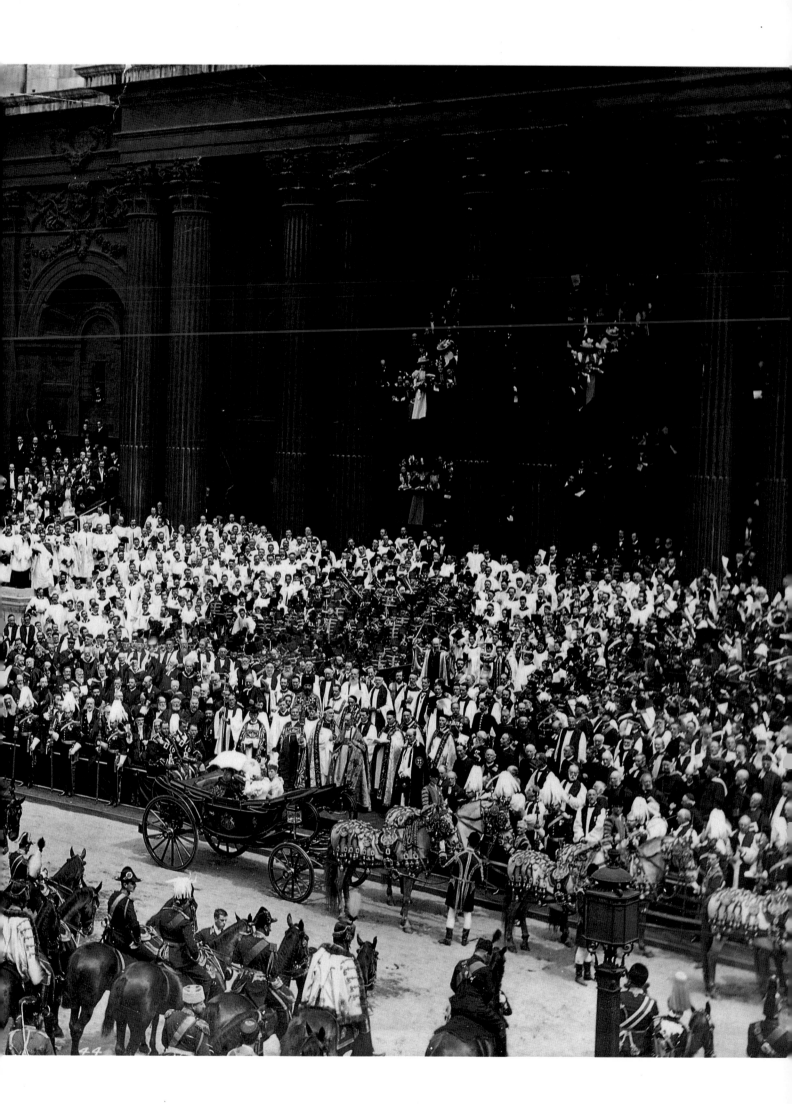

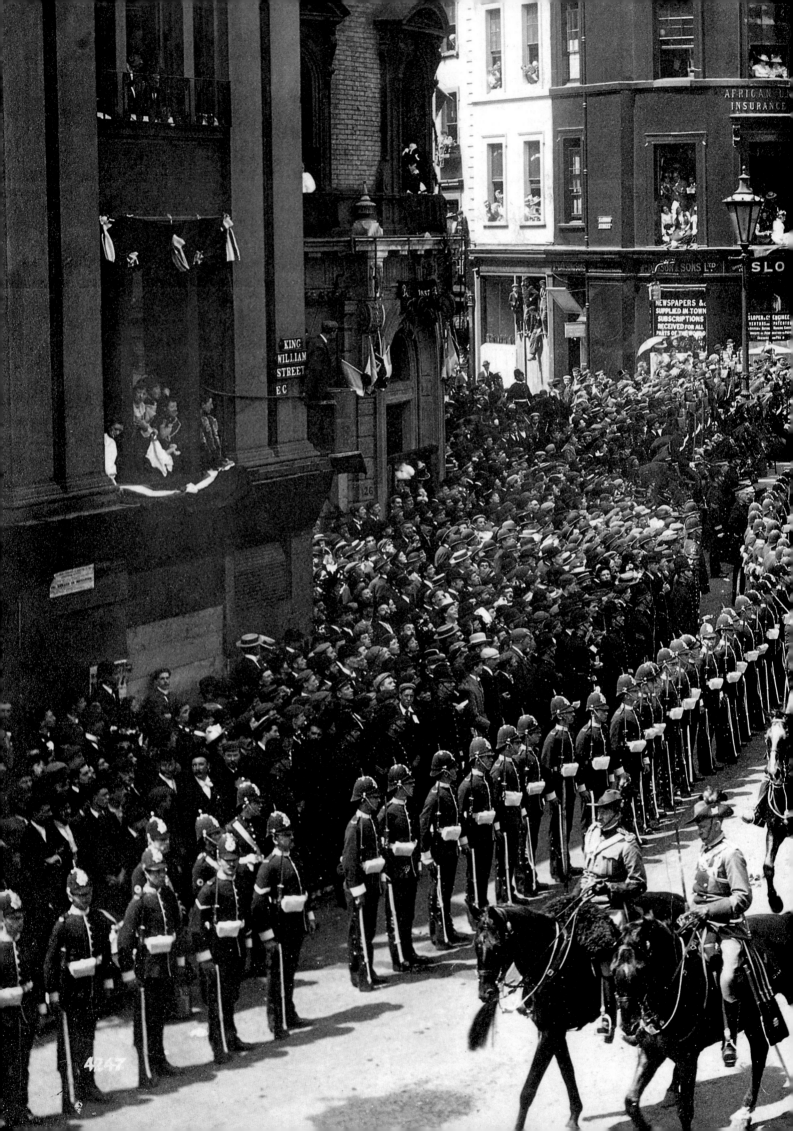

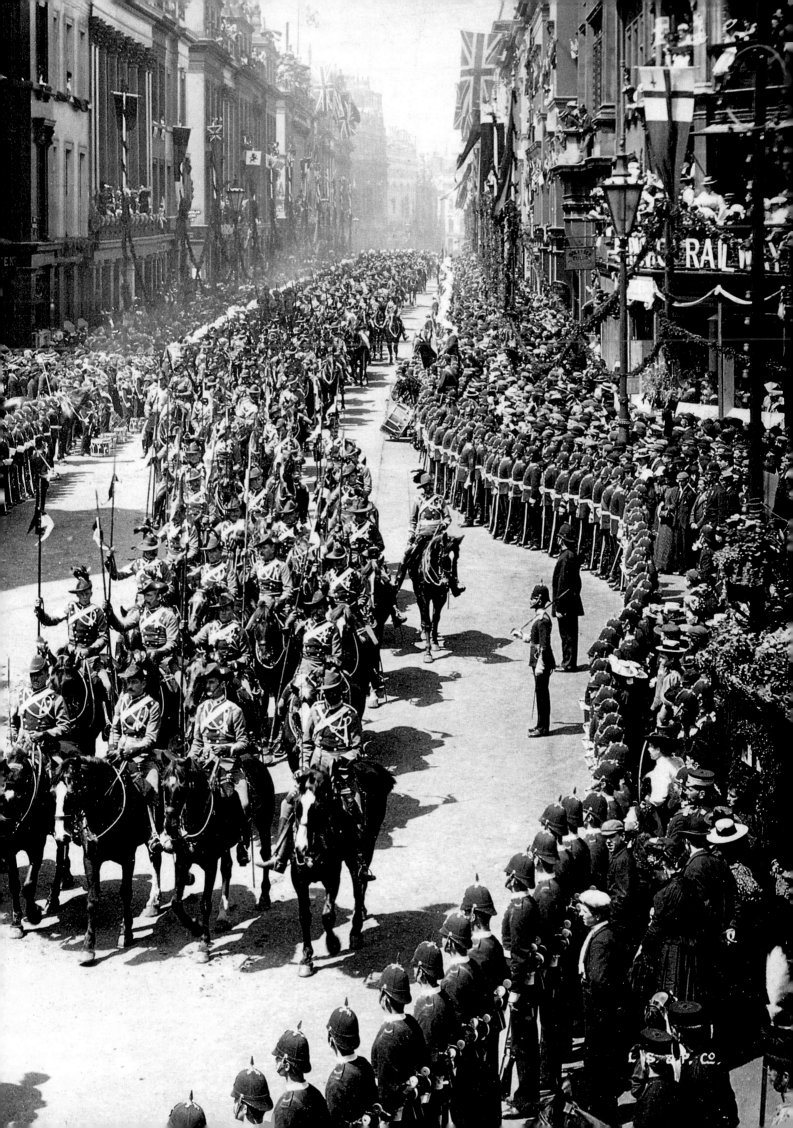

THE Coronation of Edward VII had originally been scheduled for 26 June 1902, but the new King was ill, so arrangements were postponed, and the Coronation feast was given away to the poor – though the caviare and quail were put on ice. The Coronation took place on 9 August (2). 'When the King entered the Abbey, the huge congregation watched anxiously to see if he would falter because of his recent illness. But the King – I learned later that he had been laced into a metal girdle – walked confidently to the throne' (Dorothy Brett, an eyewitness).

Nine years later, the streets of London were once again decorated when Edward's son was crowned George V (3). The King's diary recorded: 'The service in the Abbey was most beautiful, but it was a terrible ordeal…Worked all the afternoon answering telegrams and letters, of which I have had hundreds … May and I showed ourselves again to the people. Bed at 11.45. Rather tired.' He wasn't the only one (1).

Die Krönung von Edward VII. war ursprünglich für den 26. Juni 1902 vorgesehen, aber der neue König war krank, so daß die Feierlichkeiten verschoben werden mußten. Das Festmahl wurde an die Armen verteilt, Kaviar und Wachteln jedoch auf Eis gelegt. Die Krönung fand schließlich am 9. August des Jahres statt (2). »Als der König die Abtei betrat, waren die versammelten Gäste besorgt, daß er wegen seiner Krankheit ins Stocken geraten könnte. Aber der König trug, wie ich später erfuhr, ein metallenes Korsett und schritt zuversichtlich zum

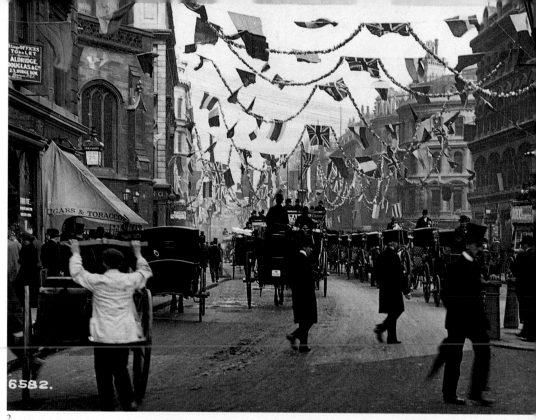

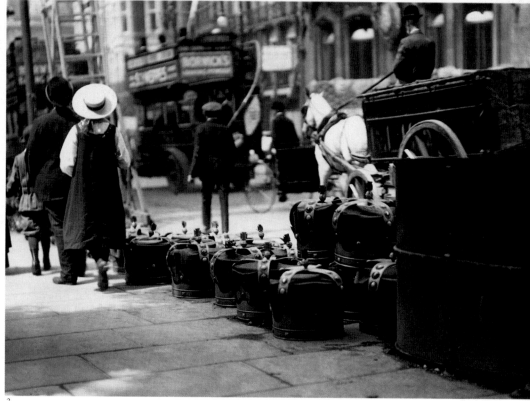

Thron.« (Dorothy Brett, eine Augenzeugin)

Neun Jahre später waren die Straßen von London anläßlich der Krönung von Edwards Sohn, George V., erneut geschmückt (3). Der König schrieb in sein Tagebuch: »Der Gottesdienst in der Abtei war wundervoll, aber es war eine fürchterliche Tortur … Habe den ganzen Nachmittag gearbeitet und Hunderte von Telegrammen und Briefen beantwortet … May und ich zeigten uns noch einmal dem Volk. Zu Bett um 23.45 Uhr. Ziemlich müde.« Er war nicht der einzige (1).

LE couronnement d'Édouard VII devait à l'origine avoir lieu le 26 juin 1902. Il fut différé en raison de la maladie du nouveau roi, et le festin prévu fut distribué aux pauvres, à l'exception du caviar et des cailles qui furent rangés en attendant des jours meilleurs. Le couronnement eut lieu le 9 août (2). « Lorsque le roi pénétra dans l'Abbaye, toute l'assemblée le suivit d'un regard anxieux craignant de le voir trébucher après sa récente maladie. Mais le roi, je devais par la suite apprendre qu'il avait été enserré dans un corset en métal, marcha d'un pas assuré jusqu'au trône. » (Dorothy Brett, témoin oculaire)

Neuf ans plus tard, les rues de Londres furent à nouveau décorées à l'occasion du couronnement de George V, fils d'Édouard (3). Le roi note dans son journal : « Le service à l'Abbaye était magnifique, mais quelle épreuve … Me suis employé toute l'après-midi à répondre aux télégrammes et aux lettres que j'avais reçus par centaines … May et moi nous sommes de nouveau montrés au peuple. Couché à 23 h 45. Plutôt fatigué. » Il n'était pas le seul (1).

IN the 1880s, Lord Salisbury, the Prime Minister, said of Africa, 'British policy is to drift lazily downstream, occasionally putting out a boathook.' Also drifting lazily downstream were the crocodiles and hippopotamuses hunted by white settlers and incautious visitors alike (1). T. E. Todd (2) photographed them on his visit in 1879.

PREMIERMINISTER Lord Salisbury sagte in den 1880er Jahren über Afrika: »Britische Politik bedeutet, gemächlich flußabwärts zu gleiten und von Zeit zu Zeit einen Bootshaken auszuwerfen.« Ebenso gemächlich glitten die Krokodile und Nilpferde flußabwärts, die von weißen Siedlern und waghalsigen Touristen gejagt wurden (1). T. E. Todd (2) photographierte sie bei seinem Besuch im Jahre 1879.

DANS les années 1880, le Premier ministre Lord Salisbury disait en parlant de l'Afrique : « La politique britannique consiste à se laisser aller paresseusement au fil du courant en se servant de temps à autre de la gaffe. » Se laissaient aussi paresseusement aller au fil du courant les crocodiles et les hippopotames pourchassés par les colons blancs et les visiteurs imprudents (1). T. E. Todd (2) les a photographiés pendant sa visite en 1879.

TODD returned several times to Africa, taking a unique series of photographs. It may appear artificially staged, but this photograph (1) is probably genuine. One of the native bearers or porters attached to the hunting party has climbed a pole to scan the landscape for game. Sadly, the picture of the hunter with a dead rhinoceros (2) is certainly not staged. No tally was ever kept in those days of the number of animals in any species that were left alive – all that mattered was the trophy count.

TODD reiste mehrere Male nach Afrika und machte einzigartige Aufnahmen. Diese Photographie (1) mag gestellt wirken, ist aber vermutlich natürlich. Einer der eingeborenen Träger der Jagdgesellschaft ist an einem Stab hinaufgeklettert, um nach Wild Ausschau zu halten. Leider ist das Bild des Jägers mit dem toten Rhinozeros (2) mit Sicherheit nicht gestellt. Niemand zählte in jenen Tagen die Tiere all der verschiedenen Arten, die am Leben gelassen wurden; worauf es ankam, war einzig die Zahl der Trophäen.

TODD retourna plusieurs fois en Afrique où il prit une série unique de photographies. Même si la photographie semble mise en scène ici, tel n'a probablement pas été le cas (1). L'un des porteurs indigènes de la partie de chasse s'est perché tout en haut d'un poteau pour scruter le paysage à la recherche du gibier. Malheureusement la photographie montrant un chasseur à côté d'un rhinocéros mort (2) n'est, elle, certainement pas une mise en scène. On ne faisait jamais à l'époque le compte des animaux laissés en vie, quelle qu'en soit l'espèce. Seul comptait le nombre des trophées.

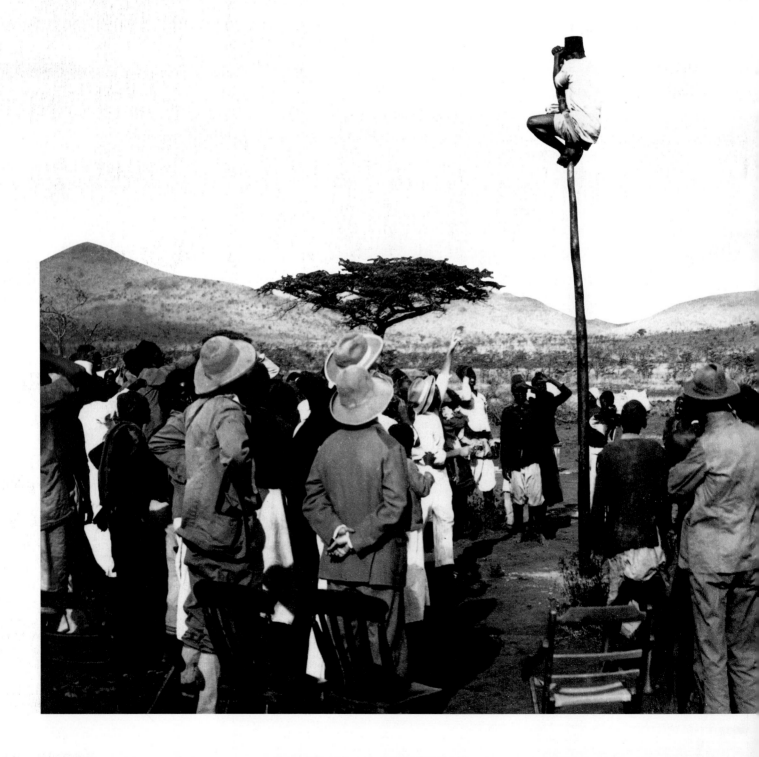

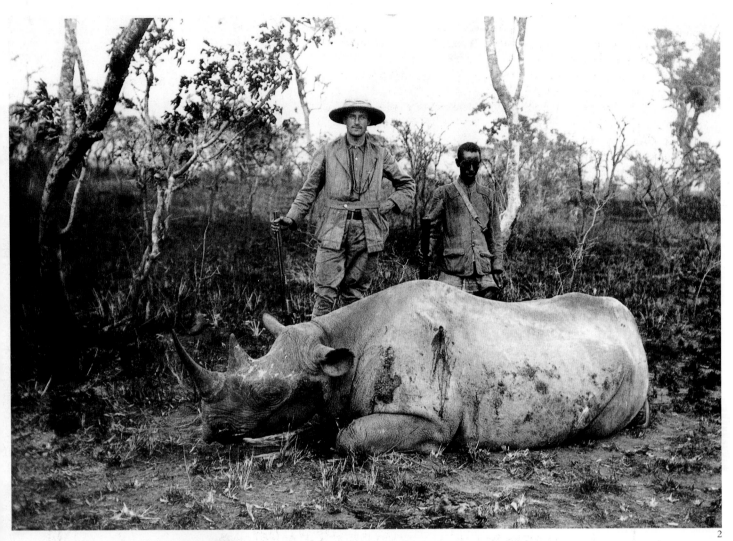

THREE times during the British Raj in India the notables of that vast sub-continent were summoned to Delhi, for an Imperial Durbar, or 'court'. The grandest was the last, in 1911, to celebrate the accession of George V. The King was most impressed: 'The weather was all that could be wished, hot sun, hardly any wind, no clouds… I wore a new crown made for India which cost £60,000 which the Indian Government is going to pay for…' The ceremonies lasted three and a half hours. 'Rather tired,' wrote the King at the end of the day, 'after wearing the crown… it hurt my head, as it is pretty heavy.'

DREIMAL während der britischen Oberherrschaft in Indien wurden die bedeutenden Persönlichkeiten dieses großen Subkontinents zu einem Durbar oder »Hof« des Empires nach Delhi zitiert. Der prächtigste war auch der letzte und fand im Jahre 1911 anläßlich der Thron-besteigung von George V. statt. Der König zeigte sich sehr beeindruckt: »Das Wetter hätte nicht besser sein können, heiße Sonne und kaum Wind, keine Wolken … Ich trug eine neue, für Indien angefertigte Krone im Wert von £ 60 000, die die indische Regierung zahlen wird…« Die Zeremonie dauerte dreieinhalb Stunden. »Ziemlich müde«, schrieb der König am Ende des Tages, »vom Tragen der Krone … sie drückte auf meinen Kopf, denn sie ist sehr schwer.«

TROIS fois pendant tout le temps que s'exerça la souveraineté britannique sur l'Inde, les notables de ce vaste sous-continent furent sommés de se rendre à Delhi pour assister à la réception offerte par l'empire britannique. La dernière, qui célébrait l'accession au trône de George V en 1911, fut la plus grandiose. Le roi était impressionné : « Le beau temps était au rendez-vous : soleil chaud, vent quasiment inexistant, aucun nuage … Je portais une nouvelle couronne faite exprès pour l'Inde et qui avait coûté £ 60 000 que le gouver-nement indien payera … » Les cérémonies durèrent trois heures et demie. Le roi nota à la fin de cette journée : « Plutôt fatigué d'avoir porté la couronne … elle m'a donné mal à la tête, tant elle était lourde. »

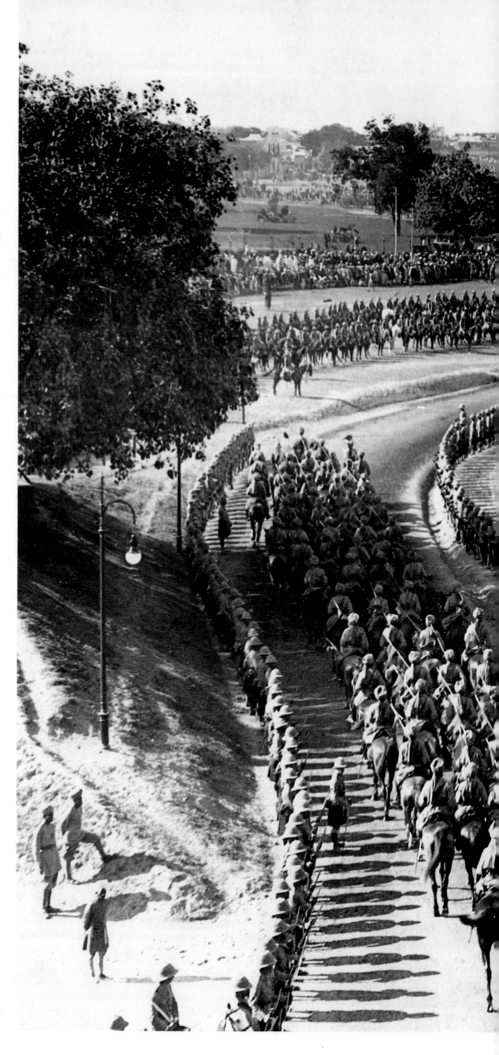

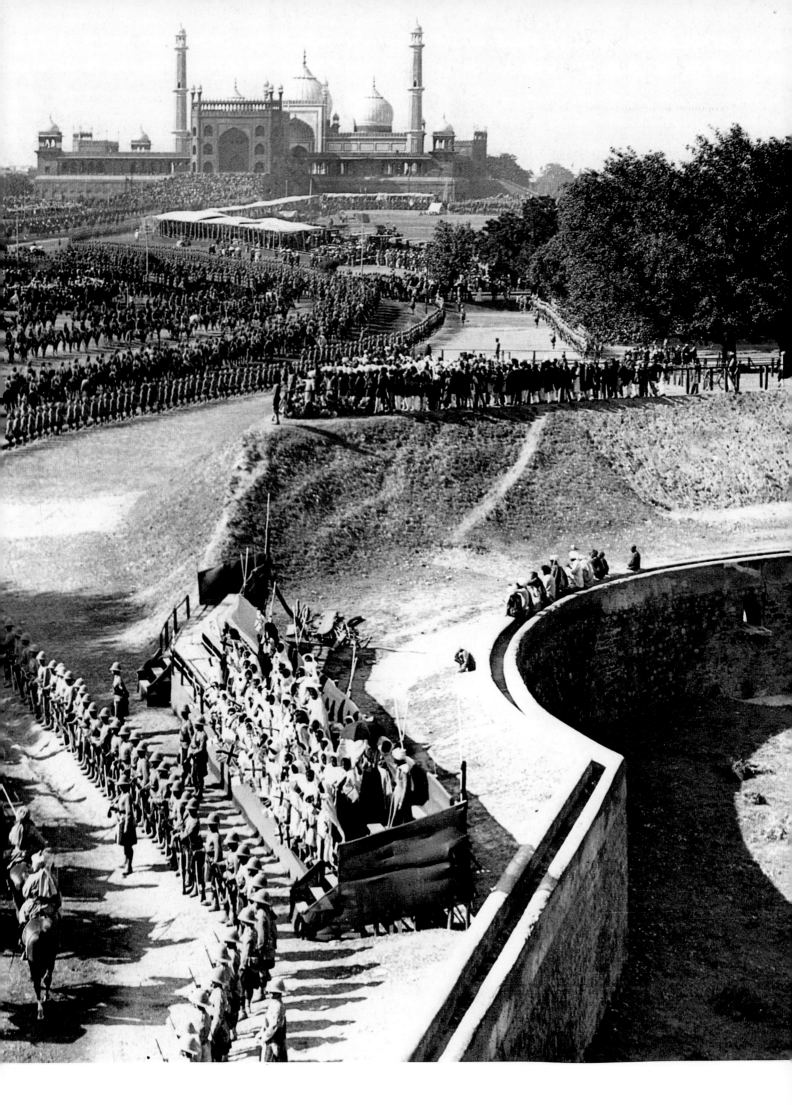

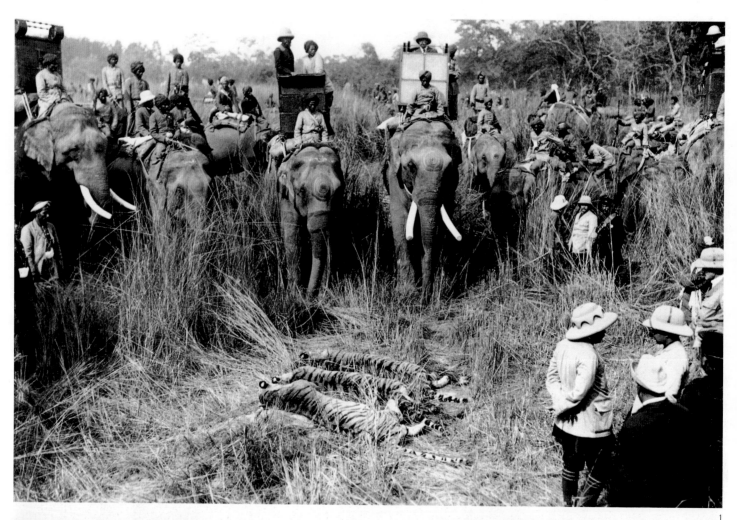

1

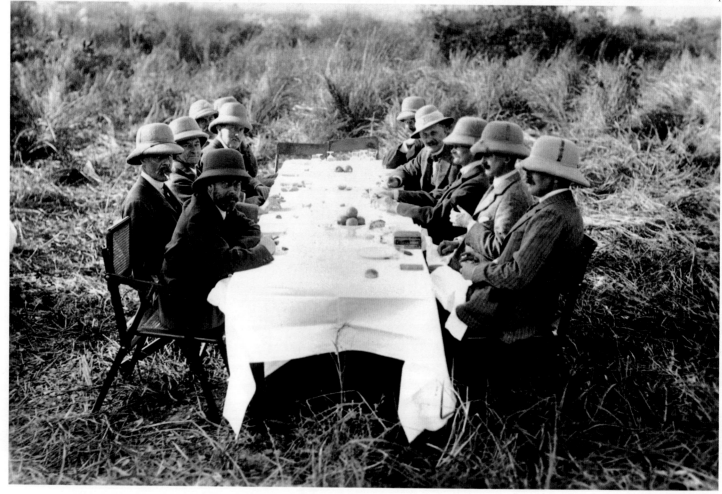

2

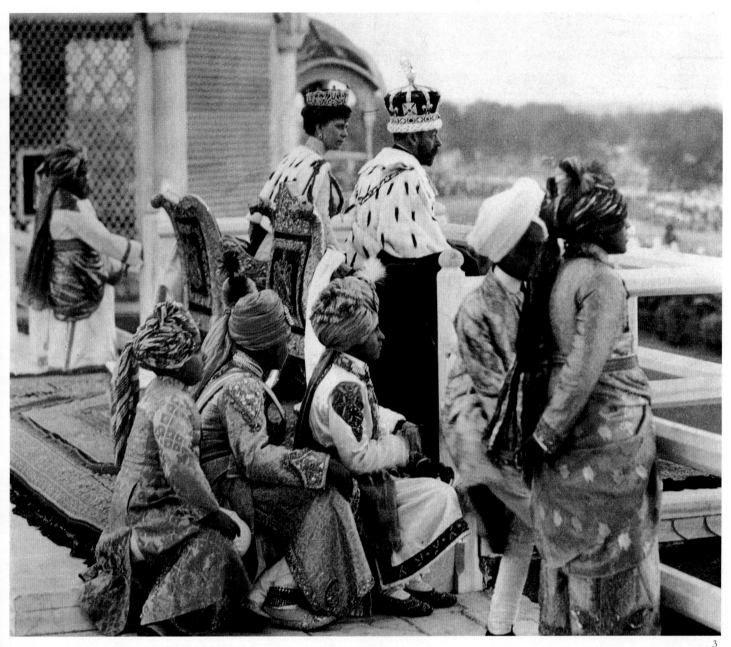

DURING the Durbar celebrations the
itinerary included the customary tiger
hunt (1) – the wholesale and much
vaunted slaughter of what was then
considered a ferocious predator rather than,
as now, an endangered species. Less violent
was the picnic that refreshed the men of
the royal party (2) – George V is nearest
the camera, on the left of the table. At the
Durbar itself, King George and Queen
Mary were attended by a clutch of young
Indian princes (3).

WÄHREND der Durbar-Feiern fand
auch die traditionelle Tigerjagd (1)
statt, das vielgepriesene Abschlachten eines
Tieres, das man damals als bösartiges
Raubtier sah, und nicht, wie heute, als
Vertreter einer gefährdeten Spezies.
Weniger gewaltsam war das Picknick zur
Erfrischung der königlichen Gesellschaft
(2). George V. sitzt vorne links am Tisch.
Beim Durbar selbst warteten King George
und Queen Mary junge indische Prinzen
auf (3).

LE programme des festivités prévoyait
l'inévitable chasse au tigre (1), massacre
en série tant exalté de ce que l'époque
considérait être un prédateur féroce et non,
comme aujourd'hui, une espèce menacée.
Dans un registre moins violent, voici le
pique-nique au cours duquel se restaurèrent
les hommes de la suite royale (2). George V
est le plus proche de nous, à gauche. Au
cours de la réception même, le roi George
et la reine Marie bénéficiaient des soins
attentifs d'un essaim de jeunes princes
indiens (3).

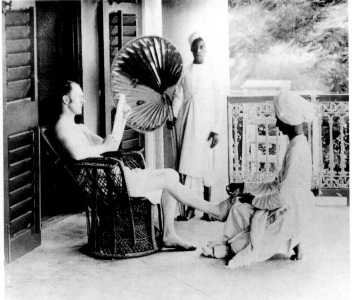

WHEREVER the British went, they took with them their love of the ideal English garden, even though someone else had to tend it. In India (1), the climate lacked the gentle co-operation of European weather, but rhododendrons and azaleas flourished almost as weeds in the northern provinces. The British also imported many plants to India, among them quinine, rubber and eucalyptus, the scent of whose leaves was thought to prevent malaria.

It took 17 days for a letter to reach India from England, so news from home was precious (2), if a little out of date – a moment of sentimental reflection while one's feet were tended to in the cool of the veranda.

WO immer es die Briten hinzog, brachten sie ihre Vorliebe für den idealen Englischen Garten mit, auch wenn jemand anders ihn pflegen mußte. In Indien (1) war das Klima nicht so mild wie in Europa, aber Rhododendron und Azaleen vermehrten sich in den nördlichen Provinzen beinahe wie Unkraut. Die Briten importierten auch viele Pflanzen nach Indien, darunter Chinin, Kautschuk und Eukalyptus, dessen Blätter mit ihrem Duft angeblich die Malaria verhindern sollten.

Ein Brief von England nach Indien brauchte siebzehn Tage, und Nachrichten aus der Heimat waren kostbar (2), wenn auch ein wenig veraltet. Das Lesen eines Briefes war meist ein Moment sentimentaler Erinnerungen, während man sich auf der kühlen Veranda die Füße pflegen ließ.

PARTOUT où ils se rendaient, les Britanniques emportaient avec eux leur amour du jardin anglais idéal, même si c'était à quelqu'un d'autre de s'en occuper. En Inde (1), le climat ne se montrait pas aussi coopératif qu'en Europe, et pourtant les rhododendrons et les azalées y fleurissaient telle la mauvaise herbe dans les provinces du Nord. Les Britanniques importèrent aussi de nombreuses plantes, dont le quinquina, le caoutchouc et l'eucalyptus, parce qu'on croyait que le parfum de leurs feuilles écartait le paludisme.

Une lettre expédiée d'Angleterre mettait dix-sept jours pour parvenir en Inde. C'est dire si les nouvelles étaient précieuses (2), même si elles dataient un peu. Un moment de rêverie sentimentale pendant qu'on s'occupe de vos pieds dans la fraîcheur de la véranda.

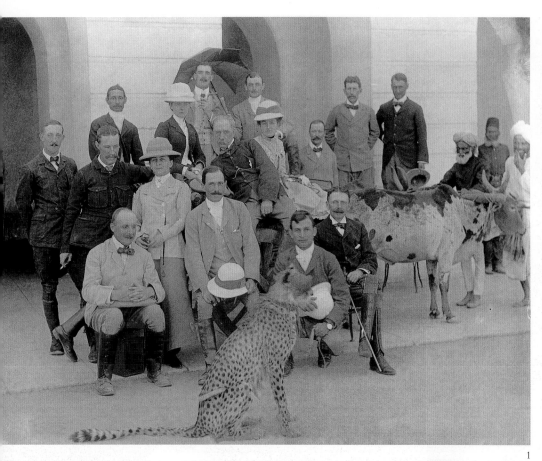

1

2

Colonial conversation was frustratingly limited. Social life was restrictive – a round of dances and amateur theatricals, of race meetings and tennis parties. The group photographed with a pet leopard in 1906 in Secunderabad, a provincial town a few miles north of Hyderabad, look typically bored (1). The trophies on wall and floor (2) indicate that almost any beast was considered fair prey. When all else failed, the British turned to pig-sticking, hare hunting, and arranging fights between captured jackals and their own dogs. The tennis party in honour of Major and Mrs Beale (3) was a much tamer affair.

3

IN den Kolonien gab es nur wenig
Gesprächsstoff. Das gesellschaftliche
Leben beschränkte sich auf Tanztees und
Laientheater, Pferderennen und Tennis-
matches. Die Gruppe, die 1906 mit einem
zahmen Leoparden in Secunderabad,
einer Provinzstadt nördlich von Hydera-
bad, photographiert wurde, sieht
entsprechend gelangweilt aus (1). Die
Trophäen an den Wänden und auf dem
Boden (2) weisen darauf hin, daß man
fast jedes Tier als lohnenswerte Beute
betrachtete. Wenn alles nichts mehr half,
vertrieben sich die Briten die Zeit mit

Wildschweinjagden, Windhundrennen
und Kämpfen zwischen gefangenen
Schakalen und eigenen Hunden. Das
Tennisspiel zu Ehren von Major und
Mrs. Beale (3) war eine weitaus zahmere
Angelegenheit.

LES conversations coloniales étaient
d'une pauvreté désolante. La vie sociale
n'était pas sans contrainte ; il y avait quel-
ques bals, des spectacles donnés par des
théâtres d'amateurs, des réunions de courses
et des parties de tennis. Le groupe photo-
graphié ici avec un léopard apprivoisé en

1906 à Secunderabad, ville provinciale
située à quelques kilomètres au nord
d'Hyderabad, affiche un ennui caractéris-
tique (1). Les trophées disposés aux murs
et sur le sol (2) indiquent que presque tout
animal était considéré comme une proie
légitime. Au pis aller, les Britanniques
se tournaient vers la chasse au sanglier à
l'épieu, chassaient le lièvre ou organisaient
des combats entre les chacals capturés et
leurs propres chiens. La partie de tennis
donnée en l'honneur du lieutenant-colonel
Beale et de son épouse (3) était bien plus
anodine.

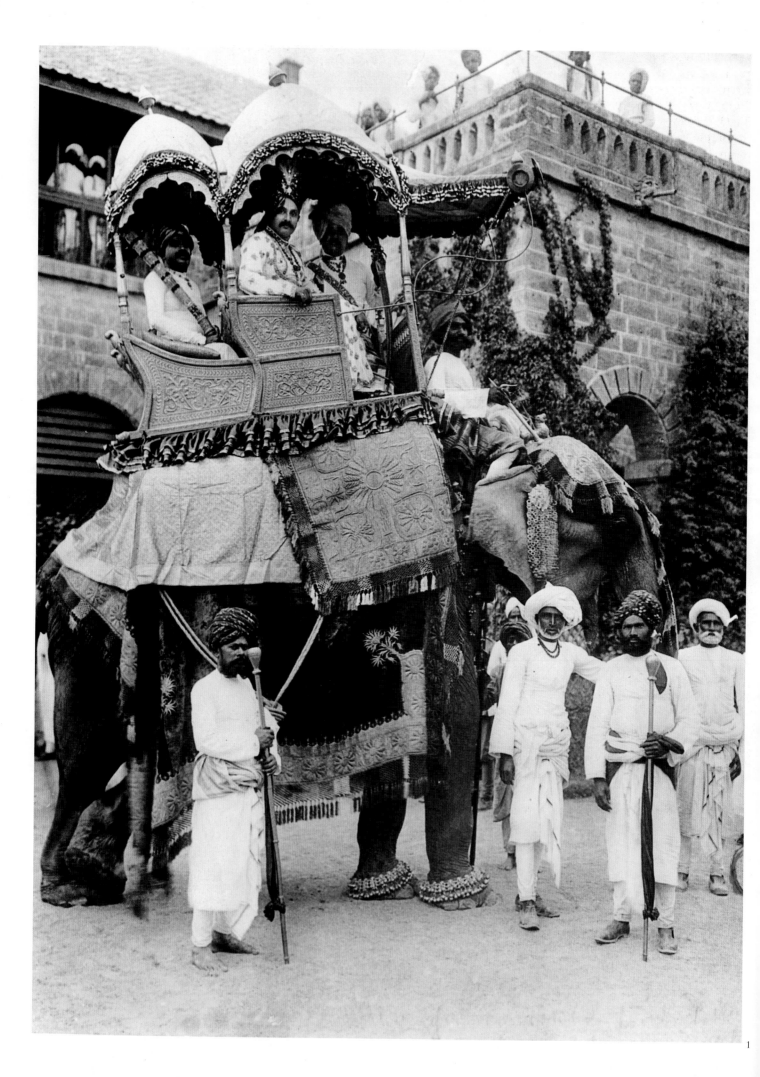

1

THERE were over 600 states in India ruled, not directly by the British, but by princes, nabobs, and maharajahs (1). These rulers had submitted peacefully to the Raj (3), rather than making the mistake of choosing to fight. Though their power was cramped, they were 'radiant with jewels… on their turbans and their very shoes, glistened diamonds, emeralds, rubies and pearls.' The Maharajah Holkar of Indore was indeed weighed down with wealth when photographed in 1887 (5), as was the Maharajah of Sahaha in 1916 (2). The Maharajah of Jodhpur (4) may have appeared more warlike, but lived co-operatively enough under British administration.

IN Indien gab es über 600 Staaten, die nicht direkt von den Briten, sondern von Prinzen, Nabobs und Maharadschas (1) regiert wurden. Dies waren die Herrscher, die sich ohne Widerstand der britischen Oberherrschaft (3) unterworfen hatten, statt den Fehler zu begehen, sich gegen sie aufzulehnen. Ihre Macht wurde eingeschränkt, aber sie blieben »geschmückt mit Juwelen … an ihren Turbanen und selbst an ihren Schuhen, überall funkelten Diamanten, Smaragde, Rubinen und Perlen«. Der Maharadscha Holkar von Indore war wirklich mit Schmuck behangen, als er 1887 photographiert wurde (5), ebenso wie der Maharadscha von Sahaha im Jahre 1916 (2). Der Maharadscha von Jodhpur (4) mag zwar kriegerisch ausgesehen haben, aber auch er kooperierte mit der britischen Administration.

L'INDE comptait plus de six cents états gouvernés par des princes, des nababs et des maharajahs (1). Ces dirigeants-là avaient préféré se soumettre paisiblement à la souveraineté britannique et ses particularités (3) que commettre l'erreur de se battre. Même si leurs pouvoirs étaient limités par les règles de l'administration britannique, c'étaient des hommes très riches, « radieux et portant des pierres précieuses … autour du cou, sur la poitrine, le turban et même les chaussures ; partout étincelaient les diamants, les émeraudes, les rubis et les perles. » Le maharajah Holkar d'Indore pliait littéralement sous le poids de sa fortune au moment où a été prise cette photographie en 1877 (5), de même que le maharajah de Sahaha à son vingt-cinquième anniversaire en 1916 (2). Le maharajah de Jodhpur (4) avait peut-être l'air plus combattif, mais il n'en coopéra pas moins avec l'administration britannique.

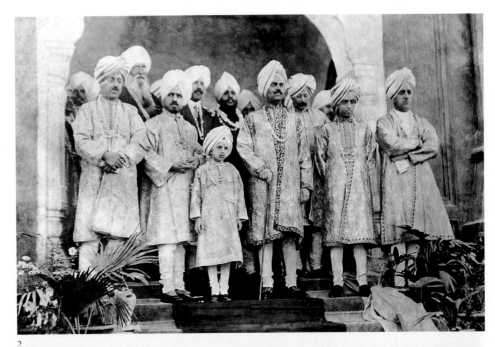

2

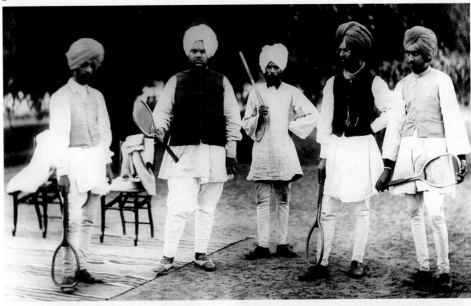

3

4

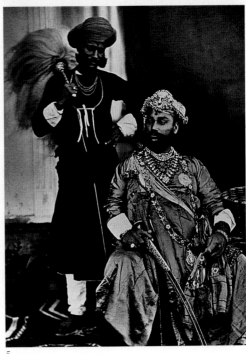

5

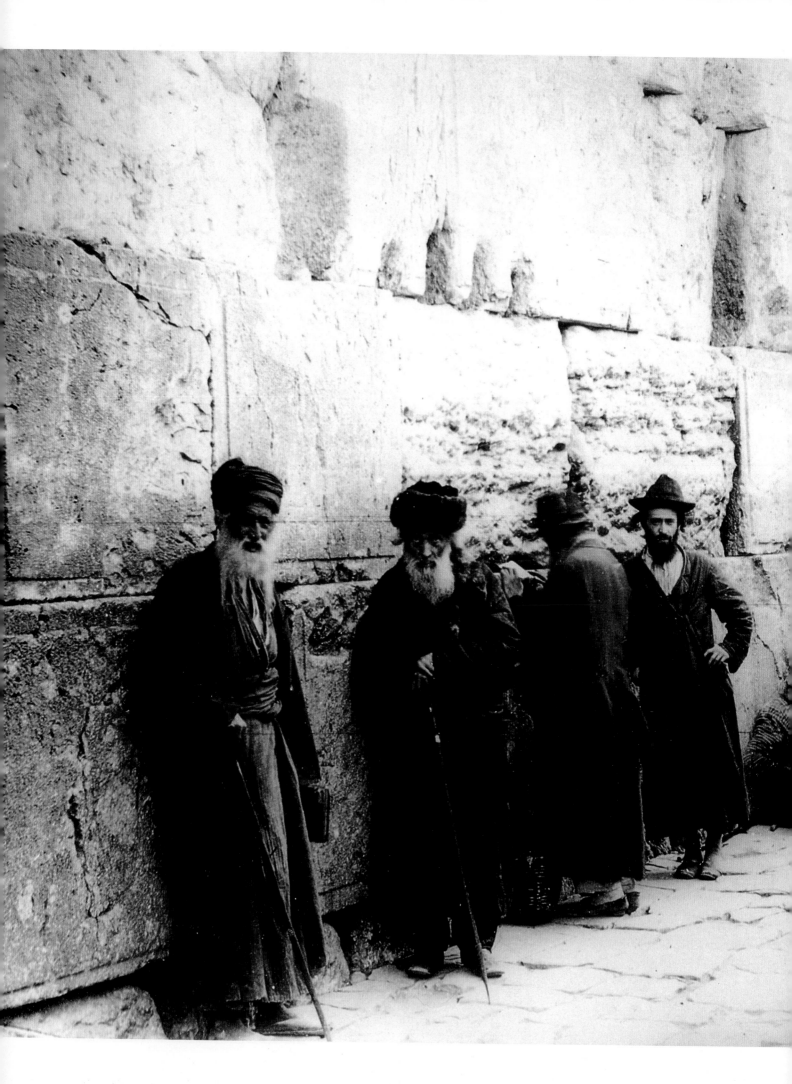

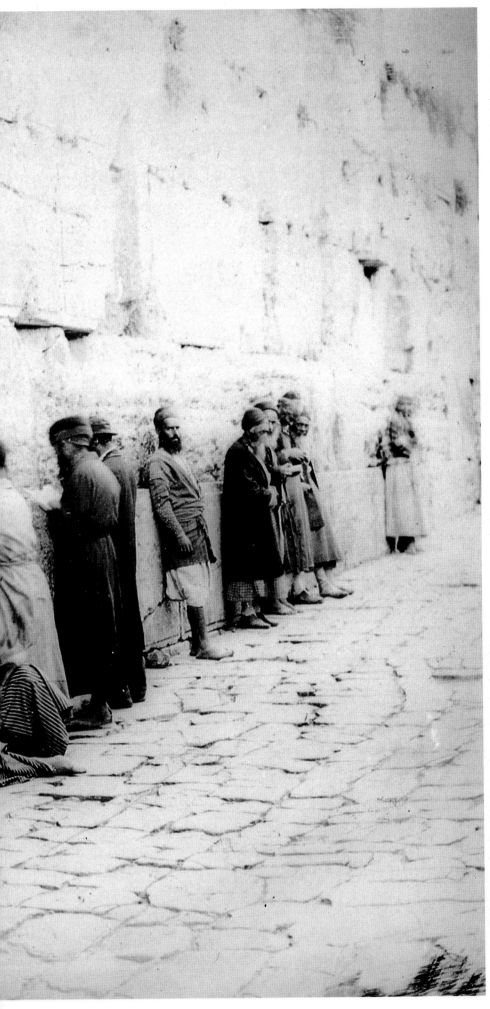

SLOWLY and cautiously, religious toleration was creeping across the world. No one could see evil in a group of old men leaning against a wall, as in the case of these elderly Jews at the Wailing Wall in Jerusalem. Protestants and Catholics began to allow each other the right to hold high office, to become members of government, to gain important posts in military and civil service. Christians and Jews began to trust each other. Hindus and Moslems lived in comparative peace in India.

Perhaps a reason for all this was that new enemies of religion and faith had emerged: Darwinism, free-thinking, Marxism. In industrial societies, churchgoing decreased dramatically.

ALLMÄHLICH und behutsam setzte sich religiöse Toleranz in der Welt durch. Niemand konnte etwas Böses in einer Gruppe alter Männer sehen, die sich an eine Mauer lehen, wie in dieser Aufnahme älterer Juden an der Klagemauer in Jerusalem. Protestanten und Katholiken begannen, einander das Recht zu gewähren, hohe Ämter zu bekleiden, Mitglieder der Regierung zu werden und wichtige Positionen im militärischen und öffentlichen Dienst zu bekleiden. Christen und Juden vertrauten sich allmählich, und in Indien lebten Hindus und Moslems relativ friedlich zusammen.

Der Grund für all diese Entwicklungen lag auch darin, daß neue Feinde der Religion und des Glaubens aufgetaucht waren: Darwinismus, Freidenkertum und Marxismus. In den Industrieländern gingen immer weniger Menschen zum Gottesdienst.

LENTEMENT et précautionneusement, la tolérance religieuse se répandait à travers le monde. Il faut être bien fou pour voir le mal dans un groupe de vieillards appuyés contre un mur, tels ces vieux juifs près du mur des Lamentations à Jérusalem. Les protestants et les catholiques se mettaient à s'accorder réciproquement le droit d'occuper des fonctions élevées, d'obtenir des portefeuilles, d'accéder à des postes importants dans la fonction militaire ou civile. Les chrétiens et les juifs commençaient à se faire confiance. En Inde, les hindous et les musulmans vivaient relativement en paix.

Une des raisons en était peut-être que des nouveaux ennemis de la religion et de la foi avaient surgi : le darwinisme, la libre pensée et le marxisme. Dans les sociétés industrielles, la fréquentation des églises diminuait de façon dramatique.

WISDOM and holiness were still almost synonymous with old age. The camera respectfully recorded a Samaritan High Priest, displaying the Pentateuch Roll said to have been written by Eleazar (1); three aged Jews reflecting beneath a fig tree (2); and a Georgian Jew wearing a phylactery on his forehead (3).

WEISHEIT und Heiligkeit waren noch immer nahezu gleichbedeutend mit hohem Alter. Respektvoll nahm die Kamera einen Samariter-Priester auf, der die angeblich von Eleazar verfaßte Pentateuch-Rolle hält (1); drei alte Juden in Andacht unter einem Feigenbaum (2) und ein georgischer Jude mit einem Phylakterion auf der Stirn (3).

LA sagesse et la sainteté demeuraient synonymes, ou presque, de grand âge. L'appareil photographique a respectueusement pris un haut dignitaire samaritain présentant le rouleau du pentateuque supposé avoir été écrit par Eléazar (1) ; trois juifs âgés réfléchissent sous un figuier (2) ; ici un juif géorgien portant un phylactère sur le front (3).

1

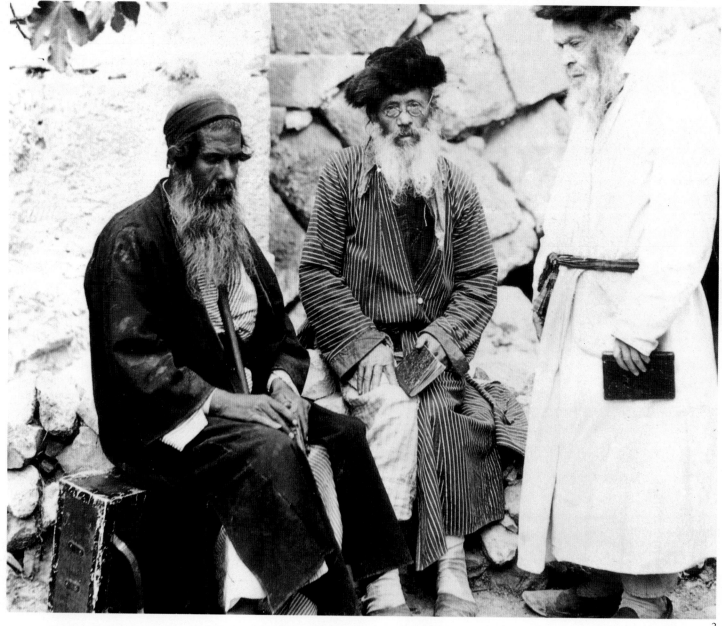

2

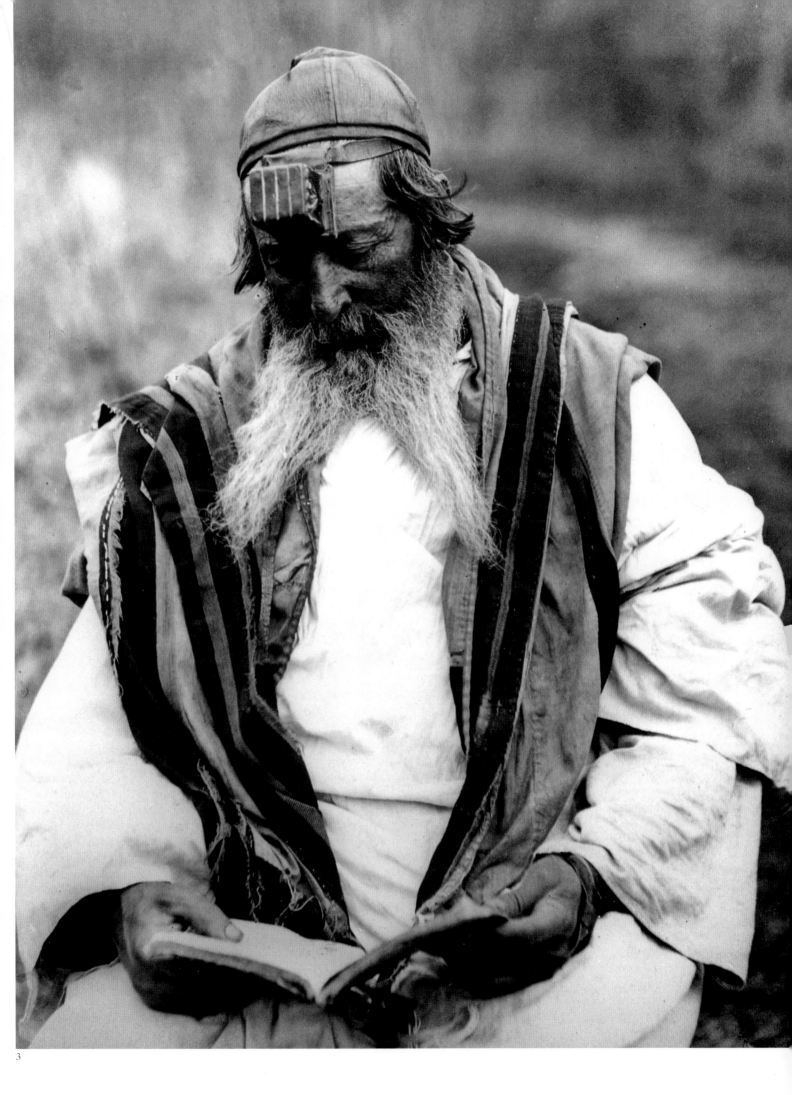

3

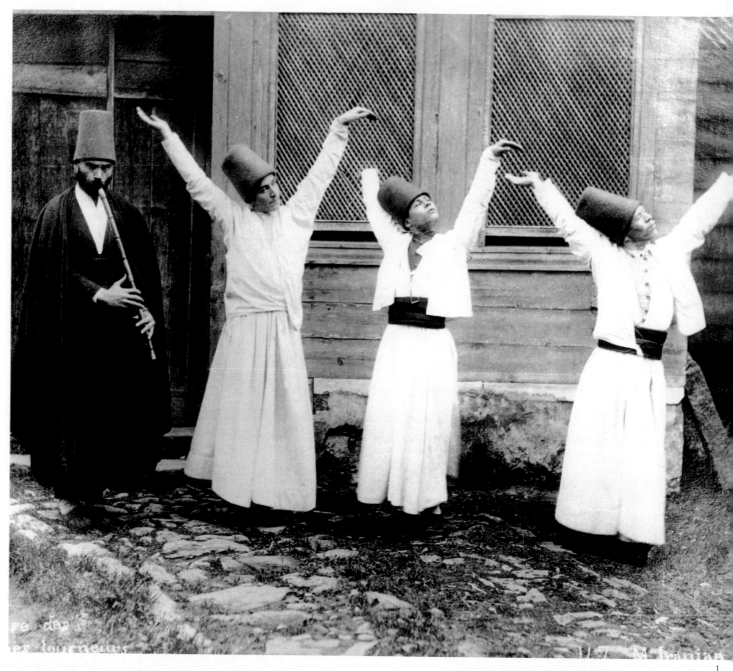

MARK Twain was impressed by the whirling Dervishes he came across in Constantinople in 1869. To induce a trance-like state, 'they spun on the left foot, and kept themselves going by passing the right rapidly before it and digging it against the floor. Most of them spun around 40 times in a minute, and one averaged about 61 times to the minute, and kept it up for 25 minutes... They made no noise of any kind, and most of them tilted their heads back and closed their eyes, entranced with a sort of devotional ecstasy... Sick persons came and lay down... and the patriarch walked upon their bodies. He was supposed to cure their diseases by trampling upon their breasts or backs or standing on the backs of their necks.'

MARK Twain zeigte sich beeindruckt von den wirbelnden Derwischen, die er 1869 in Konstantinopel sah. Um einen tranceartigen Zustand zu erreichen, »drehten sie sich auf dem linken Fuß, wobei sie sich schnell mit dem rechten Fuß abstießen. Die meisten von ihnen drehten sich vierzigmal in der Minute, und einer brachte es für die Dauer von fast einer halben Stunde sogar auf 61 Umdrehungen pro Minute ... Sie machten keinerlei Geräusche, und die meisten warfen ihre Köpfe zurück, schlossen die Augen und brachten sich in einen Zustand hinge-bungsvoller Ekstase ... Kranke Menschen kamen und legten sich auf den Boden ... und der Älteste der Derwische ging über ihre Körper. Er sollte sie von ihren Krankheiten heilen, indem er ihnen auf die Brust oder auf den Rücken sprang oder sich auf ihren Nacken stellte.«

MARK Twain fut impressionné par les derviches tourneurs qu'il découvrit à Constantinople en 1869. « Ils induisaient leur état de transe en pivotant rapidement sur leur pied gauche, et pour conserver leur élan donnaient de petits coups rapides sur le sol en faisant passer leur pied droit devant celui de gauche. La plupart d'entre eux faisaient 40 tours à la minute, tandis que l'un d'entre eux tournait en moyenne 61 fois dans la minute et cela pendant 25 minutes ... Ils ne faisaient absolument aucun bruit, la plupart renversaient la tête en arrière et fermaient les yeux en pleine transe de dévotion et d'extase ... Les malades venaient s'allonger ... et le patriarche des derviches leur marchait sur le corps. Il était censé soigner leurs maladies en leur piétinant la poitrine, le dos ou encore en se tenant debout sur leur nuque. »

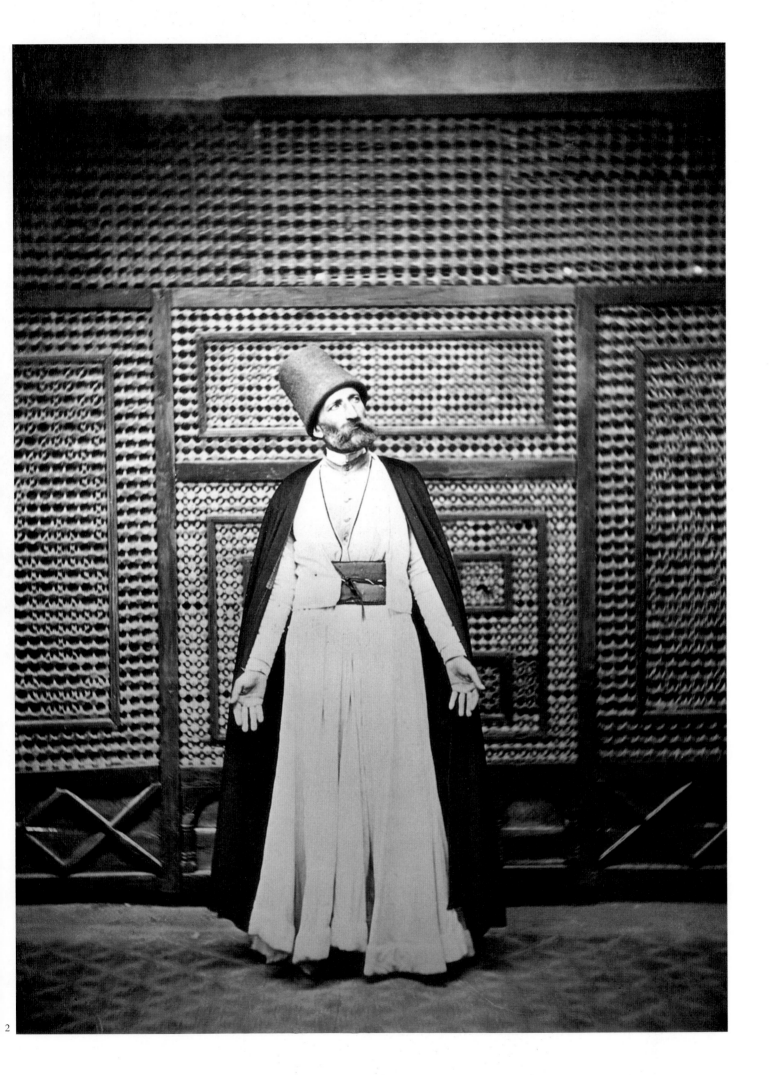

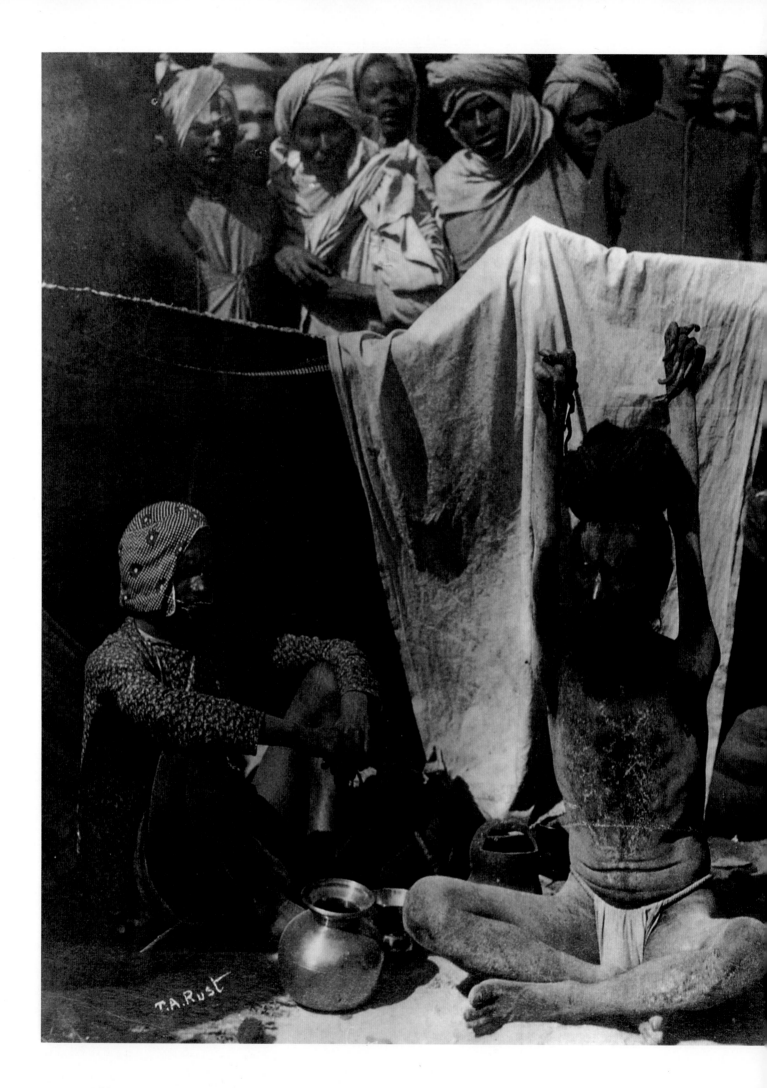

THE wandering mendicants known as fakirs were to be found all over India. They were common to many religions, practising several forms of self-mortification – lying on beds of nails, walking over hot coals. Fakirs took vows of poverty, and poverty originally meant 'need of God'. The origin of the word *fakir* comes from a saying of Muhammad: 'al-faqr-fakhri', meaning 'poverty is my pride'.

DIE als Fakire bekannten wandernden Bettelmönche der verschiedensten Religionen konnte man in ganz Indien antreffen. Sie praktizierten viele Formen der Selbstkasteiung, legten sich auf Nagelbetten oder liefen über glühende Kohlen. Fakire legten Armuts-gelübde ab, denn Armut bedeutete ursprünglich »Notwendigkeit Gottes«. Das Wort *Fakir* entstammt einem Ausspruch Mohammeds: »al-faqr-fakhri«, was soviel heißt wie »Armut ist mein Stolz«.

LES mendiants itinérants connus sous le nom de fakirs étaient répandus à travers toute l'Inde. Ils étaient communs à de nombreuses religions et pratiquaient diverses formes de mortification : s'étendre sur des lits de clous ou marcher sur des braises incandescentes. Les fakirs faisaient vœu de pauvreté, laquelle signifie à l'origine « besoin de Dieu ». Le mot *fakir* vient d'une parole de Mahomet : « Al-faqr-fakhri » qui signifie « la pauvreté est ma fierté ».

1

As the enquiring Europeans toured the world, they found cultures and ceremonies which had remained unchanged for centuries. In Ceylon, Buddhist monks and worshippers gathered at Anoy for the exposition of the Buddha's tooth (1). In China, elaborate paper horses were constructed when someone died (2). The horse was then burnt at the funeral, to provide a safe journey for the deceased's spirit to the next world. In Japan, Kamu-So Buddhist priests placed baskets over their heads while playing sacred music on their bamboo flutes (3).

Als die forschenden Europäer die Welt bereisten, fanden sie Kulturen und Rituale vor, die seit Jahrhunderten unverändert waren. In Anoy auf Ceylon versammelten sich buddhistische Mönche und Gläubige, um den Zahn des Buddha zu sehen (1). Wenn in China jemand starb, baute man kunstvolle Papierpferde (2), die bei der Beerdigung verbrannt wurden, um dem Geist des Toten eine sichere Reise in die nächste Welt zu ermöglichen. In Japan stülpten sich buddhistische Kamu-So-Priester Körbe über den Kopf und spielten auf ihren Bambusflöten heilige Lieder (3).

2

Au cours de leur quête à travers le monde, les Européens découvraient des cultures et des cérémonies demeurées inchangées à travers les siècles. À Ceylan, les moines bouddhistes et les fidèles se réunissaient à Anoy pour voir exposée la dent du Bouddha (1). En Chine, on fabriquait avec le plus grand soin des chevaux en

3

papier lorsque quelqu'un mourait (2). Le cheval était ensuite brûlé
pendant les funérailles afin qu'il transportât à bon port l'âme du
défunt. Au Japon, les prêtres bouddhistes Kamu-So jouaient de la
musique sacrée avec une flûte en bambou (3) en portant un panier
renversé au-dessus de leur tête.

NEARER home, the Fratelli della Misericordia (1) were a radical spiritual branch of the Franciscan Order, originally strongly anti-clerical, and regarded by some as heretics. Like the nuns of Biarritz (2), they kept their faces well hidden from camera and public. The monks of St Bernard in Switzerland (3) were more outgoing – the pose here seems to suggest an early all-male version of *The Sound of Music*.

IN heimatlichen Gefilden gab es die Fratelli della Misericordia (1), ein radikaler spiritueller Zweig des Franziskanerordens, der ursprünglich äußerst antiklerikal war und von manchen als ketzerisch betrachtet wurde. Wie die Nonnen von Biarritz (2) verhüllten sie ihre Gesichter vor der Kamera und der Öffentlichkeit. Die Mönche von St. Bernhard (3) in der Schweiz waren der Welt mehr zugewandt; diese Pose hier erinnert an eine frühe, rein männliche Version von *Meine Lieder, meine Träume*.

PLUS proches de nous, les Fratelli (1) della Misericordia composaient une branche spirituelle radicale de l'ordre des franciscains et, en raison de leur origine fortement anticléricale, passaient aux yeux de certains pour des hérétiques. De même que les nonnes de Biarritz (2), ils tenaient soigneusement leurs visages à l'abri des appareils photographiques et du public. Les moines de Saint-Bernard, en Suisse (3), étaient plus extravertis. Leur pose évoque ici une version précoce et entièrement masculine de *The Sound of Music*.

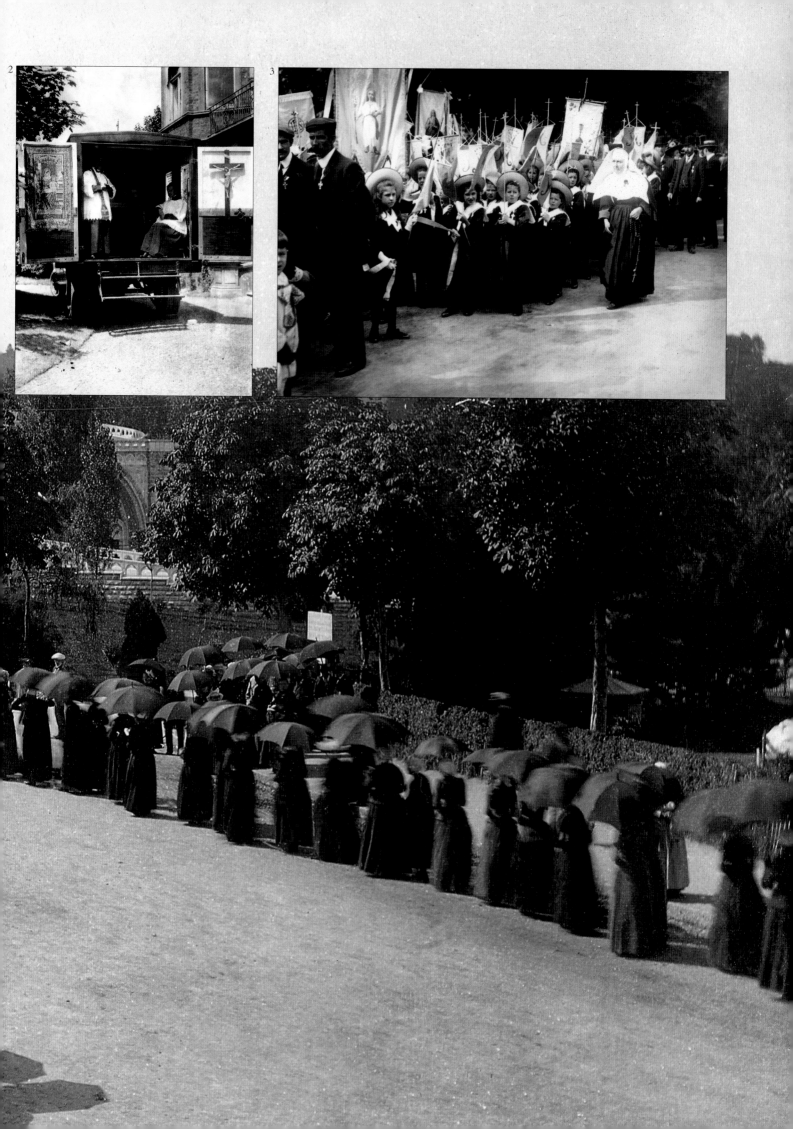

(Previous pages)

IN 1858 Bernadette Soubirous and her
sister reported their vision of the Virgin
Mary in a cave near Lourdes. Within a few
years it had become a major shrine and
Lourdes itself had become a pilgrim centre
(1). If the people didn't come to God,
however, in 1911 the Motor Mission Van
brought God to the people (2). But the
Catholic Church still had a firm hold on
the souls of many in Europe, and a
religious procession (3) was sure to bring
out the crowds.

(Vorherige Seiten)

IM Jahre 1858 berichteten Bernadette
Soubirous und ihre Schwester, in einer
Grotte in der Nähe von Lourdes sei ihnen
die Jungfrau Maria erschienen. Innerhalb
weniger Jahre war die Grotte zum Schrein
und Lourdes zu einem Wallfahrtsort
geworden (1). Wenn die Menschen im
Jahre 1911 jedoch nicht zu Gott kamen,
brachte der Missionswagen Gott zu den
Menschen (2). Aber die katholische Kirche
hatte noch immer großen Einfluß auf
das Seelenleben vieler Europäer, und eine
religiöse Prozession (3) lockte die
Menschen in Scharen auf die Straße.

(Pages précédentes)

EN 1858, Bernadette Soubirous et sa
sœur racontèrent avoir eu une vision
de la Vierge Marie dans une grotte de
Lourdes. En l'espace de quelques années,
celle-ci et la ville de Lourdes elle-même
devinrent un haut lieu de pélerinage (1). Si
les gens n'allaient pas à Dieu, en 1911 la
mission motorisée le leur amenait dans un
fourgon (2). Du reste l'Église catholique
conservait une solide emprise sur de nom-
breuses âmes en Europe, et toute proces-
sion religieuse (3) était assurée d'attirer du
monde.

2

THE Christian Church came under
increasing criticism: 'The poor man is
made to feel that he is a poor man, the rich
is reminded that he is rich, in the great
majority of our churches and chapels,'
wrote one correspondent in 1849. But
most Europeans (and many others) still
wanted the Church to baptize their
newborn, and expected to be given a
Christian funeral at the end of their lives.
And the Church still had a virtual
monopoly of the right to join couples in
holy matrimony, even if some marriages
were conducted in strange places. In 1914,
this floating barge in Berlin (1) was not
only a church, it also provided a room and
all essentials for the wedding breakfast (2).

DIE christliche Kirche wurde immer
heftiger kritisiert. »In den meisten
unserer Kirchen und Kapellen sorgt man
dafür, daß der arme Mann sich auch fühlt
wie ein armer Mann, und der Reiche wird
daran erinnert, daß er reich ist«, schrieb ein
Korrespondent im Jahre 1849. Aber die
meisten Europäer (und viele andere)
wollten von der Kirche noch immer ihre
Kinder taufen lassen und erwarteten am
Ende ihres Lebens eine christliche Beerdi-
gung. Zudem besaß die Kirche mehr oder
weniger das Monopol, junge Paare im
heiligen Stand der Ehe zu vereinen, auch
wenn manche Hochzeiten an seltsamen
Orten stattfanden. Dieses Berliner Haus-
boot (1) diente im Jahre 1914 nicht nur als
Kirche, sondern auch als Gasthaus für die
Hochzeitsfeier (2).

L'ÉGLISE chrétienne était de plus en
plus critiquée : « On fait sentir au
pauvre sa pauvreté et on rappelle au riche
sa richesse dans la très grande majorité de
nos églises et de nos chapelles », écrivait
un correspondant en 1849. Cependant, la
plupart des Européens (et de nombreux
autres) continuaient à vouloir faire baptiser
leur nouveau-né et souhaitaient des funé-
railles chrétiennes. En plus, l'Église détenait
un véritable monopole pour ce qui est du
droit d'unir les couples par les liens sacrés
du mariage, même si certains de ces mariages
se déroulaient dans de curieux endroits.
En 1914, cette barge flottante à Berlin (1)
était non seulement une église, mais elle
fournissait en plus une salle et tout ce qu'il
fallait pour le repas de noces (2).

FOR the wealthy middle classes, a wedding was a great affair, an opportunity to parade in finery, pose for the cameras (1 and 3), and invite the famous. When the Reverend Frederick Manners Stopford married Florence Augusta Saunders in London on 8 June 1857 (2), the great railway engineer Isambard Kingdom Brunel was among the guests. The bride's father was the first General Secretary of Brunel's Great Western Railway.

FÜR die reichen Angehörigen der Mittelklasse war eine Hochzeit eine große Sache, die Gelegenheit bot, Eleganz zur Schau zu stellen, für die Kameras zu posieren (1, 3) und Berühmtheiten einzuladen. Als der Reverend Frederick Manners Stopford am 8. Juni 1857 in London Florence Augusta Saunders heiratete (2), befand sich der bedeutende Eisenbahningenieur Isambard Kingdom Brunel unter den Hochzeitsgästen. Der Vater der Braut war erster Generalsekretär von Brunels Great Western Railway.

POUR les classes moyennes aisées, un mariage ne se traitait pas à la légère : c'était l'occasion de parader dans de beaux atours, de poser pour une photo (1 et 3) et d'inviter des célébrités. Lorsque le révérend Frederick Manners Stopford épousa Florence Augusta Saunders à Londres le 8 juin 1857 (2), il comptait parmi ses invités le grand ingénieur des chemins de fer Isambard Kingdom Brunel. Le père de la mariée était le premier secrétaire général du Great Western Railway où travaillait Brunel.

3

FEW European weddings could rival those of more exotic cultures in the lavishness of costume and decoration. This Arab procession in Cairo could almost be a scene from *Kismet*. Hired musicians preceded the bridal party to the house of the bridegroom. The European writer of the caption to this photograph described the camels as being 'decked in gaudy trappings'.

WENN es um prachtvolle Kostüme und Dekorationen ging, konnten nur wenige europäische Hochzeiten mit denen exotischerer Kulturen mithalten. Diese arabische Prozession in Kairo mutet an wie eine Szene aus *Kismet*. Gemietete Musikanten geleiteten die Braut und ihre Gesellschaft zum Haus des Bräutigams. Der europäische Verfasser der Unterschrift zu dieser Photographie beschrieb die Kamele als »in leuchtend bunten Schmuck gehüllt«.

PEU de mariages européens pouvaient rivaliser en faste avec ceux des cultures plus exotiques. Cette procession arabe au Caire pourrait presque sortir d'une scène de *Kismet*. Des musiciens avaient été engagés pour précéder le cortège de la mariée jusqu'à la maison du futur époux. L'européen qui a rédigé la légende de cette photographie a écrit que les chameaux étaient « recouverts d'ornements criards ».

UNTIL the 19th century, the Grand Tour of Europe and the Near East had been a privilege enjoyed only by the rich, an adventure for the bold or desperate. But by 1850 tourism had become a well established industry in Europe. Mark Twain sailed from New York in 1867 with a party of American tourists, to visit Paris, Heidelberg, Rome, Constantinople and the Holy Land. At the end of his tour he wrote: 'I have no fault to find with the manner in which our excursion was conducted. It would be well if such an excursion could be gotten up every year and the system regularly inaugurated.' A fellow American writer, Henry James, was less complimentary about the average British tourist – such as these at Athens in 1860. 'They are always and everywhere the same,' he wrote, 'carrying with them in their costume and physiognomy, that indefinable expression of not considering anything out of England worth making, physically or morally, a toilet for.' William Howard Russell, a newspaper correspondent, disliked all tourists: 'They fill hotels inconveniently, they crowd sites which ought to be approached in reverential silence… The very haggling and bargaining which accompany their ways makes one feel uncomfortable.'

BIS zum 19. Jahrhundert war die »Grand Tour« durch Europa und in den Nahen Osten ein Privileg der Reichen, ein Abenteuer für Mutige und Verzweifelte. Aber um 1850 war der Tourismus in Europa zu einem etablierten Industriezweig geworden. Mark Twain bestieg 1867 zusammen mit anderen amerikanischen Touristen in New York ein Schiff und besuchte Paris, Heidelberg, Rom, Konstantinopel und das Heilige Land. Am Ende seiner Reise schrieb er: »Ich habe nichts auszusetzen an der Art, wie unsere Exkursion geführt wurde. Es wäre schön, wenn eine solche Reise jedes Jahr veranstaltet und das System zur festen Einrichtung würde.« Ein amerikanischer Schriftstellerkollege, Henry James, war weniger gut auf englische Touristen, wie diese 1860 in Athen, zu sprechen: »Sie sind immer und überall gleich…und tragen in ihrer Kleidung und ihrer Physiognomie diesen undefinierbaren Ausdruck, daß es außerhalb von England nichts gibt, das es wert wäre, sich körperlich oder moralisch herzurichten.« William Howard Russell, ein Zeitungskorrespondent, verabscheute alle Touristen: »Sie füllen rücksichtslos die Hotels, scharen sich um Sehenswürdigkeiten, denen man sich in respektvoller Stille nähern sollte … Durch ihr ständiges Handeln und Feilschen fühlt man sich äußerst unbehaglich.«

1

(*Pages précédentes*)

Jusqu'au XIXᵉ siècle, le grand circuit européen et le Proche-Orient étaient un privilège réservé aux seuls riches, une aventure pour les téméraires ou les désespérés. Mais dès 1850, l'industrie touristique était bien implantée en Europe. Mark Twain s'embarqua à New York en 1867 en compagnie d'un groupe de touristes américains pour visiter Paris, Heidelberg, Rome, Constantinople et la Terre Sainte. Au terme du circuit il nota : « Je n'ai rien à redire de la manière dont s'est déroulée notre excursion. Ce serait bien qu'une excursion comme celle-ci soit mise sur pied chaque année et que sa pratique en soit institutionnalisée. » Un écrivain de ses compatriotes,

Henry James, parlait en termes moins élogieux du touriste britannique moyen, tels ceux-ci en 1860 : « Ils sont toujours et partout les mêmes, arborant sur toute leur personne et leur physionomie cet air indéfinissable de ne rien trouver hors de l'Angleterre qui vaille le dérangement, ni physique ni mental. » William Howard Russell, qui était correspondant de presse, détestait tous les touristes : « Ils encombrent fâcheusement les hôtels, envahissent les sites qui devraient être approchés dans un silence révérencieux ... La seule vision des chipotages et des marchandages auxquels ils se livrent vous met horriblement mal à l'aise. »

2

It took Mark Twain an hour and a
quarter to climb up the rough narrow
trail over the old lava bed from Annunziata
to the summit of Mount Vesuvius. Other
tourists, like these in 1880 (1), had the
services of local porters. 'They crowd you,
infest you, swarm about you, and sweat
and smell offensively, and look sneaky and
mean and obsequious.' At the summit
Twain recorded: 'Some of the boys thrust
long strips of paper down into the holes
and set them on fire, and so achieved the
glory of lighting their cigars by the flames
of Vesuvius.' Others cooked eggs.

At Luxor (2) tourists could enjoy the
wonders of the Temple of Karnak, picnic
in the Valley of the Kings, or inhale
the putrefying stink that arose from pits
of imperfectly preserved mummies.

MARK Twain brauchte eineinviertel
Stunden, um über den rauhen,
schmalen Pfad des Lavabetts von Annunziata
zum Gipfel des Vesuv zu gelangen. Andere
Touristen, wie diese im Jahre 1880 (1),
nahmen die Dienste einheimischer Träger
in Anspruch. »Sie umzingeln einen, fallen
über einen her, schwirren um einen herum,
sie schwitzen und stinken fürchterlich und
sehen verschlagen, böse und unterwürfig
aus.« Auf dem Gipfel notierte Twain:
»Einige der Jungen warfen lange Papier-
streifen in Löcher und steckten sie in Brand,
so daß sie ruhmreich behaupten konnten,
ihre Zigarren mit den Flammen des Vesuv
angezündet zu haben.« Andere kochten
Eier.

In Luxor (2) konnten sich Touristen
am Wunder des Karnak-Tempels erfreuen,
im Tal der Könige picknicken oder den
Verwesungsgestank einatmen, der schlecht
konservierten Mumien entströmte.

MARK Twain dut grimper une heure et
quart durant l'étroit et rude sentier
qui mène au-dessus de l'ancien lit de lave de
l'Annunziata jusqu'au sommet de la mon-
tagne du Vésuve. D'autres touristes, comme
ceux-ci en 1880 (1), faisaient appel aux
services des porteurs locaux. « Ils vous
envahissent, vous infestent, grouillent autour
de vous, transpirent de manière malodorante,
et ont des allures de serpents mesquins et
obséquieux. » Au sommet Twain nota : « Des
garçons lançaient de longues bandes de papier
à l'intérieur des trous qu'ils enflammaient,
se couvrant ainsi de la gloire d'allumer leurs
cigares aux flammes du Vésuve. » D'autres
se faisaient cuire des œufs.

À Louxor (2), les touristes pouvaient
s'émerveiller devant le temple de Karnak,
pique-niquer dans la vallée des Rois ou
inhaler les odeurs putrides qui s'élevaient
des fosses où finissaient de se décomposer
des momies mal conservées.

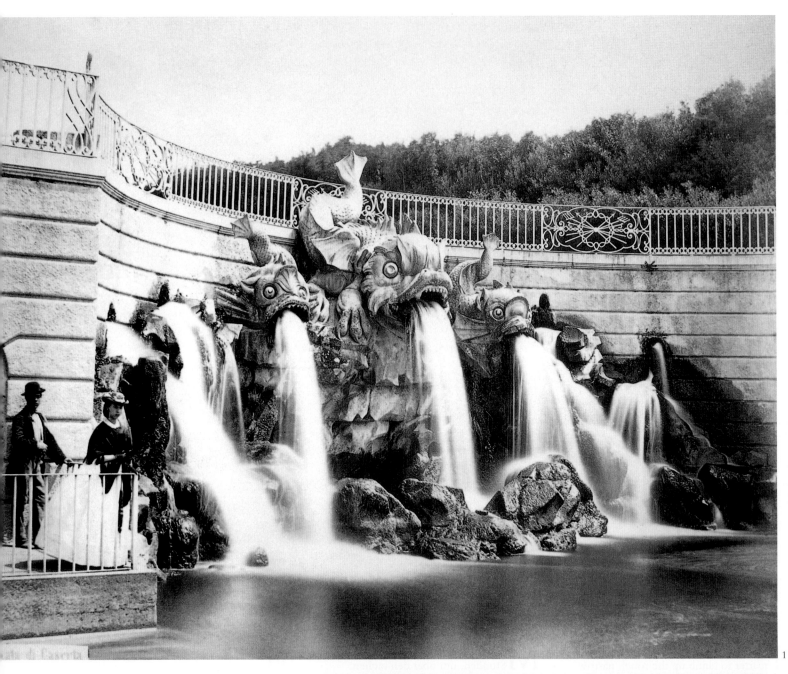

THE Ubiquitous Tourist. English
visitors to the Cascata di Caserta, 1860
(1). All aboard the Obersabsberg Express
(2). A mixed party go mountaineering in
1865 (3). The interior of the bath house,
Hotel del Monte, San Francisco (4).

DER allgegenwärtige Tourist: englische
Besucher der Kaskaden von Caserta
im Jahre 1860 (1). An Bord des Obersabs-
berg Express (2). Eine gemischte Gesell-
schaft beim Bergsteigen im Jahre 1865 (3).
Das Innere eines Badehauses – Hotel del
Monte, San Francisco (4).

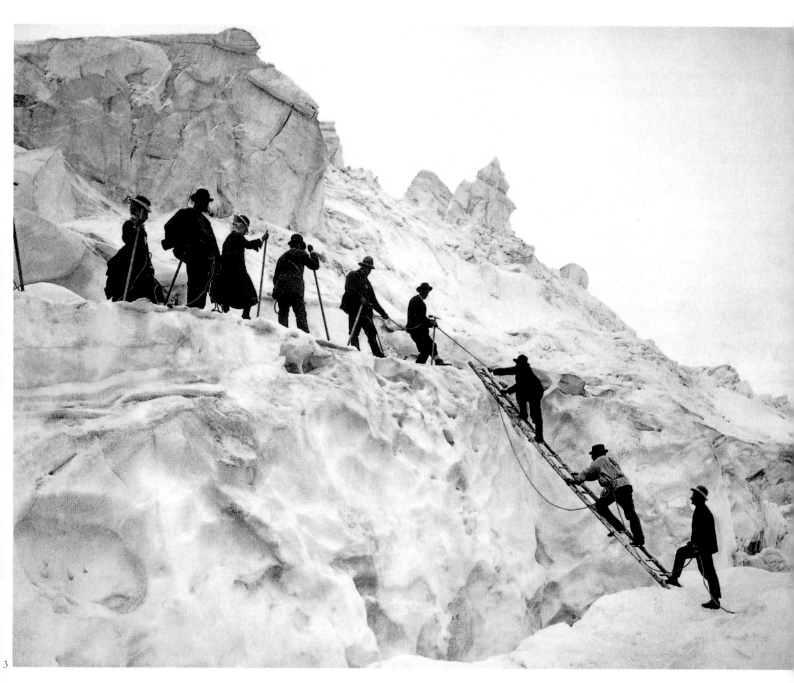

3

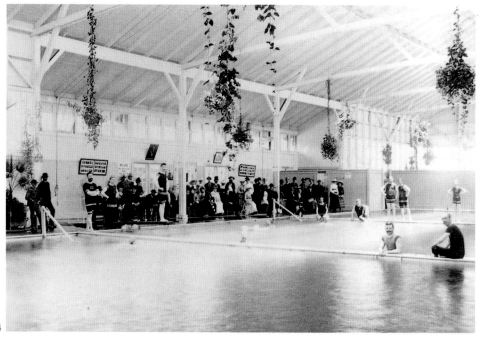

4

LE touriste est partout. Des Anglais à
Cascata di Caserta en 1860 (1). À bord
du Obersabsberg Express (2). Groupe
d'alpinistes, hommes et femmes, en 1865
(3). Les bains de l'hôtel del Monte à San
Francisco (4).

1

FOR some Europeans, travel was more a matter of economic necessity. Europe could be a cruel place, and the New World really did seem to offer freedom from want, fear and oppression. For emigrants, the first sight of the United States or Canada (2) held out a promise that sadly wasn't always fulfilled. And for all immigrants to the United States – such as this Jewish family from England (1) – there was the ordeal of inspection and possible rejection on Ellis Island.

FÜR einige Europäer war das Reisen eher eine wirtschaftliche Notwendigkeit. Europa konnte grausam sein, und die neue Welt schien Freiheit von Not, Angst und Unterdrückung zu verheißen. Für Emigranten war der erste Anblick der Vereinigten Staaten oder von Kanada (2) ein Versprechen, das leider nicht immer erfüllt wurde. Und auf alle, die wie diese jüdische Familie aus England in die Vereinigten Staaten von Amerika einwanderten (1), wartete die Tortur der Untersuchung und die mögliche Einreiseverweigerung auf Ellis Island.

CERTAINS Européens voyageaient plutôt par nécessité économique. L'Europe pouvait être un endroit cruel ; d'autre part le Nouveau Monde semblait vraiment offrir une vie libre où l'on ne connaissait pas la pauvreté, la peur et l'oppression. Pour les émigrants qui les découvraient, les États-Unis ou le Canada (2) semblaient contenir une promesse qu'ils ne tenaient malheureusement pas toujours. De toute façon, ceux qui entraient aux États-Unis, telle cette famille juive arrivée d'Angleterre (1), devaient se soumettre à l'épreuve de l'inspection d'Ellis Island, près de New York, à l'issue de laquelle ils seraient peut-être refusés.

2

ELLIS Island wasn't just a place of educational tests, physical examinations and disinfectant baths. Immigrants occasionally had the chance to celebrate the culture they brought with them – this Ukrainian concert took place in 1916 (1). But bureaucracy was strict – all arrivals were labelled – and there was an overall atmosphere of a cattle market about many of the proceedings (2). The journey itself was long and hard – thousands of miles across Europe to the coast, and then the wait for a boat (3). It took these Norwegian immigrants up to two weeks to sail across the Atlantic in 1870 (4).

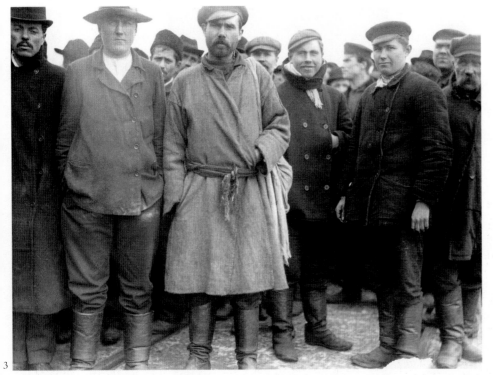

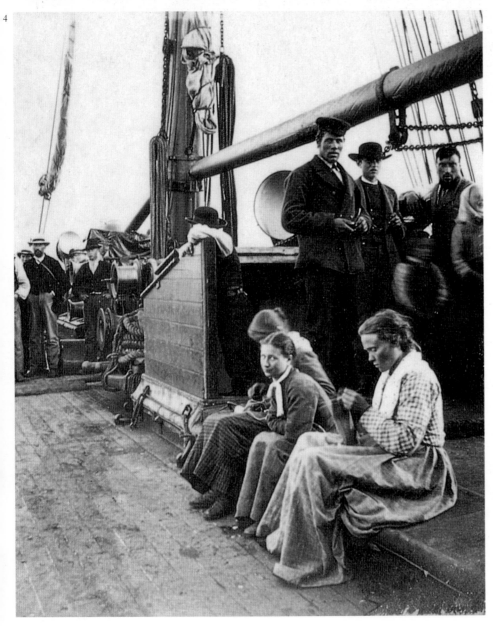

Ellis Island war nicht nur ein Ort für Schulprüfungen, ärztliche Untersuchungen und Desinfektionsbäder. Gelegentlich hatten Immigranten die Möglichkeit, die Kultur zu feiern, die sie mitgebracht hatten – dieses ukrainische Konzert fand im Jahre 1916 statt (1). Aber die Bürokratie war streng. Alle Ankömmlinge wurden registriert, und bei vielen Prozeduren herrschte die Atmosphäre eines Viehmarktes (2). Die Reise selbst war lang und strapaziös; Tausende von Kilometern mußten durch Europa bis zur Küste zurückgelegt werden, bevor das Warten auf ein Schiff begann (3). Diese norwegischen Immigranten brauchten 1870 fast zwei Wochen, um den Atlantik zu überqueren (4).

Ellis Island n'était pas seulement un endroit où étaient vérifiés le niveau d'instruction et la condition physique ni où l'on prenait des bains désinfectants. Les immigrants avaient de temps à autre l'occasion de célébrer la culture qu'ils emportaient avec eux : concert ukrainien en 1916 (1). Mais la bureaucratie était rigoureuse ; toute arrivée était étiquetée, et bien des procédures se déroulaient dans une ambiance générale évoquant le marché aux bestiaux (2). Le voyage lui-même, long et pénible, imposait de parcourir des milliers de kilomètres à travers l'Europe jusqu'à la côte, et pour finir d'attendre avant de pouvoir embarquer (3). Ces immigrants norvégiens ont mis deux semaines à traverser l'Atlantique en 1870 (4).

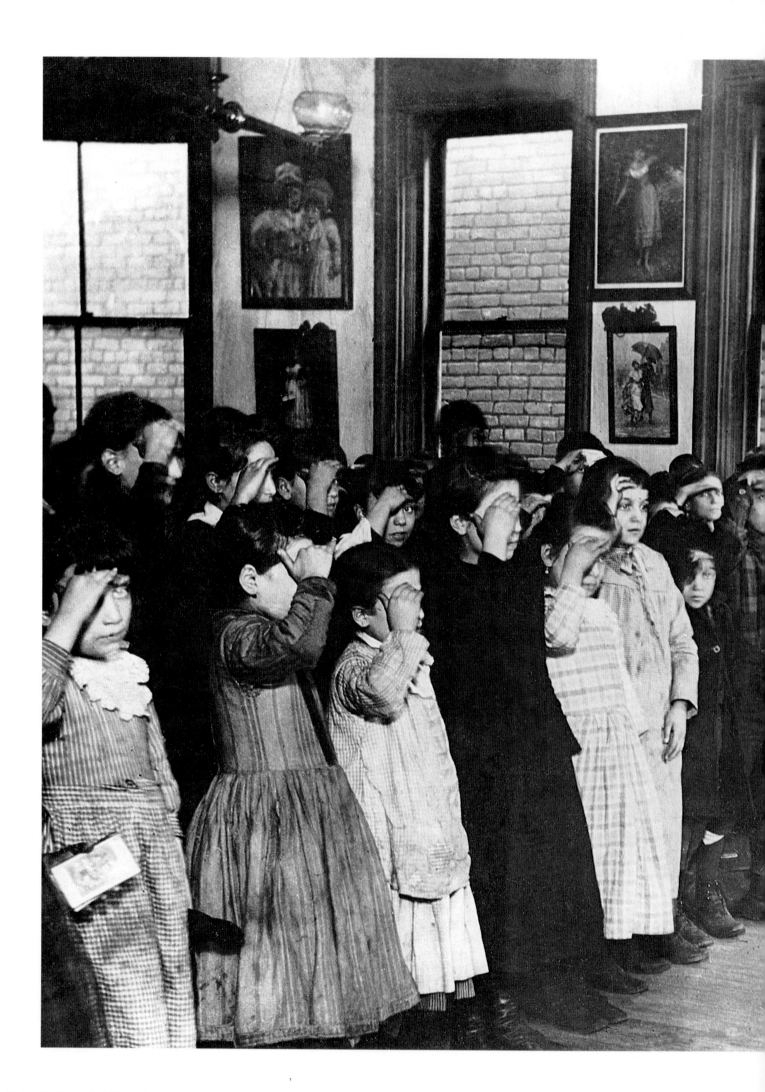

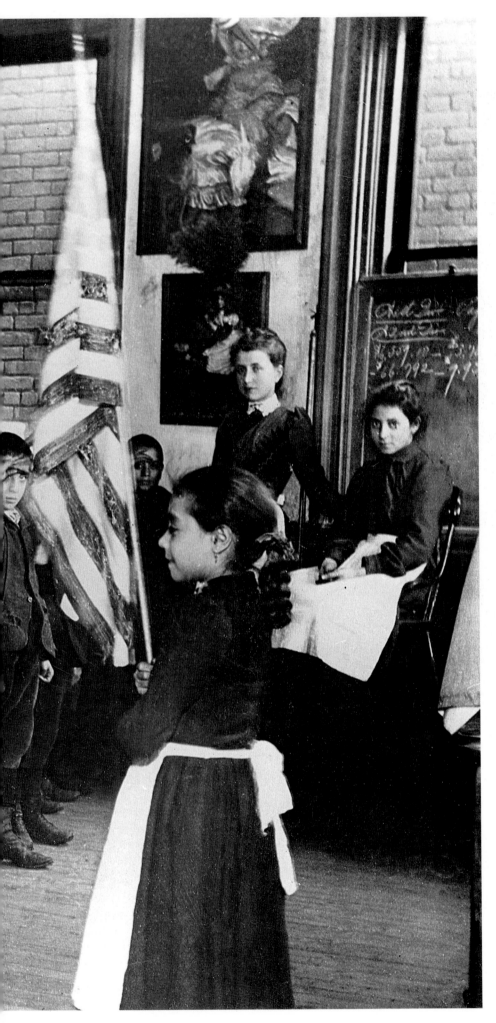

IN 1887, a police reporter for the New York *Daily Tribune* took some of the earliest flashlight photographs, to record the lives and hard times of refugees from Europe. His name was Jacob Riis, and he was himself from Denmark. His most lasting work was the series of hundreds of pictures he took in the slums of New York. The pictures were lost for nearly 60 years, but were rediscovered in 1947 and presented to the Museum of the City of New York. Describing the children saluting the flag and repeating the oath of allegiance at the Mott Street Industrial School, Riis wrote: 'No one can hear it and doubt that the children mean every word and will not be apt to forget that lesson soon.'

IM Jahre 1887 machte ein Polizeireporter der New Yorker *Daily Tribune* einige der ersten Blitzlichtaufnahmen und photographierte das harte Leben europäischer Flüchtlinge. Er hieß Jacob Riis und war selbst ein Immigrant, aus Dänemark. Seine beeindruckendste Arbeit waren die vielen hundert Photographien, die er in den Slums von New York gemacht hatte. Die Bilder waren fast sechzig Jahre lang verschollen, sie tauchten 1947 jedoch wieder auf und wurden dem Museum der Stadt New York übergeben. Über die Kinder, die vor der Flagge salutieren und den Treueeid in der Erziehungsanstalt für verwahrloste Kinder in der Mott Street sprechen, schrieb Riis: »Niemand, der es hört, kann daran zweifeln, daß diese Kinder jedes Wort, das sie sagen, ernst meinen und diese Lektion so bald nicht vergessen werden.«

EN 1887, un reporter chargé de couvrir les affaires policières pour le *Daily Tribune* new-yorkais prenait quelques-unes des toutes premières photographies au flash, sauvant ainsi de l'oubli la vie et les durs moments des réfugiés venus d'Europe. Il s'appelait Jacob Riis et il était lui-même immigré du Danemark. Les centaines de photos qu'il a prises des bidonvilles de New York restent son œuvre la plus marquante. Ces images avaient été perdues pendant près de soixante ans, avant d'être redécouvertes en 1947 et offertes au musée de la ville de New York. Décrivant la cérémonie de l'allégeance au drapeau des enfants de l'Industrial School à Mott Street, Riis écrit : « Quiconque les entend ne peut être que convaincu que ces enfants croient chacun de leurs mots et qu'ils ne sont pas prêts d'oublier cette leçon de si tôt. »

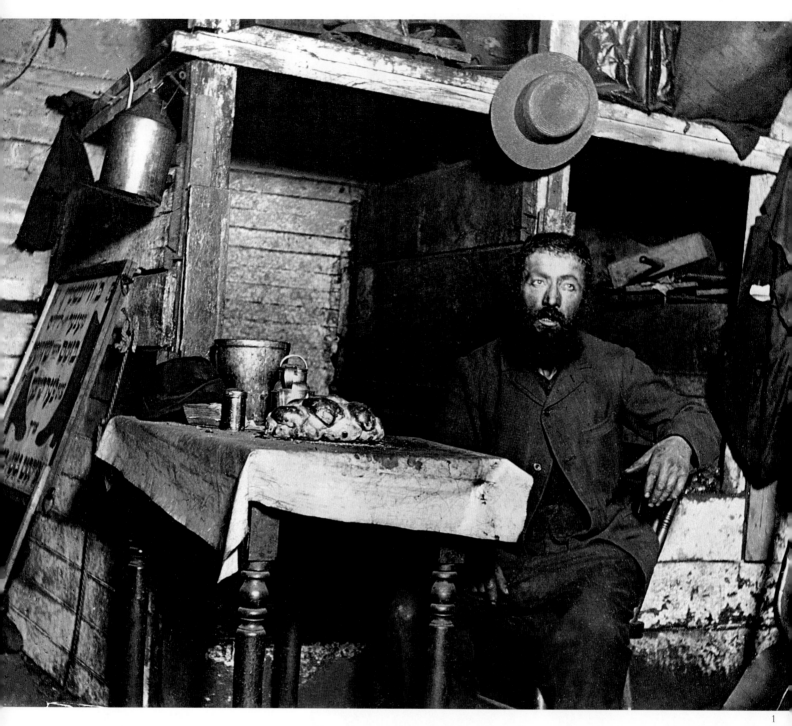

1

RIIS captioned the picture of the poor Jewish cobbler (1): 'Ready for the Sabbath Eve in a coal-cellar ... The Board of Health has ordered the family out... but it will require the steady vigilance of the police for many months to make sure that the cellar is not again used for a living room. Then it will be turned into a coal cellar or a shoe-shop by a cobbler of old boots, and the sanitary police in their midnight tours will find it a bedroom for mayhaps half a dozen lodgers, all of whom "happened in", as the tenant will swear the next day, and fell asleep here.' The family of Jewish tailors (2) fared better – at least they were working above ground.

ZUM Bild des armen jüdischen Schusters (1) schrieb Riis: »Fertig für den Abend des Sabbat im Kohlenkeller ... Das Gesundheitsamt hat die Familie ausgewiesen ... aber es wird vieler Monate der ständigen Überwachung durch die Polizei bedürfen, um sicherzustellen, daß der Keller nicht wieder als Wohnraum genutzt wird. Dann wird daraus ein Kohlenkeller oder das Geschäft eines

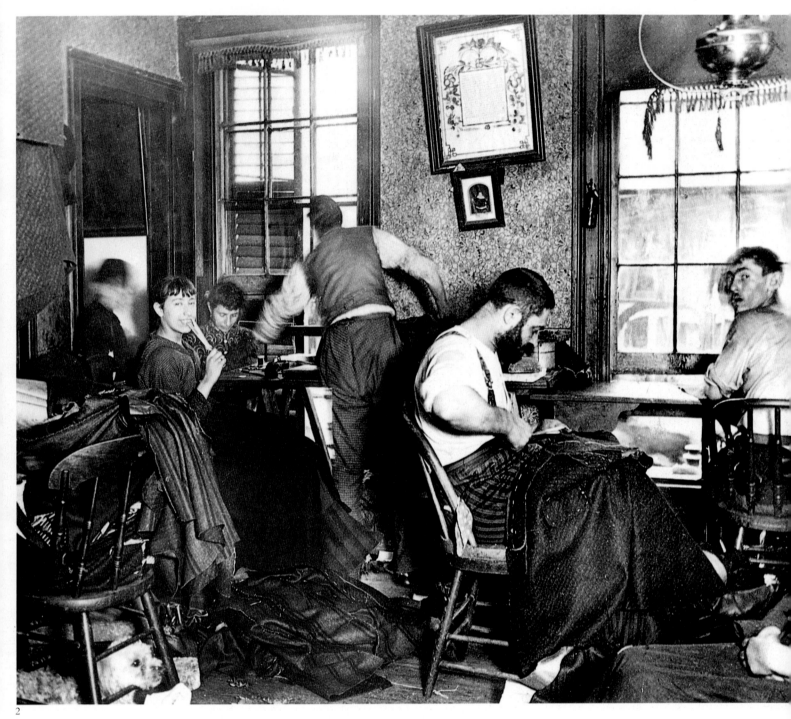

2

Flickschusters, und die Gesundheitspolizei wird auf ihren nächtlichen Kontrollgängen darin ein Schlafzimmer für etwa ein halbes Dutzend Untermieter vorfinden, die alle ›zufällig vorbeigekommen‹ und dort eingeschlafen sind, wie der Hauptmieter am nächsten Tag beteuern wird.« Der Familie des jüdischen Schneiders (2) erging es besser, zumindest arbeitete sie nicht unter der Erde.

RIIS a rédigé la légende de la photographie du pauvre savetier juif : « Préparatifs de Sabbat dans une cave à charbon ... Les services sanitaires ont ordonné l'expulsion de la famille ... cependant il faudra une vigilance soutenue de la police des mois durant pour empêcher que la cave ne serve à nouveau d'habitation. Elle sera ensuite transformée en cave à charbon ou en magasin de chaussures par un savetier faisant le commerce de vieux souliers, jusqu'à ce qu'un jour la police sanitaire au cours d'une ronde de nuit n'y découvre une chambre à coucher contenant peut-être six occupants qui tous, en jurera le locataire le lendemain, ‹ passant par là › s'y étaient endormis. » La famille de tailleurs juifs (2) était mieux lotie, au moins elle ne travaillait pas sous terre.

FOR some, western Europe was itself a new world. Chinatown (1 and 2) had long been a thriving community in London when these photographs were taken in 1911. Following the abortive revolution of 1905 in Russia, many political refugees fled to the West. In Paris, this group established their own Russian newspaper (3).

FÜR einige war Europa selbst eine neue Welt. Chinatown in London (1, 2) war bereits seit langer Zeit eine wachsende Gemeinde gewesen, als diese Photos im Jahre 1911 aufgenommen wurden. Nach der gescheiterten Russischen Revolution von 1905 kamen viele politische Flüchtlinge in den Westen. In Paris gründete diese Gruppe ihre eigene russische Zeitung (3).

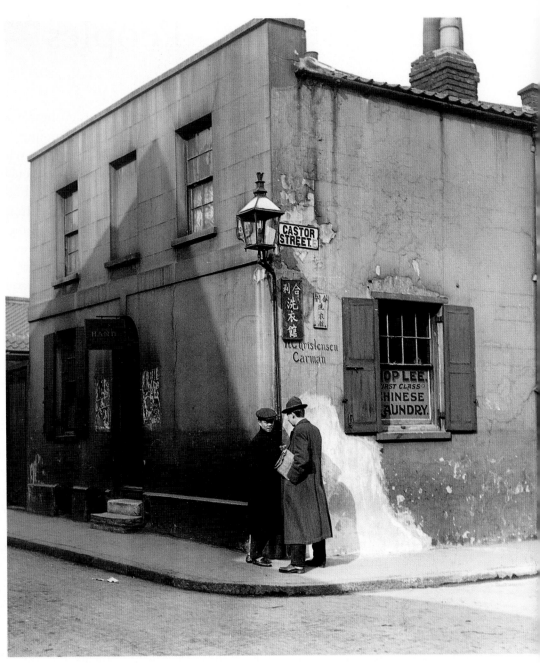

Pour certains, le Nouveau Monde était l'Europe occidentale. La communauté chinoise (1 et 2) était déjà florissante à Londres au moment où ces photographies ont été prise, en 1911. Après l'avortement de la révolution russe en 1905, de nombreux réfugiés politiques s'enfuirent en Occident. Ce groupe-ci fonda son propre journal russe à Paris (3).

Peoples

For centuries, the advance of European civilization had posed a major threat to the indigenous people of many parts of the world. In the 16th century, Spanish conquistadores under Cortés had not only conquered Mexico, but had completely destroyed the Aztec culture they found there. The Aztecs believed that, for their society to continue, the sun and the earth had to be nourished with human blood and human hearts. In the heyday of their empire, the Aztecs had sacrificed 10,000 victims a year to appease their principal god, Huitzilopochtli. By the time this photograph was taken (1), some 350 years later, the Aztec couple in it were among the last survivors of this warlike race that had once been the most powerful in Central America. Their numbers had dwindled to a pitiful few.

For, wherever they went, the Europeans brought with them a mixture of blessings and curses. They abolished slavery in Africa but plundered most of the continent for its raw materials and cheap labour. They abolished Thuggee in India, where for hundreds of years travellers had feared this secret society of stranglers – but denied the citizens of India any say in their own government. They helped put an end to the time-honoured system of binding a young girl's feet in China, but greatly increased the trade in and consumption of opium, so that millions became addicts.

In some cases the blessings are hard to discern. Australian aborigines had lived contentedly for thousands of years, before settlers and farmers brought fever, greed and an inexhaustible supply of cheap alcohol. For centuries, the Plains Indians of North America had prospered as nomadic hunters over millions of square miles. They were proud people who respected the earth and even the buffalo that they killed for food, clothing, tools and shelter. Within a few decades of the coming of the white man they had been driven into reservations, slaughtered in their thousands and weakened by disease. In the 1880s George Augustus Sala saw once great warriors begging at railroad stations. 'The white post-traders sell them poisonous whisky and cheat them in every conceivable manner, while the white squatters crowd them out by stealing the land assigned for Indian occupancy by the United States.' The inhabitants of Tasmania were rounded up en masse and shipped off to tiny Flinders Island by British government agents. 'When they saw from shipboard the splendid country which they were promised,' wrote an eye-witness of this appalling genocide, 'they betrayed the greatest agitation, gazing with strained eyes at the

sterile shore, uttering melancholy moans, and, with arms hanging beside them, trembling with convulsive feeling. The winds were violent and cold, the rain and sleet were penetrating and miserable… and this added to their foreboding that they were taken there to die.' Many died from chest and stomach complaints. Most died from homesickness. Not one survived.

But wherever they went, the Europeans also took their cameras and their notebooks, and maybe we should be grateful that they recorded the very people, places and cultures that they were about to destroy. In 1874 Viscountess Avonmore saw – from the safety of a train – 'a number of Indians on the war-path, dressed in all the glory of feathers, skins and scarlet blankets, leading their horses in single file over a frozen stream.' The same year the explorer John Forrest faced the terror of an aborigine attack in Australia: 'I saw from fifty to sixty natives running towards the camp, all plumed up and armed with spears and shields… One advanced to meet me and stood twenty yards off; I made friendly signs; he did not appear very hostile. All at once the whole number made a rush towards us, yelling and shouting with their spears shipped…' Forrest survived to tell the tale.

Among the most inflexible Christian interlopers were the Afrikaaners of South Africa. Theirs was a harsh, unforgiving God, who they believed approved their treatment of Hottentot and Bushman, whom they almost completely exterminated. Not for them the mealy-mouthed British insistence that black and white were equal before the law. More than any other group of European descent, the Boers of South Africa embodied the deafness and blindness of colonization and commerce to the values of other societies and cultures.

The problem was, of course, that Europeans saw themselves as superior to all other people, and therefore had a right to be in charge of the world. They had more advanced industries, weapons, ideas, commercial know-how, and public health. They were more inventive, better governed, better educated. And, above all, Europe was the workshop of Christianity, the faith that could save the heathen hordes from eternal damnation, whether they wanted it or not.

It was a two-way process. Europeans gained new markets and bigger dividends on their shares: everyone else gained the chance of life everlasting. It was God's will. The working millions of Africa, India, Asia had not come under European management 'merely that we might draw an annual profit from them, but that we

1

might diffuse among [these] inhabitants the light and the benign influence of the truth, the blessings of well-regulated society, the improvements and comforts of active industry.'

The tragedy was that these noble sentiments arose from an utter disregard for the older civilizations that were being swept aside. The people of Hindustan were 'lamentably degenerate and base'. The Africans were 'cannibal butchers'. The Chinese were 'revolting, diseased and filthy objects'. So it was small wonder that the Bushman and the Tasmanian disappeared, and the Sioux and the Cheyenne were herded into reservations. As for the Aztecs – well, they hadn't even managed to invent the wheel; they simply passed away, and only their language remained.

JAHRHUNDERTELANG hatte der Fortschritt der europäischen Zivilisation eine große Bedrohung für die Ureinwohner vieler Länder dieser Erde bedeutet. Im 16. Jahrhundert hatten die spanischen Conquistadores unter Cortéz nicht nur Mexiko erobert, sondern auch die aztekische Kultur, die sie dort vorfanden, völlig zerstört. Die Azteken glaubten, zur Erhaltung ihrer Gesellschaft die Sonne und die Erde mit menschlichem Blut und menschlichen Herzen speisen zu müssen. In der Blütezeit ihres Reiches hatten sie jährlich 10 000 Menschenopfer dargebracht, um ihren Hauptgott Huitzilopochtli zufriedenzustellen. Zu der Zeit, als obenstehende Aufnahme (1) gemacht wurde,

etwa 350 Jahre später, gehörte das abgebildete aztekische Paar zu den letzten Überlebenden dieses kriegerischen Volkes, einst das mächtigste in Zentralamerika.

Denn wo die Europäer auch hinkamen, brachten sie eine Mischung aus Segnungen und Flüchen mit. Sie schafften zwar die Sklaverei in Afrika ab, beuteten aber fast den gesamten Kontinent wegen seiner Bodenschätze und billigen Arbeitskräfte aus. In Indien beseitigten sie die Thug, eine Raubmörderbande, die Reisende seit Hunderten von Jahren gefürchtet hatten, verweigerten den Bürgern von Indien aber jedes Mitspracherecht in ihrer eigenen Regierung. In China trugen sie zwar zur Beendigung des althergebrachten Brauchs bei, die Füße junger Mädchen zusammenzuschnüren, sie förderten aber auch Handel und Konsum von Opium, so daß Millionen von Menschen süchtig wurden. Der Photograph John Thomson beschrieb die Freuden einer eleganten Opiumhöhle in den 1870er Jahren: »... mit Mädchen, die sich stets bereithalten, einige, um die Pfeife vorzubereiten und mit Opium zu stopfen, andere, um süße Lieder zu singen, und den Schlafenden in das Reich der Träume zu geleiten.«

In einigen Fällen sind die Segnungen nur schwer auszumachen. Australische Aborigines hatten Tausende von Jahren zufrieden gelebt, bevor Siedler und Farmer das Fieber, Habgier und unerschöpfliche Vorräte billigen Alkohols brachten. Jahrhundertelang hatten die Indianer der nordamerikanischen Prärie als jagende Nomaden ein Gebiet von Millionen Quadratkilometern bevölkert. Sie waren stolze Menschen, die nicht nur die Erde respektierten, sondern auch den Büffel, den sie töteten, um Essen, Kleidung, Werkzeuge und Zelte von ihm herzustellen. Innerhalb weniger Jahrzehnte nach der Ankunft des weißen Mannes waren sie in Reservate getrieben, zu Tausenden abgeschlachtet und durch Krankheiten geschwächt worden. In den 1880er Jahren sah George Augustus Sala einst große Krieger, die auf Bahnhöfen bettelten. »Die weißen Händler verkaufen ihnen schädlichen Whisky und machen sich auf jede nur erdenkliche Art über sie lustig, während die illegalen weißen Siedler sie von dem Land verdrängen, das ihnen von den Vereinigten Staaten zugewiesen wurde.« Die Bewohner von Tasmanien wurden in Massen zusammengetrieben und von britischen Regierungsvertretern auf das winzige Flinders Island verschifft. »Als sie von Bord des Schiffes aus das ›herrliche‹ Land sahen, das man ihnen versprochen hatte«, schrieb ein Augenzeuge dieses entsetzlichen Völkermords, »zeigten sie große Aufregung, starrten mit aufgerissenen Augen auf die karge Küste und stießen melancholische Seufzer aus; ihre Arme hingen kraftlos herab, und sie wurden von Krämpfen geschüttelt. Der Wind war rauh und kalt, Regen und

Graupelschauer durchnäßten sie bis auf die Haut ... und ihre Vorahnung, daß man sie zum Sterben hierhergebracht hatte, wurde bestätigt.« Viele starben an inneren Krankheiten, die meisten jedoch an Heimweh. Nicht ein einziger überlebte.

Aber wohin die Europäer auch reisten, sie nahmen ihre Kameras und Notizbücher mit, und vielleicht sollten wir dankbar dafür sein, daß sie Berichte über die Menschen, Orte und Kulturen verfaßten, die sie dann zerstören sollten. Im Jahre 1874 sah die Viscountess Avonmore vom sicheren Eisenbahnabteil aus »einige Indianer auf dem Kriegspfad, die prächtige Federn, Häute und rote Decken trugen und ihre Pferde in einer Reihe über einen zugefrorenen Fluß führten«. Im selben Jahr erlebte der Forscher John Forrest in Australien die Schrecken eines Angriffs der Aborigines: »Ich sah zwischen fünfzig und sechzig Eingeborene auf das Lager zurennen, alle mit Federn geschmückt und mit Speeren und Schilden bewaffnet ... Einer lief auf mich zu und blieb etwa zwanzig Meter vor mir stehen; ich machte ihm freundschaftliche Zeichen; er machte keinen sehr feindseligen Eindruck. Plötzlich rannten alle auf uns zu, schrien und schleuderten ihre Speere ...« Forrest überlebte, um die Geschichte zu erzählen.

Zu den verbohrtesten christlichen Eindringlingen gehörten die Afrikaaner in Südafrika. Ihr Gott galt als streng und unversöhnlich, und sie waren überzeugt, er billige ihre Behandlung der Hottentotten und Buschmänner, die sie fast vollständig auslöschten. Die heuchlerische Behauptung der Briten, der schwarze und der weiße Mann seien vor dem Gesetz gleich, galt für sie nicht. Mehr als jede andere Gruppe von Europäern verkörperten die Buren Südafrikas die Taubheit und Blindheit von Kolonisation und Kommerz für die Werte anderer Gesellschaften und Kulturen.

Das Problem bestand natürlich darin, daß die Europäer glaubten, allen anderen Völkern überlegen zu sein, und daher das Recht und die Pflicht zu besitzen, die Verantwortung für die Welt zu übernehmen. Sie verfügten über besser entwickelte Industrien, bessere Waffen und Erfindungen, besseres kommerzielles Know-how und ein besseres Gesundheitswesen. Auch ihre Kultur war weiter entwickelt, was sie jedoch nicht daran hinderte, den Rest der Welt seiner Kunstschätze zu berauben. Die Europäer waren erfindungsreicher, besser regiert sowie besser erzogen und ausgebildet. Vor allem war Europa die Heimat des Christentums, jenes Glaubens, der die heidnischen Horden vor ewiger Verdammnis bewahren konnte, ob sie es nun wollten oder nicht.

Es war ein Prozeß des Gebens und Nehmens: Europäer erschlossen neue Märkte und erzielten höhere Dividenden auf ihre Aktien, während alle anderen die Aussicht auf das ewige Leben erhielten. Es war Gottes Wille. Die Millionen arbeitender Menschen in Afrika, Indien und Asien unterstanden der europäischen Verwaltung nicht »nur, damit wir einen jährlichen Gewinn durch sie erzielen, sondern damit wir unter diesen Einwohnern das Licht und das Gute der Wahrheit, die Segnungen einer gut organisierten Gesellschaft und die Annehmlichkeiten einer aktiven Industrie verbreiten können«.

Das Tragische war, daß diese ehrenwerten Absichten einer krassen Mißachtung der älteren Zivilisationen entsprangen, die verdrängt wurden. Die Menschen aus Hindustan waren »beklagenswert degeneriert und niederträchtig«. Die Afrikaner waren »kannibalistische Metzger«. Die Chinesen waren »aufsässige, verseuchte und dreckige Subjekte«. In den Augen eines britischen Premierministers waren selbst die Iren »wild, gefährlich, faul, unzuverlässig und abergläubisch«.

Kein Wunder also, daß der Buschmann und der Tasmane verschwanden und die Sioux und Cheyenne in Reservate getrieben wurden. Was die Azteken betraf, so hatten sie es ja noch nicht einmal geschafft, das Rad zu erfinden; sie verschwanden einfach, und nur ihre Sprache blieb übrig.

L'EXPANSION de la civilisation européenne avait représenté pendant des siècles une très grosse menace pour les peuples indigènes de bien des régions du monde. Au XVIe siècle, les conquistadors espagnols dirigés par Cortès avaient non seulement conquis le Mexique, mais en plus anéanti la culture aztèque. Les Aztèques croyaient qu'il leur fallait nourrir le soleil et la terre de sang et de cœurs humains pour que leur société perdure. À l'apogée de leur empire, ils sacrifiaient 10 000 victimes chaque année pour apaiser leur dieu principal, Huitzilopochtli. Le couple aztèque que l'on voit sur cette photographie (1, page précédente) prise environ 350 ans plus tard faisait partie des derniers survivants de cette race guerrière, jadis la plus puissante de l'Amérique centrale.

En effet, partout où ils allaient, les Européens faisaient tout à la fois le bien et le mal. Ils abolirent certes l'esclavage en Afrique, mais pillèrent la plupart des matières premières du continent et en exploitèrent la main-d'œuvre. En Inde, ils interdirent les thugs, cette société secrète d'étrangleurs qui avaient fait vivre les voyageurs dans la terreur pendant des siècles, mais refusèrent aux citoyens le droit d'intervenir dans la façon dont on les gouvernait. En Chine, ils contribuèrent aussi bien à la disparition de la pratique traditionnelle du bandage des pieds des fillettes qu'à la formidable expansion du commerce et de la consommation d'opium qui fit des millions de drogués. Le photographe John Thomson décrivant les plaisirs d'une fumerie d'opium fréquentée par la haute société dans les

années 1870 : « ... entourés par des filles attentives, les unes à préparer l'opium pour en remplir le fourneau de la pipe, les autres à accompagner en douceur le fumeur dans le royaume des rêves de leurs chants mélodieux ».

Il est dans certains cas difficile de parler de bienfaits. Les Aborigènes australiens avaient vécu heureux pendant des milliers d'années jusqu'au jour où les colons et les fermiers étaient arrivés avec leurs maladies, leur cupidité et leurs provisions inépuisables de mauvais alcool. Pendant des siècles, les Indiens des prairies de l'Amérique du Nord avaient mené une existence prospère de chasseurs nomades sur un territoire couvrant des millions de kilomètres carrés. C'était un peuple fier qui respectait la terre et même le bison qu'ils tuaient pour se nourrir, s'habiller, fabriquer leurs outils et leurs abris. En l'espace de quelques décennies après l'arrivée de l'homme blanc, ils se retrouvèrent parqués dans des réserves, massacrés par milliers et affaiblis par les maladies. Dans les années 1880, George Augustus Sala voyait mendier dans les gares des Indiens qui autrefois avaient été de grands guerriers. « Les fournisseurs blancs de l'armée leur vendent un whisky empoisonné et les trompent de toutes les manières imaginables, pendant que les squatters blancs les envahissent de plus en plus en volant les terres que les États-Unis ont assignées aux Indiens. » Les habitants de Tasmanie étaient heureux, affectueux et primitifs ; tous furent rassemblés puis expédiés sur l'île Flinders par les agents du gouvernement britannique. C'était un marché de dupes. La Tasmanie s'étend sur approximativement 68 000 kilomètres carrés, alors que l'île Flinders en couvre tout juste 1 800. Les Tasmaniens, cependant, partirent sans faire trop d'histoires. « Lorsqu'ils aperçurent du bateau le pays splendide qui leur avait été promis », rapporte un témoin de cet effroyable génocide, « ... ils manifestèrent une agitation extrême, s'usant les yeux à fixer la plage stérile, poussant des grognements mélancoliques, le corps parcouru de convulsions tandis que leurs bras pendaient ballants. Les vents étaient violents et froids, la pluie mêlée à la bruine tombait sale et pénétrante ... ce qui venait s'ajouter au pressentiment qu'ils avaient d'être amenés là-bas pour y mourir. » Beaucoup moururent d'affections de la poitrine et de l'estomac. La plupart du mal du pays. Pas un seul ne survécut.

Mais partout où ils allaient, les Européens prenaient aussi leurs appareils photographiques et leurs carnets, et ils ont enregistré précisément les gens, les lieux et les cultures qu'ils s'apprêtaient à détruire. En 1874, l'explorateur John Forrest faisait face, terrorisé, à une attaque des Aborigènes en Australie : « Je vis cinquante à soixante indigènes courir en direction du camp, tous recouverts de plumes et armés de lances et de boucliers... L'un se porta à ma rencontre et s'arrêta à environ 18 mètres de moi. Je lui adressai des gestes

amicaux : il n'avait pas l'air très hostile. Soudain, ils se ruèrent sur nous comme un seul homme en poussant des hurlements et en projetant leurs lances ... » Forrest survécut pour le raconter.

Certains se référaient à des principes chrétiens. Les Afrikaners furent les plus inflexibles et les plus dénués de scrupules. C'était un Dieu dur et impitoyable que le leur, censé approuver leur façon de traiter les Hottentots et les Bochimans, qu'ils exterminèrent presque complètement. Ce n'est pas eux qui auraient réclamé, à l'instar de ces timorés de Britanniques, l'égalité des Noirs et des Blancs devant la loi. Plus que tout autre groupe d'ascendance européenne, les Boers personnifièrent l'aveuglement colonial et commercial face aux valeurs des autres sociétés et cultures.

Le problème était bien sûr que les Européens se considéraient supérieurs à tous les autres peuples, et de ce fait en droit de diriger le monde. Ils possédaient des industries, des armes, des idées, un savoir-faire commercial et un système de santé public plus avancés. Leur culture était supérieure, ce qui ne les empêchait pas de piller avec fébrilité les richesses artistiques du reste du monde. Ils étaient plus inventifs, mieux gouvernés et plus instruits. Et surtout, l'Europe était l'atelier de la chrétienté, de la foi qui pouvait sauver les hordes païennes de la damnation éternelle, avec ou sans leur consentement. L'Afrique, l'Inde et l'Asie et les millions de personnes qui y travaillaient n'étaient pas passés sous administration européenne « uniquement afin que nous en tirions un profit annuel, mais pour que nous puissions répandre parmi leurs habitants la lumière et l'influence bénéfique de la vérité, les bienfaits d'une société bien ordonnée, ainsi que les améliorations et agréments d'une industrie active ».

Hélas, ces nobles sentiments allaient de pair avec un manque absolu de considération pour les civilisations plus anciennes qu'on était ainsi en train de balayer. Le peuple de l'Hindoustan était « lamentablement dégénéré et vil », les Africains étaient « des bouchers anthropophages » et les Chinois « des objets révoltants, souffreteux et sales ». Aux yeux d'un des premiers ministres britanniques, les Irlandais eux-mêmes étaient « sauvages, impulsifs, indolents, incertains et superstitieux ».

Qui s'étonnera, dans ces conditions, de la disparition des habitants de la brousse et des Tasmaniens ou des réserves dans lesquelles on parqua les Sioux et les Cheyennes. Quant aux Aztèques, dont une terrible prophétie prédisait une bataille à l'issue fatale, ils disparurent purement et simplement. Tous ces peuples ne laissèrent derrière eux que leur langue.

'Not one Chinaman in ten thousand knows anything about the foreigner,' reported the (European) Chief Inspector of the Chinese Customs Service in the late 19th century. 'Not one Chinaman in a hundred thousand knows anything about foreign in-ventions and discoveries; and not one in a million acknowledges any superiority in either the condition or the appliances of the West.' These Manchu families followed the old teachings of Confucius, which stressed the responsibilities of parents to children, and the duties of children to parents.

Nicht einer von zehntausend Chinesen weiß etwas über Fremde«, berichtete der (europäische) Oberinspektor des chinesischen Zollwesens Ende des 19. Jahrhunderts. »Nicht einer von hunderttausend Chinesen weiß irgend etwas über ausländische Erfindungen und Entdeckungen, und nicht einer von einer Million erkennt die Überlegenheit westlicher Verhältnisse und Errungenschaften an.« Diese Familien aus der Mandschurei folgten den alten Lehren des Konfuzius, der die Verantwortung der Eltern für ihre Kinder und die Pflichten der Kinder gegenüber ihren Eltern betonte.

Pas un Chinois sur dix mille ne sait la moindre chose de l'étranger » rapportait l'inspecteur en chef (européen) du service des douanes chinoises à la fin du XIXe siècle. « Pas un Chinois sur une centaine de mille n'a la moindre idée de ce qui a été inventé ou découvert par des étrangers ; et pas un sur un million ne dit trouver aux conditions ou aux techniques occidentales la moindre supériorité. » Ces familles mandchoues suivaient les anciens enseignements de Confucius qui soulignaient les responsabilités des parents envers leurs enfants et les devoirs des enfants vis-à-vis des parents.

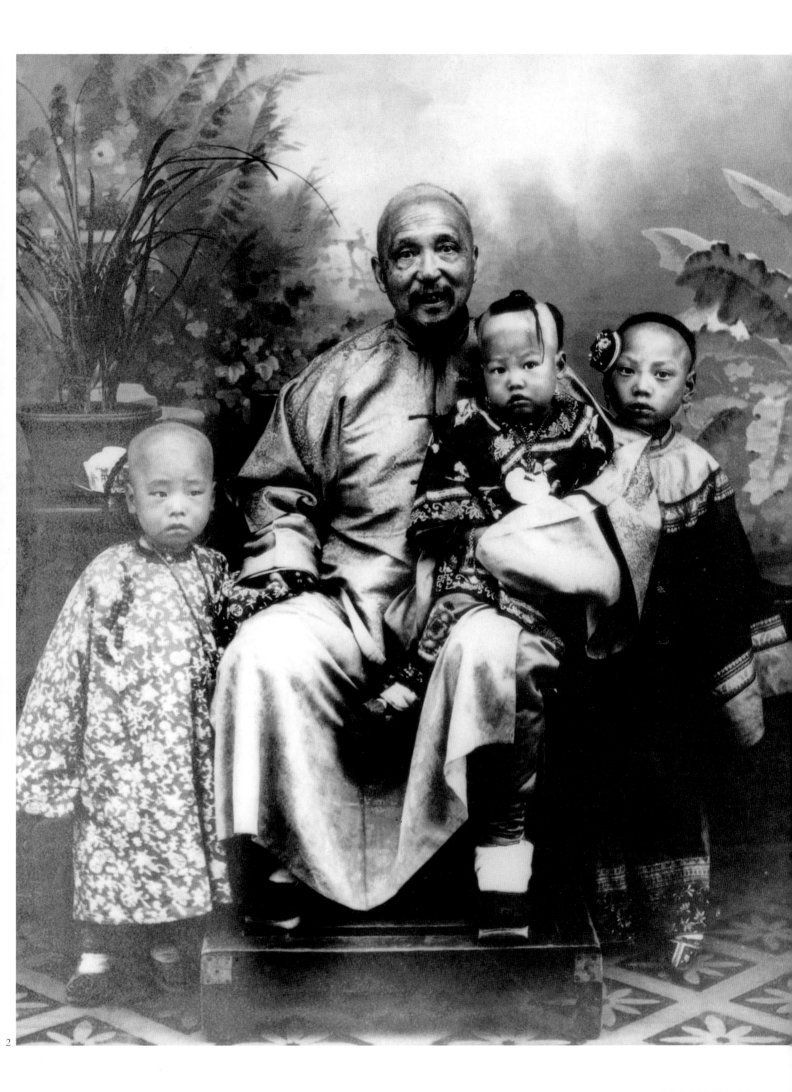

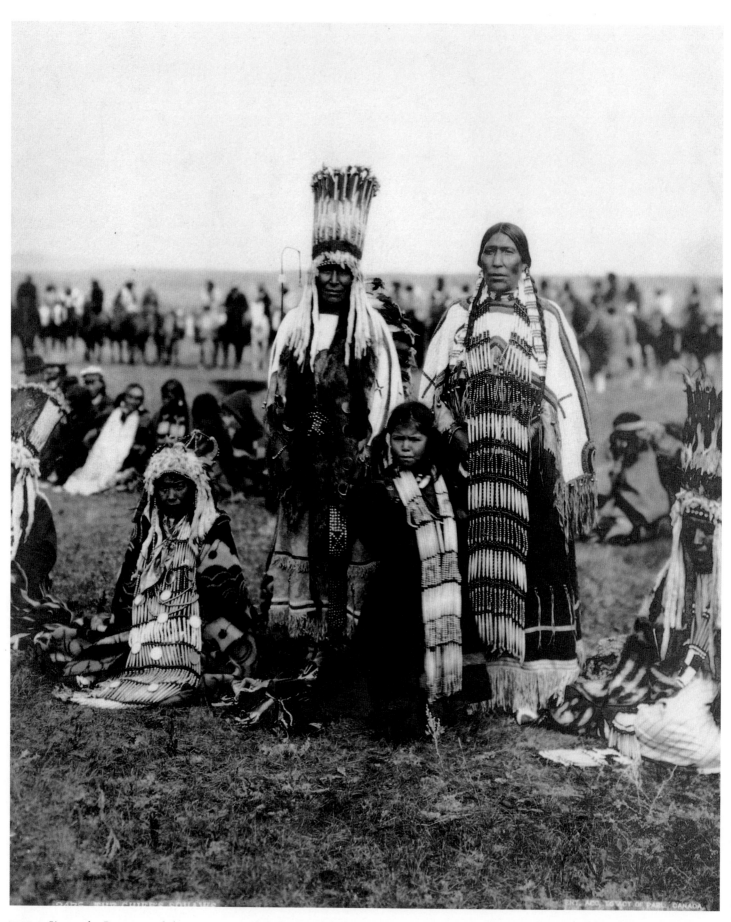

THE Sioux, the Pawnee and the Blackfoot were the great tribes of the American Plains. Learning from the first European settlers, they became great horsemen, and used horses to drag teepee poles and hides. But the transcontinental railroad of 1869 cut the buffalo grazing land in two, and the white hunters that travelled on it reduced the numbers of buffalo to a few hundred. The Plains Indians fought long and hard to preserve their way of life – but the end came at Wounded Knee in 1890.

DIE Sioux, die Pawnee und die Blackfoot waren die größten Indianerstämme der amerikanischen Prärie. Sie lernten von den europäischen Siedlern und wurden hervorragende Reiter; sie nutzten die Pferde, um Pfähle und Häute für ihre Zelte zu transportieren. Aber 1869 wurde das Weide-

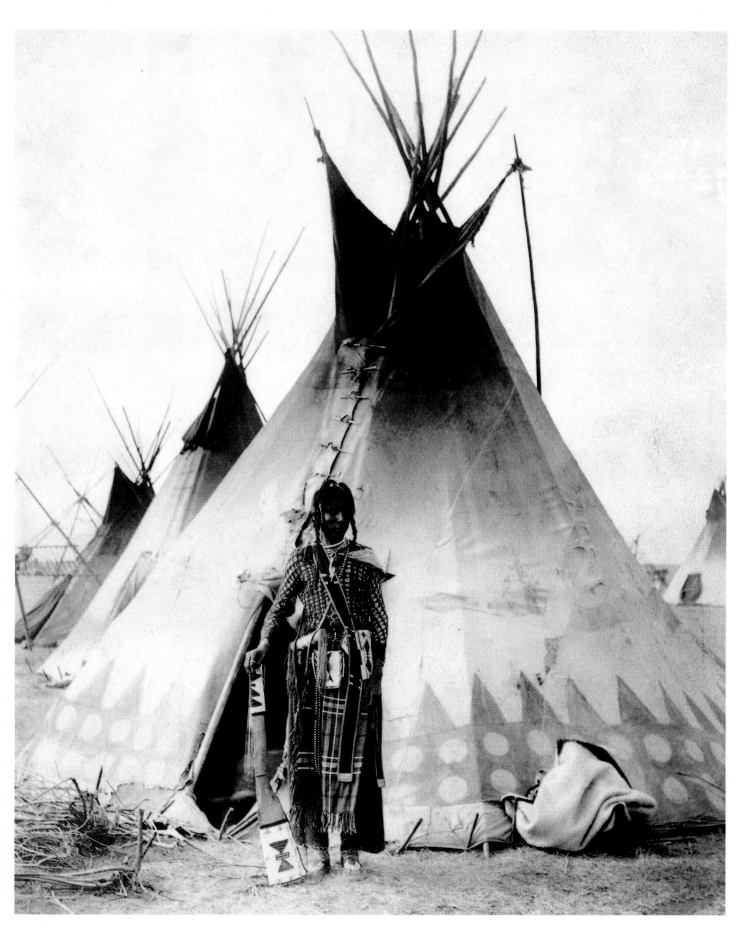

land der Büffel durch die transkontinentale Eisenbahn geteilt, und die weißen Jäger, die mit ihr reisten, reduzierten die Zahl der Büffel auf ein paar Hundert. Die Indianer kämpften lange und erbittert um den Erhalt ihrer Lebensweise, aber ihr Ende kam 1890 mit der Schlacht bei Wounded Knee.

LES Sioux, les Pawnees et les Blackfoot étaient les grandes tribus des prairies américaines. L'arrivée des premiers colons européens entraîna un épanouissement de la culture des Amérindiens. Les Indiens des prairies devinrent de grands cavaliers qui se servaient des chevaux pour traîner les mâts et

les peaux de leurs tipis. Cependant les rails du train transcontinental, en 1869, vinrent couper en deux les pâturages des bisons et amenèrent les chasseurs blancs qui les décimèrent. Les Indiens des prairies menèrent une longue et âpre lutte, mais elle prit fin à Wounded Knee en 1890.

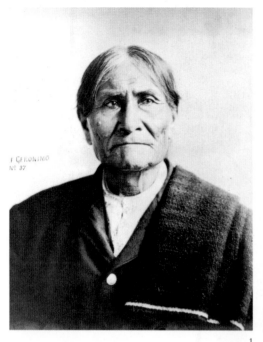

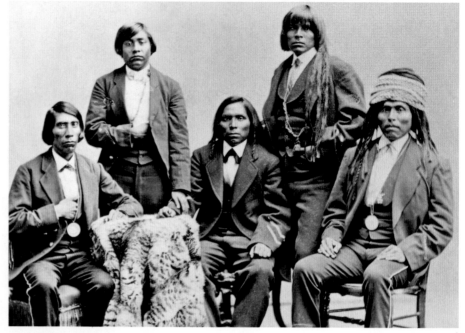

1

2

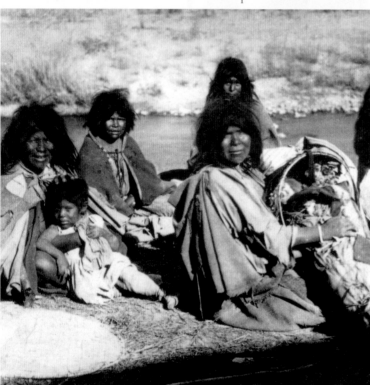

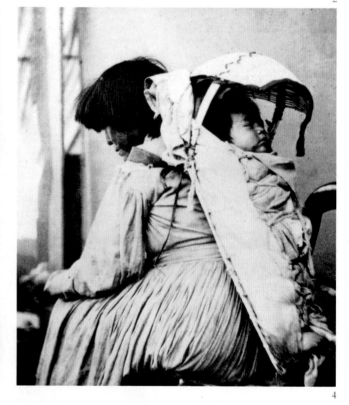

3

4

THE Indian wars ended: the chiefs lived on. Geronimo (1) ended his days on an Apache reservation. The Shoshone (3 and 4) stayed in Utah, and were westernized for the camera by the Mormons (2). These Fraser River Indians in British Columbia (5) had to scratch for the poorest of livings. The Blackfoot stayed on the Plains, but fighting days were over for this warrior (6), and for Red Cloud and American Horse (7). By 1891 'The Home of Mrs American Horse' (8) in South Dakota had a forlorn look to it, although it had once been a chief's lodge.

DIE Indianerkriege waren zu Ende, aber die Häuptlinge lebten weiter. Geronimo (1) verbrachte seine letzten Tage in einem Apachenreservat. Die Shoshonen (3, 4) blieben in Utah und wurden von Mormonen für die Kamera westlich zurechtgemacht (2). Diese Indianer vom Fraser River in British Columbia (5) mußten um ihren kargen

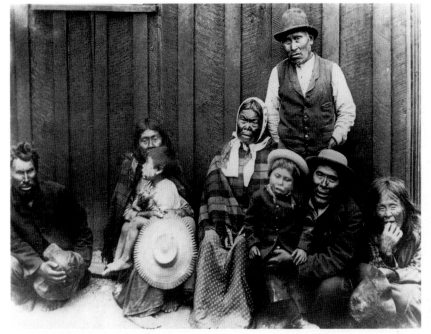

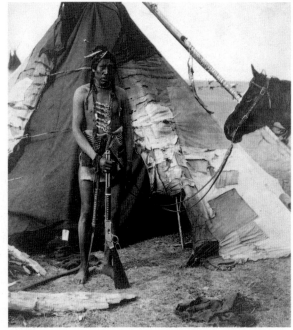

5

6

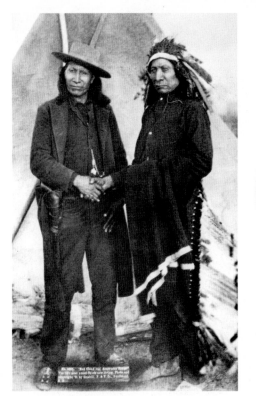

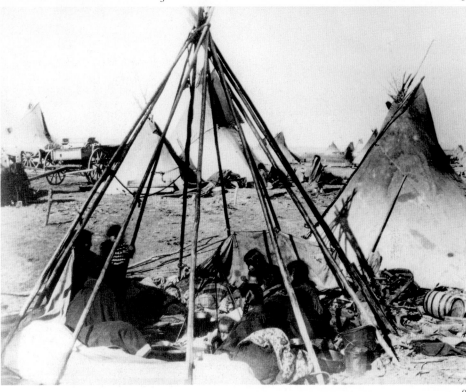

7

8

Lebensunterhalt kämpfen. Die Blackfoot blieben in der Prärie, aber für diesen Krieger (6), für Red Cloud und American Horse (7) waren die Tage des Kampfes vorbei. »The Home of Mrs American Horse« (8) in South Dakota sah 1891 heruntergekommen und verlassen aus, obwohl es einst Wohnsitz eines Häuptlings gewesen war.

L ES guerres indiennes s'achevèrent. Geronimo (1) finit ses jours dans une réserve apache. Les Shoshones (3 et 4) demeurèrent en Utah où l'appareil photo-graphique des Mormons les occidentalisa (2). Ces Indiens du Fraser menaient une exis-tence misérable en Colombie-Britannique (5). Les Blackfoot restèrent dans les prairies,

mais le temps des combats était terminé pour ce guerrier (6), comme pour Red Cloud et American Horse (7). En 1891, « la maison de Madame American Horse » (8) dans le Dakota du Sud avait un air de solitude délabrée ; et pourtant elle avait été autrefois le camp d'un chef.

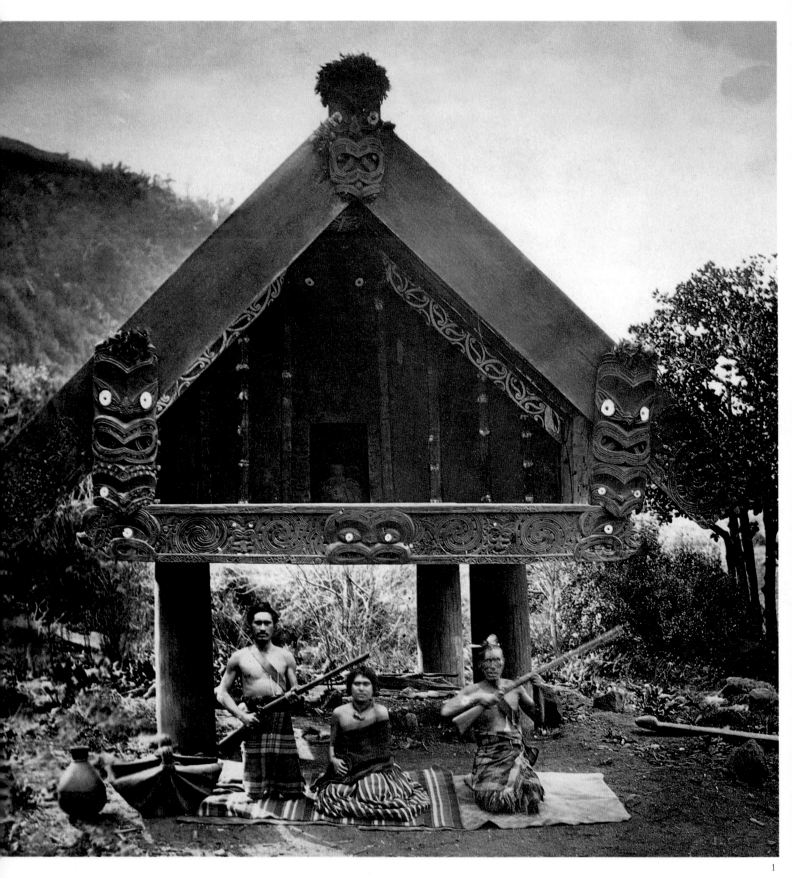

UNTIL 1871, the Maoris (1) were
frequently at war with the British,
though they were more likely to shoot
each other in wars of blood-vengeance
than to kill white settlers. The Ashanti (2)
were also an aggressive people. 'If power is
for sale,' ran one of their proverbs, 'sell

your mother to buy it – you can always
buy her back again.' Life was more relaxed
in Freetown (3), capital of Sierra Leone
on the West Africa coast, and a haven for
thousands of freed slaves. It was a town
of 'civilization, Christianity and the
cultivation of the soil.'

BIS zum Jahre 1871 führten die Maori
(1) häufig Krieg gegen die Briten,
obwohl es wahrscheinlicher war, daß
sie sich gegenseitig in Blutfehden
erschossen, als weiße Siedler zu töten.
Die Ashanti (2) waren ebenfalls ein
aggressives Volk. »Wenn man Macht
kaufen kann«, so lautete eines ihrer
Sprichwörter, »dann verkauf deine

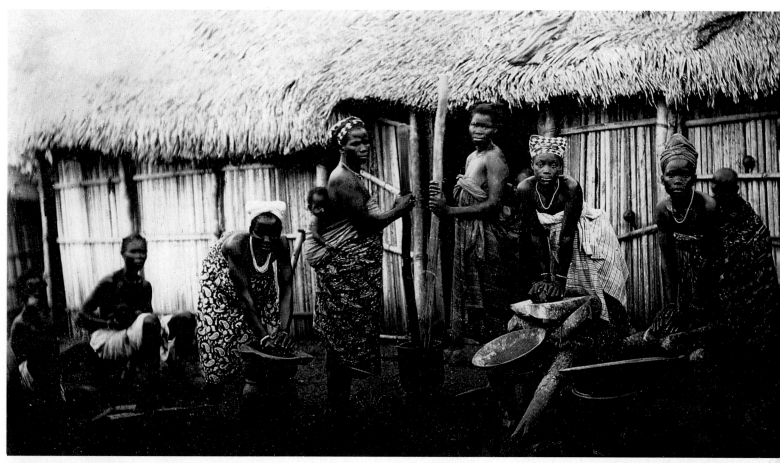

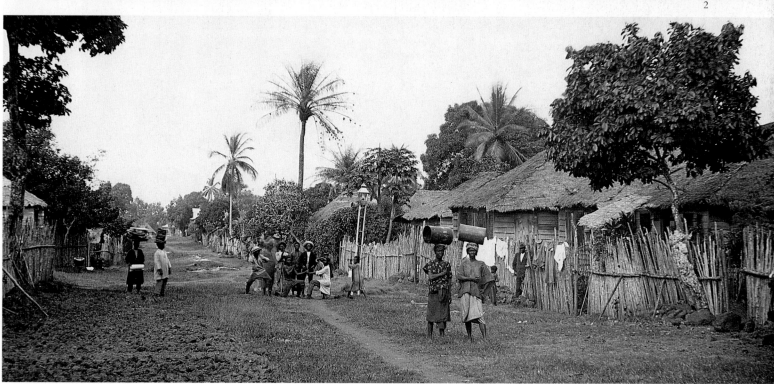

Mutter, um sie dir zu kaufen, du kannst deine Mutter ja jederzeit zurückkaufen.« Entspanntere Verhältnisse herrschten in Freetown (3), der Hauptstadt von Sierra Leone an der afrikanischen Westküste, einem Zufluchtsort für Tausende befreite Sklaven. Es war eine Stadt der »Zivilisation, des Christentums und der Kultivierung des Bodens«.

Jusqu'en 1871 les Maoris (1) étaient souvent en lutte contre les Britanniques. Il était cependant plus courant de les voir s'entre-tuer que supprimer les colons blancs. Les Ashanti (2) étaient eux aussi un peuple agressif. Un de leurs proverbes disait : « Si le pouvoir est à vendre, vends ta mère et

achète-le. Tu pourras toujours la racheter. » La vie était plus tranquille à Freetown (3), la capitale du Sierra Leone, située sur la côte de l'Afrique de l'Ouest, qui accueillit des milliers d'esclaves affranchis. C'était une ville de « civilisation, de chrétienté et de culture du sol. »

Paila

EUROPEANS were interested in Chile for two reasons: nitrates and manganese. For the inhabitants of a run-down street (1) the best that life could offer was a ticket to sail a few thousand miles up the Pacific coast to California. Life was better on Bermuda (2), a coaling station for the ubiquitous British fleet, blessed with its own Constituent Assembly and a railway line – although the island is only twenty miles long. The black workers who lived in log huts at Thomasville, Georgia, in the USA (3), were also near a railway – the Florida and Western Railroad – but they had little occasion to use it on the wages they were paid.

DIE Europäer waren an Chile aus zwei Gründen interessiert: Nitrate und Mangan. Für die Bewohner eines Slums (1) war das Beste, was ihm das Leben bieten konnte, eine Schiffspassage einige Tausend Meilen die Pazifikküste hinauf nach Kalifornien. Auf Bermuda (2) war das Leben besser; dort befand sich ein Kohlenlager der allgegenwärtigen britischen Flotte, die über

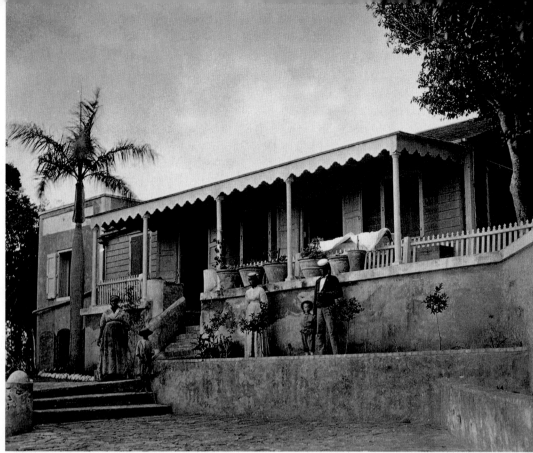

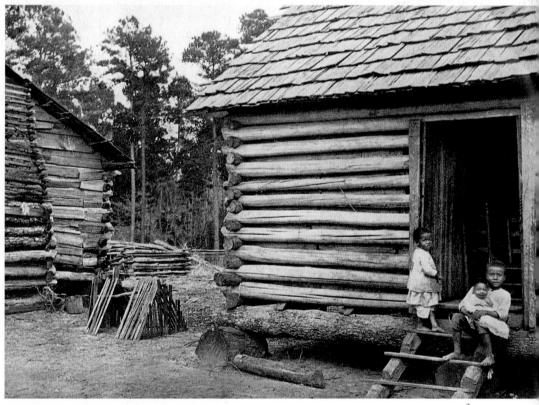

eine eigene konstituierende Versammlung und eine Eisenbahnlinie verfügte, obwohl die Insel nur 32 Kilometer lang ist. Die schwarzen Arbeiter, die in Holzhütten in Thomasville, Georgia, USA, lebten (3), waren auch in der Nähe einer Eisenbahn, der Florida and Western Railroad, aber angesichts ihrer niedrigen Löhne hatten sie kaum Gelegenheit, sie zu benutzen.

LES Européens s'intéressaient au Chili pour deux raisons : les nitrates et le manganèse. Pour les habitants de cette rue délabrée (1), ce qui pouvait leur arriver de mieux était de se voir offrir un billet de bateau pour remonter le littoral du Pacifique jusqu'à la Californie. On vivait mieux aux Bermudes (2), qui servaient de dépôt de charbon à l'omniprésente flotte britannique et bénéficiaient de leur propre assemblée

constituante ainsi que d'une voie de chemin de fer alors que l'île ne fait que 32 kilomètres de long. Les ouvriers noirs vivant dans des cabanes en rondins à Thomasville, en Géorgie, aux États-Unis (3), se trouvaient eux aussi près d'une ligne de chemin de fer – the Florida and Western Railroad – qu'ils n'avaient cependant guère l'occasion d'utiliser étant donné leurs salaires.

THE Psalms proclaimed that 'the earth is the Lord's and the fulness thereof'. But the Lord clearly intended most of the fruits of the earth to end up in Europe – whether rubber, tea, or coal. Man, mule and ox-cart carried tons of these and many other fruits to the nearest port, where local and international traders jostled for space – as here in Calcutta.

IN den Psalmen steht geschrieben: »Die Erde in all ihrer Fülle ist das Werk des Herrn.« Aber ob Kautschuk oder Kohle, der Herr hatte die meisten Früchte der Erde eindeutig für Europa bestimmt. Mensch, Lastesel und Ochsenkarren brachten Tonnen von diesen und anderen Früchten zum nächstgelegenen Hafen, wo sich, wie hier in Kalkutta, einheimische und internationale Händler tummelten.

LES psaumes proclament : « À l'Éternel la terre et ce qu'elle renferme ». Toutefois, le Seigneur avait manifestement voulu que la plupart des fruits de la terre finissent en Europe, qu'il s'agisse du caoutchouc, du thé ou du charbon. Des tonnes entières en étaient transportées, et bien d'autres fruits, à dos d'homme ou de mule, et dans des charrettes tirées par des bœufs jusqu'au port le plus proche où les commerçants locaux et les négociants internationaux se disputaient la place, comme ici à Calcutta.

Aviation and Railways

THE world was turned upside down by changes in transport during the latter half of the 19th century. Bus rides across cities, train journeys across continents, voyages by steamship across oceans – all were faster, cheaper, safer, more reliable. The Duke of Wellington had grumpily declared that he saw no reason to suppose that steam trains 'would ever force themselves into general use', but His Grace was profoundly wrong. By 1850 there were 1870 miles (3,000 km) of railway in France, 3,735 miles (6,000 km) in Germany and 6,621 miles (10,500 km) in Britain. There were railways in North America, China, Japan, India, Africa, and Australia. Along the sea lanes of the world steamships huffed and puffed their prosperous way transporting hundreds of thousands of tons of pig-iron – the basic ingredient of any railway system.

There were underground railways (the first in 1865), electric railways (the first main line service in 1895), rack-and-pinion mountain railways (Thomas Cook owned the funicular up Mount Vesuvius), and luxury railways (the *Orient Express* was inaugurated on 4 October 1883). In 1891 Tsar Alexander gave the go-ahead for the Trans Siberian Railway to the Tsarevich in bold and imperious words:

'Your Imperial Highness!
Having given the order to build a continuous line of railway across Siberia… I entrust you to declare My will, upon your entering the Russian dominions after your inspection of the foreign countries of the East.'

And, so there should be no doubt as to the route of this 4,000-mile (6,400 km) undertaking, the Tsar drew a straight line right across the said dominions. Dostoyevsky hated railways. Dickens loved them.

In 1852 Henry Giffard, a French engineer, built an airship driven by a screw-propelled steam engine. It was a success, chugging along at only some five miles (eight km) an hour but staying up in the sky. But this was not enough for the German pioneer Otto Lilienthal. He had spent years studying the principles of flight, watching birds to see how they used air currents and how their wings controlled their speed, their ascent and descent. In 1889 he published *Bird Flight as a Basis of Aviation*. Two years later he built a glider with two wings made from cotton twill stretched over a willow framework (1). By running and leaping from a platform 20 ft (6 m) high, Lilienthal was able to glide for 25 yards (25 m). In 1896 he built a more solid glider (2), with two sets of wings and better controls, allowing him more time in the air, but that same year he was killed in a gliding accident at Stollen.

Others took up where Lilienthal left off. An Englishman, Percy Pilcher, built a glider with an undercarriage, and was experimenting with a powered machine when he, too, was killed. The following year (1900) the American Wright brothers began gliding at Kitty Hawk, North Carolina. They streamlined the gliding process by lying along the lower wing, instead of dangling their bodies from the framework as Lilienthal had done. By 1901 they were able to make flights of some 200 yards. From then on, progress was ridiculously rapid, spurred by much competition and the obvious military advantages to be gained from mastery of the skies.

Within a few years Alcock and Brown flew almost two thousand miles non-stop, at an average speed of 117 mph (184 kph), to cross the Atlantic.

Life was never the same again.

1

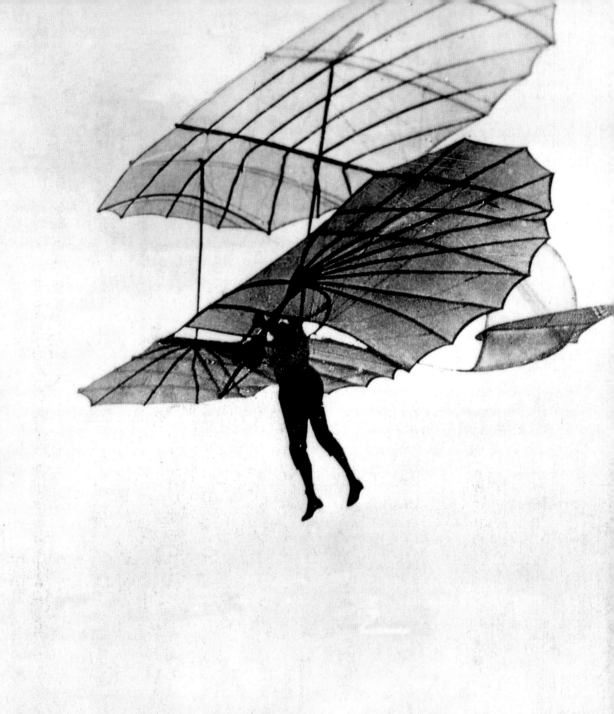

DIE Welt wurde durch die Veränderungen im Transportwesen, die sich in der zweiten Hälfte des 19. Jahrhunderts vollzogen, auf den Kopf gestellt. Busfahrten durch Städte, Zugreisen durch Kontinente, Überquerungen von Ozeanen mit dem Dampfschiff – alles war schneller, billiger, sicherer und zuverlässiger geworden. Der Duke of Wellington hatte mürrisch erklärt, er sehe keinen Grund zu der Annahme, daß Dampflokomotiven »sich jemals durchsetzen werden«, aber Seine Hoheit irrte gewaltig. Im Jahre 1850 zogen sich 3 000 Kilometer Gleise durch Frankreich, 6 000 Kilometer durch Deutschland und 10 500 Kilometer durch Großbritannien. Es gab Eisenbahnen in Nordamerika, China, Japan, Indien, Afrika und Australien. Auf den Seewegen der Welt fuhren rauchende Dampfschiffe und transportierten Hunderttausende Tonnen Roheisen – Grundbestandteil eines jeden Eisenbahnnetzes.

Es gab Untergrundbahnen (die erste im Jahre 1865), elektrische Eisenbahnen (die erste Hauptstrecke wurde 1895 in Betrieb genommen), Zahnradbahnen (Thomas Cook gehörte die Seilbahn, die zum Vesuv hinaufführte) und Luxuseisenbahnen (der *Orient Express* wurde am 4. Oktober 1883 eingeweiht). Im Jahre 1891 gab Zar Alexander dem Zarewitsch grünes Licht für die Transsibirische Eisenbahn – mit den kraftvollen und gebieterischen Worten:

»Eure Kaiserliche Hoheit!
Ich habe den Befehl gegeben, eine Eisenbahnstrecke durch Sibirien zu bauen … und ich beauftrage Sie, nach der Inspektion der fremden Länder des Ostens beim Betreten der russischen Herrschaftsgebiete meinen Willen zu verkünden!«

Und damit es keinen Zweifel über die Route des 6 400 Kilometer langen Unternehmens gab, zog der Zar eine gerade Linie durch die besagten Gebiete. Dostojewski haßte die Eisenbahn. Dickens liebte sie.

Im Jahre 1852 konstruierte der französische Ingenieur Henry Giffard ein Luftschiff, das mit einem dampfgetriebenen Schraubenpropeller angetrieben wurde. Ein voller Erfolg: Zwar tuckerte es nur mit acht Stundenkilometern dahin, es blieb aber in der Luft. Für den deutschen Luftfahrtpionier Otto Lilienthal war das jedoch nicht genug. Er hatte jahrelang die Gesetze des Fluges durch Beobachtung der Vögel studiert, um herauszufinden, wie diese die Luftströme nutzten und mit ihren Flügeln Geschwindigkeit, Auf- und Abstieg steuerten. Im Jahre 1889 veröffentlichte er die Schrift *Der Vogelflug als Grundlage der Fliegekunst*. Zwei Jahre später baute er einen Gleiter mit zwei Flügeln aus Baumwollköper, der über einen Rahmen aus Weidenholz gespannt war (1). Nach Anlauf und dem Sprung von einer sechs Meter hohen Plattform konnte Lilienthal 25 Meter weit gleiten. 1896 baute er einen stabileren Gleiter (2) mit zwei Flügelpaaren und verbesserter Steuerung, die es ihm ermöglichte, länger in der Luft zu bleiben, aber noch im selben Jahr verunglückte er tödlich mit dem Gleiter bei Stollen.

Andere setzten fort, was Lilienthal begonnen hatte. Der Engländer Percy Pilcher konstruierte einen Gleiter mit Fahrgestell und experimentierte mit Antriebsmaschinen, bis auch er ums Leben kam. Im darauffolgenden Jahr (1900) begannen die amerikanischen Gebrüder Wright in Kitty Hawk, North Carolina, mit ihren Gleitexperimenten. Sie machten den Gleitvorgang stromlinienförmig, indem sie sich auf den unteren Flügel legten, anstatt sich, wie Lilienthal, an den Rahmen des Gleiters zu hängen. Im Jahre 1901 konnten sie etwa 200 Meter weit fliegen. Seitdem wurden in kürzester Zeit große Fortschritte gemacht, gefördert durch die Konkurrenz und die offensichtlichen militärischen Vorteile, die man durch die Beherrschung der Lüfte gewinnen konnte.

Nur wenige Jahre später überquerten Alcock und Brown mit einer durchschnittlichen Geschwindigkeit von 184 Stundenkilometern den Atlantik im Nonstopflug.

Das Leben sollte nun nicht mehr dasselbe sein.

L'ÉVOLUTION des transports de la deuxième moitié du XIXe siècle avait chamboulé le monde. Les trajets en bus dans les grandes villes, les voyages en train à travers les continents, les traversées des océans en bateau à vapeur, tout était devenu plus rapide, meilleur marché, plus sûr et plus fiable. Le duc de Wellington maugréait qu'il ne voyait aucune raison de supposer que les trains à vapeur « parviennent jamais à s'imposer à l'usage de tous », mais sa Grâce était dans l'erreur. Dès 1850, il y avait 3 000 kilomètres de voies ferrées en France, 6 000 kilomètres en Allemagne et 10 500 en Grande-Bretagne. Il y avait des voies ferrées en Amérique du Nord, en Chine, au Japon, en Inde, en Afrique et en Australie. Sillonnant à coups de sirène les mers du monde, les bateaux à vapeur prospéraient grâce au transport des centaines de milliers de tonnes de saumon de fonte qui constituait la composante de base de tout système de chemin de fer.

Il y avait des voies ferrées souterraines (les premières datant de 1865), ou électriques (la première grande ligne entra en service en 1895), des chemins de fer à crémaillère en montagne (Thomas Cook possédait le funiculaire qui montait jusqu'en haut de la montagne du Vésuve) et des lignes pour trains de luxe (l'*Orient Express* fut inauguré le 4 octobre 1883). En 1891, le tsar Alexandre donna au tsarévitch le feu vert pour le chemin de fer transsibérien en ces termes clairs et impérieux :

« Votre Altesse !
Ayant donné l'ordre de construire une ligne
de chemin de fer continue à travers la Sibérie …
Je vous confie le soin de faire connaître que
telle est Ma volonté lorsque vous pénétrerez dans
les dominions russes une fois que vous en aurez
terminé avec votre inspection des pays étrangers de
l'Est. »

De manière à ne laisser planer aucun doute sur le tracé de ces 6 400 kilomètres d'ouvrage, le tsar traça un trait rectiligne au travers desdits dominions. Dostoïevski détestait les chemins de fer, Dickens les adorait.

En 1852, Henry Giffard, un ingénieur français, construisit un dirigeable mû par une machine à vapeur et une hélice. L'appareil fut un succès : émettant un bruit sourd et haletant, il ne faisait qu'environ huit kilomètres à l'heure, mais au moins il restait dans le ciel. Cela ne suffit cependant pas au pionnier que fut l'Allemand Otto Lilienthal. Il avait passé des années à étudier les principes du vol en observant les oiseaux et comment ceux-ci utilisaient les courants de l'air et leurs ailes pour contrôler leur vitesse, leur ascension ou leur descente. En 1889 il fit paraître *Bird Flight as a Basis of Aviation* (Du vol des oiseaux comme base de l'aviation). Deux ans plus tard, il construisait un planeur équipé de deux ailes en cotonnade de serge tendue sur une armature en saule (1). En s'élançant en courant d'une plateforme placée à une hauteur de six mètres, Lilienthal parvint à planer sur 25 mètres. En 1896 il construisit un planeur plus solide (2) équipé de deux paires d'ailes et de commandes perfectionnées qui lui permettaient de rester plus longtemps dans les airs. Mais il mourut la même année à Stollen dans un accident de planeur.

D'autres reprirent le flambeau. Un Anglais, Percy Pilcher, construisit un planeur muni d'un train d'atterrissage ; lui aussi se tua alors qu'il expérimentait une machine à moteur. L'année suivante (1900) des Américains, les frères Wright, se lancèrent dans les vols en planeur à Kitty Hawk, en Caroline du Nord. Ils en perfectionnèrent la technique en s'allongeant sur l'aile inférieure pour faire corps avec l'ossature, contrairement à ce que faisait Lilienthal. Dès 1901, ils étaient en mesure de planer sur environ 180 mètres. À partir de là, on peut parler de progrès ridiculement rapides, aiguillonnés par une forte concurrence et par les avantages militaires évidents que représentait la maîtrise des cieux.

À peine quelques années plus tard, Alcock et Brown traversaient l'Atlantique à la vitesse moyenne de 184 km/h en volant près de 32 186 kilomètres sans s'arrêter.

La vie avait changé du tout au tout.

THE French took to aviation like eagles to the air. In the great tradition of the Montgolfier Brothers, they were experimenting with vertical take-off planes in 1907 – Paul Cornu's prototype got a metre and a half off the ground before his brother threw himself on it, fearful that it was going out of control. On 13 January 1908, Henri Farman flew for 88 seconds at a height of 25 metres and a speed of 24 miles per hour (39 kph). Another early enthusiast was the Comte d'Ecquevilly, whose plane, seen here, seemed designed in honour of Chinese lanterns.

DIE Franzosen begeisterten sich für die Luftfahrt wie der Adler für die Lüfte. In der großen Tradition der Gebrüder Montgolfier experimentierten sie 1907 mit Flugzeugen, die senkrecht starteten. Paul Cornus Prototyp erhob sich 1,50 Meter über den Boden, bevor sein Bruder sich darauf warf, weil er befürchtete, das Flugzeug könne außer Kontrolle geraten. Am 13. Januar 1908 flog Henri Farman mit einer Geschwindigkeit von 39 Stundenkilometern 88 Sekunden lang in einer Höhe von 25 Metern. Ein weiterer früher Enthusiast war der Comte d'Ecquevilly, dessen hier abgebildetes Flugzeug von chinesischen Laternen inspiriert zu sein schien.

LES Français se lancèrent dans l'aviation tels des aigles à la conquête des airs. Fidèles à la grande tradition inaugurée par les frères Montgolfier, ils s'essayaient en 1907 au décollage à la verticale. Le prototype de Paul Cornu s'éleva de 150 centimètres au-dessus du sol avant que son frère ne se jetât dessus, craignant que la machine ne répondît plus aux commandes. Le 13 janvier 1908, Henri Farman vola pendant 88 secondes à une hauteur de 25 mètres et à une vitesse de 39 km/h. On voit ici l'avion aux allures de lanterne chinoise du comte d'Ecquevilly, un des enthousiastes de la première heure.

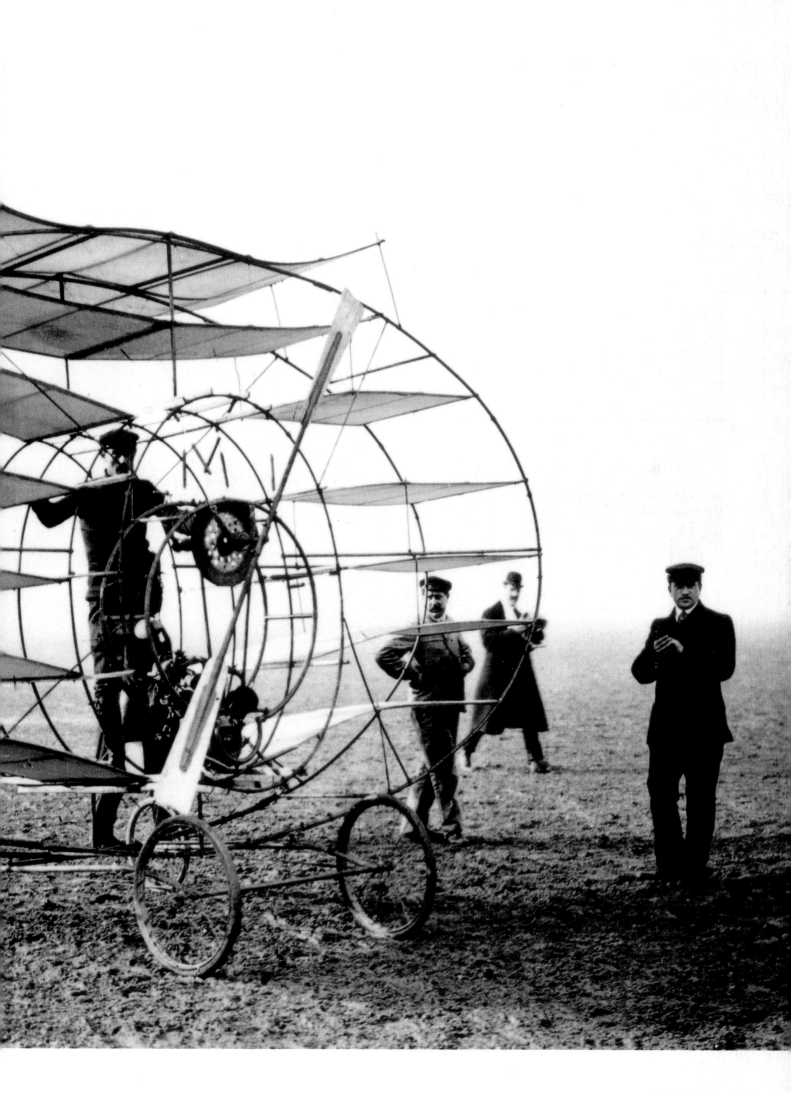

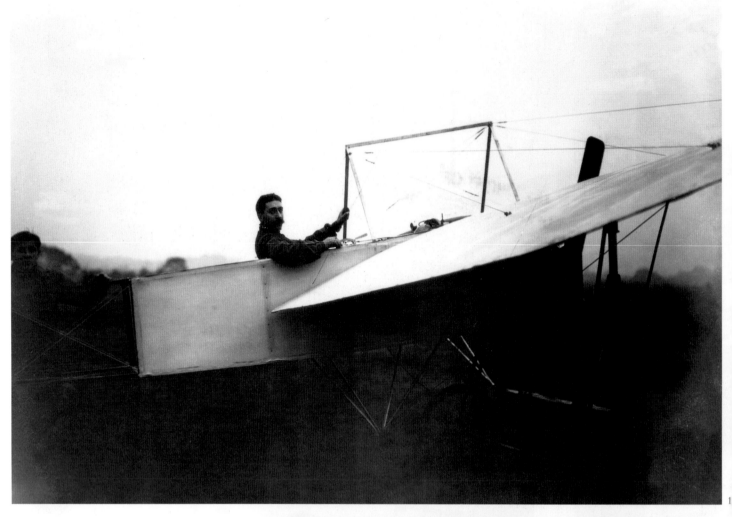

In 1909 a Blériot monoplane (1) flew across the Channel in 37 minutes. Wilbur Wright in 1908 (2): his brother Orville had made the first ever powered flight in an aeroplane. Tommy Sopwith (3). Alcock and Brown's historic Atlantic flight came to an abrupt end in Ireland on 15 June 1919 (4): their Vickers Vimy grounded.

Im Jahre 1909 überflog ein Blériot-Eindecker (1) den Ärmelkanal in 37 Minuten. Wilbur Wright (1908, 2): Sein Bruder Orville steuerte das erste Flugzeug mit Antriebsmaschine. Tommy Sopwith (3). Der historische Atlantikflug von Alcock und Brown kam am 15. Juni 1919 zu einem abrupten Ende (4): Ihre Vickers Vimy erhielt Startverbot.

En 1909, le monoplan de Blériot (1) traversa la Manche en 37 minutes. Wilbur Wright (1908, 2), l'année précédente. Orville, son frère, avait effectué le premier vol de l'histoire dans un aéronef à moteur. Tommy Sopwith (3). Le vol historique d'Alcock et de Brown au-dessus de l'océan Atlantique s'acheva de manière abrupte le 15 juin 1919 (4): leur Vickers Vimy n'obtint pas l'autorisation de décoller.

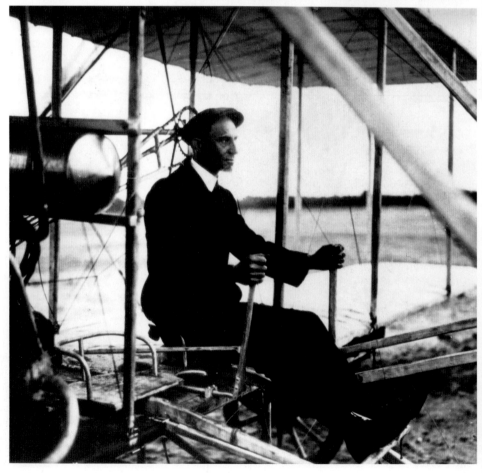

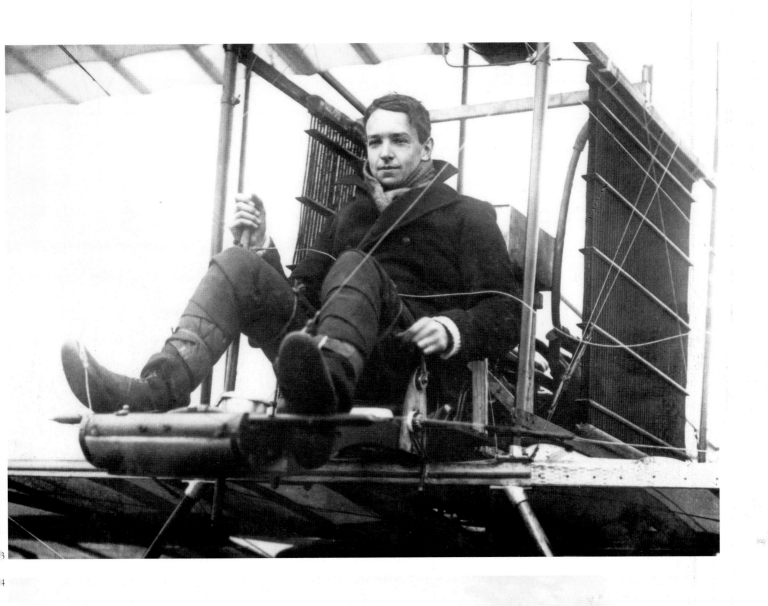

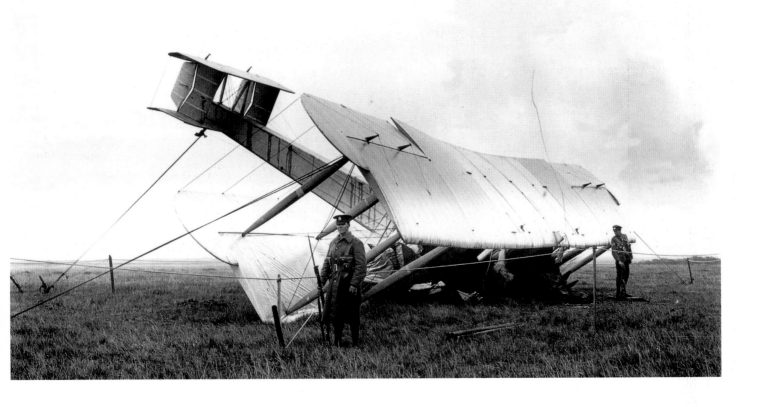

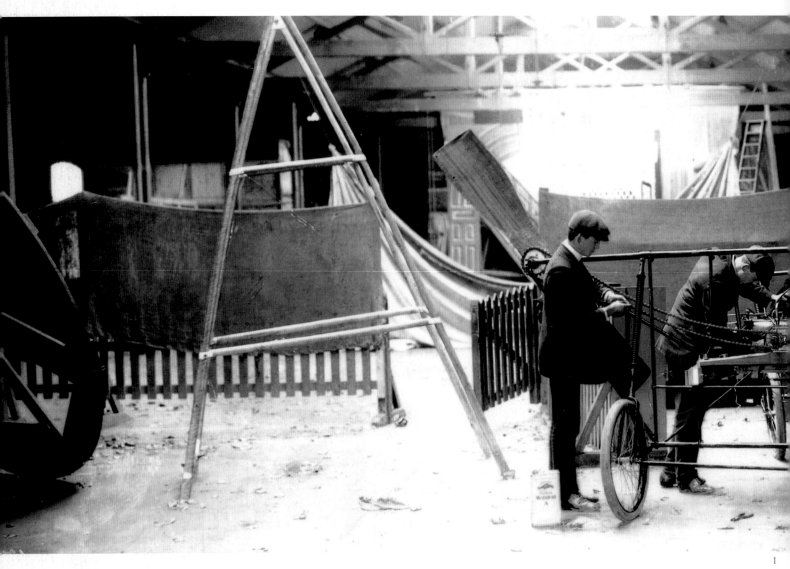

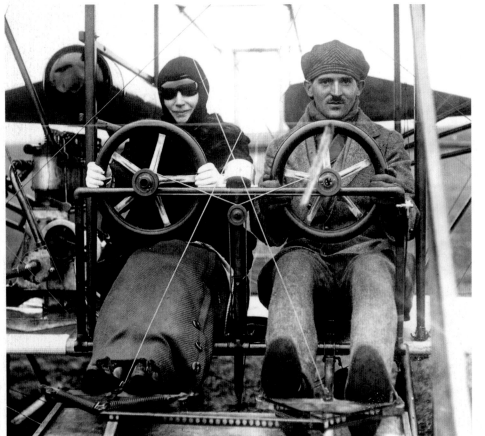

THE early days of flying belonged to the amateur (1). Princess Ludwig of Löwenstein-Wertheim learnt to fly in a dual-control biplane (2). Three men were needed to keep a plane steady once the engine had been started at the Army aeroplane testing ground in 1912 (3).

DIE frühen Tage der Fliegerei gehörten dem Amateur (1). Die Gemahlin des Prinzen Ludwig von Löwenstein-Wertheim lernte in einem Doppeldecker mit Doppelsteuerung fliegen (2). Bei den Flugzeugtests der britischen Armee (3) brauchte es 1912 drei Männer, um das Flugzeug am Boden zu halten, sobald der Motor gestartet war.

AU début, le vol était l'affaire d'amateurs (1). La princesse Ludwig de Löwenstein-Wertheim apprit à voler dans un biplan à double commande (2). Au cours des essais de l'armée de l'air en 1912 (3), trois hommes étaient nécessaires pour maintenir un avion au sol une fois déclenchés les moteurs de l'appareil.

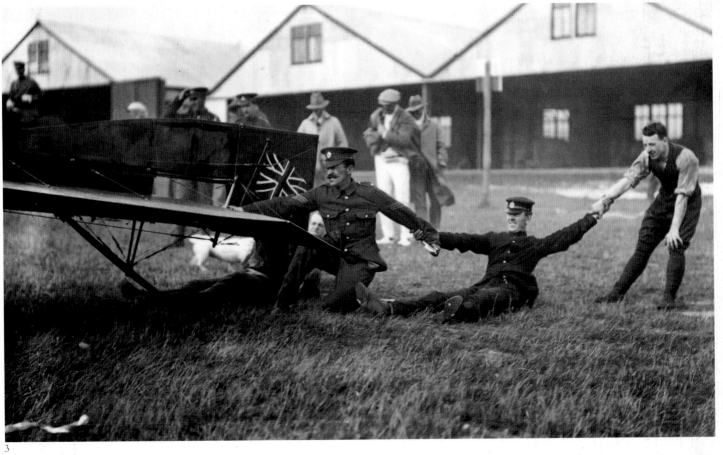

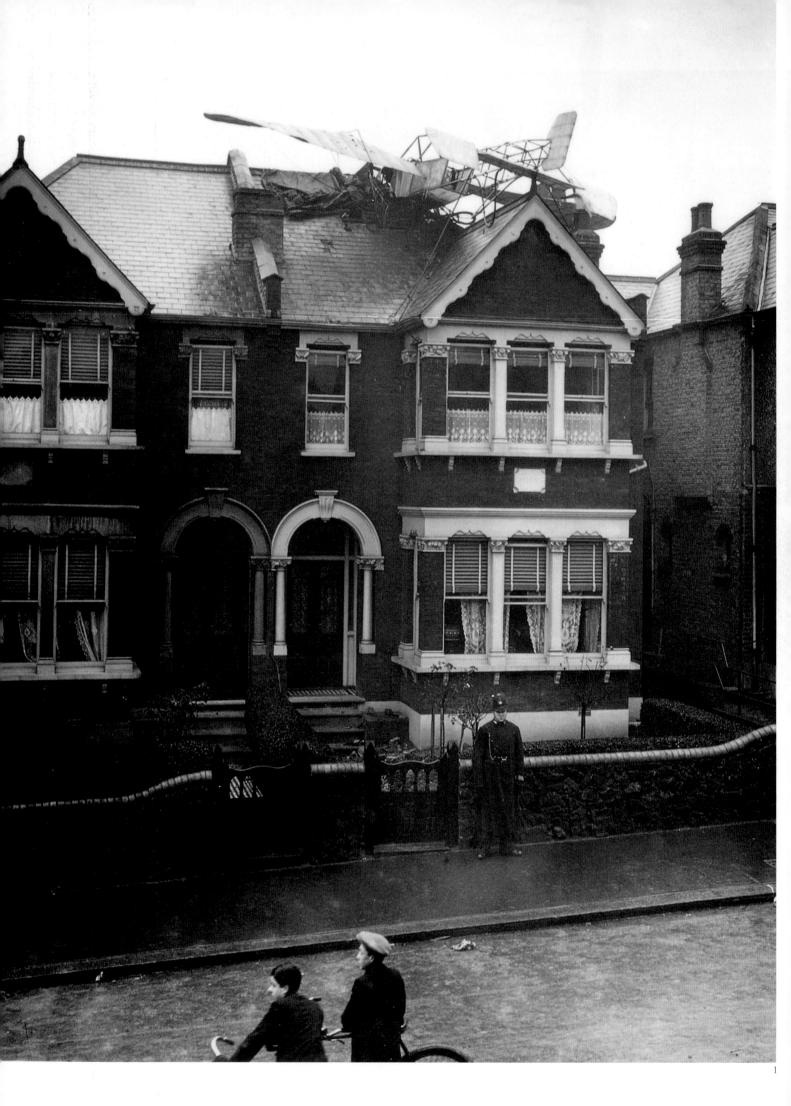

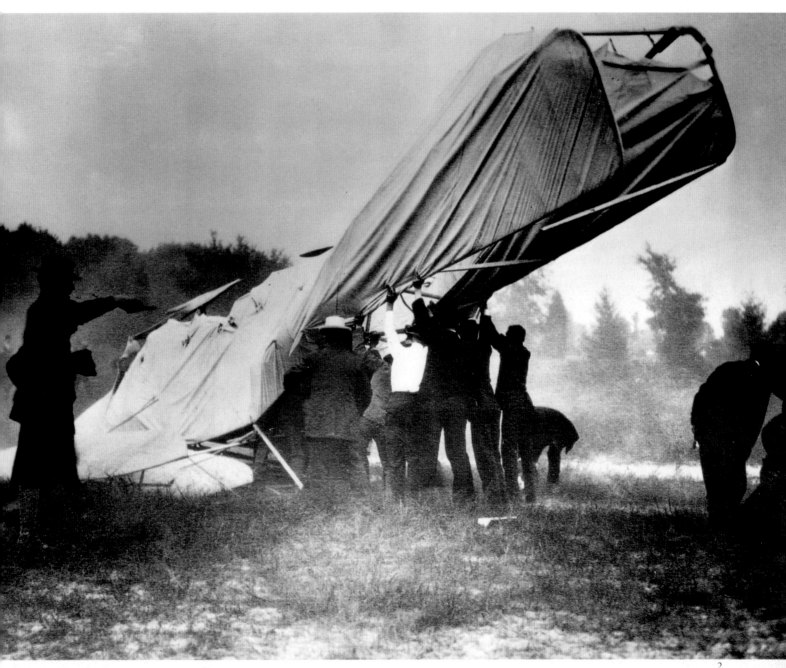

EARLY machines were frail, which made some of them unreliable, but at least meant that a minimum of damage was done when they fluttered from the sky, out of control. The roof of this house at Palmers Green, London, needed only a few slates replaced after a monoplane crashed into it in December 1912 (1). Pilots were often less fortunate. When a Wright Brothers plane crash-landed at Fort Meyer, Virginia, in September 1908, Orville Wright was injured and his co-pilot, Lieutenant Selfridge, was killed (2).

DIE ersten Maschinen waren zerbrech-lich und unberechenbar. Deshalb richteten sie auch nur wenig Schaden an, wenn sie außer Kontrolle gerieten und vom Himmel fielen. Beim Dach dieses Hauses in Palmers Green, London, mußten nur ein paar Pfannen erneuert werden, nachdem im Dezember 1912 ein Flugzeug hineingestürzt war (1). Die Piloten hatten oft weniger Glück. Als ein Flugzeug der Gebrüder Wright im September 1908 in Fort Meyer, Virginia, eine Bruchlandung machen mußte, wurde Orville Wright verletzt und sein Kopilot, Lieutenant Selfridge, getötet (2).

LES premières machines étaient frêles, ce qui les rendait parfois peu fiables, mais au moins elles causaient des dégâts minimes quand, ne répondant plus aux commandes, elles venaient s'abattre sur le sol. Il suffit de remplacer quelques ardoises sur le toit de cette maison à Palmers Green à Londres après qu'un monoplan s'y abattit en décembre 1912 (1). Les pilotes avaient souvent moins de chance. Lorsqu'un des avions des frères Wright s'écrasa au sol à Fort Meyer en septembre 1908 en Virginie, Orville Wright fut blessé et son copilote, le Lieutenant Selfridge, tué (2).

AIRSHIPS lacked the manoeuvrability of planes, but were believed to be more reliable, and could carry heavier loads. The Stanley Spencer airship, which made its first flight across London in 1902 (1), appears a direct descendant of the hot-air balloons of the Montgolfier Brothers, a hundred and twenty years earlier. But airships needed vast supplies of gas, such as these cylinders for the British R34 in 1919 (2), and even airships were not totally safe. L2, one of the earliest Zeppelins, crashed near Berlin in October 1913 (3).

LUFTSCHIFFE besaßen nicht die Manövrierfähigkeit von Flugzeugen, aber sie wurden für zuverlässiger gehalten und konnten größere Lasten transportieren. Das Luftschiff von Stanley Spencer, das 1902 seinen ersten Flug über London machte (1), war ein direkter Nachfahre des 120 Jahre zuvor entwickelten Heißluftballons der Gebrüder Montgolfier. Aber Luftschiffe brauchten große Mengen Gas, wie diese Zylinder für das britische R34 im Jahre 1919 zeigen (2), und selbst sie waren nicht vollkommen sicher. Der L2, einer der ersten Zeppeline, verunglückte im Oktober 1913 in der Nähe von Berlin (3).

LES dirigeables étaient moins maniables que les avions, mais ils passaient pour plus fiables et pouvaient transporter des charges plus lourdes. Le dirigeable Stanley Spencer, qui effectua son premier survol de Londres en 1902 (1), semble un descendant direct des ballons remplis d'air chaud des frères Montgolfier, quelque 120 ans plus tôt. Mais les dirigeables avaient d'énormes besoins en gaz, comme le montrent ces réservoirs cylindriques destinés au R34 britannique en 1919 (2), et même eux n'étaient pas totalement sûrs. Le L 2, un des premiers Zeppelins, s'écrasa près de Berlin en octobre 1913 (3).

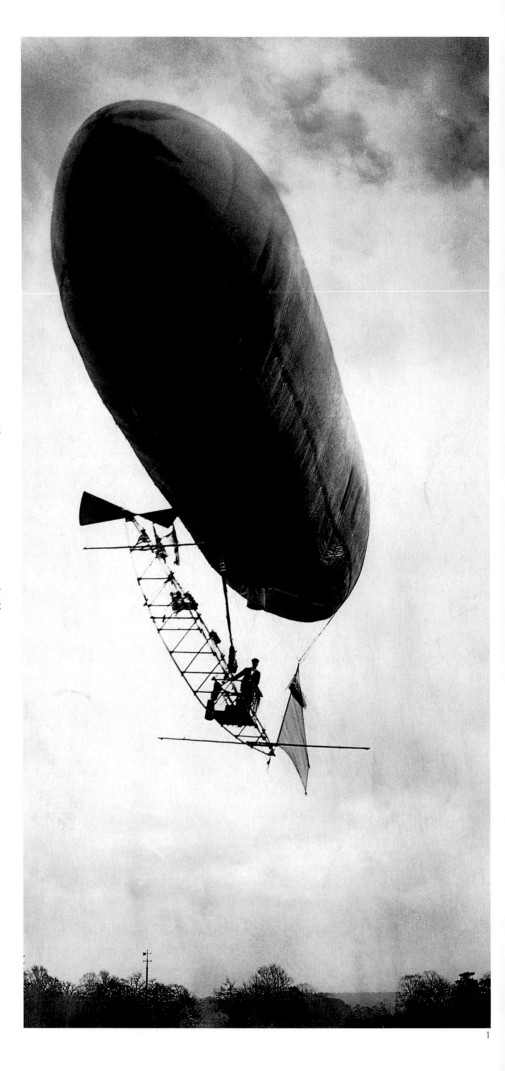

1

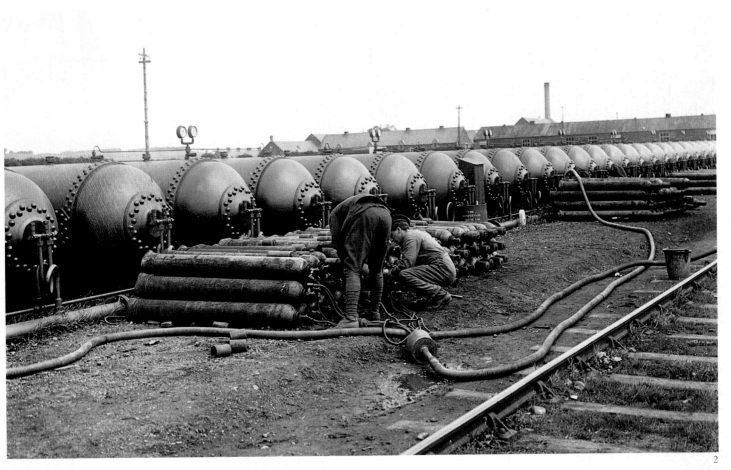

2

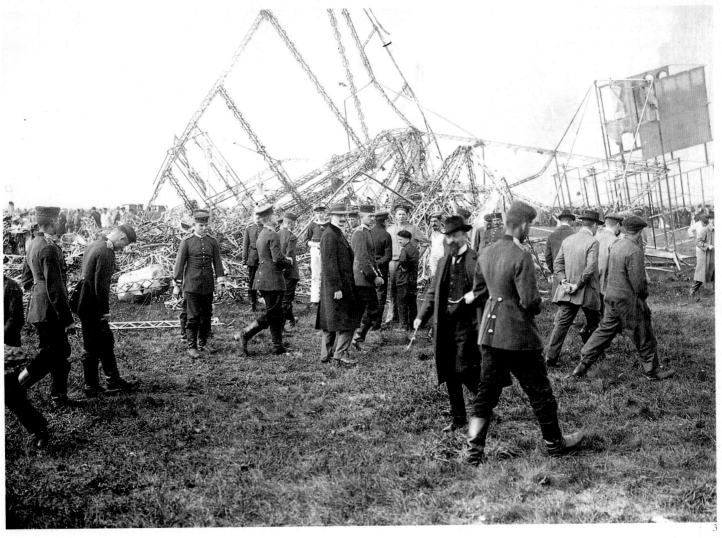

3

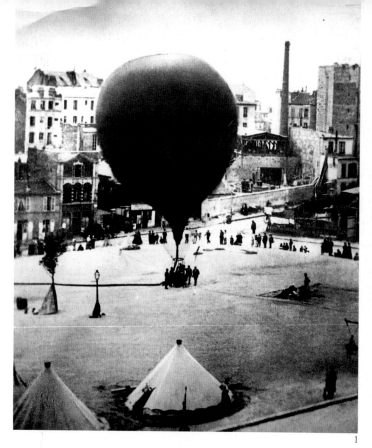

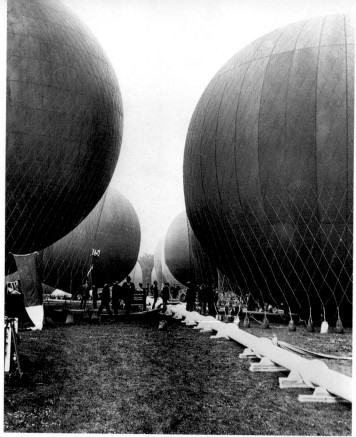

1

2

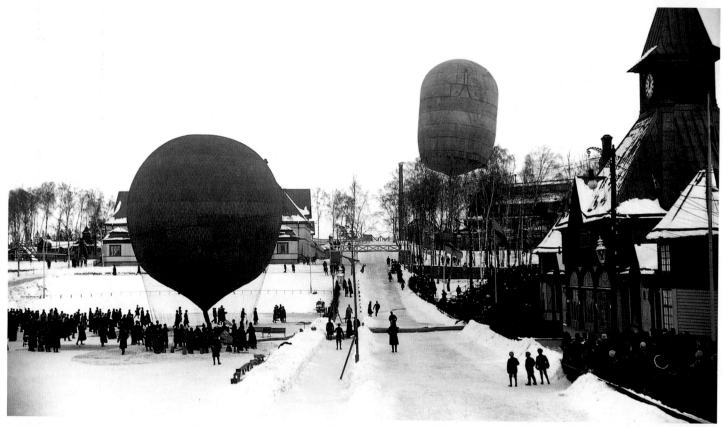

3

Dᴜʀɪɴɢ the siege of Paris in 1870, balloons took off each week with official despatches and news of conditions in the city. The most famous flight was that of Gambetta, on a mission to raise a provincial army (1). Massed balloons at Hurlingham in 1908 (2); at the Northern games in 1909 (3); the Berlin Balloon Society's meeting in 1908 (4).

Wᴀ̈ʜʀᴇɴᴅ der Belagerung von Paris im Jahre 1870 stiegen in der französischen Hauptstadt regelmäßig Ballons mit offiziellen Depeschen und Berichten über die Zustände in der Stadt in die Höhe. Der berühmteste Flug war der von Gambetta (1), dessen Mission darin bestand, eine Provinzarmee aufzustellen. Eine Ansammlung von Ballons 1908 in Hurlingham (2); 1909 bei den Nordischen Spielen (3); das Treffen der Berliner Ballongesellschaft 1908 (4).

Dᴜʀᴀɴᴛ le siège de Paris en 1870, deux à trois ballons en moyenne quittaient la ville chaque semaine en transportant des dépêches officielles et des nouvelles sur la situation. Le vol le plus fameux fut celui de Gambetta (1) qui avait pour mission de lever une armée en province. Un rassemblement de ballons à Hurlingham en 1908 (2) ; les jeux nordiques en 1909 (3). Un rassemblement organisé par la société pour la promotion des ballons à Berlin en 1908 (4).

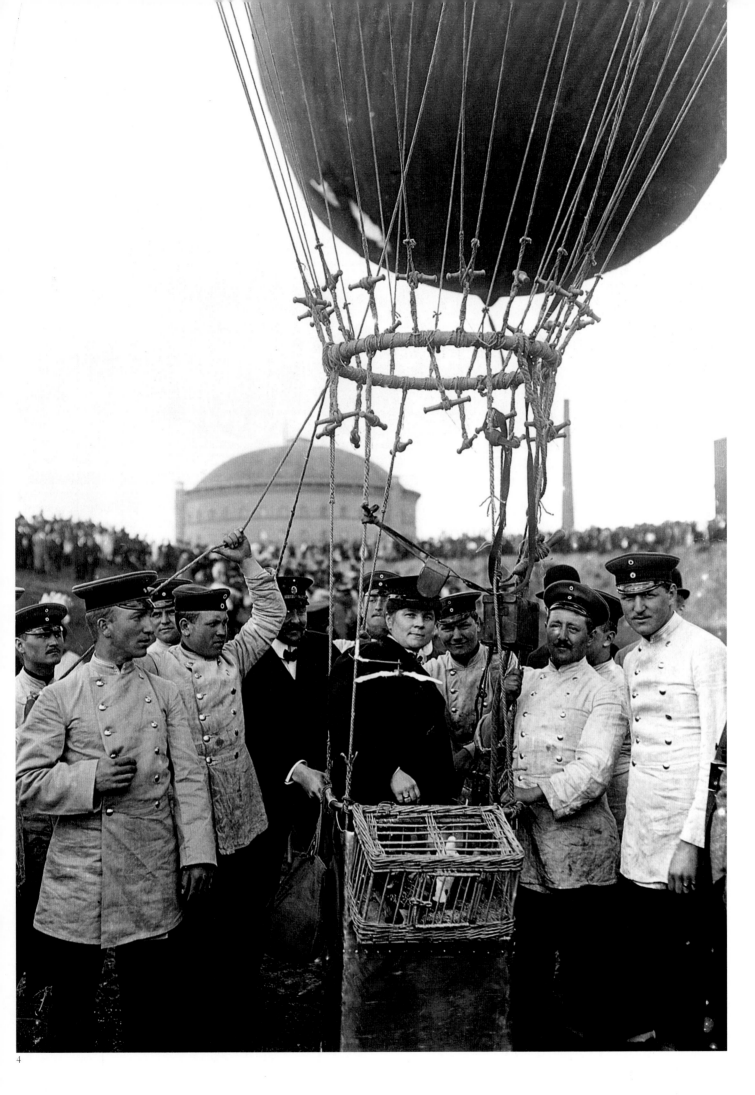

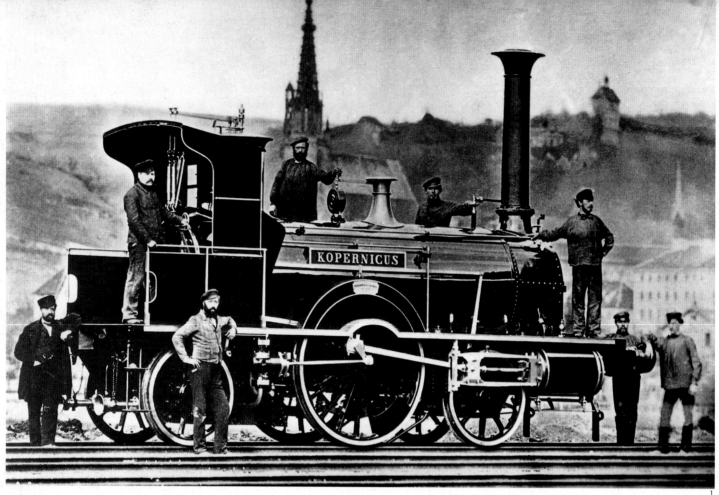

As far back as 1828, Goethe had told his friend Eckermann that Germany would one day be united – its good highways and future railways would make sure of that. Twelve years later, Treitschke wrote: 'It is the railways which first dragged the nation from its economic stagnation.' One machine that helped do the dragging was Kopernicus, a mighty iron monster of 1858 (1). Less impressive but more ingenious was the first electric train, made by Werner Siemens in 1879 (2). The world's first underground railway, between Padding-ton and the City of London, opened on 24 May 1862: Gladstone was on board (3). In 1860, this locomotive had to be hauled by road from the nearest railhead to its Welsh branch line (4).

Bereits 1828 hatte Goethe seinem Freund Eckermann gesagt, es bestehe kein Zweifel daran, daß Deutschland eines Tages vereint sein werde, seine guten Straßen und zukünftigen Eisen-bahnen würden dafür sorgen. Zwölf Jahre später schrieb Treitschke: »Es war die Eisenbahn, die die Nation aus ihrer wirtschaftlichen Stagnation gezogen hat.« Eine Maschine, die dabei half, war Koper-nicus, ein mächtiges eisernes Monster aus dem Jahre 1858 (1). Weniger beein-druckend, aber genialer war die erste Elektrolok von Werner Siemens von 1879 (2). Die erste Untergrundbahn der Welt fuhr zwischen Paddington und London City; sie wurde am 24. Mai 1862 ein-geweiht. Gladstone war an Bord (3). Im Jahre 1860 mußte diese Lokomotive auf der Straße zum nächstgelegenen Gleisende des walisischen Schienennetzes gezogen werden (4).

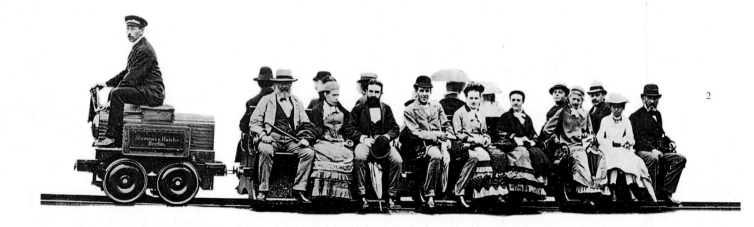

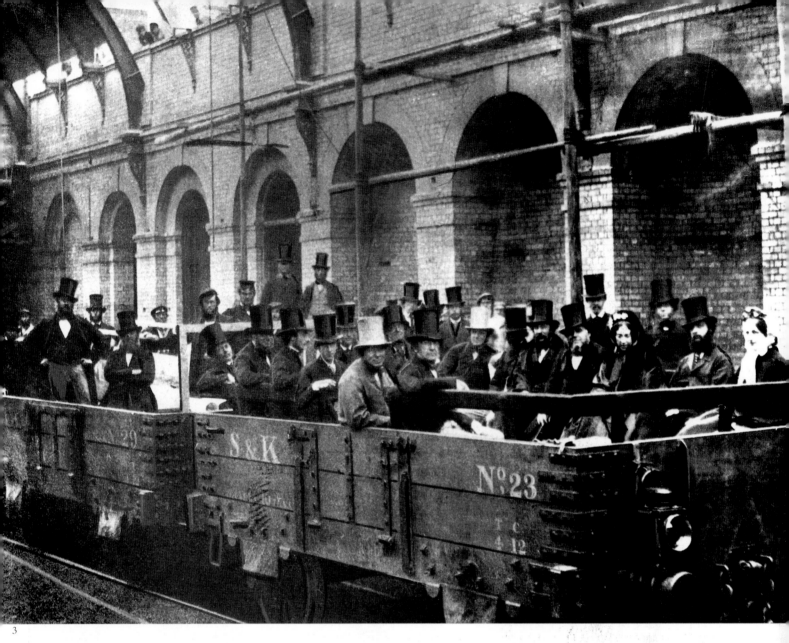

3

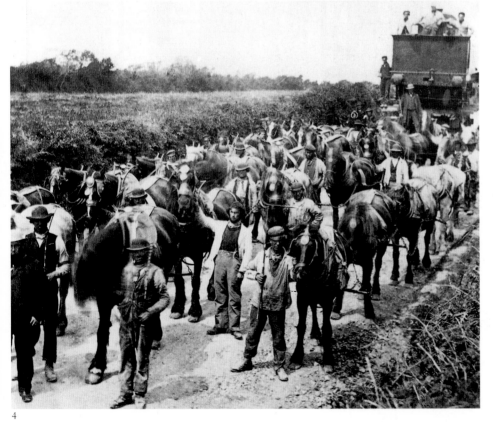

Déjà en 1828 Goethe disait à son ami Eckermann qu'il ne faisait aucun doute que l'unité de l'Allemagne se ferait un jour, et cela grâce à son bon réseau routier et à ses futures lignes de chemin de fer. Douze ans plus tard, Treitschke écrivait : « C'est le chemin de fer qui le premier a fait sortir la nation [allemande] de sa stagnation économique. » Une des machines qui y contribua fut le Kopernicus, puissant monstre d'acier apparu en 1858 (1). Moins impressionnant mais plus ingénieux était le premier train électrique fabriqué par Werner Siemens qui fut présenté à la foire commerciale de Berlin en 1879 (2). Le premier métro souterrain du monde reliait Paddington à la city de Londres et fut mis en service le 24 mai 1862. William Gladstone (3) était à bord.

En 1860, cette locomotive devait être remorquée par la route de la tête de ligne la plus proche jusqu'à la station d'embranchement ferroviaire galloise (4).

4

THE most famous railways were those that straddled entire continents. Some countries owed their integrity to such lines. British Columbia refused to join the Dominion of Canada until a transcontinental line had been promised – the Canadian Pacific. Its forerunner was the Great Western Railway of Canada (1), photographed in 1859. In the early days, speeds were slower on North American railroads than European ones, so coaches and carriages had to provide a higher standard of comfort for passengers.

The dream of Cecil Rhodes and fellow empire-builders was a trans–African railway running from Cairo to the Cape of Good Hope, entirely in British hands. One leg of the route was completed with the line from Salisbury to Umtali in 1909 (2). But Cairo was a further 3,200 miles (5,000 km) away.

DIE berühmtesten Eisenbahnen waren jene, die ganze Kontinente durchquerten. Einige Länder verdankten solchen Eisenbahnnetzen ihre Einheit. British Columbia weigerte sich so lange, dem Dominion Kanada beizutreten, bis man eine transkontinentale Eisenbahn versprach, die Canadian Pacific. Ihr Vorläufer war die Great Western Railway of Canada (1), aufgenommen im Jahre 1859. In früheren Zeiten war die Reisegeschwindigkeit nordamerikanischer Eisenbahnen langsamer als die europäischer,

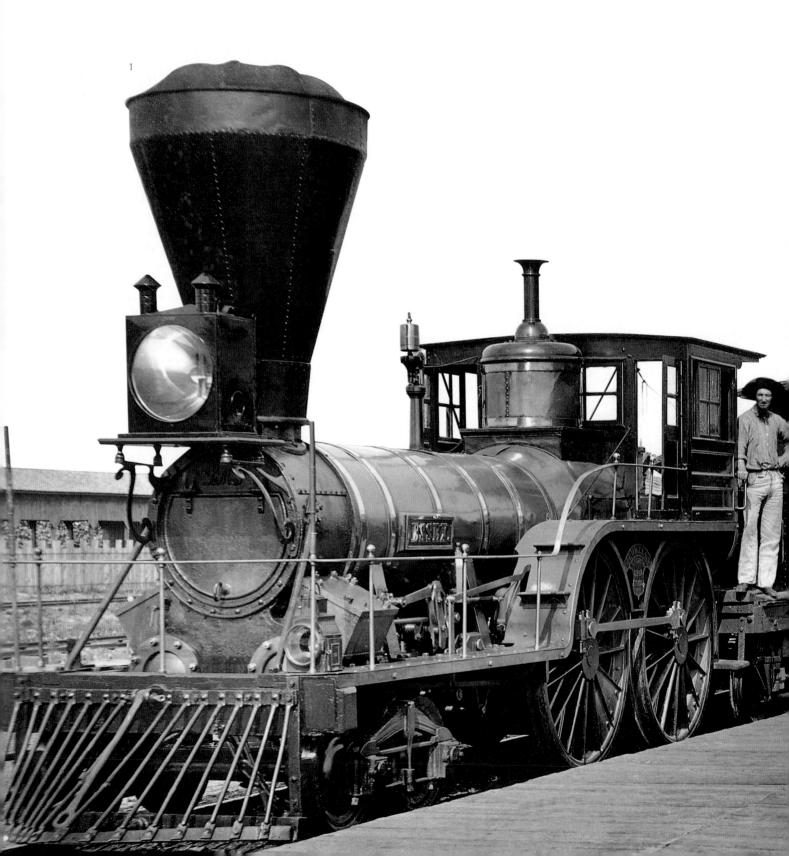

1

so daß die Waggons und Abteile den Passagieren mehr Komfort bieten mußten.

Der Traum von Cecil Rhodes und anderer Begründer des Empire war eine transafrikanische Eisenbahn, die von Kairo bis zum Kap der Guten Hoffnung fahren und völlig in britischer Hand sein sollte. Ein Teil der Route wurde 1909 mit der Verbindung von Salisbury nach Umtali fertiggestellt (2). Aber Kairo war noch weitere 5 000 Kilometer entfernt.

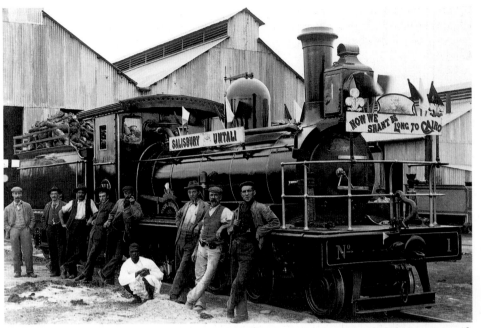

2

L ES lignes de chemin de fer les plus réputées étaient celles qui chevauchaient des continents entiers. Certains pays étaient entiers grâce à elles. La Colombie-Britannique refusa de rejoindre le dominion du Canada tant qu'il ne lui fut pas promis la construction d'une voie transcontinentale, le Canadian Pacific. Celle-ci fut précédée du Great Western Railway du Canada (1) photographié en 1859. Dans les premiers temps, les vitesses sur les tracés nord-américains étaient moindres qu'en Europe, de sorte que les compartiments et les voitures de voyageurs devaient fournir aux passagers un plus grand confort.

Le rêve de Cecil Rhodes et des bâtisseurs d'empires qu'étaient ses contemporains était une ligne transafricaine qui relierait le Caire au cap de Bonne-Espérance et qui serait entièrement entre les mains des Britanniques. Un des tronçons du tracé fut achevé avec la ligne de Salisbury jusqu'à Umtali en 1909 (2). Mais, jusqu'au Caire, il restait encore 5 000 kilomètres.

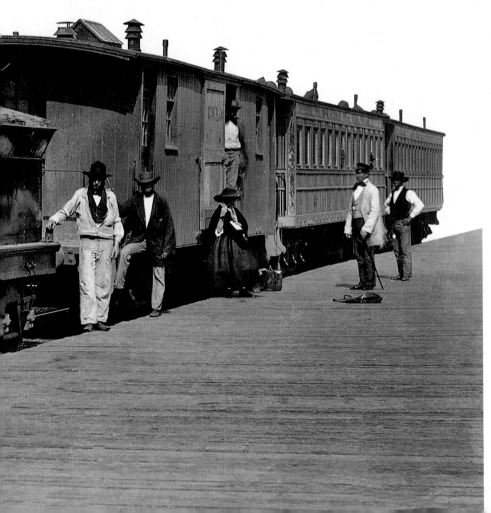

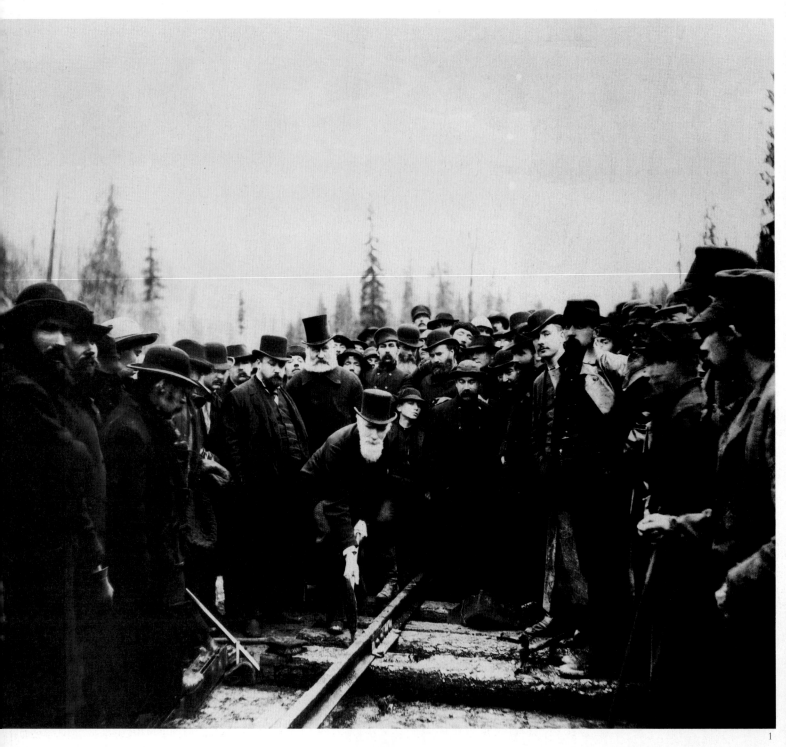

1

A T 9.30 am on 7 November 1885, the Honourable D. A. Smith drove in the silver spike that marked the completion of the Canadian Pacific Railroad, from the eastern seaboard to Vancouver (1). Third-class passengers on the CPR in 1885 were supplied with sleeping cars (2), an early form of the European couchette. Twenty-six years earlier, first-class passengers had more luxurious sleeping accommodation (3), but sleeping facilities for the men who built the railroads were primitive. These tents were for the engineers of the CPR, at the summit of the Selkirk Mountains in British Columbia (4). For a slightly more comfortable night, there were the liquors, cigars and beds available at Ed Lawler's Hotel – if the harp didn't keep you awake all night (5).

A M 7. November 1885 um 9.30 Uhr schlug D. A. Smith den silbernen Nagel ein, der die Fertigstellung der Canadian Pacific Railroad von der Ostküste nach Vancouver markierte (1). Passagiere der dritten Klasse der CPR konnten 1885 in solchen Liegewagen (2), einer frühen Form der europäischen *Couchettes*, fahren. Sechsundzwanzig Jahre zuvor hatten die Passagiere der ersten Klasse luxuriösere Schlafmöglich-

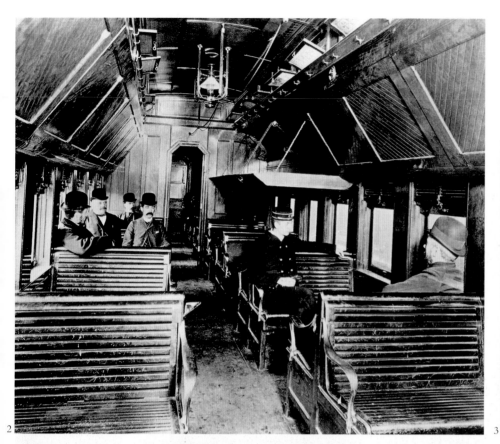

keiten (3), aber die Schlafplätze der Gleis-
arbeiter waren primitiv. Die Ingenieure
der CPR waren in diesen Zelten auf dem
Gipfel der Selkirk Mountains in British
Columbia untergebracht (4). Für eine beque-
mere Nacht gab es in Ed Lawlers Hotel
alkoholische Getränke, Zigarren und Betten,
falls die Harfenklänge einem nicht den
Schlaf raubten (5).

À 9 h 30 le 7 novembre 1885,
l'Honorable D. A. Smith marqua
solennellement avec une pointe en argent
l'achèvement de la ligne du chemin de
fer Pacifique canadien (CPR) reliant la
côte est à Vancouver (1). Les passagers
voyageant en troisième classe sur la CPR
en 1885 avaient à leur disposition des
voitures (2) équipées de couchettes qui
rappelaient les toutes premières couchettes
européennes. Vingt-six ans auparavant, les
voyageurs de première classe dormaient

dans des conditions plus luxueuses (3) ; en
revanche, les hommes qui construisaient
les chemins de fer dormaient dans des con-
ditions primitives. Ces tentes-ci étaient
réservées aux ingénieurs du CPR au sommet
des montagnes Selkirk en Colombie-
Britannique (4). Pour une nuit légèrement
plus confortable, il y avait les liqueurs,
les cigares et les lits de l'hôtel d'Ed Lawler,
si toutefois la harpe ne vous empêchait
pas de fermer l'œil de la nuit (5).

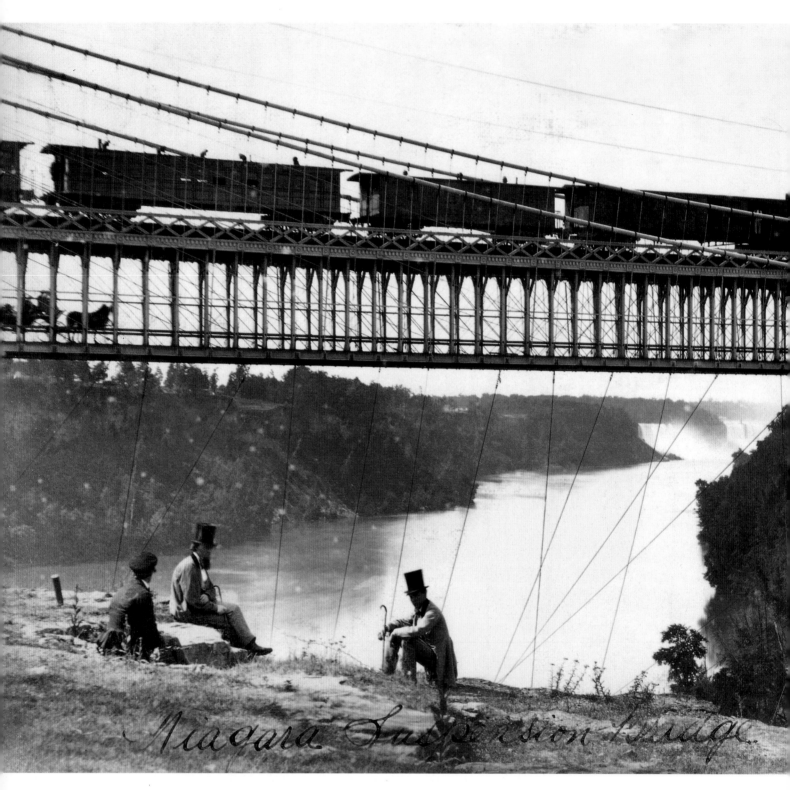

Niagara Suspension Bridge

THE engineering feats of the early railway builders were among the greatest of the age. The suspension bridge of the 1850s over the Niagara had a boxed-in roadway beneath the railroad line (1). Lethbridge Viaduct, Alberta, Canada, was a single-line track across an intricate series of metal supports (2). Many viaducts were originally built of timber trestles, later replaced by metal, as in the case of the Dale Creek bridge in Wyoming (3). The 'cowcatchers' fixed to the front of Canadian and American locomotives (4) really were to remove cows that had wandered on to the line, but were more often needed to shunt fallen timber or other obstacles.

DIE Konstruktionsleistungen der ersten Eisenbahningenieure gehörten zu den größten ihrer Zeit. Unter den Eisenbahngleisen der Hängebrücke über die Niagarafälle, die in den 1850er Jahren gebaut wurde, verlief ein weiteres Gleis (1). Der Lethbridge Viadukt in Alberta, Kanada, mit seiner komplizierten Anordnung von Metallträgern, konnte nur eingleisig befahren werden (2). Viele Viadukte waren ursprünglich auf Holzträgern gebaut, die später durch Metall ersetzt wurden, wie im Falle der Dale Creek Bridge in Wyoming (3). Der »Kuhfänger« am vorderen Teil kanadischer und amerikanischer Lokomotiven (4) sollte tatsächlich Kühe von den Gleisen vertreiben, wurde jedoch häufiger benötigt, um umgestürzte Baumstämme oder andere Hindernisse aus dem Weg zu räumen.

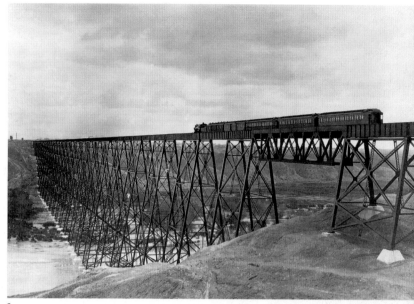

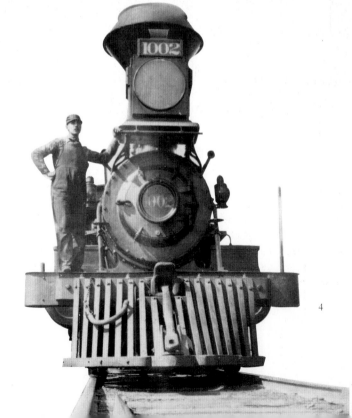

2

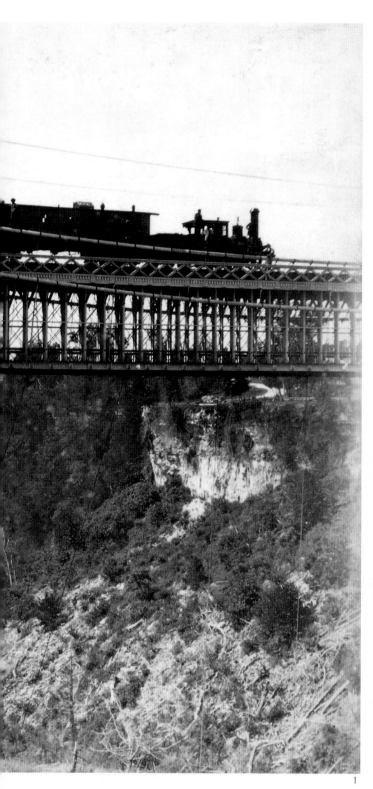

3

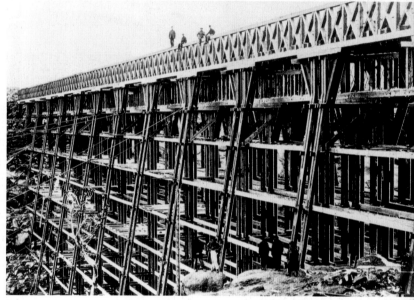

4

1

L ES audaces techniques des premiers chemins de fer comptaient parmi les plus grands exploits de l'époque. Le pont suspendu, construit dans les années 1850 au-dessus du Niagara, avait été conçu avec une voie routière encastrée qui passait sous celle du chemin de fer (1). Le viaduc de Lethbridge à Alberta, au Canada, consistait en un seul tracé qui passait à travers toute une série de supports métalliques entrelacés (2). De nombreux viaducs étaient originalement construits sur des chevalets en bois d'œuvre, mais ceux-ci, par la suite, furent remplacés par des structures métalliques, comme dans le cas du pont Dale Creek au Wyoming (3). Les chasse-pierres fixés à l'avant des locomotives canadiennes et américaines (4) et qu'on appelait là-bas des « attrape-vaches » étaient vraiment destinés à écarter les vaches qui s'étaient aventurées sur les rails ; mais ils servaient plus souvent à dégager ceux-ci des bois ou autres objets qui les encombraient.

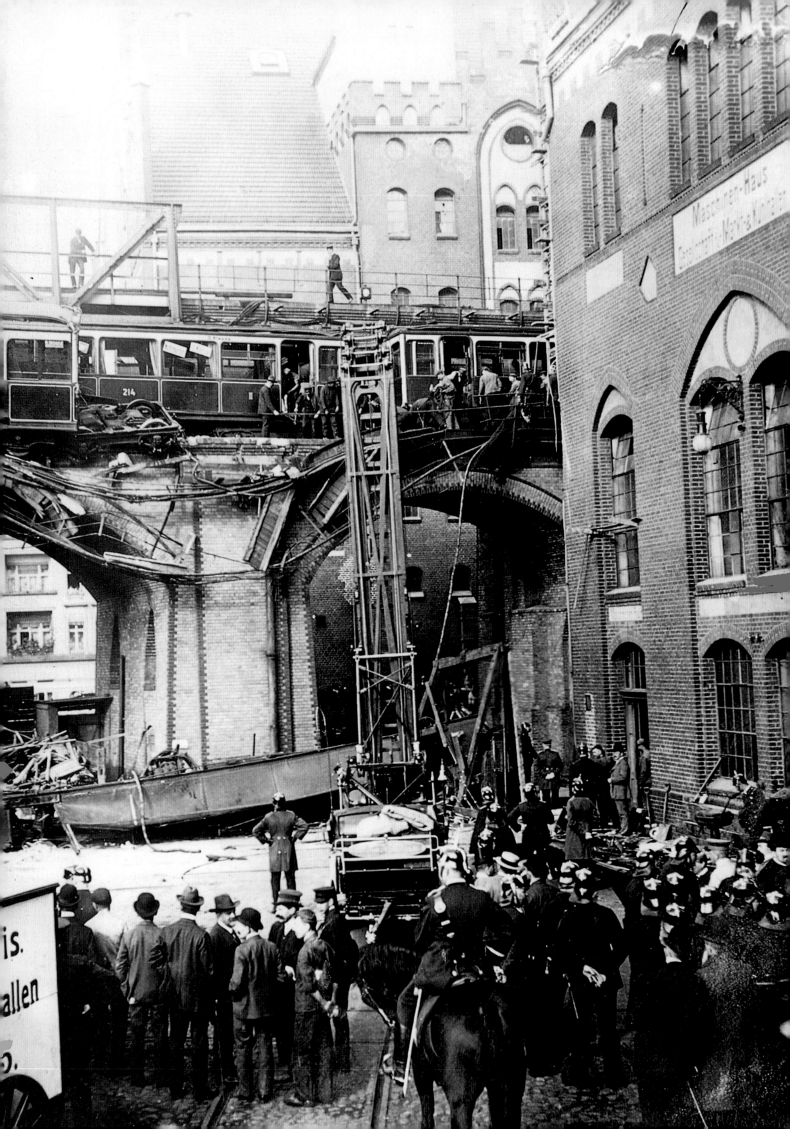

IN September 1908 crowds gathered to watch the aftermath of a crash on the Berlin Overhead Railway (1). In India there were plenty of crashes (2, 3). One of the most famous disasters in railway history was in Scotland, the Great Tay Bridge Disaster of 1879. The locomotive, recovered from the river bed, survived surprisingly well (4). The tragedy was celebrated in the poetic gem of William McGonagall:

Beautiful Railway Bridge of the Silv'ry Tay!
Alas! I am very sorry to say
That ninety lives have been taken away
On the last Sabbath day of 1879
Which will be remembered for a very long time.

IM September 1908 liefen die Menschen zusammen, um sich die Folgen eines Unfalls der Berliner Hochbahn anzusehen (1). In Indien gab es viele Unfälle (2, 3). Einer der spektakulärsten Unfälle in der Geschichte der Eisenbahn ereignete sich in Schottland, das Great Tay Bridge Desaster von 1879. Die Tragödie wurde in dem Gedicht von William McGonagall verewigt (oben). Die Lokomotive wurde aus dem Fluß geborgen; sie war in einem erstaunlich guten Zustand (4).

EN septembre 1908, les gens accoururent pour regarder ce qui restait d'une collision survenue sur les voies du métro aérien à Berlin (1). En Inde les collisions ne manquaient pas (2, 3). Une des catastrophes les plus célèbres de l'histoire du chemin de fer se déroula en Écosse ; il s'agit du grand désastre du pont Tay de 1879 célébré par William McGonagall dans une magnifique poésie :

Beau pont de fer du Tay argenté !
Hélas ! Je dois le dire le cœur serré
Que quatre-vingt-dix vies il fut emporté
Le dernier jour du sabbat de 1879, an
Qui restera dans les mémoires longtemps.

La locomotive qui tirait le train fatal fut retirée du lit de la rivière : elle avait étonnamment peu souffert (4).

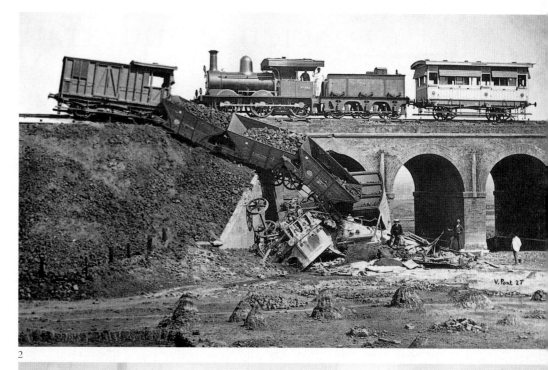

2

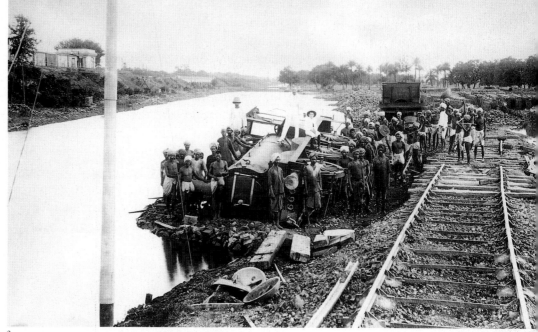

3

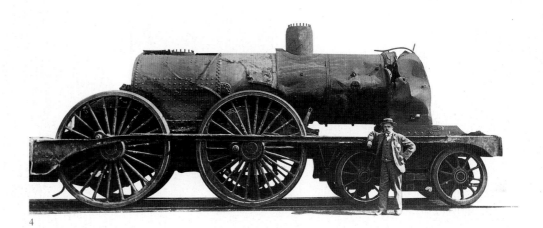

4

Science and Transport

On 1 November 1895, while experimenting with cathode rays, Wilhelm Konrad Röntgen (1) accidentally stumbled across the greatest discovery of the 1890s: the X-ray – a source of light that penetrated flesh but not bone, as the hand of Albert Köllicher bore testimony (2).

It was a typical 19th-century advance, the product of one man (or one woman) working alone in a laboratory, painfully edging his or her way towards new knowledge that we take for granted today, but that changed the lives of ordinary people beyond all recognition: Pasteur and fermentation, Curie and radiation, Lister and antiseptics, Liston and anaesthetics, Bell and the telephone, Parsons and the steam turbine, Benz and the internal combustion engine, Marconi and the telegraph, Edison and electric light.

Public health improved immeasurably. Sewage was no longer pumped raw into the nearest river. Hospitals became places of healing, no longer the hell-holes in which death was likely – even preferable to the mutilated life that formerly had so often resulted. Homes were safer, better built, more comfortable. Buildings were stronger – Monier developed reinforced concrete in 1867. A revolution took place in communication. Journeys that had taken weeks took days. News – good and bad – which had taken days to reach its destination on the other side of the world could be sent thousands of miles in a matter of minutes, thanks to the telegraph.

On the ocean, sail gave way to steam. Paddle steamers plied the Mississippi, ploughed their way across the Atlantic (with library, musical instruments and all luxuries on board); bustled across the North Sea, the Black Sea, the Mediterranean and the Channel. People began to take to the sea for pleasure – a totally novel concept. Just like X-rays.

Bei seinem Experimentieren mit Kathodenstrahlen machte Wilhelm Konrad Röntgen (1) am 1. November 1895 zufällig die größte Entdeckung des Jahrzehnts: der Röntgenstrahl, eine Lichtquelle, die durch den Körper, aber nicht durch die Knochen drang, wie die Hand von Albert Köllicher zeigte (2).

Es war eine für das 19. Jahrhundert typische Errungenschaft: das Produkt eines einzigen Mannes (oder einer Frau), der oder die alleine in einem Labor arbeitete und sich mühsam zu neuen Erkenntnissen vortastete, die wir heute als selbstverständlich erachten, das Leben der Menschen damals jedoch entscheidend veränderten – Pasteur und die Fermentation, Curie und die Strahlen, Lister und das Antiseptikum, Liston und die Anästhesie, Bell und das Telephon, Parsons und die Dampfturbine, Benz und der Verbrennungsmotor, Marconi und der Telegraph, Edison und das elektrische Licht.

Die öffentliche Gesundheitsvorsorge verbesserte sich enorm: Abwässer wurden nicht mehr ungefiltert in den nächstgelegenen Fluß gepumpt. Krankenhäuser wurden zu Orten der Heilung und blieben nicht länger jene gräßlichen Anstalten, in denen der Tod regierte und sogar dem elenden Leben vorzuziehen war, das zu früheren Zeiten nach der Behandlung auf einen wartete. Wohnhäuser waren sicherer, besser konstruiert und bequemer, große Gebäude stabiler; Monier entwickelte im Jahre 1867 den verstärkten Beton. Im Kommunikationswesen vollzog sich eine technische Revolution. Reisen, für die man früher Wochen gebraucht hatte, dauerten jetzt nur wenige Tage. Gute und schlechte Nachrichten, die bis dahin Tage gebraucht hatten, bevor sie ihren Bestimmungsort irgendwo am anderen Ende der Welt erreichten, konnten dank des Telegraphen in wenigen Minuten über eine Distanz von bis zu mehreren tausend Meilen übermittelt werden.

Auf den Meeren wichen die Segel dem Dampf. Raddampfer

2

durchpflügten den Mississippi, bahnten sich ihren Weg über den Atlantik (mit Bibliotheken, Musikinstrumenten und aller Art von Luxus an Bord) und eilten über die Nordsee, das Schwarze Meer, das Mittelmeer und den Ärmelkanal. Die Menschen begannen, aus Vergnügen zur See zu fahren – ein ebenso neues Phänomen wie die Röntgenstrahlen.

LE 1er novembre 1895, alors qu'il faisait des expériences sur les rayons cathodiques, Wilhelm Konrad Röntgen (1) fit accidentellement la plus grande découverte des années 1890 : les rayons X, une source lumineuse qui traverse la chair mais pas les os, ainsi que la main d'Albert Köllicher en témoigna (2).

Il s'agit d'un progrès typique du XIXe siècle, résultant des travaux isolés d'un seul homme (ou d'une seule femme) s'efforçant péniblement dans son laboratoire d'acquérir des connaissances que nous trouvons aujourd'hui banales, mais qui transformèrent radicalement la vie de tous les jours : Pasteur et la fermentation, Curie et la radiation, Lister et les antiseptiques, Liston et les anesthésiques, Bell et le téléphone, Parsons et la turbine à vapeur, Benz et le moteur à combustion interne, Marconi et le télégraphe sans fil, Edison et la lumière électrique.

La santé publique s'améliora au-delà de toute mesure. Les détritus n'étaient plus déversés tels quels dans la plus proche rivière. Les hôpitaux devenaient des endroits où l'on guérissait et non plus des enfers où la mort était certaine. Les maisons étaient plus sûres, mieux construites et plus confortables. Les édifices étaient plus solides : en 1867, Monier mit au point le béton armé. Les communications connurent une révolution. Les voyages qui avaient exigé des semaines prenaient des journées. Les nouvelles, bonnes ou mauvaises, qui mettaient des jours à parvenir à destination, pour peu que celle-ci se trouvât à l'autre bout du monde, parcouraient des milliers de kilomètres en quelques minutes grâce au télégraphe.

Sur l'océan, la vapeur avait remplacé la voile. Les bateaux à roues faisaient la navette sur le Mississippi, sillonnaient l'Atlantique (avec à leur bord des bibliothèques, des instruments de musique et autres luxueux agréments) ; ils fourmillaient dans la mer du Nord, la mer Noire, la Méditerranée et la Manche. On commençait à assimiler la mer au plaisir, ce qui, à l'instar des rayons X, était entièrement nouveau.

IN 1876 the telephone was invented by Alexander Graham Bell (2 – seated at desk), a Scotsman who had emigrated to the United States five years earlier. Bell was greatly interested in oral communication (and lack of it – he devoted much of his life to the education of deaf-mutes). The first telephone service between London and Paris was opened in 1891. At first, telephones were used almost entirely for commercial purposes, and by 1900 there were enough in use to warrant large switchboards, like this of the National Telephone Company (3). The early hand-crank set (1) was used at the Hull Exchange – the only local-authority-owned service in Britain.

IM Jahre 1876 erfand der Schotte Alexander Graham Bell (2, am Tisch sitzend), der fünf Jahre zuvor in die Vereinigten Staaten emigriert war, das Telephon. Bell war sehr an mündlicher Kommunikation interessiert (und an ihrem Fehlen; er widmete viele Jahre seines Lebens der Arbeit mit Taubstummen). Die erste Telephonverbindung zwischen London und Paris wurde 1891 in Betrieb genommen. Zunächst wurde das Telephon fast ausschließlich für kommerzielle Zwecke genutzt, aber bereits im Jahre 1900 gab es so viele Anschlüsse, daß große Schaltzentralen erforderlich waren, wie die der National Telephone Company (3). Das frühe Telephon mit Handkurbel (1) wurde bei der Börse in Hull verwendet, der einzigen Telephongesellschaft in Großbritannien, die sich im Besitz einer Gemeinde befindet.

EN 1876, Alexander Graham Bell (2, assis à sa table de travail) inventa le téléphone. Cet Écossais était arrivé aux États-Unis cinq ans auparavant. Bell s'intéressait beaucoup à la communication orale (et à son absence ; il consacra une grande partie de sa vie à l'éducation des sourds-muets). La première ligne téléphonique fut mise en service entre Londres et Paris en 1891. Au départ, les téléphones servaient presque uniquement à des fins commerciales, et dès 1900 leur nombre suffisait à justifier l'installation de vastes standards comme celui de la Compagnie nationale de téléphone (3). Le premier combiné (1) fut utilisé au Hull Exchange, le seul service téléphonique municipal de Grande-Bretagne.

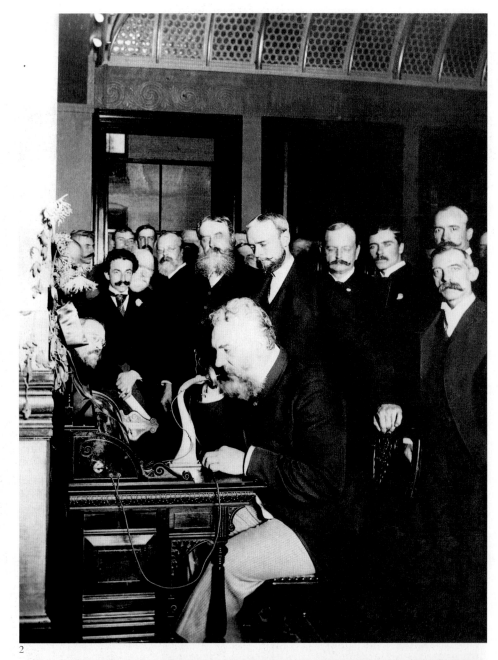

2

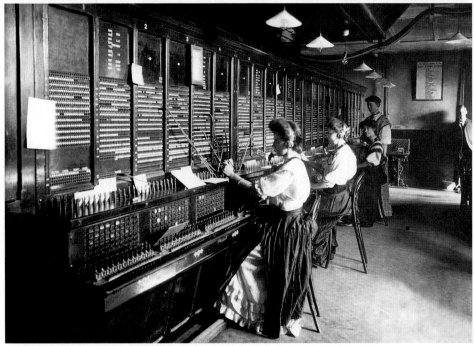

3

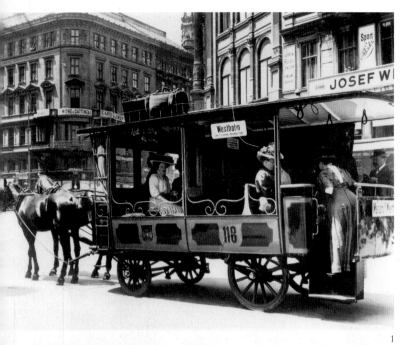

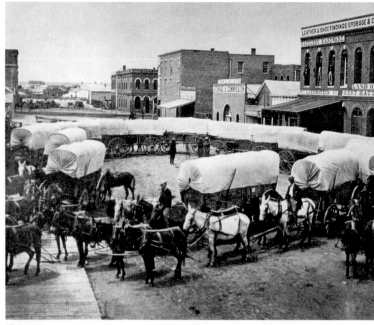

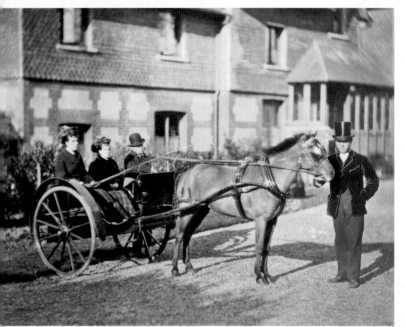

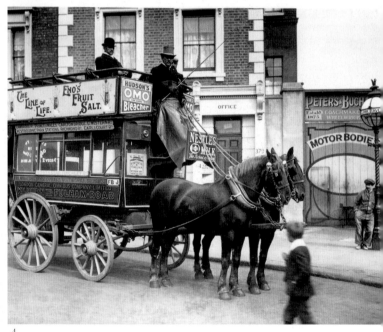

3 4

HORSE-drawn buses were still being used in Vienna in 1904 (1), and in London in 1911 (4). Outside Europe, heavy freight was carried on mule trains – Denver, Colorado, in 1870 (2). In Europe, the smart trap was the forerunner of the family car (3). In city centres, traffic moved as slowly as it does now – London Bridge was congested daily in the 1890s (5). With a little decoration, such as a painting of a battle, the family cart could become a vehicle of individual beauty – though six people might have been a tough load for one horse in Palermo (6). The London Hansom cab (7) was such as Sherlock Holmes would have hailed when he and Dr Watson went sleuthing.

PFERDEBUSSE gab es noch 1904 in Wien (1) und 1911 in London (4). Außerhalb Europas wurden schwere Frachten mit von Maultieren gezogenen Planwagen-Konvois befördert, wie hier 1870 in Denver, Colorado (2). In Europa war der flotte zweirädrige Pferdewagen der Vorläufer des Familienautos (3). Der Verkehr in den Stadtzentren bewegte sich so schnell oder so langsam wie heute – die London Bridge war in den 1890er Jahren täglich verstopft (5). Durch ein wenig Verzierung, beispielsweise mit einem Schlachtengemälde, konnte man aus dem Familienwagen ein Gefährt von individueller Schönheit machen – obwohl sechs Personen vielleicht eine etwas schwere Last für dieses Pferd in Palermo waren (6). Der Londoner Hansom (7) war ein Einspänner, wie ihn Sherlock Holmes benutzt haben mag, wenn er zusammen mit Dr. Watson seine Nachforschungen anstellte.

LES omnibus tirés par des chevaux étaient encore utilisés à Vienne en 1904 (1), et à Londres en 1911 (4). Hors d'Europe, les lourdes charges étaient transportées par des convois de mulets : à Denver dans le Colorado, en 1870 (2). En Europe, cette élégante charrette anglaise précéda la voiture familiale (3). Dans le centre des grandes villes, la circulation était aussi rapide ou aussi lente qu'aujourd'hui : le pont de Londres était congestionné tous les jours dans les années 1890 (5). Décoré, par exemple d'une scène guerrière, l'attelage familial se transformait en véhicule doté d'une beauté individuelle, quand bien même six personnes pouvaient se révéler une lourde charge à tirer pour un cheval de Palerme (6). Ce fiacre londonien (7) ressemble à l'un de ceux que Sherlock Holmes aurait hélés pour se lancer, avec le docteur Watson, dans une de leurs enquêtes.

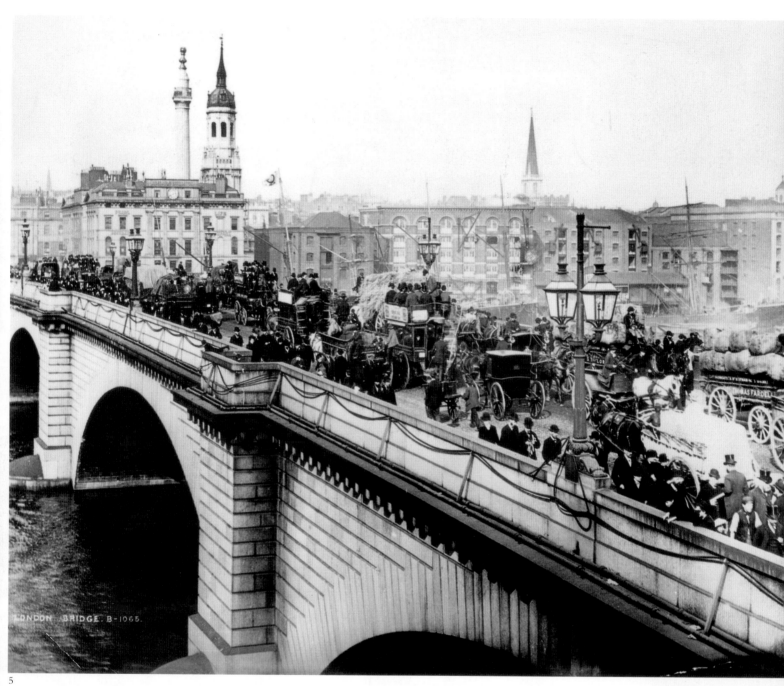

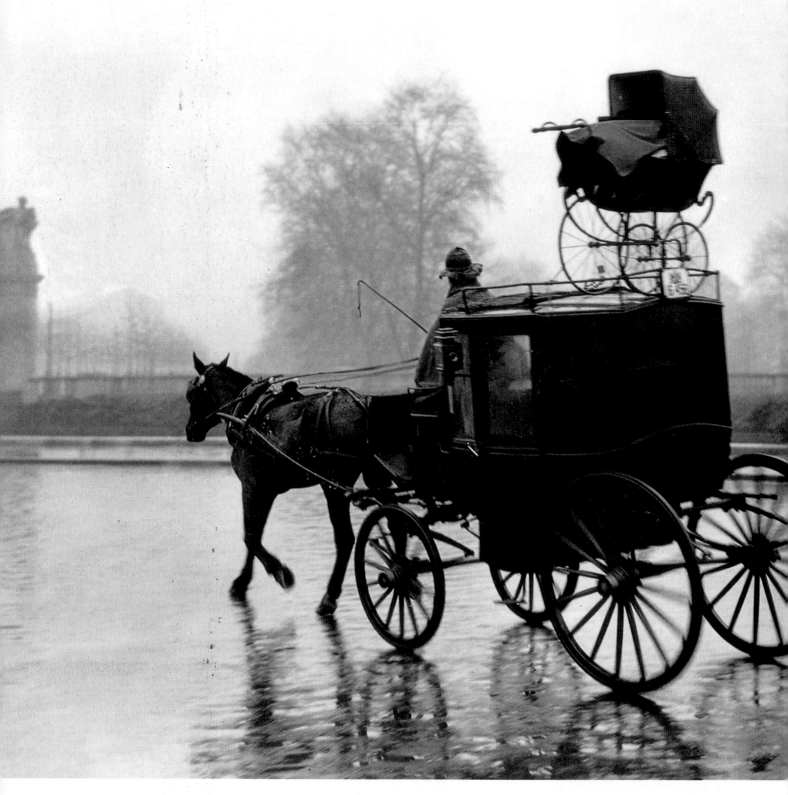

FEW sensations evoke an image of 19th-century city life more strongly than the sound of horses' hooves rattling over cobblestones (1). Vast stables were needed on the outskirts of Berlin, Madrid, Rome, Paris and other capitals to supply the tens of thousands of horses needed to pull public conveyances. A popular London cab was the Growler (2), first put in service in 1865. Fifty years later, horse-drawn traffic was in decline, but this smart little zebra was still trotting along London streets (3).

Es gibt nur wenige Geräusche, die stärker an das Stadtleben im 19. Jahrhundert erinnern als das Geklapper von Pferdehufen auf Kopfsteinpflaster (1). Am Stadtrand von Berlin, Madrid, Rom, Paris und anderen Metropolen befanden sich große Ställe, um die vielen tausend Pferde unterzubringen, die man für den öffent-

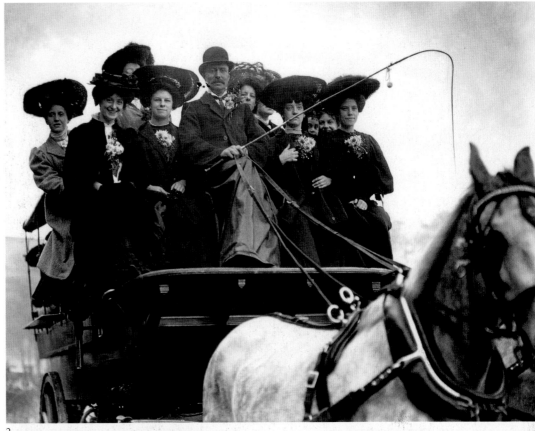

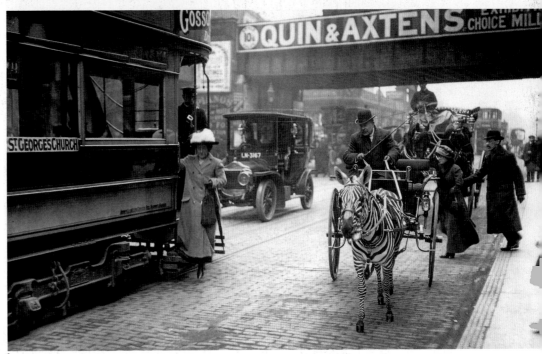

lichen Verkehr benötigte. Ein beliebter Londoner Wagen war der Growler (2), der erstmals 1865 eingesetzt wurde. Fünfzig Jahre später verschwanden die Pferdewagen allmählich von den Straßen, aber dieses flinke kleine Zebra trottete noch immer durch London (3).

PEU de sensations évoquent avec plus de force la vie dans les grandes villes au XIXᵉ siècle que le claquement des sabots des chevaux sur les pavés ronds (1). Aux abords de Berlin, de Madrid, de Rome, de Paris et des autres capitales, il fallait prévoir de vastes étables pour fournir les dizaines de milliers de chevaux nécessaires aux attelages publics. Un fiacre était populaire à Londres : le Growler (2), mis en service pour la première fois en 1865. Cinquante ans après, les voitures tirées par les chevaux disparaissaient, à l'exception de ce charmant petit zèbre qui continuait à trotter dans les rues de Londres (3).

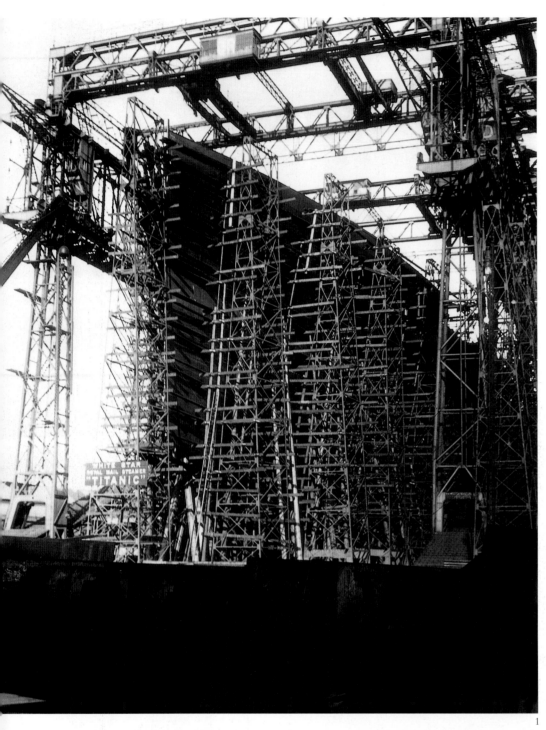

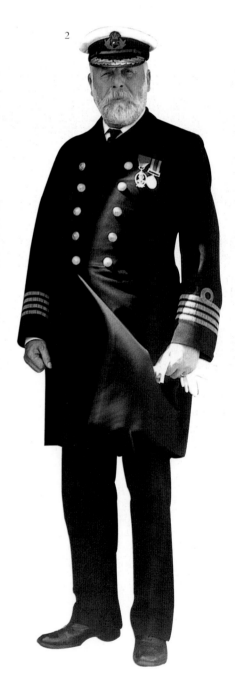

Ce fut une carrière brève et dramatique. En 1910 commençait la construction dans les chantiers navals d'Harland and Wolff à Belfast (1) du puissant *Titanic*, pesant 46 000 tonnes, fierté de la White Star Line. Le capitaine Smith (2) avait été nommé pour en prendre le commandement pendant sa première traversée de l'Atlantique. En 1912 le *Titanic* est remorqué au large pour ses premières manœuvres en mer (3). Il était énorme, superbe, puissant et luxueux : on le disait insubmersible.

It was a short and sad life. In 1910 work began at Harland and Wolff's shipyard in Belfast (1) on the mighty 46,000-ton *Titanic*, the pride of the White Star Line. Captain Smith (2) was appointed captain for her maiden voyage across the Atlantic. The *Titanic* was towed out for her sea trials early in 1912 (3). She was huge, superb, powerful, luxurious, and, so it was said, unsinkable.

Es war ein kurzes und trostloses Leben: 1910 begann auf der Schiffswerft von Harland und Wolff in Belfast (1) die Arbeit an der 46 000 Tonnen schweren *Titanic*, dem Stolz der White Star Line. Kapitän Smith (2) erhielt das Kommando für die Jungfernfahrt über den Atlantik. Die *Titanic* wurde zu Beginn des Jahres 1912 zur Erprobung ihrer Seetüchtigkeit aus dem Hafen geschleppt (3). Sie war gewaltig, großartig, kraftvoll, luxuriös und, so behauptete man, unsinkbar.

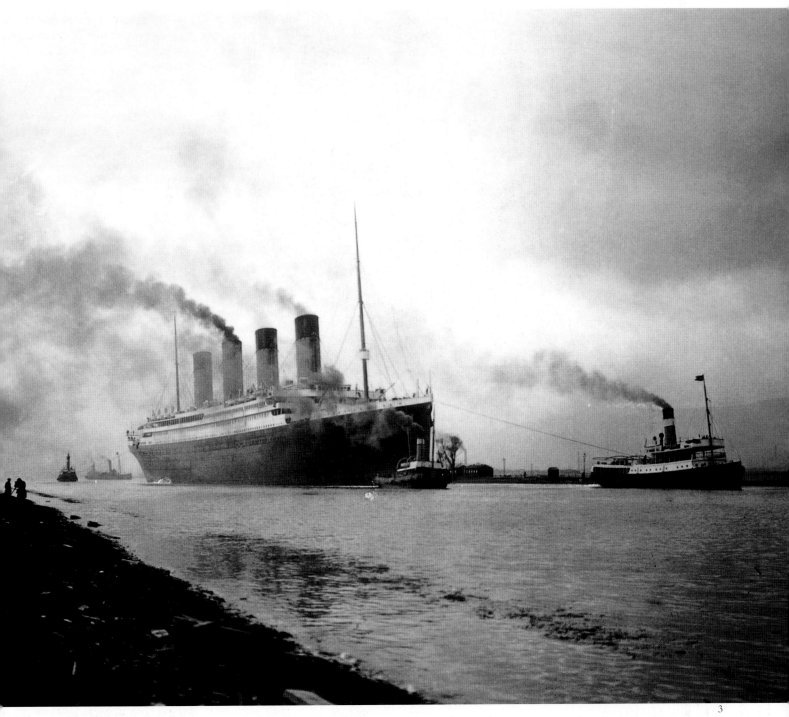

(*Overleaf*)

IT was a proud but empty boast. On 12 April 1912, on that maiden voyage, the *Titanic* hit an iceberg in the North Atlantic and sank with the loss of 1 513 lives out of the 2 224 on board. There were not enough lifeboats (1). Other ships were said to have ignored *Titanic*'s calls for help. Understandably, many panicked. When the survivors reached safety, they were dazed and bewildered by their ordeal (2). Relatives who greeted them were more obviously emotional (3). The disaster shocked Britain and the United States, and men, women and children contributed to the appeal fund set up to aid the families of those who had drowned (5). Survivors became short-term celebrities – crowds queued for their autographs (4).

(*Folgende Seiten*)

DER Stolz war groß, aber nicht berechtigt. Am 12. April 1912 rammte die *Titanic* auf ihrer Jungfernfahrt einen Eisberg im Nordatlantik und ging mit 1 513 der 2 224 Passagiere unter. Es gab nicht genügend Rettungsboote (1). Andere Schiffe hatten angeblich die Hilferufe der *Titanic* ignoriert. Verständlicherweise gerieten viele Passagiere in Panik. Als sich die Überlebenden in Sicherheit befanden, waren sie von den schrecklichen Erlebnissen benommen und wie gelähmt (2). Ihre Angehörigen, die auf sie warteten, zeigten mehr Emotionen (3). Die Katastrophe schockierte Großbritannien und die Vereinigten Staaten, und Männer, Frauen und Kinder spendeten für den Hilfsfonds, der den Familien der Ertrunkenen zugute kommen sollte (5). Die Überlebenden waren für kurze Zeit Berühmtheiten, und ihre Autogramme sehr begehrt (4).

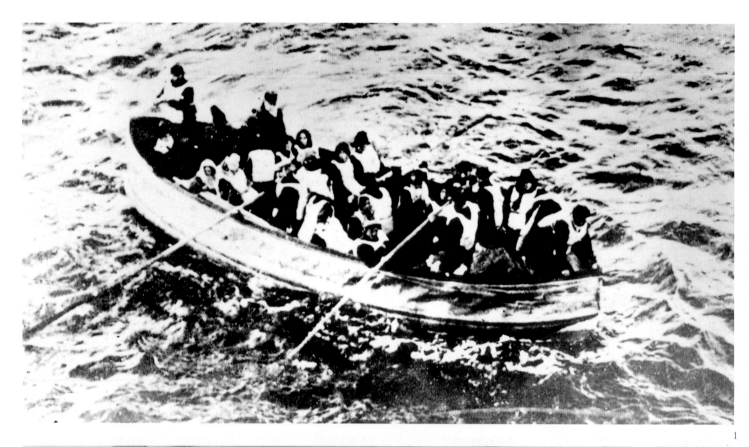

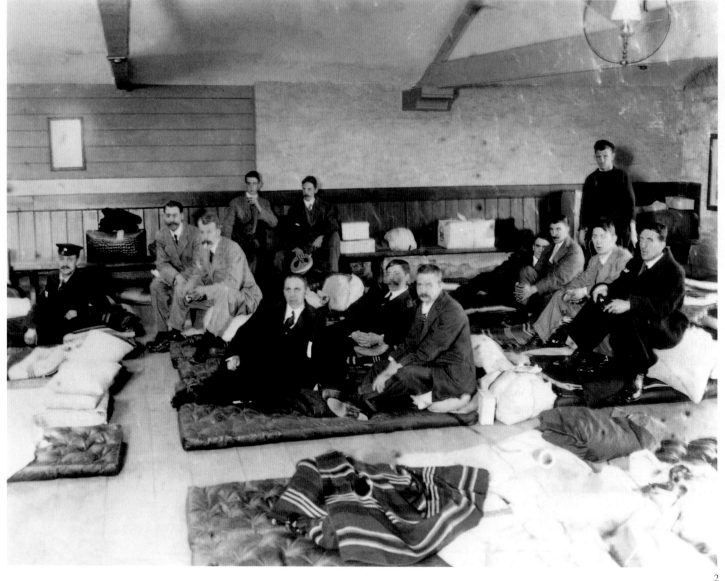

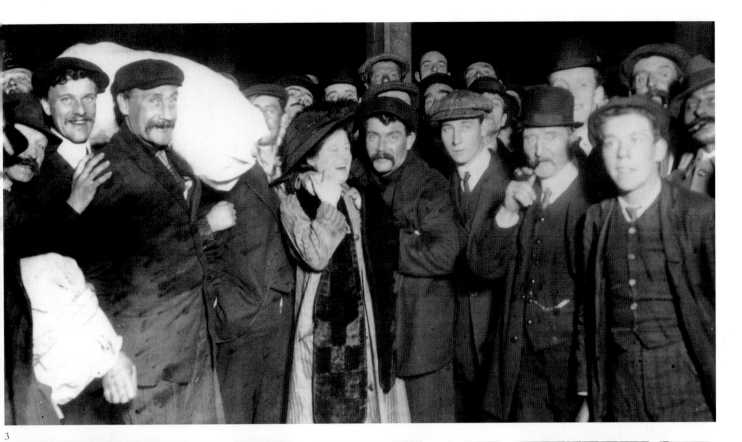

3

4

5

Une vanité sans fondement. Le 12 avril 1912, au cours de cette première traversée, le *Titanic* heurta un iceberg au nord de l'Atlantique et sombra. Il avait à son bord 2 224 personnes : 1 513 moururent. Les canots de sauvetage n'étaient pas assez nombreux (1). On a dit que les autres navires n'avaient pas répondu aux appels de détresse du *Titanic*. On comprendra que beaucoup furent pris de panique. Les rescapés étaient hébétés et en plein désarroi à la suite de leur épreuve (2). Leurs parents, en les accueillant, se montraient plus démonstratifs (3). Ce désastre secoua la Grande-Bretagne et les États-Unis : hommes, femmes et enfants versèrent des dons au fonds de secours qui avait été constitué pour venir en aide aux familles des noyés (5). Les survivants jouirent d'une célébrité sans lendemain et l'on faisait la queue pour obtenir d'eux des autographes (4).

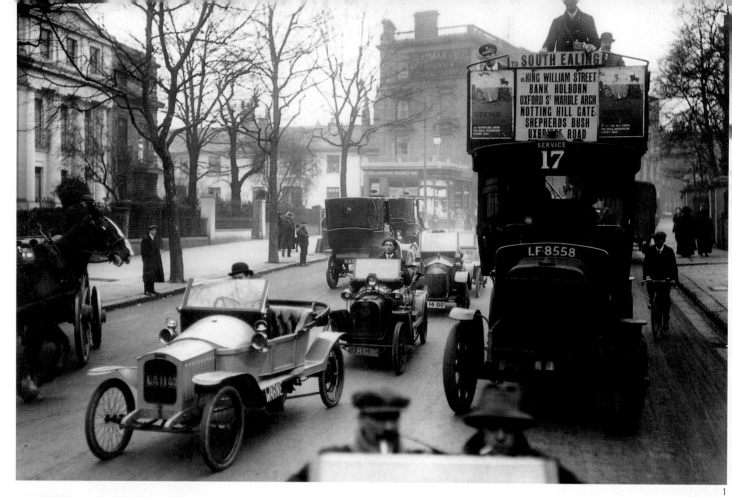

LANE discipline was a thing unknown in the early days of motoring (1). The volume of commercial road transport grew rapidly – this US mail truck (2) was a far cry from the Pony Express of a generation or two earlier. Rehearsals began for an airmail service at Hendon, near London, in 1911. The plane was named *Valkyrie* (4). Horse buses disappeared for ever – they could not compete with the power and increasing reliability of motorbuses (3).

IN den ersten Tagen des Autoverkehrs war eine disziplinierte Fahrweise noch unbekannt (1). Der kommerzielle Transport auf den Straßen wuchs schnell an – dieses amerikanische Postauto (2) hatte mit dem Ponyexpress früherer Generationen nichts mehr zu tun. In Hendon in der Nähe von

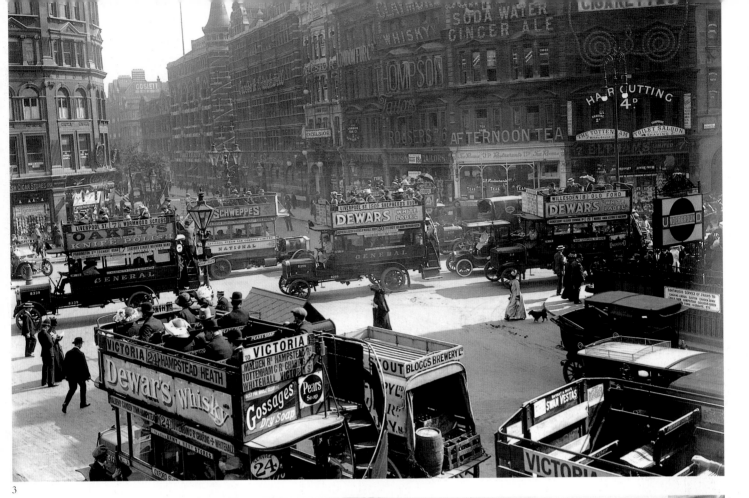

3

4

London begann man 1911 mit der Erprobung eines Luftpostdienstes. Das Flugzeug hieß *Valkyrie* (4). Pferdebusse verschwanden für immer aus dem Straßenbild, denn sie konnten mit der Leistung und der zunehmenden Sicherheit der Motorbusse nicht konkurrieren (3).

Rester dans sa voie était une règle inconnue des premiers temps de l'automobile (1). Le volume des transports commerciaux par la route augmentait rapidement. Ce fourgon postal aux États-Unis (2) n'a plus rien de commun avec le Pony Express qui existait une ou deux générations auparavant.

On commençait à faire des tentatives de courrier aérien à Hendon, près de Londres, en 1911. L'avion avait été baptisé *Valkyrie* (4). Les voitures publiques hippo-mobiles disparurent à jamais, faute de pouvoir soutenir la comparaison avec la fiabilité toujours plus grande des omnibus à moteur (3).

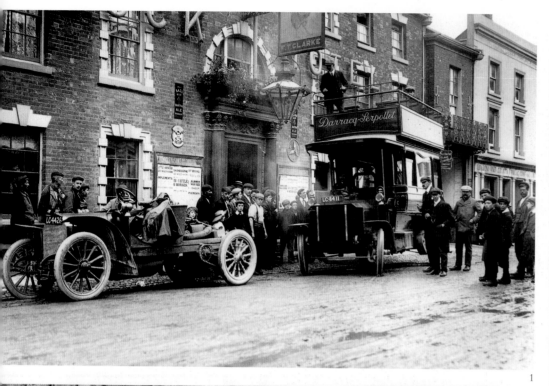

THE charabanc (3) was one of the most popular motor vehicles for a day out. It was noisy, a little slow, and open to the elements, but with its raked seats it gave everyone on board a good view of whatever troubles or delights lay ahead. Bolder motorists dressed for longer journeys. In 1903 Madame Lockart and her daughter set off from Notre Dame in Paris (2). They were bound for St Petersburg, over 1,800 miles (3,000 km) away.

Motor cars, buses and charabancs brought a new lease of life to the old coaching inns. Enthusiasts off to the Blackpool Motor Races in 1906 in the Serpollet bus paused for refreshment at the Cock Hotel, Stratford (1).

DER Charabanc (3) war eines der beliebtesten Motorfahrzeuge für einen Ausflug ins Grüne. Er war zwar laut, ein wenig langsam und offen, aber mit seinen ansteigenden Sitzen bot er allen Passagieren an Bord einen guten Ausblick auf all die Schrecken und Freuden, die auf sie zukamen. Kühnere Autofahrer unternahmen längere Fahrten. Im Jahre 1903 starteten Madame Lockart und ihre Toch-

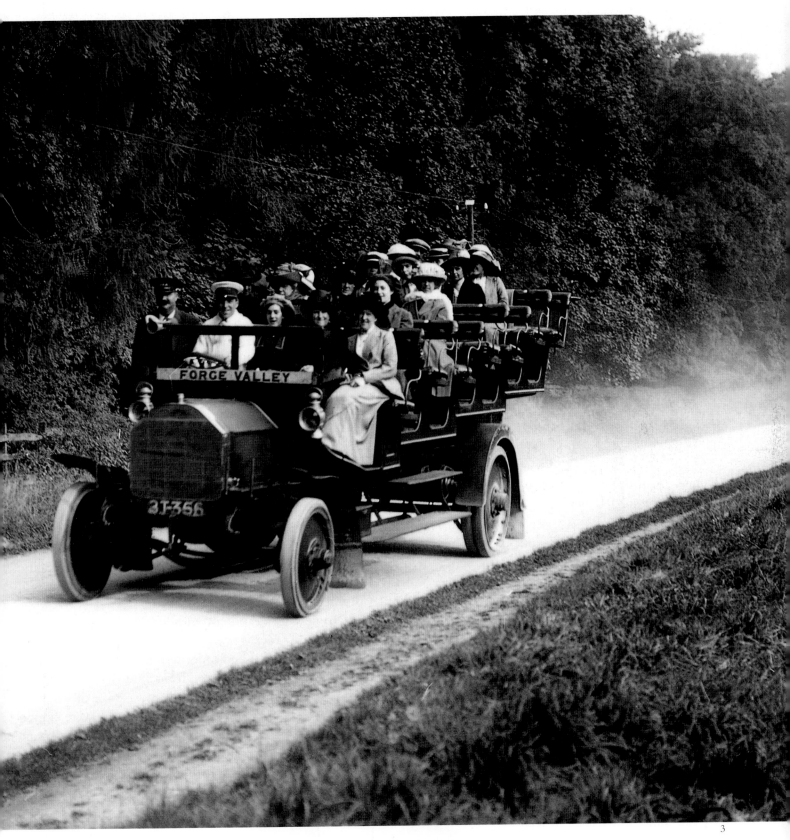

ter von Notre Dame in Paris (2). Ihr
Ziel war das 3.000 Kilometer entfernte
St. Petersburg.

Autos, Busse und Charabancs brachten
den alten Rasthäusern neuen Aufschwung.
Anhänger des Motorsports, die 1906 in
diesem Serpollet-Bus auf dem Weg zum
Autorennen in Blackpool waren, machten
im Cock Hotel in Stratford Rast, um sich
zu erfrischen (1).

L E char à bancs motorisé (3) était l'un
des véhicules automobiles les plus prisés
pour une journée d'excursion. Il était
bruyant, un peu lent et ouvert à tous les
éléments, mais aussi garni de rangs super-
posés qui permettaient à leurs occupants
d'apprécier pleinement les inconvénients
et les plaisirs que leur réservait le trajet.
Les plus hardis s'habillaient en prévision
de voyages plus longs. Madame Lockart

et sa fille en 1903 prenant le départ à
Notre-Dame-de-Paris (2). Leur voyage
devait les mener jusqu'à Saint-Pétersbourg,
à plus de 3 000 kilomètres de distance.

Les automobiles, les omnibus et les
chars à bancs remirent en activité les anciens
relais de poste. Les enthousiastes, se rendant
aux courses automobiles à Blackpool
en 1906 en bus Serpollet, descendaient se
restaurer au Cock Hotel à Stratford (1).

Social Unrest

For some, the world was beginning to spin a little too fast. The established order found itself giddy, perplexed, outraged as new ideas threatened to take over. Darwin's theories challenged the literal truth of the Old Testament story of the Creation. Freud suggested that all men and women possessed dark unexplored regions of the subconscious far more terrifying than anywhere that Livingstone or Stanley had visited. Marx informed the workers that they had nothing to lose but their chains, and a whole world to gain – however fast it was spinning.

Trade unions were becoming more vociferous, encouraging people to demand better pay, better protection, better conditions, shorter hours. The suffragists were demanding votes for women. Married women had the impertinence to suggest that they should have the right to own property. The unemployed were demanding work and shattering the windows of the rich to show the strength of their feeling. Nationalists in Africa and India were demanding independence, or at least a say in how they were governed.

There was a disturbing amount of talk about 'rights' – to education, to better housing, to better medical care. There was open discussion of such heresies as birth control, homosexuality, free love, republicanism, atheism, socialism, anarchy. Students were questioning their teachers, servants arguing with their masters. Children, it was said, were disobeying their parents.

What had happened? A hundred years later it may be impossible to tell, but the words of a German worker early in the 20th century may hold a clue: 'I got to know a shoemaker called Schröder... Later he went to America... he gave me some newspapers to read and I read a bit before I was bored, and then I got more and more interested... They described the misery of the workers and how they depended on the capitalists and landlords in a way that was so lively and true to nature that it really amazed me. It was as though my eyes had been closed before. Damn it, what they wrote in those papers was *the truth*. All my life up to that day was proof of it.'

People's lives were undergoing a faster and more profound change than at any other time in history. They lived in different places in different conditions under different rules from those that had ordered the lives of generations before. The rhythm of rural life had been broken. When they trudged to the cities, seeking work, they were transported to another world. And one of the first things they wanted to do in this new world was to try to understand it, to make sense of it. A sleeping curiosity had been awakened. People looked about them – saw, compared, contrasted, drew conclusions. 'Only connect,' wrote the novelist E. M. Forster in 1910, 'and the beast and the monk, robbed of the isolation that is life to either, will die.'

Many may have drawn the wrong conclusions, but many made the right connections. Ideas poured forth in plays, books, newspapers, even paintings and cartoons – about the subjugation of woman to man; about the right of the Church to have a monopoly on morality; about equality before the law; about the tyranny of privilege; about the power of the masses.

No new idea can exist without threatening someone, and there was an almighty backlash. The established order sent its army and its police force to the front line. Revolutionaries were bundled away, to exile if they were lucky. Suffragettes were bound and forcibly fed. Socialists were hunted down. Homosexuals were imprisoned. Nationalists were whipped, and their ideas temporarily stifled.

But the old system of unquestioning obedience to orders was on its way out. It had one last grossly triumphant chance to show what it was capable of – in the slaughter of the First World War.

1

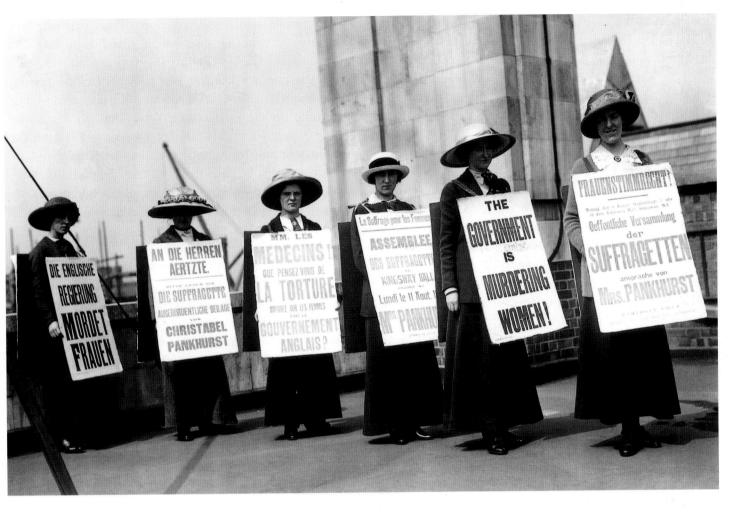

THE VICTIM OF AN ANCIENT ANTI-SEMITISM: ALFRED DREYFUS (1). AN INTERNATIONAL RESPONSE TO BRITISH PERSECUTION OF SUFFRAGETTES (2).

DAS OPFER EINES URALTEN ANTISEMITISMUS: ALFRED DREYFUS (1). EINE INTERNATIONALE ANTWORT AUF DIE VERFOLGUNG DER SUFFRAGETTEN IN GROSSBRITANNIEN (2).

ALFRED DREYFUS (1): UNE VICTIME DE L' ANTISÉMITISME AMBIANT ET DE L'AVEUGLEMENT NATIONALISTE. RÉACTION INTERNATIONALE DEVANT LA PERSÉCUTION DES SUFFRAGETTES PAR LES BRITANNIQUES (2).

FÜR einige drehte sich die Welt ein wenig zu schnell. Die etablierte Ordnung geriet ins Wanken, war verwirrt und zum Teil schockiert, als neue Ideen sich durchzusetzen drohten. Darwins Theorien stellten die Wahrheit der Schöpfungsgeschichte des Alten Testaments in Frage. Freud behauptete, der Mensch berge dunkle, unentdeckte Bereiche des Unterbewußten in sich, die weitaus erschreckender seien als all die Orte, die Livingstone oder Stanley besucht hatten. Marx sagte den Arbeitern, daß sie außer ihren Ketten nichts zu verlieren und eine ganze Welt zu gewinnen hätten – so schnell sie sich auch drehen mochte.

Die Gewerkschaften wurden immer energischer und ermutigten die Menschen, höhere Löhne, besseren Schutz, bessere Bedingungen und kürzere Arbeitszeiten zu fordern. Die Suffragetten verlangten das Wahlrecht für Frauen. Verheiratete Frauen besaßen die Unver-schämtheit, das Recht auf eigenen Besitz einzufordern. Die Arbeitslosen wollten Arbeit und warfen die Fenster der Reichen ein, um ihren Gefühlen Nachdruck zu verleihen. Nationalisten in Afrika und Indien forderten die Unabhängigkeit, oder zumindest ein Mitspracherecht in Regierungsfragen.

Überall gab es Diskussionen um »Rechte« auf Erziehung und Ausbildung, auf bessere Wohnungen, bessere medizinische Versorgung. Man diskutierte offen über solche Ketzereien wie Geburtenkontrolle, Homosexualität, freie Liebe, Republikanismus, Atheismus, Sozialismus und Anarchie. Studenten zweifelten ihre Professoren an, Diener stritten sich mit ihren Herren, und Kinder gehorchten ihren Eltern nicht mehr.

Was war passiert? Hundert Jahre später ist es vielleicht nicht mehr möglich, darauf eine Antwort zu

finden, aber die Worte eines deutschen Arbeiters vom Beginn des 20. Jahrhunderts könnten einen Hinweis enthalten: »Ich lernte einen Schuhmacher namens Schröder kennen … Er ging später nach Amerika … er gab mir ein paar Zeitungen zu lesen, und ich las ein bißchen darin, bevor sie mich langweilten, aber dann interessierten sie mich immer mehr … Sie be-schrieben das Elend der Arbeiter und ihre Abhängigkeit von den Kapitalisten und Grundbesitzern auf eine so lebendige und wirklichkeitsnahe Art, daß es mich völlig erstaunte. Es war, als hätte ich meine Augen vorher geschlossen gehabt. Verdammt, was sie in diesen Zeitungen schrieben, war *die Wahrheit*. Mein ganzes Leben bis zu diesem Tag war der Beweis dafür.«

Das Leben der Menschen veränderte sich schneller und grundlegender als zu jeder anderen Zeit in der Geschichte. Sie lebten an anderen Orten, unter anderen Bedingungen und anderen Gesetzen als denen, die das Leben früherer Generationen bestimmt hatten. Der Rhythmus des Landlebens war zerstört. Als die Menschen in die Städte zogen, um Arbeit zu suchen, wurden sie in eine andere Welt katapultiert. Und vor allem wollten sie diese neue Welt verstehen, ihr einen Sinn geben. Eine schlafende Neugier war geweckt worden. Die Menschen sahen sich um, erkannten, verglichen, unterschieden, zogen Schlüsse. »Sobald man Verbindungen herstellt«, schrieb der Romancier E. M. Forster 1910, »werden das Tier und der Mönch ihrer Isolation, die für beide das Leben bedeutet, beraubt und sterben.«

Sehr viele haben die falschen Schlüsse gezogen, aber viele haben die richtigen Verbindungen hergestellt. Theaterstücke, Bücher, Zeitungen und sogar Gemälde und Karikaturen steckten voller Ideen – über die Unterwerfung der Frau durch den Mann, über das Recht der Kirche auf ein Monopol in Fragen der Moral, über die Gleichheit vor dem Gesetz, über die Tyrannei der Privilegien, über die Macht der Massen.

Es gab keine neuen Ideen, die nicht die bestehende Ordnung bedrohen würden, und es kam zu einer heftigen Gegenreaktion. Das etablierte System schickte seine Armee und seine Polizei an die Front. Revolutionäre ließ man verschwinden – ins Exil, wenn sie Glück hatten. Suffragetten wurden gefesselt und zwangsernährt, Sozialisten wurden gejagt, Homosexuelle verhaftet. Nationalisten peitschte man aus und machte sie vorübergehend mundtot.

Aber das alte System des blinden Gehorsams gegenüber der Obrigkeit verschwand allmählich. Es hatte eine letzte, schrecklich triumphale Chance zu zeigen, wozu es fähig war – im Gemetzel des Ersten Weltkriegs.

L E monde commençait à tourner un peu trop vite pour certains. Les gens bien pensants se sentaient étourdis, embarrassés, malmenés par les idées nouvelles qui menaçaient l'ordre établi. Les théories de Darwin remettaient en cause la vérité de l'histoire de la Création telle qu'elle est racontée dans l'Ancien Testament. Freud laissait entendre que les hommes et les femmes possédaient une région sombre et inexplorée, le subconscient, plus terrifiant encore que les endroits visités par Livingstone et Stanley. Marx disait aux travailleurs n'avoir rien à perdre que leurs chaînes, et tout un monde à conquérir.

Les syndicats élevaient la voix, encourageant les travailleurs à exiger de meilleurs salaires, une meilleure protection, de meilleures conditions de travail et des horaires plus courts. Les suffragettes exigeaient le droit de vote pour les femmes. Les femmes mariées avaient l'impertinence de revendiquer la possession de biens en propre. Les chômeurs exigeaient du travail en cassant les fenêtres des riches pour faire savoir leur détermination. En Afrique et en Inde les nationalistes réclamaient l'indépendance, ou du moins la mise en œuvre de réformes.

On parlait avec une fréquence alarmante de « droits » à l'instruction, à un meilleur logement et à de meilleurs soins médicaux. On débattait sur la place publique d'hérésies telles que la limitation des naissances, l'homosexualité, l'amour libre, le républicanisme, l'athéisme, le socialisme et l'anarchie. Les étudiants remettaient leurs professeurs en question, les serviteurs discutaient les ordres de leurs maîtres. On prétendait que les enfants désobéissaient à leurs parents.

Que s'était-il passé ? Il est difficile de répondre à cette question une centaine d'années après. Cependant les paroles d'un ouvrier allemand du début du XXe siècle peuvent fournir une réponse : « J'ai rencontré un cordonnier nommé Schröder … Après il est parti en Amérique … il m'avait donné des journaux à lire, ce que j'ai fait un peu puis cela m'a ennuyé. Mais après ils m'ont intéressé de plus en plus. Ils décrivaient la condition misérable des travailleurs et leur dépendance par rapport aux capitalistes et aux propriétaires terriens d'une façon si vivante et si réaliste que j'en ai été absolument abasourdi. C'était comme si mes yeux avaient été fermés jusqu'alors. Nom d'une pipe ! Ce que ces journaux disaient, c'était *la vérité*. Toute ma vie jusqu'à ce jour était là pour en témoigner. »

L'existence des gens changeait avec rapidement et profondément, comme jamais auparavant. Ils vivaient dans des lieux différents, dans des conditions différentes et selon des règles différentes de celles des générations précédentes. Les rythmes de la vie rurale avaient été cassés. Lorsque ces gens gagnaient la ville à la recherche

d'un travail, ils se transportaient dans un autre monde. Et ils voulaient avant tout essayer de comprendre ce nouveau monde, lui trouver un sens. Une curiosité s'était éveillée. Les gens regardaient autour d'eux, voyaient, comparaient, relevaient les différences et tiraient des conclusions. Le romancier E. M. Forster écrivait en 1910 : « Faites seulement des associations, et la bête et le moine dérobés à l'isolement qui est leur vie mourront. »

D'aucuns s'adaptèrent et la moitié échouèrent. Les idées se déversaient dans les pièces de théâtre, les livres et les journaux. Même les tableaux et les dessins humoristiques n'échappaient pas aux idées : ils traitaient de la soumission de la femme ; de l'Église en tant que gardienne de l'ordre moral ; de l'égalité devant la loi ; des privilèges et du pouvoir ouvrier.

Une nouvelle idée représente toujours une menace, et le retour de flamme fut puissant. Les bien-pensants firent monter en ligne l'armée et la police. Les révolutionnaires furent retirés de la circulation, exilés pour les plus chanceux. Les suffragettes furent enchaînées et alimentées de force. Les socialistes furent traqués sans merci et les homosexuels emprisonnés. Les nationalistes furent fouettés et leurs idées temporairement étouffées.

Cependant le vieux système de l'obéissance inconditionnelle aux ordres était condamné. Il triompha une dernière fois en montrant brutalement de quoi il était capable en provoquant la boucherie de la Première Guerre mondiale.

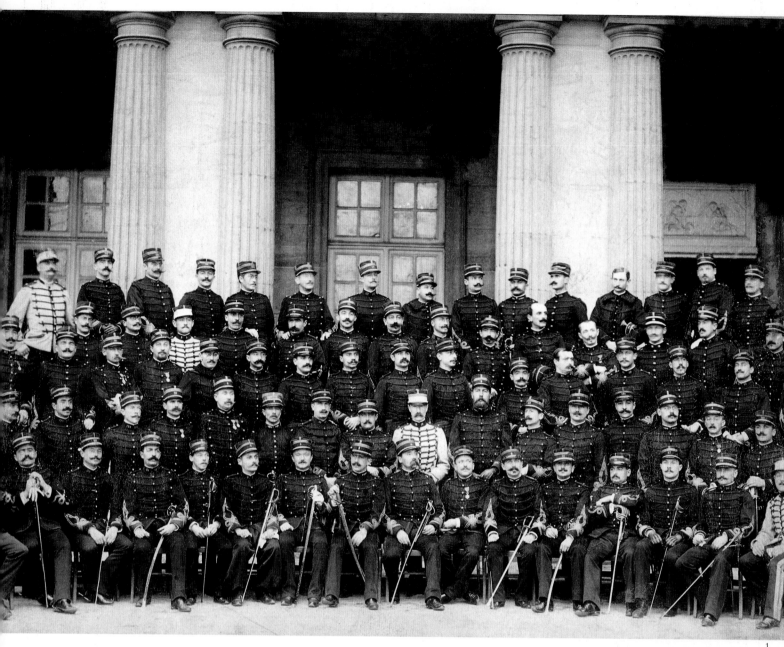

L'AFFAIRE Dreyfus dura douze ans et marqua profondément la France. Dreyfus (1, le sixième au dernier rang à gauche), d'obédience juive, sortit diplômé de l'école Polytechnique de Paris en 1891 et entra à l'état-major général de l'armée française. Il fut accusé à tort de vendre des secrets militaires à l'Allemagne, et se retrouva au centre d'une polémique révélant de profonds clivages entre d'un côté les royalistes, les militaristes et l'opinion catholique, et de l'autre les républicains, les socialistes et les anticléricaux. Dreyfus fut déclaré coupable et déporté à l'île du Diable. Cependant

l'affaire fut réexaminée à Rennes en 1899. Les membres du tribunal (2) avaient des opinions divergentes. Les journalistes affluèrent dans la ville pour le deuxième procès (3), et parmi eux Bernard Lazare qui avait mené une longue campagne en faveur de Dreyfus (4, au centre). Le colonel Picquart (5, à gauche) fut un des rares officiers de l'armée à soutenir Dreyfus. Même après que son innocence fut rétablie à l'issue du deuxième procès, l'armée lui tourna le dos (6) parce que les termes du jugement prononcé déclaraient Dreyfus coupable avec des circonstances atténuantes.

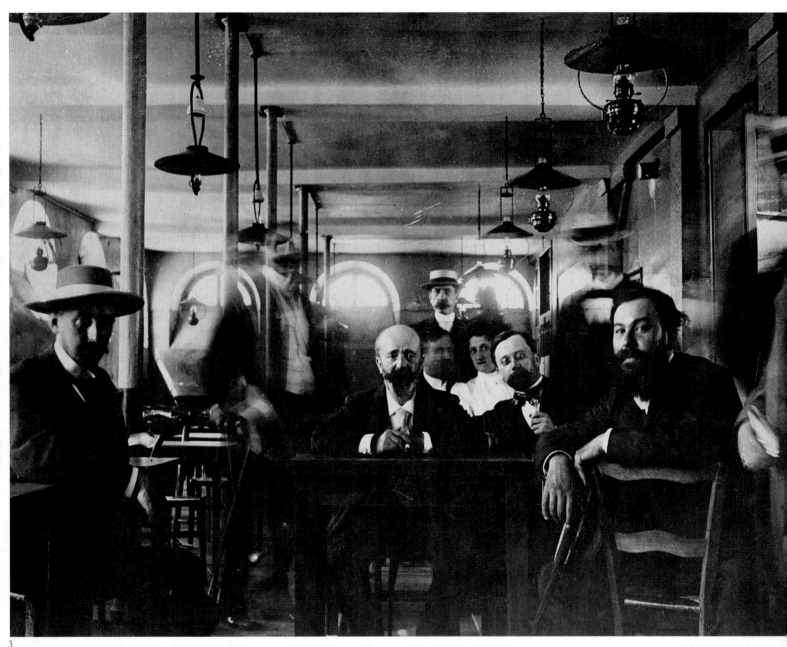

3

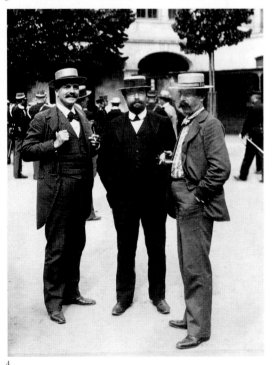

4

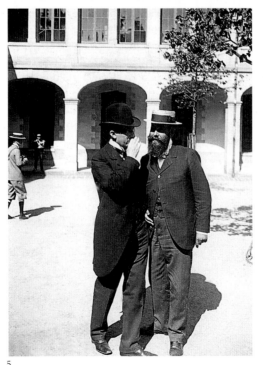

5

6

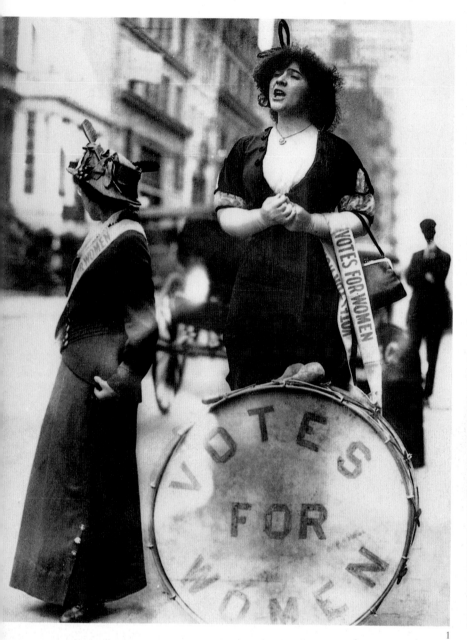

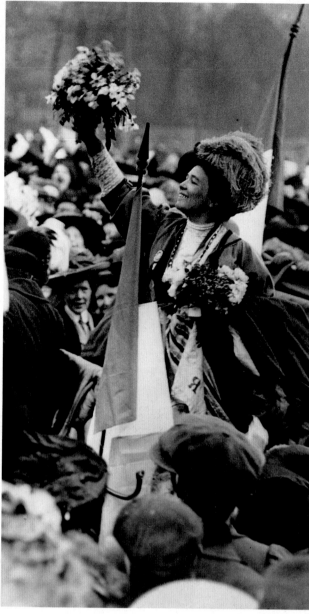

THE Women's Suffrage Movement
began in 1865 in Manchester, and was
largely limited to Britain and North
America (1). It sprang from, and appealed
largely to, the middle classes – though
there were plenty of active members of
the aristocracy, such as Lady Emmeline
Pethwick-Lawrence (2). The militant
Women's Social and Political Union
(WSPU) was formed in 1903 by Emmeline
Pankhurst. It used arson and bombing as
weapons in its campaign to get Votes for
Women. In quieter moments, Emmeline's
daughter Sylvia, also an activist, painted
the Women's Social Defence League shop-
front in 1912 (3).

DIE Suffragetten-Bewegung entstand
1865 in Manchester und blieb weit-
gehend auf Großbritannien und Nord-
amerika beschränkt (1). Sie war von Frauen
aus der Mittelklasse ins Leben gerufen
worden und zielte auch überwiegend auf
diese ab, aber es gab auch zahlreiche aktive
Mitglieder aus der Aristokratie, darunter
Lady Emmeline Pethwick-Lawrence (2).
Die militante Women's Social and Political
Union (WSPU), 1903 von Emmeline
Pankhurst gegründet, setzte in ihrem Kampf
für das Frauenwahlrecht auch Brandstiftung
und Bomben ein. In ruhigeren Zeiten,
1912, bemalte Emmelines Tochter Sylvia,
ebenfalls eine Aktivistin, die Fassade
des Büros der Women's Social Defence
League (3).

LE mouvement en faveur du suffrage des
femmes naquit en 1865 à Manchester
et se limitait principalement à la Grande-
Bretagne et à l'Amérique du Nord (1). Il
provenait des classes populaires et bénéficiait
d'un très large écho, bien qu'il comptât aussi
énormément de membres actifs au sein
de l'aristocratie tels que Lady Emmeline
Pethwick-Lawrence (2). L'Union féminine
sociale et politique (WSPU) fondée en
1903 par Emmeline Pankhurst, utilisa les
incendies et les grenades dans sa campagne
en faveur du droit de vote des femmes.
Dans des moments plus calmes, en 1912,
Sylvia, la fille d'Emmeline et activiste
comme elle, peignait la devanture du local
de la Ligue pour la défense sociale des
femmes (3).

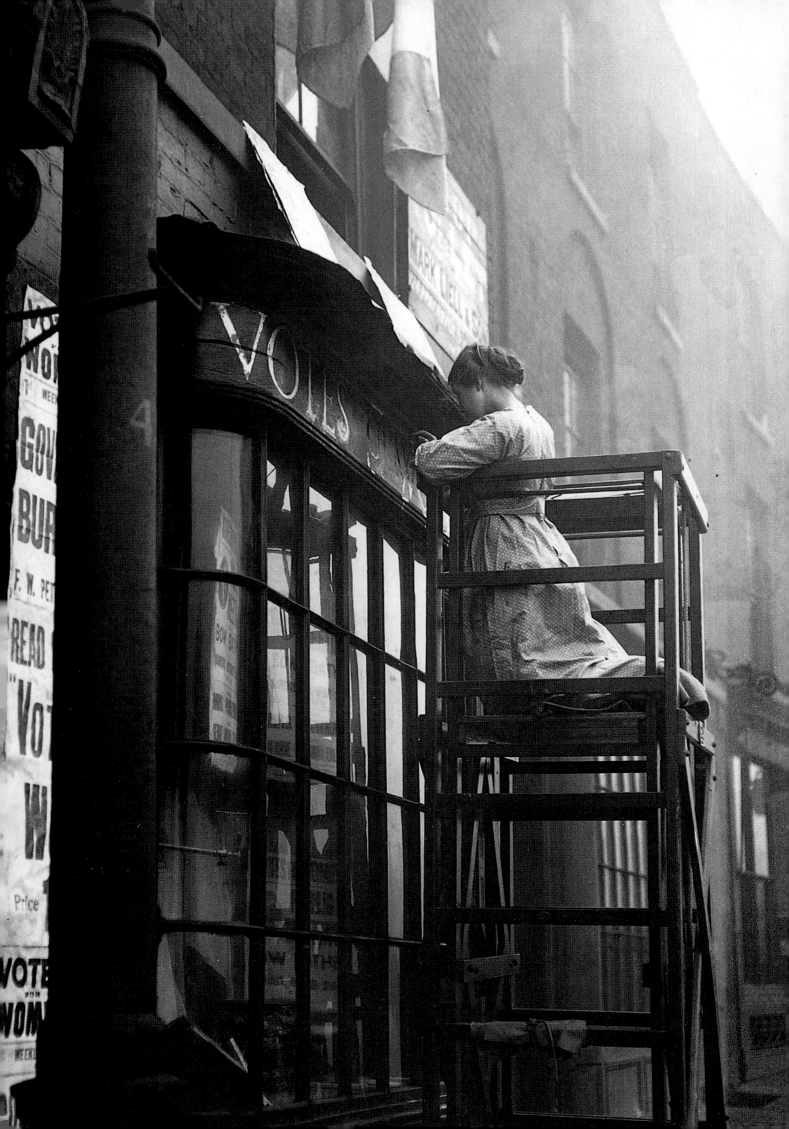

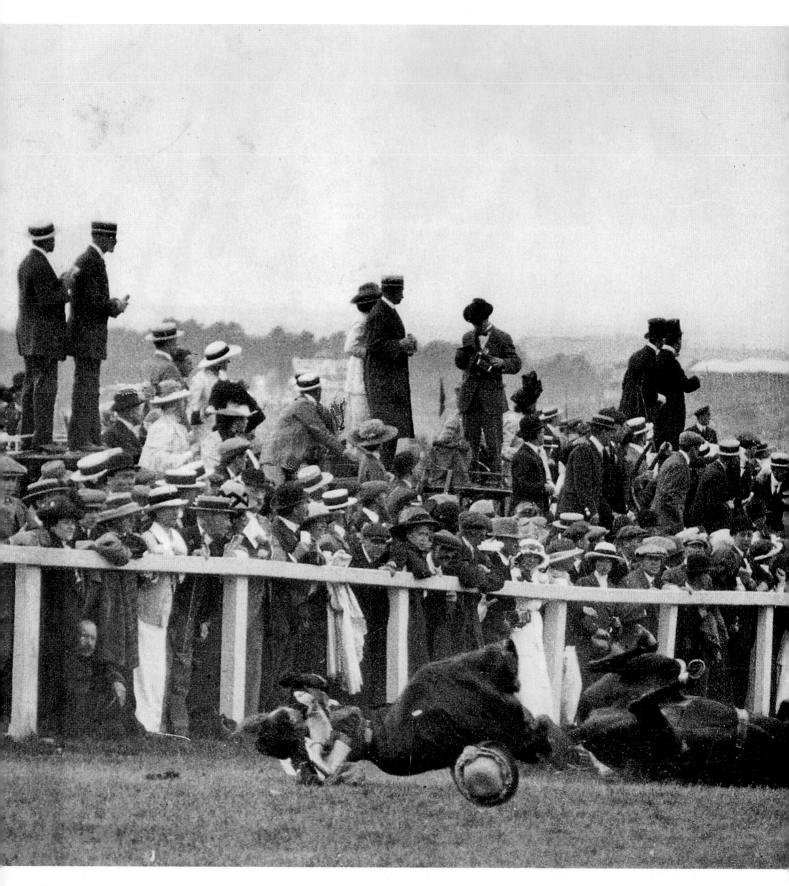

THERE were many men and women who decried the actions of the suffragettes – there still are. But most were shocked at the death of Emily Davison, who threw herself in front of the King's horse in the 1913 Derby (1). The campaign of direct action also included window smashing (3) and setting fire to the churches of unsympathetic ministers (2).

DIE Aktionen der Suffragetten wurden und werden noch immer von vielen Frauen und Männern verurteilt. Trotzdem waren die meisten über den Tod Emily Davisons schockiert, die sich beim Derby

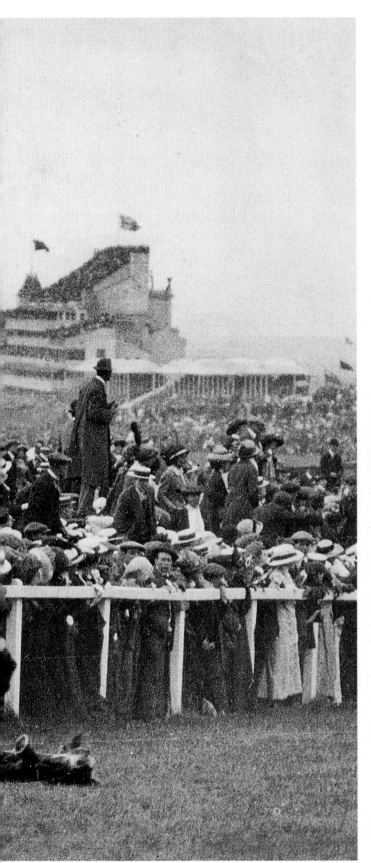

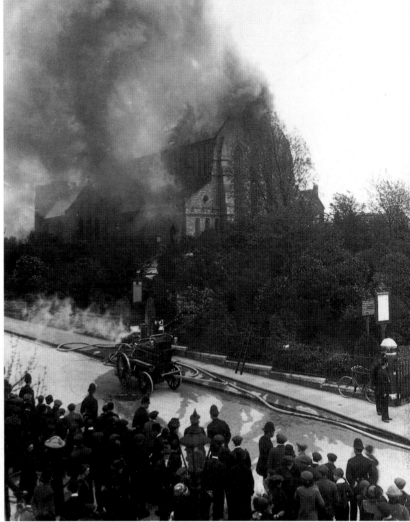

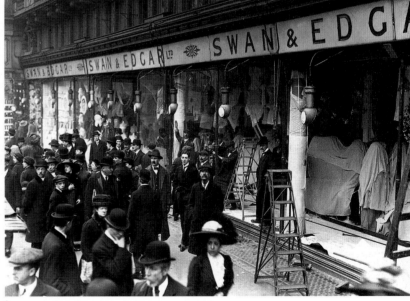

1913 vor das Pferd des Königs warf (1). Die Kampagne direkter Aktionen umfaßte auch das Einwerfen von Fensterscheiben (3) und das Anzünden der Kirchen verständnisloser Priester (2).

Les hommes et les femmes qui décriaient les agissements des suffragettes étaient nombreux – et ils le sont toujours. La plupart furent cependant choqués par la mort d'Emily Davison qui se jeta devant le cheval du roi au cours du Derby de 1913 (1). La campagne d'action directe consistait aussi à casser les fenêtres (3) et incendier les églises des pasteurs et des ministres de culte hostiles au progrès (2).

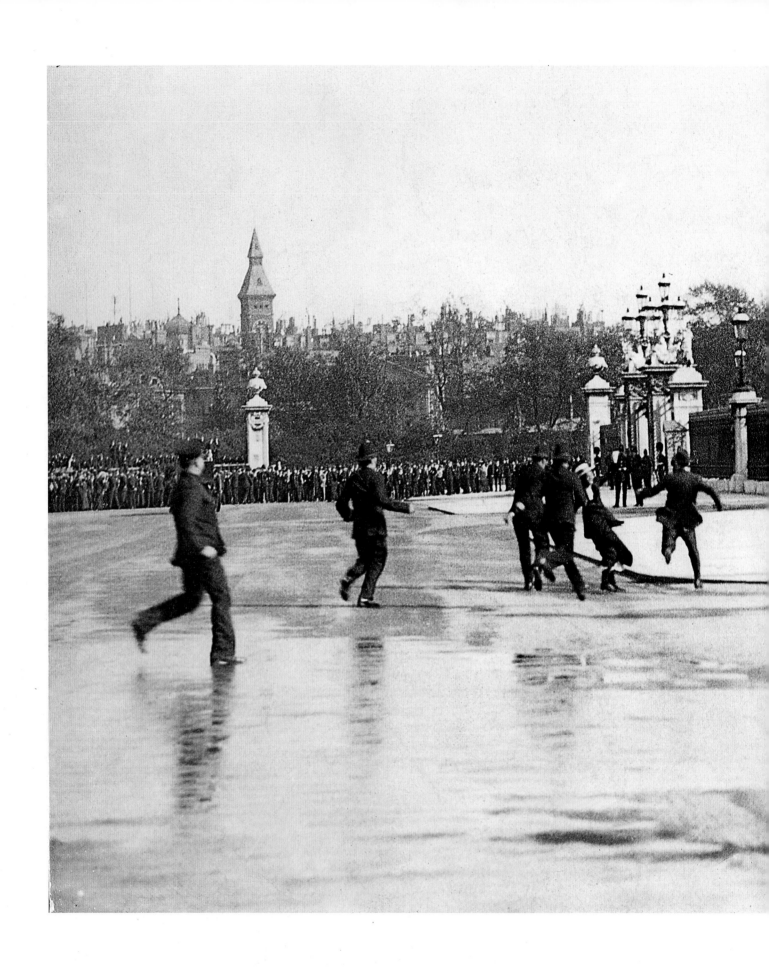

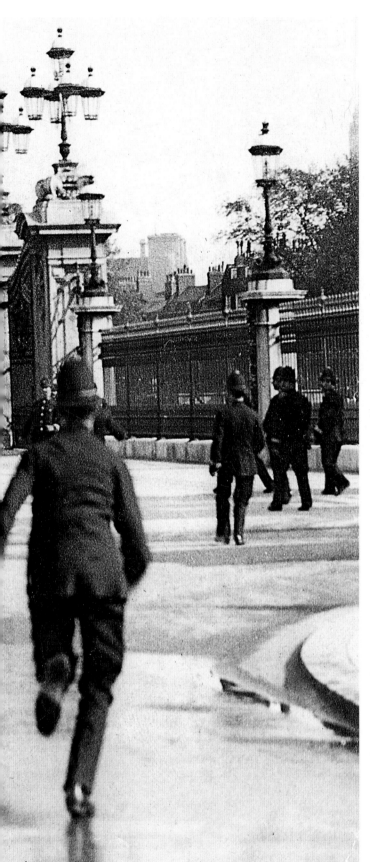

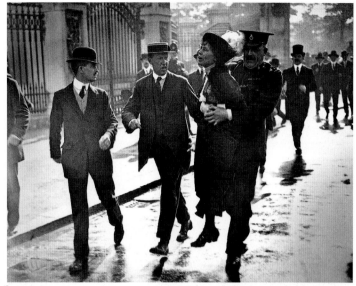

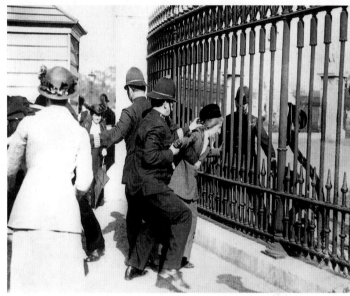

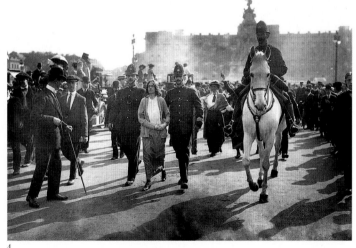

One of the suffragettes' most effective moves was to chain themselves to the railings of Buckingham Palace (1, 3). The founder of the WSPU, Emmeline Pankhurst (2), and many others were arrested on this occasion (4).

EINE der wirksamsten Aktionen der Suffragetten bestand darin, sich an das Gitter vor dem Buckingham Palace anzuketten (1, 3). Die Gründerin der WSPU, Emmeline Pankhurst (2), und viele andere wurden bei dieser Gelegenheit verhaftet (4).

UNE des actions les plus efficaces des suffragettes consistait à s'enchaîner aux grilles du palais de Buckingham (1 et 3). La fondatrice de la WSPU, Emmeline Pankhurst (2), et beaucoup d'autres furent arrêtées à cette occasion (4).

1

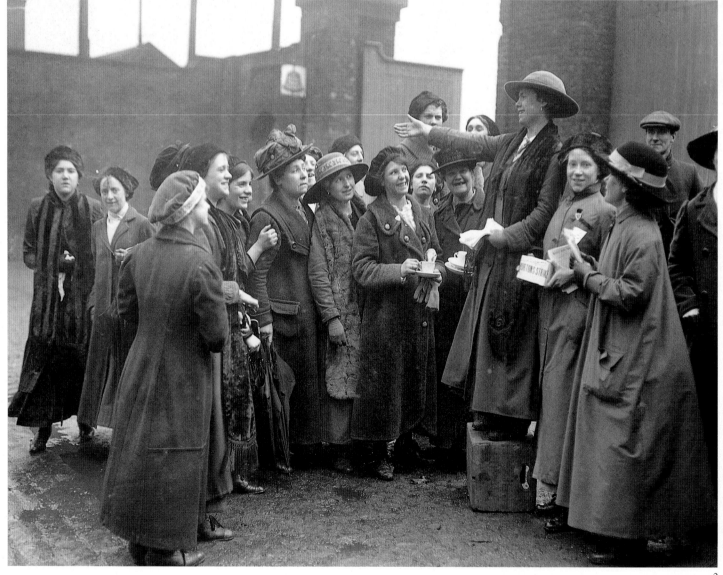

2

3

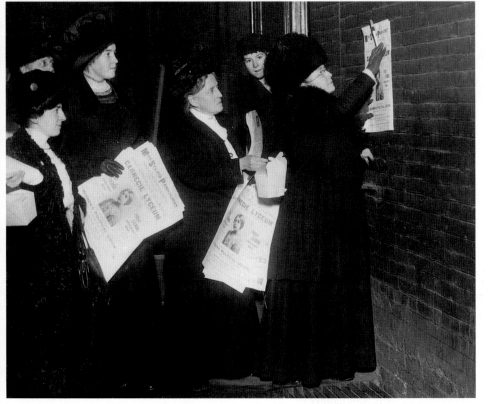

4

THE International Council of Women (1); women strikers outside a Millwall factory in 1914 (2); suffragettes dressed as the Abbesses who had attended Ancient English Parliaments (3); New York suffragettes with posters for a lecture by Sylvia Pankhurst (4).

DER International Council of Women (1); streikende Frauen 1914 vor einer Fabrik in Millwall (2); Suffragetten, gekleidet wie die Äbtissinnen, die an Sitzungen früher englischer Parlamente teilgenommen hatten (3); New Yorker Frauenrechtlerinnen mit Plakaten, die einen Vortrag von Sylvia Pankhurst ankündigten (4).

LE Conseil international des femmes (1) ; des grévistes assemblées à l'extérieur d'une fabrique à Millwall en 1914 (2). Des suffragettes habillées comme les abbesses de jadis qui siégeaient dans les parlements anglais (3). Des suffragettes à New York collant des affiches annonçant une conférence de Sylvia Pankhurst (4).

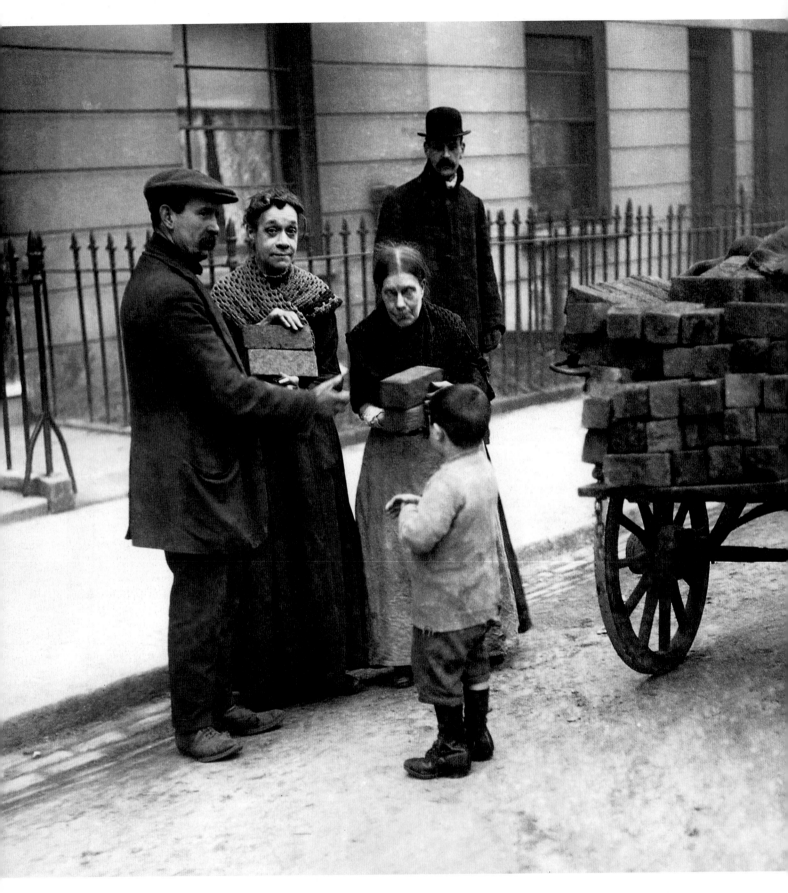

STRIKES in the coal industry were seen as threats to the economic well-being of much of the world, which relied on coal for most of its industrial energy. But conditions in mines were appalling. Safety standards were heartlessly low. Pay was barely adequate, and was sometimes cut. When coal production was halted, domestic users could make do with wood (1); miners occupied power houses in South Wales (2); women and children scavenged for bits of coal from the slagheaps that surrounded the closed mines (3).

STREIKS im Kohlebergbau galten als Gefährdung des wirtschaftlichen Wohlergehens weiter Teile der Welt, die auf Kohle als Energiequelle für die meisten Industriezweige angewiesen waren.

Aber die Arbeitsbedingungen in den Gruben waren geradezu entsetzlich, die Sicherheitsstandards erschreckend schlecht. Die Löhne waren alles andere als angemessen und wurden manchmal sogar noch

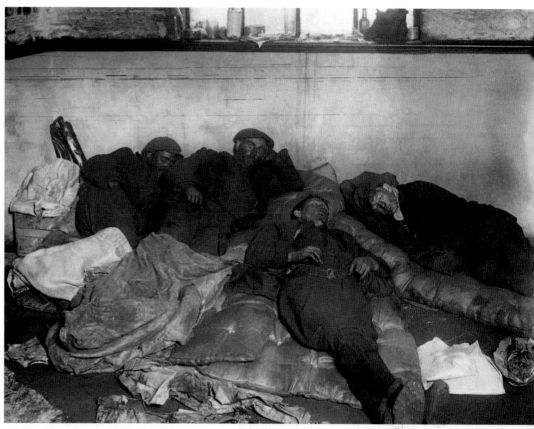

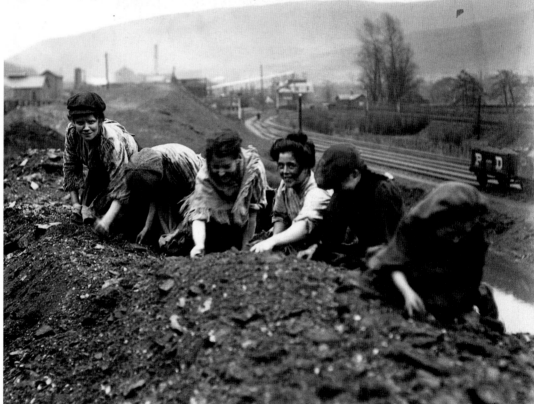

gekürzt. Wenn die Kohleförderung zum Stillstand kam, konnte man in privaten Haushalten noch immer mit Holz heizen (1). Bergarbeiter besetzten Kraftwerke in Südwales (2). Frauen und Kinder sammelten Kohlestückchen von den Schlackenhalden vor den geschlossenen Gruben (3).

LES grèves dans l'industrie charbonnière étaient considérées comme une menace pour le bien économique d'une grande partie du monde, car le charbon produisait 90 % de l'énergie industrielle.

Dans les mines, les normes de sécurité étaient cruellement déficientes, les salaires à peine suffisants baissaient parfois. Lorsque la production de charbon était arrêtée, les particuliers compensaient par le bois de chauffage (1). Les mineurs occupant des installations de production d'électricité dans le sud du Pays de Galles (2). Des femmes et des enfants récupérant dans les terrils autour des mines fermées des morceaux de charbon (3).

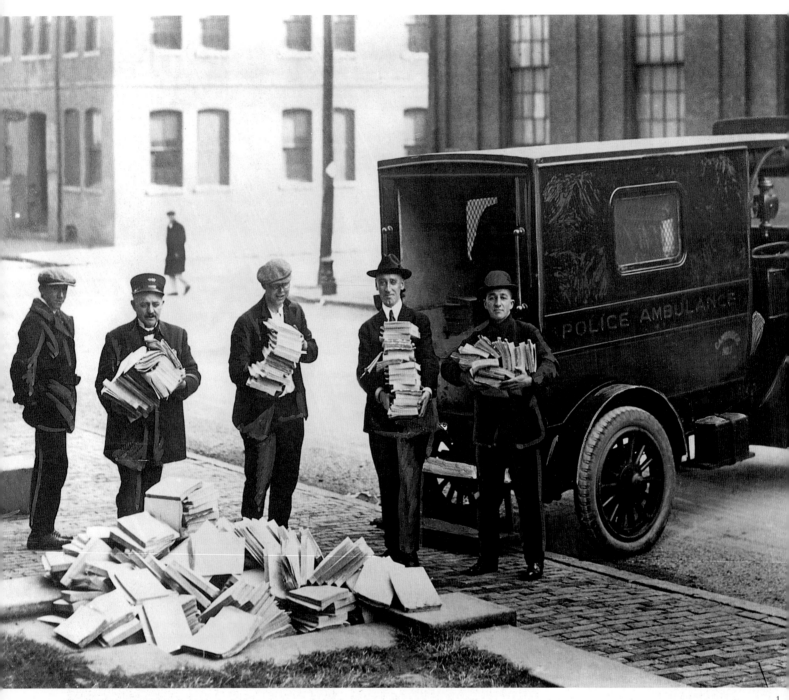

1

UNREST was not confined to the industrial front. The rumblings of revolution in Russia had shocked and inspired the rest of the world in equal parts. To poor people in rich countries socialism brought hope. To rich people in rich countries it brought fear. 'Revolution in Boston nipped in the bud' was the caption to this photograph in 1919 (1). Presumably, once these few dozen books had been destroyed all would be safe for the onward march of capitalism. In Paris in 1911 students clashed with police outside the Faculty of Justice (2, 3).

DIE Unruhen beschränkten sich aber nicht nur auf die Industrie. Die Erschütterungen der Revolution in Rußland hatten den Rest der Welt ebenso schockiert wie inspiriert. Für die armen Menschen der reichen Länder brachte der Sozialismus Hoffnung. Für die reichen Menschen der reichen Länder brachte er Angst. »Revolution in Boston im Keim erstickt«, lautete 1919 die Bildzeile zu dieser Photographie (1). Wenn diese Bücher erst einmal verbrannt waren, würde dem Vormarsch des Kapitalismus vermutlich nichts mehr im Wege stehen. In Paris lieferten sich Studenten 1911 vor der Juristischen Fakultät Kämpfe mit der Polizei (2, 3).

L'AGITATION ne se limitait pas au hair front industriel. Les échos de la révolution en Russie avaient, à parts égales, offensé et inspiré le reste du monde. Pour les pauvres vivant dans les pays riches, le socialisme apportait l'espoir. Pour les riches desdits pays, la peur. « La révolution étouffée dans l'œuf à Boston » titrait cette photographie en 1911 (1). Il est à présumer qu'une fois détruits ces quelques dizaines de livres, la marche en avant du capitalisme n'aura plus rien à craindre. À Paris en 1911 : des étudiants en prise avec les forces de police à l'extérieur de la faculté de droit (2 et 3).

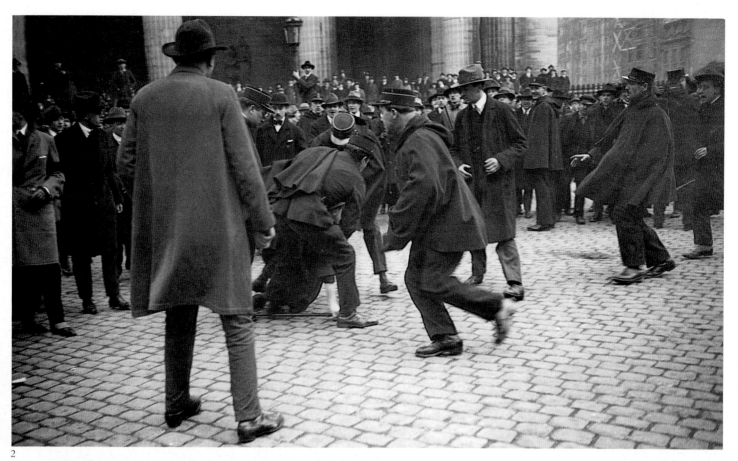

2

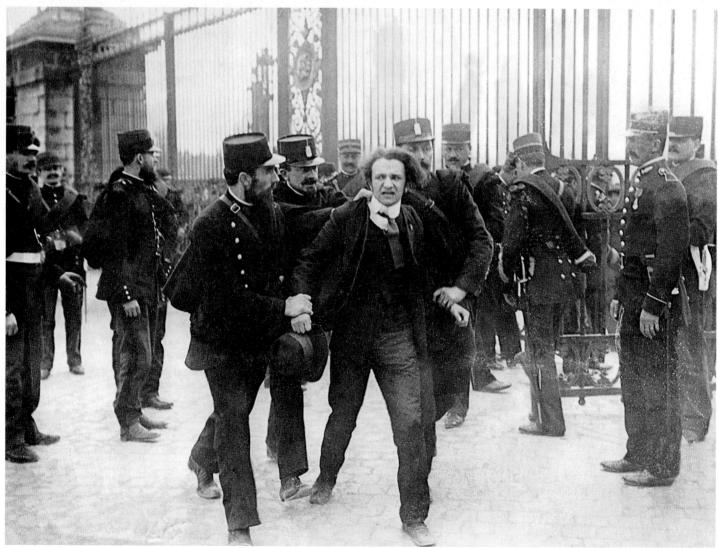

3

THROUGHOUT Europe, the most powerful workers were the dockers, miners and railway workers. The Great Railway Strike of 1919 in Britain was triggered by the threat of a reduction in wages. Office workers fought to get on trams as alternative transport (1). Where trains did run, seats were scarce and passengers sat wherever they could (2). 'Blacklegs' provoked fights in the streets (3). Supplies were brought in by road. The food depot in London's Hyde Park was guarded by troops (4) – but the strike was successful.

IN ganz Europa waren Dockarbeiter, Bergarbeiter und Eisenbahner die wichtigsten und daher mächtigsten Arbeiter. Der große Eisenbahnerstreik in Großbritannien wurde 1919 durch die Ankündigung von Lohnkürzungen aus-gelöst. Büroangestellte aus der Mittel-schicht erkämpften sich einen Platz in der Straßenbahn (1). Dort, wo die Züge fuhren, waren Sitzplätze rar, und die

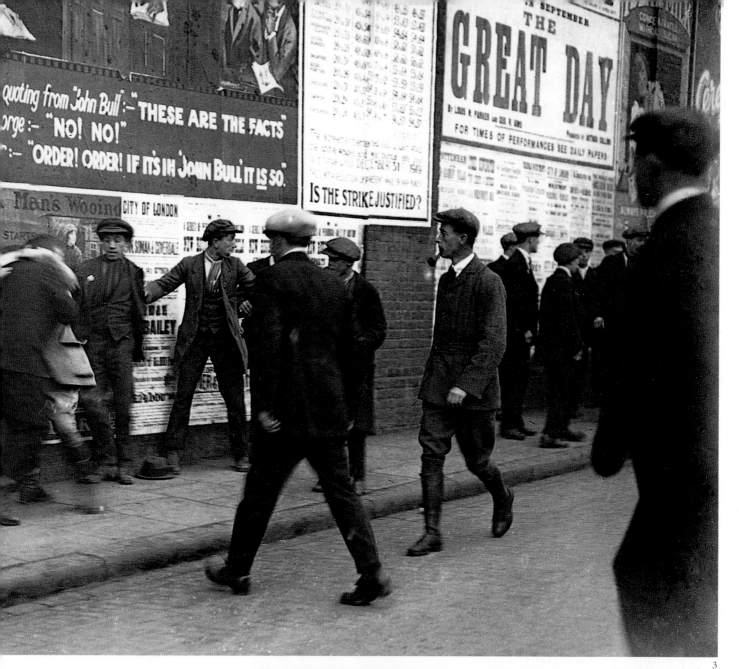

Passagiere setzten sich hin, wo sie konnten (2). Streikbrecher provozierten Kämpfe auf den Straßen (3). Lieferungen wurden über die Straßen transportiert. Das Lebensmitteldepot im Londoner Hyde Park wurde von Truppen bewacht (4) – aber der Streik war erfolgreich.

En Europe, les travailleurs les plus puissants étaient les dockers, les mineurs et les cheminots. La grève générale des cheminots en 1919 en Grande-Bretagne s'était déclenchée à la suite d'une menace de réduction des salaires. Les classes moyennes se battaient pour monter dans les trams, l'autre moyen d'aller et de revenir du travail (1). Dans les trains qui circulaient, les places étaient rares et les passagers s'asseyaient là où ils pouvaient (2). Les « briseurs de grève » provoquaient des combats dans les rues (3). L'approvisionnement se faisait par la route. Les dépôts de vivres de Hyde Park, à Londres, étaient gardés par les troupes (4). La grève fut malgré tout couronnée de succès.

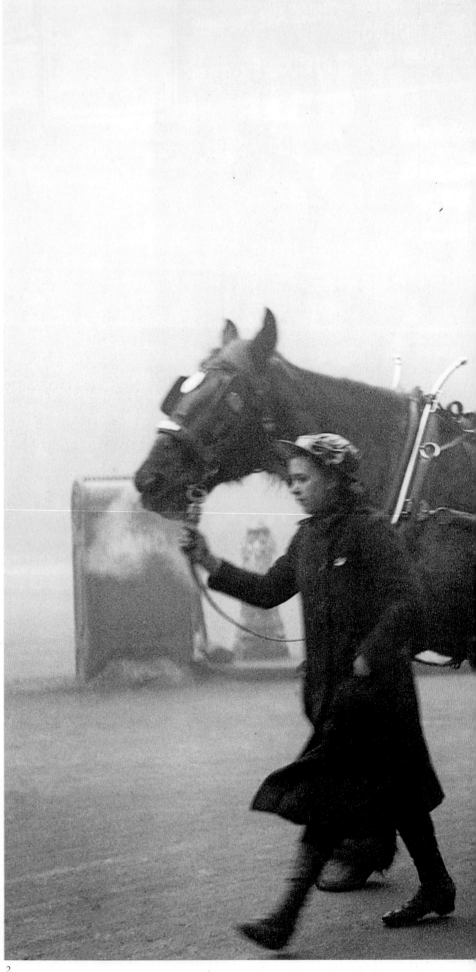

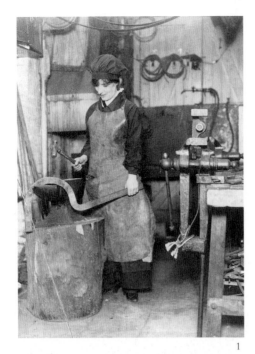

WOMEN left the prison of home or service in increasing numbers. As far as possible, the male establishment kept them from positions of power or authority, but they were prepared to allow women the more menial or less prestigious jobs available. Some became blacksmiths (1), others coal heavers (2).

IMMER mehr Frauen brachen aus dem Gefängnis ihres Heims oder ihrer Stellung aus. Das männliche Establishment schloß Frauen so weit wie möglich von Machtpositionen aus, aber man war bereit, ihnen die niedrigeren und weniger prestigeträchtigen Arbeiten zu überlassen. Einige wurden Schmied (1), andere lieferten Kohle aus (2).

DE plus en plus de femmes quittaient leur foyer-prison ou la maison où elles servaient. Le monde masculin les écartait autant que faire se peut des positions de pouvoir ou d'autorité ; en revanche, il leur laissait volontiers les emplois moins importants ou moins prestigieux qui étaient disponibles. Certaines se mettaient à la forge (1), d'autres au transport du charbon (2).

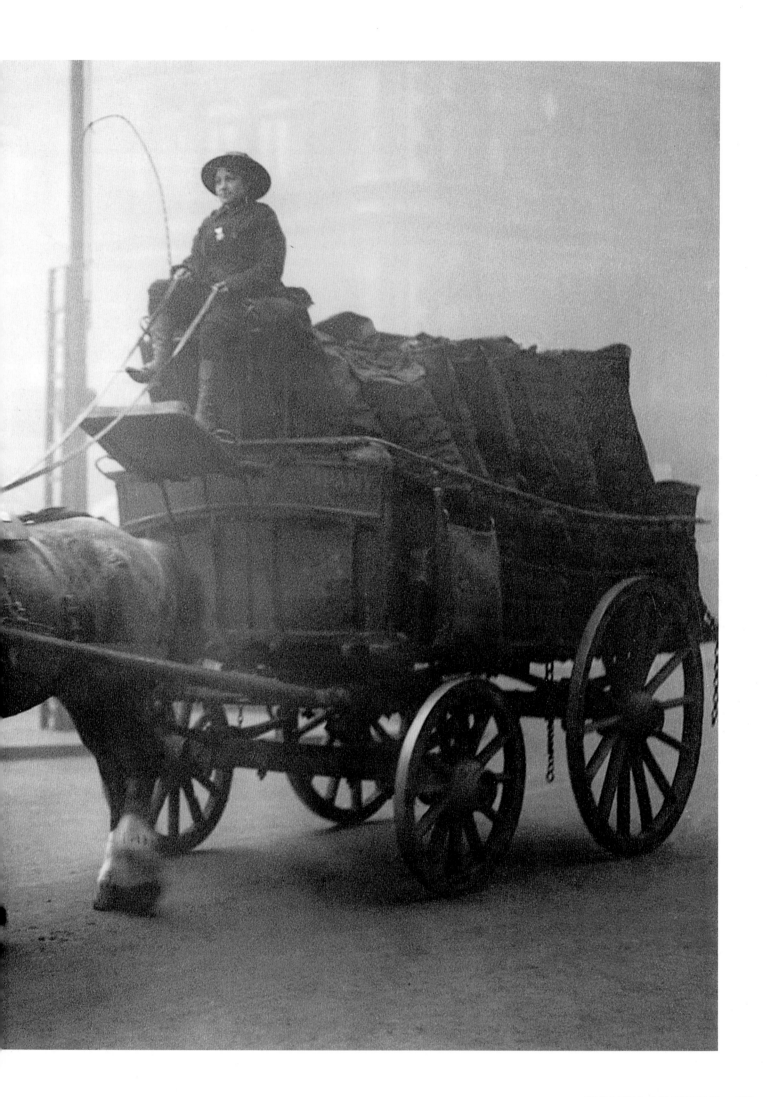

THE First World War deprived labour markets of millions of fighting men, and women were encouraged and ordered to take on many new roles. The Women's Volunteer Reserve ran their own garages and motor workshops (1). Women worked in armament factories in France (2) and all over Europe. The First Aid Yeomanry were forerunners of women's army corps (3). And women found themselves once again working in collieries (4).

DER Erste Weltkrieg beraubte den Arbeitsmarkt vieler kämpfender Männer, und Frauen wurden ermutigt und aufgefordert, viele neue Rollen anzunehmen. Die freiwillige Frauenreserve, Women's Volunteer Reserve, betrieb eigene Garagen und Autowerkstätten (1). In Frankreich (2) und in ganz Europa arbeiteten Frauen in Rüstungsfabriken. Die First Aid Yeomanry war eine Vorläuferin des ersten weiblichen Armeekorps (3). Und erneut arbeiteten Frauen in Bergwerken (4).

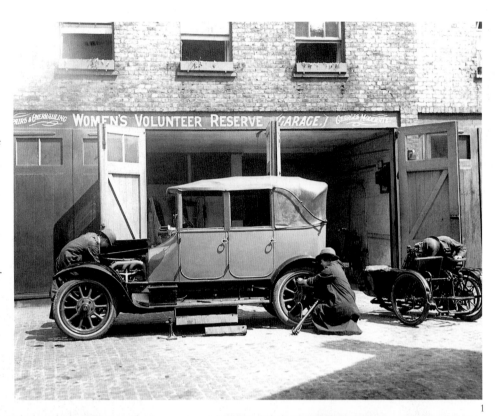

1

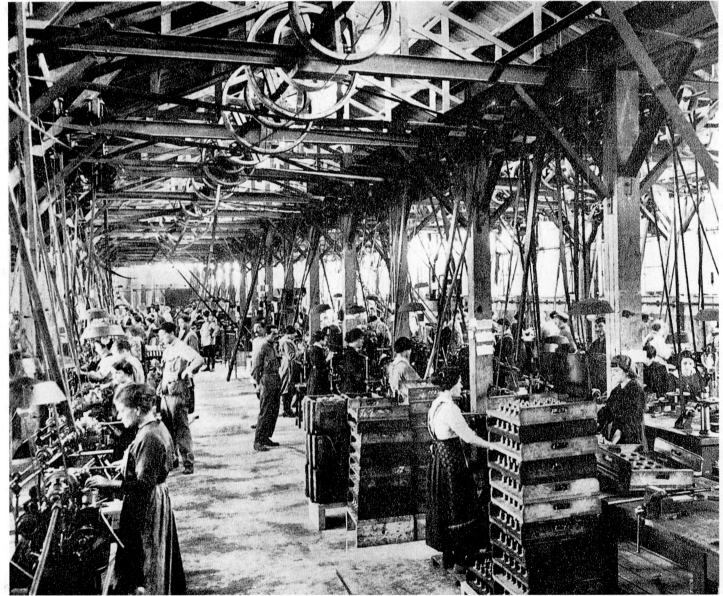

2

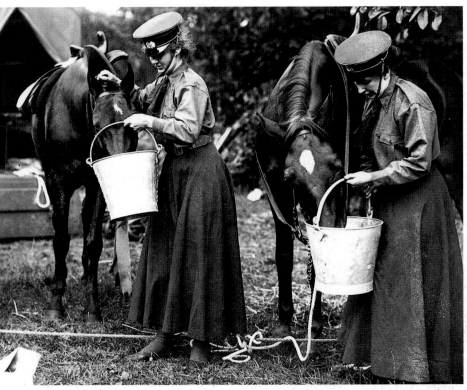

LA Première Guerre mondiale privant le marché du travail des millions d'hommes envoyés se battre, encouragea et contraignit les femmes à assumer un grand nombre de rôles nouveaux. La réserve des volontaires féminines exploitait ses propres garages et ateliers de réparation automobile (1). Les femmes travaillaient dans les usines d'armement en France (2) comme dans le reste de l'Europe. Le First Aid Yeomanry fut l'ancêtre des corps de volontaires féminins (3). Et les femmes se retrouvèrent une fois de plus au fond des houillères (4).

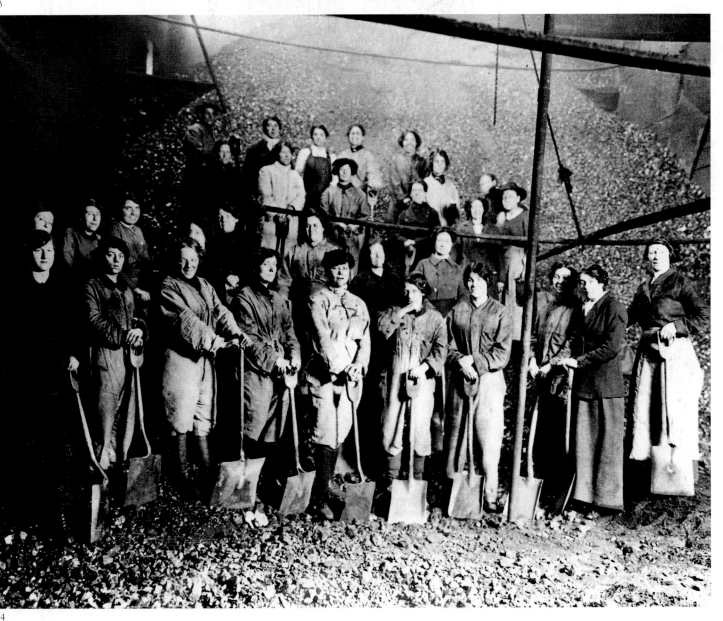

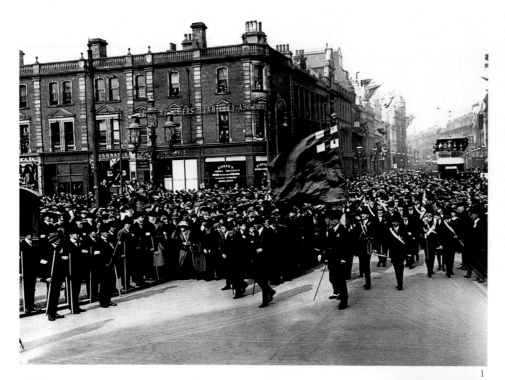

Tage lang abwehren. Die Hauptpost von Belfast brannte aus (3) und Teile der Sackville Street sahen aus, als seien sie bombardiert worden (4).

Dès le XXᵉ siècle, les autorités britanniques négociaient sérieusement l'indépendance de l'Irlande. Sous la direction habile, pour ne pas dire rusée, de Sir Edward Carson, les unionistes essayèrent de s'y opposer. Ils levèrent la Force armée des volontaires de l'Ulster et organisèrent d'importantes manifestations populaires contre le mouvement Home Rule réclamant l'autonomie : on

By the 20th century, British governments were seriously negotiating independence for Ireland. Under the skilled, not to say cunning, leadership of Sir Edward Carson, the Unionists sought to prevent this. They raised the armed Ulster Volunteer Force and organized massive rallies against Home Rule, such as this in 1912, when Carson and others led a parade to Belfast's City Hall (1). Four years later, the Irish Volunteers – who supported Irish independence – rose in open rebellion against the British. They barricaded the Dublin streets (2), took possession of key buildings and held out against British troops for four days. The General Post Office was gutted (3), and parts of Sackville Street looked as though they had been bombed (4).

In den ersten Jahrzehnten des 20. Jahrhunderts verhandelten britische Regierungen ernsthaft über die Unabhängigkeit Irlands. Unter der fähigen, um nicht zu sagen listigen Führung von Sir Edward Carson versuchten die Unionisten, dies zu verhindern. Sie stellten bewaffnete Truppen auf, die Ulster Volunteer Force, und organisierten Kundgebungen gegen die Selbstbestimmung, die Home Rule, beispielsweise die 1912 von Carson angeführte Demonstration zum Belfaster Rathaus (1). Vier Jahre später erhoben sich die Irish Volunteers, die die irische Unabhängigkeit unterstützten, in offener Rebellion gegen die Briten. Sie errichteten Barrikaden in den Straßen von Dublin (2), besetzten wichtige Gebäude und konnten die Angriffe der britischen Truppen vier

voit ici, entre autres, Carson à la tête d'une manifestation, marchant sur l'hôtel de ville de Belfast en 1912 (1). Quatre ans plus tard, les volontaires irlandais qui soutenaient l'indépendance du pays entrèrent en rébellion ouverte contre les Britanniques. Ils élevèrent des barricades dans les rues de Dublin (2), s'emparèrent de bâtiments-clés et tinrent tête aux troupes britanniques quatre jours durant. L'intérieur de la poste générale fut démoli (3), tandis que la rue de Sackville donnait à certains endroits l'impression d'avoir été bombardée (4).

3

Conflict

WAR broke out between Russia and Turkey in 1853. France and Britain sided with Turkey, and sent armies to the Crimea. It was nearly 40 years since there had been a major European war, and the generals of both sides were a little rusty. Lord Raglan (1 – on left, in fancy pith helmet), Commander-in-Chief of the British troops, had an unfortunate habit of referring to the enemy as 'the French', a hangover from his last campaign, against Bonaparte. Quite what the French Commander-in-Chief, General Pélissier (1 – on right), thought of this is not recorded.

The Crimean War was the first to be covered by reporters – William Howard Russell (2) was war correspondent of *The Times*. People at home learnt of the appalling blunders made by those in charge. One consignment of woollen underwear, sent to keep troops warm in temperatures that were sometimes 30° below zero, had been made for children under ten.

Inefficiency apart, it was a war of traditional bravado and heroism, run on old-fashioned lines – a war in which cavalry charged artillery, infantries clashed in thick fog, and the *vivandière* revictualled the troops (3).

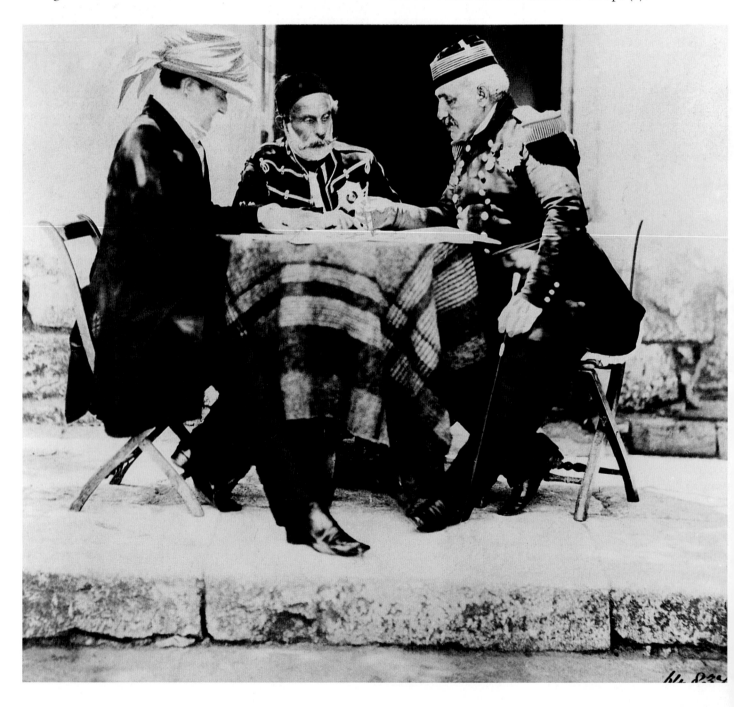

2

3

IM Jahre 1853 brach zwischen Rußland und der Türkei Krieg aus. Frankreich und Großbritannien unterstützten die Türkei und schickten Armeen an die Krim. Der letzte große Krieg in Europa lag fast vierzig Jahre zurück, und die Generäle waren ein wenig aus der Übung. Lord Raglan (1, links, mit Tropenhelm), Oberkommandeur der britischen Truppen, hatte die unselige Angewohnheit, den Feind als »der Franzose« zu bezeichnen, wie in seinem letzten Feldzug gegen Bonaparte. Was der französische General Pélissier (1, rechts) davon hielt, ist nicht überliefert.

Der Krimkrieg war der erste, über den Kriegsberichterstatter schrieben. W. H. Russell (2) war Korrespondent der *Times*. Die Menschen zu Hause erfuhren von den Fehlern, die den Verantwortlichen unterliefen. Eine Sendung wollener Unterwäsche, die die Truppen bei Temperaturen von unter minus dreißig Grad warmhalten sollte, war für Kinder unter zehn Jahren gemacht.

Von den Fehlern abgesehen, war es ein Krieg des traditionellen Heldentums, der mit altmodischen Strategien geführt wurde; ein Krieg, in dem die Kavallerie die Artillerie angriff, Infanterien in dichtem Nebel zusammenstießen und die Marketenderin die Truppen mit Proviant versorgte, wohin sie auch gingen (3).

LA guerre éclata entre la Russie et la Turquie en 1853. La France et la Grande-Bretagne épousèrent la cause de la Turquie et envoyèrent leurs armées en Crimée. Lord Raglan (1, à gauche en casque colonial fantaisiste), commandant en chef des troupes britanniques, avait la déplorable habitude d'appeler l'ennemi « les Français », nostalgie de sa dernière campagne contre Bonaparte. L'histoire ne dit pas ce qu'en pensait le commandant en chef, le général Pélissier (1, à droite).

La guerre de Crimée fut la première à être photographiée et couverte sur place par des reporters de presse : William Howard Russell (2) était le correspondant de guerre du journal *The Times*. La population civile entendait parler des effroyables bourdes commises par les responsables : un lot de sous-vêtements en laine pour enfants de moins de dix ans fut expédié aux troupes qui les attendaient par -30°. Cette inefficacité mise à part, c'était une guerre traditionnelle et démodée de bravade et d'héroïsme : une guerre dans laquelle la cavalerie chargeait l'artillerie, les infanteries s'entremêlaient dans un brouillard épais. Les vivandières ravitaillaient les troupes où qu'elles fussent (3).

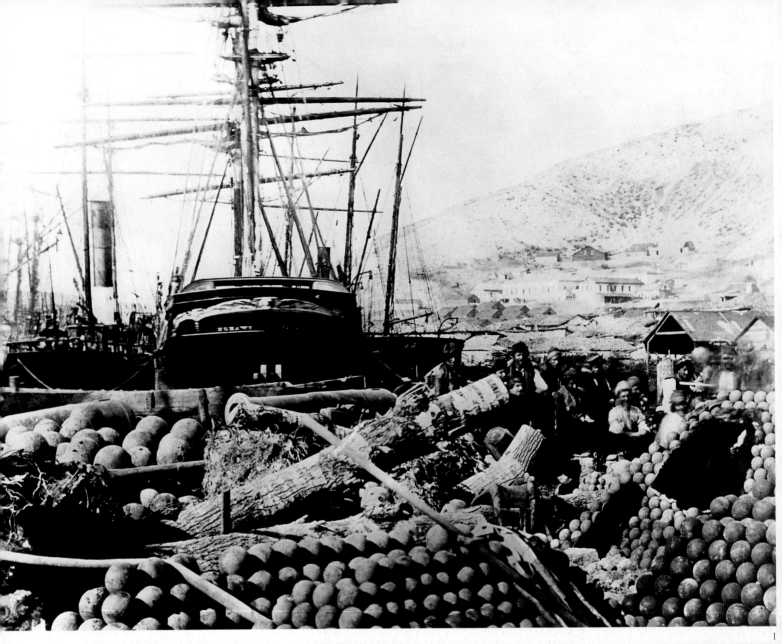

The French and British base was at
Balaclava (1). Into this small harbour
poured powder, shot, cannonballs, siege
weapons, food, clothing, huts, blankets and
boots. The war centred around the siege
of the Russian stronghold, Sebastopol. Life
in the trenches was boring rather than
dangerous (2). Life inside the Redan, the
inner fortress of Sebastopol, was more
exciting, especially once the French and
British had realized the futility of the siege
and turned instead to a direct assault. The
Russians left little behind (3).

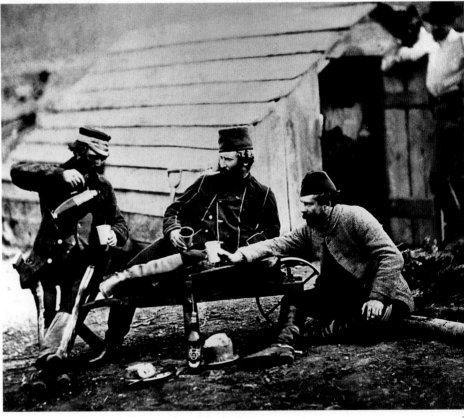

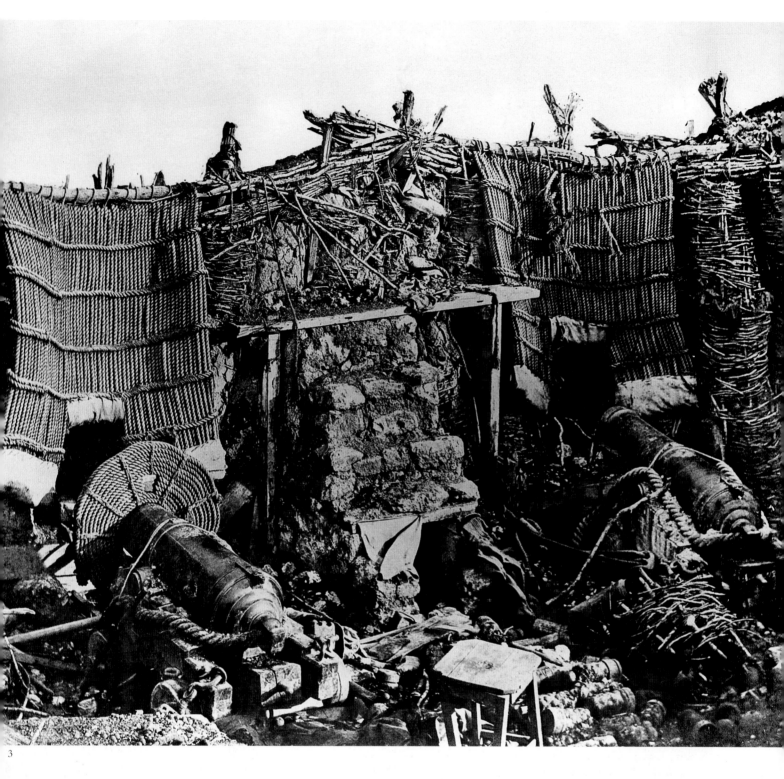

3

DER Stützpunkt der Briten und
Franzosen befand sich in Balaclava (1).
In diesen kleinen Hafen wurden Schieß-
pulver, Kanonenkugeln, Belagerungswaffen,
Lebensmittel, Kleidung, Zelte, Decken
und Stiefel gebracht. Der Krieg konzen-
trierte sich auf die Belagerung des russischen
Stützpunktes Sebastopol. Das Leben in
den Schützengräben war eher langweilig
als gefährlich (2). In Redan, der Festung im
Inneren von Sebastopol, war es aufregen-
der, besonders als die Franzosen und Briten
die Sinnlosigkeit der Belagerung erkannt
hatten und zum direkten Angriff über-
gingen. Die Russen ließen nur wenig
zurück (3).

LES Français et les Britanniques avaient
leur base à Balaklava (1). Dans ce petit
port arrivaient la poudre, les balles et autres
projectiles, les boulets de canon, les armes
destinées aux sièges, les vivres, l'habille-
ment, les baraques, les couvertures et les
chaussures. La guerre se concentrait sur le
siège de la place forte russe de Sébastopol.
La vie dans les tranchées autour de Sébasto-
pol était plus ennuyeuse que dangereuse, et
la pause café était la bienvenue (2). La vie
à l'intérieur de Redan, ouvrage fortifié dans
Sébastopol, était plus excitante, surtout
lorsque les Français et les Britanniques, ayant
réalisé la futilité du siège, montèrent directe-
ment à l'assaut. Les Russes ne laissèrent que
peu de choses derrière eux (3).

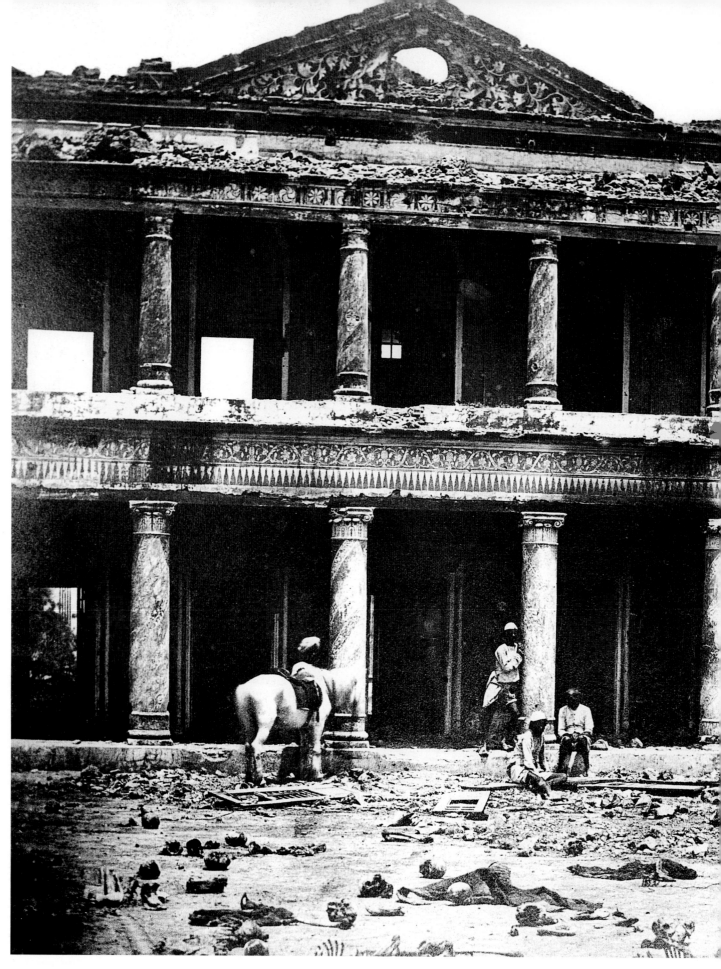

IN 1857, during Ramadan, five English people were murdered in the fortress palace of the Moghul Emperor. It was the start of the Indian Mutiny, a cruel war, with atrocities committed by both sides. During

Sir Colin Campbell's relief of Lucknow, 2,000 rebel sepoys were killed (1). Mutineers (2) were brave but ill-led. Hodson's Horse was a mixed troop of British and Indian officers (3).

WÄHREND des Ramadan im Jahre 1857 wurden fünf Engländer im Palast des Moguls umgebracht. Es war der Beginn des indischen Aufstands, eines brutalen Krieges, der von beiden Seiten mit der gleichen Grausamkeit geführt wurde. Während der Befreiung der Garnison

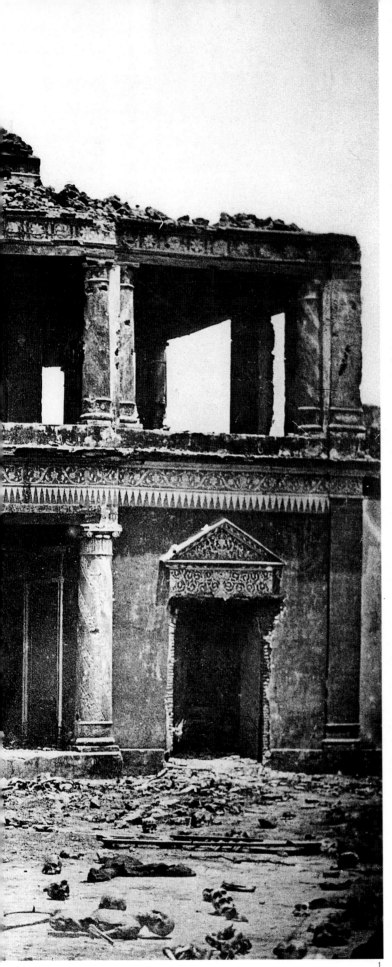

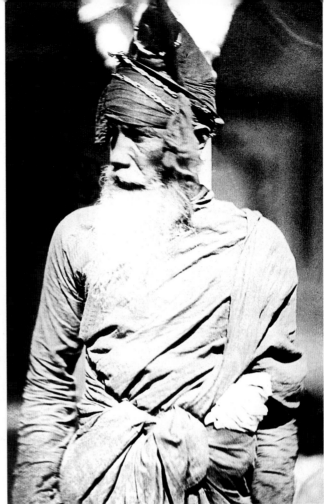

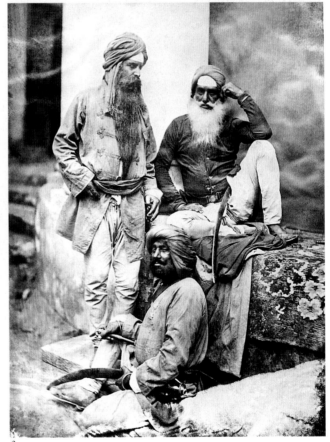

Lucknow durch Sir Colin Campbell wurden 2 000 rebellische Sepoys, eingeborene Soldaten der britischen Armee in Indien, getötet (1). Aufständische (2) waren zwar tapfer, aber schlecht organisiert. Hodson's Horse war eine aus Briten und Indern zusammengesetzte Truppe (3).

EN 1857, durant le ramadan, cinq Anglais furent assassinés dans le palais fortifié de l'empereur moghol. Ce fut le départ de la révolte des cipayes, une guerre cruelle avec des atrocités commises des deux côtés. Lorsque Sir Colin Campbell arriva à la rescousse de la garnison assiégée à Lucknow, il laissa ses hommes massacrer 2 000 cipayes rebelles à Secundra Bagh (1). Les mutins, comme ce Sikh (2), étaient courageux mais mal commandés. Les troupes irrégulières britanniques incluaient le célèbre Hodson's Horse, un corps mêlé d'officiers britanniques et indiens (3).

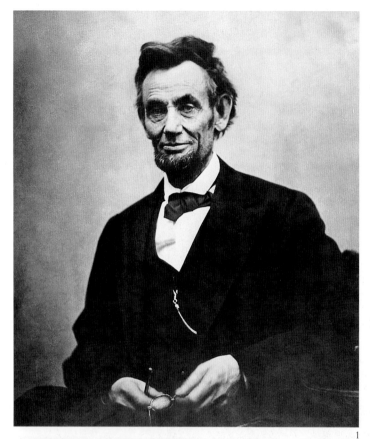

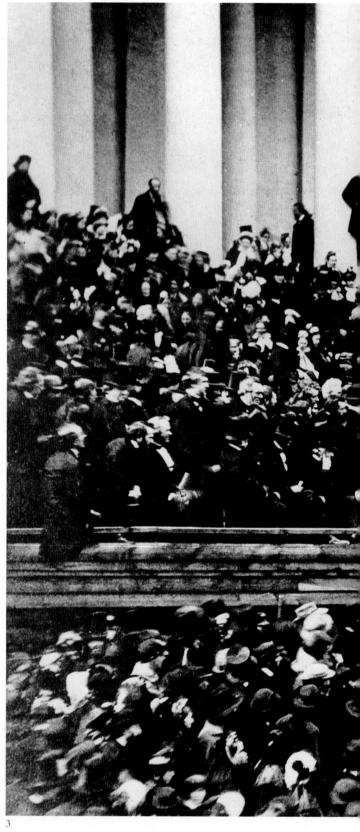

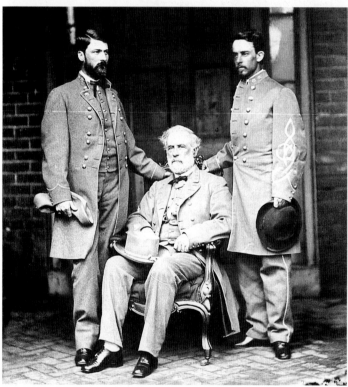

THE War Between the States was the first truly modern war. It was also the bloodiest conflict in American history. More Americans died in the Civil War than in all the nation's other wars put together. For four years, from 1861 to 1865, father fought son, brother fought brother, and the land east of the Mississippi was torn apart. The issues were a bull-headed mixture of political, economic and moral factors. For the South, secession from the Union was almost inevitable once Abraham Lincoln (1) had been inaugurated as President (3). The champion of the South was General Robert E. Lee (2 – seated centre), brave in battle, gentlemanly in defeat.

DER Amerikanische Bürgerkrieg war der erste wirklich moderne Krieg und zudem der blutigste Konflikt in der amerikanischen Geschichte. Es starben mehr Amerikaner als in den gesamten übrigen Kriegen, die das Land führte. Vier Jahre lang, von 1861 bis 1865, kämpfte Vater gegen Sohn, Bruder gegen Bruder, und das Land östlich des Mississippi wurde zerrissen.

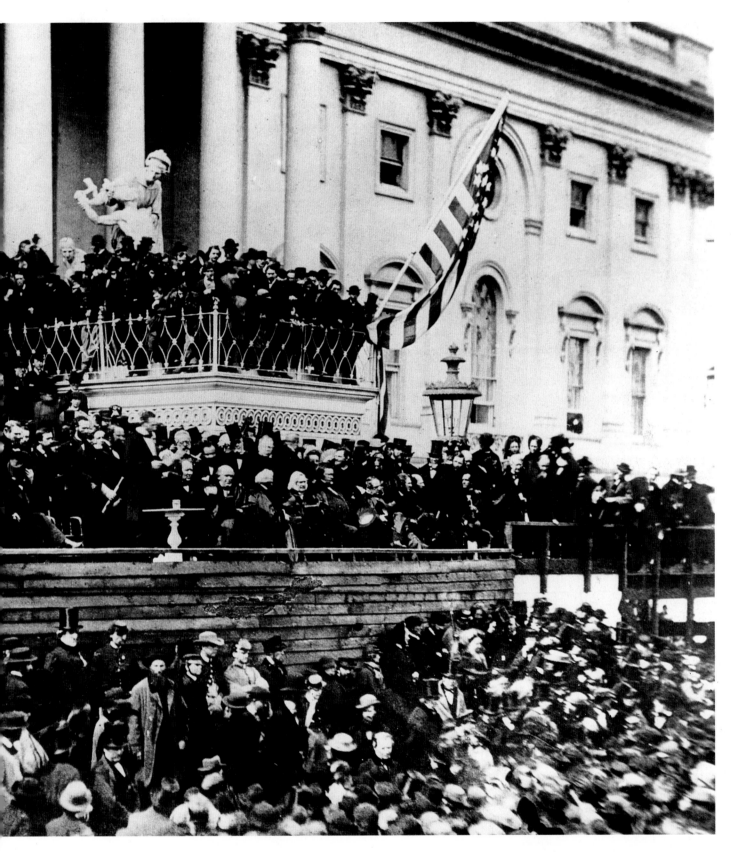

Der Anlaß war eine starrköpfige Mischung aus politischen, wirtschaftlichen und moralischen Faktoren. Für den Süden war die Abspaltung vom Bund fast unvermeidlich, nachdem Abraham Lincoln (1) das Amt des Präsidenten angetreten hatte (3). Der Held des Südens war General Robert E. Lee (2, Mitte), tapfer in der Schlacht und ein Gentleman in der Niederlage.

LA guerre de Sécession fut la première véritable guerre moderne. Ce fut aussi le conflit le plus sanglant de l'histoire d'Outre-Atlantique. Il mourut plus de Nord-Américains durant la guerre civile que pendant toutes les autres guerres livrées par la nation. Quatre années durant, de 1861 à 1865, le père combattit le fils, le frère son frère, et les territoires, à l'est du Mississippi, se déchirèrent.

Les enjeux en résultaient d'un mélange détonant de considérations politiques, économiques et morales. Pour le Sud, sa sortie de l'Union était devenue quasiment inévitable dès lors qu'Abraham Lincoln (1) avait été investi de la présidence (3). Le champion du Sud était le général Robert E. Lee (2, assis au centre), brave sur le champ de bataille et gentilhomme dans la défaite.

1

2

3

4

immens. Eine der schlimmsten Schlachten war die von Chancellorsville im Mai 1863 – hier kümmert sich ein schwarzer Soldat um einen verwundeten Kameraden (3). Dieser Krieg wurde überwiegend mit Angriffen der Infanterie (4) aus Stellungen geführt, die von der Artillerie gedeckt waren, beispielsweise von Robertsons Brigade der vierten US-Artillerie (5).

DE nombreuses nations envoyèrent des observateurs étudier sur place la puissance destructrice des armes modernes. Parmi eux se trouvait le comte allemand Zeppelin (1, deuxième à droite). Une des nouvelles armes les plus impressionnantes par ses dimensions était l'obusier géant, le « Dictateur » (2), que le Nord avait utilisé au début de 1865. Les batailles étaient sanglantes et les morts et

les blessés s'accumulaient des deux côtés. Une des pires fut la bataille de Chancellorsville en mai 1863 : ici un soldat noir s'affaire autour d'un camarade blessé (3). Ce fut en grande partie une guerre où l'infanterie (4) attaquait les positions défendues par l'artillerie : ici la batterie A, quatrième corps d'artillerie des États-Unis, brigade de Robertson (5).

5

IN many ways the American Civil War was a direct forerunner of the First World War. These defensive positions at Fort Sedgewick 1865 in (1) bear a strong resemblance to the trenches on the Western Front 50 years later. The South was finally pounded into surrender in April 1865, after its capital, Richmond, Virginia (3), and many other cities had been razed to the ground. Exactly one week after Lee's surrender at Appomattox, Lincoln was assassinated. There was no mercy for the conspirators responsible. John Wilkes Booth died in a shoot-out with Federal troops. Mrs Surratt and three other conspirators were hanged (2).

1

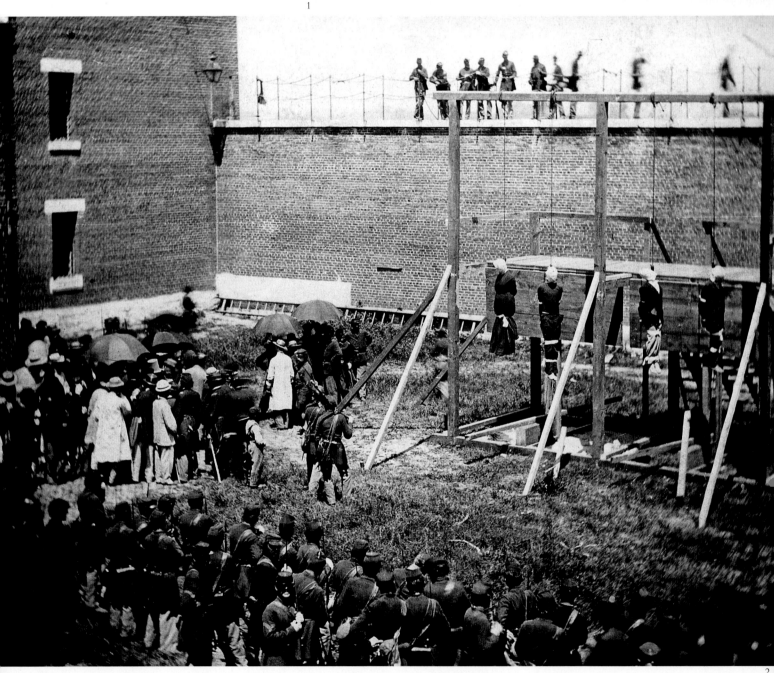

2

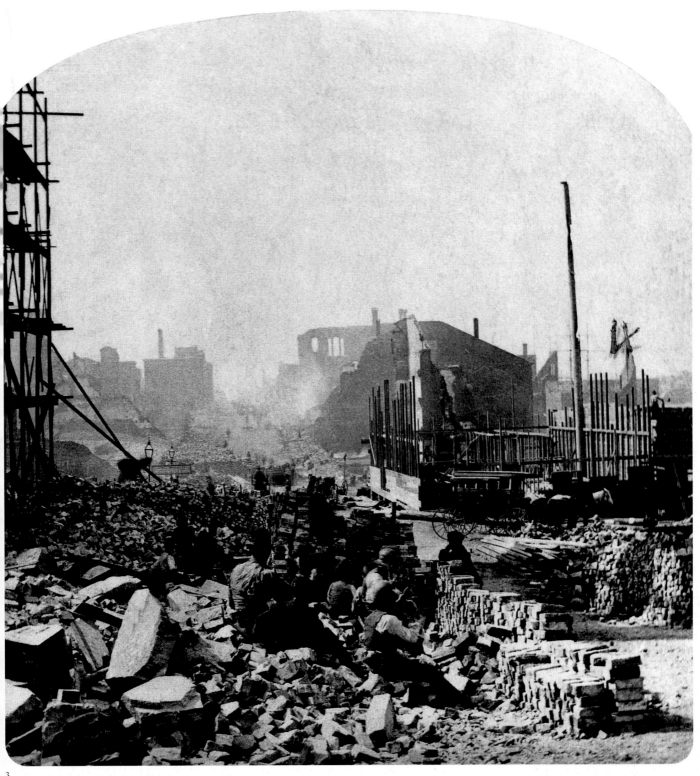

3

IN vieler Hinsicht war der Amerikanische Bürgerkrieg ein direkter Vorläufer des Ersten Weltkriegs. Die Verteidigungsstellungen in Fort Sedgewick 1865 (1) hatten große Ähnlichkeit mit den Schützengräben an der Westfront fünfzig Jahre später. Der Süden wurde schließlich im April 1865 zur Aufgabe gezwungen, nachdem seine Hauptstadt Richmond in Virginia (3) und viele andere Städte dem Erdboden gleichgemacht worden waren. Genau eine Woche nach Lees Kapitulation bei Appomattox wurde Lincoln durch ein Attentat getötet. Für die Verschwörer gab es keine Gnade. John Wilkes Booth starb in einer Schießerei mit den föderalistischen Truppen. Mrs. Surratt und drei andere Verschwörer wurden gehängt (2).

À bien des égards la guerre civile américaine servit de banc d'essai à la Première Guerre mondiale. Ces positions défensives à Fort Sedgewick en 1865 (1) ressemblent fort aux tranchées du front Ouest cinquante années plus tard. Le Sud fut finalement contraint de se rendre en avril 1865, après que sa capitale, Richmond en Virginie (3), et beaucoup d'autres grandes villes eurent été rasées. Une semaine après la capitulation de Lee à Appomattox, Lincoln était assassiné. Les conspirateurs furent traités impitoyablement. John Wilkes Booth fut tué par les troupes fédérales au cours d'un échange de balles. Madame Surratt et trois autres conspirateurs furent pendus (2).

THE Franco-Prussian war was swift and deadly. It was also a war of massive armies and big battles.

For Prussia it was a brilliant success. For the rest of the German Confederation it was proof that unity under Prussian leadership was sound policy. For France it was a humiliating defeat, sowing the seeds of the bitter harvest of the First World War. The trap was laid by the German Chancellor, Bismarck. On 2 June 1870 news reached France that the Spanish throne had been offered to Prince Leopold of Hohenzollern, a relative of the Prussian King. It was unthinkable for France to face potentially hostile regimes on two fronts. The Emperor Napoleon III insisted that Leopold's candidature be withdrawn. It was. But Napoleon went further, and demanded an undertaking that the candidature would never be renewed. Wilhelm of Prussia refused to discuss this with the French Ambassador in Berlin. Bismarck subtly changed the wording of the telegram informing the French Emperor of this sad state of affairs, giving the impression that

the French Ambassador had been summarily dismissed. France declared war.

From then on, in the words of a French commander, the French Army was in a chamber pot, 'about to be shitted upon'. Prussian victories at Woerth, Gravelotte and Sedan, where vast numbers of French artillery pieces were captured (2), led to ignominious French retreat, with worse to follow. 'There was something in the air, a subtle and mysterious emanation, strange and intolerable, which hung about the streets like a smell – the smell of invasion. It filled the houses and the public places, gave to the food an unfamiliar taste, and made people feel as though they were in a distant land among dangerous and barbaric tribes' (Guy de Maupassant, *Boule de Suif*).

They were not barbaric, but they were efficient – Crown Prince Friedrich Wilhelm, Chief of the Prussian Southern Army, with his General Staff at their headquarters, 'Les Ombrages', 13 January 1871, less than two weeks before the surrender of Paris (1).

DER Deutsch-Französische Krieg war kurz und tödlich, ein Krieg der gewaltigen Armeen und großen Schlachten.

Für Preußen war es ein glänzender Erfolg, für den Rest des Deutschen Bundes dagegen der Beweis, daß eine Einheit unter preußischer Führung eine vernünftige Politik war. Für Frankreich bedeutete es eine demütigende Niederlage und die Saat für die bittere Ernte des Ersten Weltkriegs. Die Falle hatte der deutsche Kanzler Bismarck gelegt. Am 2. Juni 1870 traf in Frankreich die Nachricht von der spanischen Thronkandidatur des Prinzen Leopold von Hohenzollern ein, einem Verwandten des preußischen Königs. Für Frankreich war es undenkbar, an zwei Grenzen mit potentiell feindlichen Regimes konfrontiert zu werden. Kaiser Napoleon III. verlangte den Verzicht Leopolds auf die Thronkandidatur. So kam es. Aber Napoleon ging weiter und verlangte die Garantie, daß die Kandidatur nicht erneuert würde. Kaiser Wilhelm weigerte sich, darüber mit dem französischen Botschafter in Berlin zu verhandeln. Bismarck nahm eine subtile Änderung des Wortlauts des Telegramms vor, in dem der französische Kaiser über den traurigen Stand der Verhandlungen informiert wurde, und vermittelte den Eindruck, der französische Botschafter

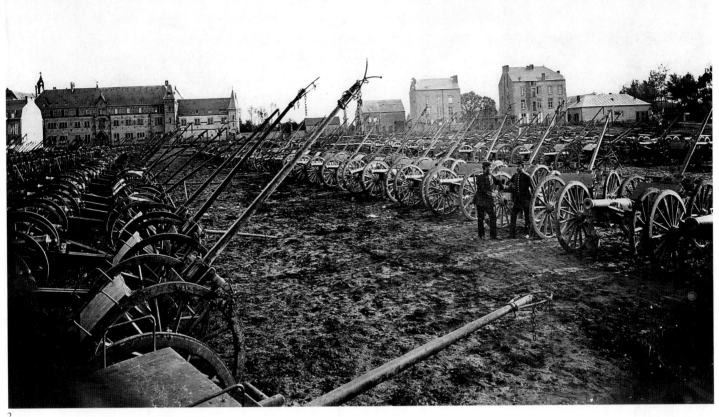

2

sei abgewiesen worden. Daraufhin erklärte Frankreich den Krieg.

Um mit den Worten eines französischen Kommandanten zu sprechen, befand sich die französische Armee von nun an in einem Nachttopf, »kurz davor, vollgeschissen zu werden«. Preußische Siege bei Woerth, Gravelotte und Sedan, bei denen große Mengen französischer Angriffswaffen erobert wurden (2), führten zu einem schmachvollen Rückzug der Franzosen, dem Schlimmeres folgen sollte. »Es lag etwas in der Luft. Eine subtile und mysteriöse Atmosphäre, seltsam und unerträglich, hing wie ein Geruch über den Straßen – der Geruch der Invasion. Er erfüllte die Häuser und die öffentlichen Plätze, verlieh dem Essen einen fremden Geschmack und gab den Menschen das Gefühl, sich in einem fernen Land unter gefährlichen und barbarischen Stämmen zu befinden.« (Guy de Maupassant, *Boule de Suif*)

Sie waren nicht barbarisch, sondern effizient. Kronprinz Friedrich Wilhelm, Oberbefehlshaber der preußischen Armee im Süden, mit seinem Generalstab im Hauptquartier »Les Ombrages« am 13. Januar 1871, weniger als zwei Wochen vor der Kapitulation von Paris (1).

ENTRE la France et la Prusse, ce fut une guerre éclair et mortelle, qui eut aussi ses immenses armées et ses grandes batailles.

Pour la Prusse ce fut un succès éclatant. Pour le reste de la confédération germanique la preuve que la politique de l'unité sous la houlette de la Prusse avait été judicieuse. La France connut une défaite humiliante qui conforta les raisons de la Première Guerre mondiale. Le chancelier allemand Bismarck tendit le piège. Le 2 juin 1870, la France apprenait que le trône d'Espagne avait été offert au prince Léopold de Hohenzollern, parent du roi de Prusse. Pour la France il n'était pas question de se retrouver presque encerclée par deux régimes potentiellement hostiles. L'empereur Napoléon III insista pour que Léopold retirât sa candidature. Ce qui fut fait. Mais Napoléon exigea en plus que cette candidature ne soit plus jamais représentée. Guillaume de Prusse refusa de discuter de la question avec l'ambassadeur de France à Berlin. Bismarck changea subtilement le libellé du télégramme informant l'empereur français du triste état des choses et qui donnait l'impression que l'ambassadeur de France avait été purement et simplement renvoyé. La France déclara alors la guerre.

À partir de là, pour reprendre les termes d'un commandant français, l'armée française se trouvait dans un pot de chambre. Les victoires prussiennes à Woerth, Gravelotte et Sedan au cours desquelles de grandes quantités de pièces d'artillerie française furent saisies (2) forcèrent la France à une retraite ignominieuse, et ce n'était qu'un commencement. « Il y avait cependant quelque chose dans l'air, quelque chose de subtil et d'inconnu, une atmosphère étrangère intolérable, comme une odeur répandue, l'odeur de l'invasion. Elle emplissait les demeures et les places publiques, changeait le goût des aliments, donnait l'impression d'être en voyage, très loin, chez des tribus barbares et dangereuses » (Guy de Maupassant, *Boule de Suif*).

Barbares ou pas, ils étaient efficaces : le prince héritier Frédéric-Guillaume, chef de l'armée prussienne du Sud, entouré de son état-major dans ses propres quartiers, « Les Ombrages », le 13 janvier 1871, moins de deux semaines avant la capitulation de Paris (1).

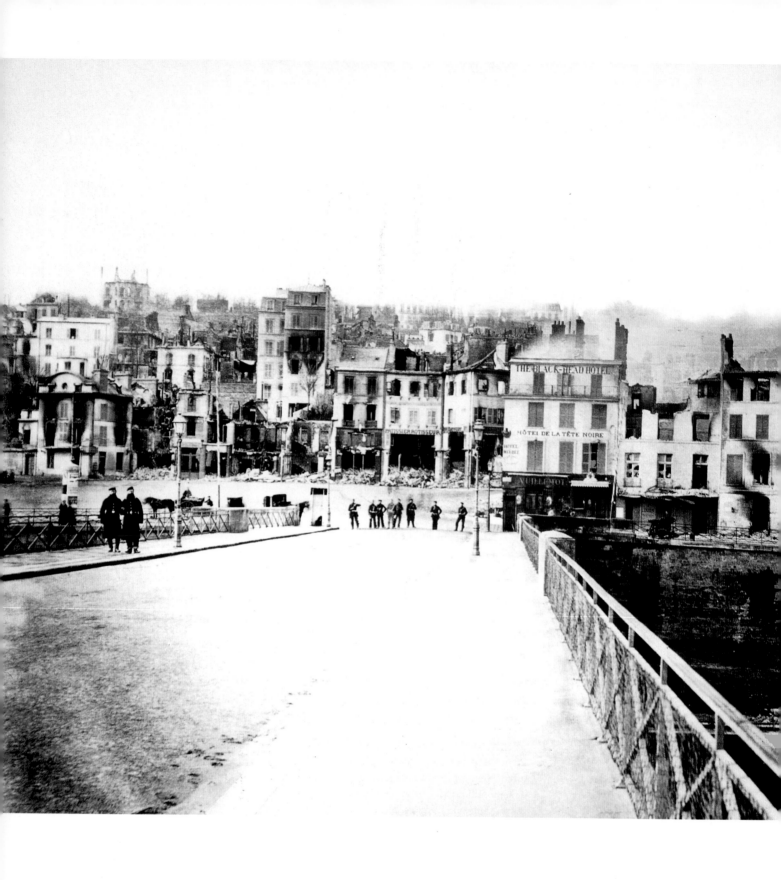

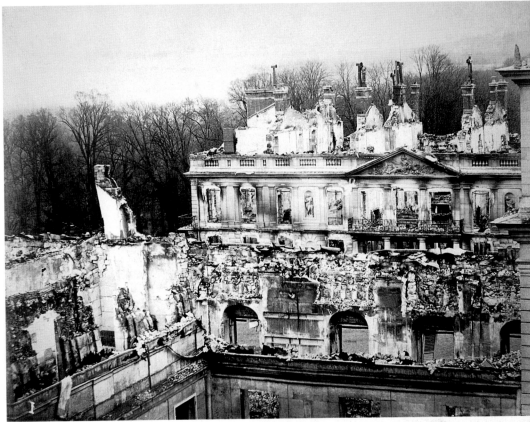

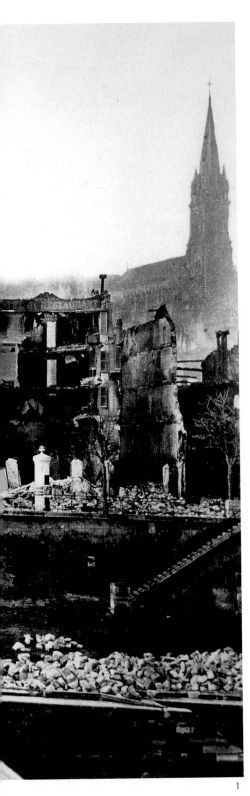

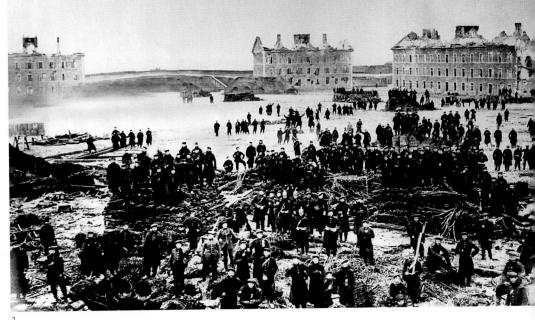

2

1 3

IN Paris, crowds shouted 'à Berlin!' In Berlin, the cry was 'nach Paris!' – but the traffic was all one way, westwards. Prussian guns bombarded French towns such as Rézonville (1), and kept firing all the way to the Château de Saint-Cloud (2). The Armistice was signed on 28 January 1871, and three days later Prussian troops posed for photographs in Fort Issy, one of the strategic defence posts of Paris (3).

IN Paris schrie die Menge »à Berlin!«. In Berlin rief sie »nach Paris!« – aber die Reise führte nur in eine Richtung, nach Westen. Preußische Kanonen bombardierten französische Städte wie Rézonville (1) und schossen sich den Weg nach Château de Saint-Cloud frei (2). Das Waffenstillstandsabkommen wurde am 28. Januar 1871 unterzeichnet, und drei Tage später ließen sich preußische Soldaten in Fort Issy photographieren, einem der strategischen Verteidigungsposten in Paris (3).

À Paris la foule hurlait : « À Berlin ! ». À Berlin on criait : « Nach Paris ! ». Mais la circulation se fit à sens unique, vers l'ouest. Les canons prussiens bombardaient les villes françaises, comme ici Rézonville (1), poursuivant leurs tirs jusqu'au château de Saint-Cloud (2). L'armistice fut signé le 28 janvier 1871, et trois jours plus tard les troupes prussiennes posaient pour les photographes à Fort Issy, un des postes de la défense stratégique de Paris (3).

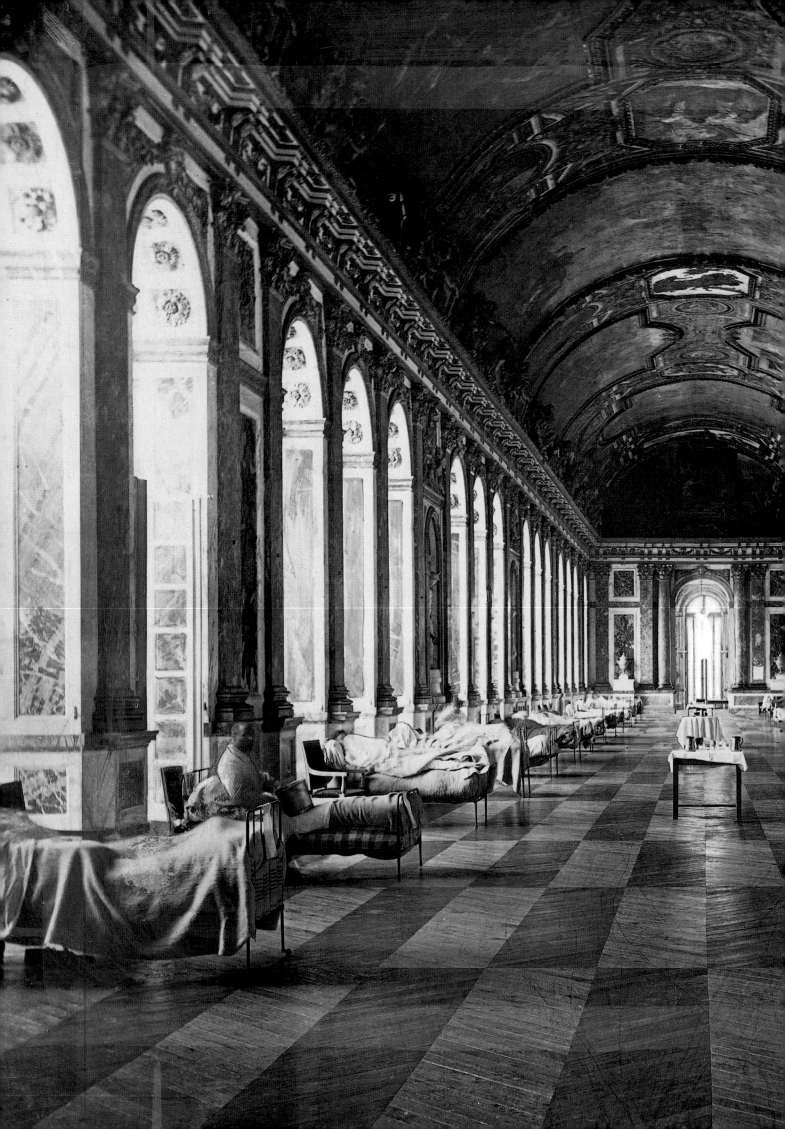

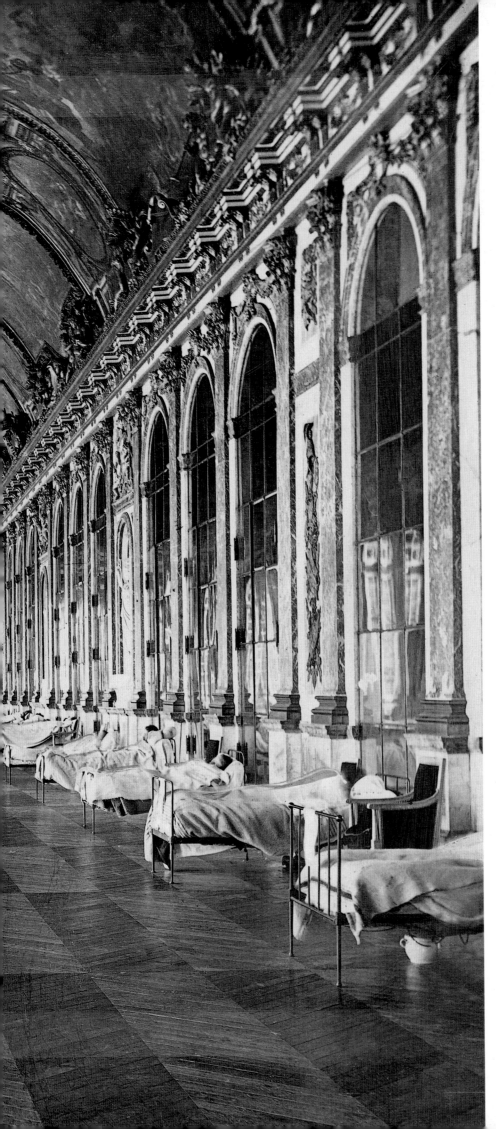

THE German occupation of France, 1870-71: the Gallery of Mirrors, Versailles, converted into a German hospital during the Franco-Prussian War.

DIE deutsche Besatzung Frankreichs, 1870 bis 1871: Der Spiegelsaal in Versailles diente den Deutschen während des Deutsch-Französischen Krieges als Hospital.

L'OCCUPATION de la France par les Allemands de 1870 à 1871 : la Galerie des glaces à Versailles reconvertie en hôpital allemand pendant la guerre entre la France et la Prusse.

THE Prussians found it easier to defeat the French Emperor than the French people. In late September 1870, Paris was completely encircled, but the city held out for four months. The people were reduced to eating sparrows, rats, dogs, cats and all the animals in the zoo. It was said that only the French genius for cooking could make the elephants palatable. Pigeons were spared – they were needed to take Nadar's micro-photos out of the city.

After the siege came the Commune. On 18 March 1871, the red banner flew over Paris. Barricades were raised by the Communards and the National Guard in the Place Vendôme (1), and by opposing government troops (2). French ingenuity resulted in mobile barricades (3), which could be rushed from one part of the city to another, wherever the action was hottest.

FÜR die Preußen war es leichter, den französischen Kaiser zu besiegen als das französische Volk. Paris war gegen Ende September 1870 vollständig umzingelt, aber die Stadt konnte sich vier Monate lang halten. Die Menschen waren gezwungen, Spatzen, Ratten, Hunde, Katzen und alle Tiere aus dem Zoo zu essen. Es hieß, nur das französische Kochgenie habe es geschafft, die Elefanten genießbar zu machen. Tauben blieben verschont, denn sie wurden benötigt, um Nadars Mikrofilme aus der Stadt herauszubringen.

Der Belagerung folgte der Aufstand der Pariser Kommune. Am 18. März 1871 wehte das rote Banner über Paris. Auf der Place Vendôme (1) wurden sowohl von Kommunarden und Nationalgardisten als auch von gegnerischen Regierungstruppen Barrikaden errichtet (2). Französischer Erfindungsreichtum brachte mobile Barrikaden (3) hervor, die schnell von einem Kampfschauplatz der Stadt zum anderen transportiert werden konnten.

2

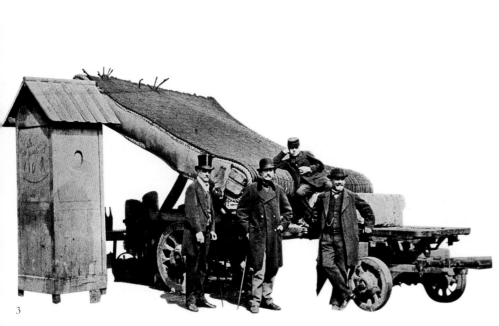

3

LES Prussiens s'aperçurent qu'il était plus facile de battre l'empereur français que le peuple français. Fin septembre 1870, bien qu'encerclé complètement, Paris résista quatre mois durant. La population en était réduite à manger des moineaux, des rats, des chiens, des chats et tous les animaux du Jardin des Plantes. On a dit que seul le génie culinaire français avait pu rendre la viande d'éléphant savoureuse. Les pigeons furent épargnés car on en avait besoin pour faire sortir les microphoto-graphies de Nadar de la ville.

Au siège succéda la Commune. Le 18 mars 1871, la bannière rouge flottait au-dessus de Paris. Des barricades avaient été érigées par les communards et la Garde nationale sur la place Vendôme (1), mais également par les troupes gouvernementales auxquelles ils s'opposaient (2). Les Français firent la preuve de leur ingéniosité en construisant des barricades mobiles (3) que l'on pouvait rapidement déplacer d'un bout à l'autre de la capitale, suivant le lieu des affrontements.

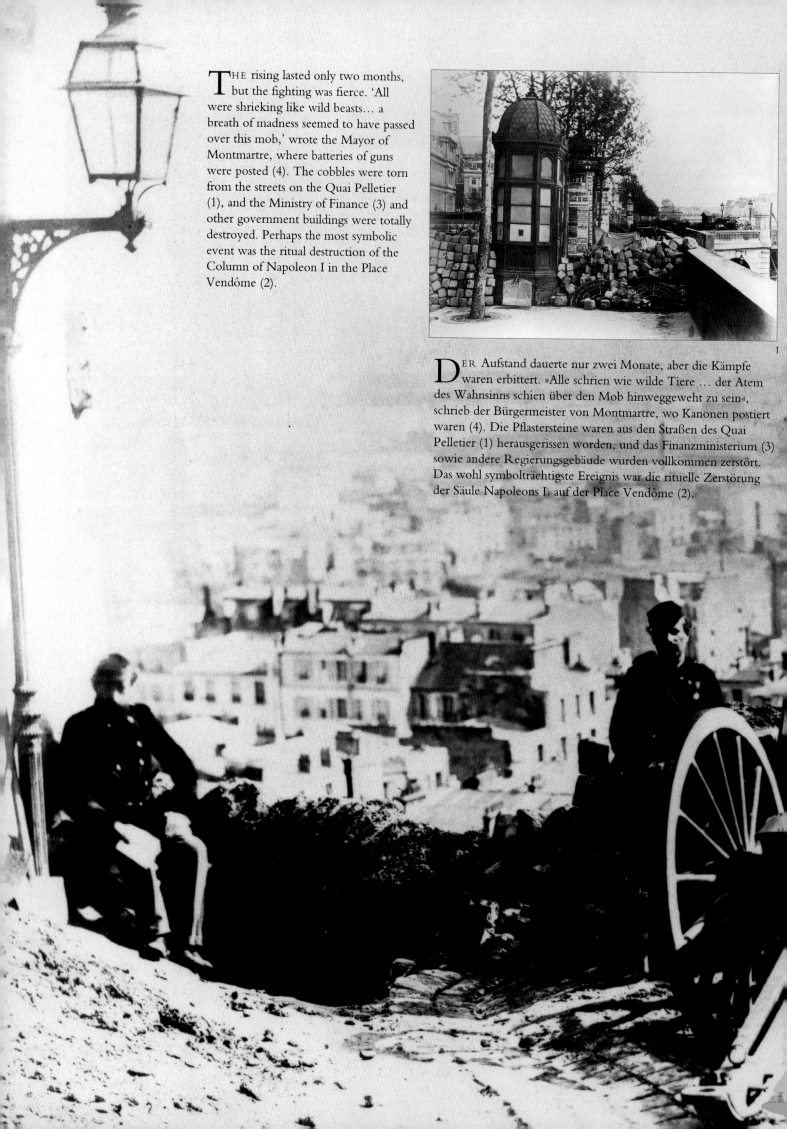

THE rising lasted only two months, but the fighting was fierce. 'All were shrieking like wild beasts… a breath of madness seemed to have passed over this mob,' wrote the Mayor of Montmartre, where batteries of guns were posted (4). The cobbles were torn from the streets on the Quai Pelletier (1), and the Ministry of Finance (3) and other government buildings were totally destroyed. Perhaps the most symbolic event was the ritual destruction of the Column of Napoleon I in the Place Vendôme (2).

DER Aufstand dauerte nur zwei Monate, aber die Kämpfe waren erbittert. »Alle schrien wie wilde Tiere … der Atem des Wahnsinns schien über den Mob hinweggeweht zu sein«, schrieb der Bürgermeister von Montmartre, wo Kanonen postiert waren (4). Die Pflastersteine waren aus den Straßen des Quai Pelletier (1) herausgerissen worden, und das Finanzministerium (3) sowie andere Regierungsgebäude wurden vollkommen zerstört. Das wohl symbolträchtigste Ereignis war die rituelle Zerstörung der Säule Napoleons I. auf der Place Vendôme (2).

1

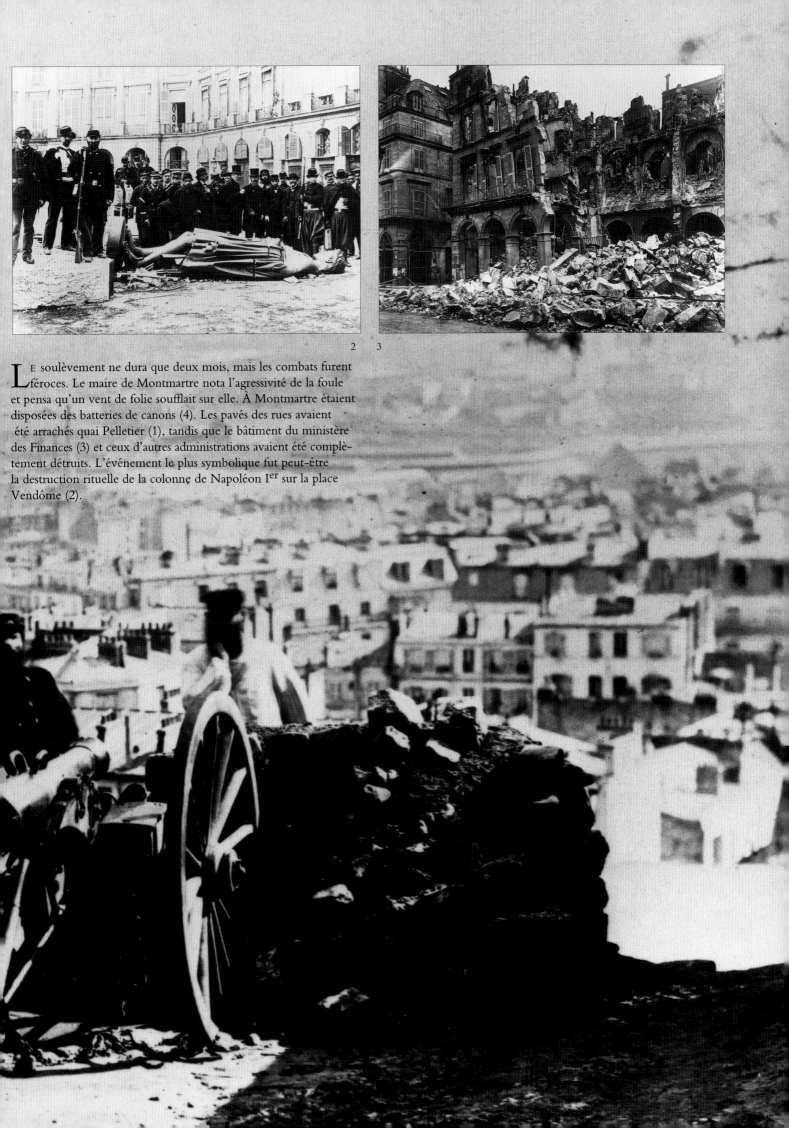

2 3

L E soulèvement ne dura que deux mois, mais les combats furent
féroces. Le maire de Montmartre nota l'agressivité de la foule
et pensa qu'un vent de folie soufflait sur elle. À Montmartre étaient
disposées des batteries de canons (4). Les pavés des rues avaient
été arrachés quai Pelletier (1), tandis que le bâtiment du ministère
des Finances (3) et ceux d'autres administrations avaient été complè-
tement détruits. L'événement le plus symbolique fut peut-être
la destruction rituelle de la colonne de Napoléon Ier sur la place
Vendôme (2).

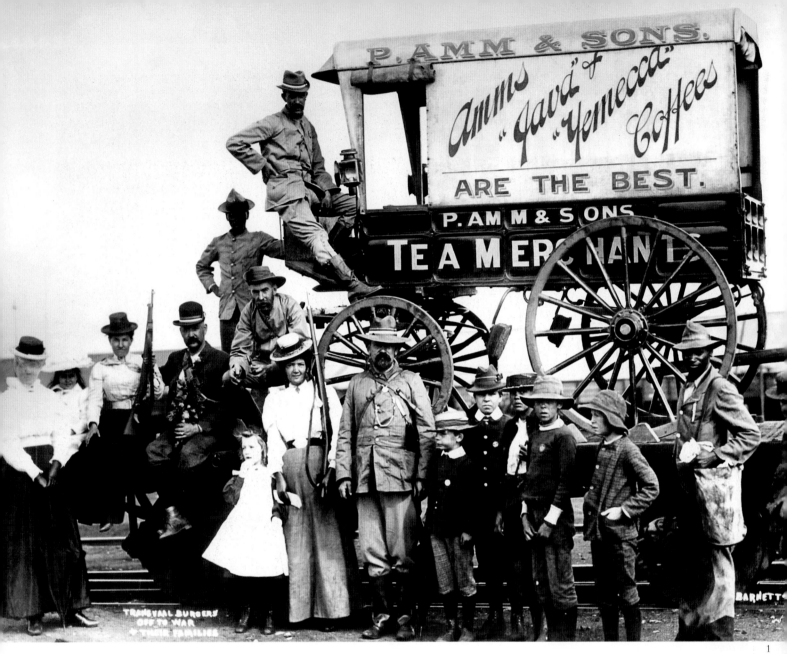

1

FOR over 80 years the British had ruled South Africa, with ever-increasing friction between them and the Boer descendants (1) of the Dutch settlers in Transvaal and the Orange Free State. In 1899 British avarice provoked a second war with the Boers, and for two months half a million troops of the greatest Imperial power in the world (3) were being contained and besieged by 40,000 guerrillas – while those whose land it had once been scratched for a living, or slaved to bring the white man diamonds from the Big Hole at Kimberley, a mile round at the top and over 200 metres deep (2).

DIE seit über achtzig Jahren bestehende Herrschaft der Briten in Südafrika wurde überschattet von immer größeren Spannungen mit den Buren (1), Nachfahren niederländischer Siedler in Transvaal und im Oranje-Freistaat. In Jahre 1899 führte die britische Habgier zu einem zweiten Krieg mit den Buren, und zwei Monate lang wurde eine halbe Million Soldaten der größten imperialen Macht der Welt (3) von 40 000 Guerillas in Schach gehalten und belagert – während jene, denen das Land einst gehört hatte, ums Überleben kämpften oder als Sklaven für den weißen Mann im Big Hole bei Kimberley über 200 Meter tief nach Diamanten gruben (2).

DEPUIS plus de quatre-vingts ans que les Britanniques étaient les maîtres de l'Afrique du Sud, les frictions n'avaient fait que s'accroître entre eux et les descendants Boers (1) des colons néerlandais installés dans le Transvaal et dans l'État libre d'Orange. En 1899, la progression des Britanniques provoqua une deuxième guerre contre les Boers : pendant deux mois, un demi-million de soldats de la plus grande puissance impériale du monde (3) furent assiégés par 40 000 combattants. Les noirs vivotaient sur leur terre ou travaillaient comme des esclaves dans le Big Hole (le Grand Trou, profond de 200 mètres) à Kimberley pour en rapporter les diamants (2).

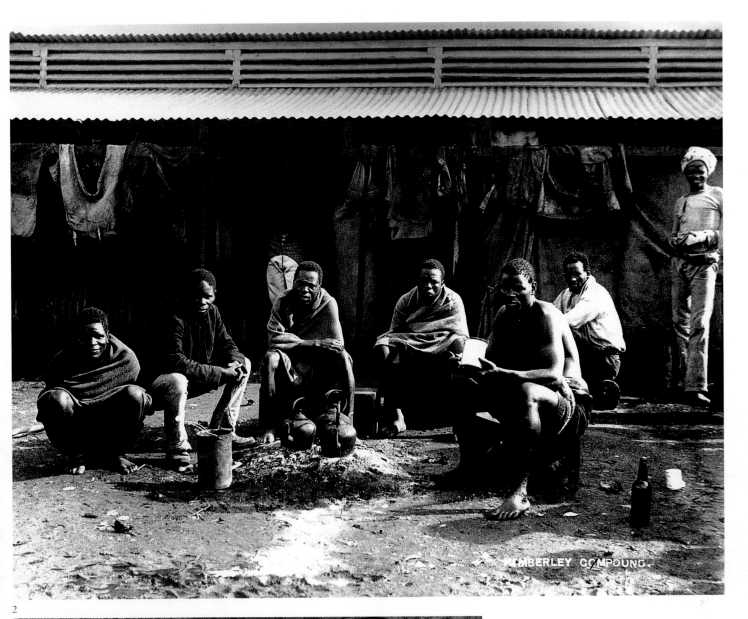

2

3

THOUGH outnumbered and outgunned, the Boers knew how to use their terrain, and throughout 1899 the British suffered a series of embarrassing defeats – at Nicholson's Nek, Ladysmith, Stormberg, Magersfontein and Colenso.

Boer morale was high, recalling victories of the war of 1881 – 'don't forget Majuba Boys' was scratched on the wall of a Boer homestead (1). But Britain summoned up fresh resources and appointed new generals. Boer sieges of Ladysmith and Mafeking

were raised, and a combined force of English and Imperial troops defeated the Boers at the battle of Spion Kop, where Canadians drove the Boers at bayonet point from the kopje (2).

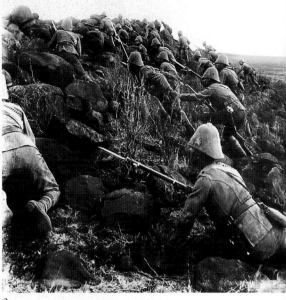

machten neue Reserven mobil und setzten neue Generäle ein. Die von den Buren besetzten Städte Ladysmith und Mafeking wurden zurückerobert, und eine Armee aus britischen Soldaten und Truppen des Empire besiegte die Buren in der Schlacht von Spion Kop, wo Kanadier die Buren mit Bajonetten vom Hügel vertrieben (2).

S'ILS étaient inférieurs en nombre et en armement, les Boers connaissaient bien le terrain ; ils infligèrent ainsi aux Britanniques une série de défaites embarrassantes tout au long de 1899, à Nicholson's Nek, Ladysmith, Stormberg, Magersfontein et Colenso. Le moral des Boers était très bon ; ils se rappelaient les victoires de 1881 : « N'oubliez pas les gars de Majuba », pouvait-on lire sur le mur de la ferme d'un Boer (1). Cependant la Grande-Bretagne rassembla de nouvelles ressources et nomma de nouveaux généraux. Les sièges des Boers à Ladysmith et Mafeking furent levés, tandis que les forces anglaises et impériales combinées aboutirent à la défaite des Boers à la bataille de Spion Kop, où les Canadiens forcèrent ces derniers à redescendre à la pointe de leurs baïonnettes du sommet de Kopje (2).

OBWOHL sie zahlenmäßig unterlegen waren und weniger Waffen besaßen, wußten die Buren ihr Terrain zu nutzen und fügten 1899 den Briten eine Reihe schmachvoller Niederlagen zu, beispielsweise bei Nicholson's Nek, Ladysmith, Stormberg, Magersfontein und Colenso. Die Kampfmoral der Buren war enorm, denn sie erinnerten sich an die Siege über die Briten im Krieg von 1881 – »Denkt an Majuba Boys« war in die Wand eines Buren-Hauses gekratzt (1). Aber die Briten

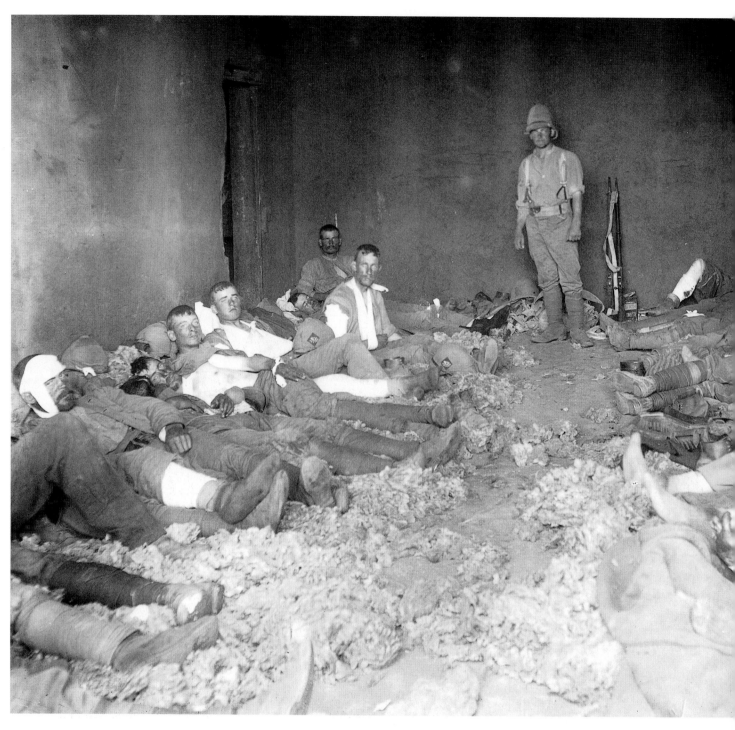

To the reports from South Africa of war correspondents such as Rudyard Kipling, Winston Churchill and Conan Doyle were added the pictures of many war artists, and at least one great photographer – Reinhold Thiele – whose photographs of troops training, marching, resting (3) and recuperating were reprinted in the *London Daily Graphic*. The realism of pictures of British wounded lying in the filth of a wagon house (1) contrasted starkly with propaganda studies taken in a military hospital many miles from the actual fighting (2). But in general it was still the war artists, rather than the photographers, who recorded the battles, and there was no suggestion in their drawings that the British were suffering heavy defeats.

DEN Berichten über den Krieg in Südafrika von Korrespondenten wie Rudyard Kipling, Winston Churchill und Conan Doyle wurden die Bilder vieler Kriegszeichner und zumindest eines bedeutenden Photographen beigefügt, Reinhold Thiele, dessen Aufnahmen von exerzierenden, marschierenden, rastenden (3) und verwundeten Soldaten in der *London Daily Graphic* abgedruckt wurden. Der Realismus der Bilder von britischen Verwundeten im

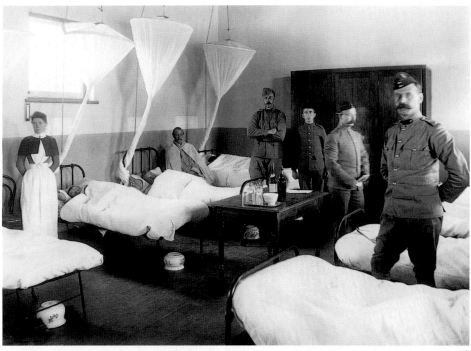

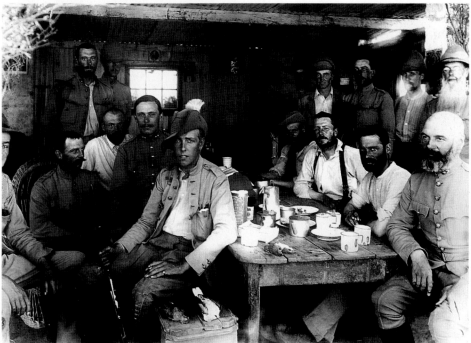

Schmutz eines Schuppens (1) stand in starkem Kontrast zu den Propagandaaufnahmen, die in einem Militärhospital viele Meilen von den Kampfschauplätzen entfernt gemacht wurden (2). Aber im allgemeinen waren es noch immer die Kriegszeichner, und nicht die Photographen, die die Schlachten dokumentierten, und in ihren Zeichnungen gab es keinen Hinweis darauf, daß die Briten große Verluste erlitten hatten.

Aux rapports expédiés d'Afrique du Sud par les correspondants de guerre tels que Rudyard Kipling, Winston Churchill et Conan Doyle, s'ajoutaient les images réalisées par de nombreux artistes de guerre, parmi lesquels un grand photographe – Reinhold Thiele – dont les clichés montrant des troupes à l'entraînement, en marche, au repos (3) et en convalescence furent repris dans le *London Daily Graphic*. Le réalisme des images montrant des Britanniques gisant blessés dans la saleté d'un wagon aménagé (1) contrastait vivement avec les études de propagande réalisées dans un hôpital militaire situé à plusieurs kilomètres du théâtre même des combats (2). Mais, de façon générale, c'étaient toujours les artistes de guerre, et non les photographes, qui représentaient les batailles, et rien dans leurs dessins ne laissait entrevoir les importants et cuisants revers subis par les Britanniques.

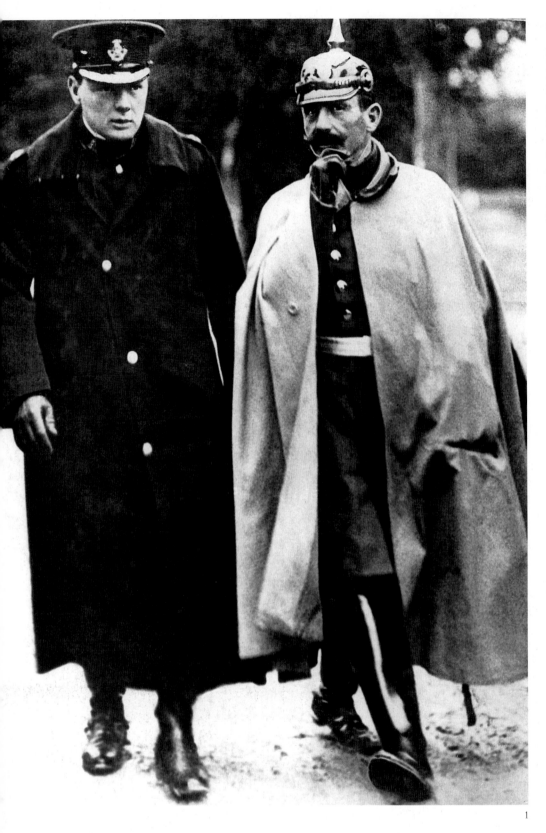

THE monarchs of Europe were one big, though not happy, family in the years leading up to the First World War. The Kaiserin Friedrich (2 – with her son, later Kaiser Wilhelm II) was Vicky, the eldest daughter of Queen Victoria. An unlikely friendship: Winston Churchill with Wilhelm II at the German Army manoeuvres of 1909 (1). An unlikely *entente*: Edward VII with Wilhelm II during a visit to Germany in 1910 (3). More in touch with popular feeling: John Bull of England attempts to swallow the German Navy, a float at the Mainz Carnival of February 1912 (4).

DIE Monarchen Europas bildeten in den Jahren vor dem Ersten Weltkrieg eine große, aber nicht sehr glückliche Familie. Die Kaiserin (2, hier mit ihrem Sohn, dem späteren Kaiser Wilhelm II.), war Vicky, die älteste Tochter von Königin Victoria. Eine unwahrscheinliche Freundschaft: Winston Churchill mit Wilhelm II. beim deutschen Armeemanöver 1909 (1). Eine unwahrscheinliche Entente: Edward VII. mit Wilhelm II. während eines Besuchs in Deutschland im Jahre 1910 (3). Näher am Volk: John Bull aus England versucht die Deutsche Flotte zu verschlucken – ein Wagen im Mainzer Karnevalszug, Februar 1912 (4).

LES monarques européens constituaient une grande famille, même si celle-ci n'était guère heureuse, dans les années qui précédèrent la Première Guerre mondiale. L'impératrice (2, avec son fils, le futur empereur Guillaume II) était Vicky, la fille aînée de la reine Victoria. Une amitié invraisemblable : Winston Churchill et Guillaume II assistant aux manœuvres de l'armée allemande en 1909 (1). Une entente incroyable : Édouard VII et Guillaume II en 1910 au cours d'une visite en Allemagne (3). Plus en accord avec le sentiment général : la nation anglaise essayant d'avaler la flotte allemande sur ce char du carnaval de Mayence en février 1912 (4).

1

2

3

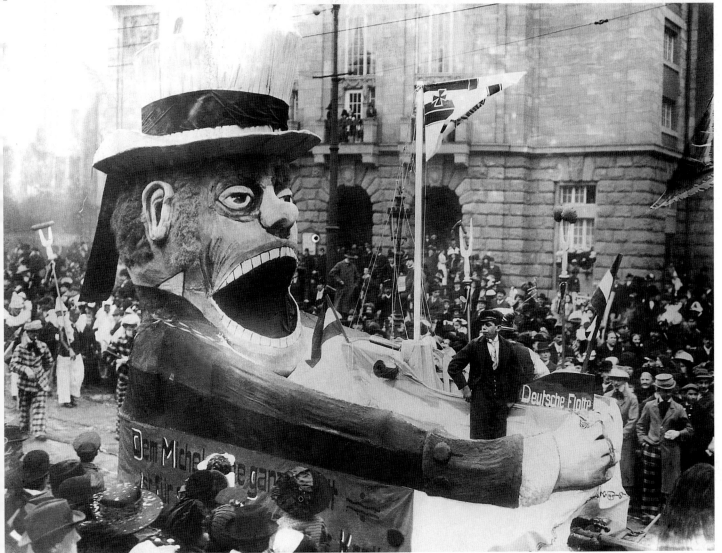

4

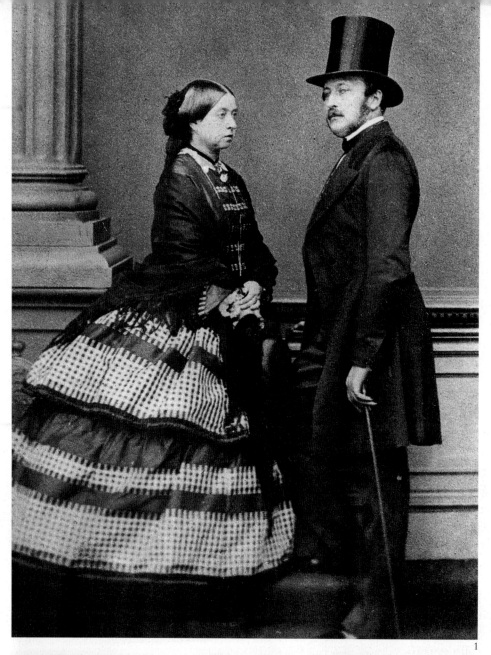

KINGS, emperors, princes and dukes arrived and departed during the 19th century – Queen Victoria went on for ever (3). She was mother or grandmother to most of the royal families of Europe, a matriarchal figure who was never afraid to admonish those whose subjects trembled beneath them. In 1857 her beloved husband, Albert of Saxe-Coburg-Gotha, was made Prince Consort. She was heartbroken when he died in 1861, the year of this photograph (1). It was said that, although she lived a further 40 years, she never loved another – though it was also said that John Brown (2, on left, with Princess Louise, centre) was more to Her Majesty than a mere personal servant.

DAS 19. Jahrhundert sah viele Könige, Kaiser, Prinzen und Herzöge, aber Königin Victoria schien sie alle zu überleben (3). Sie war die Mutter oder Großmutter der meisten königlichen Familien Europas, eine matriarchalische Figur, die niemals davor zurückschreckte, jene zu ermahnen, deren Untertanen unter ihnen litten. 1857 ernannte sie ihren geliebten Mann Albert von Sachsen-Coburg-Gotha zum Prinzgemahl. Unter seinem Tod im Jahre 1861, in dem diese Aufnahme entstand (1), litt sie sehr. Man sagte, sie habe in den vierzig Jahren, die sie ihn überlebte, nie wieder einen anderen geliebt – aber man sagte auch, John Brown (2, links, mit Prinzessin Louise) sei für Ihre Majestät mehr gewesen als nur ein persönlicher Diener.

LES rois, les empereurs, les princes et les ducs défilèrent tout au long du XIXe ; la reine Victoria demeura à jamais (3). Elle était la mère et la grand-mère de la plupart des membres des familles royales d'Europe, un personnage matriarcal qui n'avait jamais craint d'adresser de doux reproches à ceux qui faisaient trembler leurs sujets. En 1857, son époux bien-aimé, Albert de Saxe-Cobourg-Gotha, fut fait prince consort. La mort de celui-ci en 1861, l'année de cette photographie (1), lui brisa le cœur. La rumeur veut que bien qu'elle lui survécût encore quarante années, elle n'en aima jamais d'autre ; toutefois on a aussi dit que John Brown (2, à gauche aux côtés de la princesse Louise au centre) n'était pas seulement le serviteur attitré de Sa Majesté.

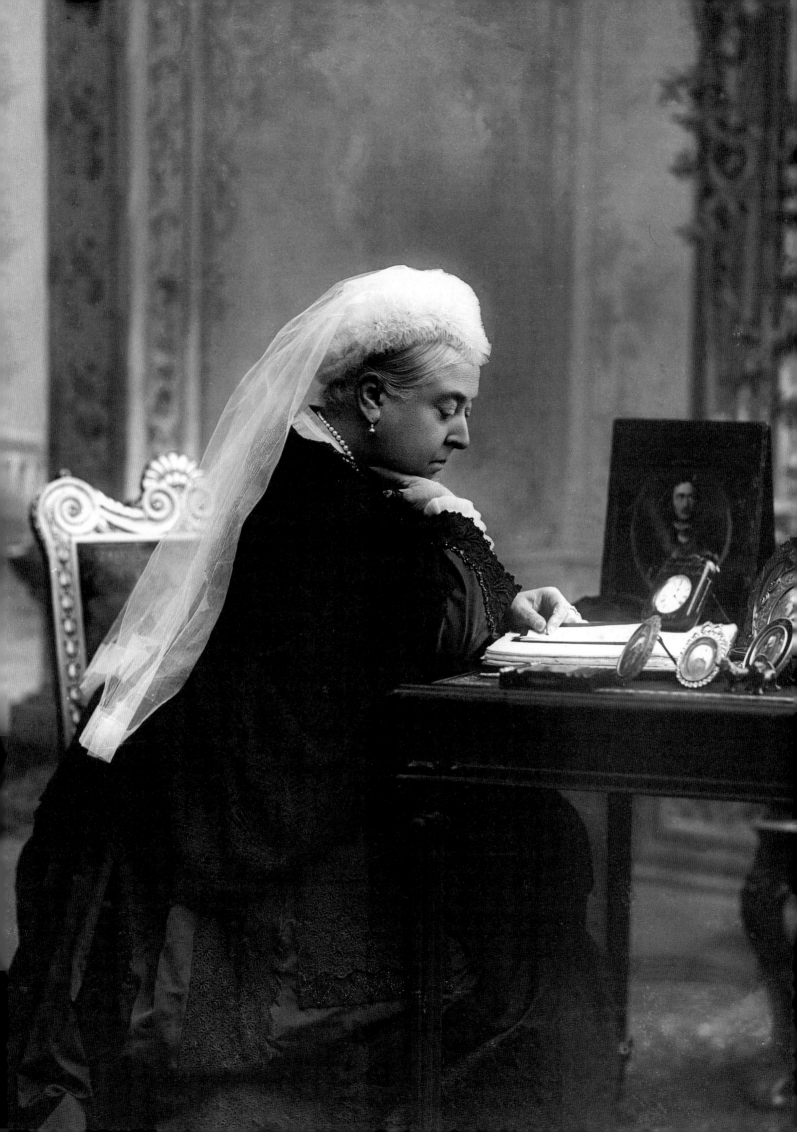

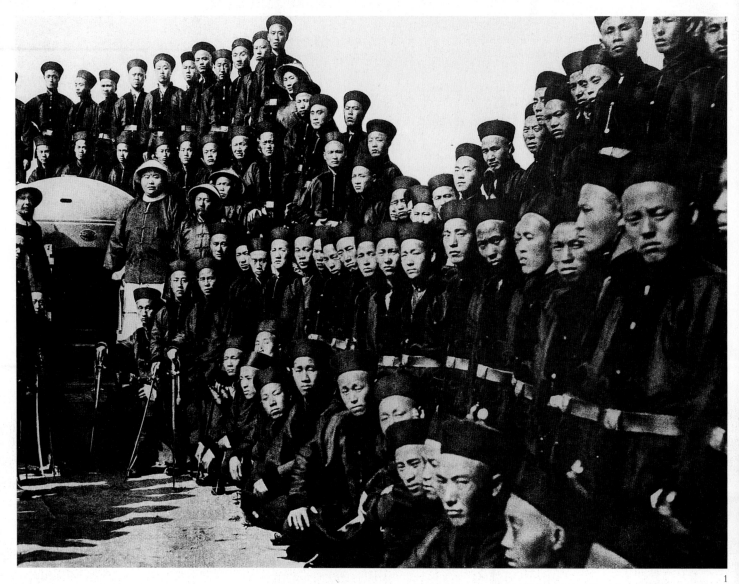

1

THE Boxer Rising of 1900 was directed against foreign influence in China, and championed the traditional Chinese way of life. There was some support for the insurgents from the Imperial Court and from members of the army, among them cadets at Tientsin (1), but the lead was taken by the Fist-Fighters for Justice and Unity, part of the ancient Buddhist secret society known as the White Lotus. Western powers joined forces to crush the rising: German cavalry occupied the centre of Peking (2).

DER Boxeraufstand von 1900 richtete sich gegen fremde Einflüsse in China und kämpfte für den Erhalt der traditionellen chinesischen Lebensart. Die Aufständischen wurden zum Teil vom kaiserlichen Hof und von Mitgliedern der Armee unterstützt, darunter Kadetten aus Tientsin (1). Die Führung übernahmen aber die »Faust-Rebellen« der Vereinigung für Recht und Eintracht, Teil der alten buddhistischen Geheimgesellschaft, die als Weißer Lotus bekannt war. Die Westmächte entsandten Truppen, um den Aufstand niederzuschlagen: Die deutsche Kavallerie besetzte das Zentrum von Peking (2).

EN 1900, les Boxers se soulevèrent contre l'influence des étrangers en Chine et en faveur du mode de vie traditionnel chinois. Les insurgés bénéficièrent d'un certain soutien auprès des membres de la cour impériale et de l'armée, et parmi celle-ci des cadets de T'ien-tsin (1). Cependant, le soulèvement était dirigé par les « milices combattant à coups de poing pour la justice et l'unité », qui faisaient partie de l'ancienne société secrète bouddhiste connue sous le nom du Lotus blanc. Les puissances occidentales unirent leurs forces pour écraser le soulèvement : la cavalerie allemande occupa le centre de Pékin (2).

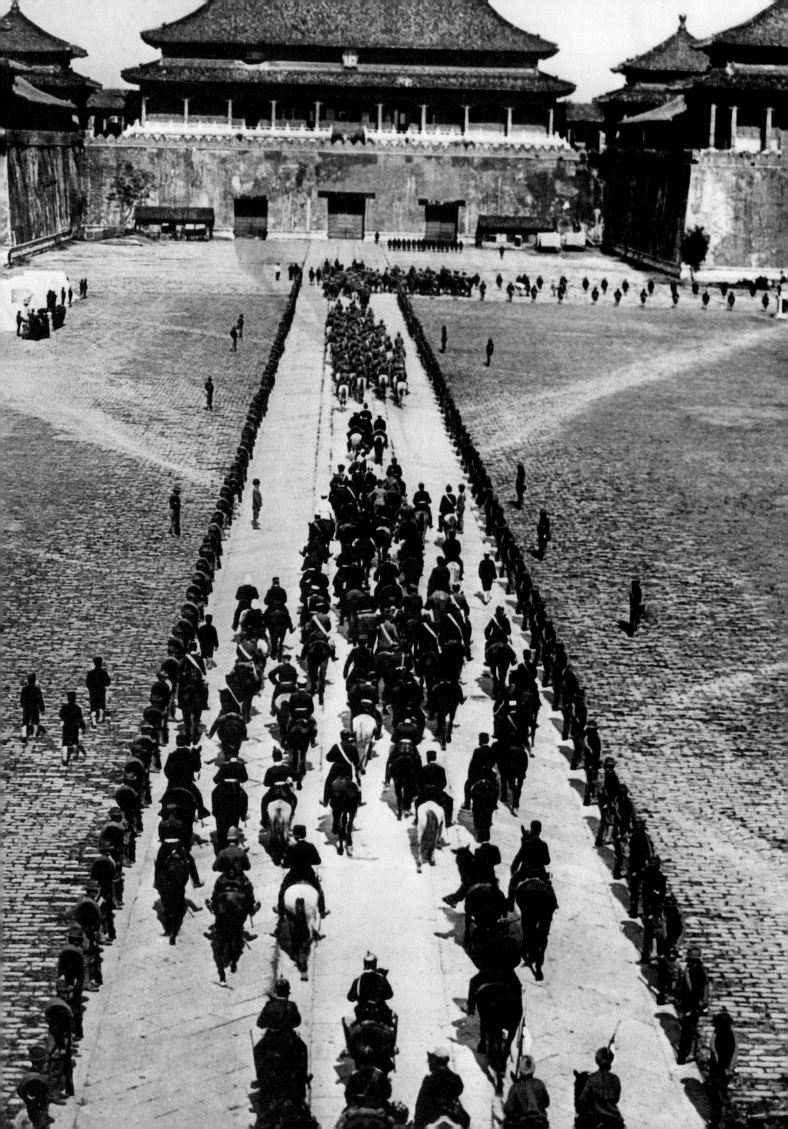

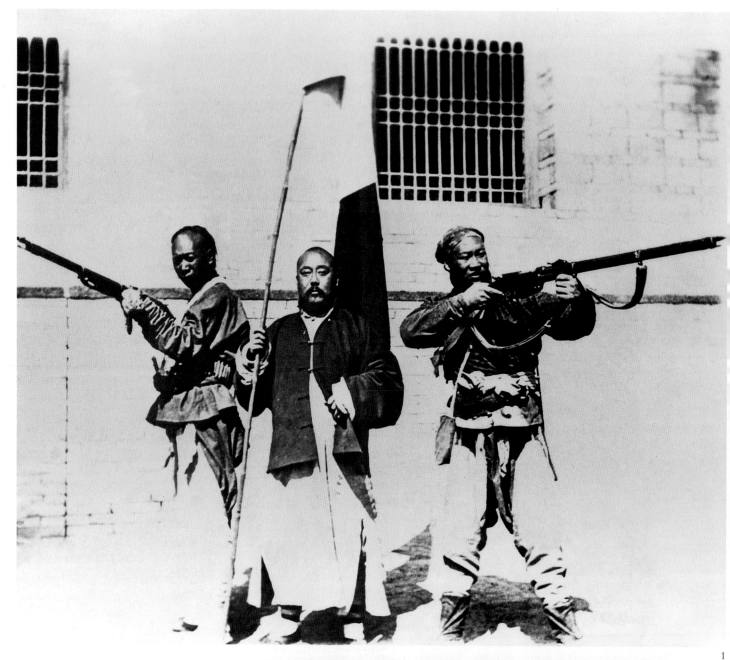

THE Boxers also wished to put an end to Christian influence in China, such as that of the Roman Catholic priest, Pater Schen – here accompanied by two Roman Catholic soldiers (1). In a rare example of international co-operation, German, British, French, Italian, American and Russian forces combined to defeat the Boxers (2). The rising was centred around Peking, where the Chien Men Gate (3) and the British Legation (4) were both attacked.

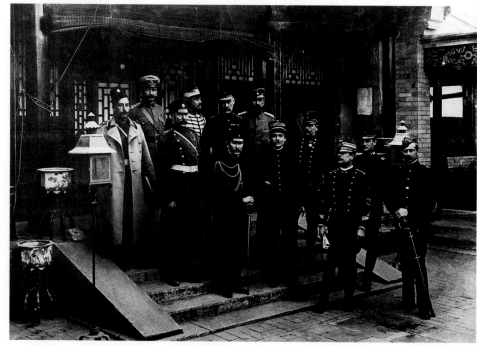

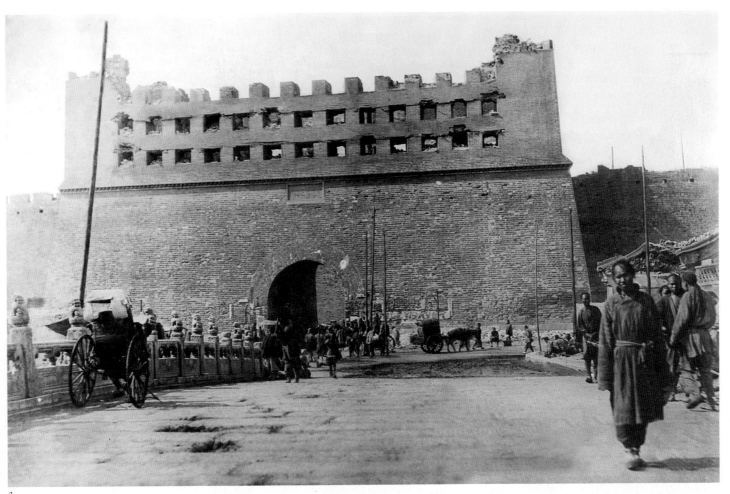

3

4

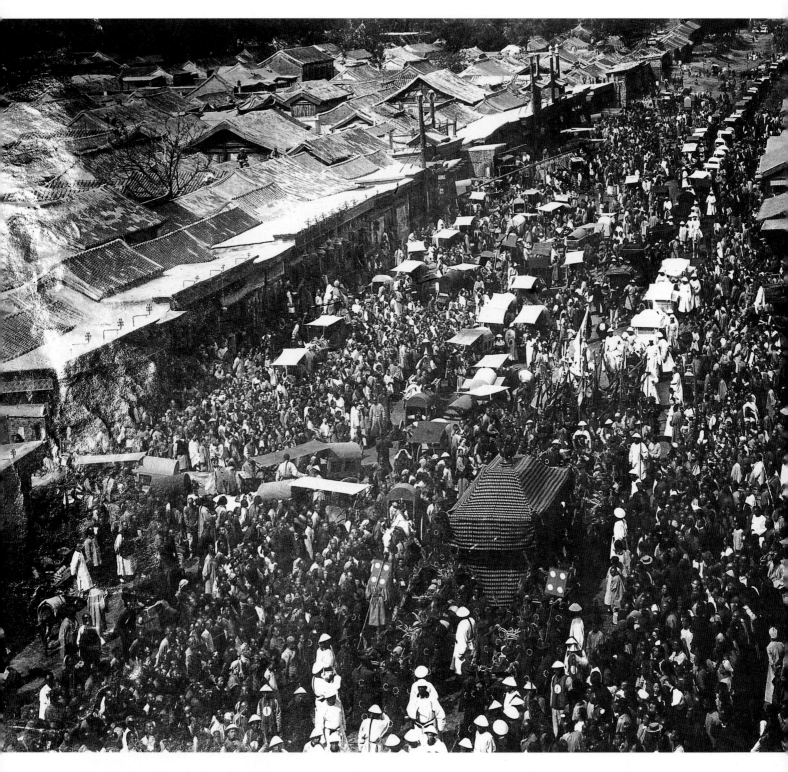

(*Vorherige Seiten*)

DIE Boxer wollten auch dem christlichen Einfluß in China ein Ende machen, wie dem des katholischen Priesters, Pater Schen, der hier von zwei römisch-katholischen Soldaten begleitet wird (1). In einem seltenen Beispiel internationaler Kooperation schlossen sich deutsche, britische, französische, italienische, amerikanische und russische Streitkräfte zusammen, um die Boxer zu bekämpfen (2). Das Zentrum des Aufstands war Peking, wo das Chien-Men-Tor (3) und die Britische Vertretung (4) unter Beschuß genommen wurden.

(*Pages précédentes*)

LES Boxers voulaient aussi mettre fin à l'influence chrétienne en Chine, et par exemple à celle du prêtre catholique romain Pater Schen, que l'on voit ici accompagné de deux soldats catholiques romains (1). Dans un rare exemple de coopération internationale, Allemands, Britanniques, Français, Italiens, Américains et Russes joignirent leurs forces pour les vaincre (2). Le soulèvement était concentré autour de Pékin, où la porte de Chien Men (3) et la légation britannique (4) furent tous deux attaqués.

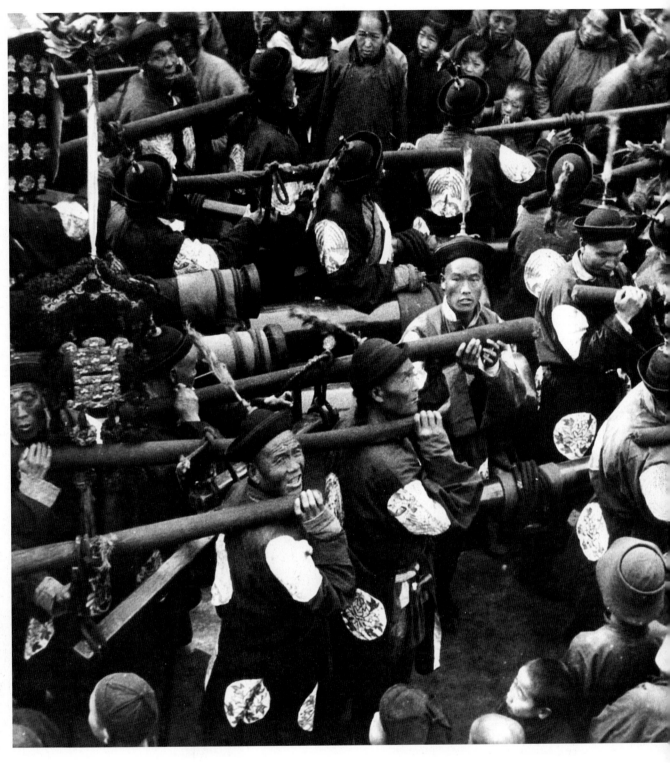

THE funeral of the aged, but feared, Dowager Empress Tz'u-hsi took place in 1908. Born in 1835, she had ruled with a rod of iron since the death of her husband Hsien-feng in 1861. Greedy and unprincipled, she was a powerful figure in a country where women were traditionally subservient, but ultimately she made no positive contribution to China.

DIE alte, aber gefürchtete Kaiserwitwe Tz'u-Hsi wurde 1908 zu Grabe getragen. Sie war 1835 zur Welt gekommen und hatte das Land seit dem Tod ihres Gemahls, Kaiser Hsien-Feng, im Jahre 1861 mit eiserner Hand regiert. Habgierig und skrupellos, war sie eine mächtige Figur in einem Land, in dem Frauen traditionsgemäß unterwürfig waren, aber letztlich tat sie nichts Positives für China.

LES funérailles de l'impératrice douairière Tseu-hi, redoutée en dépit de son grand âge, eurent lieu en 1908. Née en 1835, elle gouvernait d'une main de fer depuis la mort de son époux Hsien-Feng en 1861. Cupide et dénuée de principes, c'était un personnage puissant dans un pays où les femmes étaient traditionnellement dociles et déférentes, mais la période de son règne s'avéra négative pour la Chine.

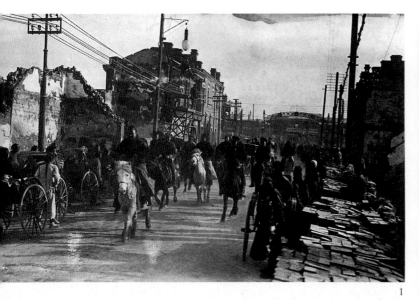

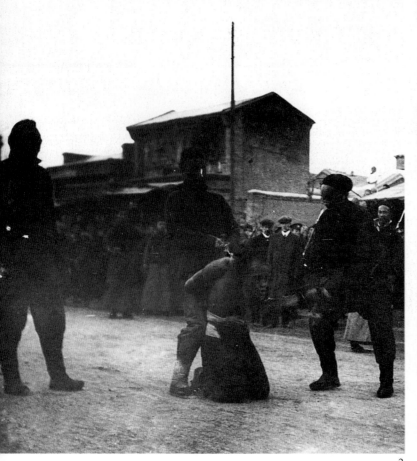

1

2 3

ELEVEN years after the Boxer Rising, a more serious revolution took place in China. Following the death of the Dowager Empress, the Manchu dynasty lost much of its authority in southern China. Imperial officials fled from Tientsin (1) early in 1912, when followers of Sun Yat-sen raised the army of nationalism, republicanism and socialism (a mild form of agrarian reform). Reprisals were swift, and executions summary (2 and 3), but the Empire fell.

ELF Jahre nach dem Boxeraufstand fand in China eine größere Revolution statt. Nach dem Tod der Kaiserwitwe verlor die Mandschu-Dynastie viel von ihrer Autorität in Südchina. Beamte des Hofes flohen zu Beginn des Jahres 1912 aus Tientsin (1), als Anhänger von Sun Yat-Sen eine nationalistische, republikanische und sozialistische Armee aufstellten (eine milde Form der Agrarreform). Vergeltungsmaßnahmen folgten prompt: Hinrichtungen wurden im Schnellverfahren vorgenommen (2, 3), aber das Kaiserreich fiel.

ONZE ans après le soulèvement des Boxers, une révolution autrement plus grave eut lieu en Chine. Dès la mort de l'impératrice douairière, l'autorité de la dynastie mandchoue se mit à faiblir grandement en Chine du Sud. Les officiers impériaux fuirent T'ien-tsin (1) au début de 1912, quand les sympathisants de Sun Yat-Sen levèrent l'armée du Guomintang (pour une forme atténuée de réforme agraire). Les représailles ne se firent pas attendre : on procéda à des exécutions sommaires (2 et 3). L'empire s'effondra tout de même.

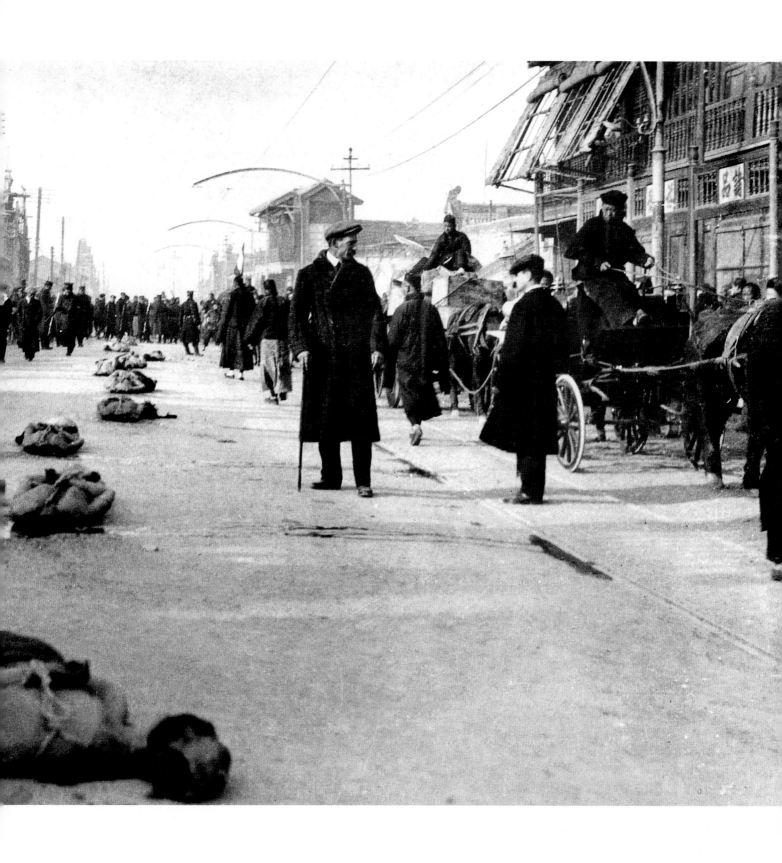

World War I

In 1909 the Italian futurist F. T. Marinetti wrote: 'We will glorify war – the world's only hygiene – militarism, patriotism, the destructive gesture of freedom-bringers, beautiful ideas worth dying for, and scorn for woman.'

Everyone had wondered when the great conflict was coming, but all professed surprise when it broke out. Many had looked forward to the day: 'In the life of camps and under fire,' wrote one French student, 'we shall experience the supreme expansion of the French force that lies within us.' A cartoon in the British humorous magazine *Punch* in 1909 depicted three cavalry officers discussing the Great War. The caption read:

MAJOR: It's pretty certain we shall have to fight 'em in the next few years.
SUBALTERN: Well, let's hope it comes between the polo and the huntin'.

There were old scores to settle, old rivalries to renew – between France and Germany, Russia and Austria. There were new weapons to be tried, fleets to be matched against each other. A whole new generation of generals needed to be put through their old paces on the battlefield. There were plans, timetables, mobilization orders ready to be put into effect.

But no one wanted it, and no one was prepared to take responsibility for it. Indeed, we shall never know exactly what caused the First World War, for each of the combatants had a different theory. These theories have one thing in common – all nations protested that what they did, they did out of self-defence.

There is, however, general agreement on what precipitated the headlong dash into war. On 28 June 1914, the Archduke Franz-Ferdinand, heir to the great Austro-Hungarian Empire, and his wife visited Sarajevo. They arrived by train and toured the city in an open motor car (1). They were given a mixed reception. Roses were presented, but bombs were thrown. The Archduke decided enough was enough, and headed back to the railway station. But the car took a different route, and made a wrong turning into a cul de sac. The street was narrow. The car stopped to turn round. A Bosnian student named Gavrilo Princip, one of several who had been armed by the Intelligence Bureau of the Serbian General Staff, found himself opposite the man he had sworn to assassinate. He leapt on to the running board of the car and fired his pistol at point-blank range. The Archduke and his wife were both killed.

A month later Austro-Hungary declared war on Serbia. Russia declared war on Austro-Hungary. On 1 August Germany declared war on Russia, and two days later on France. On 4 August Britain declared war on Germany. The cast was almost fully assembled. Turkey joined in 1914, Italy in May 1915. The United States waited until April 1917.

And when that terrible war finally arrived, it was greeted with wild acclaim. 'Now God be thanked who had matched us with His hour, and caught our youth and wakened us from sleeping,' wrote the English poet Rupert Brooke. Enthusiastic crowds gathered in London, Paris, Vienna and on the Unter den Linden in Berlin on the day war was declared. Young men flocked to join the army. Their elders had other priorities – crowds also gathered outside this Berlin bank eager to draw out their savings (overleaf). As in every war, everyone expected to win, and most believed it would all be over by Christmas.

It was not. Four years and three months later the last shots were fired on the Western Front. Millions had been killed, many millions wounded, mutilated, maddened. No army had gained any ground, save a corner of north-eastern France still in German hands. An hour before the Armistice came into force, Canadian troops entered Mons, the site of the first battle of the war in 1914.

Whole empires disappeared, new nations emerged. The German Kaiser abdicated and fled to Holland. The Russian Tsar and most of his family were assassinated. An era ended. Europe was never the same again.

1

D ER italienische Futurist F. T. Marinetti schrieb 1909: »Wir werden den Krieg verherrlichen – diese einzige Hygiene der Welt – Militarismus, Patriotismus, die destruktive Geste der Friedensbringer, wunderschöne Ideen, für die es sich lohnt, zu sterben, und Verachtung für die Frau.«

Jedermann hatte sich gefragt, wann es zum großen Konflikt kommen würde, aber alle waren überrascht, als er dann wirklich ausbrach. Viele hatten sich auf den Tag gefreut: »Beim Leben in Lagern und unter Beschuß«, schrieb ein französischer Student, »werden wir die absolute Ausbreitung der französischen Kraft erfahren, die in uns schlummert.« In einer Karikatur des britischen Satiremagazins Punch wurden 1909 drei Kavallerieoffiziere dargestellt, die über den großen Krieg diskutierten. Die Bildunterschrift lautete:

MAJOR: Es ist ziemlich sicher, daß wir in den nächsten paar Jahren gegen sie kämpfen müssen.
UNTERGEBENER: Nun, hoffen wir, daß es zwischen Polo und Jagd staffindet.

Zwischen Frankreich und Deutschland und zwischen Rußland und Österreich gab es alte Rechnungen zu begleichen und alte Rivalitäten zu erneuern. Neue Waffen mußten getestet werden und Flotten mußten gegeneinander antreten. Eine völlig neue Generation von Generälen wurde auf dem Schlachtfeld auf Herz und Nieren geprüft. Es gab Strategien, Zeitpläne und Mobilmachungsbefehle, die jederzeit in die Tat umgesetzt werden konnten.

Aber das wollte niemand, und niemand war bereit, die Verantwortung zu übernehmen. Wir werden die genauen Gründe, die zum Ausbruch des Ersten Weltkriegs führten, wohl niemals erfahren, denn alle Beteiligten hatten eine andere Theorie. Diese Theorien haben jedoch eines gemeinsam: Alle Nationen gaben vor, einzig und allein aus Gründen der Selbstverteidigung gehandelt zu haben.

Über die Ursache des überstürzten Eintritts in den Krieg herrscht jedoch allgemein Einigkeit. Am 28. Juni 1914 besuchten Erzherzog Franz Ferdinand, Thronfolger des großen österreichisch-ungarischen Reiches, und seine Frau Sarajevo. Sie kamen mit dem Zug an und fuhren in einem offenen Automobil durch die Stadt (1). Man bereitete ihnen einen gemischten Empfang. Rosen wurden überreicht, und Bomben wurden geworfen. Der Erzherzog eilte zurück zum Bahnhof.

Aber der Wagen nahm eine andere Route und bog in eine enge Sackgasse ein, wo er anhielt, um zu wenden. Ein bosnischer Student namens Gavrilo Princip, einer der vielen, die vom Geheimdienst des serbischen Generalstabs mit Waffen versorgt worden waren, fand sich plötzlich dem Mann gegenüber, den er geschworen hatte, umzubringen. Er sprang auf das Trittbrett des Autos und feuerte seine Pistole aus kürzester Distanz ab. Der Erzherzog und seine Frau waren sofort tot.

Einen Monat später erklärte Österreich-Ungarn Serbien den Krieg. Rußland erklärte Österreich-Ungarn den Krieg. Am 1. August erklärte Deutschland Rußland den Krieg und zwei Tage später auch Frankreich. Am 4. August erklärte Großbritannien Deutschland den Krieg. Die Teilnehmer waren fast komplett. Die Türkei kam 1914, Italien im Mai 1915 dazu. Die Vereinigten Staaten warteten bis zum April 1917.

Als dieser schreckliche Krieg endlich ausbrach, wurde er stürmisch willkommen geheißen. »Nun danken wir Gott, der uns mit Seiner Stunde gesegnet, unsere Jugend genommen und uns aus dem Schlaf erweckt hat«, schrieb der englische Dichter Rupert Brooke. Am Tag der Kriegserklärung versammelten sich begeisterte Menschenmengen in London, Paris, Wien und Unter den Linden in Berlin. Tausende junger Männer traten freiwillig in die Armee ein. Ihre älteren Zeitgenossen hatten andere Prioritäten; Menschenmengen versammelten sich auch vor dieser Berliner Bank, um ihre Ersparnisse abzuheben (2). Wie in jedem Krieg zeigten sich alle siegessicher, und die meisten glaubten, alles werde bis Weihnachten vorbei sein.

Aber das war nicht der Fall. Vier Jahre und drei Monate später fielen an der Westfront die letzten Schüsse. Millionen von Menschen kamen ums Leben, viele Millionen waren verwundet, verstümmelt oder wahnsinnig geworden. Keine der Armeen hatte Boden gewonnen, außer einer Ecke im Nordosten Frankreichs, die sich noch immer in deutscher Hand befand. Eine Stunde vor Inkrafttreten des Waffenstillstands trafen kanadische Truppen in Mons ein, dem Schauplatz der ersten Schlacht des Krieges im Jahre 1914.

Ganze Reiche verschwanden, und neue Nationen entstanden. Der deutsche Kaiser dankte ab und ging in die Niederlande. Der russische Zar und die meisten seiner Angehörigen wurden ermordet. Eine Ära ging zu Ende. Das alte Europa gehörte der Vergangenheit an.

En 1909, le futuriste italien F. T. Marinetti écrivait : « Nous glorifierons la guerre, la seule hygiène du monde, le militarisme, le patriotisme, le geste destructeur de ceux qui apportent la paix, les belles idées valant la peine de mourir et le mépris de la femme. »

Chacun s'était demandé quand le grand conflit allait arriver, pourtant tout le monde se montra surpris lorsqu'il éclata. Beaucoup avaient espéré ce jour : « Dans la vie des camps et sous le feu », écrivait un étudiant français, « nous ferons l'expérience de l'expansion suprême de la force française qui est en nous. » Un dessin satirique dans le magazine humoristique *Punch* en 1909 montre trois officiers de cavalerie discutant de la grande guerre. La légende est la suivante :

OFFICIER SUPÉRIEUR : *Il est plus que probable que nous devrons nous battre contre eux dans les toutes prochaines années.*
OFFICIER SUBALTERNE : *Et bien espérons que ça sera entre le polo et la chasse.*

Il y avait de vieux comptes à régler, de vieilles rivalités à réveiller entre la France et l'Allemagne, la Russie et l'Autriche. Il y avait de nouvelles armes à tester, des flottes à comparer sur le terrain. Toute une nouvelle génération de généraux devait faire ses premières armes sur le champ de bataille. Des plans, des calendriers et des ordres de mobilisation attendaient de servir.

Mais nul n'en voulait, et personne n'était prêt à en accepter la responsabilité. En fait nous ne saurons jamais exactement ce qui provoqua la Première Guerre mondiale car chacun des belligérants présenta sa propre théorie. Celles-ci avaient une chose en commun, à savoir que toutes les nations protestèrent avoir agi en situation de légitime défense.

Toutefois l'on s'accorde à dire ce qui précipita cette guerre. Le 28 juin 1914, l'archiduc François-Ferdinand, héritier du grand empire austrohongrois, et son épouse se rendirent à Sarajevo. Ils arrivèrent en train et firent le tour de ville dans une voiture décapotée (1), où on leur fit un accueil mitigé. On leur offrit des roses, mais des grenades furent aussi lancées. L'archiduc en eut assez et reprit le chemin de la gare en sens inverse. Cependant la voiture prit une route différente de celle empruntée à l'arrivée et, après un mauvais tournant, entra dans un cul-de-sac. La rue était étroite et la voiture s'arrêta pour faire demi-tour. Un étudiant bosniaque du nom de Gavrilo Princip, un des nombreux individus armés par les services de renseignements de l'état-major serbe, se retrouva en face de

2

l'homme qu'il avait juré d'assassiner. Il s'élança au passage sur le marchepied et tira à bout portant. L'archiduc et son épouse furent tués sur-le-champ.

Un mois plus tard, l'Autriche-Hongrie déclara la guerre à la Serbie. La Russie déclara la guerre à l'Autriche-Hongrie. Le 1er août, l'Allemagne déclara la guerre à la Russie et deux jours plus tard à la France. Le 4 août la Grande-Bretagne déclara la guerre à l'Allemagne. Toutes les forces étaient presque en place. La Turquie entra en guerre en 1914, et l'Italie en mai 1915. Les États-Unis attendirent jusqu'en avril 1917.

Et lorsque cette terrible guerre se déclara enfin, elle fut accueillie par des vivats. « Dieu soit loué de nous avoir confrontés à Son heure, d'avoir pris notre jeunesse et de nous avoir tirés de notre sommeil », écrivait le poète anglais Rupert Brooke. Les foules manifestèrent leur enthousiasme à Londres, Paris, Vienne et sur le Unter den Linden à Berlin le jour où la guerre fut déclarée. Les jeunes gens s'enrôlaient en masse. Leurs aînés avaient d'autres priorités : cette foule impatiente

s'est, elle aussi, assemblée à l'extérieur d'une banque berlinoise pour retirer ses économies (2). Comme c'est le cas dans toutes les guerres, chacun s'attendait à la gagner, et la plupart croyaient que tout serait terminé pour Noël.

Ce ne fut pas le cas. Quatre années et trois mois plus tard, les derniers coups de feu étaient tirés sur le front Ouest. Des millions de personnes avaient été tuées, d'autres blessées, mutilées ou avaient sombré dans la folie. Aucune armée n'avait progressé sur le terrain si ce n'est dans le Nord-Est de la France, demeuré aux mains des Allemands. Une heure avant l'entrée en vigueur de l'armistice, les troupes canadiennes pénétraient dans Mons, qui avait été en 1914 le théâtre de la première bataille.

Des empires entiers avaient disparu, de nouvelles nations virent le jour. L'empereur allemand abdiqua et s'enfuit en Hollande. Le tsar russe et la majorité des membres de sa famille furent assassinés. Une ère prit fin. L'Europe avait changé du tout au tout.

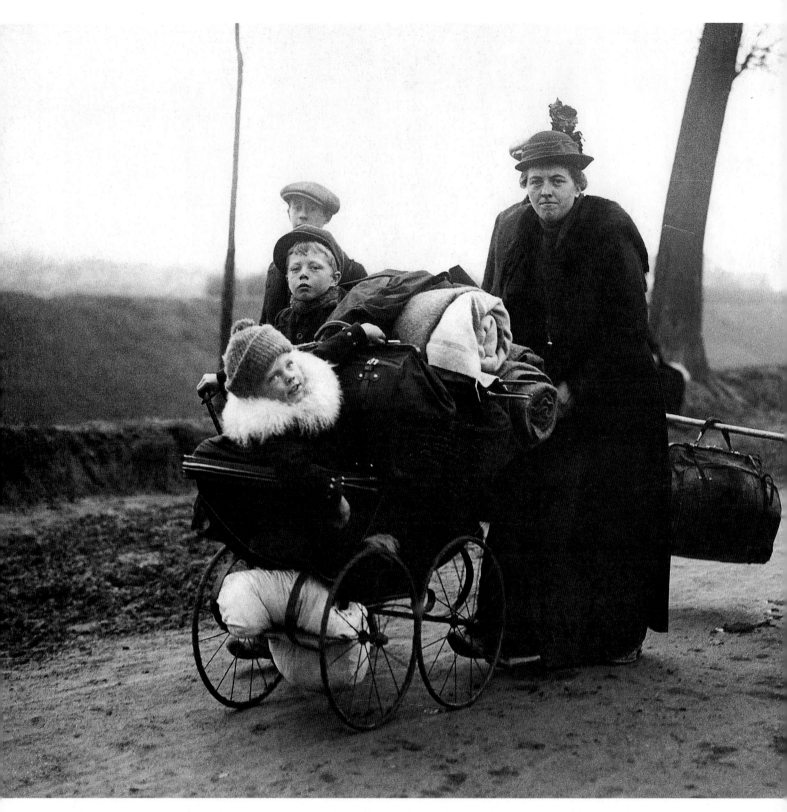

AT first it was a war of movement. German armies marched westward, passing through Belgium to strike at Paris. Belgian refugees trundled their most precious belongings ahead of the invading troops (1). In the east, Austrian troops mobilized, and officers bade farewell to wives and sweethearts at railheads (2). Within a few days they, too, were on the march (3), heading east to meet the vast Russian army as it headed west. The killing had begun.

ANFANGS zeichnete sich der Krieg durch große Mobilität aus. Deutsche Armeen marschierten westwärts und durchquerten Belgien, um Paris anzugreifen. Belgische Flüchtlinge brachten sich vor den einfallenden Truppen in Sicherheit (1). Im Osten machten österreichische

Truppen mobil, und Offiziere sagten an den Bahnhöfen ihren Frauen Lebewohl (2). Innerhalb weniger Tage befanden auch sie sich auf dem Marsch nach Osten (3), um auf die nach Westen vorrückende russische Armee zu treffen. Das Töten hatte begonnen.

CE fut d'abord une guerre de mouvement. Les armées allemandes marchèrent vers l'ouest, traversant la Belgique pour attaquer Paris. Les réfugiés belges fuirent pour se mettre à l'abri face aux troupes de l'envahisseur (1). À l'est, les troupes autrichiennes étaient mobilisées et les officiers disaient adieu à leurs épouses et petites amies dans les gares de départ menant aux lignes (2). Quelques jours plus tard, ils étaient eux aussi en marche (3) vers l'est pour couper la route à la vaste armée russe en marche vers l'ouest. La tuerie avait commencé.

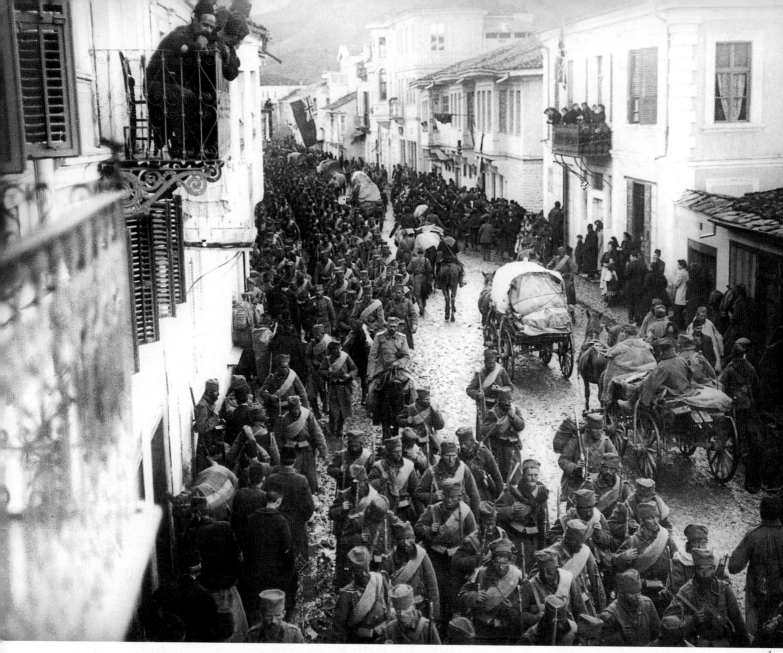

IN the east, the first casualty was Serbia. Austrian and Bulgarian troops inflicted a series of defeats on the Serbian army, which was in retreat by the summer of 1915 (1). As on the Western Front, the war soon became bogged down into one of attrition. Spotter planes, machine guns, artillery and, later, tanks put an end to the old supremacy of cavalry on the battlefield. The Bulgarian trenches on the Macedonian front (2) were every bit as uncomfortable as those in Flanders. After a prolonged spell in them, soldiers could sleep anywhere (3).

IM Osten wurde zuerst Serbien besiegt. Nach einer Reihe vernichtender Niederlagen durch österreichische und bulgarische Truppen trat die serbische Armee im Sommer 1915 den Rückzug an (1). Wie bereits an der Westfront kam es auch hier zu einem Zermürbungskrieg. Aufklärungsflugzeuge, Maschinengewehre, Artillerie und später Panzer machten der alten Vormachtstellung der Kavallerie auf dem Schlachtfeld ein Ende. Die bulgarischen Schützengräben an der mazedonischen Front (2) waren genauso unbequem wie die in Flandern. Nachdem sie viele Stunden darin verbracht hatten, konnten die Soldaten überall schlafen (3).

À l'est, les premières victimes furent serbes. Les troupes autrichiennes et bulgares infligèrent toute une série de défaites à l'armée serbe qui battit en retraite dès l'été 1915 (1). Quant aux opérations sur le front Ouest, elles ne tardèrent pas à s'enliser dans une guerre d'usure. Les avions d'observation, les mitrailleuses, l'artillerie et plus tard les chars d'assaut mirent fin à la vieille suprématie de la cavalerie sur les champs de bataille. Les tranchées bulgares sur le front macédonien (2) étaient tout aussi inconfortables que celles des Flandres. Après un séjour prolongé dans l'une d'entre elles, les soldats pouvaient dormir n'importe où (3).

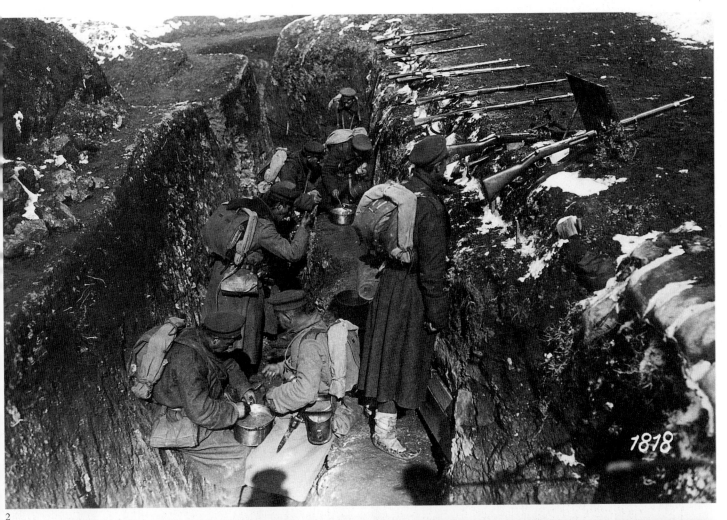

2

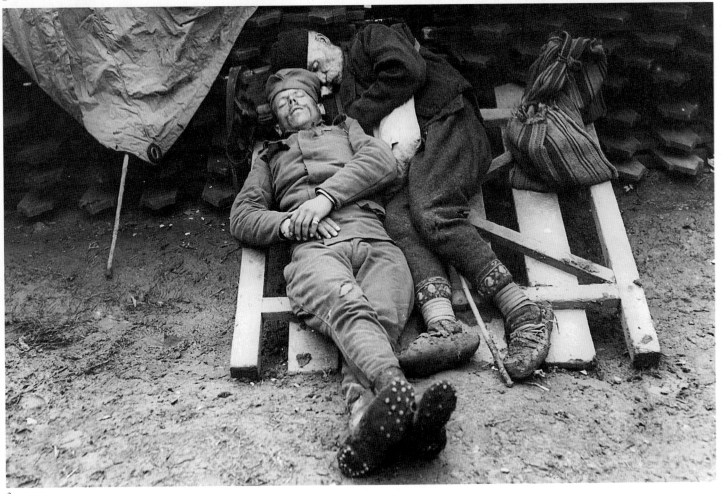

3

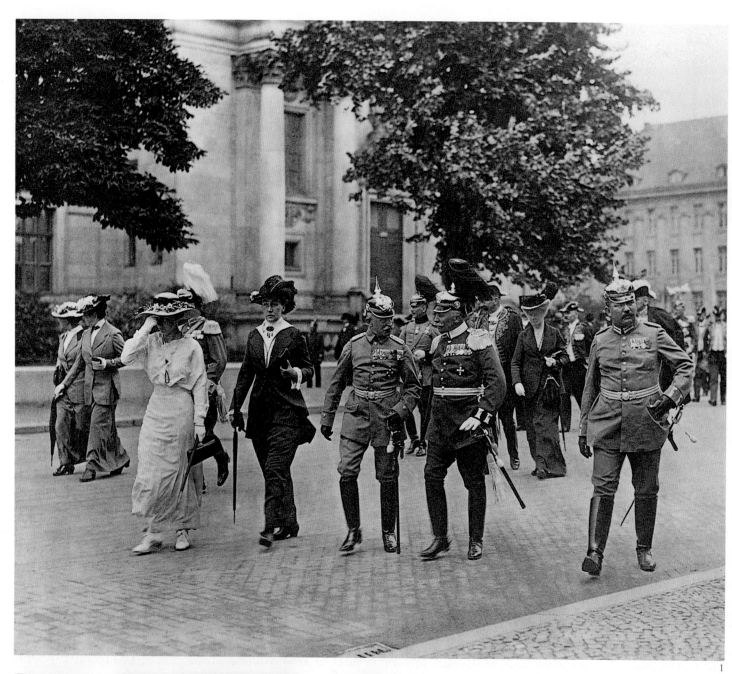

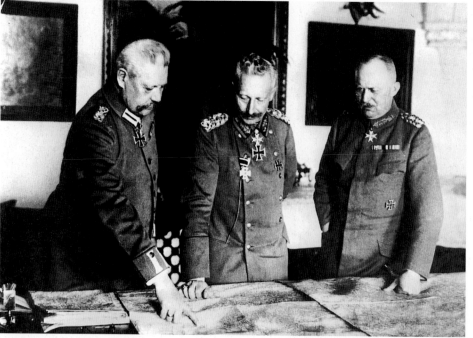

OF all the nations involved, Germany was perhaps the best prepared. God's blessing was sought at the Dom (cathedral) in Berlin (1). Kaiser Wilhelm II (2, centre) had enough sense to leave German strategy in the hands of Generals Ludendorff (2, left) and Hindenburg (2, right). Young Germans were trained in the arts of war, including the maintenance of planes (3). And on the Ruhr, the weapons of war were forged in vast furnaces (4).

VON allen beteiligten Nationen war Deutschland wahrscheinlich am besten vorbereitet. Im Berliner Dom (1) beteten die Menschen um Gottes Segen. Kaiser Wilhelm II. (2, Mitte) war so vernünftig, die deutsche Strategie den Generälen Ludendorff (2, links) und Hindenburg (2, rechts) zu überlassen.

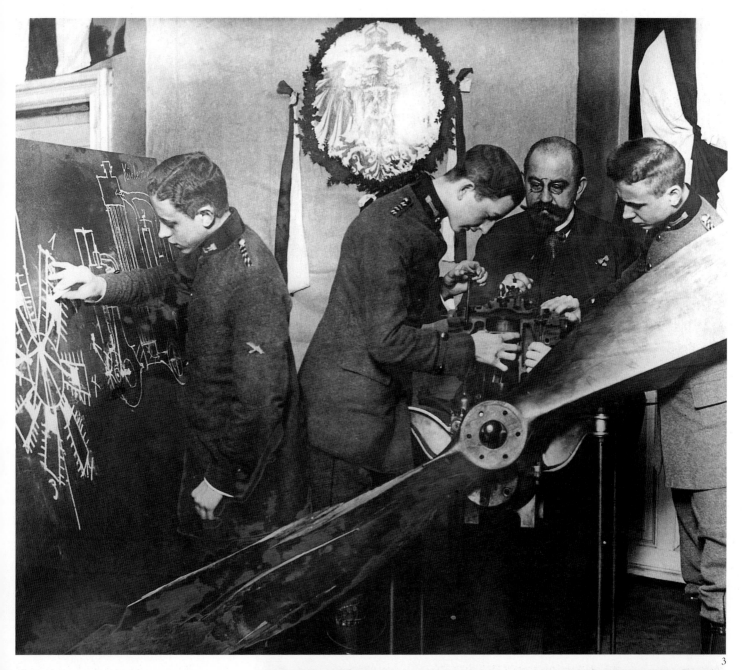

Jungen Deutschen wurde die Kriegskunst
beigebracht, einschließlich der Wartung
von Flugzeugen (3). Und an der Ruhr
wurden die Waffen in der Hitze riesiger
Hochöfen geschmiedet (4).

DE toutes les nations, l'Allemagne était
peut-être la mieux préparée. Dieu
fut remercié et prié de bénir les armes alle-
mandes au cours de services spéciaux qui
eurent lieu au Dom (la cathédrale) de
Berlin (1). L'empereur Guillaume II (2, au
centre) eut suffisamment de bon sens pour
laisser les généraux Ludendorff (2, à gauche)
et Hindenburg (2, à droite) conduire la
stratégie allemande. Les jeunes Allemands
furent initiés aux arts de la guerre, notam-
ment à l'entretien des avions (3). Tandis
que dans la Ruhr les armes de guerre
étaient forgées dans la chaleur et la furie
des vastes fourneaux (4).

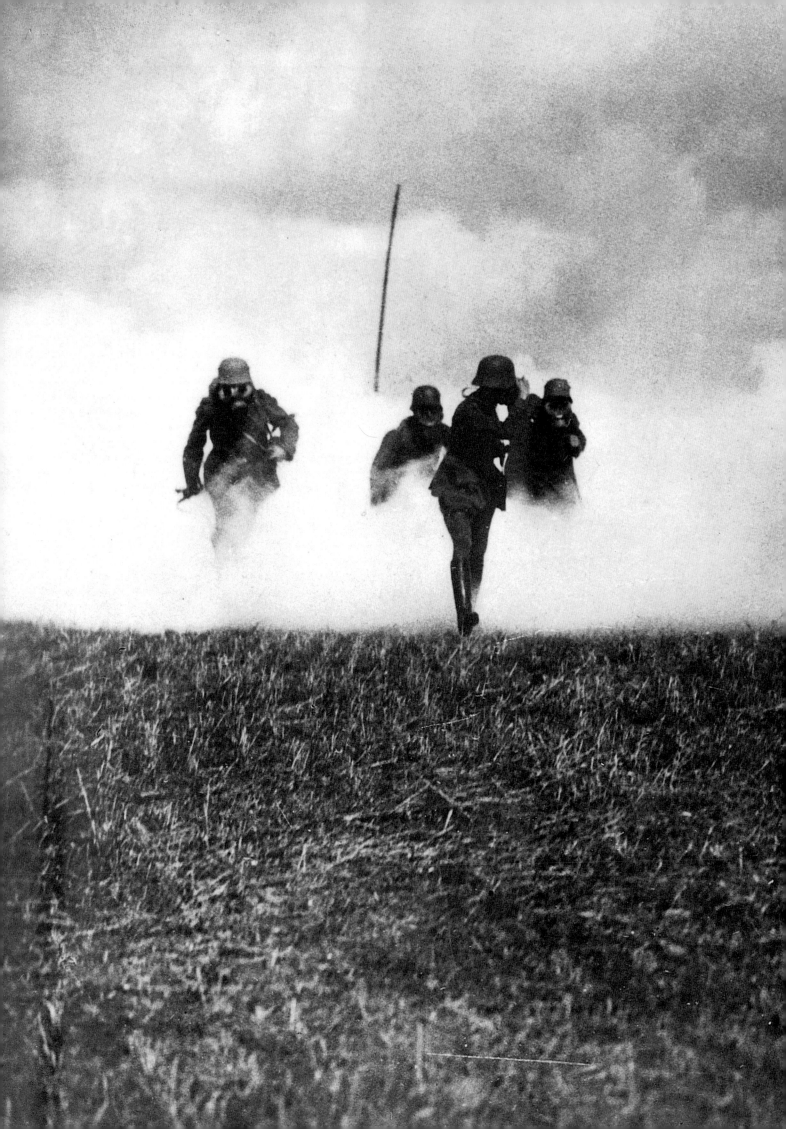

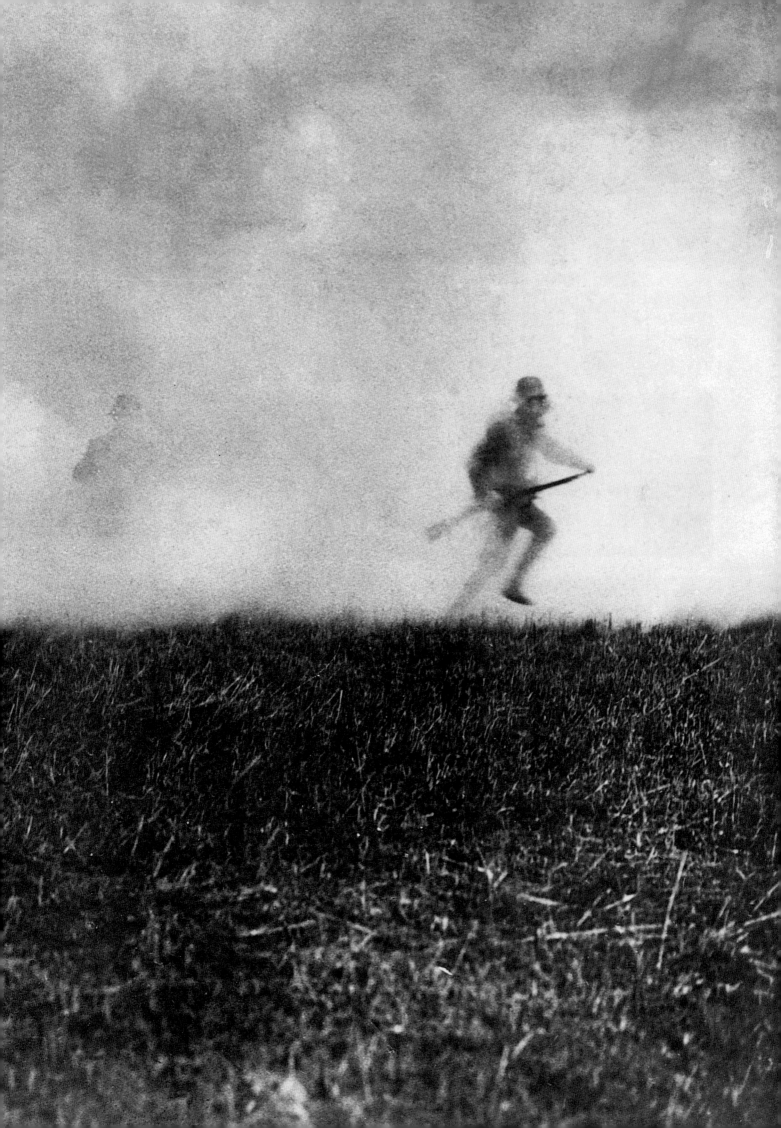

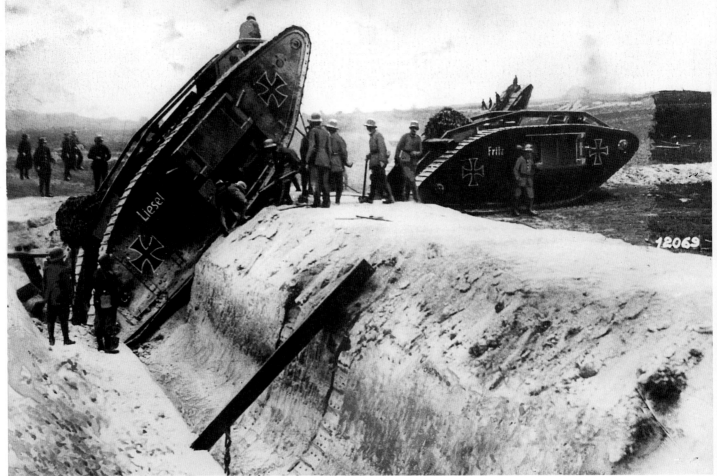

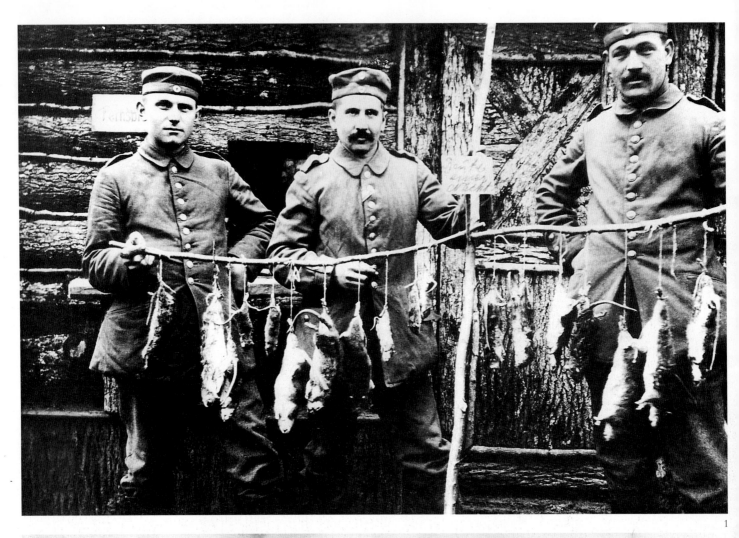

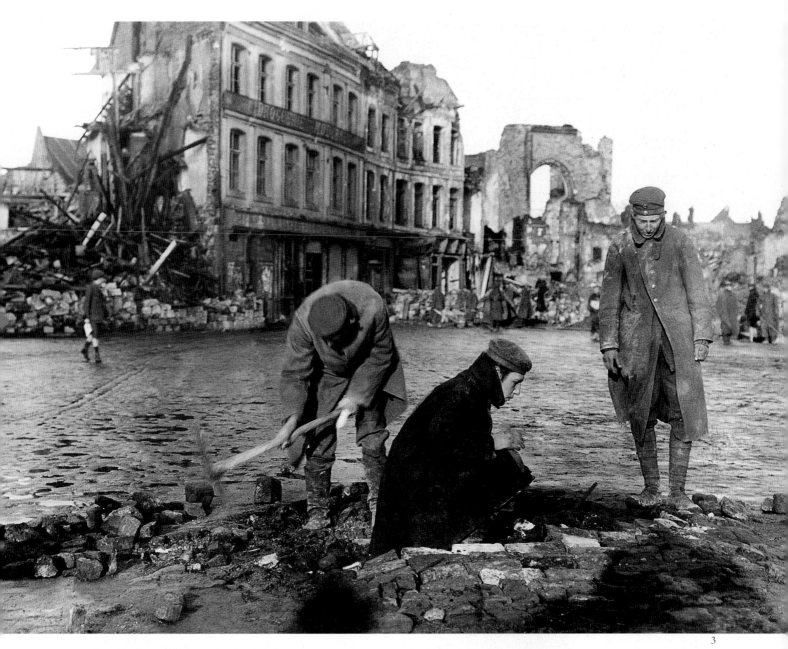

3

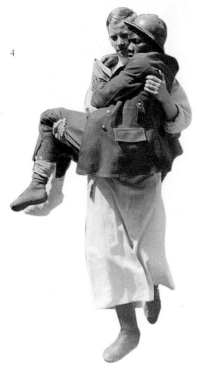

4

A German officer leads his platoon through a cloud of phosgene gas in an attack on British trenches (previous pages). By March 1916, German troops were stuck in the muddy trenches of Flanders, which crawled with rats. This was just one night's catch (1). A luckier catch were these captured British tanks – the one secret weapon possessed by the British (2). In the ruins of Béthune, German prisoners were made to repair the roads (3). A wounded Senegalese soldier is carried by a German nurse (4).

EIN deutscher Offizier führt in einem Angriff auf britische Schützengräben seine Einheit durch eine Wolke aus dem Giftgas Phosgen (vorherige Seiten). Im März 1916 saßen deutsche Truppen zusammen mit Ratten in den schlammigen Gräben von Flandern fest. Dies war nur der Fang einer Nacht (1). Ein besserer Fang waren diese britischen Panzer, die Geheimwaffe der Briten (2). In den Ruinen von Béthune mußten deutsche Gefangene die Straßen ausbessern (3). Ein verwundeter senegalesischer Soldat wird von einem deutschen Pfleger getragen (4).

UN officier allemand guide son unité à l'assaut des tranchées britanniques à travers un nuage de gaz de phosgène (pages précédentes). Dès mars 1916, les troupes allemandes se retrouvèrent enlisées dans la boue des Flandres, dans des tranchées fourmillant de rats. La prise d'une seule nuit (1). Une prise plus heureuse étant celle de ces chars d'assaut britanniques – l'arme secrète des Britanniques – capturés, repeints et testés sur le terrain (2). Dans les ruines de Béthune, les prisonniers allemands étaient affectés à la réfection des routes (3). Un infirmier allemand emmène un soldat sénégalais blessé à l'infirmerie (4).

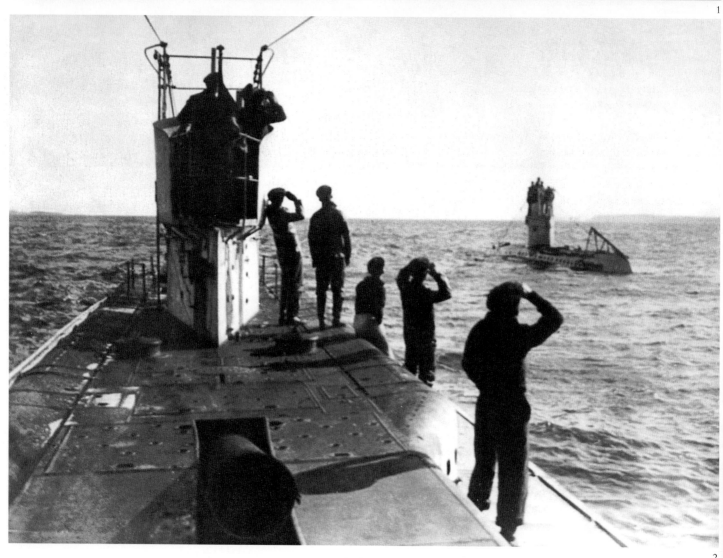

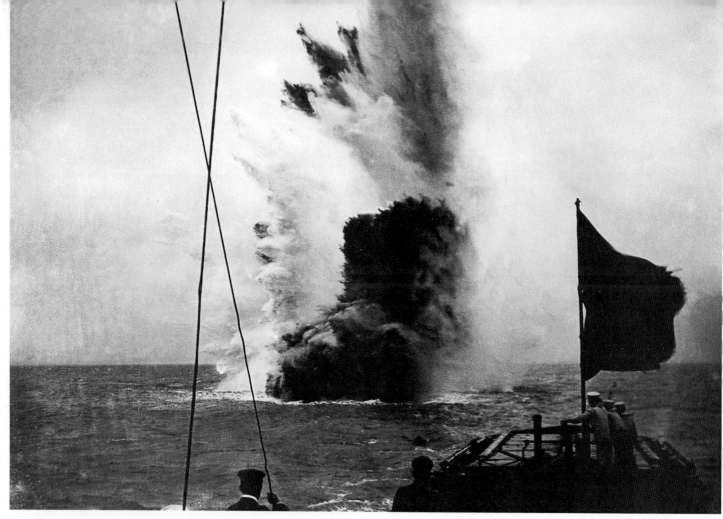

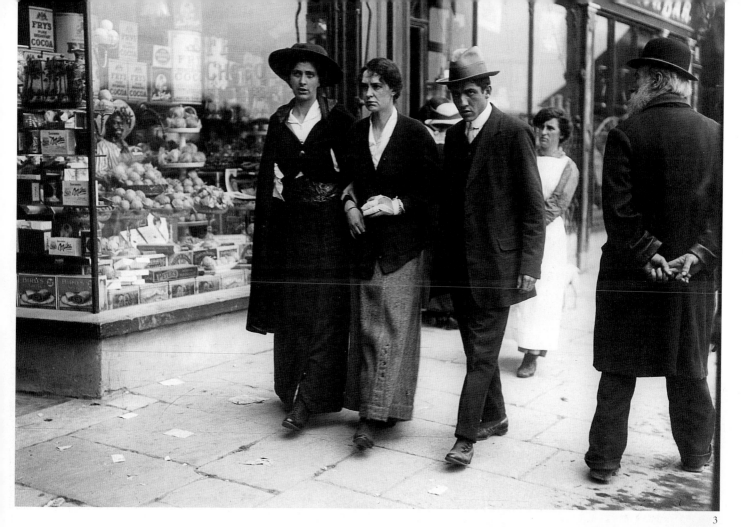

THE war at sea was mostly a contest
between submarine and merchant
ship, or merchant ship and mine (1). Sailors
on board the German U35 and U42 must
have been relieved when they surfaced
within sight of land in the Mediterranean
(2). One of the most notorious episodes
was the sinking of the *Lusitania*, which was
almost certainly carrying war supplies as
well as passengers and was thus a legitimate
target. Shocked survivors were brought
ashore at Queenstown, Ireland (3). Victims
were buried in mass graves (4).

DER Seekrieg bestand größtenteils
aus Auseinandersetzungen zwischen
U–Booten und Handelsschiffen, oder
zwischen Handelsschiffen und Minen (1).
Matrosen an Bord der deutschen U35
und U42 müssen aufgeatmet haben, als sie
beim Auftauchen aus dem Mittelmeer
Land sahen (2). Eine der berüchtigtsten
Episoden des Krieges war der Untergang
der *Lusitania*, ein Passagierschiff, das mit
großer Wahrscheinlichkeit auch Kriegs-
gerät transportierte und daher ein legitimes
Angriffsziel war. Die entsetzten Über-
lebenden wurden bei Queenstown in
Irland an Land gebracht (3), die Opfer in
Massengräbern beigesetzt (4).

LES batailles navales mettaient princi-
palement aux prises un sous-marin
et un navire marchand, ou un navire
marchand et une mine (1). Les équipages
à bord des U35 et U42 allemands se sont
certainement sentis soulagés de refaire
surface aux abords de la terre ferme en
Méditerranée (2). Un des épisodes
notoires de la guerre fut le torpillage du
Lusitania, un paquebot de ligne transportant
très vraisemblablement des fournitures de
guerre en même temps que des passagers,
et qui en conséquence représentait une cible
légitime. Les survivants en état de choc
furent ramenés sur la terre ferme à Queens-
town en Irlande (3). Les victimes furent
enterrées dans des fosses communes (4).

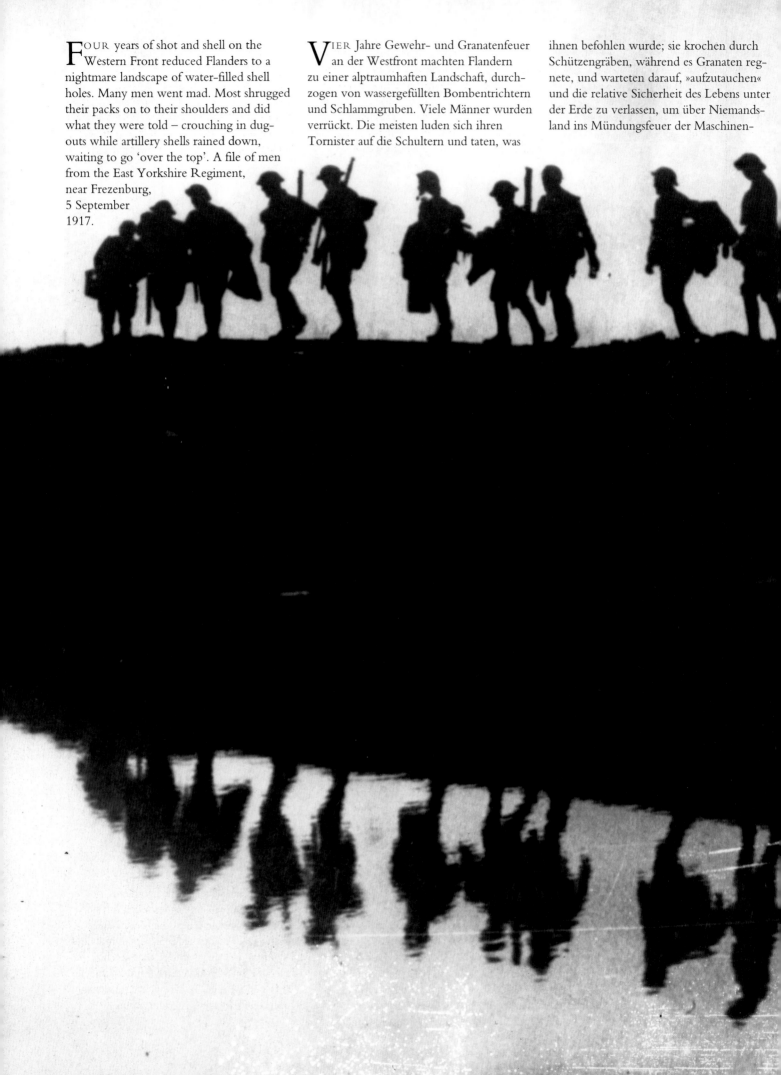

FOUR years of shot and shell on the Western Front reduced Flanders to a nightmare landscape of water-filled shell holes. Many men went mad. Most shrugged their packs on to their shoulders and did what they were told – crouching in dugouts while artillery shells rained down, waiting to go 'over the top'. A file of men from the East Yorkshire Regiment, near Frezenburg, 5 September 1917.

VIER Jahre Gewehr- und Granatenfeuer an der Westfront machten Flandern zu einer alptraumhaften Landschaft, durchzogen von wassergefüllten Bombentrichtern und Schlammgruben. Viele Männer wurden verrückt. Die meisten luden sich ihren Tornister auf die Schultern und taten, was

ihnen befohlen wurde; sie krochen durch Schützengräben, während es Granaten regnete, und warteten darauf, »aufzutauchen« und die relative Sicherheit des Lebens unter der Erde zu verlassen, um über Niemandsland ins Mündungsfeuer der Maschinen-

gewehre zu laufen. Wenn sie überlebten, marschierten sie zurück zu den Reserve-gräben, wie diese Männer des East York-shire Regiments am 5. September 1917 in der Nähe von Frezenburg, denn man hatte keinen Boden gewonnen.

QUATRE années de pilonnage du front Ouest transformèrent le paysage des Flandres en un cauchemar de trous d'obus emplis d'eau. Beaucoup perdirent la raison. La plupart réajustant d'un mouvement d'épaule leur paquetage sur leur dos exécu-taient les ordres : ils se terraient dans les tranchées-abris, sous la pluie des obus tirés par l'artillerie, attendant « d'en finir ». S'ils survivaient, ils regagnaient les retranchements de réserve – colonne d'hommes du régiment de l'Est du Yorkshire, près de Frezenbourg le 5 septembre 1917 –, car il était peu pro-bable que le moindre terrain eût été gagné.

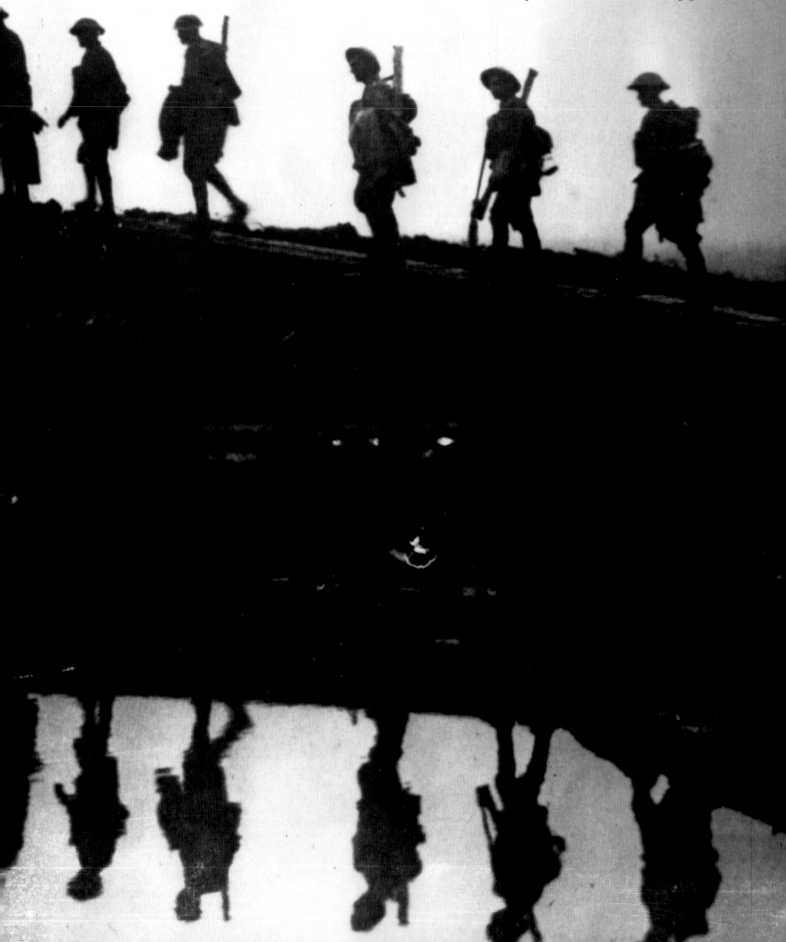

SOME died thousands of miles from home –
Canadian troops of the 16th Machine Gun
Company at Passchendaele, 1917 (1); US 23rd
Infantry in action in the Argonne (2). Others died on
their native soil, many of the French at Verdun (3).

EINIGE starben Tausende von Kilometern fern der
Heimat. Eingegrabene kanadische Soldaten der
16. Machine Gun Company bei Passchendaele Ridge,
1917 (1); die 23. US-Infanterie in Aktion in der
Argonne (2). Andere starben auf heimatlichem Boden,
viele Franzosen bei Verdun (3).

CERTAINS allaient mourir à des milliers de kilo-
mètres de chez eux : troupes canadiennes de
la 16e compagnie de mitrailleurs terrées à Passchendaele
Ridge en 1917 (1) ; 23e unité d'infanterie américaine
en pleine action dans l'Argonne (2). D'autres mou-
raient sur le sol natal ; de nombreux Français
moururent à Verdun (3).

1

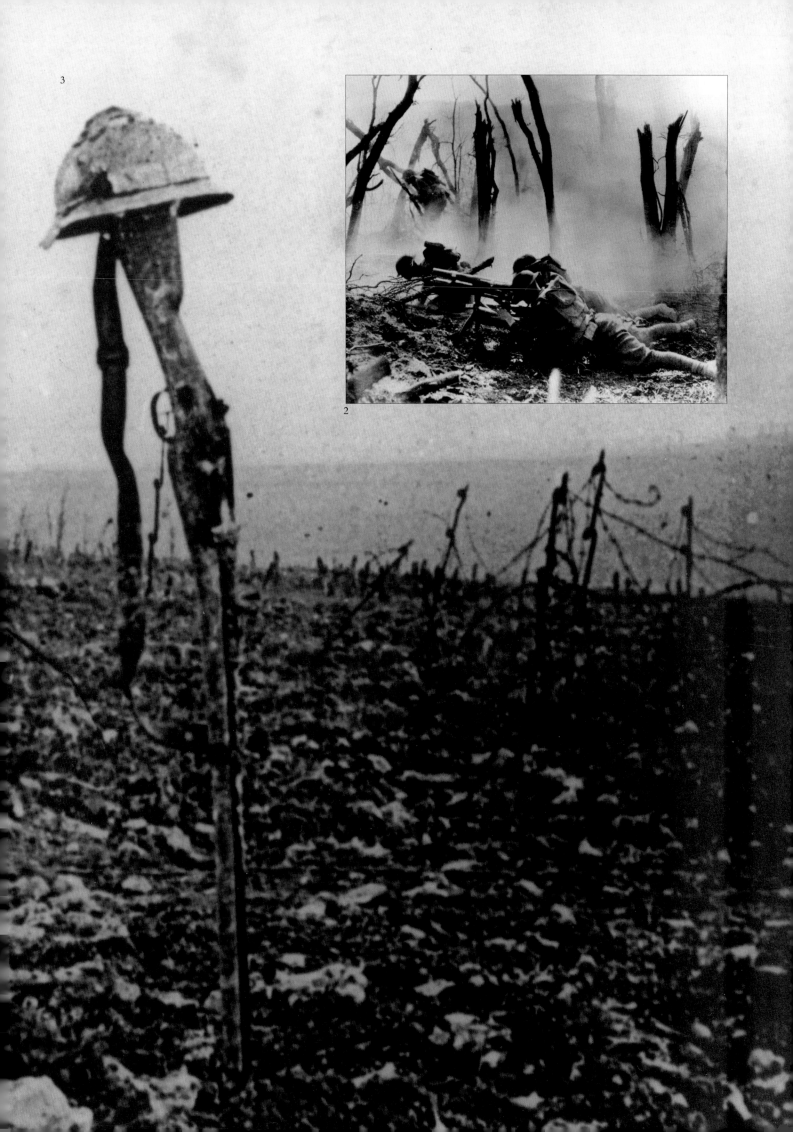

3

2

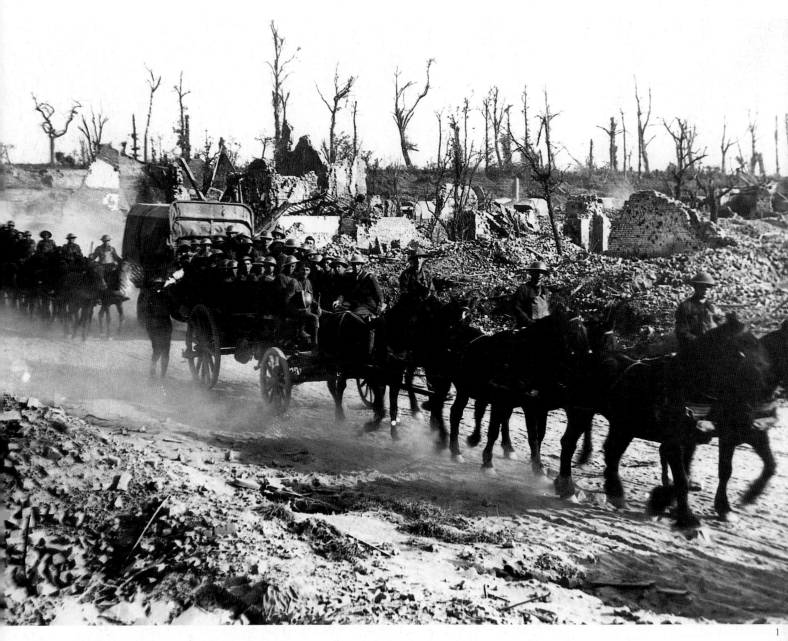

TROOPS often moved up the line towards death (2) and the enemy in greater comfort than they returned – British troops are carried on gun limbers past what was left of Polderhoek during the Battle of Ypres (1).

DER Vormarsch der Truppen auf Tod (2) und Feind war oft bequemer als der Rückzug; britische Truppen fahren auf Geschützwagen an dem vorüber, was von Polderhoek nach der Schlacht von Ypres übriggeblieben war (1).

LES troupes marchaient souvent vers la mort (2) ou l'ennemi dans des conditions plus confortables qu'elles n'en revenaient. Ici des troupes britanniques transportées sur des avant-trains dépassent ce qui reste de Polderhoek au cours de la bataille d'Ypres (1).

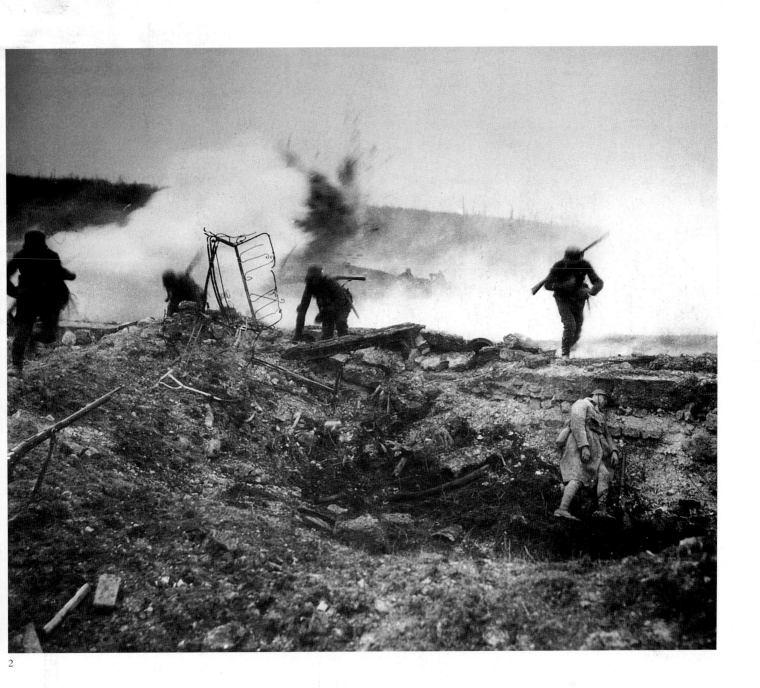

2

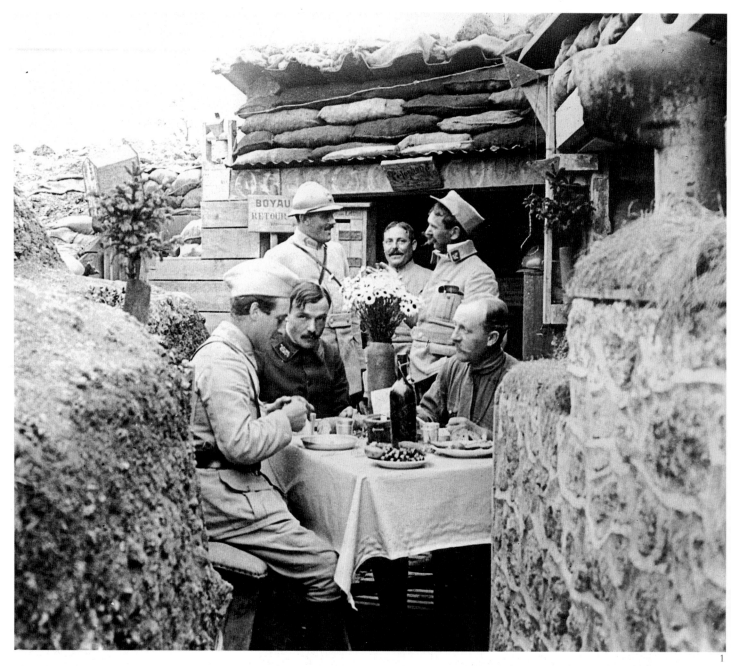

1

TRENCH life for French officers had a few civilized touches (1). But for others clothing had to be regularly inspected for unwelcome visitors (2).

The following pages show French trenches in 1916 (left) and the devastation wrought by German machine guns in the Italian trenches at Cividale (right).

SOGAR in den Schützengräben gelang es französischen Offizieren, dem Leben etwas Zivilisiertes zu verleihen (1). Andere hingegen mußten die Kleidung regelmäßig nach unwillkommenen Gästen durchsuchen (2).

Die folgenden Seiten zeigen einen französischen Schützengraben im Jahre 1916 (links) und die Verwüstung durch deutsche Maschinengewehre in einem italienischen Schützengraben bei Cividale (rechts).

LES officiers français apportaient quelques touches de civilisation à l'intérieur des tranchées (1). Mais pour les autres l'habillement devait être régulièrement inspecté (2).

Dans les tranchées françaises en 1916 (pages suivantes à gauche), et les ravages des armes allemandes dans les tranchées italiennes à Cividale (pages suivantes à droite).

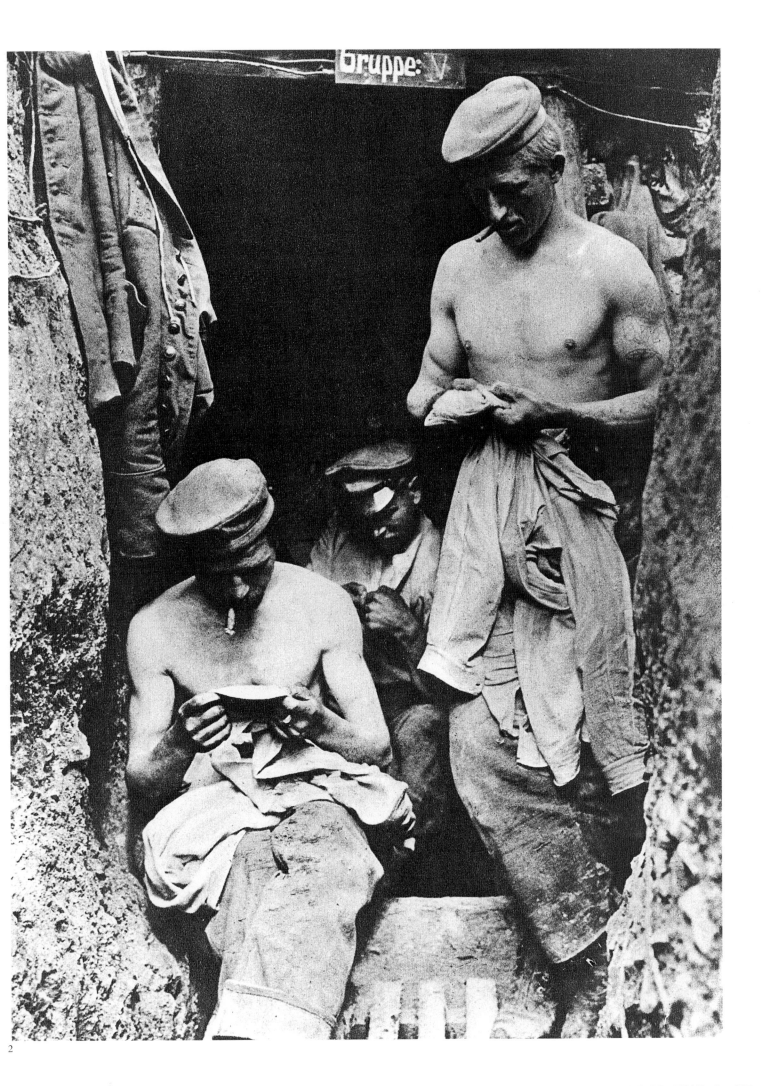

2

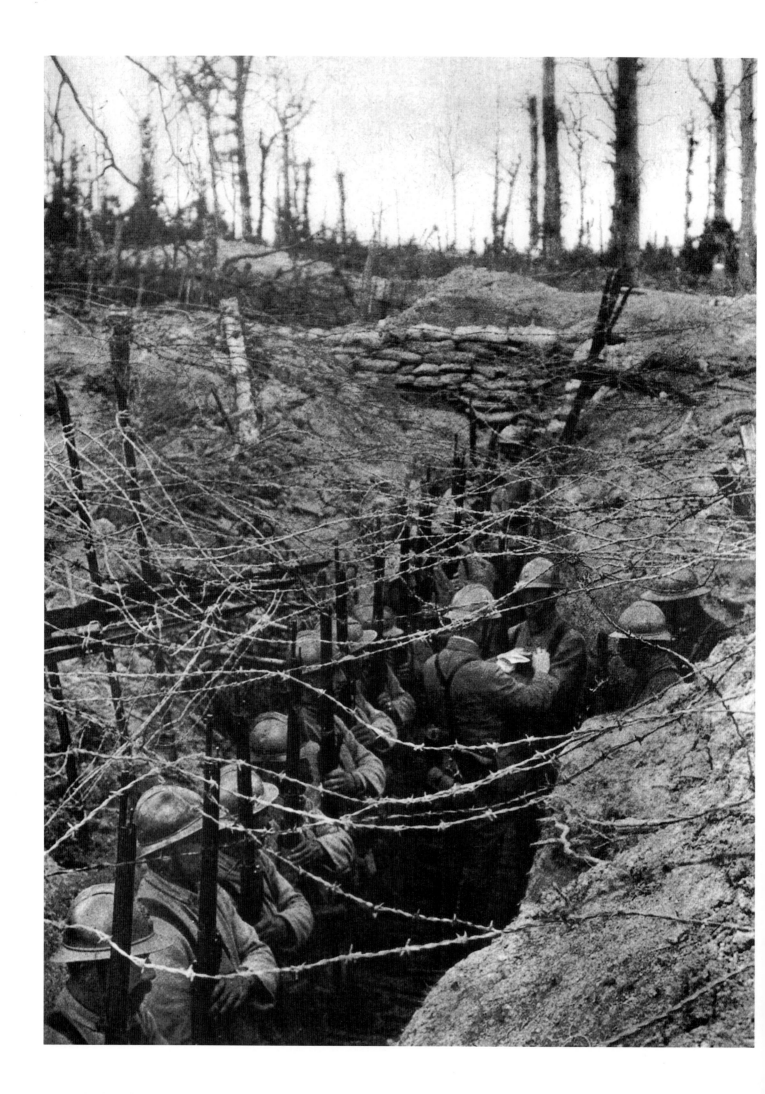

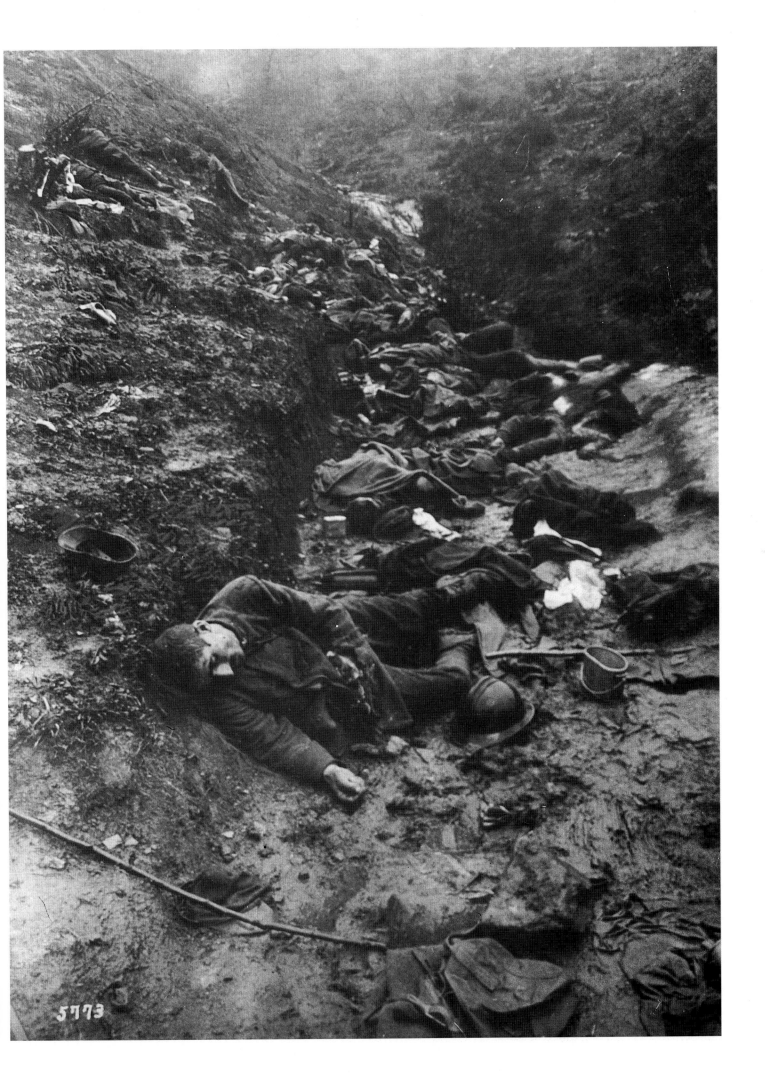

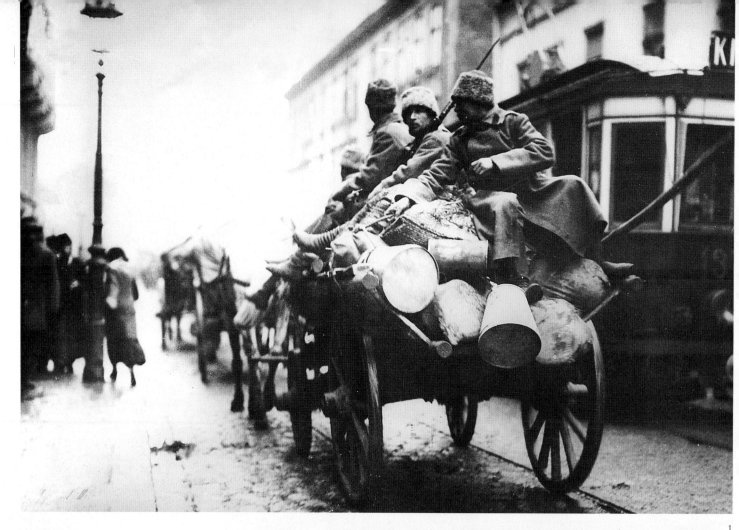

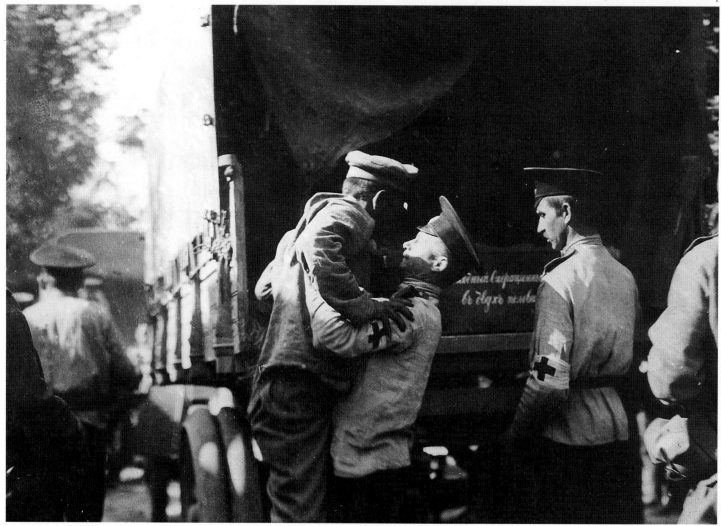

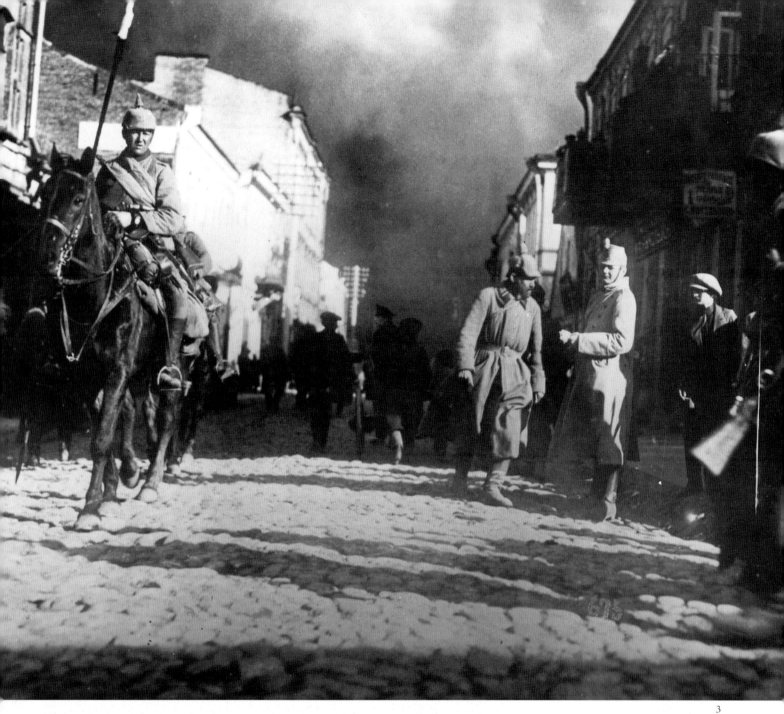

3

THE Tsar's great war machine had
rolled westwards in the autumn of
1914. It was immense, but poorly equipped
and incompetently led, and streams of
wounded poured back into Russia after
defeats by both German and Austrian
armies. Some were lucky enough to get
a ride on a wagon – Russian wounded
enter Lemberg (now L'vov) (1) – or an
ambulance (2). As the Russians retreated,
the Germans advanced (3).

DIE große Kriegsmaschine des Zaren
war im Herbst 1914 nach Westen
gerollt. Sie war zwar riesig, aber schlecht
ausgerüstet und inkompetent geführt, und
unzählige Verwundete strömten nach
Niederlagen gegen die deutsche und die
österreichische Armee zurück nach Ruß-
land. Einige, wie diese russischen Verwun-
deten bei der Ankunft in Lemberg, dem
heutigen Lwow (1), hatten das Glück, auf
einem Karren oder in einem Lazarettwagen
mitgenommen zu werden (2). Als sich die
Russen zurückzogen, rückten die Deutschen
vor (3).

LA grande machine de guerre du tsar
avait été dirigée vers l'ouest en automne
1914. Elle était immense, mais mal équipée
et mal commandée. Des vagues entières de
blessés rentrèrent en Russie après les défaites
infligées par les armées allemandes et autri-
chiennes. Certains eurent la chance de faire
le voyage en charrette, tels ces blessés russes
entrant dans Lemberg (aujourd'hui Lvov) (1),
ou en ambulance (2). Au fur et à mesure
que les Russes battaient en retraite, les
Allemands avançaient (3).

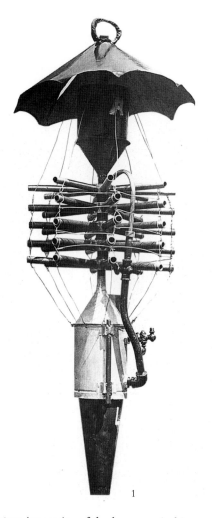

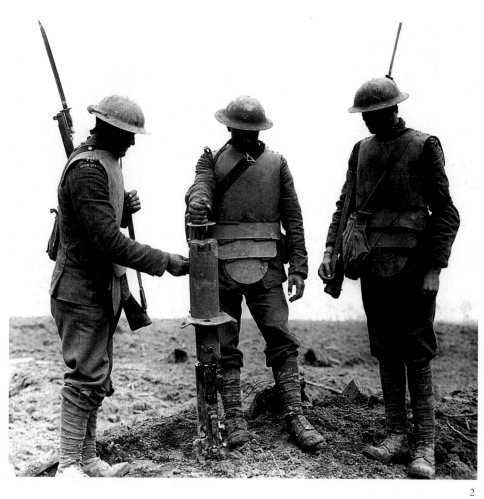

THE ingenuity of the human mind is always well to the fore in any war. One of the problems in the First World War was that of lighting a battlefield after dark. The days of chivalry – when battles ceased at dusk – were long gone, and there was always the fear of a surprise night attack. This flare was fired into the air above No-Man's-Land, where it ignited, and then fluttered slowly down under its parachute, throwing light on the ground below (1). Working parties of British troops wore breastplates of armour to protect them from stray bullets (2). German troops mounted large guns on canal barges in Belgium to transport them more easily to the battlefield (3). Tanks used in the war were descendants of this early caterpillar-track farm machine of 1902, first used in eastern England (4).

DER menschliche Geist vollbringt in jedem Krieg Höchstleistungen. Eines der Probleme im Ersten Weltkrieg bestand darin, ein Schlachtfeld nach Einbruch der Dunkelheit zu beleuchten. Die Tage der Ritter im Mittelalter, als Schlachten in der Abenddämmerung endeten, lagen lange zurück, und es herrschte immer die Angst vor einem nächtlichen Überraschungs-angriff. Diese Leuchtrakete wurde über Niemandsland in die Luft geschossen, wo sie sich entzündete, und dann langsam an einem Fallschirm herabsank und dabei das darunterliegende Gebiet beleuchtete (1). Arbeitstrupps der britischen Armee trugen gepanzerte Brustplatten, um sich vor verirrten Kugeln zu schützen (2). In Belgien luden deutsche Soldaten große Kanonen auf Schleppkähne, um sie einfacher zum Schlachtfeld transportieren zu können (3). Die im Krieg eingesetzten Panzer waren Abkömmlinge dieses landwirtschaftlichen Raupenfahrzeugs aus dem Jahre 1902, das zuerst auf Farmen im Osten Englands verwendet wurde (4).

LES hommes se montrent toujours ingénieux en temps de guerre. Un des problèmes qui se posaient pendant la Première Guerre mondiale était l'éclairage des champs de bataille après la tombée de la nuit. Les temps de la chevalerie où les batailles cessaient au crépuscule étaient révolus depuis longtemps. Chaque camp vivait dans la crainte continuelle de faire les frais d'une attaque-surprise en pleine nuit. Cette fusée éclairante, suspendue à son parachute, tirée au-dessus du no man's land, s'est enflammée et redescend en tourbil-lonnant, éclairant le sol au-dessous (1). Les soldats britanniques travaillaient en plastron de cuirasse pour se protéger des balles per-dues (2). En Belgique, les troupes allemandes fixaient sur des barges d'énormes canons qu'elles transportaient ainsi plus facilement jusqu'au champ de bataille par la voie des canaux (3). Les chars d'assaut utilisés pendant la guerre descendaient de cette première machine agricole sur chenilles de 1902, qui fut pour la première fois utilisée dans les fermes de l'est de l'Angleterre (4).

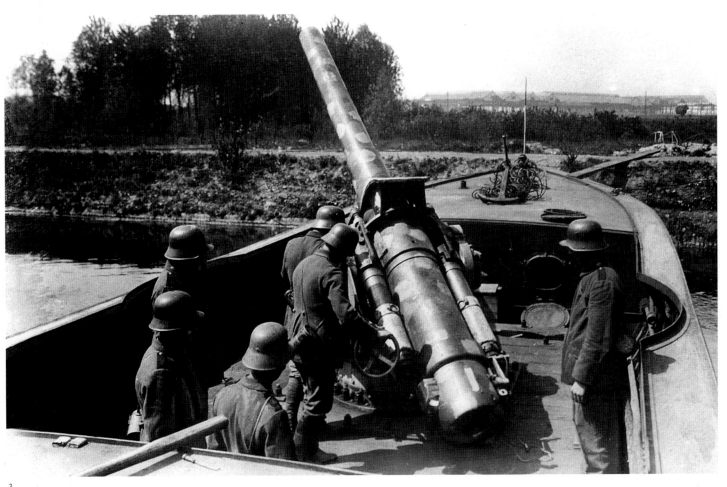

3

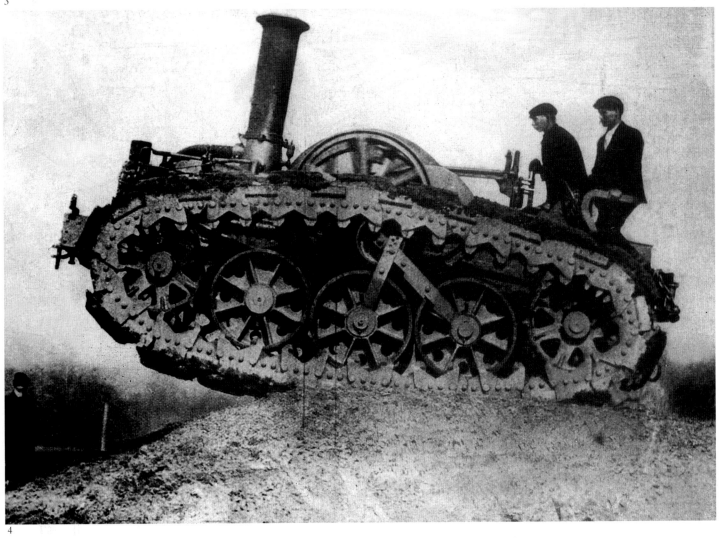

4

THE poem *The Last Laugh* by Wilfred Owen, provides a poignant commentary on the horror of war as seen in these pictures (1 and 2).

'O Jesus Christ! I'm hit,' he said; and died.
Whether he vainly cursed, or prayed indeed,
The Bullets chirped – In vain! vain! vain!
Machine guns chuckled, – Tut-tut! Tut-tut!
And the Big Gun guffawed.

It was a war of words as well as weapons, and a war of information. All armies feared and loathed spies, and punishment was swift and terrible for anyone convicted, rightly or wrongly, of espionage. The caption on the post reads: 'Spy – traitor to his country' (3). The graffiti painted on this French gate marks the house as the home of a traitor (4) – what happened to the occupant, we can only guess.

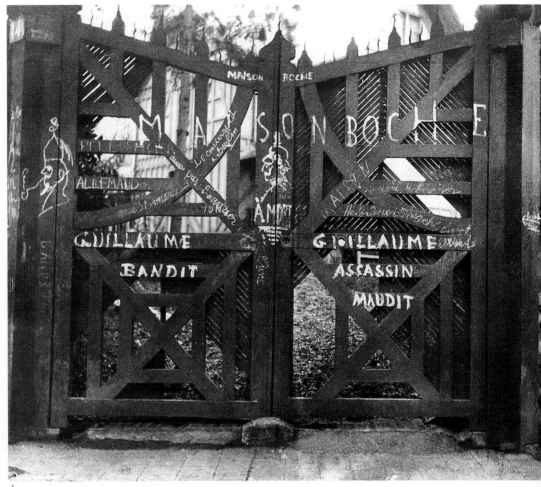

4

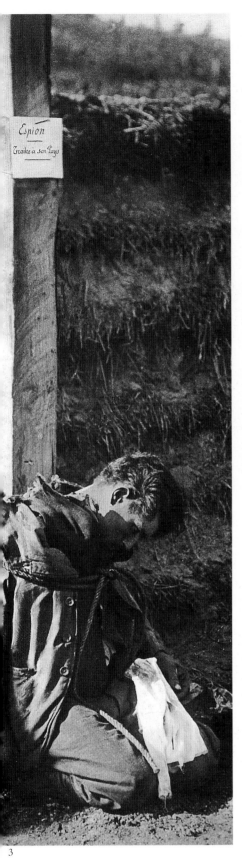

3

DAS Gedicht *The Last Laugh* von Wilfred Owen kommentiert ergreifend den Schrecken des Krieges auf diesen Bildern (1 und 2).

»Oh, mein Gott! Ich bin getroffen«, sagte er und starb.
Ob er vergeblich fluchte, oder tatsächlich betete,
Die Kugeln zwitscherten – umsonst, umsonst!
Maschinengewehre kicherten – Tut-tut! Tut-tut!
Und die große Kanone lachte schallend.

Es war ein Krieg der Worte, der Waffen und der Informationen. Alle Armeen fürchteten und haßten die Spione, und jeden, der zu Recht oder zu Unrecht der Spionage angeklagt wurde, ereilte eine schnelle und schreckliche Strafe. Auf der Karte an diesem Pfahl ist zu lesen: »Spion, Vaterlandsverräter« (3). Die Aufschriften auf diesem französischen Tor brandmarken das Haus als das eines Verräters (4) – was mit seinem Bewohner geschah, läßt sich nur vermuten.

LE poème *The Last Laugh* de Wilfred Owen est un commentaire poignant sur l'horreur de la guerre telle qu'elle apparaît dans ces images (1 et 2).

« Ô Doux Jésus ! Je suis touché », dit-il, et il mourut.
Qu'il maudît en vain ou qu'il criât, ou même qu'il priât,
Les balles chantaient : en vain ! vain ! vain !
Les mitrailleuses gloussaient : Tut-Tut ! Tut-Tut !
Et le gros canon s'esclaffait.

Ce fut une guerre des mots autant que des armes, et une guerre de renseignements. Toutes les armées redoutaient et exécraient les espions : le châtiment de toute personne reconnue coupable d'espionnage, à tort ou à raison, était prompt et terrible. L'inscription sur le poteau est la suivante : « Espion, traître à son pays » (3). Les graffiti peints sur ce portail en France signalent qu'un traître vit dans cette maison (4) ; nous devinons sans peine le sort réservé à son occupant.

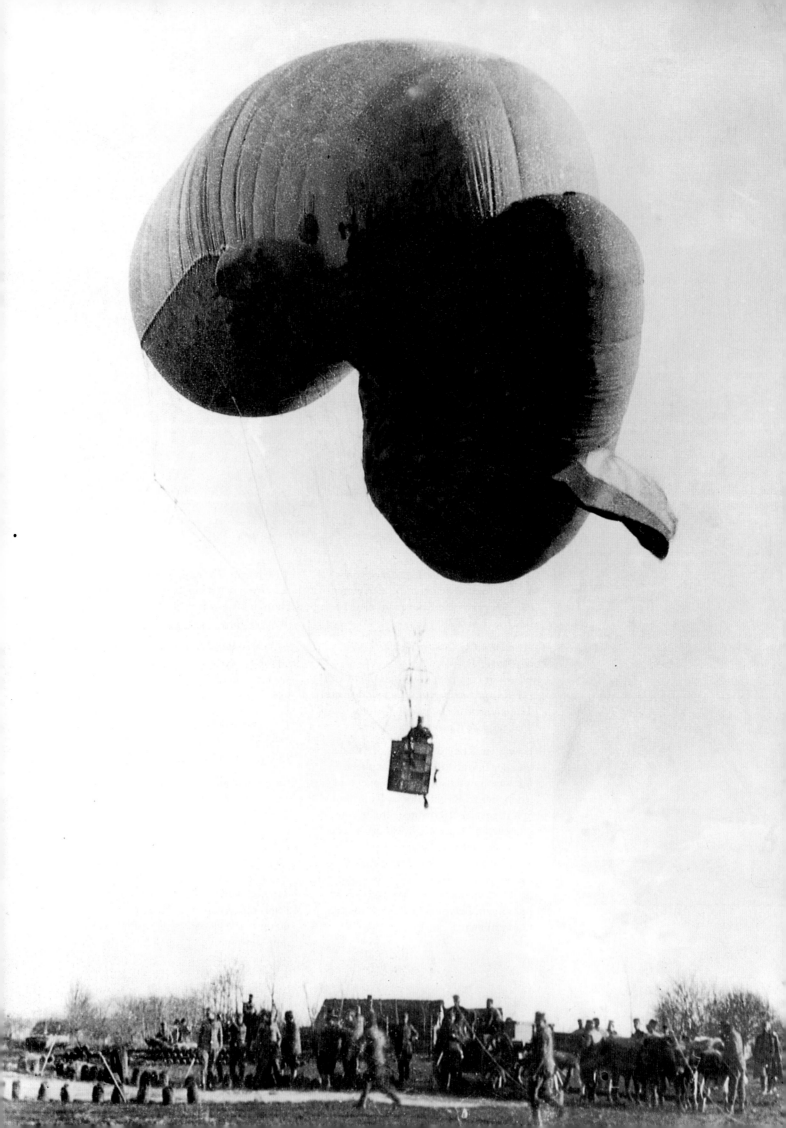

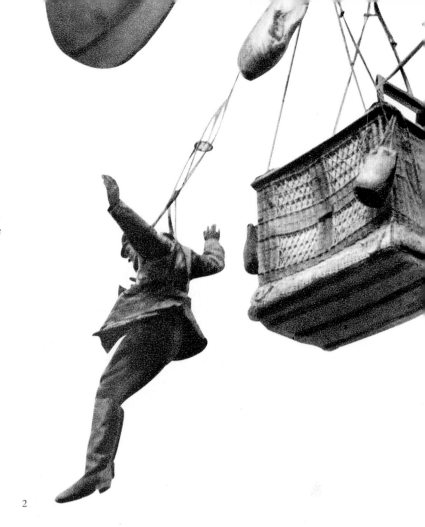

BALLOONS had one main function in the war – as observation posts. Some were of bizarre design, as this Serbian military balloon (1). Maybe the enemy died of laughter. Life in an observation balloon was uncomfortable and exposed. There was always the danger that it would drift within range of enemy guns – this German observer leaps from his gondola after his balloon has been hit (2 – note the primitive parachute). It took a whole team of mechanics to help inflate a balloon with gas (3). Zeppelins had a different use. They were powerful enough to carry a load of bombs from Germany to London, and produce panic in the streets. Not all returned, however. Crowds turned out to see the wreckage of a Zeppelin that crashed at Potters Bar on 2 October 1916 (4).

BALLONS dienten im Krieg hauptsächlich als Beobach-tungsposten. Einige hatten eine bizarre Form, beispielsweise dieser serbische Militärballon (1). Vielleicht lachte sich der Feind ja tot. Das Leben in einem Observationsballon war unbequem und gefährlich. Es konnte immer passieren, daß der Ballon in die Schußlinie des Feindes abdriftete; dieser deutsche Späher springt aus der Gondel, nachdem sein Ballon getroffen wurde (2, man beachte den primitiven Fallschirm). Es bedurfte eines ganzen Teams von Mechanikern, um den Ballon mit Gas aufzupumpen (3). Zeppeline wurden für andere Zwecke eingesetzt. Sie waren stark genug, um eine Ladung Bomben von Deutschland nach London zu befördern und für Panik in den Straßen zu sorgen. Aber nicht alle kamen zurück. Die Menschen liefen zusammen, um das Wrack eines Zeppelins zu sehen, der am 2. Oktober 1916 bei Potters Bar abgestürzt war (4).

LES ballons avaient une tâche essentielle pendant la guerre : servir de postes d'observation. Certains étaient de forme bizarre, tel ce ballon militaire serbe (1). L'ennemi en mourut peut-être de rire. La vie dans un ballon d'observation était inconfortable et périlleuse. Il pouvait toujours dériver à portée de tir des canons ennemis : cet observateur allemand saute hors de sa nacelle après que son ballon a été touché (2, on notera le parachute primitif). Il fallait toute une équipe de mécaniciens pour gonfler un ballon au gaz (3). Les zeppelins servaient à autre chose. Leur puissance leur permettait de transporter un chargement de bombes de puis l'Allemagne jusqu'à Londres et de semer ainsi la panique dans les rues. Cependant tous ne revenaient pas. Attroupement autour des débris d'un zeppelin qui s'écrasa à Potters Bar le 2 octobre 1916 (4).

2

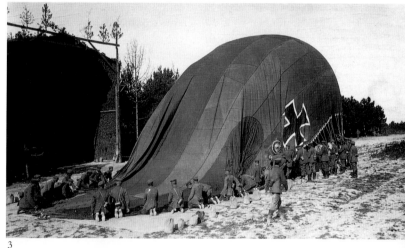

3

4

SUCH glamour as there was in the First World War came from the war in the air. A new hero was born – the 'air-ace'. Their names were not always household words, for those in command did what they could to keep the names of Ball, Richthofen, and Roland Garros out of the newspapers. There were also those who regarded the single-combat duels between these brave young men as reminiscent of the days of chivalry – though one British airman spat out, on hearing that Richthofen had been shot down and killed: 'I hope he roasted all the way down'. But to the earthbound, the courage and audacity of the men who flew the fragile biplanes – such as this Vickers bomber (2) – became legendary. And they looked so good in propaganda films (1).

BESONDERS die Auseinandersetzungen in der Luft verliehen dem Ersten Weltkrieg seine Brisanz. Ein neuer Heldentypus wurde geboren, das »Luft-As«. Die Namen Ball, Richthofen und Roland Garros waren jedoch nicht immer ein Begriff, denn die Befehlshabenden taten alles, um sie aus den Zeitungen herauszuhalten. Manch einer fühlte sich durch die Luftduelle dieser tapferen jungen Männer an die Tage des Rittertums erinnert, obwohl ein britischer Pilot ausspuckte, als er hörte, daß Richthofen abgeschossen worden war: »Ich hoffe, er hat den ganzen Weg nach unten geschmort.« Aber bei den Menschen am Boden wurden diese mutigen und verwegenen Männer, die fragile Doppeldecker wie den Vickers-Bomber (2) flogen, zu Legenden. Und sie sahen so gut aus in den Propagandafilmen (1).

TOUT l'éclat qu'il put y avoir dans la Première Guerre mondiale doit être attribué à la guerre des airs. Un nouveau héros était né : l'« as des airs ». Leurs noms n'étaient pas toujours familiers à cause de ceux qui, tout en haut, faisaient de leur mieux pour empêcher les noms de Ball, Richthofen et Roland Garros de figurer dans les journaux. D'autres pensaient que les duels que se livraient ces téméraires jeunes gens remémoraient l'époque des chevaliers. Cela n'empêcha pas un aviateur britannique de commenter avec aigreur la nouvelle de la mort de Richthofen en combat aérien par : « J'espère qu'il aura rôti jusqu'au sol. » Quoi qu'il en soit, pour ceux qui restaient sur terre, le courage et l'audace de ces hommes aux commandes des fragiles biplans, comme ce bombardier Vickers (2), devinrent légendaires. Et puis ils avaient si belle allure dans les films de propagande (1).

2

ITALY entered the war on the side of France and Britain on 23 May 1915. For two years there was stalemate between Italian and Austrian troops. The Bersaglieri, or rifle battalions, were clearly ready for a war of movement, whether on bicycle (1) or foot (2). An Italian column trudges slowly up the Rurtor Glacier (3). Eventually, the stalemate was broken by a massive victory for German and Austrian troops at Caporetto in October 1917.

ITALIEN verbündete sich mit Frankreich und Großbritannien und trat am 23. Mai 1915 in den Krieg ein. Zwei Jahre lang herrschte eine Pattsituation zwischen der italienischen und der österreichischen Armee, obwohl die italienischen Bersaglieri oder Scharfschützentruppen eindeutig zu einem mobilen Krieg bereit waren, sei es auf dem Fahrrad (1) oder zu Fuß (2). Eine italienische Kolonne zieht langsam den Rurtor-Gletscher hinauf (3). Im Oktober 1917 wurde die Pattsituation durch einen entscheidenden Sieg deutscher und österreichischer Truppen bei Caporetto beendet.

L'ITALIE entra en guerre aux côtés de la France et de la Grande-Bretagne le 23 mai 1915. Deux années durant, les armées italiennes et autrichiennes restèrent bloquées face à face le long de l'Isanzo, bien que les bersagliers italiens fussent manifestement prêts pour une guerre de mouvement à bicyclette (1) ou à pied (2). Une colonne italienne escalade ici péniblement le glacier de Rurtor (3). Finalement la victoire massive remportée par les troupes allemandes et autrichiennes à Caporetto en octobre 1917 mit fin à la confrontation.

1

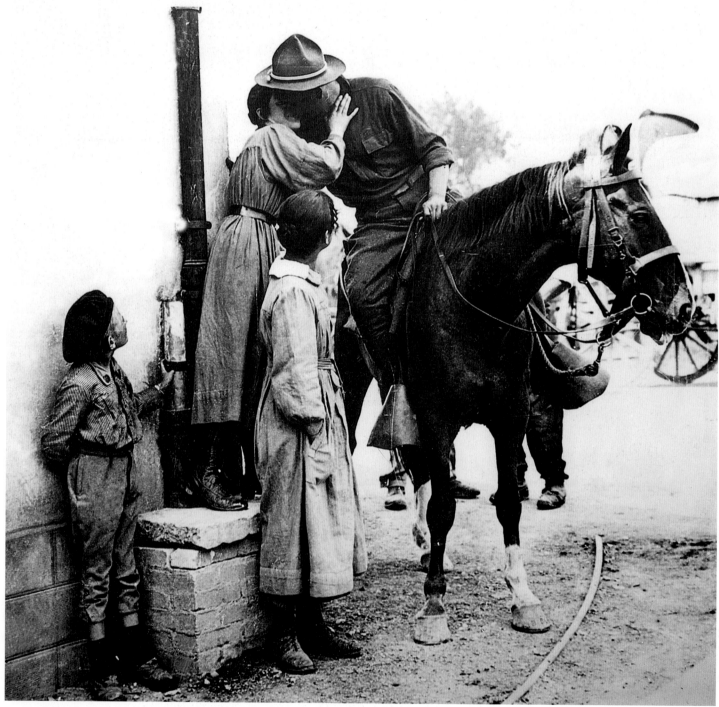

2

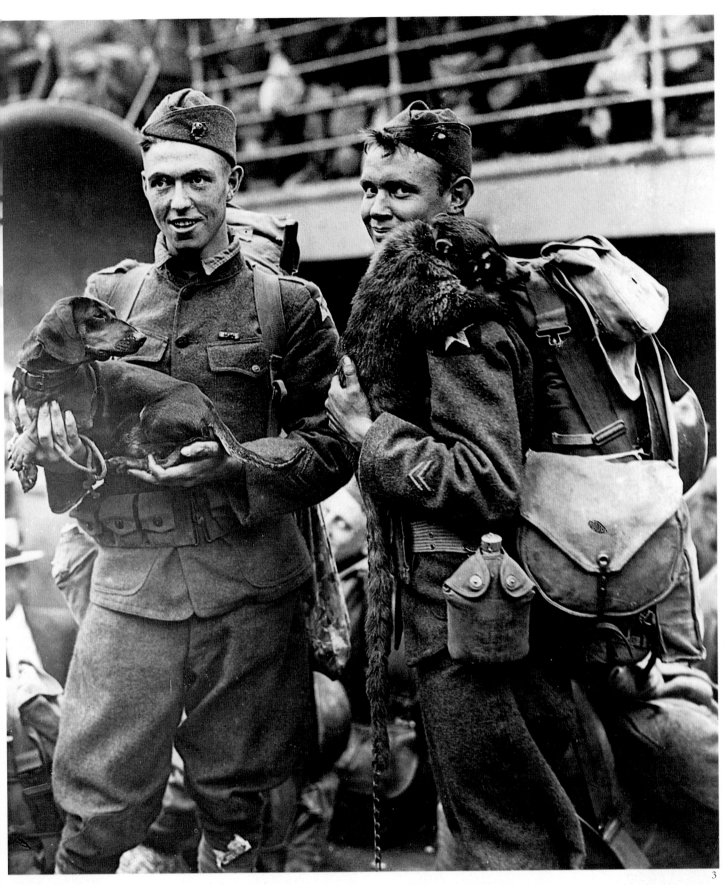

LAST into the war were the Americans, who did everything with style and panache, whether fraternizing (2), or displaying cavalry skills of limited use in modern warfare (1). They were young and brave and tough, if sentimentally attached to their pets (3).

ALS letzte traten die Amerikaner in den Krieg ein, und sie taten alles mit Stil und Verve, sei es die Verbrüderung mit den Einheimischen (2) oder die Vorführung von Kavallerie-Kunststücken, für die in moderner Kriegsführung allerdings wenig Bedarf herrschte (1). Sie waren jung, tapfer und hart, mit einem Herz für Tiere (3).

LES derniers à entrer en guerre furent les Américains qui firent tout avec style et panache, qu'il s'agît de fraterniser (2) ou de déployer des qualités de cavalier sans grande utilité dans une guerre moderne (1). Ils étaient jeunes et courageux en dépit de l'attachement qu'ils portaient à leurs animaux familiers (3).

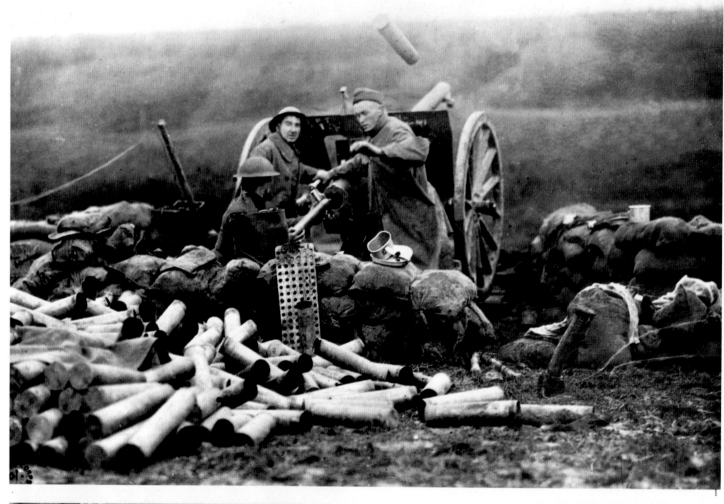

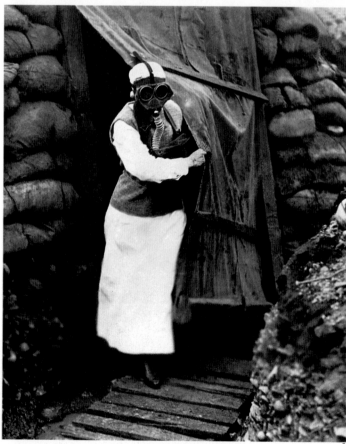

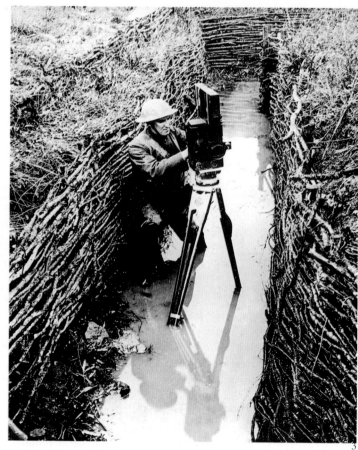

THOUGH late into the war, the Americans played a vital role in communications: a semaphore unit of the U.S. Army (4). Sir Douglas Haig, Commander-in-Chief of the British troops, prayed: 'Give me victory, O Lord, before the Americans arrive', but without their help, defeat would have been a distinct possibility. When the final push came, American gunners were in the thick of it (1). American nurses were near enough to the front lines to need gas masks (2), and American cinematographers filmed the Big Parade for the folks back home (3).

OBWOHL sie erst spät in den Krieg eintraten, spielten die Amerikaner eine entscheidende Rolle für die Kommunikation: ein Semaphor der amerikanischen Armee (4). Sir Douglas Haig, Oberbefehlshaber der britischen Truppen, betete: »Schenk' mir den Sieg, O Herr, bevor die Amerikaner kommen«, aber ohne ihre Hilfe wäre eine Niederlage unausweichlich gewesen. Als die letzte Offensive gestartet wurde, kämpften die Amerikaner mittendrin (1). Amerikanische Krankenschwestern waren so nah an der Front, daß sie Gasmasken tragen mußten (2); amerikanische Kameramänner filmten die große Schlacht für die Menschen in der Heimat (3).

BIEN qu'entrés tardivement dans la guerre, les Américains jouèrent un rôle capital dans le domaine des communications : sémaphore de l'armée américaine (4). Sir Douglas Haig, commandant en chef des troupes britanniques priait : « Accorde-moi la victoire, ô Seigneur, avant l'arrivée des Américains. » Mais sans leur aide la défaite aurait été de l'ordre du possible. Lors de l'assaut, les artilleurs américains se retrouvèrent aux premières loges (1). Les infirmières américaines étaient suffisamment proches des lignes de front pour devoir porter des masques à gaz (2), tandis que les cinématographes américains filmaient la grande parade pour leurs compatriotes restés chez eux (3).

4

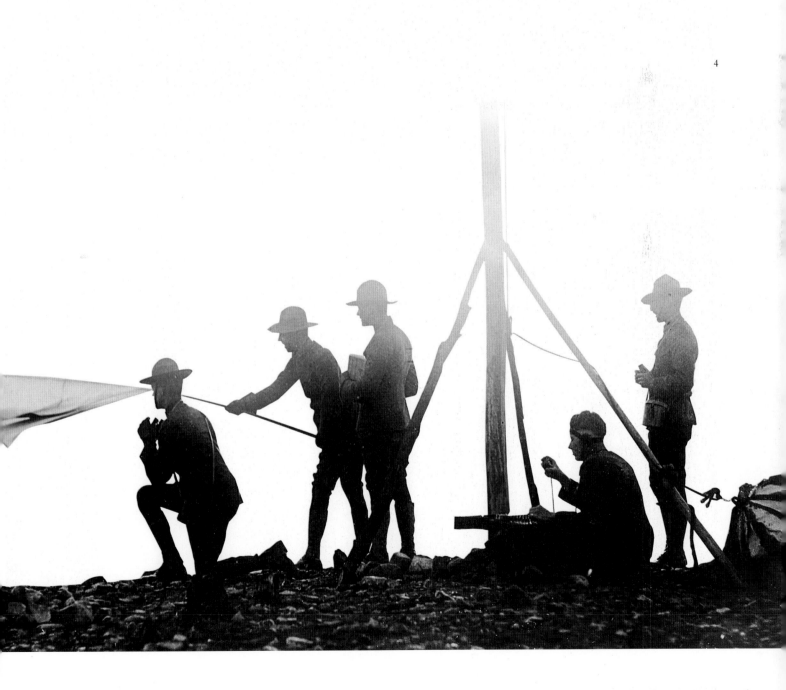

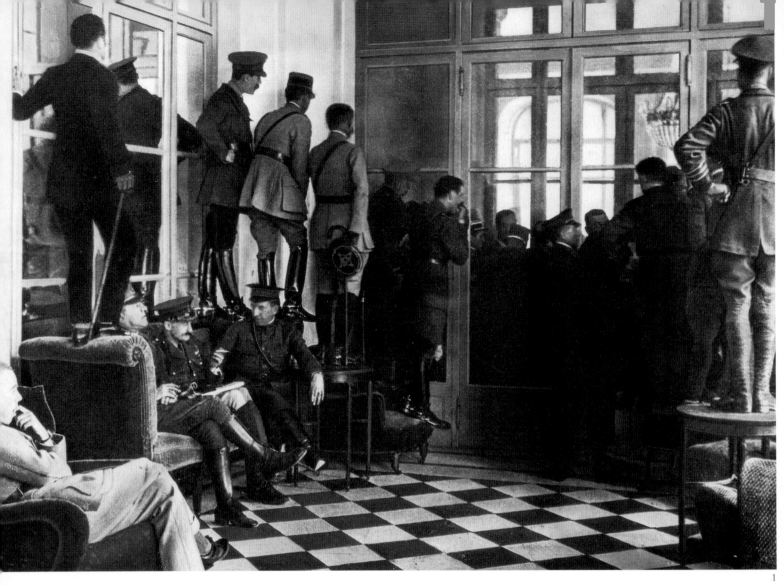

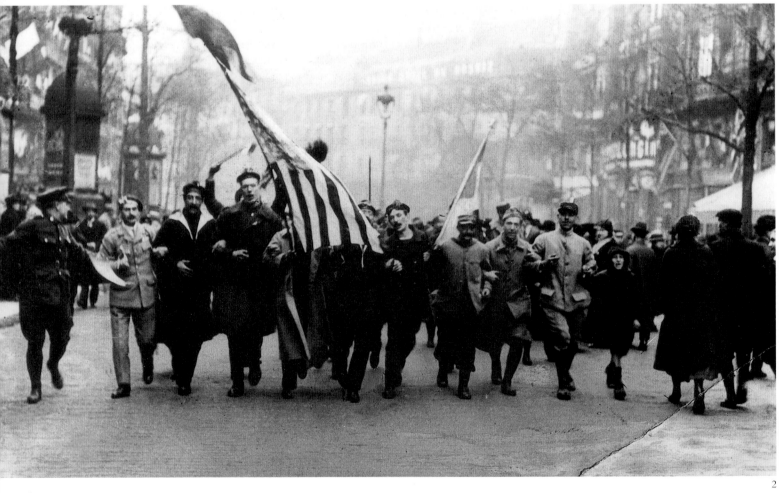

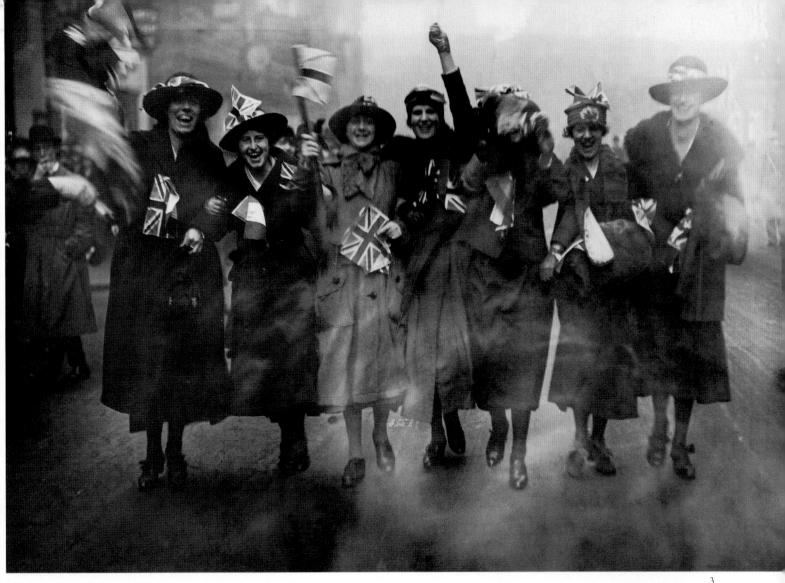

IN September 1918, Lord Northcliffe, an English newspaper tycoon, had prophesied: 'None of us will live to see the end of the war'. But on the eleventh hour of the eleventh day of the eleventh month of that year, the guns finally stopped. Some 14 million people had died – an average of 9,000 every day since the war began. Troops were bewildered; there was no fraternization and little cheering in the trenches. But among those at home there was widespread jubilation. Crowds thronged the boulevards of Paris (2) and the streets of London (3). Couples made love in public, an affirmation of new life after four years of death. There followed a great deal of bickering among the victors, but the Peace Treaty was finally signed at the Palace of Versailles in June 1919. Allied officers stood on chairs and tables to witness the signing (1). Peace was a great relief. The Treaty was a disaster.

IM September 1918 hatte der englische Zeitungsverleger Lord Northcliffe prophezeit: »Niemand von uns wird das Ende des Krieges erleben.« Aber zur elften Stunde des elften Tages im elften Monat jenes Jahres schwiegen die Waffen endlich. Etwa vierzehn Millionen Menschen waren getötet worden – im Durchschnitt 9 000 pro Tag seit Kriegsbeginn. Die Soldaten waren verwirrt; es gab keine Verbrüderung und wenig Jubel in den Schützengräben. Aber bei den Menschen zu Hause war die Freude grenzenlos. Sie liefen in Scharen über die Pariser Boulevards (2) und durch die Straßen von London (3). Paare küßten sich in der Öffentlichkeit – ein Ausbruch neuen Lebenswillens nach vier Jahren des Tötens. Die Siegermächte waren sich lange nicht einig, aber schließlich wurde der Friedensvertrag im Juni 1919 im Schloß von Versailles unterzeichnet. Alliierte Offiziere standen auf Stühlen und Tischen, um Zeuge der Unterzeichnung zu werden (1). Der Frieden war eine große Erleichterung. Der Vertrag aber war eine Katastrophe.

EN septembre 1918, Lord Northcliffe, magnat de la presse britannique, avait prophétisé : « Aucun de nous ne verra la fin de la guerre de son vivant. » Pourtant, à la onzième heure du onzième jour du onzième mois de cette année-là, les armes se turent enfin. Environ quatorze millions de personnes avaient péri, soit une moyenne de neuf mille par jour depuis le début de la guerre. Les troupes étaient en plein désarroi. On ne fraternisa pas et on ne s'enthousiasma que très peu dans les tranchées. En revanche, ailleurs l'allégresse était générale. La foule envahit les boulevards de Paris (2) et les rues de Londres (3). Les couples s'embrassaient en public, une nouvelle vie reprenait après quatre années de mort. Les vainqueurs se lancèrent dans des querelles innombrables et futiles, puis finalement le traité de paix fut signé au château de Versailles en juin 1919. Les officiers des forces alliées montèrent sur des chaises et des tables pour être témoins de la signature (1). La paix fut un énorme soulagement, le traité un désastre.

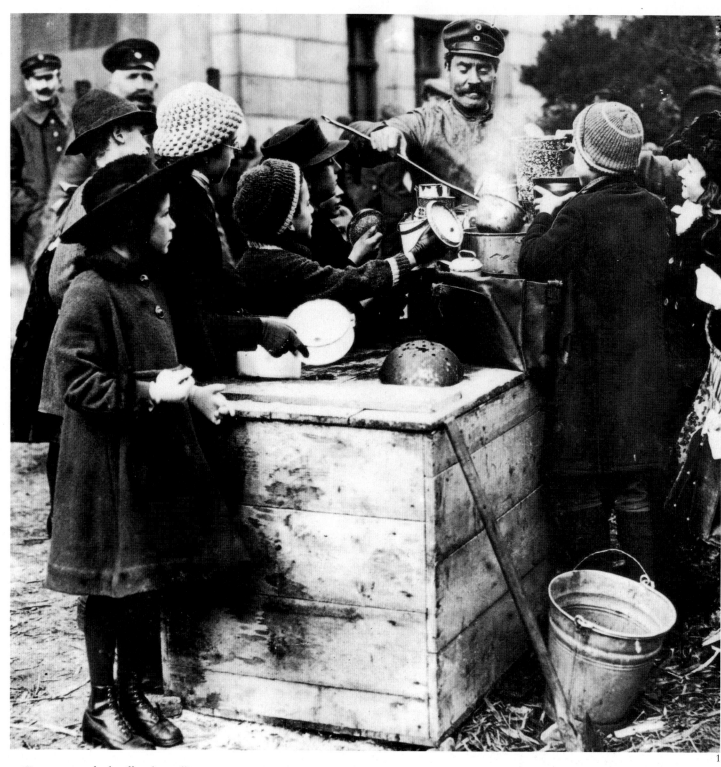

1

GERMANY had suffered appalling hardship during the war. The Imperial German Navy had made it difficult for Britain, France and Russia to obtain all the supplies they needed, but had been unable to bring any supplies at all to Germany. By 1917 there were queues for food in most German cities (3). Berlin schoolgirls helped clear snow from the streets (2). And even after the war, in December 1918, street kitchens were needed to supply children with a barely adequate diet (1).

DEUTSCHLAND hatte während des Krieges große Not gelitten. Die Kaiserliche Marine hatte es Großbritannien, Frankreich und Rußland zwar schwergemacht, auf dem Seeweg Vorräte und Waffen zu transportieren, sie war aber nicht in der Lage gewesen, Deutschland zu versorgen. In den meisten deutschen Städten standen die Menschen 1917 bei der Verteilung von Lebensmitteln Schlange (2). Und selbst nach dem Krieg, im Dezember 1918, gab es in den Suppenküchen nicht gerade reichhaltige Kost für Kinder (1).

L'ALLEMAGNE avait effroyablement souffert pendant la guerre. La flotte impériale allemande avait rendu difficile l'approvisionnement de la Grande-Bretagne, de la France et de la Russie, sans pour autant réussir à approvisionner l'Allemagne. Dès 1917, on faisait la queue dans la plupart des grandes villes allemandes afin de recevoir des denrées alimentaires (3). À Berlin, des écolières aident à dégager la neige dans les rues (2). Même après la guerre, en décembre 1918, des cuisines durent être installées dans les rues pour distribuer aux enfants des repas tout juste suffisants (1).

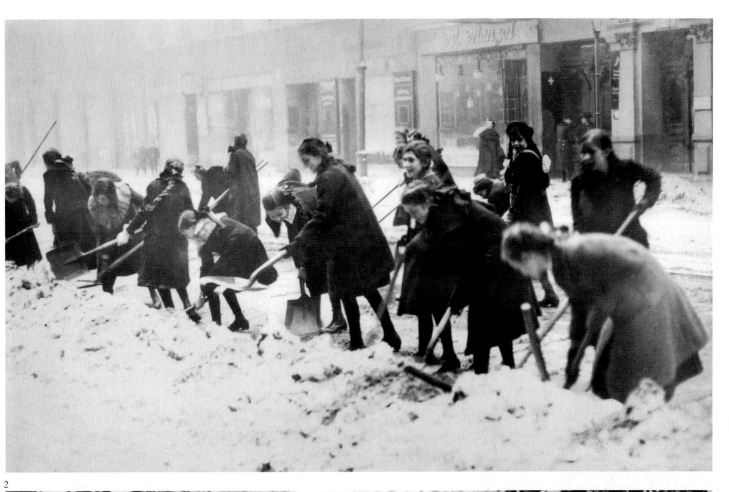

2

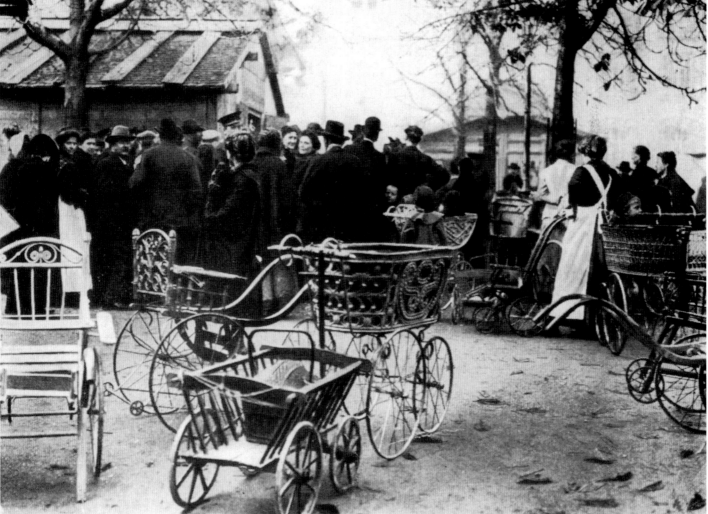

3

Russian Revolution

THOUGH they were perhaps the most autocratic rulers in Europe, life was seldom easy for the Tsars. The role of God as well as Emperor is a difficult one to play. Shot at and bombed, disliked and derided by rich and poor alike, ill-advised and unwise, they pleased practically none of the people most of the time.

Within a year of becoming Tsar in 1855, Alexander II had to face the humiliation of defeat in the Crimea. Although he embarked on a series of progressive reforms, such as freeing Russian serfs, his policies always gave too little, too late. And throughout his reign, the secret police and their activities were hardly secret. In 1881 Alexander was assassinated by a Polish student, who hurled a bomb at him in a St Petersburg street.

He was succeeded by his son, Alexander III. The new Tsar believed in repression. He increased police powers, crushed liberalism where he could, and persecuted the Jews and other minority groups. After the earlier taste of his father's reforms – seen as weaknesses by many – this hardline approach provoked riots throughout Russia. Colonel Wellesley, British Military Attaché in Russia, remarked how 'Curiously enough, the minimum of political liberty and the maximum of social freedom are to be found side by side under this strange Autocratic Government. Although in Russia the press is gagged, obnoxious articles in foreign newspapers are obliterated, and the native dares not even whisper an opinion as to politics, he can have his supper at a restaurant at 1 a.m. if it so pleases him ...'

But late-night suppers did little to relieve ever-increasing political frustration, especially among middle-class Russians. When Alexander III died in 1894, ceremoniously mourned by many, sincerely mourned by few, he was succeeded by Nicholas II, doomed to be the last of the Romanov Tsars.

Within two years there were more serious outbreaks of rioting in St Petersburg. For the next twenty years reform and revolution jostled for position as the next obvious step. The crushing military defeat of Russia in the war with Japan (1904-5) led to the establishment of a short-lived Soviet in St Petersburg and the famous mutiny on the battleship *Potemkin*. In 1906 Nicholas summoned the Duma, the Russian parliament, and two years later granted freedom of religious worship to all Russians – but it was again too little, too late. The suffering and defeat of the Russian troops in the First World War merely hastened the end. Reform was swept aside. Revolution carried the day.

OBWOHL sie die wohl autokratischsten Herrscher in Europa waren, hatten die russischen Zaren nur selten ein leichtes Leben. Die Rolle eines Gottkaisers ist schwer zu erfüllen. Sie wurden beschossen und bombardiert, von Reichen und Armen gleichermaßen abgelehnt und verachtet, sie waren schlecht beraten und unklug – das Volk war fast nie mit ihnen zufrieden.

Ein Jahr nach seiner Proklamation zum Zar im Jahre 1855 sah sich Alexander II. mit der demütigenden Niederlage im Krimkrieg konfrontiert. Obwohl er eine Reihe fortschrittlicher Reformen erließ, beispielsweise die Abschaffung der Leibeigenschaft, waren seine politischen Maßnahmen nicht effizient und kamen zu spät. Während seiner Herrschaft konnte man die Geheimpolizei und ihre Aktivitäten kaum als geheim bezeichnen. Im Jahre 1863 brach in Polen eine Rebellion aus, und 1881 wurde Alexander von einem polnischen Studenten durch eine Bombe in St. Petersburg ermordet.

Ihm folgte sein Sohn, Alexander III. Der neue Zar suchte sein Heil in der Unterdrückung. Er verstärkte die Polizeikräfte, bekämpfte den Liberalismus, wo er konnte, und verfolgte Juden und andere Minderheiten. Nach den Reformen seines Vaters, in denen viele eine Schwäche sahen, provozierte diese harte Linie Unruhen im ganzen russischen Reich. Colonel Wellesley, britischer Militärattaché in Rußland, sagte: »Merkwürdigerweise gibt es unter dieser seltsamen autokratischen Regierung gleichzeitig ein Minimum an politischer und ein Maximum an sozialer Freiheit. Obwohl man in Rußland die Presse knebelt, unangenehme Artikel in ausländischen Zeitungen unkenntlich gemacht werden, und die Einheimischen es nicht einmal wagen, eine politische Meinung auch nur zu flüstern, können sie um ein Uhr nachts im Restaurant speisen, wenn es ihnen gefällt ...«

Aber nächtliche Mahle änderten wenig an der ständig wachsenden politischen Enttäuschung besonders der russischen Mittelklasse. Als Alexander III. 1894 starb, von vielen im Rahmen der offiziellen Feierlichkeiten betrauert, aber nur von wenigen aufrichtig beweint, folgte ihm Nikolaus II., der letzte der Romanow-Zaren.

Innerhalb von zwei Jahren gab es weitere Unruhen in St. Petersburg. In den folgenden zwanzig Jahren schwankte die Politik zwischen Reform und Revolution. Die vernichtende russische Niederlage im Krieg gegen Japan (1904-1905) führte zur Einrichtung eines kurzlebigen Sowjet in St. Petersburg und zur berühm-

AUTOCRACY, ORTHODOXY AND NATIONALITY:
ALEXANDER III AND HIS FAMILY IN THE TWILIGHT
SPLENDOUR OF THE ROMANOV DYNASTY, 1881.

AUTOKRATIE, ORTHODOXIE UND NATIONALITÄT:
ALEXANDER III. UND SEINE FAMILIE IM UNTERGEHENDEN
GLANZ DER ROMANOW-DYNASTIE, 1881.

AUTOCRATIE, ORTHODOXIE ET NATIONALITÉ :
ALEXANDRE III ET SA FAMILLE DANS TOUTE LA SPLENDEUR
DÉCADENTE DE LA DYNASTIE DES ROMANOV, 1881.

ten Meuterei auf dem Panzerkreuzer *Potemkin*. 1906
berief Nikolaus das russische Parlament, die Duma, ein,
und zwei Jahre später gewährte er allen Russen Reli-
gionsfreiheit, aber auch dies kam zu spät. Das Leid und
die Niederlage der russischen Truppen im Ersten Welt-
krieg beschleunigten das Ende nur. Reformen kamen
nicht mehr in Frage, die Revolution flammte auf.

BIEN qu'ils fussent peut-être les dirigeants les plus
autocratiques d'Europe, les tsars russes avaient rare-
ment la tâche facile. Il est difficile d'être à la fois dieu et
empereur. On leur tirait dessus, on leur lançait des
grenades, riches et pauvres les détestaient et les rail-
laient. Ils étaient mal conseillés et dépourvus de sagesse :
ils ne plaisaient pratiquement à personne la majeure
partie du temps.

Dans l'année qui suivit son accession au trône, en
1855, le tsar Alexandre II dut subir une défaite humi-

liante en Crimée. Bien qu'il eût entamé une série de
réformes progressistes comme l'affranchissement des
serfs russes, ses mesures politiques pesèrent toujours trop
peu. Tout au long de son règne l'existence de la police
secrète et de ses activités n'étaient un secret pour
personne. En 1863 une rébellion éclata en Pologne, et
en 1881 Alexandre fut assassiné par un étudiant polonais
qui lui lança une grenade dans une rue de Saint-
Pétersbourg.

Son fils Alexandre III lui succéda. Le nouveau tsar
croyait en la répression. Il augmenta les pouvoirs de la
police, écrasa le libéralisme partout où il le put et
persécuta les juifs ainsi que les autres minorités. Après
les réformes du père, considérées par beaucoup comme
des faiblesses, cette politique dure provoqua des émeutes
dans tout l'empire russe. Le colonel Wellesley, attaché
militaire britannique en poste en Russie, faisait remar-
quer : « On voit se côtoyer curieusement le minimum
de liberté politique et le maximum de liberté sociale
sous cet étrange régime autocratique. Bien qu'en Russie
la presse soit bâillonnée, les articles désapprobateurs
supprimés dans les journaux étrangers et que les gens ici
n'osent même pas chuchoter une opinion d'ordre
politique, vous pouvez souper dans un restaurant à une
heure du matin si le cœur vous en dit... »

Cependant les soupers tardifs ne contribuèrent guère
à atténuer la frustration politique qui allait croissante,
surtout au sein de la classe moyenne russe. Alexandre III
mourut en 1894 ; il fut solennellement pleuré par beau-
coup et sincèrement par peu, et Nicolas II lui succéda :
il devait être le dernier tsar de la lignée des Romanov.

Deux ans plus tard, des émeutes plus graves éclatè-
rent à Saint-Pétersbourg. Puis pendant vingt ans, réformes
et révolutions s'enchaînèrent tour à tour. La défaite
militaire écrasante de la Russie dans la guerre contre le
Japon (1904) aboutit à la mise en place d'un soviet
éphémère à Saint-Pétersbourg et à la célèbre mutinerie
du cuirassé *Potemkine*. En 1906, Nicolas convoqua la
Douma (le parlement russe), puis accorda deux ans plus
tard la liberté de culte à tous les Russes. Là encore ce
fut trop peu et trop tard. Les souffrances et les défaites
subies par les troupes russes au cours de la Première
Guerre mondiale ne firent que précipiter la fin. Les
réformes furent balayées. La révolution triompha.

ICHOLAS II was born in 1868 (1) and became Tsar at the age of twenty-six on the death of his unpopular father. His coronation procession was the greatest ever seen in Moscow (2), a combination of ancient pomp and modern stage-management. Heralds rode through the streets proclaiming the great day – 26 June (3). Church and military played leading parts in the ceremonies, as did many military bands, such as the Russian Juvenile Band (4).

NIKOLAUS II. wurde im Jahre 1868 geboren (1). Nach dem Tod seines unbeliebten Vaters wurde er im Alter von sechsundzwanzig Jahren neuer Zar. Seine Krönungsprozession war die größte, die man je in Moskau gesehen hatte (2), eine Kombination aus altehrwürdigem Pomp und moderner Bühneninszenierung. Boten ritten durch die Straßen und verkündeten den großen Tag, den 26. Juni (3). Kirche und Militär spielten eine führende Rolle in der Zeremonie, ebenso wie viele Militär-kapellen, darunter die Russische Jugend-kapelle (4).

NICOLAS II, né en 1868 (1), devint tsar à 26 ans à la mort de son père, qui fut impopulaire. La cérémonie de son couronnement fut d'une magnificence jamais vue à Moscou (2) ; elle combinait pompe ancienne et art moderne de la mise en scène. Le 26 juin (3), des hérauts à cheval proclamèrent le grand jour dans les rues. L'Église et les militaires jouèrent les rôles principaux au cours des cérémonies, de même que les nombreux orchestres militaires tels que celui des jeunesses russes (4).

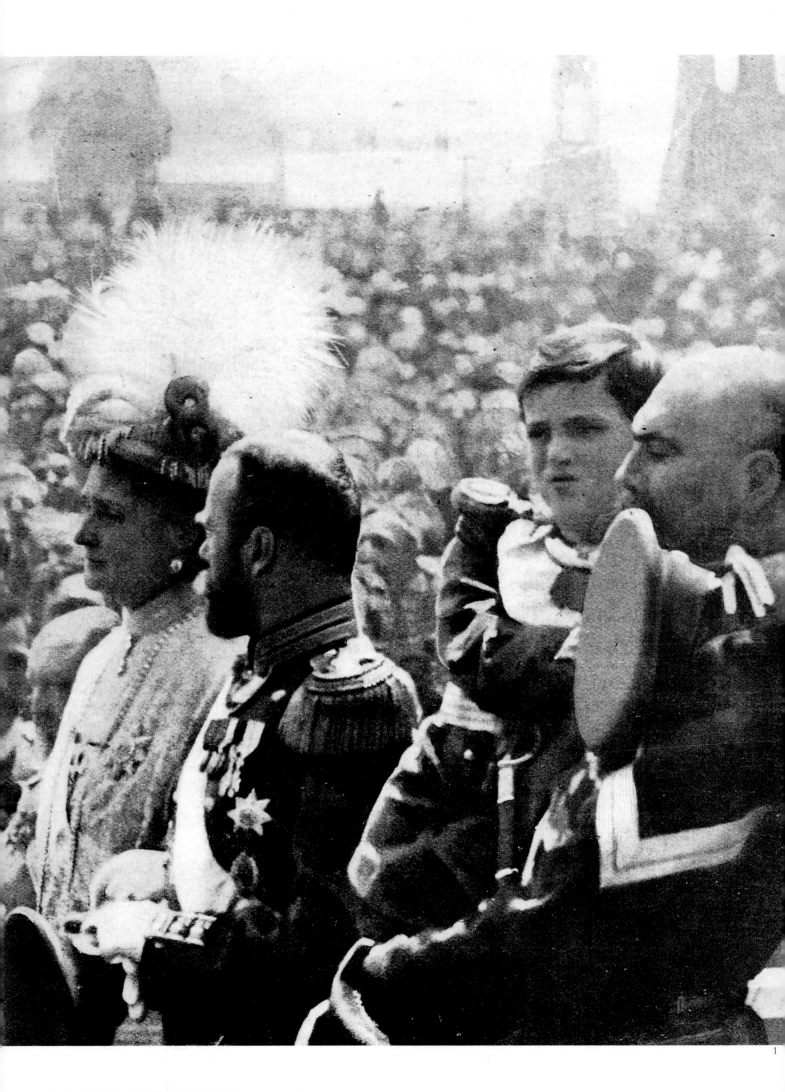

IN 1896, Nicholas and his wife Alexandra – another of Queen Victoria's grand-daughters – visited the Queen (2) and Edward, Prince of Wales (right), at Balmoral, taking with them their bonnie baby, the Grand Duchess Tatiana. In 1913, Nicholas, Alexandra and the Tsarevich Alexis (1 – held by a Cossack) celebrated the centenary of the Romanov dynasty at the Kremlin. And in 1916, the Russian Imperial family posed at Tsarskoe Selo (3, left to right, back row – the Princes Nikita, Rostislav, and Dmitri; middle row – an officer, The Tsar, the Grand Duchesses Tatiana, Olga, Marie, Anastasia, and the Tsarevich: front – Prince Vasili).

IM Jahre 1896 besuchten Nikolaus und seine Frau Alexandra, eine weitere Enkelin von Königin Victoria, zusammen mit ihrem wohlgenährten Baby, der Groß-herzogin Tatjana, die englische Königin (2) und Edward, Prince of Wales (rechts) auf Schloß Balmoral. 1913 feierten Nikolaus, Alexandra und der Zarewitsch Alexis (1, auf dem Arm eines Kosaken) im Kreml das hundertjährige Bestehen der Dynastie der Romanows. Und im Jahre 1916 posier-te die russische Zarenfamilie bei Zarskoje Selo (3, von links nach rechts in der hinte-ren Reihe: die Prinzen Nikita, Rostislaw und Dimitrij; mittlere Reihe: ein Offizier, der Zar, die Großherzoginnen Tatjana, Olga, Marie, Anastasia und der Zarewitsch; vorne: Prinz Wassilij).

EN 1896, Nicolas et son épouse Alexan-dra, une des arrière-petites-filles de la reine Victoria (2), se rendirent à Balmoral accompagnés d'Édouard, prince de Galles, (à droite), ainsi que d'un poupon à la mine plaisante, la grande-duchesse Tatiana. En 1913, Nicolas, Alexandra et le tsarévitch (1, porté par un cosaque) célébraient le centenaire de la dynastie des Romanov au Kremlin. En 1916, la famille impériale russe posait à Tsarskoïe Selo (3, de gauche à droite au dernier rang les princes Nikita, Rostislav et Dmitri ; au milieu, les grandes-duchesses Tatiana, Olga, Marie, Anastasia et le tsarévitch ; devant, le prince Vassili).

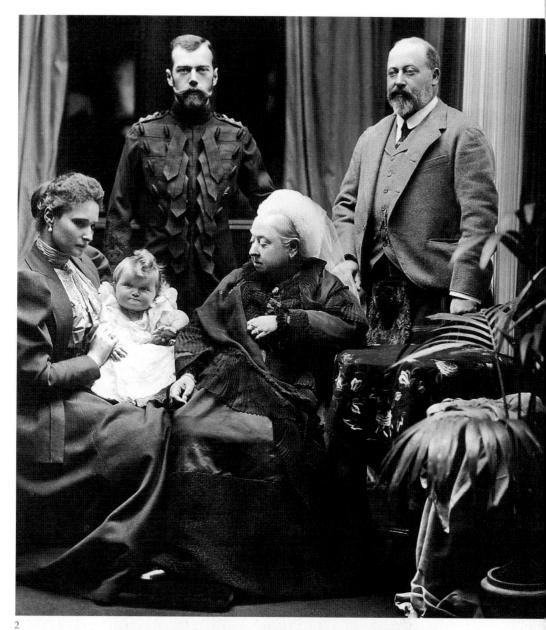

2

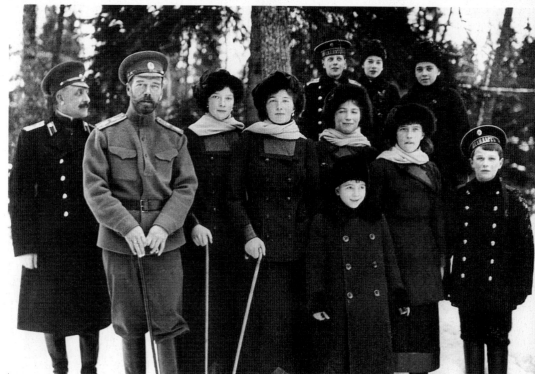

3

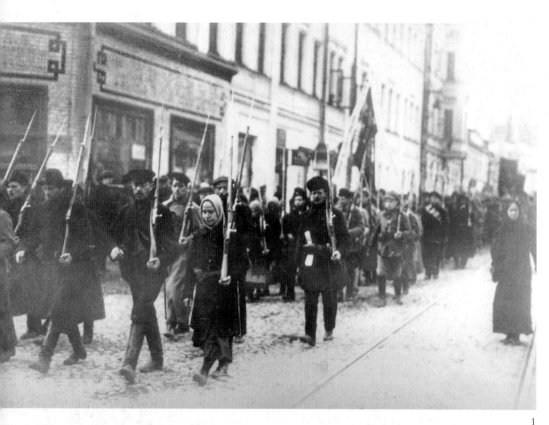

1

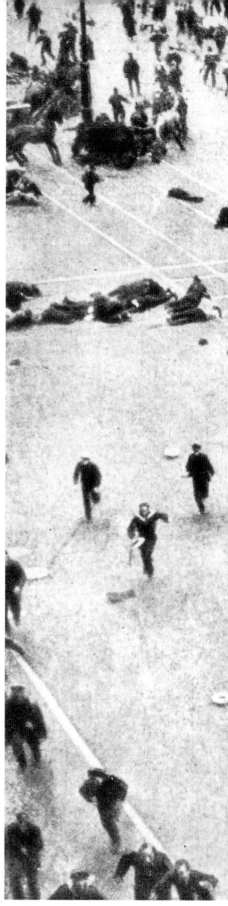

I N March 1917, the English writer Arthur Ransome cabled from Moscow: 'This is not an organized revolution. It will be impossible to make a statue of its organizer… unless it be a statue representing a simple Russian peasant soldier…'. Revolutionary troops marched through Petrograd, March 1917 (1). Four months later, Leninists

besieged the Duma, and the provisional government responded with force, producing panic (3). Not all demonstrations were in favour of revolution, however. A patriotic demonstration of blind ex-soldiers marched through Petrograd behind a banner proclaiming: 'Continue the war until victory is complete! Long live liberty!' (2).

2

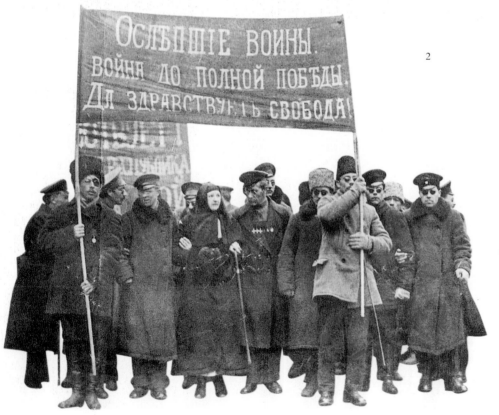

I M März 1917 telegraphierte der englische Schriftsteller Arthur Ransome aus Moskau: »Dies ist keine organisierte Revolution. Es wird nicht möglich sein, eine Statue ihres Anführers anzufertigen … es sei denn, sie stellt einen einfachen russischen Soldaten dar …« Revolutionstruppen marschierten im März 1917 durch Petrograd (1). Vier Monate später besetzten Leninisten

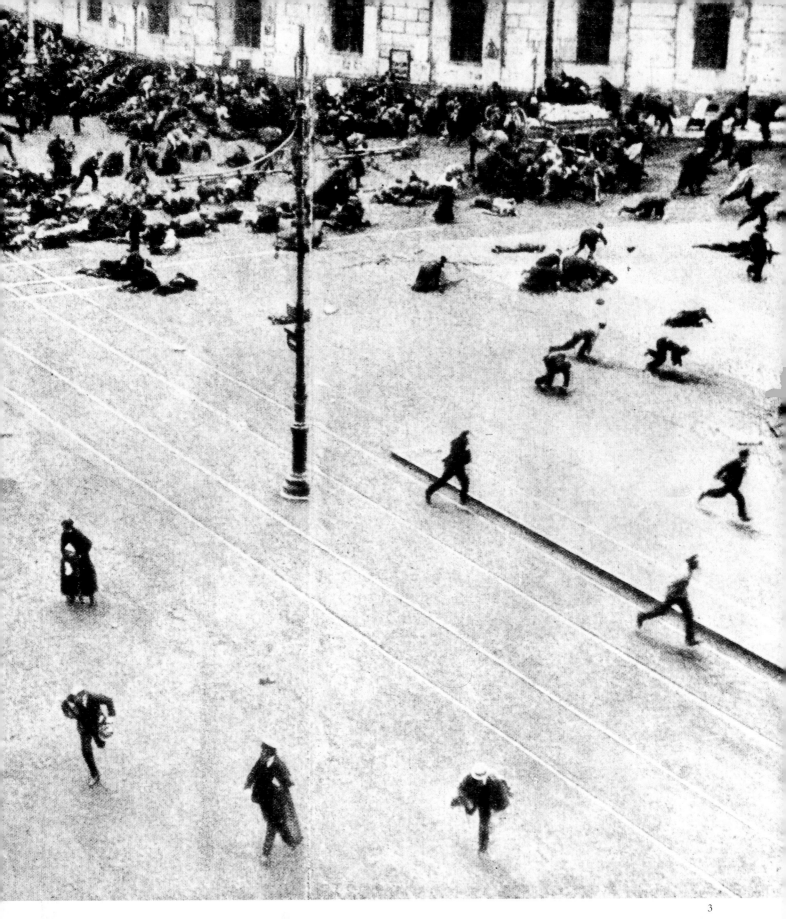

die Duma, die provisorische Regierung antwortete mit Gewalt und löste eine Panik aus (3). Aber nicht alle gingen für die Revolution auf die Straße. Patriotische blinde Veteranen marschierten hinter einem Banner durch Petrograd, auf dem zu lesen war: »Kämpft weiter bis zum Sieg! Lang lebe die Freiheit!« (2)

EN mars 1917, l'écrivain anglais Arthur Ransome câblait de Moscou : « Il ne s'agit pas d'une révolution organisée. Il sera impossible d'ériger à son organisateur une statue ... sauf à représenter un simple Russe à la fois soldat et paysan ... » Les troupes révolutionnaires défilent dans les rues de Petrograd en mars 1917 (1). Quatre mois plus tard les partisans de Lénine assiégèrent la Douma. Le gouvernement provisoire employa alors la force, provoquant ainsi la panique (3). Toutes les manifestations n'étaient pas en faveur de la révolution. Des anciens combattants aveugles défilent dans Petrograd en proclamant : « Poursuivez la guerre jusqu'à la victoire complète ! Vive la liberté ! » (2).

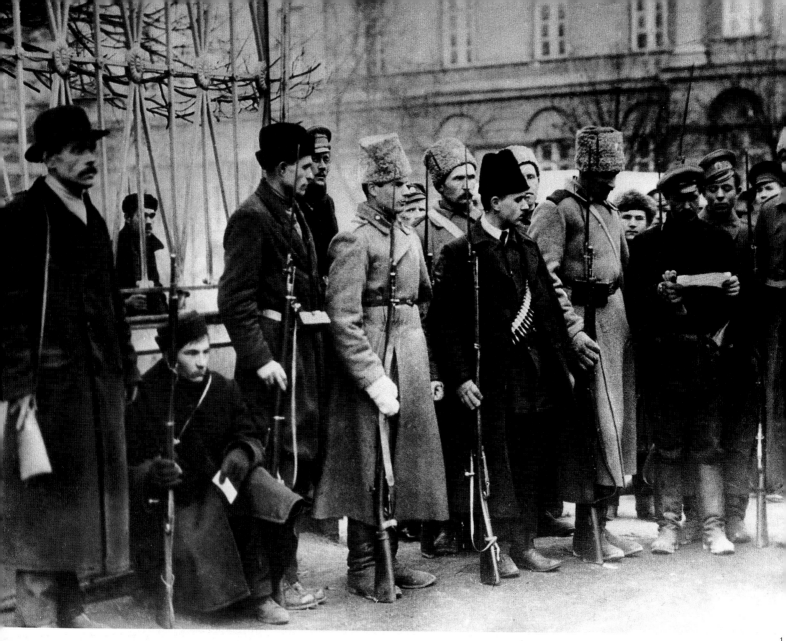

By the autumn of 1917, the Bolsheviks (4) were increasingly in charge of Moscow and other major Russian cities. In Petrograd troops checked the mandates of Soviet deputies (1). Red Guards protected Lenin and Trotsky's offices, October 1917 (2). The architects of the Bolshevik Revolution were Vladimir Ilyich Lenin and Leon Trotsky (3). The Tsar and his family posed for one of their last group photographs while in captivity at Tobol'sk, during the winter of 1917-18 (5 – left to right: Olga, Anastasia, Nicholas, the Tsarevich, Tatiana and Marie).

Im Herbst 1917 hatten die Bolschewiken (4) Moskau und andere große russische Städte immer fester im Griff. In Petrograd überprüften Truppen die Mandate von Abgeordneten des Sowjets (1). Rotarmisten bewachten im Oktober 1917 die Büros von Lenin und Trotzki (2). Die Architekten der bolschewistischen Revolution waren Wladimir Iljitsch Lenin und Leo Trotzki (3). Der Zar und seine Familie posierten für eines der letzten Gruppenphotos, während sie sich im Winter 1917/18 in Tobolsk in Gefangenschaft befanden (5, von links nach rechts: Olga, Anastasia, Nikolaus, der Zarewitsch, Tatjana und Marie).

Des l'automne 1917, les bolcheviks (4) étaient en passe de contrôler Moscou et les autres principales grandes villes russes. À Petrograd, les troupes vérifiaient les mandats des députés soviétiques (1). Les gardes rouges protégeaient les bureaux de Lénine et de Trotski en octobre 1917 (2). Les architectes de la révolution bolchevique étaient Vladimir Ilitch Lénine et Lev Davidovich Bronstein dit Trotski (3). Le tsar et sa famille posant pour l'une de leurs dernières photographies de groupe durant leur captivité à Tobolsk pendant l'hiver 1917 (5, de gauche à droite : Olga, Anastasia, Nicolas, le tsarévitch, Tatiana et Marie).

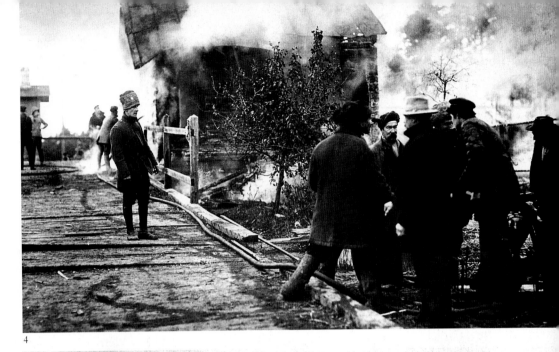

4

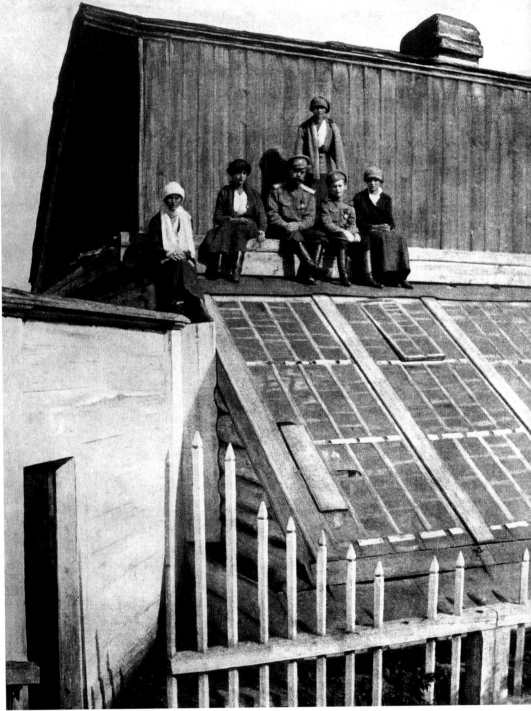

5

Construction

NEVER had the earth been so built upon: houses, hotels, engine-rooms, pumping stations, hospitals, churches, museums, skyscraper office blocks, towers, exhibition halls, factories and workshops, blast furnaces and boiler-houses. Old cities were rebuilt, reshaped, resettled. The cluttered medieval streets, so vividly described in Victor Hugo's *Notre Dame de Paris*, were hacked down and cleared away, and grand avenues, boulevards and Allees were erected in their place. The commercial hearts of London, Paris, Rome, Berlin, Madrid, Vienna, New York, Chicago and many more cities were ringed with new suburbs – orderly, respectable, convenient, scorned by the glitterati of the day.

But the achievements of the great engineers were hailed as modern monuments that rivalled the Wonders of the Ancient World. There was Joseph Paxton's Crystal Palace, home of the Great Exhibition of 1851; Alexandre Gustave Eiffel's extraordinary Tower, for the Paris Exhibition of 1889; the ever-enlarging Krupp works at Essen, and the gloomy two-hundred-room Villa Hügel built for Krupp himself a few miles away; Frédéric Auguste Bartholdi's Statue of Liberty, built in Paris for the people of the United States; the Singer works at Glasgow in Scotland; the Forth, Brooklyn, Niagara and hundreds more bridges. In the last age before mass circulation newspapers and moving pictures, engineers were second only to soldiers as public heroes: Brunel, de Lesseps, Roebling, Vickers, Eiffel (1, in top hat), Rathenau.

Capitalism was enjoying its finest and most lucrative hour. There was always money at hand to back these giant enterprises, and labour was cheap, plentiful and often desperate. The designs may have been the work of individual genius, but the hard work of construction was done by sweating thousands in scruffy trousers, worn waistcoats, shirtsleeves, bowler hats and metal-tipped boots – hammering, digging, quarrying, welding, riveting, fetching and carrying, mixing and shovelling. Many died as tunnels collapsed, scaffolding tumbled, mines exploded. Nobody played for safety, least of all for that of their employees.

Whole new cities appeared, made by the discovery of gold, by the coming of the railway, by military necessity or convenience, by the sheer single-mindedness of a founding figure. In many cases we may have forgotten those responsible for the masterpieces of the late 19th century, but their achievements remain.

NIEMALS wurde auf der Erde soviel gebaut: Häuser, Hotels, Maschinenhallen, Pumpstationen, Krankenhäuser, Kirchen, Museen, Bürohochhäuser, Türme, Ausstellungshallen, Fabriken und Werkshallen, Hochöfen und Kesselhäuser. Alte Städte bekamen so ein neues Gesicht und wurden neu besiedelt. Die überfüllten mittelalterlichen Straßen, die Victor Hugo in *Notre Dame de Paris* so lebhaft beschrieben hat, wurden aufgerissen und machten Platz für große Avenuen, Boulevards und Alleen. Die Stadtzentren von London, Paris, Rom, Berlin, Madrid, Wien, New York, Chicago und vielen anderen Metropolen bekamen neue Vororte – ordentlich, überschaubar, zweckmäßig und von der damaligen Hautevolee verachtet.

Die Errungenschaften der bedeutenden Ingenieure wurden als moderne Bauwerke gepriesen, die die Wunder der alten Welt in den Schatten stellten. Da war Joseph Paxtons Kristallpalast für die Londoner Weltausstellung 1851; Alexandre Gustave Eiffels außergewöhnlicher Turm für die Pariser Weltausstellung 1889; die ständig wachsenden Krupp-Werke in Essen und die prächtige Villa Hügel mit ihren 200 Zimmern, die einige Kilometer entfernt für Krupp selbst gebaut wurde; Frédéric Auguste Bartholdis Freiheitsstatue, für das Volk der Vereinigten Staaten in Paris geschaffen; die Singer-Werke im schottischen Glasgow; die Forth-, die Brooklyn-, die Niagara- und Hunderte anderer Brücken. Im letzten Zeitalter ohne Massenblätter und bewegte Bilder waren Ingenieure fast ebenso große Helden wie die Soldaten: Brunel, de Lesseps, Roebling, Vickers, Eiffel (1, unten) und Rathenau.

Der Kapitalismus erlebte seine beste und lukrativste Zeit. Also war stets Geld vorhanden, um diese gigantischen Unternehmungen zu finanzieren, und Arbeitskräfte waren billig, reichlich vorhanden, und oft genug waren das Verzweifelte. Die Entwürfe mögen das Werk einzelner Genies gewesen sein, aber die harte Arbeit auf den Baustellen wurde von Tausenden schwitzenden Männern in abgerissenen Hosen, zerschlissenen Westen, Hemdsärmeln, Melonen und Stiefeln mit Stahlspitzen geleistet: Hämmern, Graben, Schweißen, Vernieten, Auf- und Abladen, Mischen und Schaufeln. Viele starben, wenn Tunnel einstürzten, Gerüste zusammenbrachen oder Minen explodierten. Niemand kümmerte sich um Sicherheit, am wenigsten um die der Arbeiter.

Es entstanden neue Städte durch die Entdeckung von Gold, die Verlegung von Eisenbahnschienen, durch

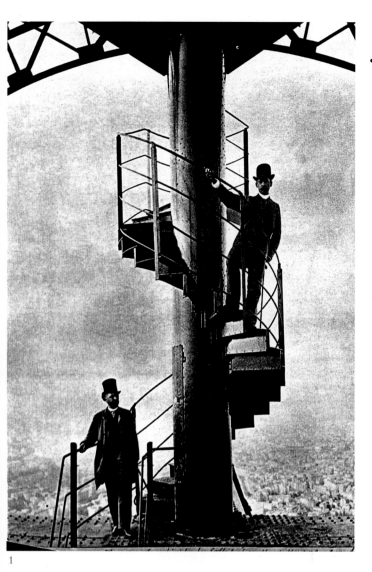

1

militärische Notwendigkeit oder Willkür und durch die Zielstrebigkeit von Gründerpersönlichkeiten. In vielen Fällen haben wir heute vermutlich vergessen, wer für die Meisterwerke des späten 19. Jahrhunderts verantwortlich war, aber die Errungenschaften dieser Menschen bleiben.

JAMAIS il n'y avait eu autant d'édifices sur la terre : maisons, hôtels, salles des machines, stations de pompage, hôpitaux, églises, musées, gratte-ciel de bureaux, tours, salles d'exposition, usines et ateliers, hauts fourneaux et salles des chaudières. Les vieilles cités étaient reconstruites, remodelées et repeuplées. Les rues médiévales pleines de bruits confus dont Victor Hugo avait donné une description si vivante dans *Notre-Dame de Paris* étaient démolies et rasées pour faire place aux grandes avenues, aux boulevards et aux allées. Les cœurs commerciaux de Londres, Paris, Rome, Berlin, Madrid, Vienne, New York, Chicago et d'un millier d'autres grandes villes se retrouvaient encerclés par des banlieues neuves – ordonnées, respectables, commodes et méprisées par les *célébrités* du jour.

Cependant les exploits des grands ingénieurs étaient salués comme autant de monuments modernes rivalisant avec les merveilles du Vieux Monde. Il y avait le Crystal Palace de Joseph Paxton qui abrita la grande exposition de 1851 ; l'extraordinaire tour de Gustave Eiffel construite pour l'exposition de Paris en 1889 ; les usines Krupp à Essen qui ne cessaient de se développer, et la sinistre villa Hügel de deux cents pièces que Krupp s'était fait bâtir à quelques kilomètres de là ; la statue de la liberté de Frédéric Auguste Bartholdi construite à Paris pour le peuple américain ; les usines Singer à Glasgow en Écosse ; les ponts Forth, Brooklyn, Niagara et des centaines d'autres.

À cette époque, qui a précédé les journaux de grande circulation et les images animées, les ingénieurs ne le cédaient qu'aux soldats comme figures héroïques dans le cœur du public : Brunel, de Lesseps, Roebling, Vickers, Eiffel (1, en chapeau haut de forme) et Rathenau.

Le capitalisme vivait ses heures les plus belles et les plus lucratives. On trouvait toujours de l'argent pour financer ces entreprises géantes, par ailleurs la main-d'œuvre était bon marché, abondante et souvent résignée. Ces constructions sont peut-être les fruits du génie d'une seule personne, mais elles furent exécutées à la sueur de milliers d'autres travaillant dans des pantalons dégoûtants, des gilets élimés, en bras de chemise, chapeaux ronds et chaussures à bouts en métal qui ont martelé, creusé, extrait, soudé, rivé, transporté, mélangé et pelleté. Beaucoup moururent, car personne ne pensait à se protéger.

Des villes entières furent créées à la faveur de la ruée vers l'or, l'arrivée du chemin de fer, la nécessité ou la commodité militaire ou grâce à la pugnacité de leur fondateur. Les chefs-d'œuvre de la fin du XIXᵉ siècle demeurent, mais dans bien des cas nous avons peut-être oublié à qui nous les devons.

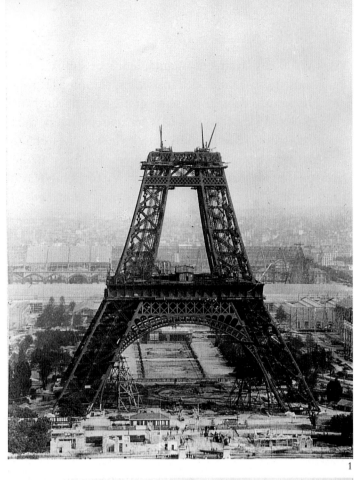

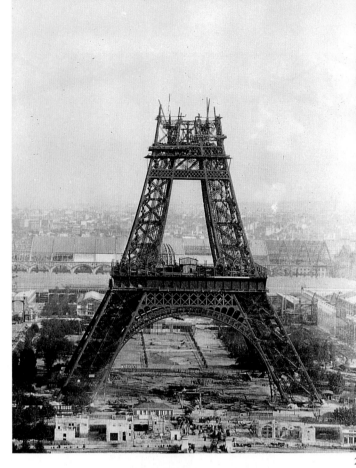

1

2

3

4

IT took almost a year to complete the Eiffel Tower. As it steadily rose above the Paris skyline (1-4), there were those who loved it, those who detested it. The French writer Edouard Drumont, who hated urban life, Dreyfus, the Jews, de Lesseps and almost everything modern, regarded it as a symbol of all that was wrong with France. But once the Tower was finished in 1889, it became the most famous landmark in Paris, outlasting the Globe Céleste, which was dismantled after the Paris Exhibition of 1900 (5).

DIE Fertigstellung des Eiffelturms dauerte fast ein Jahr. Als er sich allmählich immer höher über Paris erhob (1-4), gab es Menschen, die ihn liebten, aber auch solche, die ihn verabscheuten. Der französische Schriftsteller Edouard Drumont haßte das urbane Leben, Dreyfus, die Juden, de Lesseps und fast alles Moderne, denn es war für ihn ein Symbol all dessen, was mit Frankreich nicht stimmte. Aber als der Turm 1889 fertig war, wurde er zum berühmtesten Wahrzeichen von Paris und überragte den Globe Céleste, der nach der Pariser Weltausstellung von 1900 wieder entfernt wurde (5).

IL fallut près d'un an pour terminer la tour Eiffel. Au fur et à mesure qu'elle s'élevait à l'horizon de Paris (1 à 4) – on découvrait ceux qui l'adoraient et ceux qui la détestaient. L'écrivain français Édouard Drumont qui exécrait la vie urbaine, Dreyfus, les juifs, de Lesseps et presque tout ce qui était moderne la considérait comme le symbole de tout ce qui allait de travers en France. Mais une fois que la tour fut achevée en 1889, on l'identifia à Paris, et elle a survécut au Globe Céleste qui fut démonté après l'exposition de Paris en 1900 (5).

1

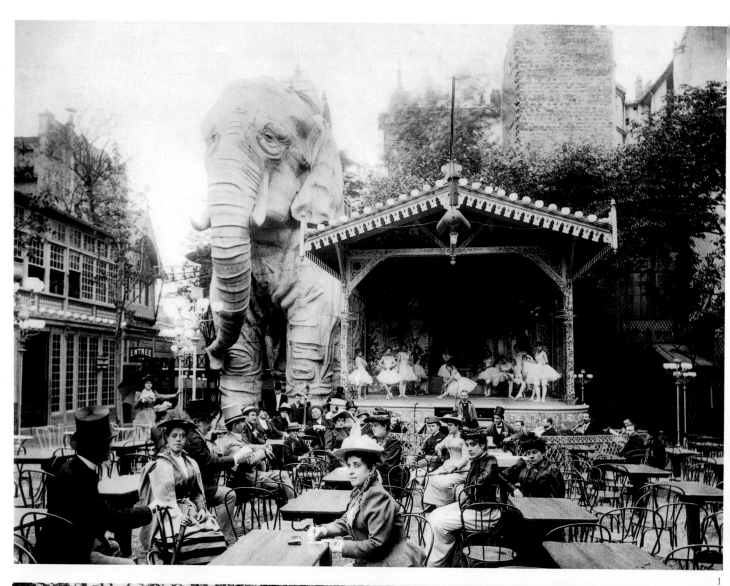

2

3

FOR many, Paris was the one city that symbolized *La Belle Epoque*, with its mixture of excitement and gaiety. The shame of defeat in 1871 and the bitterness left by the aftermath of the Commune were a generation away. The city had been grandly rebuilt. It was a place of passion and beauty, of art and music, of sensual delight and great good humour. In Montmartre, a vast elephant – built for the 1900 Paris Exhibition – dwarfed the famous Moulin Rouge (1), and artists gathered at the Cabaret Artistique du Lapin Agile (2). Visitors to the Exhibition travelled effortlessly in bath-chairs pushed by porters along the boulevards of Baron Haussmann (3).

MIT seiner Mischung aus Aufregung und Fröhlichkeit war Paris für viele die Stadt, die wie keine andere die *Belle Epoque* verkörperte. Die Schande der Niederlage von 1871 und die Verbitterung in der Zeit nach der Kommune lagen eine Generation zurück. Die Stadt war in aller Pracht wiederaufgebaut worden. Sie war ein Ort der Leidenschaft und der Schönheit, der Kunst und der Musik, der Sinnenfreuden und der guten Laune. In Montmartre ließ der riesige Elefant, der für die Pariser Weltausstellung von 1900 gebaut worden war, das Moulin Rouge (1) winzig erscheinen; Künstler trafen sich im Cabaret Artistique du Lapin Agile (2). Besucher der Ausstellung wurden bequem in Rollstühlen über die Boulevards des Baron Haussmann geschoben (3).

POUR beaucoup Paris symbolisait par excellence *La Belle Époque* et offrait un mélange d'effervescence et de gaieté. La honte de la défaite de 1871 et l'amertume laissée par la Commune appartenaient à la génération précédente. La capitale avait été reconstruite de façon grandiose. C'était un lieu de passions et de beauté, d'art et de musique, de plaisirs sensuels et de formidable bonne humeur. À Montmartre, l'éléphant construit pour l'exposition de Paris en 1900 faisait paraître minuscule le célèbre Moulin-Rouge (1), tandis que les peintres se donnaient rendez-vous au Lapin Agile (2). Les visiteurs de l'exposition se déplaçaient dans des fauteuils roulants que poussaient des porteurs le long des boulevards du baron Haussmann (3).

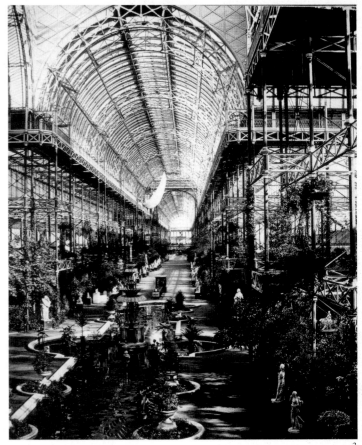

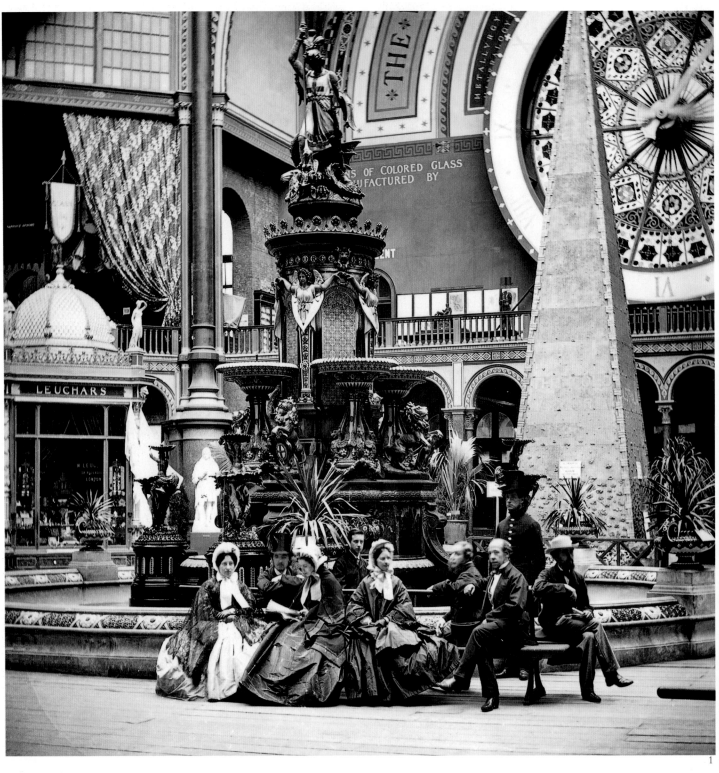

1

(*Previous pages*)

THE Great Exhibition of 1851 was staged in London's Hyde Park. It was held in the vast Crystal Palace (3), an iron and glass construction (2) built to house 'the Works and Industry of all Nations' which was re-erected in South London in 1854 (1). It was a celebration of modern achievement, a chance for every country to show off its accomplishments, in peaceful competition. National emblems were proudly displayed – the finishing touches are put to a plaster head of 'Bavaria' (4).

(*Vorherige Seiten*)

DIE Weltausstellung von 1851 fand im Londoner Hyde Park im riesigen Kristallpalast (3) statt, einer Stahl- und Glaskonstruktion (2), die gebaut worden war, um »die Errungenschaften und Industrien aller Nationen« zu beherbergen und die 1854 im Süden Londons wieder aufgebaut wurde (1). Die Ausstellung feierte die modernen Errungenschaften und bot jedem Land die Möglichkeit, in einem friedlichen Wettbewerb seine Leistungen und Fertigkeiten zu demonstrieren. Nationale Embleme wurden stolz zur Schau gestellt – hier erhält ein Gipskopf der Bavaria den letzten Schliff (4).

(*Pages précédentes*)

LA grande exposition de 1851 avait été installée à Hyde Park à Londres. Elle était logée à l'intérieur du Crystal Palace (3), vaste palais en fer et en verre (2) construit pour abriter les travaux et l'industrie de toutes les nations et qui fut transféré dans le sud de Londres en 1854 (1). Cette exposition célébrait les réalisations des Temps modernes en offrant à chaque pays la possibilité de démontrer ses capacités de façon concrète dans un esprit de compétition pacifique. Les emblèmes nationaux étaient fièrement exposés : les dernières touches sont apportées à un plâtre représentant la tête de la « Bavière » (4).

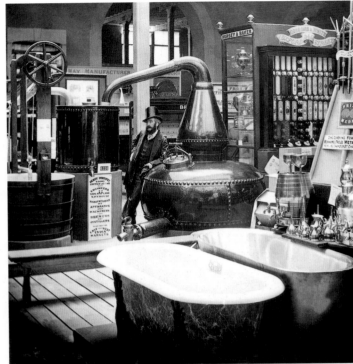

O N the opening day of the Inter-national Exhibition of 1862 in South Kensington, the British historian Thomas Macaulay wrote in his diary: 'I was struck by the number of foreigners in the streets. All, however, were respectable and decent people' (1). Though the aim was peaceful, Armstrong guns were prominent in the Exhibition (2). Less warlike were Henry Pontifex's plumbing artefacts (3), Fenton's ivory-turning machines (4), and a number of titillating statues (5).

A M Tag der Eröffnung der Weltausstel-lung von 1862 in South Kensington schrieb der britische Historiker Thomas Macaulay in sein Tagebuch: »Ich war verblüfft über die vielen Fremden in den Straßen. Aber es waren alles ehrwürdige und anständige Menschen.« (1) Trotz der friedlichen Absichten der Ausstellung sprangen diese Armstrong-Kanonen besonders ins Auge (2). Weniger kriegerisch waren die sanitären Anlagen von Henry Pontifex (3), Fentons Elfenbeinschleifer (4) und eine Reihe aufregender Statuen (5).

L E jour de l'ouverture de l'exposition internationale de 1862 à South Ken-sington, l'historien britannique Thomas Macaulay notait dans son journal : « J'étais frappé par le nombre des étrangers qu'il y avait dans les rues. Tous, par ailleurs, gens respectables et honnêtes » (1) . Bien que le but en fût pacifique, les canons d'Arm-strong étaient bien en vue à l'exposition (2). Moins guerriers étaient les objets de plom-berie fabriqués par Henry Pontifex (3), les tours de Fenton pour le façonnage de l'ivoire (4) et un certain nombre de statues émoustillantes (5).

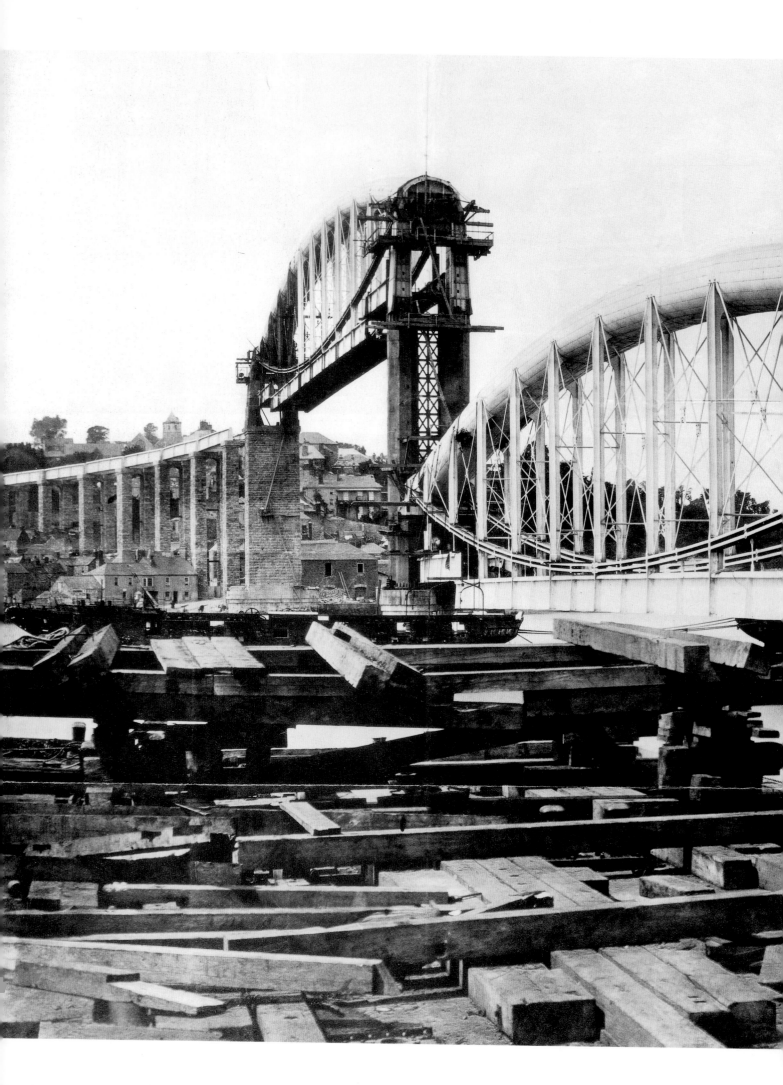

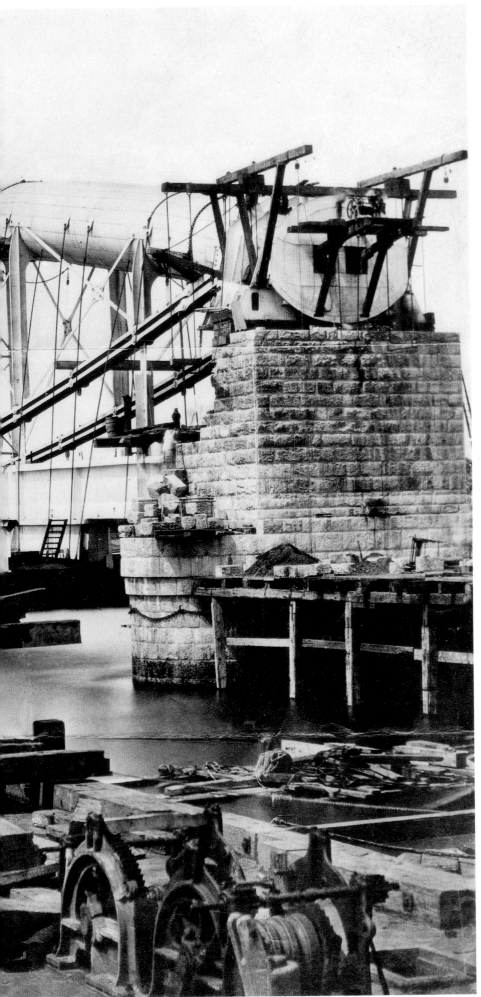

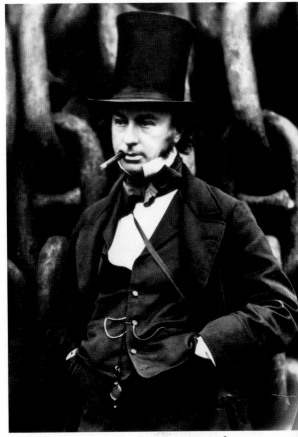

ONE of the finest British engineers of the
19th century was Isambard Kingdom
Brunel (2 – seen here in front of the massive
chains tethering his steamship *Great Eastern*
while under construction). Brunel built
ships, railways and bridges, among them the
Royal Albert Bridge over the River Tamar
at Saltash, south-west England (1).

EINER der bedeutendsten britischen
Ingenieure des 19. Jahrhunderts war
Isambard Kingdom Brunel (2, hier vor den
gigantischen Ketten, die sein Dampfschiff
Great Eastern während des Baus festhielten).
Brunel konstruierte Schiffe, Eisenbahnen
und Brücken, darunter die Royal Albert
Bridge über den Fluß Tamar bei Saltash im
Südwesten Englands (1).

UN des ingénieurs britanniques les plus
brillants du XIXᵉ fut Isambard
Kingdom Brunel (2, ici devant les chaînes
massives retenant son bateau à vapeur, le
Great Eastern, en cours de construction).
Brunel construisit des navires, des chemins
de fer et des ponts, et parmi ces derniers le
Royal Albert Bridge au-dessus de la rivière
Tamar à Saltash dans le sud-ouest de
l'Angleterre (1).

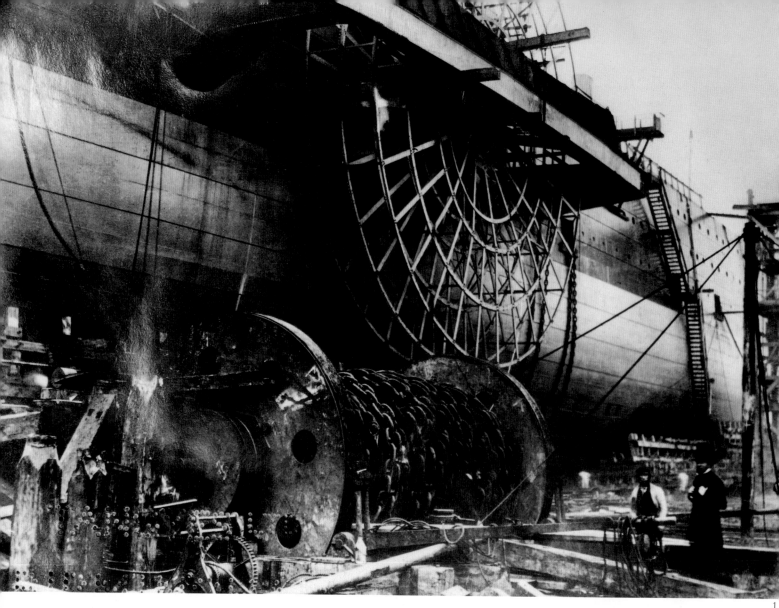

THE *Great Eastern* (1 and 4) was Brunel's masterpiece of engineering – a huge ship weighing 18,915 tons, almost six times the size of any vessel then afloat. She was built with both paddle-wheels (2) and a screw propeller, but had a tragic and haunted history. The first attempted launch was in November 1857 (3, left to right: J. Scott Russell, I. K. Brunel, Henry Wakefield). It was one of the first examples of photo-reporting, though the launch could not be completed. The ship stuck on the slipway for two months. She was eventually launched on 31 January 1858, but on her first trial voyage a boiler burst, killing six men. From then on, there were repeated stories that the ship was cursed. It was said that a riveter working on her had been incarcerated between the plates of her hull, and that ghostly hammerings could be heard.

When she was broken up in 1888, the skeleton of a riveter – with hammer – was found in her bilge.

DIE *Great Eastern* (1, 4) war Brunels technisches Meisterwerk – ein riesiges Schiff mit einem Gewicht von 18 915 Tonnen, fast sechsmal so groß wie die meisten damaligen Schiffe. Es wurde mit Schaufelrädern (2) und einer Schiffsschraube ausgestattet, es hatte aber eine tragische Geschichte. Der erste Versuch des Stapellaufs fand im November 1857 statt (3, von links nach rechts: J. Scott Russell, I. K. Brunel, Henry Wakefield). Eine der ersten Photoreportagen dokumentierte das Ereignis, auch wenn der Stapellauf nicht durchgeführt werden konnte. Das Schiff steckte zwei Monate lang auf den Gleitplanken fest. Schließlich wurde es am 31. Januar 1858 zu Wasser gelassen, aber auf seiner ersten Probefahrt explodierte ein Kessel und tötete sechs Männer. Von nun an kursierten wiederholt Gerüchte, das Schiff sei verflucht. Man erzählte sich, ein Nieter sei bei der Arbeit zwischen den Platten des Schiffsrumpfes eingekerkert worden, und nun sei sein gespenstisches Hämmern zu hören.

Als das Schiff 1888 zerlegt wurde, fand man in seinem Rumpf das Skelett eines Nieters – mit Hammer!

LE *Great Eastern* (1 et 4) fut le chef-d'œuvre de Brunel. Il s'agissait d'un immense navire de 18 915 tonnes, près de six fois la taille de n'importe quel autre vaisseau navigant à l'époque. Il avait été muni à la fois de grandes roues (2) et d'une hélice. Il eut cependant une histoire tragique. La première tentative de lancement eut lieu en novembre 1857 (3) en présence des ingénieurs qui l'avaient construit (de gauche à droite : J. Scott Russell, I. K. Brunel et Henry Wakefield). C'est là un des premiers exemples de reportage photographique, même si le lancement avorta. Le navire ne quitta pas la cale deux mois durant. Son lancement eut finalement lieu le 31 janvier 1858 ; mais au cours de son premier voyage d'essai une chaudière éclata, tuant six hommes. La rumeur qui courut alors prétendait que le navire était maudit. On disait qu'un riveur y travaillant était resté coincé dans le blindage de la coque et qu'on pouvait entendre son fantôme donner des coups de marteau.

Lorsque le *Great Eastern* fut mis en pièces en 1888, on trouva dans la sentine le squelette d'un riveur avec son marteau.

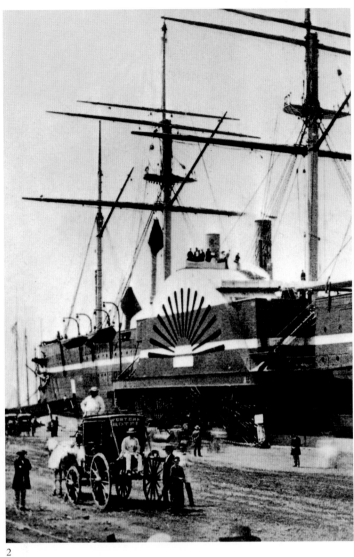

2

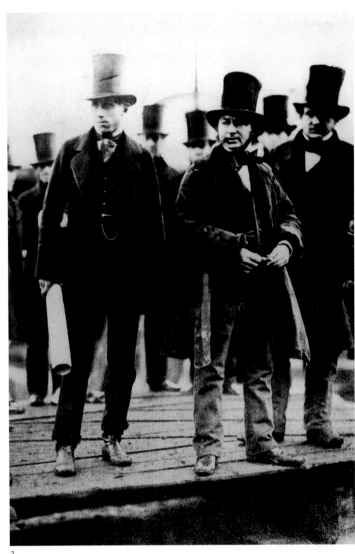

3

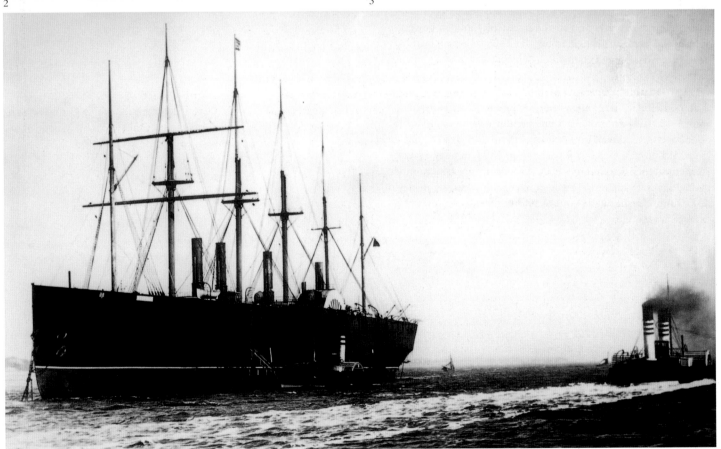

4

No other people know how to unite with the same harmonious force the cult of the past, the religion of tradition, to an unchecked love of progress and a lively and insatiable passion for the future,' wrote a French enthusiast for London's Tower Bridge. It was completed in 1894, with an opening of 250 ft (76 m), the two ramps being operated by steam-driven hydraulic pumps. It was the last bridge to be built over the Thames before the motor car began to exercise its tyranny.

KEIN anderes Volk versteht es, mit einer solch harmonischen Kraft den Kult der Vergangenheit und die Religion der Tradition mit einer ungezügelten Liebe zum Fortschritt und einer lebendigen und unstillbaren Leidenschaft für die Zukunft zu vereinen«, schrieb ein Franzose voller Begeisterung über die Londoner Tower Bridge. Die Brücke wurde 1894 fertiggestellt; ihr Öffnungswinkel maß 76 Meter, und ihre beiden Rampen wurden durch dampfbetriebene hydraulische Pumpen bewegt. Sie war die letzte Brücke, die über die Themse gebaut wurde, bevor das Auto seine Tyrannenherrschaft antrat.

AUCUN autre peuple ne sait unir avec autant de force har-monieuse le culte du passé et la religion de la tradition à un amour sans faille du progrès et une passion vivante et insatiable pour l'avenir », écrivait un Français enthousiasmé par le pont de la Tour de Londres. Celui-ci fut achevé en 1894, sa portée faisait 76 mètres et ses deux rampes étaient actionnées par des pompes hydrauliques à vapeur. Ce fut le dernier pont construit au-dessus de la Tamise avant que la voiture automobile ne commençât à exercer sa tyrannie.

THE TOWER BRIDGE.—APRIL·1892. B·1068

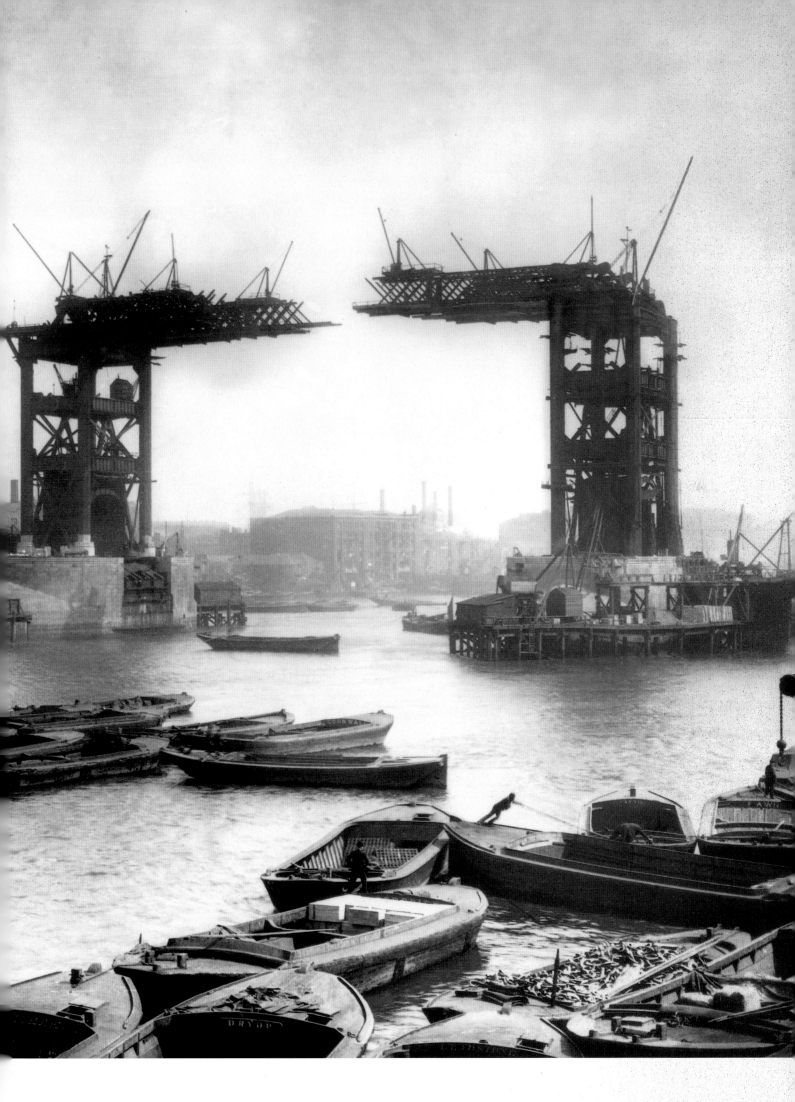

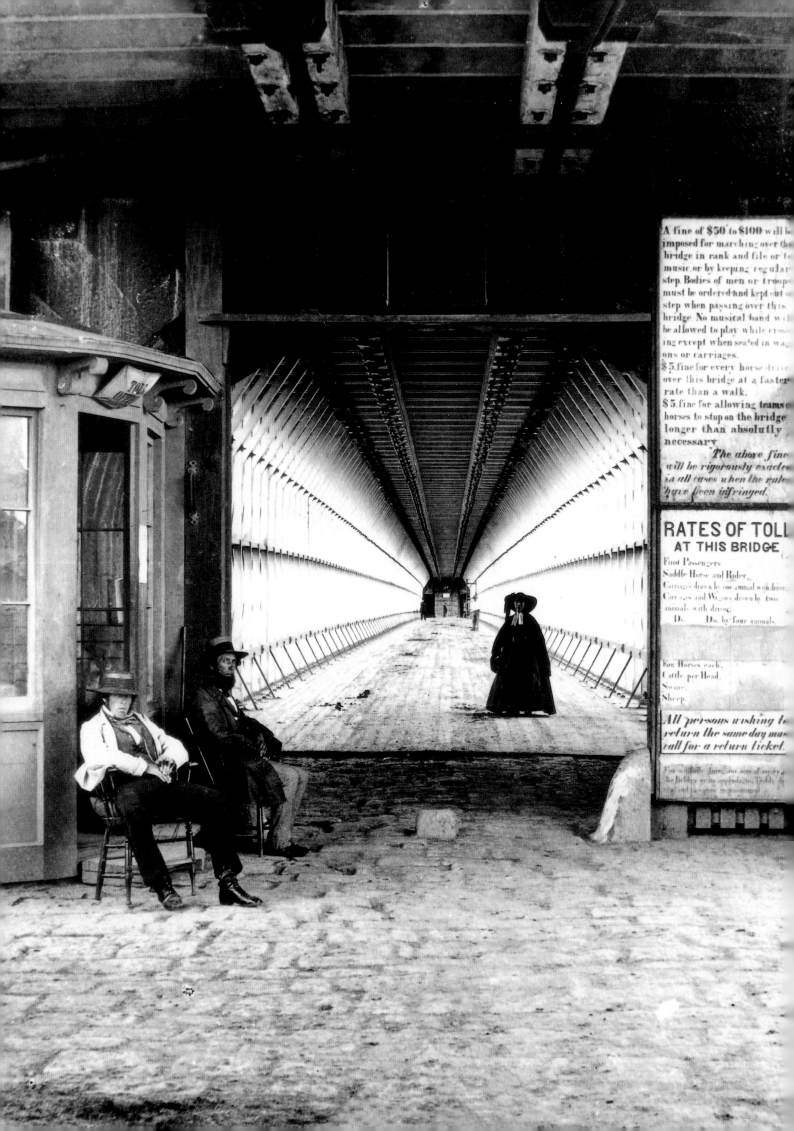

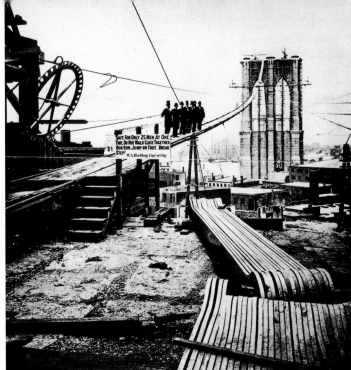

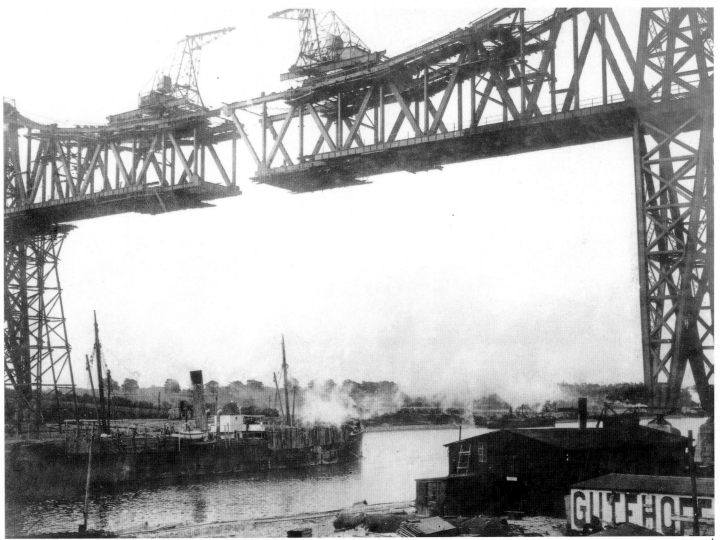

THE suspension bridge over the Niagara River was a two-decker (1, 2). The four main cables of the 1,000 yd-long Brooklyn Bridge (3) were each made up of 5,000 strands of steel wire. The bridge over the Kiel canal at Rendsburg in North Germany (4) was the largest bridge in the world when it was built in 1913.

DIE Hängebrücke über den Niagara war zweistöckig (1, 2). Die vier Hauptkabel der knapp 1 000 Meter langen Brooklyn Bridge (3) bestanden jeweils aus 5 000 Stahldrähten. Die 1913 erbaute Brücke über den Nord-Ostee-Kanal bei Rendsburg in Norddeutschland (4) war seinerzeit die größte der Welt.

LE pont suspendu au-dessus du Niagara comprenait deux niveaux (1-2). Les quatre câbles principaux du pont Brooklyn, long de 910 mètres (3), étaient composés chacun de cinq mille fils d'acier. Le pont au-dessus du canal de Kiel à Rendsbourg, dans le nord de l'Allemagne (4), était le plus grand du monde quand il fut construit en 1913.

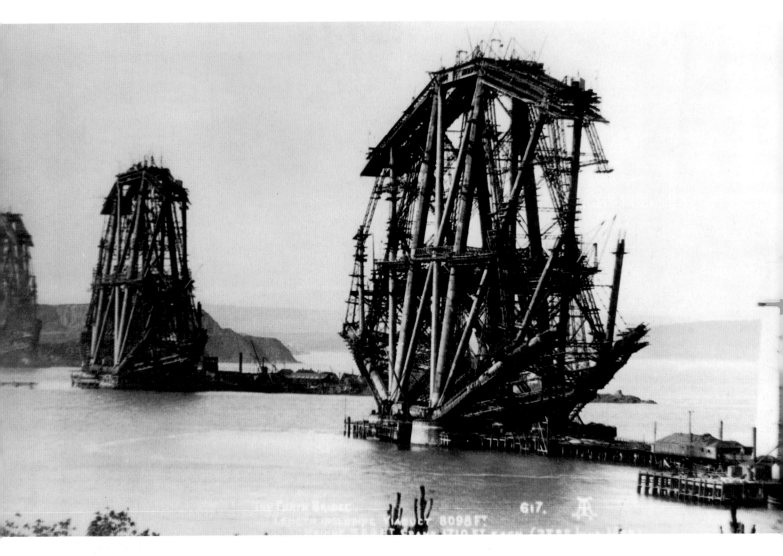

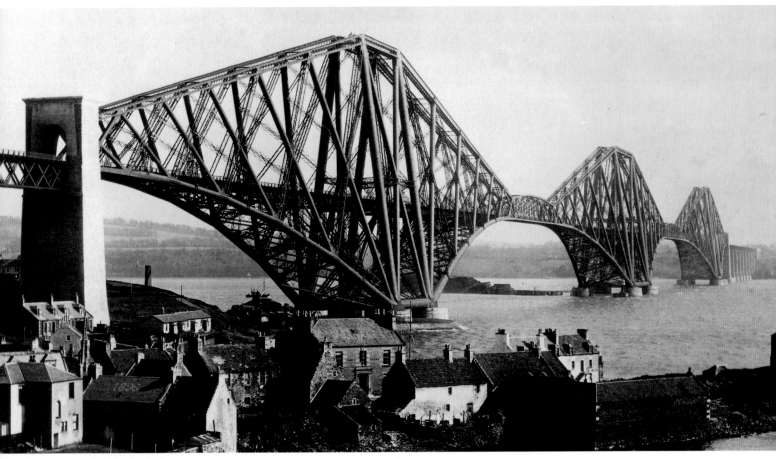

THE Forth Bridge in Scotland was one of the first cantilever bridges to be built, and was the longest bridge in the world. It cost £3 million – an enormous amount of money in the 1880s. William Morris, a British artist, designer and writer, called it 'the supremest specimen of all ugliness'.

DIE Forth Bridge in Schottland war eine der ersten Auslegerbrücken und bei ihrer Fertigstellung die längste Brücke der Welt. Ihr Bau kostete £ 3 Millionen, in den 1880er Jahren eine gewaltige Summe. William Morris, der britische Künstler, Designer und Schriftsteller, bezeichnete diese Eisenbahnbrücke als »unerreichten Inbegriff aller Häßlichkeit«.

LE pont Forth en Écosse fut un des premiers ponts cantilever construits, et c'était le pont le plus long du monde. Il avait coûté trois millions de livres, ce qui en 1880 représentait une somme gigantesque. William Morris, peintre, artiste et écrivain britannique, qualifiait le pont et son chemin de fer de « spécimen parfait du comble de la laideur ».

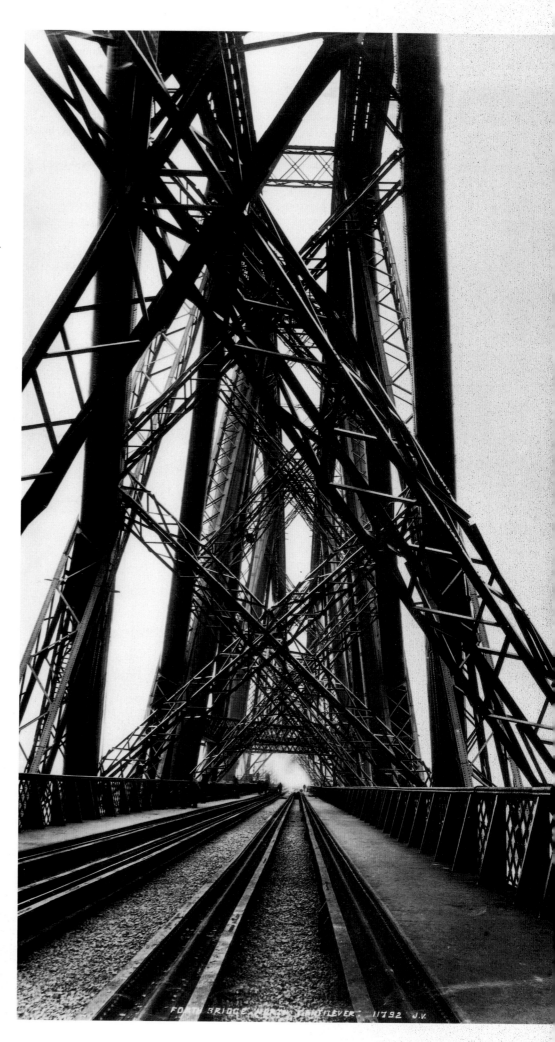

THE Suez Canal was begun in the early 1860s (1). The opening ceremony (2) on 17 November 1867 was attended by the Emperor and Empress of Austria, the Egyptian Khedive and the Crown Prince of Prussia. It did not, however, go according to plan, and was marred by the absence of Verdi and the opera that had been specially commissioned for the occasion, and by the absence of much of Port Said, which had been destroyed by an explosion in a firework warehouse. For Ferdinand de Lesseps (3 – surrounded by grandchildren), the engineer who devised and superintended the work, it was the height of his career. He was an exotic character who, like many Europeans, liked to dress in Arab clothes (4 – seen here with a group of colleagues, second from right).

IN den frühen 1860er Jahren begannen die Arbeiten am Suezkanal (1). An der Einweihungszeremonie (2) am 17. November 1867 nahmen der Kaiser und die Kaiserin von Österreich, der ägyptische Vizekönig und der Kronprinz von Preußen teil. Sie verlief jedoch nicht planmäßig und war getrübt durch die Abwesenheit von Verdi und der eigens für diesen Anlaß in Auftrag gegebenen Oper. Außerdem fehlten weite Teile von Port Said, die durch eine Explosion in einem Sprengkörperlager zerstört worden waren. Für Ferdinand de Lesseps (3, umgeben von seinen Enkeln), den Ingenieur, der den Bau geplant und beaufsichtigt hatte, war es der Höhepunkt seiner Karriere. Er war eine exotische Persönlichkeit und trug wie viele Europäer gerne arabische Kleidung (4, zweiter von rechts).

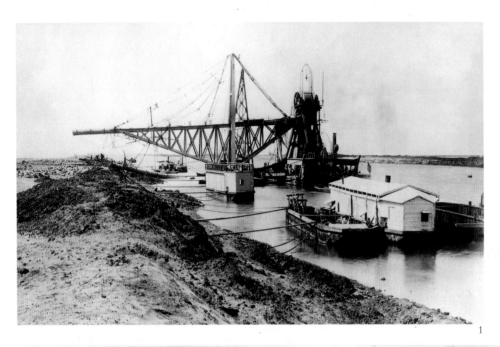

1

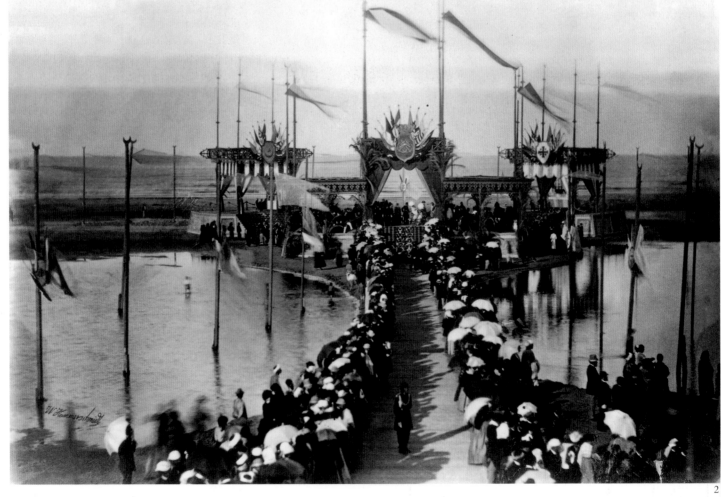

2

3

LES travaux du canal de Suez commen-
çèrent au début des années 1860 (1).
La cérémonie d'ouverture (2) eut lieu le
17 novembre 1867 en présence de l'empe-
reur et de l'impératrice d'Autriche, du
khédive d'Égypte et du prince héritier de
Prusse. Cependant elle ne se déroula pas
comme prévu, assombrie par l'absence de
Verdi et de l'opéra spécialement commandé
à cette occasion, et par la destruction d'une
grande partie de Port-Saïd due à l'explo-
sion d'un entrepôt de pièces d'artifice.
Ferdinand de Lesseps (3, entouré de ses
petits-enfants), l'ingénieur qui avait conçu
et supervisé les travaux, connaissait alors
l'apogée de sa carrière. C'était un person-
nage exotique qui, comme beaucoup
d'Européens, aimaient s'habiller à la manière
des Arabes (4, le deuxième à droite).

4

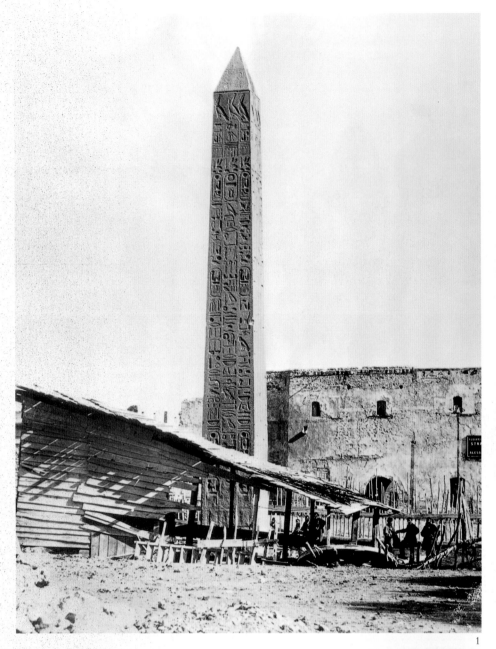

1

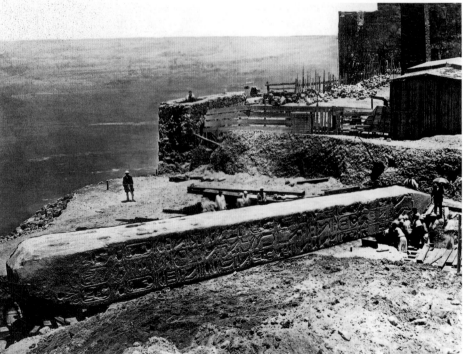

THE Suez Canal focused European attention on Egypt and made things Egyptian fashionable. For nearly two thousand years, the monolith known as Cleopatra's Needle had stood near Alexandria (1). Now, English archaeologists had their greedy eyes on it, and it was removed from site (2), wrapped in a specially built torpedo-shaped shell (3) – which nearly sank in the Bay of Biscay – and towed to London, where it was reerected on the Thames Embankment (4).

2

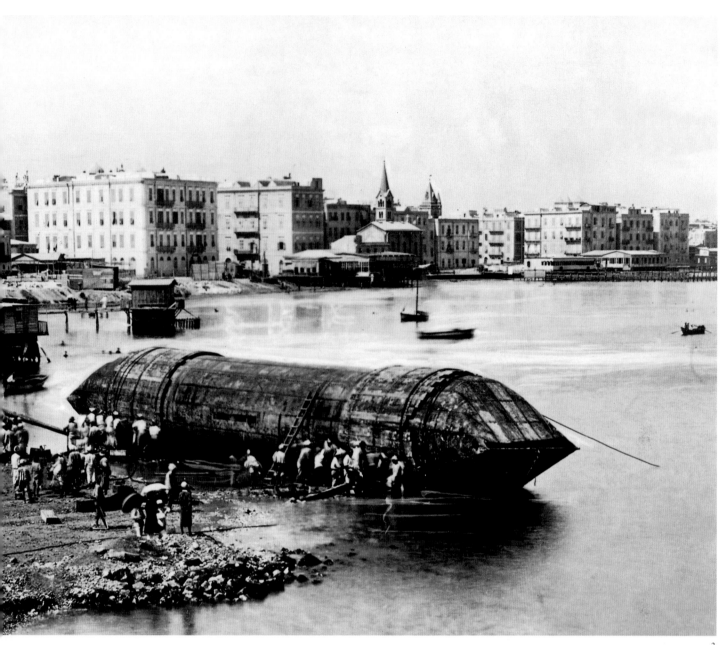

DER Suezkanal lenkte die europäische
Aufmerksamkeit nach Ägypten und
brachte Ägyptisches in Mode. Fast 2 000 Jah-
re hatte der als Kleopatras Nadel bekannte
Monolith in der Nähe von Alexandria
gestanden (1). Jetzt hatten britische Archäo-
logen ein gieriges Auge darauf geworfen.
Er wurde von seinem Standort entfernt (2),
in eine speziell dafür angefertigte, torpedo-
förmige Ummantelung verpackt (3), die in
der Bucht von Biskaya fast gesunken wäre,
und nach London geschleppt, wo man ihn
am Ufer der Themse wiederaufstellte (4).

LE canal de Suez concentra l'attention
des Européens sur l'Égypte et mit
les objets égyptiens à la mode. Depuis près
de deux mille ans le monolithe connu sous
le nom d'aiguille de Cléopâtre se dressait
près d'Alexandrie (1). Et voilà que les
archéologues anglais le contemplaient de
leurs yeux concupiscents ; il fut retiré du
site (2), enveloppé dans une capsule spécia-
lement conçue en forme de torpille (3) –
qui faillit bien sombrer dans le golfe de
Gascogne – et remorqué jusqu'à Londres
pour se dresser de nouveau sur le quai de
la Tamise (4).

4

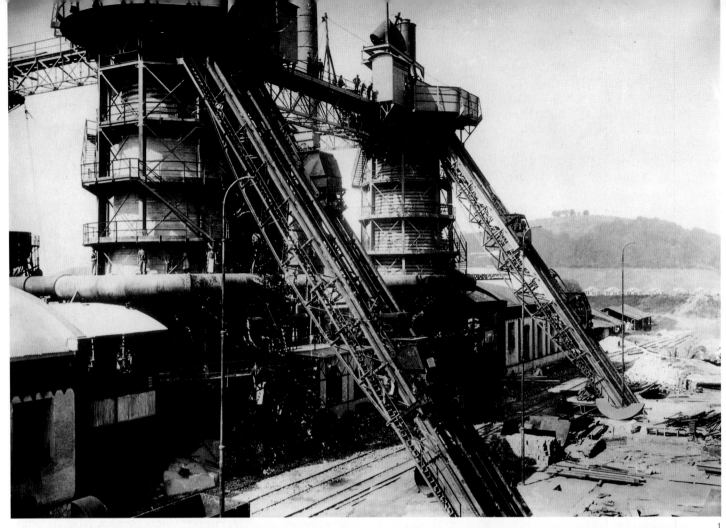

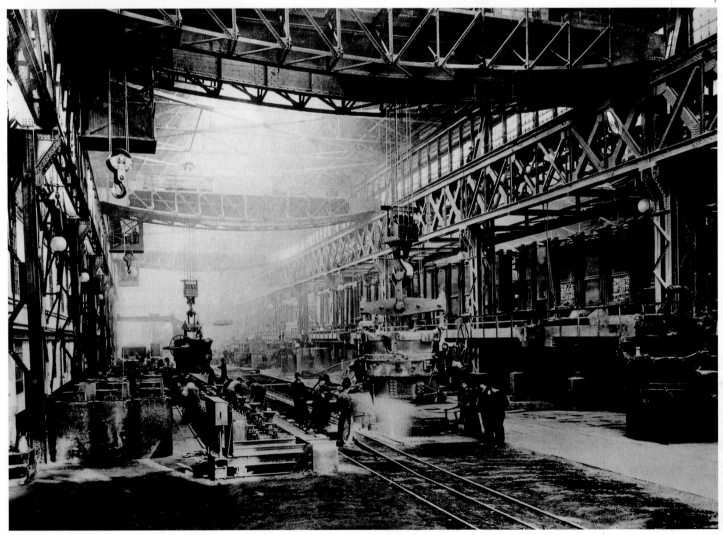

THE Krupp family were the richest in Germany, producing the guns and armaments that made possible implementation of Bismarck's policy of 'blood and iron' in the late 19th century. At the outbreak of the First World War, the Essen works (1 and 2) employed 70,000 workers. In one year alone, Alfred Krupp (3) bought three hundred iron ore mines, to provide the raw material for his colossal foundries. His most famous gun was Big Bertha (4), a monster cannon with a range of 76 miles (122 km) and weighing 200 tons. It fired a shell 12 miles (20 km) high and for twenty weeks in 1918 bombarded Paris.

DIE Krupps waren die reichste Familie Deutschlands. Sie stellten die Waffen für die Umsetzung von Bismarcks Blut-und-Eisen-Politik des ausgehenden 19. Jahrhunderts her. Beim Ausbruch des Ersten Weltkriegs waren in den Essener Werken 70 000 Arbeiter beschäftigt (1, 2). In nur einem Jahr kaufte Alfred Krupp (3) 300 Eisenerzminen, um seine riesigen Gießereien mit Rohstoffen zu versorgen. Seine berühmteste Waffe war die Dicke Bertha (4), eine riesige Kanone mit einer Reichweite von 122 Kilometern und einem Gewicht von 200 Tonnen. Sie feuerte eine Granate 20 Kilometer hoch in die Luft; 1918 bombardierte sie 20 Wochen lang Paris.

3

LA famille Krupp était la plus riche d'Allemagne ; elle produisit les canons et les armements qui permirent à Bismarck de mettre en œuvre sa politique de « sang et de fer » à la fin du XIX^e siècle. Lorsque la Première Guerre mondiale éclata, les usines d'Essen (1 et 2) employaient 70 000 salariés. Alfred Krupp (3) acheta en une seule année trois cents mines de minerai de fer pour fournir la matière première indispensable à ses fonderies colossales. Son canon le plus célèbre fut la Grosse Bertha (4), un canon monstrueux de 200 tonnes qui avait une portée de tir de 122 km. Il tirait des obus qui montaient à 20 km de hauteur. Il pilonna Paris vingt semaines durant en 1918.

M.G.3h.

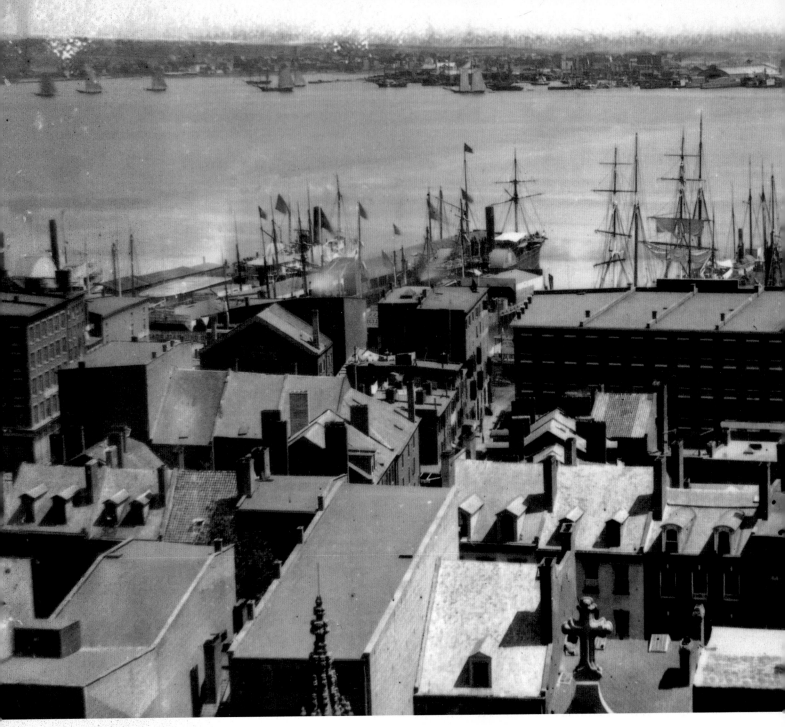

In 1859 William England photographed New York City: the docks (1), the fine brownstone buildings (3), and Wall Street (2), already the financial centre of the city. From the top of the Brandreth Hotel he took pictures of Broadway (overleaf), a street filled with some of the largest shops in the world.

WILLIAM England photographierte New York im Jahre 1859: die Docks (1), die prächtigen Sandsteinhäuser (3) und die Wall Street (2), bereits damals das Finanzzentrum der Stadt. Vom Dach des Brandreth Hotels machte er Aufnahmen vom Broadway (folgende Seiten), einer Straße, in der es einige der größten Geschäfte der Welt gab.

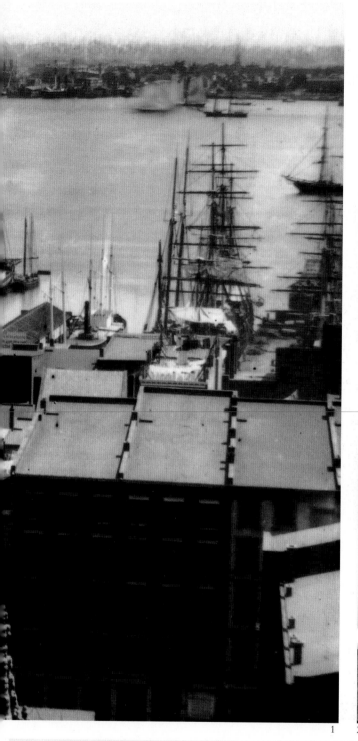

1 2

WILLIAM England photographia New York en 1859 : les quais (1), de beaux bâtiments de grès brun (3), et Wall Street (2), déjà le centre financier de la ville. Il prit du haut de l'hôtel Brandreth des photographies de Broadway (pages suivantes), rue où l'on trouvait quelques-uns des plus vastes grands magasins du monde.

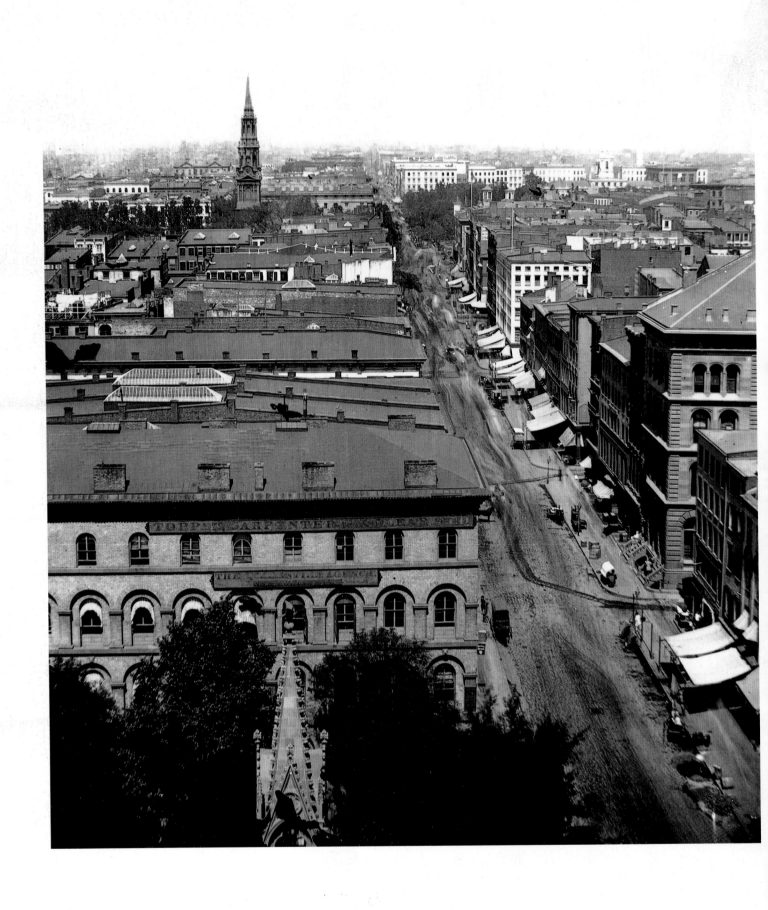

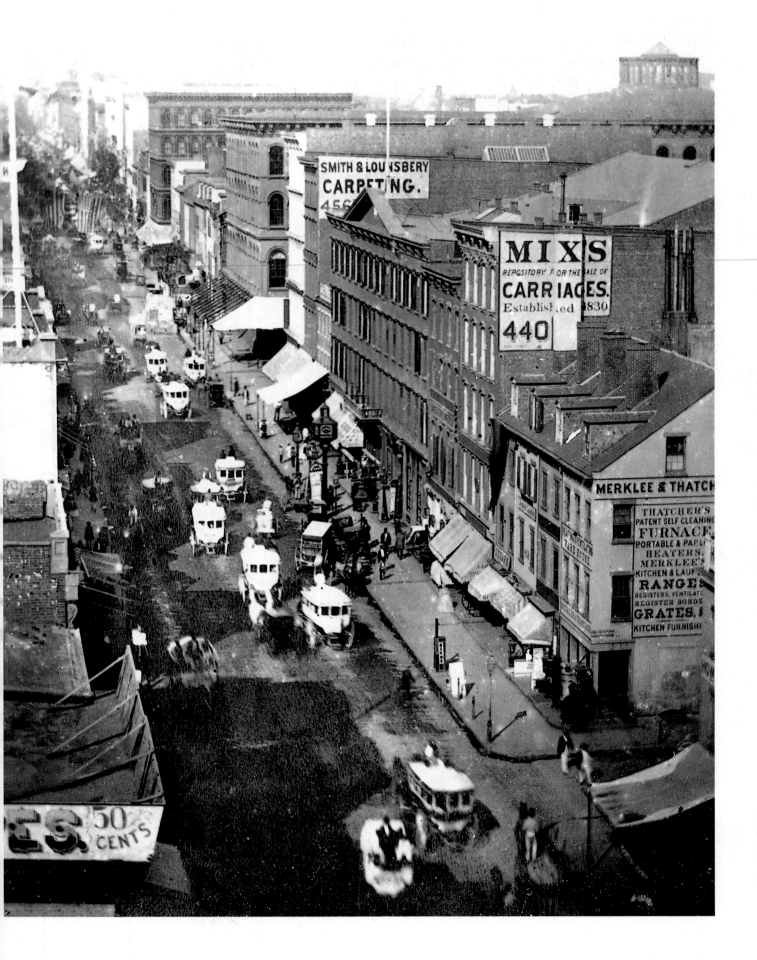

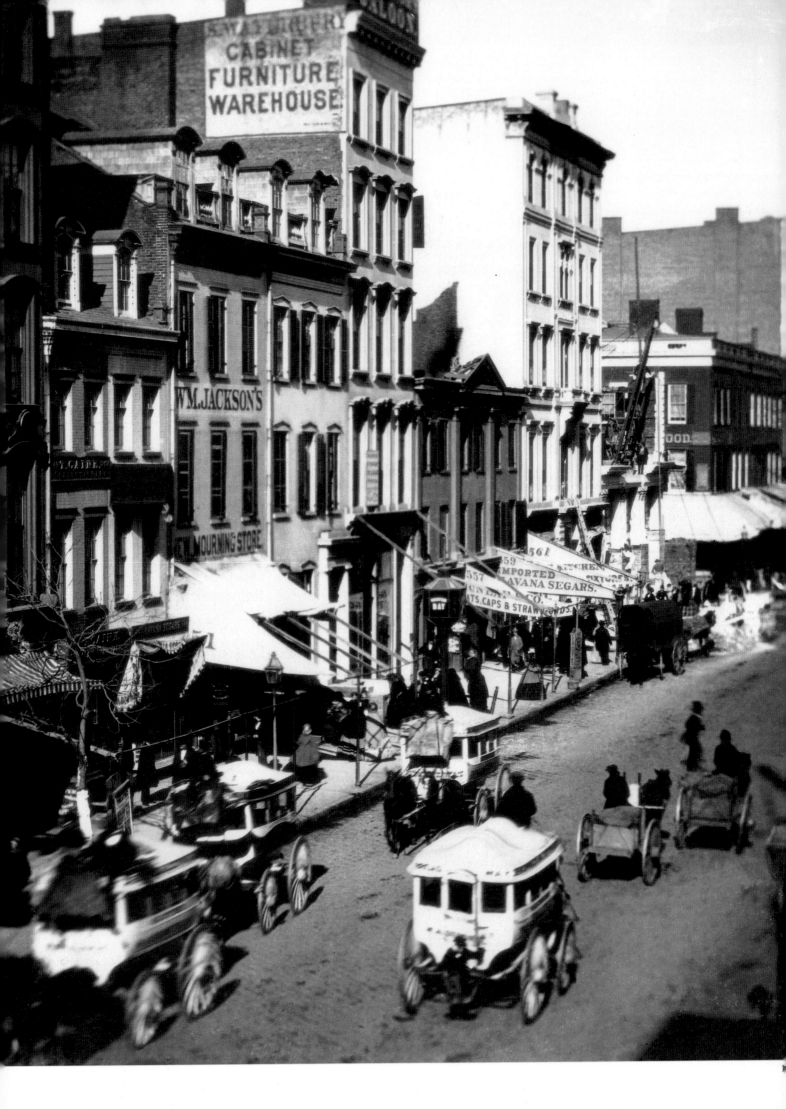

By the mid-1870s, George Augustus Sala, who had last seen Broadway (1) in 1863, was amazed at what had happened: 'Where I remembered wildernesses I now behold terraces after terraces of lordly mansions of brown stone, some with marble façades, others wholly of pure white marble.' By 1890, Fulton's ferries had been superseded by the bold span of the Brooklyn Bridge (2). And by 1917, it took a bold man or woman to build, clean or decorate the towering office and apartment blocks – here Miss Lucille Patterson, an American artist, is painting bills on the side of a skyscraper (3).

Mitte der 1870er Jahre staunte George Augustus Sala, der den Broadway (1) zum letzten Mal im Jahre 1863 gesehen hatte, über die Veränderungen: »Wo damals eine Wildnis war, fand ich jetzt Reihen herrschaftlicher Sandsteinhäuser, einige mit marmornen Fassaden, andere ganz aus weißem Marmor.« In den 1890er Jahren waren Fultons Fähren von der riesigen Brooklyn Bridge (2) verdrängt worden. Und 1917 brauchte es kühne Männer oder Frauen, um die alles überragenden Büro- und Appartementhochhäuser zu bauen, zu reinigen oder zu dekorieren – hier sieht man Miss Lucille Patterson, eine amerikanische Künstlerin, die Werbeanzeigen an die Wand eines Hochhauses malt (3).

Dès le milieu des années 1870, George Augustus Sala, dont la dernière visite à Broadway (1) remontait à 1863, était abasourdi par les changements : « Là où dans mes souvenirs se trouvaient des étendues en friche, j'étais frappé de voir se succéder les terrasses d'orgueilleuses demeures en pierre brune, certaines avec une façade en marbre, d'autres entièrement recouvertes d'un marbre blanc et pur. » Dès 1890, les ferry-boats de Fulton avaient été supplantés par la portée hardie du pont Brooklyn (2). En outre, dès 1917, il fallait avoir le cœur bien accroché pour construire, nettoyer ou décorer les bureaux et les immeubles haut perchés : Mademoiselle Lucille Patterson, peintre américain, en train de peindre des affiches sur la face d'un gratte-ciel (3).

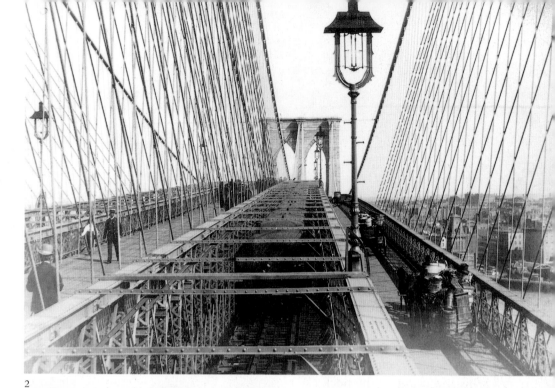

2

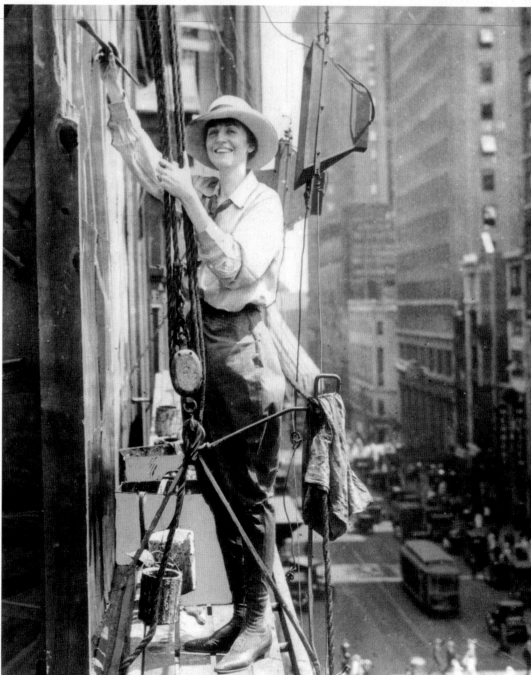

3

New Frontiers

FOR the first time, the camera could capture the glories and eccentricities, the disasters, wonders, heroes and horrors of the age. Early daguerreotypes needed cumbersome equipment and lengthy exposures. It was hardly surprising that most 'sitters' regarded having their photograph taken as more an ordeal than a bit of fun. A good portrait required up to twenty minutes' exposure, during which time the subject must neither move nor blink, while his or her body was fastened into weird metal frameworks that gripped the arms and clamped the neck (1).

By the 1850s, the camera had become more portable, though photographers still travelled with a great deal of heavy apparatus. In 1856 Francis Frith set out on an 800-mile (1,250 km) journey into the Nile Valley with three glass-plate cameras and a complete darkroom. The same year the Bisson brothers of France employed 25 porters to carry their equipment into the Alps. Two years earlier, Roger Fenton had covered the Crimean War from a horse-drawn wagon proudly named 'The Photographic Carriage'. Action pictures were not yet possible, but Fenton was forbidden to photograph death and destruction – even though corpses didn't move during exposures of ten to fifteen seconds.

For a further ten years, photographers toured the world in their vans and wagons, capturing scenes of life in the Far East and the Far West. The Venetian-born Felice Beato visited India to photograph the Mutiny in 1857; he then went on to China, where he took pictures of the rebellion of 1860, before settling in Japan in 1862, where he opened his own photographic business.

In the 1860s the first truly portable cameras appeared on the market, and by the 1880s photography was sufficiently accessible for the general public to become the most popular hobby of the day. Informal 'snapshots' (the word was first used in 1890) preserved for eternity the everyday life of ordinary people. For the first time in history it was possible for one half of the world to see how the other half lived; for the sons and daughters of miners, shopkeepers, parlour-maids, stable-lads, factory hands and chimney-sweeps to know what their parents had looked like when they, too, were young; for stay-at-homes to see the Taj Mahal, the Eiger, the Golden Horn or the Great Wall of China.

And before the century ended, there were pictures that moved.

ZUM ersten Mal konnte die Kamera den Stolz und die Exzentrizität, die Desaster, Wunder, Helden und Schrecken der Zeit einfangen. Für die frühen Daguerrotypien waren eine umfangreiche Ausrüstung und lange Belichtungszeiten erforderlich. Es überraschte kaum, daß die meisten Modelle es eher anstrengend als lustig fanden, eine Photographie von sich machen zu lassen. Ein gutes Portrait mußte bis zu zwanzig Minuten belichtet werden; in dieser Zeit durfte sich das Modell weder bewegen noch blinzeln, und sein oder ihr Körper steckte in einem merkwürdigen Metallrahmen, der die Arme festhielt und das Genick festklammerte (1).

Um die Mitte des 19. Jahrhunderts war die Kamera transportabler geworden, obwohl die Photographen noch immer mit vielen schweren Apparaten herumreisten. Francis Frith begab sich 1856 mit drei Glasplattenkameras und einer kompletten Dunkelkammer auf eine 1 250 Kilometer lange Reise ins Niltal. Im selben Jahr beschäftigten die französischen Bisson-Brüder 25 Träger, um ihre Ausrüstung in die Alpen zu bringen. Zwei Jahre zuvor hatte Roger Fenton den Krimkrieg von einem Pferdewagen aus photographiert, der den stolzen Namen »The Photographic Carriage« trug. Aufnahmen von Bewegungen waren noch nicht möglich, aber Fenton wurde es verboten, Tod und Zerstörung zu photographieren – auch wenn sich Leichen während einer Belichtungszeit von zehn bis fünfzehn Sekunden bestimmt nicht bewegten.

Weitere zehn Jahre bereisten Photographen die Welt in ihren Wagen und Waggons und fingen Szenen des Lebens im Fernen Osten wie im Fernen Westen ein. Der in Venedig geborene Felice Beato besuchte 1857 Indien, um den Aufstand zu photographieren, und fuhr dann nach China, wo er 1860 Aufnahmen von der Rebellion machte, bevor er sich 1862 in Japan niederließ und dort sein eigenes Photoatelier eröffnete.

In den 1860er Jahren erschienen die ersten wirklich tragbaren Kameras auf dem Markt. In den 1880er Jahren hatte fast jedermann Zugang zur Photographie, und sie wurde zum beliebtesten Hobby der Zeit. Zwanglose »Schnappschüsse« (das Wort wurde zum ersten Mal 1890 verwendet) hielten das Alltagsleben der einfachen Menschen für die Ewigkeit fest. Zum ersten Mal in der Geschichte der Menschheit konnte die eine Hälfte der Welt sehen, wie die andere Hälfte lebte, erfuhren die Söhne und Töchter von Bergarbeitern, Ladenbesitzern, Dienstmädchen, Stallburschen, Fabrikarbeitern und

1

Schornsteinfegern, wie ihre Eltern in jungen Jahren ausgesehen hatten, und konnten die zu Hause Gebliebenen Bilder vom Taj Mahal, dem Eiger, dem Goldenen Horn oder der chinesischen Mauer betrachten.

Und bevor das Jahrhundert zu Ende ging, gab es Bilder, die sich bewegten.

POUR la première fois, l'appareil photographique pouvait capter les gloires et les excentricités, les désastres, les merveilles, les héros et les horreurs de l'époque. Les tout premiers daguerréotypes nécessitaient un équipement encombrant et des temps d'exposition extrêmement longs. Rien d'étonnant donc si la plupart des « modèles » considéraient la séance photographique davantage comme une épreuve que comme une partie de plaisir. Un bon portrait exigeait jusqu'à vingt minutes de pose sans bouger ni ciller, tandis que le corps de la personne photographiée était sanglé dans d'étranges cadres de métal qui enserraient ses bras et son cou (1).

Dès les années 1850, l'appareil photographique devint plus maniable, bien que les photographes continuassent à se déplacer avec un lourd appareillage. En 1856, Francis Frith entreprit un voyage de 1 250 km dans la vallée du Nil en transportant trois appareils photographiques munis de plaques en verre et une chambre noire complète. La même année, des Français, les frères Bisson, employèrent vingt-cinq porteurs pour transporter leur équipement dans les Alpes. Deux ans plus tôt, Roger Fenton avait couvert la guerre de Crimée à partir d'un chariot tiré par des chevaux et fièrement qualifié d'« attelage photographique ». Les photographies animées n'étaient pas encore possibles ; pourtant on avait interdit à Fenton de photographier les morts et les destructions, même si les cadavres ne bougeaient pas pendant les dix à quinze secondes que duraient l'exposition.

Au cours des dix années qui suivirent, les photographes parcoururent le monde dans leurs fourgons et chariots, fixant les scènes de la vie en Extrême-Orient et dans le Far West. Felice Beato, qui était né à Venise, se rendit en Inde pour y photographier la révolte de 1857, puis en Chine la rébellion de 1860, avant de s'installer au Japon en 1862 où il se mit à son propre compte comme photographe.

Dans les années 1860 apparurent sur le marché les premiers appareils photographiques véritablement portables ; dès les années 1880, le grand public avait accès à la photographie de sorte que celle-ci devint le loisir le plus populaire de l'époque. Les « instantanés » (le terme apparut en 1890) informels préservaient pour l'éternité la vie quotidienne des gens ordinaires. Pour la première fois dans l'histoire, une moitié du monde pouvait regarder vivre l'autre; les fils et filles de mineurs, boutiquiers, femmes de chambre, garçons d'étable, les ouvriers d'usine et les ramoneurs pouvaient voir à quoi avaient ressemblé leurs parents plus jeunes ; les pantouflards avaient la possibilité de voir le Taj Mahal, le mont Eiger, la Corne d'Or ou la Grande Muraille de Chine.

Et le siècle n'était pas achevé que déjà les images s'animaient.

Matthew Brady (1) was an early travelling photographer who covered the American Civil War. The federal soldiers whom he photographed called the converted buggy in which he had his darkroom 'The Whatisit Wagon' (2). Francis Frith (3) made three journeys into Egypt and opened a photographic printing firm. Eadweard Muybridge (4) was an Englishman who pioneered the technique of using trip wires, taking a series of action pictures to study how humans and animals moved.

Matthew Brady (1) war ein früher Reisephotograph, der über den Amerikanischen Bürgerkrieg berichtete. Die von ihm photographierten föderalistischen Soldaten nannten den umgebauten Wagen, in dem er seine Dunkelkammer eingerichtet hatte, »The Whatisit Wagon« (2). Francis Frith (3) unternahm drei Reisen nach Ägypten und gründete ein Unternehmen für Photabzüge. Der Engländer Eadweard Muybridge (4) leistete Pionierarbeit für die Technik der Fernauslöserdrähte, mit denen er eine Serie von Aktionsphotos machte, um die Bewegungen von Mensch und Tier zu studieren.

Matthew Brady (1) fut l'un des premiers photographes itinérants à documenter la guerre civile américaine. Les soldats fédéraux qu'il photographiait appelaient le chariot qu'il avait converti pour y placer sa chambre noire « le chariot qu'est-ce-que-c'est » (2). Francis Frith (3) se rendit trois fois en Égypte et monta une entreprise de films photographiques. Eadweard Muybridge (4) fut un pionnier de la technique du déclenchement par fil et fit une série de photographies animées permettant d'étudier les mouvements de l'homme et de l'animal.

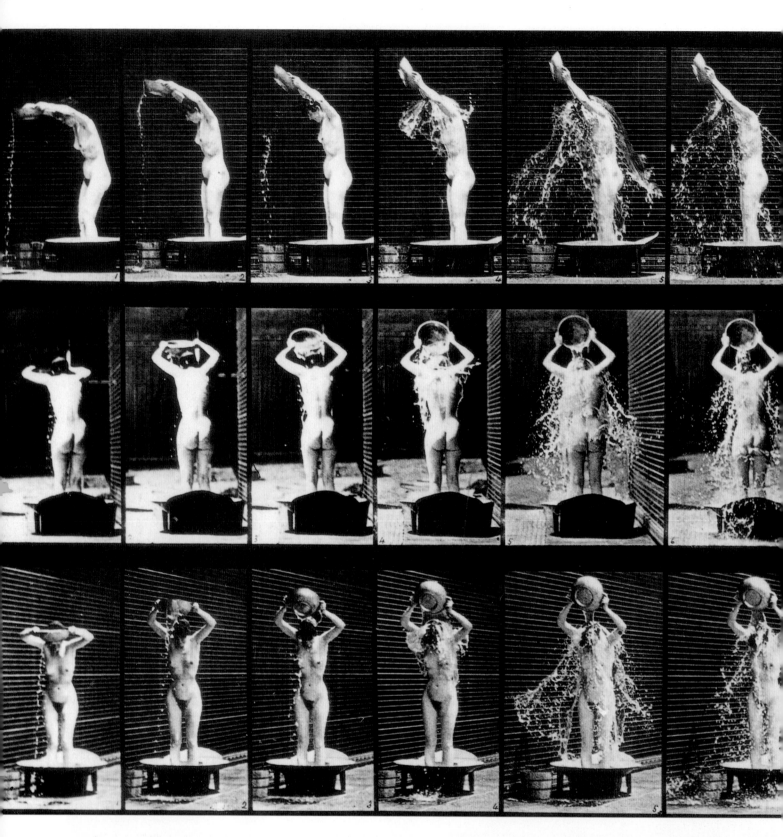

THIS is one of Muybridge's most famous (and most popular) studies of movement – a naked woman dowsing herself with water in a bathtub. There were some who regarded these pictures as shocking, some who considered them delightful, and many who looked on them as both. Among Muybridge's more

ridiculous models in the 1880s were a naked cricketer, a naked hurdler, and a naked swordsman. The pictures were taken with a series of 12 to 24 cameras at an exposure of 1/500th of a second and caused a sensation at the Chicago Exhibition of 1893 when projected on a Zoopraxiscope.

DIES ist eine von Muybridges berühmtesten (und beliebtesten) Bewegungs-studien, eine nackte Frau, die sich in einer Badewanne mit Wasser übergießt. Manche fanden diese Bilder schockierend, andere reizend, und für viele waren sie beides. Zu Muybridges eher lächerlichen Modellen gehörten in den 1880ern ein Kricketspieler,

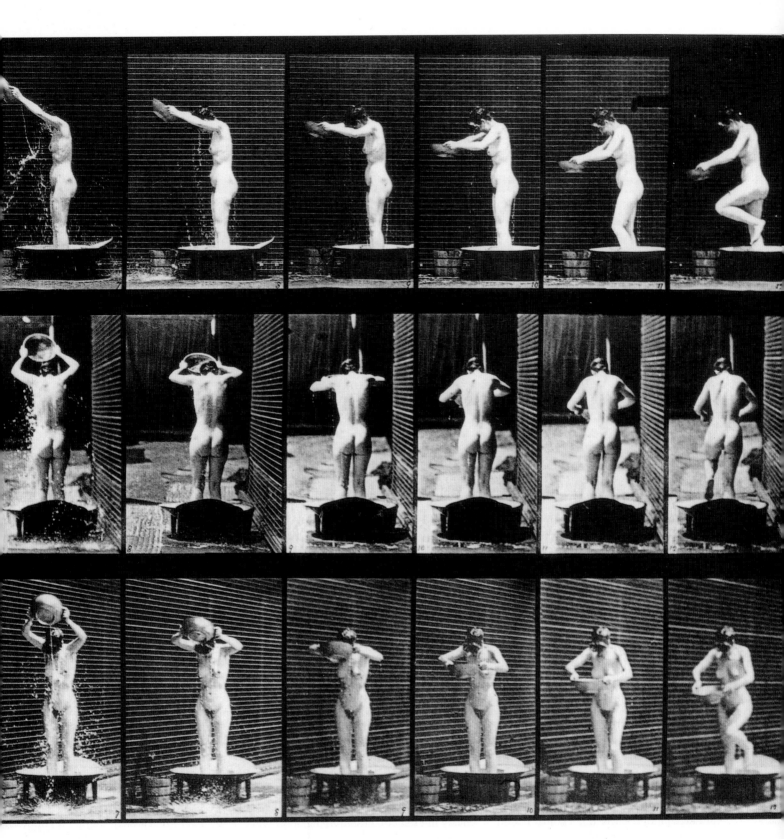

ein Hürdenläufer und ein Fechter – alles Akte. Die Aufnahmen wurden mit 12 bis 24 Kameras bei einer Belichtungszeit von einer Fünfhundertstelsekunde gemacht und sorgten bei der Chicagoer Weltausstellung von 1893 für eine Sensation, als sie auf ein Zoopraxiskop projiziert wurden.

VOICI une des études de mouvement les plus célèbres (et les plus prisées) de Muybridge : une femme nue qui s'asperge d'eau dans une baignoire. Certains trouvèrent ces photos choquantes, d'autres plaisantes et beaucoup les deux à la fois. Parmi les modèles les plus ridicules de Muybridge durant les années 1880 figurent un joueur de cricket,

un sauteur de haies et un escrimeur nus. Les photographies avaient été prises avec une batterie de 12 à 24 appareils photographiques et une exposition de 1/500 de seconde. Elles firent sensation lorsqu'elles furent projetées au moyen de son zoopraxiscope en 1893 à l'exposition de Chicago.

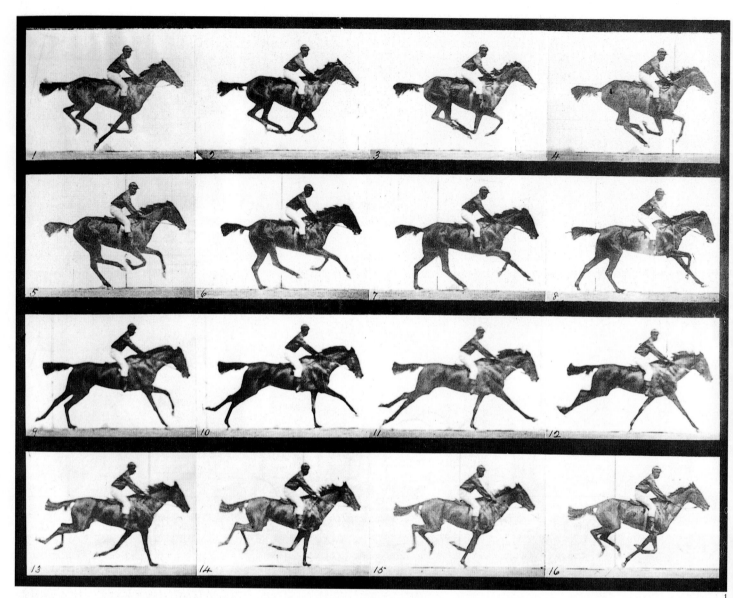

THANKS to Muybridge's action shots of a horse (1), it was possible to establish that the horse did at one time have all four feet off the ground when trotting – news that pleased Governor Leland Stanford of California, who had made a wager to that effect. There were some, however, who claimed that a horse's legs could never assume such unlikely positions. Among others who had experimented with moving action pictures was Dr Jules Marey, with his chrono-photograph of a fencer (2). Thomas Edison (3) pioneered micrography – the study of microscopic objects by photography.

DANK Muybridges Bewegungsstudien eines Pferdes (1) konnte man feststellen, daß beim Trab für einen Moment keines seiner vier Beine den Boden berührte – eine Neuigkeit, die dem kalifornischen Gouverneur Leland Stanford sehr gefiel, denn er hatte darauf eine Wette abgeschlossen. Es gab jedoch auch manche, die behaupteten, die Beine eines Pferdes könnten niemals solch unwahrscheinliche Haltungen einnehmen. Zu denen, die ebenfalls mit Bewegungs-photos experimentierten, gehörte Dr. Jules Marey mit seiner Chronophotographie eines Fechters (2). Thomas Edison (3) erfand die Mikrophotographie, das Studium mikro-skopisch kleiner Objekte mit Hilfe der Photographie.

GRÂCE aux instantanés animés d'un cheval (1) pris par Muybridge, on put constater que l'animal au trot avait à un moment donné ses quatre sabots en l'air ; la nouvelle réjouit le gouverneur de Califor-nie, Leland Stanford, qui avait parié en ce sens. Certains affirmèrent malgré tout qu'il était tout à fait impossible que les jambes d'un cheval prissent des positions aussi invrai-semblables. Parmi ceux qui s'essayèrent à la photographie animée, on trouve Jules Marey et sa chronophoto-graphie d'un escrimeur (2). Thomas Edison (3) fut un pionnier de la micrographie, l'étude des objets microscopiques grâce à la photo-graphie.

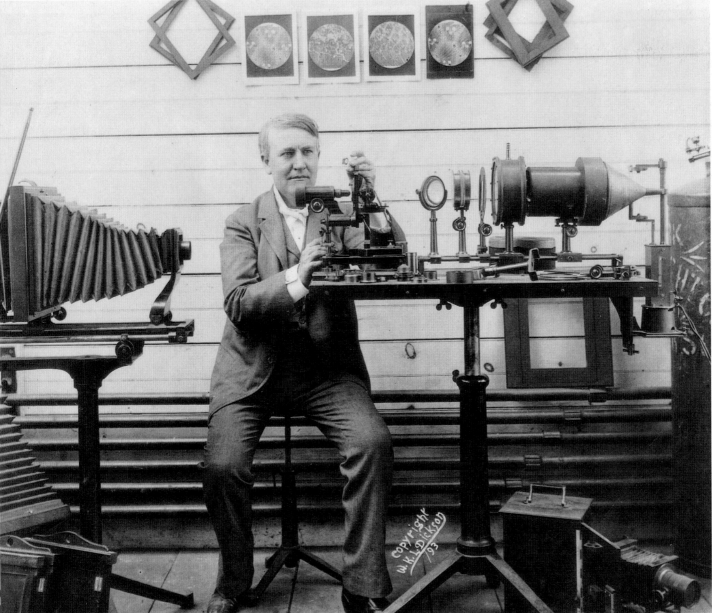

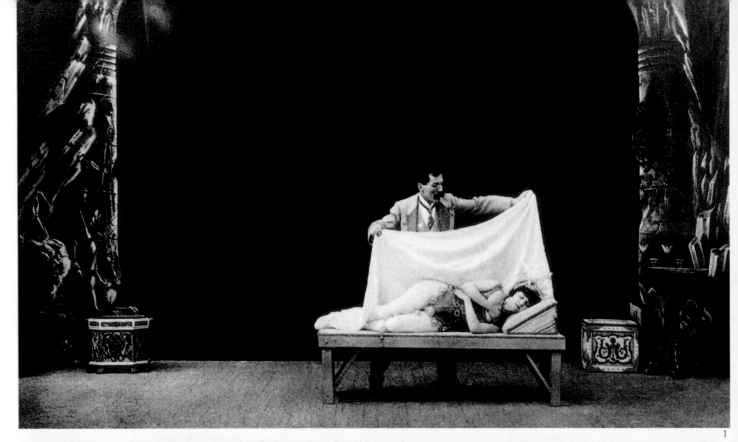

GEORGES Méliès was a French
magician, designer, actor and theatre
manager. He quickly saw how magic and
fantasy could be combined with the new
cinematograph cameras. Here he turns a
woman into a butterfly (1 and 2). His later
films were more lavish and complex, with
specially built sets (3) and special effects (4).

DER Franzose Georges Méliès war
Magier, Designer, Schauspieler und
Theaterdirektor. Er erkannte schnell, daß
die neuen kinematographischen Kameras
neue Horizonte für Magie und Phantasie
eröffneten. Hier verwandelt er eine Frau
in einen Schmetterling (1, 2). Seine späteren
Filme waren überschwenglicher und
komplexer, mit speziellen Dekorationen (3)
und Effekten ausgestattet (4).

GEORGES Méliès était un illusionniste
français, créateur, comédien et
directeur de théâtre. Il comprit rapidement
comment combiner et photographier la
magie et le fantastique grâce aux nouvelles
caméras cinématographiques. Il transforme
ici une femme en papillon (1 et 2). Après
1899, ses films se firent complexes et
nécessitaient des décors (3) et des effets
spéciaux (4).

3

4

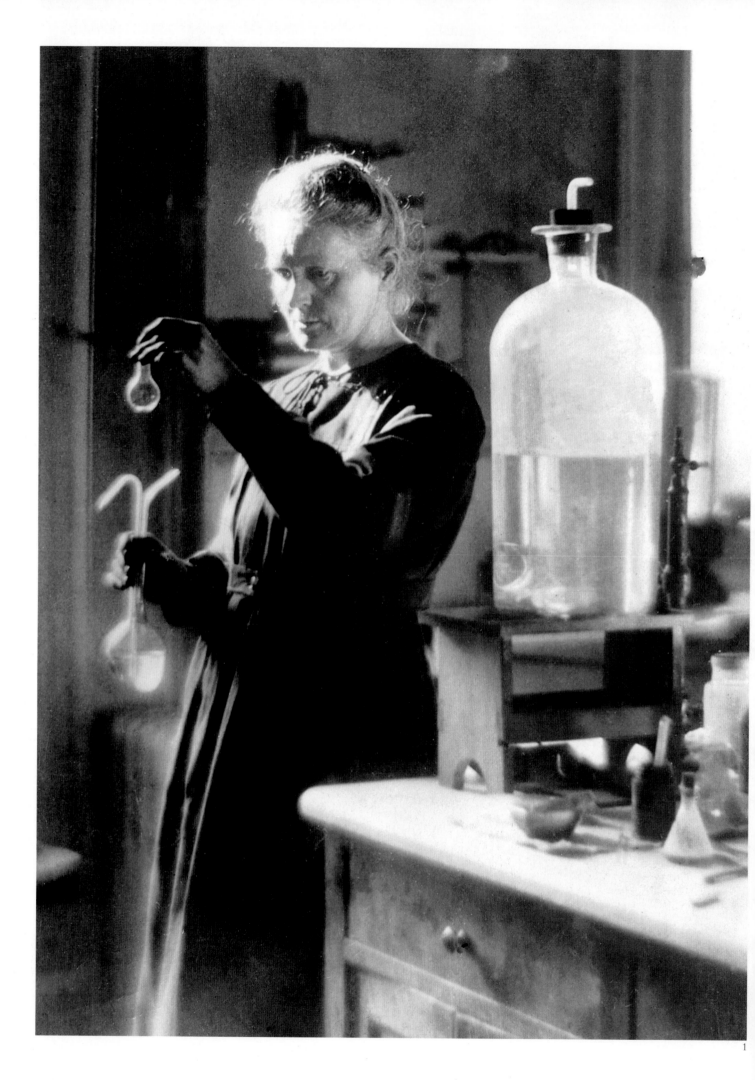

THOMAS Edison and Henry Ford (3, right and left) examine Edison's light bulbs. Marie Curie at work in her laboratory (1). Amateur astronomers examine the heavens in the days before flashlight photography (2). The Marchese Marconi (4, centre) at Signal Hill, Newfoundland, before receiving the first trans-Atlantic wireless signal.

THOMAS Edison und Henry Ford (3, rechts und links) untersuchen Edisons Glühbirnen. Marie Curie bei der Arbeit in ihrem Labor (1). In den Tagen vor der Erfindung der Blitzlichtphotographie untersuchen zwei Amateurastronomen den Himmel bei Tag (2). Der Marchese Marconi (4, Mitte) auf dem Signal Hill in Neufundland, kurz vor dem Empfang des ersten transatlantischen Telegraphensignals.

THOMAS Edison et Henry Ford (3, à droite et à gauche) examinent la première ampoule électrique d'Edison. Marie Curie au travail dans son laboratoire (1). Deux astronomes amateurs examinant les cieux à la lumière du jour avant l'arrivée de la photographie au flash (2). Le marquis Marconi (4, au centre) à Signal Hill, Terre-Neuve, quelques instants avant de recevoir le premier signal transatlantique par ondes hertziennes.

A stuffed mammoth from Siberia is exhibited in the St Petersburg Museum in the 1860s (2), while an unknown archaeologist holds a newly discovered fossil of a leg bone from some colossal animal (1).

EIN ausgestopftes Mammut aus Sibirien wird in den 1860er Jahren im Museum von St. Petersburg ausgestellt (2). Ein unbekannter Archäologe hält den jüngst entdeckten versteinerten Beinknochen eines riesigen Tieres (1).

UN mammouth empaillé en provenance de Sibérie est exposé au musée de Saint-Pétersbourg dans les années 1860 (2). Un archéologue inconnu tient un fossile que l'on vient de découvrir : le tibia d'un animal gigantesque (1).

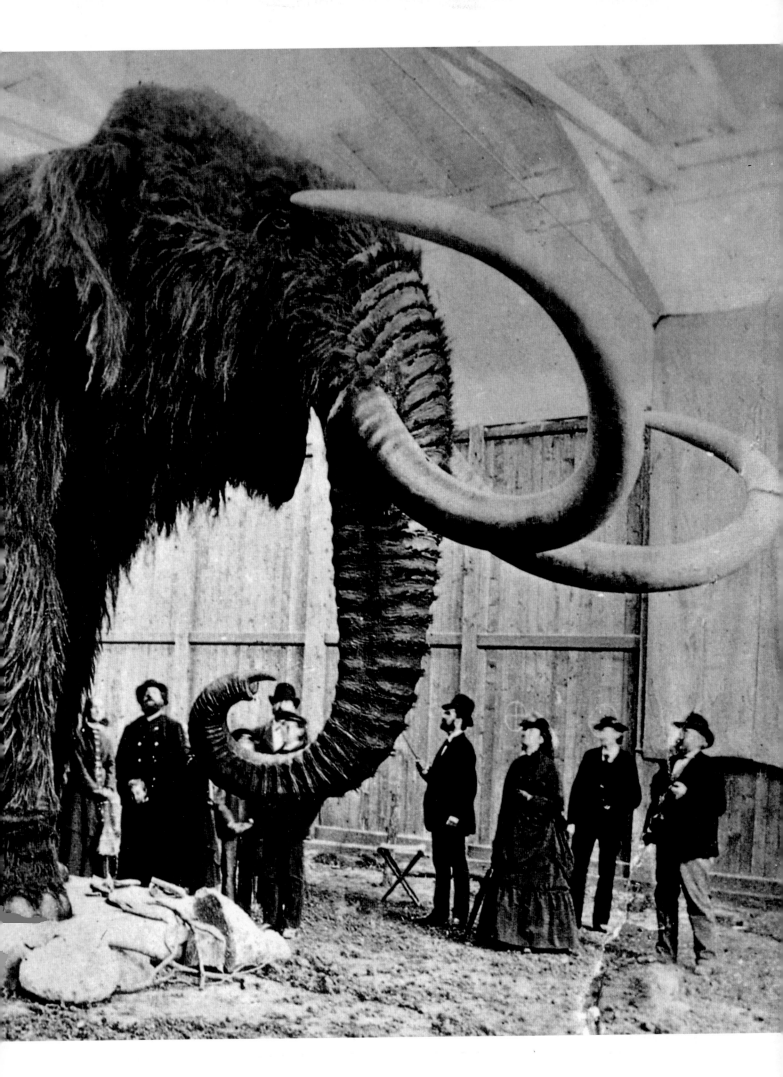

2

IN 1898 gold was discovered in the Klon-
dike in north-west Canada. 22,000 pro-
spectors a year poured in, dragging their
stumbling pack-horses up the ice (1).
In their wake came saloon-keepers and
'actresses' (2, crossing the Dyea River).
Towns like Skagway – the most lawless
place on earth – sprang up overnight (3).
Dawson City (4) was the biggest boom
town.

IM Jahre 1898 wurde im Klondike im
Nordwesten Kanadas Gold gefunden.
Jährlich kamen 22 000 Goldsucher und
zogen ihre stolpernden Packpferde über das
Eis (1). Mit ihnen kamen Saloonbetreiber
und »Schauspielerinnen« (2, beim Über-
queren des Flusses Dyea). Städte wie Skag-
way, der gesetzloseste Ort der Welt,
entstanden über Nacht (3). Dawson City
war die größte Goldgräberstadt (4).

3

EN 1898, on découvrit de l'or dans le Klondike, au nord-ouest du Canada. 22 000 chercheurs d'or arrivaient chaque année, tirant leurs chevaux de bât qui trébuchaient sur la glace (1). Dans leur sillage suivaient les tenanciers de tripots et les « actrices » (2, traversant la rivière Dyea). Des villes comme Skagway – l'endroit aux mœurs les plus dissolues de la terre – surgirent en une nuit (3). Dawson City (4) fut la ville qui connut la plus grande prospérité.

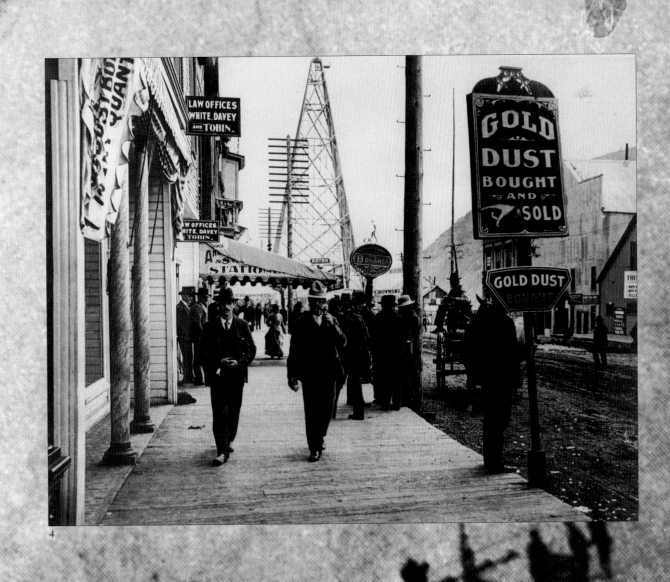

4

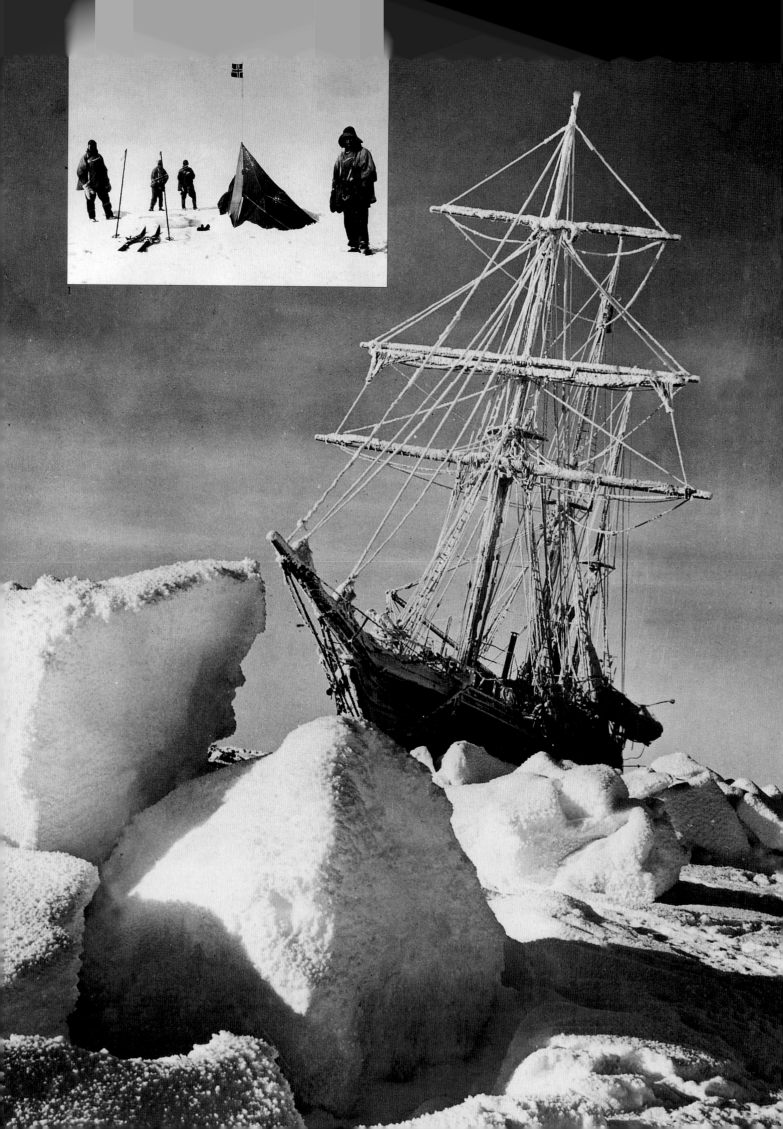

MEMBERS of Scott's last South Polar Expedition outside Amundsen's tent at the Pole, January 1912 (1). Shackleton's *Endurance* caught in the Antarctic ice in 1917 (2) . The Aurora Borealis (3), photographed in 1876 by members of the British Nares Expedition (4 – with dead walrus).

MITGLIEDER der letzten Expedition zum Südpol unter Kapitän Scott stehen im Januar 1912 vor Amundsens Zelt am Pol (1). Shackletons *Endurance* wurde 1917 im antarktischen Eis aufgenommen (2). Die Aurora Borealis am arktischen Himmel (3), 1876 von Mitgliedern der britischen Nares-Expedition photographiert (4, mit totem Walroß).

LES membres de la dernière expédition du capitaine Scott au pôle Sud à côté de la tente d'Amundsen en janvier 1912 (1). L'*Endurance* de Sir Ernest Shackleton pris dans les glaces de l'Antarctique en 1917 (2) ; une aurore boréale dans le ciel de l'Arctique (3) photographiée en 1876 par les membres de l'expédition britannique Nares (4, près d'un morse mort).

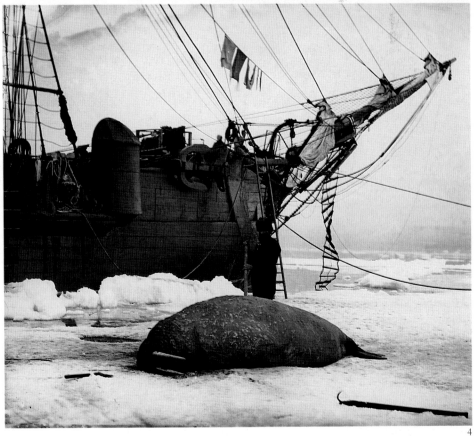

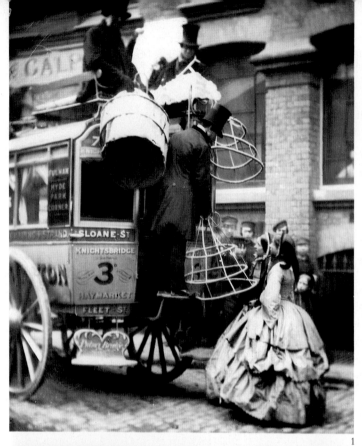

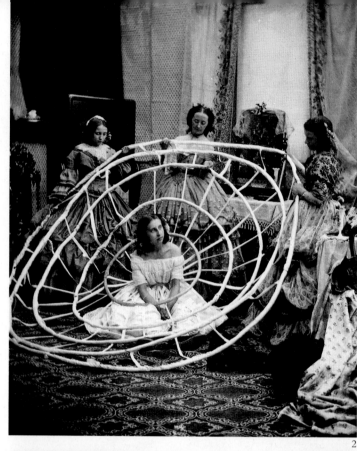

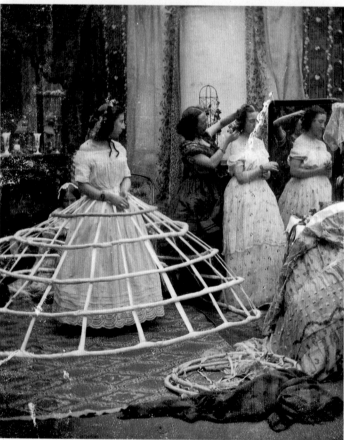

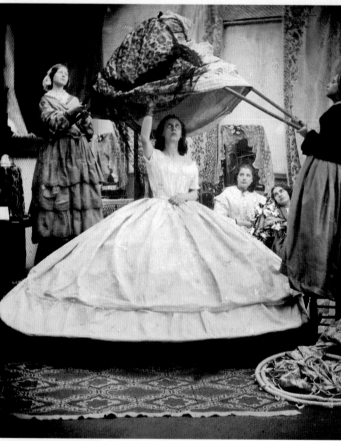

FROM 1830 onwards, skirts had grown steadily fuller, supported by 'long lace-trimmed drawers, an under-petticoat three and a half yards wide, a petticoat wadded at the knees and stiffened with whalebone, a white starched petticoat, with three stiffly starched flounces, and a muslin petticoat…'.

When the true crinoline arrived in 1854, with its cage of steel and whalebone, it was a blessed relief, being a much lighter and more manoeuvrable mode of dress. It lasted only a few years before being replaced by the bustle, but while it lasted it provided plenty of scope for humour.

SEIT 1830 waren die Röcke immer ausladender geworden, gestützt von »langen, spitzenbesetzten Unterhosen, einem dreieinhalb Meter breiten Reifrock, einem Unterrock, der an den Knien ausgestellt und mit Walknochen verstärkt war, einem weißen, gestärkten Unterrock mit drei steifen Volants besetzt, und einem

Unterrock aus Musselin …« Als 1854 die echte Krinoline mit ihrem Käfig aus Draht und Fischbein auftauchte, war dies eine große Erleichterung, denn dieses Kleidungsstück erlaubte eine viel größere Bewegungsfreiheit. Schon nach wenigen Jahren wurde sie durch die Turnüre ersetzt, die jedoch viel Anlaß zur Belustigung bot.

À partir de 1830 les jupes se gonflèrent régulièrement au-dessus de « longues culottes garnies de dentelles, d'un premier jupon de trois mètres de largeur, d'un jupon ouaté aux genoux et raidi sur des baleines, d'un jupon blanc empesé et orné de trois volants amidonnés pour les raidir, et d'un jupon en mousseline … » Lorsque la vraie

crinoline arriva en 1854 avec son armature d'acier ou de baleines, ce fut un véritable soulagement : le vêtement s'en trouva bien plus allégé et fonctionnel. Elle ne subsista qu'un petit nombre d'années avant d'être remplacée par la tournure, et fut tout au long de son époque une source inépuisable de plaisanteries.

1

2

PIN-UP pictures became popular in the early 1900s. Scorning the fashion scene, however, were those who favoured practicality in costume – an afternoon tea party in rational dress in 1895 (2). But some were prepared almost to cut themselves in half to display a wasp waist – the French music-hall singer Polaire in 1890 (1).

DIE beliebtesten Pin-up-Bilder kurz nach 1900 waren die der Gibson Girls. Verachtet wurde die Modeszene von den Befürwortern praktikabler Bekleidung – eine nachmittägliche Teaparty in zweckmäßiger Kleidung im Jahre 1895 (2). Aber es gab auch Frauen, die bereit waren, sich fast in der Mitte durchzutrennen, um eine Wespentaille präsentieren zu können, wie die französische Sängerin Polaire im Jahre 1890 (1).

LES photographies de dames les plus appréciées au début des années 1900 représentaient les Gibson Girls. Il y avait celles qui faisaient fi de la mode et voulaient que le vêtement fût seulement pratique : un goûter dans une robe fonctionnelle en 1895 (2). Mais certaines étaient prêtes à se couper quasiment en deux pour montrer une taille de guêpe – la chanteuse Polaire, en 1890 (1).

1

On Folkestone Pier in August 1913, contestants in an early International Beauty Show parade their smiles (1 – from left to right: England, France, Denmark, Germany, Italy and Spain). The camera played a highly culpable part in popularizing fashion displays and beauty competitions – a prizewinner in a Paris magazine contest in 1902, one of the first 'cover-girls' (2).

Edward VII died on 6 May 1910. A month later, society was still in mourning, but fashionably so for the Ascot Race Meeting (3). At the racecourse at Long-champs, Paris, in 1914, just before the outbreak of war, the fashion of the day was the harem skirt (4).

Am Pier von Folkestone präsentieren die Mitstreiterinnen eines frühen Schönheitswettbewerbs im August 1913 ihr Lächeln (1, von links nach rechts: England, Frankreich, Dänemark, Deutschland, Italien und Spanien). Die Kamera trug dazu bei, daß sich Modenschauen und Schönheitswettbewerbe immer größerer Beliebtheit erfreuten; die Gewinnerin des Wettbewerbs eines Pariser Magazins aus dem Jahre 1902, eines der ersten »Cover-girls« (2).

Edward VII. starb am 6. Mai 1910. Einen Monat später trauerte die Gesellschaft zwar noch immer, für das Pferderennen in Ascot tat sie dies jedoch modebewußt (3). Auf der Rennbahn von Longchamps in Paris waren 1914, kurz vor Ausbruch des Krieges, Haremsröcke der letzte Schrei (4).

2

3

4

Sur la jetée de Folkestone en août 1913, les concurrentes participent à l'un des premiers concours internationaux de beauté (1, de gauche à droite : Angleterre, France, Danemark, Allemagne, Italie et Espagne). L'appareil photographique a joué ici un rôle extrêmement coupable puisqu'il popularisa les défilés de mode et les concours de beauté. La lauréate du concours organisé par un magazine parisien en 1902, une des premières « cover-girls » (2).

Édouard VII mourut le 6 mai 1910. Un mois plus tard, la haute société le pleurait toujours, sans que la mode ne perdît ses droits aux courses d'Ascot (3). Aux courses de Longchamp à Paris, en 1914, juste avant que n'éclatât la guerre, la jupe « Harem » était alors en vogue (4).

IN sport, education, the arts, society and employment, the New Woman had made considerable progress against enormous opposition. 'They dress ... like men. They talk ... like men. They live ... like men. They don't ... like men' was *Punch's* funny little view in 1895. Women now smoked cigarettes in public, took their own lodgings or at least demanded a key to the family home, and challenged outmoded social conventions. By the beginning of the 20th century, all caution – and many swimsuits – had been thrown to the wind (2). Decent folk were outraged by the wanton shamelessness of bathing belles who dared to pose (rather than swim) in the one-piece bathing costume (1).

IM Sport, in der Ausbildung und Erziehung, in der Kunst, der Gesellschaft und der Arbeitswelt hatte die Neue Frau trotz einer äußerst starken Opposition enorme Fortschritte gemacht. »Sie kleiden sich ... wie Männer. Sie reden ... wie Männer. Sie leben ... wie Männer. Sie mögen ... keine Männer«, war 1895 *Punchs* Meinung. Frauen rauchten nun in der Öffentlichkeit, hatten ihre eigenen Wohnungen oder verlangten zumindest einen Schlüssel für das Familienheim und stellten überkommene gesellschaftliche Konventionen in Frage.

Zu Beginn des 20. Jahrhunderts war alle Vorsicht – und viele Badeanzüge – über Bord geworfen worden (2). Viele Leute waren entsetzt über die sträfliche Schamlosigkeit von Badeschönheiten, die es wagten, (statt zu schwimmen) in einem einteiligen Badeanzug zu posieren (1).

DANS le monde du sport, de l'éducation, des arts, dans la société et sur le marché du travail, la Femme Nouvelle avait gagné un terrain considérable face à une énorme opposition. « Elles s'habillent ... comme les hommes. Elles parlent ... comme les hommes. Elles vivent ... comme les hommes. Elles ne font pas ... comme les hommes. »

Telle était la plaisanterie sans finesse qu'on pouvait lire dans *Punch* en 1895. Les femmes fumaient maintenant des cigarettes en public, avaient leurs propres appartements ou au moins exigeaient de posséder une clé du domicile familial, et défiaient les conventions sociales démodées.

Dès le début du XXe siècle, toute précaution – et bien des maillots de bain – furent mis au vestiaire (2). Les gens honnêtes se sentirent outragés par l'impudeur de ces belles baigneuses qui avaient l'audace de poser (plutôt que de nager) dans un costume de bain une pièce (1).

Part II

1918 to the present

ALAN BEAN AND CHARLES CONRAD,
NOVEMBER 1969.

Introduction

WITHIN the span of fifty years this century, Europe was in the eye of two world wars. Thereafter, western powers were increasingly accused of exporting wars overseas, ostensibly on ideological grounds but in reality to protect economic and neo-colonial interests. Whilst the causes of the First World War remain debatably obscure, the Second World War united the Allied against the Axis countries in a battle increasingly portrayed as one against evil. The allegiance forged between Churchill, de Gaulle, Eisenhower and Stalin was soon to falter. The Korean and Vietnam Wars were joined by US forces sent on the pretext of halting the 'tumbling dice' of world Communism.

The Kremlin's determination to maintain control of the satellite states of the Soviet Union led to its much-decried military interventions in Hungary (1956) and Czechoslovakia (1968). Here the crushing was of largely spontaneous populist uprisings. In other countries, politically organized national liberation movements engaged in an armed struggle against the old imperial foreign powers. Erstwhile Commonwealth countries such as Canada won their autonomy without a struggle, although there is still a frustrated secessionist movement among the French-speaking Québecquois. India had blazed an independence trail through Gandhi's massively successful campaign of civil disobedience, only to find itself faced with partition, granting its substantial Moslem minority the northern territories that became known as Pakistan.

It became a hallmark of this allegedly godless century that religious wars were endemic once more. The increasing militance of Islam and the recourse to *jihad* (or holy war against the infidel) divided many countries against themselves, particularly in Balkan Europe and the Middle East. Here, too, the foundation of the state of Israel in 1948 appeared to Palestinians as another way in which Europe sought to displace its own problems. Civil wars erupted in countries overthrowing the ancient systems of oppression, most particularly in China where in 1949 Mao Tse-Tung inaugurated the People's Republic, the world's largest and one of the few continuing Communist countries.

Yet, curiously, the twentieth century has also been characterized by a popular desire and demand for peace. From small organisms of conscientious objectors during the First World War to worldwide Campaigns for Nuclear Disarmament, groups of individuals have grown into mass movements that have insisted on putting the human race first. Partly this is because wars increasingly affect civilians as much as or more than armies: according to Red Cross statistics, while 85 per cent of First World War casualties were military, the percentage was inverted (15 per cent military: 85 per cent civilian) during the Gulf War of 1988. While no one would advocate a return to the decimating trench warfare of the former, technological advances also rendered redundant the lining-up of armies for the battlefield slaughter. New technologies brought other sorts of advances too. In medicine, the spread of vaccines brought the eradication of smallpox, scarlet fever and leprosy worldwide; that of polio, yellow fever and hepatitis in many countries. Life expectancy virtually doubled in 'developed' countries with many living into their eighties and nineties, twice as long as a century earlier. Yet poorer regions remained plagued by avoidable diseases such as cholera and malaria.

Technological advances could also bring many of us culturally closer. Television soap serials have achieved mass popularity. A whole new art form, cinema, advanced to a peak in the Thirties and Forties. Realistic imaging came further within the popular remit through the widespread availability of cheap photo and video cameras. North American films and video games in particular were widely blamed for the promotion of impersonal violence, especially among the young, among whom sophisticated weaponry and a 'drug culture' were pervasive.

Fashions in music and clothes became complementary, with many regions abandoning traditional customs. Cheap travel on charter aircraft led to exotic tourist resorts producing interchangeable T-shirts and carrier bags worldwide. In turn, western centres of fashion sought inspiration in natural fibres and traditional patterns, particularly with the emergence of Japan on the fashion scene. Other clothes styles mimicked other technological advances: the first moonwalkers of the 1960s generated a rash of space outfits on the catwalks of Paris and Milan. Overall the move was towards more comfortable, wearable clothes and less formality, particularly in women's wear.

The fashionable emaciated look from the 1960s onwards also conflicted with what people increasingly knew about 'slimmer's diseases' such as anorexia and bulimia, and with the extent of world starvation. Wars that the cynical claimed were promoted more by arms manufacturers than ideological causes led to the number

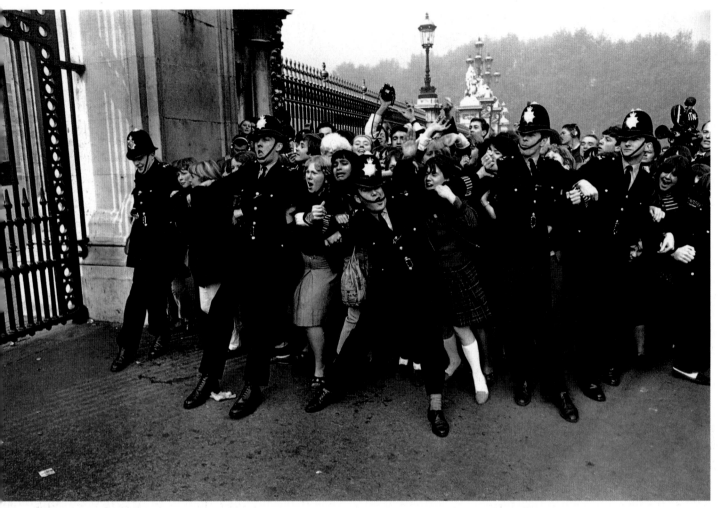

POLICE KEEP BACK BEATLES FANS
(AND PRESS CAMERAMEN) OUTSIDE
BUCKINGHAM PALACE, LONDON,
WHERE THEY WHERE RECEIVING OBE'S
(ORDER OF THE BRITISH EMPIRE),
OCTOBER 1965.

DIE POLIZEI HÄLT DIE BEATLESFANS
UND PRESSEPHOTOGRAPHEN VOR DEM
BUCKINGHAM PALAST IN ZAUM, WO
DEN BEATLES IM OKTOBER 1965 DER
ORDEN DES BRITISCHEN EMPIRES
VERLIEHEN WURDE.

LA POLICE EMPÊCHE LES FANS DES
BEATLES (ET LES PHOTOGRAPHES)
D'ENTRER DANS LE PALAIS DE
BUCKINGHAM À LONDRES OÙ L'ORDRE
DE L'EMPIRE BRITANNIQUE (OBE) LEUR
EST DÉCERNÉ, OCTOBRE 1965.

of migrants doubling in the 1980s alone. Whole peoples moved, fleeing wars and natural catastrophes, but also increasingly as 'economic refugees', seeking to escape living conditions under which they could not survive. While the global shift was from south to north and east to west, a continent such as Australasia became a whole new regional melting pot.

Despite flickering support for a revival of Italian fascism under Mussolini's granddaughter; the neo-Nazis in Germany and Austria; the racist policies of Le Pen's National Party in France and the British Movement, Europe at the close of this century is consolidating its union, finally incorporating the 'guest' populations it invited to immigrate at a time of rising employment following the Second World War. If the nineteenth century saw a net emigration of Europeans to overseas colonies, then the twentieth has witnessed a shift in the reverse direction. South Africa has finally (and relatively peacefully) transferred to majority rule, as has the last outpost of British imperialism, Northern Ireland. A belated consideration for the situation of indigenous peoples – from Amazon to Africa to Australia – goes hand-in-hand with a respect for their common understanding of the delicate interrelationship between the species of our planet.

For many of today's young generation, the overriding concern is for the sustainable future of the world as a whole, regardless of boundaries and nationalities. A scientifically raised awareness of the five species that every hour become extinct in this unrenewable world has galvanized the ecological impetus to render the destruction of the jungles of Borneo or Brazil of immediate impact in industrialized North America or Western Europe. The European Union, the Congress of Non-Aligned States, and the Organization of African or American States, are all phenomena that could not have been foreseen at this century's start. It remains for the next to reveal where present-day global concerns will lead, if the pursuit of harmony will outweigh that of war.

Einführung

IN einem Zeitraum von nur fünfzig Jahren haben in unserem Jahrhundert in Europa zwei Weltkriege getobt. Und seit Ende des letzten wird immer häufiger der Vorwurf laut, daß der Westen Kriege in andere Länder exportiere, unter ideologischem Vorwand, doch in Wirklichkeit aus ökonomischen und neokolonialistischen Motiven. Wie es zum Ersten Weltkrieg kam, ist bis heute umstritten; im Zweiten galt der Krieg der Alliierten gegen die Achsenmächte zusehends als der Kampf gegen das Böse schlechthin. Die Solidarität zwischen Churchill, de Gaulle, Eisenhower und Stalin sollte nicht lange halten – schon bald griffen amerikanische Truppen in den Korea- und den Vietnamkrieg ein, um, wie es hieß, dem Vormarsch des Weltkommunismus Einhalt zu gebieten.

Der Kreml war fest entschlossen, die Satellitenstaaten der Sowjetunion an der kurzen Leine zu halten, daher die militärischen Interventionen in Ungarn (1956) und der Tschechoslowakei (1968), die dem Ansehen der Sowjets sehr schadeten. Wurden hier weitgehend spontane Volksaufstände niedergeschlagen, so kämpften in anderen Ländern politisch organisierte nationale Befreiungsbewegungen mit Waffengewalt gegen die alten Kolonialmächte. Einstige Commonwealth-Staaten wie zum Beispiel Kanada erlangten ihre Unabhängigkeit kampflos, auch wenn im französischsprachigen Québec bis heute eine glücklose Separatistenbewegung tätig ist. In Indien hatte der ungeheure Erfolg von Gandhis Kampagne des zivilen Ungehorsams den Weg zur Unabhängigkeit gebahnt, doch mit ihr kam auch die Zweiteilung des Landes, bei der die bedeutende islamische Minderheit die nördlichen Territorien übernahm, die den Namen »Pakistan« erhielten.

Bezeichnend für dieses angeblich so gottlose Jahrhundert war, daß überall wieder Glaubenskriege aufflammten. Die zunehmende Militanz des Islam und die Rückkehr zum Dschihad (dem »heiligen Krieg« gegen die Ungläubigen) spaltete die Bevölkerung vieler Länder, besonders auf dem Balkan und im Mittleren Osten. Hier hatten die Palästinenser die Gründung des Staates Israel von 1948 als einen weiteren Versuch der Europäer empfunden, ihre eigenen Probleme auf die Einheimischen abzuwälzen. Überall, wo Länder das Joch ihrer alten Unterdrücker abschüttelten, kam es zu Bürgerkriegen, besonders heftig in China, wo Mao Tse-tung 1949 die Volksrepublik ausrief, das größte kommunistische Land der Erde und heute eines der letzten des Kommunismus.

Doch kurioserweise läßt sich das 20. Jahrhundert ebenso als ein Jahrhundert des weltweiten Strebens nach Frieden verstehen. Von einzelnen Kriegsdienstverweigerern im Ersten Weltkrieg zu weltweiten Kampagnen für nukleare Abrüstung sind aus Grüppchen und einzelnen Massenbewegungen geworden, für die die Rechte der Menschheit an erster Stelle stehen. Ein Grund dafür ist sicher, daß Kriege in zunehmendem Maße die Zivilbevölkerung treffen und im Verhältnis immer weniger das Militär: Nach Statistiken des Roten Kreuzes waren 85 Prozent der Opfer des Ersten Weltkriegs Soldaten, im Golfkrieg von 1988 war das Verhältnis umgekehrt (15 Prozent Soldaten gegenüber 85 Prozent Zivilisten). Doch niemand wird ernsthaft fordern, zu den verlustreichen Stellungskriegen zurückzukehren, und der technische Fortschritt macht den Aufmarsch der Truppen auf dem Schlachtfeld inzwischen ganz überflüssig. Auch im zivilen Bereich hat die neue Technik viele Schlachten gewonnen. In der Medizin sind durch Fortschritte der Impftechnik Pocken, Scharlach und Lepra weltweit ausgerottet, und Kinderlähmung, Gelbfieber und Hepatitis in vielen Ländern. Die Lebenserwartung in den Industrieländern verdoppelte sich, viele Menschen werden achtzig und neunzig Jahre, doppelt so alt, wie sie vor einem Jahrhundert geworden wären. Doch in den ärmeren Weltgegenden wüten vermeidbare Krankheiten wie Cholera und Malaria nach wie vor.

Technische Fortschritte brachten viele von uns auch kulturell näher zusammen. Fernsehserien erreichen ein gewaltiges Publikum. Eine ganz neue Kunstform, das Kino, kam in den 30er und 40er Jahren zur Blüte. Abbilder der Wirklichkeit wurden mit billigen Photoapparaten und Videokameras für jedermann erschwinglich. Doch andererseits gelten besonders nordamerikanische Filme und Videospiele als eine der Hauptursachen dafür, daß sinnlose Gewalt überall zunimmt, besonders unter Jugendlichen, die leicht den hochtechnisierten Waffen und der »Drogenkultur« verfallen.

Musik- und Kleidungsmoden wurden weltumspannend und verdrängten in vielen Gegenden die einheimischen Traditionen völlig. Billige Charterflüge verbreiteten die immergleichen T-Shirts und Plastiktüten exotischer Reiseziele rund um den Erdball. In Gegenzug suchten die westlichen Modezentren ihre

TWO JEWISH GIRL REFUGEES LOOKING THROUGH THE PORTHOLE OF THE HAMBURG-AMERIKA LINER SS. *ST. LOUIS*, WHICH WAS REFUSED ENTRY TO CUBA AND THE USA, ON ARRIVAL BACK IN EUROPE AT ANTWERP, 17 JUNE 1939.

ZWEI JÜDISCHE FLÜCHTLINGSMÄDCHEN SCHAUEN DURCH DAS BULLAUGE DES PASSAGIERSCHIFFS SS. *ST. LOUIS*, DAS NACH AUFNAHMEVERWEIGERUNG IN DEN USA UND KUBA NACH EUROPA ZURÜCKKEHREN MUSSTE, 17. JUNI 1939.

DEUX JEUNES RÉFUGIÉES JUIVES REGARDANT PAR LE HUBLOT DU PAQUEBOT SS. *ST. LOUIS* DE LA LIGNE HAMBOURG-AMÉRIQUE À SON ARRIVÉE À ANVERS. L'ENTRÉE À CUBA ET AUX ÉTATS-UNIS LUI AYANT ÉTÉ REFUSÉE, IL AVAIT DÛ RETOURNER EN EUROPE, 17 JUIN 1939.

Inspiration in Naturfasern und traditionellen Mustern, gerade nachdem die Japaner in der Modeszene Furore machten. Anderswo ahmte die Mode andere technische Fortschritte nach: Als die ersten Menschen auf dem Mond spazierten, sah man in den 60er Jahren auf den Laufstegen von Paris und Mailand eine wahre Flut von Raumanzügen. Insgesamt ging die Tendenz hin zu bequemeren, tragbareren Kleidern, und besonders die Damenmode war weniger formell geworden.

Das Schlankheitsideal der 60er Jahre stand in einem kuriosen Spannungsverhältnis zu dem, was nun über Krankheiten wie Magersucht und Bulimie bekannt wurde, und dem Hunger überall auf der Welt. Kriege, von denen die Zyniker sagten, sie seien eher von den Waffenhändlern als von Ideologien angefacht, sorgten dafür, daß sich allein in den 80er Jahren die Zahl der Flüchtlinge verdoppelte. Ganze Völker waren auf Wanderschaft, flohen vor Kriegen und Naturkatastrophen, waren aber auch in immer stärkerem Maße als »Wirtschaftsflüchtlinge« auf der Flucht vor Verhältnissen, in denen sie nicht überleben konnten. Die globalen Wanderbewegungen verliefen von Süd nach Nord und von Ost nach West, und ein Kontinent wie Australien und Ozeanien wurde zum neuen regionalen Schmelztiegel.

Obwohl noch dann und wann die italienischen Neofaschisten unter Mussolinis Enkelin von sich reden machen, die Neonazis in Deutschland und Österreich, Le Pens Nationalpartei in Frankreich und die britischen Europagegner, steht doch am Ende dieses Jahrhunderts die europäische Einigung bevor, bei der auch die »Gäste« einbezogen werden, die nach dem Zweiten Weltkrieg zu der Zeit, als Arbeitskräftemangel herrschte, in die einzelnen Länder geholt wurden. Im 19. Jahrhundert emigrierten die Europäer in die überseeischen Kolonien, doch im 20. Jahrhundert kehrte sich die Richtung des Stromes um. Südafrika hat nun endlich (und vergleichsweise friedlich) die Regierung der Mehrheit übergeben, und ebenso haben es die Engländer in ihrer letzten Kolonie Nordirland getan. Nun endlich findet auch die Lage der Ureinwohner die Aufmerksamkeit, die sie verdient – vom Amazonas über Afrika bis nach Australien –, und mit dieser Aufmerksamkeit entsteht ein Verständnis des ihnen allen gemeinsamen Sinns für das empfindliche Gleichgewicht der Spezies auf unserem Planeten.

Vielen in der heutigen jüngeren Generation kommt es vor allem darauf an, den Fortbestand der Welt als solcher zu sichern, ohne Rücksicht auf Grenzen und Nationalitäten. In jeder Stunde werden fünf Spezies dieses Planeten für immer ausgelöscht, und ein geschärftes ökologisches Bewußtsein hat uns vor Augen geführt, daß die Zerstörung der Regenwälder von Borneo und Brasilien nicht ohne Folgen für die Industrienationen Nordamerikas und Westeuropas bleiben wird. Die Europäische Union, der Kongreß unabhängiger Staaten, die Organisation afrikanischer oder amerikanischer Staaten – das alles sind Dinge, die zu Anfang dieses Jahrhunderts niemand vorausgesehen hätte. Es bleibt dem nächsten Jahrhundert überlassen zu zeigen, wohin die Sorgen der heutigen Welt führen werden und ob das Streben nach Harmonie den Drang zum Krieg überwinden wird.

Introduction

C'EST à deux reprises, au XXe siècle, qu'en l'espace de cinquante ans l'Europe s'est trouvée au cœur d'un conflit mondial. Par la suite, les puissances occidentales furent très vivement accusées d'exporter les guerres dans les régions d'outre-mer, masquant sous de fausses préoccupations idéologiques une défense évidente de leurs intérêts économiques et coloniaux. Alors que les causes de la guerre de 1914-1918 demeurent contestables et obscures, la Seconde Guerre mondiale unit les Alliés contre les pays de l'Axe dans une confrontation qui prendra de plus en plus l'allure d'une croisade contre le Mal. L'entente entre Churchill, De Gaulle, Eisenhower et Staline fut de courte durée. En effet, les États-Unis engagèrent la guerre de Corée puis celle du Viêt-nam sous le prétexte de stopper la progression du communisme dans le monde.

Comme par le passé, le Kremlin, qui était décidé à contrôler les États satellites de l'Union soviétique, intervint militairement en Hongrie (1956) et en Tchécoslovaquie (1968). Dans ces pays, le soulèvement populaire était en grande partie spontané. Dans d'autres, au contraire, ce furent des mouvements de libération nationale politiquement organisés qui engagèrent une lutte armée contre les vieilles puissances impérialistes. Pour la première fois, des pays appartenant au Commonwealth comme le Canada, malgré un mouvement indépendantiste frustré qui perdure chez les Québécois, obtinrent pacifiquement leur indépendance. L'Inde fit office de pionnière avec ses campagnes de désobéissance civile prônées par Gandhi. Elles rencontrèrent un écho favorable et montrèrent une réelle efficacité dans la lutte contre les Anglais. Plus tard, ce grand pays devra accorder les territoires du Nord à sa forte minorité musulmane, lesquels formeront ultérieurement le Pakistan.

Ce siècle, que l'on dit sans Dieu, est paradoxalement caractérisé par les guerres à caractère religieux. La montée en puissance de l'islamisme et le recours au Djihad (la Guerre sainte) divisa de nombreux pays en Europe, particulièrement dans la région des Balkans, mais aussi au Moyen-Orient. En 1948, la création de l'État d'Israël apparut aux Palestiniens comme une façon pour l'Europe de déplacer ses propres problèmes. Des guerres civiles éclatèrent dans des pays qui renversaient les anciens systèmes d'oppression. Ce fut le cas en Chine où, dès 1949, Mao Tsé-Toung inaugura la République populaire, le plus vaste pays communiste du monde.

Paradoxalement, ce XXe siècle s'illustre aussi par une forte aspiration populaire à la paix. Depuis les petits groupes d'objecteurs de conscience contre la Première Guerre mondiale aux campagnes internationales pour le désarmement nucléaire, les individus organisés se sont regroupés au sein de mouvements de masse n'ayant pour autre ambition que de donner à l'être humain une place prépondérante. Il est vrai que, de plus en plus, les guerres modernes affectent tout autant, voire plus, les civils que les militaires. Selon les chiffres fournis par la Croix-Rouge, si 85 % des victimes de la Première Guerre mondiale étaient des militaires, le pourcentage s'était exactement inversé en 1988 pendant le conflit du Golf. Si la guerre meurtrière des tranchées appartient à une époque révolue, les progrès technologiques rendent également caduc l'alignement des armées sur le champ de bataille. Les techniques nouvelles ont généré aussi des progrès d'un autre genre, tout particulièrement dans le domaine médical. En effet, la propagation des vaccins a entraîné la disparition de la variole, de la scarlatine et de la lèpre dans le monde. L'éradication de la poliomyélite, de la fièvre jaune et de l'hépatite virale est en cours dans de nombreux pays. L'espérance de vie dans les nations développées, où l'existence se prolonge souvent entre quatre-vingts et quatre-vingt-dix ans, a doublé par rapport au siècle dernier. Néanmoins, les régions plus pauvres sont encore affligées de maladies, comme le choléra et le typhus, qu'il serait pourtant possible d'éradiquer.

Culturellement, les progrès technologiques seraient aussi susceptibles de rapprocher les populations. Qu'on le salue ou qu'on le déplore, il est incontestable que les séries télévisées populaires ont conquis de larges secteurs du public planétaire. Une toute nouvelle forme d'art, le cinéma, a connu son apogée durant les années 30 et 40. Puis l'image se popularisa irrésistiblement avec l'accession à la photo bon marché et au caméscope. Dans cette saga moderne, les films américains et les jeux vidéo furent accusés d'avoir servi la promotion de la violence anonyme, en particulier auprès des jeunes.

Dans le domaine de la musique et de la confection, l'apparition de la mode comme un important phéno-

TWO GIRLS HITCHHIKING IN THE SOUTH
OF FRANCE, JULY 1954.

ZWEI MÄDCHEN FAHREN PER AUTOSTOPP DURCH
DEN SÜDEN FRANKREICHS, JULI 1954.

DEUX JEUNES FILLES FAISANT DE L'AUTO-STOP DANS
LE SUD DE LA FRANCE, JUILLET 1954.

En général, la mode s'orientait vers une conception plus confortable et moins formelle de la confection, en particulier pour le vêtement féminin.

Dans les seules années 80, le nombre des émigrants doubla. Si la cause est à chercher dans les conflits où les intérêts des marchands d'armes et des usines d'armement l'emportent sur les motifs purement idéologiques, il n'en demeure pas moins qu'un exode de type nouveau est en train d'apparaître : celui des « réfugiés économiques » cherchant à échapper à des conditions difficiles qui ne permettent plus leur survie.

Tandis qu'on assistait à des transformations globales aussi bien du nord au sud que de l'est à l'ouest, un continent, s'affirma de plus en plus comme un tout nouveau creuset de cultures : l'Australie.

À la fin de ces années 80, en dépit de certains mouvements réactionnaires, l'Europe de cette fin de siècle consolide néanmoins son union, et tente tant bien que mal d'intégrer les travailleurs émigrés appelés à y travailler lors du boom de l'emploi consécutif à la Seconde Guerre mondiale.

Si le XIXe siècle a vu les Européens émigrer vers les colonies d'outre-mer, le XXe siècle fut le témoin du phénomène inverse.

L'Afrique du Sud, à l'instar de l'Irlande du Nord, est enfin (presque pacifiquement) passée à un gouvernement digne des nations démocratiques. Une nouvelle considération, bien que tardive, pour les populations autochtones amazonniennes, africaines et australiennes s'accompagne du respect et de la compréhension communes des relations délicates gouvernant les espèces qui peuplent notre planète.

Aujourd'hui, faisant fi des frontières et des nationalités, le souci primordial d'un grand nombre de jeunes concerne notre avenir commun. La prise de conscience, entretenue par les scientifiques, que chaque heure passée voit disparaître inexorablement cinq espèces dans le monde, a galvanisé l'élan écologique. Hormis une aide efficace en direction des jungles de Bornéo ou du Brésil, cet élan a permis d'avoir un impact immédiat dans les pays industrialisés d'Amérique du Nord et d'Europe de l'Ouest. L'Union européenne, le Congrès des États non alignés, l'Organisation des États africains ou américains sont autant de structures qu'il eût été difficile d'imaginer au début du siècle. Ce qu'il reste présentement à faire, c'est avant tout d'anticiper sur les problèmes actuels et de tout mettre en œuvre afin que la recherche de l'harmonie prenne le pas sur celle de la guerre.

mène de société obligea de nombreuses régions à se défaire de leurs habitudes traditionnelles. Des charters se mirent à emmener les touristes, à des prix de plus en plus économiques, pour des destinations exotiques. Ceux-ci en ramenèrent tee-shirts et sacs en matière plastique qui, à leur tour, essaimèrent le globe. L'un après l'autre, les centres occidentaux de la confection cherchèrent l'inspiration dans les fibres naturelles et les modèles traditionnels. Ce mouvement fut surtout sensible après l'entrée du Japon sur la scène de la mode. D'autres styles vestimentaires intégrèrent les progrès scientifiques dans leurs créations : en 1968, les premiers hommes à marcher sur la Lune inspirèrent une série de tenues « spatiales » dans les défilés parisiens et milanais.

FIDEL CASTRO

VIRGINIA WOOLF

ALBERT EINSTEIN

INDIRA GANDHI

ALEXANDER FLEMING

PRINCESS ELIZABETH

LE CORBUSIER

EVA PERÓN

CHARLES DE GAULLE

PRINCESS GRACE

NIKITA KHRUSHCHEV

JACQUELINE ONASSIS

SIMONE DE BEAUVOIR

WINSTON CHURCHILL

ANNE FRANK

IDI AMIN

MARILYN MONROE

ROBERT OPPENHEIMER

MOTHER TERESA

RICHARD NIXON

THE PRINCESS OF WALES

MAO TSE-TUNG

MARGARET THATCHER

ANDY WARHOL

Aspects of the 1920s and 1930s

UNTIL the twentieth century, fashion concerned men at least as much as women. Concepts such as 'power dressing' and 'dressing to kill' may not have been so labelled, but clothing as an expression of sex and control was a male province.

Fashion in women's attire developed relatively gradually in the nineteenth century, from the smooth sweep of crepe and chiffon in Empire-line gowns to the fussy bustles and lacy overskirts of the Victorian era. Power and sexuality were not yet linked to the role of women, which in the eighteenth and nineteenth centuries was primarily to be demure and obedient. That, at least, was the behaviour expected of upper-class women, those belonging to the only level of society which could afford to follow fashion anyway. Perhaps one of the greatest changes to take place in women's fashions this century is the factor of economic control. No longer attired merely as a delightful ornament displaying her husband's wealth, the twentieth-century woman can dress to please herself at a price she can afford. This has meant two major differences, both closely linked to women's new purchasing power. One is the growth of a medium-price range, independent of either couturier exclusivity or chain-store mass production; the other is a preference for garments practicable for work and daily living rather than decoration and ostentation.

1

The first major shift came in the wake of the Great War. With so many men away, women entered the industrial workplace in considerable numbers. Even after the war the male death toll from the trenches and the aftermath of the 'flu epidemic was so high that women never wholly returned to their home-bound role. The 1920s saw an adaptation of styles – bobbed haircuts, suits and trousers – to new living conditions, coloured by the whole mood of the flappers' jazz era.

The 1930s saw the parallel development of the well-dressed woman, with her fitted bodice, stiletto heels and neat hat, and increasingly frenetic leisure designs to match the mood of the times. Fashion moved with the speed of new transport through increasingly racy styles. The rise of cabaret and film stars began to set the more masculine trends that became common currency in the 1940s: tailored trouser suits demonstrated that women were increasingly wearing the pants and even the top hats of the men, with accessories that stretched to copies of their cigarette holders and briefcases.

Gabrielle Chanel, nicknamed 'Coco', became a byword for neat elegance in the 1920s and '30s (2). She liberated women from corsets and heavy dresses, putting them instead into tailored suits and chemises and bobbed hairstyles. From a poor background, she mingled with the richest and most famous, but claimed never to feel truly at home. She never married. Her first perfume (called No. 5 after her lucky number) became a world best-seller, and her costume jewellery gave the *nouveaux riches* permission to set aside their pearls. There was also plenty of scope for other unorthodox details – like the metal garters and the clocks on these silk stockings (1).

The elegance of Thirties fashion, as epitomized by the films of Myrna Loy, Ginger Rogers and Marlene Dietrich, was in strong contrast to the hard lives of Mid-West American farmers and their families, or the families of the poor and unemployed in Britain. The Depression following the Wall Street Crash of 1929 was a deeper and more far-reaching recession than any before or since. It led to a world slump, beginning with a drastic drop in wheat prices when over-production in the US and Canada flooded markets, and new competition from Soviet timber caused a further collapse. The despair of the Mid-West farmers was documented in the seminal book by Walker Evans and James Agee, *Let Us Now Praise Famous Men* (1930).

Bis zu unserem Jahrhundert war Mode mindestens ebensosehr eine Sache der Männer wie der Frauen. Zwar diente die Kleidung noch nicht zur Demonstration von »Macht« oder der »Verführung«, doch von jeher kleideten Männer sich, um ihre Überlegenheit und Sexualität zu zeigen.

Die Damenmode des 19. Jahrhunderts entwickelte sich nach und nach vom weichen Fall der Empirekleider aus Crêpe und Chiffon zu den gekünstelten Turnüren und Spitzenüberröcken der viktorianischen Zeit. Macht und Sexualität kamen im Frauenbild dieser Zeit noch nicht vor, denn im 18. und frühen 19. Jahrhundert hatte eine Frau vor allem still und gehorsam zu sein, zumindest eine Frau der Oberschicht, und sie waren die einzigen, die es sich leisten konnten, mit der Mode zu gehen. Darin bestand vielleicht die größte Neuerung der Mode unseres Jahrhunderts – daß sie nun nicht mehr den Wohlhabenden vorbehalten war. Die Frau des 20. Jahrhunderts war nicht mehr nur ein hübsches Zierstück, mit dem ihr Mann seinen Wohlstand demonstrierte, sondern Frauen konnten tragen, was sie wollten, jede nach ihrem Geschmack und ihrem Geldbeutel. Das brachte zwei große Veränderungen mit sich. Zum einen kamen Kleider mittlerer Preislage auf, unabhängig von den exklusiven Modehäusern und den Massenprodukten der Kaufhäuser; zum anderen lag das Schwergewicht nun auf praktischer Kleidung für Alltag und Beruf und nicht mehr auf Prunk und Dekor.

Die ersten grundlegenden Wandlungen kamen im Zuge des Ersten Weltkriegs. Ein Großteil der Männer war im Feld, und ein beträchtlicher Teil der Frauen begann nun in den Fabriken zu arbeiten. Und auf den Schlachtfeldern und anschließend der großen Grippeepidemie kamen so viele Männer um, daß die Frauen nie wieder ganz an ihren alten Platz am heimischen Herd zurückkehrten. In den 20er Jahren paßte sich der Stil den veränderten Lebensumständen an – die Frauen hatten nun kurze Haare, trugen Kostüme und Hosen, und alles war geprägt vom Lebensgefühl des Jazz-Zeitalters.

In den 30er Jahren entwickelten sich nebeneinander das Bild der gut gekleideten Frau mit enger Taille, hohen Absätzen und adrettem Hut und eine immer ausgefallener werdende Freizeitmode, in der die Stimmung der Zeit zum Ausdruck kam. Der Aufstieg von Kabarett- und Filmstars prägte nun den eher maskulin bestimmten Stil der 40er Jahre: Maßgeschneiderte Anzüge zeigten, daß Frauen zusehends die Hosen und sogar die Zylinderhüte der Männer trugen, und zudem schmückten sie sich mit typisch männlichen Accessoires, mit Zigarettenspitzen und Aktentaschen.

Gabrielle Chanel, genannt »Coco«, wurde in den 20er und 30er Jahren zum Inbegriff gepflegter Eleganz (1).

FASHION PHOTOGRAPHIES FOR THE HOUSE OF SEEBERGER FRÈRES
MODEPHOTOGRAPHIEN DER GEBRÜDER SEEBERGER

Sie befreite die Frauen von Korsetts und schweren Stoffen und steckte sie statt dessen in Schneiderkostüme und Hemden.

Nirgends kommt die Eleganz der Mode der 30er Jahre besser zum Ausdruck als in den Filmen mit Stars wie Myrna Loy, Ginger Rogers und Marlene Dietrich, und der Kontrast zum anstrengenden Leben amerikanischer Farmer im Mittelwesten oder den Armen und Arbeitslosen in England hätte nicht größer sein können. Die Wirtschaftskrise nach dem Schwarzen Freitag 1929 brachte tiefgreifendere Veränderungen mit sich als jede andere Krise zuvor oder danach. Die ganze Welt wurde in den Strudel gerissen; die Weizenpreise fielen drastisch, als die Überproduktion aus den Vereinigten Staaten und Kanada die Märkte überschwemmte, und die neue Konkurrenz sowjetischer Holzhändler brachte einen weiteren Markt zum Zusammenbruch. Walker Evans und James Agee hielten das Elend der Farmer des Mittelwestens 1930 in einem einflußreichen Buch fest, *Let Us Now Praise Famous Men*.

PHOTOGRAPHIES DE MODE POUR
LA MAISON DE SEEBERGER FRÈRES.

JUSQU'AU XXᵉ siècle la mode était une affaire d'hommes autant que de femmes. Même si l'habit en tant qu'arme de « puissance » et de « séduction » était encore un concept inexistant, il n'en demeurait pas moins à l'usage exclusif des hommes comme l'expression du pouvoir sexuel et de la domination.

La mode s'imposa dans le vêtement féminin plutôt petit à petit au cours du XIXᵉ siècle, évoluant du drapé lisse du crêpe et du chiffon de la ligne Empire jusqu'aux tournures maniérées et aux tabliers en dentelle de l'ère victorienne. Ni le pouvoir ni la sexualité n'étaient encore rattachés au rôle de la femme, qui se devait avant tout, aux XVIIIᵉ et XIXᵉ siècles, d'être grave et obéissante. Tel était du moins le comportement attendu des femmes de la bourgeoisie, seules à pouvoir se permettre le luxe de suivre la mode. La maîtrise du pouvoir économique permettra à la femme du XXᵉ siècle de s'habiller selon ses moyens et ses propres goûts. Deux grands phénomènes sont étroitement liés au nouveau pouvoir d'achat de la femme. L'un est l'apparition d'une gamme de prix moyens indépendants des couturiers exclusifs et des productions en série des grands magasins. L'autre est la préférence donnée aux vêtements de travail ou de tous les jours pour lesquels on privilégie le côté pratique au détriment de la décoration et de l'ostentation.

Le premier grand changement se produisit dans le sillage de la Grande Guerre. À cause du nombre élevé d'hommes absents, les femmes s'engouffrèrent en masse dans l'industrie. Même après la fin de la guerre, où tant d'hommes avaient trouvé la mort dans les tranchées tandis que d'autres avaient été décimés par l'épidémie de grippe, les femmes ne se cantonnèrent plus jamais entièrement à un rôle exclusif de ménagère. Dans les années 20, les styles s'adaptent – coiffures à la Jeanne d'Arc, ensembles et pantalons – aux nouvelles conditions de vie et aux couleurs d'une époque jazzy à l'humeur « garçonne ».

Au cours des années 30, on assiste à une évolution vers la femme bien habillée, au corsage ajusté, aux talons aiguilles et au chapeau coquet, à l'apparition de lignes toujours plus frénétiquement décontractées pour répondre à l'humeur du jour. Le succès grandissant des cabarets et des vedettes de cinéma participe au lancement des tendances plus masculines qui devaient se généraliser durant les années 40 : les femmes portent de plus en plus le pantalon et même le chapeau haut-de-forme agrémentés d'accessoires inspirés de leurs fume-cigarettes et leurs serviettes. Gabrielle Chanel, surnommée « Coco », devint synonyme d'élégance dans les années 20 et 30 (1). Elle débarrassa la femme de ses corsets et de ses lourdes robes qu'elle remplaça par des ensembles sur mesure, des robes-chemisiers et des coiffures courtes. Issue d'un milieu modeste, elle fréquenta les plus riches et les plus célèbres, mais affirma toujours ne pas se sentir vraiment à l'aise en leur compagnie. Elle ne se maria jamais. Son premier parfum (baptisé Nᵒ 5, d'après son chiffre porte-bonheur) remporta un succès commercial mondial, tandis que ses bijoux, en toc, donnaient aux nouveaux riches la permission de laisser leurs perles à la maison. D'autres détails aussi peu orthodoxes étaient admis, telles ces jarretières métalliques et les broderies sur le côté de ces bas en soie (2). L'élégance de la mode des années 30 dont les films de Myrna Loy, Ginger Rogers et Marlène Dietrich se faisaient les ambassadeurs contrastait violemment avec l'existence difficile des pauvres et des chômeurs en Grande-Bretagne. L'effondrement de la bourse de Wall Street en 1929 entraîna une récession d'une ampleur et d'une gravité sans précédent. Elle fut suivie d'un marasme mondial qui commença par la chute brutale des prix du blé. Le désespoir des fermiers du Middle West est décrit dans un ouvrage, écrit par Walker Evans et James Agee, intitulé *Let Us Now Praise Famous Men* (1930).

© MACK SENNETT COMEDIES
5110 B.

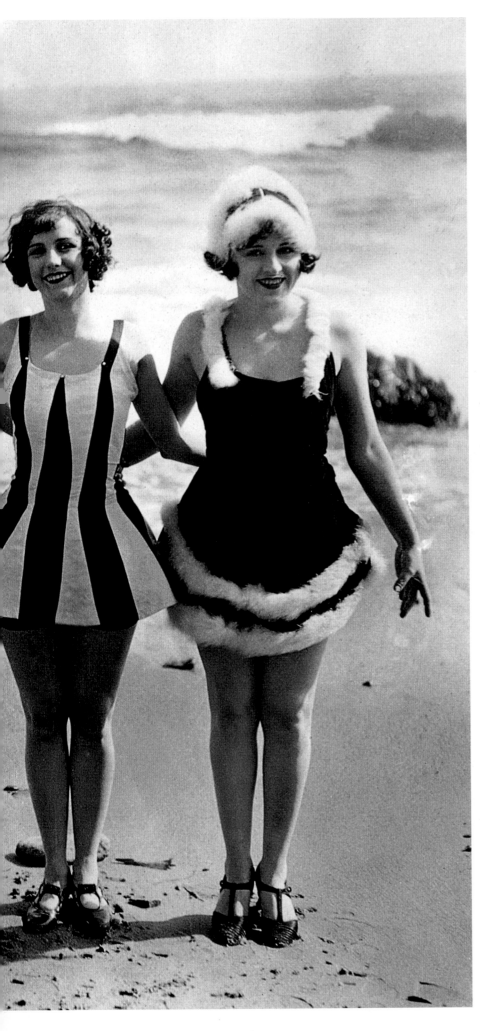

THE cult of the body beautiful, 1925. Suntanned legs might just be coming into fashion but shoes must be worn on the beach at all costs. These bathing belles sport costumes as artificial as their smiles, and what happens to this kind of 'skating skirt' in the salt water doesn't bear thinking about. But perhaps swimming is not too high up on the agenda.

DER Kult des schönen Körpers, 1925. Sonnengebräunte Beine kamen gerade in Mode, doch niemand ging ohne Schuhe an den Strand. Diese Badenixen führen Kleider vor, die genauso unnatürlich sind wie ihr Lächeln, und was aus einem solchen Röckchen, das eher an ein Eislaufkostüm erinnert, wird, wenn es ins Salzwasser kommt, ist gar nicht auszudenken. Doch hatte Badevergnügen wahrscheinlich ohnehin keine Priorität.

LE culte du beau corps, 1925. Les jambes bronzées devenaient peut-être à la mode, mais les chaussures n'en restaient pas moins, quoi qu'il en coûtât, indispensables sur la plage. Ces jolies baigneuses paradent dans des tenues aussi artificielles que leurs sourires. En outre, on frémit à la pensée de ce qui pouvait arriver dans l'eau salée avec ce genre de « jupe de patinage ». Mais la nage ne figurait pas forcément au programme.

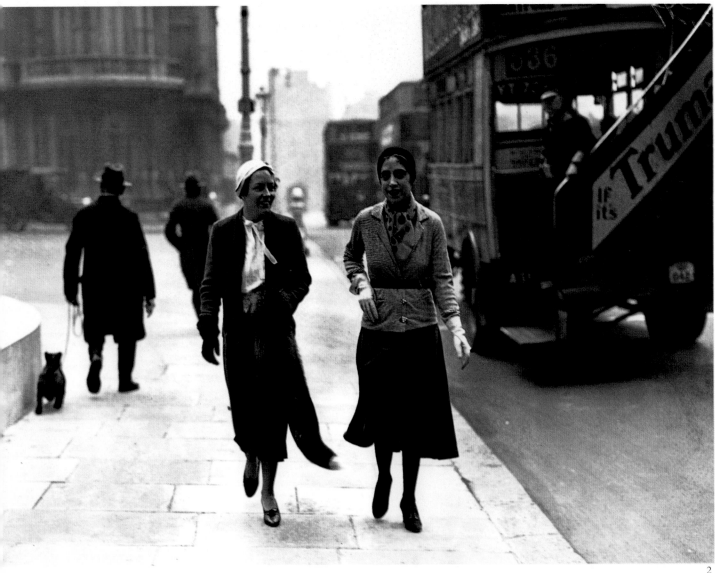

THEATRE had a part to play in a model's training. This German model is dramatically posed and lit to make a back view as alluring as a front one, the head tossed to one side like a cabaret singer's (1). Elsa Schiaparelli (2), remarkable for her unexpected plainness in one devoted to beauty, and primarily known for her fashion choice of a shocking pink that came to be called after her, here puts down a further marker. Arriving in London in 1935, she announced 'Trousers for Women' in the same crusading tone as 'Votes for Women'. And to demonstrate that she, too, is on to a winner, she wears them herself, albeit in more restrained form as culottes.

DAS Theater spielte einen wichtigen Part bei der Ausbildung eines Models. Dieses deutsche Mannequin nimmt eine dramatische Pose ein und ist so beleuchtet, daß die Rückenansicht genauso anziehend wirkt wie ein Frontalporträt; den Kopf hat sie zur Seite geworfen wie eine Sängerin im Kabarett (1). Elsa Schiaparelli (2), die sich für eine Modeschöpferin immer betont einfach kleidete, und die vor allem durch den nach ihr benannten schockierenden Pinkton im Gedächtnis geblieben ist, macht hier ein weiteres Mal Geschichte. Bei ihrer Ankunft in London im Jahre 1935 forderte sie »Hosen für die Frau« mit den gleichen flammenden Worten, mit denen zuvor »Wahlrecht für die Frau« gefordert worden war. Und um zu zeigen, daß sie ebenso siegesgewiß ist, trägt sie sie gleich selbst, wenn auch in der gemäßigten Form des Hosenrocks.

L'ART dramatique faisait partie de la formation des mannequins. On a fait prendre à ce mannequin allemand une pose théâtrale sous un éclairage destiné à la rendre aussi aguichante de dos que de face, la tête inclinée sur le côté à la manière d'une chanteuse de cabaret (1). Elsa Schiaparelli (2), remarquable de simplicité, ce qui est inattendu chez quelqu'un qui se consacre à la beauté, était avant tout connue en raison du rose flamboyant, qui reçut son nom, et qu'elle choisit de mettre à la mode. On la voit poser ici un nouveau jalon. Arrivée à Londres en 1935, elle proclama « les femmes en pantalon » sur le même ton revendicatif que « le vote aux femmes ». Elle-même le portait pour se montrer dans le coup, bien que dans sa variante plus modeste de jupe-culotte.

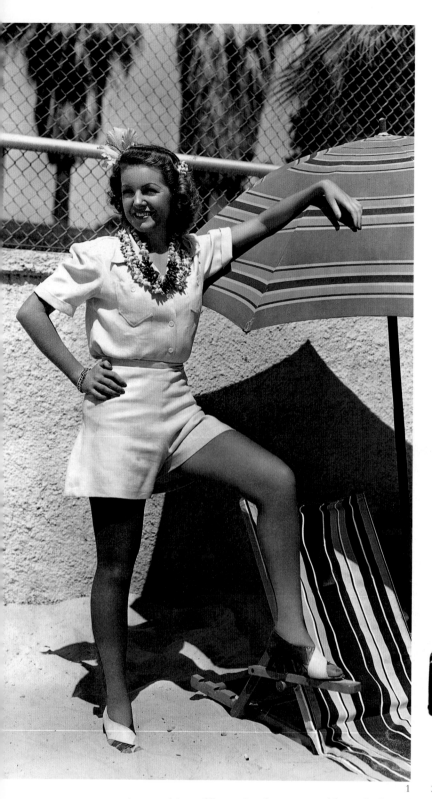

1 2

THERE is something self-consciously out-to-shock about the contemporary captions to these beach beauty pictures. Though it is evidently *risqué* to show her legs in a public place, this model's daring has to be infantilized: she is dressed like a child in 'a yellow linen sunsuit [which] makes a charming background for the quaint shell bead necklace, the latest in country jewellery' (1). In 1932, the outsized Japanese butterflies beneath their parasols remind us: 'Women smokers number almost as many as the men these days, and it was natural for these bathers to produce cigarettes and matches as they enjoyed a laze in the sun on the diving board at Cliftonville' (2).

DIE Texte, mit denen seinerzeit diese Bilder von Strandschönheiten präsentiert wurden, haben etwas bemüht Kokettes. Bei dem linken zum Beispiel wird das Mannequin, obwohl es ja damals gewagt war, soviel Bein in der Öffentlichkeit zu zeigen, beschrieben wie ein kleines Mädchen: »Sonnenanzug aus gelbem Leinen, genau das Richtige, um das putzige Muschelkollier zu zeigen, der letzte Schrei in Naturschmuck« (1). 1932 geben

uns diese Mesdames Butterfly unter ihren Sonnenschirmen zu verstehen: »Es gibt heute fast ebenso viele Raucherinnen wie Raucher, und diese drei, die auf einem Sprungbrett in Cliftonville die Sonne genießen, finden überhaupt nichts dabei, ihre Zigarettenpäckchen und Streichhölzer hervorzuholen.« (2)

LES légendes rédigées par les contemporains sur ces photographies de beautés posant sur la plage ont décidément un petit quelque chose de délibérément choquant ! Même s'il était manifestement risqué de montrer ses jambes dans un lieu public, l'audace de ce mannequin se doit d'être infantilisée : elle est habillée de manière enfantine, sa « tenue de plage en lin jaune faisant ressortir

de façon charmante un bien joli collier de coquillages, dernier cri en matière de bijou de plein air » (1). En 1932, ces papillons japonais plus grands que nature sous leurs parasols nous rappellent que « les femmes sont presque aussi nombreuses à fumer que les hommes aujourd'hui, et [que] c'était un geste naturel pour ces baigneuses de sortir des cigarettes et des allumettes tout en prenant le soleil sur leur plongeoir à Cliftonville. » (2)

DANCERS take a break from Manhattan's *Merry Whirl* show, sporting their 'Koko Kooler' headgear to protect themselves less from the New York sun than from its refraction off the water's surface (1). Meanwhile in Britain in 1932, the craze for sailor flares allowed copious display of back and behind at Thorpe Bay's 'pyjama parade', worthy of the West End hit musical *The Pajama Game* (2).

EINE Pause für die Tänzerinnen der *Merry Whirl*-Show in Manhattan. Die »Koko Kooler«-Hüte schützen sie weniger vor der New Yorker Sonne als vor den Reflexionen des Lichts im Wasser (1). In

1

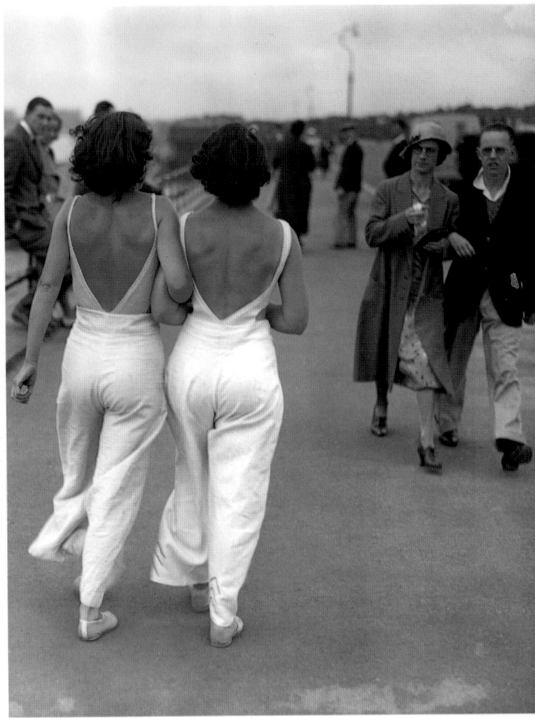

2

England waren 1932 nach dem großen Erfolg des West-End-Musicals *The Pajama Game* Seglerhosen in Mode, und hier auf der »Pyjama-Parade« in Thorpe Bay wurden Rücken und Po gezeigt (2).

L ES danseuses pendant une pause du spectacle de Manhattan, *Merry Whirl*, paradent avec leur couvre-chef « Koko Kooler », moins destiné à les protéger du soleil new yorkais que de sa réfraction à la surface de l'eau (1). Pendant qu'en

Grande-Bretagne, à Thorpe Bay, en 1932, l'engouement pour les lignes évasées des vêtements de marin permettait de dénuder généreusement le dos et les reins à la « pyjama parade », digne du spectacle de variétés en vogue à West End, *The Pajama Game* (2).

PHYSICAL studies, often linked to eurythmics and Isadora Duncan-style 'Greek' dancing, was a part of a whole back-to-nature programme current in the 1920s. In Germany this had a more sinister dimension, working on an assumption of human perfectability that chimed in with Hitlerian notions of higher beings derived from the combination of female spirituality and male superiority.

LEIBESÜBUNGEN, oft verbunden mit Eurhythmie und »griechischen« Tänzen in der Art Isadora Duncans, waren ein wichtiger Teil der Zurück-zur-Natur-Bewegung der 20er Jahre. In Deutschland hatte dies eine unheilvolle Seite, weil dort die Vervollkommnung des Körpers mit der Nazi-Ideologie einherging, nach der die Verbindung weiblicher Spiritualität mit männlicher Überlegenheit Übermenschen hervorbringen sollte.

L'ÉTUDE du corps, souvent liée à la gymnastique rythmique et à la danse d'inspiration « grecque » telle que celle d'Isadora Duncan, faisait partie de tout un programme de retour à la nature alors en vogue dans les années 20. En Allemagne elle avait pris des contours plus sinistres, développant l'affirmation de la perfectibilité de l'homme et popularisant les notions hitlériennes d'êtres supérieurs nés de la combinaison de la spiritualité féminine et de la supériorité masculine aryennes.

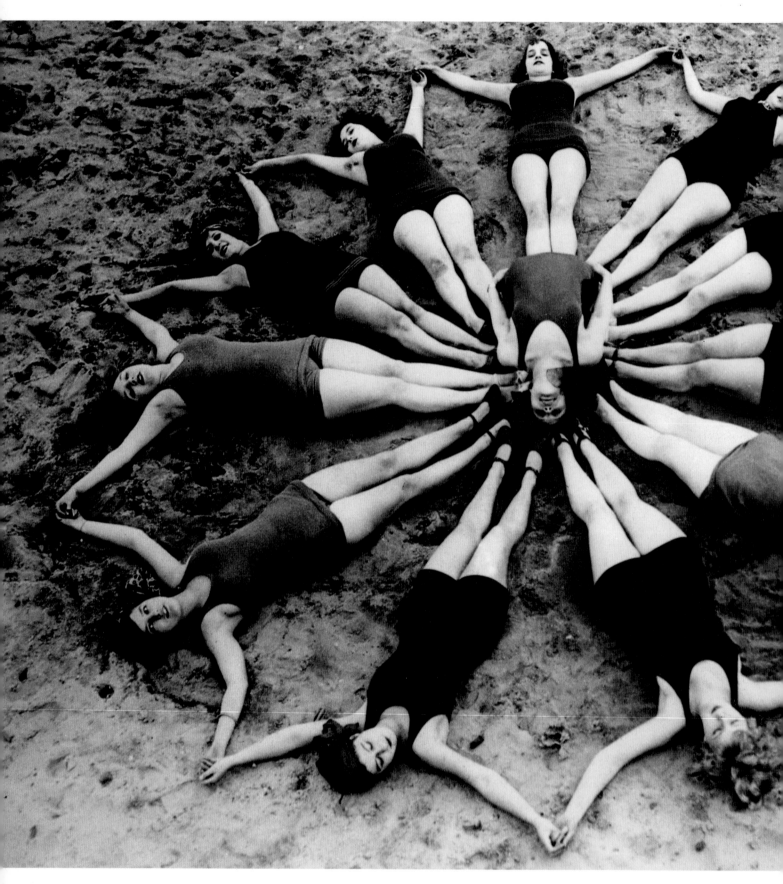

THE theories behind the cult of physical education had something in common with present-day 'New Age' philosophies, communing with nature, attuning to the elements and 'alpha-waving' the brain into

harmony with the spheres. American girls took it up enthusiastically, whether singly (2) or in groups like Ida Schnall's Daily Dozen girls, forming a starfish on Brighton Beach, New York (1).

DIE Weltanschauung, die hinter solchen Leibesübungen stand, hatte vieles mit unseren heutigen New-Age-Philosophien gemeinsam – Einklang mit der Natur, »Alphawellen« des Hirns, die im Rhythmus der

Sphärenharmonien schwingen. Amerikanerinnen machten begeistert mit, ob allein (2) oder in Gruppen wie Ida Schnalls Daily Dozen Girls, die hier einen Seestern am New Yorker Brighton Beach bilden (1).

LES théories inspirant le culte de la culture physique présentent des traits communs avec les philosophies actuelles du « Nouvel Âge » : communier avec la nature, être à l'unisson des éléments et amener le cerveau en harmonie avec les sphères par le « flux alpha ». Elles furent reprises avec enthousiasme par les Américaines, en solitaire (2) ou en groupe ; ainsi les Daily Dozen Girls de Ida Schnall dessinant sur la plage de Brighton, à New York, une étoile de mer (1).

HOUSEWIVES in 1930s Germany were encouraged to accompany domestic virtue with body-toning gymnastics, high heels notwithstanding: how to make the bed healthily! (3). Filmstar Joan Crawford (1), formerly a dancer, gave the high kick her all – and an international seal of marketability. At the English Scandinavian Summer School of Physical Education in Kent, 130 pupils from 14 countries demonstrated their lessons in balance and poise on the parallel bars (2).

DEUTSCHE Hausfrauen der 30er Jahre sollten auch bei der Hausarbeit ihren Körper mit Gymnastik stählen: So wird athletisch das Bett gemacht, und noch dazu in Stöckelschuhen! (3) Als ehemalige Tänzerin wußte Filmstar Joan Crawford die Beine zu schwingen (1) und kam damit überall auf der Welt an. An der Englisch-Skandinavischen Sommerschule für Sporterziehung in Kent demonstrierten 130 Schülerinnen aus 14 Ländern ihr Gleichgewicht und ihre Haltung auf dem Schwebebalken (2).

DANS les années 30, les ménagères allemandes étaient encouragées à ne pas oublier, outre leurs vertus domestiques, de travailler leurs corps par la gymnastique : comment faire le lit de façon efficace avec de hauts talons ! (3). La vedette de cinéma, Joan Crawford (1), avait été danseuse : elle donna ici son maximum ; ce qui lui valut de connaître une réussite commerciale internationale importante. À l'école d'été d'éducation physique anglo-scandinave, dans le Kent, 130 élèves venues de 14 pays font une démonstration de ce qu'elles ont appris en restant en équilibre sur des barres parallèles (2).

2

3

IN 1932, office workers from the City of London took to the rooftops. With Tower Bridge in the background and Adelaide House beneath their feet, 40 secretaries spent their lunch-hour skipping (1). A decade later, the great outdoors was a suitable background for some rather strained and unusual ballet exercises, demonstrated by dancers for the average housewife to follow (3). In 1935, contingents of The Women's League of Health and Beauty, an organization which had adopted some of the ideals then current in Germany, proclaimed 'AIM: RACIAL HEALTH' on their banners as they arrived in London's Hyde Park to give a display (2).

IM Jahre 1932 stiegen Londoner Büro-angestellte auf die Dächer. Vierzig Sekre-tärinnen verbringen ihre Mittagspause mit Seilspringen, im Hintergrund die Tower Bridge, unter sich das Adelaide House (1). Zehn Jahre später gab die freie Natur den passenden Hintergrund für diese merkwür-digen und nicht ganz einfach aussehenden Ballettübungen ab; Tänzerinnen führten sie vor, und Hausfrauen sollten sie nach-turnen (3). 1935 marschierte die Women's League of Health and Beauty (Frauenliga für Schönheit und Gesundheit), die einige der damals in Deutschland herrschenden Ideale übernommen hatte, unter dem Banner »UNSER ZIEL: GESUNDHEIT DER RASSE« im Londoner Hyde Park auf (2).

EN 1932, des employées de la City de Londres montent sur les toits. Le pont de la Tour dans le dos, l'Adelaïde House sous les pieds, 40 secrétaires font du saut à la corde pendant leur pause-déjeuner (1).

Dix ans plus tard, les grands espaces se prêteront tout à fait à des exercices de ballet passablement éprouvants et inhabituels à l'intention de la ménagère ordinaire (3). En 1935, des détachements de la Ligue féminine de la santé et de la beauté, organisation qui avait adopté certains des idéaux en vogue en Allemagne, déployaient des bannières procla-mant « OBJECTIF : SANTÉ RACIALE » en arrivant à Hyde Park, à Londres, pour s'y livrer à une démonstration(2).

DEVICES for those loath to undertake serious exercise but prepared to submit to slimming devices. One woman greets the 'first appearance in England of New Gymnastic Apparatus' designed for a confined space by simultaneously somersaulting and cartwheeling (1). Another demonstrates the 'spring leg' which comes with the aim of 'perfecting the limbs' as a 'developing treatment for our athletic ladies' (2). Rosemary Andree straps her high heels and, rather bravely, her neck into a 'slimming exerciser' whose exact function remains a mystery (3).

GERÄTE für alle, die zwar nichts für Sport übrighatten, aber um der Schlankheit willen turnen wollten. Eine Frau begrüßt »das erste Exemplar eines neuartigen Gymnastikapparates in England«, mit dem man auf engem Raum gleichzeitig einen Salto machen und radschlagen konnte (1). Eine andere führt die »Beinfeder« vor, die »perfekte Waden« versprach, eine »Trainingshilfe für unsere Athletinnen« (2). Rosemary Andree hat keine Furcht, Stöckelschuhe und Hals in diesen »Schlankheitstrimmer« zu stecken, dessen genaue Funktion rätselhaft bleibt (3).

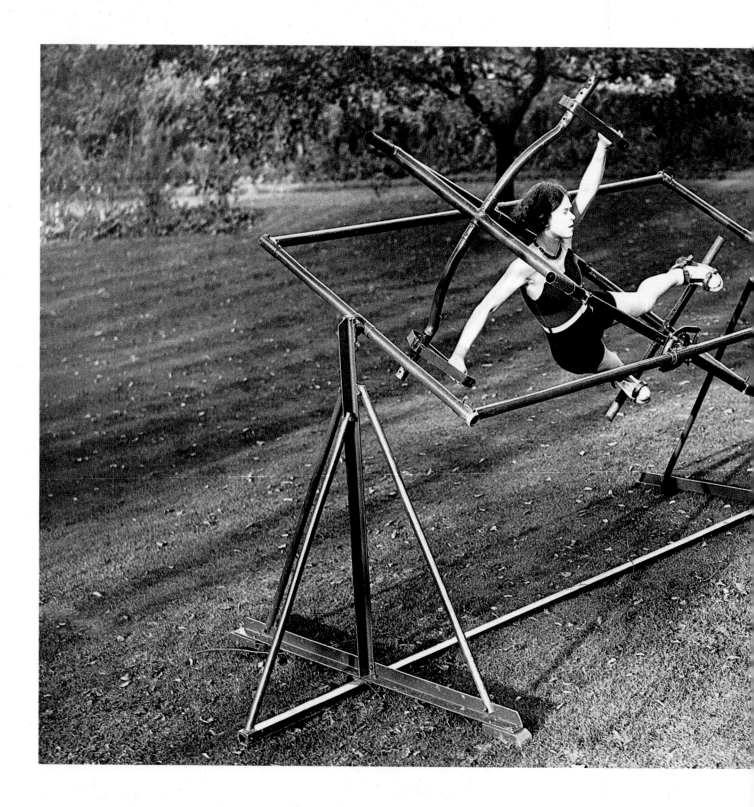

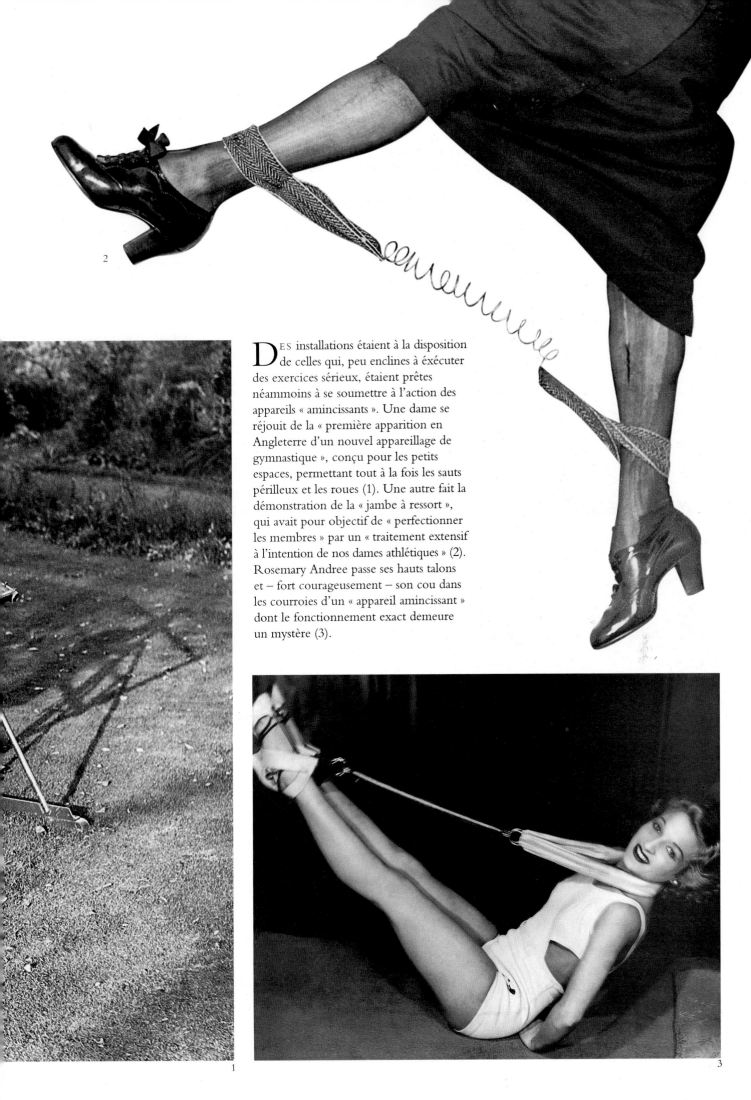

DES installations étaient à la disposition de celles qui, peu enclines à éxécuter des exercices sérieux, étaient prêtes néammoins à se soumettre à l'action des appareils « amincissants ». Une dame se réjouit de la « première apparition en Angleterre d'un nouvel appareillage de gymnastique », conçu pour les petits espaces, permettant tout à la fois les sauts périlleux et les roues (1). Une autre fait la démonstration de la « jambe à ressort », qui avait pour objectif de « perfectionner les membres » par un « traitement extensif à l'intention de nos dames athlétiques » (2). Rosemary Andree passe ses hauts talons et – fort courageusement – son cou dans les courroies d'un « appareil amincissant » dont le fonctionnement exact demeure un mystère (3).

2

1

3

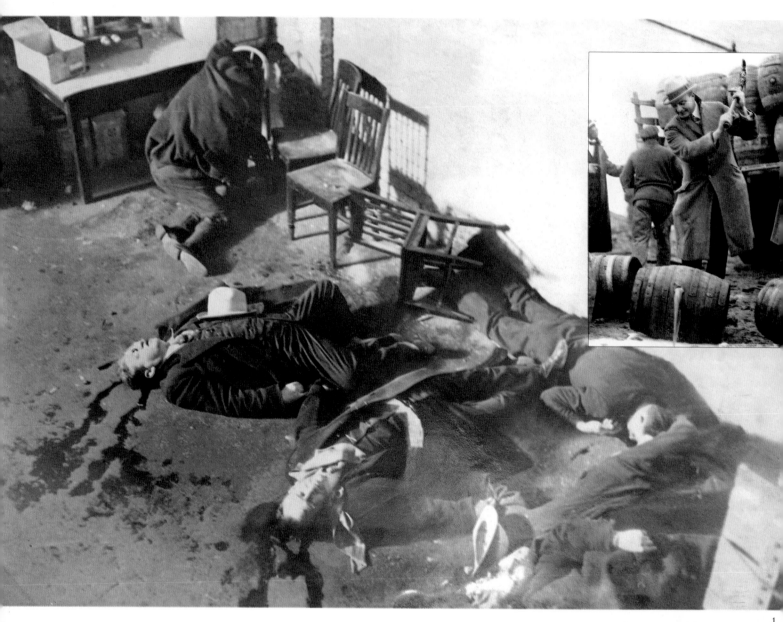

1

FROM January 1920 until December
1933 'the manufacure, sale or carriage'
of alcoholic drink was forbidden by the
18th Amendment to the US Constitution.
Kegs (2) were destroyed by federal police.
'Bootlegging' (illicit distilling and distri-
bution) fell under the control of criminal
gangs who went to war with each other
to secure profits. Seven members of the
O'Banion-Moran gang were lined up
against a Chicago warehouse wall in 1929
and machine-gunned in what became
known as the St Valentine's Day Massacre
(1). The Depression that followed the Wall
Street Crash of 1929 led to a world slump.
The US bread-basket turned rapidly into a

dustbowl, forcing families to tramp off in
search of work (5). Some joined the bread-
lines in the major cities (3). The photograph-
er Dorothea Lange documented some of
the resulting desolation (4).

VOM Januar 1920 bis zum Dezember
1933 waren »Herstellung, Verkauf oder
Besitz« von Alkohol in den Vereinigten
Staaten per Gesetz verboten (18. Zusatz der
Verfassung, die Prohibition). Bundespolizisten
zerschlugen die Fässer (2). Das Schwarz-
brennen (*bootlegging*) wurde von Verbrecher-
banden gesteuert, die sich gegenseitig
bekämpften, um sich möglichst hohe Profite
zu sichern. Im sogenannten Massaker am

Valentinstag wurden 1929 in Chicago sieben
Mitglieder der O'Banion-Moran-Bande
in einem Lagerhaus an die Wand gestellt
und mit dem Maschinengewehr erschossen
(1). Die große Wirtschaftskrise, die auf den
Schwarzen Freitag an der Wall Street (1929)
folgte, zog die ganze Welt mit hinab. Die
Kornkammer Amerikas verwandelte sich
im Handumdrehen in eine Staubwüste, die
Farmerfamilien mußten fortziehen und
anderswo Arbeit suchen (5). Manche standen
bald bei den Suppenküchen der Großstädte
an (3). Die Photographin Dorothea Lange
gehörte zu denen, die das Elend doku-
mentierten (4).

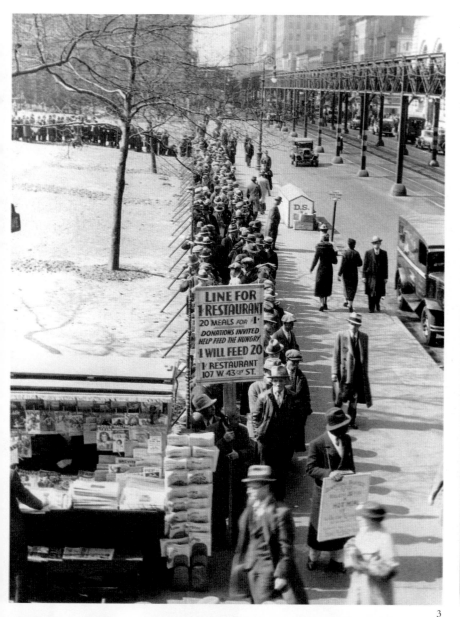

3

4

5

DE janvier 1920 à décembre 1933, « la fabri-
cation, la vente ou le transport » de boissons
alcoolisées sont interdits en vertu du dix-huitième
amendement de la Constitution des États-Unis.
Les barils (2) étaient détruits par la police fédérale.
La distillation et la distribution illégales sont réglées
par les gangs de malfaiteurs qui se font la guerre
afin d'en contrôler les bénéfices. Sept membres du
gang O'Banion-Moran furent alignés et mitraillés
contre le mur d'un entrepôt à Chicago en 1929 au
cours de ce qui fut appelé le massacre de la Saint-
Valentin (1). La dépression, qui suivit l'effondre-
ment de la bourse de Wall Street en 1929, entraîna
le marasme mondial. L'Eldorado américain s'assécha
très vite, contraignant des familles entières à partir
sur les routes à la recherche d'un travail (5). Cer-
taines vinrent gonfler les queues devant les centres
de ravitaillement des principales villes (3). La photo-
graphe Dorothea Lange exécuta tout un dossier
sur les ravages ainsi produits (4).

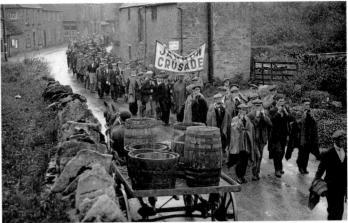

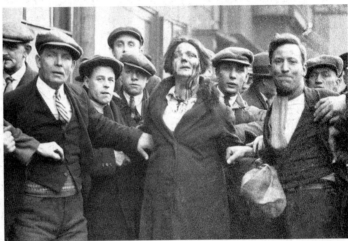

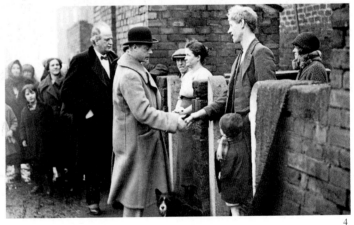

Unemployment in the 1930s: sit-ins at a Welsh colliery (1); the Jarrow Crusade, a march by the jobless from the North (2); riots in Bristol (3); the Prince of Wales visits miners' homes on a tour of the coalfields (4).

Arbeitslosigkeit in den 30er Jahren: Proteste walisischer Bergarbeiter (1); der »Jarrow-Kreuzzug«, ein Hungermarsch der Arbeitslosen aus dem englischen Norden (2); Aufstände in Bristol (3); der Prince of Wales besucht Bergarbeiterhäuser auf seiner Rundfahrt durch die Bergwerksgebiete (4).

Chômage dans les années 30 : occupation d'une houillère dans le Pays de Galles (1) ; la croisade de Jarrow, marche des chômeurs descendus du Nord (2) ; émeutes à Bristol (3) ; le Prince de Galles rendant visite à des familles de mineurs au cours d'une tournée dans les bassins houillers (4).

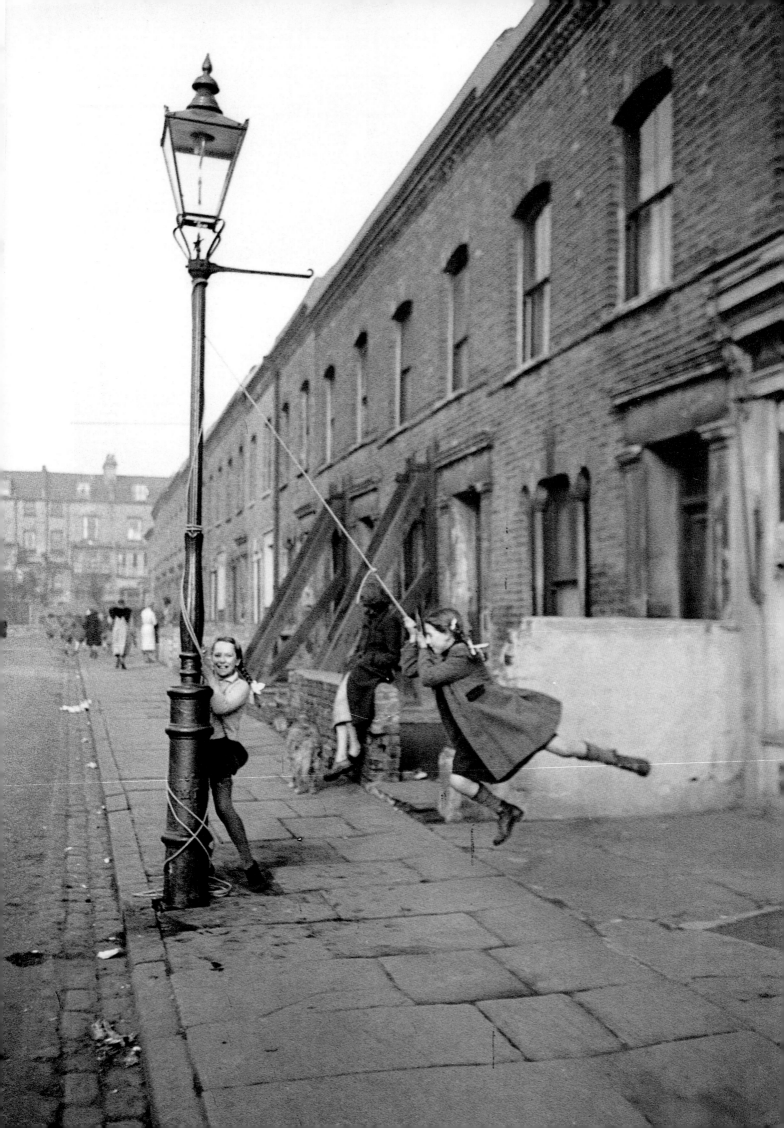

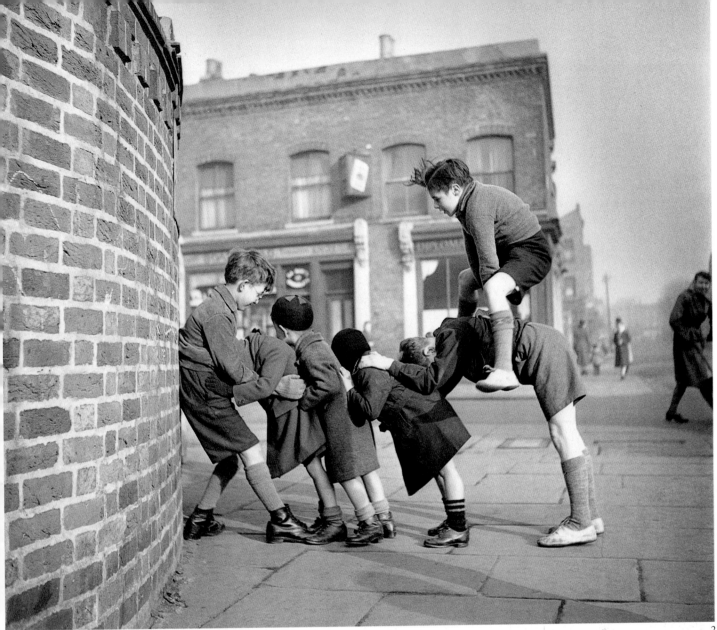

2

CHILDREN'S street games include any number of domestic improvisations: washing lines for swings (1) and skipping-ropes; chalked pavements for hopscotch and football; old furniture goalposts and a particular kind of leapfrog (2) to cries of 'Jimmy Jimmy Knacker 1-2-3!' These pictures of East End slums were published in *Picture Post* in 1950, at the height of Labour Party reforming welfare legislation. The magazine had been a longtime campaigner for the Beveridge Report, written by the Master of University College, Oxford, and published in 1942. It proposed a comprehensive scheme of social insurance 'from the cradle to the grave' as checks against poverty and mass unemployment. It was the Churchill government's refusal to take its implementation seriously that helped the Labour Party's victorious landslide in the 1945 elections on a platform of 'free welfare, healthcare and education for all'.

DIE Kinder auf der Straße konnten aus allem ein Spiel machen: Aus Wäscheleinen wurden Schaukeln (1) oder Springseile; auf das Pflaster wurden mit Kreide Fußballfelder oder Felder für Himmel und Hölle gezeichnet; Torpfosten bestanden aus alten Möbeln, und es gab eine bestimmte Art von Froschhüpfen (2), zu dem man »Jimmy Jimmy Knacker 1-2-3!« brüllte. Diese Aufnahmen aus den Slums des Londoner East End erschienen 1950 in der *Picture Post*, zu der Zeit, als die Labour-Regierung die Wohlfahrtsgesetze reformierte. Die Illustrierte hatte sich schon seit längerem für den Beveridge Report eingesetzt, ein vom Rektor des University College, Oxford, 1942 veröffentlichtes Papier, in dem dieser sich für eine umfassende Sozialversicherung »von der Wiege bis zum Grabe« als dem besten Mittel gegen Verelendung und Massenarbeitslosigkeit aussprach. Die Regierung Churchill nahm diese Vorschläge nicht ernst, und dadurch erklärt sich der überwältigende Erfolg der Labour Party bei den Wahlen von 1945.

LES enfants jouaient dans la rue avec toutes sortes d'articles ménagers : des cordes à linge en guise de balançoires (1) et cordes à sauter ; de la craie pour la marelle et le football ; du vieux mobilier comme poteaux de but et pour un saute-mouton particulier (2) aux cris de « Jimmy Jimmy Knacker 1-2-3 ! » Ces photographies des bidonvilles de East End parurent dans le *Picture Post* en 1950, au plus fort de la mise en place par le parti travailliste d'une législation réformant la protection sociale. La revue faisait depuis longtemps campagne en faveur du rapport Beveridge, paru en 1942, dont l'auteur n'était autre que le principal du University College à Oxford. Il proposait un plan exhaustif d'assurance sociale pour parer « du berceau jusqu'à la tombe » à la pauvreté et au chômage généralisé. C'est le refus du gouvernement de Churchill de le mettre sérieusement en œuvre qui valut au parti travailliste sa victoire éclatante aux élections de 1945 sur la plate-forme de la « gratuité pour tous des services sociaux, des soins de santé et de l'instruction ».

THESE back-to-backs had changed little since they were first built at the height of the Industrial Revolution. Insanitary, with their outdoor privies, their lack of a bathroom or safe kitchens, they nevertheless fostered a sense of community missing in the post-war high-rise blocks. In 1920, a visitor from Dr Barnardo's inspects the unhygienic conditions of the slums (1). In 1945, a teenage daughter cleans shoes for a family of sixteen crammed into a typical 'two-up two-down' lebt (2). In Liverpool in 1954, a summer dawn sees a row of housewives out scrubbing their front steps and pavement areas (3).

DIESE Reihenhäuser waren seit ihrer Errichtung in der Blütezeit der industriellen Revolution kaum verändert worden. Sie hatten unhygienische Toiletten im Garten, kein Bad, keine feuersichere Küche. 1920 inspiziert ein Repräsentant der Dr.-Barnardo-Kinderheime die unge-

sunden Verhältnisse in den Slums (1). 1945 putzt dieses junge Mädchen die Schuhe einer sechzehnköpfigen Familie, die in einem typischen Häuschen mit vier Zimmern lebt (2). An einem Sommermorgen 1954 in Liverpool reinigen die Frauen dieser Straße ihre Treppenstufen und den Bürgersteig (3).

CES maisons dos à dos construites au plus fort de la révolution industrielle n'ont guère changé. Malgré leur insalubrité (sans commodités, salle de bains et cuisine), elles favorisaient une vie communautaire. En 1920, un visiteur est envoyé par le docteur Barnardo examiner les conditions d'hygiène désastreuses des bidonvilles (1). 1945, une adolescente nettoyant les chaussures des seize personnes de sa famille entassées dans un « deux pièces en haut – deux pièces en bas » typique (2). Liverpool en 1954 : des ménagères frottent les marches devant leur porte (3).

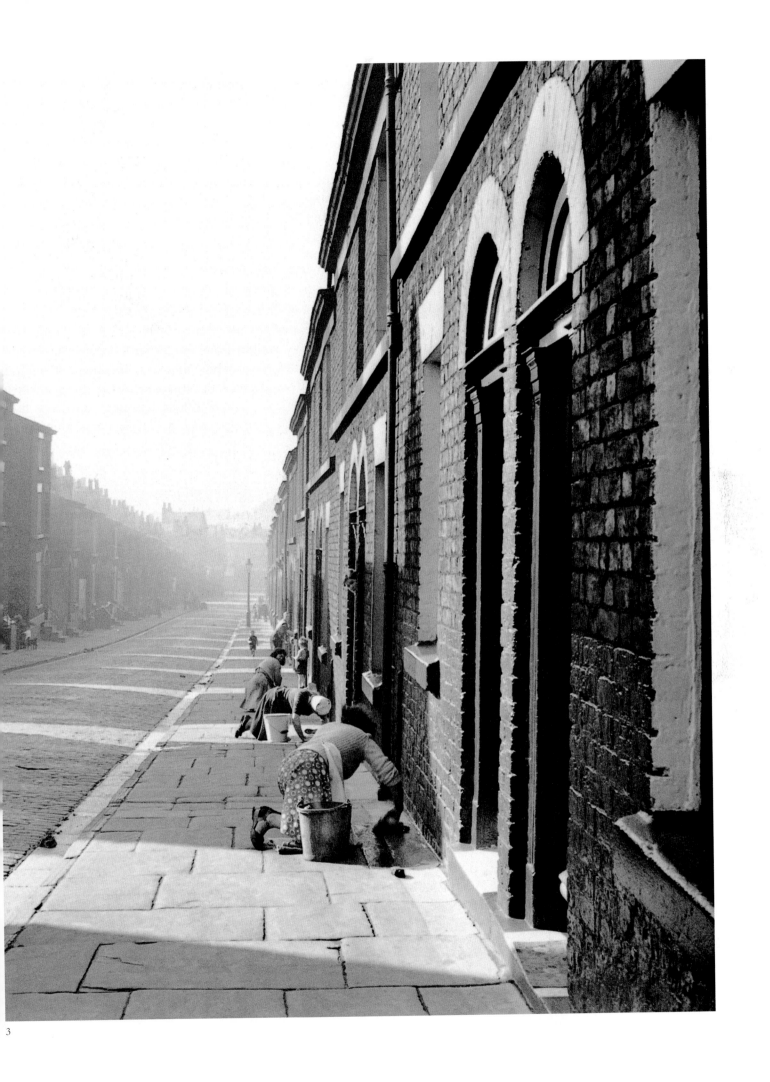

3

The Rise of Fascism

PERHAPS the most damning feature to emerge from all the books, lectures and opinions about European fascism is that the reasons for its rise were so predominantly negative. Economically, Europe was reeling from crash, depression and slump. To counter the ignominy as well as the poverty wrought by mass unemployment by guaranteeing not only wages and housing but uniforms and status through military conscription was an offer to which there seemed little alternative. Rearmament was also attractive to a Germany that felt herself humiliated by the terms of the Treaty of Versailles at the conclusion of the Great War; one result was a witch-hunt for the 'enemies within' that could be blamed for defeat.

Political enemies at first took precedence over racial ones, in Germany as in Italy. The smashing of the Spartacists and the killing of Rosa Luxemburg and Karl Liebknecht in 1919 failed to unseat a nascent but entrenched Socialist and Communist movement. Fears that the recent Russian Revolution would spread through Europe were in no way allayed by the vacillations of the Weimar régime, apparently as incapable of pursuing a political as an economic programme. If democracy could not deal with the problems, it was argued, then maybe democracy should make way.

The term 'Fascism' originated in Milan in 1919 with the formation of the *Fascio di Combattimento*, an anti-Socialist militia called after the bundle of rods that was the symbol of ancient Roman legislature. It took an authoritarian form under Mussolini in the decade from 1922. Rome in 1932 saw 40,000 Junior Fascists aged between 14 and 18 gather for a rally addressed by him. This very junior Junior Fascist served as a mascot, and is seen here saluting Il Duce (2). A former Socialist himself, Mussolini confusingly boasted: 'We allow ourselves the luxury of being aristocratic and democratic, reactionary and revolutionary'. Unlike Hitler, Mussolini primarily vaunted his pride in the glories of a real imperial past; a wish to destroy both the

'putrefying corpse' of parliamentary democracy and to strangle at birth any attempt at creating a Marxist state. His anti-internationalism extended to an insistence that Fascism was an Italian creed 'not for export'. It took until July 1938 and the formation of the Axis alliance for him to renege and become overtly anti-Semitic and to issue a *Manifesto della Razza* in imitation of his German ally.

Meanwhile in Spain, between 1936 and 1939 Franco's Falangist Party fought with German support to unseat the elected Republican government. Civil war erupted when the army rose against the government in July 1936: here, a Republican soldier throws a hand grenade at enemy trenches (1). General Franco, the future dictator who would rule Spain repressively for 35 years, stationed his headquarters in Spanish Morocco. From there he had to ferry insurgents across the Straits of Gibraltar and would have been unable to attain victory without the assistance of Fascist forces from Germany and Italy.

The postwar English historian A. J. P. Taylor has sought to diminish Hitler's role, considering that 'in principle and in doctrine, Hitler was no more wicked and unscrupulous than many other contemporary statesmen'. Few, however, would rush to concur. One has only to take, almost at random, a passage from *Mein Kampf* (My Struggle, 1923) to establish the histrionic fanaticism that swept so much before it, determining the fate of nations and the deaths of 55 millions:

'The adulteration of the blood and racial deterioration conditioned thereby are the only causes that account for the decline of ancient civilizations; for it is never by war that nations are ruined but by the loss of their powers of resistance, which are exclusively a characteristic of pure racial blood. In this world everything that is not of sound stock is like chaff.'

That this reads today as nonsensical rhetoric more appropriate to a stock-breeders' manual than a political manifesto is a measure of the discredit into which the term 'Fascism' has finally fallen.

DIE Quintessenz all der Bücher, Vorträge und Meinungen über den europäischen Faschismus ist die Erkenntnis, daß er so große Macht gewinnen konnte, weil die Zeiten so schlecht waren. Europa lag nach der Weltwirtschaftskrise am Boden, und hier wurden nicht nur Arbeit und Unterkunft versprochen, durch die man mit der Schande und Armut der Massenarbeitslosigkeit fertigwerden konnte, sondern auch noch Uniformen und das Ansehen eines militärischen Dienstranges – dazu schien es keine Alternative zu geben. Für die Deutschen, die sich von den Bedingungen des Versailler Vertrages gedemütigt fühlten, war die Aussicht auf Wiederaufrüstung verlockend, und nun konnten sie die Feinde im eigenen Lande gnadenlos verfolgen.

Zunächst stand in Deutschland wie in Italien eher politische Feindschaft im Vordergrund und nicht die Rassenzugehörigkeit. Die Niederwerfung des Spartakistenaufstandes und die Ermordung Rosa Luxemburgs und Karl Liebknechts 1919 konnte die noch junge, aber schon verwurzelte sozialistische und kommunistische Bewegung nicht vernichten. Die Ängste, daß die Russische Revolution auf ganz Europa übergreifen könnte, wurden durch die Schwäche der Weimarer Regierung noch geschürt, die in politischer Hinsicht ebenso orientierungslos wirkte wie in wirtschaftlicher. Wenn die Demokratie nicht mit den Schwierigkeiten fertigwerden konnte, sagten sich die Leute, dann sollte die Demokratie einer anderen Staatsform Platz machen.

Die Bezeichnung »Faschismus« kam 1919 in Mailand auf, wo der *Fascio di Combattimento* gegründet wurde, eine antikommunistische Miliz, die sich nach dem Rutenbündel benannte, das im alten Rom das Symbol der Legislative gewesen war. Seit 1922 nahm er unter Mussolini autoritäre Züge an. 1932 versammelten sich in Rom 40 000 Jungfaschisten zwischen 14 und 18 Jahren, um ihn sprechen zu hören. Dieser sehr junge Juniorfaschist (2) war als Maskottchen dabei, und man sieht, wie eifrig er den Duce begrüßt. Mussolini, der früher selbst Sozialist gewesen war, rühmte sich in Paradoxen: »Wir erlauben uns den Luxus, aristokratisch und demokratisch, reaktionär und revolutionär zugleich zu sein.« Anders als Hitler konnte Mussolini stolz auf die Tradition eines Weltreichs zurückblicken, und er wollte den »stinkenden Leichnam« der Demokratie beiseite räumen und jeglichen Versuch, einen marxistischen Staat zu errichten, im Keime ersticken. Sein Nationalismus ging so weit, daß er sogar verlauten ließ, der Faschismus sei eine italienische Weltanschauung, die »nicht für den Export bestimmt« sei. Erst im Juli 1938, als der Bund der Achsenmächte geschlossen war, gab er sich offen antisemitisch und veröffentlichte ein *Manifesto della Razza* nach dem Vorbild seiner deutschen Verbündeten.

In Spanien bekämpfte derweil 1936 bis 1939 Francos Falangistenpartei mit deutscher Unterstützung die gewählte republikanische Regierung. Als die Armee sich im Juli 1936 gegen die Regierung erhob, hatte der Bürgerkrieg begonnen: Hier (1) wirft ein republikanischer Soldat eine Handgranate auf feindliche Schützengräben. General Franco, der künftige Diktator, der 35 Jahre lang über Spanien herrschen sollte, errichtete sein Hauptquartier im spanischen Marokko. Von dort mußte er seine Aufständischen per Schiff über die Straße von Gibraltar bringen und hätte sich niemals durchsetzen können, wenn faschistische Truppen aus Deutschland und Italien ihm nicht geholfen hätten.

Der englische Historiker A. J. P. Taylor schrieb später, man solle Hitlers Rolle nicht überbewerten: »In seinen Prinzipien und Ansichten war Hitler nicht schlechter und gewissenloser als viele andere Politiker seiner Zeit.« Doch nur wenige pflichteten ihm bei. Man muß sich nur eine willkürlich ausgewählte Passage aus *Mein Kampf* von 1923 ansehen, dann begreift man, daß hier ein größenwahnsinniger Fanatiker das Schicksal ganzer Nationen und den Tod von mehr als 55 Millionen Menschen besiegelte: »Die Blutsvermischung und das dadurch bedingte Senken des Rassenniveaus ist die alleinige Ursache des Absterbens aller Kulturen; denn die Menschen gehen nicht an verlorenen Kriegen zugrunde, sondern am Verlust jener Widerstandskraft, die nur dem reinen Blute zu eigen ist. Was nicht gute Rasse ist auf dieser Welt, ist Spreu.« Daß sich das heute als hohle Rhetorik liest, die eher in ein Handbuch für Viehzüchter paßt als in ein politisches Manifest, zeigt uns, welcher Verachtung der Begriff »Faschismus« anheimgefallen ist.

ES ouvrages, conférences et opinions qu'inspirèrent le fascisme européen, on retiendra le souci contant de mettre en valeur un contexte essentiellement négatif propice à son essor. Économiquement, l'Europe e trouvait dans un état d'effondrement, de dépression et le marasme. Tant pour échapper à l'angoisse qu'à la pauvreté causées par un chômage massif, il n'y avait guère d'autre choix possible que d'accepter non seulement le salaire et le logement, mais aussi l'uniforme et e statut que garantissait un engagement dans l'armée. Le réarmement séduisait aussi une Allemagne humiliée par les clauses du traité de Versailles qui avait conclu la Grande Guerre. Il en résulta notamment une chasse aux sorcières contre les « ennemis de l'intérieur » rendus responsables de la défaite.

L'Allemagne, à l'instar de l'Italie, s'en prit d'abord aux ennemis politiques avant de s'occuper de la question raciale. L'écrasement des spartakistes, suivi de l'assassinat de Rosa Luxemburg et de Karl Liebknecht en 1919 ne parvinrent pas à déstabiliser un mouvement ouvrier où les communistes jouaient déjà un grand rôle. La crainte de voir la jeune révolution russe se propager en Europe ne se trouvait guère dissipée devant les hésitations du régime de Weimar apparemment incapable de mettre en œuvre un programme économique et politique. Si la démocratie n'était pas en mesure d'affronter les problèmes, disait-on, c'est peut-être qu'elle devait céder la place.

Le terme « Fascisme » prit naissance à Milan en 1919 avec la formation du *Fascio di Combattimento*, milice antisocialiste qui tenait son nom du faisceau de verges servant de symbole à la magistrature romaine dans l'Antiquité. Il incarna dès 1922 le régime autoritaire de Mussolini, et cela pendant dix ans. À Rome, en 1932, ce sont 40 000 jeunes fascistes âgés de 14 à 18 ans qui sont ici rassemblés pour écouter Mussolini. Ce tout petit fasciste servait de mascotte ; on le voit ici saluant *Il Duce* (2). Ancien socialiste lui-même, Mussolini aimait à répéter ces paroles qui rendent perplexes : « Nous nous offrons le luxe d'être aristocratiques et démocratiques, réactionnaires et révolutionnaires ». Contrairement à Hitler, il était animé d'une fierté qui puisait dans un véritable passé impérial : du désir tout à la fois de détruire la « carcasse pourrissante » de la démocratie parlementaire et d'étouffer dans l'œuf toute tentative de créer un état marxiste. Son anti-internationalisme allait jusqu'à souligner que le fascisme était une croyance italienne « non destinée à l'exportation ». Il faut attendre juillet 1938 et la constitution de l'alliance de l'Axe pour qu'il se dédise, se déclare ouvertement antisémite et fasse publier son *Manifesto della Razza* à l'instar de son alliée allemande.

Pendant ce temps, en Espagne, de 1936 à 1939, le parti phalangiste de Franco était soutenu par l'Allemagne dans sa lutte qui visait à confisquer la République. La guerre civile éclata lorsque l'armée entra en Juillet 1936 en rébellion contre le gouvernement : un soldat républicain lance ici une grenade à main vers une tranchée ennemie (1). Le général Franco, candillo d'un régime qui durera trente-cinq ans, établit son quartier général au Maroc espagnol. De là il lui fallut faire traverser aux insurgés le détroit de Gibraltar en bateau : c'est aux forces fascistes venues d'Allemagne et d'Italie qu'il devra en partie la victoire.

L'historien anglais de l'après-guerre, A.J.P. Taylor, s'emploie à minimiser le rôle de Hitler, estimant que « s'agissant du principe et de la doctrine, Hitler ne fut ni plus mauvais ni moins dénué de scrupules que beaucoup d'autres de nos hommes d'État contemporains ». Peu s'empresseront cependant de lui donner raison. Il suffit de prendre, presque au hasard, un passage de *Mein Kampf* (1923), pour se convaincre qu'il s'agit bien là d'un fanatisme orchestré et dévastateur qui devait tracer la destinée de nations entières et décider de la mort de 55 millions de personnes :

« L'adultération du sang et la dégénérescence raciale qui en a résulté sont là les seules causes du déclin des civilisations antérieures ; car ce n'est jamais la guerre qui cause la ruine des nations mais bien la perte de leurs pouvoirs de résistance, qui sont une caractéristique exclusive d'un sang de race pure. Dans ce monde, tout ce qui n'est pas de souche saine est de l'ivraie ».

Aujourd'hui, cette ineptie ampoulée résonne plus comme un manuel destiné aux éleveurs que comme un manifeste politique, à la mesure du discrédit attaché au terme « fascisme ».

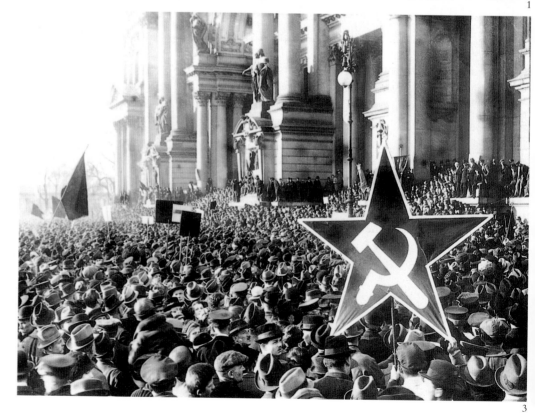

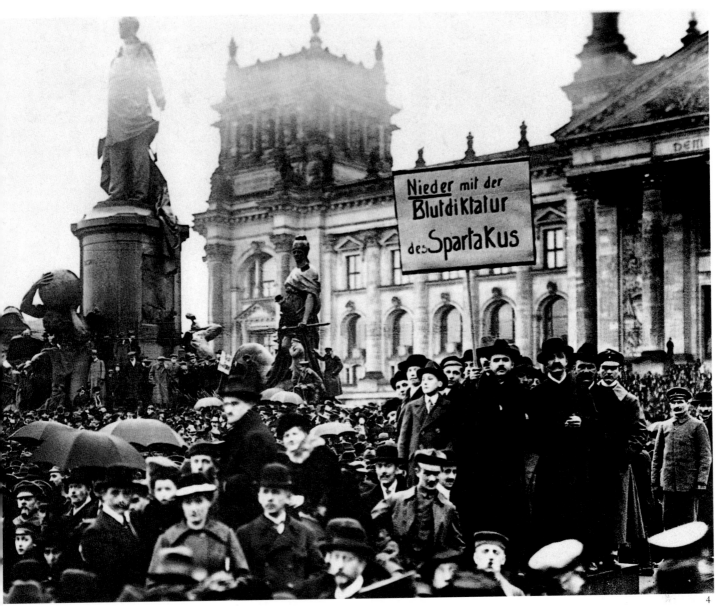

ON 7 January 1919 the Spartacists – their name derived from the slaves who led the last revolt to overthrow Roman rule – took to the streets of Berlin, which they then barricaded. For over a week the battle raged. Fighting deeds and speeches (1) followed; rallies and allegiances blurred – the hammer and sickle (3) v. 'Down with the Spartacists' Dictatorship of Blood!' (4). On 16 January the popular revolutionary leaders 'Red Rosa' Luxemburg (2) and former Reichstag deputy Karl Liebknecht were murdered by officers of the Gardekavallerie-Schützendivision, an irregular right-wing force officered by professionals from the dissolved army, sent to arrest them. Instead the leaders were tortured, shot and their bodies thrown into a canal. The officers were never brought to trial.

AM 7. Januar 1919 gingen die Spartakisten – die sich nach dem Anführer des letzten Sklavenaufstands gegen die Römer benannt hatten – in Berlin auf die Straße und errichteten ihre Barrikaden. Über eine Woche dauerten die Straßenkämpfe. Kämpfe in Taten und Worten folgten (1); Zugehörigkeit verwischte sich – Hammer und Sichel (3) kontra »Nieder mit der Blutdiktatur des Spartakus!« (4) Am 16. Januar wurden die populäre Revolutionsführerin Rosa Luxemburg (die »Rote Rosa«) (2) und der ehemalige Reichstagsabgeordnete Karl Liebknecht von Mitgliedern der Gardekavallerie-Schützendivision, eines inoffiziellen rechtsgerichteten Freikorps, dessen Offiziere Berufssoldaten aus der aufgelösten Armee waren, ermordet. Die Männer hatten die beiden Anführer verhaften sollen, doch statt dessen folterten und erschossen sie sie und warfen ihre Leichen in einen Kanal. Die Offiziere wurden nie vor Gericht gestellt.

LE 7 janvier 1919, les spartakistes, du nom des esclaves qui organisèrent la dernière révolte contre la domination romaine, – entreprirent de barricader les rues de Berlin. Pendant plus d'une semaine la bataille fit rage. Les accords tactiques et les discours suivirent (1) ; les rassemblements et les allégeances se déroulèrent dans la confusion. Ici, la faucille et le marteau (3). « À bas la dictature sanguinaire et spartakiste » (4). Le 16 janvier, les chefs de file de la révolution populaire « Rosa la rouge » Luxemburg (2) et l'ancien député au Reichstag, Karl Liebknecht, sont blessés par des officiers en mission commandée de la Gardekavallerie-Schützendivision, une force irrégulière rassemblant des éléments de droite et encadrée par des professionnels issus de l'armée dissoute. En fait de cela, ils furent torturés avant d'être abattus, et leurs cadavres furent jetés dans un canal. Les officiers ne furent jamais traduits en justice.

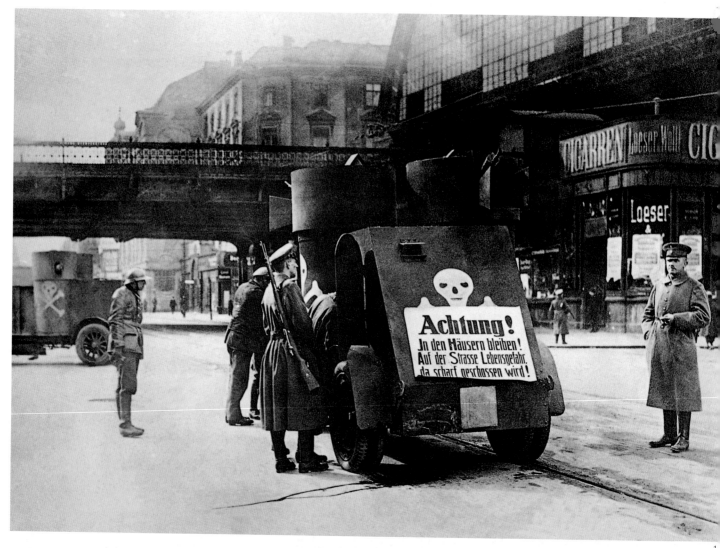

JANUARY 1919 was a time of elections to the National Assembly, which had before it the task of drawing up a new constitution. Because of the disturbances on the streets of Munich and Berlin, much of the business had to be moved to Weimar. In Berlin this quaint-looking government armoured car bears a warning skull and placard: 'Beware! Stay in your homes! Coming onto the streets can put your life at risk: you will be shot!' (1). As though bearing this out, Berlin civilians flee the machine-gun fire from Chancellor Ebert's government troops (2).

IM Januar 1919 wurde die National-versammlung gewählt, die eine neue Verfassung ausarbeiten sollte. Wegen der Unruhen in den Straßen von München und Berlin wurden die Amtsgeschäfte größtenteils nach Weimar verlegt. In Berlin warnt dieser kuriose offizielle Panzerwagen unter dem Totenschädel: »Achtung! In den Häusern bleiben! Auf der Straße Lebensgefahr, da scharf geschossen wird!« (1) Wie um dies zu beweisen, fliehen Berliner vor den Maschinengewehren von Reichspräsident Eberts Regierungstruppen (2).

JANVIER 1919 fut l'époque des élections à l'Assemblée nationale, laquelle avait pour tâche d'élaborer une nouvelle Constitution. En raison des troubles qui avaient éclaté dans les rues de Munich et de Berlin, on transféra presque tout à Weimar. À Berlin, ce véhicule blindé des autorités publiques offre un bien curieux spectacle avec sa tête de mort et son inscription en guise d'avertissement : « Attention ! Restez chez vous ! Sortir dans la rue peut vous coûter la vie : vous risquez d'être abattus ! » (1). Comme pour lui donner raison, des civils s'enfuient à Berlin sous les rafales des mitraillettes gouvernementales du chancelier Ebert (2).

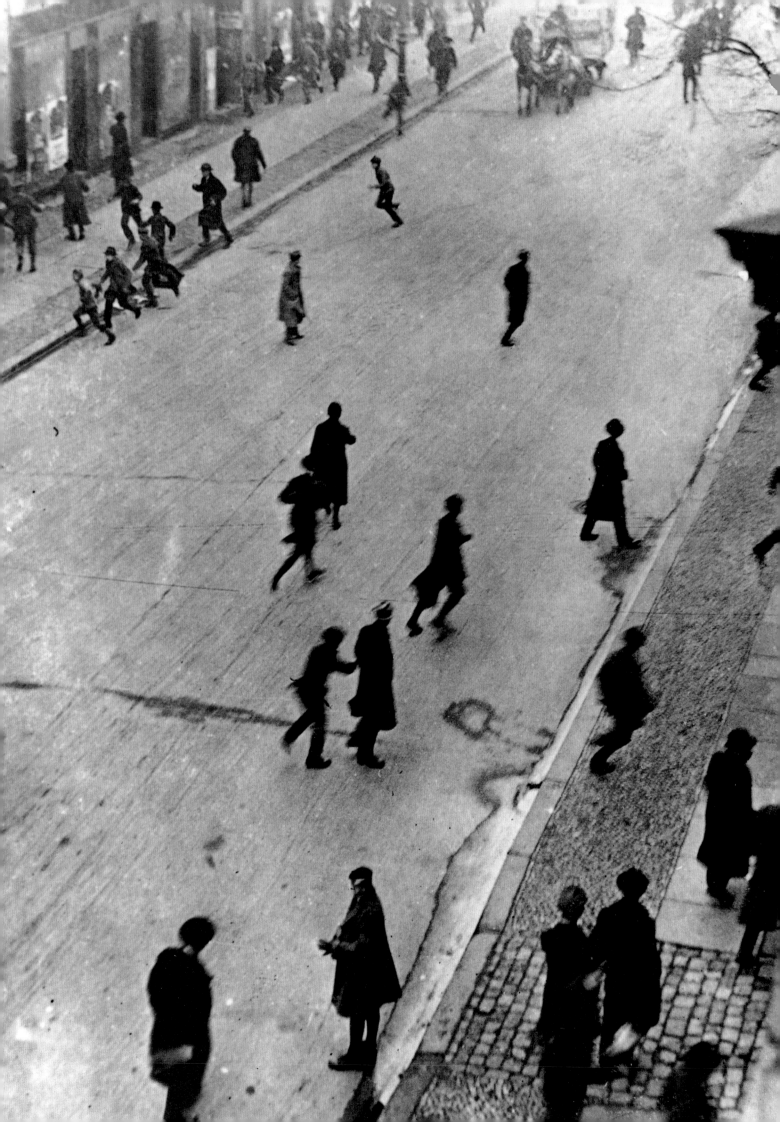

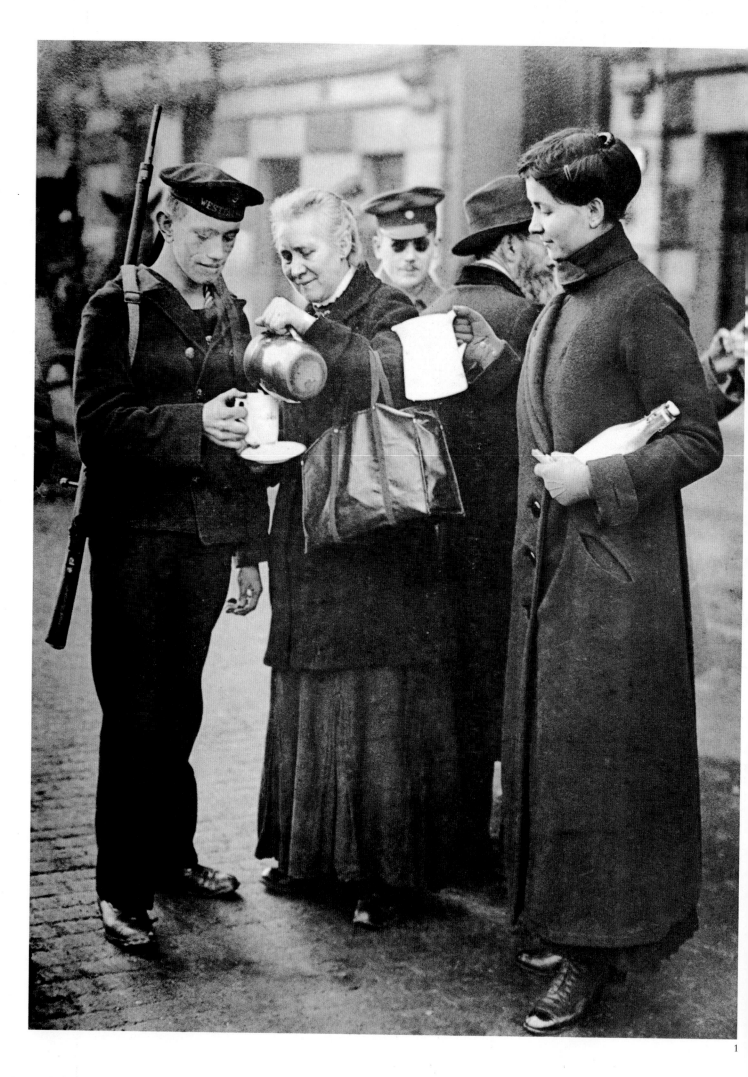

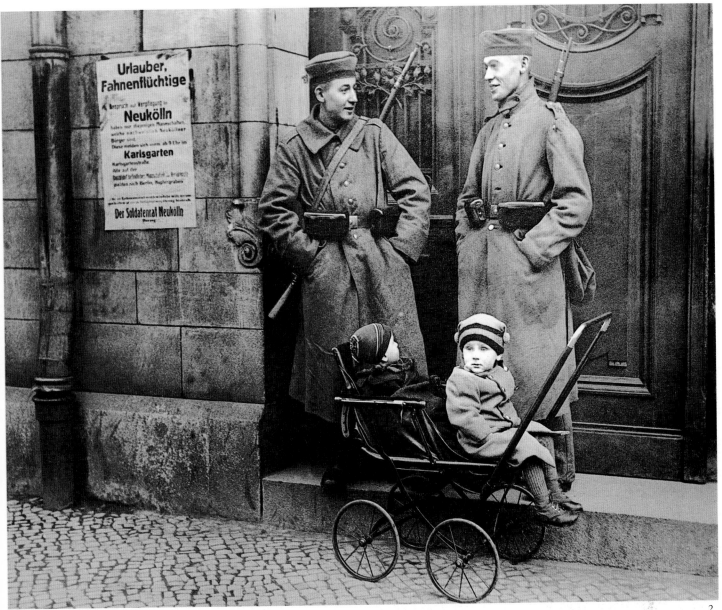

2

THE confusion caused by circumstances at the war's end led women (1) and even children (2) to fraternize with the military. While the Spartacists looked to nascent workers' soviets to create a 'free socialist republic of Germany', there were rapid and increasing signs that the Socialist People's Militia and *Freikorps* would not fight with the newly created city soviets. The revolution collapsed when the militias threw in their lot with the police and armed forces.

IN den Wirren, die am Ende der deutschen Revolution herrschten, sympathisierten Frauen (1) und sogar Kinder (2) mit den Militärs. Die Spartakisten hofften, daß Arbeiterräte »eine freie sozialistische Republik in Deutschland« schaffen würden, doch bald war offensichtlich, daß die sozialistischen Volksmilizen und Freikorps nicht gegen die neugeschaffenen Stadträte kämpfen würden. Die Revolution war zu Ende, als die Milizen sich auf die Seite der Polizei und der Armee schlugen.

LA confusion qui règne à la fin de la guerre conduisit des femmes (1), voire des enfants (2) à fraterniser avec les militaires. Tandis que les spartakistes comptaient sur les comités ouvriers naissants pour créer la base d'une « République socialiste libre d'Allemagne », il apparut bientôt de plus en plus clairement que la milice du peuple socialiste et les *Freikorps* (volontaires) ne combattraient pas aux côtés des comités tout juste créés dans les villes. La fin de la révolution était scellée lorsque les milices décidèrent de lier leur sort à celui de la police et des forces armées.

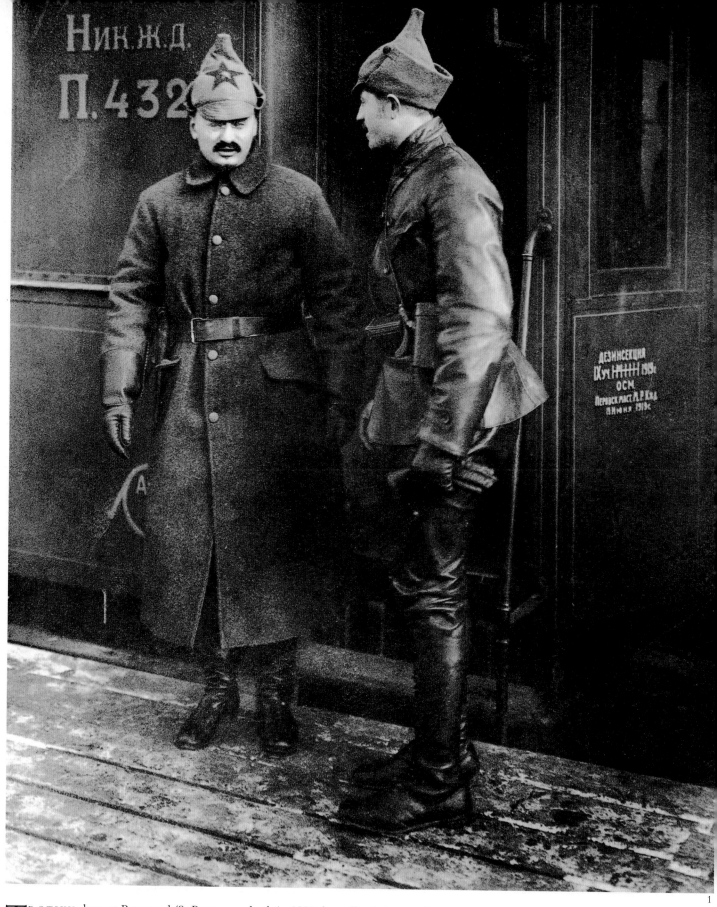

TROTSKY, here at Petrograd (St Petersburg) in 1921 (1), was supposedly 'in the vanguard of the Revolution, while Lenin was in the guard's van'. As erstwhile War Minister and Head of the Red Army, he paid a visit to the Red Commanders of the Russian Military Academy at Moscow (2). From 1917 to 1922, Lenin was undisputed leader, but from 1922 until his death in 1924, he suffered three serious heart attacks and was obliged to retire to the country (3). His meeting there with Stalin in the summer of 1922 was a prophetic one (4). While Trotsky described Stalin as 'the Party's most eminent mediocrity', Lenin concluded: 'I am not always sure that he knows how to use power with caution.' In 1923, he recommended Stalin's dismissal.

TROTZKI, hier 1921 in Petrograd (St. Petersburg) (1), galt als »der Schaffner der Revolution, und Lenin war der Bremser«. Als damaliger Kriegsminister und Oberbefehlshaber der Roten Armee stattet er hier (2) den Roten Kommandeuren der Russischen Militärakademie in Moskau einen Besuch ab. Von 1917 bis 1922 war Lenin der unangefochtene Führer der

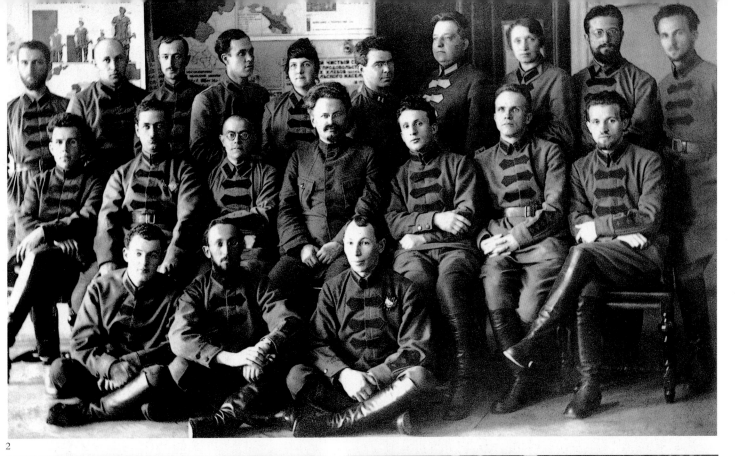

2

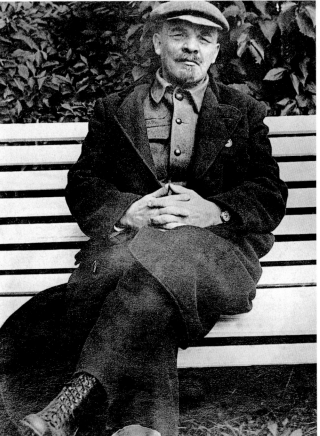

3

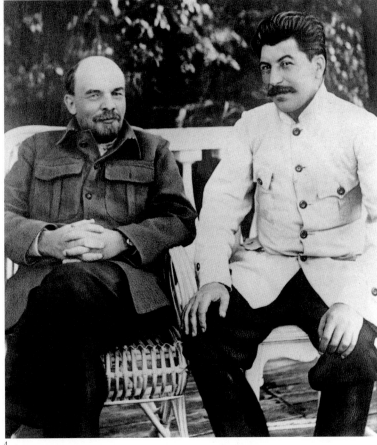

4

Revolution, doch von 1922 bis zu seinem Tode 1924 erlitt er drei schwere Herzanfälle und mußte sich aufs Land zurückziehen (3). Sein Treffen dort mit Stalin im Sommer 1922 sollte zukunftsweisend sein (4). Lenin kam zu dem Schluß: »Ich bin mir nicht immer sicher, ob er beim Umgang mit der Macht das rechte Maß kennt.« 1923 empfahl er, Stalin zu entlassen.

TROTSKI, ici à Petrograd (Saint-Pétersbourg) en 1921 (1) était supposé « à l'avant-garde de la Révolution et Lénine sous la garde de celle-ci ». Ancien ministre de la Guerre et de chef de l'Armée rouge, il rendit visite aux commandants communistes à Moscou (2). Lénine régna de 1917 à 1922. Mais, dès 1922 et jusqu'à sa mort en 1924, trois graves attaques cardiaques le

contraignirent à se retirer à la campagne (3), où il eut une entrevue avec Staline au cours de l'été 1922 (4). Alors que Trotski qualifiait Staline de « médiocrité la plus éminente du Parti », Lénine concluait : « Je ne suis pas toujours sûr qu'il sache faire un bon usage du pouvoir. » En 1923, il recommanda le limogeage de Staline.

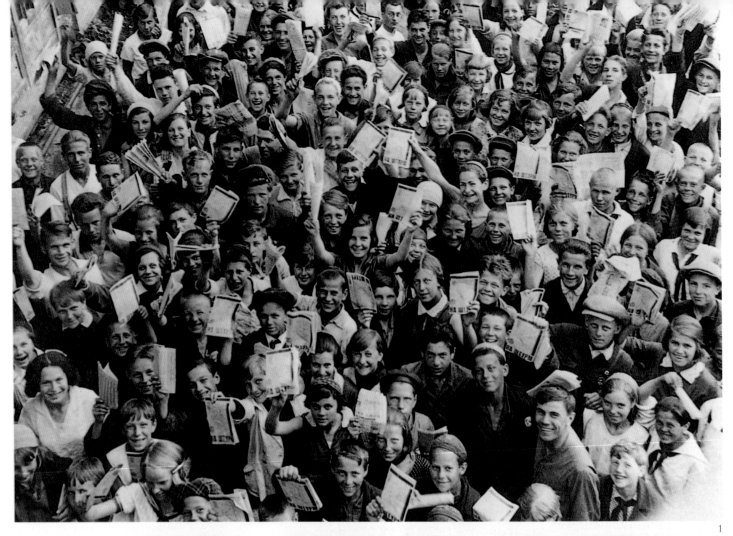

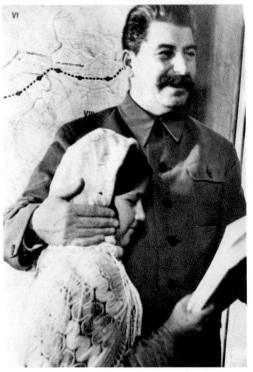

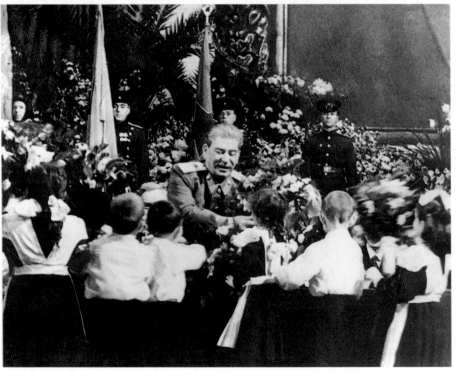

JOSEF Djugashvili – Stalin – the sole Bolshevik leader of peasant stock, was born the son of an impoverished Georgian shoemaker in 1879. During 1917 he edited *Pravda*, the Communist Party newspaper, and became Party Secretary in 1922. Despite the scale of his purges, he saw himself as a great populist, in touch with the real grassroots. Here, in

his Marshal's uniform, he visits Schelkovo aerodrome (4), and is presented with flowers by young Pioneers (3). Eleven-year-old Mamlakat Nakhengova travels from Tajhikistan to present a Tajik translation of his book *Stalin about Lenin* (2). Children were also commandeered to sell certificates for government construction loans (1).

JOSEF Dschugaschwili, genannt Stalin, der einzige Bolschewikenführer aus niederem Stand, kam 1879 in Georgien zur Welt. 1917 war er leitender Redakteur der Parteizeitung *Prawda*, und 1922 wurde er Generalsekretär der Partei. Trotz der Grausamkeit seiner Säuberungen verstand er sich als populistischer Politiker, der wußte, was das Volk wirklich wollte. Hier

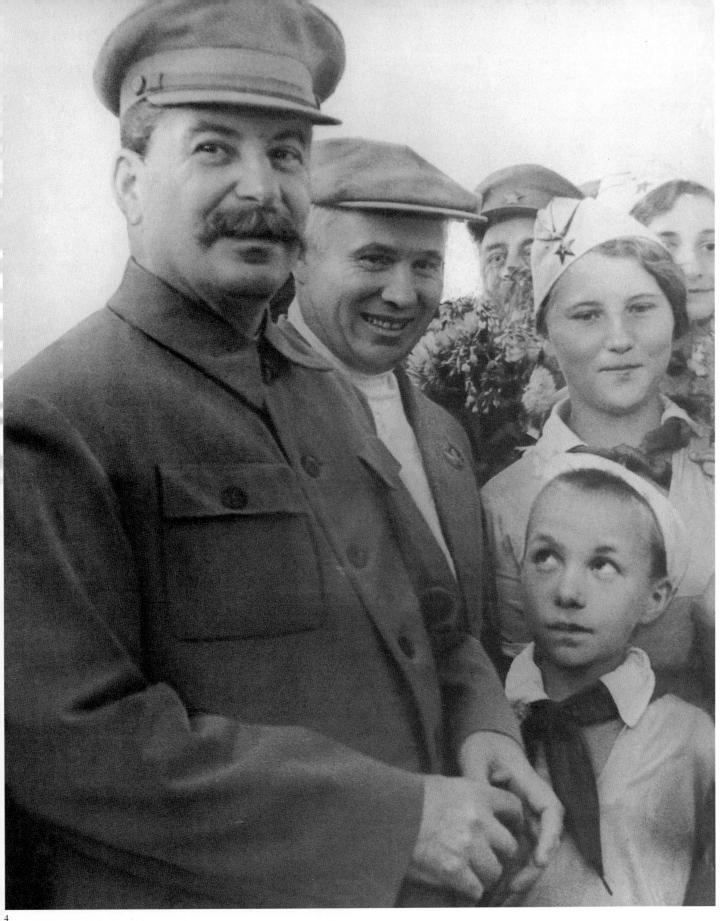

4

besucht er, in seiner Marschallsuniform, den Flugplatz Schelkovo (4) und bekommt von jungen Pionieren Blumen überreicht (3). Die elfjährige Mamlakat Nakhengova ist aus Tadschikistan gekommen, um eine tadschikische Ausgabe von Stalins Buch *Stalin über Lenin* zu präsentieren (2). Kinder wurden auch dazu verpflichtet, staatliche Bauanleihen zu verkaufen (1).

JOSEPH Djougachvili – Staline – le seul chef bolchevique d'origine paysanne, naquit en 1879 dans la famille d'un bottier géorgien tombé dans la misère. Pendant l'année 1917, il fut rédacteur à la *Pravda*, le journal du Parti, avant de devenir son secrétaire général en 1922. Malgré l'ampleur des purges qu'il ordonna, il s'estimait toujours proche de la base. On le voit ici en uniforme de maréchal visitant l'aéroport de Schelkovo (4) et recevant des fleurs des mains de jeunes pionniers (3). Mamlakat Nakhengova, âgée de onze ans, a fait le voyage du Tadjikistan pour lui remettre la traduction de son ouvrage *Staline à propos de Lénine* (2). On réquisitionnait aussi des enfants chargés de vendre des bons d'emprunt pour financer la construction (1).

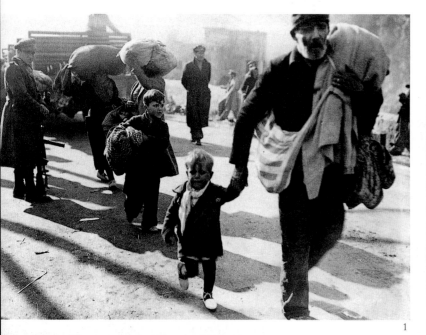

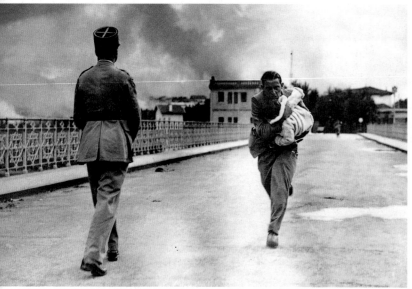

IN the Spanish Civil War, over half a million people died and
millions more were made refugees (1). Children were pushed to
the front of the bread queue at Le Perthus on the French border (3).
At Irún, a French journalist, Raymond Vanker, discovered a baby
alone in a house under intense fire. He escaped to France over the
Hendaye bridge, the child in his arms (2).

IM Spanischen Bürgerkrieg kam über eine halbe Million Menschen
um, und Millionen waren auf der Flucht (1). Hier in Le Perthus
an der französischen Grenze werden die Kinder zur Essensausgabe
vorgeschickt (3). In Irún fand der französische Journalist Raymond
Vanker in einem Haus, das unter schwerem Beschuß stand, ein
zurückgelassenes Baby. Er floh mit dem Kind in den Armen über
die Brücke von Hendaye nach Frankreich (2).

LA guerre civile espagnole coûta la vie à plus d'un demi-million
de personnes et transforma des millions d'autres en réfugiés (1).
Au Perthus, à la frontière française, on poussait les enfants au premier
rang des queues de ravitaillement (3). À Irún, le journaliste français
Raymond Vanker trouva un bébé resté seul dans une maison sou-
mise à des tirs nourris. Il s'enfuit en direction de la France par le pont
Hendaye avec l'enfant dans les bras (2).

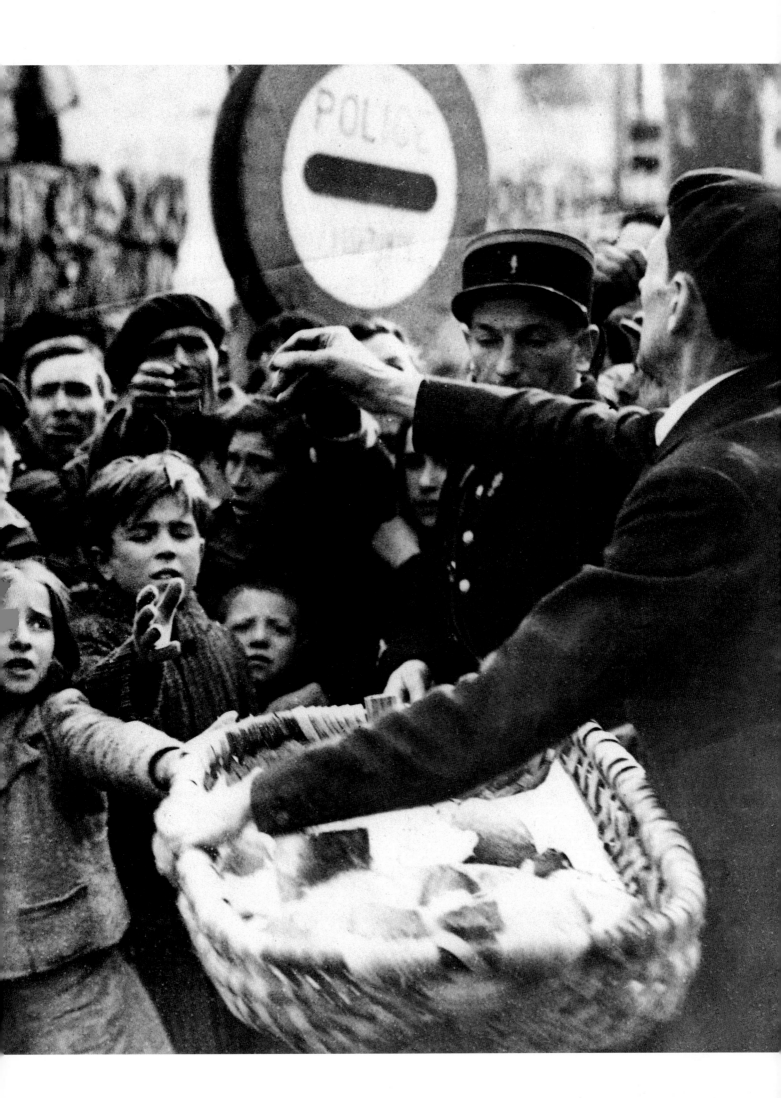

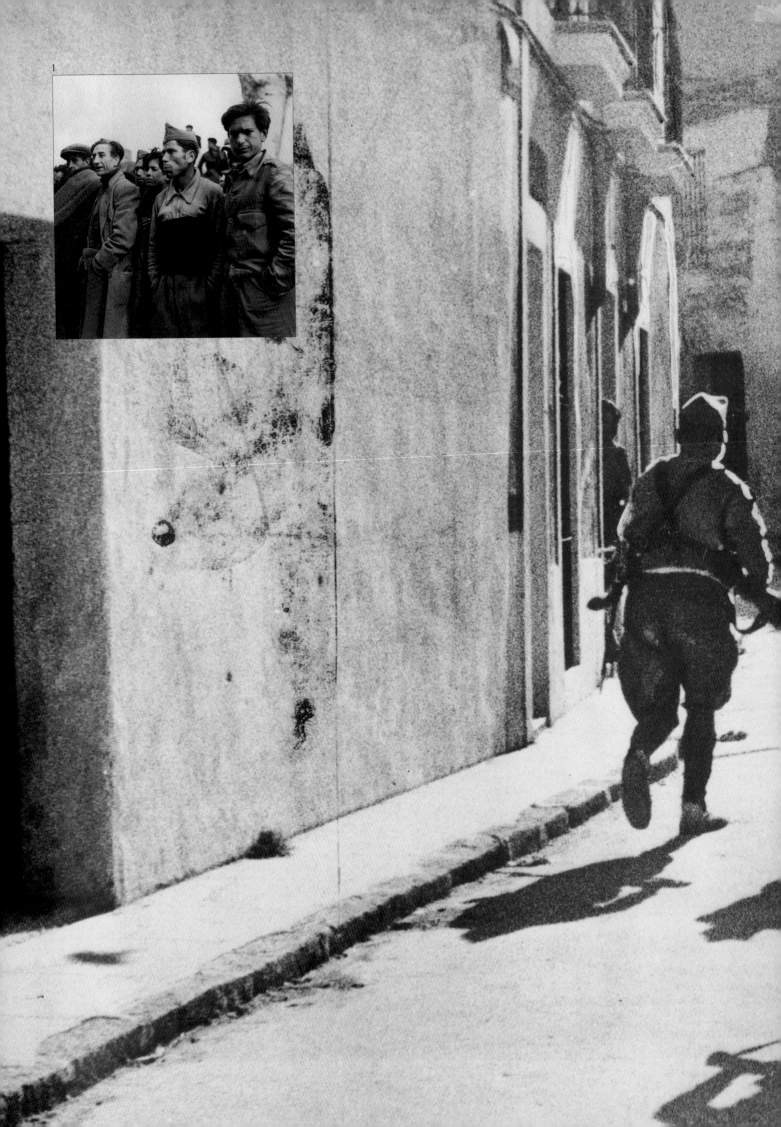

LOYAL Republican Spanish troops at ease in 1936 (1) contrast with jack-booted Foreign Legionaries on a 'hunt the Reds' mission in Mérida, rifles raised (2).

LOYALE Truppen der spanischen Republik während einer Pause, 1936 (1), und im Kontrast dazu die fremden Legionäre in Mérida, wie sie in ihren Stiefeln mit erhobenen Gewehren »die Roten jagen« (2).

LA décontraction des troupes espagnoles républicaines loyalistes en 1936 (1) contraste avec la « chasse aux rouges » dans laquelle se sont lancés les hommes de la légion étrangère, bottes montantes et fusils brandis à Mérida (2).

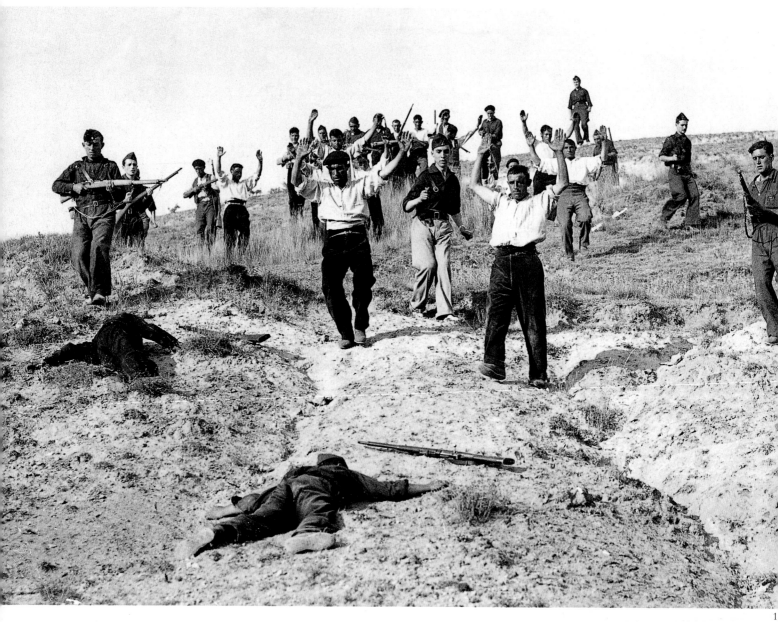

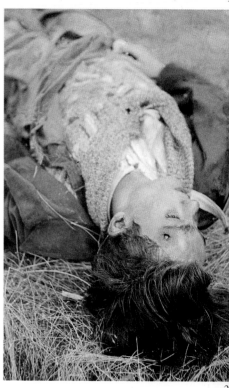

On 29 August 1936, this group of Republicans was forced to surrender by the Nationalist rebels (1). In their ill-assorted uniforms and weapons, they look more like a ragtag than a national army, suggesting how many of the regular troops were anti-Republican. A 17-year-old lies dead from a bullet in the head (2). A vivid account of one man's experience is offered by George Orwell's *Homage to Catalonia*. Words were enormously important to the ideological battle: after all, Franco's Falangists adopted the Foreign Legionaries' war cry 'Death to Intellectuals! Long live death!' The Republicans responded with poster propaganda like this Catalan advertisement post calling women to arms (4). All the unions, particularly female-dominated ones such as the garmentworkers, organized women like these militia seated wearily at a roadside (3). Their lack of uniforms, even boots, implies that this was taken late in the war.

Am 29. August 1936 zwangen die nationalistischen Rebellen diesen Trupp Republikaner zur Kapitulation (1). In ihren verschiedenerlei Uniformen und Waffen sehen sie eher wie ein bunt zusammengewürfelter Haufen aus als wie eine Nationalarmee, und man kann ahnen, wie viele reguläre Truppen sich auf die Seite der Gegner geschlagen hatten. Ein siebzehnjähriger Gefallener mit einer Kugel im Kopf (2). George Orwell hat in *Mein Katalonien* eindrucksvoll seine Kriegserlebnisse in Spanien beschrieben. Ideologische Kriegführung war von großer Bedeutung: Schließlich hatten Francos Falangisten den Kampfruf der Fremdenlegion übernommen, »Tod den Intellektuellen! Lang lebe der Tod!« Die Republikaner antworteten mit Plakaten darauf, wie hier an einer Litfaßsäule in Katalonien, wo Frauen zu den Waffen gerufen werden (4). Gewerkschaften, besonders von Frauen beherrschte wie die Näherinnengewerkschaft, organisierten

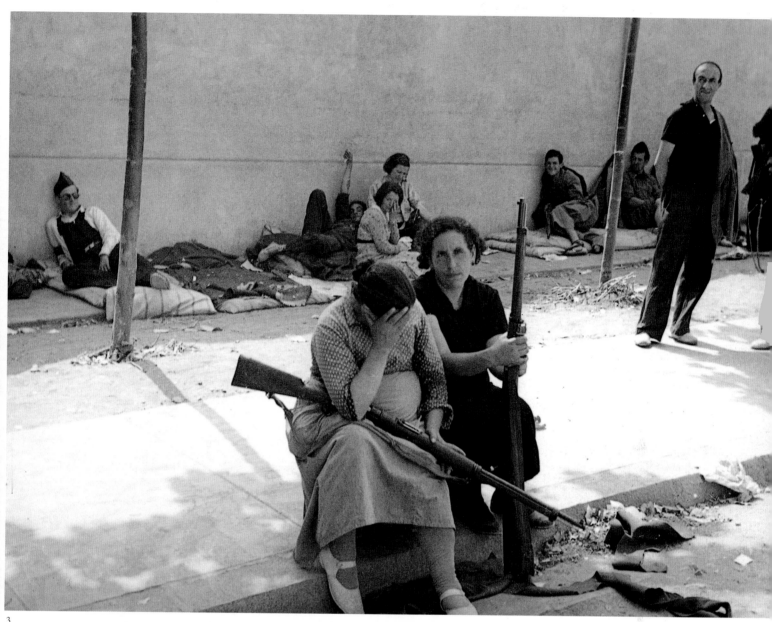

3

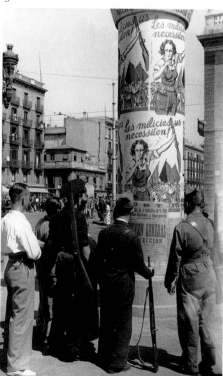

4

Frauenmilizen; hier (3) sieht man einige Kämpferinnen erschöpft am Straßenrand sitzen. Da sie keine Uniformen tragen, nicht einmal Stiefel, dürfte das Bild gegen Ende des Krieges entstanden sein.

Le 29 août 1936, les insurgés forcent un groupe de républicains à se rendre (1). Leurs uniformes dépareillés et leurs armes leur donnent plus l'allure d'une armée en déroute que d'une armée nationale. Un jeune homme de dix-sept ans tué d'une balle dans la tête (2). George Orwell, dans son *Hommage à la Catalogne*, raconte d'une manière vivante l'expérience d'un homme.

Les mots comptaient énormément : après tout, les phalangistes de Franco n'avaient-ils pas adopté le cri de guerre du *Tercio* (une légion étrangère) : « Vive la mort ! » Les républicains ripostaient par des affiches de propagande pour inviter les femmes à prendre les armes (4). Tous les syndicats, en particulier féminins, comme celui des ouvrières du vêtement, embrigadaient les femmes, comme ces miliciennes assises, épuisées, sur le bord de la route (3). L'absence d'uniforme et de bottes laisse penser que la photographie a été prise vers la fin de la guerre.

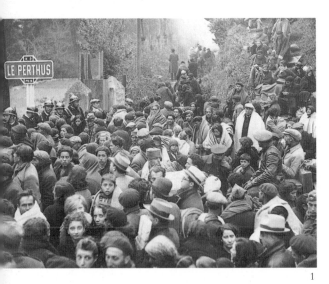

REFUGEES jam the roads into France (1). In January 1939, Franco's victorious troops entered Barcelona supported by General Yague's feared 'Moors', meeting with only sporadic resistance. Here some of the 3,000 Czech, Polish and German members of the International Brigade merge with the retreating Republican army and the mass of refugees fleeing north (2).

FLÜCHTLINGE drängen sich auf den Straßen nach Frankreich (1). Im Januar 1939 marschierten Francos siegreiche Truppen, verstärkt durch General Yagues gefürchtete »Mauren«, in Barcelona ein und trafen nur noch auf vereinzelten Widerstand. Auf diesem Bild (2) schließen sich einige der 3 000 Tschechen, Polen und Deutschen, die mit der Internationalen Brigade ins Land gekommen waren, der geschlagenen republikanischen Armee und den zahllosen Flüchtlingen im Strom nach Norden an.

LES réfugiés s'amassaient sur les routes en direction de la France (1). En janvier 1939, les troupes victorieuses de Franco entraient dans Madrid appuyées par les redoutés « Maures » du général Yague, où elles ne rencontrèrent qu'une résistance sporadique. Ici quelques-uns des 3 000 Tchèques, Polonais et Allemands, membres des brigades internationales, se mêlent à l'armée républicaine battant en retraite et aux flots de réfugiés qui font route vers le Nord (2).

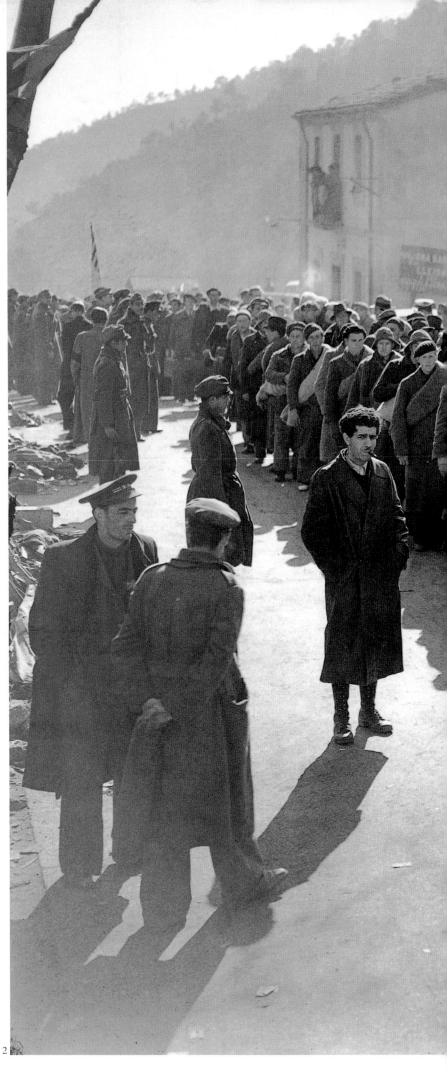

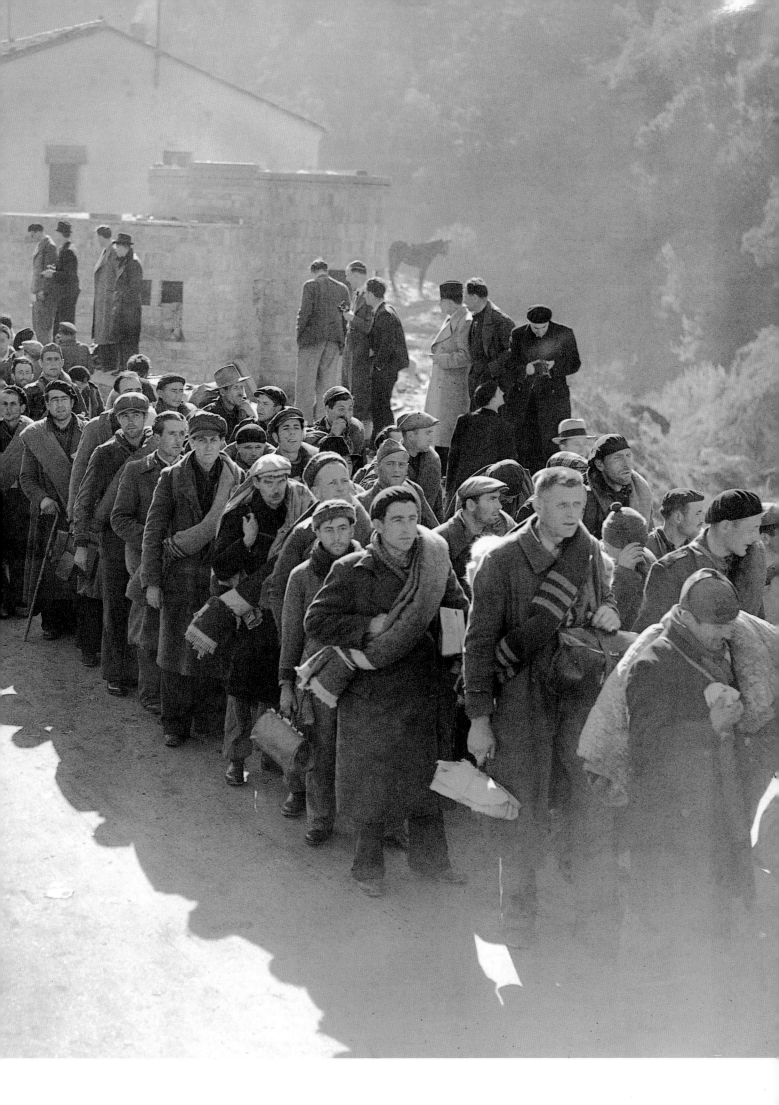

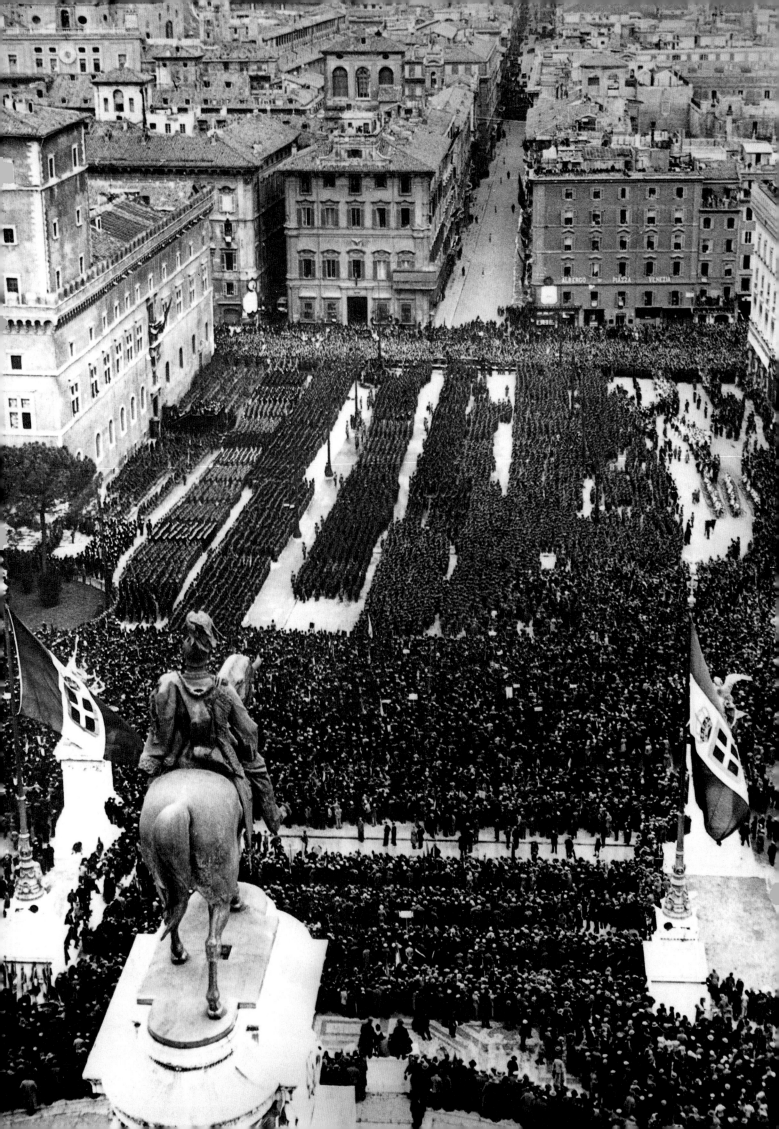

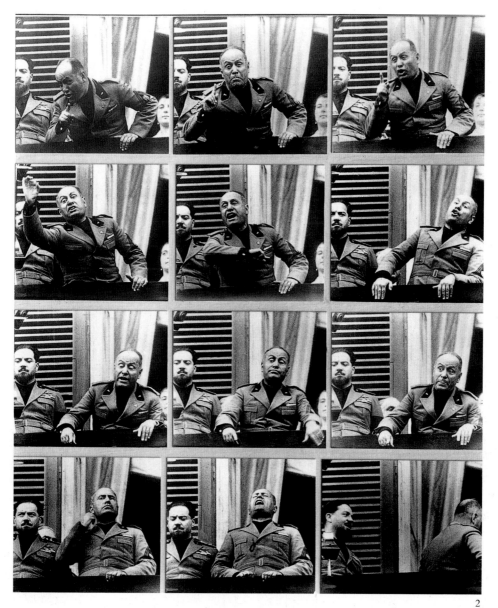

2

THE March on Rome has been called 'the Fascist-inspired myth of the way in which Mussolini came to power in Italy'. In 1922, civil war appeared imminent and the ex-socialist Mussolini demanded the formation of a Fascist government to save the country from socialism. On 29 October, King Victor Emmanuel III invited him to come from Milan to Rome, and Mussolini did so on the overnight express. On 30 October Mussolini formed the government and on the 31st some 25,000 blackshirts were imported, also by train, for a ceremonial parade (1). The 'March on Rome' was as histrionic an exaggeration as the expressions on Il Duce's face as he addresses his 'marchers', the 'Representatives of National Strengths', from the Palazzo Venezia (2).

DEN Marsch auf Rom hat man den »faschistischen Mythos von Mussolinis Machtergreifung in Italien« genannt. 1922 schien ein Bürgerkrieg unvermeidlich, und der ehemalige Sozialist Mussolini forderte die Bildung einer faschistischen Regierung, um das Land vor dem Sozialismus zu bewahren. Am 29. Oktober lud König Viktor Emmanuel III. ihn ein, von Mailand nach Rom zu kommen, woraufhin Mussolini schon den Nachtexpress nahm. Am 30. Oktober bildete er seine Regierung, und am 31. kamen, ebenfalls per Zug, etwa 25 000 Schwarzhemden zur feierlichen Parade (1). Der »Marsch auf Rom« war eine genauso lächerliche Übertreibung wie der Gesichtsausdruck des Duce, mit dem er die Eintreffenden, die »Vertreter nationaler Stärke«, vom Palazzo Venezia aus begrüßt (2).

LA marche sur Rome a été appelée « l'arrivée au pouvoir de Mussolini en Italie mythifiée par les fascistes ». En 1922, alors que la guerre civile semble imminente, l'ex-socialiste Mussolini réclame la constitution d'un gouvernement fasciste pour sauver le pays du socialisme. Le 29 octobre, le roi Victor Emmanuel III convie à Rome Mussolini, qui se trouvait alors à Milan. Celui-ci arrive par l'express de nuit. Le 30 octobre, il constitue son gouvernement ; le 31 il fait venir quelque 25 000 chemises noires, également par le train, pour participer à une parade solennelle (1). La « marche sur Rome » est une affabulation, tout comme sont volontairement exagérées les mimiques du Duce s'adressant du Palazzo Venezia à ses « marcheurs », aux « représentants des forces nationales » (2).

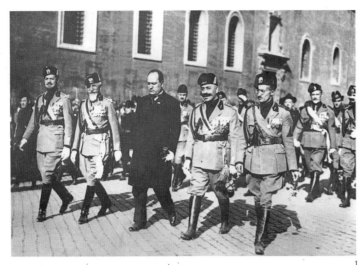

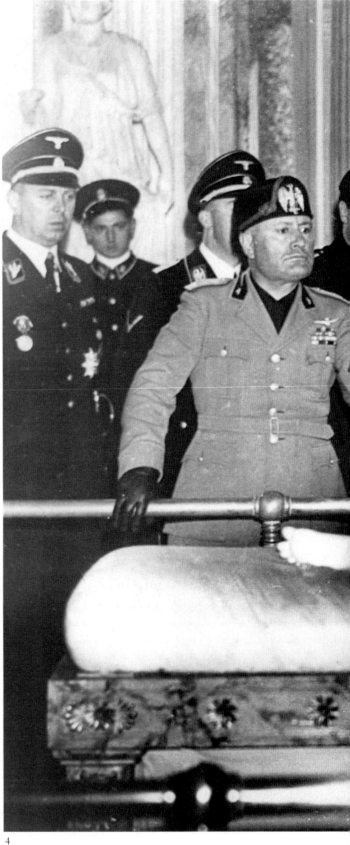

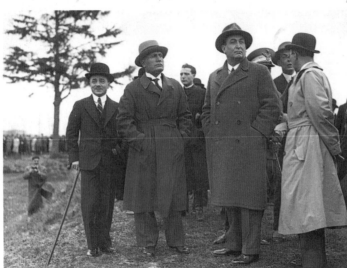

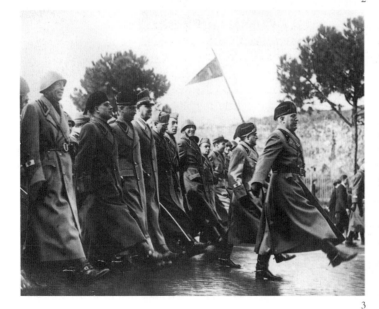

3 4

Mussolini in mufti between (left to right) Generals Balbo, de Bono, de Vecchi and Bianchi (1). Napoleonic theories about small men with big ambitions and complexes seemed exemplified by Franco, Hitler and – especially – Mussolini. This applied even more so to the Austrian Chancellor Dollfuss (at left), known as Millimetternich or Mickey Mouse for

being under 5 feet tall, here fraternizing with his fellow-dictator shortly before his assassination in 1934 (2). Mussolini brought the Führer to gaze at the hefty white marble nymph Pauline Borghese, Napoleon's sister, at the Villa Borghese (4). He then led the Fascist officials off in a disorderly goose-step during the Roman Parade (3).

Mussolini in Zivil zwischen den Generalen Balbo, de Bono, de Vecchi und Bianchi (1, von links nach rechts). Die Idee vom »Napoleonkomplex« – daß klein- wüchsige Männer einen ganz besonderen Ehrgeiz entwickeln – scheint durch Franco, Hitler und ganz besonders durch Mussolini bestätigt zu werden. Noch mehr traf das auf den österreichischen Kanzler Dollfuß zu (links), den man wegen seiner knappen

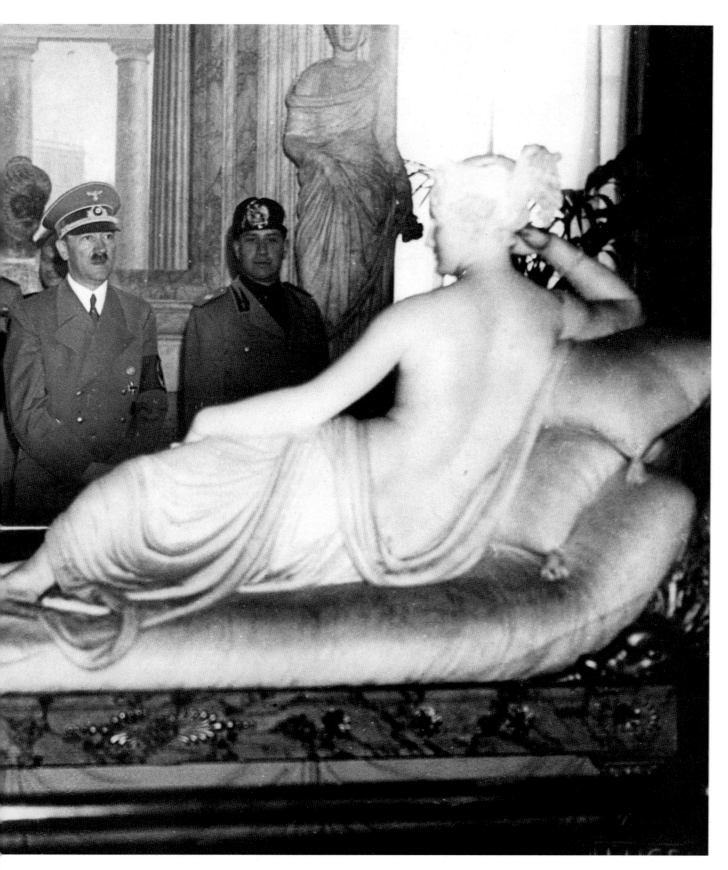

ein Meter fünfzig den »Millimetternich« nannte; hier sieht man ihn in bestem Einvernehmen mit seinem Diktatorkollegen, kurz vor seiner Ermordung 1934 (2). Dem Führer zeigte Mussolini in der Villa Borghese die Marmorstatue Venus (4). Er führte die faschistische Prominenz in einem etwas aus dem Takt gekommenen Gänsemarsch zur Römischen Parade (3).

Mussolini en civil entre (de gauche à droite) les généraux Balbo, de Bono, de Vecchi et Bianchi (1). Les théories à propos de Napoléon et des hommes de petite taille dotés de grandes ambitions et de gros complexes semblent se vérifier à travers Franco, Hitler et Mussolini. Elles sont encore plus vraies dans le cas du chancelier autrichien Dollfuss (à gauche) surnommé « Mickey la souris », fraternisant avec un de ses homologues dictateurs peu de temps avant d'être assassiné en 1934 (2). À la Villa Borghese, Mussolini conduisit le Führer contempler la nymphe qui représente Pauline Borghese, sœur de Napoléon (4). Il entraîna ensuite la délégation fasciste dans un pas de l'oie désordonné à la Parade romaine (3).

1

FASCIST march-pasts were intended to unite the nations and the generations. In 1936 the Marine branch of the *Figli della Lupa* (Sons of the She-wolf – presumably a reference to Romulus, Remus and the glories of ancient Rome) marched beneath Mussolini's raised salute (1). In 1945 in Tripoli Fascist women were organized in militias, possibly as advance warning of fresh neo-imperialist intentions in the region, only months before the invasion of Abyssinia (2). And secondary schoolboys underwent military training even when it was too hot to wear much beyond plimsolls and sunhats (3).

DIE Faschistenaufmärsche sollten die Nationen und Generationen zusammen-bringen. 1936 zog die Marineabteilung der *Figli della Lupa* (Söhne der Wölfin – eine Anspielung auf Romulus und Remus und den Ruhm des alten Rom) an Mussolini vorüber, der die Hand zum Gruß erhoben hat (1). 1945 werden die Faschistenfrauen in Tripolis zu Milizen organisiert, möglicherweise ein Vorzeichen, daß sich neoimperialistische Ambitionen in der Gegend zu regen begannen, nur Monate vor der Invasion Abessiniens (2). Und Schuljungen mußten ihre soldatische Ausbildung auch dann absolvieren, wenn es so heiß war, daß man außer Sonnenhut und Turnschuhen nicht viel tragen konnte (3).

L'IDÉE des défilés fascistes était de réunir les nations et les générations. En 1936, la section marine des *Figli della Lupa* (les fils de la louve ; probable référence à Romulus, Remus et aux gloires de la Rome antique) défilent au-dessous de Mussolini qui salue debout (1). En 1945, à Tripoli, les femmes fascistes sont organisées en milices, probablement afin de prévenir les velléités néo-impérialistes qui se font jour dans la région, à quelques mois seulement de l'invasion de l'Abyssinie (2). Ailleurs, des écoliers du secondaire suivent un entraî-nement militaire en dépit d'une chaleur n'autorisant guère que les sandales et le chapeau de soleil (3).

Nazism

ADOLF Hitler was on the face of it perhaps the least likely of Fascist dictators. Non-German and erratically educated, a professional failure in everything he had tried before entering politics, at first he neither looked nor acted the part. Instead of the statuesque physique of a Nordic god, he was small and black-haired and dark-eyed, a vegetarian in a decidedly carnivorous country. Yet his own mixed psychology succeeded in touching a chord that played on both Germans' fears and their pride. By creating an enemy 'other' of mythic dimensions, he could unite the German-speaking peoples in pursuit of his goal, the foundation of the 1000-year Third Reich.

If the enemy did not actually exist, then it would have to be invented. In Central Europe, Ashkenazi Jews had been largely assimilated during their 500-year-long sojourn, many having been known as 'Court Jews' for their sought-after pre-eminence in the arts that sent them from one principality to the next to perform as musicians and artists. Many of these described themselves by nationality rather than religion and thought of themselves as Germans or Austrians before Jews. Ironically, by defining Jews not by their religion but by being even one-eighth of Jewish blood, Hitler was including himself in, by dint of one grandparent. If the stereotype of the grasping miser didn't exist, it would be promoted by scurrilous graffiti and wild accusations. When, after Kristallnacht, Propaganda Minister Goebbels surveyed the mess of shattered glass on the streets of Berlin, he groaned: 'They [the SA/Stormtroopers' mob] should have broken fewer Jewish windows and taken more Jewish lives.'

When the Communists failed to carry out the awaited revolutionary putsch, the burning of the Reichstag was staged as a pretext to clamp down in their suppression. Much blame has been attached to the policy of appeasement pursued by both French and British governments through the 1920s and 30s, though Churchill was the sole politician in favour of a military response when Hitler annexed the Rhineland in 1936. The truth was probably that too much of Europe was preoccupied with licking its own wounds from the Great War and with the shortage of manpower and political will to wish for any further warmongering.

ADOLF Hitler war unter den faschistischen Dikta toren vielleicht derjenige, dem man es am wenig sten zutraute. Als Österreicher mit nur unvollständige Schulbildung, der in allem, was er versucht hatte, bevo er in die Politik ging, völlig gescheitert war, sah er nicl nur nicht danach aus, sondern benahm sich auch an fangs nicht wie ein Führer. Er hatte nicht die Statu eines nordischen Gottes, sondern war klein und schwarz haarig mit dunklen Augen, ein Vegetarier im Land de Fleischesser. Und doch rührte er mit seiner konfuse Psyche eine Saite an, die sowohl die Ängste als auc den Stolz der Deutschen erklingen ließ. Er beschwo ein Feindbild von geradezu mythischen Ausmaße herauf, und damit konnte er die deutschsprachigen Völ ker vereint für sein großes Ziel gewinnen, die Grün dung eines »tausendjährigen Dritten Reichs«.

Wenn es keine Feinde gab, dann mußte man welch erfinden. In Mitteleuropa hatten sich im Laufe ihre fünfhundertjährigen Wanderschaft zahlreiche Ostjude niedergelassen, viele davon »Hofjuden«, die als gefragt Musiker oder Miniaturmaler von einem Fürstenhc zum anderen zogen. Viele davon fühlten sich eher eine Nation zugehörig als einer Religionsgemeinschaft un verstanden sich zuerst als Deutsche oder Österreiche und erst dann als Juden. Für Hitler war es nicht di Religion, sondern das Blut, das zählte, und ironischer weise hätte er sich, da auch jemand mit einem Achte Judenblut noch als Jude galt, selbst dazurechnen müsser denn dem Vernehmen nach hatte er einen jüdischei Großvater. Wenn die Leute nicht von sich aus da Vorurteil vom »raffgierigen Geizkragen« hatten, bekamei sie es durch verleumderische Wandsprüche und aus de Luft gegriffene Anschuldigungen eingetrichtert. Al nach der »Reichskristallnacht« der Propagandaministe Goebbels das zerschmetterte Schaufensterglas auf de Berliner Straßen musterte, seufzte er: »Ich wünscht nur, [die SA-Männer] hätten weniger jüdische Scheiber und mehr jüdische Schädel eingeschlagen.«

Als der vorausgesagte Kommunistenaufstand auf sicl warten ließ, wurde der Brandanschlag auf den Reichs tag inszeniert, damit man einen Vorwand für ihr Verfolgung hatte. Vieles ist später der zu nachgiebige Haltung der französischen und britischen Regierunge der 20er und 30er Jahre angelastet worden, doch im

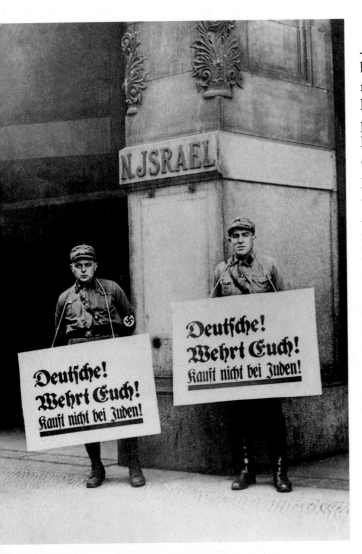

NAZI PICKETS OUTSIDE JEWISH STORE IN BERLIN, APRIL 1933: 'GERMANS! DEFEND YOURSELVES! DON'T BUY FROM JEWS!' READ THE PLACARDS.

STREIKPOSTEN DER NAZIS VOR EINEM JÜDISCHEN GESCHÄFT IN BERLIN, APRIL 1933.

DES PIQUETS DE GRÈVE NAZIS DEVANT UN MAGASIN JUIF À BERLIN, AVRIL 1933 : «ALLEMANDS! DÉFENDEZ-VOUS MÊMES! N'ACHETEZ PAS CHEZ LES JUIFS!» PEUT-ON LIRE SUR LES AFFICHES.

A DOLF Hitler était peut-être le plus paradoxal de tous les dictateurs fascistes. Non Allemand, ayant bénéficié d'une éducation disparate et échoué à tous les métiers auxquels il s'était essayé avant de se lancer dans la politique, il n'avait a priori ni le parcours ni le physique de l'emploi. Au lieu d'avoir la stature et l'apparence d'un dieu nordique, sa chevelure était noire et ses yeux foncés. Enfin, il était végétarien dans un pays résolument carnivore. Pourtant, sa psychologie composite sut jouer des peurs et de l'orgueil des Allemands. En créant un ennemi « différent », aux dimensions mythiques, il réussit à unir les peuples de langue allemande derrière lui à la poursuite de son objectif : fonder le Troisième Reich millénaire.

Puisque l'ennemi n'existait pas vraiment, il serait inventé. En Europe centrale, les Juifs ashkénazes étaient largement assimilés depuis leur arrivée, cinq siècles plus tôt. Beaucoup étaient appelés les « Juifs de cour » parce qu'ils excellaient dans les métiers artistiques. Ils étaient de ce fait très recherchés, voyageant d'une principauté à l'autre en tant que musiciens ou portraitistes. Ils se définissaient davantage par rapport à leur nationalité qu'en fonction de leur religion, et se considéraient d'abord allemands ou autrichiens avant d'être juifs. L'ironie voulut qu'en ne définissant pas le Juif par sa religion mais par le fait d'avoir un huitième de sang juif, Hitler s'incluait lui-même. En effet, l'un de ses grands-parents était juif. Le stéréotype du Juif âpre au gain sera accentué par des graffiti injurieux et des accusations insensées. Quand, après la Nuit de cristal, Goebbels, ministre de la Propagande, se rendit sur les lieux, devant le triste état des rues de Berlin jonchées de débris de verre, il gémit : « Ils [les sbires des troupes d'assaut] auraient mieux fait de briser un peu moins de vitres juives et de supprimer plus de Juifs. »

Après l'échec du putsch révolutionnaire tant attendu, l'incendie du Reichstag fut monté de toutes pièces et utilisé comme un prétexte pour réclamer la suppression des activités communistes. On a beaucoup reproché, tant au gouvernement français que britannique, la politique d'apaisement qui fut la leur tout au long des années 20 et 30. C'est oublier que Churchill fut le seul homme politique favorable à une riposte militaire en 1936 après l'annexion de la Rhénanie par Hitler. La vérité était probablement que l'Europe, trop préoccupée de panser ses propres blessures au lendemain de la Grande Guerre, manquait de ressources humaines et de volonté politique pour risquer de s'engager dans une autre guerre.

merhin war Churchill der einzige Politiker, der sich für einen militärischen Gegenschlag einsetzte, als Hitler 1936 das Rheinland besetzte. In Wahrheit war wohl ganz Europa zu sehr damit beschäftigt, die Wunden des Ersten Weltkriegs zu lecken, mit Massenarbeitslosigkeit und politischer Orientierungslosigkeit, als daß man sich auf einen neuen Krieg hätte einlassen können.

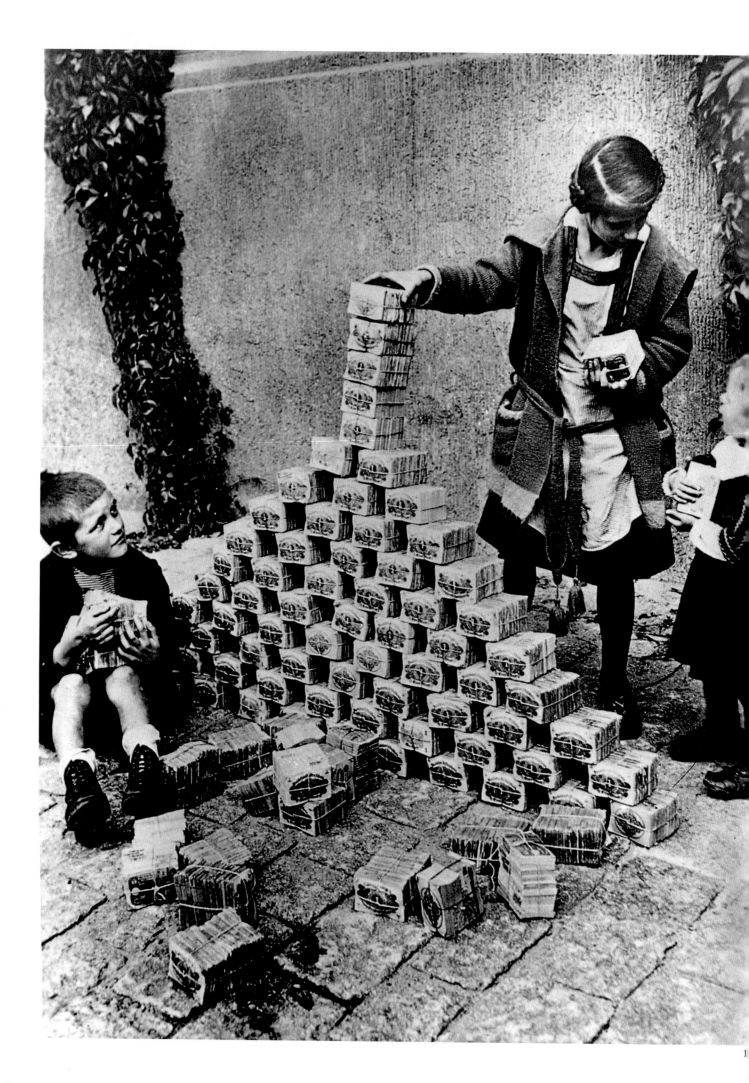

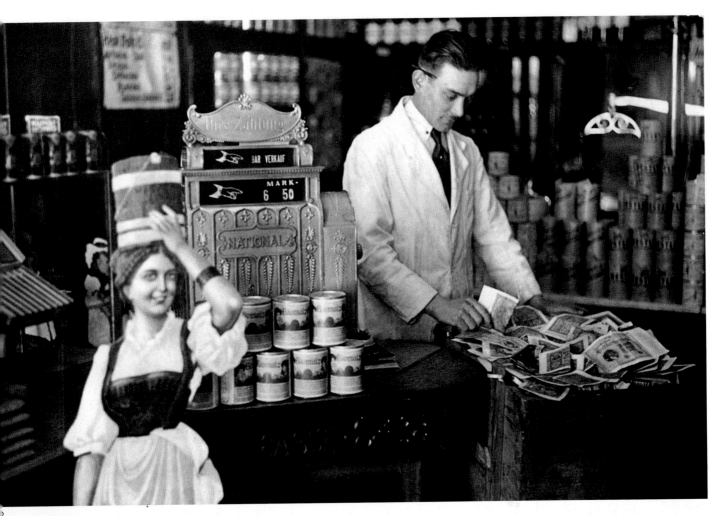

INFLATION turned to hyperflation in the wake of the Great War. In 1923, one US dollar became worth 4.2 m Reichsmarks; five years later it had doubled its decline. Banknotes became cheaper than toys (1) or wallpaper (3), and this shopkeeper abandoned his till for tea-chests to store the wads (2). Politically, the Reichstag proved itself likewise bankrupt. In the September elections, the Nazi Party increased its own vote from 810,000 to a staggering 6,409,600. Parliamentary democracy was now suspended and parliament became paralysed by the rot within and the threat from without.

DIE Inflation nahm nach dem Ersten Weltkrieg bis dahin ungekannte Ausmaße an. 1923 war ein US-Dollar 4,2 Millionen Reichsmark wert; fünf Jahre darauf war der Wert der Mark auf die Hälfte gesunken. Banknoten waren weniger wert als Bauklötze (1) oder Tapete (3), und hier hat ein Ladenbesitzer es aufgegeben, die Bündel noch in die Kasse zu stopfen, und nimmt statt dessen Teekisten (2). Und der Reichstag erwies sich in politischer Hinsicht als ebenso bankrott. Bei den Wahlen im September 1930 konnten die Nationalsozialisten ihre Stimmen von 810 000 auf unglaubliche 6 409 600 erhöhen. Damit war die parlamentarische Demokratie am Ende, und das Parlament gelähmt von der Zersetzung im Inneren und der Bedrohung von außen.

L'INFLATION se changea en hyperinflation au lendemain de la Grande Guerre. En 1923, un dollar des États-Unis valait 4,2 millions de Reichsmarks, et perdait le double de sa valeur cinq ans plus tard. Les billets de banque valaient moins cher que les jouets (1) ou le papier peint (3). Ce commerçant a délaissé sa caisse pour entreposer ses rouleaux de billets dans des caisses à thé (2). Politiquement le Reichstag s'avérait tout aussi en faillite. Au cours des élections de septembre, le parti nazi augmenta son score, lequel passa de 810 000 voix au chiffre inquiétant de 6 409 600. La démocratie parlementaire se trouva alors suspendue, le Parlement paralysé sous le coup de sa propre déliquescence et de la menace extérieure.

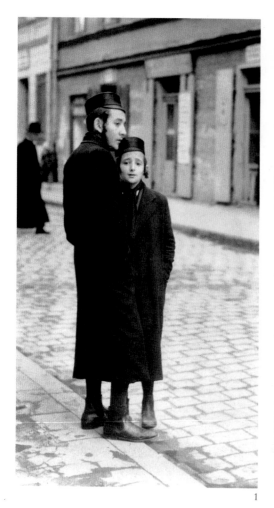

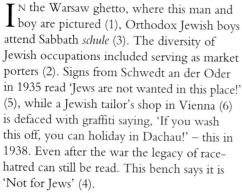

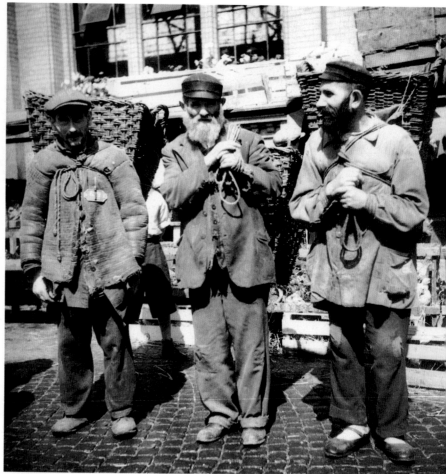

IN the Warsaw ghetto, where this man and
boy are pictured (1), Orthodox Jewish boys
attend Sabbath *schule* (3). The diversity of
Jewish occupations included serving as market
porters (2). Signs from Schwedt an der Oder
in 1935 read 'Jews are not wanted in this place!'
(5), while a Jewish tailor's shop in Vienna (6)
is defaced with graffiti saying, 'If you wash
this off, you can holiday in Dachau!' – this in
1938. Even after the war the legacy of race-
hatred can still be read. This bench says it is
'Not for Jews' (4).

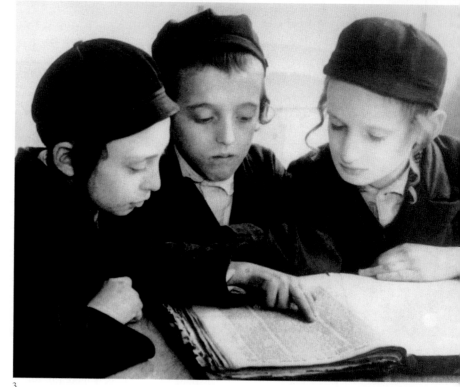

IM Warschauer Ghetto, wo diese Aufnahme
von einem Mann und einem Jungen ent-
stand (1), gingen die orthodoxen jüdischen
Jungen am Sabbatabend zur Schule (3). Juden
waren in den verschiedensten Berufen tätig,
hier als Träger auf dem Markt (2). Schwedt an
der Oder zeigte 1935 deutlich, wo es politisch
stand (5), und einem jüdischen Schneider in
Wien (6) wird Urlaub in Dachau versprochen,
wenn er die Schmierereien übertüncht – und
das schon 1938. Selbst nach dem Krieg blieben
die Zeichen des Rassenhasses noch sichtbar:
Diese Bank ist »nicht für Juden« (4).

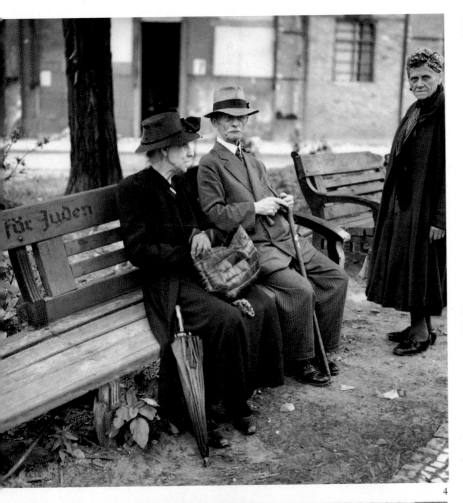

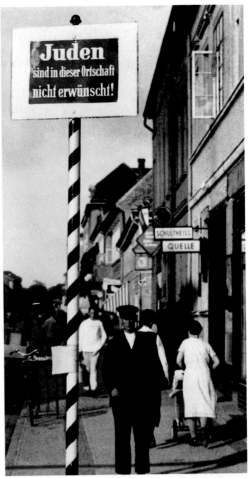

4

5

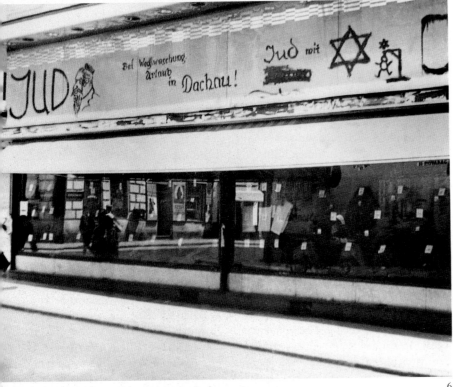

6

Dans le ghetto de Varsovie, où fut prise la photographie de cet homme et de cet enfant (1), les garçonnets juifs orthodoxes allaient à la *Schule* (école) sabbatique (3). Parmi les divers emplois exercés par les Juifs, on trouve celui de porteur sur le marché (2). Les panneaux à Schwedt an der Oder signalaient en 1935 : « Ici on ne veut pas de Juifs ! » (5). Ailleurs, la boutique d'un tailleur juif à Vienne (6) est barbouillée de graffiti prévenant : « Si tu effaces cette inscription, tu es bon pour un petit voyage à Dachau ! » Cela en 1938 ! Même après la guerre, la haine raciste pouvait encore s'affiches dans des inscriptions à l'image de celle figurant sur ce banc : « Pas pour les Juifs » (4).

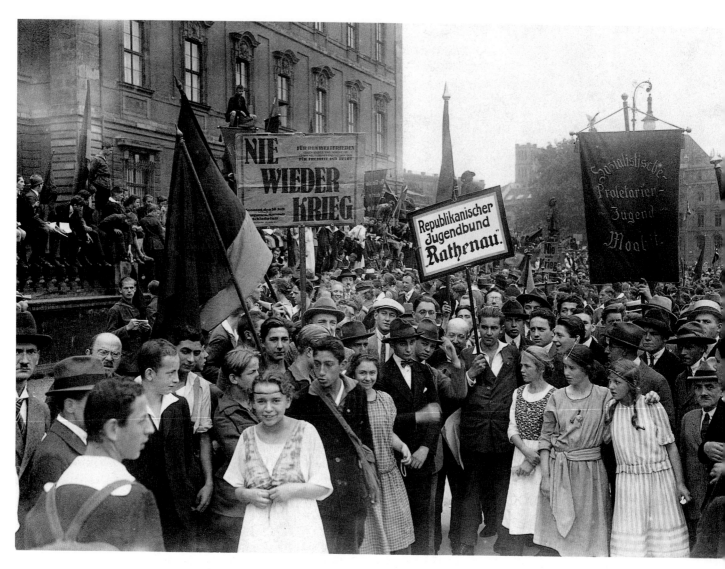

THE aftermath and humiliation of the Great War took time to dispel. In July 1922 the Rathenau Youth Organization assembled before the castle on a 'No More War' demonstration (1). During the so-called 'Kapp Revolution' of 1920, named after an obscure provincial official, right-wingers attempted a *coup d'état* and a proclamation of a new government led by Kapp but were swiftly routed by a general strike of Berlin workers. The rising was noted, however, for the early use of the swastika (however amateurishly painted onto helmets) and for revealing an embryonic Nazi Party (3). Among a group of Hitler's stormtroopers who participated in the Munich putsch of 9 November 1923 is Heinrich Himmler (holding the flag), later Nazi Gestapo chief (2).

ES dauerte seine Zeit, bis Schrecken und Erniedrigung des Ersten Weltkriegs vorüber waren. Im Juli 1922 versammelte sich der Jugendbund Rathenau zu einer Demonstration unter dem Motto »Nie wieder Krieg« (1). Beim sogenannten Kapp-Putsch von 1920, nach einem obskuren Provinzbeamten benannt, versuchten rechtsgerichtete Kräfte einen Staatsstreich und proklamierten eine neue, von Kapp geführte Regierung, die aber nach einem Generalstreik der Berliner Arbeiter bald wieder aufgeben mußte. Bemerkenswert ist dieser Putsch für den frühen Einsatz von Hakenkreuzen, wenn auch recht amateurhaft auf die Stahlhelme gemalt, der erste größere Auftritt der eben erst gegründeten NSDAP (3). Zu den SA-Männern, die an Hitlers Münchner Putsch vom 9. November 1923 beteiligt waren, gehörte auch Heinrich Himmler (mit Flagge), der spätere Gestapochef (2).

LES conséquences de la Grande Guerre et l'humiliation qui s'ensuivit mirent du temps à disparaître. En juillet 1922, l'organisation Rathenau de la jeunesse manifestait devant le château pour qu'il n'y ait « jamais plus de guerre » (1). En 1920, au cours de ce qu'on appela la « révolution Kapp », du nom d'un obscur responsable provincial, des éléments de droite tentaient de proclamer par un coup d'État un nouveau gouvernement dirigé pas Kapp. Ils furent promptement mis en déroute grâce à la grève générale déclenchée par les ouvriers berlinois. L'émeute retint cependant l'attention parce qu'à cette occasion la croix gammée apparut pour la première fois (même si son dessin laisse à désirer), révélant ainsi l'existence d'un parti nazi à l'état embryonnaire (3). Au milieu de l'un des groupes formés par les troupes d'assaut d'Hitler, qui participa au putsch de Munich le 9 novembre 1923, on aperçoit Heinrich Himmler (tenant le drapeau), qui devint plus tard le responsable de la Gestapo (2).

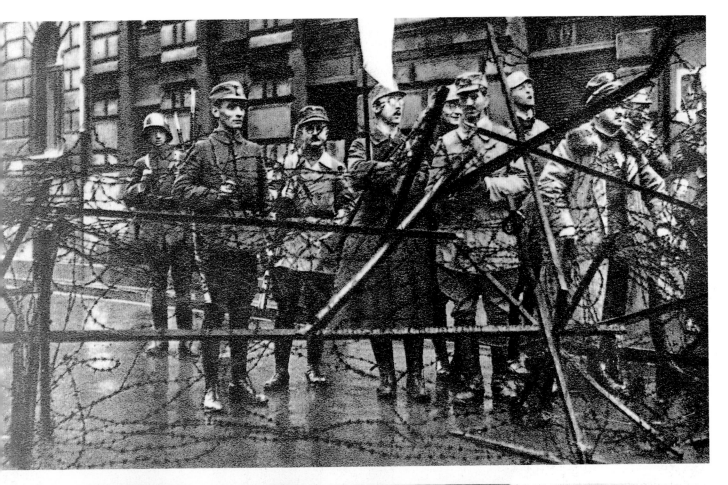

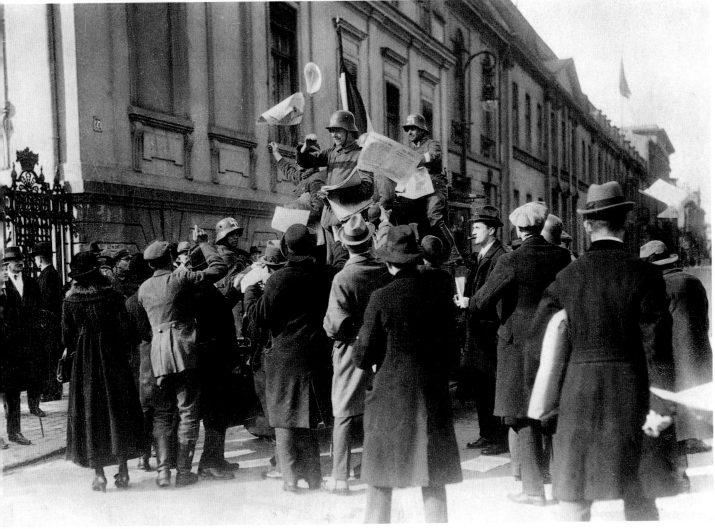

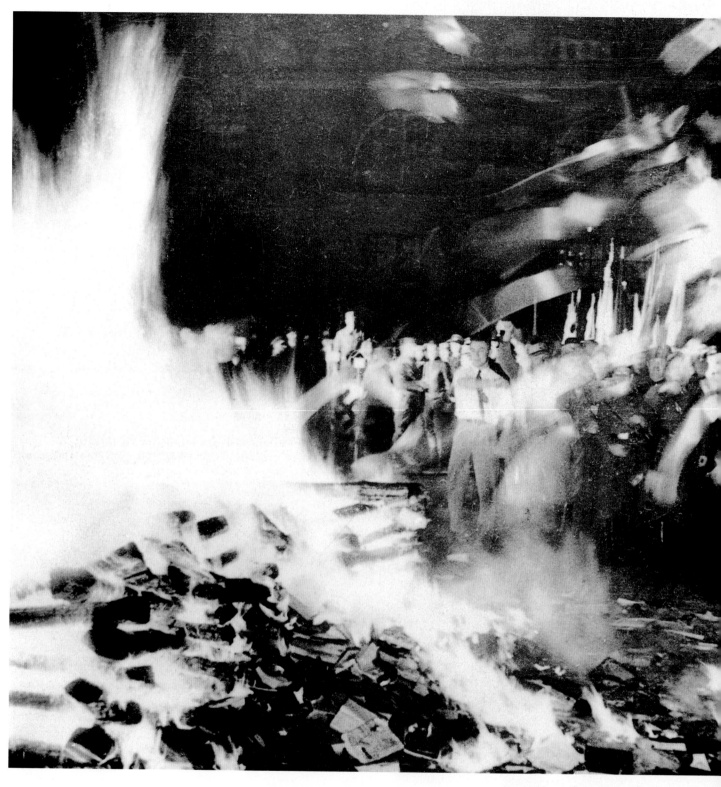

NOT since Savonarola had Europe seen such pyres of books. As part of the 1933 bonfire of 'anti-German literature' many of Europe's greatest writers were consigned to the flames in Berlin's Opernplatz (1). Another bonfire in 1933 was that of the Reichstag (2). Goering reached the scene, already proclaiming: 'The Communist Party is the culprit... We will show no mercy. Every Communist must be shot on the spot.'

SEIT Savonarola hatte es in Europa keine solche Bücherverbrennung mehr gegeben. Als 1933 auf dem Berliner Opernplatz »undeutsches Schrifttum« in Flammen aufging, waren die Werke vieler der bedeutendsten Schriftsteller Europas dabei (1). Ein anderer großer Scheiterhaufen des

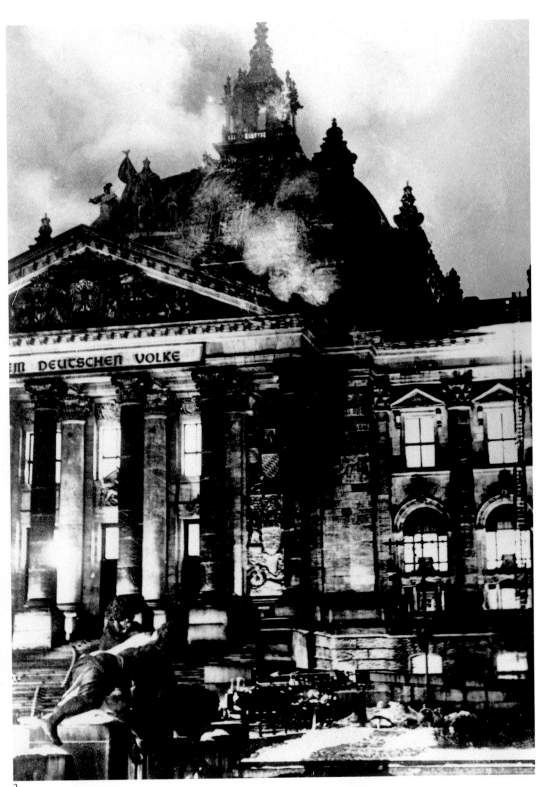

Jahres 1933 war der Reichstag (2). Als Göring am Ort des Geschehens eintraf, brüllte er unverzüglich: »Das ist das Werk der kommunistischen Partei … Wir werden keinerlei Gnade walten lassen. Jeder Kommunist muß auf der Stelle erschossen werden.«

Depuis Savonarole, l'Europe n'avait plus jamais connu de tels autodafés. Un grand nombre d'immenses écrivrains européens comptèrent parmi ceux dont les livres brûlèrent sur la Opernplatz à Berlin, en 1933 (1), dans le feu de joie de la « littérature anti-allemande ». L'autre feu de joie fut celui du Reichstag en 1933 également (2). Goering, en arrivant sur les lieux, clama tout de suite : « C'est le parti communiste le coupable … nous ne ferons pas de quartier. Tout communiste doit être abattu sur place. »

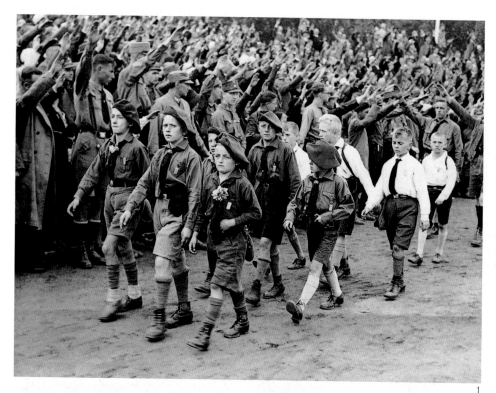

YOUNG Nazis, dressed remarkably like their Italian counterparts, at the 1932 Reich Youth Convention of the Nazi Party held at Potsdam in the presence of the Führer (1). Adolf Hitler, here ascending the steps of Bückeberg (3), called the destruction of the Reichstag 'a God-given signal', meaning that 'There is nothing that shall now stop us from crushing out this murderous pest with an iron fist.' Others deduced that it was perhaps the country's short-lived democracy that had just gone up in smoke, particularly when Interior Minister Frick added that whatever the outcome of impending elections: 'A state of emergency will exist which will authorize the government to remain in office.' In March 1933, this was followed up with mass police raids particularly aimed at artists, journalists, students and intellectuals – presumably anyone who read books. Trucks were loaded with 'banned material' and residents from the Berlin artists' quarter round Südwestkorso (2).

JUNGE Nazis, deren Uniformen auffallend denjenigen ihrer italienischen Brüder ähneln, beim Reichsjugendtag der nationalsozialistischen Partei, der 1933 in Potsdam im Beisein des Führers stattfand (1). Adolf Hitler, der hier zum ersten nationalsozialistischen Erntedankfest den Bückeberg hinaufschreitet (3), nannte den Brand des Reichstags ein »Geschenk des Himmels«, denn: »Nun gibt es nichts mehr, was uns daran hindern wird, dies mörderische Ungeziefer mit eiserner Faust auszumerzen.«

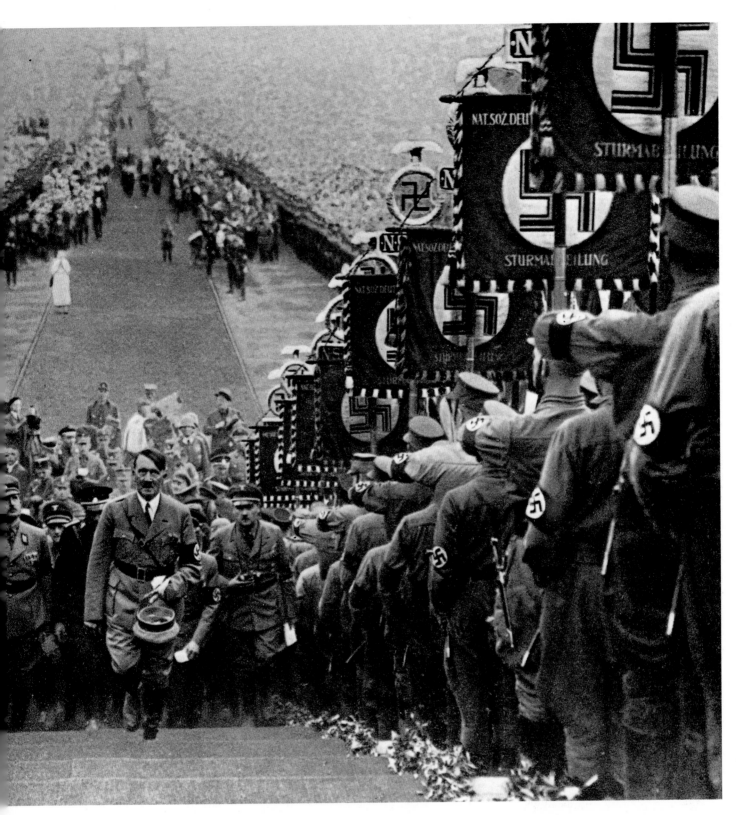

Andere fanden eher, daß es die junge Demokratie des Landes war, die da in Flammen aufging. Im März 1933 folgte eine Welle von Polizeirazzien, die besonders Künstler, Journalisten, Studenten und Intellektuelle traf – alle, die Bücher lasen. Lastwagenweise wurden Bewohner und »verbotenes Schrifttum« aus dem Berliner Künstlerviertel um den Südwestkorso abtransportiert (2).

Jeunes nazis, à la Convention de la jeunesse du Parti, qui se déroula en 1932 à Potsdam en présence du Führer (1). On notera la similitude avec les uniformes de leurs homologues italiens. Adolf Hitler, qu'on voit ici gravir les marches de Bückeberg (3), qualifia de « signe divin » la destruction du Reichstag, parce que « rien ne pourra maintenant nous empêcher d'écraser cette engeance d'assassins sous un poing d'airain. » D'autres, peut-être, y virent la fin d'une brève démocratie, notamment lorsque le

ministre de l'intérieur, Frick, ajouta que quels que soient les résultats des élections à venir, « l'état d'urgence sera décrété pour permettre au gouvernement de rester en place. » En mars 1933, il se vit confirmé par les rafles de police visant tout particulièrement les artistes, les journalistes, les étudiants et les intellectuels. Le « matériel interdit » et les habitants du quartier autour de Südwestkorso, où vivaient les artistes berlinois, furent embarqués dans des camions (2).

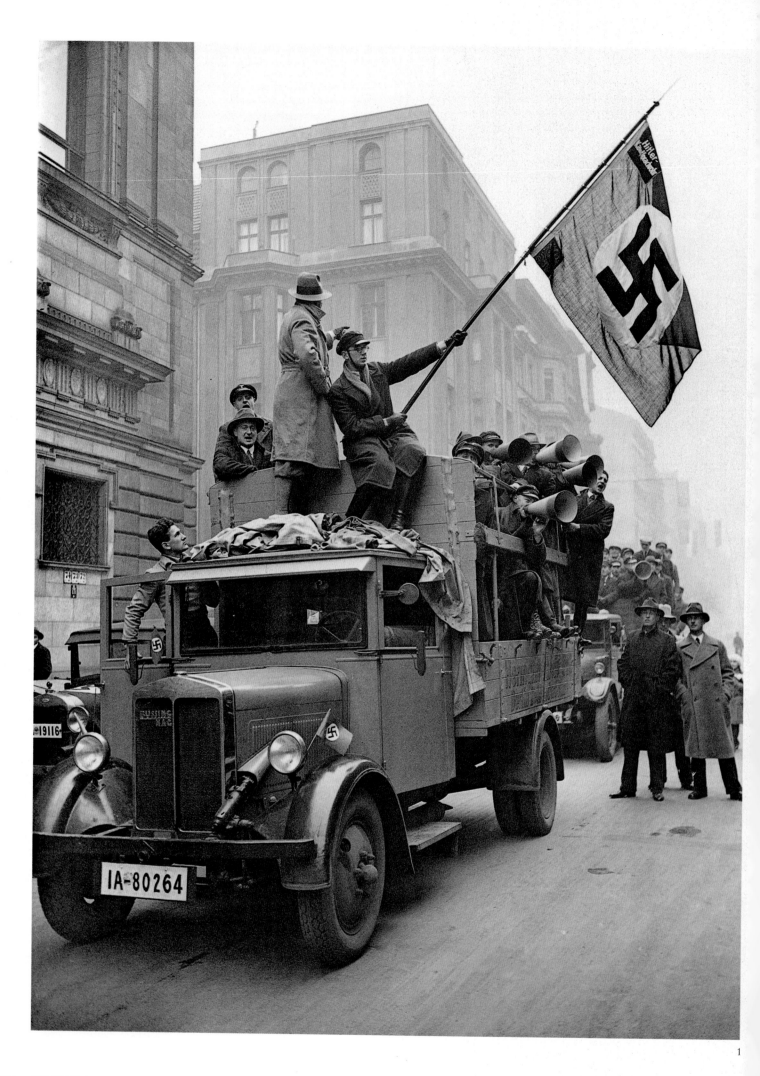

On 12 November 1933 Berlin streets were packed with flag-waving, megaphone-bearing Nazis, calling out voters for the plebiscite (1). Stormtroopers dispatched to the polling booth anyone who had failed to vote (2). The 1936 anniversary of the 1923 March on Munich was restaged by Hitler and his cohorts from the beer hall where the original putsch was plotted to the Königsplatz (3).

Am 12. November 1933 waren die Berliner Straßen voll von Nazis, die Wähler zu den Urnen nötigten (1). SA-Männer halfen nach, wenn sich jemand der Wahl entziehen wollte (2). 1936 fand zum Jahrestag des Münchner Aufstandes von 1923 eine Parade statt, bei der Hitler und seine Kohorten vom Bürgerbräukeller, in dem sie den Putsch geplant hatten, zum Königsplatz zogen (3).

Le 12 novembre 1933, les nazis envahirent les rues de Berlin pour appeler les électeurs à participer au plébiscite (1). Les troupes d'assaut expédiaient à l'isoloir tous ceux qui n'avaient pas voté (2). L'anniversaire de la marche sur Munich de 1923, célébré en 1936 par Hitler et ses troupes, est organisé depuis la brasserie où le putsch avait été conçu jusqu'à la Königsplatz (3).

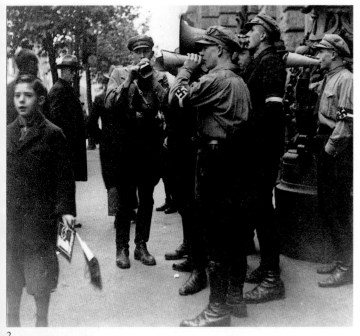

2

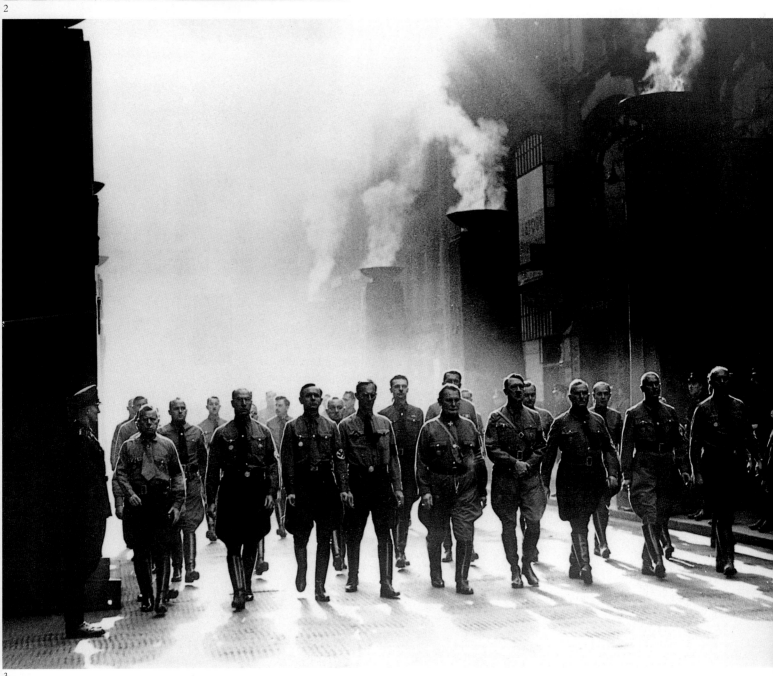

3

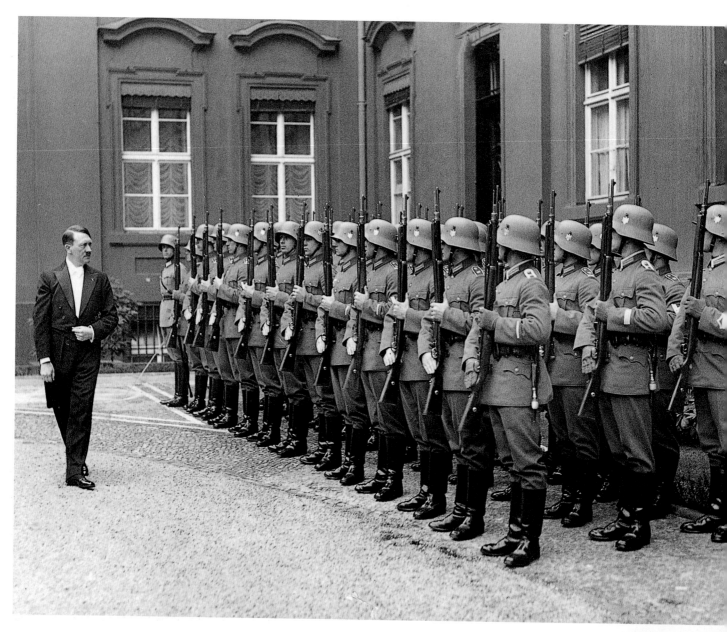

IN 1935 Hitler inspected the guard of honour before receiving the new Spanish Ambassador at the presidential palace (1). Hermann Goering displays an unusually ambiguous response to the attention he and his medals are receiving from his pet lioness, oddly named 'Caesar' (2). Some say this is Hitler's only worthwhile legacy – the Volkswagen, a car tough and reliable as a tank, designed in 1938 and still running (4). This one-theme postcard vendor (3) is clearly a Hitler fan, having adopted his moustache and adapted his clock to suit.

IM Jahre 1935 inspiziert Hitler die Ehrengarde vor dem Empfang des neuen spanischen Botschafters im Präsidentenpalast (1). Hermann Göring ist ausnahmsweise einmal die Aufmerksamkeit, die ihm und seinen Orden entgegengebracht wird, zuviel – von seiner zahmen Löwin, die auf den Namen »Cäsar« hörte (2). Nach Meinung vieler die einzig positive Hinterlassenschaft Hitlers – der Volkswagen, ein Auto so robust wie ein Panzer, 1938 entworfen und noch immer fahrtüchtig (4). Dieser Postkartenverkäufer hat nur ein einziges Bildmotiv für seine Karten und ist offenbar ein Verehrer des Führers, denn er hat nicht nur sein Bärtchen übernommen, sondern besitzt sogar eine passende Wanduhr (3).

HITLER inspectant en 1935 la garde d'honneur avant d'accueillir le nouvel ambassadeur d'Espagne au palais présidentiel (1). Hermann Goering a un comportement singulièrement ambigu face aux attentions prodiguées sur sa personne et ses médailles par sa lionne apprivoisée répondant au nom de « Caesar » (2). Certains estiment que c'est la seule chose valable léguée sous Hitler: la Volkswagen, une voiture fiable comme un char d'assaut, conçue en 1938 et encore aujourd'hui sur les routes (4). Ce vendeur de cartes postales (3) au thème unique est manifestement un admirateur d'Hitler auquel il emprunte la moustache et en l'honneur duquel il a adapté son horloge.

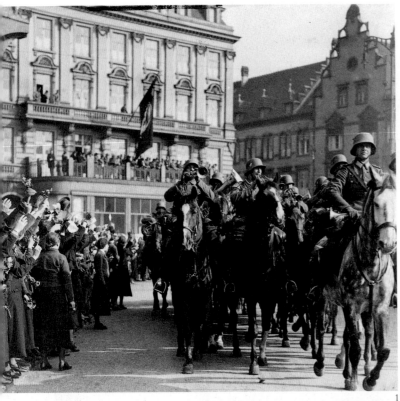

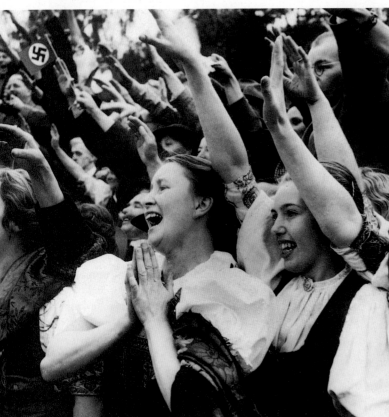

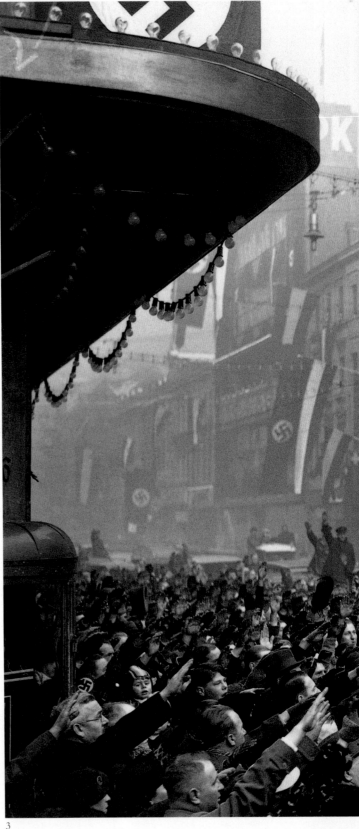

IN 1935 Hitler's army entered the
Saarland (3), in 1936 the Rhineland (1);
in 1938 it was the Egerland (Bohemia).
Female adoration seems to have increased
over the period, with 50,000 young
women of Carlsbad sporting their best
scarves and *dirndln*, their brightest smiles (2).
Each step nearer France proved more of
a pushover than the Germans anticipated,
it being against the terms of the treaties of
Versailles and Locarno. When in 1935
Britain also signed a treaty permitting
Germany to rebuld its naval strength, the
French press fumed: 'Does London
imagine that Hitler has renounced any of
the projects indicated in his book *Mein
Kampf*? If so, the illusion of our friends
across the Channel is complete'.

1935 marschierten Hitlers Armeen im
Saarland ein (3), 1936 im Rheinland (1),
und 1938 im Egerland (Böhmen). Scheinbar
steigerte sich die Begeisterung der Frauen
für die Soldaten zusehends. Hier in Karlsbad
sind 50 000 Frauen gekommen und zeigen
ihr schönstes Lächeln (2). Der Vormarsch in
Richtung Frankreich war für die Deutschen
ein Kinderspiel, obwohl jeder Schritt ein
Verstoß gegen die Verträge von Versailles

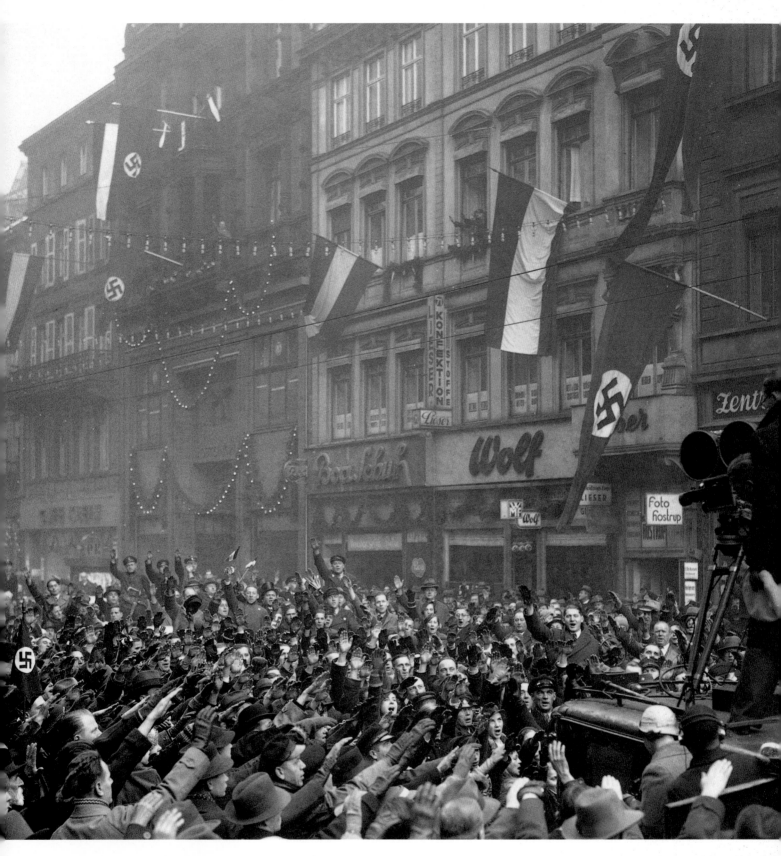

und Locarno war. Als 1935 die Engländer einen Vertrag mitunterzeichneten, der den Deutschen gestattete, ihre Marine wiederaufzubauen, empörte sich die französische Presse: »Glaubt denn die Regierung in London, Hitler habe die Ziele aufgegeben, die er in seinem Buch *Mein Kampf* beschreibt? Wenn ja, dann könnten unsere Freunde jenseits des Ärmelkanals sich nicht schwerer täuschen.«

EN 1935 l'armée d'Hitler pénètre en Sarre (3) et en 1936 en Rhénanie (1) avant d'arriver dans l'Egerland (la Bohême) en 1938. 50 000 jeunes femmes à Carlsbad arborent leurs plus beaux fichus et leur sourire le plus éclatant (2). Au fur et à mesure qu'ils se rapprochaient de la France, sa conquête apparaissait aux Allemands de plus en plus facile, bien qu'elle allât ainsi à l'encontre des clauses stipulées sur les traités de Versailles et de Locarno. Lorsqu'en 1935 la Grande-Bretagne signa à son tour le traité permettant à l'Allemagne de reconstituer sa puissance navale, la presse française fulmina : « Londres s'imagine t-elle qu'Hitler ait renoncé à un seul de ses projets mentionnés dans son livre *Mein Kampf*? Si oui, nos amis d'Outre-Manche se font bel et bien des illusions ».

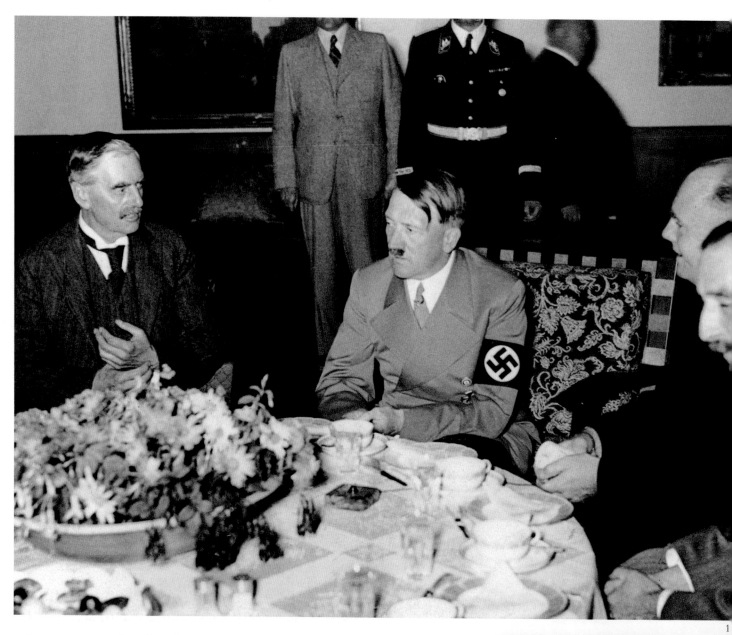

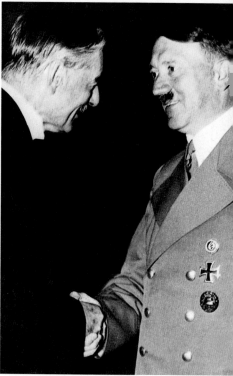

CHAMBERLAIN's policy of appeasing Hitler pleased some, not least, of course, the Führer himself, who fêted him at no fewer than three conferences in September 1938 (1, 2); or the Ludgate Circus florist (4) honouring the British Prime Minister who wanted 'peace at any price'. Unfortunately, appeasement went too far: the Czechs and French felt betrayed by it; many English politicians and commentators mistrusted it; and finally even Hitler turned out to have been keener on invading the Sudetenland than accepting the Czech surrender brokered for him by Chamberlain. On 1 October Hitler occupied the Sudetenland anyway, and Chamberlain waved his famous scrap of white paper (3), announcing that the terms of the Munich agreement spelt the intention of the British and German nations 'never to go to war with one another again'.

CHAMBERLAINS versöhnlicher Kurs gefiel manchem, nicht zuletzt natürlich dem Führer selbst, der ihn auf gleich drei Konferenzen im September 1938 feierte (1, 2), oder auch der Floristin in Ludgate, die ihr Fenster zu Ehren des britischen Premiers dekorierte, der »Frieden um jeden Preis« wollte (4). Leider ging die Appeasement-Politik zu weit: Tschechen und Franzosen fühlten sich betrogen; viele englische Politiker und Kolumnisten trauten ihr nicht; und am Ende stellte sich heraus, daß Hitler es eher auf das Sudetenland abgesehen hatte als auf die tschechische Kapitulation, die Chamberlain für ihn aushandelte. Am 1. Oktober marschierten die deutschen Truppen im Sudetenland ein, und Chamberlain zeigte sein berühmtes Blatt Papier und verkündete, daß gemäß den Münchner Verträgen die britischen und deutschen Nationen »nie wieder gegeneinander Krieg führen werden« (3).

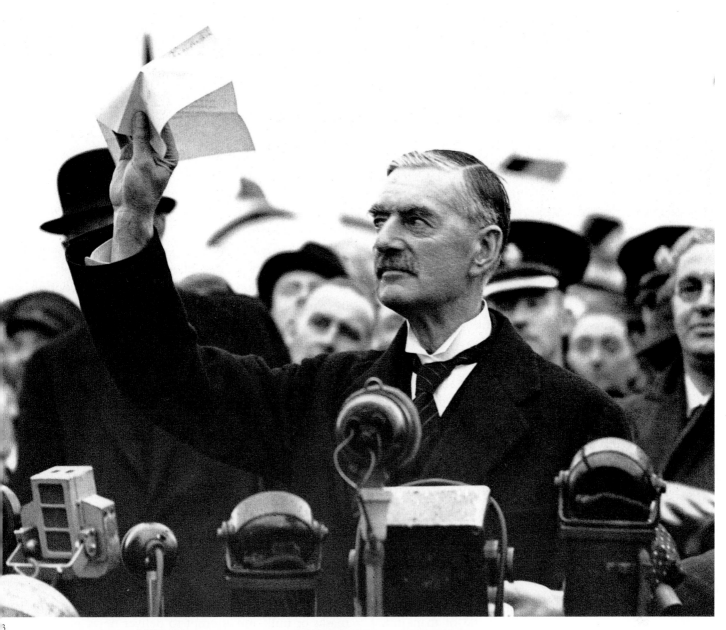

3

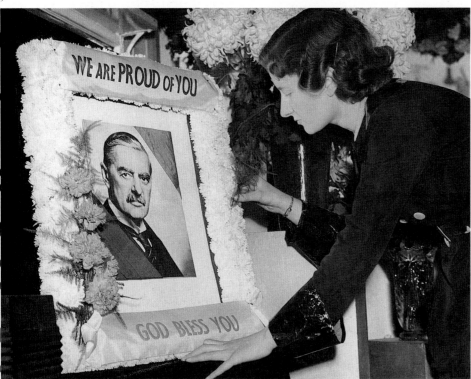

WE ARE PROUD OF YOU

GOD BLESS YOU

4

La politique menée par Chamberlain en vue d'apaiser Hitler plaisait à certains, en premier au Führer, qui le fêta à l'occasion de trois conférences qui se déroulérent en septembre 1938 (1, 2) ; mais aussi à la fleuriste du cirque Ludgate (4) qui rend hommage au Premier ministre britannique désireux de présenter « la paix à tout prix ». Malheureusement il alla trop loin dans l'apaisement, donnant aux Tchèques et aux Français le sentiment d'être trahis, suscitant la méfiance de bien des hommes politiques et observateurs anglais. Hitler lui-même préféra l'invasion des Sudètes à une capitulation tchèque que Chamberlain lui offrait. Le 1er octobre, Hitler occupait tout de même les Sudètes tandis que Chamberlain annonçait en agitant son célèbre chiffon de papier blanc (3) que les clauses de l'accord de Munich énonçaient l'intention des nations britannique et allemande de « ne plus jamais se livrer la guerre ».

War in Europe: The Blitz

Hitler's 'secret weapon' – in Goering's words the 'miracle weapon' – was intended to bomb the British into submission. It came out of the Occupied Pas de Calais as a jet-propelled bomber flying at 400 mph and carrying a ton of explosives. The beauty for the Germans was that it required no pilot and was capable of scoring two hits in one: steered by a gyroscope it left a characteristic trail of orange smoke and exploded within fifteen seconds of impact; it also scored a major propaganda coup by being the first of its kind and remaining immune to anti-aircraft fire from the 'ack-ack' units deployed on Britain's south coast.

The onslaught became known as London's 'second blitz' and the aircraft themselves as 'doodlebugs' or 'buzz bombs' from the noise they made, flying at low altitudes. Colin Perry, an eighteen-year-old living with his family in Tooting, kept a diary. One night he recorded: 'Two incendiary bombs fell in the next road to us, but the wardens speedily put out the small fires. Bombs fell everywhere. Midnight and we were all indoors, undressed... As I lay asleep, rather half-and-half, I listened to the roar of hundreds of 'planes. Three or four bombs fell just near us with deafening explosions, like a firework – Bang! and the shsssing and hissing of sparks... This was Hitler's big attempt, and I knew that the 'planes I had seen in the afternoon, was hearing now, constituted part of the greatest air-battle of mankind. I went back to bed, guns, guns, guns, thud, thud, thud... I listened to three screamers, meooowwwwheeelll – they went. About a mile away I think. I preferred the screaming bomb, it at least gave, however brief, a warning. How those outside the shelters dived for cover. Not a word said but one, impulsive, automatic dive. The screech certainly was rather ghostly.'

400 people were killed and at least 1,400 seriously injured, thousands more fleeing their shattered East End as refugees. London's Dockland was on fire, the gasworks also burning; some blazes lasted up to a week. 86 of the Luftwaffe's 500 were shot down to 22 of the RAF, but they returned the following night to hit every borough of Metropolitan London. On 11 September, Churchill made a morale-raising broadcast: 'These cruel, wanton indiscriminate bombings of London are, of course, a part of Hitler's invasion plans. He hopes, by killing large numbers of civilians, and women and children, he will terrorize and cow the people of this mighty imperial city ... What he has done is to kindle a fire in British hearts, here and all over the world, which will glow after all traces of the conflagration he has caused in London have been removed.' When, of course, Churchill determined to bomb the civilian populations of historic Dresden, Leipzig and Berlin, 'cruel', 'wanton' and 'indiscriminate' were not the adjectives employed in his propaganda.

The Civil Defence volunteers, with those conscripted into the Firefighters and the Home Guard, took on the firing and flattening of unsafe buildings; the re-laying of gas and water mains and telephone lines; the rebuilding of roads and bridges. They had also to help dig out the dead, rescue the wounded, bring in supplies of gas-masks or milk and attempt to deliver news and letters to houses that no longer existed. Masks were issued in 1939 to the British population, including the youngest: Neville Mooney was the first baby born in London after the declaration of war and arrived home from hospital in a new designer model (1). During one of Hitler's last forays in 1944, little Barbara James is being carried from the shell of her home (2).

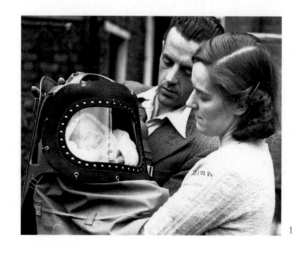

1

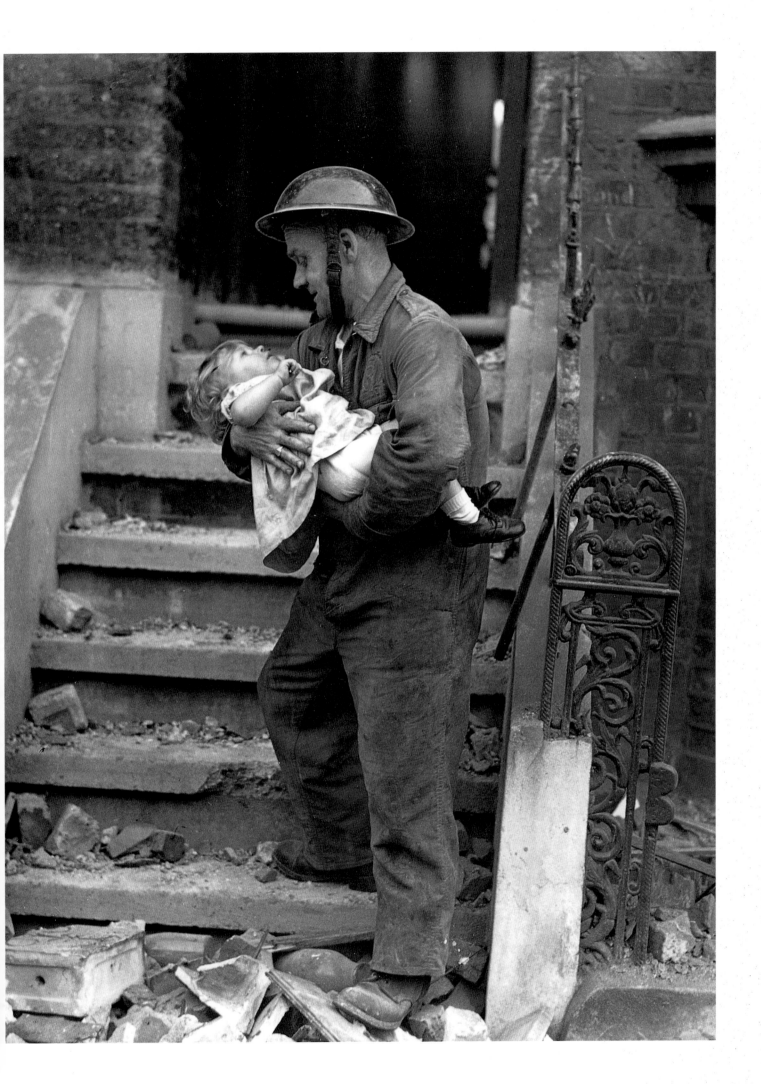

HITLERS »Geheimwaffe« – oder, wie Göring sie nannte, die »Wunderwaffe« – sollte England in die Knie zwingen. Die raketengetriebenen Flugbomben wurden im okkupierten Pas-de-Calais gestartet und brachten ihre Tonne Sprengstoff mit 600 Stundenkilometern über den Kanal. Aus deutscher Sicht war das Beste an den V-Waffen, daß sie keine Piloten brauchten, und zudem wirkten sie gleich zweifach: Die durch einen Gyroskop gesteuerten Raketen, die einen orangeroten Rauchstreifen hinterließen, explodierten binnen fünfzehn Sekunden nach dem Aufschlag, und sie waren als erste Geschosse ihrer Art, die noch dazu immun gegen die Flakstellungen entlang der britischen Südküste waren, ein gelungener Propagandacoup.

In London wurde die Kampagne als »zweiter Blitz« bekannt, die Raketen hießen *doodlebugs* oder *buzz bombs*, nach dem typischen Geräusch, das sie kurz vor dem Aufschlag machten. Der achtzehnjährige Colin Perry, der mit seiner Familie im Londoner Stadtteil Tooting wohnte, führte Tagebuch. In jener Nacht schrieb er: »Zwei Brandbomben gingen draußen auf der Straße nieder, aber die Wachposten hatten die kleinen Brände schnell gelöscht. Überall regnete es Bomben. Mitternacht, wir waren alle im Haus, im Nachtzeug... Ich lag im Bett, schlief aber nur halb und hörte dem Dröhnen der Flugzeuge zu, Hunderte davon. Ein paar Bomben schlugen direkt in unserer Nähe ein, mit ohrenbetäubendem Knall, wie Feuerwerkskörper – Womm! Und dann das Zischen und Fauchen der Funken... Das war Hitlers Großangriff, und ich wußte, daß die Flugzeuge, die ich am Nachmittag gesehen hatte, deren Motoren ich nun hörte, in der größten Luftschlacht flogen, die die Menschheit je gesehen hatte. Ich zog mir die Decke über den Kopf, überall die Flaks, tack-tack-tack... drei Heuler hintereinander hörte ich, miiiiiauuuuuwiiiie – dann waren sie vorbei. Vielleicht eine Meile weit fort. Mir waren die Heuler lieber, weil sie einen warnten, wenigstens ein paar Sekunden vorher. Was rannten die Leute draußen, die nicht in einen Schutzraum gekommen waren, und suchten nach Deckung! Kein einziges Wort fiel, doch wie auf Kommando, automatisch, warfen sich alle nieder. Das Heulen ging einem wirklich durch Mark und Bein.«

400 Menschen kamen um, und mindestens 1 400 wurden schwer verwundet; Tausende flohen aus ihren zerbombten Wohnungen im East End. Die Docks standen in Flammen, die Gasanstalt brannte, manche Feuer konnten erst nach einer Woche gelöscht werden. 86 der 500 Luftwaffenbomber wurden abgeschossen, die Briten verloren 22, doch in der folgenden Nacht waren die Deutschen wieder da, und kein Viertel der Londoner Innenstadt blieb verschont. Am 11. September hielt Churchill zur Stärkung der Moral eine Rundfunkansprache: »Diese grausamen, gewissenlosen, willkürlichen Bombenangriffe auf London sind natürlich Teil von Hitlers Invasionsplänen. Er hofft, wenn er Zivilisten in großer Zahl tötet, Frauen und Kinder, könne er die Menschen dieser gewaltigen Hauptstadt in Angst und Schrecken versetzen ... Doch statt dessen hat er ein Feuer in den britischen Herzen entfacht, hier zu Hause und überall auf der Welt, das noch wärmen wird, wenn die Brände in London längst gelöscht sind.« Als Churchill sich entschloß, Bomben auf die Bewohner der Städte Dresden, Leipzig und Berlin zu werfen, war freilich in den offiziellen Verlautbarungen von »grausam«, »gewissenlos« und »willkürlich« nicht die Rede.

Die Helfer des Zivilschutzes mußten sich auch um die Opfer kümmern: die verschütteten Leichen bergen, die Verletzten retten, Gasmasken und Milch bringen, Zeitungen und Briefe zustellen, wo die Häuser gar nicht mehr existierten. Jeder bekam 1939 eine Gasmaske, selbst die Jüngsten: Neville Mooney war das erste Kind, das nach der Kriegserklärung in London zur Welt kam, und verließ das Krankenhaus mit einem maßgeschneiderten Exemplar (1). Die kleine Barbara James wird 1944 nach einem der letzten Nazi-Angriffe aus ihrem ausgebombten Heim getragen (2).

L'ARME secrète de Hitler, ou plutôt l' « arme miracle », pour reprendre les termes de Goering, devait finir par soumettre les Britanniques à force bombardements. Elle apparut dans le Pas-de-Calais occupé sous l'aspect d'une fusée propulsée par des réacteurs, qui volait à la vitesse d'environ 644 km/h avec une tonne d'explosif à son bord. Pour les Allemands, son intérêt résidait dans le fait qu'elle n'avait nul besoin de pilote et qu'elle pouvait frapper simultanément deux cibles. À pilotage gyroscopique, après avoir laissé dans son sillage une traînée de fumée orange caractéristique, elle explosait moins de quinze secondes dès l'objectif atteint. Première de son genre invulnérable aux tirs antiaériens des unités de DCA déployées sur le littoral sud de la Grande-Bretagne, elle servit grandement la propagande.

Les Anglais baptisèrent l'offensive sur Londres le « deuxième éclair », quant aux aéroneufs eux-mêmes, ils furent surnommés « punaises » ou encore « bombes bourdonnante » en raison du bruit qu'ils faisaient à basse altitude. Colin Perry, un jeune homme de dix-huit ans, qui vivait à Tooting avec sa famille, tenait un journal. Il y nota cette nuit-là : « Deux bombes incendiaires ont touché la rue voisine, mais les *wardens* (civils chargés de la défense passive) sont rapidement parvenus à éteindre les débuts d'incendie. Des bombes sont tombées partout. Il était minuit, nous étions tous rentrés, tous habillés … Je m'étais allongé pour dormir, plutôt d'un œil, tout en écoutant le rugissement de centaines d'avions. Trois ou quatre bombes explosèrent tout près de là, dans un vacarme assourdissant, tel un feu d'artifice. Les éclairs fusaient … Ce fut un formidable coup d'essai de la part de Hitler. Je savais bien que les avions aperçus dans l'après-midi et qui maintenant menaient la danse livraient la plus grande bataille aérienne de tous les temps. Je retournai alors au lit tandis que les canons bégayaient. J'écoutai trois bombes dites « hurlantes » passer au loin en miaulant. À environ un kilomètre et demi d'ici, pensai-je. Je préférais les bombes hurlantes qui, même si ce n'était qu'un cours instant avant, prévenaient avant d'exploser. Les gens hors des abris plongeaient alors à couvert. Tandis que se faisaient ces plongeons impulsifs et automatiques, le hurlement semblait sorti tout droit de la gorge d'un spectre. »

400 personnes périrent tandis que 1 400 autres furent gravement blessées, sans oublier les milliers de réfugiés qui avaient fui East End après que leurs foyers furent dévastés. La zone autour du port de Londres était en flammes, de même que l'usine à gaz. Certains incendies mirent une semaine avant de s'éteindre. Sur les 500 appareils alignés par la Luftwaffe, 86 furent abattus contre 22 appareils pour l'aviation britannique ; mais cela n'empêcha pas les pilotes allemands de revenir la nuit suivante pilonner chaque arrondissement de la métropole londonienne. Le 11 septembre, Churchill délivra sur les ondes un discours réconfortant : « Ces bombardements cruels, aveugles et sauvages de Londres font, bien entendu, partie du plan d'invasion de Hitler. Ce dernier espère, en massacrant massivement les populations civiles, femmes et enfants compris, soumettre par la terreur le peuple de cette puissante cité impériale … Il a en fait allumé un brasier dans le cœur des Britanniques, ici et partout à travers le monde, qui brûlera bien après que toutes traces des dévastations qu'il a infligées à Londres auront été supprimées. » Il va de soi que lorsque Churchill prit la décision de faire bombarder les populations civiles des villes historiques qu'étaient Dresde, Leipzig et Berlin, son vocabulaire fut moins virulent.

Les membres de la Défense passive, les pompiers et l'armée affectée à la défense du territoire (*Home Guard*), tous volontaires, se chargeaient d'incendier et de démolir les bâtiments représentant un danger pour la sécurité, de remplacer les principales canalisations d'eau et de gaz, ainsi que les lignes téléphoniques, et de reconstruire les routes et les ponts. Ils devaient aussi aider à déterrer les morts, secourir les blessés, ravitailler en lait ou en masques à gaz, et s'efforcer de délivrer les nouvelles et les lettres à des adresses qui n'existaient plus. Des masques furent fournis en 1939 à la population britannique, y compris aux plus jeunes : Neville Mooney fut le premier bébé à naître à Londres après la déclaration de la guerre. Il fit le trajet de l'hôpital jusqu'à chez lui équipé d'un modèle de masque de conception nouvelle (1). En 1944, pendant l'un des derniers raids hitlériens, la petite Barbara James est transportée hors de sa maison dont il ne reste plus que la carcasse (2).

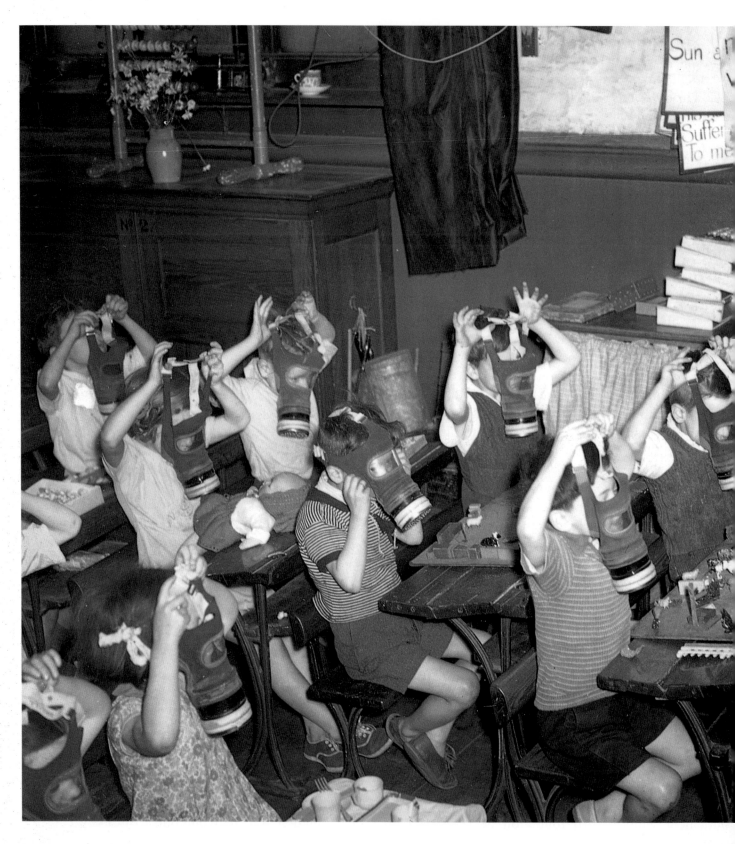

THE Great War had seen an estimated
million gas casualties, a figure clearly
deliberately reduced for propaganda
purposes by each of the combatant nations.
Gas warfare had been introduced by the
Germans and the assumption was that in

the next war it was to become a weapon of
choice in bombing campaigns. All children
in state schools were given 'gas instruction
lessons' (1) while housewives practised
wearing them as they carried on their daily
pursuits (2).

DER Erste Weltkrieg forderte nach
Schätzungen eine Million Gas-Tote,
wobei die Zahlen auf beiden Seiten aus
Gründen der Propaganda zu niedrig ange-
setzt sein dürften. Der Gaskrieg war eine
deutsche Erfindung, und alle gingen davon

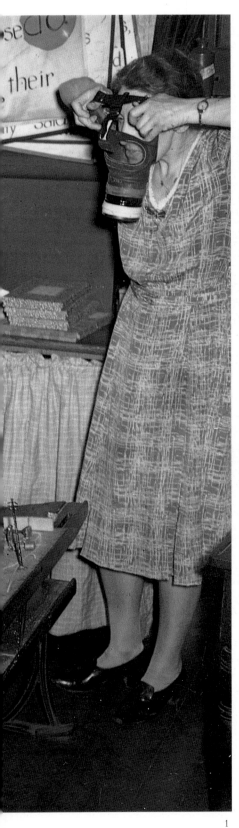

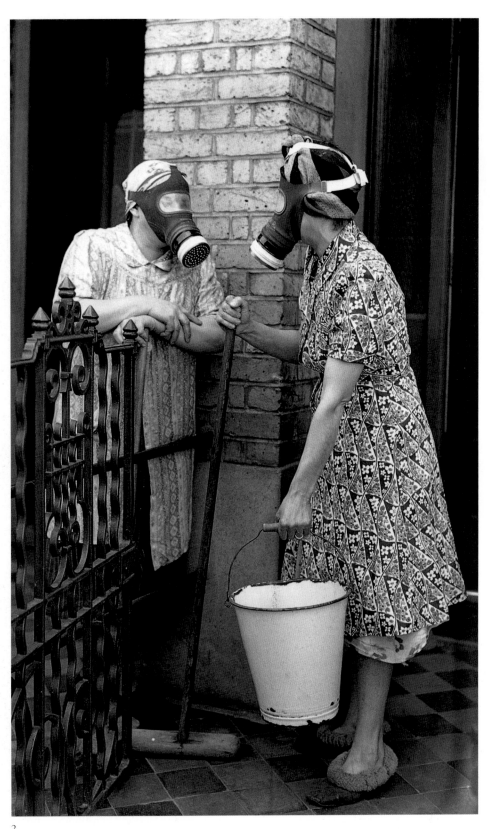

aus, daß Gasbomben im nächsten Krieg eine Hauptwaffe sein würden. In den staatlichen Schulen bekamen sämtliche Kinder »Gasunterricht« (1), und Hausfrauen trugen Gasmasken bei der täglichen Arbeit (2).

LES victimes du gaz se comptèrent par millions durant la Grande Guerre. Pour des raisons évidentes, ce chiffre était volontairement minimisé dans chaque camp pour les besoins de la propagande. Utilisé pour la première fois dans le conflit par les Allemands, on était persuadé que le gaz deviendrait l'arme préférée au cours des bombardements de la prochaine guerre. Tous les élèves des écoles publiques recevaient des « cours d'initiation au gaz » (1) pendant que les ménagères s'exerçaient à exécuter leurs tâches quotidiennes affublées d'un masque (2).

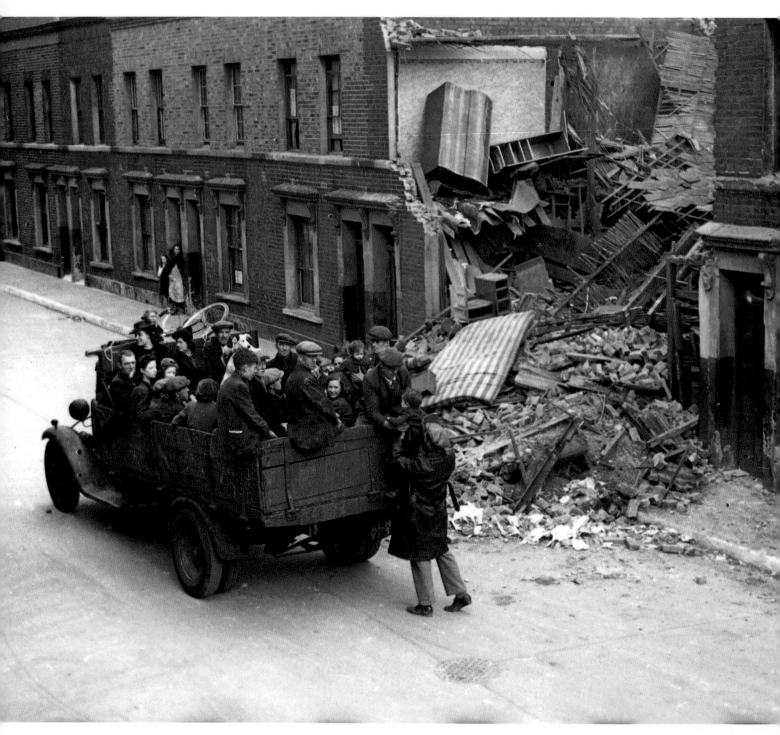

FROM 1939, upwards of three million children, including infants and babes-in-arms with their mothers, were evacuated from the major city centres to the countryside to avoid the bombing (1). Some 'sea evacuees' were even sent as far afield as Canada and the United States, where many languished, though some thrived apart from their families (3), keeping up to date with newspapers. These children (2), along with their boxed gas masks, are returning via Waterloo Station after taking the risk of spending Christmas 1939 in their London homes.

VON 1939 an wurden drei Millionen Kinder, darunter Säuglinge und Kleinkinder mit ihren Müttern, aus den Zentren der Großstädte aufs Land evakuiert, wo ihnen weniger Gefahr durch Bomben drohte (1). Einige wurden »nach Übersee verschickt« und kamen bis in die USA und nach Kanada, wo viele todunglücklich wurden; andere genossen das Leben fernab ihrer Familie, und Zeitungen halfen ihnen, auf dem laufenden zu bleiben (3). Hier (2) kehren Kinder, jedes mit seiner Gasmaske im Täschchen, von der Waterloo Station zu ihren Evakuierungsorten zurück, nachdem sie riskiert hatten, das Weihnachtsfest 1939 zu Hause in London zu verbringen.

À partir de 1939, on évalue à plus de trois millions le nombre des enfants, y compris les tout-petits, les nourrissons et leurs mères, à être évacués des grandes villes pour être amenés dans les campagnes (1). Certains « évacués par mer » partaient pour le Canada ou les États-Unis. Si beaucoup d'entre eux languissaient, d'autres s'épanouissaient loin de leurs familles (3) en suivant l'actualité dans les journaux. Ces enfants (2) qui transportent leur masque à gaz dans une boîte repartent par la gare de Waterloo, après avoir pris le risque de passer l'hiver 1939 dans leur foyer londonien.

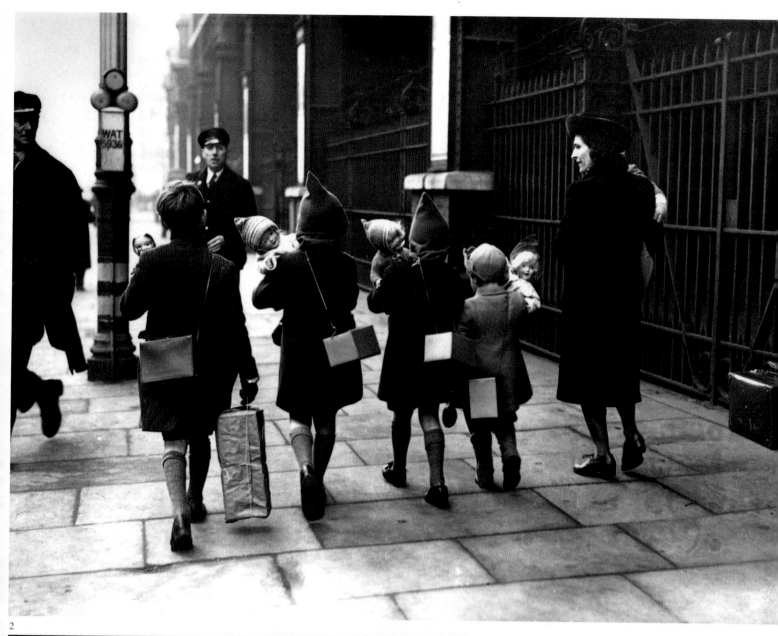

2

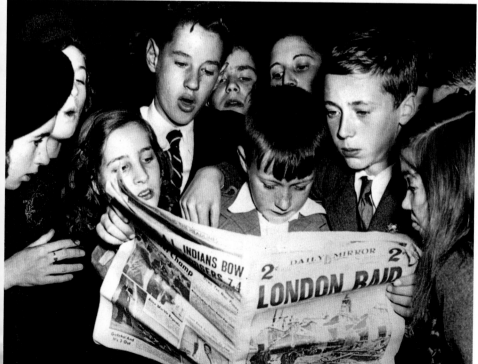

3

PERHAPS the most famous British picture of the War (overleaf). New Year's Eve 1940 and, two days after the raid, London's East End still burns around St Paul's Cathedral. The cathedral, however, remained standing, a symbol of resistance.

DIES (folgende Seiten) ist vielleicht das berühmteste Kriegsbild aus England überhaupt. Silvester 1940, und zwei Tage nach dem Luftangriff brennt das Londoner East End rund um die St.-Pauls-Kathedrale noch immer. Doch die Kathedrale blieb bestehen, ein Symbol des Widerstands.

VOICI peut-être la photographie la plus célèbre de la guerre en Grande-Bretagne (pages suivantes). Il l'agit du réveillon de 1940, tandis que depuis deux jours, l'incendie d'East End continue de faire rage. La cathédrale Saint Paul demeura toutefois debout, comme le symbole de la résistance.

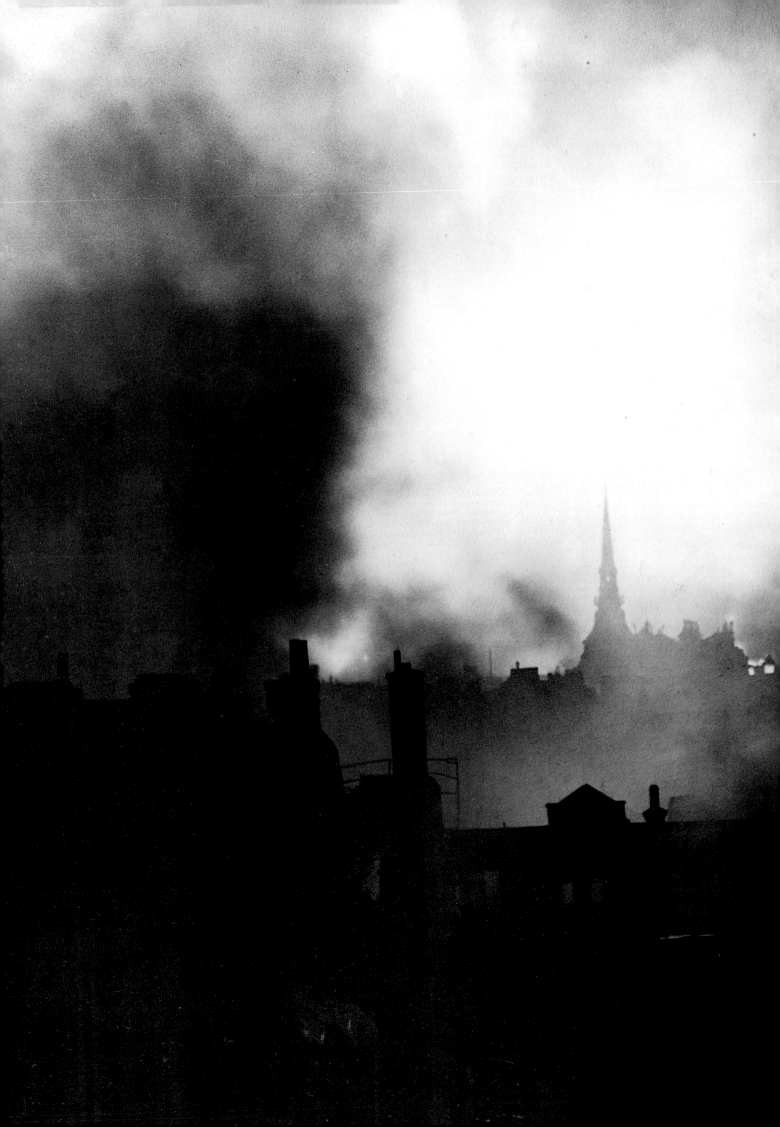

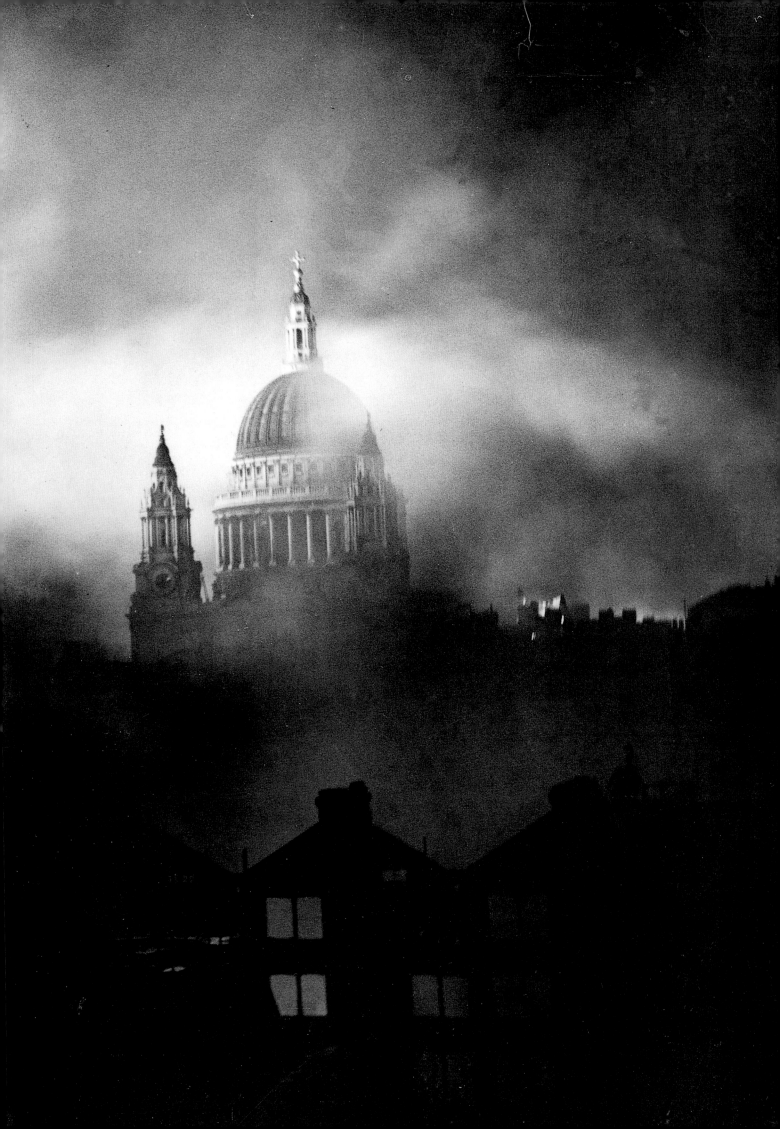

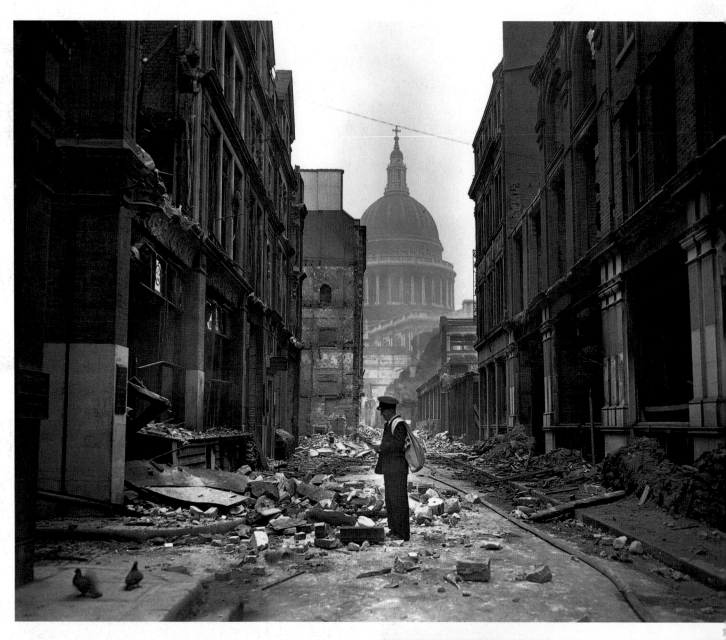

AIR raids also struck other cities: these show some of the devastation meted out to Liverpool and Canterbury. With many women requisitioned for war work once the men were conscripted, it was the grandparents (and the foster parents of evacuee children) who took responsibility for the young (2, 3). London's old Roman Wall with its outer ring of city churches and dwellings was severely damaged: here, in May 1941, a postman attempts to deliver in historic Watling Street (1); a fruit stall does good business in 1940 under the slogan 'Hitler's bombs can't beat us' (5); and in Kensington, the library of the famous Holland House (built in 1607 by Sir Walter Cope, Gentleman of the Bedchamber to James I) was virtually destroyed by a Molotov 'breadbasket' (4). The east wing was somehow saved, and now houses the King George Memorial Youth Hostel.

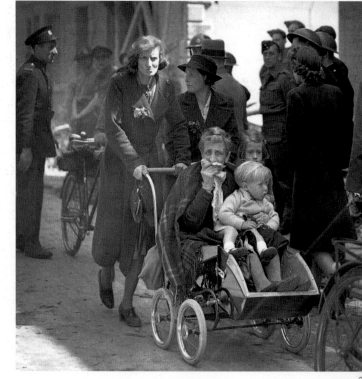

AUCH andere Großstädte hatten unter den Luftangriffen zu leiden – diese Bilder geben einen Eindruck von den Zerstörungen in Liverpool und Canterbury. Viele Frauen wurden zur Arbeit in den Fabriken verpflichtet, nachdem die Männer eingerückt waren, und die Großeltern (und Pflegeeltern der evakuierten Kinder) übernahmen nun die Verantwortung für die Kleinen (2, 3). Die römischen Stadtmauern Londons und der Ring von Stadtkirchen und Siedlungen, der sie umgab, nahmen schweren Schaden; hier versucht ein Postbote im Mai 1941, in der historischen Watling Street zuzustellen (1); ein Obstkarren macht 1940 gute Geschäfte mit dem Slogan »Wir lassen uns von Hitlers Bomben nicht unterkriegen« (5); und in Kensington sieht man die Trümmer der Bibliothek von Holland House (1607 erbaut von Sir Walter Cope, dem Kammerjunker Jakobs I.), das eine Brandbombe fast völlig zerstörte (4). Nur der Ostflügel wurde verschont und dient heute als Jugendherberge, das King George Memorial Youth Hostel.

D'AUTRES grandes villes firent également les frais des attaques aériennes : ici les dévastations infligées à Liverpool et à Canterbury.Parce que nombre de femmes avaient été réquisitionnées pour les travaux de guerre, tandis que les hommes étaient mobilisés, les grands-parents (et les parents nourriciers des enfants évacués) se retrouvèrent chargés de prendre soin des enfants (2 et 3). Le vieux mur romain de Londres, avec sa ceinture extérieure d'églises et de logements, fut sérieusement endommagé : ici en mai 1941, le facteur s'efforce d'assurer la distribution postale dans la rue historique de Watling Street (1) ; un vendeur de fruits fait de bonnes affaires en 1940, fort du slogan : « Les bombes de Hitler ne peuvent pas nous abattre » (5) ; tandis qu'à Kensington, la bibliothèque de la célèbre Holland House (construite en 1607 par Sir Walter Cope, gentilhomme attaché au service de la chambre de Jacques 1er) fut pratiquement détruite par une « corbeille à pain » molotov (4). L'aile orientale, qui en réchappa par miracle, abrite aujourd'hui l'auberge de jeunesse du mémorial du roi George.

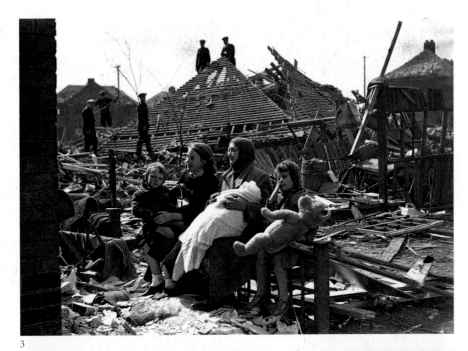

3

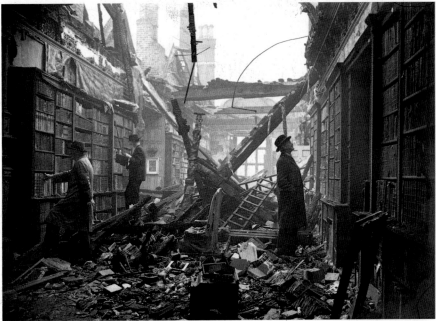

4

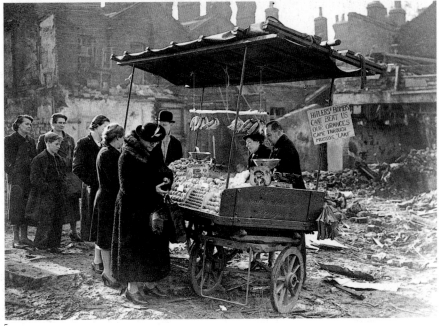

5

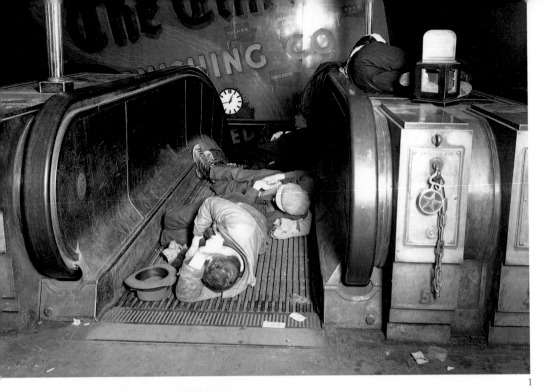

EVERYTHING that could afford shelter was invoked for those who stayed in the cities. Anderson shelters that served to resist all but a direct hit were useless to houses without garden space in which to erect them. That included all of the tenement blocks and back-to-backs of the poorer areas in every town. Street shelters were found to suffer from weak mortar; houses could not withstand blast. Everything was utilized, from railway arches, cellars, schools and civic buildings, train and underground stations, right down to day-nursery cupboards (2) for the young and staircases for the rest (1).

In 1940 the government appeal for aluminium and iron led to this aircraft production dump (3), at which the whole population could contribute to the war effort. From the wealthy of Chelsea who removed their garden railings to this young lad who, possibly with a degree of relief, brought in the family bathtub from a house clearly off the mains (4), everyone could contribute at least a pot or a pan to be smelted into aluminium for the aircraft assembly presses across the country.

DIEJENIGEN, die in den Städten blieben, suchten Luftschutz, wo sie ihn fanden. Die sogenannten Anderson-Shelter aus Stahlblech, die alles mit Ausnahme eines direkten Treffers aushielten, konnte man nur im Garten aufstellen, und bei den Miets- und Reihenhäusern der ärmeren Stadtviertel war oft kein Platz dafür. Der Mörtel der Schutzhütten an den Straßen erwies sich als zu schwach, und Häuser hielten dem Druck nicht stand. Man nutzte alles, von Eisenbahnbrücken über Keller, Schulen und Verwaltungsgebäude, von Bahnhöfen und U-Bahn-Stationen bis hin zu Schränken in den Kindergärten (2), und wer nichts anderes fand, mußte sich mit einer Treppe begnügen (1).

1940 appellierte die Regierung an die Bevölkerung, Aluminium und Eisen für die Waffenproduktion zu spenden, und dieser Schrotthaufen bei einer Flugzeugfabrik zeigt, daß alle mithalfen (3). Von den Reichen aus Chelsea, die ihre Gartenzäune hergaben, bis hin zu diesem Jungen (4), der – offenbar aus einem Haus, das keinen Wasseranschluß mehr hat, und vielleicht nicht ganz ohne Erleichterung – die Badewanne der Familie bringt, konnte jeder zumindest einen Topf oder eine Pfanne erübrigen, die eingeschmolzen wurden, um Aluminium für die über das ganze Land verteilte Flugzeugproduktion zu gewinnen.

TOUT ce qui pouvait servir d'abri était bon à prendre pour ceux qui restaient dans les grandes villes. L'abri Anderson qui résistait à tout, sauf à un impact direct, n'était d'aucune utilité si la maison ne possédait pas de jardin suffisamment grand pour l'y ériger. C'était le lot commun des immeubles construits dos à dos, situés dans les zones les plus défavorisées de chaque ville. Les abris extérieurs s'avérèrent inefficaces contre les tirs de mortier, aussi faibles fussent-ils, et les maisons ne résistaient pas au souffle de l'explosion. On utilisait tout, qu'il s'agît des arches des voies ferrées, des caves, des bâtiments scolaires ou municipaux, des gares ferroviaires ou des stations de métro, jusqu'à employer les armoires des pouponnières (2) pour les plus jeunes et la cage d'escalier (1) pour les autres.

L'appel lancé en 1940 à la population par les autorités nationales pour recueillir de l'aluminium et du fer favorisa l'apparition de ces décharges (3) de matériaux destinés à la production aéronautique. Chacun put y aller de sa contribution à l'effort de guerre. En y voit des gens appartenant aux couches aisées de Chelsea qui apportaient les barreaux entourant leur jardin jusqu'à ce jeune gars qui, peut-être un peu soulagé, apportait la baignoire familiale retirée d'une maison bien évidemment coupée du réseau de distribution (4). Dans tout le pays, chacun put faire au moins le don d'une marmite ou d'une casserole dont l'aluminium serait fondu et pressé aux fins de l'industrie de guerre.

3

4

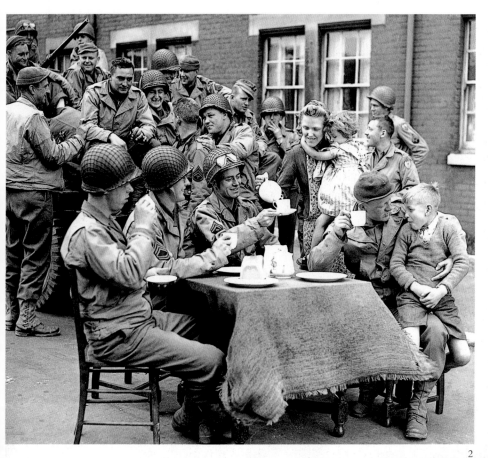

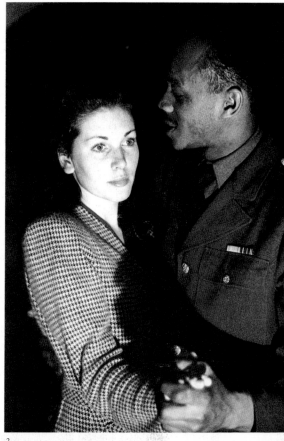

2　3

American GIs – Overpaid, Over-sexed and Over Here – brought gloom to British men and a sparkle to the women. Children came fresh to Wrigley's gum and Hershey bars (2); women to tipped Virginia tobacco (3); and the GIs themselves demanded big-band Bourbon-fuelled night clubs to remind them of home (4). Even the American Red Cross got involved in running a 'Coney Island' arcade provided by the Amusement Caterers' Association (1).

Die amerikanischen GIs waren den englischen Männern ein Dorn im Auge, doch bei den Frauen hochwillkommen. Die Kinder bekamen ihre ersten Wrigley-Kaugummis (2), die Frauen Virginia-Zigaretten mit Filtern (3). Die GIs selbst waren immer auf der Suche nach Nacht-clubs mit Big Bands und Bourbon, damit sie sich wie zu Hause fühlen konnten (4). Selbst das amerikanische Rote Kreuz half mit, den »Coney Island«-Spielsalon zu betreiben (1).

Alors que les femmes britanniques découvraient l'Amérique par le biais de ses soldats, les enfants découvraient la gomme Wrigley et les barres Hershey (2). Si les Anglaises appréciaient les cigarettes de Virginie (3), les GIs, quant à eux, voulaient reconstituer l'atmosphère de la mère patrie (4). La Croix-Rouge américaine elle-même géra la galerie Coney Island, proposée par l'Association des fournisseurs de distractions (1).

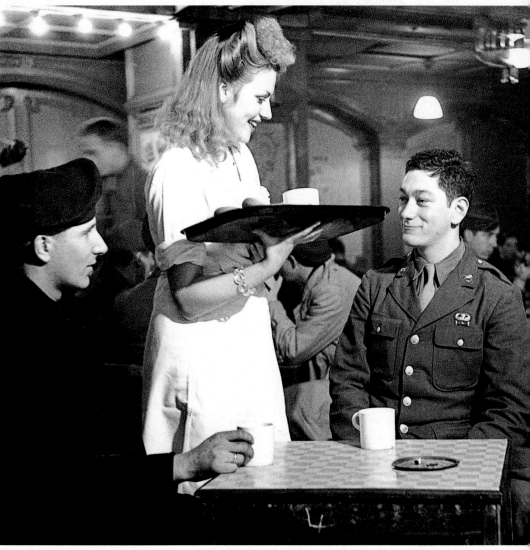

4

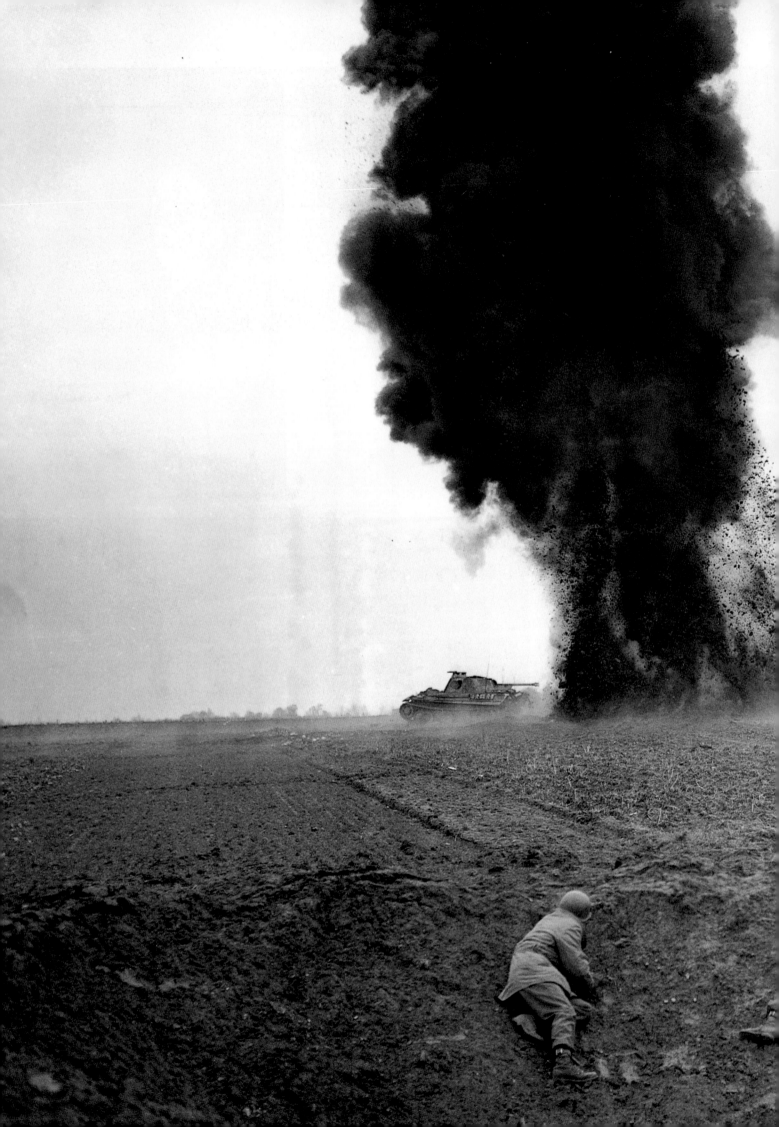

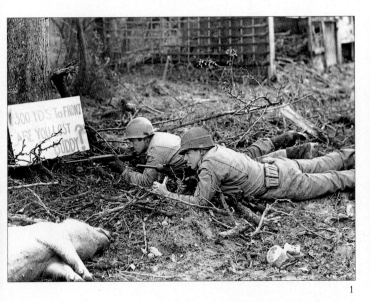

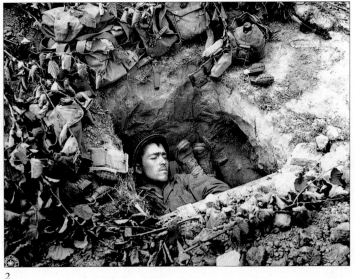

1　2

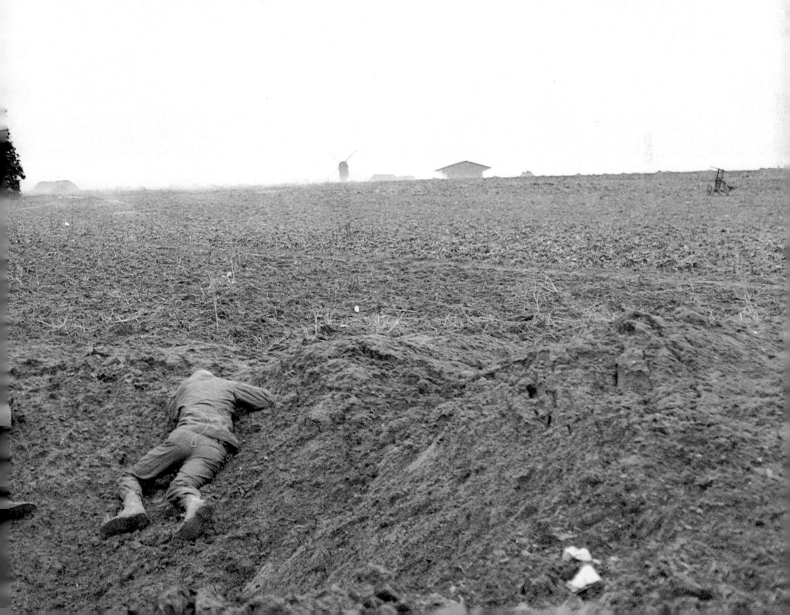

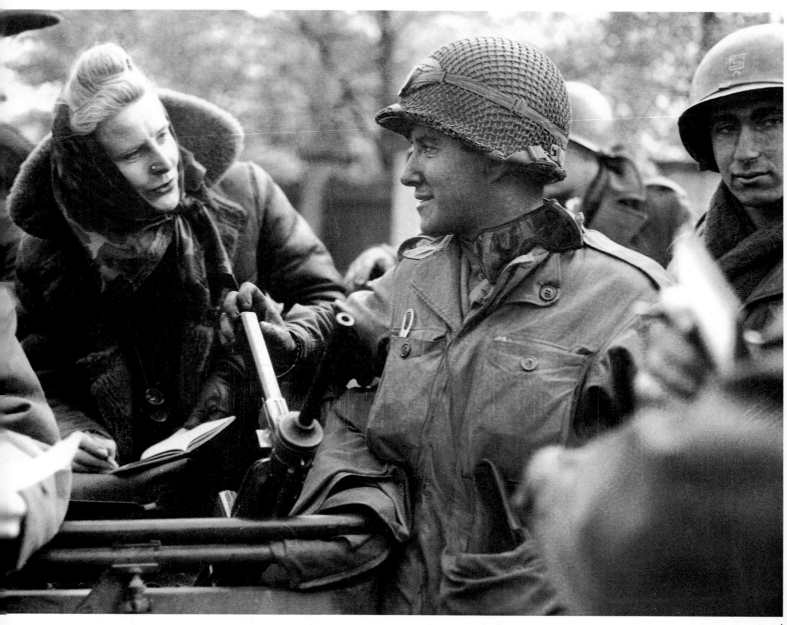

(Previous pages)

1944 saw the US army advancing through Nazi terrain (1). This tank was knocked out by US engineers (3). The Signal Corps, in Normandy await the Allied landings (2).

(Vorherige Seiten)

1944 schoben amerikanische Truppen die Front durch das von den Nazis eroberte Terrain zurück (1). Dieser deutsche Panzer wurde von amerikanischen Pionieren kampfunfähig geschossen (3). Die US-Fernmeldetruppe (2) erwartet 1944 die Landung der Alliierten in der Normandie.

(Pages précédentes)

DÈS 1944, l'armée américaine repoussait la ligne de front nazie (1). Ce char d'assaut allemand a été mis hors de combat par le génie américain (3). Des radiotélégraphistes américains se reposent en 1944 en Normandie (2), en attendant les Alliés.

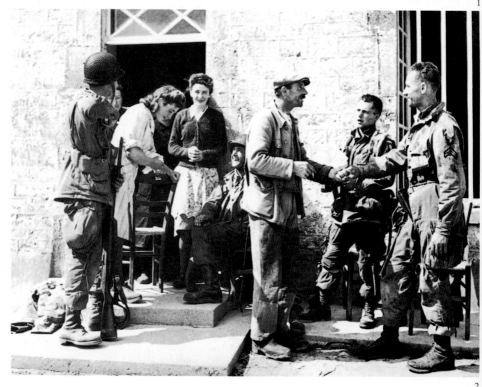

LANGUAGE is clearly not a necessary means of communication when there is something in common to celebrate. After regaining their country from the German Occupation, French villagers fraternize with GIs of the liberating forces (2, 4), while in the town of Saint-Sauveur-Lendelin residents shower armoured personnel carriers with flowers (3). When, close to the end of the war on the continent (27 April 1945), the US and the Ukraine First Armies met at Torgau on the Elbe, reporter Iris Carpenter of the *Boston Globe* (1) wanted to get her compatriot's first-hand account.

MAN muß nicht unbedingt dieselbe Sprache sprechen, wenn es etwas Gemeinsames zu feiern gibt: Nach der Befreiung von der deutschen Besatzung verbrüdern sich die Bewohner eines französischen Dorfes mit den GIs der Befreiungstruppen (2, 4), und die Frauen des Städtchens Saint-Sauveur-Lendelin werfen den Soldaten in ihren Panzerwagen Blumen zu (3). Als sich am 27. April 1945, kurz vor Ende des Krieges in Europa, die Erste US-Armee und die Erste Armee der Ukraine in Torgau an der Elbe trafen, war Iris Carpenter, Reporterin des *Boston Globe*, dabei, um von ihren Landsleuten einen Bericht aus erster Hand zu bekommen (1).

IL est manifestement possible de comprendre la langue de l'autre lorsqu'on a quelque chose en commun à célébrer. Après la libération des pays, les villageois français fraternisent avec les soldats américains des forces de libération (2 et 4), tandis que dans la ville de Saint-Sauveur-Lendelin, les habitants font pleuvoir des fleurs sur les véhicules blindés transportant les troupes (3). Quand, vers la fin de la guerre sur le continent (le 27 avril 1945), les premières armées américaine et ukrainienne opérèrent leur jonction à Torgau, sur l'Elbe, la journaliste Iris Carpenter du *Boston Globe* (1) voulut obtenir d'un de ses compatriotes un compte rendu de première main.

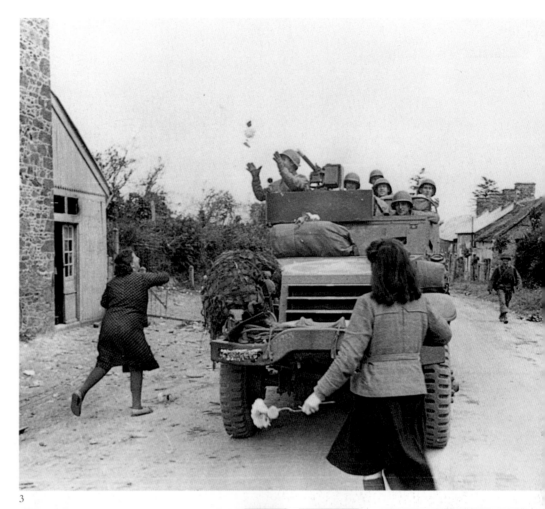

3

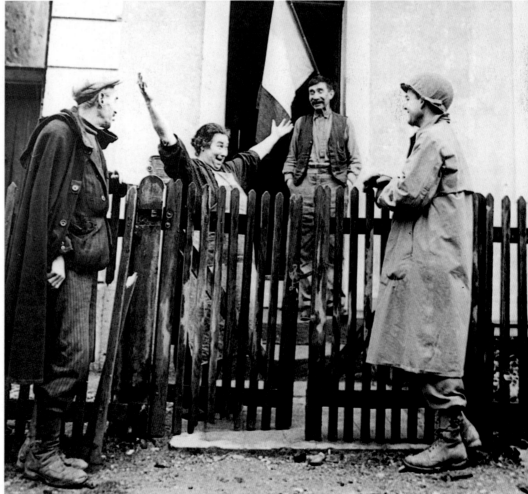

4

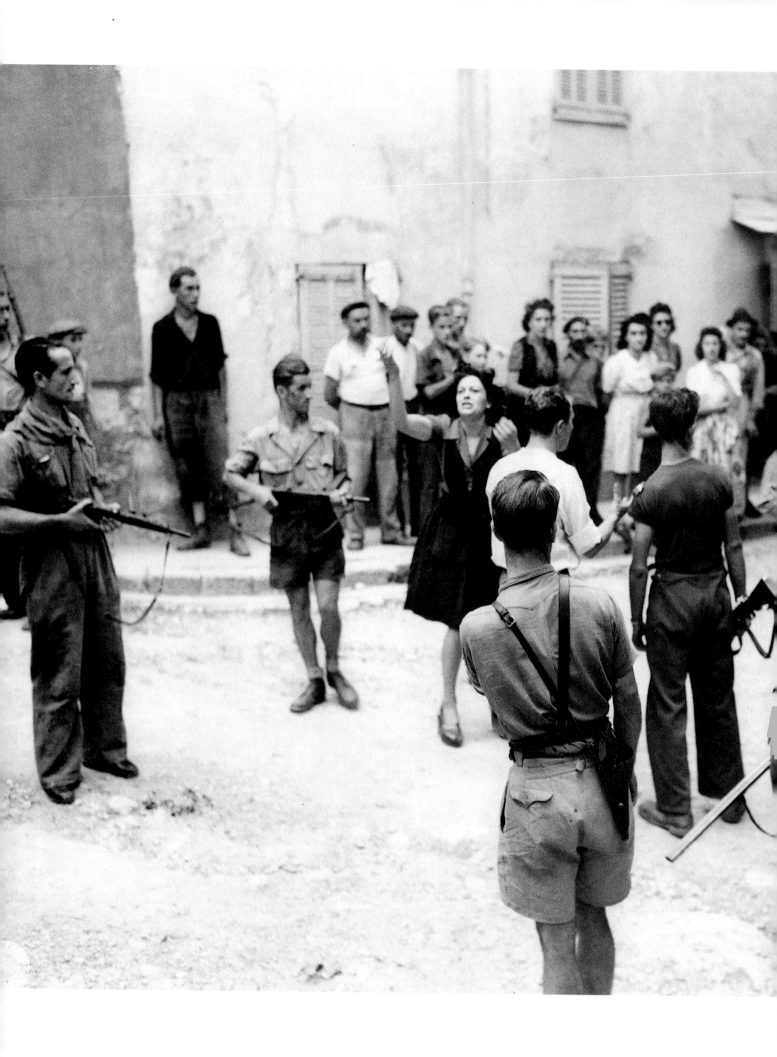

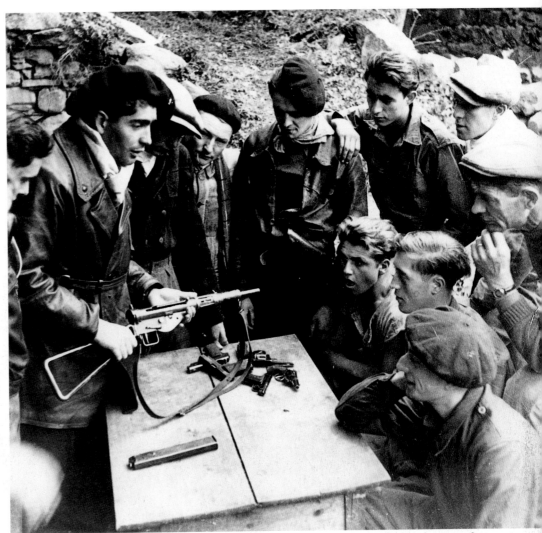

THE end of the German Occupation
brought recriminations for many in
France (1). Here youthful members of the
maquis (Resistance fighters) undergo
weapons training (2) with an international
variety of Sten, Ruby, Mark II and Le
Français pistols, Colt and Bulldog
revolvers, air-dropped by the London-
based Free French, led by General de
Gaulle.

NACH dem Ende der deutschen
Besatzung hatten sich viele Franzosen
wegen Kollaboration zu verantworten (1).
Hier sieht man jugendliche Widerstands-
kämpfer (*maquis*) bei Übungen mit einer
internationalen Mischung an Waffen, mit
Sten-, Ruby-, Mark II- und Le Français-
Pistolen, Colt- und Bulldog-Revolvern,
allesamt von Flugzeugen der Freien Fran-
zösischen Armee abgeworfen, die von
London aus operierte und unter der
Führung von General de Gaulle stand (2).

EN France, avec la fin de l'occupation
allemande, sonna également l'heure des
règlements de comptes (1). Ici, des jeunes
du maquis s'entraînent au maniement des
armes provenant d'un arsenal international
(2) – Sten, Ruby, Mark II, Le Français,
Colt et Bulldog –, parachutées par la France
libre, l'organisation du général de Gaulle,
basée à Londres.

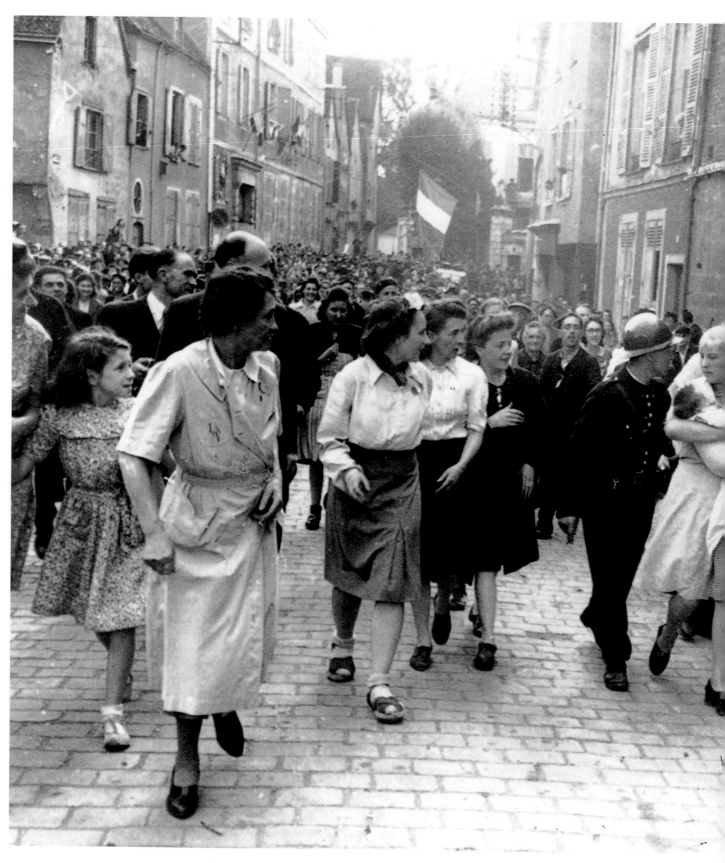

WITH the recapture of Chartres on 18 August 1944, women collaborators suffer the indignities of having their hair publicly shaved and of being jeered and jostled and whistled at by the local population (1, 3). The women (2) are mother and grandmother of this German-fathered baby.

NACH der Rückeroberung von Chartres am 18. August 1944 werden Kollaborateurinnen öffentlich kahlgeschoren und dem Spott der Bevölkerung preisgege-

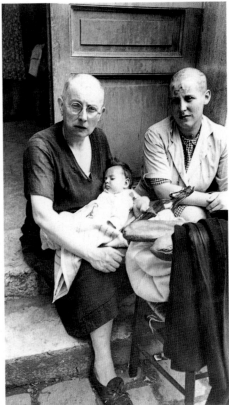

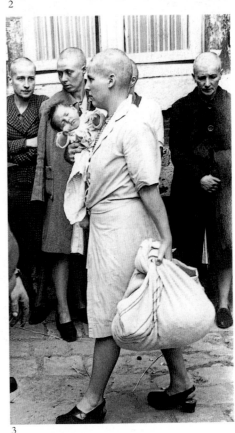

ben (1, 3). Die beiden Frauen (2) sind Mutter und Großmutter des Kindes von einem deutschen Vater.

APRÈS la reprise de Chartres le 18 août 1944, les femmes soupgounées d'avoir collaboré avec l'ennemi sont humiliées : rasées en public, raillées, injuriées et sifflées par la population locale (1 et 3). Ces femmes (2) sont respectivement la mère et la grand-mère de ce bébé de père allemand.

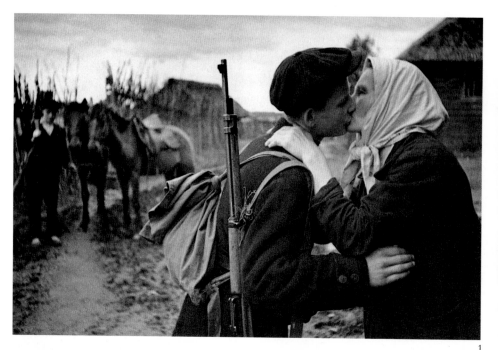

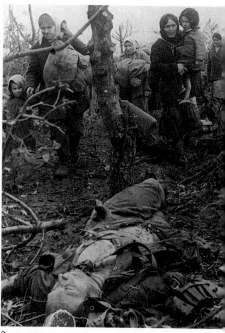

1　2

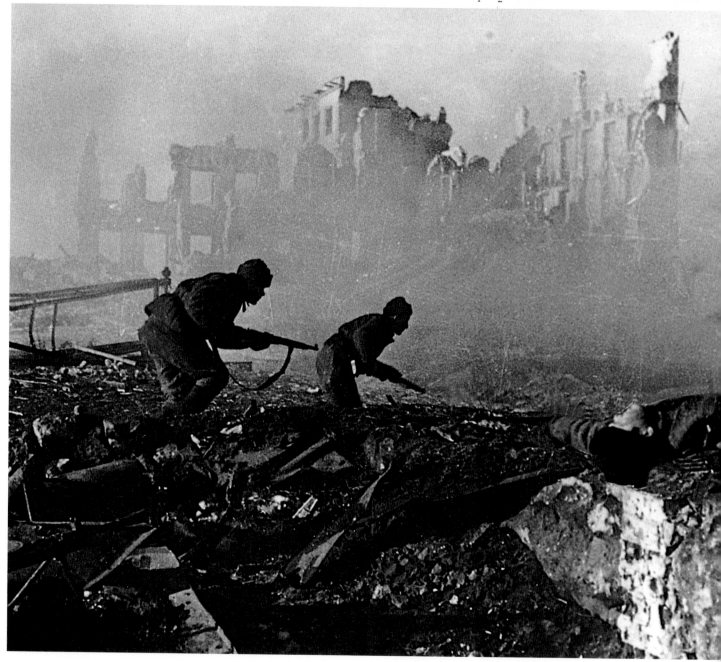

THE Russian people lost more lives than any other nation during the Second World War: over 20 million are estimated to have died. Like Napoleon, Hitler threw division after division into the war on the eastern front, only to see them driven back or, more humiliatingly still, defeated by the Russian winter, an even fiercer enemy than the Russian troops. The fall of Stalingrad in November 1942 (3) was for many the turning-point of the war, while the siege of Leningrad led to starvation for its beleaguered inhabitants. Even youths joined up to fight, like this boy bidding his mother farewell (1), while Russian villagers who had taken to the woods near Orel to flee the German army were pass the corpses of their soldiers on their return home (2).

DIE Russen waren das Volk im Zweiten Weltkrieg, das die meisten Toten zu beklagen hatte: vermutlich über 20 Millionen Menschen kamen um. Wie Napoleon schickte auch Hitler Division um Division in den Krieg an der Ostfront, und alle wurden sie vom russischen Winter, einem noch erbitterteren Feind als die russische Armee, zurückgetrieben oder ganz geschlagen. Der Fall Stalingrads im November 1942 (3) war für viele die entscheidende Wende des Krieges; in Leningrad verhungerte die belagerte Bevölkerung. Selbst Kinder kamen an die Front, wie dieser Junge, der sich hier von seiner Mutter verabschiedet (1). Russische Bauern, die bei Orel in die Wälder geflohen waren, als die Deutschen kamen, finden bei ihrer Rückkehr ihre gefallenen Soldaten (2).

LE peuple soviétique fut, au cours de la Seconde Guerre mondiale, de toutes les nations, celui qui paya le plus lourd tribut en vies humaines : on l'estime à plus de 20 millions de morts. Comme Napoléon, Hitler lança ses divisions l'une après l'autre à l'assaut du front est avec pour seul résultat de les voir repoussées ou, plus humiliant encore, tenues en échec par l'hiver russe. La chute de Stalingrad, en novembre 1942 (3), signala pour beaucoup un tournant dans la guerre, alors que le siège de Leningrad affamait les habitants de la ville. Même les jeunes s'enrôlèrent pour combattre, tel ce garçon faisant ses adieux à sa mère (1). Ailleurs, des villageois russes, qui s'étaient réfugiés dans les bois non loin d'Orel pour échapper à l'armée allemande, prennent le chemin du retour au milieu des cadavres de leurs soldats (2).

3

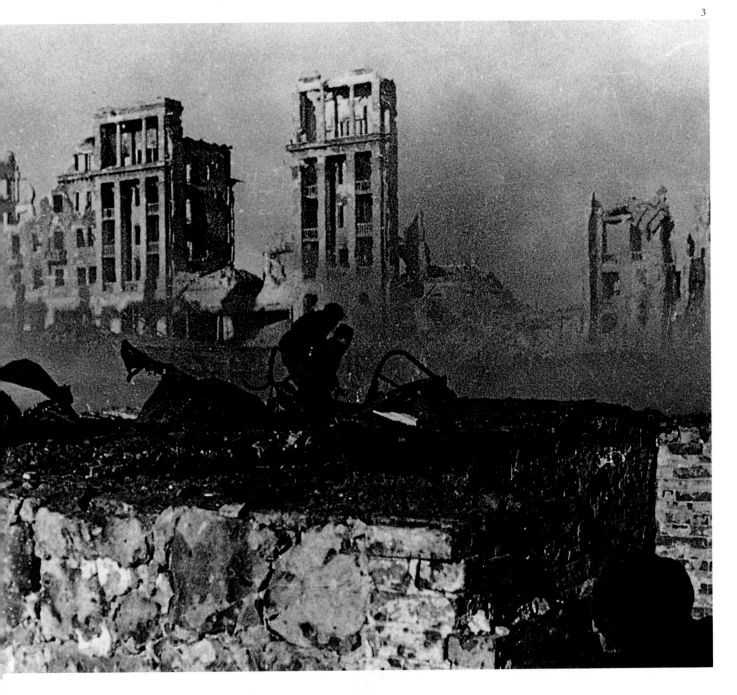

EVEN the Soviet army were bogged down in freezing conditions more familiar to them than to the Germans (1). In January 1943 these German prisoners are on a forced march north-west of Stalingrad (2). Red Army instructors take Moscow schoolchildren on 'manoeuvres' in Sokolniky Park (3). They are being taught to build up a 'Front Line' with a gun emplacement.

OBWOHL ihnen die harten Winter vertrauter waren als ihren deutschen Feinden, saßen auch die russischen Truppen fest (1). Im Januar 1943 marschieren deutsche Kriegsgefangene von Stalingrad nordwestwärts (2). Ausbilder der Roten Armee auf »Manöver« mit Moskauer Schulkindern im Sokolniky-Park (3). Hier lernen sie, eine »Front« und eine Geschützstellung aufzubauen.

MÊME l'armée soviétique, pourtant plus acclimatée que les Allemands s' retrouva enlisée dans le froid glacial (1). Janvier 1943 : prisonniers allemands accomplissant une marche forcée au nord-ouest de Stalingrad (2). Des instructeurs de l'Armée rouge font exécuter à des écoliers des « manœuvres » dans le parc Sokol'niki (3). Ils apprennent à édifier une « ligne de front » de canons.

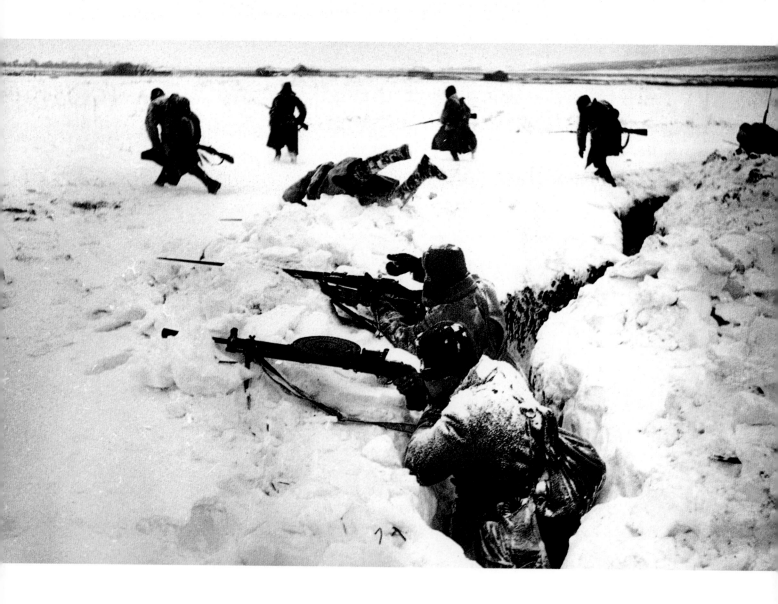

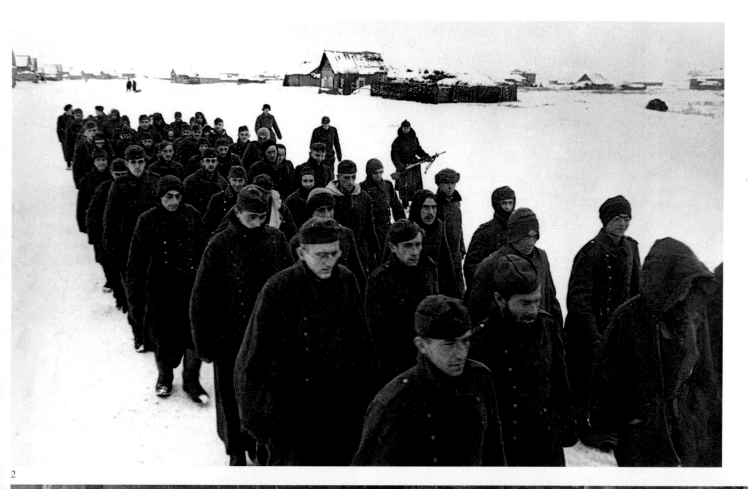

2

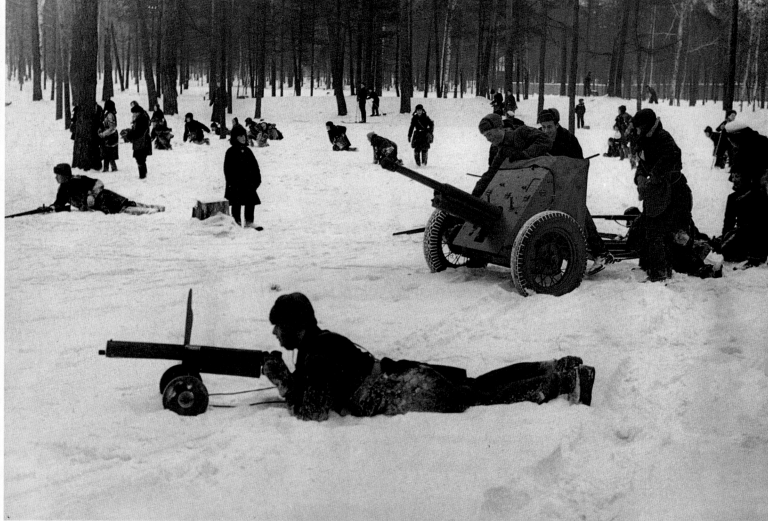

3

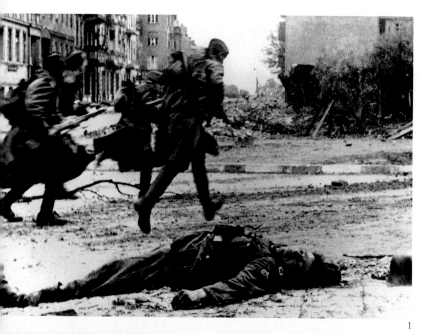

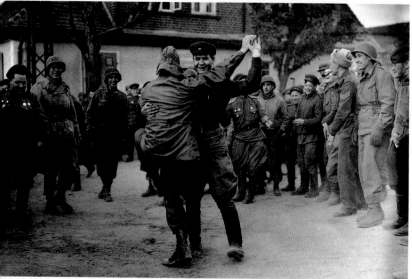

IN April 1945 Berlin was subjected to street-by-street fighting to gain control of the capital (1). Dimitri Baltermants, famous Russian photographer and war hero, took the victory pictures: the Soviet hammer-and-sickle is raised over the Reichstag (3). May Day 1945: the US Ninth Army meets the Russians on the Elbe. Two soldiers celebrate in a dance, watched by their comrades-in-arms (2).

IM April 1945 kämpften sich in Berlin die einrückenden Armeen Straße um Straße vor (1). Dimitri Baltermants, der berühmte russische Photograph und Kriegsheld, hielt den Sieg in Bildern fest: Die sowjetische Flagge mit Hammer und Sichel wird über dem Reichstag gehißt (3). 1. Mai 1945: Die Neunte US-Armee und die russischen Truppen treffen sich an der Elbe. Zwei Soldaten beim Freudentanz, und ihre Waffenbrüder sehen zu (2).

EN avril 1945, Berlin était le théâtre de combats dont l'enjeu était de conquérir la capitale, rue après rue (1). Dimitri Baltermants, célèbre photographe et héros de guerre russe, prit les photographies de la victoire : le marteau et la faucille soviétiques sont hissés au-dessus du Reichstag (3). 1er mai 1945 : la 9e armée des États-Unis rejoint les Russes sur les bords de l'Elbe. Deux soldats dansent de joie sous le regard de leurs compagnons d'armes (2).

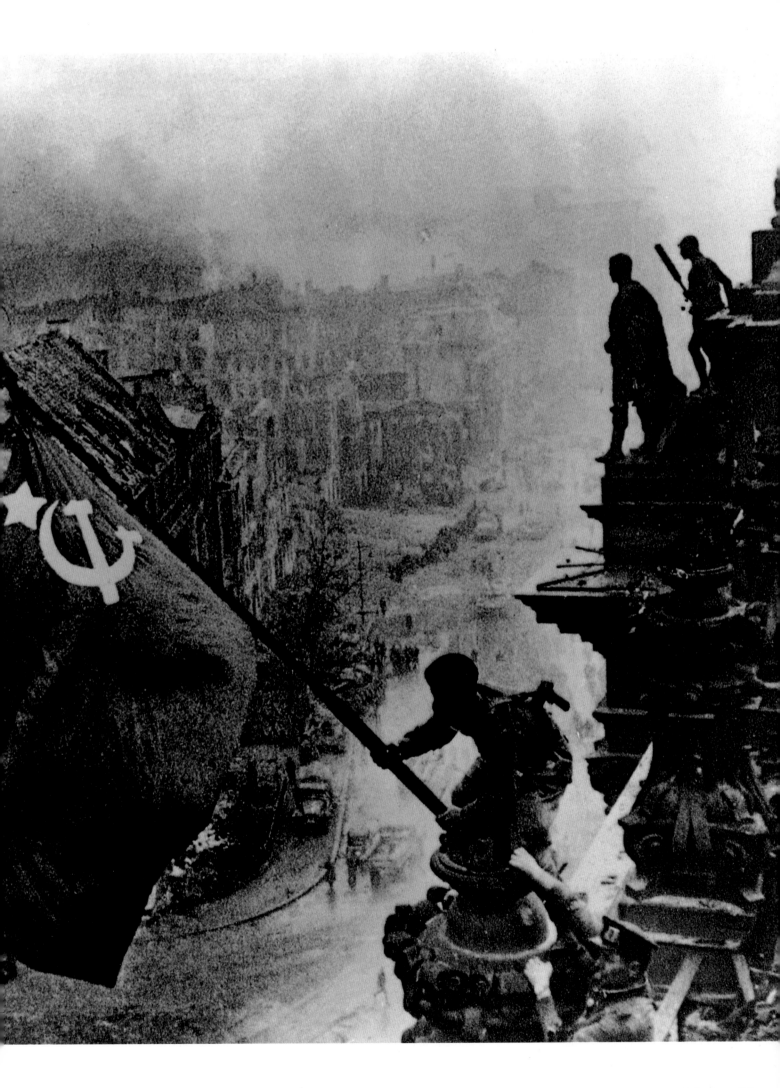

1 2

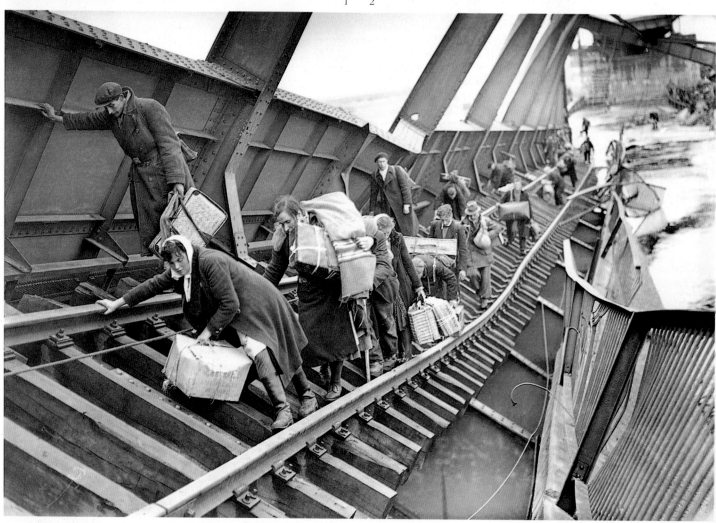

3

THE War left the problem of ten million displaced persons and refugees. Some cross the Elbe on a damaged bridge (3). A Russian soldier falls asleep at the historic meeting with the Ninth Army (2). He and his horse have travelled over 2,000 miles. In Mönchengladbach (1), German residents extend white flags and handkerchiefs in surrender. This Berlin girl fraternizes with British troops (5), while on the balcony of Hitler's Chancellery, Russian, British and US soldiers line up in greeting (4).

AM Ende des Krieges waren zehn Millionen Flüchtlinge unterwegs. Einige überqueren die Elbe auf einer halbzerstörten Brücke (3). Nach einem Weg von 3 200 Kilometern ist dieser russische Soldat (2) kurz vor dem historischen Treffen mit der 9. Armee eingeschlafen. In Mönchengladbach (1) ergibt sich die Zivilbevölkerung. Eine Berlinerin (5) fraternisiert mit britischen Soldaten und auf dem Balkon von Hitlers Reichskanzlei versammeln sich russische, britische und amerikanische Soldaten (4).

AVEC la fin de la guerre se posa le problème de dix millions de personnes déplacées et réfugiées. Certaines passent l'Elbe sur un pont endommagé (3). Un soldat russe s'endort pendant la jonction historique avec la 9e armée (2). Il a parcouru plus de 3 200 kilomètres. À Mönchengladbach (1), les habitants allemands font signe de reddition. Cette Berlinoise fraternise avec les troupes britanniques (5) Au palais de Hitler, des soldats russes, britanniques et américains alignés saluent la foule (4).

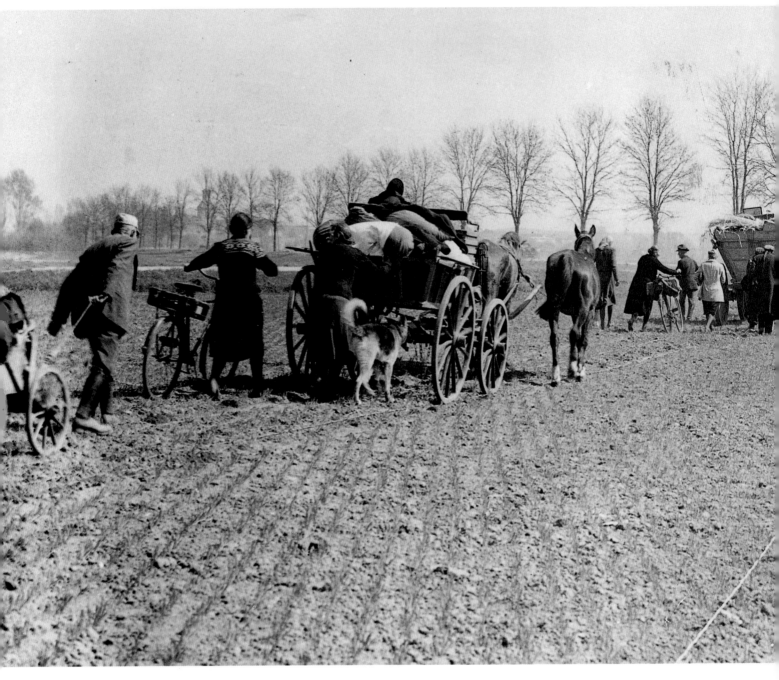

AMONG the most heartbreaking of situations was that of the internal displacement of refugees who ceased to belong anywhere. Particularly in eastern Europe, borders were so frequently shifted that some no longer knew if they were German-speaking Poles or Polish-speaking Germans. These Germans are unable either to travel on the roads prohibited to all but military transport, or to cross the Elbe with

their horses and cattle (1). Neither can they return, so they are condemned to wander endlessly in circles like some kind of an outer Inferno. The other hellish landscape is on the outskirts of Berlin, where this tiny group (2) are the sole survivors of the 150 who left Lodz on what became known as the 'Death March'. Far from finding sanctuary in Berlin, these exiles are now trailing aimlessly along a railroad.

BESONDERS hart war das Los der Flüchtlinge, die nirgendwohin mehr gehörten. Vor allem in Osteuropa ver- änderten die Grenzen sich so häufig, daß manche nicht mehr wußten, ob sie nun deutsche Polen oder polnische Deutsche waren. Die Deutschen auf diesem Bild (1) dürfen nicht auf der Straße weiterziehen, die den Militärfahrzeugen vorbehalten ist, und auch nicht mit ihren Pferden und dem Vieh die Elbe überqueren. Aber sie können

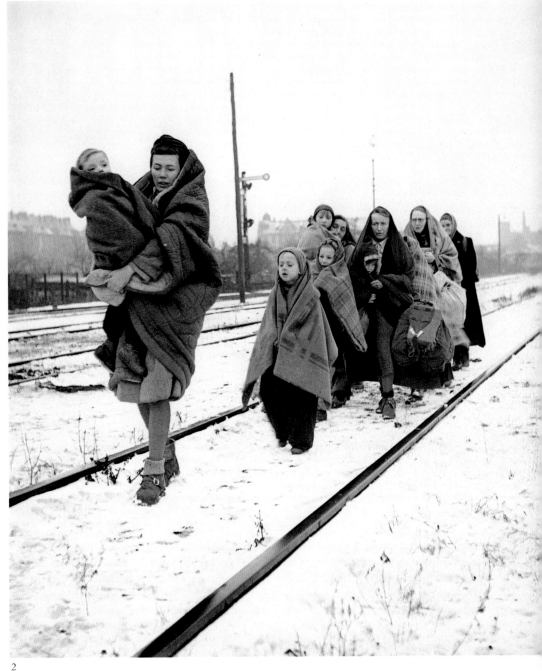

auch nicht zurück und müssen endlos umherirren wie in einem Höllenkreis. Die Höllenlandschaft des anderen Bildes (2) liegt vor den Toren Berlins, und dieses Grüpplein sind die einzigen Überlebenden des sogenannten Todesmarsches, den sie zu 150 in Lodz begonnen hatten. Diese Heimatlosen fanden nicht die erhoffte Zuflucht in Berlin, sondern irren nun eine Bahntrasse entlang.

Parmi les situations les plus douloureuses figurait celle des gens réfugiés et déplacés. Le cas était surtout classique en Europe de l'Est où le tracé des frontières avait été si souvent modifié que certains ne savaient plus s'ils étaient des Polonais germanophones ou des Allemands d'expression polonaise. Ici ces Allemands ne peuvent ni prendre les routes, interdites à toute circulation civile, ni traverser l'Elbe avec leurs chevaux et leurs bestiaux (1). Ils ne peuvent pas non plus rentrer, condamnés qu'ils sont à tourner sans fin dans un univers devenu absurde. Cette autre scène infernale se déroule dans la banlieue de Berlin : ce minuscule groupe (2) représente les rescapés des 150 personnes qui avaient quitté Lódz pour entreprendre ce qu'on a appelé la « Marche de la mort ». À défaut de trouver refuge à Berlin, ces exilés cheminent maintenant sans but le long d'une voie ferrée.

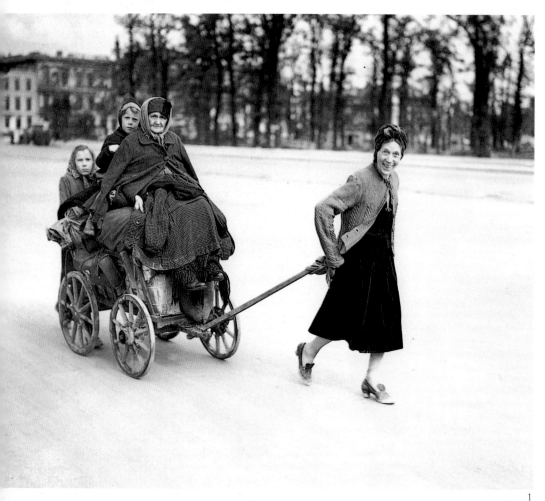

1

GIVEN the high number of male casualties, by 1945 many families consisted entirely of women and children. Here, the conditioned reflex of smiling for the camera overtakes the misery of the Berlin winter – without coal and under snow. One refugee pulls her mother – to whom she has awarded her coat – and offspring along on a cart (1), while another has raided firewood from a forest eight miles away (2). In October 1945, four million Berliners were confronted by the harshest winter in their history.

DA so viele Männer umgekommen waren, bestanden viele Familien 1945 nur noch aus Frauen und Kindern. Auf diesem Bild ist der konditionierte Reflex des Lächelns vor der Kamera stärker als selbst das Elend des Berliner Winters im tiefen Schnee und ohne Kohlen. Eine Flüchtlingsfrau zieht ihre Mutter – der sie den Mantel überlassen hat – und die Kinder in einem Handkarren (1), eine andere hat Feuerholz in einem zwölf Kilometer entfernten Wald gesammelt (2). Im Oktober 1945 begann für vier Millionen Berliner der härteste Winter in der Geschichte der Stadt.

2

À cause des pertes masculines élevées, nombreuses étaient les familles entièrement composées de femmes et d'enfants en 1945. Ici le réflexe conditionné de sourire

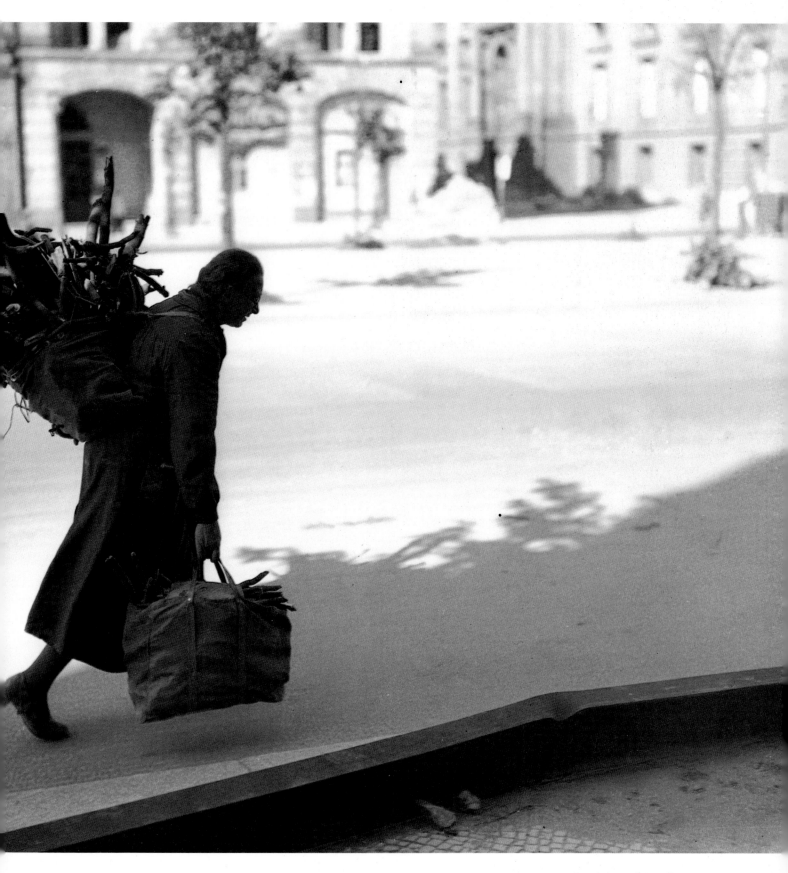

devant l'objectif l'emporte sur la détresse dans laquelle les plonge l'hiver berlinois, sans charbon et sous la neige. Une réfugiée tire sa mère – qu'elle a vêtu de son manteau – et son enfant perchés sur un charreton (1), tandis qu' une autre est allée dérober du bois de chauffage dans une forêt située à quelque douze kilomètres de là (2). En octobre 1945, quatre millions de Berlinois faisaient face à l'hiver le plus rigoureux de toute leur histoire.

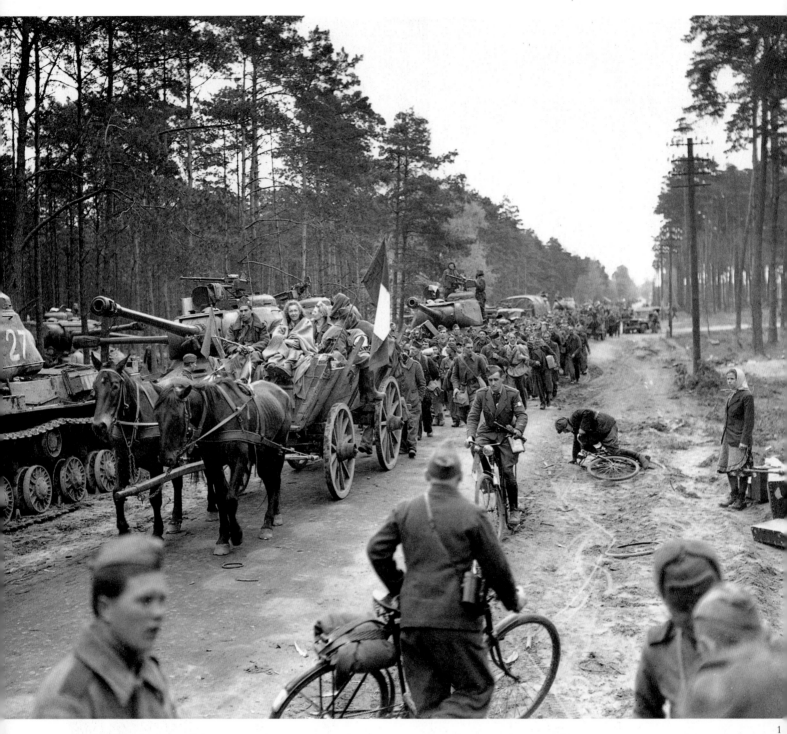

1

FORMER prisoners of a confusion of nationalities seek to overtake a tank along the way, even when the horses are weary and a bicycle sticks and falls in the mud (1). Liberation didn't necessarily provide transport in a Europe short of fuel and vehicles. Those in striped uniforms are former Free French internees (2) and German anti-Nazis (3) imprisoned for their religious beliefs and refusal to take the 'Sieg Heil' salute. They are on the road near Parchim, still 55 miles from Berlin.

BEFREITE Gefangene aller Nationalitäten versuchen einen Panzer zu überholen, doch die Pferde sind müde, und einer bleibt mit seinem Fahrrad stecken und fällt in den Schlamm (1). Fahrzeuge und Brennstoff waren in Europa Mangelware, und die Befreiung bedeutete noch lange nicht, daß es auch wieder Transportmittel geben würde. Die Männer in Sträflingskleidung sind befreite Kämpfer des Freien Frankreich (2), und die Frauen sind deutsche Antifaschisten (3), die aus religiösen Gründen in die Gefängnisse gewandert waren oder weil sie sich geweigert hatten, mit dem Hitlergruß zu grüßen. Sie sind nur noch 88 Kilometer vor Berlin.

D'ANCIENS prisonniers, toutes nationalités confondues, juchés sur des chevaux fourbus, s'efforcent de rattraper un char sur le chemin ; une bicyclette bascule, enlisée dans la boue (1). La Libération ne procura pas nécessairement de moyens de transport dans une Europe à court de véhicules et d'essence. Dans ces uniformes rayés passent d'anciennes prisonnières de guerre de la France libre (2) et des opposants allemands au régime, emprisonnés (3) pour leurs convictions religieuses, politiques ou leur refus de faire le salut nazi. Ils ne sont pas loin de Parchim, mais à encore 88 kilomètres et demi de Berlin.

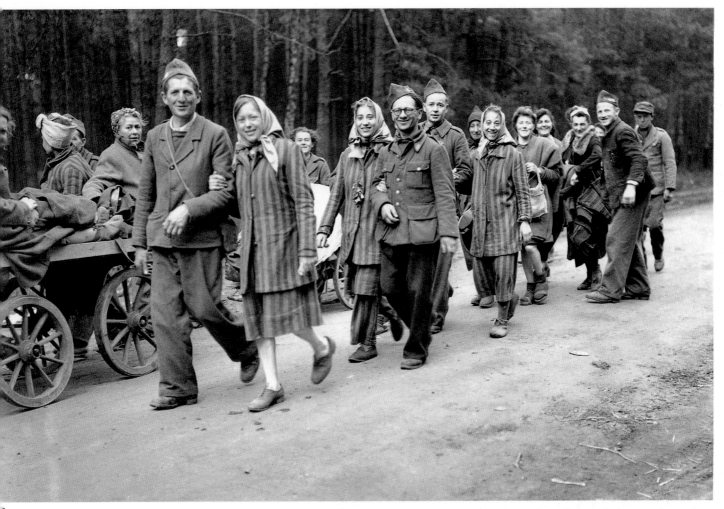

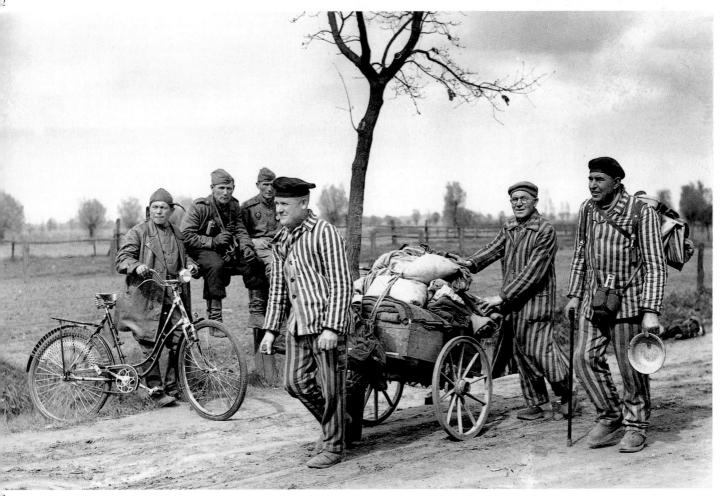

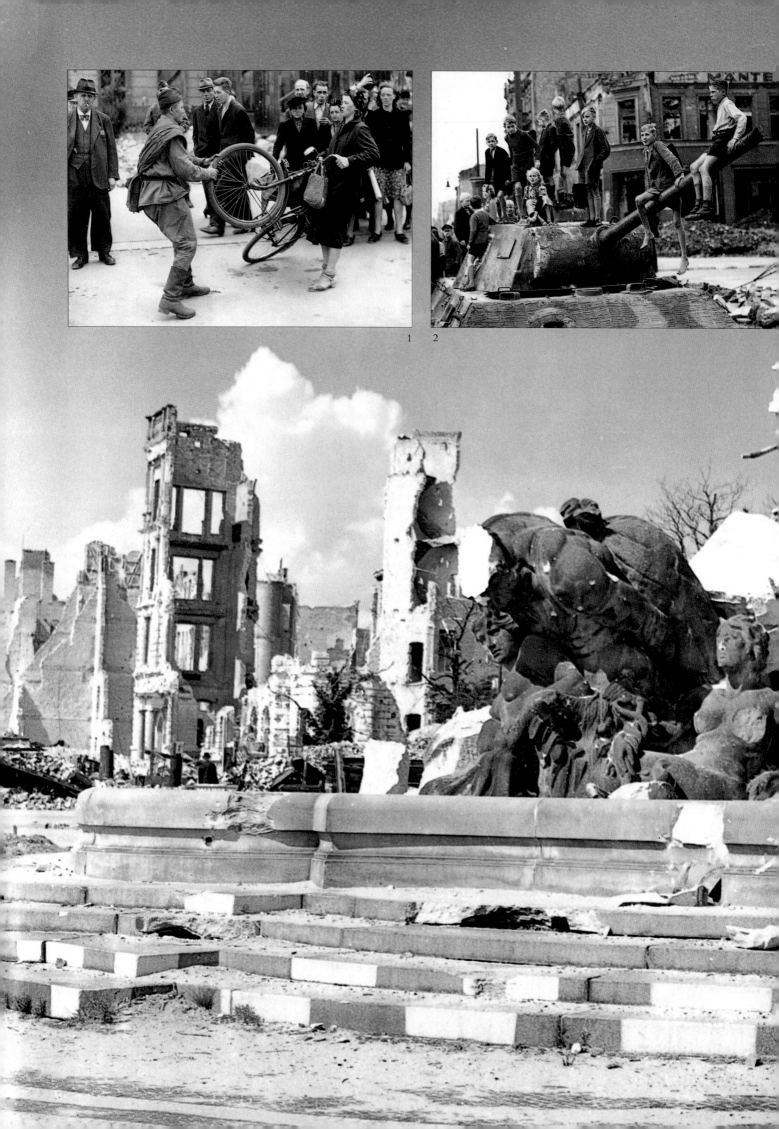

1 2

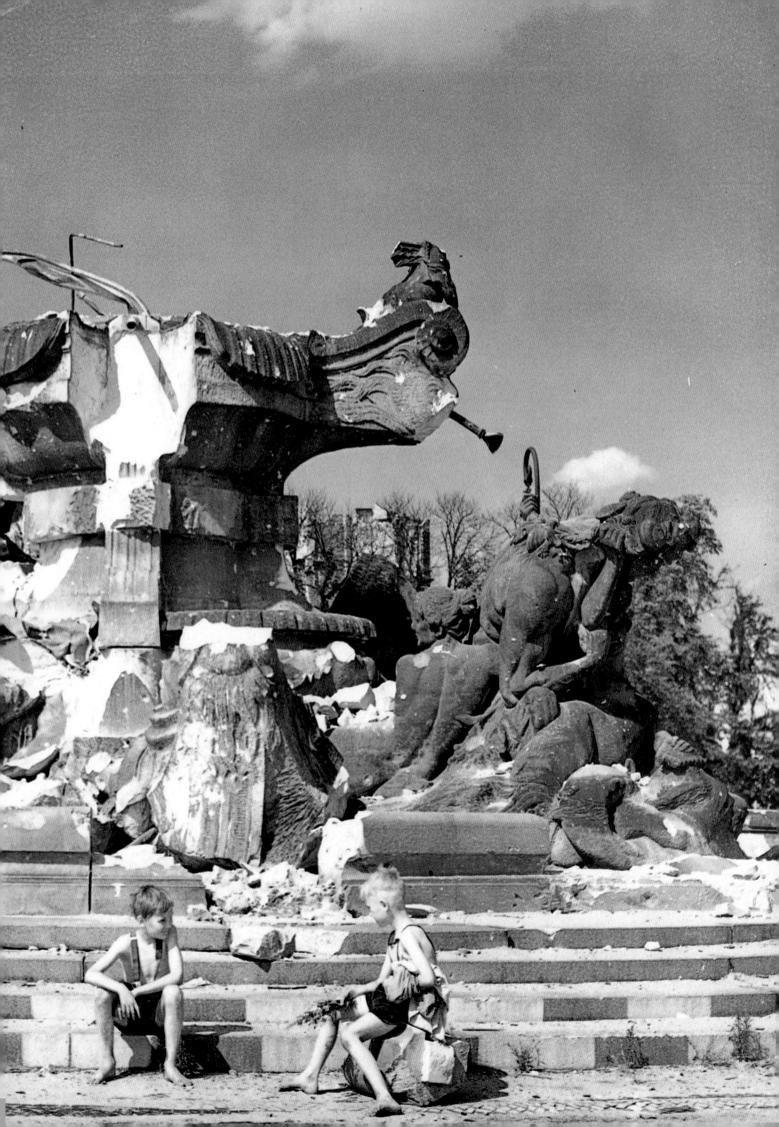

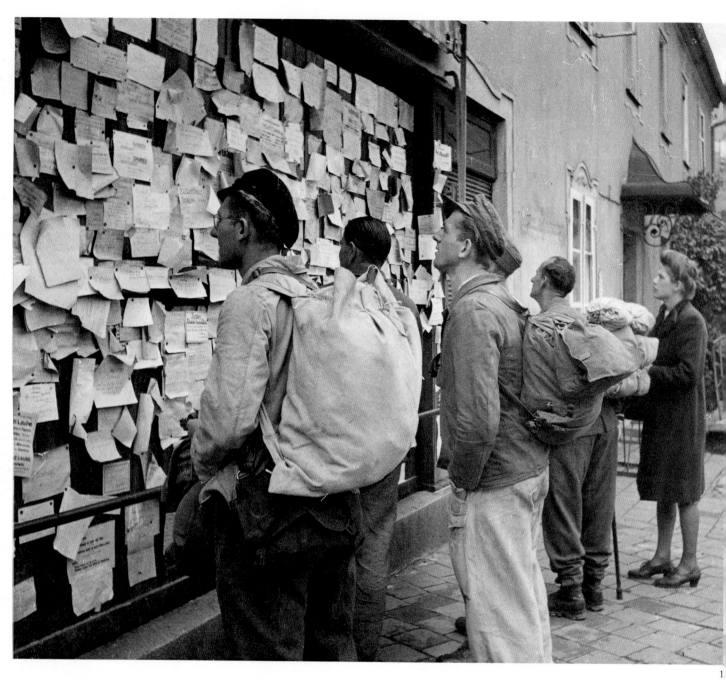

1

(*Previous pages*)

LACK of a common language sometimes led to misunderstanding. A Russian soldier presses money into the hand of a German woman and seeks to depart with her precious bicycle. She seems to be suggesting that it is not for sale (1). Also in Berlin, youngsters play among the ruins of the Hercules Statue (3) or wrecked tanks (2) for lack of schools or playgrounds to go to.

(*Vorherige Seiten*)

DIE Sprachenvielfalt führte oft zu Mißverständnissen. Dieser russische Soldat drückt einer Deutschen Geld in die Hand und will ihr das wertvolle Fahrrad abkaufen. Sie antwortet ihm allem Anschein nach, daß es nicht zu verkaufen sei (1). Für die Kinder gab es keine Schulen oder Spielplätze, hier in Berlin spielen sie zwischen den Trümmern der Herkules-statue (3) oder auf zerschossenen Panzern (2).

(*Pages précédentes*)

L'ABSENCE de langue commune pro-voquait parfois des malentendus. Un soldat russe, après avoir mis de l'argent dans la main d'une Allemande, cherche à s'éloigner avec la précieuse bicyclette. La mine de la dame semble indiquer que sa bicyclette n'est pas à vendre (1). À Berlin toujours, faute d'écoles ou de terrains de jeux, des enfants jouent au milieu des ruines de la statue d'Hercule (3) ou des débris de chars d'assaut (2).

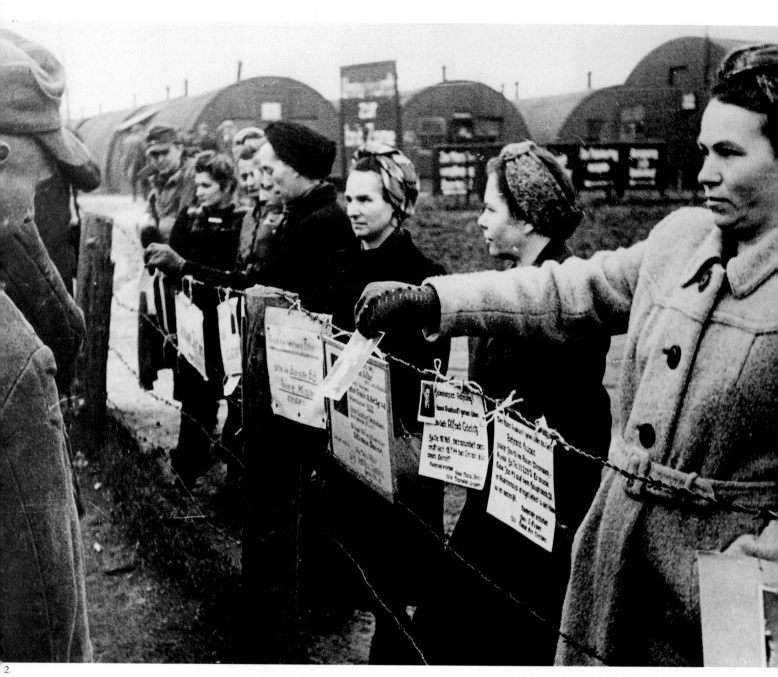

2

NOTICES pasted on trees, boards, railings or strung from barbed wire served multiple functions. A dearth of newspapers led to this means of disseminating information. Specifically in Germany and Austria notes were posted at train stations in an attempt to recover sons and husbands who had failed to return from the eastern front (1). In former POW camps relatives posted faded photographs with the rubric 'Have you seen this man?' beneath (2).

NACHRICHTEN wurden an Bäume, Anschlagtafeln, Geländer oder Drahtzäune geheftet; es war die einzige Möglichkeit, Informationen weiterzugeben, denn Zeitungen gab es kaum. Besonders in Deutschland und Österreich hängten Familien Nachrichten in den Bahnhöfen aus, in der Hoffnung, Männer oder Söhne wiederzufinden, die nicht von der Ostfront zurückgekehrt waren (1). In ehemaligen Kriegsgefangenenlagern hängten die Angehörigen verblaßte Fotografien aus, mit der Frage darunter: »Wer kennt diesen Mann?« (2)

LES bouts de papier collés sur les arbres, les panneaux et les barrières ou accrochés aux fils barbelés servaient à toutes sortes de choses. La pénurie de journaux faisait recourir à ce moyen pour diffuser les nouvelles. En Allemagne et en Autriche, en particulier, on placardait dans les gares ferroviaires des notices pour essayer de retrouver des fils ou des époux qui n'étaient pas revenus du front de l'Est (1). Dans les anciens camps de prisonniers, les parents plaçaient des photos vieillies sur lesquelles on pouvait lire : « Avez-vous vu cet homme ? » (2)

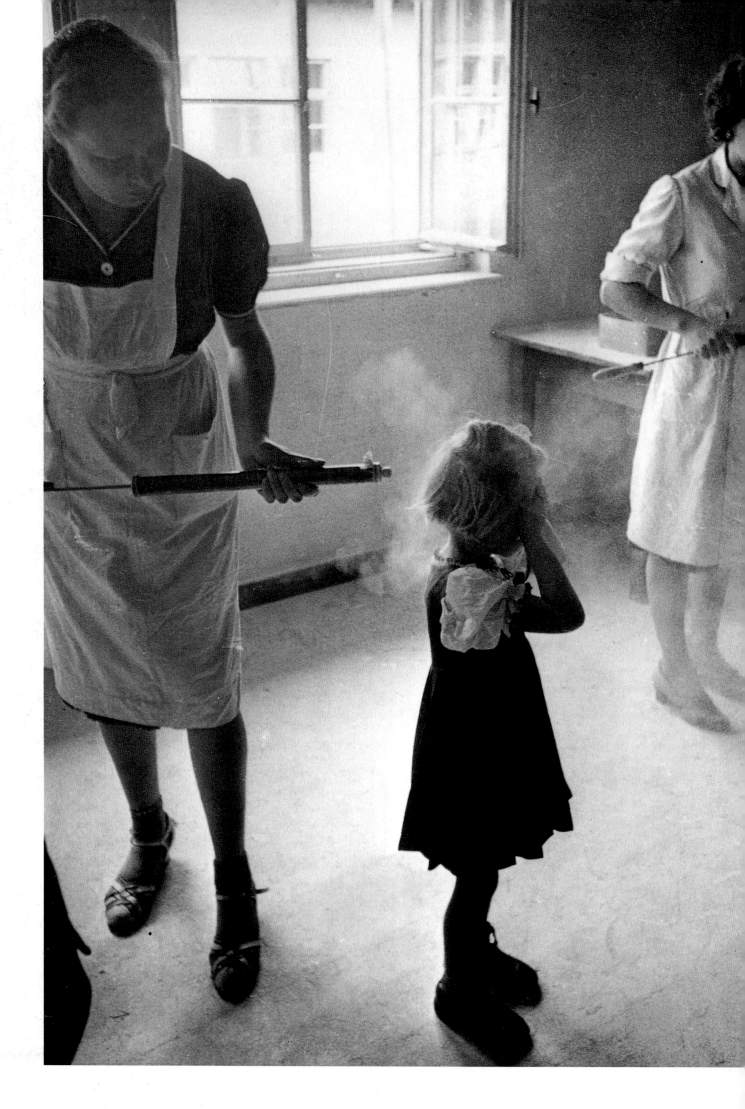

SHORTLY after its foundation in 1948, UNESCO implemented a child healthcare programme intended to combat communicable infections – and infestations. This little refugee from the former Sudetenland (Czechoslovakia) is being deloused (1) while, ten years earlier, these 'Jewish and non-Aryan' refugee children from Vienna are waiting to be transferred by train from Harwich to Dovercourt Bay Camp (2). Since 502 names are too many to remember, each is given a number tagged to their clothes: a final straw in the process of depersonalization brought by the Nazi régime, as the tears here indicate (3).

KURZ nach ihrer Gründung im Jahre 1948 startete die UNESCO ein Gesundheitsprogramm für Kinder, das ansteckende Krankheiten bekämpfen sollte – und Parasiten. Diese kleine Heimatvertriebene aus dem Sudetenland (das nun wieder tschechisch war) wird gerade entlaust (1); zehn Jahre zuvor warteten »jüdische und nicht-arische« Flüchtlingskinder aus Wien auf den Zug, mit dem sie von Harwich in das englische Lager Dovercourt Bay gebracht werden sollten (2). Da keiner sich 502 Namen merken kann, bekommt jedes eine Nummerntafel angesteckt, mit der ihnen das Naziregime, wie die Tränen hier beweisen, auch noch das letzte bißchen Individualität genommen hat (3).

PEU après sa fondation, en 1848, l'Unesco mit en œuvre un programme de soins de santé infantiles en vue de lutter contre les maladies contagieuses et les infections. Cette petite réfugiée, originaire de l'ex-région des Sudètes (Tchécoslovaquie), subit un épouillage (1). Dix ans plus tôt, ces enfants réfugiés « juifs et non aryens », venus de Vienne, attendaient le train qui devait les transférer de Harwich au camp de Dovercourt Bay (2). Parce qu'il est impossible de mémoriser 502 noms, chacun d'eux reçut un numéro attaché à ses vêtements : touche finale dans le processus de dépersonnalisation mis en place par le régime nazi (3).

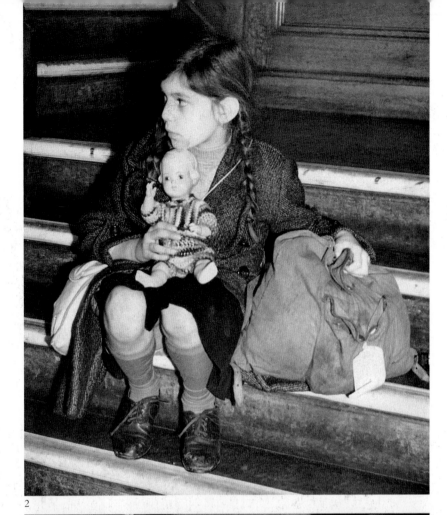

2

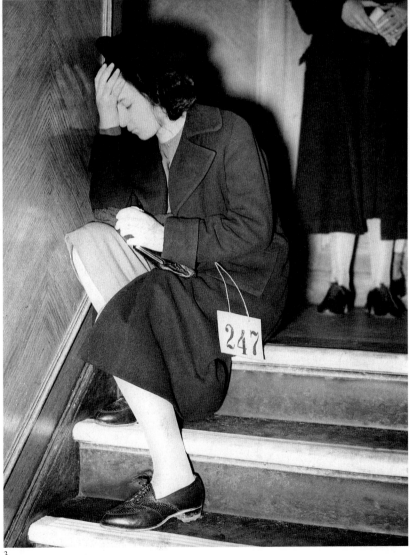

3

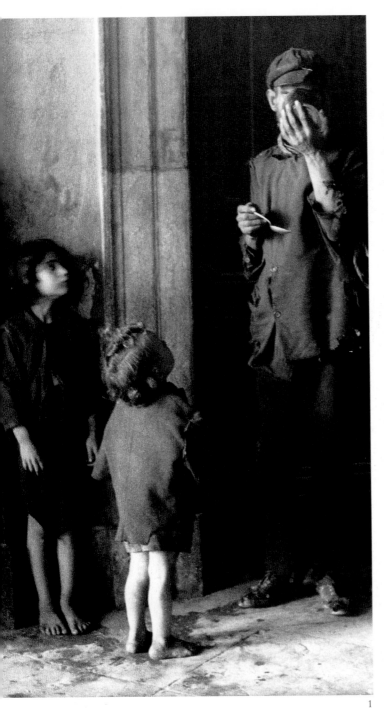
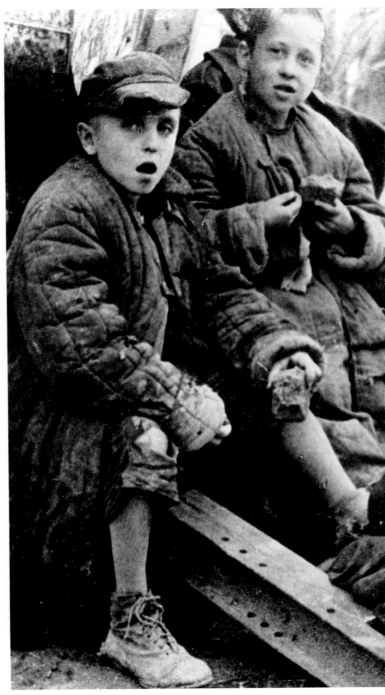

1 2

IN wartime Italy, poverty and hunger dogged these Sicilian children. Barefoot infants dressed in sacking watch enviously as their father drains his bowl (1). Polish children evacuated from Russia have somehow ended up tranported to Iran at the end of the war (2); at the height of the Spanish Civil War that preceded World War Two, 4,000 Republican children arrive at a camp near Southampton (3) – many had already fled first to France.

DIE sizilianischen Kinder hatten im Krieg in Italien unter Armut und Hunger schwer zu leiden. Die barfüßigen, in Säcke gekleideten Kleinen schauen neidisch zu, wie der Vater seine Schale leert (1). Aus Rußland evakuierte polnische Kinder sind bei Kriegsende im Iran gelandet (2); auf dem Höhepunkt des Spanischen Bürgerkriegs, der dem Zweiten Weltkrieg vorausgegangen war, kommen 4 000 Republikanerkinder, von denen viele zuvor nach Frankreich geflüchtet waren, in Southampton an (3).

PENDANT la guerre, en Italie, ces enfant siciliens étaient pauvres et tenaillés par la faim. Des tout-petits, nu-pieds et habillé dans de la toile à sac, regardent avec envie leur père vider le contenu de son bol (1). Des enfants polonais évacués de Russie se retrouvent inexplicablement transportés en Iran à la fin de la guerre (2). Au plus fort de la guerre civile espagnole, qui précéda la Seconde Guerre mondiale, 4 000 enfants républicains arrivent dans un camp près de Southampton (3). Beaucoup d'entre eux avaient d'abord tenté de se réfugier en France.

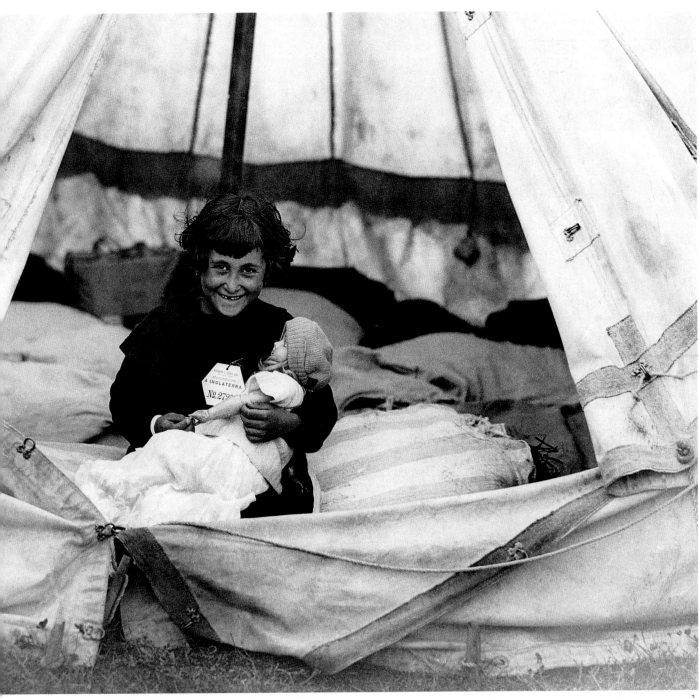

3

(Overleaf)

THIS was the true face of Nazism: the face of death. Marked with yellow [stars] (3), deportees were herded onto trains [like] cattle, so ignorant of their fate that [the]y brought their pitiful minimum of [be]longings with them. At Auschwitz, where [thi]s cattle-truck was bound (2), 1.5 million [w]ere gassed and incinerated. At Buchen-[w]ald, liberated by US forces in 1945, [the]se living skeletons (1) were the scant [su]rvivors of a further 800,000 who died.

(Folgende Seiten)

DAS wahre Gesicht des Nazismus: das Antlitz des Todes. Die mit Juden-sternen gekennzeichneten Deportierten (3) wurden in Güterwagen verladen wie Vieh, und sie ahnten so wenig, was ihnen bevorstand, daß sie ihre armselige Habe mitbrachten. In Auschwitz, wohin dieser Viehwagen unterwegs ist (2), wurden 1,5 Millionen Menschen vergast und ver-brannt. In Buchenwald, das 1945 von amerikanischen Truppen befreit wurde, kamen weitere 800 000 um, und diese bis aufs Skelett Abgemagerten (1) waren die einzigen Überlebenden.

(Pages suivantes)

LA mort, voilà ce qu'incarnait le nazisme. Marqués de l'étoile jaune (3), les déportés étaient parqués comme du bétail dans les trains, emportant avec eux un minimum d'affaires, ignorant tous du sort qui leur était réservé. À Auschwitz, desti-nation finale de ce fourgon, qui aurait dû servir aux bestiaux (2), un million et demi de personnes furent gazées et précipitées sous terre. À Buchenwald, libéré par les forces américaines en 1945, ces hommes et femmes réduits à l'état de squelettes (1) ont à peine survécu, tandis que 800·000 autres sont morts.

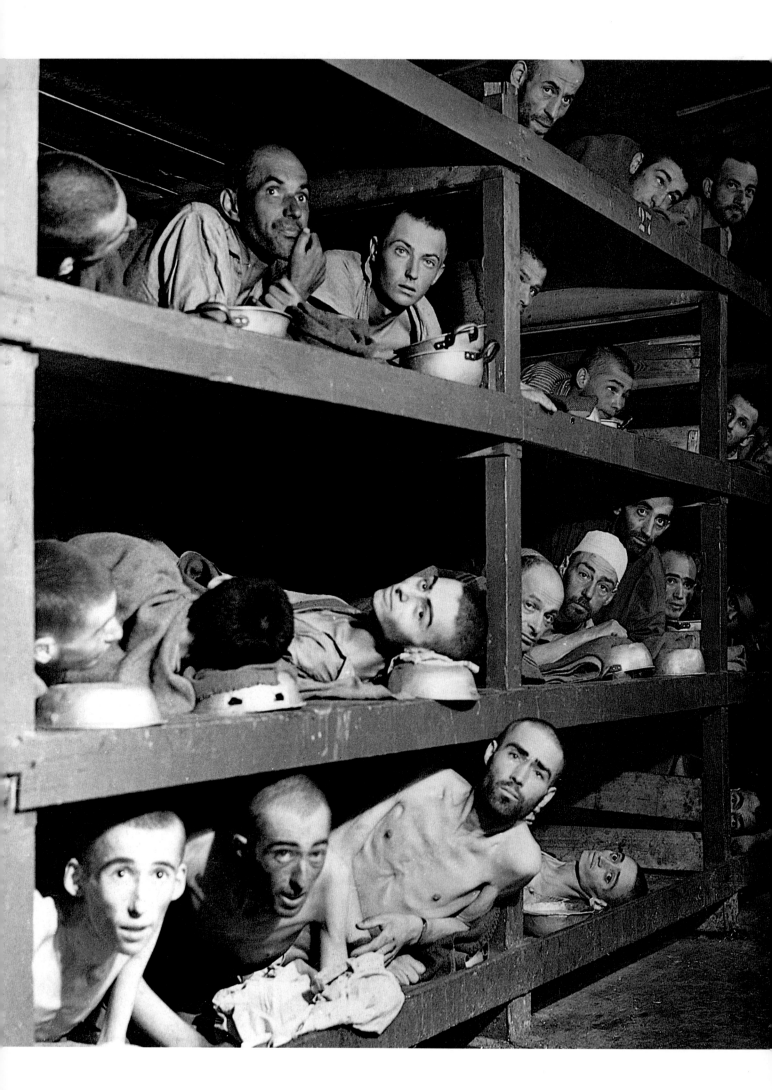

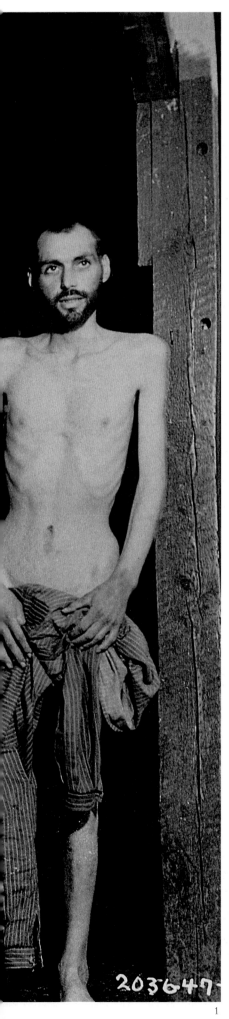

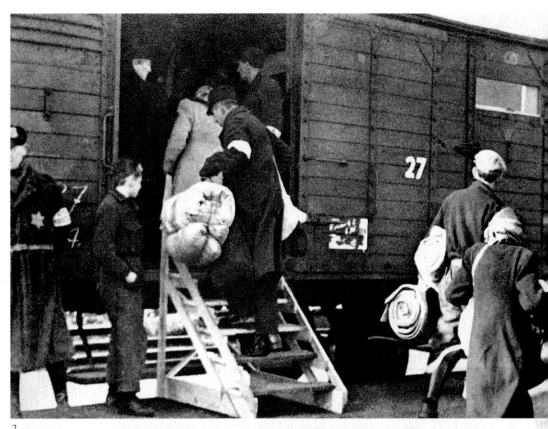

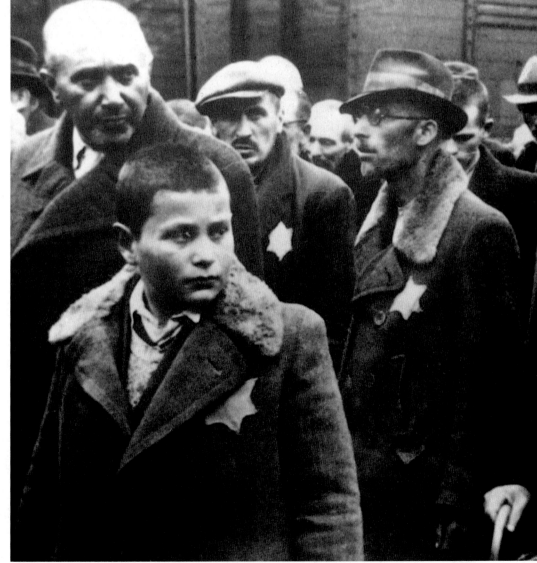

1

2

3

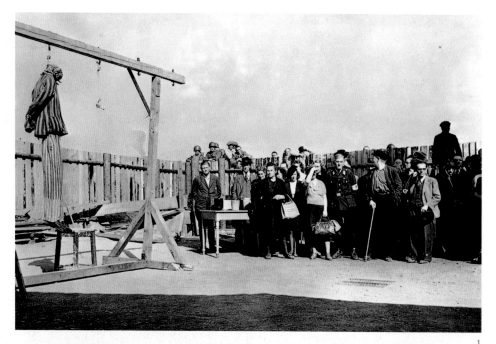

1

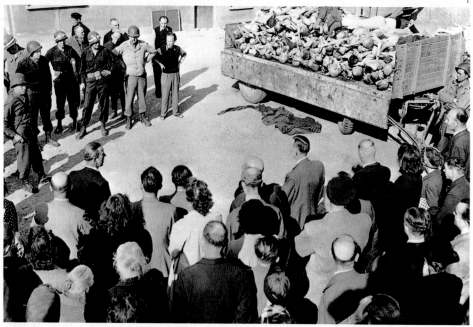

2

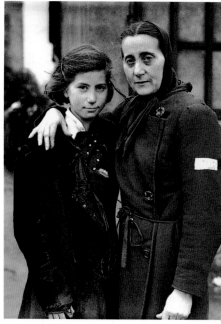

4

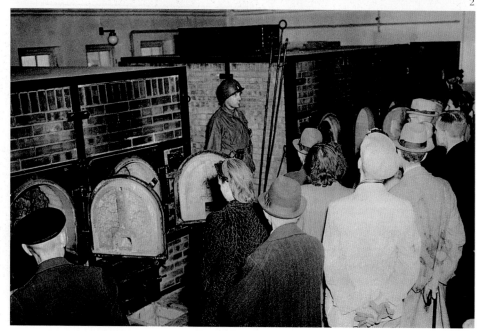

3

The Allies and then the West German government sought to implement a programme of 're-education', through recognition of what had actually taken place. It began at Buchenwald in April 1945, where local civilians were brought i to acknowledge what so many had previously refused to open their eyes to. Some look away before the swinging man (1), and a lorry stacked with corpses, nake and in extreme emaciation (2). Finally, the visit the ovens, whose smoke Weimar townspeople must have witnessed daily (3) A contemporary report noted: 'Many of the witnesses leave the camp in tears. Others appear indifferent and claim they are being subjected to Allied propaganda.'

A few of the sturdiest inmates, brought in as slave-labour from across Europe, survived on minimum rations, working a 12- to 18-hour day. An 11-year-old Czech 'child slave' is reunited with her mother at Kaunitz in 1945 (4). *J'accuse* – a Russian slave labourer singles out a German camp commander notorious for his sadistic brutality (5). At Dachau, some released prisoners rounded on their SS guards in enraged retaliation: soldiers of the US 42n Division hook out a corpse from the moat round the camp (6).

Die Alliierten und später die westdeutsch Regierung wollten in einer »Umerzie hungskampagne« den Deutschen die Greu vor Augen führen, die geschehen waren. Sie begann im April 1945 in Buchenwald, wo Einheimische durchs Lager geführt und gezwungen wurden zu sehen, wovor zuvor so viele die Augen verschlossen hatte Einige wenden den Blick von dem Erhäng ten (1) und von dem Wagen ab, auf dem

die nackten Leichen verhungerter Menschen aufgestapelt liegen (2). Als letztes sehen sie die Verbrennungsöfen, deren aufsteigenden Rauch die Bewohner von Weimar täglich gesehen haben müssen (3). Ein Reporter berichtete seinerzeit: »Viele Zeugen verlassen das Lager mit Tränen in den Augen. Andere machen einen gleichgültigen Eindruck und behaupten, es sei alles alliierte Propaganda.«

Ein paar besonders kräftige Insassen, die als Zwangsarbeiter aus ganz Europa hierher gebracht wurden, überlebten den Hunger und den zwölf- bis achtzehnstündigen Arbeitstag. Ein elfjähriges tschechisches »Sklavenmädchen« findet seine Mutter 1945 in Kaunitz wieder (4). *J'accuse* – ein russischer Zwangsarbeiter klagt einen Lagerkommandanten an, der die Gefangenen besonders brutal und sadistisch behandelte (5). In Dachau nahmen einige befreite Gefangene an ihren SS-Wachen selbst Rache: Soldaten der 42. US-Division holen eine Leiche aus dem Lagergraben (6).

L ES Alliés et le gouvernement ouest-allemand cherchèrent ensuite à promouvoir un programme de « rééducation » qui impliquait la reconnaissance de la réalité des faits. Il débuta à Buchenwald, en avril 1945, qu'on fit visiter aux populations des alentours pour leur faire reconnaître ce que tant de gens avaient auparavant refusé de voir. Certains détournent les yeux devant le corps qui se balance (1) et le camion où s'empilent les cadavres nus et émaciés (2). La visite se termine devant les fours dont les habitants de la ville de Weimar avaient dû chaque jour apercevoir les fumées (3). Un rapport de l'époque note : « Beaucoup des personnes présentes quittent le camp en larmes. D'autres semblent indifférentes, affirmant subir la propagande des Alliés. »

Un petit nombre de détenus, les plus vigoureux parmi ceux qui furent amenés de toute l'Europe dans les camps de travaux forcés, survécurent aux rations minimales et aux journées de travail de douze à dix-huit heures. Une « enfant des camps », tchèque âgée de onze ans, retrouve sa mère à Kaunitz en 1945 (4). Un prisonnier signale la présence d'un commandant de camp allemand, réputé pour sa brutalité sadique (5). À Dachau, des prisonniers libérés, ivres de revanche, s'en prennent à leurs gardes SS : des soldats de la 42e division américaine repêchent un cadavre dans les douves entourant le camp (6).

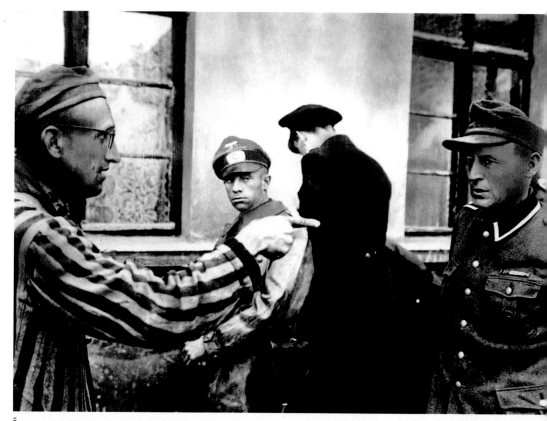

5

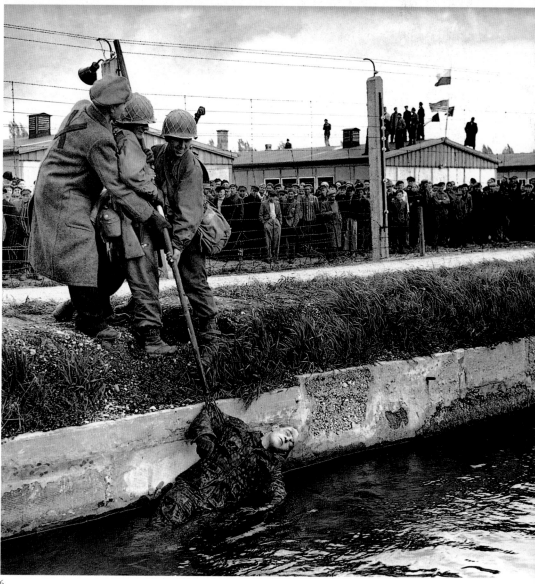

6

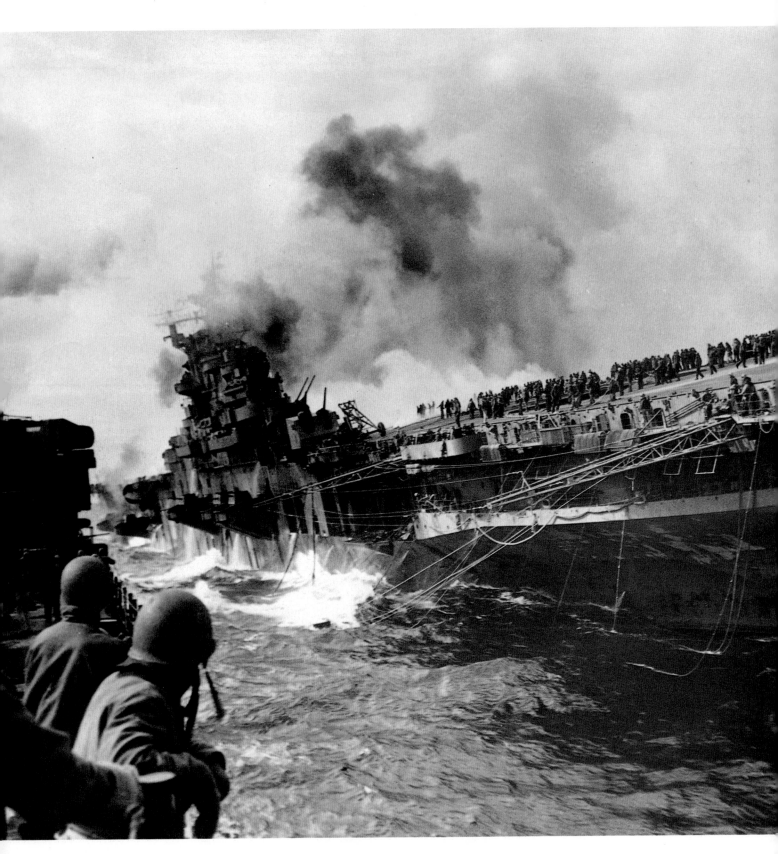

IN the war at sea, the US Navy suffered in the western Pacific. In December 1944, a wounded US soldier under the auspices of a surgical nurse, his arms raised in agony at the bullet wound to his stomach, lies near the baptismal font of Leyte Cathedral in the Philippines (2). The cathedral alternated as hospital and place of worship. And on 17 May 1945,

the cruiser *Santa Fé* pulls away from the burning carrier USS *Franklin*, victim of a Japanese dive-bombing attack (1). Retreating from the flames of exploding bombs and rockets, the ship's crew cluster on the flight deck. Despite a thousand casualties, the *Franklin* eventually limped thousands of miles home to the Brooklyn Navy Yard.

DIE US-Navy erlitt ihre schwersten Verluste im Westpazifik. Im Dezemb 1944 hält eine Krankenschwester in der Kathedrale von Leyte auf den Philippinen Wache bei einem verwundeten Soldaten; er liegt am Taufbecken und wirft wegen der Schmerzen seiner Bauchwunde die Ar in die Luft (2). Die Kathedrale wird für Gottesdienste und gleichzeitig als Lazarett genutzt. Und am 17. Mai 1945 legt der

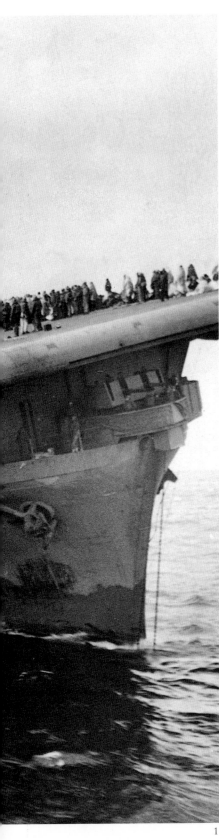

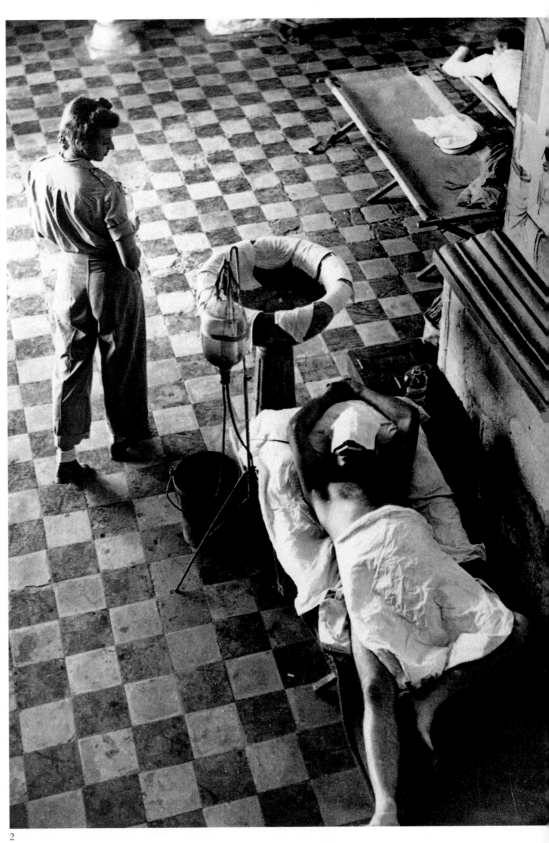

Panzerkreuzer *Santa Fé* von dem brennenden amerikanischen Flugzeugträger USS *Franklin* ab, der von japanischen Tieffliegern getroffen ist (1). Die Besatzung flieht vor den explodierenden Bomben und Raketen und drängt sich auf dem Flugdeck. Obwohl die *Franklin* tausend Männer verlor, bewältigte sie doch aus eigener Kraft die weite Strecke zurück zum heimischen Brooklyn Navy Yard.

Au cours de la guerre navale, la flotte des États-Unis essuya des pertes dans l'Ouest du Pacifique. Décembre 1944 : un soldat américain blessé est pris en charge par une infirmière de l'équipe chirurgicale ; touché au ventre par une balle, il souffre allongé près des fonts baptismaux de la cathédrale de Leyte aux Philippines (2). La cathédrale sert tour à tour d'hôpital et de lieu de culte. 17 mai 1945 : le croiseur

Santa Fé s'éloigne du navire de transport américain en flammes, le USS *Franklin*, atteint par les bombardements japonais (1). Battant en retraite devant les incendies provoqués par les explosions, l'équipage du navire s'est rassemblé sur le pont d'envol. Malgré la perte de mille de ses hommes, le *Franklin* parvint à rentrer tant bien que mal, couvrant les milliers de milles qui le séparaient du centre naval de Brooklyn.

JAPANESE kamikaze pilots were famous for their
resolve during the Pacific War. While European
officers had their cyanide pills to take if captured,
Japanese pilots volunteered to fly suicide missions and
blow themselves up with their bombers. Here one is
helped on with his scarf bearing the Emperor's 'golden
sun' (1); another attempts to manoeuvre his 'Zeke' on to
the deck of a US warship (2). In the event he crashed
into the sea (4), but a neighbouring hospital ship, the
USS *Comfort*, was hit; 29 were killed and 33 injured.
Luck was allied with the skill of this American pilot,
Ensign R. Black: shot up over Palau, he managed to land
on an aircraft carrier with his hydraulic system gone and
one wing and part of the tailplane shorn off (3).

DIE japanischen Kamikazeflieger waren im Pazifik-
krieg berühmt für ihren Mut. Europäische Offiziere
hatten ihre Zyanidkapseln, für den Fall, daß sie in
Gefangenschaft gerieten, doch die japanischen Piloten
meldeten sich freiwillig für Selbstmordflüge. Hier wird
einem der Schal umgebunden, den die »goldene Sonne«
des Kaisers ziert (1); ein anderer versucht, seine »Zeke«
auf dem Deck eines amerikanischen Schlachtschiffs

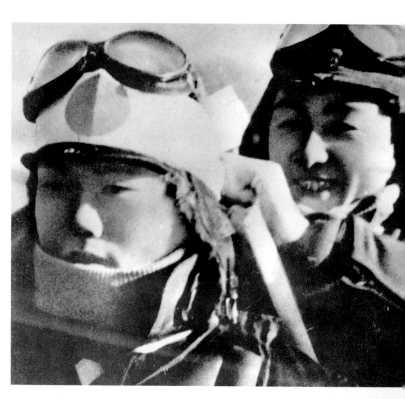

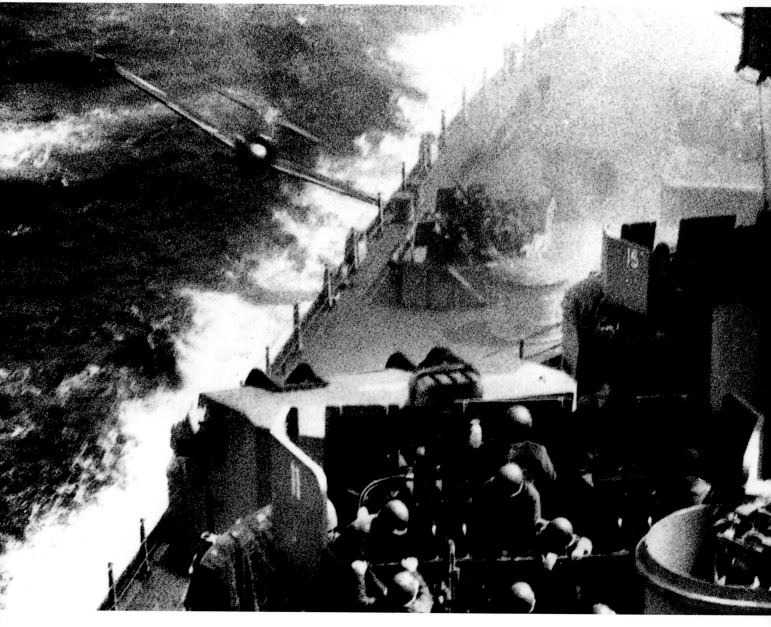

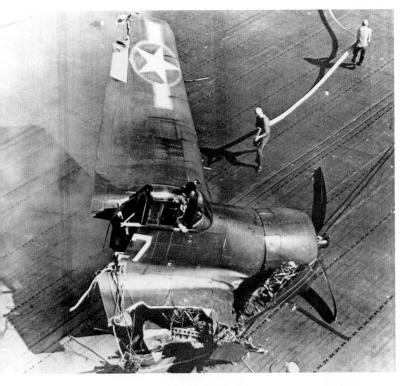

abzusetzen (2). Dieser verfehlte sein Ziel und stürzte
ins Meer (4), doch ein benachbartes Hospitalschiff, die
USS *Comfort*, wurde getroffen; es gab 29 Tote und
33 Verwundete. Glück im Unglück und viel Geschick
hatte der amerikanische Flieger Ensign R. Black: Er
wurde über Palau getroffen, und es gelang ihm, mit nur
einer Tragfläche auf einem Flugzeugträger zu landen (3).

L ES kamikazes japonais se rendirent célèbres par leur
résolution durant la guerre du Pacifique. Tandis
que les officiers européens avalaient du cyanure en cas
d'interception, les pilotes japonais se portaient volon-
taires lors des missions suicides à l'aide de leurs avions
chargés d'explosifs. On voit ici l'un d'eux se faire nouer
son foulard surmonté du « soleil d'or » impérial (1). Un
autre tente d'amener son « zeke » sur le pont d'un navire
de guerre américain (2). Ce faisant il s'écrase en mer (4),
touchant toutefois un navire-hôpital de la marine des
États-Unis, le *Comfort* : il y eut 29 morts et 33 blessés.
Ce pilote américain réussit à poser son appareil touché
au-dessus de Palau sur un navire porte-avions, alors qu'il
n'avait plus de système hydraulique, qu'une aile et une
partie de la queue de l'avion (3).

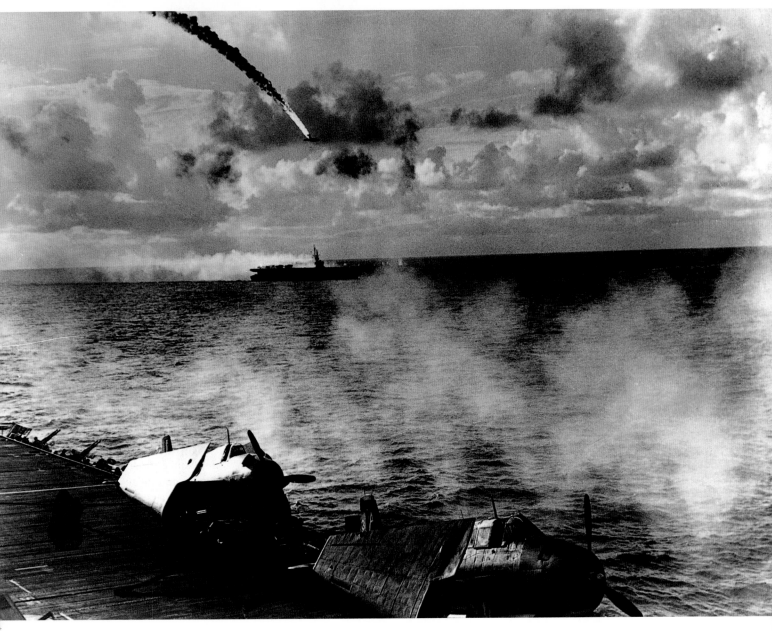

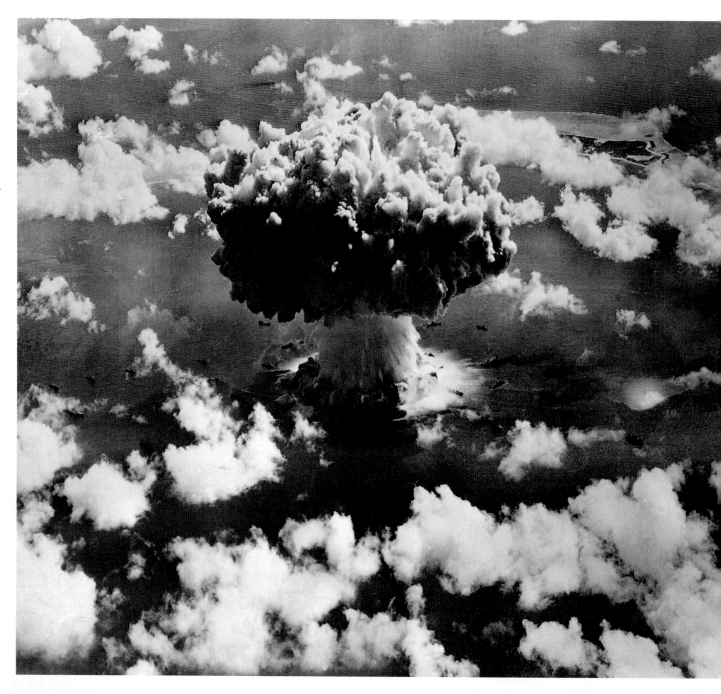

A 'mushroom' or 'cauliflower' cloud and a 'Christmas pudding' were some of the friendly and edible descriptions of the most lethal weapon ever invented. For at least twenty years after the war atomic bomb tests were continued without adequate warnings or precautions. Those at Bikini Atoll by the United States in 1946 show the effects of underwater explosions (aerial view,1); 'crown' of water shooting upwards with the speed of a bullet, (3). Several obsolete ships were sunk (one on the right, (2) and 31 out of 73 were severely damaged. Experts speculated on whether the USS Arkansas could have been carried up in the giant waterspout and plunged back as the spout broke. Photos were taken by the US Air Force.

PILZ«, »Blumenkohl« oder »Weihnachtspudding« waren die freundlichen Bezeichnungen, mit denen man die tödlichste Waffe aller Zeiten schmackhaft machte. Mindestens zwanzig Jahre lang wurden nach dem Krieg noch Atomtests ohne ausreichende Vorwarnungen durchgeführt. Auf diesen Bildern zeigen Tests, die die Vereinigten Staaten 1946 im Bikini-Atoll durchführten, die Wirkung von Explosionen unter Wasser (1); eine »Krone« aus Wasser schießt mit der Geschwindigkeit einer Gewehrkugel empor (3). Mehrere außer Dienst gestellte Schiffe wurden versenkt (eines davon rechts zu sehen (2). Die Experten spekulierten darüber, ob die USS Arkansas von der gewaltigen Fontäne in die Luft geschleudert worden sei und dann wieder aufgesetzt habe. Aufnahmen der US-Air Force.

CHAMPIGNON », « choux-fleur » ou encore « pudding de Noël » sont quelques-uns des surnoms donnés par les Anglo-Saxons à l'arme la plus mortelle. Après la guerre atomique, on continua pendant au moins vingt ans à faire exploser des bombes expérimentales sans prendre les mesures élémentaires de sécurité. Celles-ci déclenchées par les États-Unis sur l'atoll de Bikini en 1946, montrent les effets des explosions sous-marines (1). Sur cette prise de vue aérienne, ou distingue bien la couronne d'eau projetée à la vitesse d'une balle (3). Plusieurs navires hors d'usage sombrèrent (droite, 2) et 31 sur 73 furent gravement endommagés. Les spécialistes se demandaient si l'Arkansas de la marine américaine serait soulevé dans les airs. Les vues proviennent de l'armée de l'air américaine.

1 2

ON 6 August 1945 a first atomic bomb
was unleashed on Hiroshima (2). On
9 August a second landed on Nagasaki (1).
The former killed 100,000 outright; another
100,000 were to die in the ensuing months
from burns and radiation sickness. The latter
killed 75,000 outright. On 10 August, Japan
sued for peace – two days after Russia
had joined the war against her old enemy.
On 14 August President Truman formally
declared the end of the Second World War,
in which 55 million people died.

AM 6. August 1945 ging die erste Atom-
bombe der Welt auf Hiroshima nieder
(2). Am 9. August traf eine zweite Nagasaki
(1). In Hiroshima fanden 100 000 Menschen
sofort den Tod; weitere 100 000 sollten an
den Folgen der Verbrennungen und an
Strahlenschäden sterben. Der zweite Abwurf
forderte 75 000 unmittelbare Opfer. Am
10. August kapitulierte Japan – zwei Tage
nachdem Rußland in den Krieg gegen
seinen alten Feind eingetreten war. Am
14. August verkündete der amerikanische
Präsident Truman offiziell das Ende des
Zweiten Weltkriegs, in dem mehr als
55 Millionen Menschen ihr Leben verloren
hatten.

LE 6 août 1945, une première bombe
atomique fut lâchée sur Hiroshima (2).
Le 9 août, une seconde tomba sur Nagasaki
(1). La première tua instantanément
100 000 personnes, tandis que 100 000 autres
devaient mourir dans les mois qui suivirent
consèquemment aux brûlures et aux radia-
tions. La seconde tua 75 000 personnes
sur le coup. Le 10 août, le Japon abdiquait –
deux jours après que l'URSS lui eut déclaré
la guerre. Le 14 août, le président Truman
annonçait officiellement la fin de la Seconde
Guerre mondiale qui avait coûté la mort à
55 millions de personnes.

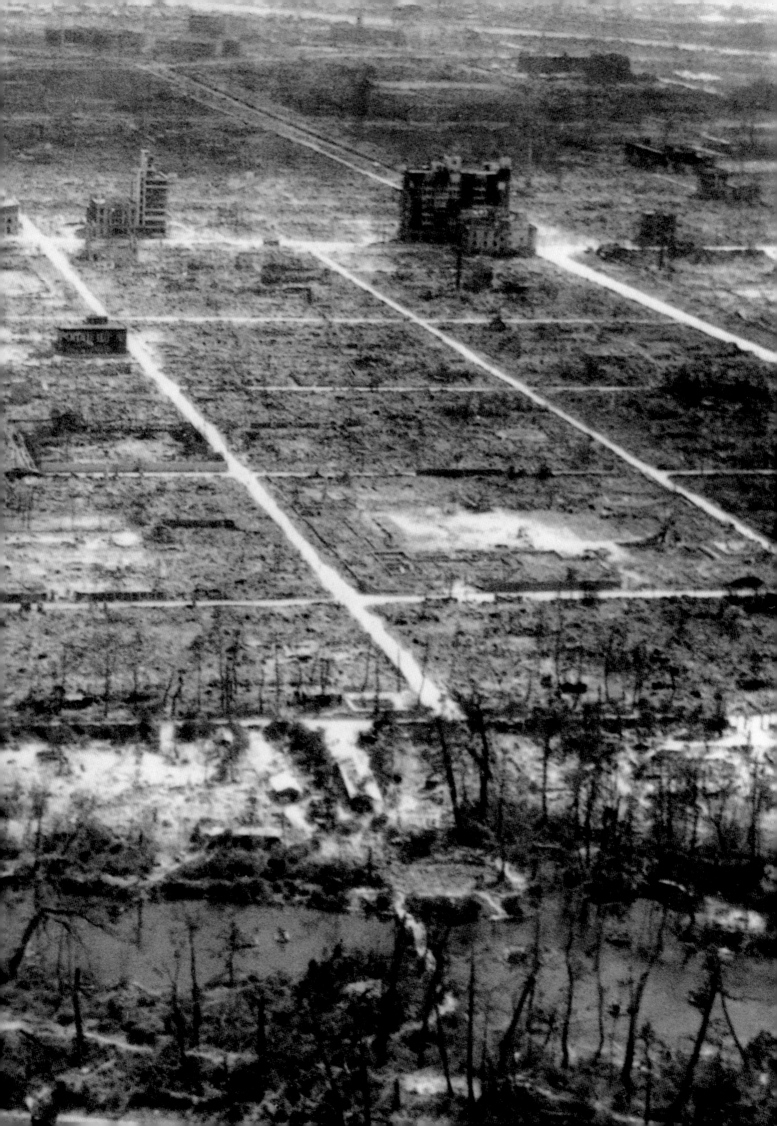

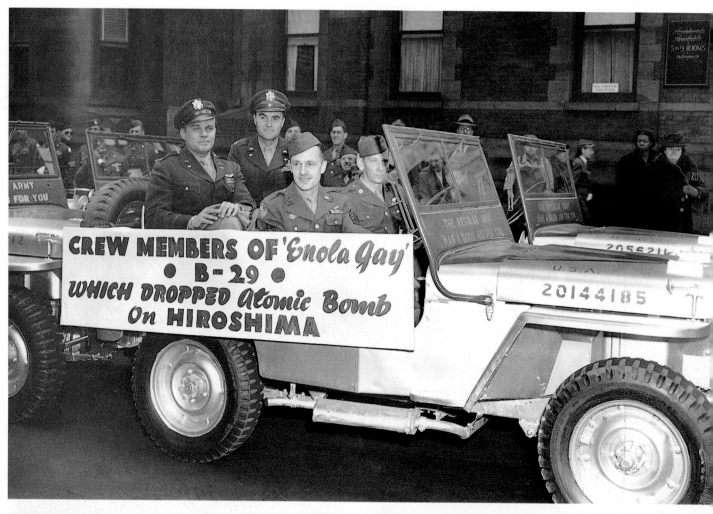

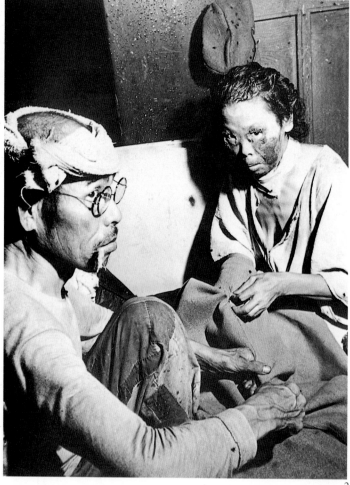

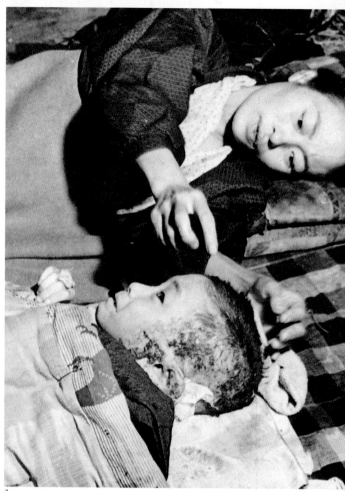

2 3

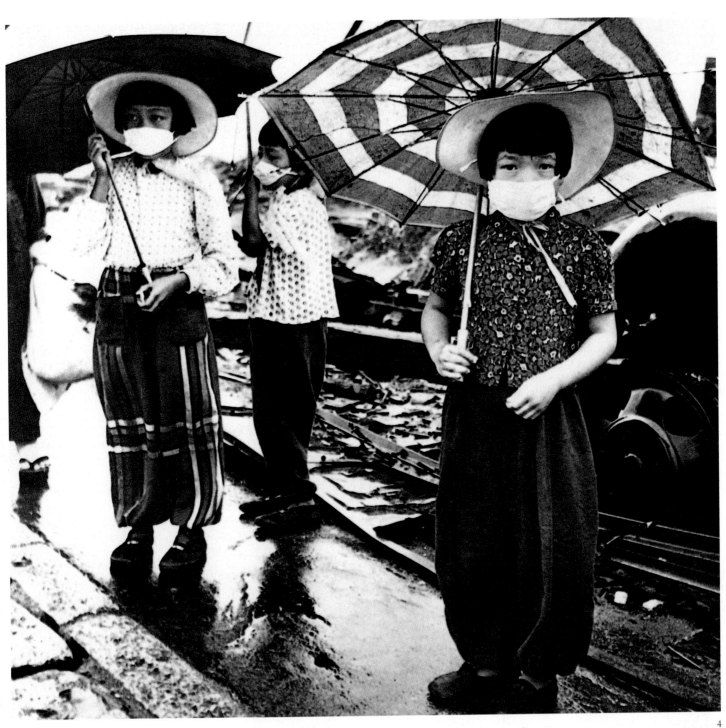

4

DESPITE the devastation wrought on a civilian population, the bomber crew responsible returned home to a tickertape heroes' welcome at New York's Army Day parade (1). Their jeep boasted of their mission and advertised that 'The Regular Army has a Good Job for you'. In Hiroshima, civilian victims were effectively left to care for themselves in a damaged bank near the blasted town centre (2), where burns and injuries were treated by parents substituting for medical staff (3). Those who survived relatively unscathed wore wartime issue long bloomers and masks against the stench of death within their ruined city (4).

TROTZ der verheerenden Auswirkung auf die Zivilbevölkerung wurde der Bombercrew bei der Militärparade in New York ein rauschender Empfang bereitet (1). Auf ihrem Jeep war ihr Auftrag groß zu lesen, und der Werbespruch lautet: »Die Army hat immer einen guten Job für Dich.« In Hiroshima waren die verwundeten Opfer praktisch sich selbst überlassen; in einem halb eingestürzten Bankgebäude der in Trümmern liegenden Innenstadt (2) richteten sie ein Hospital ein, und Eltern statt Sanitätern kümmerten sich um die Verletzungen ihrer Kinder (3). Diejenigen, die vergleichsweise ungeschoren davonkamen, banden sich Masken um gegen den Todesgeruch in ihrer zerstörten Stadt (4).

MALGRÉ les dévastations infligées aux populations civiles, les équipages des bombardiers furent acclamés à New York à l'occasion de la journée de l'Armée (1). Leurs jeeps portaient des inscriptions vantant leur exploit et prévenait que « dans l'armée de métier vous attend un emploi intéressant ». À Hiroshima, les victimes civiles sont abandonnées à leur sort dans une banque du centre ville dévasté par le souffle de l'explosion (2). Leurs brûlures et leurs blessures sont soignées par des parents, à défaut de personnel médical (3). Ceux qui s'en sortirent portaient les longues culottes bouffantes et les masques distribués pendant la guerre afin de se prémunir contre la puanteur des cadavres (4).

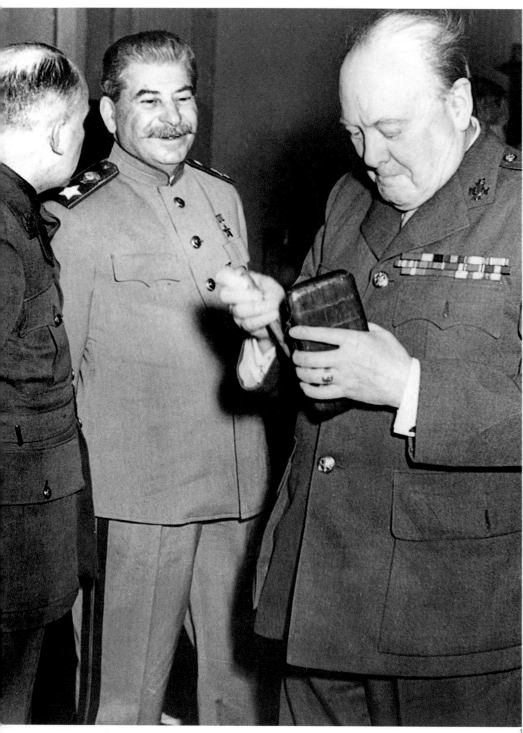

IM Februar 1945 fand im Livadia-Palast in Jalta auf der Krim die Dreimächte-Konferenz zwischen Premierminister Churchill, Präsident Roosevelt und Marschall Stalin statt (2). Roosevelt rang Stalin die Zusage ab, in den Krieg gegen Japan einzutreten und die Gründung der Vereinten Nationen zu unterstützen. Churchill, hier mit Stalin und Zigarren (1), erhielt die russische Unterschrift auf dem Vertrag, der die Teilung Deutschlands in französische, britische, russische und amerikanische Besatzungszonen vorsah. Als Gegenleistung bekam Stalin eine neu festgelegte russisch-polnische Grenze mit polnischer Westgrenze entlang der Oder-Neiße-Linie. Zwar wurde in einer »Erklärung zum befreiten Europa« der Wunsch der drei Staatsmänner nach »freien Wahlen« und »demokratischen Institutionen« in den von Deutschland besetzten Ländern bekräftigt, doch die Vereinbarungen von Jalta erfuhren bittere Kritik auf beiden Seiten. Westliche Kommentatoren beschuldigten Roosevelt, er habe »Rußland das Tor zum Fernen Osten geöffnet« und überlasse Stalin Osteuropa, und in England war die Empörung groß, daß Churchill die kosakischen Soldaten verraten habe, die zurück in die UdSSR verbracht wurden, wo der sichere Tod auf sie wartete. Doch die sowjetisch-amerikanischen Beziehungen waren nie herzlicher als damals in Jalta.

1

THE three-power conference held at Livadia Palace, Yalta, in the Crimea, in February 1945, between Prime Minister Churchill, President Roosevelt and Marshal Stalin (2). Roosevelt succeeded in obtaining Stalin's agreement to enter the war against Japan and to cooperate in the founding of the United Nations Organization. Churchill, here with Stalin and cigars (1), further obtained Stalin's signature to the partition of Germany into French, British, Russian and US-controlled zones. Stalin, in return, achieved recognition of a redrawn Russian-Polish border and a western frontier on the Oder-Neisse Line. Despite a 'Declaration on Liberated Europe', affirming the three leaders' desire for 'free elections' and 'democratic institutions' in lands previously controlled by Germany, the Yalta accords were bitterly criticized on both sides. Western commentators accused Roosevelt of 'bringing Russia into the Far East' and 'handing eastern Europe over to Stalin', whilst Britain's part in betraying the Cossack soldiers, forcibly returned to their death in the USSR, caused a row which still resonates. Soviet-US relations were, however, never more cordial than here.

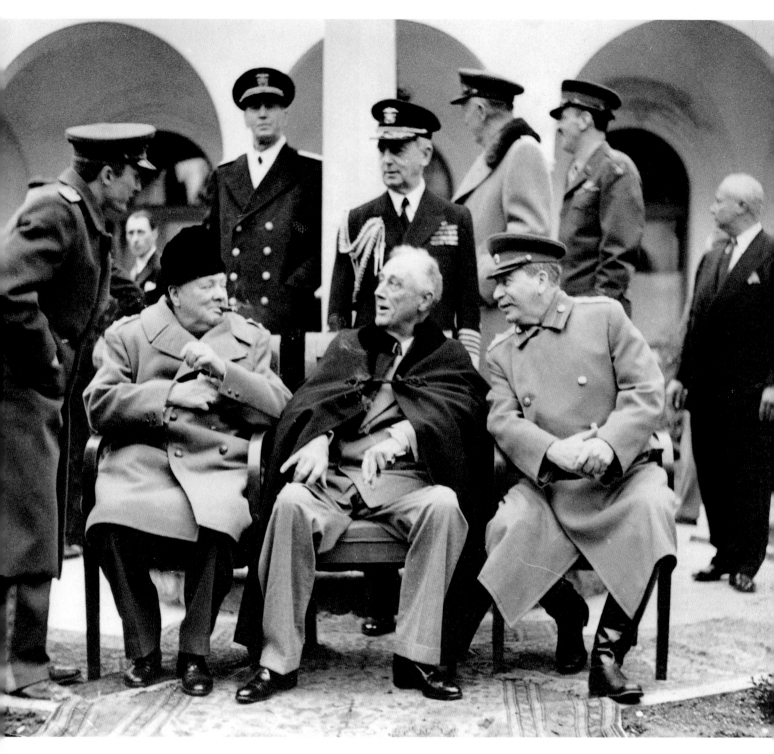

LA conférence des trois grandes puissances se déroula au palais de Livadia, à Yalta, en Crimée, dès février 1945. Elle réunit le Premier ministre Churchill, le président Roosevelt et le maréchal Staline (2). Roosevelt obtint de Staline que celui rentrât en guerre contre le Japon et coopérât à la fondation de l'Organisation des Nations Unies. Churchill que l'on voit ici, cigare à la main, en compagnie de Staline (1), obtint en plus de ce dernier qu'il validât la division de l'Allemagne en zones contrôlées par les Français, les Britanniques, les Soviétiques et les Américains. En contrepartie, Staline fit reconnaître le nouveau tracé des frontières séparant l'URSS et la Pologne ainsi que la frontière occidentale de la ligne Oder-Neisse. Malgré une « Déclaration sur l'Europe libérée », formulant le souhait des trois dirigeants de voir s'instaurer des « élections libres » et des « institutions démocratiques » dans les pays auparavant sous domination allemande, les accords de Yalta furent amèrement critiqués de part et d'autre. Les observateurs occidentaux accusèrent Roosevelt d'avoir « ouvert à la Russie la porte de l'Extrême-Orient » et d'avoir « cédé l'Europe orientale à Staline ». La Grande-Bretagne, quant à elle, en trahissant les soldats cosaques qui furent renvoyés de force en URSS où les attendait une mort certaine, provoqua une vive émotion. Les relations soviéto-américaines, toutefois, ne furent jamais plus cordiales qu'à ce moment-là.

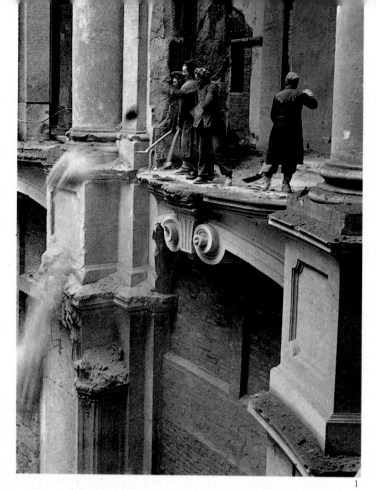
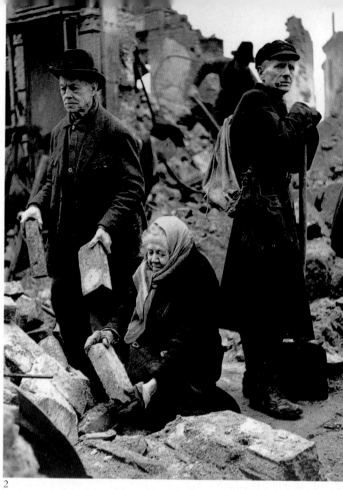

1 2

On 14 February 1945, the RAF and USAF started a day and a half of relentless bombardment that reduced the German city of Dresden to a smoking ruin. It remained impossible to ascertain how many civilians died, since the population had already doubled to over a million seeking a 'safe haven'. Estimates of the death toll swung from 130,000 to 400,000. In addition to this colossal human cost, Dresden had been compared to Florence for its wealth of Baroque and Rococo art and architecture, its galleries of Dutch and Flemish paintings. Senior Allied military officers were tight-lipped about the diversion of effort away from German centres of communication and oil installations to predominantly civilian and symbolic targets. The Chief of RAF Bomber Command, Air Marshal Arthur Harris, vehemently persisted in his controversial theory that terror bombing was the way to destroy the enemy's will to fight. A year later, these Dresden survivors are still struggling to rebuild their city via a 'human brick chain' (2) while a women's squad starts the first stages of rehabilitating the Zwinger Palace (1). Meanwhile in Berlin's ruined Nollendorfplatz, a Russian-language sign and a knocked-out German tank speak volumes of the city's recent history, in the wake of which these citizens are still searching for a home among the desolation (3).

Am 14. Februar 1945 begannen die Royal Air Force und die US Air Force mit einem anderthalbtägigen Bombardement, das die Stadt Dresden in Schutt und Asche legte. Die Zahl der toten Zivilisten ließ sich nie genau bestimmen, denn die Bevölkerung hatte sich durch den Zustrom von Flüchtlingen auf der Suche nach einem »sicheren Hafen« auf über eine Million verdoppelt. Schätzungen variierten zwischen 130 000 und 400 000 Opfer. Es wurde eine Stadt zerstört, die wegen ihres Reichtums an Kunst und Architektur als »Florenz des Nordens« galt. Die Alliierten hüllten sich in Schweigen, wenn gefragt wurde, warum sie statt Verkehrsknotenpunkten und petrochemischen Einrichtungen nun zivile und letzten Endes symbolische Ziele bombardierten. Der Chef der britischen Luftwaffe, General Arthur Harris, verteidigte vehement seine umstrittene Ansicht, daß Bombardements den Willen der Zivilbevölkerung breche. Ein Jahr später versuchen diese Überlebenden von Dresden noch immer, ihre Stadt mit einer »menschlichen Backsteinkette« wiederaufzubauen (2), und ein Frauentrupp unternimmt erste Anstrengungen, den Zwinger wieder bewohnbar zu machen (1). Am Nollendorfplatz in Berlin sprechen derweil russische Hinweisschilder und ein zerschossener deutscher Panzer Bände über die jüngste Vergangenheit der Stadt. Heimatlos gewordene Berliner suchen zwischen den Trümmern nach einer neuen Bleibe (3).

Le 14 février 1945, les forces aériennes britannique et américaine entreprirent de bombarder sans répit un jour et demi durant la ville de Dresde, en Allemagne. Il fut impossible d'établir le nombre des civils disparus, car la population, grossie des centaines de milliers de personnes qui cherchaient à « se mettre à l'abri », comptait plus d'un million d'habitants. Les estimations oscillaient entre 130 000 et 400 000. Jadis, on comparait Dresde à Florence pour ses richesses artistiques. La hiérarchie militaire des troupes alliées se montrait avare de commentaires sur le fait que son effort portait moins sur les centres de communications ou les installations pétrochimiques allemandes que sur les objectifs civils et symboliques. Le chef de l'aviation britannique, le général Arthur Harris, s'en tenait énergiquement à sa théorie discutable selon laquelle la terreur provoquée par les bombardements brisait la combativité de l'ennemi. Un an plus tard, ces survivants de Dresde luttent toujours pour reconstruire leur ville, recourant à une « chaîne humaine de briques » (2), et des femmes entreprennent de réhabiliter le palais Zwinger (1). Ailleurs, dans les ruines de la Nollendorfplatz à Berlin, les panneaux en langue russe et le char d'assaut allemand mis hors de combat expliquent à eux seuls que ces citoyens sont toujours à la recherche d'un refuge (3).

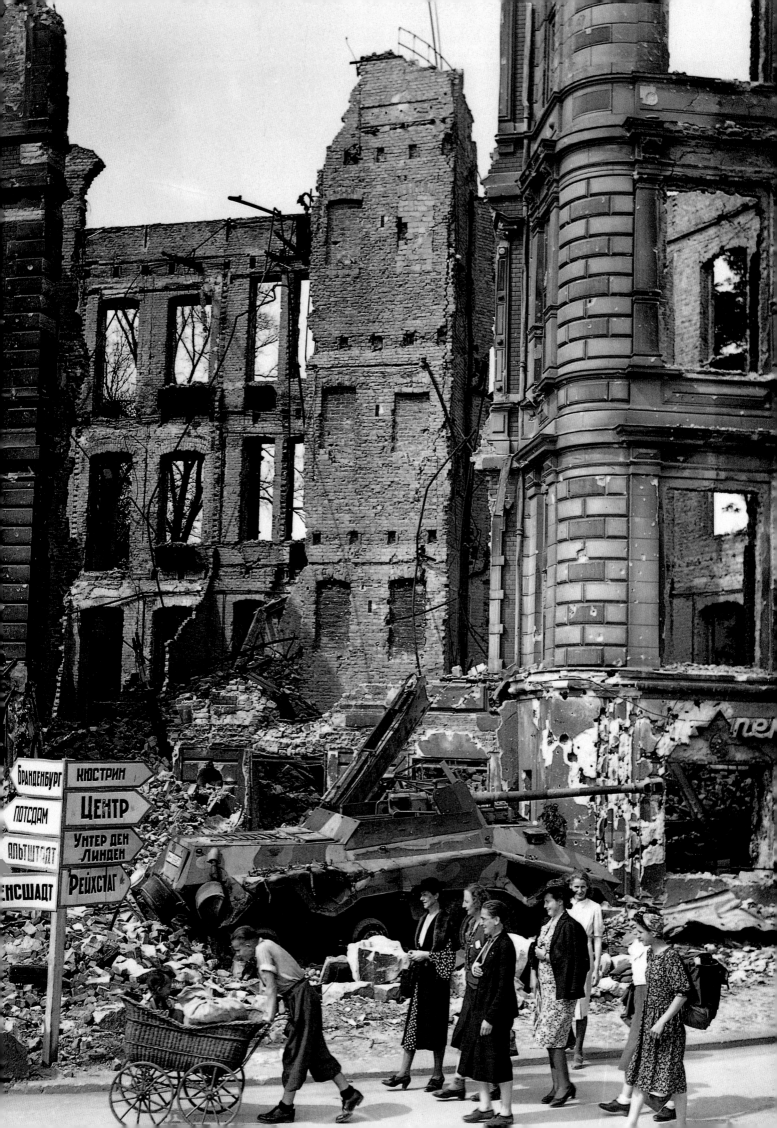

1

2

IN the USA after the war, the Coty Award was instituted for designers who 'have the most significant effect on the American way of dressing'. Despite Christian Dior's much-vaunted New Look that took women out of the regulatory minimum and swathed them in the maximum of pleats, folds and lengths, restrictions were still in place in Europe until the 1950s. A woollen coat could not be wool-lined; no furs were to be employed; no dress could contain over three metres of fabric; only 60 models could take to the catwalk in a single showing.

Postwar undergarments allow a glimpse of what went on beneath Dior's New Look. While, a couple of decades earlier, the most a gel required under her flapper's fringed shift was a bandage to flatten her femininity and a sequinned garter or two, now women were again to be strapped, tied and buckled into undergarments worthy of Scarlett O'Hara. Girdle and corsets (3), suspenders (1) and brassières (2) came with as much seductiveness – and the same range of colouring – as false teeth.

IN den Vereinigten Staaten wurde nach dem Krieg der Coty-Preis gestiftet, für Designer, deren Werk »außerordentlichen Einfluß auf die Art hat, wie Amerikaner sich kleiden«, und Christian Dior machte mit seinem New Look, mit üppigem Überschwang an reich gefälteten Stoffen, Furore; doch in Europa war die Mode noch bis in die 50er Jahre hinein reglementiert. Ein Wollkleid durfte kein wollenes Futter haben, Pelze durften nicht verwendet werden und kein Kleid sollte mehr als drei Meter Stoff verbrauchen.

Ein Blick darauf, wie es unter dem New Look von Dior aussah – Unterwäsche der Nachkriegszeit. Wo noch zwei Jahrzehnte zuvor ein Brustband, um unter dem gefransten Charlestonkleid die weiblichen Rundungen zu verstecken, das Äußerste gewesen war, wurden Frauen nun wieder in Unterwäsche gezwängt, geschnürt und geklammert, die einer Scarlett O'Hara würdig gewesen wären. Hüfthalter und Korsett (3), Strumpf- (1) und Büstenhalter (2) waren ungefähr so verführerisch – und hatten auch dieselbe Farbe – wie ein Satz falscher Zähne.

C'EST au lendemain de la guerre que le Coty Award fut institué aux États-Unis pour récompenser les stylistes dont « l'influence est la plus significative sur les habitudes vestimentaires américaines ». Malgré Christian Dior et son « New look », tant célébré pour avoir sorti les femmes du minimum obligatoire afin de les envelopper dans un maximum de plissés, de plis et de longueurs, l'Europe resta soumise à des restrictions jusque dans les années 50. Un manteau en lainage ne pouvait pas être doublé de laine ; l'utilisation de la fourrure n'était pas possible ; trois mètres de tissu était le maximum autorisé pour une robe ; enfin, seuls soixante mannequins pouvaient défiler au cours d'une même présentation de mode.

Les sous-vêtements de l'après-guerre permettent de se faire une idée de ce qui se passait sous le « New Look » de Dior. Vingt ans auparavant, le gel obligeait les jeunes femmes à porter un bandage destiné à aplatir leur féminité; elles se retrouvaient maintenant de nouveau sanglées, serrées et bouclées. Gaines et corsets (3), jarretelles (1) et bustiers (2) étaient rarement réduisants.

ON fashion's wilder shores… painting the sky with seaweed (1), hobbling to Ascot on toilet-roll heels (2), polka-dotting and criss-crossing the beach with *piqué* prints (3). By the 1940s, women were clearly confident enough to be their own escorts, rakish enough to bring their own booze, and some were even rich enough to own a camera: altogether smart enough to make their own amusement, whatever appearances might suggest to the contrary with their fashionable but unarguably silly romper suits.

3

AN den stürmischen Ufern der Mode… da werden Bilder mit Seegras in den Himmel gemalt (1), da hoppeln die Damen auf Klopapierrollen nach Ascot (2) und schäkern in tupfen- und streifenbedrucktem Piqué am Strand (3). Es waren die vierziger Jahre, und inzwischen waren Frauen selbstbewußt genug, ohne männliche Begleitung auszugehen, lebenslustig genug, ihre eigene Flasche Wein mitzubringen, und einige waren sogar so reich, daß sie sich eine eigene Kamera leisten konnten – sie hatten Köpfchen genug, daß sie auf ihre Kosten kamen, so albern sie in diesen modischen, aber doch wirklich unmöglichen Spielanzügen auch aussahen.

SUR les plages les plus follement dans le vent, … on peignait le ciel avec des algues (1), on claudiquait jusqu'à Ascot perchées sur des rouleaux de papier hygiénique (2), on transformait les plages en imprimés piqués de pois et de rayures enchevêtrées (3). Dès les années 40, les femmes avaient suffisamment d'assurance pour sortir seules, elles étaient suffisamment débauchées pour arriver avec leurs propres alcools, et certaines étaient même suffisamment riches pour posséder un appareil photographique. Dans l'ensemble, elles se montraient tout à fait capables de pourvoir à leur propre divertissement, malgré ce que laissent suggérer leurs ensembles barboteuses certes à la mode mais incontestablement idiots.

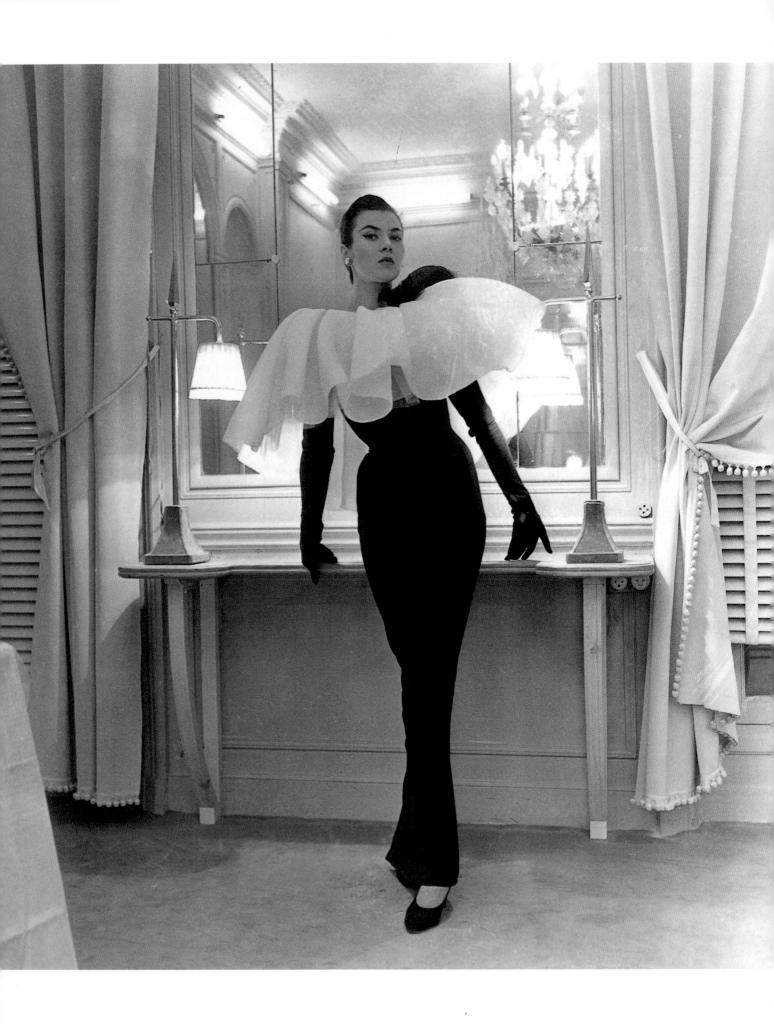

THE 1950s seemed to want to prove that the years of austerity were forever behind us. In Britain, Macmillan was telling the population they had 'never had it so good', while in Germany Adenauer promoted economic expansion through the 'rebuilding' generation. Lashings of fabric and trimmings spared neither expense nor fuss – with a certain tongue-in-cheek mockery in the labels: Jacques Fath's 'lampshade look' (1) – a bell shape here (2), a pie frill there.

IN den Fünfzigern wollte offenbar jeder beweisen, daß die entbehrungsreichen Jahre für immer vorbei waren. Den Briten verkündete Macmillan, daß sie es »noch nie so gut hatten«, und in Deutschland feuerte Adenauer zum Wiederaufbau an. Bei der Mode wurde an Stoff und Zierat und damit an den Kosten nicht gespart – doch immerhin spricht aus den Bezeichnungen ein gewisser Humor: Jacques Faths »Lampenschirm-Look« (1), hier mit einer Glockenform (2), dort mit einem Rüschenkragen.

DANS les années 50, on semblait vouloir prouver que l'époque de l'austérité était à jamais révolue. En Grande-Bretagne, Macmillan disait à la population que « ses conditions n'avaient jamais été aussi bonnes qu'aujourd'hui », pendant qu' en Allemagne Adenauer encourageait l'expansion économique portée par la génération de la « reconstruction ». On n'épargnait ni argent ni strass dans des modèles où l'abondance de tissu ne le cédait qu'à celle de l'ornementation, et auxquels étaient donnés, non sans un certain humour pince-sans-rire, des noms de baptême tels que : « Style abat-jour » (1) de Jacques Fath – ici une forme de cloche (2), là des fronces.

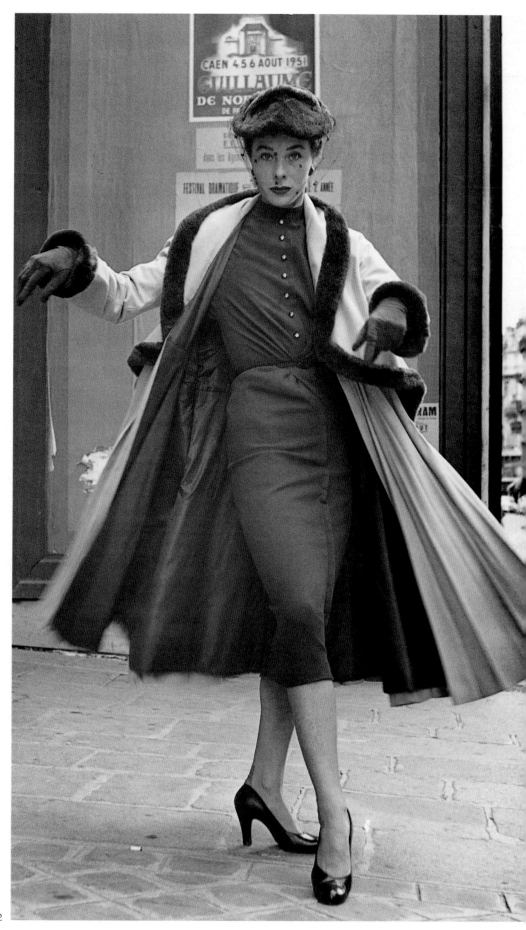

2

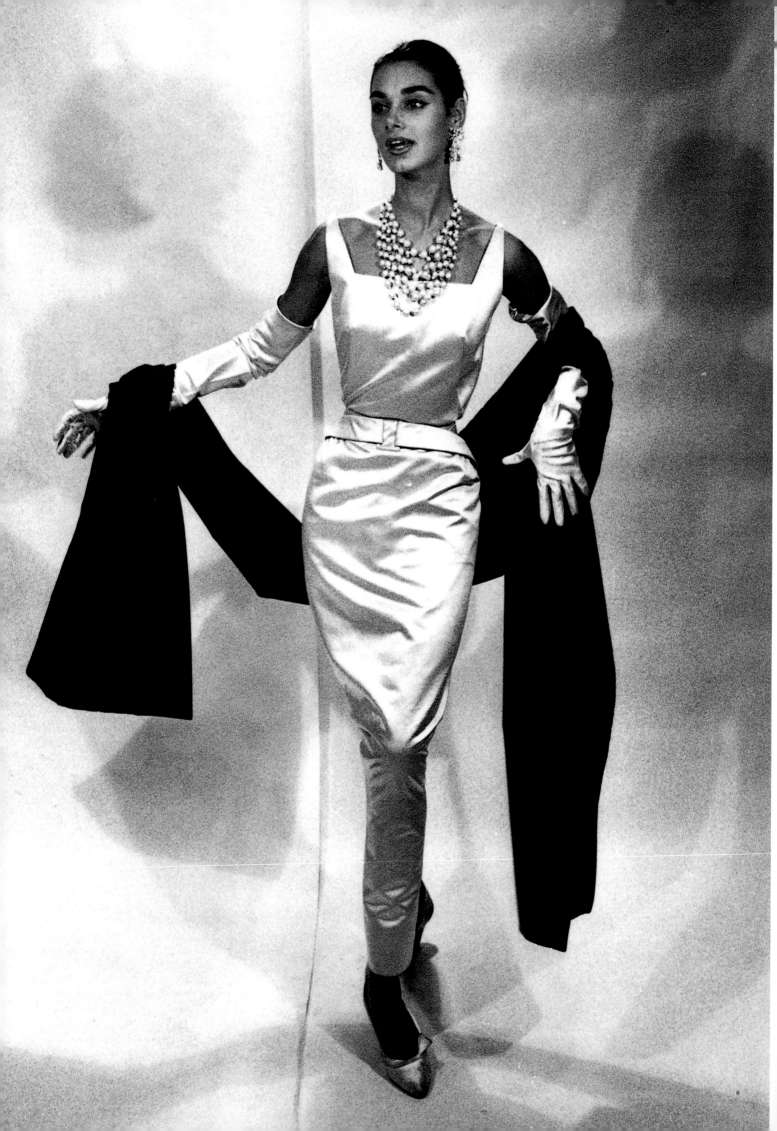

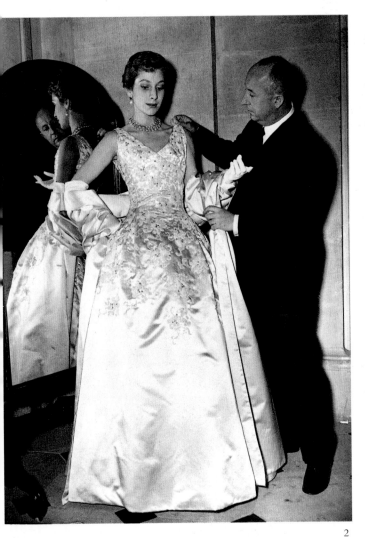

2 3

THE English aristocracy were assumed even by French couturiers to have a certain *je ne sais quoi*. Dior paid his homage to Churchill with *Blenheim*, a wide white satin gown embroidered with flowers (2). Givenchy, a new boy to Paris fashion in 1955, came to Park Lane's grand new Dorchester Hotel to display his 'dazzling white satin dinner dress, slit from calf to ankle, and worn with a crimson velvet stole and pearl and rhinestone bib necklace' (1). And Margaret, Duchess of Argyll (notorious for the slant she gave a favourite good health maxim – 'Go to bed early and often'), here keeps sedate company with her daughter and Norman Hartnell, the Queen's couturier (3).

SELBST französische Couturiers waren überzeugt, daß die englische Aristokratie ein gewisses *je ne sais quoi* hatte. Dior erwies Churchill seine Reverenz, indem er dieses weite, weiße, blumenbestickte Satinkleid *Blenheim* nannte (2). Givenchy, 1955 noch ein junger Spund in der Pariser Modewelt, kam nach London und stellte im exklusiven neuen Dorchester-Hotel in der Park Lane sein »blendend weißes Abendkleid aus Satin« vor, »geschlitzt von der Wade bis zum Knöchel, getragen mit karminroter Samtstola und Kollier aus Perlen und Straß« (1). Und Margaret, die Herzogin von Argyll (berühmt für die neue Wendung, die sie einer altehrwürdigen Gesundheitsregel gab – »Man sollte früh und oft ins Bett gehen«) wird wohlweislich von ihrer Tochter und dem Hofschneider der Königin, Norman Hartnell, begleitet (3).

MÊME les couturiers français prêtaient à l'aristocratie anglaise un certain je ne sais quoi. Dior présenta ses hommages à Churchill avec *Blenheim*, une robe ample de satin blanc brodée de fleurs (2). Givenchy, qui faisait en 1955 figure de nouvel arrivant sur la scène de la mode parisienne, vint montrer dans le nouvel et magnifique hôtel Dorchester, à Park Lane, son « époustouflante robe de dîner de satin blanc, fendue du mollet à la cheville, portée avec une étole de velours cramoisi et un pectoral de perles et de faux diamants » (1). Margaret, duchesse d'Argyll, célèbre pour son détournement de sens d'une maxime très prisée – « Couchez-vous tôt et souvent » – tient ici sagement compagnie à sa fille et à Norman Hartnell, le couturier de la reine (3).

SPOTS, stripes and floral prints – separately or, where possible, in conjunction. In 1956 the photo-magazine *Picture Post* gave six holiday game prize-winners a tour

of popular seaside resorts. And perhaps provided them with their Fifties uniform of cotton waisted frocks?

DRUCKSTOFFE in Pünktchen-, Streifen-, Blumenmustern – einzeln oder, wenn es sich machen ließ, auch zusammen. Die Illustrierte *Picture Post* schickte 1956 sechs

Preisausschreibengewinnerinnen auf eine Reise durch die englischen Seebadeorte. Und vielleicht stiftete sie die Uniform der Fünfziger dazu, das taillierte Baumwollkleid?

P OINTS, bandes et imprimés floraux. Seuls ou, si possible, combinés. En 1956, le magazine photographique *Picture Post* offrit aux six gagnantes d'un jeu de vacances une tournée dans les stations balnéaires à la mode. Est-ce aussi le magazine qui leur fournit leur uniforme de coton ceintré dans le style des années 50 ?

FEET first… and lasts. The morning queue outside the original Baker Street Marks and Spencer in 1955 is clearly in a mood to promote sensible footwear – and some curious shopping bags (1). Florence has been known for fine leather since the Middle Ages, and Salvatore Ferragamo

made his reputation by keeping the old tradition alive, making lasts for shoes and shoes to last. Each pair was handmade to measure, and the measure of his success was reflected in the roll-call of his famous customers and their named lasts (2).

SCHUSTER, bleib' bei deinen Leisten… wenn man sie sich denn leisten konnte! Die Frauen, die an einem Morgen des Jahres 1955 darauf warten, daß das alte Marks and Spencer in der Londoner Baker Street öffnet, sind wohl eher für vernünftiges Schuhwerk – und stellen auch an Einkaufstaschen keine gehobenen Ansprüche (1). Florentiner Leder ist seit dem Mittelalter

1 2

berühmt, und Salvatore Ferragamo beruft sich auf diese jahrhundertealte Tradition – er wurde selbst berühmt mit Schuhen für Berühmtheiten. Jedes Paar wurde nach Maß handgeschustert, und das Maß seines Erfolges läßt sich an der Kollektion von Leisten der Prominenz ermessen, die er hier stolz präsentiert (2).

EN 1955, la queue matinale qui s'est formée devant le Marks and Spencer, à l'origine dans la rue de Baker Street, a manifestement envie de souliers raisonnables – et de curieux cabas (1). Les cuirs de Florence étaient en effet réputés pour leur beauté depuis le Moyen Âge: Salvatore

Ferragamo bâtit sa réputation en pérennisant cette tradition ancienne, fabriquant des formes pour les chaussures et des chaussures qui gardaient la forme. Chaque paire était fabriquée à la main, sur mesure, tandis que son succès se mesurait à leurs formes (2) et à la liste de ses clients célèbres.

1

MASOCHISM has played its part in hairdressing at least since the ancient Babylonians started slapping heavy layers of mud and wigs on to their heads. This was as nothing compared with the 1935 Gallia machine (1), which resembles a contraption designed by *Alice in Wonderland's* White Knight, looking all the more dangerous for its approval 'by the Medical Societies as safe and absolutely shock-proof'. The tentacled hair-dryer (2) made its appearance at the Hair and Beauty Fair at London's Olympia Exhibition Centre in 1936. At the White City Fair, a Boadicea helmet mounted on a kind of bellows (3) barely covers the model's plaited earphones in what must be the least practicable and slowest method of drying hair ever invented.

MASOCHISMUS gehört zum Friseurgewerbe, mindestens seit die alten Babylonier sich Lehm und Perücken auf den Kopf klebten. Aber das war nichts im Vergleich zur Gallia-Maschine von 1935 (1), die vom Weißen Ritter aus *Alice im Wunderland* entworfen sein könnte und die noch bedrohlicher wirkt, wenn man bedenkt, daß sie »vom Ärzteverband geprüft und für absolut stromschlagsicher befunden wurde«. Der Haartrockner mit den Tentakeln (2) gab sein Debüt bei der Messe »Haar und Schönheit« im Londoner Olympia Exhibition Centre, 1936. Bei einer anderen Londoner Messe wurde dieser große Fön gezeigt, der in eine Art Ritterhelm bläst (3). Die zu Schnecken geflochtenen Haare der Vorführdame, die aussehen wie Kopfhörer, läßt er frei – wohl der langsamste und unpraktischste Haartrockner, der je gebaut wurde.

LA part de masochisme qui existe dans l'art de la coiffure remonte au moins à l'époque antique, lorsque les Babyloniens entreprirent d'appliquer sur leurs têtes de lourdes couches de boue et des perruques. Mais ce n'était rien en comparaison de la machine Gallia en 1935 (1), qui semblait conçue, tant elle était bizarre, par le cavalier blanc d'*Alice au pays des merveilles*, et d'autant plus dangereuse qu'elle était approuvée « par les sociétés médicales en raison de sa fiabilité et de sa résistance absolue aux chocs ». Ce sèche-cheveux tentaculaire (2) fit son apparition à l'occasion de la Foire de la beauté et de la chevelure qui se déroula en 1936 au centre d'exposition Olympia à Londres. À la foire de White City, un casque à la Boadicée, monté sur une sorte de soufflet (3) et recouvrant à peine les tresses en forme d'écouteurs du modèle, figure ce qui devait être la méthode la moins pratique et la plus lente jamais inventée pour sécher les cheveux.

2

3

1

ALL that glisters is clearly not gold, to judge by this 1932 model surmounted by metallic foil twists torturing her hair into silver curls (1). Messrs Vascos, a London hairdresser's, were responsible for promoting the process which changed a model's hair colour to match her every change of evening dress (including shades of gold, silver and mother-of-pearl): a fashion surely stemming from the Spanish willingness 'to suffer whatever-it-takes – for beauty'. These model girls on a yacht seem rather more inclined to take it easy, cruising down the Côte d'Azur to introduce British-designed polka-dotted bikinis to Cap Ferrat, Cannes and Juan-les-Pins (2).

ES ist nicht alles Gold, was glänzt, jedenfalls nach den Wicklern aus Metallfolie zu urteilen, die hier 1932 silberne Locken produzieren (1). Der Londoner Friseur Vascos warb mit diesem Verfahren, mit dem eine Frau ihre Haarfarbe täglich der Farbe des Abendkleides anpassen konnte (darunter Gold-, Silber- und Perlmutt-Töne) – die Spanier fanden ja schon'immer, daß für die Schönheit kein Leid zu groß sei. Da haben es diese Models an der Côte d'Azur schon leichter. Sie sind auf einer Yacht unterwegs und führen in Cap Ferrat, Cannes und Juan-les-Pins britische Pünktchenbikinis vor (2).

TOUT ce qui brille n'est manifestement pas de l'or, à en juger par ce modèle en 1932, dont la tête est surmontée de papillotes métalliques qui lui torturent la chevelure pour la changer en boucles argentées (1). On devait à M. Vascos, coiffeurs à Londres, la promotion du procédé qui modifiait la couleur de la chevelure en l'assortissant à chaque nouvelle tenue de soirée (y compris les nuances d'or, d'argent et de nacre) : une mode qu'on devait certainement au fait que l'Espagnole est prête « à souffrir pour être belle ». Sur ce yacht, ces mannequins semblent plus enclines à prendre du bon temps tandis qu'elles descendent sur la Côte d'Azur pour aller présenter les créations britanniques de bikinis à pois dans les villes de Cap-Ferrat, Cannes et Juan-Les-Pins (2).

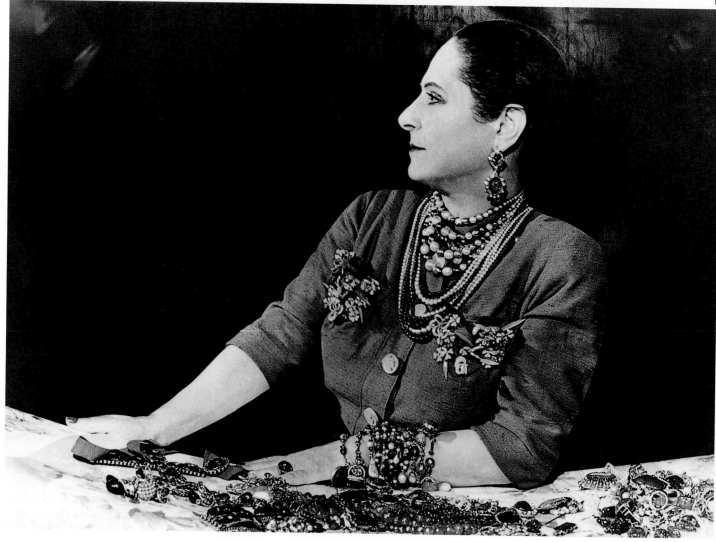

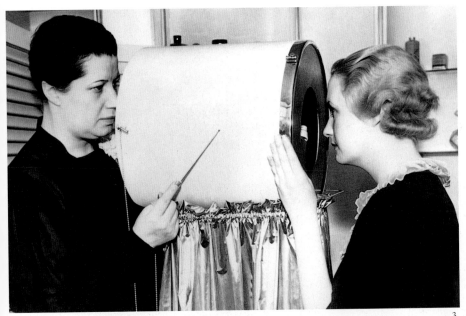

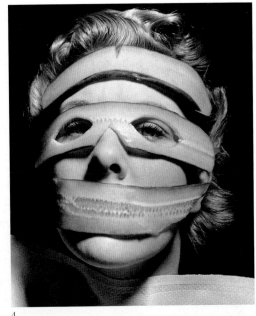

3 4

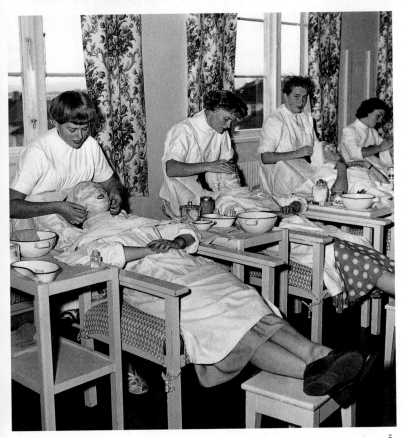

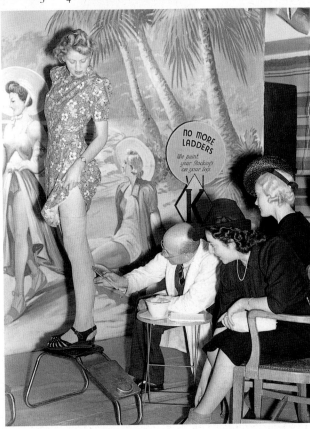

5 6

MAX Factor shows 1930s Hollywood starlet Renee Adoree how to apply his rouge (1). Helena Rubinstein became a formidable arbiter of women's skin-care and colouring (2). In 1935 she even developed a 'line lie detector' that would show up any crows' feet or giggle wrinkles before the 'patient' was aware of them herself (3). This Norwegian beauty school reverted to *papier mâché* wrapover (5), while others preferred cucumbers (4). The message was plain: 'if you want a peaches and cream complexion, the answer's a lemon'. And wartime exigencies demanded painted 'stockings' (6).

MAX Factor zeigt Renee Adoree, einem Hollywood-Starlet der 30er Jahre, wie Rouge aufgetragen wird (1). Helena Rubinstein wußte ganz genau, welche Pflege und welches Make-up das Gesicht einer Frau brauchte (2). 1935 entwickelte sie sogar einen »Fältchendetektor«, der Krähenfüße und Lachfältchen entdeckte (3). Eine Kosmetikerinnenschule in Norwegen arbeitet mit Gesichtsmasken aus Papiermaché (5). Das Rezept war einfach: »Wer Pfirsichhaut will, braucht Zitronen« (4). Als im Krieg keine Strümpfe zu haben waren, wurde die Strumpfnaht einfach aufgemalt (6).

MAX Factor montre à une starlette hollywoodienne dans les années 30, Renee Adoree, comment appliquer son fond de teint (1). Héléna Rubinstein devint l'arbitre redouté en matière de soins de la peau et de teint (2). Elle mit même au point, en 1935, un « détecteur » de rides (3). Cette école de beauté norvégienne est revenue au masque de papier mâché (5), tandis que d'autres préféraient le concombre (4). Le message était simple : « Si vous voulez un teint de pêche à la crème, la solution est le citron ». D'autre part, vu les temps difficiles, il fallait bien recourir aux « bas » peints (6).

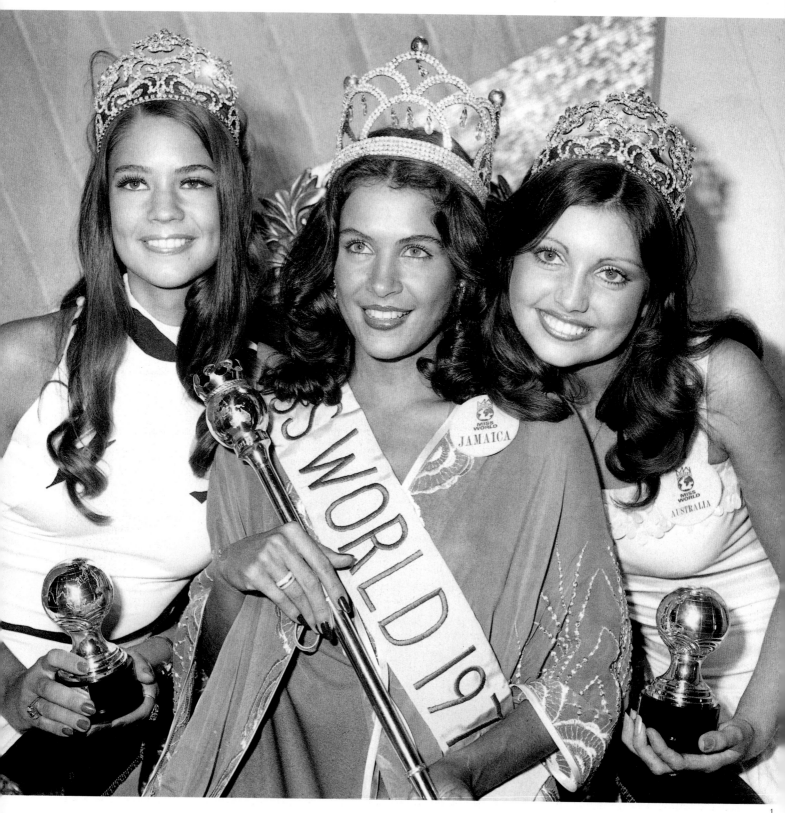

THE 1976 Miss World contest provoked a storm when it was won by Miss Jamaica, Cindy Breakespeare, the problem being that Jamaica is over 90 per cent black, while Ms Breakespeare (not to mention her lady-in-waiting, Miss Ghana) was very definitely white (1). Feminist protesters from the British Women's Liberation Movement deplored the exploitation of women's bodies by a system that simply sought to promote them as marketable commodities, while marginalizing others who did not conform to the slender, youthful white stereotype (2).

DIE 1976er Wahlen zur »Miß Welt« sorgten für Aufruhr. Die Siegerin war Cindy Breakespeare, Miß Jamaika, doch obwohl über neunzig Prozent der jamaikanischen Bevölkerung schwarz sind, war Ms. Breakespeare (von der Zweitplazierten, Miß Ghana, gar nicht zu reden) eindeutig

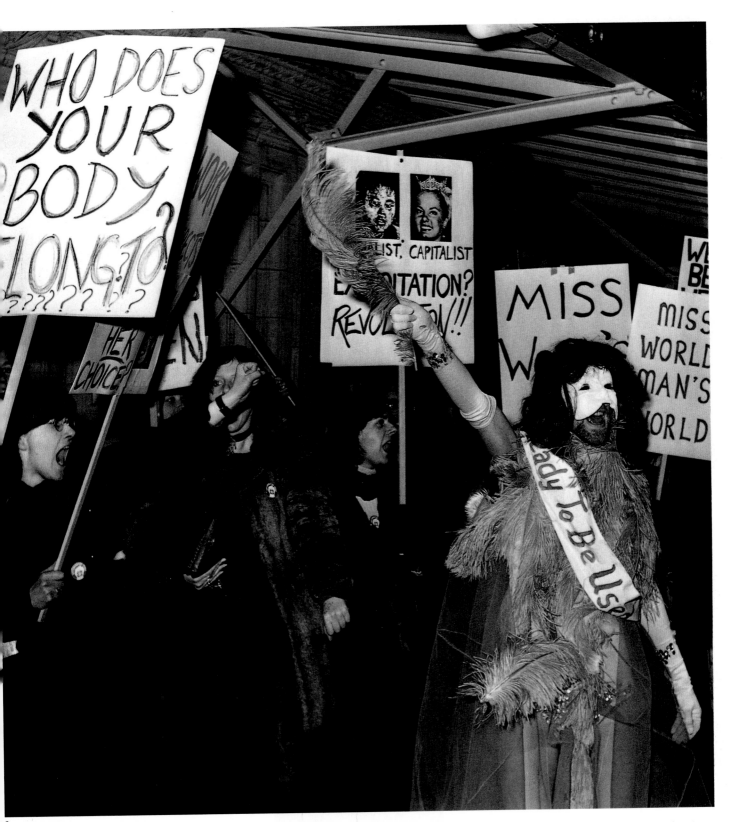

2

eine Weiße (1). Britische Feministinnen demonstrierten gegen ein System, bei dem Frauenkörper als vermarktbare Waren ausgebeutet und alle diskriminiert werden, die nicht dem Stereotyp der schlanken, jungen Weißen entsprechen (2).

En 1976, l'élection de Cindy Breake-speare, Miss Jamaica, au titre de Miss World, déclencha une tempête. En effet la Jamaïque est peuplée à plus de 90% de Noirs, or Mademoiselle Breakespeare (et ne parlons pas de sa dame d'honneur, Miss Ghana) est incontestablement blanche (1). Les militantes féministes du Mouve-

ment de libération des femmes britanniques déplorèrent l'exploitation faite du corps féminin par un système qui ne cherchait qu'à le promouvoir en tant que marchandise, marginalisant toutes celles qui n'étaient pas conformes au stéréotype de la femme mince, jeune et blanche (2).

Cinema

CINEMA is essentially a twentieth-century phenomenon, and although silent films are regarded nostalgically by buffs, the real heyday of the movies did not begin until the first 'talkie', Al Jolson's *The Jazz Singer*, came out in 1927. The Thirties saw a peak of activity, with the first colour films and the development of the Hollywood star system. Among the most luminous of the stars was Charlie Chaplin (1889-1977), reckoned the most popular film personality in the world for the best part of 25 years. Although he achieved great things as a writer, director, producer, musician and actor, it was as the last that he excelled. He created a character that was both entirely of its period and entirely his own: the tramp. For this he borrowed Fatty Arbuckle's voluminous trousers, one of Mack Swain's bushy moustaches (drastically trimmed), Ford Sterling's boatsized shoes (on the wrong feet), a tight jacket and a tiny derby, and the little tramp emerged, forever down-at-heel, out of luck and on a collision course with the unwieldy world around him. This still from 1928 (1) shows Chaplin as he epitomized silent cinema, introducing pathos and humour to an adoring audience.

The decades of the Thirties and Forties could boast such highly stylized screen goddesses as Marlene Dietrich, Bette Davis and Greta Garbo. One other Nordic beauty boasted far more natural attributes, and contributed a lengthy variety of performances with many of the major directors of the day. Ingrid Bergman, known equally for her luminous loveliness and her 'immoral' (i.e. Swedish) love-life (for which a US senator denounced her as Hollywood's Apostle of Degradation), made her best films early on. Here she relaxes at the Tower of London with director Alfred Hitchcock in 1948 before making *Under Capricorn*, a film that commenced the downward spiral of her career (2).

Dietrich was Paramount's answer to MGM's Greta Garbo – both embodied the alluring and ambiguous spirit of the Thirties, and both had relatively little success beyond it. While dancing in a revue Dietrich was spotted by the director Josef von Sternberg (overleaf, 1). He immediately cast her to play the part of the cabaret singer and *femme fatale* Lola opposite Emil Jannings as the ultimately destroyed professor in perhaps his – and her – most famous film, *The Blue Angel* (1930). For this Von Sternberg transformed Dietrich into his creature: suddenly blonde; exotically dressed in what was to become her masculine hallmark, including top hat and cigar; decadent rather than innocent. This whole new look was pursued by thousands of women who sought to start wearing the trousers. Paramount signed her for the astronomical fee of $125,000 a film, six of them to be made by 'Svengali' von Sternberg.

Brigitte Bardot came a generation later, a blonde sex kitten to Dietrich's sophisticate. Known in her native France as Bébé after both her initials and her babydoll looks, she made a string of little-remembered films in which her essential role was as the eternal feminine, personified in husband Roger Vadim's *And God Created Woman*. Here she causes head-scratching as she parades through the 1956 Cannes Film Festival, swinging her beads and her hips (overleaf, 2).

1

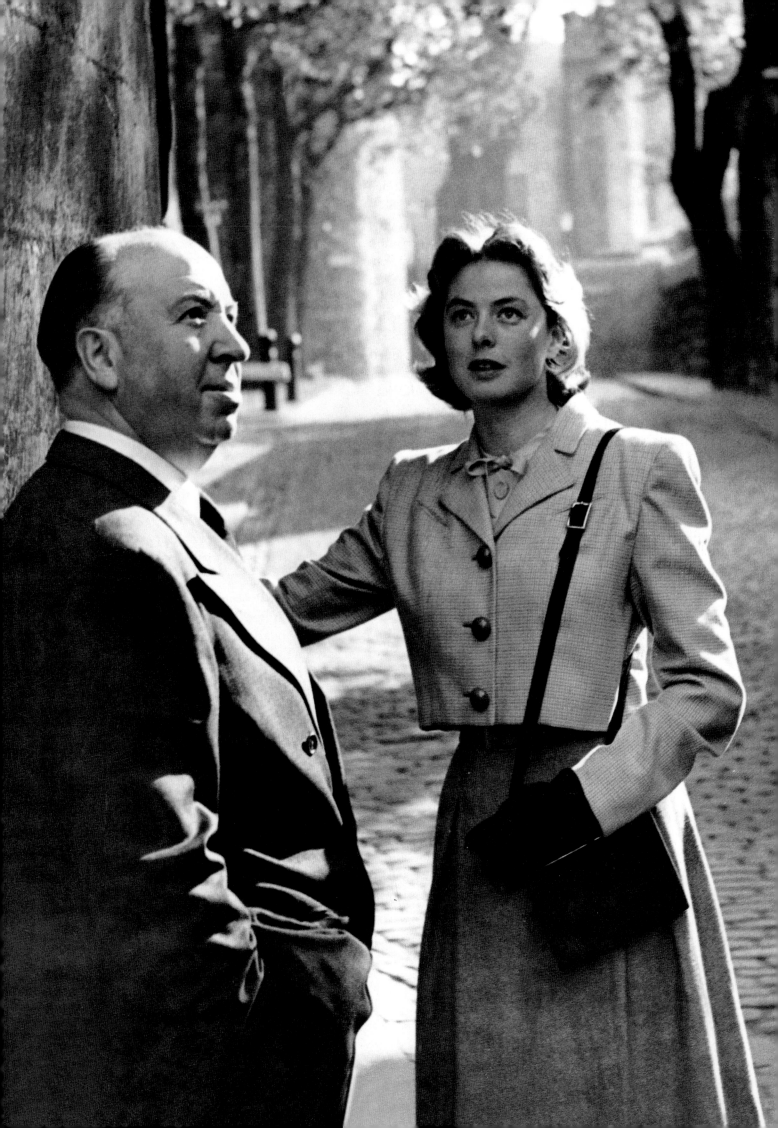

DAS Kino ist im Grunde ein Phänomen des 20. Jahrhunderts, und auch wenn Stummfilme ihre nostalgischen Verehrer haben, begann doch die eigentliche Blütezeit des Films erst mit dem ersten »talkie«, *Der Jazzsänger* mit Al Jolson von 1927. Ein erster Höhepunkt waren die 30er Jahre mit der Entwicklung des Farbfilms und der Etablierung des Hollywood-Starsystems. Zu den größten Stars dieser Ära zählte Charlie Chaplin (1889-1977), knapp 25 Jahre lang weltweit der beliebteste Filmschauspieler überhaupt. Auch als Drehbuchautor, Regisseur, Produzent und Komponist von Filmmusiken leistete er Großes, doch vor allem war er natürlich ein begnadeter Schauspieler. Er schuf eine Gestalt, die Inbegriff ihrer Zeit und auch Inbegriff von Chaplin selbst war: den Tramp. Dazu borgte er sich von Fatty Arbuckle die zu weiten Hosen, von Mack Swain den struppigen Schnurrbart (drastisch getrimmt), von Ford Sterling die unförmigen Schuhe (und vertauschte rechten und linken), nahm eine enge Jacke und einen winzigen Bowler, und schon war der kleine Tramp geboren, stets abgerissen, der ewige Verlierer, immer auf Kollisionskurs mit der allzu schwierigen Welt. Dieses Standphoto von 1928 (vorherige Seite, 1) zeigt uns Chaplin, wie er zum Inbegriff des Stummfilms wurde, zu einem Mann, der wie kein anderer dem Publikum Humor und Melancholie nahebrachte – und das Publikum liebte ihn dafür.

Die 30er und 40er Jahre glänzten mit hochstilisierten Filmgöttinnen wie Marlene Dietrich, Bette Davis und Greta Garbo. Eine andere nordische Schönheit gab sich im Vergleich dazu wesentlich natürlicher und spielte die verschiedensten Rollen unter einigen der bedeutendsten Regisseuren ihrer Zeit: Ingrid Bergman, für ihre strahlende Schönheit wie für ihren »unmoralischen« (sprich schwedischen) Lebenswandel bekannt (für den ein amerikanischer Senator sie »Hollywoods Apostel der Schamlosigkeit« nannte), drehte ihre besten Filme zu Anfang ihrer Karriere. Hier macht sie mit dem Regisseur Alfred Hitchcock einen Ausflug in den Londoner Tower, vor Beginn der Dreharbeiten zu *Sklavin des Herzens* (1948); das war der Film, mit dem der Niedergang ihrer Karriere begann (vorherige Seite, 2).

Die Dietrich war Paramounts Antwort auf MGMs Greta Garbo – beide verkörperten den Typus der geheimnisvollen und verführerischen Frau der 30er Jahre, und beide kamen über diese Rolle nie hinaus. Dietrich wurde von Regisseur Josef von Sternberg (1) in einer Revuetruppe entdeckt. Er gab ihr auf Anhieb die Rolle der Nachtclubsängerin und *Femme fatale* Lola, die in seinem – und vielleicht auch ihrem – berühm-

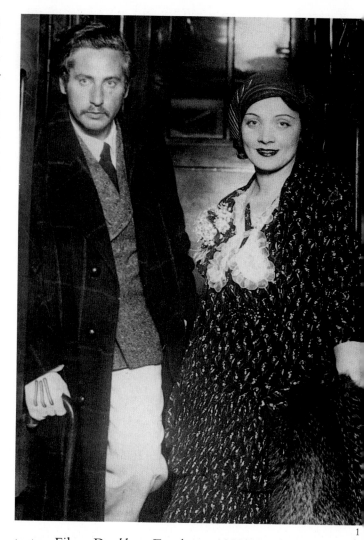

1

testen Film, *Der blaue Engel* von 1930, Emil Jannings ins Verderben stürzt. Für diesen Film schuf Sternberg die Dietrich vollkommen neu: als Blondine, in exotisch-maskuliner Kleidung, die zu ihrem Markenzeichen werden sollte, mit Zylinder und Zigarre – ein Todes- und kein Unschuldsengel. Tausende von Frauen wollten nun selbst die Hosen anhaben und ahmten diesen Look nach. Paramount engagierte die Dietrich für astronomische 125 000 Dollar pro Film, und sechs davon sollte »Svengali« von Sternberg drehen.

Brigitte Bardot war der Star der nächsten Generation, eine sexy Blondine, ungleich unkomplizierter als die Dietrich. Zu Hause in Frankreich nannte man sie »Bébé«, ein Spiel mit ihren Initialen und ihrem Auftreten als naive Kindfrau, und in einer Unzahl von Filmen, die heute fast vergessen sind, verkörpert sie das Weibliche schlechthin, am überzeugendsten in dem Film ihres Ehemannes Roger Vadim, *Und immer lockt das Weib.* Hier kann sich ein Betrachter nur noch an den Kopf fassen, als sie 1956 ketten- und hüftschwingend zum Filmfestival in Cannes stolziert (2).

L E cinéma est essentiellement un phénomène du XXᵉ siècle, et bien que les experts contemplent les films muets avec un brin de nostalgie, le véritable âge d'or du Septième Art n'a commencé qu'avec *Le Chanteur de jazz,* de Alan Crosland, premier film parlant, sorti en 1927 avec la voix de Al Jolson. Les années 30 ont vu un sommet d'activité avec les premiers films en couleurs et le développement du *star-system* à Hollywood. L'un des monstres sacrés fut Charlie Chaplin (1889-1977), considéré pendant près d'un quart de siècle comme la plus grande vedette populaire au niveau planétaire. Bien qu'il réalisât de grandes choses en tant qu'écrivain, réalisateur, producteur et musicien, il excellait surtout dans son activité de comédien. Il a créé une figure qui correspondait à la fois parfaitement à cette époque et à lui-même : le clochard. Pour cela, il emprunta les vastes pantalons de Fatty Arbuckle, la moustache touffue de Mack Swain (radicalement taillée), les chaussures démesurées de Fors Sterling (portées sur le « mauvais » pied), une veste étroite et un chapeau melon minuscule. Le petit clochard était né, toujours déguenillé, malchanceux et en perpétuel affrontement avec le monde alentour. Cette photo de 1928 (pages précédentes, 1) montre Charlie Chaplin au temps du muet, quand il présentait le tragique et le comique à un public qui le vénérait.

Les années 30 et 40 peuvent s'enorgueillir de divinités du grand écran aussi sophistiquées que Marlene Dietrich, Bette Davis et Greta Garbo. Une autre beauté nordique, qui possédait des atouts beaucoup plus naturels et interpréta des rôles très divers avec nombre des plus grands réalisateurs de l'époque, Ingrid Bergmann, était aussi connue pour son charme lumineux que pour sa vie amoureuse « immorale » (un sénateur américain la dénoncera d'ailleurs comme un agent de la dégradation hollywoodienne). Elle fit ses meilleurs films en début de carrière. Ici, elle se détend devant la Tour de Londres en compagnie d'Alfred Hitchcock, en 1948, avant de tourner *Les Amants du Capricorne,* un film qui amorce le début de son déclin (pages précédentes, 2).

Marlene Dietrich était la réponse de la Paramount à la Greta Garbo de la MGM. Elles incarnaient toutes les deux l'esprit séduisant et ambigu des années 30, et toutes deux connurent relativement peu de succès plus tard. Le réalisateur Josef von Sternberg découvrit Marlene Dietrich alors qu'elle se produisait comme danseuse dans une revue (1). Il l'engagea immédiatement pour lui faire jouer le rôle de Lola, chanteuse de cabaret et femme fatale qui donne la réplique à Emil

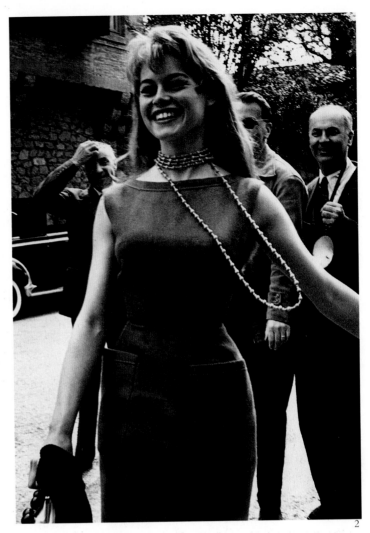

2

Jannings, le professeur qu'elle finira par détruire, dans ce qui fut peut-être, à l'un comme à l'autre, leur plus grand film, *L'Ange bleu* (1930). Pour ce faire, von Sternberg créa une nouvelle Marlene : blonde, vêtue de ce qui deviendra sa marque « masculine », haut-de-forme et cigare, incarnant plus la décadence que l'innocence. Cette mode entièrement nouvelle fut suivie par des milliers de femmes qui demandaient à porter le pantalon. Paramount l'engagea pour la somme astronomique de 125 000 dollars par film ; six d'entre eux furent réalisés par « Svengali » von Sternberg.

La génération suivante fut celle de Brigitte Bardot, blonde coquette et sexy. Connue sous le nom de B. B., elle réalisa une série de films où elle incarnait l'éternel féminin, comme dans *Et Dieu créa la femme,* réalisé par son mari Roger Vadim. Ici les hommes restèrent sans voix quand elle parada en 1956 à l'occasion du Festival de Cannes, faisant sauter ses perles et roulant des hanches (2).

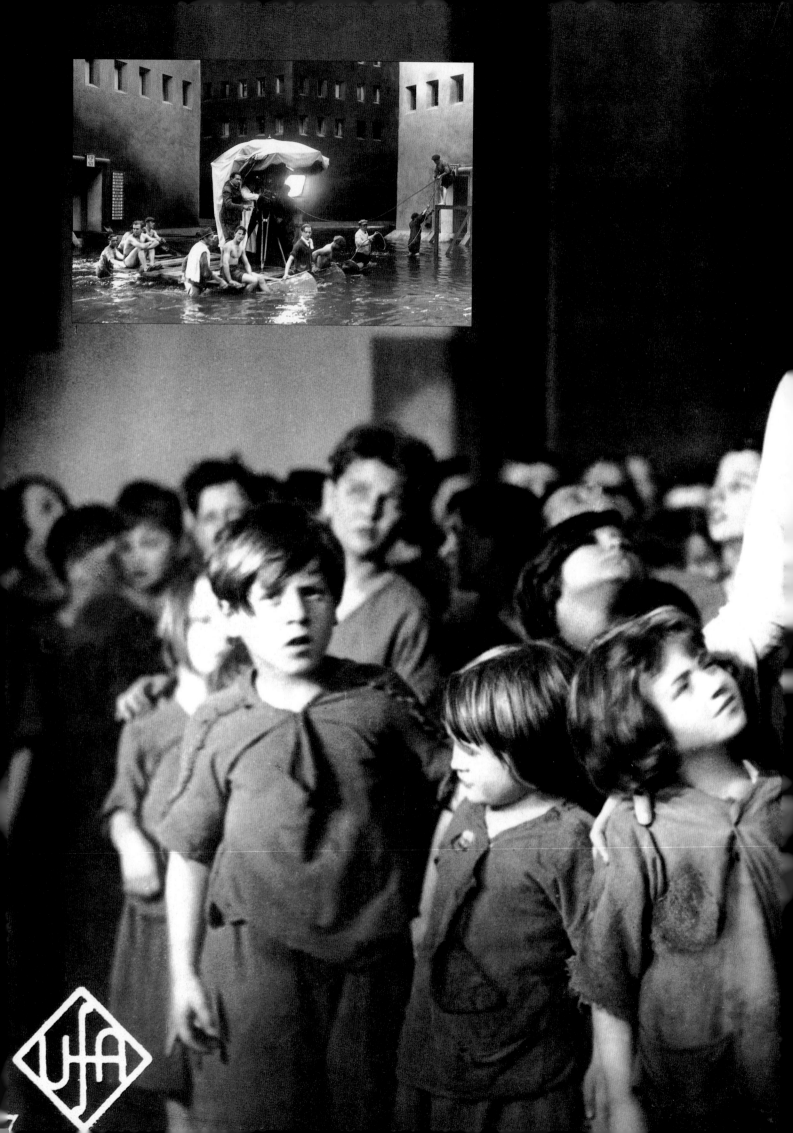

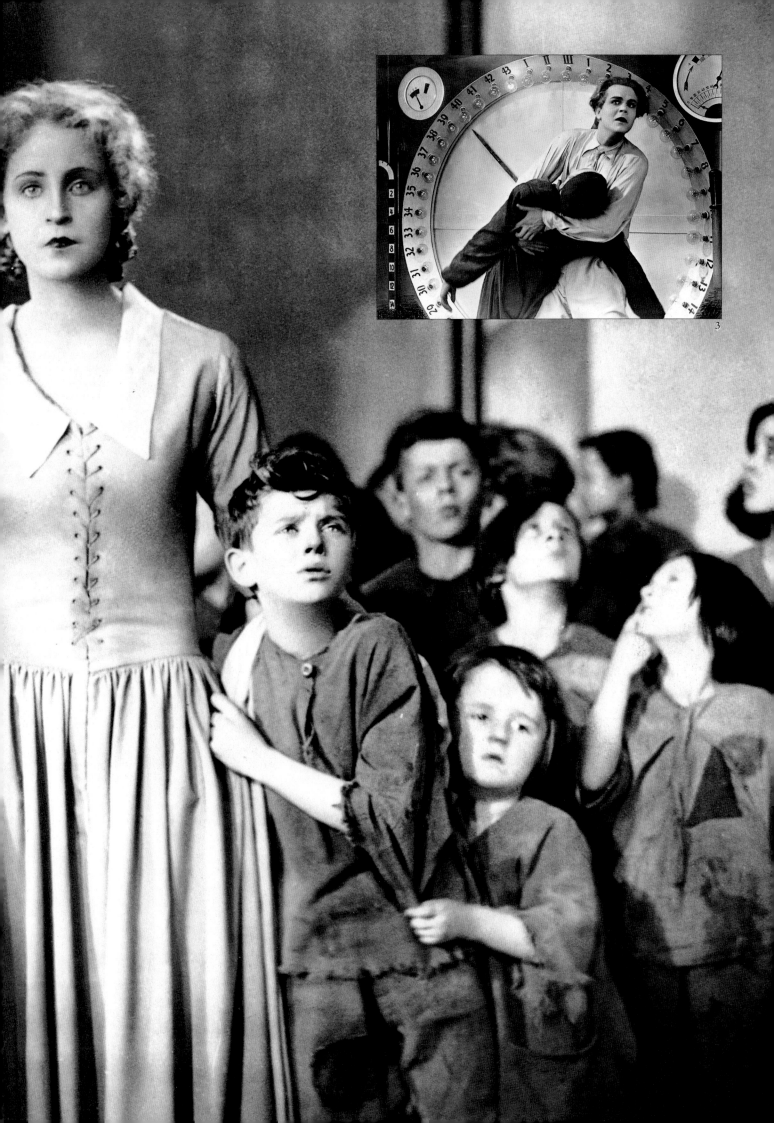

3

Previous pages)

PERHAPS the most famous film made by Fritz Lang was *Metropolis* (1926), which played on the fundamental fears of a post-industrial age. In it time becomes all-controlling and the clock cannot be turned back (3); the demands of the market-place lead to child slavery (2); and a flood threatens an apocalyptic finale (1).

Vorherige Seiten)

DER berühmteste Film Fritz Langs ist wohl *Metropolis* (1926), in dem er die tiefsitzenden Ängste eines postindustriellen Zeitalters zum Thema macht. Zeit wird zum alles beherrschenden Faktor, und keiner kann die Uhr zurückdrehen (3); die Anforderungen des Marktes versklaven die Kinder (2); und eine große Flutwelle droht mit einem apokalyptischen Finale (1).

Pages précédentes)

LE film le plus célèbre de Fritz Lang est certainement *Métropolis* (1926), qui joue sur les craintes fondamentales de l'ère post-industrielle. C'est le temps qui contrôle tout et il est impossible de reculer les aiguilles de l'horloge (3) ; sur la place du marché les enfants sont vendus comme esclaves (2), et une inondation menace de l'apocalypse finale (1).

FIFTEEN years of Charlie Chaplin's film career: from *The Kid* (1) with Jackie Coogan in the eponymous part (1920) to *Modern Times* with Paulette Goddard (2). The playing-card posters came captioned: 'A gentleman from Paris sent us these French posters used over there to advertise Charlie. I had them posted up and photographed. Charlie liked the centre top and lower right ones' (3).

FÜNFZEHN Jahre in Charlie Chaplins Filmkarriere: *Das Kind* mit Jackie Coogan als Titelheld »the kid« (1920, 1) bis hin zu *Moderne Zeiten* mit Paulette Goddard (2). Die Unterschrift zu dem Bild mit den Spielkarten-Plakaten lautete: »Ein Herr aus Paris schickte uns diese Plakate, mit denen dort für Charlie Werbung gemacht wird. Ich ließ sie ankleben und aufnehmen. Charlie mochte besonders die Bilder oben in der Mitte und unten rechts.« (3)

QUINZE années de la carrière cinématographique de Charlie Chaplin : depuis *Le Kid* (1) avec Jackie Coogan dans le rôle éponyme (1920) aux *Temps modernes* avec Paulette Goddard (2). Les affiches en forme de cartes à jouer devinrent légendaires :

2

3

« Un monsieur de Paris nous a envoyé ces affiches françaises utilisées là-bas pour faire de la publicité à Charlie. Je les ai installées et photographiées. Charlie aimait celle d'en haut au centre et celle d'en bas à droite. » (3)

A deck of the most accomplished silent screen comedians who made it into the 'talkies'. Harold Lloyd was reckoned to be even more popular than Chaplin. Like the latter's 'tramp' character, Lloyd's 'Glasses' became swiftly identified with what would later be called a yuppie – college-educated, on the make and bent on success. Here, 'Glasses' dolefully pursues that sought-after acclaim among a large party of children at a picture theatre (1). Buster Keaton was equally popular, demonstrating stoical fortitude in the face of every eventuality. His experiments with cinema's technical potential – image manipulation and other special effects – are mimicked by this conversation he's having with a miniaturized version of himself (2). Stan Laurel and Oliver Hardy were a lovable duo who relied on heavy stereo-typing and comforting familiarity, never varying from the weedy pathos of the one and the plump bluster of the other. They take a break from performing at the London Palladium in 1947 to drive the inaugural train on the reopened Hythe and Dymchurch line (3).

EIN Kleeblatt der beliebtesten Stumm-filmkomiker, die den Sprung in die »talkies« schafften. Harold Lloyd war seinerzeit womöglich noch bekannter als Chaplin. Lloyds Brille wurde genauso zum Markenzeichen wie Chaplins Trampkostüm, und sie symbolisierte Eigenschaften, die man später dem Yuppie zuordnen sollte – gebildet, aufstrebend und erfolgreich. Hier tut Lloyd etwas für diesen Erfolg und läßt sich, wenn auch etwas halbherzig, mit einer ganzen Schar Schulkinder in einem Kino aufnehmen (1). Nicht weniger populär war Buster Keaton, der selbst die größten Katastrophen mit stoischer Miene meisterte. Er experimentierte auch mit den technischen Möglichkeiten des Films – mit nachträglichen Veränderungen des Bildes und anderen »special effects« –, und hier scheint er im Zwiegespräch mit seinem miniaturisierten Alter ego darüber nachzudenken (2). Stan Laurel und Oliver Hardy waren ein liebens-

wertes Duo, dessen Erfolgsrezept immer wiederkehrende Stereotypen waren; und zeit ihres Lebens mimten sie den sentimentalen Umstandskrämer und den tolpatschigen Tatmenschen. Hier nehmen sie sich von ihren Auftritten im Londoner Palladium (1947) einen Tag frei und sind Lokomotivführer im ersten Zug der wiedereröffneten Miniatureisenbahn von Hythe nach Dymchurch (3).

SUR le pont, les comédiens les plus accomplis du cinéma muet qui continuèrent dans le « parlant ». Harold Lloyd était même plus populaire que Charlie Chaplin. Comme plus tard le rôle de « clochard » de Charlot, les lunettes d'Harold Lloyd le firent rapidement identifier à ce qu'on appellera plus tard un « yuppie », de formation supérieure, programmé pour la réussite. Ici, l'homme aux célèbres lunettes rondes pose d'un air morne dans un cinéma

au milieu d'une grande fête donnée pour des enfants (1). Buster Keaton, tout aussi populaire, faisait preuve d'un courage imperturbable dans l'adversité. Ces expériences avec les possibilités techniques du cinéma – manipulation des images et autres effets spéciaux – sont rendues ici par la conversation qu'il tient en ce moment avec sa propre version miniature de lui-même (2). Stan Laurel et Oliver Hardy formaient un duo adorable qui associait le stéréotype lourd et la familiarité réconfortante ; l'un invariablement mauviette tragique et souffreteuse, l'autre colérique et bien en chair. Ici, un moment de détente pendant la représentation au Palladium de Londres en 1947 : ils conduisent le train inaugurant la ligne Hythe et Dymchurch de nouveau en circulation (3).

THE Marx Brothers were not only the most variously talented comedy team in Hollywood but the precursors of the zany 'Jewish humour' of later US comedians such as Mel Brooks and Woody Allen (2, photographed here in 1971). Groucho's droopy slouch, eyebrows and moustache; Chico's Italianate gobbledy-gook and magical piano-playing; Harpo's silly wig, dumb insolence and – of course – harp, with fourth brother Zeppo as a foil in the earlier movies, were fought over by the major film companies. While they made *Monkey Business, Horse Feathers* and *Duck Soup* (1) with Paramount, they added *A Night at the Opera, A Day at the Races, At the Circus* and *Go West* to MGM's list, being criticized by supremo Irving Thalberg for being 'too funny'. Love interest was his solution, often in the somewhat surprising person of Margaret Dumont at her most stately.

DIE Marx Brothers waren seinerzeit die wohl begabteste Truppe in Hollywood, die Urahnen des kuriosen »jüdischen Humors« späterer amerikanischer Komiker wie Mel Brooks oder Woody Allen (2, hier in einer Aufnahme von 1971). Die großen Studios rissen sich um Groucho mit seinem schleichenden Gang, den buschigen Augenbrauen und dem aufgemalten Schnurrbart, Chico mit seinem italienischen Akzent und magischen Klavierspiel sowie um Harpo mit der albernen Perücke, dem stummen Starrsinn und – wie der Name schon sagt – seiner Harfe, wobei anfangs der vierte Bruder,

Zeppo, noch für ein wenig ausgleichende Normalität sorgte. *Die Marx Brothers auf See, Horse Feathers* und *Die Marx Brothers im Krieg* (1) drehten sie für Paramount, während *Die Marx Brothers in der Oper, Ein Tag beim Rennen, At the Circus* und *Go West* das Repertoire von MGM zierten. Der dortige Boß, Irving Thalberg, fand sie »zu lustig«, und so kamen Liebeshandlungen hinzu, oft mit der pompösen Margaret Dumont.

LES Marx Brothers n'étaient pas seulement les comédiens aux talents les plus variés de Hollywood, ils furent aussi les précurseurs de « l'humour juif », type d'humour loufoque dont Mel Brooks et Woody Allen (2, photographié ici en 1971) seront les futurs représentants. L'allure avachie de Groucho, ses sourcils et sa moustache ; le charabia à l'italienne de Chico et son inimitable talent de pianiste ; la perruque impossible de Harpo, son insolence idiote et – évidemment – sa harpe, et Zeppo, faire-valoir dans les premiers films. Les plus grandes compagnies se battirent pour les engager. Pendant qu'ils tournaient *Monnaie de singe, Plumes de cheval* et *la Soupe au canard* (1) pour Paramount, ils ajoutaient *Une nuit à l'opéra, Un jour aux courses, Un jour au cirque* et *Chercheurs d'or* à la liste de MGM, critiqués par le grand chef Irving Thalberg parce que « *too funny* ». Pour remédier à cela, il eut l'idée de les rendre souvent amoureux, ce qui peut surprendre, de Margaret Dumont dans sa plus grande majesté.

UNITED Artists was founded by arguably the four greatest silent film giants in 1919: Douglas Fairbanks, Mary Pickford, D. W. Griffith and Charlie Chaplin (2), with the invisible assistance of US Treasury Secretary William McAdoo. Mack Sennett, nicknamed 'The King of Slapstick', produced – among others – W. C. Fields, but his company hit the rocks for a second and final time in 1937. This photo was taken on the Sennett film lot just before it was torn down, at a visibly dismal last lunch shared by Marion Davies, Will Haines, King Vidor, Ulric Bush and Eileen Percy (3). Mickey Mouse takes Walt Disney for a walk (1). Disney (1901-66) was not necessarily the most innovative but he was certainly the most businesslike of film animators. Mickey Mouse was born in 1928 and greatly helped Disney's company to win its 19 Oscars.

IM Jahre 1919 taten sich vier der einfluß- reichsten Persönlichkeiten der Stumm- filmzeit zusammen – Douglas Fairbanks, Mary Pickford, D. W. Griffith und Charlie Chaplin – und gründeten die Filmgesell- schaft United Artists (2), wobei William McAdoo vom US-Schatzamt hinter den Kulissen entscheidend mitwirkte. Mack Sennett, der »König des Slapstick«, produ- zierte unter anderem W. C. Fields, doch 1937 mußte seine schon zuvor in Schwie- rigkeiten geratene Firma endgültig Konkurs anmelden. Unser Bild zeigt die gedrückte Stimmung bei einem Abschiedsessen auf dem Gelände der Sennett-Studios, un- mittelbar bevor sie abgerissen wurden (3). Mit von der Partie sind Marion Davies, Will Haines, King Vidor, Ulric Bush und Eileen Percy. Micky Maus bei einem Spaziergang mit Walt Disney (1). Disney (1901-1966) war vielleicht nicht der inno- vativste unter den Trickfilmzeichnern, aber er hatte zweifellos den besten Geschäfts- sinn von allen. Micky Maus kam 1928 zur Welt und trug seinen Teil zu den 19 Oscars bei, die die Disney-Studios errangen.

UNITED Artists a été fondée par les plus formidables géants du muet en 1919 : Douglas Fairbanks, Mary Pickford, D. W. Griffith et Charlie Chaplin (2) avec l'assistance invisible du secrétaire du ministère des Finances, William McAdoo. Mack Sennett, « le roi du slapstick », pro- duisit – entre autres – W.C. Fields, mais sa compagnie fit naufrage une seconde et dernière fois en 1937. Cette photo a été prise sur le terrain des studios Sennet, juste avant qu'ils ne fussent rasés. On y assiste à un dernier repas visiblement lugubre avec Marion Davies, Will Haines, King Vidor, Ulric Bush et Eileen Percy (3). Mickey Mouse emmène Walt Disney en promenade (1). Disney (1901-1966) ne fut pas néces- sairement le plus inventif, mais certainement le plus efficace des animateurs du cinéma. Mickey Mouse, né en 1928, a beaucoup aidé la compagnie de Walt Disney à gagner ses 19 Oscars.

2

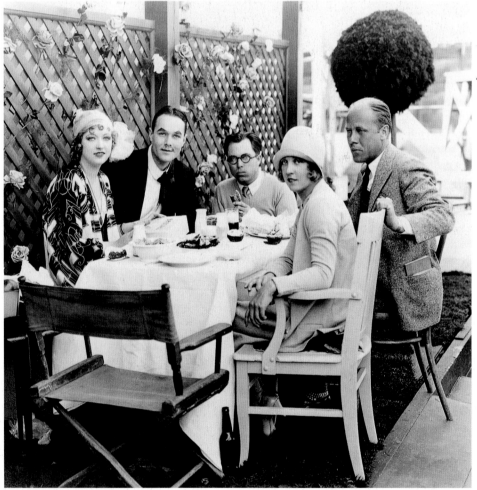

3

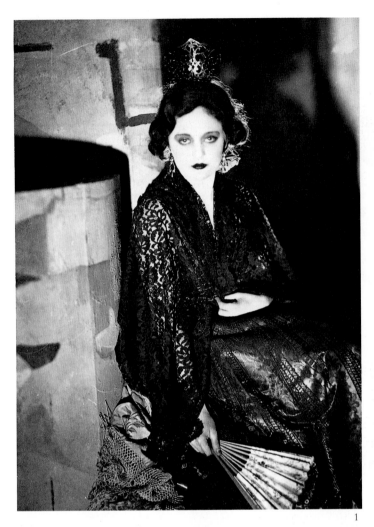

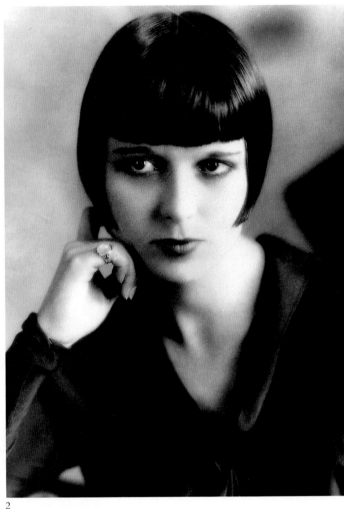

1 2

KNOWN for her sensuality and volatile temperament (the two fused when, having failed to seduce Marlon Brando during filming of *The Eagle has Two Heads*, she had him fired), Tallulah Bankhead changed leading men as rapidly as her exotic costumes. Here she is dressed to slay as the Spanish siren *Conchita* (1). Louise Brooks' press photos invite us to consider her as both demurely pensive (2) and as dressed in feather boa and high heels to undertake a little light exercise on her Hollywood home trapeze (3). Famous for her role in the German expressionist Pabst's *Pandora's Box* (1928), she captured the mood and set the hairstyle of the time.

TALLULAH Bankhead, bekannt für ihre Sinnlichkeit und ihr stürmisches Temperament, wechselte die Hauptdarsteller an ihrer Seite ebenso häufig wie ihre exotischen Kostüme. Sinnlichkeit und Temperament kamen bei den Dreharbeiten zu *The Eagle has Two Heads* zusammen: Als Marlon Brando ihren Verführungskünsten widerstand, sorgte sie dafür, daß er gefeuert wurde. Hier ist sie umwerfend als die spanische Sirene *Conchita* kostümiert (1). Louise Brooks wirkt auf den Pressephotos still und nachdenklich (2), zeigt sich aber auch in hochhackigen Schuhen und Federboa, bei ein paar Übungen auf dem Trapez ihres Hauses in Hollywood (3). Berühmt für ihre Rolle in *Die Büchse der Pandora* (1928) des deutschen Expressionisten G. W. Pabst, verkörperte sie wie keine andere die Stimmung jener Zeit, und alle Welt ahmte ihre Frisur nach.

CÉLEBRE pour son tempérament sensuel et volage (un mélange explosif, on le verra, quand n'ayant pu séduire Marlon Brandon durant le tournage de *L'Aigle à deux têtes*, elle le renvoya), Tallulah Bankhead changeait d'hommes aussi rapidement que de costumes. Ici, elle est vêtue en espagnole dans *Conchita* (1). Les photos de presse de Louise Brooks nous la montrent à la fois songeuse et réservée (2), ou en boa à plumes et hauts talons pour exécuter un petit exercice facile sur son trapèze dans sa maison de Hollywood (3). Fameuse pour son rôle dans le film de l'expressionniste allemand Pabst *Loulou* (1928), elle sut saisir l'esprit du temps et imposa un style de coiffure.

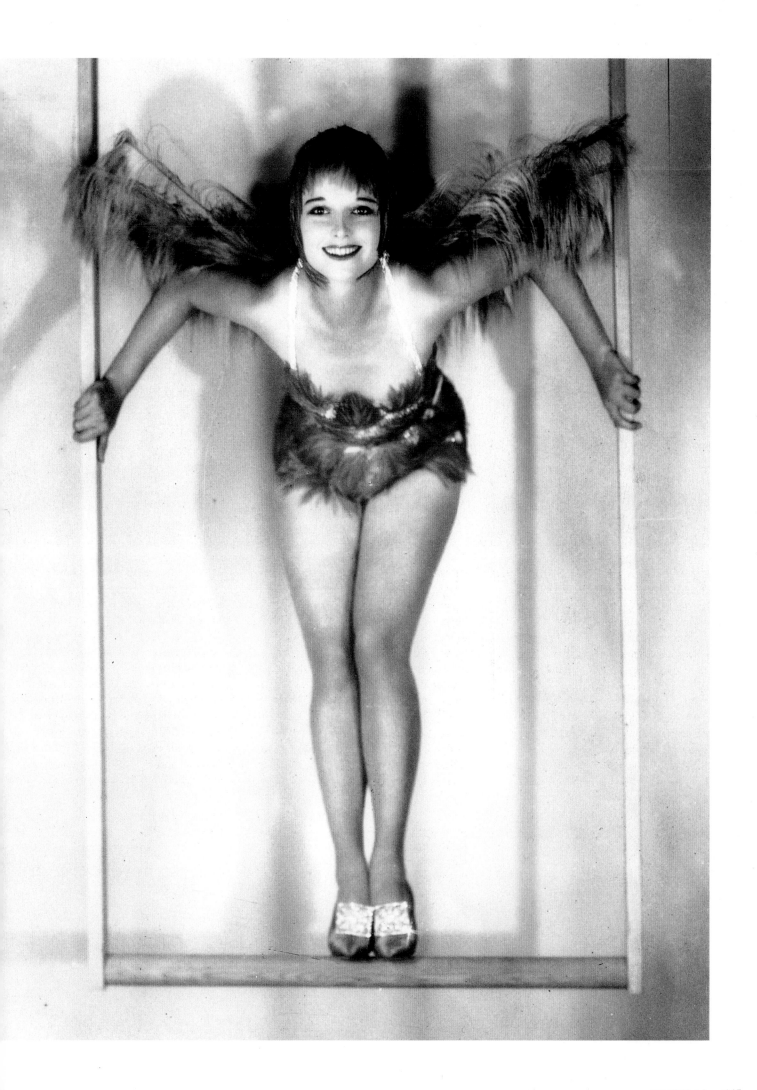

ILLIAN Gish (1) and Rudolph Valentino (2) were legends of the silent screen. Gish started as a child actress and often played alongside her sister, Dorothy, until the latter's death in 1968. However, her later films never had the impact of such epic masterpieces as *Birth of a Nation* (1914) and *Orphans of the Storm* (1922). Her most prolific year was 1926 when she played tragic lead roles in both *La Bohème* and *The Scarlet Letter* for MGM. Valentino also started young, alternating professional dancing with sidelines as (among other things) a gardener and a thief. The film that turned him into the hottest property of the 1920s was *The Four Horsemen of the Apocalypse* (1921), grossing over $4.5 m. For five years, Valentino made films with titles like *The Sheikh* (1921) and *Blood and Sand* (1922) that established his reputation as a sultry and exotic screen lover. His sudden death in 1926, from a perforated ulcer brought on by overwork, brought street riots at his funeral and even female suicides.

ILLIAN Gish (1) und Rudolph Valentino (2) waren Legenden des Stummfilms. Gish stand schon als kleines Mädchen auf der Bühne, oft zusammen mit ihrer Schwester Dorothy, die 1968 starb. Doch ihre späteren Filme erreichten nie wieder die Kraft von *Die Geburt einer Nation* (1914) und *Orphans of the Storm* (1922). Ihr produktivstes Jahr war 1926, als sie bei MGM die tragischen Hauptrollen in *La Bohème* und in *Der scharlachrote Buchstabe* spielte. Auch Valentino begann jung und verband Auftritte als Tanzprofi mit Nebenverdiensten als (unter anderem) Gärtner und Dieb. Der Film, der ihn zum größten Star der 20er Jahre machte und über viereinhalb Millionen Dollar einspielte, war *Die vier apokalyptischen Reiter* von 1921. Fünf Jahre lang drehte Valentino einen Film nach dem anderen, mit Titeln wie *Der Scheich* (1921) oder *Blood and Sand* (1922); mit seinem Schmollmund wurde er zum Inbegriff des exotischen Liebhabers auf der Leinwand. Sein plötzlicher Tod 1926 – ein Magengeschwürdurchbruch, die Folge einer rastlosen Arbeit – führte zu erschütternden Szenen bei der Beerdigung, und manche Frauen begingen sogar Selbstmord deswegen.

2

LILLIAN Gish (1) et Rudolf Valentino (2) font partie de la légende du cinéma muet. Lilian Gish fut actrice dès l'enfance et joua souvent aux côtés de sa soeur Dorothy jusqu'à la mort de celle-ci, survenue en 1968. Cependant, ses derniers films n'ont jamais eu l'impact des chefs-d'œuvre épiques comme *Naissance d'une nation* (1914) et *À travers l'orage* (1922). 1926 fut son année la plus féconde : elle y joue de grands rôles tragiques dans *Au temps de la Bohème* et *La Lettre rouge* pour la MGM. Valentino débuta aussi très jeune dans le métier, alternant la danse professionnelle avec des activités secondaires dans le jardinage et le cambriolage. Le film *Les Quatre Cavaliers de l'Apocalypse* (1921) en a fait la star des années 20 et il généra à lui seul une recette de plus de 4,5 millions de dollars. Pendant cinq ans, Valentino tourna des films aux titres prometteurs comme *le Cheik* (1921) et *Arènes sanglantes* (1922) qui lui firent à l'écran une réputation d'amant, sensuel et exotique. Il mourut brusquement en 1926 d'un ulcère dû au surmenage. Au cours de ses funérailles, on assista à des émeutes dans les rues et des femmes se suicidèrent.

P1396-207

1

MIT ihrer sauberen, allem Anschein nach braven Art gehörten Cary Grant (1) und Gary Cooper (2) zu den größten Kassenschlagern jenseits des Atlantiks. Grant (1) kam aus armen Verhältnissen im englischen Bristol und ging nach Hollywood, um dort sein Glück zu machen: Die erste Gage bei Paramount waren immerhin schon 450 Dollar die Woche. Mit seinem guten Aussehen, dem vornehmen Akzent und seiner lässigen Nonchalance spielte er die männlichen Hauptrollen in Filmen mit Göttinnen wie Mae West, Marlene Dietrich und Katharine Hepburn. Cooper – hier zusammen mit William Anderson, dem »Mann, der ganz Hollywood füttert« (die fünfhundert Mann, die immer mit Außenaufnahmen beschäftigt waren, verköstigte er dreimal am Tag) – war 35 Jahre lang ein Star in Hollywood. Obwohl er in Western, Thrillern, Komödien und Literaturverfilmungen spielte (einmal sogar einen Baseballstar), verstand er sich immer als »der Amerikaner von nebenan«. Jemand hat einmal gesagt, die Bandbreite seiner Ausdrucksmittel reiche von »na klar« bis »von wegen«.

CARY Grant (1) and Gary Cooper (2) were two of the biggest Stateside box office draws of the clean-shaven, apparently clean-living variety. Abandoning his poverty-stricken background in Bristol, England, Grant (1) was right to seek his fortune in Hollywood: his first Paramount salary was $450 a week. His refined accent, smooth looks and casual nonchalance brought him starring roles opposite such goddesses as Mae West, Marlene Dietrich and Katharine Hepburn. Cooper, here standing next to William Anderson, 'the man who feeds the movies' and provided three meals a day for the 500 people on location, was a Hollywood star for 35 years. Despite working across a range that covered westerns, thrillers, comedies, literary adaptations (he even played a baseball star), he described himself as 'Mr Average Joe American'. His dramatic span has been described as running from 'Yep' to 'Nope'.

CARY Grant (1) et Gary Cooper (2), qui étaient deux des plus grandes attractions du box-office américain dans le genre « rasé de près », menaient apparemment une vie bien réglée. Abandonnant son milieu misérable de Bristol en Angleterre (1) Grant chercha fortune à Hollywood : son premier salaire à la Paramount s'élevait à 450 dollars par semaine. Son accent raffiné, son doux regard et sa nonchalance décontractée lui firent endosser des rôles qui l'opposaient à des déesses de l'écran comme Mae West, Marlene Dietrich et Katharine Hepburn. Gary Cooper, ici à côté de William Anderson, « l'homme qui nourrissait le cinéma » en procurant trois repas par jour aux 500 figurants, fut une star de Hollywood pendant trente-cinq ans. Bien qu'il ait travaillé dans tous les genres : westerns, thrillers, comédies, adaptations littéraires (il joua même une vedette du base-ball), se décrit lui-même comme « Mr. Average Joe American ». On a dit de son envergure dramatique qu'elle allait du « ouais » au « non ».

1 2

BETTE Davis, Jean Harlow and Greta Garbo were all known as the vamps of the 1930s. The first became Hollywood's most enduring female star (1). Her tempestuous personality gave her a dark reputation, enhanced by a career renewed in the 1960s by the psychological thrillers *Whatever Happened to Baby Jane?* and *The Nanny*. Harlow was the 'blonde bombshell' whose locks were more platinum and cleavage more exposed than any other actress's (2). Paired with Clark Gable in five films, she played tough, funny and sexy through the 1930s. Her sudden death, aged only 26, made her last film *Saratoga* (1937) a huge box office success. Garbo's seductive but intelligent dreaminess made her 'the standard against which all other screen actresses are measured' (3). *Queen Christina*, *Ninotchka*, *Grand Hotel* and *Camille* afforded her most famous parts.

BETTE Davis, Jean Harlow und Greta Garbo galten als die drei Vamps der 30er Jahre. Bette Davis war wegen ihrer Temperamentsausbrüche gefürchtet (1). In den 60er Jahren erlebte sie mit Thrillern wie *Whatever Happened to Baby Jane?* und *The Nanny* noch einmal eine Blütezeit. Harlow war die »Sexbombe«, die platinblondere Locken und tiefere Ausschnitte hatte als jede andere Schauspielerin (2). In fünf Filmen mit Clark Gable spielte sie in den 30er Jahren ihren zähen, gewitzten und aufreizenden Frauentyp. Ihr plötzlicher Tod mit nur 26 Jahren machte aus ihrem letzten Film *Saratoga* (1937) einen Kassenschlager. Die verführerische, doch kluge Verträumtheit der Garbo macht sie zum »Standard, an dem alle anderen Schauspielerinnen sich messen müssen« (3). *Königin Christina*, *Ninotschka*, *Grand Hotel* und *Die Kameliendame* waren ihre größten Rollen.

BETTE Davis, Jean Harlow et Greta Garbo : les vamps des années 30. La première devint la vedette féminine à battre le record de longévité à Hollywood (1). Son caractère ombrageux lui fit une mauvaise réputation qu'un nouveau départ dans les années 60 avec les thrillers psychologiques *Qu'est-il arrivé à Baby Jane ?* et *La Nanny* ne fit qu'accentuer. Harlow était la « bombe blonde », aux boucles les plus platinées et au décolleté le plus large du cinéma d'alors (2). Avec Clark Gable, durant les années 30, elle joua dans cinq films qui la montrèrent solide, amusante et sexy. Sa mort soudaine, à l'âge de 26 ans, fit de son dernier film, *Saratoga* (1937), un énorme succès au box-office. Le caractère rêveur, séduisant, mais intelligent de Garbo firent d'elle « la norme à laquelle sont mesurées toutes les autres actrices » (3). *La Reine Christine*, *Ninotchka*, *Grand Hôtel* et *Camille* lui offrirent ses plus grands rôles.

CLARK Gable's reputation as King of Hollywood came with *Gone With the Wind* in 1939 (4). Later Hollywood heroes were James Dean (1) and the longer-lived Marlon Brando (5). Burt Lancaster's pin-up was taken while shooting *A Child is Waiting* with Judy Garland in 1966, at the height of his beef-cake popularity (3). His films became subtler and more inventive as he aged, ranging from Louis Malle's *Atlantic City* in 1980 to Bill Forsythe's *Local Hero* in 1983. Gregory Peck was caught during the filming of *The Million Pound Note* in 1953 (2).

2

3

4

CLARK Gable erwarb sich seinen Ruf als König von Hollywood im Jahre 1939 mit *Vom Winde verweht* (4). Spätere Hollywood-Stars waren James Dean (1) und Marlon Brando (5). Das Starphoto von Burt Lancaster entstand 1966, als er mit Judy Garland *Ein Kind wartet* drehte, auf dem Höhepunkt seiner Karriere als Muskelprotz (3). Im Alter wurde sein Spiel subtiler und charaktervoller, von Louis Malles *Atlantic City, USA* von 1980 bis zu *Local Hero* von Bill Forsythe, 1983. Das Bild von Gregory Peck entstand bei der Verfilmung von Mark Twains *Die Million-Pfund-Note* im Jahre 1953 (2).

EN 1939 Clark Gable devint le roi de Hollywood avec *Autant en emporte le vent* (4). Parmi les héros de Hollywood plus jeunes étaient James Dean (1) et – encore vivant – Marlon Brando (5). La photo de Burt Lancaster a été prise pendant le tournage de *Un enfant attend* avec Judy Garland en 1966. À l'époque, il était l'un des rois du « beefcake » (3). À mesure qu'il vieillissait, ses films devinrent plus subtils et plus inventifs, allant d'*Atlantic City* de Louis Malle, en 1980, à *Local Hero* de Bill Forsythe en 1983. Gregory Peck a été saisi sur le vif en 1953 pendant le tournage de l'adaptation du livre de Mark Twain, *Un pari de milliardaires* (2).

5

MAE West (2, in 1954) was accused of looking more female impersonator than sex symbol. She became as known for her witty ripostes as for her overblown allure (George Raft commented: 'In this picture, Mae West stole everything but the cameras'). Brigitte Bardot was the St-Tropez version, who never quite recognized the funnier aspects of some of her movies. In 1971, clearly too much *Private Life* led to her fainting while on set, and to being mobbed as she was carried off (1). Sophia Loren in the 1960s co-starred with 'cowboy actor' John Wayne in *Legend of the Lost*, coming off set in Libya to do a little extra dance for the press cameras (3).

ÜBER Mae West (2, 1954) hört man gelegentlich, sie sehe eigentlich eher wie ein Transvestit als wie ein Sexsymbol aus. Sie war ebenso bekannt für ihre schlagfertigen Antworten wie für ihre grenzenlosen Allüren (George Raft meinte dazu: »Auf diesem Photo hat Mae West alles gestohlen außer den Kameras«). Das Gegenstück in St. Tropez war Brigitte Bardot, die nie so ganz durchschaute, wie unfreiwillig komisch manche ihrer Filme sind. 1971 wurde sie, wahrscheinlich wegen zuviel *Privatleben*, bei Dreharbeiten ohnmächtig, und die Schaulustigen drängen sich, als sie abtransportiert wird (1). Sophia Loren spielte in den 60er Jahren an der Seite des Cowboydarstellers John Wayne in *Legend of the Lost*; hier gibt sie am Drehort in Libyen eine extra Tanzvorführung für die Presse (3).

ON a dit de Mae West (2, en 1954) qu'elle était plus une parodie de la femme qu'un sex-symbol. Ses ripostes spirituelles la rendirent aussi populaire que son allure extravagante (commentaire de George Raft : « Sur cette photo, Mae West vole tout sauf les caméras. »). Brigitte Bardot, la version Saint-Tropez, ne reconnut jamais vraiment les aspects plus drôles de certains de ses films. En 1971, *Vie privée* l'a manifestement affaiblie : elle s'évanouit durant un tournage avant d'être assaillie par la foule alors qu'on la transporte (1). Sophia Loren, dans les années 60, jouant aux côtés du cow-boy de l'écran, John Wayne, dans *La Cité disparue*. Venue tourner en Lybie, elle fait quelques pas de danse devant les caméras de presse (3).

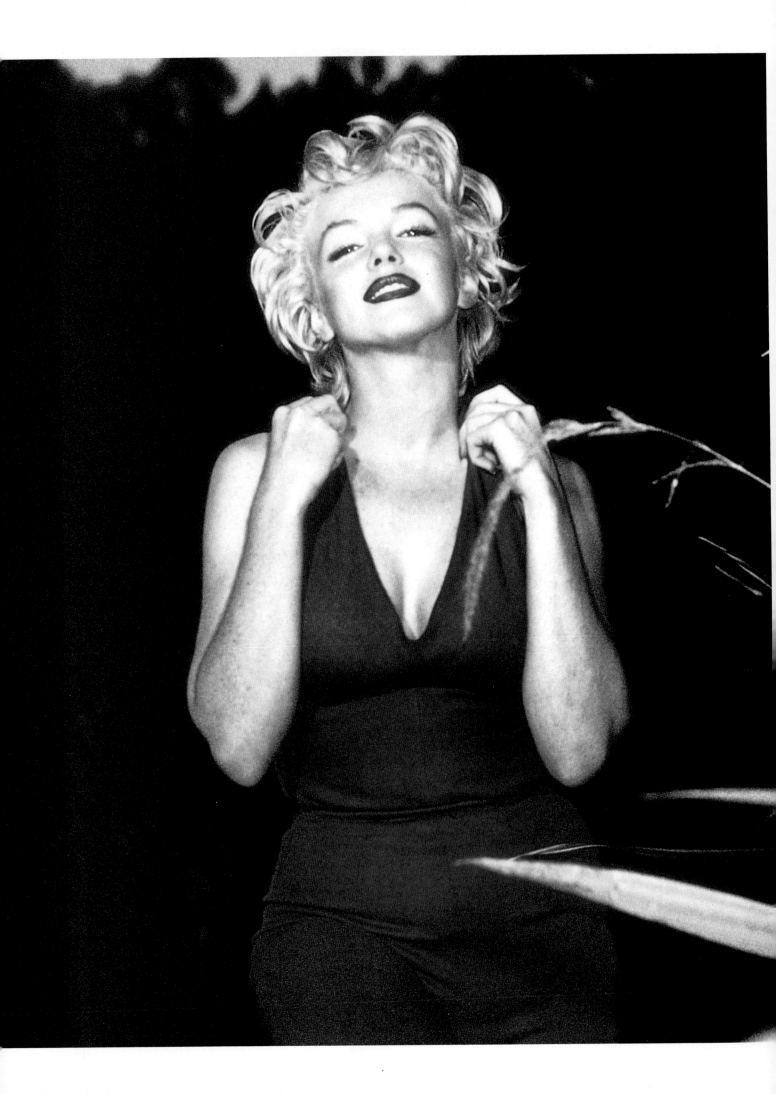

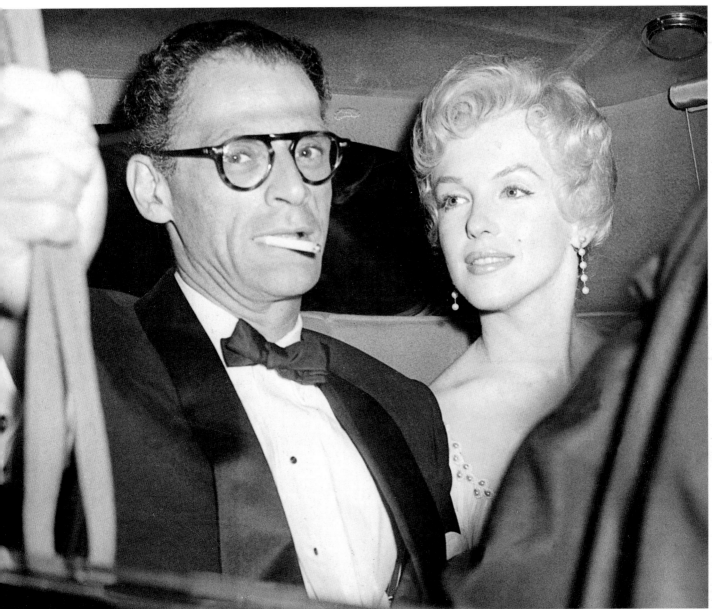

2

MARILYN Monroe (1) conserved her little-girl-lost vulnerability, dying, aged 36, of a drugs overdose before age would have caused her to outlive it. Her fragile sexiness and breathy singing are best seen and heard in *Gentlemen prefer Blondes* and *How to Marry a Millionaire* (both 1953); *The Seven Year Itch* (1955); *Bus Stop* (1957) and *Some Like it Hot* (1959). Seeking to go beyond her dumb blonde/gold-digger roles, in 1961 she starred in *The Misfits*, written for her by the leading playwright (and her last husband) Arthur Miller. British playwright Terence Rattigan was also the author of *The Prince and the Show-girl*, in which she starred with Laurence Olivier. Here, in 1957, Monroe and Miller are on their way to attend a party given by Rattigan (2).

MARILYN Monroe (1) erweckte bis zuletzt das Bild des verirrten kleinen Mädchens und starb mit 36 an einer Überdosis Tabletten, bevor sie zu alt für diese Rolle wurde. Ihre fragile Erotik und die schüchterne Singstimme sind am besten in *Blondinen bevorzugt, Wie angelt man sich einen Millionär?* (beide 1953), *Das verflixte siebente Jahr* (1955), *Bus Stop* (1957) und *Manche mögen's heiß* (1959) zu sehen und zu hören. Sie wollte mehr spielen als nur das blonde Dummchen, und so übernahm sie die weibliche Hauptrolle in *Nicht gesellschafts-fähig* (1961) nach einem Stück des führen-den amerikanischen Dramatikers Arthur Miller, der auch ihr letzter Ehemann war. Millers britischer Kollege Terence Rattigan lieferte die Vorlage zu *Der Prinz und die Tänzerin*, in dem sie zusammen mit Lau-rence Olivier spielte. Hier sieht man die Monroe und Miller 1957, unterwegs zu einer Party bei Rattigan (2).

MARYLIN Monroe (1) resta la petite fille désemparée, disparue à 36 ans d'une overdose avant que l'âge lui fit perdre sa vulnérabilité. On la voit et on peut écouter sa voix fragile, sensuelle et un rien haletante dans des films comme *Les Hommes préfèrent les blondes*, et *Comment épouser un millionnaire* (tournés en 1953) ; *Sept Ans de réflexion* (1955) ; *Bus Stop* (1957) et *Certains l'aiment chaud* (1959). Cherchant à aller au-delà de ses rôles de petite blonde niaise, elle jouera en 1961 dans *Les Désaxés*, écrit pour elle par le grand dramaturge Arthur Miller, son dernier mari. Le dramaturge britannique, Terence Rattigan, était égale-ment l'auteur du *Prince et la Danseuse,* où elle donne la réplique à Laurence Olivier. Ici, en 1957, Marylin Monroe et Arthur Miller au cours d'une fête donnée par Rattigan (2).

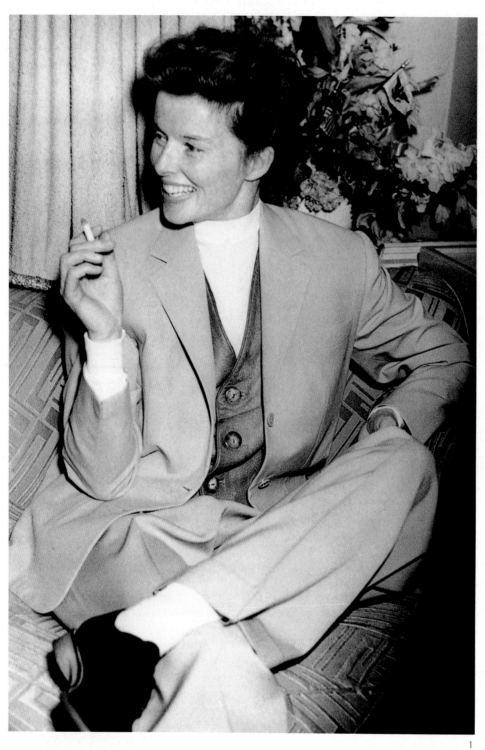

IM Laufe ihrer außerordentlich langen Karriere errang Katharine Hepburn vie Oscars als beste Hauptdarstellerin, mehr a jede andere (1). Zwei ihrer liebsten Filme *Leoparden küßt man nicht* und *Holiday* (beid 1938), fielen beim zeitgenössischen Publikum durch, so daß sie als »Kassengift« galt. Doch sowohl die neun Filme, die sie mit Spencer Tracy drehte, von der frühen *Philadelphia Story* an (1939, ein Film, an dem sie mit ihrem bemerkenswerten Geschäftssinn auch die Rechte erwarb) wi auch die späte *African Queen* (1951), wo si zusammen mit Humphrey Bogart spielte, waren sehr erfolgreich. Lauren Bacall war natürlich nicht nur auf der Leinwand, sondern auch im Leben Bogarts Partnerin (2). Ihre größten Erfolge waren *Tote schlafen fest* (1946), *Dark Passage* (1947) und *Gangster in Key Largo* (1948); später kehrte sie zu den Broadway-Shows zurück, in dener sie angefangen hatte, und eroberte sich ein neues Publikum.

FAIT sans précédent, Katharine Hepbur obtint quatre fois l'Oscar de la meilleur interprète au cours de sa carrière exceptionnellement longue (1). Deux de ses films favoris, *L'impossible Mr. Bébé* et *Vacances* (tous deux tournés en 1938), n'ont pas connu le succès à l'époque, lui valant la réputation de « poison » du box-office. Mais les neuf films qu'elle réalisa avec Spencer Tracy, ainsi que *Philadelphia Story* en 1939 (dont Katharine Hepburn acquit les droits, faisant aussi preuve d'un grand sens des affaires) et le film ultérieur *African Queen* (1951), qui la met face à Humphrey Bogart, furent de grands succès. Lauren Bacall était évidemment la partenaire de Bogart à l'écran comme en privé (2). Ses plus grands succès restent *Le Grand Somme* (1946), *Les Passagers de la nuit* (1947) et *Ke Largo* (1948), bien qu'elle recommençât plus tard une carrière et conquis un nouveau public avec des spectacles à la mode à Broadway.

1

KATHARINE Hepburn won an unprecedented four Oscars for Best Actress throughout her exceptionally long career (1). Two of her own favourites (*Bringing Up Baby* and *Holiday*, both 1938) were contemporary flops, giving her the label of 'box office poison'. But the nine films she made with Spencer Tracy, as well as the earlier *Philadelphia Story* (1939, to which, with considerable business acumen, Hepburn bought film rights) and the later *African Queen* (1951), playing opposite Humphrey Bogart, were hugely successful. Lauren Bacall was, of course, Bogart's partner on and off screen (2). Their greatest hits were *The Big Sleep* (1946), *Dark Passage* (1947) and *Key Largo* (1948), though latterly she returned to and won new audiences in mainstream Broadway shows.

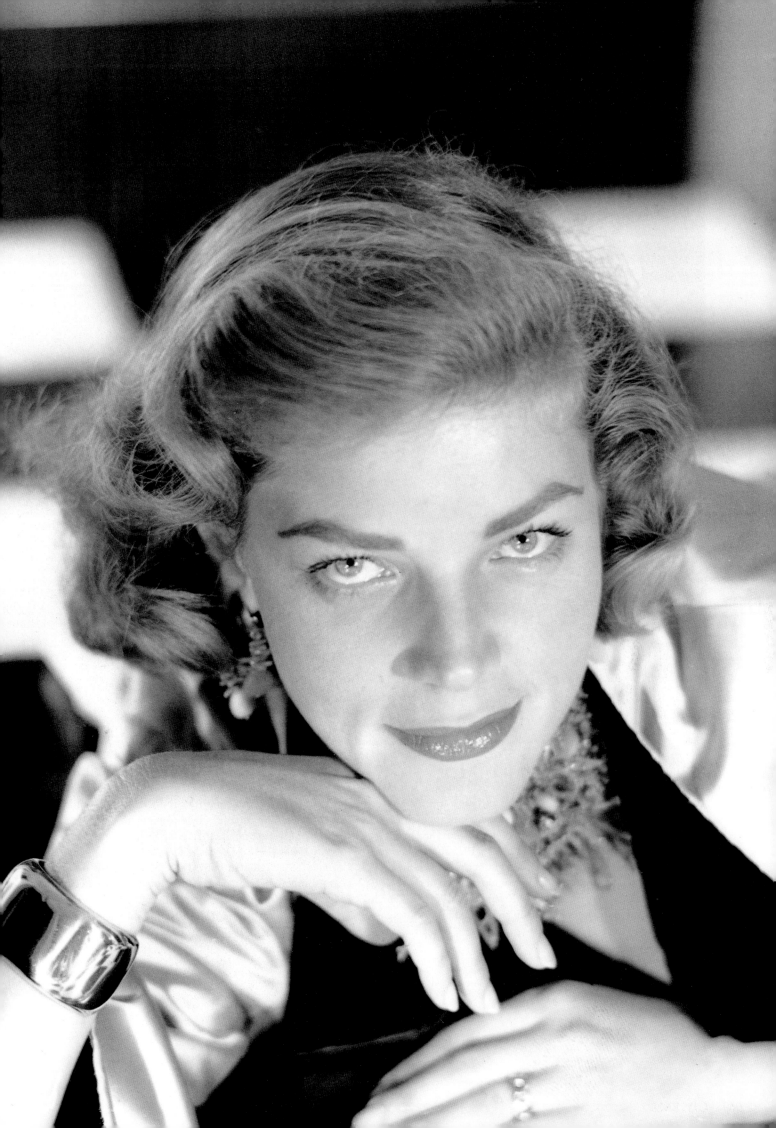

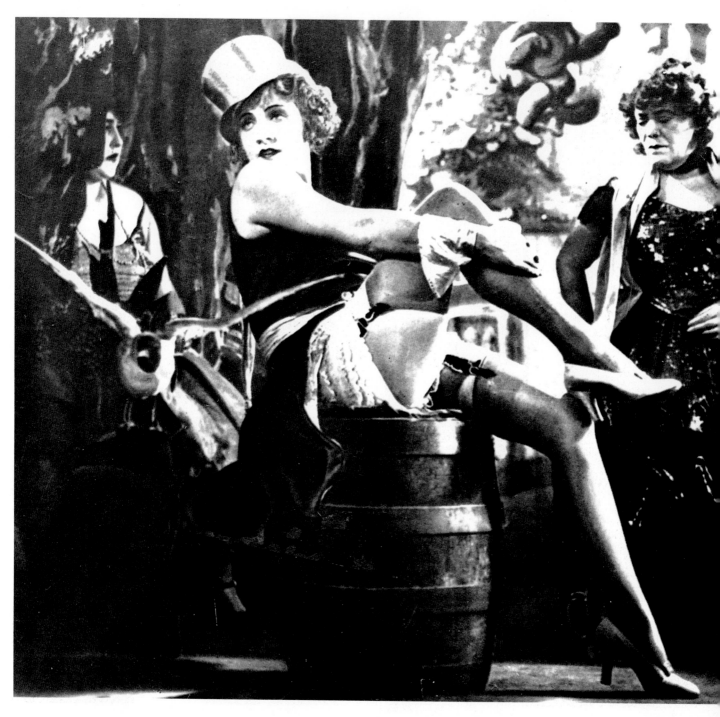

FOLLOWING the stunning impact of *The Blue Angel* (1), Marlene Dietrich became the first of a generation of smoky-voiced, androgynous stars of both screen and cabaret (2). Despite the lampshade millinery she excelled in elegance in such films as *Blonde Venus* (1932), *The Scarlet Empress* (1934) and *The Devil is a Woman* (3). It was after the latter film that in 1935 she applied to become a US citizen, in order to elude Hitler's reiterated invitations to her to 'return home' and – paradoxically – her career dived. It began to revive with *Destry Rides Again* (1939), in which she was teamed with James Stewart in an inspired bit of casting.

MIT dem gewaltigen Eindruck, den sie im *Blauen Engel* machte wurde Marlene Dietrich zum Prototyp einer ganzen Generation von Leinwand- und Kabarettstars, allesamt androgyn und mit rauchiger Stimme (2). Selbst mit einem Lampenschirm auf dem Kopf war sie noch ein Muster an Eleganz in Filmen wie *Die blonde Venus* (1932), *Die große Zarin* (1934) und *Die spanische Tänzerin* (3). Nach diesem Film, 1935, beantragte sie die amerikanische Staatsbürgerschaft, um sich Hitlers wiederholten Einladungen zur »Rückkehr nach Hause« zu entziehen. Paradoxerweise ging es danach mit ihrer Karriere abwärts, und ihr nächster Erfolg kam erst 1939 mit *Der große Bluff*, wo sie – eine inspirierte Idee – an der Seite von James Stewart spielte.

1
2

3

SUITE à l'impact stupéfiant que connut *L'Ange bleu* (1), Marlene Dietrich devint la première d'une génération de stars de l'écran et du cabaret à la silhouette androgyne et au timbre voilé par le tabac (2). En dépit de la coiffure en abat-jour qu'elle porte ici, elle brillait par son élégance dans des films comme *Blonde Vénus* (1932), *L'Impératrice rouge* (1934) et *La Belle Ensorceleuse* (3). C'est après ce dernier film qu'elle demanda, en 1935, la citoyenneté américaine afin de mettre fin aux invitations répétées de Hitler, qui lui demandait de « rentrer à la maison » et – paradoxalement – sa carrière en pâtit. Le succès lui sourit à nouveau avec des films comme *Les Deux Cavaliers* (1939), où elle a pour partenaire James Stewart.

HUMPHREY Bogart and Katharine Hepburn, not up the Zambesi but at Britain's Isleworth studios during the filming of a storm-lashed scene from *The African Queen* (1). As soon as this last scene was shot, Bogart bailed out and scrambled on board the Île de France to sail for home with wife Lauren Bacall and son Stevie.

Some years before, in 1938, Hepburn proved she was no slouch, practising an acrobatic feat for *Holiday* with Cary Grant (2). Audrey Hepburn on set, discussing what must be her most unlikely role as the Cockney flower-seller Eliza in *My Fair Lady* with director George Cukor in 1964 (3).

HUMPHREY Bogart und Katharine Hepburn fahren den stürmischen Sambesi hinauf, und zwar in den englischen Isleworth-Studios während der Aufnahmen zu *African Queen* (1). Als diese letzte Szene im Kasten war, hielt Bogart nichts mehr: Er ging an Bord der Île de France und fuhr mit Ehefrau Lauren Bacall und Sohn Stevie nach Hause. Ein paar Jahre zuvor, 1938,

2 3

ewies Hepburn ihre akrobatischen Talente in *Holiday* mit Cary Grant, hier bei der Probe (2). Audrey Hepburn bei Aufnahmen im Jahre 1964 (3). Sie diskutiert mit Regisseur George Cukor ihre Rolle als Cockney-Blumenmädchen Eliza in *My Fair Lady*, unter allen Figuren, die sie verkörperte, diejenige, die man sich am wenigsten bei ihr vorstellen konnte.

HUMPHREY Bogart et Katharine Hepburn ne remontent pas le Zambèze, ils sont aux studios de Britain's Isleworth où se tourne la scène d'orage d'*African Queen* (1). À peine cette dernière scène fut-elle en boîte que Bogart s'éclipsa et grimpa à bord de *l'Île de France* pour rentrer chez lui avec sa femme Lauren

Bacall et son fils Stevie. Quelques années plus tôt, en 1938, Hepburn avait prouvé sa bonne condition physique, réalisant dans *Vacances,* avec Cary Grant, des prouesses acrobatiques (2). Audrey Hepburn en scène, discutant de ce qui sera son rôle le plus invraisemblable, la vendeuse de fleurs populaire, Eliza, dans *My Fair Lady,* réalisé par George Cukor en 1964 (3).

1

2

3

4

5

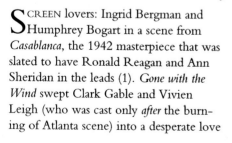

Screen lovers: Ingrid Bergman and Humphrey Bogart in a scene from *Casablanca*, the 1942 masterpiece that was slated to have Ronald Reagan and Ann Sheridan in the leads (1). *Gone with the Wind* swept Clark Gable and Vivien Leigh (who was cast only *after* the burning of Atlanta scene) into a desperate love story that also caught the mood of the times (1939). Rhett Butler's infamous 'Frankly, my dear, I don't give a damn' became the statutory rat's farewell, against the epic backdrop of the Civil War (2). Claude Rains, known for bouffant hairstyles and boxes to add height to his love scenes, here plays to Bette Davis in *Deception* (3). James Mason and Margaret Lockwood donned stagecoach costume for *The Wicked Lady* (4) and Richard Burton breeches and doublet for his *Hamlet* to Claire Bloom's balletic Ophelia (5). Gloria Swanson and William Holden (6) have a lovers' tiff in Billy Wilder's *Sunset Boulevard* (1950).

LIEBESPAARE auf der Leinwand: Ingrid Bergman und Humphrey Bogart in einer Szene aus *Casablanca*, dem Meisterwerk von 1942, für dessen Hauptrollen ursprünglich Ronald Reagan und Ann Sheridan vorgesehen waren (1). *Vom Winde verweht* warf Clark Gable und Vivien Leigh (die erst für die Rolle ausgesucht wurde, als der Brand Atlantas schon gedreht war) in eine verzweifelte Liebesgeschichte, die ganz der Stimmung der Zeit entsprach (1939). Rhett Butlers berüchtigtes »Offen gesagt ist mir das gleichgültig« vor dem epischen Hintergrund des Bürgerkriegs wurde zum Standard-Abschiedsgruß des Leinwandschurken (2). Claude Rains, der mit fülligem Haar und manchmal auch mit einer Kiste seinen Liebesszenen Größe verlieh, hier zusammen mit Bette Davis in *Deception* (3). James Mason und Margaret Lockwood warfen sich für *The Wicked Lady* in Kostüme der Postkutschenzeit (4), Richard Burton für *Hamlet* in Wams und Kniehose mit Claire Blooms als Ophelia, die eher wie eine Balletteuse wirkt (5). Bei Gloria Swanson und William Holden geht es in Billy Wilders *Boulevard der Dämmerung* (1950) hoch her (6).

LES amants du cinéma : Ingrid Bergmann et Humphrey Bogart dans une scène de *Casablanca*, le chef-d'œuvre de 1942 qui faillit compter Ronald Reagan et Ann Sheridan dans les rôles principaux (1). *Autant en emporte le vent* entraîne Clark Gable et Vivian Leigh (qui ne joua le rôle qu'après la scène de l'incendie d'Atlanta) dans une histoire d'amour désespérée qui reflétait aussi l'esprit du temps (1939). Le mot infâme de Rhett Butler : « Franchement, mon petit, je m'en fiche comme d'une guigne » devint l'adieu notoire du traître, sur la toile de fond épique de la guerre civile (2). Claude Rains, connu pour ses coiffures bouffantes et ses gifles censées donner de l'épaisseur à ses scènes amoureuses, joue ici à côté de Bette Davis dans *Déception* (3). James Mason et Margaret Lockwood, en costumes de diligence pour tourner *The Wicked Lady* (4) ; Richard Burton en chausses et pourpoint dans *Hamlet,* avec Claire Bloom en Ophélie dansante (5). Gloria Swanson et William Holden (6) ont une petite querelle amoureuse dans *Boulevard du crépuscule* (1950).

6

THUNDER and lightning on set to accompany Maurice Chevalier's 20th Century Fox hit *Folies Bergère* in 1935 (1). Since Chevalier was made to take second billing to actress Grace Moore, he did not return to Hollywood until 1956. Similar musical style is adopted by a dancing James Cagney in Warner Bros' *Yankee Doodle Dandy* (3). Paul Whiteman as *The King of Jazz* and his orchestra making music on a

grand scale (2), seated at a piano built for ten hands (1930).

EIN Bühnengewitter für Maurice Chevaliers in *Folies Bergère*, 1935 ein großer Erfolg der 20th Century Fox (1). Chevalier verließ Hollywood aus Empörung darüber, daß sein Name erst an zweiter Stelle nach Partnerin Grace Moore genannt wurde, und kehrte erst 1956 zurück. Ähnliche Musical-

Elemente verwendete *Yankee Doodle Dandy* der Warner Bros., das einen tanzenden James Cagney zu bieten hatte (3). Paul Whiteman macht mit seinem Orchester in *The King of Jazz* Musik im großen Stil (2), an einem Klavier für zehn Hände (1930).

TONNERRE et lumières accompagnent le succès de la 20th Century Fox : *Folies Bergère* (1935) avec Maurice Chevalier (1).

Comme Chevalier devait passer au pro-
gramme à la suite de l'actrice Grace Moore,
il ne remit plus les pieds à Hollywood avant
1956. James Cagney a adopté un style simi-
laire pour danser dans *Yankee Doodle Dandy*
(3) de Warner Bros. Paul Whiteman, *Le Roi
du jazz* et son orchestre font de la musique
à grande échelle (2), assis devant un piano
construit pour dix mains (1930).

ORSON Welles as Harry Lime in
Carol Reed's adaptation of Graham
Greene's story *The Third Man*. Made in
1949, it was one of the few films to tackle
directly the sensitive theme of war racket-
eering by Allied Forces and the growing
rift between east and west Europeans in the
divided city of Vienna. Its most famous
scenes were set at the top of the Ferris
wheel in the Prater Gardens and inside the
city's underground sewers.

ORSON Welles als Harry Lime in
Der dritte Mann. Carol Reeds 1949
entstandener Film nach einer Vorlage von
Graham Greene war einer der wenigen,
die sich wirklich mit dem heiklen Thema
des Schwarzhandels der Alliierten in der
geteilten Stadt Wien und mit der immer
größer werdenden Kluft zwischen Ost-
und Westeuropa auseinandersetzten. Die
berühmtesten Szenen spielten auf dem
Riesenrad im Prater und in den Abwasser-
kanälen der Stadt.

ORSON Welles interprétant Harry Lime
dans l'adaptation cinématographique
par Carol Leed du livre de Graham Greene,
Le Troisième Homme. Réalisé en 1949, ce
fut un des rares films à attaquer de front le
sujet délicat des activités criminelles des
forces alliées durant la guerre, et la fissure
croissante entre les Européens de l'Est et de
l'Ouest à Vienne, cité en pleine division.
Les scènes les plus célèbres ont été prises au
sommet de la Grande Roue dans les jardins
du Prater et dans les égouts souterrains de
la ville.

FRED and his sister Adele Astaire dance on the roof of London's
Savoy Hotel in 1923 (1); a diminutive Mickey Rooney and
Judy Garland attend the Ice Follies (2); and Bogie, Bacall and son
Stevie stroll on Southampton docks in 1951 before going home (3).

FRED Astaire tanzt mit seiner Schwester Adele auf dem Dach
des Londoner Savoy-Hotels, 1923 (1); der kleine Mickey
Rooney besucht mit Judy Garland eine Eisrevue (2); und Bogie,
Bacall und Sohn Stevie machen 1951 einen Spaziergang in
den Docks von Southampton, bevor sie das Schiff zur Heimfahrt
besteigen (3).

FRED Astaire et sa sœur, Adele, dansent sur le toit de l'hôtel
Savoy à Londres en 1923 (1) ; Mickey Rooney, minuscule, et
Judy Garland assistent aux Ice Follies (2) ; Bogie, Bacall et leur
fils Stevie flânent sur les quais de Southampton en 1951 avant de
rentrer chez eux (3).

PAUL Newman gets behind the camera to check a shot (1). The 20-month-old Natasha Richardson shoves her camera in for a close-up of newborn sister Joely (2), held by their famous actress mother, 27-year-old Vanessa Redgrave (1965). Peter Sellers takes the director's chair from his Swedish wife Britt Ekland during filming of Vittorio de Sica's *Caccia alla Volpe* at Sant'Angelo d'Ischia (3).

PAUL Newman begibt sich hinter die Kamera, um eine Einstellung zu prüfen (1). Die zwanzigmonatige Natasha Richardson macht eine Nahaufnahme von ihrer erst ein paar Tage alten Schwester Joely im Arm ihrer Mutter, der damals 27jährigen Vanessa Redgrave (1965, 2). Peter Sellers läßt sich im Stuhl seiner Ehefrau Britt Ekland nieder, in Sant'Angelo d'Ischia während der Dreharbeiten zu Vittorio de Sicas *Jagt den Fuchs* (3).

PAUL Newman surveille la prise de vue derrière la caméra (1). Natascha Richardson, âgée de vingt mois, pousse son appareil-photo pour faire un gros plan de sa sœur Joely, laquelle vient de naître (2). Leur mère, la célèbre actrice Vanessa Redgrave, 27 ans, lui vient en aide (1965). Peter Sellers emprunte le fauteuil de régie de son épouse suédoise Britt Ekland sur le tournage du film de Vittorio de Sica *La Chasse au renard* à Sant'Angelo d'Ischia (3).

1 2

SCHOOLCHILDREN in 1937, queuing to see a matinée performance of *Flash Gordon* in East London. Saturday cinema rapidly gained popularity as a whole new experience, a definite improvement on merely reading about comic strip heroes, and the ultimate in safe and relatively cheap babysitting for harassed working parents. Here the cinema manager polices an orderly queue of unaccompanied children, many wearing their school caps and all clutching their penny-ha'penny (less than 1p) admission money (1). For this they would get two full-length feature films and a newsreel that would only change every few months, and often functioned more as a piece of geographical reportage and political propaganda than as up-to-the-minute news. Still, to judge from both the extent of the preparation (the usher going down the checklist in front of the mirror, for one – 2) and the results (the children shrinking from the action in delighted horror – 3), everyone emerged well satisfied.

SCHULKINDER stehen 1937 im Londoner East End an, um eine Matineevorstellung von *Flash Gordon* zu sehen. Der samstägliche Besuch im Kino erfreute sich großer Beliebtheit und war ein ganz neuartiges Erlebnis, viel besser, als wenn man über die Comic-Helden nur lesen konnte – und für überbeanspruchte Eltern das Ideal eines sicheren und vergleichsweise billigen Kinderhorts. Hier sorgt der Leiter des Kinos dafür, daß sie ordentlich antreten, viele in Schulkappen und alle mit den anderthalb Pence (weniger als ein heutiger Penny) Eintrittsgeld in der Hand (1). Dafür bekamen sie zwei ganze Filme und eine Wochenschau zu sehen, die oft nur alle paar Monate wechselte und daher wenig Neues, dafür aber geographisches Lehrmaterial und politische Propaganda brachte. Doch wohlvorbereitet, wie alles war (zum Beispiel hatte der Platzanweiser einen Spiegel mit Checkliste, damit er immer adrett aussah, 2), und auch nach dem Blick in den Saal zu urteilen (Kinder, die vor den entsetzlichen Geschehnissen auf der Leinwand zurückschrecken, 3), waren alle zufrieden.

DES écoliers font la queue en 1937 dans l'Est de Londres pour voir la projection de *Flash Gordon* en matinée. Le cinéma du samedi gagne rapidement en popularité : c'est une expérience nouvelle, une amélioration par rapport à la simple lecture des bandes dessinées, et fin du fin pour des parents harassés par le travail et voulant faire garder leurs enfants sans danger et à bon marché. Ici, le directeur du cinéma fait se ranger les enfants non accompagnés en une belle file. Beaucoup portent leurs casquettes d'écolier et tous tiennent bien serré leur *penny-ha'penny* (moins qu'un penny), prix d'entrée de la séance (1). Pour ce prix, ils assisteront à deux films long métrage et à des actualités qui restent plusieurs mois à l'affiche. Ce sont plus souvent des reportages géographiques et de la propagande politique que des nouveautés. En tout cas, à en juger par l'étendue des préparatifs (le placeur étudie les différents points de la liste de contrôle dans le miroir, 2) et les résultats (les enfants blottis dans leurs fauteuils sont en proie à une terreur délicieuse, 3), chacun sort fort satisfait.

HOLLYWOOD became synonymous with cinema in the 1930s and 40s. Many exiles from Nazi Europe joined the westward drift to contribute to the rapid expansion of the silver screen. The Californian climate also gave rise to a fresh dimension of the American Dream. If everyone was to own a smart car, then cinemas themselves would have to accommodate this. In the 1950s, a time of gas-guzzling Chevrolets, Oldsmobiles and Thunderbirds, roadsters with white tyres, wide wings and chromium teeth – the 'drive-in' was born (1). Your car was an additional fashion accessory, an extra-flashy outfit; bus-boys came and served the regulation hot dog and soda on a tray hooked into the window; the giant screen afforded but part of the entertainment, which also involved going as far as you could with your girl, or stopping the next driver from necking with his. That said, in this instance one driver is a woman, a far more common sight than in Europe at the time (2).

IN den 30er und 40er Jahren wurde Hollywood zum Synonym für Kino. Viele Flüchtlinge aus Nazieuropa ließen sich weiter nach Westen treiben und trugen ihren Teil zum kometenhaften Aufstieg der Filmstadt bei. Das kalifornische Klima gab auch dem Amerikanischen Traum eine ganz neue Dimension. Wenn nun jeder mit einem schicken Wagen kam, dann mußte auch das Kino entsprechend dafür eingerichtet sein. In den 50er Jahren, in der Zeit der Chevrolets, Oldsmobiles und Thunderbirds – der Straßenkreuzer mit ihren Weißwandreifen, Heckflossen und gewaltigen Chromkühlern –, entstand das »Drive-in« (1). Der eigene Wagen wurde zu einem Teil der Mode, er war ein eleganter Anzug; Servierer hängten ein Tablett am Fenster ein und brachten den unvermeidlichen Hot Dog mit Sodawasser; die gewaltige Leinwand war dabei nur ein Teil der Attraktion, denn es ging ja auch darum, bei seinem Mädchen so weit zu kommen wie nur möglich oder wenigstens den Nachbarn daran zu hindern, mit seinem zu knutschen. Immerhin haben wir hier einmal eine Frau am Steuer (2), in Amerika damals schon weit häufiger zu sehen als in Europa.

C'EST au cours des années 30 et 40 que le mot Hollywood devint synonyme de cinéma. De nombreux exilés, fuyant le nazisme en Europe, arrivèrent et contribuèrent à la rapide expansion du septième art. En outre, le climat californien fit beaucoup pour conférer une dimension nouvelle au rêve américain. Tandis que tout un chacun désirait posséder une voiture chic, les cinémas eux-mêmes devaient s'en accommoder. Ce sont les années 50, à l'époque des Chevrolet, Oldsmobile, Thunderbird et autres gouffres à essence – les routières à pneus blancs, larges ailes et dents de chrome –, qui ont vu naître le *drive-in*. La voiture, devenue un accessoire à la mode, était d'un tape-à-l'œil extrême ; les garçons de bus venaient et servaient les hot dogs et cocas de rigueur sur un plateau accroché à la fenêtre ; l'écran géant, qui ne représentait qu'une partie du divertissement, invitait à aller aussi loin que possible avec sa petite amie ou empêchait le conducteur d'à côté de bécoter la sienne. Cela dit, scène bien plus répandue qu'en Europe, ici c'est une femme qui tient le volant (2).

The Changing Role of Women

SINCE at least Roman times there has been debate over whether women who 'sell themselves' into arranged matches with wealthy men are in essence doing anything very different from the women who offer a more short-term sexual union in return for money. The 'season' of débutante parties (such as this 1950s Red Cross ball, 1) and social events which still takes place in Britain and to a lesser extent elsewhere is a vestige of the arranged marriage system.

Throughout history women were bartered much as other forms of investment or currency. The brokers were usually men, a father if the 'marriage market' were being played; a pimp if the girl were being sold on the streets. It was only when women themselves could become the agents of change that their situation altered.

The long campaign to obtain the vote for women aimed to help them to step from the domestic to the political arena. Women had been grudgingly accorded token recognition within various education systems, so long as their betterment should not lead them beyond the home to outside spheres of influence. It was further determined that women's voting be tied to property rights – a way of reducing both the gender and the class component of the franchise, since women were considerably less likely to be house-owners. Switzerland was the last 'developed' country to grant women the vote – only in 1971.

Worldwide, even in the 1990s, women compose half of the world's population; perform two-thirds of its work; earn 10 per cent of its income and own 1 per cent of its wealth. Even recent campaigns such as that for 'equal work for equal pay', which resulted in the 1976 Equal Pay and Sex Discrimination Acts in Britain, still leave a majority of women worse off than their male counterparts. And if it is hard to achieve even the implementation of existing legislation based on broad consensus, it is far harder to guarantee equal rights in more controversial areas to do with female sexuality and fertility; childcare and education; sexual harassment and exploitation.

1

MINDESTENS seit den Zeiten der alten Römer wird darüber debattiert, ob Frauen, die sich für eine ausgehandelte Ehe mit einem reichen Mann »verkaufen«, nicht im Grunde das Gleiche tun wie Frauen, die in zeitlich begrenzterem Rahmen ihren Körper für Geld feilbieten. Die »Saison« der Debütantinnenbälle und anderer sozialer Ereignisse (hier ein Rotkreuzball in den 50er Jahren, 1), die es auch heute noch in Großbritannien und in geringerem Maße in anderen Ländern gibt, ist ein Überbleibsel der Zeit, als Ehen ausgehandelt wurden.

In vergangenen Zeiten wurden Frauen wie Investitionsgüter oder Geld gehandelt. Die Händler waren meist Männer – der Vater, wenn es um den »Ehemarkt« ging, ein Zuhälter, wenn es ein Straßenmädchen war. Erst als Frauen die Macht bekamen, selbst etwas dagegen zu unternehmen, änderten sich die Verhältnisse.

Das Wahlrecht, um das die Frauen so lange kämpfen, sollte das Mittel sein, von der häuslichen in die politische Arena zu gelangen. Nur widerwillig war den Frauen Zugang zu gewissen Bildungseinrichtungen gewährt worden, und auch das nur pro forma und nicht mit dem Ziel, daß sie mit ihrer Universitätsbildung hinaus in die Öffentlichkeit gingen und Einfluß nahmen. Außerdem war das Frauenwahlrecht noch lange an Grundbesitz geknüpft, wodurch Frauen sexuell wie sozial diskriminiert wurden, denn sie waren weitaus seltener Hausbesitzer. Die Schweiz war die letzte unter den Industrienationen, die Frauen das Wahlrecht gewährte – erst 1971.

Selbst heute stellen Frauen zwar die Hälfte der Weltbevölkerung und leisten zwei Drittel aller Arbeit, doch verdienen sie nur zehn Prozent des Gesamteinkommens und besitzen nur ein Prozent aller Vermögen. Auch nach den Kampagnen unserer Tage wie etwa den Aktionen unter dem Motto »gleicher Lohn für gleiche Arbeit«, die 1976 in Großbritannien zu Antidiskriminierungsgesetzen führten, steht ein Großteil der Frauen schlechter da als vergleichbare Männer. Und wenn es schon schwer ist, bestehende Gesetze durchzusetzen, die von einer breiten Mehrheit befürwortet werden, dann ist es noch weitaus schwieriger, Gleichberechtigung in strittigeren Bereichen zu erlangen, in Fragen der weiblichen Sexualität, der Kindererziehung und der sexuellen Belästigung und Ausbeutung.

LE débat date au moins de la Rome antique : les femmes des unions arrangées avec des hommes riches font-elles vraiment autre chose que monnayer leurs corps ? Le « bal des débutantes » (ici, par exemple en 1950, le bal de la Croix-Rouge, 1) et d'autres événements de la vie sociale qui ont toujours existé en Grande-Bretagne et à un degré moindre ailleurs, sont un vestige du système des mariages arrangés.

Tout au long de l'Histoire, les femmes ont été échangées plus que toute autre forme d'investissement ou de monnaie. Les courtiers étaient habituellement des hommes, un père si on jouait au « marché du mariage » ; un souteneur, si la fille devait être vendue dans les rues. La situation des femmes ne changea que lorsqu'elles purent devenir elles-mêmes agents de change.

La longue campagne en vue d'obtenir le droit de vote pour les femmes visait à les aider à sortir de l'arène domestique pour entrer dans l'arène politique. On avait accordé aux femmes, de mauvaise grâce, une reconnaissance symbolique par des systèmes variés d'éducation, aussi longtemps que leurs progrès ne les amenaient pas à sortir de leur foyer pour entrer dans les sphères extérieures d'influence. De plus, on avait décidé que le vote des femmes serait lié aux droits à la propriété – une façon de réduire à la fois le nombre de participants féminins aux élections et de manipuler la composition sociale, puisque les femmes étaient probablement assez rarement propriétaires de leur maison. La Suisse a été le dernier pays « développé » à reconnaître le droit de vote aux femmes – ce fut seulement en 1971.

À l'échelle planétaire, même dans les années 90, les femmes composent près de la moitié de la population mondiale ; elles exécutent les deux tiers du travail ; gagnent 10 % des revenus et possèdent 1 % des richesses. Même si des campagnes récentes, dans le genre « à travail égal, salaire égal », qui résultent des lois de 1976 sur l'égalité du salaire et la discrimination sexuelle, la plupart des femmes restent, aujourd'hui encore, moins bien payées que leurs homologues masculins. Et s'il est déjà difficile de seulement imposer l'application de la législation existante basée sur un consensus général, il s'avère plus compliqué encore de garantir l'égalité des droits dans des domaines plus controversés traitant de la sexualité de la femme et de sa fertilité ; des crèches et de l'instruction ; du harcèlement sexuel et de l'exploitation.

THESE Barcelona 'ladies of the night' bargain with a prospective client under posters advertising a comedy called *If Eve were a Flirt* (1). Although firmly prohibited from street-soliciting by Franco's draconian laws, in 1951 these women were so hungry that their fee was a loaf of bread. In 1940s Hamburg there was already a street licensed for prostitution. Each woman has her own room and washroom – and her own windowsill from which to dangle her legs (2).

SCHÖNHEITEN der Nacht« in Barcelona verhandeln mit einem interessierten Kunden unter Plakaten für eine Komödie namens *Wenn Eva flirtet* (1). Zwar war die Straßenprostitution unter den drakonischen Gesetzen Francos streng verboten, doch diese Frauen im Jahre 1951 waren so hungrig, daß sie es für einen Laib Brot taten. In Hamburg gab es schon in den 40er Jahren eine Straße mit legaler Prostitution. Jede Frau hatte ihr eigenes Zimmer mit Waschgelegenheit – und ein eigenes Fensterbrett, von dem sie die Beine baumeln lassen konnte (2).

CES « reines de la nuit » barcelonaises négocient avec un client potentiel sous des affiches présentant une comédie intitulée *If Eve were a Flirt* (1). Malgré la ferme interdiction du racolage, promulguée en 1951 par Franco, ces femmes avaient si faim qu'elles se vendaient pour une miche de pain.

En 1940, à Hambourg, il existait déjà une rue où l'on permettait la prostitution. Chaque femme disposait de sa chambre, de sa salle de bains et de son rebord de fenêtre, comme celui sur lequel cette femme est assise, les jambes pendantes (2).

Bᴿᴼᵀᴴᴱᴸ keeper Cyn Payne, Madam Cyn (1), clearly showed initiative on more than the choice of her name. In the 1980s she claimed to have been visited by many eminent Tory Party members. While gentlemen prefer private clubs (2), humbler punters took to the streets where

the women posed at their windows (3). Baghdad has a 'shopping street' for the trade in women's bodies (5), while in 1930s Calcutta (4) and Cairo (6) women are transported and caged like animals in order to force them into prostitution.

Dɪᴇ Bordellbesitzerin Cyn Payne, genannt Madam Cyn (1), behauptete in den 80er Jahren, ihr Etablissement sei von zahlreichen Mitgliedern der Konservativen Partei frequentiert worden. Während der feine Herr Clubs bevorzugte (2), zog der einfache Mann durch die Straßen, wo

4

5

6

Frauen sich an den Fenstern feilboten (3). Bagdad hat eine »Einkaufsstraße« für Frauenkörper; in den 30er Jahren hingegen wurden Frauen in Kalkutta (4) und Kairo (6) wie Tiere in Käfigen gehalten und zur Prostitution gezwungen.

L A gardienne de bordel Cyn Payne, Madame Cyn (1), a fait preuve d'une initiative manifeste. En 1980, elle a affirmé avoir reçu la visite de membres éminents du parti conservateur. Tandis que le monsieur distingué préfère des clubs privés (2), les clients plus humbles allaient dans les

rues où les femmes posaient dans leurs fenêtres (3). Bagdad a une rue marchande réservée au commerce du corps féminin (5), pendant qu'à Calcutta (4) et au Caire (6) les femmes étaient transportées dans des cages et obligées à se prostituer.

S TRIPTEASE becomes a profession (1).
In 1973 Soho, bookshops, strip joints
and parts of Berwick Street market were
given over entirely to the sex industry (2):

quite a displacement for an area that once
boasted illustrious (and sometimes scurrilous)
residents like the Duke of Monmouth, Mozart,
the author Hazlitt, and the King of Corsica.

S TRIPTEASE als Beruf (1). Eine Auf-
nahme aus Soho zeigt, daß Buch-
läden, Lokale und Teile des Markts in de
Berwick Street 1973 ganz zum Geschäft
mit dem Sex übergegangen waren (2):

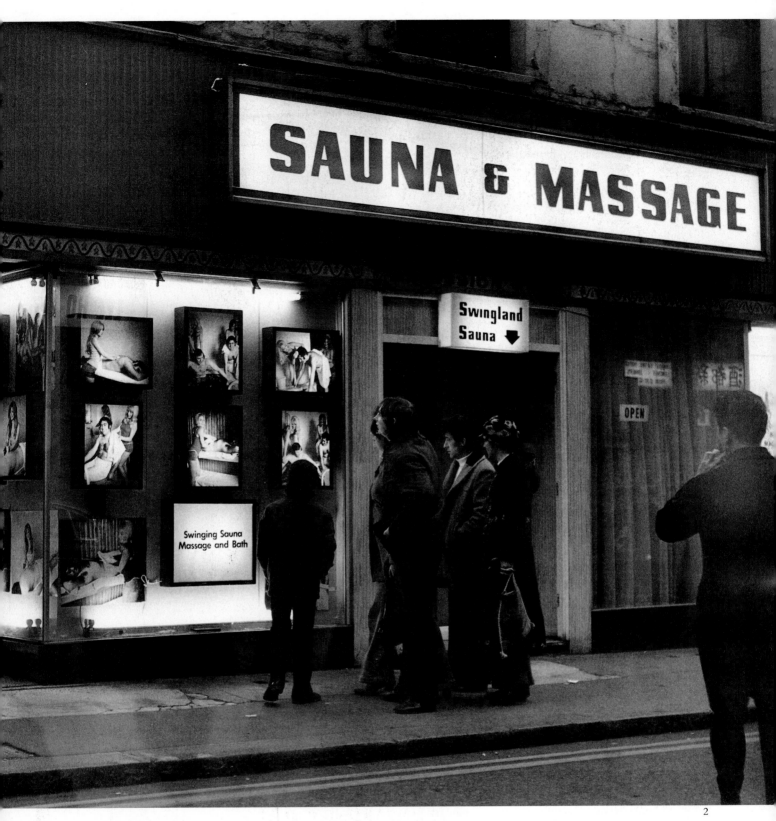

ein tiefer Fall für ein Viertel, in dem einst so illustre (oder auch dubiose) Gestalten wie der Herzog von Monmouth, Mozart, der Schriftsteller Hazlitt und der König von Korsika wohnten.

L E strip-tease devient l'affaire des professionnelles (1). En 1973 à Soho, les librairies, les tripots et des tronçons de la Berwick Street se consacrèrent entièrement à l'industrie du sexe (2) : une drôle

d'évolution pour un endroit qui avait vu défiler des habitants illustres (et quelquefois bizarres) comme le Duc de Monmouth, Mozart, l'écrivain Hazlitt et le roi de Corse.

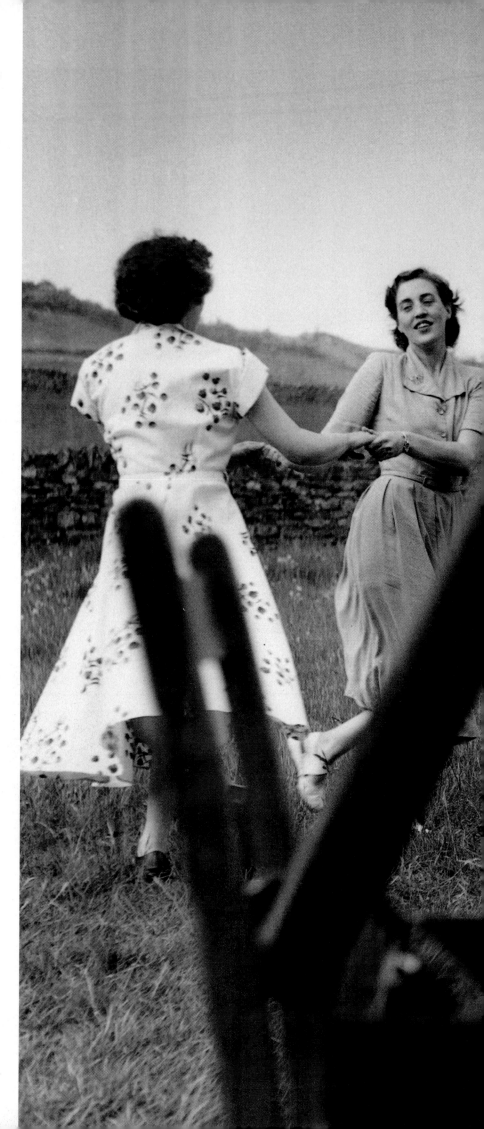

APPARENTLY the first British Women's Institute opened in a summerhouse on Anglesey Island. By the 1950s it had a membership of over half a million, and a considerable lobbying voice in all sectors of government, standing particularly firm on matters relating to the family and Christianity. Their domestic concerns were often summarized as 'jam and Jerusalem', which refers to their fund-raising through home-produced goods and the hymn (with words by the eighteenth-century poet William Blake) they always sing at the end of their national rally. Here members from Eastgate participate in some lively outdoor country dancing at Weardale, County Durham.

DER erste britische Frauenverein wurde offenbar in einem Sommerhaus auf der Insel Anglesey gegründet. In den 50er Jahren hatte der Verein bereits über eine halbe Million Mitglieder und konnte beträchtlichen Druck auf alle Bereiche der Regierung ausüben; besonders vehement setzten die Frauen sich für alles ein, was mit Familie und mit Christentum zu tun hatte. Sie bekamen den Spitznamen »Marmelade und Jerusalem«, weil sie sich das Geld für ihre Unternehmungen meist mit selbstge-machten Lebensmitteln ver-schafften und am Ende ihrer Landestreffen immer das Kirchenlied »Jerusalem« (nach einem Text des Dichters William Blake) sangen. Hier sieht man Mitglieder aus Eastgate bei einem fröhlichen Tanz auf dem Lande, in Weardale, Grafschaft Durham.

LE premier Institut pour les femmes de Grande-Bretagne s'ouvrit apparemment dans une résidence d'été des îles d'Angle-sey. Durant les années 50, il comptait plus de 500 000 membres, et son influence en tant que groupe de pression était importante dans tous les domaines du gouvernement, particulièrement quant aux sujets relevant de la famille et du christianisme. Les affaires domestiques des femmes étaient souvent résumées sous la devise « Confiture et Jéru-salem », parce qu'elles collectaient des fonds par la vente d'aliments fabriqués à la maison et entonnaient immanquablement un hymne (avec un texte du poète du XVIIIe siècle William Blake) à la clôture de leur rassemblement national. Ici, à Weardale, comté de Durham, quelques membres d'Eastgate participent à un charmant bal de campagne en plein air.

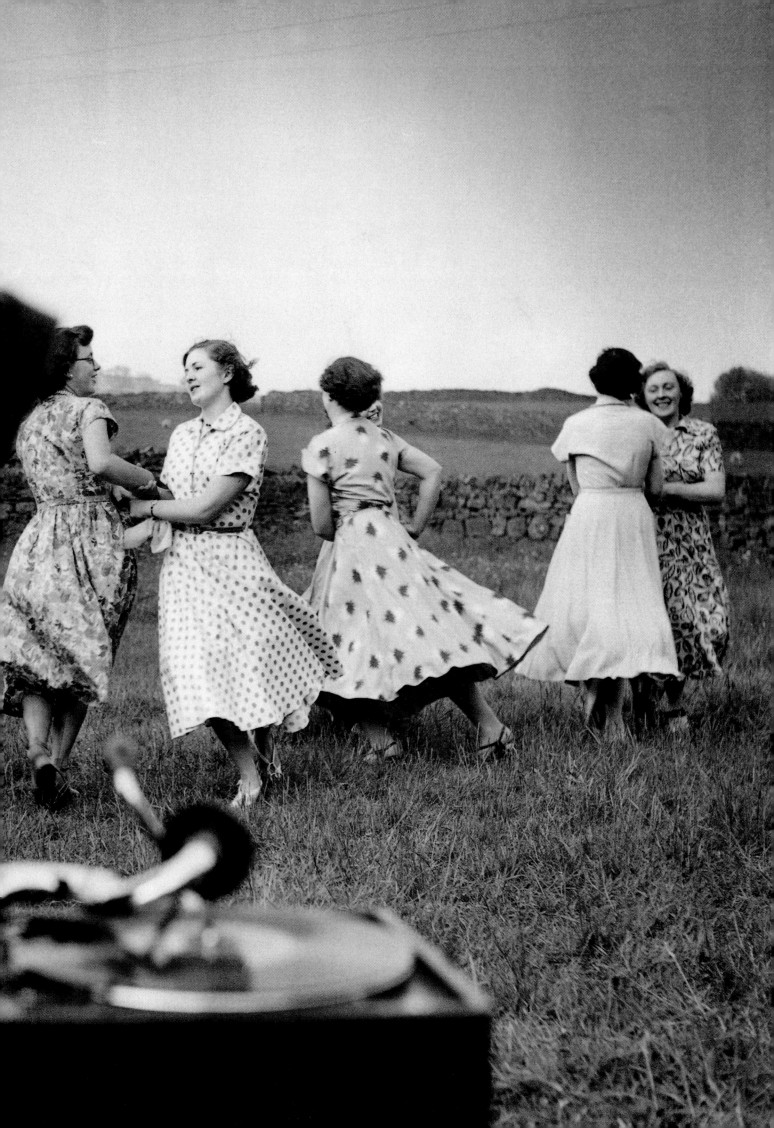

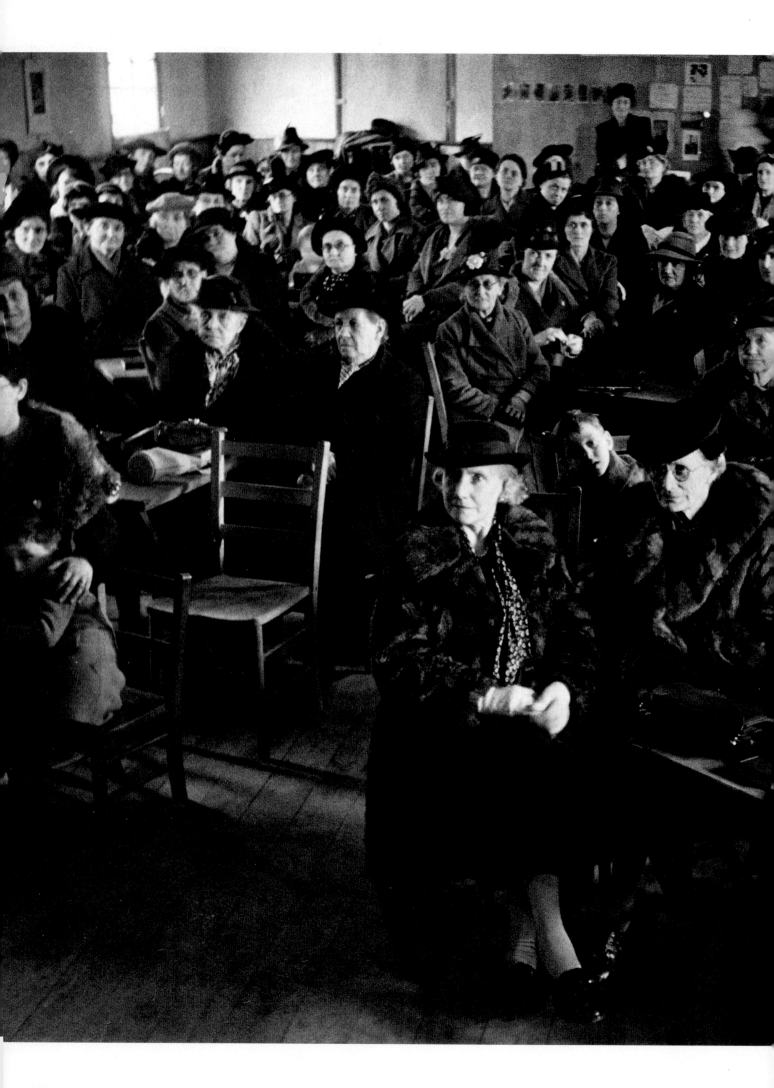

A parallel British organization stemming from Edwardian times was the Mothers' Union, meeting here in a church hall in their hats and wire-rimmed spectacles (1). In the 1940s, too, Russian women decorated for service in the Second World War march through Red Square on a Victory Day Parade (3). And in Bradford, Yorkshire, Spinsters' Club members go public in their campaign for a national pension (2).

EINE ähnliche britische Organisation, die vom Anfang des Jahrhunderts stammte, war die Mothers' Union (Mütterverein), die sich hier in einem Kirchensaal trifft, alle mit Hüten und den typischen Nickelbrillen der Zeit (1). Diese russischen Frauen (3), ebenfalls in den 40er Jahren, sind als Kriegsheldinnen ausgezeichnet worden und nehmen an einer Parade auf dem Roten Platz zum Jahrestag des Kriegsendes teil. In Bradford, Yorkshire, demonstrieren Frauen des Spinsters' Club (Verein unverheirateter Frauen) für eine staatliche Rente (2).

L'UNION des mères était une organisation britannique remontant à Édouard VII. On les voit ici dans une église, coiffées de leurs chapeaux et arborant des lunettes cerclées de fer (1). Au cours des années 40, également, des femmes russes décorées pour leurs bons et loyaux services durant la Seconde Guerre mondiale traversent la Place rouge pour célébrer le jour de la Victoire (3). À Bradford, dans le Yorkshire, les membres du Spinsters' Club manifestent pour la retraite nationale (2).

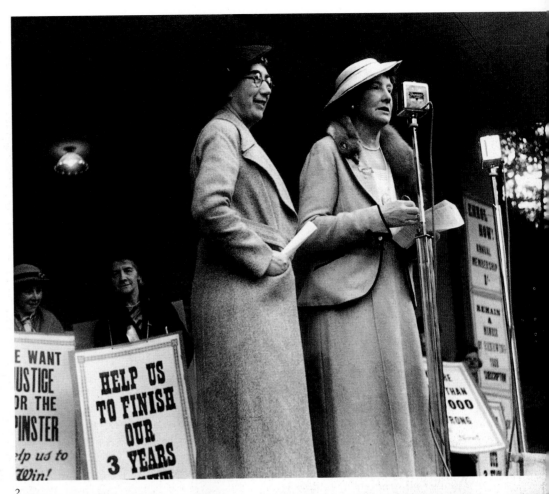

2

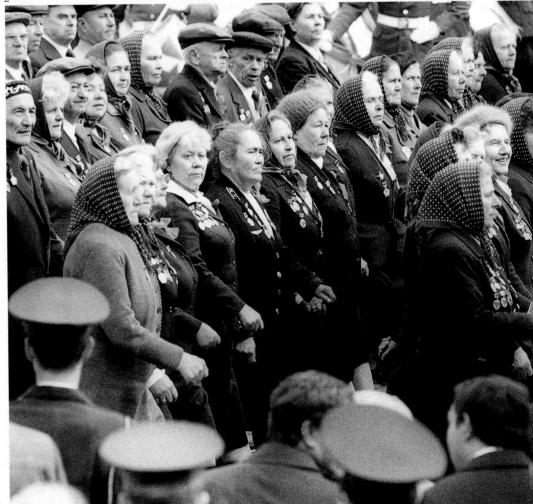

3

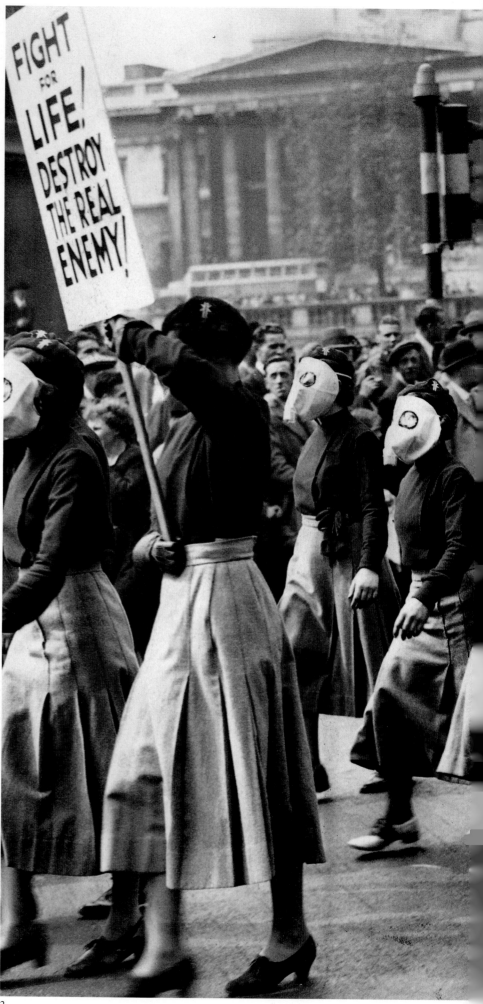

WOMEN have had a long and
dynamic connection with pacifism.
In 1923 a Women's Rally of the Workers'
Union deplored the millions of sons and
husbands lost in the Great War and opposed
rearmament (1). In 1936 thousands of
women donned hideous paper gas masks
for the Assembly for Peace in Trafalgar
Square (2).

FRAUEN spielen schon lange eine wich-
tige Rolle für den Pazifismus. 1923
gedachten die Frauen der Arbeitergewerk-
schaft der Millionen von Söhnen und
Männern, die im Ersten Weltkrieg umge-
kommen waren, und protestierten gegen
die Wiederaufrüstung (1). 1936 setzten
Tausende von Frauen bei einer Friedens-
demonstration am Trafalgar Square häßliche
Papier-Gasmasken auf (2).

LES femmes ont eu une relation longue
et dynamique avec le pacifisme. En
1923 un rassemblement féminin de l'Union
des travailleurs déplorait les millions de
fils et de maris disparus pendant la Grande
Guerre et s'opposait au réarmement (1).
En 1936, des milliers de femmes portent
d'horribles masques à gaz en papier pen-
dant l'Assemblée pour la paix à Trafalguar
Square (2).

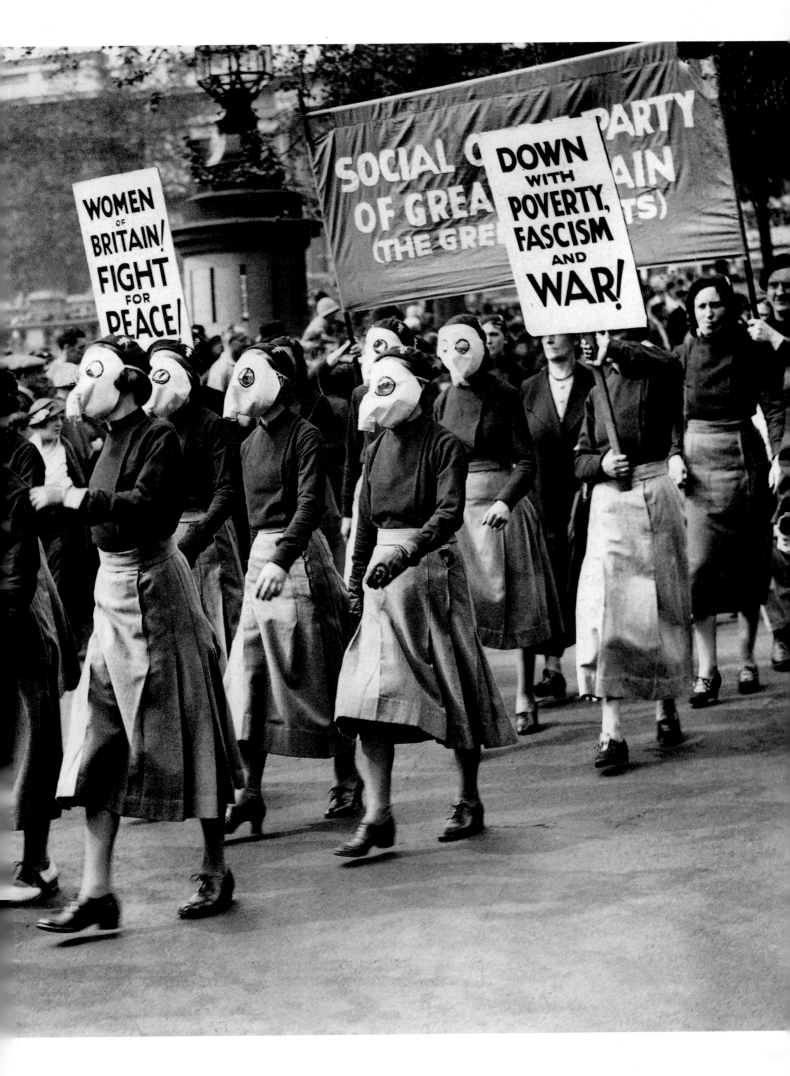

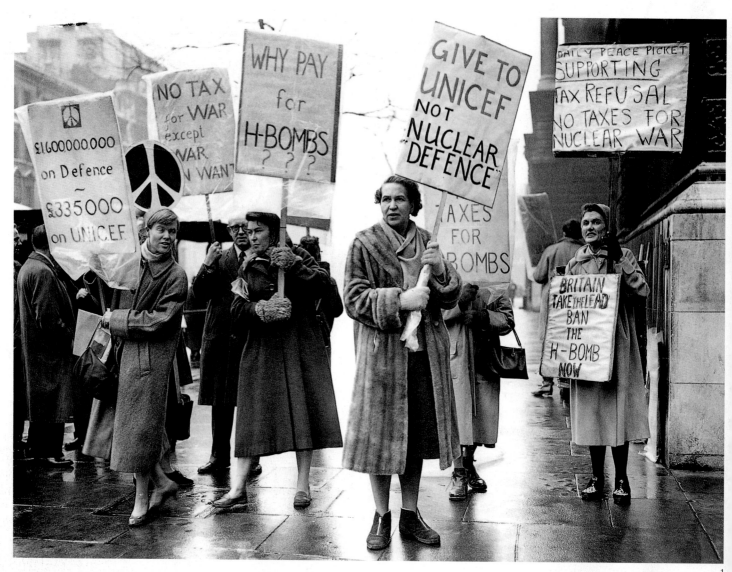

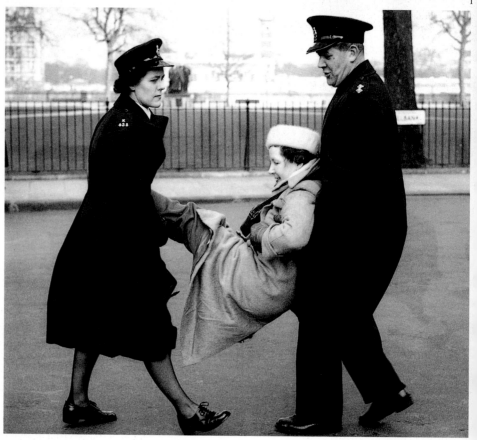

SUPPORTERS of the anti-nuclear Committee of a Hundred are carted away from Parliament Square (2). These marchers declare their intention of withholding income tax designated for nuclear arms (1). Jean Shrimpton spends a hungry Christmas protesting at British complicity in the 1967–70 Biafra conflict (3).

ATOMKRAFTGEGNERINNEN werden vom Londoner Parliament Square getragen (2). Die Demonstrantinnen wollen ihre Einkommensteuer zurückbehalten, weil sie für nukleare Aufrüstung verwendet werden soll (1). Jean Shrimpton in weihnachtlichem Hungerstreik aus Protest gegen die britische Haltung im Biafrakrieg (1967–70) (3).

DES manifestants du Comité antinucléaire des Cent sont emportés hors du Parliament Square (2). Ceux-ci refusent l'impôt sur le revenu devant financer les armes nucléaires (1). Jean Shrimpton passe un Noël en faisant la grève de la faim pour protester contre la complicité britannique dans la guerre du Biafra en 1967–1970 (3).

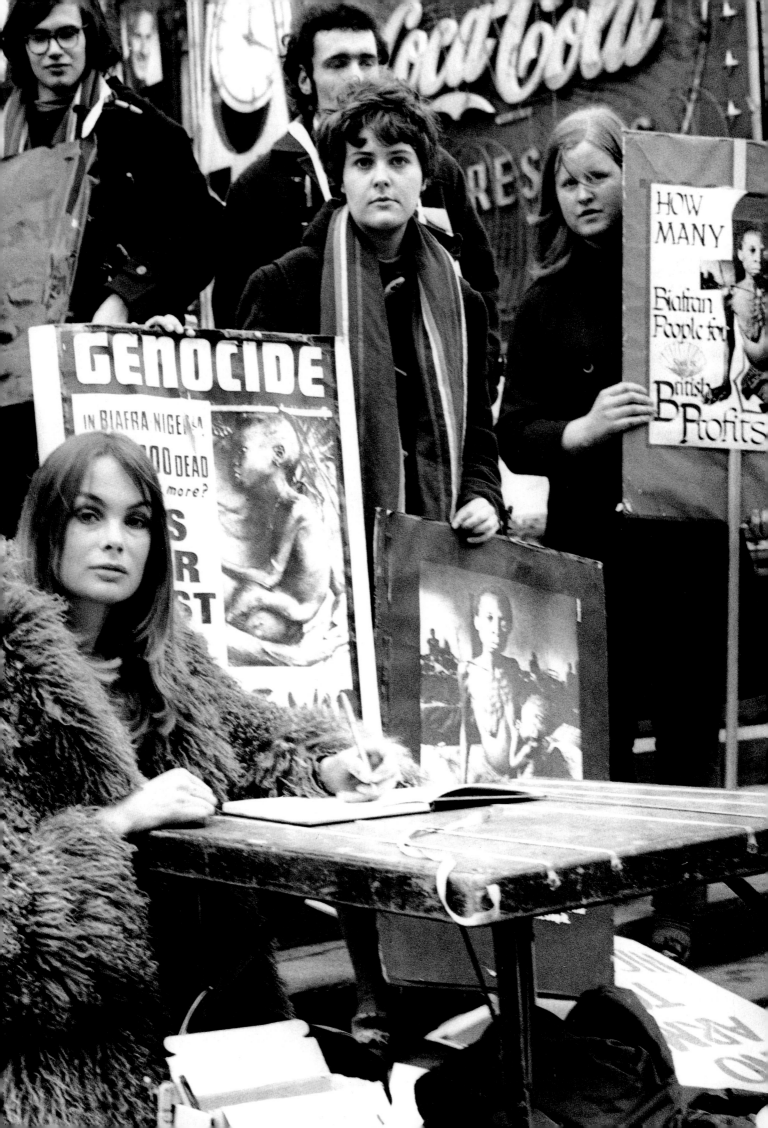

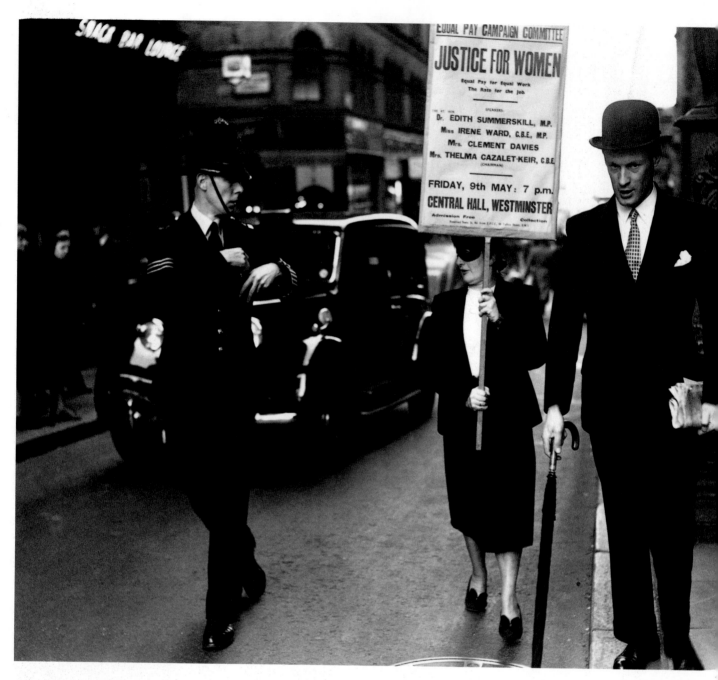

A woman, in the 1950s, wears a mask under the watchful and sceptical eyes of a copper and a city gent, flagging a meeting for equal pay to be addressed at London's largest rallying hall by MP Edith Summerskill and Labour premier Clement Attlee (1). By 1971, women are still making the same demand. Tired of waiting, they hand in a petition to Prime Minister Edward Heath at No. 10 Downing Street, calling for equal educational and job opportunities; equal pay now; free contraception and abortion on request; and free 24-hour child care centres (2).

EINE Frau, in den 50er Jahren, hat sich eine Maske umgebunden und ruft unter den skeptischen Blicken eines Polizisten und eines Geschäftsmannes zu einer Versammlung für Lohngerechtigkeit auf. In London werden die Parlamentsabgeordnete Edith Summerskill und der Labour-Premierminister Clement Attlee sprechen (1). 1971 sind die Forderungen noch dieselben. Diese Frauen haben das Warten satt und sind zur Downing Street Nr. 10 gezogen, wo sie dem Premierminister Edward Heath eine Petition überreichen, in der sie Gleichstellung bei Ausbildungs- und Arbeitschancen fordern, sofortige Angleichung der Löhne, das Recht auf Abtreibung sowie Verhütungsmittel und Ganztags-Kinderhorte auf Staatskosten (2).

AU cours des années 50, une femme masquée porte une pancarte sous les yeux attentifs et sceptiques d'un policier et d'un citadin. Elle indique le rassemblement organisé par MP Edith Summerskill et le Premier ministre travailliste Clement Attlee, qui demande l'égalité des salaires et qui se déroule dans la plus grande salle de Londres (1). En 1971, les femmes demanderont toujours la même chose. Fatiguées d'attendre, elles présentent une pétition au Premier ministre Edward Heath au n° 10, Downing Street, demandant l'égalité en termes d'éducation et de droit au travail ; le salaire égal maintenant ; la contraception libre et l'avortement sur demande ; et des crèches ouvertes 24 heures sur 24 (2).

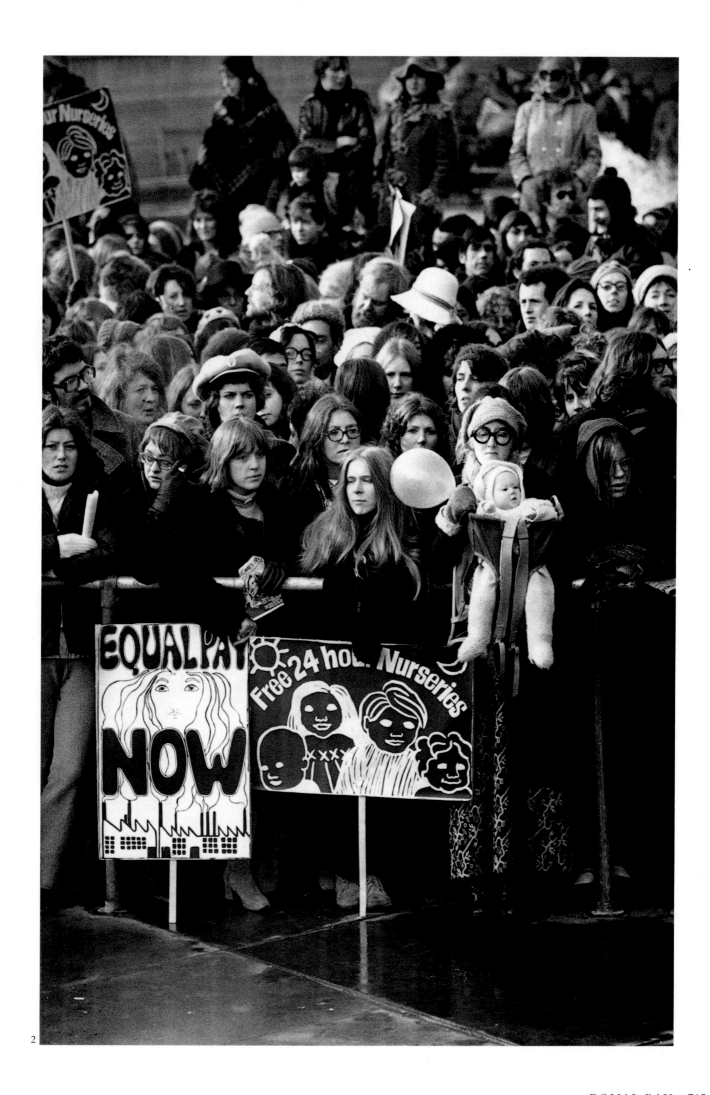

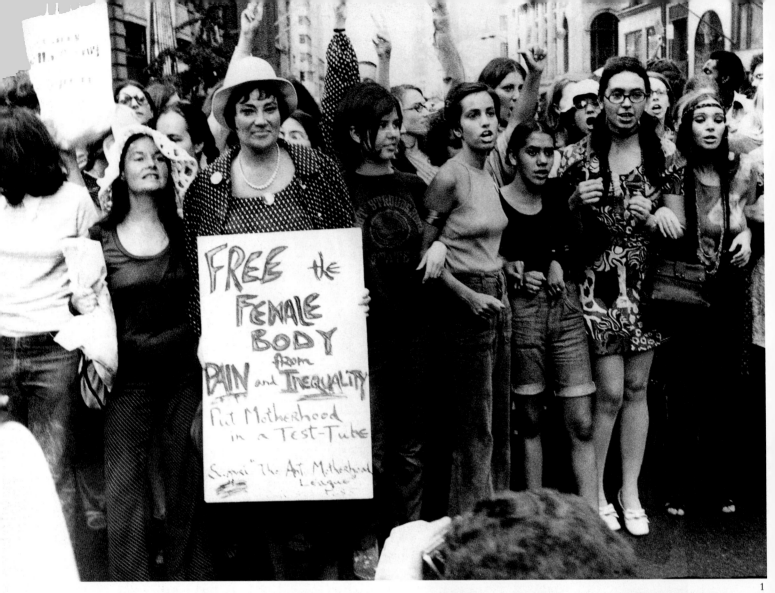

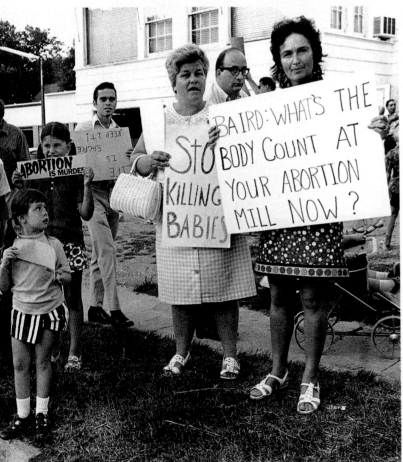

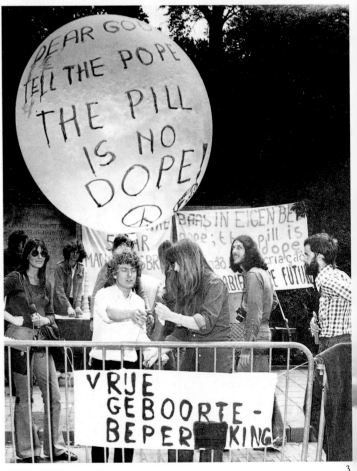

THROUGH the 1970s, women appeared to be on the march across the world. In the United States there emerged a clash between those, led here by Bella Abzug, who regarded a pregnancy as purely a transient condition of the female body (1), and the 'right-to-lifers' who considered abortion as tantamount to infanticide (2). In 1973 Dutch members of 'Dolle Mina' marked the fifth anniversary of the papal encyclical *Humanae Vitae* by releasing a balloon with the message: 'Dear God – tell the Pope the Pill is no Dope!' (3). In Italy, seat of the Vatican and country with the lowest birth rate in the world, women protest at the detention of a gynaecologist who performed abortions on demand (4).

IN den 70er Jahren erhoben Frauen überall auf der Welt ihre Stimmen. In den Vereinigten Staaten kam es zu Auseinandersetzungen zwischen denen, hier angeführt von Bella Abzug, die Schwangerschaft lediglich als einen vorübergehenden Zustand des weiblichen Körpers betrachteten (1), und der »Recht-auf-Leben«-Fraktion, für die eine Abtreibung einem Kindesmord gleichkam (2). 1973 begingen Mitglieder der holländischen Gruppe »Dolle Mina« den fünften Jahrestag der päpstlichen Enzyklika *Humanae vitae* damit, daß sie einen Ballon mit der Aufschrift in den Himmel steigen ließen: »Lieber Gott – sag dem Papst, daß die Pille keine Droge ist!« (3). In Italien, dem Sitz des Vatikans und dem Land mit der weltweit geringsten Geburtenrate, protestieren Frauen gegen die Verhaftung eines Gynäkologen, der auf Bitten von Patientinnen Abtreibungen vorgenommen hatte (4).

AU cours des années 70, la cause des femmes semble faire bouger le monde entier. Aux États-Unis, on voit apparaître des divergences entre Bella Abzug et ses disciples. Les unes estiment que la grossesse n'est qu'un état passager du corps féminin (1) tandis que les autres, « Droit à la vie », assimilent l'avortement à l'infanticide (2). En 1973, les membres néerlandais de la « Dolle Mina » marquent le cinquième anniversaire de l'encyclique papale *Humanae Vitae*, lâchant à cette occasion un ballon porteur d'un message à Dieu. Il postule ceci : « Dis au pape que la pilule n'est pas de la drogue ! » (3). En Italie, siège du Vatican, pays où le taux de natalité est le plus faible, les femmes protestent contre la détention d'un gynécologue qui a procédé à des interruptions de grossesse (4).

1

A New York woman police officer in the 1970s demonstrates to a quizzical audience how to disarm an assailant armed with a knife (1). According to the caption: 'Ravishing good looks may lure an assailant, but [she] tackles the problem with cool counterstrategy. There's daggers in her eyes!' Following a succession of rapes and sexual assaults near Stockport, Cheshire, youth leader (and ex-commando) George Ashton started training girls in 'how to say no to a rapist' (2). The classes were particularly popular with girls on local factory night shifts, or indeed anyone who wanted to learn 'how to blind your attacker' or 'how to cripple him by stamping on his feet'.

EINE New Yorker Polizistin der 70er Jahre zeigt einem nachdenklichen Publikum, wie man jemanden entwaffnet, der einen mit dem Messer bedroht (1). Die Bildunterschrift lautete: »Wenn eine Frau so gut aussieht, kann das einen Angreifer schon provozieren, aber sie weiß, wie sie damit fertig wird. Und ihre Augen schießen Pfeile!« Nachdem es in der Gegend von Stockport, Cheshire, mehrfach zu Vergewaltigungen und Fällen von sexueller

Belästigung gekommen war, begann der Jugendführer George Ashton (ehemals Mitglied einer Kommandotruppe) mit Kursen, in denen er den Mädchen beibrachte, »wie man Nein zu einem Vergewaltiger sagt« (2). Die Kurse fanden besonderen Zuspruch bei Mädchen, die auf Nachtschicht in den Fabriken arbeiteten, zogen aber auch andere an, die wissen wollten, »wie man dem Angreifer die Augen aussticht« oder »wie man ihm die Füße zertritt«.

À New York, dans les années 70, une femme agent de police enseigne à un public narquois comment désarmer un attaquant muni d'un couteau (1). La légende précise : « Une belle apparence peut tromper un assaillant, mais [elle] s'attaque au problème avec une contre-stratégie froide. Il y a des poignards dans ses yeux ! » Suite à une série de viols et d'agressions sexuelles près de Stockport, dans le Cheshire,

George Ashton, chef d'un centre de jeunes (et ancien membre de commando) a initié un programme d'entraînement destiné aux filles qui s'appelle « Comment dire non à un violeur » (2). Les cours étaient particulièrement populaires auprès des filles des équipes de nuit des usines locales, de toutes celles qui voulaient apprendre « comment aveugler un attaquant » ou « comment l'estropier en lui marchant sur les pieds ».

Music and Dance

THE musical scene in the twentieth century brought wildly varying styles and extraordinary new techniques. While composers such as Richard Strauss (1864-1949) and Edward Elgar (1857-1934) were happy to develop in the mainstream as the natural successors of Wagner and Brahms, others went out on a limb. Arnold Schoenberg (1874-1951) devised the twelve-tone compositional method, in which 'old-fashioned' concepts of key and chromaticism were thrown out and instead a 'row' of twelve notes arranged in unrelated order was used as a thematic basis. His disciples, Berg and Webern, also used this method, although less rigidly. But it cannot be said that the average music-lover finds it easy to whistle a snatch or two of many of their works, despite the unquestioned merits of such operas as *Wozzeck* and *Lulu*. A later generation headed by the Frenchman Pierre Boulez and the German Karlheinz Stockhausen turned to electronic music, mixing tapes with live performance and using newly invented instruments such as the *ondes martenot*, a type of synthesizer. Their works, too, have met with critical attention rather than widespread popularity.

Stockhausen (1, overleaf) was born in 1928. In 1971 he created a programme of 'Anthems' of concrete sound to last all evening. Divided into four sections, each of which featured the national anthem of a different country, it provided a natural accompaniment of sounds ranging from the breathing of jungle animals to that of the instrumentalists. Asked if the listener could tell the difference and whether it mattered, the composer replied: 'Music is a state of being. It is a means to a new awareness.' Boulez (b. 1925) founded the Paris-based IRCAM institute in 1976 for research into experimental composition techniques (2, overleaf). He is an outstanding conductor, of Wagner in particular, somewhat surprisingly.

As ballet branched away from Russia and underwent a revitalization at the hands of Serge Diaghilev (1872-1929), the young Igor Stravinsky was coming to the fore. His three early works (*Firebird*, *Petruchka*, *Rite of Spring*) are among the best ballet scores of this or any century, and indeed are as thrilling in the concert hall as in the theatre. Diaghilev had a supremely catalytic quality, bringing together magnificent artists and composers as well as dancers like Nijinsky, now legends in the history of ballet. The influence of his splendid company percolated to Britain and the USA, and the eventual result was the establishment of the Royal Ballet in London and Balanchine's New York City Ballet. Britain produced another legend in Margot Fonteyn, while the vigorous American style was epitomized by Martha Graham and many others.

A true English opera at last became a reality with the stunning première of Benjamin Britten's *Peter Grimes* in 1945. On the face of it a gloom-laden tragedy, the opera is so gripping, with such marvellous music, that audiences emerge exhilarated and moved rather than downcast. American opera too has become firmly established over the last fifty years, through the setting up of world-class companies and performing centres throughout the United States.

Leonard Bernstein (1) was immensely successful at combining a classical training with a common touch. Born in the United States to immigrant parents in August 1918, he became internationally known as an electrifying conductor, becoming music director of the New York Philharmonic, and for the realism of his own compositions, in tune with popular rhythms and phraseology. Nowhere was this plainer than in his watershed musical *West Side Story*, a 'Romeo and Juliet' in which Montagues and Capulets are replaced by Sharks and Jets, the warring factions of New Yorker and *newyorquinos*. His symphonies and sacred compositions are in a completely different vein.

DIE Musikszene des 20. Jahrhunderts zeichnet sich durch eine große Vielfalt der Stile und durch außerordentliche neue Techniken aus. Während Komponisten wie Richard Strauss (1864-1949) und Edward Elgar (1857-1934) mit großem Erfolg die Traditionen von Wagner und Brahms fortentwickelten, begannen andere ganz von vorn. Arnold Schönberg (1874-1951) erfand die Zwölftontechnik, in der »veraltete« Vorstellungen von Tonart und Chromatik über Bord geworfen wurden und statt dessen eine »Reihe« von zwölf unverbundenen Tönen die thematische Basis lieferte. Seine Schüler Berg und Webern komponierten ebenfalls nach dieser Methode, handhaben sie jedoch flexibler. Die meisten Musikfreunde fanden es nicht gerade leicht, die Melodien aus diesen Werken nachzupfeifen, auch wenn der Rang von Opern wie *Wozzeck* oder *Lulu* außer Frage steht. Die nächste Generation wandte sich unter Führung des Franzosen Pierre Boulez und des Deutschen Karlheinz Stock-

hausen der elektronischen Musik zu, sie brachten Tonbandmusik in ihre Konzertauftritte und arbeiteten mit neuerfundenen Instrumenten wie den *ondes martenot*, einer Art Synthesizer. Auch ihre Arbeiten haben eher bei den Kritikern als beim großen Publikum Anerkennung gefunden.

1971 führte Stockhausen (1), Jahrgang 1928, ein abendfüllendes Programm konkreter Musik mit dem Titel »Hymnen« auf. Im Mittelpunkt jedes der vier Teile stand die Nationalhymne eines Landes, und dazu wurden Geräusche eingespielt, vom Atem eines wilden Tieres bis hin zum Atem der Instrumentalisten. Auf die Frage, ob der Zuschauer denn zwischen beiden unterscheiden könne und ob das von Bedeutung sei, entgegnete der Komponist: »Musik ist ein Seinszustand. Sie ist ein Mittel zur Erweiterung des Bewußtseins.« Der 1925 geborene Boulez gründete 1976 in Paris das IRCAM-Institut zur Erforschung experimenteller Kompositionstechniken (2). Er ist ein bedeutender Dirigent und hat sich – was man bei seinen sonstigen Vorlieben wohl kaum vermutet hätte – besonders als Wagner-Interpret hervorgetan.

Als das Ballett seine russische Heimat verließ und unter Sergej Diaghilew (1872-1929) eine Verjüngungs-

kur machte, trat der junge Igor Strawinsky auf den Plan. Seine frühen Werke *Der Feuervogel*, *Petruschka* und *Le sacre du printemps* zählen zu den bedeutendsten Ballettwerken dieses Jahrhunderts, wenn nicht aller Zeiten, und sind im Konzertsaal nicht weniger faszinierend als im Theater. Diaghilew war ein genialer Katalysator und brachte die bedeutendsten bildenden Künstler und Komponisten zusammen, dazu natürlich Tänzer wie Nijinsky, die heute Ballettlegende sind. Der Einfluß seiner Truppe reichte bis nach England und in die Vereinigten Staaten und war mitverantwortlich dafür, daß das Royal Ballet in London und Balanchines New York City Ballet gegründet wurden. Eine weitere Tanzlegende, Margot Fonteyn, kam aus Großbritannien, und Inbegriff des energischen amerikanischen Stils war, unter anderen, Martha Graham.

Mit der atemberaubenden Premiere von Benjamin Brittens *Peter Grimes* im Jahre 1945 wurde der Traum von einer echt englischen Oper endlich Wirklichkeit. Auf den ersten Blick ist es eine finstere Tragödie, doch die Oper ist so packend und die Musik so mitreißend, daß das Publikum nicht etwa niedergeschlagen aus dem Saal kommt, sondern gerührt und geläutert. Auch im amerikanischen Kulturleben hat sich die Oper in den letzten

infzig Jahren einen festen Platz erobert, mit erstklassigen Gruppen und Opernhäusern im ganzen Land.

Leonard Bernstein (1, vorherige Seiten) verstand es, lassische Ausbildung mit einer volkstümlichen Art zu verbinden. Als Einwanderersohn im August 1918 in Amerika geboren, wurde er für seine faszinierende Dirigentenkunst (er wurde Chef der New Yorker Philharmoniker) weltbekannt, ebenso für die Realistik seiner eigenen Kompositionen, in denen er volkstümliche Rhythmen und Gesangsstile verarbeitete. Nirgendwo war das offensichtlicher als in seinem Durchbruchswerk, dem Musical *West Side Story*, einem »Romeo und Julia«, bei dem an die Stelle der Montagues und der Capulets die Sharks und die Jets getreten sind, die verfeindeten Banden der einheimischen New Yorker und der lateinamerikanischen Einwanderer. Bernsteins Symphonien und Sakralwerke sind dagegen vollkommen anders im Ton.

Au cours des années 20, des styles très variés et des techniques nouvelles apparurent dans le monde de la musique. Alors que des compositeurs comme Richard Strauss (1864-1949) et Edwaerd Elgar (1857-1934) étaient heureux d'évoluer dans la tendance générale comme les successeurs naturels de Wagner et Brahms, d'autres sortaient des rangs. Arnold Schoenberg (1874-1951) conçut le système dodécaphonique, qui rejetait les concepts « démodés » de clés et de chromatisme et les remplaçait par une succession de douze sons n'ayant de rapport qu'entre eux. Ses disciples Berg et Webern utilisèrent aussi cette méthode, bien que de manière moins rigide. Mais il est difficile pour le mélomane de siffler facilement un extrait ou deux de nombre de leurs oeuvres, et cela malgré l'incontestable interêt des opéras comme *Wozzeck* et *Lulu*. La génération suivante, menée par le Français Pierre Boulez et l'Allemand Karlheinz Stockhausen, se tourna vers la musique électronique, mélangeant des enregistrements avec des prises en direct et utilisant des instruments nouveaux.

Stockhausen (1) est né en 1928. En 1971, il a créé un programme d' « anthems », de son concret persistant toute une soirée. Divisé en quatre sections, chacun d'eux caractérisant l'anthem national des différents pays, il propose un accompagnement naturel de sons allant de la respiration des animaux de la jungle à celle des musiciens. Quand on lui demanda si l'auditeur pourrait établir la différence, et si cela avait de l'importance, le compositeur répondit : « La musique est un état de l'existence. C'est un moyen d'arriver à un nouvel ‹ éveil › ». Boulez (né en 1925) a fondé l'IRCAM (Institut de recherche et de coordination acoustique musique) à Paris en 1976 (2). Il est en autre un chef d'orchestre remarquable, de Wagner en particulier, ce qui ne laisse de surprendre.

L'heure sonna pour le jeune Igor Stravinsky à l'époque où les ballets évoluèrent loin de la Russie et furent revitalisés par Serge Diaghilev (1872-1929). Les trois premières œuvres de Stravinski (*L'Oiseau de feu, Petrouchka, Le Sacre du printemps*) font partie des ballets les plus prestigieux et Diaghilev possédait un talent suprêmement catalytique, réunissant autant d'artistes et de compositeurs magnifiques que de danseurs comme Nijinsky, entré dans la légende de l'histoire des ballets. L'influence de sa troupe superbe se fit sentir en Grande-Bretagne et aux États-Unis, et aboutit finalement à la création du Royal Ballet à Londres et du City Ballet de Ballantine à New York. La Grande-Bretagne donna naissance à une autre légende en la personne de Margot Fonteyn, pendant que le vigoureux style américain était porté aux nues par Martha Graham et d'autres encore.

Enfin, un véritable opéra anglais vit le jour avec la première étonnante de *Peter Grimes,* de Benjamin Britten en 1945. Cet opéra, tragédie lugubre à première vue, est si passionnant, la musique est si belle que le public en sort plus vivifié et ému que mortifié. L'opéra américain, lui aussi, s'est solidement établi au cours des cinquante dernières années.

Leonard Bernstein (1918-1990) connut un succès immense en combinant une formation classique et une touche ordinaire (1, pages précédentes). Né aux États-Unis, il se fit connaître du monde entier comme un chef d'orchestre galvanisant, qui devint le directeur musical du Philharmonic de New York, et pour le réalisme de ses propres compositions en accord avec les rythmes et la phraséologie populaires. La simplicité est à son comble dans sa comédie musicale progressiste *West Side Story*, un « Roméo et Juliette » dans lequel les Montagu et les Capulet sont remplacés par les Shark et les Jet, les groupes de New-Yorkais en guerre et les *Newyorquinos*.

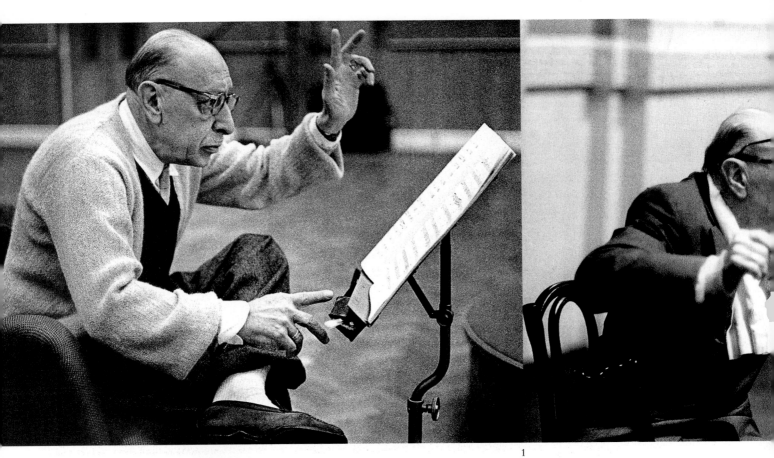

1

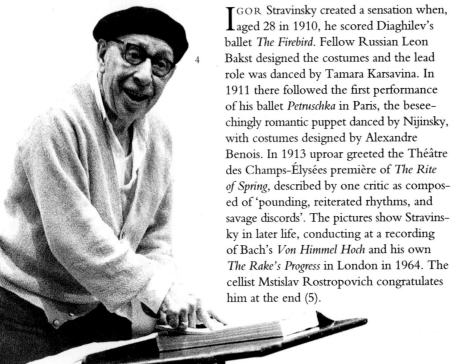

4

IGOR Stravinsky created a sensation when, aged 28 in 1910, he scored Diaghilev's ballet *The Firebird*. Fellow Russian Leon Bakst designed the costumes and the lead role was danced by Tamara Karsavina. In 1911 there followed the first performance of his ballet *Petruschka* in Paris, the beseechingly romantic puppet danced by Nijinsky, with costumes designed by Alexandre Benois. In 1913 uproar greeted the Théâtre des Champs-Élysées première of *The Rite of Spring*, described by one critic as composed of 'pounding, reiterated rhythms, and savage discords'. The pictures show Stravinsky in later life, conducting at a recording of Bach's *Von Himmel Hoch* and his own *The Rake's Progress* in London in 1964. The cellist Mstislav Rostropovich congratulates him at the end (5).

MIT der Musik, die er 1910 im Alter von 28 Jahren für Diaghilews Ballett *Der Feuervogel* schrieb, sorgte Igor Strawinsky für eine Sensation. Sein russischer Landsmann Leon Bakst entwarf die Kostüme, und Primaballerina war Tamara Karsawina. 1911 folgte die Erstaufführung seines Balletts *Petruschka* in Paris, die flehende romantische Puppe von Nijinsky getanzt, mit Kostümen von Alexandre Benois. Als *Le sacre du printemps* 1913 im Théâtre des Champs-Élysées uraufgeführt wurde, gab es Tumulte; ein Kritiker schrieb, das Werk bestehe aus »stampfenden, immergleichen Rhythmen und wilden Mißklängen«. Die Bilder zeigen Strawinsky in späteren Jahren bei Schallplattenaufnahmen von Bachs *Vom Himmel hoch* und seinem eigenen *The Rake's Progress* in London 1964. Am Ende beglückwünscht ihn der Cellist Mstislaw Rostropowitsch (5).

IGOR Stravinsky fit sensation lorsqu'il écrivit en 1910, à l'âge de 28 ans, la musique du ballet de Diaghilev, *L'Oiseau du feu*. Son compatriote Leon Bakst dessina les costumes et le rôle principal était dansé par Tamara Karsavina. En 1911 suivit la première de son ballet *Petrouchka* à Paris : le pantin pathétique est incarné par Nijinsky, et les costumes sont d'Alexandre Benois. En 1913 eut lieu au Théâtre des Champs-Élysées la première tumultueusement saluée du *Sacre du Printemps*. Un critique la décrit comme un ensemble de « rythmes martelés répétés et de dissonances sauvages ». Les photographies montrent Stravinsky à la fin de sa vie, dirigeant un enregistrement du *Von Himmel Hoch* de Bach et sa composition personnelle *The Rake's Progress* à Londres en 1964. Il est ici félicité par le violoncelliste Mstislav Rostropovitch (5).

2

3

(Overleaf)
'N 1980 the eighty-two-year-old Japanese violinist and tutor Shinichi Suzuki visited Britain to demonstrate his teaching methods. The lack of Suzuki teachers led to this demonstration at the British Suzuki Institute in Hertfordshire by the inventor of the technique himself (1). Back home in Tokyo, 2,000 little fiddlers (aged 3-10) from across Japan gathered in 1970 for a mass violin concert attended by their admiring parents (2, 3).

(Pages suivantes)
EN 1980, le violoniste et professeur particulier japonais Shinichi Suzuki, âgé de 82 ans, se rendit en Grande-Bretagne pour exposer ses méthodes d'enseignement. Les enseignants qui utilisaient cette méthode étant rares, l'inventeur de la technique en personne fait une démonstration au British Suzuki Institute de Hertfordshire (1). 2 000 petits violonistes âgés de trois à dix ans, venus de toutes les régions du Japon se rassemblèrent en 1970 à Tokyo pour un gigantesque concert de violons auquel assistaient leurs parents admiratifs (2, 3).

(Folgende Seiten)
M Jahre 1980 kam der zweiundachtzigjährige japanische Geiger und Geigenlehrer Shinichi Suzuki nach Großbritannien, um seine Lehrmethoden zu unterrichten. Es fehlte an Lehrern, und deshalb führt der Erfinder der Suzuki-Methode sie hier im British Suzuki Institute in Hertfordshire selbst vor (1). Zu Hause in Tokio versammelten sich 1970 zweitausend kleine Geigenvirtuosen aus ganz Japan (zwischen drei und zehn Jahren alt) und gaben für die stolzen Eltern ein Großkonzert (2, 3).

5

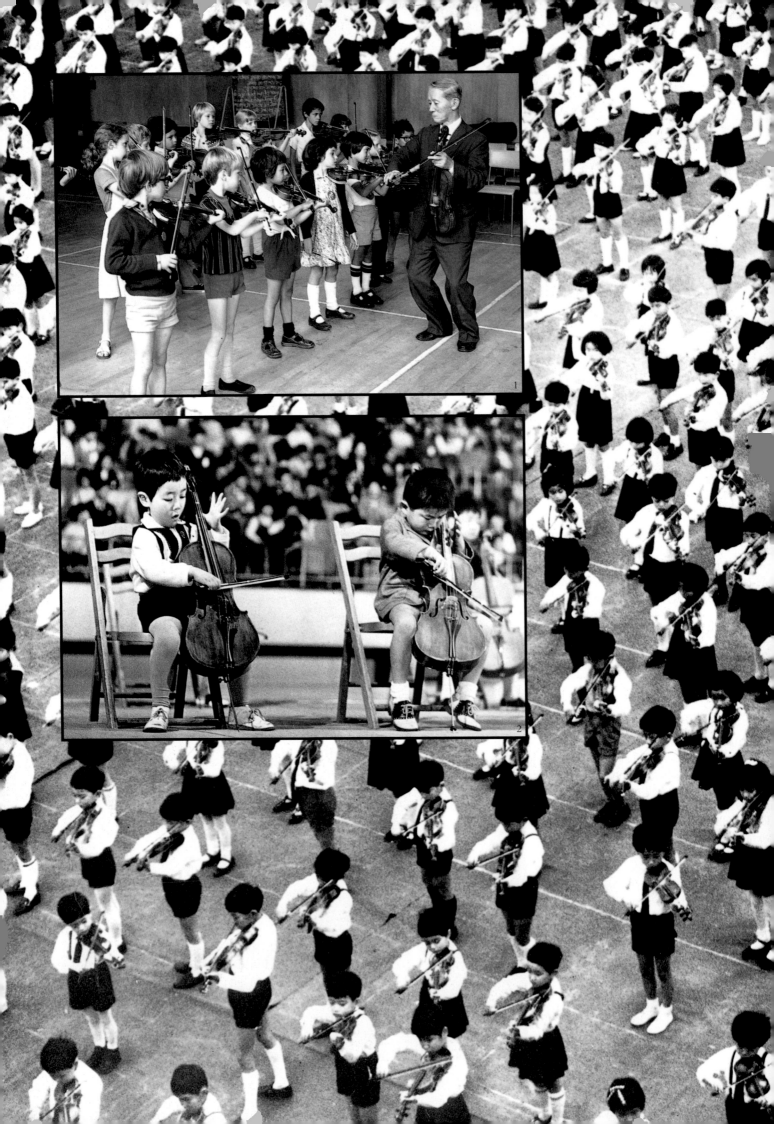

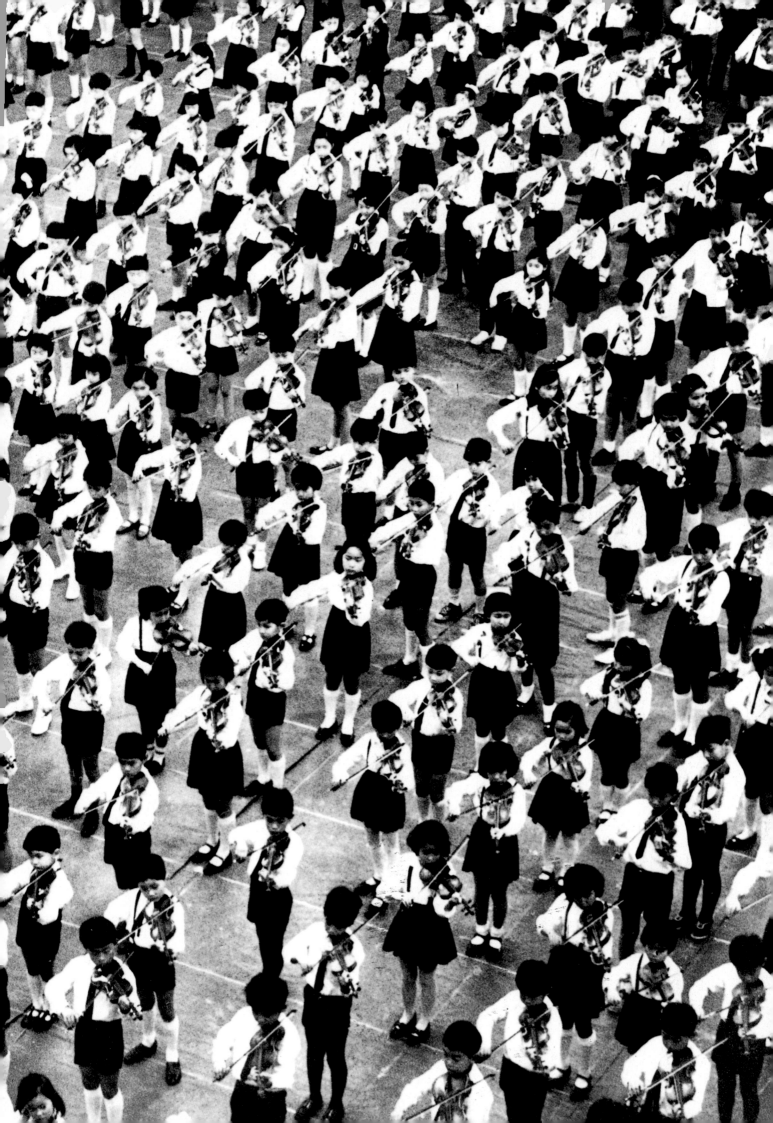

WHILE Puccini's *Tosca* was the lush apotheosis of nineteenth-century Italian opera, Alban Berg's *Lulu* was among the most daring operatic works of the present century (although it remained incomplete at Berg's death). Both are thematically realistic works, dominated by the tragedy of a powerful but doomed woman. And both are here played by outstanding singers who gave a unique interpretation to their roles: Maria Callas (2, with Tito Gobbi) in the former, Karan Armstrong (1, with Erik Saeden) in the latter. Puccini's *Tosca* goes beyond other contemporary heroines (such as Violetta in *La Traviata*) in having a political as well as a romantic dimension. *Lulu* deals with the theme of the *femme fatale*, bringing musical inventiveness to the heroine's parabolic rise and fall and the sleazy fate which even she was unable to manipulate.

DER Überschwang von Puccinis *Tosca* ist der Höhepunkt der italienischen Oper des 19. Jahrhunderts, Alban Bergs *Lulu* (die der Komponist nicht mehr vollenden konnte) zählt zu den gewagtesten Opernwerken unseres Jahrhunderts. Beide sind vom Thema her realistische Werke, und im Mittelpunkt steht jeweils die Tragödie einer machtvollen, doch dem Untergang geweihten Frau. Beide werden sie hier von Sängerinnen verkörpert, deren Interpretation Geschichte machte: Maria Callas (2, mit Tito Gobbi) als Tosca, Karan Armstrong (1, mit Erik Saeden) als Lulu. Was Puccinis Tosca vor anderen Opernheldinnen ihrer Zeit (wie etwa Violetta in *La Traviata*) auszeichnet, ist die politische Dimension, die zur Liebeshandlung hinzukommt. Das Thema von *Lulu* ist die Femme fatale, und mit bis dahin ungekannten musikalischen Mitteln werden der parabelhafte Aufstieg und Fall der Heldin und die Verwicklung des Schicksals vorgeführt, das nicht einmal sie beeinflussen konnte.

SI *Tosca* de Puccini est l'apothéose luxueuse de l'opéra italien du XIX^e siècle, le *Lulu* d'Alban Berg fait partie des œuvres les plus audacieuses de l'opéra du XX^e siècle (bien qu'elle soit restée inachevée à la mort de Berg). Les deux oeuvres sont thématiquement réalistes, dominées par la tragédie d'une femme forte mais condamnée par le destin. Et les deux opéras sont interprètés par des cantatrices exceptionnelles qui donnent une interprétation uniqu de leurs rôles : Maria Callas (2, avec Tito Gobbi) dans *Tosca* et Karan Armstrong (1, avec Erik Saeden) dans *Lulu*. La Tosca de Puccini surpasse les héroïnes de son époqu (par exemple la Violetta de *La Traviata*) par sa dimension aussi bien politique que romantique. *Lulu* traite du thème de la femme fatale, et met son inventivité musicale au service de l'ascension et la chute allégorique de l'héroïne, de son destin malheureux qu'elle est incapable de dirige

1

2

The delightful and popular Spanish mezzo-soprano Conchita Supervia imported the famous 1930s studio photographer Sasha for these 'informal' shots at her home in Mayfair (1). In fact the theatricality of the wrought-iron gates and drapes (2) well suited the disposition of the singer, whose principal roles included Carmen and the coloratura Rossini roles (Rosina, Cinderella).

DIE bezaubernde und beliebte spanische Mezzosopranistin Conchita Supervia ließ den berühmten Studiophotographen der 30er Jahre, »Sascha«, kommen, der diese »informellen« Aufnahmen in ihrem Haus im Londoner Stadtteil Mayfair machte (1). Eigentlich passen die schmiedeeisernen Gitter und die Vorhänge (2) die etwas Theatralisches haben, gut zu einer Sängerin, zu deren größten Rollen Carmen und die Koloraturen bei Rossini (Rosina, Aschenbrödel) gehörten.

ONCHITA Supervia, la ravissante et populaire mezzo-soprano espagnole, introduisit le célèbre photographe en atelier des années 30, Sasha, dans son appartement à Mayfair où il réalisa ses prises de vues « informelles » (1). En fait, le côté théâtral des barrières en fer forgé et des draperies (2) est bien en accord avec le tempérament d'une cantatrice qui a interprété entre autres Carmen et les rôles à vocalises de Rossini (Rosina, Cendrillon).

LONDON'S Royal Opera House –
originally founded in 1732 – returned
to a central position on the musical map in
the 1950s. Here Joan Sutherland (1) spreads
her bloodstained skirts and her tumbling
locks in the mad scene from Donizetti's
Lucia di Lammermoor. In her audience was
Maria Callas, the Greek 'Tigress', chatting
to German fellow-soprano Elisabeth
Schwarzkopf (2). Schwarzkopf also goes
into a huddle with conductor Wolfgang
Sawallisch for further musical exchanges
following their recording of Richard
Strauss's *Der Rosenkavalier*.

DAS Londoner Royal Opera House,
schon 1732 gegründet, konnte in den
50er Jahren an einstige Größe anknüpfen.
Hier (1) zeigt Joan Sutherland ihr blutbefleck-
tes Gewand und die wallenden Locken in
der Wahnsinnsszene aus Donizettis *Lucia di
Lammermoor*. Im Publikum saß auch die
griechische »Tigerin« Maria Callas, die hier
mit ihrer deutschen Kollegin, der Sopra-
nistin Elisabeth Schwarzkopf, plaudert (2).
Nach der Aufnahme von Richard Strauss'
Der Rosenkavalier fachsimpelt die Schwarz-
kopf mit dem Dirigenten Wolfgang
Sawallisch.

LE Royal Opera House de Londres –
fondé en 1732 – retrouva une position
centrale sur la scène musicale dans les
années 50. Joan Sutherland (1) étale ici ses
jupes trempées de sang et ses boucles en
cascade dans la scène de la folie de *Lucie de
Lammermoor* de Donizetti. Maria Callas,
la « tigresse » hellénique bavarde avec le
soprano allemand Elisabeth Schwarzkopf
(2). Elisabeth Schwarzkopf avec le chef
d'orchestre Wolfgang Sawallisch pour des
échanges musicaux plus poussés après leur
enregistrement du *Chevalier à la rose* de
Richard Strauss.

2

3

1 2

FRANCIS Egerton sings the Captain to Welsh baritone Sir Geraint Evans in the title role of Alban Berg's *Wozzeck* in this 1978 production at the Royal Opera House, London (1). A very different treatment of a military theme was revived, also at Covent Garden, in 1966 with Donizetti's *Fille du Régiment* with (left to right) a relatively slender Luciano Pavarotti, Joan Sutherland and Spiro Malas (3). The 1973 Wagner Festival at Bayreuth opened with *Die Meistersinger von Nürnberg*: the master's grandson Wolfgang Wagner directs René Kollo as Walther von Stolzing (2).

FRANCIS Egerton singt den Hauptmann, der walisische Bariton, Sir Geraint Evans, die Titelrolle in dieser Produktion von Alban Bergs *Wozzeck* im Londoner Royal Opera House, 1978 (1). Eine ganz andere Sicht des Militärs kommt 1966, ebenfalls in Covent Garden, in dieser Inszenierung von Donizettis *Die Regimentstochter* zum Ausdruck, mit (von links nach rechts) einem damals noch vergleichsweise schlanken Luciano Pavarotti, Joan Sutherland und Spiro Malas (3). Die Festspiele in Bayreuth eröffneten 1973 mit den *Meistersingern von Nürnberg*. Hier gibt Wolfgang Wagner, der Enkel des Meisters, René Kollo, der den Walther von Stolzing singt, seine Anweisungen (2).

FRANCIS Egerton chante le Capitaine au baryton gallois Sir Geraint Evans dan le rôle principal de *Wozzeck* d'Alban Berg produit en 1978 par la Royal Opera House de Londres (1). Le thème militaire est traité tout à fait différemment et revivifié à Coven Garden en 1966 dans *La Fille du régiment* de Donizetti qui réunit (de gauche à droite) u Luciano Pavarotti relativement svelte, Joan Sutherland et Spiro Malas (3). Le Festival de Bayreuth de 1973 ouvrit ses portes avec *Les Maîtres chanteurs de Nuremberg* : le petit-fi du maître, Wolfgang Wagner, dirige ici René Kollo qui interprète Walther von Stolzing (2).

(Overleaf)

THE opening of the 1934 Glyndebourne
opera season brought forth Lady Diana
Cooper, aristocratic leader of the social
scene and author of a racy literary auto-
biography (2). Five years later the German
photographer Felix Man (formerly Bau-
mann) took this image of an interval in the
grounds of the stately home where operas
are staged (1). Despite the summer season,
several of the women find it necessary to
attend in their furs. Similar fashions, includ-
ing buttonholes, accompany first-nighters
attending the opening of the 1937 season at
the Royal Opera House, picking their way
through the crates of vegetables at Covent
Garden (3).

(Folgende Seiten)

LADY Diana Cooper, damals erste
Dame der englischen Gesellschaft (und
Verfasserin einer skandalträchtigen Auto-
biographie), erscheint zur Eröffnung der
Opernsaison in Glyndebourne, 1934 (2).
Fünf Jahre später nahm der deutsche Photo-
graph Felix Man (vormals Baumann) dieses
Bild von einer Aufführungspause im Park
des aristokratischen Opernhauses auf (1).
Obwohl es Sommer ist, finden einige der
Damen Pelz angebracht. Ähnlich gekleidet,
komplett mit Knopflochnelke, kommen
diese Besucher zur Eröffnung der 1937er
Saison im Royal Opera House (3). Ihr
Weg führt sie zwischen den Gemüsekisten
am Markt von Covent Garden hindurch.

L'OUVERTURE de la saison 1934 de l'opéra de Glyndebourne vit l'arrivée de Lady Diana Cooper, leader aristocratique de la scène sociale et auteur d'une autobiographie osée (2). Cinq ans plus tard, le photographe allemand Felix Man (autrefois Baumann) prit cette photo d'un entracte dans le parc du château où les opéras sont donnés (1). C'est l'été, mais quelques femmes estiment visiblement nécessaire de porter leurs fourrures. On retrouve le même goût vestimentaire, incluant l'œillet à la boutonnière, chez ces noctambules qui viennent d'assister à la soirée d'ouverture de la saison du Royal Opera House en 1937 et qui marchent avec précaution entre les cageots de légumes à Covent Garden (3).

2

3

EPSTEIN, Dalí and Picasso: three prolific and international giants of twentieth-century art. Jacob Epstein (1880-1954) was a formidable sculptor, known mainly for large and majestic works such as that of St Michael the Archangel, over the portico of the new Coventry Cathedral; he also produced this Earth Mother statue (1). An anonymous ditty ran: 'I don't like the family Stein;/ There is Gert, there is Ep, there is Ein./Gert's writings are punk,/ Ep's statues are junk,/And nobody understands Ein.' Dalí and Picasso were both Catalan, but had absolutely nothing in common. The former (2) was a truculent eccentric with a genius for publicity and moustaches, an exponent of Dada and Surrealist art. Having left Spain after the Guernica bombing that was to give rise to one of his most famous works, Picasso based himself in the South of France. Here he is meditating on his sinister carving of a goat (3) – a sculpture apparently light-years away from Picasso the Cubist, or of the Blue, Pink, abstract or later periods.

EPSTEIN, Dalí und Picasso: drei Giganten der internationalen Kunst des 20. Jahrhunderts. Jacob Epstein (1880-1954) war ein begnadeter Bildhauer, der vor allem für seine großformatigen, majestätischen Werke, wie den Erzengel Michael über dem Portikus der neuen Kathedrale von Coventry und seine Erdmutter (1), bekannt ist. Unser alter Freund Anonymus verspottet in einem Verslein die Marotten des großen Bildhauers: »Ich mag sie nicht, die Familie Stein, / Nicht die Gert, nicht den Ep, nicht den Ein. / Gerts Bücher sind schal, / Eps Statuen 'ne Qual, / Und Einstein versteht kein Schwein.« Dalí und Picasso waren beide Katalanen, doch das war auch ihre einzige Gemeinsamkeit. Dalí war ein hundertprozentiger Exzentriker mit einem Talent für Publicity und Schnurrbärte, ein Vertreter von Dada und Surrealismus (2). Picasso verließ Spanien nach der Bombardierung Guernicas, die ihm das Thema für eines seiner berühmtesten Bilder lieferte, und lebte seitdem in Südfrankreich. Hier sitzt er nachdenklich auf seinem Ziegenbock (3) – eine Skulptur, die Lichtjahre von

Picassos kubistischer, blauer, rosa und abstrakter Periode entfernt ist.

EPSTEIN, Dalí et Picasso : trois géants du XXe siècle, célèbres dans le monde entier. Jacob Epstein (1880-1954) était un formidable sculpteur, surtout connu pour ses œuvres monumentales et majestueuses comme l'archange saint Michel écrasant le démon sous son talon, érigée sur le portique de la nouvelle cathédrale de Coventry. Il a également créé la Grande Mère (1). Une mélodie anonyme dit irrévérencieusement : « Je n'aime pas la famille Stein / Il y a Gert, il y a Ep, il y a Ein / Les écrits de Gert sont moches / Les statues de Ep sont cloches / Et nul ne comprend Ein. » Le seul trait commun entre Dalí et Picasso était leur origine catalane. Dalí (2) faisait figure d'excentrique au caractère rebelle et était doué d'un sens génial de la publicité. Quant à Picasso, qui avait quitté l'Espagne à la suite du bombardement sur Guernica, il allait engendrer l'une de ses plus célèbres toiles. On le voit ici méditer sur sa sinistre chèvre sculptée (3), œuvre se situant apparemment à des années-lumière de sa période cubiste, bleue, rose, abstraite ou tardive.

(Overleaf)
IN 1966 the debonair Sir Malcolm Sargent conducts *Rule Britannia*, accompanied by considerable flag- and balloon-waving, at the Last Night of the Proms at the Royal Albert Hall.

(Folgende Seiten)
IM Jahre 1966 dirigiert ein gutgelaunter Sir Malcolm Sargent unter wehenden Flaggen und Ballons *Rule Britannia* bei der »Last Night of the Proms« in der Royal Albert Hall.

(Pages suivantes)
EN 1966, le débonnaire Sir Malcolm Sargent dirigea l'orchestre jouant *Rule Britannia* sous les drapeaux et les ballons, à l'occasion de la Last Night of the Proms au Royal Albert Hall.

monde du ballet, on note ici la présence de Serge Lifar posant ici avec les muses (1) dans *Apollon Musagète* et Serge Diaghilev (à droite), avec Jean Cocteau (2). En 1909, Diaghilev fonda la troup des Ballets russes à Monte-Carlo et les fit connaître en Occident, réunissant les plus grands talents de la danse et de la musique de l'époque : Pavlova, Nijinsky, Fokine, Massine, Balanchine, Stravinsky et Prokofiev.

(Overleaf)

THE famous portraitist Kleboe's picture of the young Scottish ballerina Moira Shearer (b. 1926) as she appeared in the 1948 film *The Red Shoes*, one of the most successful ballet films, directe by Powell and Pressburger.

(Folgende Seiten)

DIESES Bild des berühmten Porträtphotographen Kleboe zeig die junge schottische Ballerina Moira Shearer (geboren 1926 bei ihrem Auftritt 1948 in *Die roten Schuhe* von Powell und Pressburger, einem der erfolgreichsten Ballettfilme aller Zeiten.

(Pages suivantes)

LA jeune ballerine écossaise Moira Shearer (née en 1926) photographiée par le célèbre portraitiste Kleboe lors de son apparition en 1948 dans le film *Les Chaussons rouges,* réalisé par Powell et Pressburger, un des films-ballets qui connut le plus de succès.

ANNA Pavlova (1881-1931) became the world's most famous exponent of classical ballet, basing herself in this house (Ivy Lodge) in London's Golders Green (3). The carefully posed swan is a heavy allusion to her signature solo, Mikhail Fokine's *Dying Swan* of 1905. Other important Russians in the world of dance at this time included Serge Lifar, posed with the muses (1) in *Apollon Musagète*, and Serge Diaghilev (on the right), with Jean Cocteau (2). In 1909 Diaghilev founded the Ballets Russes in Monte Carlo. From here, he brought Russian ballet to the west, introducing all the star composers, choreographers and dancers of the period: Pavlova, Nijinsky, Fokine, Massine, Balanchine, Stravinsky and Prokofiev.

ANNA Pawlowa (1881-1931) war die weltweit berühmteste Tänzerin des klassischen Balletts, und dieses Haus, Ivy Lodge im Londoner Golders Green, war ihr Hauptquartier (3). Der Schwan im Vordergrund steht für die Rolle, die sie zu ihrem Markenzeichen machte, Michel Fokines *Sterbenden Schwan* von 1905. Andere bedeutende Russen in der Welt des Tanzes waren damals Sergej Lifar, hier (1) mit den Musen in *Apollon Musagète* zu sehen, und Sergej Diaghilew (rechts), mit Jean Cocteau (2). 1909 hatte Diaghilew seine Ballets Russes in Monte Carlo gegründet. Von dort aus exportierte er russisches Ballett in den Westen und machte alle bedeutenden Komponisten, Choreographen und Tänzer der Zeit damit vertraut: Pawlowa, Nijinsky, Fokine, Massine, Balanchine, Strawinsky und Prokofieff.

ANNA Pavlova (1881-1931) devint la plus célèbre représentante du ballet académique, se fixant dans cette maison (Ivy Lodge) de Golders Green à Londres (3). Le cygne posant à ses côtés est une lourde allusion au *Cygne* de Mikhaïl Fokine, qu'elle créa en 1905. Parmi les autres Russes qui ont compté à cette époque dans le

3

2

THE American Martha Graham (1894–1991) in her 1927 dance *Strike* (1). The Russian-born choreographer Georges Balanchine (1904–83) founded the New York City Ballet. Here, with British choreographer Frederick Ashton (second from left), he rehearses them in 1950 (2).

(Previous pages)

MARGOT Fonteyn (1919–1991) made her debut with the Vic-Wells Ballet in 1934. After her first *Giselle* in 1937 (1, in practice dress), she rapidly became a world star. Here she is in one of the roles she made her own: Stravinsky's *Firebird*, for which she was coached by Tamara Karsavina, the original Firebird (3). Her later career was revitalized by her partnership with the young Russian émigré Rudolf Nureyev. The pair are shown in the final rehearsal for the gala of *Pelléas et Mélisande* in 1969 (2).

DIE Amerikanerin Martha Graham (1894–1991) in ihrem Tanz *Strike* 1927 (1). Der aus Rußland stammende Choreograph Georges Balanchine (1904–83) begründete das New York City Ballet. Hier bei einer Probe im Jahre 1950 mit seinem britischen Kollegen Frederick Ashton (zweiter von links, 2).

(Vorherige Seiten)

MARGOT Fonteyn (1919–1991) gab ihr Debüt beim Vic-Wells-Ballett, 1934. Ihre erste *Giselle* 1937 (1, bei der Probe) machte sie zum Weltstar. Hier ist sie in einer ihrer Leib- und Magenrollen zu sehen, Strawinskys *Feuervogel*, für den sie Unterricht von Tamara Karsawina bekam (3). Später gab die Partnerschaft mit dem jungen russischen Emigranten Rudolf Nurejew ihrer Karriere neuen Schwung. Das Bild zeigt die beiden bei der letzten Probe zu einer Galavorstellung von *Pelléas et Mélisande* 1969 (2).

L'AMÉRICAINE Martha Graham (1894–1991) dans un ballet de 1927, *Strike*. Le chorégraphe d'origine russe Georges Balanchine (1904–1983) fonda le New York City Ballet. Ici, en 1950, répétant avec le chorégraphe britannique Frederick Ashton (second à partir de la gauche, 2).

(Pages précédentes)

MARGOT Fonteyn (1919–1991) fit ses débuts en 1934 avec le Vic-Wells Ballet. Après son premier *Giselle*, en 1937 (1, pendant l'entraînement), elle devint vite une star internationale. On la voit ici dans *L'Oiseau de feu* de Stravinsky, tandis qu'elle écoute les conseils de Tamara Karsavina, l'Oiseau de feu original (3). Sa carrière connut un nouvel essor grâce à Rudolf Noureev (1938–1993). On peut voir le couple lors de la dernière répétition pour le gala de *Pelléas et Mélisande* en 1969 (2).

1

2

3

4

5

Ninette de Valois (1, extreme left) rehearses the Sadlers Wells (later the Royal Ballet) *corps de ballet* in 1943. Marie Rambert founded the Ballet Rambert in 1926 (2). The British choreographer Frederick Ashton studied with Léonide Massine and Marie Rambert before joining the Vic-Wells ballet in 1935, creating numerous roles for Margot Fonteyn. Director of the Royal Ballet 1963-70, he is seen here rehearsing *Monotones* to music by Erik Satie (3), and dancing with Robert Helpmann as the Ugly Sisters in Prokofiev's *Cinderella* (5, right). John Cranko rehearses Gillian Lynne in *New Cranks* at London's Lyric Theatre in 1960 (4).

Ninette de Valois (1, ganz links) trainiert die Truppe von Sadlers Wells (das spätere Royal Ballet), 1943. Marie Rambert begründete das Ballet Rambert 1926 (2). Der britische Choreograph Frederick Ashton studierte bei Léonide Massine und Marie Rambert, bevor er sich 1935 dem Vic-Wells-Ballett anschloß, wo er zahlreiche Rollen für Margot Fonteyn schuf. 1963-70 war er Direktor des Royal Ballet; und hier sieht man ihn bei der Probe zu *Monotones* mit Musik von Erik Satie (3) und zusammen mit Robert Helpmann als häßliche Schwestern in Prokofieffs *Aschenbrödel* (5, rechts). John Cranko probt mit Gillian Lynne für *New Cranks* im Londoner Lyric Theatre, 1960 (4).

Ninette de Valois (1, à gauche) fait répéter le corps de ballet du Sadlers Wells (plus tard Royal Ballet) en 1943. Marie Rambert fonda le Ballet Rambert en 1926 (2). Le chorégraphe britannique Frederick Ashton, fit ses études avec Léonide Massine et Marie Rambert avant de rejoindre le ballet de Vic-Wells en 1935, créant de nombreux rôles pour Margot Fonteyn. Directeur du Royal Ballet de 1963 à 1970, on le voit ici faisant répéter *Monotones* sur une musique d'Érik Satie (3), et interprétant avec Robert Helpmann le rôle des Ugly Sisters du *Cendrillon* de Prokofiev (5, à droite). John Cranko fait répéter Gillian Lynne dans *New Cranks* au Lyric Theatre de Londres en 1960 (4).

MANY social changes occurred through Fifties popular culture. Even the skifflers here look faintly suspicious of the women choosing to jive on the pavement with one another, watched by a crowd of men (1). Girls out shopping together in the heyday of the gramophone go into a listening booth to check out a record before buying (2). Other teenagers with interchangeable hats and sandals sip identical milk-shakes in an identical pose (3).

VIELE gesellschaftliche Veränderungen kamen durch die Popkultur der 50er Jahre in Gang. Diese Skiffle-Musiker scheinen den beiden Frauen selbst nicht ganz zu trauen, die da vor einer großen Zahl männlicher Zuschauer einen Jive aufs Parkett des Bürgersteiges legen (1). Es war die große Zeit der Schallplatte: Mädchen

hören sich beim Einkaufsbummel eine Platte in der Hörkabine des Ladens an, bevor sie entscheiden, ob sie sie kaufen (2). Diese Teenager haben alle die gleichen Sandalen, die gleichen Hüte, die gleichen Posen und die gleichen Milkshakes (3).

DE nombreux bouleversements sociaux se produisent à travers la culture populaire des années 50. Même les musiciens, d'un air légèrement soupçonneux, observent les femmes qui dansent le rock sous les yeux d'une foule masculine (1). C'est l'âge d'or du tourne-disques ; des filles écoutent ensemble un microsillon avant de l'acheter (2). D'autres adolescentes à chapeaux et sandalettes interchangeables sirotent les mêmes milk-shakes dans une pose identique (3).

2

Die Tanzstile wurden im Laufe des Jahrhunderts immer lockerer. Im Jahre 1927 nimmt Mrs. Harradine aus Wood Green, Nord-London, Unterricht im Black Bottom (1). Auch mit 87 Jahren möchte sie, wie sie sagt, auf dem laufenden bleiben, damit sie mit den jüngeren Familienmitgliedern Schritt halten kann. Eine andere Variante war der »Affentanz«, so genannt, weil Miss Jola Cohen aus Chicago und Arthur Murray sich die Schritte von der Äffin La Bella Pola beibringen ließen (5). Fred Astaire unterrichtet in seinem Atelier an der New Yorker Park Avenue gleich hundert Tanzlehrer in seinen Techniken. Zwei von ihnen demonstrieren den typischen Astaire-Tanz, eine Mischung aus Jitterbug, Foxtrott und einem geheimnisvollen »Jersey Bounce« (2). Das ist natürlich »der Astaire«. Latin Lovers wie Ramon Navarro führten einen »neuen Tango« ein, und im Londoner Piccadilly-Hotel eifern Josephine Head und Albert Zapp ihm nach (3). In den 60er Jahren kam es, wie es kommen mußte: Als es nicht mehr weiter voranging, konnte es nur noch rückwärts gehen (4) – und zwar bis ganz nach unten. Wer im Glenlyn Ballroom Dancing Club keinen Twist tanzt, der ist rettungslos verloren.

La danse s'échauffe et s'agite au cours du siècle. Pour rester à la page à 87 ans et danser le Black Bottom en 1927, Mme Harradine, de Wood Green, au nord de Londres, écoute les instructions (1) pour demeurer, comme elle dit, « en paix avec les plus jeunes membres de la famille ». Une autre variation était la « danse du singe » – appelée ainsi depuis que le singe, La Bella Pola, avait appris un pas ou deux à Miss Jola Cohen de Chicago et Arthur Murray lui-même (5). Fred Astaire a transmis sa technique à cent instructeurs dans son propre studio de Park Avenue à New York. Deux d'entre eux font une démonstration de sa danse qui allie le jitterbug, le fox-trot et un énigmatique « bond de Jersey » (2). C'est, bien sûr, la « Astaire ». Des « latin lovers », à la façon de Ramon Novarro, ont remis le tango au goût du jour. Au Piccadilly Hotel de Londres, Josephine Head et Albert Zapp s'y exercent intensément (3). Durant les années 60, arriva ce qui devait arriver : quand tout mouvement vers l'avant a été fait, on ne peut plus qu'aller vers l'arrière (4) – à plat sur le dos. Au club de danse de Glenlyn, vous êtes vieux jeu si vous ne dansez pas le twist.

Dance styles loosened up and shook down through the course of the century. Anxious to get with it and do the Black Bottom in 1927, 87-year-old Mrs Harradine of Wood Green, North London, takes instruction (1) in order, she says, 'to keep pace with the younger members of the family'. Another variation was the 'Monkey Dance', so-called since the monkey La Bella Pola taught Miss Jola Cohen of Chicago and Arthur Murray himself a step or two (5). Fred Astaire's technique is passed on to 100 instructors at his own studio on Park Avenue, New York. Two of them demonstrate his signature dance, which combines jitterbug, fox-trot and a mysterious 'Jersey bounce' (2). It is, of course, 'the Astaire'. Latin lovers like Ramon Novarro created a taste for a 'new-fangled tango'. At the Piccadilly Hotel, London, Josephine Head and Albert Zapp are in hot pursuit of it (4). The 1960s brought the predictable outcome: when every forward move has been made, there's nowhere to go but back (3) – flat on your back. At the Glenlyn Ballroom Dancing Club, if you're not in a Twist you're a Square.

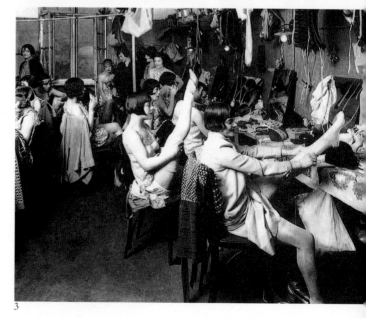

FRENCH night-life always had a certain *je ne sais quoi*. The Folies Bergère in 1929 was so grand and glamorous that it (and Maurice Chevalier) transferred direct to Hollywood's silver screen (4). Inside, the girls all acquired the same bobbed hairstyle – and the same high-kicking technique for pulling up their stockings (3). Josephine Baker was a legend in her two lifetimes: firstly as a dancer who brought her colour to the European stage and sexily sent up every racist prejudice with her oiled body, bouncing bananas and jungle seductions (1); secondly as the 'mother of a hundred' deprived and abandoned children she adopted and cherished. Edith Piaf's impoverished background; her past as a prostitute; her addiction to morphine and alcohol to help overcome the physical and emotional scars, all would have rendered her the quintessential victim, had it not been for her voice (2). Its tremendous power, combined with her fragile frame dressed always in black, made period songs like *La Vie en Rose* and *Non, je ne regrette rien* into her personal anthems.

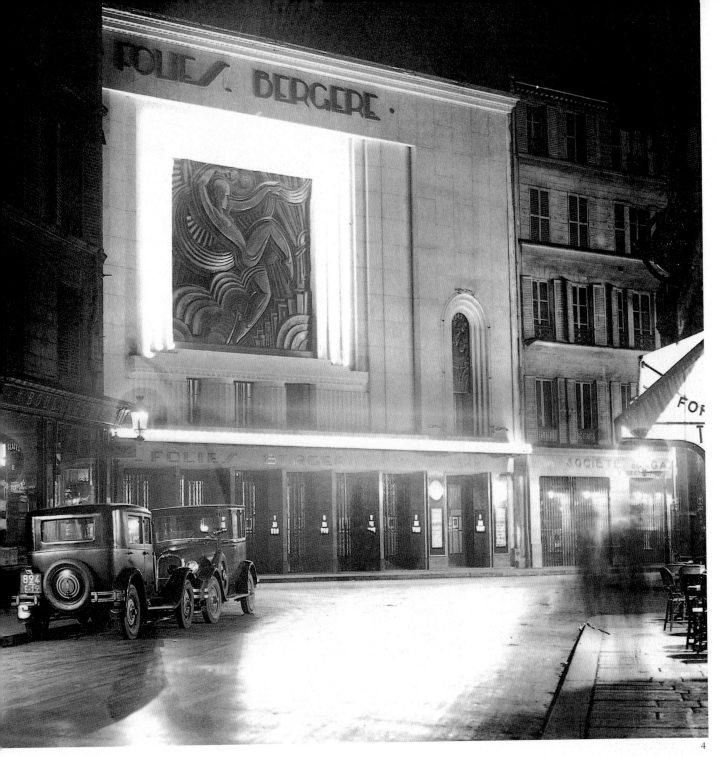

4

DAS Nachtleben in Frankreich hatte schon immer ein gewisses *je ne sais quoi*. Die Folies Bergère waren 1929 so grandios, daß man sie (und Maurice Chevalier) schnurstracks nach Hollywood verfrachtete (4). Drinnen hatten die Mädchen alle die gleiche Kurzhaarfrisur – und die gleiche Technik, um die Strümpfe anzuziehen (3). Josephine Baker wurde gleich zweimal zur Legende, in den zwei Leben, die sie führte: zuerst als Tänzerin, die Farbe auf die Bühnen Europas brachte und allen rassistischen Vorurteilen mit ihrem geölten Körper, den hüpfenden Bananen und ihrer Dschungelerotik die Spitze nahm (1), zum zweiten als Mutter von hundert verlassenen Kindern, die sie adoptierte und aufzog. Edith Piaf schien zum Opfer geboren, bei den ärmlichen Verhältnissen, aus denen sie kam, ihrer Vergangenheit als Prostituierte, ihrer Morphium- und Alkoholsucht; doch ihre Stimme rettete sie (2). Die enorme Kraft dieser Stimme, die in einem solchen Kontrast zu der zerbrechlichen, stets in Schwarz gekleideten Gestalt stand, machte Lieder wie *La vie en rose* oder *Non, je ne regrette rien* zu ihren ganz persönlichen Hymnen.

EN France, la vie nocturne possède un certain « je-ne-sais-quoi ». En 1929, le prestige et l'attrait des Folies Bergère était tels qu'on les transposa directement (avec Maurice Chevalier) sur le grand écran hollywoodien (4). À l'intérieur, les filles avaient toutes la même coupe au carré et une technique identique pour enfiler leur bas (3). Joséphine Baker fut deux fois légendaire : une première fois, en tant que danseuse de couleur en tournée européenne, elle ridiculisa tous les préjugés racistes avec son corps luisant, ses bananes bondissantes et ses attraits exotiques (1) ; une seconde fois en adoptant une centaine d'enfants abandonnés. Le milieu misérable d'où était issue Édith Piaf, son passé dans la prostitution, sa dépendance à l'alcool et à la morphine qui l'aidait à faire face aux problèmes physiques et émotionnels, tout cela aurait fait d'elle la quintessence de la victime s'il n'y avait pas eu sa voix (2). Celle-ci émanait de sa fragile silhouette toujours vêtue de noir. Grâce à elle, son nom est indissolublement lié à des chansons comme *La vie en rose* et *Non, je ne regrette rien*.

Β<small>ILLIE</small> Holiday (1); Ella Fitzgerald in
1962 (3); Thelonious Monk (2); Louis
Armstrong in the 1960s (4).

Β<small>ILLIE</small> Holiday (1); Ella Fitzgerald,
1962 (3); Thelonious Monk (2); Louis
Armstrong in den 60er Jahren (4).

Β<small>ILLIE</small> Holiday (1) ; Ella Fitzgerald
en 1962 (3) ; Thelonious Monk (2) ;
Louis Armstrong dans les années 60 (4).

The Sixties and Seventies

THE decade opened with a bang, with Africa dominant. In 1960 Harold Macmillan's 'wind of change' speech unintentionally inaugurated a period of unprecedented bloodshed, which started when unarmed civilians attending a public meeting at Sharpeville were mown down as armed police opened fire without warning. That, of course, did most to radicalize both African and world opinion against apartheid. In the United States too the Civil Rights Movement was taking off, partly inspired by a time of rising expectations with Kennedy's presidential nomination in 1960. He won against Nixon, by only 120,000 votes, and promised in his inaugural speech that: 'The old era is ending. The old ways will not do.'

Kennedy's assassination in 1963 did not stem the tide of America's rise to the heights. In 1961 the US had put a chimpanzee named Ham into space; the Russians followed with their dog Laika – and, ahead of the US, their man, Yuri Gagarin. The Space War gradually turned into Star Wars: a hundred million viewers tuned in their television sets in 1969 to watch Neil Armstrong land on the moon, taking 'one small step for man, one giant leap for mankind'.

From August 1964, the US became heavily embroiled in the Vietnam war. By 1965 international protest was growing. In Washington candle-lit vigils were held outside the White House; in London 250,000 demonstrated before the US Embassy. 'Agent Orange', used in the war to defoliate trees and starve the local population, was perhaps one of the instigators of the backlash against environmental warfare.

Outstripping everything in popularity was 'Beatlemania', however fierce the defendants of the altogether rawer and raunchier Rolling Stones. The Beatles starred at the Royal Command Performance and walked away with their CBEs: by 1964 they were the country's most popular tourist attraction. Beatlemania was said to be primarily female, primarily below the belt. Even stay-up stockings sported pictures of the Fab Four.

London was swinging: more specifically, King's Road, Chelsea, was swinging to the sounds of British and West Coast bands and the fashions of Mary Quant, Ossie Clark and Barbara Hulanicki ('Biba'). Despite a radical student movement – causing the closure of numerous European universities, particularly in Britain, Germany and France – and the Black Power movement in the United States, there was a mood of positive optimism abroad. The world was youth's oyster: international travel was suddenly cheap (especially if you hitched the hippie trail); love was suddenly 'free' (at a time when the Pill was new and AIDS unheard-of); music was both poignant and danceable (and folk was pop while blues made the classics); and politics could still be about 'liberation movements' rather than 'the stuff of corruption and negativism'.

DAS Jahrzehnt begann mit einem Paukenschlag, ganz besonders in Afrika. Harold Macmillans Rede von 1960, in der er von einem »frischen Wind« sprach, löste unbeabsichtigt eine Welle beispielloser Bluttaten aus, die damit begann, daß unbewaffnete Zivilisten, Teilnehmer einer öffentlichen Versammlung in Sharpeville, von der Polizei niedergemäht wurden, die ohne Vorwarnung das Feuer eröffnete. Mehr brauchte es nicht, um Afrika und die ganze Welt auf die Barrikaden gegen die Apartheid zu bringen. In den Vereinigten Staaten kam die Bürgerrechtsbewegung in Gang, nicht zuletzt beflügelt von den großen Erwartungen der Nominierung Kennedys als Präsidentschaftskandidat im Jahre 1960. Mit nur 120 000 Stimmen Vorsprung setzte er sich gegen Nixon durch. In seiner Antrittsrede erklärte er: »Die alten Zeiten sind vorbei. Aber die guten Traditionen nicht.«

Die Ermordung Kennedys im Jahre 1963 konnte den Aufstieg der USA zu neuen Höhen nicht aufhalten. 1961 hatten die Amerikaner einen Schimpansen namens Ham in den Weltraum geschickt; die Russen folgten mit ihrer Hündin Laika – und vor den Amerikanern mit dem ersten Menschen im Weltraum, Juri Gagarin. Aus dem Wettlauf im Weltall wurde allmählich ein Sternenkrieg: 100 Millionen Menschen saßen 1969 an ihren Fernsehgeräten, um Neil Armstrong auf dem Mond zu sehen, wie er »einen kleinen Schritt für einen Menschen, doch einen großen Sprung für die Menschheit« machte.

Vom August 1964 an engagierten die Vereinigten Staaten sich verstärkt im Vietnamkrieg. 1965 kam es weltweit zu Protesten. Vor dem Weißen Haus in Washington wurden Mahnwachen gehalten; in London demonstrierten 250 000 vor der amerikanischen Bot-

schaft. Das Entlaubungsmittel »Agent Orange«, das die Einheimischen dem Hungertod preisgab, war mitverantwortlich dafür, daß eine Kampagne gegen ökologische Kriegführung in Gang kam.

Populärer als alles andere war die »Beatlemania«, so sehr sich die Verehrer der handfesteren Rolling Stones auch ins Zeug legten. Die Beatles waren es, die vor der Queen auftraten und mit Orden dekoriert wurden – schon 1964 waren sie Großbritanniens größte Touristenattraktion. Von der Beatlemania, heißt es, waren hauptsächlich die weiblichen Fans betroffen, und sie wirkte eher unter der Gürtellinie. Selbst halterlose Strümpfe zierten das Bild der Fab Four.

Es war die Zeit des »Swinging London«; genauer gesagt, war es die King's Road in Chelsea, die zu den Klängen britischer und kalifornischer Bands swingte, mit Mode von Mary Quant, Ossie Clark und Barbara Hulanicki (»Biba«). Trotz Studentenunruhen – die zur zeitweiligen Schließung zahlreicher Universitäten führten, vor allem in England, Deutschland und Frankreich – und der Black-Power-Bewegung in den Vereinigten Staaten war es ein durch und durch optimistisches Jahrzehnt. Die ganze Welt stand der jungen Generation offen: Auslandsreisen waren plötzlich billig (besonders wenn man als Hippie per Anhalter reiste); Liebe war plötzlich »frei« (zu einer Zeit, als die Pille eben erst erfunden war und noch niemand von AIDS gehört hatte); die Musik hatte Tiefe, und man konnte trotzdem dazu tanzen (und Folk war Pop, und Blues war Klassik); und in der Politik konnte es noch um Befreiungsbewegungen gehen statt um Korruption und allgemeinen Niedergang.

LES années 60. La décennie s'est ouverte sur un véritable coup de tonnerre en Afrique du Sud. En 1960, le discours du Britannique Harold Macmillan à propos d'un certain « vent de changement » inaugura une époque d'épanouissement sans précédent, qui, paradoxalement, débuta à Sharpeville par un massacre. En effet, la police sud-africaine ouvrit le feu sans sommations sur des civils désarmés qui assistaient à un meeting public. Tout cela contribua évidemment beaucoup à durcir l'opinion africaine et mondiale contre l'apartheid.

Au États-Unis, c'est porté par une époque riche d'espoirs, dont l'élection de Kennedy à la présidence, que démarra le Mouvement pour les droits civils. Le nouveau président n'obtint que 120 000 voix de plus que Nixon et déclara dans son discours d'ouverture : « L'ère ancienne est révolue. Les vieilles méthodes ne fonctionnent plus. »

En 1963, son assassinat ne freina en rien l'ascension américaine. Dès 1961, les États-Unis avaient envoyé dans l'espace un chimpanzé du nom de Ham ; les Russes leur emboîtèrent le pas en lançant leur chienne Laïka sur orbite et, précédant les États-Unis dans ce domaine, il lancèrent Youri Gagarine. La guerre de l'espace se mua progressivement en guerre des étoiles : en 1969, pas moins de cent millions de téléspectateurs assistèrent à la sortie de Neil Armstrong sur la Lune et l'entendirent prononcer le fameux « petit pas pour un homme, pas de géant pour l'humanité » qui restera dans la postérité.

À partir du mois d'août 1964, les États-Unis furent étroitement mêlés à la guerre du Viêt-nam. Dès 1965, on assista à une vive recrudescence des protestations internationales. À Washington, on organisait des veillées aux chandelles devant la Maison Blanche ; à Londres, 250 000 personnes manifestèrent devant l'ambassade des États-Unis. L'agent orange, un défoliant utilisé pendant la guerre, destiné à affamer la population locale, inspira peut-être le « retour de manivelle » contre la guerre écologique.

Aussi populaires qu'ils fussent, les Rolling Stones, dans l'ensemble plus crus et plus sensuels que les Beatles, ne parvinrent jamais à égaler l'enthousiasme provoqué par la « beatlemania ». Les Beatles furent les vedettes de la Royal Command Performance avant de devenir « Compagnons de l'Ordre de l'Empire britannique » ; en 1964, ils incarnaient la principale attraction touristique de la nation britannique. On a prétendu que la « beatlemania » était surtout le fait des filles. Même les bas-jarretelles arboraient les portraits des quatre célèbres garçons.

Londres, ou plus spécialement King's Road, Chelsea, dansait au rythme des groupes britanniques et occidentaux, et s'habillait à la mode de Mary Quant, Ossie Clark et Barbara Hulanicki, « Biba ». En dépit d'un mouvement lancé par des étudiants radicaux – qui causa la fermeture de nombreuses universités européennes, en particulier en Grande-Bretagne, en Allemagne et en France – et du mouvement du Black Power aux États-Unis, on sentait à l'étranger un sentiment d'optimisme positif. En effet, la jeunesse avait le monde à ses pieds : les voyages internationaux étaient soudain devenus bon marché (en particulier sur le mode hippy) ; tout à coup l'amour devenait « libre » (en ces temps où la pilule était une nouveauté et le sida inconnu) ; la musique était émouvante et se prêtait à la danse tandis que les politiques s'occupaient davantage des « mouvements de libération » que des retombées liées aux affaires de corruption et au négativisme ambiant.

2

3

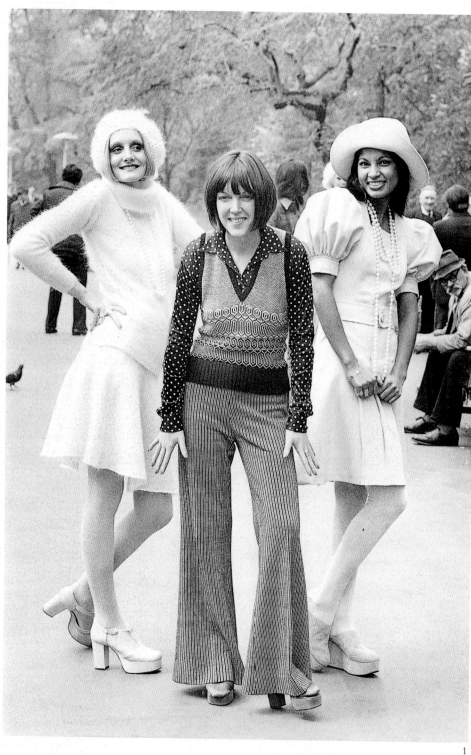

1

MARY Quant was fashion's contribution to 'Swinging London' (1). Even the staid *Time* magazine noted that: 'In a decade dominated by youth, London has burst into bloom. It swings: it is the scene'. Noted for swinging skirts and flares at near-High Street prices, and for her angular, heavily fringed haircut, Quant also attracted publicity when her husband trimmed her pubic hair into a heart-shape. Sandie Shaw (2), better known as a Eurovision Song Contest winner (with *Puppet on a String* in 1964), also launched a fashion boutique in 1967. Her perennially bare feet contrast with Quant's clumpy platform soles.

MARY Quant war der Beitrag der Modewelt zum »Swinging London« (1). Selbst die hausbackene Zeitschrift *Time* vermerkte: »In einem Jahrzehnt, das von der Jugend beherrscht wird, ist London erblüht. Es swingt: hier ist was los.« Quant war für ihre schwingenden Röcke und Schlaghosen bekannt, die sie zu Preisen verkaufte, die kaum über denen der Kaufhäuser lagen, und für den kantigen Haarschnitt mit dem tief in die Stirn gezogenen Pony. Sie erregte auch Aufsehen damit, daß ihr Mann ihr das Schamhaar herzförmig rasierte. Sandie Shaw (2), eher als Siegerin des Eurovision-Schlagerwettbewerbes bekannt (1964, mit *Puppet on a String*), eröffnete 1967 ihre eigene Modeboutique. Der Kontrast zwischen den nackten Füßen – ihrem Markenzeichen – und Mary Quants klobigen Plateausohlen könnte nicht größer sein.

MARY Quant était une haute figure de la mode au « Swinging London » (1). Même le *Time*, plutôt collet monté, notait « Dans une décennie dominée par la jeunesse, Londres s'est épanoui. Il se balance : il est la scène. » Rendue célèbre par ses jupes courtes et ses pantalons à pattes d'éléphant, à des prix presque High-Street, mais également pour sa coiffure en casque à lourde frange, Mary Quant bénéficia des retombées publicitaires, lorsque son mari arrangea les poils de son pubis en forme de cœur. Sandie Shaw (2), que sa première place au concours de l'Eurovision de la chanson en 1964, avec « *Puppet on a String* » a rendu célèbre, ouvrit aussi une boutique de mode en 1967. Ses pieds, perpétuellement nus, contrastent avec les massives semelles à plateau de Mary Quant.

(Previous pages)

YVES St Laurent with models (1). Space is big news even in 1969 fashion swimsuits (2). If a face summarized the mood of the times, it was Twiggy's – doe-eyed, freckle-nosed, topped with cropped hair (4). Her gestures and bare feet seemed designed to underline her nickname (3).

(Vorherige Seiten)

YVES Saint-Laurent mit Mannequins (1). 1969 dreht sich alles um die Raumfahrt, selbst in der Bademode (2). Wenn es ein typisches Gesicht jener Zeit gab, dann war es das von Twiggy, mit ihren Kulleraugen, der sommersprossigen Nase und dem kurzen Haar (4). Mit ihrer Haltung und den nackten Füßen schien sie ihren Spitznamen (»Zweiglein«) noch zu unterstreichen (3).

(Pages précédentes)

YVES Saint-Laurent avec des mannequins (1). L'espace est à la une en 1969, et même les maillots de bain n'y échappent pas (2). Avec ses yeux de biche, ses taches de son sur le nez et ses cheveux courts, Twiggy est, à de multiples égards, représentative de cette époque (4). Ses gestes et ses pieds nus semblaient souligner son apparence de « petite branche » (3).

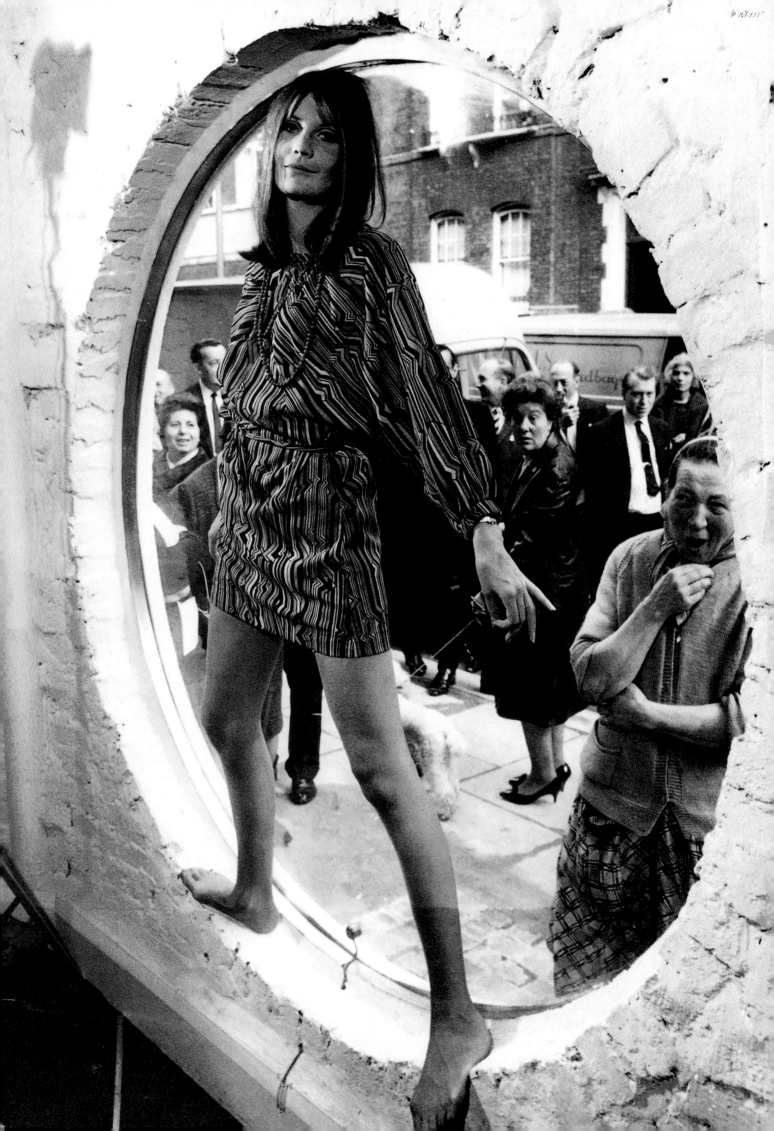

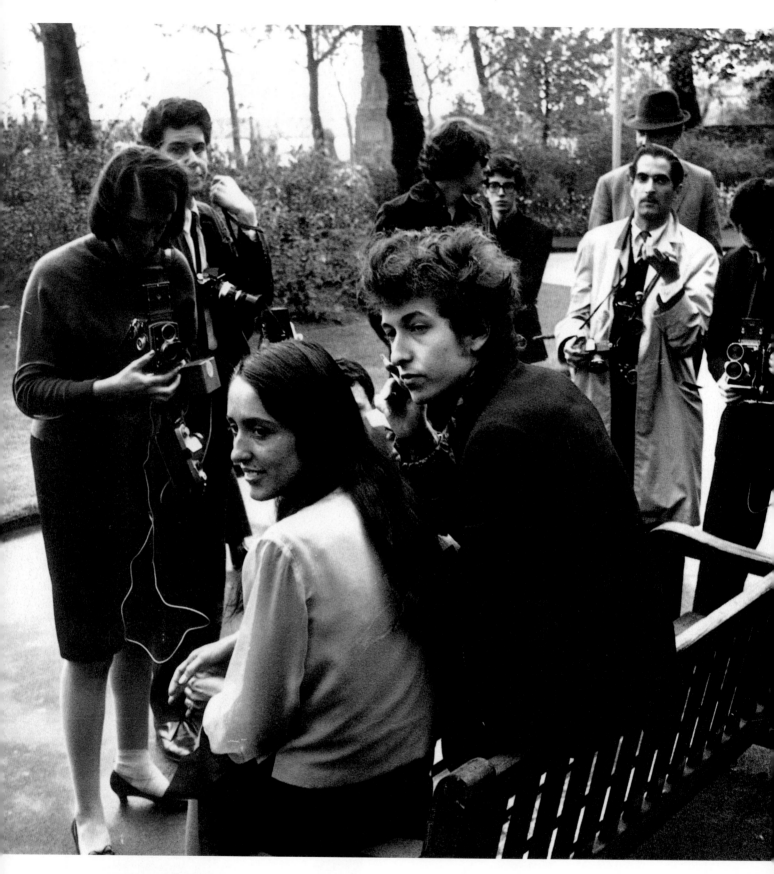

IN 1965 Bob Dylan and his girlfriend Joan Baez were still folk-singers, rooted in the 'white blues' of Woody Guthrie and Pete Seeger (1). Composers, songwriters, singers and performers, they fulfilled new ideals of new troubadours. John Lennon and his second wife, the Japanese film-maker Yoko Ono, mock another established tradition in appearing on the Eamonn Andrews Show.

While Eamonn gets to lie in the bed they made famous by taking to it for world peace, they occupy a sheet sleeping-bag at its feet (2). Having denuded themselves before the camera, they were to remove another layer by shaving their heads. And they still maintained their opposition to the Vietnam War, along with their fellow long-haired 'peaceniks'.

IM Jahre 1965 waren Bob Dylan und seine damalige Freundin Joan Baez noch Folksänger, verwurzelt im »weißen Blues« von Woody Guthrie und Pete Seeger (1). Als Komponisten, Liedermacher, Sänger waren sie die idealen Troubadoure einer neuen Zeit. John Lennon und seine zweite Frau, die japanische Fluxus-Künstlerin Yoko Ono, verspotten in der Eamonn

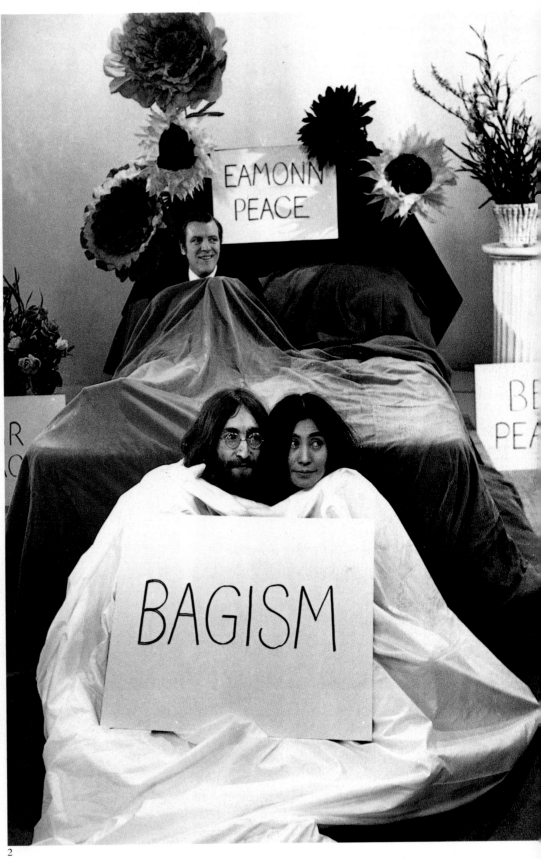

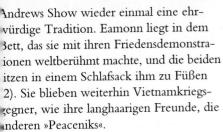

Andrews Show wieder einmal eine ehrwürdige Tradition. Eamonn liegt in dem Bett, das sie mit ihren Friedensdemonstrationen weltberühmt machte, und die beiden sitzen in einem Schlafsack ihm zu Füßen (2). Sie blieben weiterhin Vietnamkriegsgegner, wie ihre langhaarigen Freunde, die anderen »Peaceniks«.

E N 1965, Bob Dylan et sa petite amie Joan Baez étaient encore des interprètes de musique folk, laquelle prenait ses racines dans les blues blancs de Woody Guthrie et Pete Seeger (1). Compositeurs, paroliers, chanteurs et interprètes, ils correspondaient au nouvel idéal du troubadour moderne. John Lennon et sa seconde épouse, la réalisatrice japonaise Yoko Ono,

apparaissent dans le Eamonn Andrews Show. Tandis qu'Eamonn se couche dans le lit support de la campagne du couple en faveur de la paix dans le monde, ils se sont enroulés à ses pieds dans un drap blanc (2). Soutenus et accompagnés de nombreux pacifistes, jamais ils ne cesseront de s'opposer à la guerre du Viêt-nam.

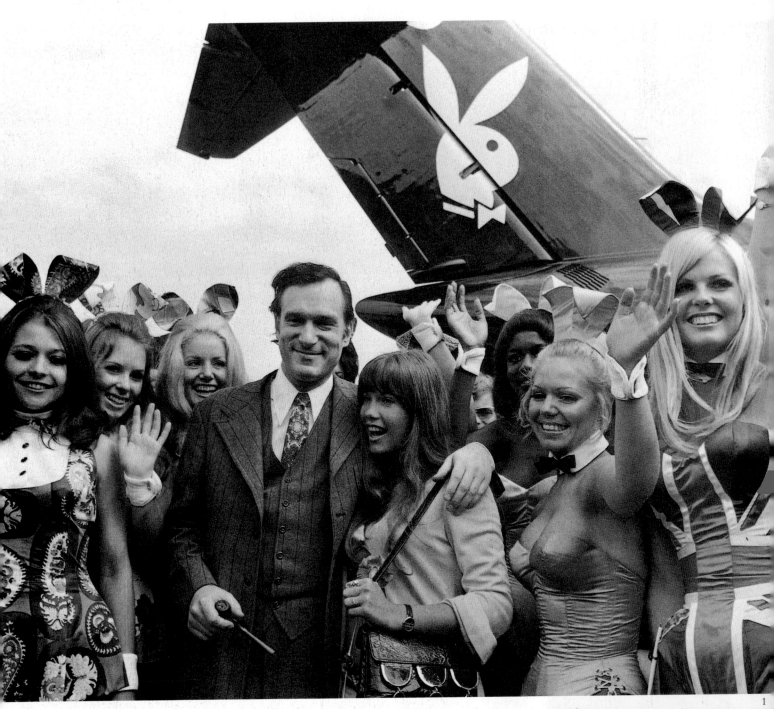

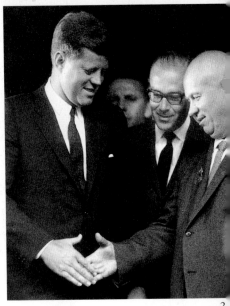

THE 1960s were little if not exuberantly heterogeneous. While Stateside 'women's libbers' burnt their bras (even if only once and for a press-orchestrated publicity stunt), Hugh Hefner, head of the Playboy empire, stuffed his 'bunny girls' into ever-tighter, upward-thrusting corsets (1). An historic moment was reached in Vienna when, 16 years after the city's partition in 1945, President Kennedy exchanged handshakes with Prime Minister Khrushchev (2). The 1963 Profumo scandal brought down a minister and, subsequently, a government. Prostitute Christine Keeler was said to have bowed to the machinations of society doctor Stephen Ward, who used extensive connections to procure her high-class clients. Here she is seen waiting outside the courtroom at his trial (4). She made a comeback of sorts at a 1969 photo-call for photographer David Bailey's book *Goodbye baby and Amen*, alongside model Penelope Tree and singer Marianne Faithfull (3).

DAS Bemerkenswerteste an den 60er Jahren war ihre Widersprüchlichkeit. Während in Amerika Feministinnen ihre BHs verbrannten, steckte Hugh Hefner, Chef des Playboy-Imperiums, seine »Bunnies« in immer engere Korsetts (1). Ein historisches Ereignis fand in Wien statt, wo Präsident Kennedy sechzehn Jahre nach der Teilung der Stadt dem russischen Premierminister Chruschtschow die Hand reichte (2). Der Profumo-Skandal von

1963 brachte in England einen Minister und am Ende eine ganze Regierung zu Fall. Es heißt, die Prostituierte Christine Keeler sei dem Arzt der High Society, Stephen Ward, gefällig gewesen, und dieser habe seine vielfältigen Kontakte spielen lassen, um ihr Kunden aus der besten Gesellschaft zu vermitteln. Hier wartet sie beim Prozeß gegen Ward vor dem Gerichtssaal (4). 1969 hatte sie eine Art Comeback, als der Photograph David Bailey der Presse sein Buch *Goodbye Baby and Amen* präsentierte. Die beiden anderen sind Model Penelope Tree und Sängerin Marianne Faithfull (3).

LES années 60 n'ont pas connu la même évolution dans chaque pays. Alors qu'aux États-Unis, les adeptes du Women's Lib brûlaient leurs soutiens-gorge (en fait un seul devant les photographes et journalistes invités), Hugh Heffner, à la tête de l'empire Playboy, affublait ses Bunnys de corsets moulants qui mettaient en valeur leurs attributs (1). Vienne vécut un moment historique quand, seize ans après le partage de la ville, le président Kennedy échangea une poignée de main avec Khrouchtchev, alors Premier ministre de l'Union soviétique (2). En 1963, le scandale Profumo ne causa rien moins que la démission d'un ministre et la chute d'un gouvernement. La prostituée Christine Keeler était mêlée aux intrigues de Stephen Ward, médecin de la bonne société lui fournissant une clientèle haute gamme. On la voit ici pendant son procès, attendant devant le tribunal (4). Elle revint en 1969, en posant pour l'album du photographe David Bailey, *Goodbye Baby and Amen*, aux côtés du mannequin Penelope Tree et de la chanteuse Marianne Faithfull (3).

FILM faces of the 1960s. Michael Caine, at home with his mother and brother in 1964 (1), the epitome of a working-class lad made good who still loved his mum. His flat South London accent and square specs were as much a part of his act as the tough-guy parts he played. Polish film director Roman Polanski married Californian starlet Sharon Tate in January 1968 (2). Nothing in the sinister oddness of his fantasy world anticipated the horror that resulted. In August 1969, Tate and their unborn child along with four friends were murdered by maniac cult leader Charles Manson and three female accomplices. And in Venice for the 1963 Film Festival, British stars Julie Christie and Tom Courtenay captured the look and spirit of a decade in the hugely successful *Billy Liar* (3).

FILMSTARS der Sechziger. Michael Caine, zu Hause mit Mutter und Bruder im Jahre 1964 (1), ganz der brave Sohn aus einfachem Hause. Der Südlondoner Akzent und die breiten Brillengläser waren ebenso eine Rolle, die er spielte, wie der harte Typ, den er so oft verkörperte. Der polnische Regisseur Roman Polanski heiratete das kalifornische Starlet Sharon Tate im Januar 1968 (2). Doch auch die abseitigsten Phantasien seiner Filme

bereiteten niemanden auf das vor, was kommen sollte. Im August 1969 wurden Sharon Tate und ihr ungeborenes Kind zusammen mit vier Freunden von dem wahnsinnigen Sektenführer Charles Manson und drei Anhängerinnen ermordet. 1963, beim Filmfestival in Venedig, waren die britischen Stars Julie Christie und Tom Courtenay ganz auf der Höhe des Jahrzehnts, und ihr Film *Billy Liar* war ein großer Erfolg (3).

VISAGES de cinéma des années 60. Michael Caine, posant en modèle de garçon de la classe ouvrière et de fils aimant, chez lui avec sa mère et son frère en 1964 (1). Son parler, dépourvu de intonations du sud de Londres, et ses lunettes démodées revêtaien une grande importance dans les rôles d'homme confirmé qu'il devait interpréter. C'est en janvier 1968 que le réalisateur polonai Roman Polanski, épousa la petite actrice californienne Sharon Tat (2). En août 1969, alors que Sharon Tate était enceinte, un nomm Charles Manson, gourou d'un culte satanique, et trois femmes complices, assassinèrent l'actrice et quatre de ses amis. En 1963, au Festival de Venise, les vedettes britanniques Julie Christie et Tom Courtenay surent capter l'allure et l'esprit d'une décennie dans *Billy Liar* (3), un énorme succès.

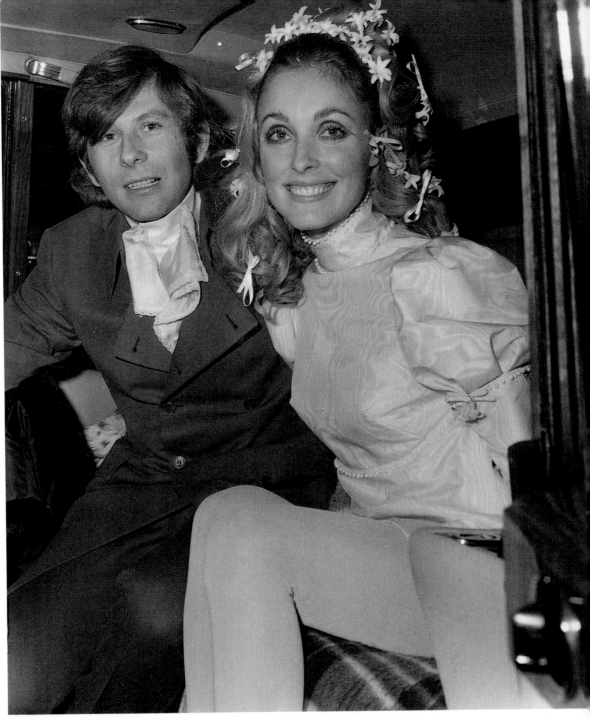

1 2

3

(Overleaf)

OUTDOOR pop festivals became big business through the 1960s and 1970s. Windsor (1), Woburn, Bath, the Isle of Wight and Hyde Park were all popular venues. And even if you couldn't hear the music, you could paint your own (or someone else's) body (2) and roll your own smoke, using an unlikely cigarette-holder (3).

(Folgende Seiten)

FREILUFT-POPFESTIVALS waren in den 60er und 70er Jahren ein großes Geschäft. Windsor (1), Woburn, Bath, die Isle of Wight und der Hyde Park waren die populärsten Orte. Wenn die Musik nicht zu hören war, konnte man sich den Körper bemalen (oder den einer Freundin) (2), oder etwas Selbstgedrehtes rauchen, wie hier mit dieser originellen Zigarettenspitze (3).

(Pages suivantes)

LES festivals de musique pop en plein air prirent une grande ampleur durant les années 60 et 70. À Windsor (1), Woburn, Bath, l'Île de Wight ou à Hyde Park, s'il était parfois difficile d'écouter la musique, on pouvait peindre son corps (ou celui de quelqu'un d'autre) (2) ou encore utiliser ce style de fume-cigarette (3).

2 3

JIMI Hendrix shortly before dying of a heroin overdose in 1970 (1). Mary Wilson, Diana Ross and Cindy Birdsong in 1968 attained stardom as the Supremes (2). In 1967, the Rolling Stones enhanced their 'bad boys' image: Mick Jagger and Keith Richards sentenced for drug offences (3).

JIMI Hendrix, 1970, kurz bevor er an einer Überdosis Heroin starb (1). Mary Wilson, Diana Ross und Cindy Birdsong 1968, als sie schon als Supremes berühmt waren (2). Die Rolling Stones 1967: Mick Jagger und Keith Richards werden wegen Drogenbesitzes verurteilt (3).

JIMI Hendrix, en 1970, avant qu'il ne succombe à une overdose d'héroïne (1). Mary Wilson, Diana Ross et Cindy Birdsong en 1968, qui devinrent plus tard les Supremes (2). En 1967, Mick Jagger et Keith Richards, des Rolling Stones, furent condamnés pour usage de stupéfiants (3), accentuant leur image de mauvais garçons.

3

1 2

3 4

5

6

ELVIS Presley's phenomenal career (1) went into almost equally dramatic decline as drugs took over his life. Michael Jackson with the family pop group at Heathrow in 1972 (2). Bob Marley (5) made it ahead of other reggae singers because of exceptional talent, as a composer, musician and singer. The Everly Brothers (3), made fame last by staying the same, while 'husband-and-wife pop singers Sonny & Cher' (6) are no more, but Sonny Bono is mayor in California and Cher keeps churning out the movies. Stevie Wonder (4) in 1965, 'little' boy Wonder with his harmonica.

ELVIS Presleys Aufstieg war kometenhaft, doch beinahe ebenso steil war sein Fall, als Medikamentensucht sein Leben ruinierte (1). Michael Jackson mit der singenden Familie auf dem Londoner Flughafen Heathrow, 1972 (2). Bob Marley (5) hatte mehr Erfolg als jeder andere Reggaesänger wegen seines herausragenden Talents als Komponist, Musiker und Sänger. Die Everly Brothers (3) blieben sich treu und waren deshalb erfolgreich; für Sonny & Cher (6) sind die Zeiten als singendes Ehepaar vorbei, doch Sonny Bono ist Bürgermeister in Kalifornien, und Cher dreht einen Film nach dem anderen. Stevie Wonder 1965, als er noch der nette Junge mit der Mundharmonika war (4).

LA carrière phénomènale d'Elvis Presley (1), à l'image de sa déché-lance physique, connut un déclin dramatique. Michael Jackson avec le groupe pop familial en 1972 à Heathrow (2). Le talent de Bob Marley (5) en tant que compositeur, musicien et chanteur en fit le pape du reggae. C'est en restant les mêmes que les Everly Brothers (3) devinrent célèbres. Le couple de chanteurs pop Sonny & Cher (6) a cessé d'exister depuis longtemps. Sonny Bono est maire en Californie et Cher se produit au cinéma. Stevie Wonder (4) en 1965 avec son harmonica.

THE punk movement of the 1970s (1) was largely launched by the likes of the Sex Pistols pop group. In October 1978 Sid Vicious was arrested by New York police and charged with murdering Nancy Spungeon while the two were high on drugs. In February 1979 he died of a heroin overdose. Just as in the 1960s, supporters of different political and musical factions had their uniforms, despite a measure of cross-over. Skinheads and bovver boots were the primary prerogative of the neo-Nazi white supremacist British Movement (2), while 'crusties' in the 1990s (3), following hippie style, adopted the New Age garb of colour-ful dreadlocks, crazy hats and fabrics and a definitely unwashed look.

DIE Punk-Bewegung der 70er Jahre (1) wurde von Gruppen wie den Sex Pistols begründet. 1978 wurde Sid Vicious von der New Yorker Polizei festgenommen und des Mordes an Nancy Spungeon angeklagt; beide standen zur Tatzeit unter Drogen. Im Februar 1979 starb er an einer Überdosis Heroin. Genau wie in den 60er Jahren hatten die Anhänger bestimmter politischer Fraktionen oder Musikrichtungen ihre Uniformen, auch wenn die Grenzen nicht mehr ganz so scharf gezogen waren. Kahlgeschorene Köpfe und Springerstiefel waren Erkennungszeichen der Neonazis (die es auch in England als rassistisches »British Movement« gab, 2), wohingegen die »crusties« der 90er Jahre (3) sich in New-Age-Gewänder hüllten, mit bunten Dreadlocks, verrückten Hüten und Stoffen, und einen ausgesprochen ungewaschenen Eindruck machten.

LE mouvement punk des années 70 (1) a en grande partie été popularisé par les faits et gestes des Sex Pistols. En octobre 1978, Sid Vicious était arrêté par la police de New York pour avoir tué Nancy Spungeon, alors qu'ils étaient tous deux sous influence de la drogue. C'est en février 1979 qu'il disparut à la suite d'une overdose d'héroïne. Dans les années 60, les supporters de différentes factions politiques et musicales arboraient l'uniforme. La tête rasée et les bottes cloutées furent la prérogative du mouvement britannique des blancs néonazis (2). Les « crusties » des années 90 (3) ont, pour leur part, adopté la panoplie New Age : des mèches rasta passées à la teinture, des chapeaux et tissus excentriques et un look irrévocablement négligé.

ST-TROPEZ, made famous by its yachts and by Brigitte Bardot's residence there, continued to flaunt fashion's bottom line into the 1970s. Buttock-cutting jeans (3), studded mini-shorts (2) and a scarf (4) – at times only a string – were rare concessions to dress when leaving the nudist beaches for the boutiques and cafés lining the boardwalks. The striped outfit (1) has more lasting appeal than the outrageous platforms (5) or the babydoll smock and bell-bottoms (6).

ST. TROPEZ – bekannt für seine Jachten und dafür, daß Brigitte Bardot sich dort niedergelassen hatte – machte auch in den 70er Jahren noch Mode. Hautenge Hüfthosen (3), nietenbewehrte, ultrakurze Shorts (2) und ein Tuch (4) – manchmal sogar nur ein String – waren die einzigen

4

5

6

Zugeständnisse, die man machte, wenn man von den Nacktbadestränden zu den Boutiquen und Straßencafés herüberkam. Der Streifenanzug (1) kann heute eher noch überzeugen als die verrückten Plateausohlen (5) oder die Babydoll-Bluse mit Schlaghosen (6).

SAINT-TROPEZ, fameuse pour ses yachts et la maison de Brigitte Bardot, continua, au cours des années 70, à montrer l'essentiel. Des jeans coupés au ras des fesses (3), des mini-shorts cloutés (2) et un foulard (4) – qui tenait plus de la ficelle à l'époque – étaient les rares concessions faites par ceux qui quittaient les plages nudistes pour les boutiques et les cafés qui s'alignaient le long des trottoirs. Les vêtements à rayures (1) présentent un attrait plus durable que les semelles à plateau incroyablement hautes (5) ou les blouses babydoll et autres pantalons à pattes d'éléphant (6).

DEMONSTRATIONS had their fashions too. While feminist marches in the United States and Britain could not fail to be reported as packed with 'dungarees-wearing, burly lesbians', the Italians had their own inimitable style, linking sunglasses and furs with demands for preschool provision and curriculum reform (1). Meanwhile rock'n'roll revivalists (2) and Notting Hill carnival celebrants (3) show a perhaps surprising convergence of glamorous and androgynous intentional vulgarity.

DEMONSTRATIONEN hatten ihre eigenen Moden. In den angelsächsischen Ländern konnte man sich darauf verlassen, daß in einem Bericht über einen feministischen Protestmarsch von »kräftigen Lesben in Latzhosen« die Rede sein würde, während Italienerinnen stilvoller in Sonnenbrille und Pelz auftraten, wenn sie für Kindergärten und Schulreformen demonstrierten (1). Es mag erstaunen, wie beim Rock 'n' Roll-Revival (2) und beim Karneval in Notting Hill (3) Glamour und ein androgyner, bewußt vulgärer Stil zusammenkommen.

LES manifestations suivent également la mode. Alors que les marches féministes aux États-Unis et en Grande-Bretagne ne manquaient pas d'être attribuées à des « lesbiennes bien charpentées vêtues de salopettes », les Italiennes, avec un style inimitable, défilaient en manteaux de fourrure, arborant des lunettes de soleil pour réclamer davantage d'écoles maternelles et une réforme des programmes d'études (1). Pendant ce temps, ceux qui faisaient revivre le rock'n'roll (2) et qui célébraient le carnaval de Notting Hill (3) montraient, curieusement peut-être, la même vulgarité provocatrice, séduisante et androgyne.

2 3

BLACK culture gave British male fashion a necessary fillip, lifting it out of its longstanding dullness. When the ex-troopship *Empire Windrush* docked at Tilbury in 1948 with 482 Jamaicans aboard, little did anyone imagine that it was Messrs Hazel, Wilmot and Richards's talents as natty dressers rather than as carpenters that would hit the headlines (1). Their chic tweeds contrast somewhat drastically with Mr Ruben Torres's 'ideal suit', which looks more appropriate to a moon landing than to Kew Gardens Railway Station (2). George Best, known for his antics off as well as on the football pitch, also fell foul of the dangling flares and the 'let it all hang out' school of fashion (3, right).

DIE Kultur der Schwarzen gab der britischen Herrenmode einen dringend benötigten Vitaminstoß und befreite sie aus ihrer althergebrachten Langeweile. Als der ehemalige Truppentransporter *Empire Windrush* 1948 mit 482 Jamaikanern an Bord in den Docks von Tilbury festmachte, hätte es niemand für möglich gehalten, daß die Herren Hazel, Wilmot und Richards eher wegen ihrer auffälligen Kleider in die Zeitung kamen, als daß sie Arbeit als Zimmerleute fanden (1). Ihre schicken Tweeds stehen in gewissem Kontrast zu Mr. Ruben Torres' »Idealanzug«, der eher zu einer Mondlandung als zum Bahnhof Kew Gardens zu passen scheint (2). George Best (3, rechts) hatte auch außerhalb des Football-Spielfelds seinen eigenen Kopf und hielt nichts von Schlaghosen und der »Schlabberkleidung« dieser Zeit.

LA culture noire donna à la mode masculine britannique le coup de fouet dont elle avait besoin pour se libérer de la grisaille qu'elle cultivait depuis trop longtemps. Quand l'ancien navire de troupes, l'*Empire Windrush*, jeta l'ancre à Tilbury en 1948 avec 482 Jamaïcains à bord, personne n'aurait imaginé que MM. Hazel, Wilmot et Richards seraient bientôt plus connus (1) pour leur chic vestimentaire que pour leur maîtrise de la charpente. Leurs tweeds élégants contrastent quelque peu avec le costume « idéal » de Ruben Torres que l'on imaginerait mieux sur la Lune qu'à la gare de Kew Gardens (2). George Best, reconnu autant pour ses bouffonneries que pour ses qualités de footballeur, s'est mis à dos les pantalons à pattes d'éléphant et les tenues « pendantes » (3, à droite).

THE 1950s British youth revolt began with the 'teddy boys', so-called after the Edwardian style of draped suits and slicked hair they adopted (1). Two decades later the hippie movement stretched from California to Katmandu, supposedly spreading 'peace and love' – and long hair, paisley tablecloths and knitted skullcaps – across the globe (2).

DIE britische Jugendrevolte der 50er Jahre begann mit den »Teddyboys«, so benannt nach ihrem Outfit und ihrer Frisur im Stil der Jahrhundertwende, als König Edward regierte (1). Zwei Jahrzehnte darauf gab es Hippies von Kalifornien bis Katmandu, und sie verbreiteten weltweit »Frieden und Liebe« – und lange Haare, Paisley-Tischtücher und Strickmützen (2).

DURANT les années 50, la jeunesse britannique se révolta avec les « Teddy boys ». Ils devaient leur nom à leurs costumes prince de Galles et à leur chevelure bien peignée (1). Vingt ans plus tard, le mouvement hippie, qui était né en Californie et s'étendait à Katmandou, faisait entendre son message – amour et paix – et popularisait son style : longs cheveux, nappes aux motifs cachemire et calottes tricotées (2).

(Overleaf)
In June 1967 the Beatles released *Sergeant Pepper's Lonely Hearts Club Band* to massive sales and acclaim. Fifteen years after he first heard the final track 'A Day in the Life', Leonard Bernstein wrote that it 'still sustained and rejuvenated me'.

(Folgende Seiten)
IM Juni 1967 veröffentlichten die Beatles *Sergeant Pepper's Lonely Hearts Club Band*, und der Verkaufserfolg war enorm. Fünfzehn Jahre nachdem er »A Day in the Life« zum ersten Mal gehört hatte, schrieb Leonard Bernstein: »Es nährt und erquickt mich bis heute.«

(Pages suivantes)
EN juin 1967, les Beatles sortent l'album *Sergeant Pepper's Lonely Hearts Club Band*, qui se vendra à des millions d'exemplaires. Quinze ans après « A Day in the Life », Leonard Bernstein écrivait : « Cela me soutient et me rajeunit toujours. »

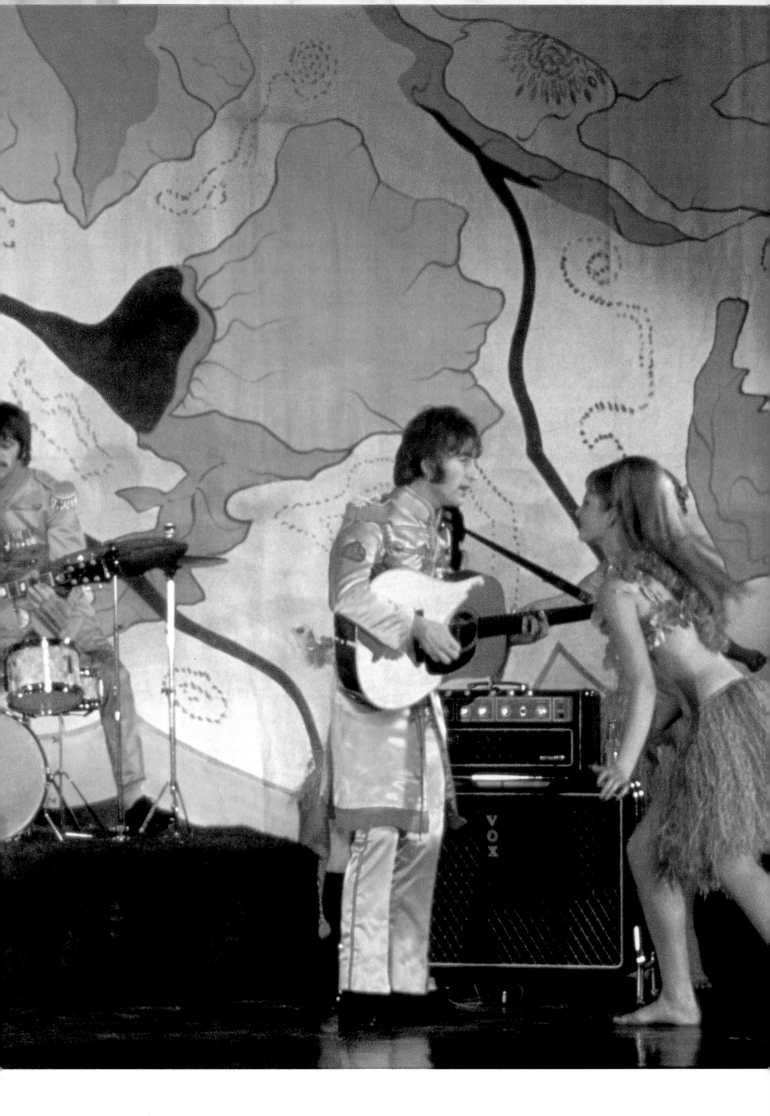

Aviation and Space

AVIATION has been one of the greatest forces for change in the modern world. Just a dozen years after the Wright Brothers achieved their historic first mission in 1903, air warfare was being introduced. Despite the new terror of being hit from the skies during the Great War, it was only in the Second World War that air power became a deciding factor.

The development of airships at the end of the 1920s was intended to provide a major new transport system. The R100 flew from Britain to Montreal in 78 hours. However, the disaster which overtook its sister ship, the R101, effectively put a stop to this innovation. The danger was always that poor weather could reduce command control and result in a collision and then an explosion. With 5.5 million cubic feet of hydrogen on board, the disaster was bound to be near-total.

English-language signpost 1,000 miles north of Oslo (1) gives an accurate estimate of air-travel time in 1951 (sponsorship crest from Scandinavian Airlines). These times are a far cry from Wilbur Wright's winning the Michelin Cup for flying 124 kms (77 miles) in 2 hours 44 years earlier; 44 years on, times would have been shortened by an even greater ratio. In 1990, the Oslo-New York run would have taken no more than five hours by the shortest route and the journey to Paris about 2 hours.

KAUM etwas hat die moderne Welt so sehr verändert wie die Luftfahrt. Nur zwölf Jahre nach dem historischen ersten Flug der Brüder Wright im Jahre 1903 begann der Luftkrieg. Doch auch wenn im Ersten Weltkrieg zu allen anderen Schrecken nun auch noch der neue hinzukam, von Bomben aus der Luft getroffen zu werden, war es doch erst der Zweite Weltkrieg, bei dem die Luftherrschaft die entscheidende Rolle spielte.

Luftschiffe versprachen Ende der 20er Jahre eine völlig neue Form der Fortbewegung. Die R100 flog in 78 Stunden von England nach Montreal. Doch mit der Katastrophe ihres Schwesterschiffes, der R101, war das Schicksal dieser neuen Erfindung besiegelt. Es bestand immer das Risiko, daß das Schiff bei schlechtem Wetter nicht mehr steuerbar war und nach einem Zusammenstoß explodierte, und mit fünfeinhalb Millionen Kubikfuß Wasserstoff an Bord war eine Katastrophe dann unvermeidlich.

1 600 Kilometer nördlich von Oslo gab diese Pfosten in englischer Sprache (eine Reklame der Fluggesellschaft SAS, 1) Auskunft über Flugzeiten im Jahr 1951. Es war ein guter Fortschritt, seit Wilbur Wright 44 Jahre zuvor 124 Kilometer in zwei Stunden geflogen war und damit den Michelin-Pokal gewonnen hatte, noch einmal 44 Jahre später, und die Flugzeiten hatten sich noch drastischer verkürzt. 1990 brauchte der kürzeste Flug von Oslo nach New York nur noch fünf Stunden, und nach Paris waren es nur etwa zwei Stunden.

L'AVIATION a été l'une des inventions essentielles amenées par le monde moderne. C'est en 1913 une douzaine d'années après que les frères Wright ont réalisé leur première mission historique que les premiers combats aériens firent leur apparition. Si les contemporains de la Grande Guerre craignaient déjà les attaques aériennes, l'aviation ne devint décisive qu'au cours de la Seconde Guerre mondiale.

Le développement des dirigeables à la fin des années 20 visait à la création d'un important système de transport aérien. Le vol du R100, de la Grande-Bretagne à Montréal, dura soixante-dix-huit heures. La catastrophe qui frappa le dirigeable R101 mit un terme à cette expérience. En effet, on craignait en permanence que le mauvais temps n'entravât le contrôle des commandes ce qui eût certainement entraîné une collision suivie d'une explosion. Avec plus d'un million et demi de mètres cube d'hydrogène à bord, la catastrophe aura été inévitable.

Ce panneau de signalisation en langue anglaise, plus de 1 600 kilomètres au nord d'Oslo (1), donne une estimation précise du temps de vol en 1951 (parrainage des Scandinavian Airlines). Il rappelle la victoire de Wilbur Wright, lequel avait gagné la Coupe Michelin 44 ans plus tôt, en couvrant 124 kilomètres en deux heures. Une quarantaine d'années plus tard, les temps se sont même améliorés dans un rapport plus élevé. En 1990, le Oslo-New York n'a mis que cinq heures par la route la plus courte tandis que le voyage à Paris ne nécessité que deux heures.

Traveltime by SAS to:

Rome 14 hrs. 15 min.

North Pole 6 hrs. 5 min.

Johannesburg 53 hrs. 55 min.

Tokyo via North Pole 32 hrs.

Fairbanks (Alaska) 14 hrs. 30 min.

Thule (Greenland) 6 hrs. 40 min.

Los Angeles Arctic routing 22 hrs.

Tokyo via India 70 hrs. 5 min.

Los Angeles via New York 36 hrs. 20 min.

New York 22 hrs. 55 min.

Santiago de Chile 74 hrs. 25 min.

Madrid 14 hrs.

London 8 hrs. 40 min.

Paris 12 hrs. 5 min.

1

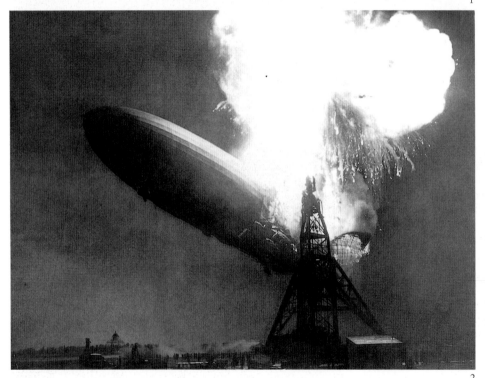

2

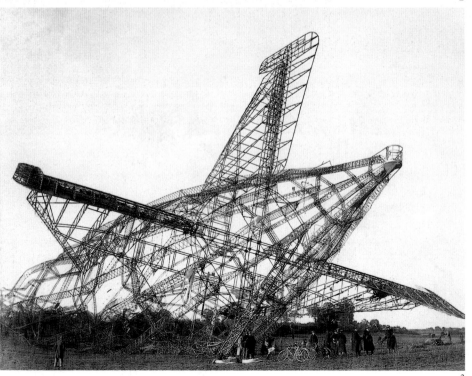

3

THE R100 airship came of age in
November 1929. Before its maiden
voyage, waitresses set the silver service in
dining-room worthy of a grand hotel (4).
After a successful launch, she was berthed
at the mooring tower at Cardington, Bed
fordshire, as the enthusiastic crowd rushed
towards her (1). The crash of the R101
(shown here, 3, as literally the skeleton of
its former self), caused the airship's demise
as a popular option. In the United States
the German airship *Hindenburg* landed
safely after a 62-hour flight from Frankfur

4

end was similar to that of the R101, en 44 people died in the crash of which re were only eight survivors (2).

AS Luftschiff R100 lief 1929 vom Stapel. Vor dem Jungfernflug decken Serviererinnen die Tafeln mit Silber, in em Speisesaal, der einem Grand Hotel re machen würde (4). Nach erfolgreich olviertem Flug legt das Schiff in Carding-, Bedfordshire, an, und die Zuschauer rmen begeistert hin (1). Nach dem Ab-rz der R101 (3) war das Luftschiff als populäres Transportmittel nicht mehr durch-zusetzen. Das deutsche Luftschiff *Hindenburg* legte nach 62stündigem Atlantikflug sicher in den Vereinigten Staaten an, doch bei einem späteren Flug erlitt sie das gleiche Schicksal wie die R101. 44 Menschen kamen bei dem Absturz um, nur acht überlebten (2).

NOVEMBRE 1929 : le dirigeable R100 va réaliser son premier voyage. Les serveuses disposent les couverts en argent dans une salle à manger digne d'un grand hôtel (4). Après un lancement réussi, il est fixé à la tour d'amarrage de Cardington dans le Bedfordshire, et la foule enthousiaste s'y précipite (1). L'explosion du R101 (3, il ne reste ici que l'« ossature » du dirigeable) mit fin à la popularité de l'engin. Aux État-Unis, le dirigeable allemand *Hindenburg* arriva sain et sauf après un vol de soixante-deux heures depuis Francfort. Il connut, hélas, une fin semblable à celle du R101. 44 personnes trou-vèrent la mort dans l'explosion et l'on ne découvrit que 8 survivants (2).

On 12 April 1961, the Russian Yuri Gagarin (1) took his first space flight on board the *Vostok I*. The race to get the first man into space was terrific, given the intensity of Cold War competition as to which side had the more sophisticated technology. Gagarin orbited the earth in the 4.5 ton spacecraft for 108 minutes, reaching a height of 190 miles. He then fired braking rockets and the aircraft returned to earth by parachute. The USSR scored another 'first' when it put the first woman – Valentina Tereshkova – into orbit, travelling further than the longest-journeying US astronaut (2). The two of them joined hands in a Red Square salute – and a heroes' welcome back to earth – with Prime Minister Khrushchev (3). An old, illiterate sheep-farmer, who looks as though he were born before the invention of the newspaper, has the cosmonauts' story read to him (4).

Am 12. April 1961 unternahm der Russe Juri Gagarin (1) mit der *Wostok I* den ersten bemannten Weltraumflug. Das Wettrennen darum, wer den ersten Menschen ins Weltall brachte, war bei der großen Rivalität der beiden Machtblöcke im Kalten Krieg ungeheuer gewesen, denn schließlich ging es darum zu zeigen, welche Seite die technisch überlegene war. Gagarin umrundete die Erde in dem viereinhalb Tonnen schweren Flugkörper 108 Minuten lang und erreichte dabei eine Höhe von 300 Kilometern. Dann zündete er die Bremsraketen, und die Raumkapsel kehrte an einem Fallschirm zur Erde zurück. Zum zweiten Mal gewann die Sowjetunion das Wettrennen, als sie die erste Frau in den Weltraum schickte – Walentina Tereschkowa, die weiter ins All hinausflog als der erfolgreichste amerikanische Astronaut (2). Der russische Premierminister Chruschtschow reicht den beiden beim Heldenempfang, der ihnen bei ihrer Rückkehr auf dem Roten

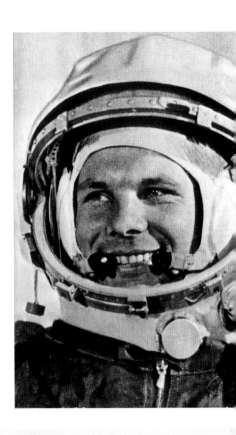

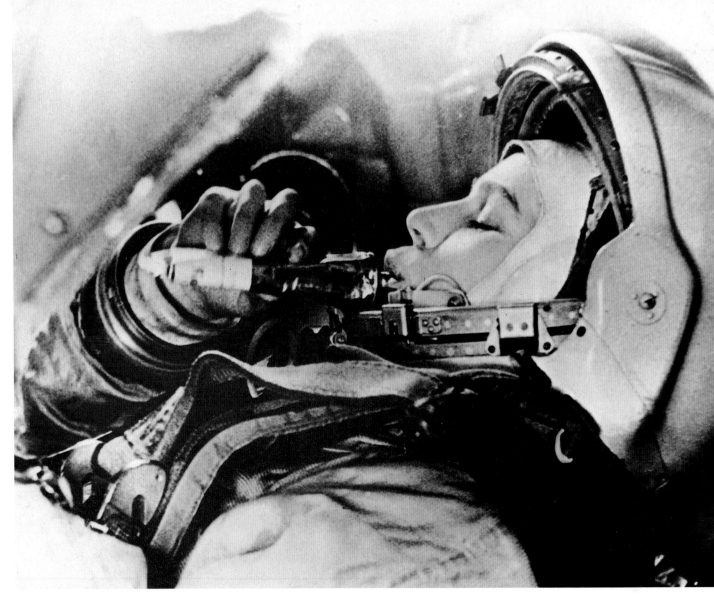

Platz bereitet wurde, die Hand (3). Dieser schafhirte, der nicht lesen kann, läßt sich om Triumph der Kosmonauten vorlesen (4).

E 12 avril 1961, le Russe Youri Gagarine (1) réalisa son premier vol dans espace à bord du *Vostock 1*. La course u'occasionna l'envoi du premier homme ans l'espace s'avéra fantastique. C'était ne façon de montrer de quel côté se trouait la technologie la plus sophistiquée. Gagarine resta en vol orbital pendant cent uit minutes à l'intérieur d'un vaisseau patial de 4 tonnes et demie à une altitude e 327 kilomètres. Il mit ensuite le feu aux sées de freinage avant d'atterrir en parahute. L'URSS releva un nouveau défi vec. Valentina Terechkova, dont le voyage ura plus longtemps que ceux des cosmoautes américains (2). À leur retour, tous s deux sont salués comme des héros sur la lace rouge. On les voit ici donner la main u Premier ministre Khrouchtchev (3). Jn vieux berger illettré se fait lire la saga es cosmonautes (4).

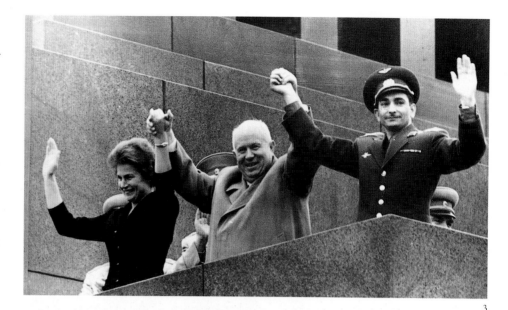

3

Overleaf)

ARTHRISE: the spectacular view of our planet from space (1). Most of frica and part of Europe and Asia can be en in this image taken from the *Apollo 11* pacecraft during its journey to the moon). Cernan salutes the US flag when the *pollo 17* lands on the moon in 1972 (2). he space module of the *Apollo 12* craft a powerful draw at the Japan World Fair f 1970 (4).

olgende Seiten)

RDAUFGANG: die Erde vom Weltall aus gesehen (1). Teile Afrikas, Europas nd Asiens sind auf diesem Bild sichtbar, s beim Mondflug der Raumkapsel *Apollo 11* ntstand (3). Nach der geglückten Mondndung von *Apollo 17* 1972 salutiert stronaut Cernan vor der amerikanischen agge (2). Die Mondfähre der *Apollo 12* h man auf der Weltausstellung in Japan, 70 (4).

ages suivantes)

OYAGE autour de la Terre : spectaculaire, notre planète vue de l'espace). Photo prise depuis *Apollo 11* (3). ernan salut le pavillon américain quand *pollo 17* atterrit sur la Lune en 1972 (2). capsule spatiale d'*Apollo 12* est une grande traction, en 1970, à la Foire internationale Japon (4).

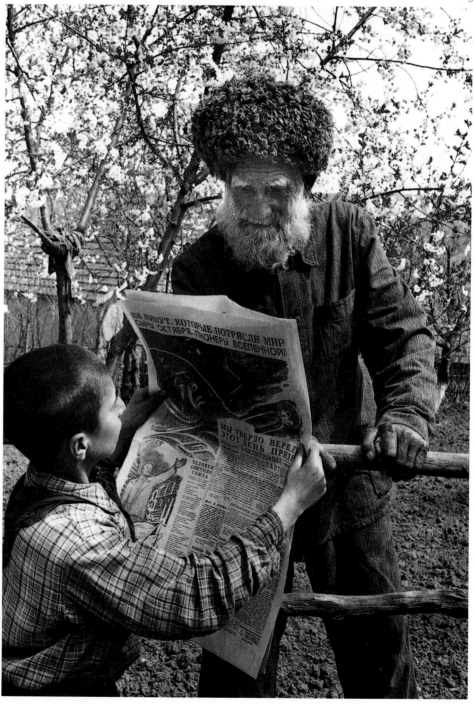

4

2 3

4

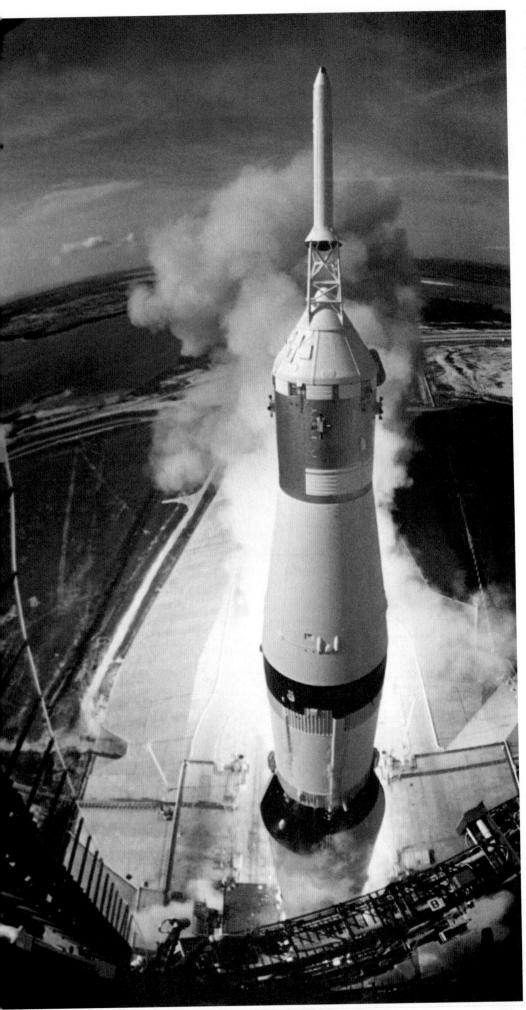

IN July 1969, Neil Armstrong, captain of the *Apollo 11* mission, was the first man on the moon, observed by hundreds of millions of television viewers around the world. He described his descent from the *Eagle* lunar module as 'one small step for man, one giant leap for mankind'. He was accompanied by Edwin 'Buzz' Aldrin, whom he photographed descending from the module (4), and who can also be seen cautiously groping his way among the footprints in the moondust (3). The rocket launcher at Kennedy Space Center blasts off *Apollo 11* in a characteristic 'pillar of flame' (1); as the module separates, it floats above the moon with the earth rising behind (2).

IM Juli 1969 betrat Neil Armstrong, Kapitän des *Apollo-11*-Fluges, als erster Mensch den Mond, unter den Augen von Millionen von Fernsehzuschauern in aller Welt. Er beschrieb seinen Ausstieg aus der Mondfähre *Eagle* mit den Worten: »Ein kleiner Schritt für einen Menschen, doch ein großer Sprung für die Menschheit.« Begleitet wurde er von Edwin »Buzz« Aldrin, den er photographierte, als dieser aus der Fähre klettert (4) und der auch zu sehen ist, wie er vorsichtig durch die Fußabdrücke im Mondstaub stakst (3). Von der Abschußrampe im Kennedy Space Center steigt *Apollo 11* in der typischen »Feuersäule« auf (1); als die Mondfähre sich löst, schwebt sie über die Mondoberfläche, und im Hintergrund geht die Erde auf (2).

EN juillet 1969, Neil Armstrong, capitaine de la mission *Apollo 11*, devient le premier homme à marcher sur la Lune. Des centaines de millions de personnes de par le monde l'observent à la télévision. Il décrit, à la sortie de la capsule *Eagle*, son court passage sur la Lune comme « un petit pas pour un homme, mais un pas de géant pour l'humanité ». Il était accompagné d'Edwin « Buzz » Aldrin, qu'il photographia à sa descente du vaisseau spatial (4). On l'aperçoit ici foulant prudemment le sol entre les traces de pas dans la poussière lunaire (3). La fusée portant *Apollo 11* fut lancée au Kennedy Space Center ; on voit ici la « colonne de flammes » caractéristique (1). La capsule séparée de la fusée flotte au-dessus de la Lune. À l'arrière-plan, on aperçoit la Terre « se lever » (2).

1

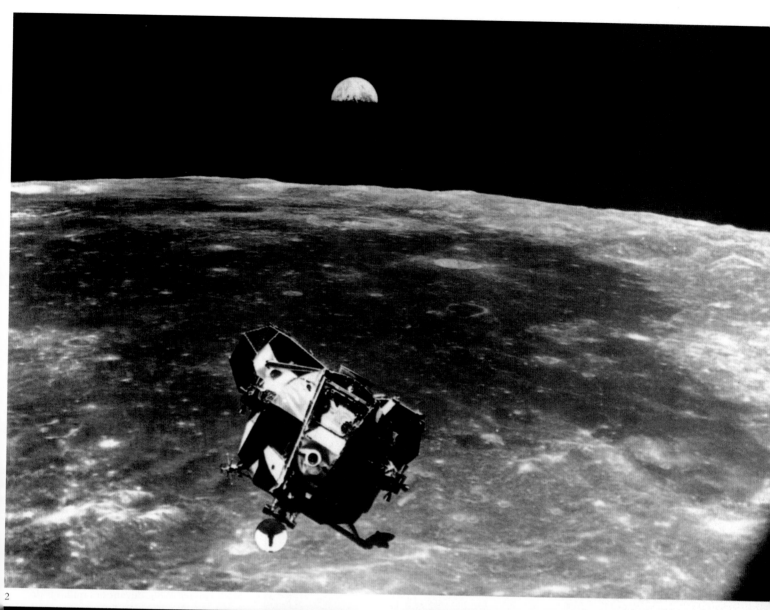

2

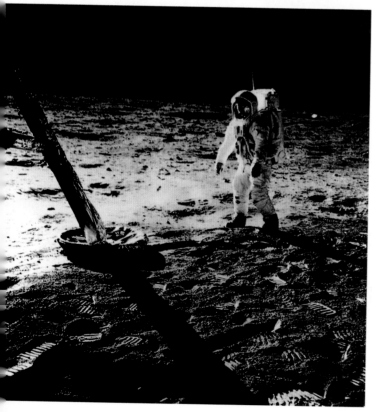

4

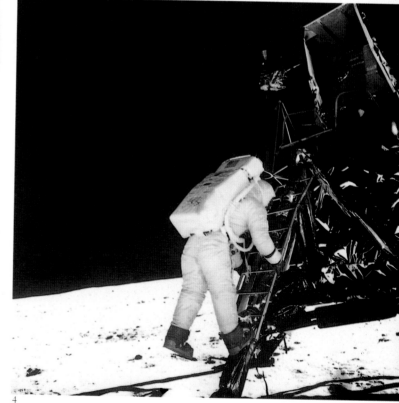

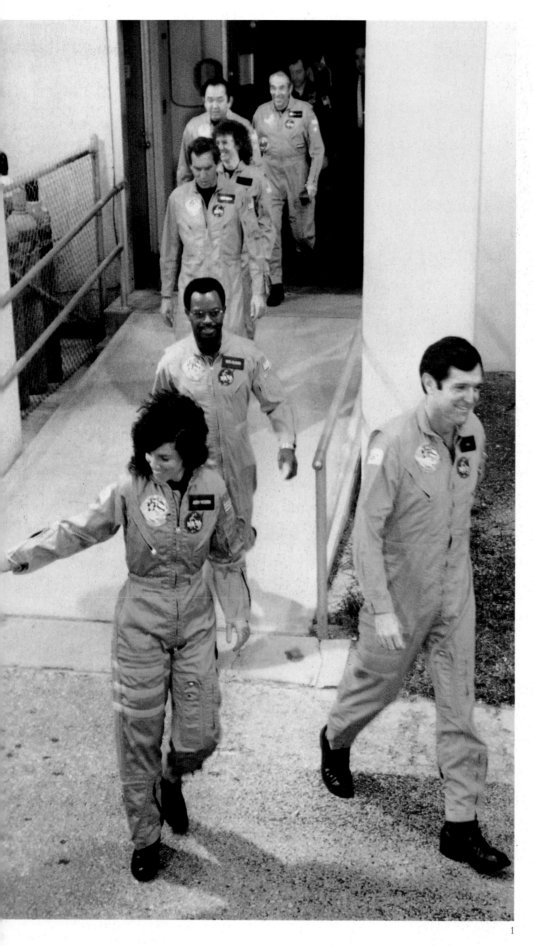

THE US space shuttle *Challenger* exploded 72 seconds after take-off on 28 January 1986, to the horror of watching millions (2). Among the crew of seven who died was Christa McAuliffe, a schoolteacher selected as the first woman to fly in a new 'citizens in space' programme (1). The flight had already been postponed five times, three of them due to bad weather. Before blast-off, icicles had to be chipped from the shuttle by hand. These were the first US casualties in space, dealing a devastating blow to a programme already in serious difficulties from drastically over-running its budget.

AM 28. Januar 1986 explodierte die amerikanische Raumfähre *Challenger* 72 Sekunden nach dem Start, zum Entsetzen der Millionen, die das an ihren Fernsehgeräten miterlebten (2). Zu der siebenköpfigen Besatzung, die dabei umkam, gehörte auch die Lehrerin Christa McAuliffe, die als erste Frau des neuen Programms »Bürger fliegen in den Weltraum« ausgewählt worden war (1). Der Flug war bereits fünfmal verschoben worden, dreimal wegen schlechtem Wetter. Vor dem Start mußte die Fähre mit der Hand von Eiszapfen befreit werden. Es waren die ersten Todesopfer, die es bei US-Weltraumflügen gegeben hatte, und es war ein schwerer Schlag für ein Programm, das ohnehin wegen drastisch überzogenem Budget in großen Schwierigkeiten war.

LA navette spatiale américaine *Challenger* explosa 72 secondes après son lancement, le 28 janvier 1986, devant des millions de spectateurs horrifiés (2). Les sept personnes qui formaient l'équipage y trouva la mort. Parmi les victimes, Christa McAuliffe, enseignante de son état, avait été sélectionnée pour être la première femme à voler dans le nouveau programme des « citoyens dans l'espace » (1). Le vol avait déjà été reporté cinq fois, dont trois à cause du mauvais temps. Avant la mise à feu, il avait fallu ôter à la main des glaçons fixés sur la navette. Cet accident, qui fit les premières victimes américaines de l'espace, porta un coup dévastateur à un programme qui connaissait déjà de sérieuses difficultés pour cause de dépassement spectaculaire du budget alloué.

1

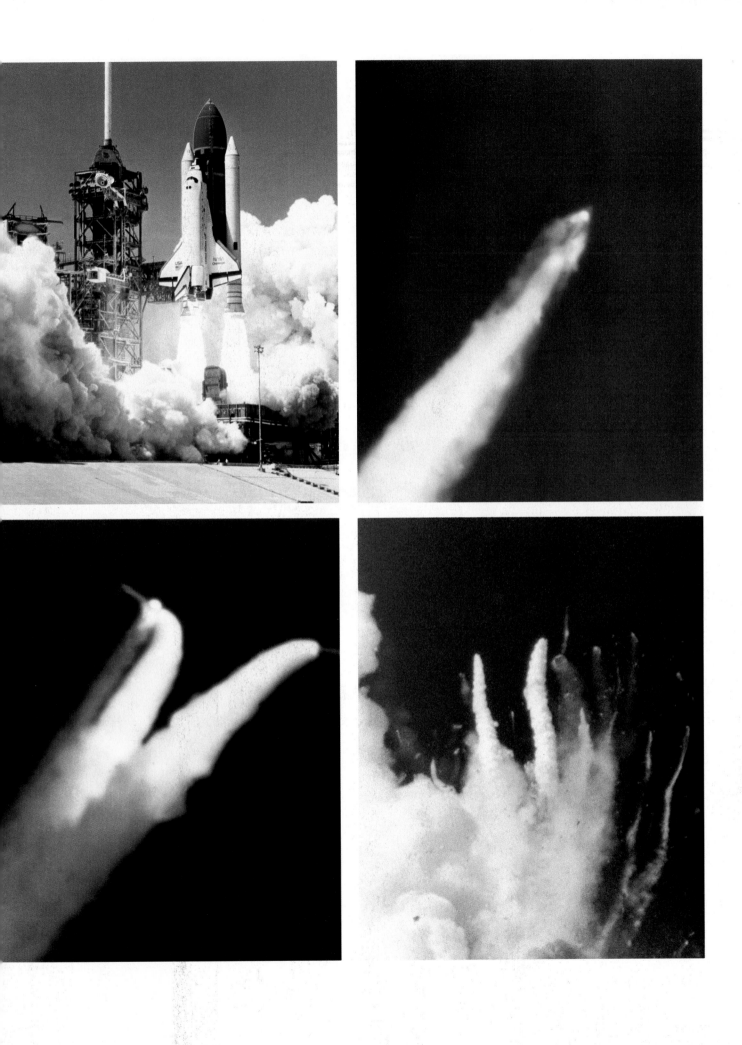

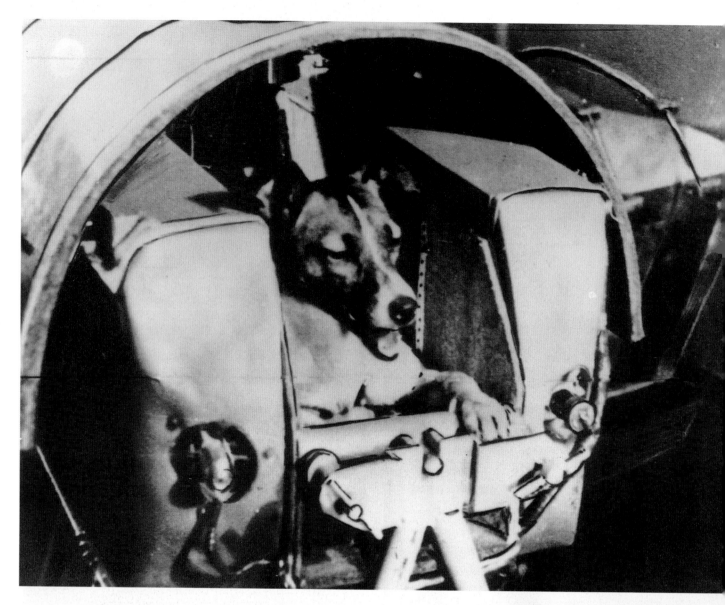

BEFORE the human guinea-pigs, the animal ones. In the 1950s animals were sent into space to see how they withstood flight conditions. Laika, the satellite dog in *Sputnik III* (1), achieved international fame – and indignation, when it was discovered that, mission accomplished, her food would be poisoned to prevent her dying slowly of starvation while still in orbit. In 1959, the US sent Sam (2), a 7-lb Rhesus monkey, 55 miles into space on a Project *Mercury* capsule. As late as 1970, NASA was performing an 'Orbiting Frog Otolith', placing two bullfrogs in a weightless environment for a period of days (3).

VOR den menschlichen Versuchskaninchen kamen die Tiere. In den 50er Jahren wurden Tiere in Raumkapseln ins All geschossen, um zu sehen, wie sie den Flug überstanden. Laika (1), die Hündin von *Sputnik III*, brachte es zu weltweiter Berühmtheit – und Empörung, als bekannt wurde, daß sie nach ihrer Mission vergiftet würde, damit sie nicht in der Erdumlaufbahn verhungerte. 1959 schickten die Amerikaner den Rhesusaffen Sam an Bord einer *Mercury*-Kapsel in den Weltraum (2). Und noch 1970 gab es bei der NASA den »Erdumlauffrosch Otolith«: Zwei Ochsenfrösche wurden der Schwerelosigkeit ausgesetzt (3).

LES cobayes animaux ont précédé les cobayes humains. Au cours des années 50, on envoie des animaux dans l'espace afin d'observer leur comportement face aux conditions de vol. La chienne Laïka, dans *Spoutnik III* (1), connut le succès international. En 1959, à 89 kilomètres d'altitude, dans une capsule du projet *Mercury*, les États-Unis envoyèrent Sam dans l'espace (2), un singer-hésus 7-lb. En 1970, la NASA procède au « Orbiting Frog Otolith » : deux crapauds-bœufs sont envoyés dans l'espace où ils resteront plusieurs jours en apesanteur (3).

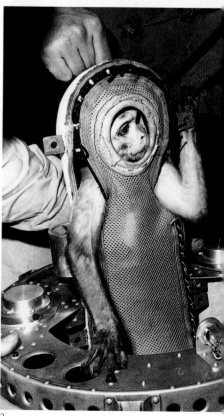

2

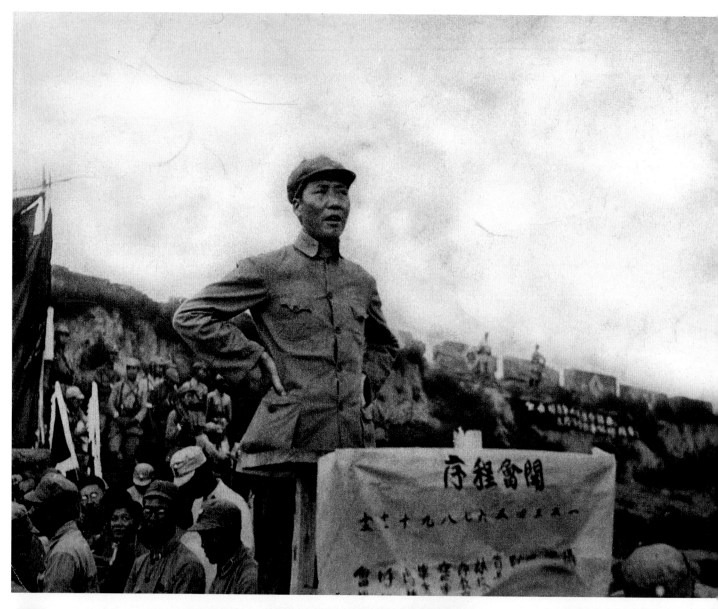

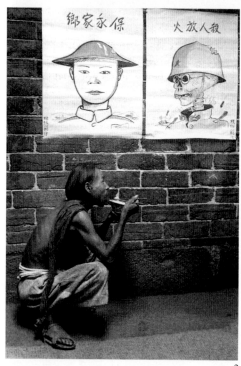

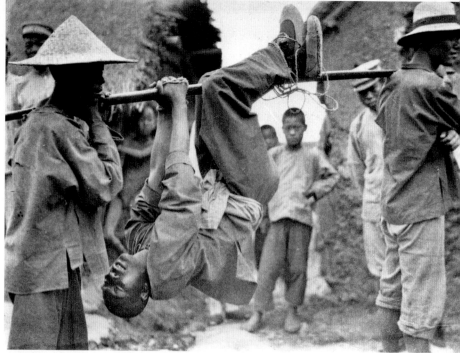

2 3

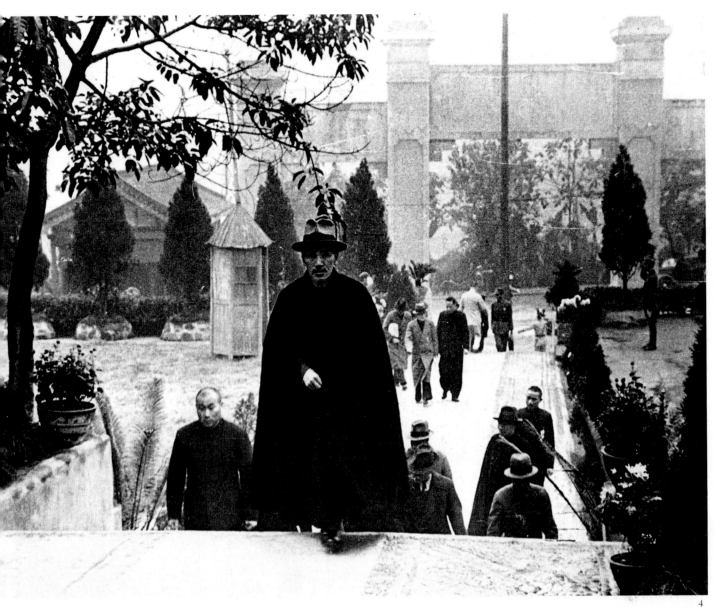

4

CHINA'S history over the last sixty years could be encapsulated in the costumes worn in these pictures. As Chairman Mao Tse-Tung addresses a meeting (1) calling for ever greater efforts against the Japanese enemy (2 – a propaganda poster in 1938), Nationalist Generalissimo Chiang Kai-Chek arrives at the 1939 meeting of the Kuomintang Nationalist Party, at which he was additionally named president of the Executive Council (4). While the Chairman's cotton kapok clothing matches that of the peasant, the Generalissimo obtains his garb from Paris outfitters. Meanwhile one of his soldiers, taken prisoner in Shantung, is given rough handling by the victorious Communists (3).

MAN könnte die ganze chinesische Geschichte der letzten sechzig Jahre aus den Kleidern ablesen, die auf diesen Bildern getragen werden. Der Parteivorsitzende Mao Tse-tung hält eine Rede (1), in der er verstärkte Anstrengungen gegen die japanischen Feinde fordert (2, ein Propagandaplakat aus dem Jahre 1938). Der Oberbefehlshaber der Nationalisten, Tschiang Kai-schek, erscheint zur Versammlung der nationalistischen Kuomintang-Partei im Jahre 1939, bei der er zusätzlich noch zum Präsidenten des Exekutivausschusses ernannt wurde (4). Der Vorsitzende Mao trägt den Baumwolldrillich der Bauern, der Oberbefehlshaber einen Pariser Maßanzug. Derweil fassen die siegreichen Kommunisten einen seiner Soldaten in Schantung nicht gerade mit Samthandschuhen an (3).

AU travers des costumes reproduits ici, on peut lire l'histoire de la Chine durant les 60 dernières années. Quand le président Mao prend la parole (1) pour demander de plus grands efforts dans la lutte contre l'ennemi japonais (2) – une affiche de propagande en 1938 ; le généralissime nationaliste Tchang Kaï-chek arrive en 1939 au meeting du Guomindang où il sera nommé président du conseil exécutif (4). Alors que les vêtements de coton du président ressemblent à ceux des paysans, le généralissime s'habille chez les couturiers français. Sur cette photographie, on peut voir l'un de ses soldats fait prisonnier à Shantung traité sans ménagements par les communistes victorieux (3).

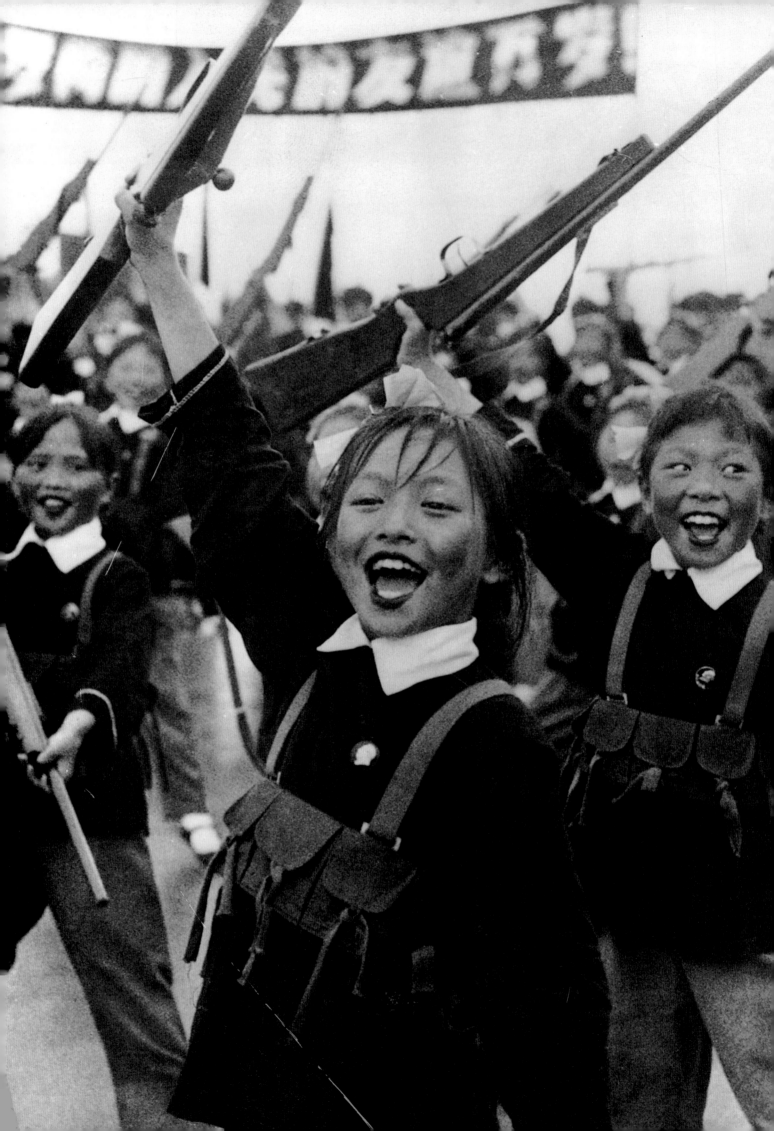

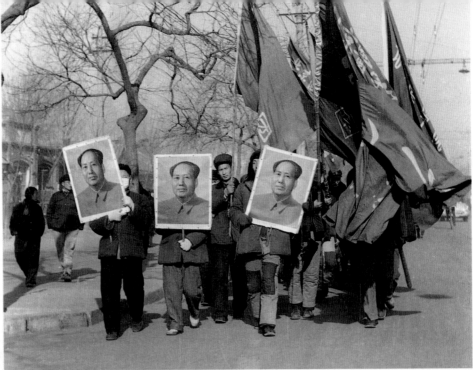

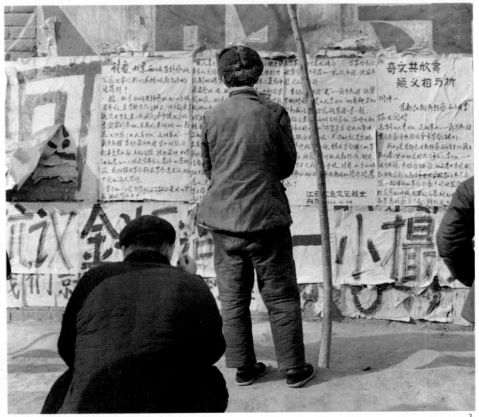

THE Communist Youth Movement in Hanking (1) learn how to handle weapons. In 1966, Mao proclaimed a Cultural Revolution. Thousands of students, organized into Red Guards, moved around the country as here in 1967 (2), bearing banners of Mao and copies of his Little Red Schoolbook. From the same period is an example of the Red Guards' 'wall to wall' poster campaign (3).

MITGLIEDER der kommunistischen Jugendbewegung in Hangking lernen an der Waffe (1). 1966 rief Mao die Kulturrevolution aus. Tausende von Studenten, zu Roten Garden organisiert, zogen mit Fahnen, Bildern Maos und der »Mao-Bibel« durchs Land (wie hier 1967, 2). Aus jener Zeit stammt auch das Bild von den Wandzeitungen, der Roten Garden (3).

LES membres du Mouvement de la jeunesse communiste à Hanking (1) apprennent à manier des armes. Mao proclame la Révolution culturelle. Des milliers d'étudiants organisés en Gardes rouges voyagent dans tout le pays, comme ici en 1967 (2). Un exemple de la campagne d'affichage « mur à mur » des Gardes rouges (3).

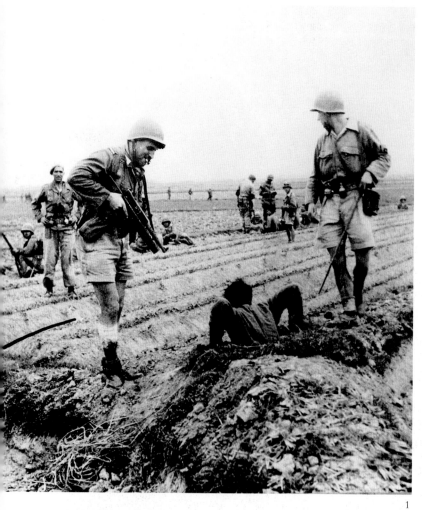

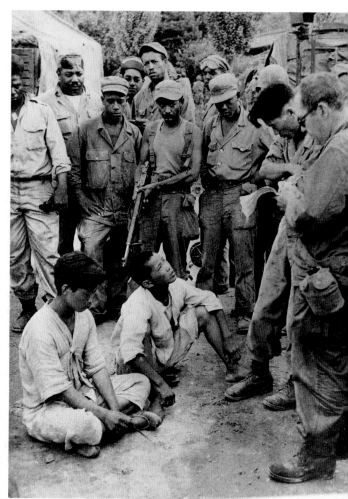

1
2

FRENCH and Vietnamese forces were already bogged down in
southeast Asia when, following the crossing of the 38th Parallel
by North Korean troops in 1950, the United Nations intervened
on the side of South Korea to defeat the 'Communist Menace
from the North'. Here French troops flush a 'rebel' from a foxhole
(1), while others question Communist suspects (2). It was a British
press photographer, Bert Hardy, who made waves with his pictures
of refugees (4) and of the maltreatment of North Korean POWs
under the banner of the UN flag (3).

DIE Fronten hatten sich in Südostasien bereits verhärtet, als
nordkoreanische Truppen 1950 den 38. Breitengrad über-
schritten und die Vereinten Nationen auf seiten Südkoreas gegen
die »kommunistische Bedrohung aus dem Norden« eingriffen. Hier
holen französische Soldaten einen »Rebellen« aus einem Schützen-
loch (1), andere verhören verdächtige Kommunisten (2). Bert Hardy,
ein britischer Pressephotograph, sorgte für Aufruhr, als er seine
Bilder von Flüchtlingen (4) und von mißhandelten nordkoreanischen
Kriegsgefangenen veröffentlichte (3).

LES forces françaises et vietnamiennes étaient déjà enlisées dans
le Sud-Est asiatique quand les Nations unies intervinrent aux
côtés de la Corée du Sud dans l'espoir d'écarter la « menace com-
muniste du Nord ». Ici, les troupes françaises tirent un « rebelle »
de son terrier (1), pendant que d'autres interrogent des suspects
communistes (2). C'est un photographe de presse britannique, Bert
Hardy, qui causa un grand trouble en publiant ces photos de réfu-
giés (4) et de prisonniers de guerre nord-coréens maltraités sous
la bannière des Nations unies (3).

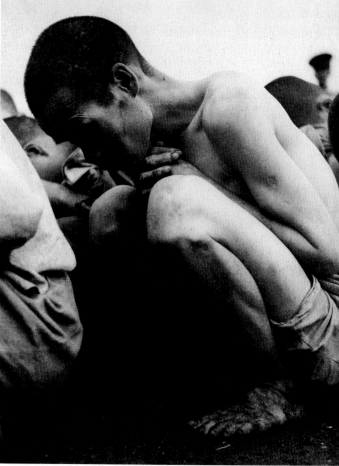

3

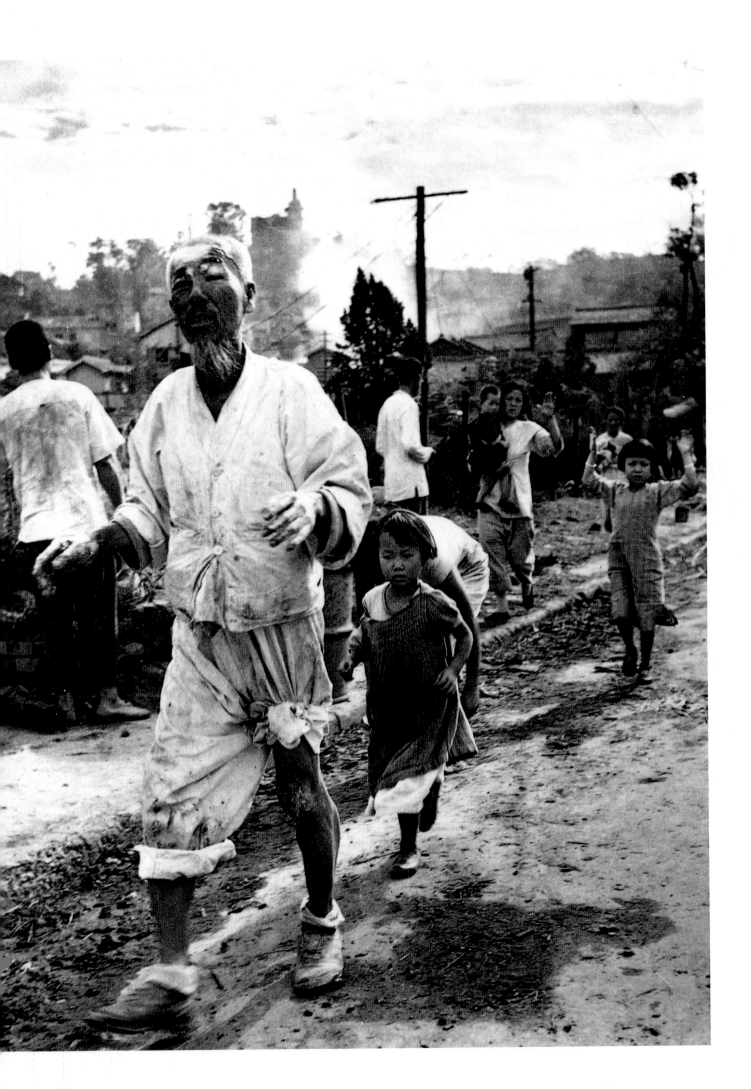

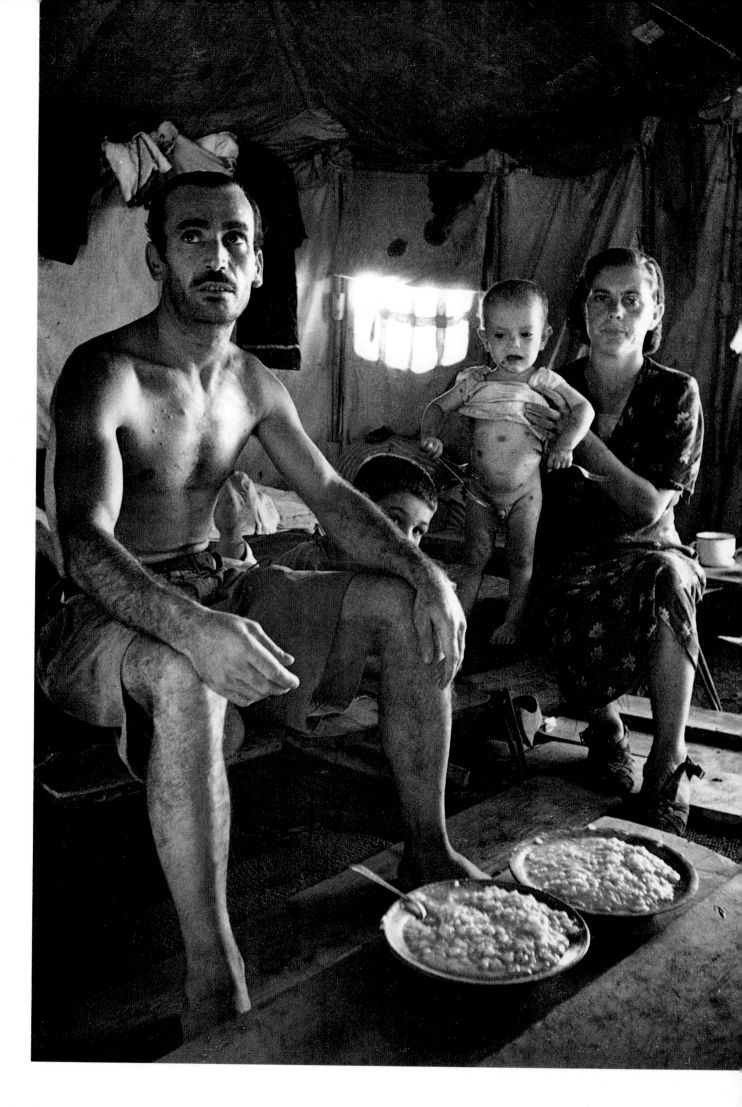

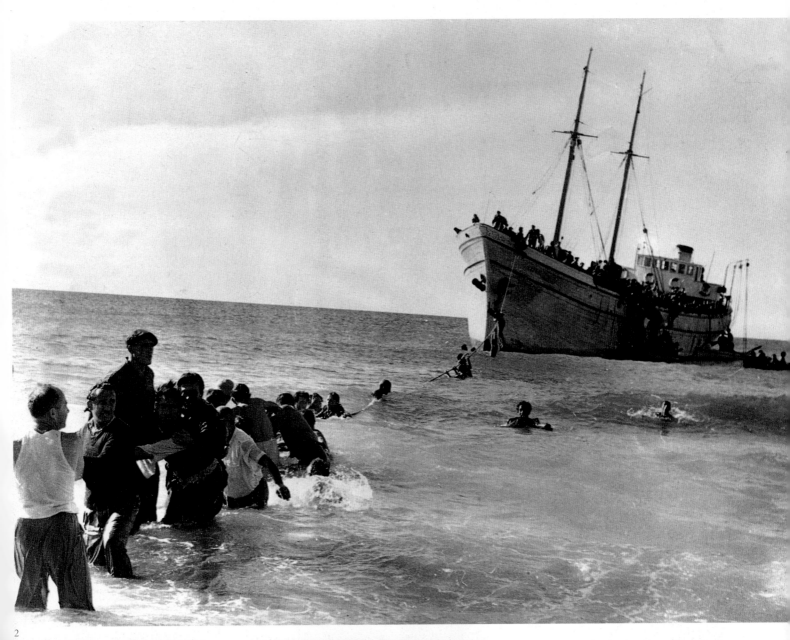

IN 1947 some hundreds of Jewish survivors were packed off to a detention camp in Cyprus (1, 3). And in 1948 the SS *United States* deliberately ran aground with 700 Jews on board, at Nahariya, near Haifa in Israel. The local population waded out to help bear the sick and old ashore (2).

IM Jahre 1947 erreichten einige Hundert jüdische Überlebende ein Lager auf Zypern (1, 3). Und 1948 setzte der Kapitän sein Schiff SS *United States*, mit 700 Juden an Bord, ein paar Meilen von dem Badeort Nahariya (nahe bei Haifa in Israel) absichtlich auf Grund; die Einheimischen kamen und holten die Alten und Kranken an Land (2).

EN 1947, des centaines de Juifs survivants sont envoyés dans un camp chypriote (1, 3). En 1948, le SS *United States*, avec 700 Juifs européens à son bord, arriva à Nahariya (près de Haïfa). La population locale vint aider à transporter les malades et les personnes âgées (2).

THESE Jewish Palestinian girls are
celebrating the successful conclusion to
hard day's work signing up some of the
35,000 volunteering for National Service
). The Hebrew posters over the doorway
e part of the propaganda that resulted in
e Israeli army being among the first to
corporate women as regular soldiers. Until
948, Britain maintained its Palestinian
andate, searching both Jews and Arabs (2)
r weapons and bombs on the streets of
rusalem and imposing a blockade along
e coast. To add to the confusion, the
gun 'terrorist' organization (one of whose
aders, David Ben Gurion, became Israel's
rst Prime Minister) waged war against the
en Israeli government in 1948. Their arms
ip was ignited by government mortar
ombs (3), destroying 600 tons of weapons.

IESE jüdischen Mädchen in Palästina
freuen sich über das Ende eines harten
rbeitstages, an dem sie einen Teil der
35 000 Freiwilligen für den Militärdienst
ngeschrieben haben (1). Die hebräischen
lakate gehören zu einer Werbekampagne,
a der auch Frauen zum Militärdienst be-
ufen wurden – die israelische Armee war
ine der ersten, die Frauen aufnahm. Bis
948 war Palästina britisches Mandatsgebiet,
nd Juden wie Araber wurden in den Straßen
erusalems nach Waffen und Bomben durch-
ucht (2); zudem gab es eine Seeblockade.
Die Lage wurde noch verwirrender da-
urch, daß die »Terroristen« der Gruppe
rgun (einer ihrer Führer war der spätere
sraelische Premierminister David Ben
Gurion) Krieg gegen die offizielle israelische
Regierung führten. Das Schiff, das ihnen
Waffen bringen sollte, wurde von Minen-
verfern der Regierungstruppen beschossen,
nd 600 Tonnen Waffen und Munition
ingen in die Luft (3).

CES jeunes Juives installées en Palestine
célèbrent l'heureuse issue d'une dure
ournée de travail : elles font partie des
35 000 volontaires au service national (1).
es affiches en langue hébraïque placées
u-dessus de la porte aidèrent l'armée israé-
ienne à intégrer des femmes en service
égulier. Jusqu'en 1948, la Grande-Bretagne,
mposant un blocus du littoral, maintint son
nandat palestinien. Elle fouillait Juifs et
Arabes dans les rues de Jérusalem (2) dans
ne hypothétique quête d'armes et de bombes.
Pour ajouter à la confusion, l'Irgoun, que les
Britanniques taxaient de terrorisme – l'un de
es chefs, David Ben Gourion, deviendra un
Premier ministre israélien – livra une guerre
arouche aux autorités. Le bateau qui abritait
eurs armes fut incendié (3), détruisant pas

2

3

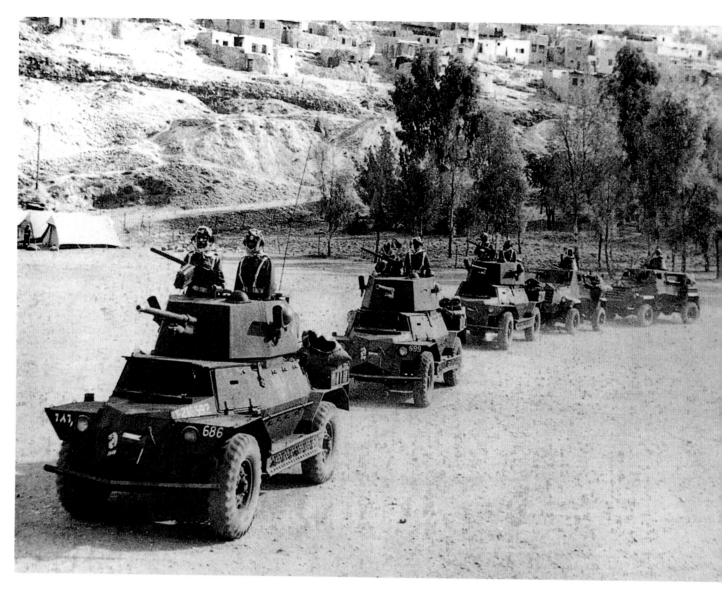

THE British mandate ended at midnight
14/15 May 1948. Immediately Egyp-
tian and Transjordan troops invaded Pales-
tine. Arab Legion tanks started out several
hours before the mandate expired (1). It
took nearly twenty years, until 5 June 1967,
for the Arab-Israeli conflict to erupt into a
full-blown war. Israel, under the charismatic
military leadership of General Moshe Dayan
(4), emerged triumphant. On 8 June, Egypt
admitted defeat (captured Egyptian troops,
2). A day later, Israel began an all-out offen-
sive hours after Syria also accepted the
ceasefire (3). Yasser Arafat (5), leader of the
Palestine Liberation Organization, became
the focus of mass opposition.

DAS britische Mandat endete am 15. Mai
1948. Sofort begannen ägyptische und
transjordanische Truppen mit ihrer Invasion
Palästinas. Die Panzer der arabischen Legion
machten sich früh auf den Weg (1). Doch
es dauerte fast zwanzig Jahre, bis am 5. Juni
1967 der israelisch-arabische Konflikt zu
einem Krieg auswuchs. Die Israelis unter
ihrem General Moshe Dayan (4) waren

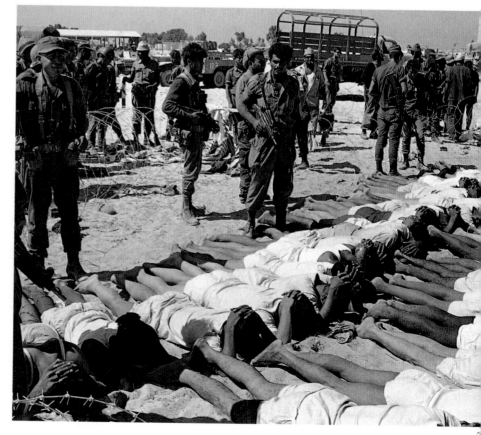

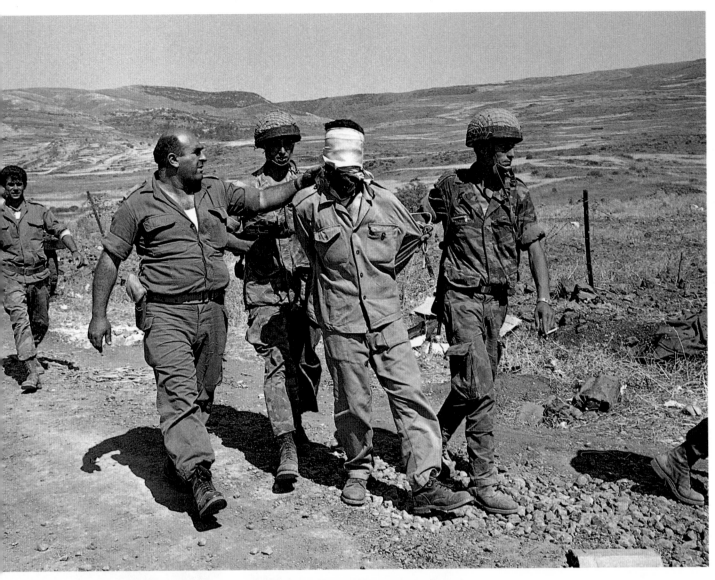

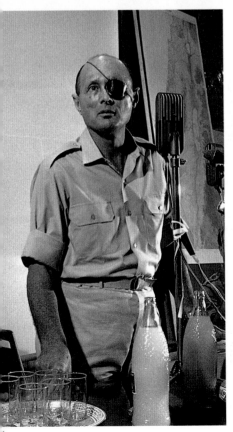

siegreich. Am 8. Juni kapitulierten die Ägypter (ägyptische Kriegsgefangene, 2). Einen Tag darauf, nur Stunden nachdem auch Syrien den Waffenstillstand akzeptiert hatte (3), gingen die Israelis zum Großangriff über. Der Palästinenserführer Yassir Arafat (5) hatte viel Kritik einzustecken.

L E mandat britannique prit fin dans la nuit du 14 au 15 mai 1948. Les troupes égyptiennes et transjordaniennes envahirent immédiatement la Palestine. Les blindés de la Légion arabe avaient démarré plusieurs heures avant l'expiration du mandat (1). Il fallut près de vingt ans, jusqu'au 5 juin 1967, pour que la lutte israélo-arabe se mue en conflit généralisé. Israël l'emporta sous le commandement du général Moshe Dayan (4). Le 8 juin, l'Égypte reconnut sa défaite (2). Le lendemain, Israël entama une offensive générale, des heures après que la Syrie eût également accepté le cessez-le-feu (3). Yasser Arafat (5), le chef de l'Organisation de libération de la Palestine, devint l'objet d'une opposition massive.

2

3

SIX years later war broke out with Syria (1, 2), again fought on the Golan Heights (3). Twenty-two years on, despite fresh peace accords signed on the White House lawn (5) in September 1993, there is still acute friction between Israelis and

Palestinians, among whom the radical Hamas movement is initiating fresh direct action. Almost as the accord was signed, Palestinians adorned Jerusalem's Old City Walls with their flags and stoned Israeli police, who responded with violence (4).

SECHS Jahre darauf brach erneut Krieg mit Syrien aus (1, 2), der wiederum auf den Golan-Höhen ausgefochten wurde (3). Auch 22 Jahre später, trotz jüngster Friedens vereinbarungen, die im September 1993 auf dem Rasen des Weißen Hauses unter- zeichnet wurden (5), halten die Konflikte

Six ans plus tard, la guerre éclata avec la Syrie (1,2), et des combats se déroulèrent de nouveau sur les hauteurs du Golan (3). Vingt-deux ans plus tard, malgré les nouveaux accords de paix de septembre 1993 signés sur la pelouse de la Maison Blanche (5), il existe toujours de graves points de friction entre Israéliens et Palestiniens, tandis que le mouvement intégriste Hamas engage une nouvelle action directe. L'accord était presque signé quand des Palestiniens plantèrent leurs drapeaux sur les murs de la Vieille Ville de Jérusalem avant de lancer des pierres sur la police israélienne, dont la riposte fut violente (4).

wischen Israelis und den Palästinensern an, leren radikale Hamas-Bewegung für neuen Zündstoff sorgt. Fast unmittelbar nach Unterzeichnung des Vertrages schmückten die Palästinenser die Wände der Jerusalemer Altstadt mit ihren Fahnen und warfen Steine auf israelische Polizisten, die zurückschossen (4).

IN July 1969, shortly after the Protestants' annual Orange Day parades, violence erupted on the streets of Belfast and Londonderry (even the name was contentious, Catholics preferring to leave off the English prefix). Sympathies in the 'six counties' of Northern Ireland were sharply divided between the Protestant majority, who wanted to retain rule from Westminster, and the Roman Catholic minority, who wanted union with Eire (Ireland). While the former organized the paramilitary forces of the Ulster Freedom Fighters and the Ulster Volunteer Forces, the latter revived the military wing of the Irish Republican Army and spawned a radical new branch, the Irish National Liberation Army. In August 1969 British troops were sent in 'to keep the warring factions apart' and 'restore the peace' – the start of twenty-five further years of 'troubles'.

A cheap weapon of choice was the petrol bomb, often fired by youths (1). Street barricades were hastily thrown up from pallets and tyres (3). With youth unemployment, especially among Catholics, being the highest in the UK, many were drawn into the street fighting almost as a rite of passage to prove their manhood (2).

IM Juli 1969 kam es kurz nach den jähr-lichen protestantischen Umzügen zum Oraniertag zu Unruhen in Belfast und Londonderry. Die Meinungen in den »sech Grafschaften« Nordirlands waren streng gespalten zwischen der protestantischen Mehrheit, die weiterhin von Westminster regiert werden wollte, und der katholische Minderheit, die eine Vereinigung mit der Republik Irland forderte. Die Protestanten organisierten sich in den paramilitärischen Truppen der Ulster Freedom Fighters und Ulster Volunteer Forces, die Katholiken ließen den militärischen Flügel der Irisch-Republikanischen Armee wiederaufleben und gründeten einen radikalen neuen Zwe

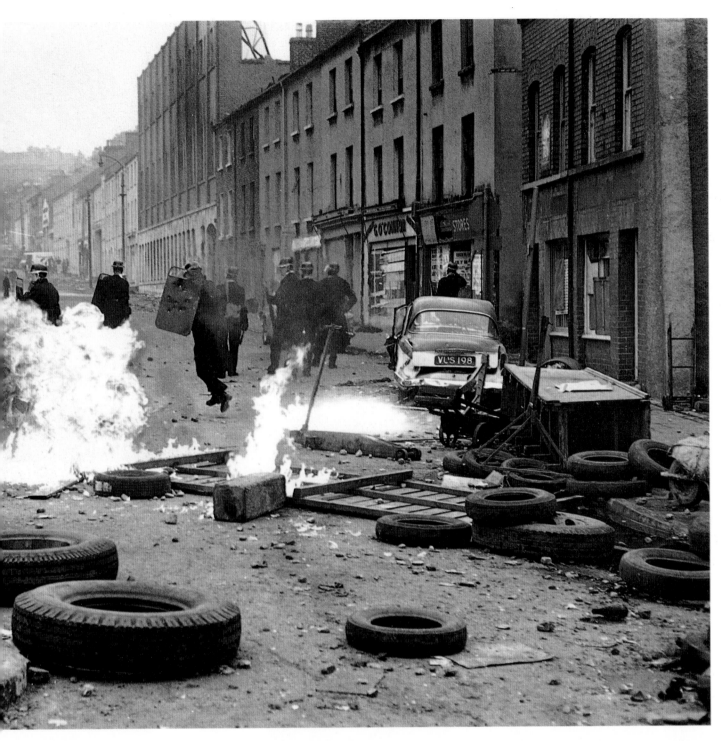

ie Irisch-Nationale Befreiungsarmee. 1969
chickte London Truppen nach Nordirland,
um Konfrontationen zwischen den sich
ekriegenden Parteien zu verhindern« und
den Frieden wiederherzustellen« – der
eginn von mittlerweile mehr als 25 Jahre
ährenden Unruhen.

Eine beliebte, weil billige Waffe waren
Brandbomben, die oft von Jugendlichen
eworfen wurden (1). Barrikaden wurden
a aller Eile aus Paletten und Autoreifen er-
chtet (3). Die Jugendarbeitslosigkeit, gerade
nter den Katholiken, war die höchste in
Großbritannien, und für viele waren die
traßenkämpfe das einzige Mittel, mit dem
e ihre Männlichkeit beweisen konnten (2).

EN juillet 1969, juste après les parades
annuelles des protestants pour le Orange
Day, la violence éclata dans les rues de
Belfast et de Londonderry (pour lequel le
nom même donnait lieu à des discussions :
les catholiques préférant ignorer le préfixe
anglais). Les sympathies dans les « six comtés »
d'Irlande du Nord étaient nettement tran-
chées entre la majorité protestante, qui dési-
rait conserver la règle de Westminster, et la
minorité catholique romaine qui désirait
l'union avec l'Eire (Irlande du Sud). Alors que
les premiers organisaient les forces paramili-
taires de l'Ulster Freedom Fighters et les
Ulster Volunteer Forces, les seconds faisaient
renaître l'aile militaire de l'Armée républi-
caine irlandaise et donnaient naissance à une

nouvelle branche radicale, l'Armée de libé-
ration nationale irlandaise. En août 1969, le
gouvernement britannique envoya des
troupes dans le but de « séparer les factions
guerrières » et de « rétablir la paix », ce qui
n'eut pour autre résultat que de déclencher
les « troubles » qui durent depuis vingt-cinq
ans. Le cocktail Molotov, une arme bon
marché, était souvent utilisé par les jeunes (1).
Les barricades de rues étaient érigées à la
hâte avec des caisses et des pneus (3). Les
jeunes chômeurs, de plus en plus nombreux
au Royaume-Uni, en particulier chez les
catholiques, se mêlent aux combats de rue
qui sont presque devenus un rite d'initiation
à la virilité (2).

RIOT-SHIELDED British soldiers with a bleeding and unarmed protester (2). To many, the face of bigotry is that of the Reverend Ian Paisley, Ulster Unionist MP and a Protestant minister who sees the Pope as the anti-Christ. Here he is protesting away from home (1), at the celebration of a Catholic Mass at Canterbury Cathedral for the first time in 400 years in July 1970. Shortly before Christmas 1993, a mother carries her child past a PEACE sign (3). Perhaps this generation will be allowed to grow up using the streets as a thoroughfare rather than a battleground.

MIT Schilden geschützte britische Soldaten führen einen unbewaffneten, blutenden Demonstranten ab (2). Für viele die Bigotterie in Person: Reverend Ian Paisley, Parlamentsmitglied der Unionisten und protestantischer Geistlicher, für den der Papst der Antichrist ist. Hier (1) protestiert er in England, vor der Kathedrale von Canterbury, wo im Juli 1970 zum ersten Mal seit 400 Jahren eine katholische Messe zelebriert wurde. Kurz vor Weihnachten 1993 trägt eine Mutter ihr Kind an einer Wand mit der Aufschrift PEACE vorbei (3). Vielleicht wird diese Generation die Straße wieder als Verbindungsweg von einem Ort zum anderen erleben, und nicht als Schlachtfeld.

LES soldats britanniques équipés d'une protection anti-émeute avec un manifestant blessé et sans armes (2). Le visage de la bigoterie est pour beaucoup symbolisé par celui du Révérend Ian Paisley, unioniste de l'Ulster et ministre protestant qui considère le pape comme un militant de l'Antéchrist. Ici, il manifeste loin de chez lui (1), en 1970, contre la célébration (la première depuis quatre siècles) d'une messe catholique à la cathédrale de Canterbury. Peu de temps avant Noël 1993, une mère portant son enfant passe devant un signe de la paix (3). Cette génération pourra-t-elle grandir et utiliser les rues comme des voies publiques et non comme des champs de bataille ?

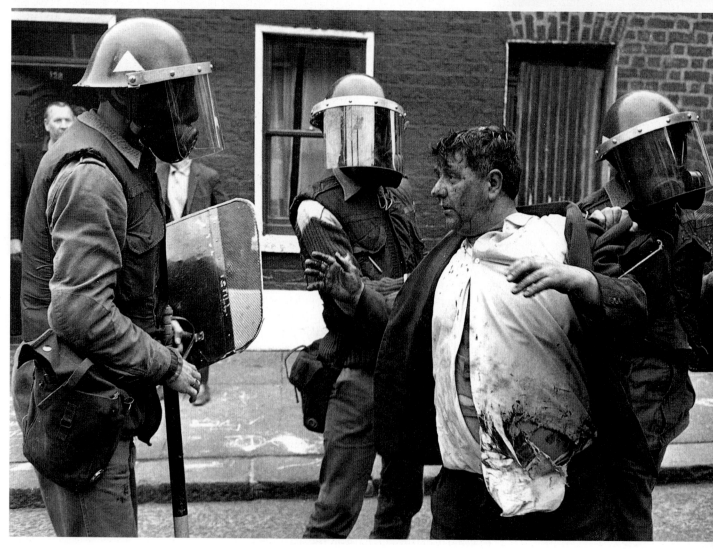

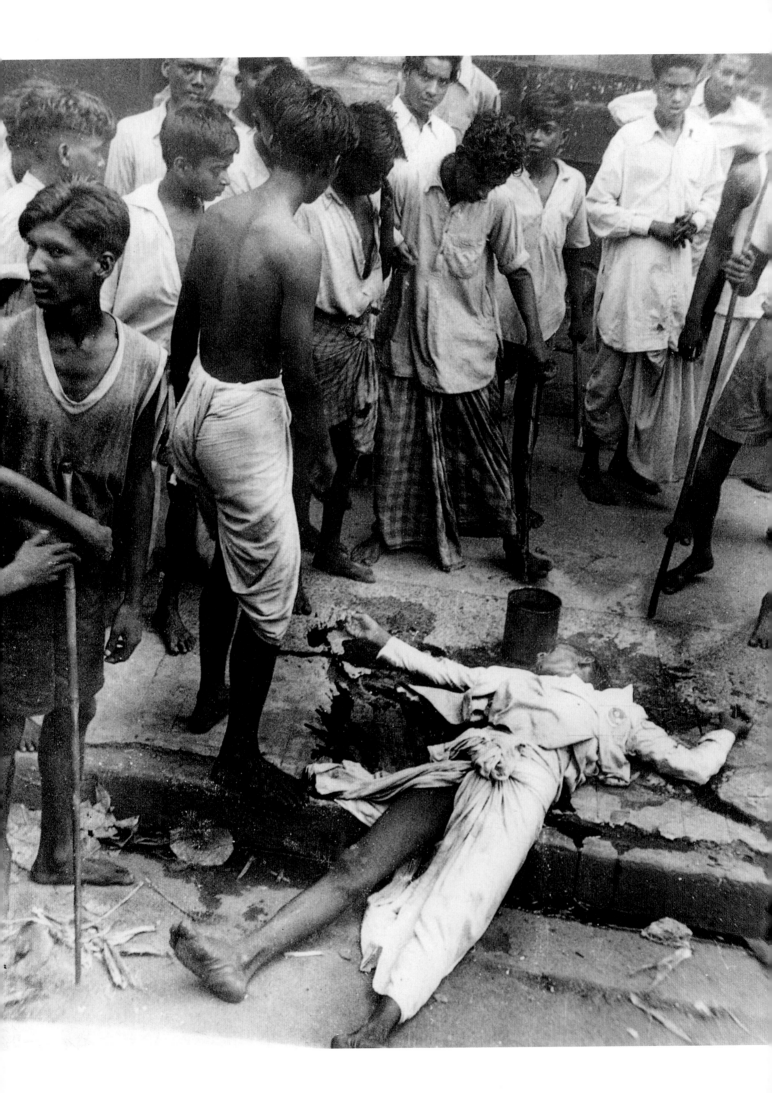

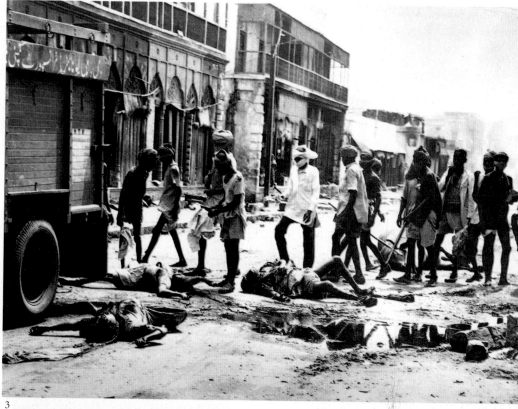

2 3

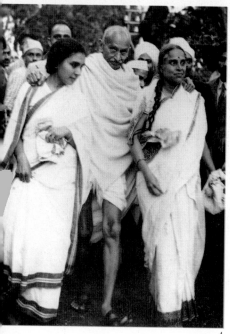

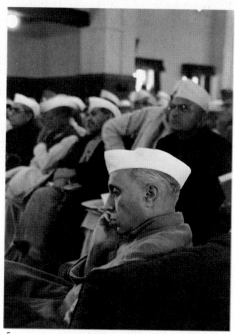

4 5

endet, und am 15. August 1947 wurde Pandit Nehru erster indischer Premierminister (5). Doch die Auseinandersetzungen um die Teilung des Landes in einen Moslemstaat Pakistan im Norden und ein hauptsächlich von Hindus bevölkertes Indien im Süden nahm ein blutiges Ende: 25 000 Tote allein in Neu-Delhi (3) und Kalkutta (1). Das hinderte König Georg VI. nicht, dem neuen indischen Parlament zu versichern: »Indem Sie Ihre Unabhängigkeit durch friedliche Verhandlungen errungen haben, haben Sie freiheitsliebenden Völkern überall auf der Welt ein Beispiel gegeben.«

E N avril 1946, la délégation du cabinet britannique en Inde entame des discussions avec le frêle leader hindou Mahatma Gandhi (soutenu ici par son médecin et un assistant, 4). L'année suivante, Lord Mountbatten (2, avec son épouse Elvira), le dernier vice-roi de l'Inde, met fin à un siècle et demi de gouvernement britannique. Le 15 août 1947, le Pandit Nehru (5) devient Premier ministre de l'ex-empire. Toutefois, le conflit généré lors de la division en un État musulman du Pakistan au nord et un État à prédominance hindoue au sud sera très violent : 25 000 morts rien qu'à New-Delhi (3) et Calcutta (1). Néanmoins, le roi George VI assure la nouvelle assemblée constituante que : « En obtenant votre indépendance par accord mutuel, vous servirez d'exemple aux gens aimant la paix de par le monde. »

I N April 1946 the British Cabinet delegation to India held discussions with the frail Hindu leader Mahatma Gandhi (here assisted by his doctor and helper, 4). The following year Lord Mountbatten (2, with his wife Edwina), last Viceroy of India, ended 150 years of British rule, and on 15 August 1947 Pandit Nehru (5) became first Indian Prime Minister. However, the fighting over Partition into the Moslem state of Pakistan to the north and predominantly Hindu India to the south provided a violent aftermath: 25,000 dead in New Delhi (3) and Calcutta (1) alone. Nonethe-

less, King George VI assured the new Constituent Assembly: 'In thus achieving your independence by agreement, you have set an example to the freedom-loving people throughout the world.'

I M April 1946 verhandelte eine Delegation der britischen Regierung mit dem Hinduführer Mahatma Gandhi (hier von seiner Ärztin und einer Helferin gestützt, 4) über das Schicksal Indiens. Im folgenden Jahr erklärte der letzte Vizekönig, Lord Mountbatten (2, mit Gattin Edwina), die 150 Jahre britischer Herrschaft über Indien für be-

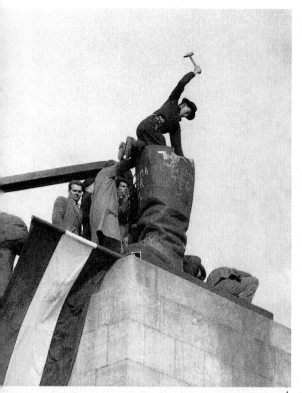

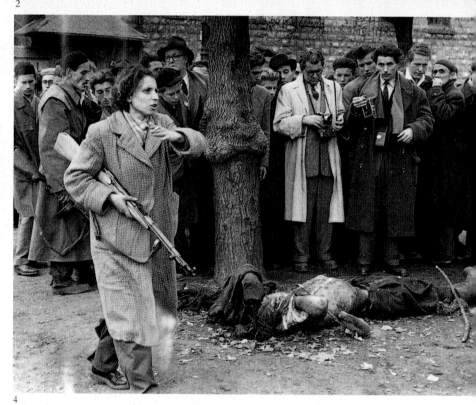

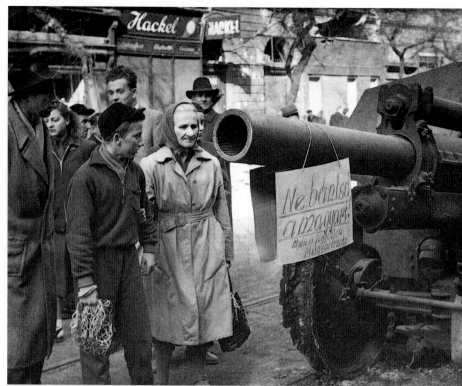

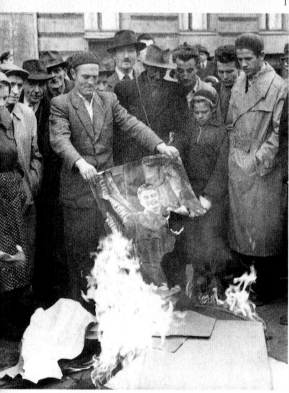

B UDAPEST, 12 November 1956:
uprising. In the brief moments of hope
that their country might break free of the
Russian occupation, these men are furiously
dismantling a giant statue of Stalin (1) while
others burn his portrait in a pyre of Soviet
propaganda (3). Even humour enters into
it, as the Russian tank has a sign hung on it
with an order not to fire (2). Suspected
members of the AVO (Secret Police) are
subjected to summary reprisal (4). Girls as
young as fifteen (5) were trained to carry
guns against the Russian invasion.

A UFSTAND in Budapest, 12. November
1956. In der Hoffnung, daß ihr Land
sich vom russischen Joch befreien könne,
reißen diese Männer ein Standbild Stalins
nieder (1), während andere sein Porträt ver-
brennen (3). Es war ein Aufstand mit Galgen-
humor, wie dieses Schild beweist, das einen
russischen Panzer auffordert, nicht zu schie-
ßen (2). Mit Mitgliedern der Geheimpolizei
AVO wurde indes kurzer Prozeß gemacht
(4). Selbst 15jährige Mädchen (5) übten den
Umgang mit Waffen gegen die russische
Invasion.

B UDAPEST, 12 novembre 1956 : le
soulèvement. Lors d'une brève lueur
d'espoir, ces hommes sont en train de déma
teler avec fureur une statue gigantesque de
Staline (1) pendant que d'autres brûlent so
portrait (3). L'humour n'est d'ailleurs pas
absent ; ici, le blindé russe porte une pancar
où l'on peut lire l'ordre de ne pas tirer (2).
Ceux que l'on soupçonne d'appartenir à
l'AVO (police secrète) sont exécutés (4). L
filles de quinze ans (5) s'entraînent à porter
des armes pour lutter contre les envahisseu
soviétiques.

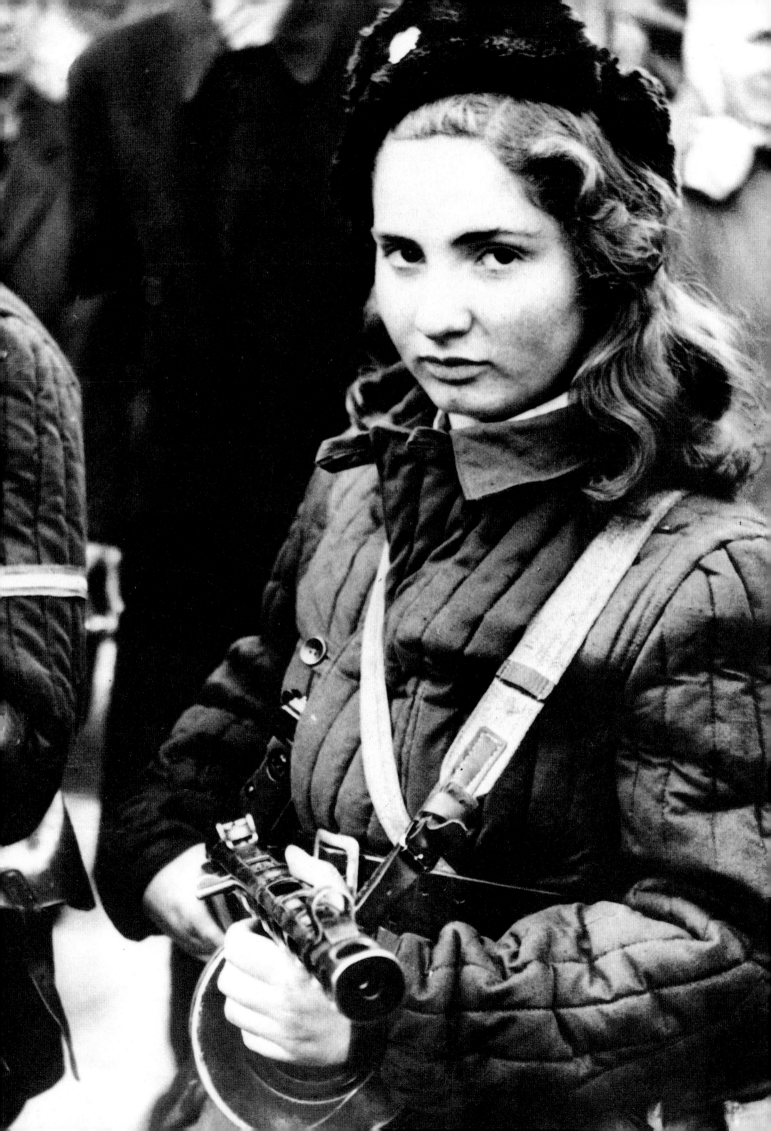

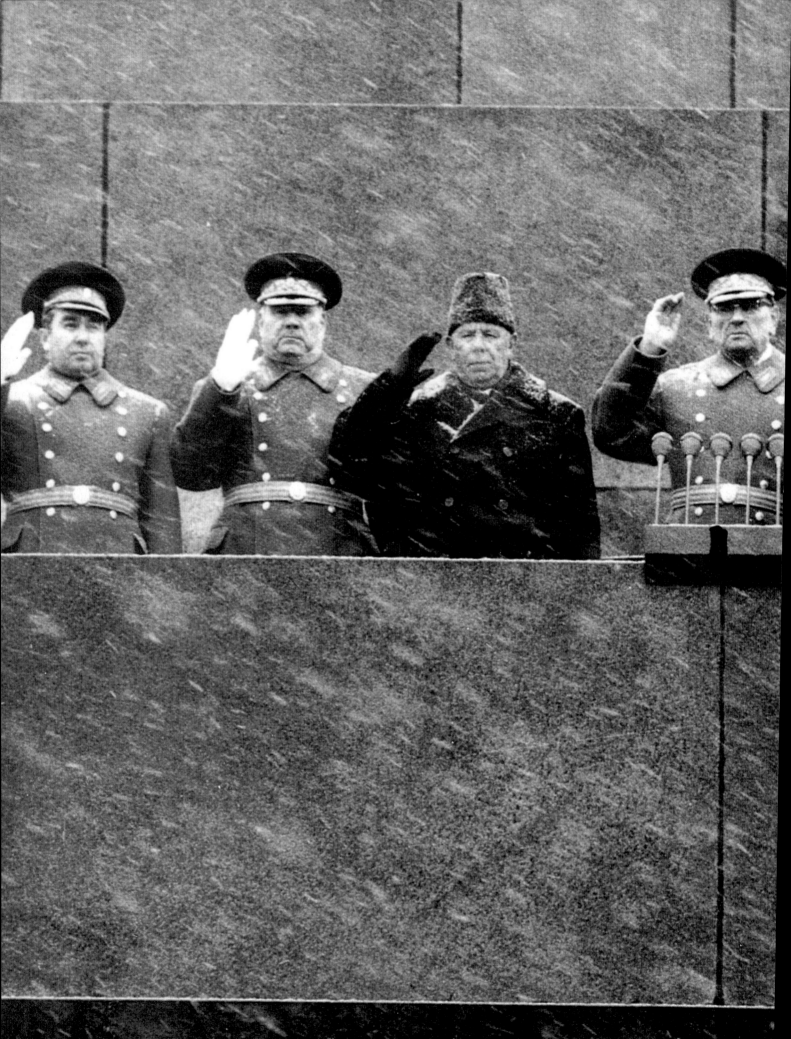

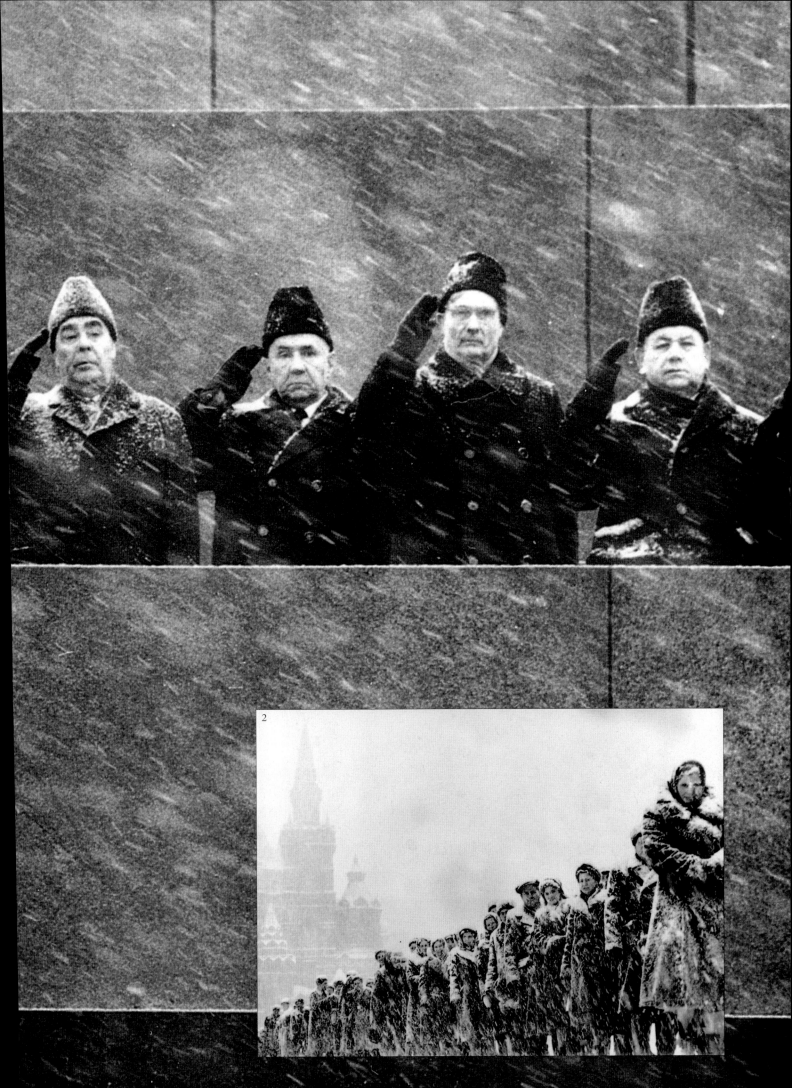

2

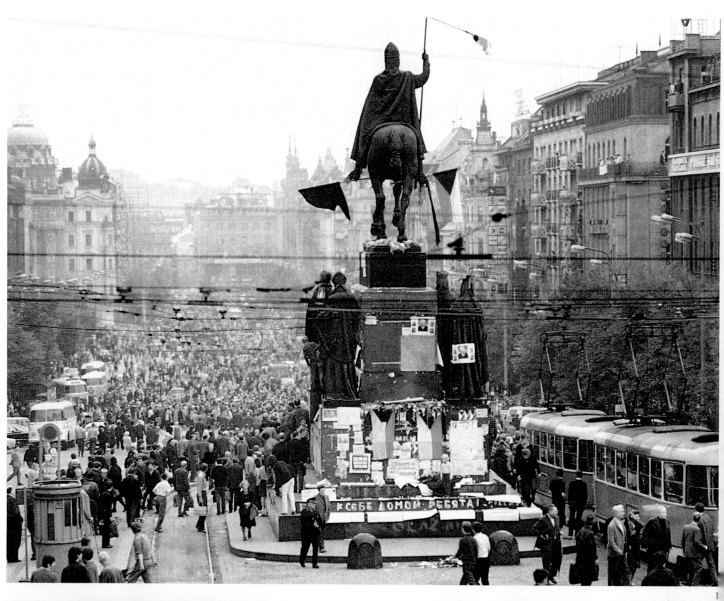

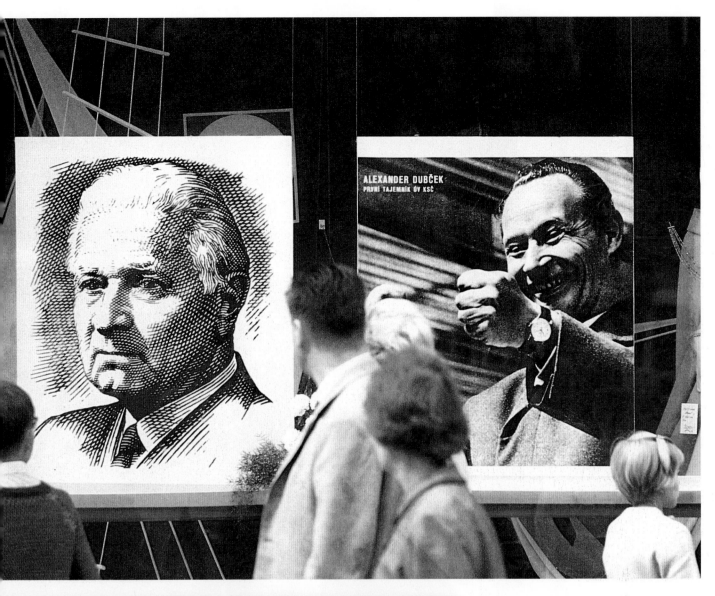

ALEXANDER DUBČEK
PRVNÍ TAJEMNÍK ÚV KSČ

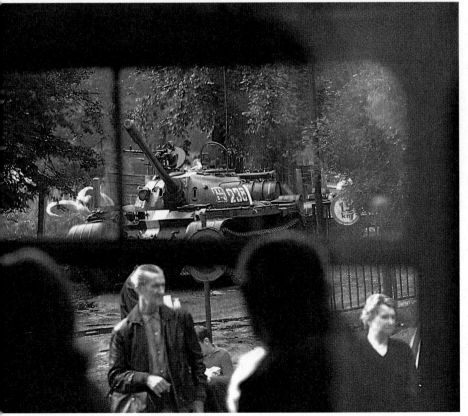

PRAGUE, August 1968, otherwise known as the 'Prague Spring', introduced as a period of liberalization by Prime Minister Dubcek, crushed as the Russian tanks (nicknamed 'Goliaths') ploughed into the largely unarmed 'Davids' who sought to hold them back with attempts at reasoning and fraternization.

PRAG, August 1968, als der »Prager Frühling«, die Liberalisierungen des Premierministers Dubcek, von russischen Panzern niedergewalzt wird. Die »Goliaths« (wie man die Panzer nannte) überrollen die größtenteils unbewaffneten »Davids«, die sie mit Argumenten oder einfacher Herzlichkeit aufhalten wollten.

PRAGUE, août 1968. Le Printemps de Prague, annoncé comme une ère de libéralisation par le Premier ministre Dubcek, fut écrasé sous les chars soviétiques, malgré l'attitude d'une population tchèque désarmée, qui ne cherchait qu'à retenir les soviétiques, en leur faisant entendre raison et en fraternisant.

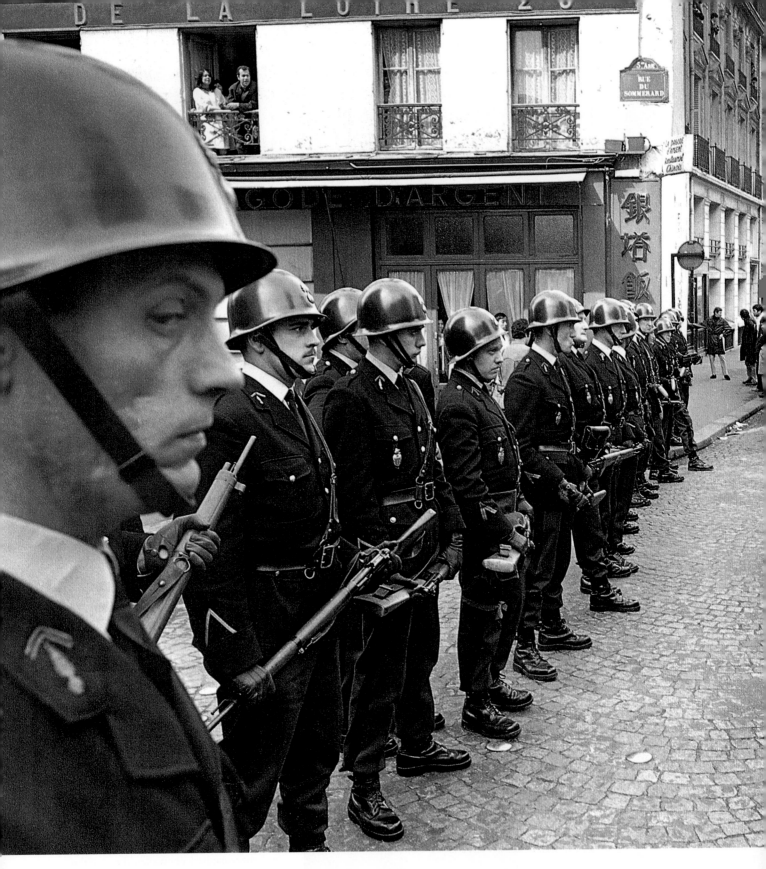

JEAN-PAUL Sartre did it. Simone de Beauvoir did it. In May 1968 it was hard to encounter anyone who *did not* have a part to play in *les événements* (1) or didn't at least claim they had, safely after the event. The Canadian writer Mavis Gallant kept a diary and observed that Sorbonne stone-throwing (4) brought forth the CRS with military responses of teargas (2) and baton charges (3): '… med. students kept out of it at the beginning, joined movement only as a reaction against the police… it wasn't safe for a doctor to help the wounded unless the doctor wore a helmet… wounded on stretchers beaten in a kind of frenzy. In Latin Quarter now, faces bruised, casts and bandages for what would seem to be ski accidents in another season, but these are fresh. Tendency of boys to behave like Old Soldiers: "I was on the barricades" like "I was in the Résistance"' (*Paris Notebooks 1968-86*).

JEAN-PAUL Sartre war dabei, Simone de Beauvoir war dabei. Im Mai 1968 war es schwer, jemanden zu finden, der *nicht* bei den *événements* dabeigewesen war (1). Die kanadische Schriftstellerin Mavis Gallant führte Tagebuch und beschreibt, wie sich die CRS von den Steinwürfen an der Sorbonne (2) zu martialischen Antworten mit Tränengas (3) und Schlagstöcken (4) hinreißen ließ: »Die Medizinstudenten hielten sich anfangs heraus und machten erst später aus Protest gegen die Polizei

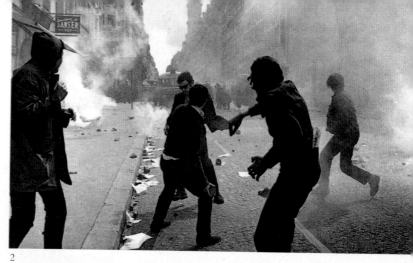

2

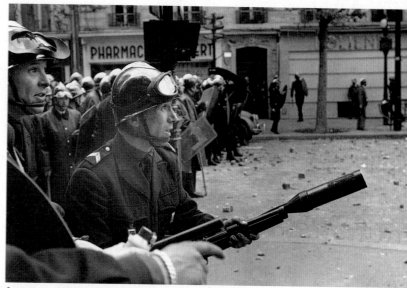

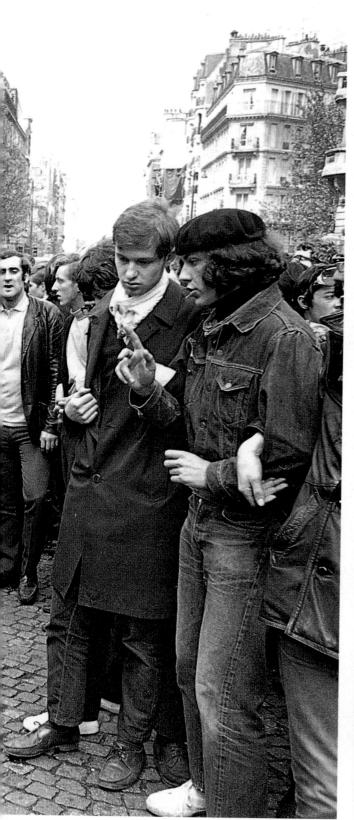

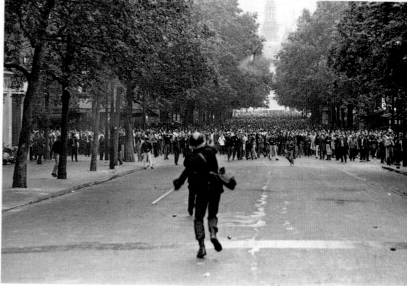

1 4

... selbst auf die Verwundeten auf ihren
ragen schlugen sie noch in einer Art
ausch ein. Jetzt bin ich im Quartier
atin, zerschundene Gesichter, Bandagen
d Gipsverbände, zu anderen Zeiten hätte
an sie für die Opfer von Skiunfällen ge-
lten, doch die Verletzungen sind frisch.
e Jungs führen sich auf wie alte Kämpfer:
ch war auf den Barrikaden‹, genau wie
e Alten einem ›Ich war bei der Résistance‹
zählen«. (*Paris Notebooks*, 1968-86).

JEAN-PAUL Sartre y était. Simone de
Beauvoir aussi. En mai 1968, il était fort
difficile de rencontrer quelqu'un qui n'avait
pas joué un rôle dans les événements, ou
du moins qui le clamait très fort dès lors
que tout danger semblait écarté (1). L'écri-
vain canadien Mavis Gallant, qui tenait son
journal, observa les lanceurs de pavés de la
Sorbonne (4) face aux CRS armés de gaz
lacrymogènes (2) et de gourdins (3) : « Les
étudiants en médecine restèrent dès le début
à l'écart, ne se joignant au mouvement que

pour réagir contre la police (...) Il était
risqué pour un médecin d'aider les blessés,
sauf si le médecin portait un casque (...)
Maintenant, au Quartier latin, des visages
meurtris, des plâtres et des pansements
pour ce qui ressemble à des accidents de
ski survenus en une autre saison (...)
Tendance des garçons à se conduire en
vétérans : ‹ J'ai fait les barricades ›, comme
‹ J'étais dans la Résistance ›. »
(*Paris Notebooks* 1968–1986)

THE early 1960s and a time of wire-laced walls (2), spotlights and sirens; Checkpoint Charlie and John Le Carré; of a miserably divided city. 'ATTENTION!: You are NOW leaving West Berlin' (1). Then, in 1989, the wall begins to come down: the first chink, seen from West (4) and East (5); with bulldozers moving in to make new crossing-points and 2.7 million East Germans given visas to go West (some of them on the Wall, 3).

DIE frühen 60er Jahre, eine Zeit der Wände mit Stacheldrähten (2), der Suchscheinwerfer und Sirenen, die Zeit von Checkpoint Charly und John Le Carré, die Zeit einer schaurig zweigeteilten Stadt. »ACHTUNG! Sie verlassen JETZT WEST-BERLIN« (1). Und dann, 1989, fällt die Mauer: die erste Kerbe, vom Westen aus gesehen (4), und vom Osten (5); dann

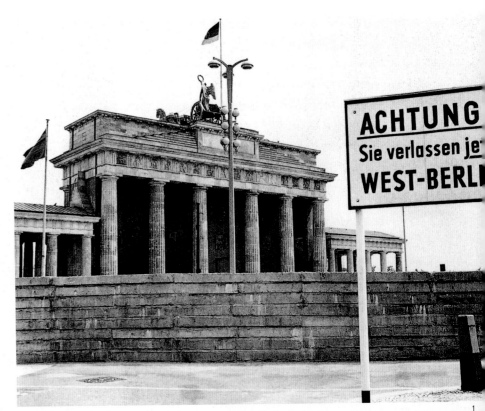

1

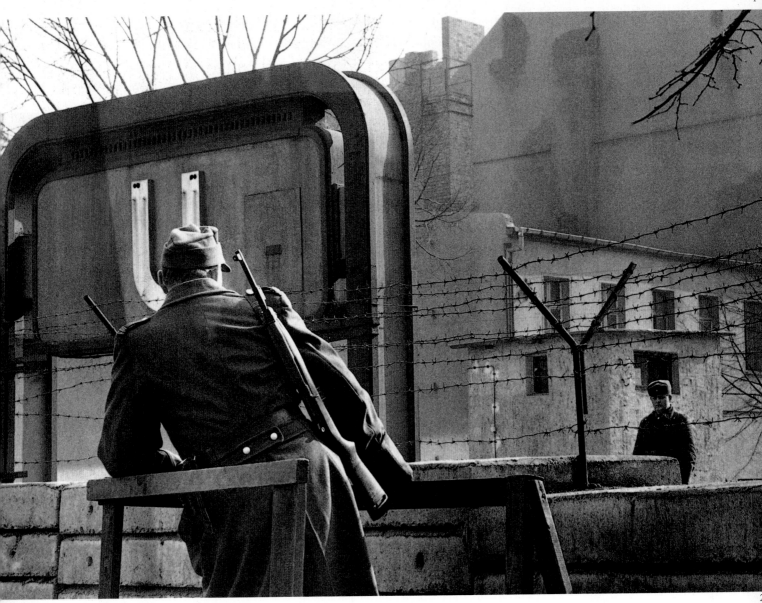

2

übernehmen die Bulldozer, um neue Übergänge zu schaffen, und 2,7 Millionen Ostdeutsche bekommen ein Visum für den Westen (ein paar von ihnen kann man hier auf der Mauer sehen, 3).

L E début des années 60, époque où les murs étaient entourés de barbelés (2), de projecteurs et de sirènes ; Check Point Charlie et John Le Carré ; temps difficiles pour une cité lamentablement divisée. « ATTENTION ! vous quittez MAINTE-NANT Berlin-Ouest » (1). Et puis, en 1989, le Mur a commencé à s'écrouler : la première brèche, vue de l'Ouest (4), et de l'Est (5) ; des bulldozers créent de nou-veaux passages et 2,7 millions d'Allemands de l'Est, munis de visas, se rendent à l'Ouest (quelques-uns d'entre eux sur le Mur, 3).

5

Civil Protest

IN South Africa the introduction of apartheid in 1948 disbanded even the moderate Natives' Representative Council, leaving blacks no recourse but to work outside government dictates in order to pursue the mild but anti-segregationist policies of the Natives' Law Commission and to resist further forced deportations and cruel restrictions on their daily lives. In the United States, the foundation of the National Association for the Advancement of Colored Peoples (NAACP) threw into relief both the aspirations and the limitations of campaigns for a better deal for those whose living conditions continued, particularly in the Southern states, to show little improvement on those of their forefathers, imported into slavery.

The sheer scope of the 'Protest Movement', as it came to be called, was tremendous. Pastors such as the Reverend Frank Chikane and Archbishop Desmond Tutu in South Africa, Martin Luther King in the United States, militant separatist Black Moslems (Malcolm X) and Black Panthers (Bobby Seale, Eldridge Cleaver, Stokeley Carmichael), all had mass followings, protesting against not only local issues but highlighting a system of injustice against which many – particularly among the young – could unite in defiance. Against them were ranged fringe extremists like the Ku Klux Klan and the Afrikaner Brotherhood (A. W. B.) who sought to revive neo-Nazi visions of racial purity based on spurious biblical texts.

The whole western protest movement could be claimed to hinge on the strikes and sit-ins that culminated in all that went by the shorthand of 'May 1968', a time of spontaneous uprising in Paris and London, Rome and Berlin, Colombia and Berkeley. Solidarity with national liberation movements around the world; opposition to the Vietnam War and US 'neo-imperialism'; concern over the relevance of much that was taught in institutes of higher education: the basic upsurge of civil rights movements worldwide was deeply idealistic, frequently religious in its motivation and romantic in its expression.

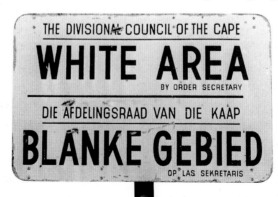

IN Südafrika wurde 1948 die Rassentrennung ei[n]geführt und selbst der bescheidene Natives' Repr[ä]sentative Council noch aufgelöst, so daß den Schwarz[en] nichts anderes übrigblieb, als sich außerhalb d[es] Gesetzes zu stellen, wenn sie die gemäßigte, doch geg[en] die Apartheid gerichtete Politik der Natives' La[w] Commission unterstützen und sich weiteren Depo[r]tationen und unwürdigen Beschränkungen ihr[es] täglichen Lebens widersetzen wollten. In den Vereini[g]ten Staaten zeigte die Gründung der National Ass[o]ciation for the Advancement of Colored Peop[les] (NAACP) sowohl die Hoffnungen wie auch die Gre[n]zen von Kampagnen, die bessere Lebensbedingung[en] für jene schaffen wollten, die, besonders im Süde[n] kaum anders lebten als ihre Vorfahren, die Sklav[en] waren.

Die Bandbreite der »Protestbewegung« war ung[e]heuer. Geistliche wie Reverend Frank Chikane u[nd] Erzbischof Desmond Tutu in Südafrika, Martin Luth[er] King in den Vereinigten Staaten, militant-separatistisc[he] Black Moslems (Malcolm X) und Black Panthe[r] (Bobby Seale, Eldridge Cleaver, Stokeley Carmicha[el]) hatten allesamt gewaltige Anhängerscharen und pr[o]testierten nicht nur regional begrenzt, sondern geg[en] das ganze ungerechte System, so daß sich viele i[m] Protest zusammenschließen konnten. Ihnen gegenüb[er] standen Extremisten wie der Ku-Klux-Klan oder d[ie] Afrikaner-Brüderschaft (AWB), die, gestützt auf ve[r]drehte Bibelworte, nazihafte Vorstellungen von Rasse[n]reinheit wiederaufleben ließen.

Angelpunkt der ganzen westlichen Protestbewegu[ng] waren die Streiks und Sit-ins, die in dem kulmintert[en] was man kurz »Mai '68« nennt, einer Zeit spontan[er] Aufstände in Paris und London, Rom und Berl[in] Columbia und Berkeley. Solidarität mit national[en] Befreiungsbewegungen überall auf der Welt, Opp[o]sition gegen den Vietnamkri[eg] und den US-amerikanisch[en] »Neoimperialismus«, die Fra[ge] nach dem Sinn von Univer[si]täten: Die Grundstimmung d[er] Bürgerrechtsbewegungen über[all] auf der Welt war außerordentli[ch] idealistisch, vielfach religiös mo[ti]viert und romantisch in ihrer A[us]

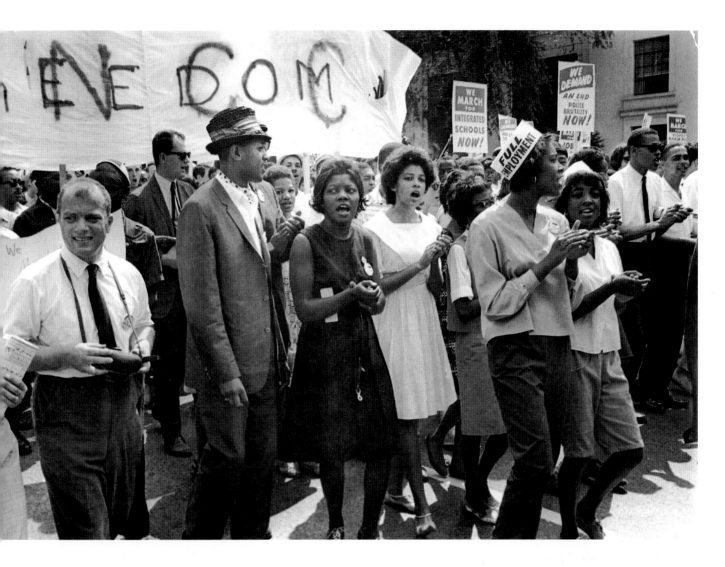

'INTRODUCTION de l'apartheid en Afrique du Sud en 1948 entraîna la désagrégation du très ͜odéré Conseil représentatif des indigènes. Dès lors, les ͜irs n'eurent pas d'autre choix que celui d'agir en ͜hors du cadre imposé par les pouvoirs publics, d'une ͜t pour suivre la Commission juridique des indigènes ͜ns la voie antiségrégationniste toute modérée qui était ͜sienne, mais aussi pour résister à la multiplication des ͜portations forcées et aux vexations cruelles qu'ils ͜issaient dans leur vie quotidienne. Aux États-Unis, ͜ssociation nationale en faveur de la promotion des ͜uples de couleur (NAACP) suppléa aux limites des ͜mpagnes visant à améliorer le sort de ceux dont les ͜nditions de vie, surtout dans les états du Sud, ne ͜ontraient guère d'amélioration par rapport à celles de ͜rs ancêtres amenés là en esclavage.

La portée du « Mouvement de protestation » comme ͜ l'appela par la suite fut tout simplement immense. Il ͜cluait des hommes d'église tels que le révérend Frank ͜ikane et l'archevêque Desmond Tutu en Afrique du ͜d, ou encore Martin Luther King aux États-Unis, les ͜litants séparatistes, Musulmans Noirs (les « Black ͜oslems » de Malcolm X) et Panthères Noires (« Black ͜nthers » – Bobby Seale, Eldridge Cleaver, Stokeley

Carmichael) ; ils comptaient tous de nombreux fidèles parce que leur protestation, qui allait bien au-delà de problèmes locaux prétextes, portait sur un système injuste que beaucoup – surtout parmi les jeunes – défiaient en s'unissant. Ils avaient à faire aux éléments extrémistes de tous bords, tels le Ku Klux Klan et la Fraternité afrikaner (AWB) qui cherchaient à raviver les mythes néonazis de la pureté de la race fondés sur de faux textes bibliques.

On a pu dire de l'ensemble du mouvement de protestation occidental qu'il se joua dans les grèves et les occupations de locaux qui culminèrent dans ce qu'on appela « Mai 68 », époque de. soulèvements spontanés à Paris, Londres, Rome, Berlin, Columbia et Berkeley. Solidarité avec les mouvements de libération nationale de par le monde, opposition à la guerre du Viêt-nam et au « néo-impérialisme » des États-Unis, vaste remise en question de la pertinence du contenu des programmes des établissements d'enseignement supérieur : au fond, les mouvements en faveur des droits civils qui avaient surgi partout à travers le monde étaient profondément idéalistes, fréquemment religieux dans leurs motivations et romantiques dans leur expression.

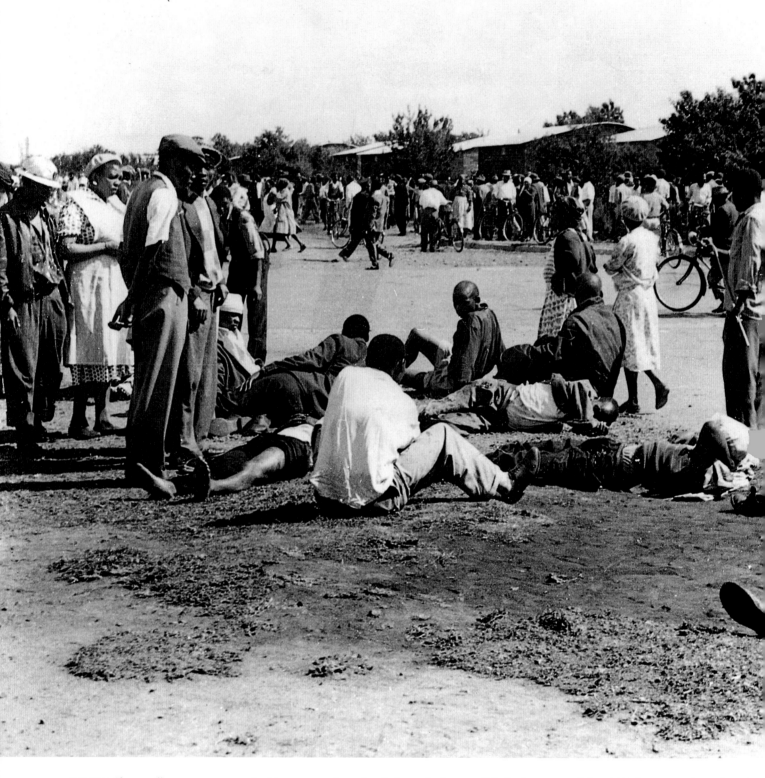

THE Sharpeville massacre, provoked by riots against the pass laws, took place in 1960 (1). Shortly afterwards Nelson Mandela, here photographed in discussion with a teacher (2), earned a reputation as the 'Black Pimpernel' for his resourcefulness in evading arrest. The 1964 Treason Trials sentenced him and eight others to life on Robben Island. Before his deportation he told the Pretoria courtroom: 'I do

not deny that I planned sabotage. We had either to accept inferiority or fight against it by violence.' In Johannesburg, in June 1976, three days of uprising, leading to rioting and looting, left over 100 dead and 1,000 injured (3). Blacks were outraged at this response to an initially peaceful pupil-led protest, provoked when Afrikaans was suddenly made a compulsory subject on the school curriculum.

IM Jahre 1960 kam es nach Aufständen gegen die Paßgesetze zum Massaker von Sharpeville (1). Später erwarb sich Nelson Mandela, hier im Gespräch mit einem Leh (2), seinen Ruf als »Schwarzer Pimpernel« weil er sich so geschickt immer wieder d Verhaftung entzog. 1964 wegen Hochver angeklagt, wurden er und acht andere zu lebenslanger Haft auf Robben Island ver- urteilt. Vor seiner Deportation sagte er: » leugne nicht, daß ich sabotieren wollte.

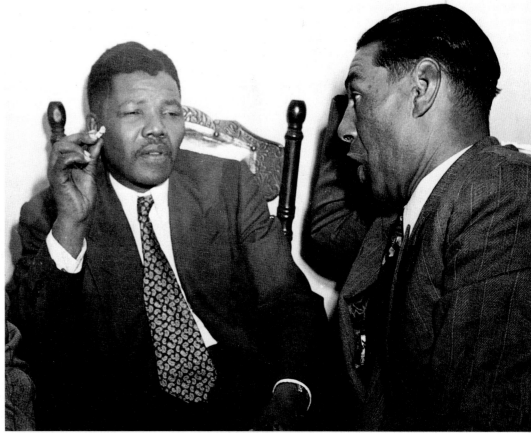

2

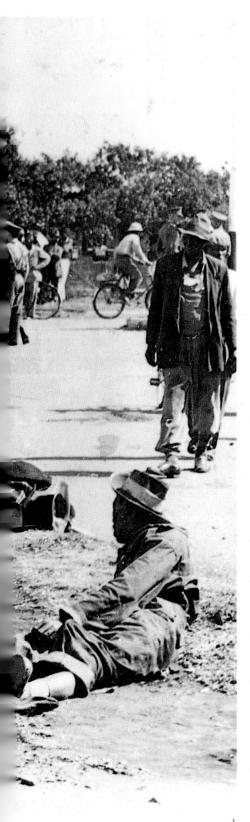

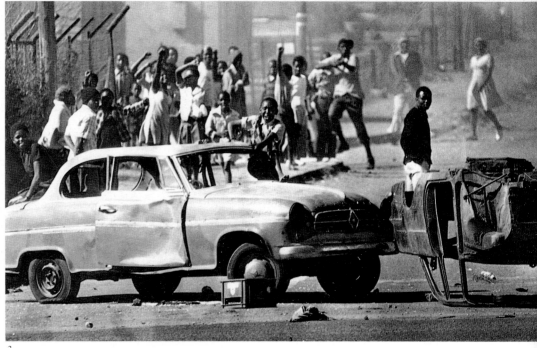

1　3

atten nur die Wahl, unsere Benachteiligung
‿ akzeptieren oder mit Gewalt dagegen
‿ kämpfen.« Im Juni 1976 kam es in Johan-
‿esburg zu Aufständen und Plünderungen,
‿it über hundert Toten und tausend Ver-
‿tzten (3). Die Schwarzen waren empört
‿ber die gewaltsame Reaktion auf einen
‿nächst friedlichen Protest gegen ein Ge-
‿tz, das Afrikaans zum Pflichtfach in den
‿hulen machte.

L E massacre de Sharpeville qui fit suite
aux émeutes déclenchées par les lois
entravant la libre circulation des Noirs eut
lieu en 1960 (1). Nelson Mandela, que l'on
voit ici photographié en discussion avec un
enseignant (2), y acquit peu de temps après
sa réputation de « Zorro Noir » tant il était
habile à échapper aux arrestations. Jugé
pour trahison en 1964, il fut condamné
avec huit autres personnes à la prison à
perpétuité sur Robben Island. Dans la salle

du tribunal à Prétoria il déclara : « Je ne
nie pas l'intention de sabotage. Soit nous
acceptions le statut d'infériorité soit nous le
combattions par la violence. » À Johannes-
burg, en juin 1976, trois jours de soulève-
ments se traduisent par mille blessés et plus
de cent morts (3). Les Noirs s'étaient sentis
outragés par cette mesure prise en réponse
à une protestation contre l'introduction
soudaine de l'afrikaans obligatoire à l'école.

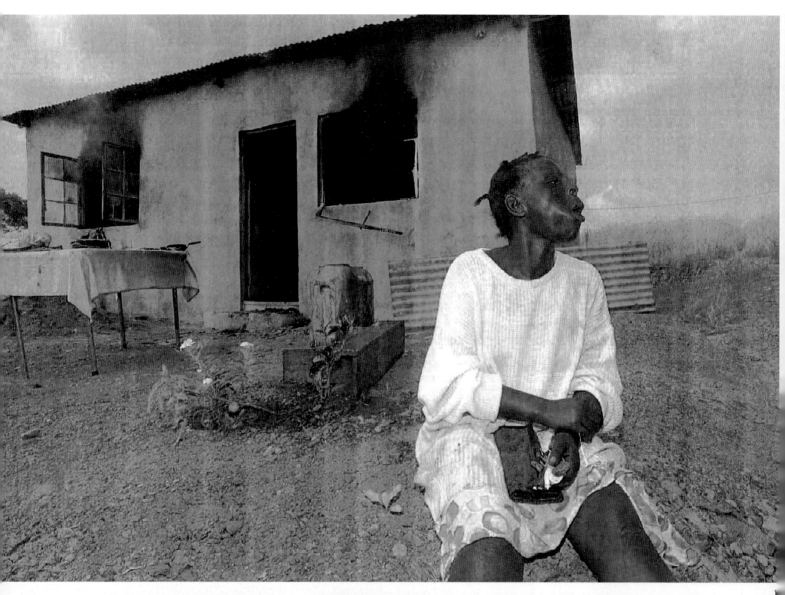

F OLLOWING the victory for the A. N. C.
on 27 April 1994, President Nelson
Mandela and Deputy President F. W. de Klerk
join hands (3). Members of the extreme
right-wing A. W. B. listen to their leader,
Eugene Terre Blanche (2), A woman sits
in the smoking ruins of her house (1).

N ach dem Wahlsieg der ANC am
27. April 1994 heben Präsident Nelson
Mandela und F. W. de Klerk vor dem Union
Building gemeinsam die Hand (3). Derweil
lauschen Mitglieder der extrem rechtsgerich-
teten AWB ihrem Führer Eugene Terre
Blanche (2); eine Frau sitzt ratlos vor den
Ruinen ihres niedergebrannten Hauses (1).

À la suite de la victoire l'ANC de 27 avril
1994, le président Nelson Mandela
et le vice-président F.W. de Klerk joignent
leurs bras levés (3). Ailleurs, les membres
d'extrême-droite de l'AWB écoutent leur
leader, Eugene Terre Blanche (2). Une
femme est assise au milieu de sa maison en
ruine (1).

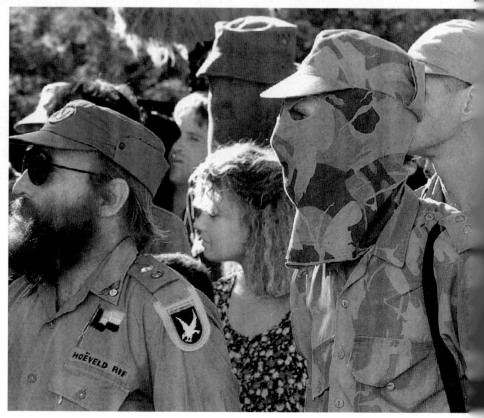

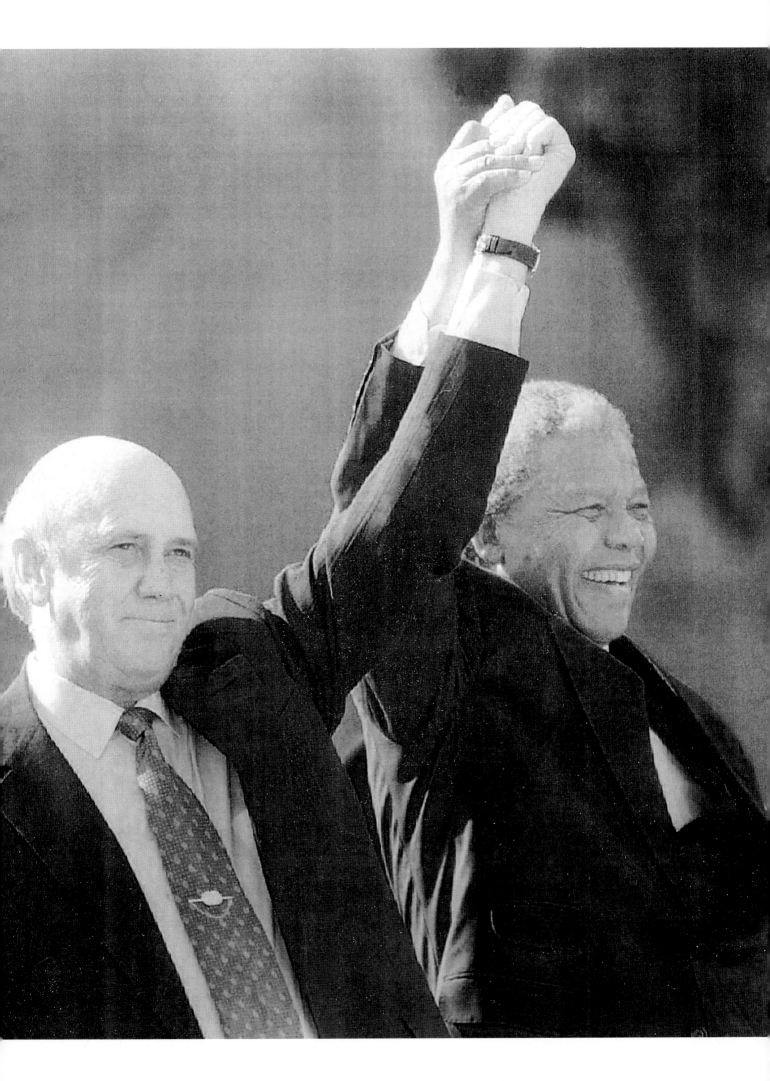

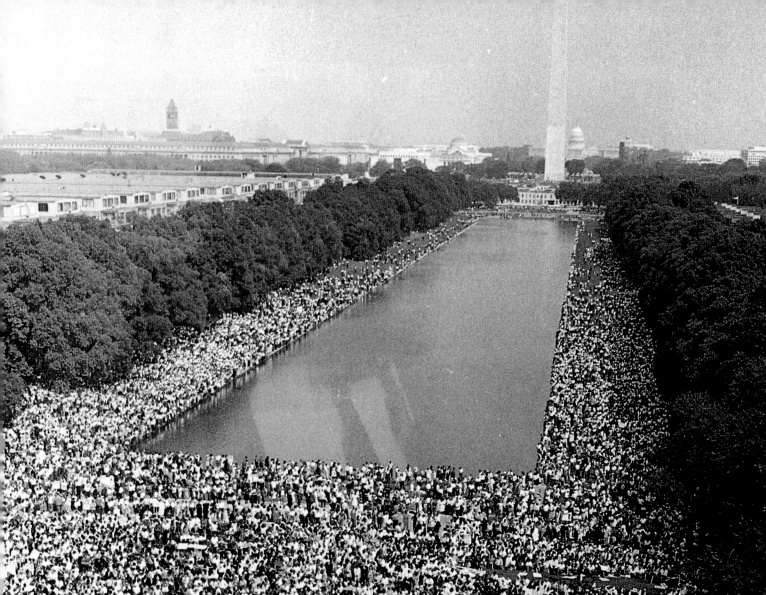
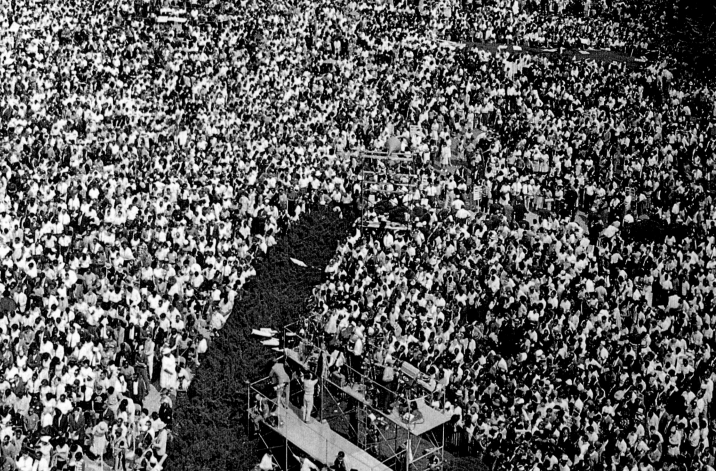

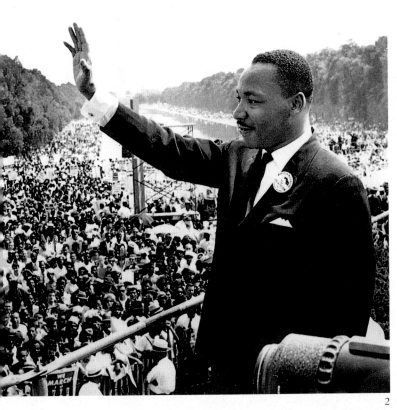

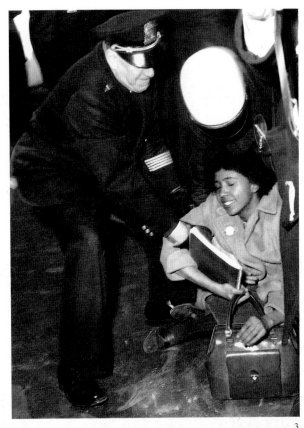

2

3

MARTIN Luther King addresses a crowd of a quarter of a million that [inc]luded show business stars Marlon Brando, [Bu]rt Lancaster, Judy Garland and Bob [Dy]lan (1, 2): 'I have a dream that one day [thi]s nation will rise up and live out the true [me]aning of its creed: "We hold these [tru]ths to be self-evident, that all men are [cre]ated equal".' A year after President [Ly]ndon Johnson signed the Civil Rights [Ac]t, he met with the six nuns leading [the] Civil Rights March from Selma, Ala[ba]ma. The protest was in defiance of the [po]lice ban imposed after a gang of white [sup]remacists attacked three liberal clergy[m]en. One, the Rev. Reep, later died from [his] injuries. Pickets sitting down before the [W]hite House were bodily hauled away [in]o police paddy wagons to be booked (3).

MARTIN Luther King spricht vor einer Viertelmillion Zuhörern, darunter die Stars Marlon Brando, Burt Lancaster, Judy Garland und Bob Dylan (1, 2): »Ich hatte einen Traum. Mir träumte, wie sich eines Tages diese Nation erheben wird und Wirklichkeit werden läßt, was sie sich auf die Fahnen geschrieben hat: Folgende Wahrheit halten wir für selbstverständlich: daß alle Menschen gleich geboren sind.« Ein Jahr nachdem Präsident Lyndon Johnson das Bürgerrechtsgesetz unterzeichnet hatte, traf er sich mit sechs Nonnen, den Führerinnen eines Protestmarsches, der von Selma, Alabama, ausging. Diese Demonstration setzte sich über das polizeiliche Verbot hinweg, das nach einem Überfall weißer Extremisten auf drei liberale Geistliche erfolgt war. Einer von ihnen, Reverend Reep, starb später an den Folgen seiner Verletzungen. Streikposten, die sich vor dem Weißen Haus niedergelassen hatten, wurden fortgezerrt und zum Verhör gebracht (3).

MARTIN Luther King harangue une foule d'un quart de millions de personnes et parmi elles des vedettes du spectacle tels que Marlon Brando, Burt Lancaster, Judy Garland et Bob Dylan (1 et 2) : « Je rêve du jour où cette nation se lèvera pour vivre pleinement le sens véritable du credo qu'elle a fait sien : nous tenons pour évidentes ces vérités comme quoi tous les hommes ont été créés égaux. » Un an après avoir paraphé la loi sur les droits du citoyen, le président Lyndon Johnson rencontra les six religieuses qui conduisaient en mars la marche en faveur des droits civils partie de Selma dans l'Alabama. Il s'agissait d'une protestation contre les mesures d'interdiction décidées par la police après l'attaque commise sur trois religieux libéraux par une bande de militants convaincus de la supériorité blanche. Un des religieux, le révérend Reep, devait plus tard décéder des suites de ses blessures. Les manifestants qui ont installé des piquets devant la Maison blanche sont traînés à l'intérieur des cars de police (3).

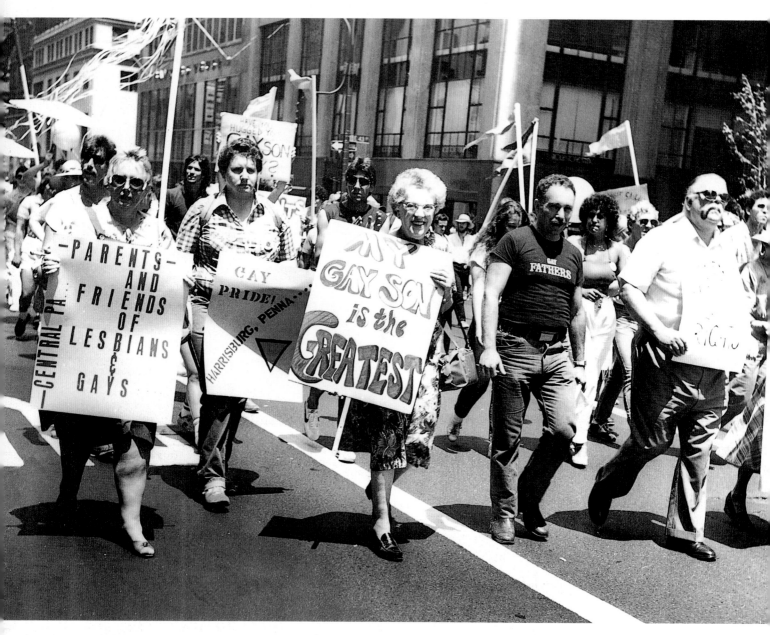

IN summer 1979 the march for Gay
Rights went right up Fifth Avenue to a
rally in Central Park (1). Gays wanted to
be able to come openly out of the closet
and into women's clothes (if they felt like
it) *and* be patriotic all-American boys (and
proud of it). Over 40,000 marched in the
1983 Gay Pride Parade in New York City
(2), on the anniversary of the founding of
the Gay Alliance Association in Greenwich
Village, formed after the police confronted
gays in a bar there in 1969 and the Stone-
wall Riots erupted. The movement swiftly
diversified so that gays became represented
in a variety of occupations and, as here,
their relatives too could come out in their
support.

IM Sommer 1979 zog der Marsch für die
Rechte der Homosexuellen mitten über
die Fifth Avenue zu einer Versammlung
im Central Park (1). Die Männer wollten
sich offen zu ihren Neigungen bekennen
können und auch in Frauenkleider
schlüpfen (wenn sie dafür eine Vorliebe
hatten); sie wollten trotzdem brave
patriotische Jungs sein dürfen (und stolz
darauf). Über 40.000 gingen 1983 für die
Gay Pride Parade in New York auf die
Straße (2), am Jahrestag der Gründung der
Gay Alliance Association. Diese Vereini-
gung war 1969 in Greenwich Village
gegründet worden, nachdem Polizisten
gegen Männer in einer Bar vorgegangen
waren und damit die sogenannten Stone-
wall Riots provoziert hatten. Die Bewegung
verzweigte sich rasch, und Homosexuelle
verschiedenster Couleur fanden dort ihr
Sprachrohr. Auch die Angehörigen konnten,
wie hier, mit auf die Straße gehen und
demonstrieren.

EN été 1979, la marche en faveur des
droits des homosexuels remonta tou
la Cinquième avenue pour se terminer p
un rassemblement à Central Park (1). Le
homosexuels voulaient pouvoir sortir au
grand jour et même s'habiller comme de
femmes (si tel était leur bon plaisir) tout
en étant « de bons Américains » (qui plus
est fiers de l'être). Plus de quarante mille
personnes prennent part à la parade des
homosexuels en 1983 à New York (2) e
commémoration de l'anniversaire de la
fondation de l'association de l'alliance
homosexuelle dans le quartier de Green-
wich Village, née au lendemain de la
bataille opposant forces de police et hom
sexuels dans un bar en 1969 et qui avait
déclenché les émeutes de Stonewall. Le
mouvement se diversifia bien vite de faç
à représenter les homosexuels dans toute
une variété d'emplois et afin que, comm
ici, leurs parents puissent eux aussi mani-
fester publiquement leur soutien.

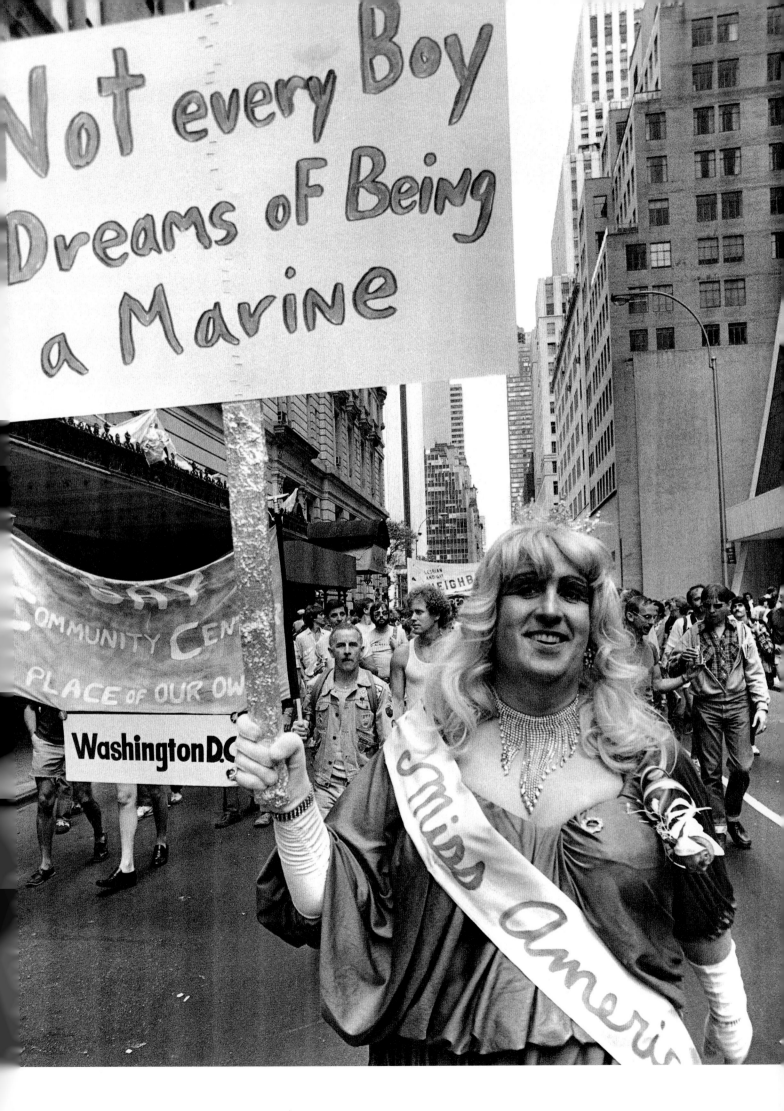

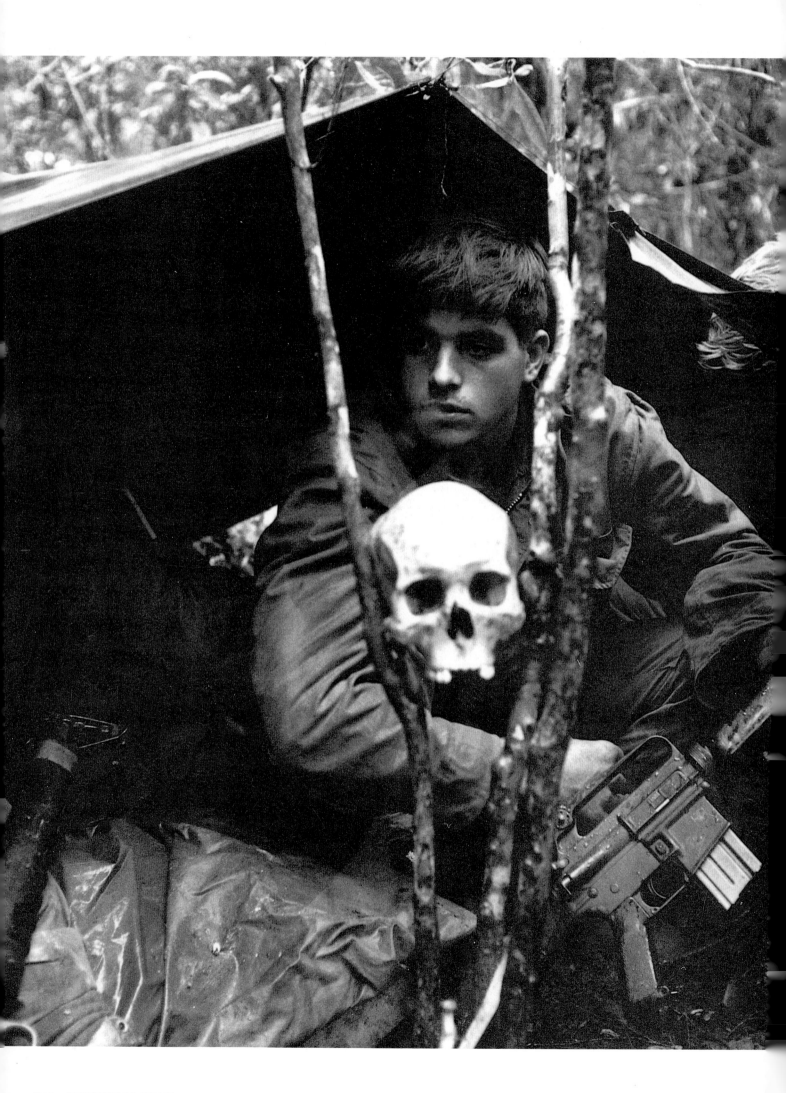

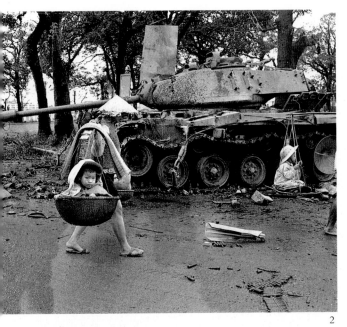

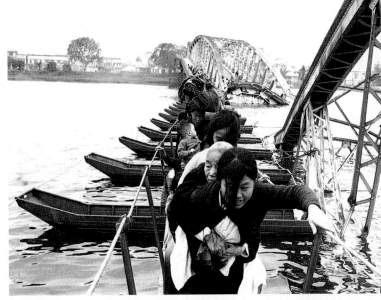

2　3

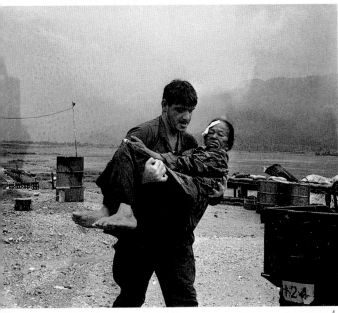

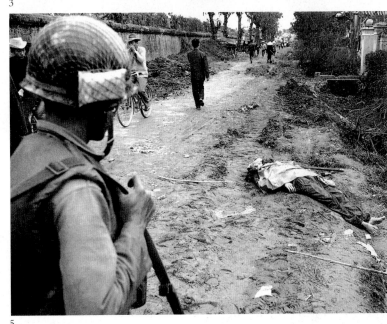

4　5

Y spring 1965 President Johnson was
sending the Marines into Vietnam
protect the US military base at Da Nang
m increasingly stringent Viet Cong guer-
la attacks. While a US soldier crouches
ease behind his automatic weapon and
skull trophy (1), a burnt-out tank lies
andoned by the road, a warning to the
eing South Vietnamese refugees (2). A
clist passes corpses in Hue, holding his
se to exclude the stench of death (5).
1968 the Viet Cong Tet offensive had
led, but this was to be a classic instance
losing the battle to win the war. Not
ly was the US signally failing to win
er the 'hearts and minds' of the South
ietnamese, but the Viet Cong were
oring one propaganda coup after another
ith pictures like these (2, 3, 4).

IM Frühjahr 1965 schickte Präsident
Johnson die Marines nach Vietnam, wo
sie die Militärbasis Da Nang vor den immer
stärker werdenden Guerilla-Angriffen des
Vietkong schützen sollten. Ein US-Soldat
hat es sich mit seinem Gewehr und seinem
Maskottchen bequem gemacht (1), und ein
ausgebrannter Panzer liegt verlassen am
Wegrand, eine Warnung für die vorbeizie-
henden südvietnamesischen Flüchtlinge (2).
Ein Radfahrer in Hué (5) hält sich die Nase
zu, damit er die Leichen nicht riechen muß.
1968 war klar, daß die Tet-Offensive des
Vietkong gescheitert war, doch war dies der
klassische Fall einer Schlacht, die man
verliert, um den Krieg zu gewinnen. Nicht
genug, daß es den Amerikanern nicht
gelang, »Verstand und Herz« der Südviet-
namesen für sich zu gewinnen, errang der
Vietkong mit Bildern wie diesen (2, 3, 4)
einen Propagandasieg nach dem anderen.

DÈS le printemps de 1965, le président
Johnson envoyait les Marines au
Viêt-nam assurer la protection de la base
militaire américaine de Da Nang contre les
attaques de la guérilla Viêt-cong de plus en
plus virulentes. Tandis qu'un soldat amé-
ricain s'accroupit derrière son arme auto-
matique et le crâne qui est son trophée (1),
un char d'assaut gît sur le côté de la route
en guise d'avertissement aux réfugiés sud-
vietnamiens qui fuient (2). Un cycliste
dépasse des cadavres dans Hue, où règne
l'odeur de la mort (5). Dès 1968 l'offensive
Tet des Viêt-congs échouait, illustration du
fait que perdre une bataille n'est pas perdre
la guerre, bien au contraire. Non seule-
ment les États-Unis se distinguèrent par
leur incapacité à gagner les « cœurs et les
esprits » des Sud-Vietnamiens, mais en plus
la propagande des Viêt-congs marqua des
points grâce à la diffusion d'images telles
que celles-ci (2, 3 et 4).

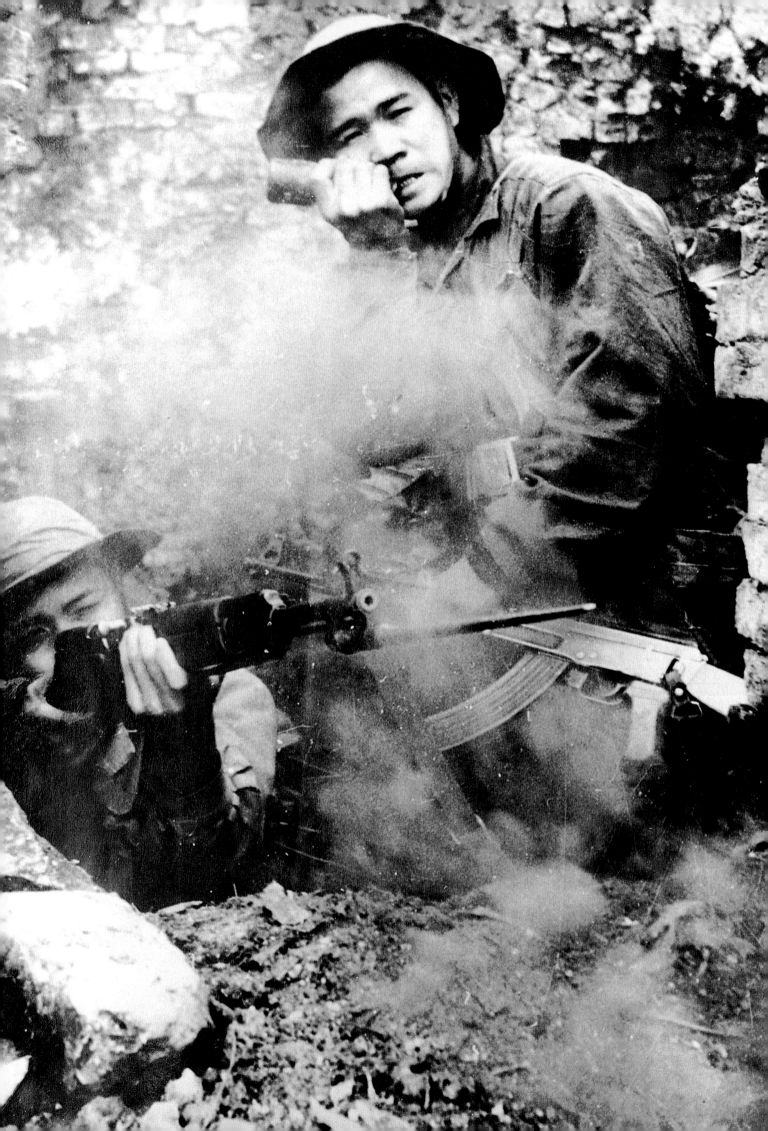

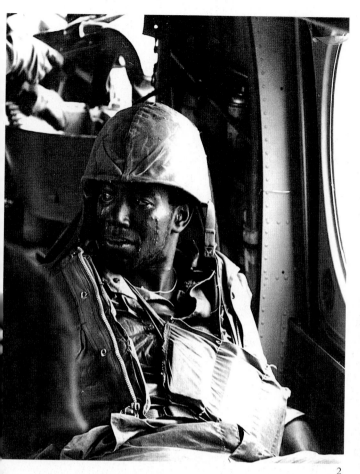

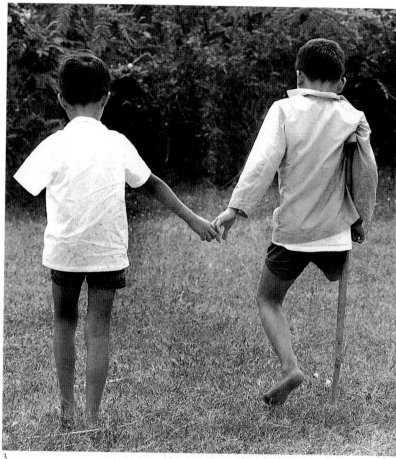

2 3

IT was unusual for western photographers to get close enough to cover Viet Cong soldiers in action. Here the pictures are taken by a fellow Communist from eastern Europe (1). Casualties of course occurred on both sides, as the grief of this airlifted marine beside the body bag indicates (2). By April 1975 when Viet Cong encirclement forced the South Vietnamese president to flee and General Duong Van Minh to surrender Saigon, the war was over. It had taken 1.3 million Vietnamese and 56,000 US lives. There were also upwards of a million orphans, many of them badly maimed, like these two, ten-year-old Le Luy and six-year-old Cu Van Anh, who somehow managed to hold hands and walk together despite a shortage of limbs (3).

NUR selten kamen westliche Reporter nahe genug heran, um Aufnahmen des Vietkong im Feld zu machen. Dieses Bild (1) stammt von einem kommunistischen Waffenbruder, einem Photographen aus Osteuropa. Verluste gab es natürlich auf beiden Seiten, und diesem Marine, der mit einem Hubschrauber aus dem Einsatzgebiet geflogen wird, steht der Schmerz im Gesicht geschrieben (2). Im April 1975 war Saigon vom Vietkong eingekreist, der südvietnamesische Präsident floh, und General Duong Van Minh kapitulierte – der Krieg war beendet. 1,3 Millionen Vietnamesen und 56 000 Amerikaner waren umgekommen. Etwa eine Million Waisen blieben zurück, viele davon verstümmelt so wie diese beiden, der zehnjährige Le Luy und der sechsjährige Cu Van Anh, die sich trotz fehlender Gliedmaßen an den Händen fassen und zusammen spazierengehen (3).

IL n'était guère donné à des photographes occidentaux de pouvoir suffisamment s'approcher des soldats Viêt-congs en action pour les photographier. Ces photographies ont été prises par un camarade communiste d'Europe de l'Est (1). Il y avait bien sûr des victimes de part et d'autre ainsi que nous l'indique le chagrin qui se lit sur le visage de ce marin américain emporté dans les airs à côté du sac contenant un corps (2). Dès avril 1975 la guerre était terminée : le président sud-vietnamien avait été contraint à s'enfuir pour échapper à l'encerclement des Viêt-congs et le général Duong Van Minh avait présenté la capitulation de Saigon. Elle avait coûté la vie à 1,3 million de Vietnamiens et à 56 000 Américains. Elle laissait aussi plus d'un million d'orphelins, beaucoup d'entre eux effroyablement mutilés comme ceux-là, Le Luy âgé de dix ans et Cu Van Anh de six ans, qui parviennent malgré tout à marcher ensemble (3).

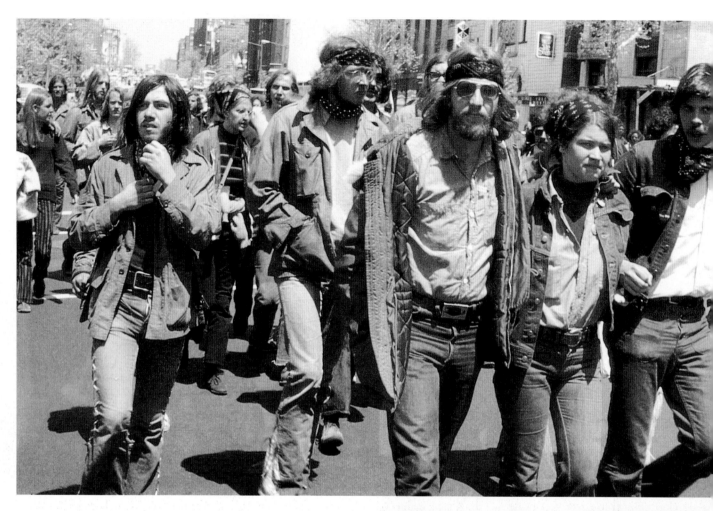

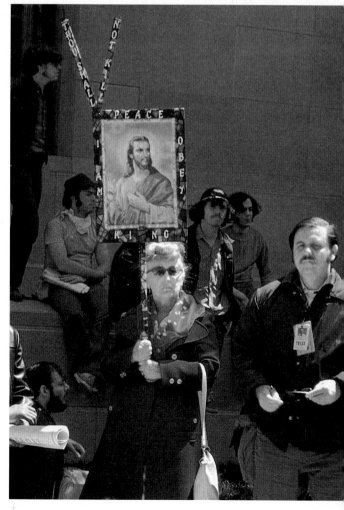

DEMONSTRATIONS against the Vietnam war took place in America: these (1, 2 and 3) were in Washington. The Pentagon blamed the press – singling out the iconic portrait of a little girl running naked down a road, burnt by napalm – for turning the tide of opinion and making it the most unpopular war in US history.

IN Amerika, hier in Washington (1, 2, 3), wurde gegen den Vietnamkrieg demonstriert. Das Pentagon machte die Presse – die Photos wie das eines kleinen Mädchens verbreitete, das nackt, vom Napalm verbrannt, die Straße hinunterläuft – dafür verantwortlich, daß dieser Krieg zum unpopulärsten in der Geschichte der Vereinigten Staaten wurde.

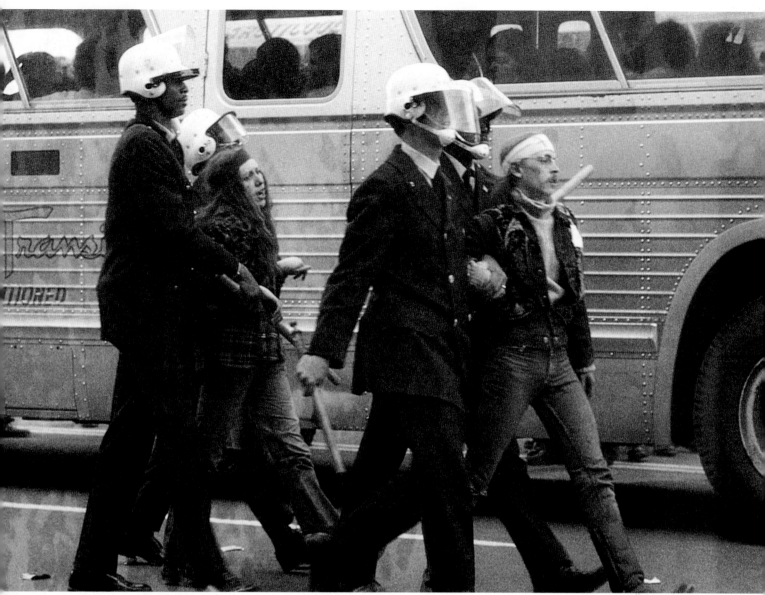

3

DES manifestations hostiles à la guerre du Viêt-nam se dérou-
lèrent en Amérique : celles-ci (1, 2 et 3) se déroulent à
Washington. Le Pentagone en rejeta la faute sur la presse. Il l'accusa
d'avoir monté en épingle et vénéré tel un icône le portrait d'une
petite fille brûlée par le napalm courant toute nue sur la route et
provoqué un revirement de l'opinion publique, au point que cette
guerre devint la plus impopulaire de toute l'histoire des États-Unis.

THE anti-war demonstrations – this
one (1) a candle-lit procession past the
White House – spread to Britain, and
erupted into violence when mounted police
and demonstrators fought outside the
American Embassy, Grosvenor Square,
London (2).

DIE Antikriegsdemonstrationen – hier
ein Kerzenzug am Weißen Haus (1) –
griffen auch nach England über, und vor
der amerikanischen Botschaft am Londoner
Grosvenor Square gingen berittene Polizisten
und Demonstranten aufeinander los (2).

LES manifestations contre la guerre –
celle-ci (1) consiste en une procession
aux chandelles devant la Maison blanche –
gagnèrent la Grande-Bretagne où elles
donnèrent lieu à de violents accrochages
entre la police montée et les manifestants
à l'extérieur de l'ambassade américaine,
à Grosvenor Square à Londres (2).

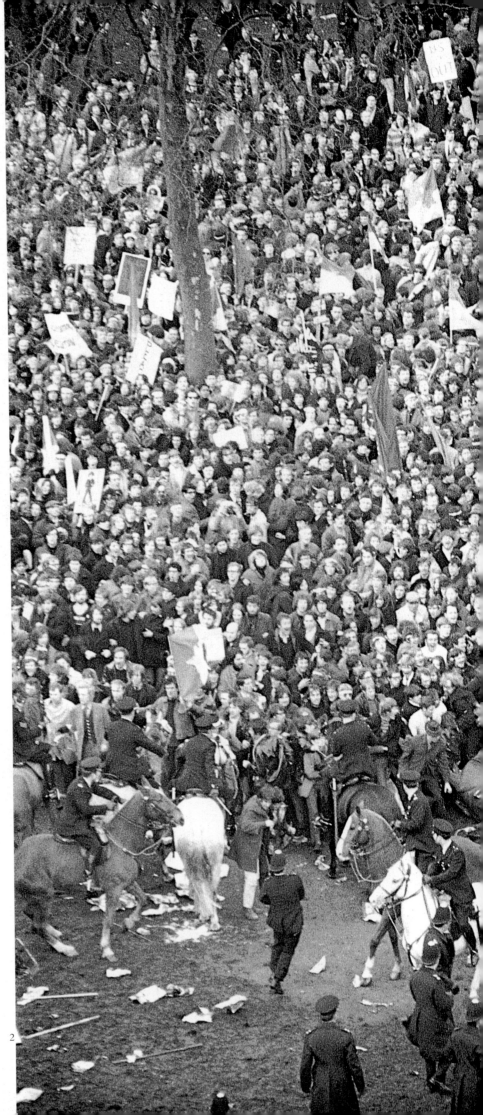

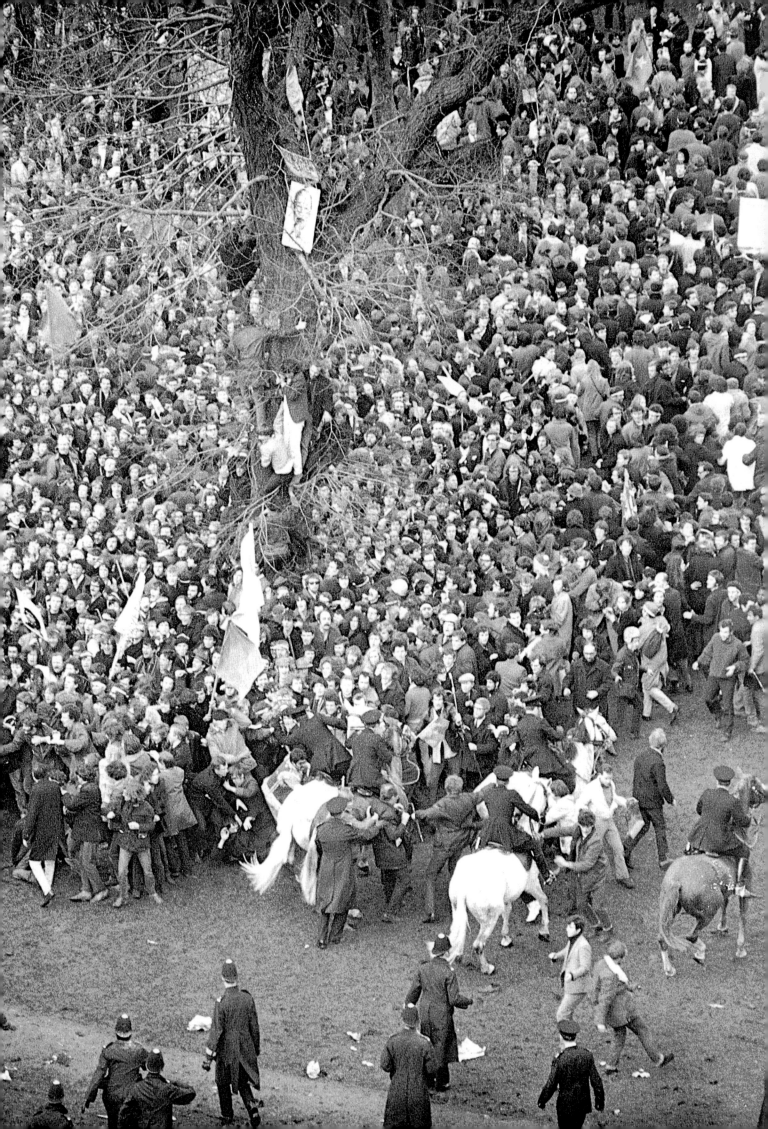

1

TWO visits to London ten years apart: Pope John Paul II paid the first papal visit to Britain in centuries when he toured England, Wales and Ireland in his 'pope-mobile' (2). Perhaps being Polish – the first non-Italian pope in 450 years – helped his keenness to travel. It was also the first occasion since the Reformation that a Pope and the Archbishop of Canterbury prayed together at Canterbury Cathedral, at the tomb of the martyred Thomas à Becket. It was in March 1959 that the Dalai Lama, spiritual leader of Tibet, was forced to flee the holy city of Lhasa in the wake of Chinese repression of a nationalist independence movement. Chinese paratroopers were ordered to capture him alive (were he to be killed, the whole of Tibet would rise up) but he escaped, first to India and then to the West. Twenty-five years later, on a fortnight's stay in England (1), he was still urging Western governments to end cultural genocide in his homeland.

ZWEI Besuche in London, und zehn Jahre liegen dazwischen: Papst Johannes Paul II. unternahm den ersten päpstlichen Besuch in Großbritannien seit Jahrhunderten und war mit dem »Papamobil« in England, Wales und Irland unterwegs (2). Vielleicht war er als Pole – der erste nicht-italienische Papst seit 450 Jahren – reiselustiger als seine Vorgänger. Es war auch das erste Mal seit der Reformation, daß ein Papst und ein Erzbischof von Canterbury gemeinsam in der dortigen Kathedrale am Grab des Märtyrers Thomas Becket beteten. Im März 1959 hatte der Dalai Lama, das geistliche Oberhaupt Tibets, aus der heiligen Stadt Lhasa flüchten müssen, als die Chinesen gegen tibetische Unabhängigkeitsbestrebungen vorgingen. Die chinesischen Fallschirmjäger hatten den Auftrag, ihn lebend zu fangen (wäre er getötet worden, hätte sich ganz Tibet erhoben), doch er entkam, zuerst nach Indien und dann in den Westen. 25 Jahre darauf kam er für zwei Wochen nach England (1), noch immer bei den Regierungen im Westen unterwegs, in der Hoffnung, daß sie etwas gegen den Völkermord in seiner Heimat unternehmen würden.

DEUX visites à Londres à dix ans d'intervalle : la tournée du pape Jean-Paul II dans sa « papamobile » (2) en Angleterre, au pays de Galles et en Irlande était la première visite effectuée depuis des siècles par un pape en Grande-Bretagne. Le fait d'être Polonais – le premier pape non italien en quatre cent cinquante ans – est peut-être un facteur important quant à sa propension aux voyages. Cette visite offrait aussi au pape et à l'archevêque de Canterbury, depuis la Réforme, une occasion de prier ensemble dans la cathédrale de Canterbury et sur la tombe du martyr Thomas à Becket. C'est en mars 1959 que le dalaï-lama, chef spirituel du Tibet, se vit contraint de fuir la cité sainte de Lhassa après que les Chinois eurent écrasé le mouvement nationaliste. Les parachutistes chinois avaient reçu l'ordre de le capturer vivant (sa mort aurait provoqué un soulèvement dans tout le Tibet) ; celuici, toutefois, réussit à s'échapper pour se réfugier d'abord en Inde puis en Occident. Vingt-cinq ans plus tard, profitant d'un séjour de deux semaines en Angleterre (1), il continuait d'inviter instamment les gouvernements occidentaux à mettre un terme au génocide culturel perpétré contre sa patrie.

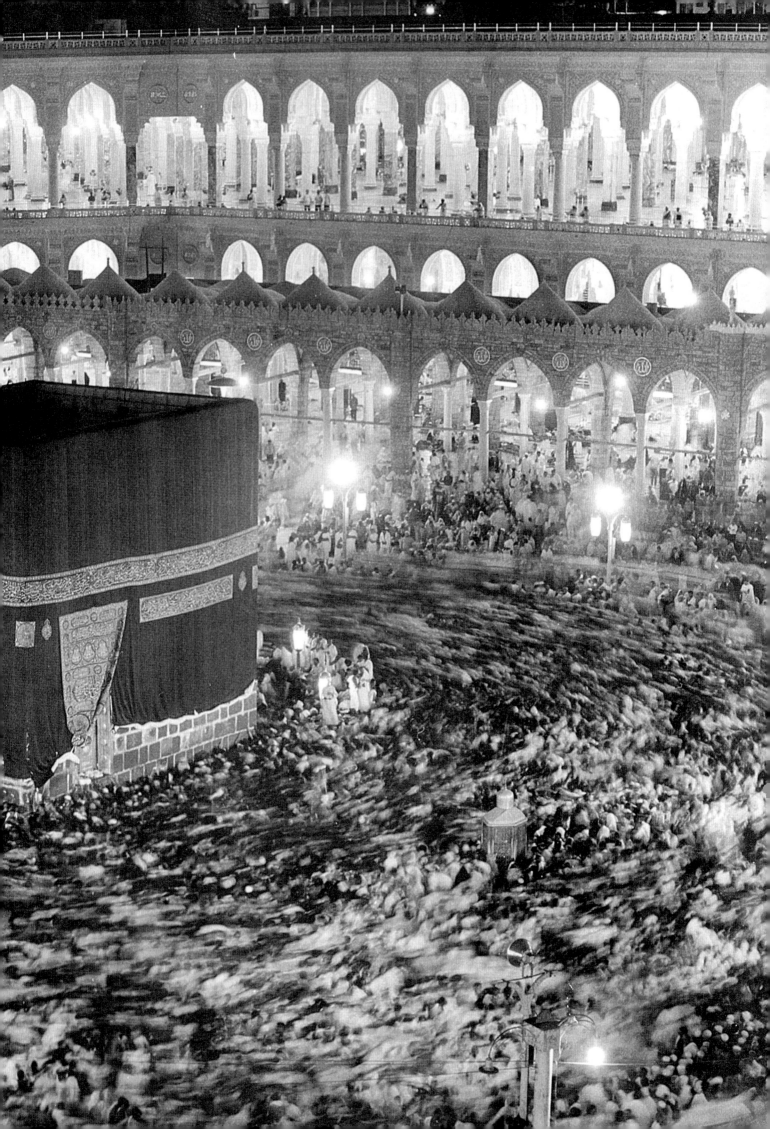

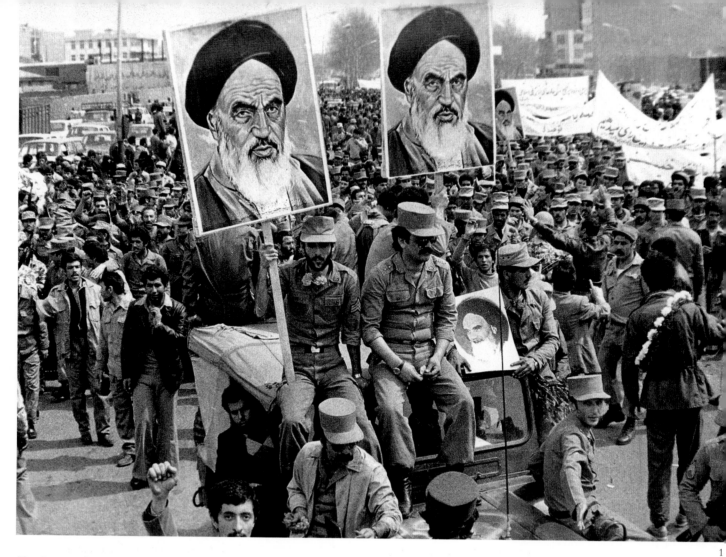

(*Previous pages*)

Awhirlpool of pilgrims in a 500-year-old ceremony: hundreds of thousands of pilgrims make their once-in-a-lifetime *Hajj* (journey to Mecca) and perform the *Tawaf* (sevenfold circling of the Ka'bah). This is the first house of God built on earth by Abraham and his son Ishmael, in the corner of which is embedded a black meteorite hurled by God at the disgraced Adam. Pilgrims are expected to kiss the stone or, at the very least if the crowds are too dense, point at it with the incantation: 'In the Name of God, God is Supreme'.

(*Vorherige Seiten*)

EIN Meer von Pilgern bei einer fünf-hundert Jahre alten Zeremonie: Hundert-tausende machen einmal im Leben ihre Hadsch (Wallfahrt nach Mekka) und voll-ziehen den Tawaf (siebenmaliges Umrunden der Kaaba). Dies ist das erste Gotteshaus auf Erden, errichtet von Abraham und seinem Sohn Ishmael, und in der Ecke eingeschlossen ist ein schwarzer Meteorit, den Gott dem gefallenen Adam nach-schleuderte. Die Pilger sollen den Stein küssen, doch wenn der Andrang zu groß ist, genügt es, darauf zu zeigen und zu rufen: »Im Namen Allahs, Allah ist groß!«

(*Pages précédentes*)

TOURBILLON de pèlerins au cours d'une cérémonie vieille de cinq cents ans : des dizaines de milliers de pèlerins effectuant leur *Hadj* (pèlerinage à La Mecque), que l'on doit faire une fois dans sa vie, exécutent le *Tawaf* (sept fois le tour de la *Ka'ba*). Voici la première maison de Dieu bâtie sur la terre par Abraham et son fils Ismaël. On y aperçoit, encastrée dans un coin, la météorite noire que le Seigneur projeta sur Adam tombé en disgrâce. Les pèlerins sont censés baiser la pierre ou, quand la foule se fait trop dense, se tourner vers le Seigneur en entonnant l'incantation : « Au nom de Dieu, Dieu est suprême. »

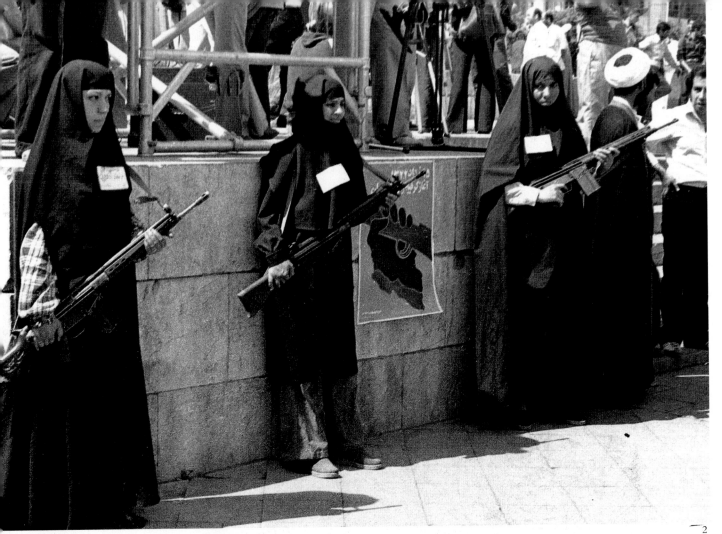

IT was with the Iranian Revolution of
1979 that a wave of politicized militancy
swept through the Moslem world (3).
Having forced their Shah into peripatetic
exile, the Iranians called on other Moslem
countries likewise to depose and replace
their 'westernized' rulers. Called 'fundament-
alism' by non-Moslems, the revolution was
epitomized by the creation of a theocratic
Islamic state by Ayatollah Khomeini (whose
picture is carried through Tehran, 1) and
by these women standing guard in Tehran
(2) – women issued with modern weapons
but directed to wear medieval clothing,
with heavy penalties for uncovering their
arms or hair.

IN der Folge der iranischen Revolution
von 1979 ging eine Welle der Politisie-
rung und Militarisierung durch die islamische
Welt (3). Nachdem die Iraner den Schah
in ein klägliches Exil gezwungen hatten,
riefen sie ihre moslemischen Brüder auf,
ihnen nachzueifern und ebenfalls ihre »ver-
westlichten« Herrscher abzusetzen. Sinn-
bilder dieser Revolution, die die Ungläubigen
»Fundamentalismus« nennen und die einen
theokratischen islamischen Staat begründe-
te, sind der Ayatolla Khomeini (dessen Bild

hier durch die Straßen Teherans getragen
wird, 1) und diese Frauen, die in Teheran
Wache halten (2) – Frauen, die moderne
Gewehre, doch mittelalterliche Kleidung
tragen, bei schwerer Strafe, wenn sie Arme
oder Haar entblößen.

AVEC la révolution iranienne de 1979,
le monde musulman fut traversé par
une vague de militantisme politico-religieux
sans précédent (3). Après avoir contraint
leur Chah à errer en exil, les Iraniens
exhortèrent les autres pays musulmans à
déposer eux aussi leurs « dirigeants occi-
dentalisés ». Taxée de « fondamentaliste »
par les non-musulmans, la révolution se
traduisit par l'instauration d'un état islamique
théocratique avec l'ayatollah Khomeyni à
sa tête (dont le portrait est arboré à travers
les rues de Téhéran, 1). Ces femmes qui
montent la garde à Téhéran (2), équipées
d'armes modernes, sont cependant enjoin-
tes de s'habiller de façon médiévale au
risque d'encourir de lourdes peines en cas
de désobéissance.

O N 21 October 1966 (the last school-day before the half-term holiday) Pantglas Junior School in Aberfan, South Wales, was buried beneath a giant slag-heap that engulfed it during heavy rains. During the miserable search through the sludge for bodies (1, 2), it turned out that nearly 200 people, from the school and 18 houses, had been entombed. Most were children, as can be seen by the diminutive coffins on the hillside above Aberfan (3). There were no survivors. The bad weather may have been 'natural' but the slag-heap, a relic of Wales's mining industry, was manmade, as was 'the disaster waiting to happen'. It was simply too near the village for safety.

A M 21. Oktober 1966 (dem letzten Schultag vor den Herbstferien) wurde die Pantglas Junior School in Aberfan, Südwales, unter einer gewaltigen Abraum-halde begraben, die bei schwerem Regen ins Rutschen gekommen war. An die 200 Menschen waren in der Schule und in 18 Häusern verschüttet, und verzweifelt wurde nach den Opfern gesucht (1, 2). Die meisten waren Kinder, wie man an den winzigen Särgen auf dem Hügel sehen kann (3). Es gab keine Überlebenden. Das schlechte Wetter mag »natürlich« gewesen sein, doch es war eine »Katastrophe, die nur darauf wartete, daß sie geschah«.

C E 21 octobre 1966 (le dernier jour d'école avant les vacances scolaires trimestrielles), l'école Pantglas Junior School à Aberfan, au pays de Galles, fut submergée par un terril qu'entraînèrent des pluies torrentielles. Les recherches entreprises pour retrouver les corps sous les tonnes de boue se déroulèrent dans des conditions épouvantables (1, 2) : environ 200 person-nes de l'école et 18 habitants des maisons environnantes avaient été ensevelis. Il s'agis-sait pour la plupart d'enfants (3). Il n'y eut aucun survivant. Le mauvais temps était un phénomène inévitable, mais le terril était surtout beaucoup trop proche du village pour être inoffensif.

1

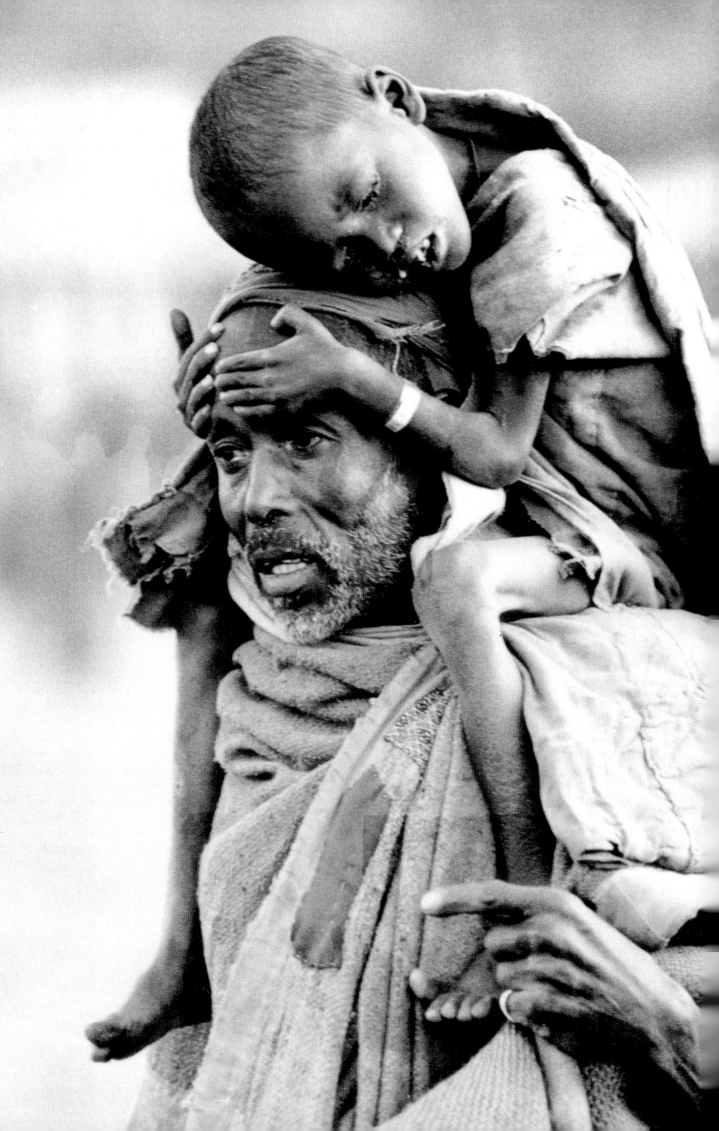

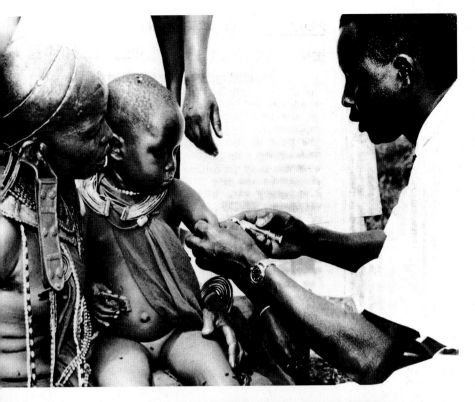

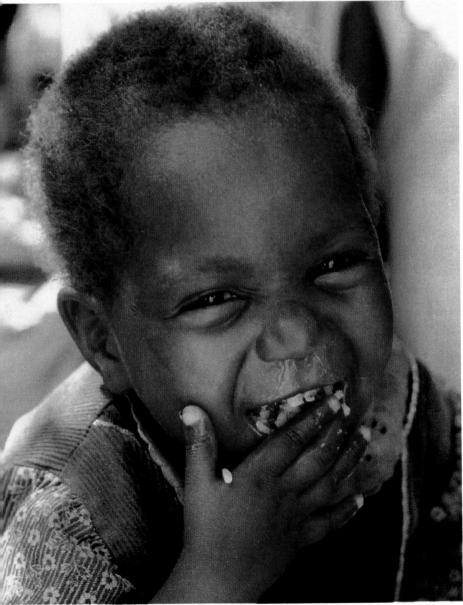

IN 1979 the UN declared the Year of the Child. In 1946 UNICEF was founded with a brief to provide every child on the planet with adequate nourishment, health, education and preparation for life. Here in the Sudan a vaccination programme gets under way (2): the eradication of smallpox and polio are two of UNICEF's major goals. Ethiopia in 1984, and a repeat of the critical famine conditions of 12 years earlier. In this area of Korem, this father and son are among 30,000 refugees who have been banished to the desert (1). In Mogadishu, Somalia, in 1993 this little girl is a survivor among over 300,000 who died (3).

DAS Jahr 1979 erklärten die Vereinten Nationen zum Jahr des Kindes. 1946 war die UNICEF gegründet worden, mit dem Ziel, jedem Kind auf der Welt genügend Nahrung, Gesundheit, Erziehung und einen guten Start ins Leben zu sichern. Hier im Sudan ist ein Impfprogramm im Gange (2) – die Ausmerzung von Pocken und Kinderlähmung gehört zu den größten Zielen der UNICEF. Äthiopien im Jahre 1984, als die Hungersnot, die das Land zwölf Jahre zuvor heimgesucht hatte, zurückkehrte. Dieses Bild von einem Vater mit seinem Sohn entstand in der Region Korem, zwei von 30 000 Flüchtlingen, die in die Wüste verbannt sind (1). Das kleine Mädchen, 1993 in Mogadischu aufgenommen (3), hat überlebt, doch über 300 000 Somalis kamen um.

L'ONU fit de l'an 1979 l'année de l'enfant. C'est en 1946 que l'Unicef fut instituée. Elle se fixait pour tâche d'assurer à chaque enfant de la planète de la nourriture, des soins, une instruction et une préparation à la vie. Un programme de vaccination est ici en cours au Soudan (2). L'éradication de la variole et de la polio sont deux des grands objectifs à mettre à l'actif de l'Unicef. L'Éthiopie, en 1984, revivait la grave famine qui avait frappé le pays douze ans auparavant. Dans la région de Korem, ce père et son fils font partie des trente mille réfugiés bannis dans le désert (1). À Mogadiscio, en Somalie, cette petite fille a survécu en 1993 à la mort qui a frappé plus de 300 000 personnes (3).

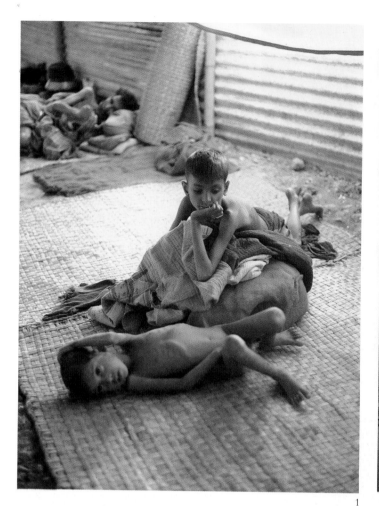

1 2

A T Mirpur Relief Camp outside Dacca, Bangladesh, in 1976 a mother waits in exhaustion in a food queue with her children (3); starving children lie on rush matting inside the shelter (1); a father carries his dead child to the cemetery (2). The parents' expressions are eloquent. There is something against the natural law when children predecease the older generation.

D IE Hilfsstation Mirpur außerhalb von Dakka, Bangladesch, im Jahre 1976: eine halbverhungerte Mutter wartet mit ihren Kindern in der Schlange vor der Essensausgabe (3); hungernde Kinder liegen auf Binsenmatten in der Station (1); ein Vater trägt sein totes Kind zum Friedhof (2). Die Mienen der Eltern sprechen für sich. Es ist gegen die Natur, wenn die Kinder vor der älteren Generation sterben müssen.

1 976 : dans le camp de secours de Mirpur à l'extérieur de Dacca, au Bangladesh, une mère fait la queue avec ses enfants, épuisée, pour recevoir des aliments (3) ; de enfants affamés sont allongés sur des paillasses en jonc à l'intérieur de l'abri (1) ; un père porte son enfant mort au cimetière (2). Les expressions qui sont peintes sur les visages des parents sont éloquentes. Il y a quelque chose de terrifiant à voir des enfants précéder les aînés dans la mort.

D ESPITE the Clean Air Act of 1956, Manchester in the 1970s suffered from a yellowish fog caused by polluting emissions (3). The 1974 Nypro chemical plant disaster killed 28 outright and turned Flixborough into a ghost village (1). Twenty years later the oil tanker *Braer* ran aground after losing power in a storm (2).

O BWOHL es seit 1956 Gesetze gegen Luftverschmutzung gab, litt Manchester noch in den 70er Jahren unter gefährlichen Rauchschwaden aus den Schornsteinen (3). Das Unglück im Chemiewerk Nypro 1974 tötete 28 Menschen und machte aus Flixborough ein Geisterdorf (1). Zwanzig Jahre später lief der Öltanker *Braer* im Sturm auf Grund (2).

E N dépit de la loi sur l'air propre de 1956, Manchester étouffait encore dans un brouillard jaunâtre dans les années 70 (3). L'usine chimique de Nypro, en 1974, tua 28 personnes et transforma Flixborough en village fantôme (1). Le pétrolier *Braer* s'échoua vingt ans après sa panne (2).

EVEN disasters can have their comical aspects. The 1993 floods in Faidhabad, Northern India, bring out children jumping from back to back of the buffaloes marooned in village floodwaters (1). Across Haryana. In the same month, but across the world in West Quincy, Illinois, a McDonald's billboard, still illuminated, pokes up from the Mississippi River after a levée burst (3). The Mayon volcano in the Philippines erupts in cascades of dust and lava (2). The Los Angeles earthquake of January 1994 created havoc through the city, with thousands (particularly the poorer people) still homeless eighteen months later. Here paramedic Dave Norman hoists rescue equipment in a tiny crevice of a collapsed parking lot (4).

SELBST Katastrophen können ihre komischen Seiten haben. Bei den Überschwemmungen im nordindischen Faidhabad, 1993, springen Kinder von einem Büffelrücken zum anderen, denn die Tiere sitzen im Wasser fest (1). Im selben Monat, doch am anderen Ende der Welt, steht in West Quincy im amerikanischen Bundesstaat Illinois ein Reklameschild von McDonald's, noch immer beleuchtet, nach einem Dammbruch in den Fluten des Mississippi (3). Beim Ausbruch des Vulkans Mayon auf den Philippinen steigen Rauchwolken und Lava auf (2). Das Erdbeben in Los Angeles im Januar 1994 richtete in der ganzen Stadt Verwüstungen an, und Tausende (gerade in den ärmeren Vierteln) waren auch anderthalb Jahre später noch ohne Unterkunft. Hier läßt der Rettungssanitäter Dave Norman seine Ausrüstung durch einen winzigen Spalt in ein eingestürztes Parkhaus hinab (4).

LES catastrophes elles-mêmes compor-
tent parfois certains aspects comiques.
Les inondations de 1993 à Faidhabad, dans
le nord de l'Inde, donnent aux enfants
l'idée de bondir du dos d'un buffle aban-
donné à l'autre dans le village inondé (1).
Le même mois, mais à l'autre bout du monde,
plus exactement à West Quincy dans
l'Illinois, l'enseigne du McDonald, qui est
restée illluminée, surnage sur le Mississipi
après l'affaissement d'une levée (3). Le
volcan Mayon en éruption aux Philippines
projette des cascades de poussière et de
lave (2). Le tremblement de terre à Los
Angeles en janvier 1994 sema la destruc-
tion dans la ville, laissant des milliers de
gens (notamment les plus pauvres) dix-huit
mois après, toujours sans foyer. On voit ici
Dave Norman, membre des services para-
médicaux, hisser du matériel de secours à
l'intérieur d'une minuscule faille qui s'est
creusée dans un lot de places de stationne-
ment effondré (4).

THE city of Kobe, Japan, was the epicentre of an earthquake which killed over 7,000 people in 1995 (1, 2). Cycles become the only functional means of transport (3). Emperor Akihito and Empress Michiko tour the disaster area (4).

DIE japanische Stadt Kobe lag im Zentrum eines Erdbebens, bei dem 1995 siebentausend Menschen umkamen (1, 2). Fahrräder waren die einzigen Transportmittel, mit denen man noch durchkam (3). Kaiser Akihito und Kaiserin Michiko besuchen das Katastrophengebiet (4).

LA cité de Kobe, au Japon, se trouvait sur l'épicentre du tremblement de terre qui tua plus de sept cent mille personnes en 1995 (1 et 2). Les bicyclettes sont devenues les seuls moyens de transport fonctionnels (3). L'empereur Akihito et l'impératrice Michiko se rendent sur les lieux sinistrés (4).

MOST of England's home matches were played at league club grounds until the 1950s, despite the availability of Wembley Stadium, which staged its first international in 1924 (England drawing 1-1 with Scotland). In fact until 1951, the only international matches played at Wembley were those between England and Scotland. White Hart Lane, the home of Tottenham Hotspur, hosted this match between England and France, England winning 4-1. Before the kick-off, the respective captains pose with three exotically dressed ladies (1).

DIE meisten Heimspiele der englischen Nationalmannschaft wurden bis in die 50er Jahre hinein auf den Plätzen der Fußballclubs gespielt, obwohl das Wembley Stadion zur Verfügung stand, wo das erste internationale Spiel 1924 stattgefunden hatte (England gegen Schottland, 1:1). Bis 1951 blieben die Spiele England gegen Schottland die einzigen internationalen, die in Wembley ausgetragen wurden. White Hart Lane, Heimat der Tottenham Hotspurs, war Schauplatz dieses Länderspiels England gegen Frankreich, das die Engländer 4:1 gewannen. Vor dem Anstoß lassen sich die Mannschaftskapitäne mit exotisch gewandeten Damen aufnehmen (1).

JUSQUE dans les années 50, malgré un stade de Wembley tout à fait disponible, la plupart des matchs joués à domicile par l'Angleterre se déroulaient sur les terrains des clubs de *League*. C'est en 1924 qu'on organisa à Wembley le premier match international (l'Angleterre ayant fait égalité 1 à 1 avec l'Écosse). De fait, jusqu'en 1951, les seuls matches internationaux disputés à Wembley furent ceux qui mettaient en présence les équipes d'Angleterre et d'Écosse. White Hart Lane, la patrie de Tottenham Hotspur, accueille cette rencontre opposant l'Angleterre et la France, que la première remportera 4 à 1. Avant le coup d'envoi, les capitaines des équipes respectives se font photographier près de trois dames habillées de façon exotique (1).

ENGLAND (in dark shirts) score in the 3-1 victory over newly-crowned world champions West Germany at Wembley, December 1954 (2). Two of England's goalscorers are in the photograph; number 8 Roy Bentley (Chelsea) and, facing the camera, Ronnie Allen (West Bromwich Albion). Seven months earlier, England suffered a humiliating 7-1 defeat at the hands of Hungary in a pre-World Cup friendly played in Budapest. The 'Magical Magyars', as they were known, reached the final of the World Cup that year only to lose 3-2.

ENGLAND (im dunklen Trikot) erringt in Wembley einen 3:1-Sieg über den frischgekürten Weltmeister Westdeutschland, Dezember 1954 (2); zwei der englischen Torschützen sind zu sehen: Roy Bentley (Chelsea), Nummer 8, und, mit Blick in die Kamera, Ronnie Allen (West Bromwich Albion). Sieben Monate zuvor hatten die Engländer bei einem Freundschaftsspiel im Vorfeld der Weltmeisterschaft in Budapest eine beschämende 7:1-Niederlage einstecken müssen. Die »Magischen Magyaren«, wie sie genannt wurden, kamen ins Weltmeisterschafts-Endspiel jenes Jahres, doch sie verloren 3:2.

L'ANGLETERRE (en maillot sombre) marquant un but au cours de la rencontre à Wembley remportée 3 à 1 contre l'Allemagne de l'Ouest, alors tout récemment sacrée championne du monde en décembre 1954 (2). Deux buteurs de l'équipe anglaise photographiés : le maillot numéro 8 de Roy Bentley (Chelsea) et, faisant face à l'objectif, Ronnie Allen (West Bromwich Albion). Sept mois plus tôt, l'Angleterre avait subi une défaite humiliante, battue 7 à 1 par la Hongrie à Budapest à l'issue du match amical précédant la Coupe du monde. Les « Magyars magiques », comme on les nommait, parvinrent la même année jusqu'à la finale de la Coupe du monde qu'ils perdirent avec deux buts à trois.

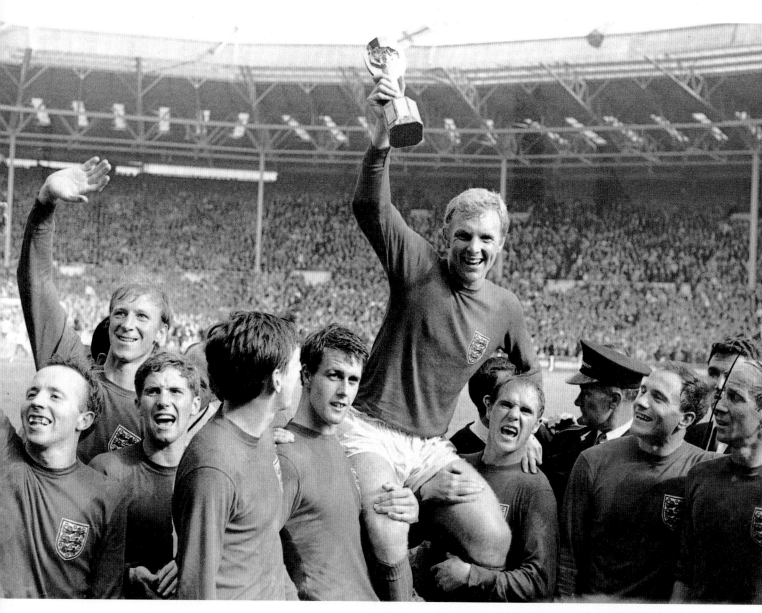

ENGLISH football captain Bobby Moore being chaired after England's victory over West Germany in the 1966 World Cup Final, which had 50 per cent of the British population tuned in (1). Moore, a West Ham United player, won 108 caps in his career – more than any other professional. At the final of the Soccer World Championships in 1974, West Germany won 2-1 against Holland to become World Champions. Here team member Franz Beckenbauer is embraced by coach Helmut Schön at the end of the match (2). Brazilian player Zito celebrates scoring a second goal in his country's International against Czechoslovakia, played in Santiago, Chile, in 1962 (3). Brazil went on to win 3-1. Pele, the most famous Brazilian player of all time, displaying the trophy (4) after he helped Brazil win the 1970 World Cup in Mexico.

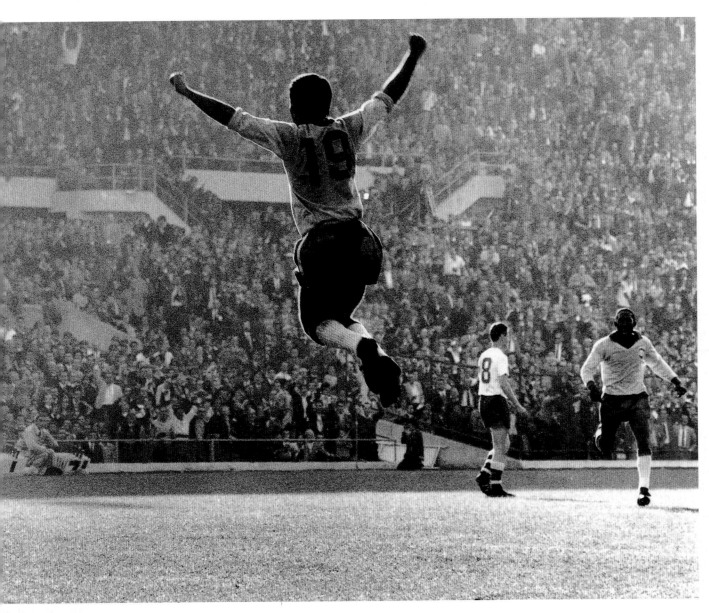

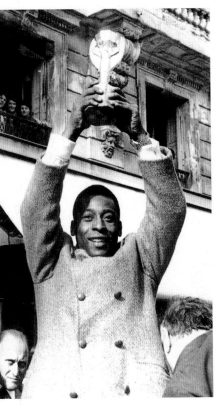

DER Kapitän der englischen Mannschaft, Bobby Moore, wird nach dem Sieg über Westdeutschland im Endspiel um den Weltmeisterschaftstitel 1966, ein Spiel, bei dem die Hälfte der britischen Bevölkerung an den Fernseh- und Radiogeräten saß, auf die Schultern gehoben (1). Moore, der für West Ham United spielte, wurde im Laufe seiner Karriere 108mal für die Nationalmannschaft aufgestellt – mehr als jeder andere Profifußballer. Im Endspiel der Weltmeisterschaft des Jahres 1974 gewann Westdeutschland gegen Holland 2:1. Hier wird Franz Beckenbauer am Ende des Spiels von Trainer Helmut Schön umarmt (2). Der brasilianische Spieler Zito freut sich im Länderspiel gegen die Tschechoslowakei, 1962 in Santiago de Chile, über sein zweites Tor (3). Brasilien gewann 3:1. Der Brasilianer Pelé, der berühmteste Fußballspieler aller Zeiten (4), hebt stolz den Weltmeisterschaftspokal des Jahres 1970, den die Brasilianer in Mexiko gewannen.

LE capitaine de l'équipe anglaise de football, Bobby Moore, est porté en triomphe après la victoire de l'Angleterre sur l'Allemagne de l'Ouest à la finale de la Coupe du monde en 1966, qui fut suivie à la radio par 50 % de la population britannique (1). Moore remporta 108 trophées au cours de sa carrière – plus que tout autre joueur professionnel. À la finale du championnat du monde, en 1974, l'Allemagne de l'Ouest battit la Hollande 2 à 1 et devint ainsi championne du monde. On voit ici le joueur Franz Beckenbauer embrassé par l'entraîneur Helmut Schön à la fin du match (2). Le joueur brésilien Zito, fou de joie après son deuxième but au cours de la rencontre avec la Tchécoslovaquie. C'était à Santiago, au Chili, en 1962 (3). Le Brésil continua sur sa lancée en l'emportant 3 à 1. Pelé, le joueur brésilien le plus célèbre de tous les temps, (4), après la victoire du Brésil lors de la Coupe du monde de Mexico en 1970.

WEST Germany's centre forward Uwe Seeler is brought down by Uruguay's Manicera in the 1966 World Cup quarter-finals (1). Barcelona's captain Johan Cruyff, Holland's most gifted international, disputing his sending off before being escorted away by two policemen (2). George Best here seen in 1976 with Fulham at the twilight of his outstanding career (3). Argentina's Diego Maradona (4), valued in the 1970s at £3 m, and possibly the greatest player ever, sabotaged his later career through drugs. Pelé celebrates with tears after Brazil's victory in the 1970 World Cup Final (5).

DER westdeutsche Mittelstürmer Uwe Seeler wird beim Weltmeisterschafts-Viertelfinale 1966 von Manicera aus Uruguay zu Fall gebracht (1). Hollands begabtester internationaler Spieler Johan Cruyff, der als Kapitän für Barcelona spielte, protestiert gegen seinen Platzverweis, doch zwei Polizisten eskortieren ihn vom Feld (2). George Best, hier 1976 mit

Fulham gegen Ende seiner Karriere (3).
Der Argentinier Diego Maradona (4) war
einer der größten Fußballspieler überhaupt;
später machte ihm Kokainsucht schwer
zu schaffen. Pelé mit Freudentränen, als
Brasilien 1970 den Weltmeisterschaftstitel
erringt (5).

SEELER, l'avant-centre allemand, est
envoyé au sol par Manicera, joueur
uruguayen, au cours des quarts de finale de
la Coupe du monde en 1966 (1). Le capi-
taine de Barcelone, Johan Cruyff, talen-
tueux international hollandais, conteste son
expulsion du terrain avant de s'exécuter,
escorté par deux policiers (2). George Best,
qu'on voit ici en 1976 jouer pour Fulham
à l'époque mal connue de sa remarquable
carrière (3). L'Argentin Diego Maradona
(4), estimé à trois millions de livres dans
les années 70, sans doute le plus formidable
joueur de tous les temps, dont la fin de
carrière fut sabotée par la cocaïne. Pelé
pleure de joie lors de la Coupe du monde
en 1970 (5).

SUZANNE Lenglen in play at the Wimbledon Lawn Tennis Championships, which she won in 1925 (1). Fred Perry, playing here in the men's semifinals in 1936, won the men's singles for the third year running (2). In 1975, US player Arthur Ashe made tennis history to become the first black Wimbledon champion (3). Björn Borg's double-handed grip served to confuse the opposition as to whether he was coming in for a forehand or backhand shot. Here he is in action against Yugoslav Nicky Pilic in 1977 (4). He was unbeaten at Wimbledon between 1976 and 1980. Martina Navratilova (5) went on to win the Wimbledon women's singles nine times before retiring in 1994 after missing the much sought-after tenth record-breaking triumph.

SUZANNE Lenglen in voller Aktion beim Tennisturnier in Wimbledon, das sie im Jahre 1925 gewann (1). Fred Perry, hier im Halbfinale der Herren 1936, gewann den Pokal drei Jahre in Folge (2). 1975 machte der Amerikaner Arthur Ashe Tennisgeschichte als erster schwarzer Wimbledonsieger (3). Björn Borgs doppelhändiger Griff verwirrte den Gegner, der nie wußte, ob er Vor- oder Rückhand spielen würde. Hier sieht man ihn 1977 im Match gegen den Jugoslawen Nicky Pilic (4). Zwischen 1976 und 1980 konnte ihn keiner in Wimbledon schlagen. Martina Navratilova (5) gewann das Damen-Einzel neunmal; 1994 beendete sie ihre Karriere, nachdem ihr der zehnte Triumph, mit dem sie einen neuen Rekord aufgestellt hätte, nicht geglückt war.

SUZANNE Lenglen, vainqueur au championnat de tennis à Wimbledon en 1925 (1). Fred Perry, qu'on voit ici disputer les demi-finales messieurs en 1936 remporta le simple messieurs pour la troisième année consécutive (2). En 1975, le joueur américain Arthur Ashe fut le premier champion Noir vainqueur à Wimbledon (3). Björn Borg, dont le jeu à deux mains désorientait ses adversaire. Le voici en action en 1977 contre le Yougoslave Nicky Pilic (4). Il resta invincible à Wimbledon de 1976 à 1980. Martina Navratilova (5) y remporta neuf fois le simple dames. Jusqu'à sa retraite, en 1994, elle ne parviendra pas à battre le record du monde en remportant la dixième victoire nécessaire.

1

2 3

4 5

2

OTHER star names of the 1980s included Gabriela Sabatini of Argentina (1), whose stunning looks caused quite a stir, and Ivan Lendl, the Czech who repeatedly returned without ever quite winning (2). West German Boris Becker, coached since early childhood by his father, won in both 1985, 1986 and 1989 (3), while American André Agassi became as famous for his fashions (which included shaving his chest and legs) as for his play (4).

WEITERE Tennisstars der 80er Jahre in Wimbledon waren die Argentinierin Gabriela Sabatini (1), die auch als Schönheit Aufsehen erregte, und der Tscheche Ivan Lendl, der immer wieder dabei war und doch nie gewann (2). Boris Becker schon als Kind von seinem Vater trainiert, siegte 1985, 1986 und 1989 (3). Der Amerikaner André Agassi war für sein Modebewußtsein (er rasierte sich Brust und Beine) ebenso berühmt wie für sein Spiel (4).

PARMI les autres étoiles des années 80, on trouve l'Argentine Gabriela Sabatini (1), dont les tenues époustouflantes ne manquaient pas de susciter l'émoi, ainsi qu'Ivan Lendl, le Tchèque qui revenait toujours sans jamais vraiment parvenir à décrocher la victoire (2). L'Allemand Boris Becker, entraîné par son père depuis sa plus tendre enfance, fut vainqueur en 1985, 1986 et en 1989 (3), tandis que l'Américain André Agassi se rendait autant célèbre par ses fantaisies (comme celle de se raser la poitrine et les jambes) que par son jeu (4).

THE 1936 Olympic Games: those cheering wear logos as diverse as India and Brazil (1). The Olympic torch is run into the stadium beneath ranked banners of swastikas surmounted with eagles (2). Jesse Owens, US sprinter and long-jumper, is seen practising on board the SS *Manhattan* (3), on his way to represent his country – against Hitler's expressed wishes.

OLYMPISCHE Spiele 1936: begeisterte Zuschauer, darunter Inder und Brasilianer (1). Das olympische Feuer wird vor adlergekrönten Hakenkreuzflaggen ins Stadion getragen (2). Jesse Owens, Läufer und Weitspringer aus den USA, trainiert noch an Bord der SS *Manhattan*, um sein Land, gegen Hitlers ausdrücklichen Wunsch, zu vertreten (3).

LES Jeux olympiques de 1936 : ceux qui acclament portent des inscriptions aussi diverses que « Inde » et « Brésil » (1). La flamme olympique traverse une rangée de croix gammées et d'aigles (2). L'Américain Jesse Owens, sprinter et sauteur en longueur, s'entraînant à bord du SS *Manhattan* (3), pour aller représenter son pays, contre les vœux de Hitler.

2

1 3

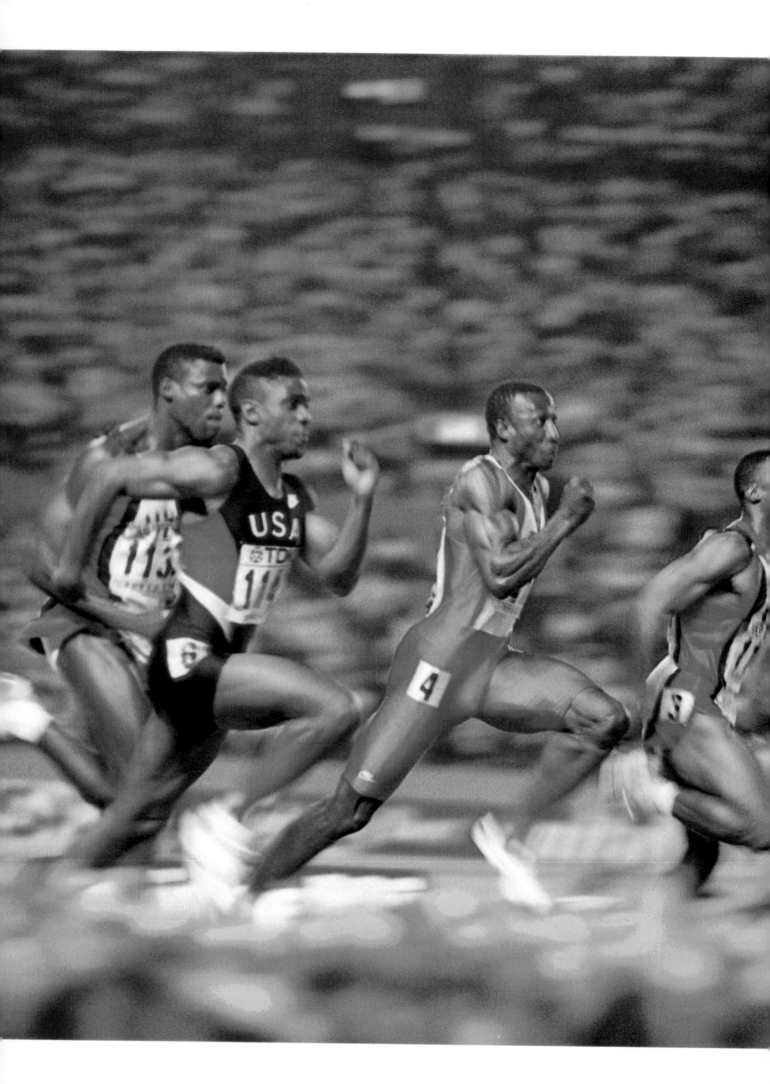

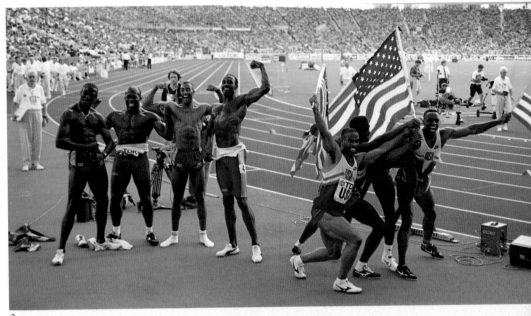

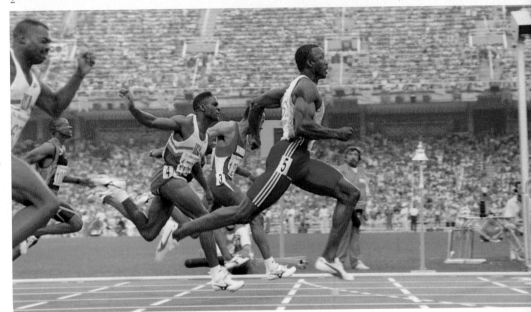

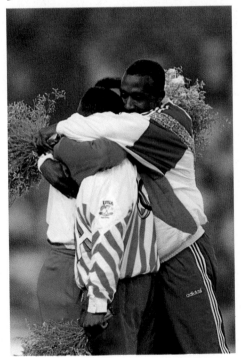

I N Tokyo in 1991, Carl Lewis (USA) set
a new men's 100 m record (1). In 1992
Linford Christie (UK) won the silver at the
Barcelona Olympics 100 m (3, 4). In the
1993 World Championships, the US (gold)
and British (silver) 100 m teams celebrate (2).

I N Tokio stellte der Amerikaner Carl Lewis
1991 einen neuen 100-Meter-Rekord
auf (1). 1992 gewann Linford Christie Silber
im Hundertmeterlauf bei den Olympischen
Spielen in Barcelona (3, 4). Bei der WM
1993 jubeln das amerikanische (Gold) und
das britische 100-Meter-Team (Silber, 2).

À Tokyo, en 1991, Carl Lewis (États-
Unis) a le nouveau record du 100 m (1).
En 1992, Linford Christie (G.-B.) est second
du 100 m aux Jeux olympiques de Barcelone
(3, 4). Aux championnats du monde de
1993, Américains (or) et Britanniques (argent)
du 100 m fêtent leur victoire (2).

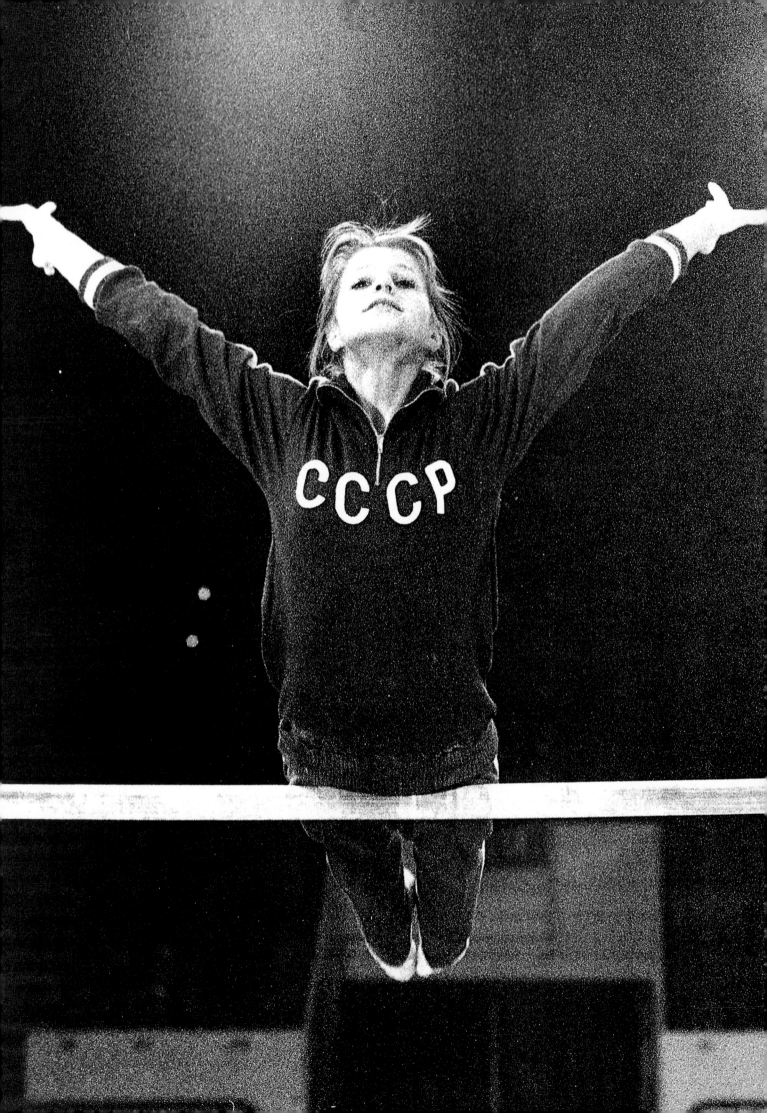

RUSSIAN Olga Korbut, aged 20 here in 1975, rehearsing for the World Athletics Championships (1), following up her successes in the Olympic Games. Gwang-Suk Kim, of the People's Republic of (North) Korea, was another precocious 'wonder child', here seen performing on the asymmetric bars at the 1992 Barcelona Olympics (2).

DIE Russin Olga Korbut, hier 1975 mit zwanzig Jahren (1), trainiert nach ihrem großen Erfolg bei den Olympischen Spielen für die Leichtathletik-Weltmeisterschaft. Gwang-Suk Kim aus Nordkorea, ebenfalls ein »Wunderkind«, am Stufenbarren bei den Olympischen Spielen 1992 in Barcelona (2).

LA Russe Olga Korbut, alors âgée de vingt ans en 1975, se prépare ici aux championnats du monde d'athlétisme (1), après ses succès aux Jeux olympiques. Gwang-Suk Kim, de la république populaire de Corée (du Nord), était un autre de ces « jeunes talents » précoces : on le voit ici aux barres asymétriques pendant les Jeux olympiques de Barcelone en 1992 (2).

2

Mr and Mrs Joe Louis take a stroll in 1936 (1). The following year he won the World Heavyweight Championship, holding it until 1949, the longest reign ever. In July 1951, Sugar Ray Robinson was caught by photographer Bert Hardy, practising at a gym in Paris shortly before his British match against Randolf Turpin (2). Robinson lost nine out of fifteen rounds and needed 14 stitches over his eye. This US heavyweight is the only champion ever to win under two names – first as Cassius Clay in 1964, then, after his conversion to Islam, as Muhammed Ali ten years later. He never missed an opportunity to say that he was the greatest champion of all time – and he probably was. He is pictured giving Sonny Liston 'a good whuppin' (his description) in their 1964 world title fight (3). Two years later, Muhammed Ali was pictured training at the Territorial Army Gymnasium, White City, London (4).

Mr. Joe Louis und Gattin machen einen Spaziergang, 1936 (1). Im folgenden Jahr wurde Joe Louis Weltmeister im Schwergewicht und hielt diesen Titel bis 1949, länger als jeder andere. Der Photograph Bert Hardy hielt Sugar Ray Robinson im Juli 1951 beim Training in einer Pariser Sporthalle fest, kurz vor seinem Kampf gegen Randolf Turpin in England (2). Robinson verlor neun von fünfzehn Runden und mußte über dem Auge mit vierzehn Stichen genäht werden. Dieser amerikanische Schwergewichtler ist der einzige Champion, der unter zwei verschiedenen Namen den Titel gewann: zuerst 1964 als Cassius Clay, und dann, nach seiner Bekehrung zum Islam, zehn Jahre später als Muhammed Ali. Er ließ nie eine Gelegenheit aus zu verkünden, daß er der Größte aller Zeiten sei – und wahrscheinlich war er das tatsächlich. Im Kampf um den Weltmeisterschaftstitel 1964 sieht man ihn mit Sonny Liston, den er (wie er das

nannte) »ordentlich durchwalkt«. Die Auf-
nahme von Muhammed Ali beim Training
entstand zwei Jahre später im Territorial
Army Gymnasium, White City, London (4).

En 1936 se promènent Mme et M. Joe
Louis (1). Il remportait l'année sui-
vante le championnat du monde des poids
lourds pour conserver son titre jusqu'en
1949, un record en matière de longévité.
En juillet 1951, Sugar Ray Robinson
est surpris par le photographe Bert Hardy
tandis qu'il s'entraîne dans une salle de
gymnastique parisienne peu de temps avant
le match qui doit l'opposer à Randolf
Turpin (2). Robinson perdit neuf rounds
sur quinze et dut recevoir quatorze points

de suture à l'arcade sourcilière. Ce poids
lourd américain est le seul champion à
avoir remporté la victoire sous deux noms :
d'abord en tant que Cassius Clay en 1964,
puis, dix ans plus tard, après sa conversion
à l'Islam, sous celui de Mohammed Ali.
Il ne perdait jamais une occasion de répéter
qu'il était le plus grand champion de tous
les temps, ce qui était probablement vrai.
On le voit ici mettre « une bonne râclée »
(selon son expression) à Sonny Liston lors
du combat qu'ils livrèrent en 1964 pour
le titre de champion du monde (3). Deux
années plus tard, Mohammed Ali est
photographié en plein entraînement au
gymnase de la « Territorial Army », à
White City, dans la capitale britannique (4).

THE racing driver Ayrton Senna was
such a hero in his native Brazil that
when he was killed on the racetrack in
May 1994, Brazil went into three days of
national mourning. Here he is engaged
in the Japanese (2) and the Australian (1)
Grand Prix races in 1993.

DER Rennfahrer Ayrton Senna war
in seinem Heimatland Brasilien ein
solcher Volksheld, daß drei Tage Staats-
trauer angeordnet wurden, als er im Mai
1994 bei einem Unfall umkam. Hier sieht
man ihn 1993 bei den Rennen in Japan (2)
und Australien (1).

POUR Ayrton Senna, considéré comme
un héros par son peuple, le Brésil prit
officiellement le deuil trois jours durant
lors de sa disparition sur un circuit en mai
1994. On le voit ici disputant les Grands
Prix japonais (2) et australien (1) en 1993.

1 2

3

BRITISH racing driver Graham Hill relaxes at home in North London in 1962, watched by his wife Bette holding their daughter Bridget, and by tiny fellow competitor and son Damon (1). Over thirty years later, in 1993, the self-same son participates in the Italian Grand Prix (2). At the Monaco Grand Prix of 1992, Eric Comas leads Martin Brundle, Riccardo Patrese and Gerhard Berger (3), while in the same year Nigel Mansell and Michael Schumacher celebrate after the Mexican Grand Prix (4).

DER britische Rennfahrer Graham Hill ruht sich in seinem Haus im Londoner Norden aus, 1962, und seine Frau Bette mit Tochter Bridget im Arm sieht zu, wie Sohn Damon dem Vater Konkurrenz macht (1). Über dreißig Jahre später: derselbe Damon beim Großen Preis von Italien (2). In Monaco, 1992, liegt Eric Comas vor Martin Brundle, Riccardo Patrese und Gerhard Berger in Führung (3), und im selben Jahr feiern Nigel Mansell und Michael Schumacher nach dem Großen Preis von Mexiko (4).

LE coureur automobile britannique Graham Hill se détend chez lui en 1962, dans le nord de Londre, avec son épouse Bette, qui tient leur fille Bridget, et son tout petit concurrent de fils, Damon (1). Plus de trente ans plus tard, celui-ci participe au Grand Prix d'Italie (2). Grand Prix de Monaco en 1992 : Eric Comas mène ici devant Martin Brundle, Riccardo Patrese et Gerhard Berger (3). La même année, Nigel Mansell et Michael Schumacher fous de joie après le Grand Prix du Mexique (4).

Index

How to buy or license a picture from this book

The pictures in this book are drawn from the extensive archives of The Hulton Getty Picture Collection. One of the largest picture libraries in the world, the collection contains approximately 15 million images, some of which d. from the earliest days of photography. Originally formed in 1947 as the Hulton Press Library, it includes original material from leading press agencies – Topical Press, Keystone, Central Press, Fox Photos and General Photographi Agency as well as from *Picture Post* magazine, *The Daily Express* and the *Evening Standard*.

Picture Licensing Information
To license any of the pictures in the book Please call Hulton Getty, or the network of Getty Images offices worldwide, with your picture selection quoting the page reference and subject.

Hulton Getty Online
All the pictures in the book and countless others are available via Hulton Getty Online **at: http://www.hultongetty.com**

Buying a print
For details of how to purchase exhibiti quality prints call **The Hulton Getty Picture Gallery + 44 020 7 376 452**

Tel: **+44 020 7266 2662**, Fax: **+44 020 7266 3154**, e-mail: **info@getty-images.com**

Picture Credits and Leading Photographers

Abbé, James 530.1, 561.3
Abrahams, Horace 615.6
courtesy Anne Frank Foundation 487.3
Alan Band Photos/Hulton Getty 692.1, 776.1, 887.3
Ambler, Maurice (for Picture Post) 485, 673.2
Apple Corps 788
Auerbach, Erich 721, 722.1, 724–725, 733.3, 735.3, 740, 750.3, 758.2
Baron 674.2, 676.1, 679.2, 749.2
Beato, Felice 44.2, 45.3, 52.4, 328, 329
Brady, Matthew 330.2, 333.3, 454.1, 454.2
Brandt, Bill (for Picture Post) 630–631, 632.1, 632.3
Capa, Robert (Life/Pool/Keystone) 588.1, 589.3
Carjat, Etienne, 16.6, 16.9
Chillingworth, John (for Picture Post) 517.3, 638
Consolidated News, Washington 850.1, 817.5
Davey, C. (for Evening Standard) 702.1
Downey, W. & D. 17.5, 17.6, 83.2, 110.2, 158.1, 158.4, 159.5, 162.1, 163.2, 168.3, 179.4, 354.2, 355.3
Delamotte, Philip Henry 426.1, 426.2, 427.4
Dutkovich, Martin (for Picture Post) 635.2
Eason, Steve 779.3, 833
Ellidge, Mark 845.5
Emerson, Peter Henry 25.2
Empics: Bildbyrån 885.2; Etherington, Steve 888, 890.2, 890.3, 891; Kinniard, Ross 878–879; O'Brien, Phil 882.1; Simpson, Neal 883.3, 883.4; Viera, Rui 883.2
England, William (for London Stereoscopic Company) 8, 66.1, 156.2, 215.3, 274.1, 278.1, 436.1, 437.2, 446–450
Esten, Jack (for Picture Post) 824.1, 824.2, 824.3, 824.4
Fenton, Roger 324, 325, 326
Ferraz, Peter 818.1
Fincher, Terry (for Daily Express) 814.2, 845.1, 845.2, 845.3, 845.4, 847.2
Frith, Francis 181.3, 185.3, 434, 454.3
Gardner, Alexander 330.1, 332.1, 334.1
Gould, Peter/Images N.Y. 716.2
Graham, Tim (for Evening Standard) 772

Grundy, William 28.1, 29.2, 463.2
Hardy, Bert (for Picture Post) 572.1, 645.1, 700.1, 823.5, 808.3
Hewitt, Charles 'Slim' (for Picture Post) 739.2, 810.2, 811.3
Hollyer, Fred 178.3
Howlett, Robert 431.2, 433.3
Hurley, Frank 468.2
Hutton, Kurt (for Picture Post) 516.2, 581.4, 651.2, 696–697, 701.2, 702.3
Jones, Roy (for Evening Standard) 780–781
Keegan, Peter (Keystone) 842.1
Khaldi, Yvgeni 594.3
Kleboe, Raymond (for Picture Post) 608.1, 744, 744.2,
Lancaster, Chris (for Daily Express) 830.1, 831.3, 831.4
Lange, Dorothea 511.4
Layfayette 743.3
London Stereoscopic Company 2, 17.2, 47.3, 67.2, 80, 85.4, 92.2, 97.5, 110.1, 144.1, 160.2, 161.2, 163.2, 177.4, 184.1, 185.2, 287.5, 435, 443.4, 470, 471
McCombe, Leonard (for Picture Post) 581.3
McKeown, Joseph (for Picture Post) 786.1
Man, Felix (for Picture Post) 736.1
Magee, Haywood (for Picture Post) 514.1, 515.2, 653.2, 759.3
Marcus, Eli 494.1
Martin, Paul 38.4, 50.1, 52.2, 53.6, 96.1, 97.2, 98.1, 100.2
Marey, Jules 459.2
Mayall, Robert 354.1
Meagher, Stanley (for Daily Express) 815.3, 819.4
Miller, H. 612.1
Minihan, John (for Evening Standard) 773.3, 778.1
Mirror Syndication International 728.1, 796.4, 816, 828–829, 847.3, 848–849, 857.3, 862–863, 864–865
Morse, Ralph (Life/Pool/Keystone) 585.3, 589.2
Mortimer, F.J. 30.1, 31.3, 51.3, 62.1, 63.2, 75.3, 92.4, 99.3, 102.2, 103.4, 290.1, 477.2
Mott, F. (for Evening Standard) 776.6

Muybridge, Eadweard 170, 456
Nadar 17.9, 177.8, 270.1
NASA 478, 796–801, 803.3
Ponting, H.G. 468.1
Ramage, Frederick (Keystone) 582.3, 5 594.2, 596, 598–603, 604.1, 604.2, 614 628–629, 637.3, 714.1
Reuters: Brylan, Desmond 838.1; Burditt, Howard 838.2; Castro, Erik de 866.2; Christensen, Jeff 867.3; Dunhill, Alice 852.1; Kishore, Kamal 8 Koyodo Japan 868.3; Mayama, Kimima 869.2, 869.4; Ngwenya, Juda 839.3; Pryke, John 869.3; Rodwell, Crispin 8 Sell, Blake 867.4; Silverman, David 817 Wong, Andrew 861.3
Rider-Rider, William 382.1
Riis, Jacob 234, 236, 237
Robertson, James 327.3
Robinson, A.H. 264.1
Sache, John 36.1
Sasha (Alex Stewart) 489, 730.1, 736.1, 746.1
Seeberger Frères 490, 491
Shaglin, Ivan 594.1
Shishkin, A. (Slava Katamidze Collectio 795.4
Sime, Jimmy (Central Press) 732.1
Smith, W. Eugene (INP/Pool/Keystone)
Startup, Ronald (for Picture Post) 706
Stroud, George (for Daily Express) 776.3, Sunami, Soichi 748.1
Sutcliffe, Frank Meadow 84.2, 86
Thomson, John 38.3, 44.3, 48, 49.7, 52
Thiele, Reinhold 347–351
Todd, T.E. 34, 35, 60.2, 190–193
US Army Signal Corps 404.1
Ustinov, Alexander (Slava Katamidze Collection) 592.1
Valentine, James 26, 69.2, 433.4, 439.3
Walmsley Brothers 18, 19, 24.1, 29.3
Ware, Chris (Keystone) 695.3
Wasserman, Dimitri 17.12
Wood, Graeme (for Daily Express) 775.
Zelma, George (Slava Katamidze Collec 590.3